The Humanities
Cultural Roots and Continuities

SEVENTH EDITION

**VOLUME TWO
THE HUMANITIES
AND THE
MODERN WORLD**

Mary Ann Frese Witt
North Carolina State University at Raleigh

Charlotte Vestal Brown
North Carolina State University at Raleigh

Roberta Ann Dunbar
University of North Carolina at Chapel Hill

Frank Tirro
Yale University

Ronald G. Witt
Duke University

With the collaboration of

John Cell
Late of Duke University

Ernest D. Mason
Late of University of North Carolina Central University

John R. Kelly (emeritus)
North Carolina State University at Raleigh

WADSWORTH
CENGAGE Learning™

Australia • Brazil • Japan • Korea • Mexico • Singapore • Spain • United Kingdom • United States

**The Humanities: Cultural Roots and Continuities,
Seventh Edition**
Mary Ann Frese Witt et al.,

Editor-in-Chief: Jean Woy

Senior Sponsoring Editor: Nancy Blaine

Development Editor: Julie Dunn

Editorial Associate: Annette Fantasia

Senior Project Editor: Jane Lee

Editorial Assistant: Eddie Fournier

Art and Design Coordinator: Jill Haber

Senior Photo Editor: Jennifer Meyer Dare

Senior Composition Buyer: Sarah Ambrose

Senior Manufacturing Coordinator: Priscilla Bailey

Senior Marketing Manager: Sandra McGuire

Marketing Assistant: Ilana Gordon

Cover Image: *Caprice in Purple and Gold:
The Golden Screen*, 1864 by James McNeill Whistler
(c. 1834–1903). Courtesy of Freer Gallery of Art,
Smithsonian Institution, Washington, DC: Gift of
Charles Lang Freer.

For product information and technology assistance, contact us at
Cengage Learning Customer & Sales Support, 1-800-354-9706

For permission to use material from this text or product,
submit all requests online at **www.cengage.com/permissions**
Further permissions questions can be e-mailed to
permissionrequest@cengage.com

Library of Congress Control Number: 2003110167

ISBN-13: 978-0-618-41777-3

ISBN-10: 0-618-41777-X

Wadsworth
20 Channel Center Street
Boston, MA 02210
USA

Cengage Learning is a leading provider of customized learning solutions with office
locations around the globe, including Singapore, the United Kingdom, Australia,
Mexico, Brazil, and Japan. Locate your local office at **www.cengage.com/global**

Cengage Learning products are represented in Canada by Nelson Education, Ltd.

To learn more about Wadsworth, visit **www.cengage.com/wadsworth**

Purchase any of our products at your local college store or at our preferred online
store **www.cengagebrain.com**

Printed in the United States of America
5 6 13 12

Contents

CHAPTER THIRTY-ONE **Modernism: Visual Arts, Music, and Dance 356**

CHAPTER THIRTY-TWO **Modernism: Theater and Literature 390**

PART ELEVEN *Cultural Plurality: From the Middle
Twentieth Century On* 423

CHAPTER THIRTY-THREE **Absurdity and Alienation: World
War II and the Postwar Period** 424

CHAPTER THIRTY-FOUR **Postcolonialism, Postmodernism,
and Beyond** 457

Reading Selections

Illustrations

Preface

The seventh edition of *The Humanities: Cultural Roots and Continuities* has benefited from the suggestions of readers, professors, and teachers from a wide variety of geographical locations and teaching situations. As we move along in the twenty-first century, some ways of approaching the humanities inevitably change. However, the spirit of the book remains basically the same.

The Western Humanities in Global Perspective

The Humanities still reflects our conviction that the Greco-Roman and Judeo-Christian traditions form the basis of the Western tradition and that the study of these should be at the core of a humanities course taught in North America. From the very first (1980) edition, however, we included a section on the West African cultural root, not only because many Americans are of African descent, but also because of the influence of African culture on Western culture generally. Recognizing that the Western humanistic tradition is itself in many ways a child of more ancient cultures in Asia and Africa, we added chapters on Mesopotamia and Egypt to the fourth edition. We also added a chapter on Islamic civilization to that edition. In the fifth edition, we introduced some of the major cultural traditions of the most ancient Asian civilizations: those of India and China. In this edition, we have added a section on Japan. Not only do we emphasize the influences of non-Western cultures on the West, we also stress that comparison with other traditions helps us to understand our own. Throughout Volume Two, we discuss at some length the influences of Asian and African cultures on Western culture and the intermingling of the civilizations—from the effects of imperialism and colonialism, for example.

Asia is of course a cultural as well as an ethnic root for an increasing number of citizens of the United States and Canada. In a book of this size and nature, we cannot present in depth the cultural traditions of India, China, and Japan, not to mention the rest of Asia. What we *can* do is highlight certain features that either influence or make interesting contrasts with the Western humanities.

Changes in This Edition

In the sixth edition, we made several changes to make the book more accessible to students. Chapters begin with a "bulletin" of the central issues discussed in it as well as a brief chronology of significant dates. Each chapter ends with a number of summary questions, as well as a list of the key terms presented in it. Unlike a conventional summary, the questions should help students to organize and think about the material for themselves. Another feature

is the "Daily Lives" boxes, which present aspects of the lives of various people in relation to the cultural period discussed in the chapter. All of these have been updated, and in some cases changed, for this edition.

The increasing tendency to globalize the humanities is reflected in this edition by the addition of a substantial section on Japan in Volume I. While the majority of the book is still devoted to the Western humanities, Asia, as well as Africa and the Middle East, now receives more attention. The modern poems in the African unit in Volume I have been moved to a new section on African, African-American, and Caribbean poetry in Volume II. Both volumes continue to reflect our commitment to give due emphasis to the contributions of women and ethnic minorities to the humanities.

Other changes reflect both specific requests by readers and our own rethinking. We now introduce Volume I with a section on the three great early riverine civilizations in Mesopotamia, Egypt, and the Indus valley. Some of the reading selections in the chapters on Mesopotamia and Egypt have been changed. The material on classical Greece has been reorganized. The chapter on Islam now includes more material from the Quran and early courtly love poetry. Major changes in Volume II include the substitution of Shakespeare's *The Tempest* for *Othello* and Molière's *Tartuffe* for *The Would-Be Gentleman*. Since it is difficult to cut *Candide* to a size limited by the demands of the book, we have substituted a short story by Voltaire, "Micro-megas." Montesquieu is now represented by *The Persian Letters*. Some of the English Romantic poems have been changed as readers requested and Realism is now represented by a short story by Guy de Maupassant, "A Fishing Excursion." Nietzsche is better represented by the prologue from *Thus Spake Zarathustra*. Colonialism and postcolonial literature now receive more attention. As always, we have updated the historical material to represent current interest. The last chapter now includes a discussion of politics in the Middle East as well as poems by both a Palestinian and an Israeli poet. Several new works of art and music have been added throughout the text. We continue to print short poems in their original languages as well as in English translation.

Purpose of the Book

Our commitment to a truly interdisciplinary introduction to the humanities through the concept of "cultural roots" remains the same. We feel that in an introductory humanities course the student's personal growth should take place on three levels—historical, aesthetic, and philosophical. The overall purpose of the two volumes can best be described by breaking it down into these three categories.

The Historical Level

We stress the concept of "cultural roots" because one cannot understand the culture in which one lives without some notion of what went into its making. In the "Continuities" sections that conclude each major part, we not only summarize the main points made about the cultures presented, but also attempt to link the "roots" discussed to aspects of the contemporary American cultural environment. This can be a knotty problem because such links can sometimes be too facile, and we also would like students to discover that cultures remote in time or space can be worth studying simply for themselves.

In our presentation of the humanities and of cultural roots in Volume I, we have attempted to focus on certain periods and monuments rather than to survey everything. For example, the focus for the Greco-Roman root is on Athens during the fifth century B.C. This means that some significant works of classical Greek drama, sculpture, and architecture can be examined rather extensively, in relation to each other, while Archaic and Hellenistic Greece receive a briefer treatment. Similarly, in our treatment of West Africa, we have chosen to focus on the culture of the Yoruba people, rather than to survey all of the cultures from this part of the world. When we study the "root" of the Judeo-Christian tradition in Judaism and in the Bible, with selections from the Old and New Testaments, we focus on the relations of arts and thought in the Gothic cathedral, with the specific example of Chartres during the European Middle Ages. The chapter on Byzantium and Islam helps to clarify the context of this focal culture. As previously mentioned, our brief and introductory presentation of India and China highlights their impact on the Western humanities.

In Volume II also, we have attempted to focus rather than to survey and spread thin. In our exploration of the Renaissance and Reformation periods we emphasize the fusion of the Greco-Roman and Judeo-Christian roots and focus on the development of humanism in fifteenth-century Italy and its diffusion in the north. The court of Louis XIV in the seventeenth century, the Enlightenment in France and America, the romantic movement, the Industrial Revolution, modernist movements, and the varied aspects of postmodernism all provide centers around which the many interrelated facets of the humanities can be discussed.

The Aesthetic Level

On the whole, we follow the same "focal" principle in the aesthetic domain. In presenting music, we operate on the assumption that a student will retain more from listening to and analyzing an entire work than from reading music history and theory and hearing snippets. In the presentation of major works of literature and art in the focal periods, we assume that it is more useful for a student to look at the whole of Chartres cathedral than to skim the history of medieval art, and to read all of *Oedipus Rex* rather than bits and summaries from several Greek tragedies. With lengthy works, such as epics and novels, this is, of course, not possible. We have thus chosen portions of the *Iliad,* the *Aeneid,* and *The Divine Comedy* that are significant in themselves and representative of the whole.

Dance, an often-neglected art form, is given more extensive treatment here than in other humanities texts. Entire dance compositions can, of course, be appreciated only in live performance or film, and we suggest that instructors exploit those resources as much as possible. Although some art forms may seem unfamiliar to students at the beginning, it has been our experience that a long introductory chapter on how to look, listen, and read is largely wasted; therefore, we cover such matters in the introductions to individual works. Questions on the nature of genre are considered in the cultural context in which they originated. We place much importance on study questions that require the student to read, look, and listen carefully.

Although we try to avoid jargon, we feel that some knowledge of the technical vocabulary of criticism in the arts is essential for literate discussion. Unfamiliar terms appear in italics in the text and are defined in the Glossary.

The Philosophical Level

It may well be objected that we compromise the focal method in our presentation of philosophy, because no entire philosophical works appear in the book. This is largely due to considerations of space; but it is also true that, when dealing with a work in terms of certain fundamental ideas rather than in terms of aesthetic wholeness, the "snippet" method is not objectionable. Beginning humanities students are probably not ready to read Aristotle's *Ethics* in its entirety, but they should be able to see how Aristotle's ideas are essential to the cultural roots of the modern world.

The student's personal growth in the philosophical area means, however, something much broader than his or her contact with formal philosophy. The (ideal) student—whose historical awareness is increased by an understanding of cultural roots and whose aesthetic sensitivity is heightened by personal confrontation with a variety of works of art—should also be able to grow intellectually through contact with diverse ideas. A humanities course should enable students to refine their thinking on the basic questions that affect all human beings, to formulate more clearly their personal values, and to discuss these with intellectual rigor rather than in vaporous "bull" sessions. Instructors should welcome debates that might arise from comparing Genesis and African mythology, the issues of women's role in society as raised by authors as diverse as Sor Juana Inés de la Cruz, John Stuart Mill, and Simone de Beauvoir, or the relative merits of modernist and postmodernist art, a

Bach fugue and a jazz improvisation. They and their students will find many more such issues to debate.

Individual instructors will decide which aspects of the humanities they wish to emphasize. We believe that this book offers enough flexibility to be useful for a variety of approaches.

Supplements to the Text

To facilitate teaching and study, we provide a package of supplements available to all who adopt this text. It includes

- an art website *(Frames: Interactive Art Gallery)* that features over fifty color art images from the text. Students will be able to read detailed descriptions of the works, link to additional art resources on the web, review key artistic terminology, and test their art knowledge with online quizzes. All works of art appearing on the *Frames* site will be designated in the text with a (**W**) in the caption line.

- a set of audio compact discs containing many of the musical selections discussed in the text

- the ClassPrep CD-ROM that features an *Instructor's Resource Manual* with advice for using the text; suggestions for approaching the interdisciplinary study of the arts, literature, philosophy, and history; and extensive bibliographic and media resource information. The CD-ROM also includes an electronic *Test Item File* and HM Testing, a computerized version of the *Test Items* that enables instructors to alter, replace, or add questions.

- an online *Student Study Guide* that offers chapter summaries, review questions, computerized flashcards of key terms, web exercises, and the ACE self-testing program.

Mary Ann Frese Witt

Charlotte Vestal Brown

Roberta Ann Dunbar

Frank Tirro

Ronald G. Witt

Acknowledgments

Many people have contributed time, work, ideas, and encouragement to the creation of this book. Gratitude is due, first of all, to those who provided their own research and writing: Professor John Mertz of North Carolina State University wrote the new section on Japan for this edition, and Professor emeritus Herbert Bodman of the University of North Carolina at Chapel Hill wrote most of the chapter on Islam. In Volume Two, the late Professor Ernest Mason of North Carolina Central University wrote the introduction to Freud as well as the material on African American culture, and Professor emeri-

tus John Kelly of North Carolina State University wrote most of the sections on Latin American culture. The late Professor John Cell of Duke University wrote most of the material on India and China in both volumes.

The plan for the first (1980) edition of *The Humanities* grew out of the four years I spent initiating and directing an interdisciplinary humanities program at North Carolina Central University in Durham. It would not have been possible without the stimulation and aid of my students and colleagues there. The late Professor Charles Ray and Dean Cecil Patterson provided me with the time, encouragement, and wherewithal to create the program. The professors who worked closely with me—Elizabeth Lee, Phyllis Lotchin, Ernest Mason, Norman Pendergraft, Earl Sanders, Winifred Stoelting, and Randolph Umberger—have all left their mark on this book. The generous support of the Kenan Foundation, which provided the humanities program with a four-year grant, enabled me to research and compile much of the material. The Kenan Foundation also gave me the opportunity to attend numerous conferences on the humanities. The workshop given at North Carolina Central University by Clifford Johnson, of the Institute for Services to Education, also provided inspiration.

The book has benefited greatly from readings and criticisms by subject-area experts. The authors particularly wish to thank Professors John Brinkman and Emily Teeter of the Oriental Institute of the University of Chicago for their careful work with the chapters on Mesopotamia and Egypt, Professors John Richards and Sucheta Mazumdar of Duke University and, for this edition, Professor David Gilmartin of North Carolina State University for their suggestions on and rewritings of the chapters on India and China, and Dr. Ylana Miller of Duke University for assistance with the sections on Israel and Palestine.

I am also grateful to the instructors who reviewed all or portions of this book: David G. Engle, California State University, Fresno; Mary Poteau-Tralie, Rider University; Robert Thurston, New Jersey City University; Rosemary Fox Thurston, New Jersey City University; Cordell M. Waldron, University of Northern Iowa; Linda Marie Zaerr, Boise State University; and Li-ping Zhang, Florida A&M University.

I am especially grateful to the following people at Houghton Mifflin: Nancy Blaine for overseeing all of the changes in this edition, Julie Dunn for her careful editorial work and helpful suggestions, and Jane Lee for overseeing the production process. We are also grateful to Jan Kristiansson for her scrupulous and insightful copyediting of the manuscript, Linda McLatchie for her proofreading, and Sherri Dietrich for her help indexing the book.

Finally, my collaborating authors deserve many thanks for their fine work and their support over the years.

Mary Ann Frese Witt

Chronicle of Events

	EGYPT/KUSH	MESOPOTAMIA-SYRIA-PALESTINE	GREECE	INDIA/CHINA
3200 B.C.	Union of North and South Egypt (3100) Writing used in Egypt (3100)	First ziggurats (3500–3000) Sumerian city-states (3400–3100) Cuneiform writing begins (3200)		
3000		Successive waves of Semites occupy Palestine		Indus Valley (Harappan) civilization (3000–2400)
2800	Tomb panels of Hesira (2750)			
2600	Old Kingdom (2686–2180) Zoser pyramid (c. 2650) Pyramids of Cheops, Chephren, and Mycerinus	Gilgamesh of Uruk (2600)		
2400	Settlement of Kerma	Agade Dynasty established by Sargon (2340)		
2200	Intermediate Period (2180–2140) Middle Kingdom (2140–1786)	Agade destroyed (2150) *Epic of Gilgamesh* (first text)	Minoan Palace construction begins on Island of Crete (Knossos)	
2000		Abraham (2000) Phoenician (Canaanite) city culture	Crete dominates Mediterranean	China: Xia Dynasty (2000) India: Aryan migrations (2000–1500)
1800	Second Intermediate Period (1786–1570) (Hyksos)	Babylonian Dynasty established: Hammurabi (1792)		
1600	New Kingdom (1570–1085)	Hittites destroy Babylon	High point of Minoan civilization (1600–1400)	
1400	Queen Hatshepsut (1504–1482) Akhenaton (Amenhotep IV) (1379–1362)	Phoenicians develop alphabet Hebrews enter Palestine Moses (1290) Judges	Destruction of Minoan Palace (Knossos) Mycenaean expansion	China: Shang Dynasty (1500)
1200		Phoenicians flourish (1200–900)	Traditional date for sack of Troy (1184) Mycenae destroyed by Dorians (1100) "Dark Ages" of Greece (1100–700)	
1000	Third Intermediate Period and the Late Period (1085–332)	Saul made King of Hebrews (1025)	Greek colonies on Aegean Coast and Greek colonies in Asia Minor established	

Date	ASIA	GREECE	ROME	MESOPOTAMIA-SYRIA-PALESTINE	AFRICA
1000 B.C.	China: Zhou Dynasty (1000–700)			Biblical texts begin to be written (1000–961); David King of Hebrews (1000–961); Assyrian empire begins (1000–900); Nineveh capital; King Solomon (970–922); Hebrew kingdom divides into Israel and Judah (922)	
900		Homer?		Assyria conquers Phoenicians and Israel (876–605)	Founding of Carthage (825); Kingdom of Kush (800 B.C.–A.D. 350)
800		Archaic period (700–480); Beginning of *polis*	Mythical date for founding of Rome (753)		Napata rules Kush (750–270)
700	Iron replaces bronze in China	Thales (640–546?)		Torah written (600–400); Nineveh falls (612)	Kushite kings of Egypt (720–656)
600	China: Lao-Zi (6th cent.); Confucius (551–479); India: Cyrus captures northwest Pakistan (530)	Sappho (c. 610–580); Beginning of drama and Panathenian festivals		Neo-Babylonian Empire of Nebuchadnezzar (604–562); Jews taken captive to Babylon (586); Persians take Babylon (550); Jews return home (538); Darius of Persia (521–486)	
500	India: Death of Gautama Buddha (486)	Heraclitus (late 6th century); Aeschylus (525–456); Persian Wars (499–480); Pericles (490–429); Euripides (480–406); Thucydides (470–400); Socrates (470?–399); Building of Parthenon (477–438); Peloponnesian War (431–404); Plato (427?–347)	Kings expelled and Republic created (509)		Persia conquers and rules Egypt (525–405)
400	China: Mencius (390–305); India: Alexander the Great's invasion (327–325)	Aristotle (384–322); Hellenistic period; Alexander of Macedon (the Great) (356–323); Epicurus (342–270); Zeno (322–264) and founding of Stoic school	Vigorous program of Roman conquest of Italy begins (343)		Alexander conquers Egypt (332)
300	India: Mauryan Dynasty (321–180); Yayoi Period in Japan (300 B.C.–A.D. 300)		I Punic War (264–241); Sardinia and Corsica annexed (238); II Punic War (218–201)		Greek dynasty rules Egypt (330–30); Meroe rules Kush (270 B.C.–A.D. 350)

Greek period labels: Archaic Age (750–480) ← → Classical Age (480–350) ← → Hellenistic Age (350–150)

Timeline

200 B.C. – A.D. 200

(left margin years: 200, 100)

- China: Han Dynasty (206 B.C.–A.D. 221)
- China: Emperor Wu-Di (141–87)

Rome begins conquest of Greece →

- Terence (195–159)
- III Punic War (149–146)
- Cicero (106–42)
- Caesar (100–44)
- Lucretius (99–55)
- Ovid (43 B.C.–A.D. 17)
- Horace's *Satires* (35–29)
- Virgil's *Aeneid* (29–19)
- Augustus begins reign (27)

- Occupation of Israel by Romans (63)
- Reign of Herod the Great in Palestine (37 B.C.–A.D. 4)

- Nok civilization at its height (200 B.C.–A.D. 200)
- Carthage destroyed (144)
- Rome conquers North Africa
- Cleopatra VII last Egyptian ruler (69–30)
- Egypt becomes Roman province (30)

A.D. *(left margin years: A.D., 100, 200, 300)*

ASIA

- China: First mention of contact with Roman Empire (97)
- China: Use of paper (c. 100–200)
- China: Period of decentralization (220–589)
- India: Gupta Dynasty (320–late 400s)
- Ramayana and Mahabharata
- China: Diffusion of Buddhism (200s–400s)
- Japan: Yamato Court (300–700); Shinto dominant (300s)

ROMAN EMPIRE

- Birth of Jesus Christ
- Death of Augustus (14)
- Conversion of Paul (35); spread of Christianity
- Conquest of Britain (43–51)
- Persecutions of Christians by Nero (64)
- Sack of Jerusalem (70)
- Juvenal's *Satires* (c. 100)
- Roman Pantheon built (118–125)
- Composition of Mishnah (200)
- Plotinus (205–270) and Neoplatonism
- Period of disorder (235–284)
- Reforms of Diocletian (280–305)
- Composition of Talmud (300–600)
- Construction of Old St. Peter's (c. 333)

AFRICA

- Foundation of Christian community at Axum (350)

(left margin years: 400, 500)

EASTERN EUROPE AND MIDDLE EAST

- Byzantium consolidates hold on area

ASIA

- Kalidasa (400s)

WESTERN EUROPE

- St. Augustine (354–430)
- Alaric sacks Rome (410)
- Vandals sack Rome (455)
- Traditional date for end of Western Empire (476)
- Franks invade Gaul (486)

AFRICA

Year	AFRICA	WESTERN EUROPE	EASTERN EUROPE AND MIDDLE EAST	ASIA
500		St. Benedict (480–542) Building of San Vitale, Ravenna (525–547) Pope Gregory I (540–604) Lombards invade Italy (568)	Justinian (527–565) extends empire in East and temporarily conquers part of Italy, Africa, and Spain—codifies Roman Law Hagia Sophia completed (537)	India: *Bhagavad Gita* composed (c. 500) China: Sui Dynasty (581–618)
600	Muslim conquest of Egypt (632)		Muhammad begins preaching (610) The Hegira (622) Muhammad dies (632) Dome of the Rock (completed 692)	India: Ajanta cave (600) China: Tang Dynasty (618–907) Establishment of examinations for government offices Japan: Buddhism (c. 7th century)
700	Empire of Ghana (700–1230)	Muslim conquest of Spain (711) Defeat of Muslims at Poitiers (732) Musical notation invented Spanish amirate establishes independence at Cordoba (756) Reign of Charlemagne (768–814)	Iconoclasts begin century-long campaign against images (717) Abbasid Caliphate established (750–1258) at Baghdad	Muslims invade India (711) Japan: Heian Court (794–1192)
800	Emergence of Swahili culture in East Africa Luba Empire (800–1200)	Second period of invasions (c. 800–950): Northmen, Hungarians, and Saracens	Final restoration of images (843)	
900		Northmen establish Normandy (911) Otto I founds German Empire (962) First systematic teaching of Aristotle's *Logic* (975) Hugh Capet King of France (987) Great mosque of Cordoba completed		China: Song Dynasty (960–1279) Fan Kuan (active c. 990–1030)
1000	Ghana and Benin become states (1000)	Economic, political, and religious revivals begin (1000) Spanish amirate splinters (1031) into small kingdoms Building of St. Sernin—Romanesque (11th and 12th centuries) Wipo, Gregorian Chant at Henry III's court Henry III of Germany emperor (1017–1056)		China: Appearance of movable type (1030)
1050		Norman invasion of England (1066) St. Bernard (1090–1153) Christians retake Toledo (1085) First Crusade (1096–1097)	East-West schism (1054) Ibn Zaydun (1003–1079) Walladah (d. 1091)	
1100	States of Kanem-Bornu (1100–1899) and Mwene Mutapa (1100–1600) founded	*Play of Daniel* Rebuilding of St. Denis on new lines—early Gothic (1140s) Letters of Abelard and Heloise (1130s)		Sufism (1100s) Japan: Kamakura Shogunate established (1180s)
1150		Averroes (Spain) dies (1198) Bernart de Ventadorn (1145–1180) Chartres Cathedral begun (1194)	Saladin, Kurdish ruler, captures Jerusalem from Crusaders (1187)	Chinese invent gunpowder (c. 1150)
1200	Revolt of Mande peoples against Ghana (c. 1200) and rise of Mali Empire (1200–1450)	Maimonides (dies 1214) European embassy sent to China (1253) St. Louis (1214–1270) Aquinas (1225–1274)	Conquest of Constantinople by Fourth Crusade (1204) Fall of Latin kingdom (1261)	Mongols invade China (1215)
1250				Mongol conquest of China (1250)

Romanesque Style (11th and 12th centuries)

Gothic Style (12th–15th centuries)

Timeline (1250–1450)

Period	ASIA	EASTERN EUROPE AND MIDDLE EAST	WESTERN EUROPE	AFRICA
1250	China: Yuan (Mongol) Dynasty (1279–1368)		Giotto (1267?–1337)	
1300	Marco Polo's travels in China (1271–1295); Japan: Muromachi Shogunate (1333–1578)	*The Thousand and One Nights* written down (c. 1300); Expansion of Ottoman Turks in Greece and elsewhere in Balkans (1308–1337)	Dante's *Divine Comedy* (1302–1321); Petrarch (1304–1374); Boccaccio (1313–1375); Salutati (1331–1406); Hundred Years War begins (1337); First appearance of Black Death (1348–1350)	Hausa City-States (1300–1900); Mansa Musa pilgrimage to Mecca (1324); Exploration of Canaries (1330s and 1340s)
1350	China: Ming Dynasty (1368–1644); Black Death (1330s)	Unsuccessful siege of Constantinople by Turks (1397–1402)	The Alhambra (c. 1354–1391); Bruni (1370–1444); Brunelleschi (1377–1446); Chaucer's *Canterbury Tales* (1390–1400)	
1400			Masaccio (1401–1428); Henry the Navigator founds navigation school at Sagres (1419); Piero della Francesca (1420–1492); Jeanne d'Arc burned (1431); Medici dominate Florence (1434); Alberti's *On Painting* (1435); Botticelli (1444–1510); Leonardo da Vinci (1452–1519); Lorenzo il Magnifico (1469–1492)	Atlantic slave trade begins (1440s)
1450		Constantinople falls to Turks (1453)	Gutenberg invents printing (1446–1450); Pico della Mirandola (1463–1494); Erasmus (1466?–1536); Copernicus (1473–1543); Spanish Inquisition established (1478); Columbus reaches America (1492); Ferdinand and Isabella finish conquest of Spanish peninsula (1492); DaGama sails for India (1497)	John Affonso d'Aveiro visits Benin (1485–1486); Songhay Empire (1464–1591)

Renaissance Style (15th and 16th centuries) ←——→

Timeline (1500–1550)

Period	ASIA	NEW WORLD	EUROPEAN CULTURE	EUROPE	AFRICA
1500	India: Mughal Empire (1500s–1700s)	First black slaves in New World (1505); Magellan circumnavigates the globe (1519); Cortés in Mexico (1519–1521); Verrazano establishes French claims in North America (1524)	Michelangelo's *David* (1504); Raphael's *School of Athens* (1510–1511); Machiavelli's *Prince* (1513–1516); First edition of Erasmus's *Colloquies* (1516); Luther publishes German *New Testament* (1521)		Duarte Pacheco Pereira's *Esmeraldo de situ orbis* (1507); Benin at the height of its power (16th and 17th centuries)
1525			Palestrina (1525–1594); Montaigne (1533–1592); First edition of Calvin's *Institutes* (1536); Copernicus's *Revolution of Heavenly Bodies* (1543)	Peasants' Revolt in Germany (1525); Henry VIII declares himself head of Church of England (1534); Jesuit Order founded (1540); Council of Trent (1545–1563)	
1550	Europeans arrive in Japan (1542–1543)				

Renaissance Style (15th and 16th centuries) ←——→

	AFRICA	EUROPE	EUROPEAN CULTURE	NEW WORLD	ASIA
1600	Ashanti state (1600–1900)		Shakespeare, *The Tempest*; Rembrandt van Rijn (1609–1669); Rubens's *Raising of the Cross* (1609–1610); Giambattista Marino (1569–1625); John Donne (1572–1631); Descartes (1596–1650); Gianlorenzo Bernini (1598–1680); Corneille (1606–1684); Bacon's *Novum Organum* (1620)	Settlement at Jamestown (1607); Founding of Quebec (1608); First slaves in Virginia (1619); Plymouth colony established (1620)	English East India Company (1600); India: Mughal Empire (16th–18th cent.)
1625		Thirty Years War begins (1618)	Harvey demonstrates circulation of blood (1628); Madame de La Fayette (1634–1693); French Academy founded (1635); Galileo's *Discourse on Two New Sciences* (1638); Richard Crashaw (1612–1649); Jan Vermeer (1632–1675)		China: Qing (Manchu) Dynasty (1644–1911)
1650		Louis XIV (1643–1715); Civil War in England begins (1643); Peace of Westphalia in Germany (1648); Restoration of English monarchy (1660); Louis revokes Edict of Nantes (1685)	Hobbes's *Leviathan* (1651); Rome's Cornaro Chapel (1645–1652); Rembrandt (1606–1669); Milton (1609–1674); Royal Society of London created (1662); Construction of Versailles begins (1669); Molière's *Tartuffe* (1664); Robert Boyle (1627–1691); Sor Juana Inés de la Cruz (1651–1695); Newton publishes *Mathematical Principles* (1687); Locke's *An Essay Concerning Human Understanding* (1690)	New York City taken by English from Dutch (1664); Salem Witch Trials (1692)	
1700	Foundation of Ashanti Confederacy (1701)	Union of Scotland and England (1707); War of Spanish Succession (1701–1713); King Louis XV of France (1710–1774); Frederick II of Prussia (1712–1786); Hanover (Windsor) dynasty begins in England (1714)	Darby cokes coal (1709); Denis Diderot (1713–1784); Watteau's *Pilgrimage to Cythera* (1717); Johann Sebastian Bach (1685–1750)		
1725					

Year	ASIA	NEW WORLD	EUROPEAN CULTURE	EUROPE	AFRICA
1725		Great Awakening (1730s); George Washington (1732–1799); Georgia, last of original thirteen colonies, founded (1733); Thomas Jefferson (1743–1826)	Building of Hôtel Soubise (1732); English repeal laws against witchcraft (1736); Handel's *Messiah* (1742); Montesquieu's *Spirit of the Laws* (1748)	War of Austrian Succession (1740–1748)	
1750		French and Indian War (1754–1763); English take Quebec (1759); English acquire Canada by Treaty of Paris (1763); Boston Massacre (1770)	Volume I of the *Encyclopédie* (1751); Mozart (1756–1791); Rousseau's *On the Origins of Inequality* (1755); Voltaire's *Candide* (1759); First blast furnace (1761); Rousseau's *Social Contract* (1762); Watt patents steam engine (1769)	George III of England (1738–1820); Death of George II (1760)	
1775	India: Establishment of British preeminence (1770s–1818)	Revolutionary War begins (1775); Treaty of Paris ends war (1783); Virginia Statute of Religious Liberty (1785); U.S. Constitution enacted (1789); Washington dies (1799)	Schiller (1759–1805); Mozart's *Don Giovanni* (1787); Goethe's *Werther* (1787); Wollstonecraft's *Vindication of Rights of Women* (1792); Eugène Delacroix (1798–1863)	Accession of Louis XVI (1774); Meeting of Estates General (May 1789); Taking of Bastille (July 1789); Fall of Robespierre (1794); Napoleon's coup d'état (1799)	
1800		Jefferson elected president (1800)	David (1748–1825); Madame de Staël (1766–1817); Wordsworth (1770–1850); Constable (1776–1837)	Napoleon consul for life (1802); Napoleon crowned emperor (1804); End of Holy Roman Empire (1806)	Islamic holy wars across West Africa (1800–1900); Rise of Fulani Empire (19th century); Britain abolishes slave trade (1807)
1810		War of 1812 (1812–1814); Founding of *North American Review* (1815)	Stephenson's locomotive (1814); Byron (1788–1824); Frédéric Chopin (1810–1849); Goya's *Executions of the 3rd of May* (1814); Keats (1795–1821); Percy Shelley (1792–1822); Blake (1757–1827)	Defeat of Napoleon and Congress of Vienna (1815); Industrialization of England (1815–1850)	France abolishes slave trade (1815)
1820		University of Virginia opens (1824)	Beethoven's Ninth Symphony (1824); First photographs taken (1826); Heine (1797–1856)	Greek War of Independence (1821–1829)	
1830		Emerson (1803–1882); Poe (1809–1849); Emily Dickinson (1830–1886)		Revolutions in France, Germany, Italy, Belgium, and Poland (1830); Industrialization of France and Belgium (1830–1860)	France annexes Algeria (1830); Liberia established (1832); England abolishes slavery (1838)

	AFRICA	EUROPE	EUROPEAN CULTURE	NEW WORLD	ASIA
1840		Industrialization of Germany (1840–1870)	*Giselle* (1841); Turner's *Rain, Steam and Speed* (1845); Marx-Engels's *Communist Manifesto* (1848); Guy de Maupassant (1850–1893); Herbert Spencer (1820–1903)	Seneca Falls convention (1844); Mexican War (1846–1848); Gold discovered in California (1848)	China: Opium War with Great Britain (1840s)
1850	Livingstone at Victoria Falls (1853–1856)	Revolutions in France, Italy, Germany, and Austria (1848); Second Empire founded in France (1852); Crimean War (1855)	Crystal Palace (1851); Millet (1814–1875); Courbet's *Manifesto* (1855); Baudelaire (1821–1867); Darwin's *Origin of Species* (1859)	Walt Whitman (1819–1892); Thomas Eakins (1844–1916)	India: Great Rebellion (Mutiny) (1857–1858)
1860		Foundation of Kingdom of Italy (1860); Emancipation of serfs in Russia (1861)	Mill's *On Subjection of Women* (1861); Ford Maddox Brown's *Work* (1862–1863); Dostoevsky's *Notes from the Underground* (1864); van Gogh (1853–1890); Manet (1832–1883)	Civil War (1861–1865)	
1870	Opening of Suez Canal (1869); Imperialism and conquest (1870–1900); Brazza explores Lower Congo (1875)	Creation of Dual Monarchy in Austria-Hungary (1867); Franco-Prussian War (1870–1871); German Empire and Third French Republic created (1871); Dual Alliance: Germany and Austria-Hungary (1879)	Nietzsche (1844–1900); Monet's *Impressions: Sunrise* (1873); Gauguin (1848–1903); Degas (1834–1917)	Period of Reconstruction (1867–1877); Stephen Crane (1871–1900)	
1880	France occupies Tunisia (1881); Britain occupies Egypt (1882); Berlin Conference divides Africa (1885); Germans in Togo and Cameroon (1886); Gold found in South Africa (1886); Rhodes establishes Rhodesia (1889–1891)	Triple Alliance: Germany, Austria-Hungary, and Italy (1882); German-Russian Reinsurance Treaty (1887)	Mallarmé (1842–1898); Verlaine (1844–1896); Rimbaud (1854–1891)	William Dean Howells (1837–1920); Henry James (1843–1916)	
1890	French annex Guinea and Ivory Coast (1893); Battle of Adowa (1896)	Industrialization of Russia (1890–1914); Franco-Russian Alliance (1894)	Cézanne (1839–1906); Matisse (1869–1954)	Reliance Building (1891); Wainwright building (1891); Spanish-American War (1898); Chesnutt's *The Conjure Woman* (1899)	Japanese annex Formosa (1895); Boxer Rebellion in China (1899)
1900					

	AFRICA	EUROPE	EUROPEAN CULTURE	NEW WORLD	ASIA
1900	British conquest of N. Nigeria (1900–1903)	Entente Cordiale: France and Great Britain (1902); First Russian Revolution (1905)	Apollinaire (1880–1918); Picasso's *Les demoiselles d'Avignon* (1907)	Louis H. Sullivan (1856–1924)	
1910	Morocco becomes French protectorate (1912); Conquest of German colonies (1914–1915)	Balkan Wars (1912–1913); First World War (1914–1918); Russian Revolution (1917); Treaty of Versailles (1919); German Weimar Republic created (1919)	Duchamp's *Nude Descending a Staircase* (1912); Mondrian (1872–1944); Kandinsky's *On the Spiritual in Art* (1912); Stravinsky's *Rite of Spring* (1913); Kirchner's *Street* (1914); Bauhaus founded (1919)	Robie House, Oak Park (1912); Armory Show (1913); U.S. declares war on Germany and Austria-Hungary (1917); Women gain vote in Canada (1917); Harlem Renaissance (1919–1932)	China: Overthrow of Manchu; beginning of Chinese Revolution (1913); India: Gandhi (1869–1948) returns to India and begins struggle against British rule (1915)
1920		League of Nations (1921); Irish Free State (1922); Mussolini establishes fascism in Italy (1922)	Kafka (1883–1924); Nijinsky (1890–1950); Joyce's *Ulysses* (1922); Hitler's *Mein Kampf* (1925–1926); Spengler's *Decline of the West* (1926–1928); Lipchitz's *Figure* (1926–1928); Brancusi's *Bird in Space* (1928); Woolf's *A Room of One's Own* (1929)	Women gain vote in the United States (1920); Frank Lloyd Wright (1869–1959); W. E. B. Dubois (1868–1963); Mariano Azuela (1873–1952); T. S. Eliot's *The Waste Land* (1922); Davis's *Egg Beater No. 1* (1927); The Radiator Building (1927); Stock Market Crash (1929)	
1930	Nigerian youth movement begins (early 1930s); Italy conquers Ethiopia (1936)	Great Depression begins (1932); Hitler rises to power (1933); Official rearmament of Germany (1935); Spanish Civil War (1936–1939); Second World War begins (1939)	Freud's *Civilization and Its Discontents* (1930); Le Corbusier's *Villa Savoye* (1929–1930); Malraux's *La Condition humaine* (1933); Antonin Artaud (1896–1948); James Joyce (1882–1941); Virginia Woolf (1882–1941); Picasso's *Guernica* (1937)	Shahn's *Passion of Sacco and Vanzetti* (1930); New Deal begins (1933); Louis Armstrong (1900–1971); Claude McKay (1890–1948); Jean Toomer (1894–1967); Georgia O'Keeffe (1887–1986); Sonia Sanchez (b. 1934); Miguel Asturias (1899–1974); Pablo Neruda (1904–1973)	Japan invades China (1931)
1940	Ethiopia liberated (1941); Léopold Sédar Senghor (1903–2001); Léon Damas (1912–1987); Aimé Césaire (b. 1913)	Formation of United Nations (1945); Fourth French Republic established (1945); Communist takeover in Eastern Europe (1946–1948); Founding of Israel (1948); China becomes communist (1949)	Camus's *The Myth of Sisyphus* (1941); Giacometti (1901–1966); Salvador Dalí (1904–1989); Jean-Paul Sartre (1905–1980); Simone de Beauvoir (1908–1986)	Welles's *Citizen Kane* (1941); Japanese attack Pearl Harbor (1941); David Smith (1906–1965); Albert Einstein (1879–1955); T. S. Eliot (1888–1965); E. E. Cummings (1894–1962); Richard Wright (1908–1960); Jackson Pollock (1912–1956); Charlie Parker (1920–1955); Allen Ginsberg (1926–1994)	India: Independence and Partition (1947); China: Communists win civil war and take over mainland China (1949)

	AFRICA	INTERNATIONAL POLITICS	EUROPEAN CULTURE	AMERICAN CULTURE	ASIA
1950	Algerian War begins (1954) Morocco and Tunisia freed (1955) Ghana first colony to gain independence (1957) Guinea independent (1958) Frantz Fanon (1925–1961) David Diop (1927–1960)	Korean War (1950–1953) Russian Sputnik (1957) Common Market (1957) de Gaulle's Fifth Republic (1958)	Giacometti's *Chariot* (1950) Albert Camus (1913–1960) Charlie Chaplin (1889–1977) Arrabal's *Picnic on the Battlefield* (1952) Beckett's *Endgame* (1957) Primo Levi's *If This Is a Man* (1958)	Ezra Pound (1885–1972) Langston Hughes (1902–1967) Duke Ellington (1899–1974) Martha Graham (1895–1991) Stuart Davis (1894–1964) Jorge Luis Borges (1899–1986) Ralph Ellison's *Invisible Man* (1952)	
1960	British, French, and Belgian colonies independent (1960s)	Berlin Wall (1961) Beginning of Russia-China split (1962) U.S. enters war in Vietnam (1964) Civil Rights Act (1965) Great Cultural Revolution in China (1966) Assassination of Martin Luther King, Jr. (1968)	Jean Genet (1910–1985) Roland Barthes (1915–1980) Frantz Fanon's *The Wretched of the Earth* (1961)	Leonard Bernstein (1918–1990) Katherine Dunham (b. 1919) Miles Davis (1926–1991) Jacob Lawrence (b. 1927) Ornette Coleman (b. 1930)	
1970	Dennis Brutus (b. 1924) Amin gains power in Uganda (1971) Breakdown of Portuguese African Empire (1974) Wathiong'O Ngugi (b. 1938) Soweto Uprising (1976)	Withdrawal of U.S. from Vietnam (1972) *Roe v. Wade* (1973) Oil prices rise (1973) Shah leaves Iran and Khomeini takes power (1979) Russian troops sent to Afghanistan (1979)	Michel Foucault (1926–1984) Jacques Derrida (b. 1930)	Millet's *Sexual Politics* (1970) Lispector's *Soulstorm* (1974) Andy Warhol (1931–1987) Alvin Ailey (1931–1992) Judy Chicago's *The Dinner Party* (1979)	
1980	Rhodesia becomes Zimbabwe (1980) Prolonged famine (1981) Liberation struggles continue in Africa (1988)	Polish solidarity movement repressed (1981) Marcos ousted in Philippines (1986) Chernobyl nuclear explosion (1986) U.S.-USSR agreement on medium-range strategic force (1988) Berlin Wall falls (1989) Collapse of communism in Europe (1989–1991)	Anselm Kiefer, *Untitled* (1980–1986)	Ishmael Reed (b. 1938) Ernesto Cardenal (b. 1925) John Barth (b. 1930) AT&T Headquarters Building (1988)	Salman Rushdie (b. 1947)
1990	South Africa repeals all racial laws (1991) Majority rule in South Africa (1994) Free elections in South Africa (1996)	War in Kosovo (1990) Gulf War (1991) Commonwealth of independent states replaces USSR (1991) Civil War in Bosnia (1993–1995)		Derek Walcott's *Omeras* (1990) Tony Kushner, *Angels in America* (1993) Rita Dove, *Mother Love* (1995)	International Women's Conference in Beijing (1995)
2000		World Trade Towers attacked (2001) U.S. invasion of Afghanistan (2001) U.S. invasion of Iraq (2003)			

Introduction: Defining the Humanities and Cultural Roots for the Twenty-First Century

The last decades of the twentieth century witnessed an intense debate over the role of the humanities in education. Representing various positions in what have been called the "culture wars" or the "canon wars," the books and articles as well as the televised and Internet discussions on the subject raised some fundamental questions: Is there indeed a "core" of great works and other cultural information that all educated people should be familiar with? Is it vital to understand the cultural tradition of one's own country before exploring other traditions? If it is not possible to study all the cultures of the world, which ones should be studied? Furthermore, do we experience art, in any form, primarily through its universal appeal to all human beings or its reflection of the values of a certain culture?

Controversies

Although the "wars" are no longer raging, these questions bear directly on the criteria for choosing the texts and works of art that should form the core of a high school and university education in the humanities. The questions, however, have yet to be resolved in any definitive way. On one side are those who defend the notion of a canon—that is, a core group of works deemed central to education both because they have been authoritative in the formation of our culture and because they are "great" according to universal aesthetic or philosophical standards. On the other side are the cultural relativists, who take issue with the very notion of universal value. Arguing that the canon has tended to be white, male, European, and elitist, they prefer to choose works according to the author's gender, race, class, or culture. Faced with the pragmatic choice of what to read and study in a semester or a year, most teachers and students of the humanities fall somewhere in between these positions, trying to reconcile the universal, the canonical, and the multicultural.

This book attempts its own form of reconciliation. We [that is, the authors] believe that we cannot know where one is going unless we know where one has come from, and that an understanding of the Western humanistic tradition is crucial to an education in the humanities. At the same time, we emphatically agree about the importance of listening to the voices of women, ethnic minorities, and others who have been unjustly marginal-ized. We are well aware, too, that the notion of cultural roots is becoming ever more global. We will return to that notion in the final section of this introduction. For now, let us attempt a definition of "the humanities" by first looking at the original formulation of the concept.

Development of the Western Humanities

Although every culture has its canon, or body of works deemed authoritative and of aesthetic or spiritual value, the notion of the humanities as an educational discipline is a Western one. It arose in Italy some six hundred years ago. The Renaissance humanists, reacting against a curriculum dominated by theology in the Middle Ages, passionately devoted themselves to reading Latin and Greek secular texts because they believed that human-centered inquiry should be revived. The studies that they called the humanities—in Latin, *studia humanitatis*—centered on the literature of antiquity.

The humanists considered the human individual the finest creature in God's creation and, like God, a maker, a doer, a creative force. Nonetheless, humans remained creatures, mortal and imperfect. The humanists' criticism of much medieval education was that it had concentrated on "man" as intellect outside a time frame. The human being was a product of history. A close study of the past, especially of the ancient Greek and Roman world, in which human achievement seemed to have been maximized, could guide people in the present and toward the future. Nor did the lessons of history contradict the truths found in the humanists' ultimate source of truth, the Holy Scriptures. For the humanists, moreover, the emotional component of human nature had to be recognized as a reality, and this recognition was the foundation for ethical development through the use of eloquence. Studying the writings of the ancients, models of eloquence, not only stimulated the mind but also aroused the passions to pursue the good. Having learned the lessons of effective presentation from the ancients, the humanists themselves not only helped others to lead a higher moral life but also, by conveying the message of Scripture, made their audience better Christians.

In spite of their affirmation of the basic dignity of all human beings, the Renaissance humanists believed that some were more "human" than others. According to them, those who studied the humanities acquired more

"humanity," not only because they were able to think for themselves more creatively and to express themselves more fully but also because they gained a deeper understanding of people. Ideally, this kind of humanistic growth should be available to all. In practice, however, it was available only to those with enough wealth, family support, or patronage to have a certain amount of leisure. Moreover, the program of humanistic studies was, with a few notable exceptions, a male monopoly.

It is only fair to point out that people who called themselves humanists, in both Europe and America, have at times associated themselves with cultural elitism, blind worship of tradition, class oppression, and racism. Yet the study of the humanities has also served to stimulate creative men and women to redefine the humanist spirit for their own time. Seventeenth-century humanists in Europe allied themselves with scientists to fight for the liberty of the questioning human mind against the dictates of established authority. Eighteenth-century humanists, speaking out for religious tolerance and for liberty, equality, and fraternity, helped to create revolutions. Nineteenth-century humanists struggled to save the human spirit from threatening industrial growth and technological progress. They also considerably broadened the areas encompassed by humanistic study through the creation of new fields such as folklore, comparative religion, art history, and music history. Late-nineteenth- and early-twentieth-century pioneers in "Oriental" and African studies began the process of making us aware that the study of the humanities can include artistic and philosophical creations from traditions other than the Western one. Humanists such as the many intellectuals who fled Nazi Germany in the 1930s reaffirmed the humanistic demand for freedom of intellectual inquiry and artistic expression, as well as the opposition to oppression, intolerance, and fanaticism in all its forms. Humanists continue to struggle against dogmatism and narrow definitions of truth. One humanistic value seems to be a commitment to the fullest possible development of the intellectual, moral, and aesthetic faculties of individual human beings, along with a belief that the study of the humanities may at least contribute to that endeavor.

The Humanities Today

Although we have come a long way from a study confined to Greek and Roman literature, it is still relevant to our present concerns. A line from the Roman poet Terence, a slave of African origin, might in fact define an ideal modern humanist:

> *Homo sum; humani nihil a me alienum puto.*
> (I am a man; I hold nothing human foreign to me.)

The interest in everything human covers a very broad range indeed. It means inquiry into the world's cultures and into the wide range of disciplines and creations focused on human beings. These include, but are not limited to, languages and literature, history, philosophy, political theory, and the histories of religion, art, music, and cinema. Contemporary technology has expanded the scope of the humanities to include productions for digital media. The question of whether or not the book and the printed word will be replaced by these remains a topic of debate. At present, however, the book publishing industry continues to flourish, and the study of books is still vital to our understanding of both past and present.

What, it may well be asked, can the study of the humanities do for a student at the beginning of the twenty-first century? We are no longer certain, as the Renaissance humanists were, that the study of the humanities will make one a better or "more human" person. Yet the study of the humanities should involve a process of individual growth and self-knowledge just as valid today as it was hundreds of years ago. Involvement in the humanities means stretching and expanding one's capacity for thought, sensitivity, and creativity. It means searching for the answers to fundamental questions, such as What are good and evil? What is the nature of God? What constitutes the good life and the just society? What is beauty? What is love?

The study of the humanities will not supply readymade answers to these or other questions, but it will provide contact with minds and imaginations that have pondered them, and it should help students to think more sharply and more critically. Understanding developed through work in the humanities may change lives as well as ideas.

The Interdisciplinary Humanities

In this introductory text, we cannot pretend to deal with all of the fields mentioned above. Our focus is on literature, art history, music history, cultural history, and philosophy, with some attention to dance, theater arts, and film. The interdisciplinary method of approaching the humanities stresses their relationships but at the same time makes clear the limits and boundaries of each discipline.

What justifies studying a poem or story, a building, a statue, a dance, a musical composition, and a work of philosophy together? One reason often given is enriched understanding of a particular human culture: for example, the study of the masks, dances, poetry, music, and religion of the Yoruba people will give more insight into their culture than will the study of their poetry alone. Another reason is that the comparative method enables one art form to shed light on another. A third, more general, reason is that all of these enable us to understand more about the human spirit and its creative capacity.

The various disciplines in the humanities are all concerned with human values, beliefs, and emotions and with the way in which these are expressed through human creations. Philosophy and religion embody more or less systematically organized values and beliefs, whereas works of art embody the creative expression of these values and beliefs. But these distinctions are not hard and fast. A philosophical tract may also be artistic, and a play or a painting may open up new dimensions in philosophy. The study of cultural history—of values and beliefs prevalent at certain times and places—helps to bind the humanities together, even if a given artist may oppose prevailing values and systems.

What do the arts have in common? Let us suppose that for the creation of a work of art basically two elements are needed: some kind of raw material and a creative spirit. Examples from the Western tradition include Michelangelo and a block of marble, Shakespeare and the English language, Beethoven and the tones of the scale and instruments of the orchestra. The artist works on the raw material, giving it shape and form. The finished product then bears the imprint of the artist's individual genius, but it also shows the influence of the cultural tradition and the era from which it comes. The combination of these constitutes its style. The work of art also has a certain subject matter, structure, and theme that are composed of the "fundamentals" of the art form used. All of these can be analyzed, step by step. A technical analysis of a work of art, though a necessary and useful step in the process of understanding, is still only a means to an end. The end can be called "aesthetic awareness"—the expansion of one's capacity to perceive meaning in art and react to it.

A humanistic education presupposes a willingness to open the mind and senses to the unfamiliar and to judge only after attempting to understand. And the interdisciplinary method invites speculation and comparisons that transcend traditional boundaries.

Culture and Cultural Roots

Culture, a word that has acquired many meanings in recent years, is in need of some definition. We all feel that we belong to a group culture, whose values we may either defend or reject; and in the educational process (broadly speaking, not limited to schooling) we also acquire an individual culture. In addition, we may classify certain works as belonging to "popular" or to "high" culture.

It may be useful to look at the root meaning of the word. In Latin, the verb *colere* means "to cultivate or till," and the noun *cultura,* "soil cultivation." Our word *agriculture* comes from this root and from the Latin word for *field*. Language often grows by metaphors, and the word *culture,* applied to human beings, suggests that the human mind, especially the mind

of a child, is like a field that must be tilled, fertilized, planted, and *cultivated* by parents, teachers, and other influential members of the society in which the child lives. Applied to an adult, it implies the acquisition of learning and knowledge not merely for their practical value but also for the growth of the mind in its intellectual, moral, and aesthetic capacities. It is in this sense that the African American poet Dudley Randall, describing the beliefs of the humanist W. E. B. DuBois, speaks of "the right to cultivate the brain."[1] We are, of course, vitally concerned with culture in this sense of individual development in the humanities. The Renaissance humanists believed, as we have seen, that this sort of culture was best acquired through the study of Greek and Latin literature. For most humanists today, the study of any and all of the fields considered to be humanistic may further this goal.

If the humanities are concerned with culture in an individual sense, they are also concerned with it in an anthropological sense. Let us return for a moment to the comparison between the child's mind and the farmer's field. As it is cultivated, that mind not only develops as an individual but also acquires certain habits, values, beliefs, and ways of thinking, seeing, feeling, and expressing that attach the child to a certain culture. When we use the word in this sense, it might help to think of its meaning in the biological sciences. Certain types of bacteria growing in certain types of environments are called "cultures." When we extend this notion to human beings, we are aware of what it means to speak of European culture, Asian culture, or African culture. More specifically, we may speak of Slavic or Latin culture, of Ibo or Bantu culture, or of Japanese culture. We may speak of American culture, or we may break it down into African American culture, Italian American culture, Midwestern culture, urban culture, rural culture, and so on. We may make other categories such as youth culture, Baptist culture, or corporate culture. In other words, there are a variety of ways to slice the cultural pie.

Anthropologists looking at a culture are interested in its language, religion, social customs, food, and clothing; its moral and philosophical beliefs; its political, economic, and familial systems; and its plastic arts, poetry, tales, music, and dance. Humanists are interested in all of these as well, but primarily in a given culture's intellectual and artistic achievements. Ideally, in the study of the humanities, we should combine the two meanings of the word *culture* discussed here: we should both acquire individual culture and learn about a social culture. In reading a Greek tragedy or examining a piece of African sculpture, we learn something about the values, beliefs,

[1] In "Booker T. and W.E.B." The relevant lines are: "Some men rejoice in skill of hand, / And some in cultivating land, / But there are others who maintain / The right to cultivate the brain."

and sense of beauty of a culture remote from us in time or space; but we also cultivate our own minds in the present through new aesthetic experiences and contact with unfamiliar ideas. Human beings differ from bacteria in that they can flourish and develop through exposure to cultures different from their own.

The matter of tracing our own cultural roots can be extremely complex. On the American continent, particularly, where so many of us have several different ethnic origins, we have all been influenced by a number of cultures. Although most would agree that the Greco-Roman and Judeo-Christian traditions still form the basis of American culture, particularly in the humanities, we are beginning to understand more fully the impact of other, diverse cultural traditions, such as the African and Asian ones represented here. We cannot, of course, study all possible cultural roots in an introductory course in the humanities. We hope that you will begin to explore your own cultural roots more fully by asking questions such as "what lies at the root of the ways in which I think, perceive, and express myself?" or "what are the origins of the books, films, TV programs, web sites, buildings, and music of my culture?"

Not every one of you who reads this book will agree that all the works presented here form part of your "cultural roots." Nevertheless, if you are willing to experience them openly and creatively, they will become part of your personal culture.

PART VI

Renaissance and Reformation: Fusion of the Roots

16 Humanism and the Early Italian Renaissance

CENTRAL ISSUES

- The difference between Italy and northern Europe in 1300
- The effects of the Black Death on Europe and especially Italy
- Why Italy turned to ancient Roman culture around 1300
- Humanist criticism of the scholastics
- What the humanists learned from the ancients
- How humanism changed between Petrarch and Bruni
- Women and humanism
- The links between Platonic philosophy and the political life of Florence after 1450

No historical change of great magnitude occurs abruptly, nor is a complete break ever made with the past. The modern Western world was hundreds of years in the making, and depending on what one considers the chief features of modernity to be, its beginnings can be dated at any time between 1300 and 1650. In this book, we have chosen to date the modern world from the beginning of the Renaissance in the fourteenth century because in these years new conceptions of God, humanity, and nature emerge, along with new forms of art and behavior that are generally recognizable as modern.

This chapter focuses on Italy because, although northern Europe shared with Italy some of the responsibility for developing new ideas about God, humanity, and nature, the transformation in thought and culture in Italy was much more profound and widespread.

Beginnings of the Modern World

An Italian Phenomenon

Whereas the center of medieval culture was located in northern France and southern Germany, the Renaissance from 1350 to 1500 was dominated by Italy. Indeed, historians generally recognize that the Renaissance was largely limited to Italy until the late fifteenth century, when northern Europe began to respond to Italian influence.

Medieval culture reflected an essentially agricultural society where the merchant was suspect and there were well-defined barriers between the classes. Monarchy was considered the best form of government, and intellectuals were almost without exception clerics. Italian society was very different. From the twelfth century on, Italy had been the leading commercial power of Europe, and by 1300 the peninsula had become the center of industry as well. Italy was far more urbanized than northern Europe. In 1300 half a dozen cities of more than fifty thousand people dotted the Italian landscape, whereas north of the Alps only Paris could boast a population above that number. Lay literacy was relatively high in urban areas, and the leading intellectuals in the society were laymen, although before 1300 education was largely oriented toward practical goals. Therefore, the figure of Dante, coming at the end of the thirteenth century, is an exception and harbinger of great things to come.

The Crisis of the Fourteenth Century

The fourteenth century was a time of trouble for Europe. By 1300 western Europe was overpopulated for the technological level of the society. The costs of food and food-bearing land were high, wages were low, and a good percentage of the population was undernourished. When a terrible famine, the worst of the Middle Ages, struck the subcontinent between 1314 and 1318, about 10 percent of the people died and the losses were not made up. Beginning in 1348 the Black Death struck repeatedly over a wide area for the next fifty years. Carried by fleas that infest rats, the Black Death appears to have begun in China in the 1330s and moved across Asia and the Middle East before reaching the European subcontinent in 1348. In Europe, as elsewhere, the plague caused enormous death tolls. Francesco Triani's fresco in the Camposanto (cemetery) at the cathedral in Pisa (Fig. 16-1), painted about 1350, demonstrates the ways in which death and the Last Judgment were envisioned. Triani, like many other artists in this period, combined elements of the late medieval preoccupation with divine retribution and a growing awareness of the attractions of the secular life, which resumed and blossomed after society's recovery from the Black Death.

By 1400 Europe had only about 60 percent of the population that it had had in 1300. The population was to remain at this low level until the last decades of the century, when a spectacular rise in population began.

> • Compare the group of figures on the right with those on the left. What is the mounted nobleman in the foreground being told? Who is the figure confronting him? Where is hell, and what does it look like? How do the angels differ from the demons? Describe your reaction to this image.

16-1 *Francesco Triani (active 1321–1370),* The Triumph of Death, *Camposanto, Pisa, c. 1350, fresco. (Alinari/Art Resource, NY)*

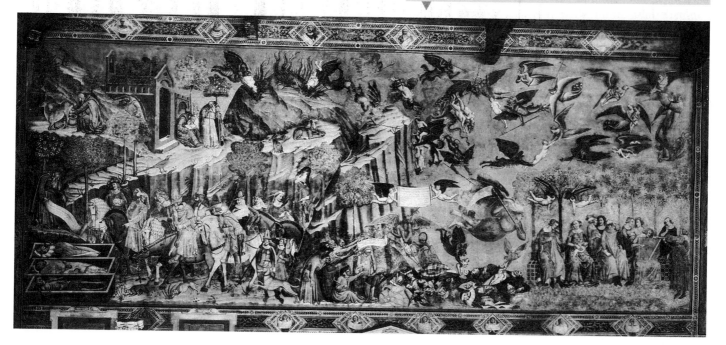

This great human loss from the plague resulted in an economic contraction, a rise in labor costs, and a drop in rents and food prices. The overall effect on the upper classes of Europe who earned their income from trade or agriculture was adverse.

In the mid-fourteenth century the deterioration and then breakup of the vast Mongol Empire closed off Europe's direct trade with China, which had flourished for almost a hundred years. The establishment of the violently xenophobic Ming dynasty in the 1360s and the expulsion or massacre of any remaining foreigners marked the final stage of cutoff. Until the sixteenth century Europeans would be forced to obtain Chinese products through Arabs acting as intermediaries, just as they had before 1250.

Although, like the rest of Europe, Italy was affected by the plague and the economic contraction, it remained the commercial and industrial center and did not suffer economic stagnation to the same degree as the North. Indeed, it appears that an imbalance in trade favorable to Italy existed in the fourteenth and fifteenth centuries. Quantities of gold and silver flowed into the peninsula from the North in exchange for luxury goods that Italians produced or imported from the East. The drain from the North could not go on forever, and as purchases of Italian goods by northerners slowed down, investment opportunities in businesses narrowed in Italy.

The effect of the economic contraction in Italy, however, was not all negative. Some of the Italian stocks of surplus precious metals, with no profitable outlet available, were subsequently funneled into culture; they paid for architecture, art objects, and patronage to scholars and writers. Both in Italy and in the North, business people learned to rationalize their production, rendering their operations more efficient to compete in a diminished market. Modern business practices such as double-entry bookkeeping and holding companies appeared. The rapid diffusion of the mechanical clock from the fourteenth century enhanced the tendency toward greater efficiency: time is, after all, money.

Humanism

The response of the best minds in Italy to the crisis of the fourteenth century brought about the intellectual movement known as *humanism*. On the whole, the humanists were hostile to scholasticism, the form of learning that had reached its perfection in the thirteenth century. Scholastics tried to use human reason to understand as much as possible about the nature of God and the construction of the universe. For the humanists, by contrast, the major object of the intellectual labor was to guide human conduct in this world. At the same time, they argued that even if speculation on God and nature was important, the mystifying reign of death and destruction in the fourteenth century testified to the futility of such investigation.

Besides divine revelation, the only sure source of human knowledge for the humanists was their own experience and history, that is, the experience of other human beings in past times. Human beings can learn from their history because, unlike nature, history is their own creation. Thus, the humanists reasoned, the study of the successes and failures of those who preceded us would teach us how to conduct our lives. The humanists, moreover, were very clear on what history they considered to be the proper source for help. For the Italian humanists of the fourteenth to the sixteenth centuries, the ancient Romans and—after 1400, when they began to learn Greek—the ancient Greeks furnished the best examples of human conduct because their societies had reached the pinnacle of worldly achievement in all aspects of human endeavor.

In fact, the Italian humanists of the fourteenth century set out to create patterns of behavior that accorded better with their way of life than did inherited medieval ethical forms. These traditional standards still fitted northern European society, which was essentially rural and socially hierarchical, with learning a preserve of the clergy. On the other hand, by the fourteenth century, Italy—like ancient Rome and Greece—was urban, with a high degree of social mobility and widespread Latin literacy among the laity. Like ancient society, moreover, Italy was organized around city-states with an intense political life. Consequently, in search of a morality compatible with their evolving urban society, Italian humanists turned for guidance to the ancient orators, moralists, and historians.

Essentially, the humanists were literary scholars interested in Greek and Latin literature, grammar, history, and ethics. These subjects, therefore, constituted the *studia humanitatis*—that is, the disciplines that made human beings truly human. For the humanist, the capacity to express oneself in words distinguished the human race from all other species. If this was the basic human characteristic, those who best expressed themselves in words were the most human. In considering human beings, however, the humanists were usually concerned only with men. They also assumed that outer speech was a reflection of inner state. If the inner man was calm and in harmony with his nature, then his speech would be fluent and harmonious. True eloquence stemmed from a fine soul, just as the highest degree of moral virtue was closely tied to eloquence. Of course, one could be virtuous and still stutter, but virtue could be maximized by helping others to become virtuous as well. The individual Christian had a responsibility to others to help them to be good Christians; this could best be done by eloquent speech that inspired the will and heart to do what was right.

Since the humanists considered the ancient pagan writers to have achieved excellence in speaking and writing, they believed that the study of Greek and Roman literature could best teach effective oral and written expression. They also thought that the writings of the pagans contained moral teachings urged with such forcefulness that they could not but influence their readers to become virtuous. In reading these writings, therefore, the humanists sharpened their moral sensibilities as well as their literary technique. They, in turn, would use their eloquence and virtue to persuade and train others.

Admittedly, the truth as found in the pagan authors—fragmentary and based on reason—had to be interpreted in the context of the overarching truths of Christianity. The humanists, however, saw no incompatibility between what the Bible taught about God and about the nature of the human soul and the moral lessons taught by the ancient writers. The eloquence and learning of the ancients, consequently, coupled with the greater vision provided by divine revelation, could be a tremendous force for Christian reform.

One of the humanists' major criticisms of the scholastics was that their language was too technical and awkward. Such a style could never inspire human beings to improve their lives. There was an enormous difference between knowing the truth and carrying out its lessons in practice. Eloquent speech was the means of making truth active in the world.

Humanism was clearly an outgrowth of the urban culture of central and northern Italy. Dante had already shown the creative vigor present in this maturing urban society, but he had written in medieval Latin as well as in Tuscan. This new movement, as we have seen, took the ancients and their Latin as its models. Once initiated, imitation of the ancient Romans seemed natural to Italians.

The Use of Classical Authors Because ancient eloquence was central to their scheme of education, the humanists from the fourteenth century on devoted enormous energy not only to recovering lost ancient writings but also to preparing good editions of those inherited from the Middle Ages. In the more than eleven or twelve hundred years since ancient Roman times, the works of the pagans, especially the most popular ones, had been copied thousands of times by thousands of scribes; thus texts were terribly corrupted. It fell to the humanists to restore as fully as possible the words and phrases of the pagan writers by a systematic comparison of surviving manuscripts. If ancient eloquence was to serve as a means of inspiring the present generation, the texts must be restored to their original purity.

Medieval writers treated the classics as a kind of quarry from which to borrow words and ideas in order to adorn and support their own schemes of thought. Although concerned with using the ancient writers for their own purposes, the humanists were also interested in defining the personalities of the great people of antiquity. Rather than attribute attitudes and ideas to pagan writers on a piecemeal basis, they tried to form an integrated picture of their thought and personalities by a careful analysis of all of an individual writer's works. Because of the similarities between their own and the ancient culture, the humanists were able to appreciate the thoughts and actions of the ancients as the Middle Ages never could. This awareness of an interest in the total personality, moreover, motivated their approach not merely to historical personages but also to people of their own time.

Furthermore, all the comparison of words and phrases in the effort to obtain accurate texts taught the humanists a concept not well understood in the Middle Ages: that languages change and have a history. The same is true of institutions, customs, and ideas. Thus the scholarly endeavors of the humanists led them gradually to develop a sense of change and development, of historicity. This deepened their appreciation of the nature of human personality, permitting them to see the extent to which individuals were conditioned by circumstances of time and place. It also led them to a growing awareness that people are responsible for their history in large part and, subsequently, for their future as well. They came to see human beings as doers and makers, endowed with the godlike powers of reason and will to create their own culture.

Humanism and Science While not completely discarding the medieval ethos, which emphasized compassion, suffering, and humility, humanism in its essential tendencies moved toward a reevaluation of the human predicament by accenting the active, dynamic aspect of human nature. Originally biased against the natural sciences because of their focus on nature rather than human beings, the humanists nonetheless furnished the scientists with better texts of antiquity on which to base their investigations. By the sixteenth century they were largely responsible for providing a vision of human creative capacities that encouraged scientific inquiry. Through the joint efforts of humanism and natural science, the task of improving human life materially as well as spiritually through a better understanding of individuals and their environment became increasingly viewed as a primary goal of learning.

Petrarch (1304–1374) Francesco Petrarca is generally considered the first of the Italian humanists. Although he was Florentine by descent and his first teacher was an exiled Tuscan like his own father, Petrarch grew to manhood in France, not Italy. In the second half of his life, which he spent primarily in Italy, Petrarch saw the city of his ancestors only twice on brief visits. Petrarch's

pioneering achievement was to formulate the basic humanistic conception of the intimate connection between ethics and eloquence just described and to develop an appreciation for ancient life and thought in its historical context.

In certain respects, however, Petrarch was still closely linked to medieval traditions. Medieval thinkers were fully committed to the belief that the contemplative life was the best form of human existence and that monarchy was the best form of government. Like these thinkers, Petrarch, who spent most of his mature life in proximity to the new princely courts of northern Italy, considered the life of the citizen—the married man with business and civic responsibilities—unquestionably inferior to that of the solitary scholar or monk, who devoted his energies to the contemplation of divine truth. Moreover, like them he believed that monarchy was the ideal political constitution and that the Roman emperors had been established by God to replace the decaying Roman Republic.

Whereas Petrarch's scholarly contemporaries and Petrarch himself believed that his principal claim to enduring fame lay in his Latin writings (he was made poet laureate for his Latin epic poem *Africa*), subsequent generations have been most influenced by the poems he wrote in Tuscan Italian, the *Rime sparse*. These include both longer poems and sonnets, and it is especially as master of the *sonnet* form that Petrarch influenced all European poetry. Petrarch's sonnets were inspired by those of Dante and the poets of the *dolce stil nuovo* (see Volume 1, Chapter 10). Like Dante's theme in the *Vita Nuova*, Petrarch's major theme in his sonnets is the poet's love for a beautiful and inaccessible lady, and like Dante, he writes of this love both during her lifetime and after her death. But Petrarch's Laura, often pictured in nature, among spring flowers, is less symbolic and medieval than Dante's Beatrice. Although there is no hard evidence for her actual existence, most scholars assume that she was a married French noblewoman whom Petrarch encountered while living in the south of France. In his poetry, Petrarch not only speaks of Laura's beauty but also analyzes the whole range of his emotions as a lover, from elation to despair. It is this interest in the problems of human nature and in the individual that differentiates Petrarch from medieval writers. Although Petrarch sometimes strives to present Laura as the transcendental ideal in imitation of Dante's Beatrice, this effort is constantly undercut by an ambivalent mixture of the sacred and the erotic.

Civic Humanism: Salutati and Bruni

By 1400 Florence was one of a dwindling number of cities still governed by republican methods. A republican government is one in which a large number of men—until the twentieth century all women were ex-

cluded—elect officials and can hold office themselves. If the citizen body is almost identical with the adult male population of the state, the government is called a democratic republic. Between the destruction of the Greek city-states and the late eighteenth century, however, no republics were democratic. During the thirteenth century many cities of northern and central Italy had been republics in that a significant portion of the male population (usually the wealthier portion) were citizens—even though a large number of people were excluded from the political process. But in the course of the fourteenth century, many popular regimes had been replaced by the rule of one person or one family. Even in Florence, where by 1400 more than two thousand public offices had to be filled annually, a narrow group of families controlled the key positions.

Republican institutions, however, were still strong enough in Florence to inspire Coluccio Salutati (1331–1406), humanist and chancellor of the city, to challenge the medieval theory of the superiority of monarchy. Both in his official work as Florentine chancellor, or secretary of state, and in his more scholarly writings, Salutati began to elaborate an argument for republicanism. His disciple Leonardo Bruni (1370–1444), however, was primarily responsible for formulating a theory of republican government that was to remain a living force down to the nineteenth century and beyond. He considered the rule of one person harmful to the common good. Since people realize themselves to the fullest in serving the state, republican government is natural and inherently stronger than monarchy. Rome reached its highest power under the Republic, not under the emperors; in fact, although some emperors might have been personally good men, as a group they destroyed Rome. Florence, founded in the days of the Roman Republic, inherited that tradition of liberty, and in contemporary Italy it served as the leader in the struggle of free people against *tyranny*.

The origins of Bruni's theory of *civic humanism* can be traced to the writings of Aristotle and Cicero. But Bruni's capacity to sense the republican spirit of these writers, which his predecessors had not perceived, stems from his personal experience as a part of a living republican society. His arguments rested both on his understanding of human nature and on the lessons he believed were found in history. The first European to formulate republican ideas with such clarity, he was followed over the next hundred years by a whole succession of writers, mainly Florentine, urging similar views.

Bruni was also one of the first of the humanists to learn Greek. Eminent Latin scholars like Petrarch and Salutati in the previous century did not know the other classical language. Aristotle's works had been translated hundreds of years before into Latin, but Bruni's knowledge of Greek gave him access to the rest of extant Greek literature.

DAILY LIVES

Marriage in Renaissance Florence

In 1422, at the age of fourteen, Alessandra Macinghi (1408–1471) married Matteo Strozzi, a member of an old, powerful Florentine family. He was about twenty-five. The Macinghi and the Strozzi families were neighbors, and the marriage was, as usual, arranged to forge an alliance between two families. Because Matteo's family had been enemies of Cosimo de' Medici, the male members of the family were exiled on Cosimo's return from exile in 1434. Two years later Matteo died, leaving Alessandra in Florence with the task of raising their five surviving children.

She never remarried. Her two oldest sons, Filippo (b. 1428) and Lorenzo (b. 1432), left Florence as young teenagers to seek their fortunes in Naples, where their father's cousins had a business, but new legislation passed in 1458 prohibited them from returning home.

Fortunately for historians, Strozzi wrote copiously to her oldest son in Naples for more than twenty years, now requesting advice, now giving it. She wrote in Tuscan, the Florentine vernacular, in a somewhat awkward style. The letter that follows was written in 1465 and concerns finding Filippo a wife.[a] Despite his growing wealth as a successful businessman and his family's name, Filippo could not expect to marry within his own class because of his exiled condition. Consequently, Alessandra is looking for a girl from a respectable family, but one of lower status and unable to provide a large dowry. Marco Parenti, mentioned in the text, was Alessandra's son-in-law, husband of her daughter Caterina and himself from a family of lesser social status than the Strozzi.

It is now the 27th and Marco Parenti has come to see me. He has been talking to me about how we discussed finding you a wife a long time ago, and how we discussed the possibilities and where we thought we'd be able to go, and how it seemed to us that the best match, all other things being equal—if she had the right ideas and was beautiful, and wasn't rough and uncouth—was Francesco di Guglielmino Tanagli's daughter. We haven't heard of anything, up to the present, which would suit you better than this. . . . However we have looked into it secretly, and we've found that there aren't any girls [whose families would marry them] to an exile, who don't have some shortcoming or other, whether [lack of] money or something else. Now the least serious drawback is the money, and when other things we want are there we shouldn't look askance at the money, as you've said to me a number of times. So on St. Jacob's Day, as Francesco is a great friend of Marco's and trusts him greatly, having already heard several months ago that we were willing to have a look at the girl, he asked Marco about it in a fine manner and choosing his words well. He said that if he [Marco] asked for her on your behalf, when we had made up our minds, she would come to us willingly, because you're a man of substance and [his family] having always made good matches, as he had little to give her he would sooner send her away to someone of substance rather than give her to whoever he could find here, someone who would have little money, and that he wouldn't want to lower [his family's status]. He wanted Marco to go with him to his house, and he called the girl down, and he [Marco] saw her, and he [Francesco] said that if Caterina or I wanted to see her at any time he would show her to us. Marco says she looks beautiful and that she seemed suitable to him. We've been told that she has the right ideas and is capable and that she runs the household to a large extent because there are twelve children, six boys and six girls, and according to what I hear she runs it all because her mother is always pregnant and doesn't do much. Those who know the household say she manages the house and that her father has trained her to do it, and he is very well thought of and one of the best-mannered young men in Florence. So as it seems to me that we will have to wait a long time, I don't think we should put off taking this step, so let us know what we should do.

a. Excerpt from *Selected Letters of Alessandra Strozzi, Bilingual Edition*, trans. Heather Gregory (Berkeley and Los Angeles: University of California Press, 1997), pp. 149, 151.

Women and Humanism

In the fifteenth century humanism's promise of endowing its adherents with wisdom and virtue could not help but attract women. Those who attained any reputation for letters, however, all came from the privileged classes. Barred from humanist grammar schools, they received their advanced training at home either from tutors or from their fathers. As young girls proficient in Latin and Greek, they were commonly celebrated in their cities as prodigies, but they were prodigies without a future. Although humanists might be intrigued by the novelty of a learned woman, they were not willing to recognize female scholars as their equals. Barred from the world of letters, a learned woman in her late teens had two alternatives: marriage or the nunnery. Neither encouraged women to continue their scholarship.

Of the twenty or so women recognized for their learning in the fifteenth century, only two—Cassandra Fedele (1465–1558) and Laura Cereta (1469–1499)—continued their scholarship after marriage. None of those taking religious vows seems to have pursued her studies once in the convent. The case of Isotta Nogarola (1418–1466) is unique because she neither married nor became a nun. By the age of twenty, she realized that she would never be accepted in the humanist circle. After having been viciously accused of immorality—"an eloquent woman is never chaste"—she abandoned any hope of gaining recognition for her learning and spent the rest of her life studying at home, but writing little. One may well ask, Was there a Renaissance for women?

The Medici and Neoplatonism

In the last decade of Bruni's life Florence came under the control of the Medici family and their supporters. An old Florentine banking family, the Medici by the early fifteenth century were the richest family in the city. In the early 1430s the head of the family, Cosimo, quarreled with the other leading members of the Florentine government and was sent into exile in 1433. The following year, when his enemies in the government proved themselves clearly incompetent, they were driven out and Cosimo was recalled. Although the republican institutions continued to function and Cosimo remained a private citizen, for all practical purposes he and his close friends were usually able to control both the internal and external policies of the republic.

When Cosimo died in 1464, his son, Piero the Gouty, inherited the authority; and when five years later Piero died, he in turn was succeeded by his two sons, Lorenzo and Giuliano, then twenty and eighteen, respectively. After the assassination of Giuliano in 1478, Lorenzo alone directed the political life of the city until his own death in 1492. The years of Lorenzo's domination in Florence were also years of some of the highest cultural achievements in the city. Because of his exquisite taste and personal talents, Lorenzo became known in his own lifetime as Lorenzo the Magnificent.

The rise of the Medici and their political control over Florentine institutions rendered Bruni's emphasis on the active life of the citizen unrealistic. Although a republican current persisted in the city, the mood was generally one of political quietism. Not by chance, the second half of the fifteenth century marked the progress of a movement usually labeled Florentine Platonism.

As we have already seen, Greek studies were introduced in Florence at the beginning of the fifteenth century and reinforced by the arrival of Greek scholars from Byzantium in the middle decades of that century. One of the first goals of Greek scholars was to translate the complete works of Plato. Whereas Aristotle had been translated into Latin in the thirteenth century, until this time only a handful of Plato's writings were in that language. Now, along with Plato's works, writings of Plato's ancient followers, the Neoplatonists, were also put into Latin. The most famous of these followers was Plotinus, an Egyptian of the second century A.D., who had given Plato's philosophy a clearly mystical bent. Plotinus stressed that through proper training the soul, whose true home was beyond this world, could at times in this life return by a mystic ascent to the world of the Ideas. The ultimate step was to merge totally with the Platonic One or Idea of the Good. Besides those of Plotinus, other Platonic writings, many of them of a magical nature, became popular with late-fifteenth-century intellectuals. This kind of literature fitted an age that was no longer interested in active participation in politics.

Rather than focus on politics as the civil humanists had done earlier, the Florentine Platonists stressed the potentialities of the human being for making contact while in this life with God and angels, the highest forms of reality. Because humans existed midway on a chain of being between the lowest material objects and God, the whole range of reality was potentially accessible to those who had received training in Platonic philosophy. One thinker, Giovanni Pico della Mirandola (1463–1494), went even further by arguing that human beings had no determined nature and that by acts of their will they could fall to the lowest depth of creation or rise to a position above that of the angels. No thinker of the Renaissance surpassed Pico in his conception of human freedom and power.

FRANCESCO PETRARCH

from the *Rime Sparse (Scattered Rhymes)*
Translation by Robert M. Durling[1]

In his collection of "scattered rhymes," Petrarch includes diverse poetic forms such as the *canzone* (song) represented by "Clear, fresh, sweet waters" in poem 126. The majority of the poems, however, are *sonnets,* a form whose possibilities of symmetry and contrast Petrarch explores with great ingenuity. The octave usually presents a situation, event, image, or generalization, and the sestet a reflection, result, or application. Sonnet 5, printed here in the original Italian as well as in translation, exemplifies Petrarch's love of technical ingenuity and his artificiality. He puns on each syllable of Laura's name in two forms (Laureta and Laure).

Note, too, the classical reference, frequent in Petrarch, to the myth of Apollo and the laurel tree. Daphne, daughter of the god of the river Peneus in Thessaly, was pursued by Apollo. She prayed to her father to preserve her virginity, and when Apollo caught up with her, she was transformed into a laurel. Apollo adopted the tree as his own and crowned himself with a wreath from it (Ovid, *Metamorphoses,* lines 452–567). The laurel was supposedly immune from lightning. Its Latin name, *laurus,* was thought to derive from the verb *laudare* (to praise). Petrarch considered it the crown both of poets and of triumphant emperors.

Another sonnet plays with the word *aura* (breeze) and its relation to Laura. Although some of Petrarch's sonnets seem natural in their use of imagery, others are highly ingenious in their attempt to portray the sufferings and joys of love.

1

You who hear in scattered rhymes the sound of those sighs with which I nourished my heart during my first youthful error, when I was in part another man from what I am now:

for the varied style in which I weep and speak between vain hopes and vain sorrow, where there is anyone who understands love through experience, I hope to find pity, not only pardon. 5

But now I see well how for a long time I was the talk of the crowd, for which often I am ashamed of myself within; 10

and of my raving, shame is the fruit, and repentance, and the clear knowledge that whatever pleases in the world is a brief dream.

5

Quando io movo i sospiri a chiamar voi
e 'l nome che nel cor mi scrisse Amore,
LAU-dando s'incomincia udir di fore
il suon de' primi dolci accenti suoi;

vostro stato RE-al che 'ncontro poi 5
raddoppia a l'alta impresa il mio valore;
ma "TA-ci," grida il fin, "ché 'farle onore
e d'altri omeri soma che da' tuoi."

Cosi LAU-dare et RE-verire insegna
la voce stessa, pur ch' altri vi chiami, 10
o d'ogni reverenza et d'onor degna;
se non che forse Apollo si disdegna
ch'a parlar de' suoi sempre verdi rami
lingua mor-TA-l presuntuosa vegna.

5

When I move my sighs to call you and the name that Love wrote on my heart, the sound of its first sweet accents is heard without in LAU-ds.

Your RE-gal state, which I meet next, redoubles my strength for the high enterprise; but "TA-lk no more!" cries the ending, "for to do her honor is a burden for other shoulders than yours." 5

Thus the word itself teaches LAU-d and RE-verence, whenever anyone calls you, O Lady worthy of all reverence and honor; 10

[1] *Petrarch's Lyric Poems* (Cambridge, Mass.: Harvard University Press, 1976), pp. 36, 40–41, 244, 270.

except that perhaps Apollo is incensed that any
 mor-TA-l tongue should come presumptuous to
 speak of his eternally green boughs.

133

Love has set me up like a target for arrows, like snow
 in the sun, like wax in the fire, like a cloud in the
 wind; and I am already hoarse, Lady, with calling for
 mercy, and you do not care.

From your eyes the mortal blow came forth, against 5
 which time and place do not avail me; from you
 alone come forth (and it seems a light matter to
 you) the sun and the fire and the wind that make
 me such.

Thoughts of you are arrows, your face a sun, desire 10
 a fire; and with all these weapons Love pierces me,
 dazzles me, and melts me;

and your angelic singing and your words, with your
 sweet breath against which I cannot defend myself,
 are the breeze[1] before which my life flees. 15

126

 Clear, fresh, sweet waters,[2] where she who alone
seems lady to me rested her lovely body,
 gentle branch where it pleased her (with sighing I
remember) to make a column for her lovely side,
 grass and flowers that her rich garment covered 5
along with her angelic breast, sacred bright air
where Love opened my heart with her lovely eyes;
listen all together to my sorrowful dying words.

 If it is indeed my destiny and Heaven exerts
itself that Love close these eyes while they are still 10
weeping,
 let some grace bury my poor body among you and
let my soul return naked to this its own dwelling;
 death will be less harsh if I bear this hope to the
fearful pass, for my weary spirit could never in a 15
more restful port or a more tranquil grave flee my
laboring flesh and my bones.

 There will come a time perhaps when to her accus-
tomed sojourn the lovely, gentle wild one will return
 and, seeking me, turn her desirous and happy 20
eyes toward where she saw me on that blessed day,
 and oh the pity! seeing me already dust amid the
stones, Love will inspire her to sigh so sweetly that

she will win mercy for me and force Heaven,
drying her eyes with her lovely veil. 25

COMMENTS AND QUESTIONS

1. Note the divisions between octave and sestet in each
of the sonnets. What is the rhyme scheme in Italian
(Sonnet 5)? In translation, they do not always have
eight and six lines. What are the advantages and
disadvantages of the sonnet as a poetic form?

2. What does Petrarch mean in the introductory poem
when he says "When I was in part another man
from what I am now"?

3. What is the function of the myth of Daphne and
Apollo in Sonnet 5?

4. What seems to be the relation between Laura and
nature in "Clear, fresh, sweet waters" (poem 126)?

5. How would you define the Petrarchan concept of
love? Of woman?

from *Letters on Familiar Matters*
Translation by Aldo Bernardo

Generally in the Middle Ages the ancient Latin au-
thor Cicero (106–43 B.C.) was considered to have
been a philosopher given to the contemplative life. In
1345, however, Petrarch discovered Cicero's corre-
spondence, unknown for centuries. The letters re-
vealed a very different Cicero: a politician willing to
compromise to maintain a leadership role in the de-
caying Roman Republic. The finding of the letters
inspired Petrarch to write a letter to his much-
admired hero, critical of his political activity, which
Petrarch considered unworthy of a scholar. This let-
ter became the first in a series written to ancient Ro-
man and Greek authors to whom Petrarch spoke as
if they were living men. The letters clearly reflect a
new attitude toward antiquity. Rather than relate to
these authors only for their ideas, Petrarch sees them
as human beings in whom strengths and weaknesses
mingled much as they did in Petrarch himself.

Fam. XXIV, 3.
To Marcus Tullius Cicero.

Francesco sends his greetings to his Cicero. After a
lengthy and extensive search for your letters, I found
them where I least expected, and I then read them with
great eagerness. I listened to you speak on many sub-
jects, complain about many things, waver in your opin-
ions, O Marcus Tullius, and I who had known the kind
of preceptor that you were for others now recognize the

[1] In Italian, *l'aura.*
[2] The waters of the river Sorgue.

kind of guide that you were for yourself. Now it is your turn, wherever you may be, to hearken not to advice but to a lament inspired by true love from one of your descendants who dearly cherishes your name, a lament addressed to you not without tears. O wretched and distressed spirit, or to use your own words, O rash and ill-fated elder, why did you choose to become involved in so many quarrels and utterly useless feuds? Why did you forsake that peaceful ease so befitting a man of your years, your profession, and your fate? What false luster of glory led you, an old man, into wars with the young, and into a series of misfortunes that then brought you to a death unworthy of a philosopher? Alas, forgetful of your brother's advice and of your many wholesome precepts, like a wayfarer at night carrying a lantern before him, you revealed to your followers the path where you yourself stumbled most wretchedly. I make no mention of Dionysius, of your brother or of your nephew, and, if you like, even of Dolabella, all men whom you praise at one moment to the high heavens and at the next rail at with sudden wrath.[1] Perhaps these may be excused. I bypass even Julius Caesar, whose oft-tested clemency proved a haven of refuge for those very men who had assailed him;[2] I likewise refrain from mentioning Pompey the Great, with whom you seemed able to accomplish whatever you liked by right of friendship.[3] But what madness provoked you against Mark Anthony?[4] Love for the Republic, I suppose you would say, but you yourself confessed that it had already collapsed. But if it were pure loyalty, if it were love of liberty that impelled you, why such intimacy with Augustus?[5] What would your answer be to your Brutus[6] who says, "If you are so fond of Octavius, you seem not to have fled a tyrant, but rather to have sought a kindlier one." There still remained your last, lamentable error, O unhappy Cicero: that you should speak ill of the very man whom you had previously praised, not because he was doing you any harm, but merely because he failed to check your enemies. I grieve at your destiny, my dear friend, I am filled with shame and distress at your shortcomings; and so even as did Brutus, "I place no trust in those arts in which you were so proficient." For in truth, what good is there in teaching others, what benefit is there in speaking constantly with the most magnificent words about the virtues, if at the same time you do not give heed to your own words? Oh, how much better it would have been, especially for a philosopher, to have grown old peacefully in the country, meditating, as you write somewhere, on that everlasting life and not on this transitory existence; how much better for you never to have held such offices, never to have yearned for triumphs, never to have had any Catilines to inflate your ego. But these words indeed are all in vain. Farewell forever, my Cicero.[7]

From the land of the living, on the right bank of the Adige, in the city of Verona in transpadane Italy, on 16 June in the year 1345 from the birth of that Lord whom you never knew.

COMMENTS AND QUESTIONS

1. What kinds of weakness of character do Cicero's letters reveal in their writer?
2. What motivation does Petrarch ascribe to Cicero to explain his eagerness to participate in politics?
3. What is the significance of Petrarch's dating of his letter?

GIOVANNI PICO DELLA MIRANDOLA

from the *Oration on the Dignity of Man*
Translation by Ronald Witt

In the following excerpt from the *Oration on the Dignity of Man,* written in 1486, Pico, the Florentine Neoplatonist, draws not only on Christian but also on Jewish and Muslim traditions to describe the unique role that humanity plays in the universe. Insisting on the superiority of Christianity in that it gives the fullest account of divine truth, he nonetheless believes that other religions contain a portion of that truth. This view encouraged the serious study of other religions of the world.

I have read, O venerable fathers, in the records of the Arabs that Abdala the Saracen,[1] when asked what he

[1] Cicero and members of his own family were sometimes in disagreement over politics.

[2] Petrarch admired Caesar (100 B.C.–44 B.C.) and he is here criticizing Cicero for his objection to Caesar's effort to control the Roman state.

[3] Pompey (106 B.C.–48 B.C.) was Caesar's mortal enemy.

[4] Cicero was violently critical of Anthony (d. 31 B.C.), who was close to Caesar and who, after the murder of Caesar, tried himself to seize power over the Republic. He succeeded in murdering Cicero.

[5] Octavian (63 B.C.–14 B.C.), who became Augustus Caesar, was the nephew of Caesar and in 31 B.C. defeated Anthony and established himself as the first emperor of Rome.

[6] Marcus Junius Brutus (84 B.C.–42 B.C.) was a leading defender of the Roman Republic against Caesar and was involved in the murder of the dictator. The arts mentioned here refer to Cicero's oratorical ability and his reputation for wisdom.

[7] In 63 B.C. Cicero established his reputation as a great leader by identifying Catiline, a Roman senator, as plotting to overthrow the Republic before the Roman Senate.

[1] Abdala was presumably the cousin of Muhammad.

believed was the most admirable thing on the stage of this world, as it were, replied that there was nothing more admirable than man. Hermes Trismegistus supported this opinion when he said, "O Asclepius, man is a great miracle!" Yet when I consider the grounds for such sayings, the many justifications, given by many, for the outstanding qualities of human nature do not satisfy me: that man is intermediary between the creatures, a friend of the higher powers, king of the lower regions; capable of understanding nature with the sharpness of his senses, the penetration of his reason, and the light of his intelligence; the space between unchanging eternity and the flux of time, and (as the Persians say) the bond of the world, nay rather, its marriage bond, and, as David testifies, only less than the angels.[2] Indeed these are great qualities but not the principal ones, that is, those which rightly serve as the basis for such extraordinary admiration. But why should we not admire the very angels and the blessed chorus of the heavens more? At length I seemed to myself to have understood why man is the most fortunate animal and therefore worthy of universal admiration and what his place in the order of the universe is that makes him an object of envy not only by brutes or by the stars, but even by minds beyond this world. It is an unbelievable and wonderful thing. Why should it not be? For on this account man is properly said to be a great miracle and a wondrous being. But now hear, Fathers, what it is and out of your kindness lend me your full attention.

The supreme Father, God the architect, had already fabricated this house of the world which we see, the most illustrious temple of the divinity, according to the laws of His secret wisdom. He had adorned the place above the heavens with minds and animated the heavenly spheres with eternal souls; He had filled the excrementary and filthy places of the lower world with all manner of animals. But, with the work finished, the artisan wanted there to be someone who could contemplate the nature of so great a work, love its beauty and admire its magnitude. For this reason with all these things finished (as Moses and Timaeus[3] bear witness) only then did He think of creating man. But there was nothing among the archetypes from which He could model a new creature, nor in His treasuries was there an inheritance to bestow on His new son, nor was there any place left in the whole world where this contemplator of the universe could sit. Everything was already full; everything in the highest, middle, and lowest orders of being was already given out. But it was not in the Father's nature to fail as if worn out in this last creation; nor was His wisdom to waver without a plan in

such a serious situation. Nor was it a part of His loving kindness that He, who would praise divine liberality in others, would condemn Himself for His lack of it. At length the consummate artificer decreed that the creature whom He could endow with no properties of its own should share in all those which the others possessed individually for themselves. Therefore, He took man, a creation of indeterminate form, and placing him at the midpoint of the world spoke to him in this way: "I have given you no fixed abode, no form of your own, no gifts peculiarly yours, O Adam, so that you might have and possess the abode, form and gifts you yourself desire according to your will and judgment. The defined nature of other beings is confined by laws which I have prescribed. You, compelled by no limitations, according to your free choice in whose hands I have placed you, shall prescribe your own limits. I have set you in the center of the world, that you might more easily observe whatever there is in the world. We have made you neither heavenly nor terrestrial, neither mortal nor immortal, so that, free of constraint and more honorable as your own moulder and maker, you might give yourself whatever form you prefer. You can degenerate toward lower beings, which are brutes, or, if you will, you can be reborn among higher beings, which are divine."

Oh, the magnificent generosity of God the Father! Oh, the extraordinary and wondrous felicity of man, who was given the power to be that which he wanted! Brutes as soon as they are born bring with them from the mother's womb everything they are to have. The highest spiritual beings either from the beginning or soon thereafter are that which they will be for eternity. In the case of man, the Father bestowed on him at birth manifold seeds and germs of every kind of life. Whichever ones he cultivates will grow and bear their fruit in him. If he cultivates vegetative seeds, then he becomes a plant; if sensual ones, then a brute; if rational seeds, then he becomes a heavenly being. If intellectual ones, then he will be an angel and son of God. And if, unhappy with being a creature of any sort, he draws into the center of his own unity, his spirit will be made one with God, and in the solitary darkness of the Father, Who is above all things, he will distinguish himself beyond all things. Who does not admire this our chameleon? Could anything else be more an object of wonder?

COMMENTS AND QUESTIONS

1. What different sources does Pico appear to use in establishing the dignity of man?

2. Compare Pico's account of man's creation with that in Genesis (Vol. 1, Chapter 7). To what extent does he remain within the Judeo-Christian tradition, and how does he differ?

[2] Psalm 8:5.

[3] Plato, *Timaeus.*

3. What is the basis for man's dignity? In what respect is man more wonderful than the angels?

4. Compare Pico's glorification of man with that of Sophocles in the choral ode from *Antigone* (see the section "Humanism and Sophoclean Tragedy" in Vol. 1, Chapter 4).

LAURA CERETA

Letter to Bibulus Sempronius: Defense of the Liberal Instruction of Women
Translation by Margaret L. King and Albert Rabil, Jr.

Laura Cereta (1469–1499) belonged to a well-established family in northern Italy. Her father personally trained her in Greek and Latin. She emulated him in her passion for mathematics. Married at fifteen, widowed at seventeen, and left without children, she continued her humanistic interests and tried to engage in correspondence with some of the leading humanists of her day. Apparently none ever responded. In Brescia itself, local critics maintained that her father had written her letters, and women were particularly hostile to her. There were men, however, who considered her as something of a marvel, but she rightly felt that such praise implicitly contained a negative judgment on women. The selection that follows (originally written in Latin) is a bitter invective against such a flatterer. The real name of the addressee is concealed under the name Bibulus Sempronius (*bibulus* is Latin for "drunkard").

My ears are wearied by your carping. You brashly and publicly not merely wonder but indeed lament that I am said to possess as fine a mind as nature ever bestowed upon the most learned man. You seem to think that so learned a woman has scarcely before been seen in the world. You are wrong on both counts, Sempronius, and have clearly strayed from the path of truth and disseminate falsehood. I agree that you should be grieved; indeed, you should be ashamed, for you have ceased to be a living man, but have become an animated stone; having rejected the studies which make men wise, you rot in torpid leisure. Not nature but your own soul has betrayed you, deserting virtue for the easy path of sin. . . .

I would have been silent, believe me, if that savage old enmity of yours had attacked me alone. For the light of Phoebus cannot be befouled even in the mud.[1] But I cannot tolerate your having attacked my entire sex. For this reason my thirsty soul seeks revenge, my sleeping pen is aroused to literary struggle, raging anger stirs mental passions long chained by silence. With just

cause I am moved to demonstrate how great a reputation for learning and virtue women have won by their inborn excellence, manifested in every age as knowledge, the [purveyor] of honor. Certain, indeed, and legitimate is our possession of this inheritance, come to us from a long eternity of ages past.

[To begin], we read how Sabba of Ethiopia, her heart imbued with divine power, solved the prophetic mysteries of the Egyptian Solomon.[2] And the earliest writers said that Amalthea, gifted in foretelling the future, sang her prophecies around the banks of Lake Avernus, not far from Baiae. A sibyl worthy of the pagan gods, she sold books of oracles to Priscus Tarquinius.[3] . . .

[She continues by naming illustrious women of ancient Greece and Rome as well as learned women of her own time.]

Only the question of the rarity of outstanding women remains to be addressed. The explanation is clear: women have been able by nature to be exceptional, but have chosen lesser goals. For some women are concerned with parting their hair correctly, adorning themselves with lovely dresses, or decorating their fingers with pearls and other gems. Others delight in mouthing carefully composed phrases, indulging in dancing, or managing spoiled puppies. Still others wish to gaze at lavish banquet tables, to rest in sleep, or, standing at mirrors, to smear their lovely faces. But those in whom a deeper integrity yearns for virtue, restrain from the start their youthful souls, reflect on higher things, harden the body with sobriety and trials, curb their tongues, open their ears, compose their thoughts in wakeful hours, their minds in contemplation, to letters bonded to righteousness. For knowledge is not given as a gift, but [is gained] with diligence. The free mind, not shirking effort, always soars zealously toward the good, and the desire to know grows ever more wide and deep. It is because of no special holiness, therefore, that we [women] are rewarded by God the Giver with the gift of exceptional talent. Nature has generously lavished its gifts upon all people, opening to all the doors of choice through which reason sends envoys to the will, from which they learn and convey its desires. The will must choose to exercise the gift of reason.

[But] where we [women] should be forceful we are [too often] devious; where we should be confident we are insecure. [Even worse], we are content with our condition. But you, a foolish and angry dog, have gone to earth as though frightened by wolves. Victory does not come to those who take flight. Nor does he remain

[1] Phoebus Apollo, that is, the Sun.

[2] Saba or Nicaula, the black queen of Meroe, who visited Solomon in Jerusalem. Cereta oddly identifies Solomon as Egyptian.

[3] Amalthea, the prophetess of Cumae, who is reported to have sold a book of prophecies to an early Roman king, Priscus Tarquinius.

safe who makes peace with the enemy; rather, when pressed, he should arm himself all the more with weapons and courage. How nauseating to see strong men pursue a weakling at bay. Hold on! Does my name alone terrify you? As I am not a barbarian in intellect and do not fight like one, what fear drives you? You flee in vain for traps craftily-laid out rout you out of every hiding place. Do you think that by hiding, a deserter [from the field of battle], you can remain undiscovered? A penitent, do you seek the only path of salvation in flight? [If you do] you should be ashamed.

I have been praised too much; showing your contempt for women, you pretend that I alone am admirable because of the good fortune of my intellect. But I, compared to other women who have won splendid renown, am but a little mousling. You disguise your envy in dissimulation, but cloak yourself in apologetic words in vain. The lie buried, the truth, dear to God, always emerges. . . .

I, therefore, who have always prized virtue, having put my private concerns aside, will polish and weary my pen against chatterboxes swelled with false glory. Trained in the arts, I shall block the paths of ambush. And I shall endeavor, by avenging arms, to sweep away the abusive infamies of noisemakers with which some disreputable and impudent men furiously, violently, and nastily rave against a woman and a republic worthy of reverence. January 13 [1488]

COMMENTS AND QUESTIONS

1. What two claims of Bibulus anger Cereta?
2. How does she explain why there have been so few outstanding women?
3. How does she explain the success of those women who have attained greatness?

Summary Questions

1. What new vision of love appears in Petrarch's poetry?
2. What were some of the positive effects of the Black Death and the subsequent economic contraction?
3. Why did the humanists emphasize the study of history?

4. What was the primary purpose of humanism?
5. How did the study of antiquity advance that interest?
6. How did humanism advance science?
7. How did the revival of Platonism after 1450 accord with the political atmosphere of the city in that period?

Key Terms

humanism

studia humanitatis

17

Art and Architecture in Florence

I n 1436 when Leon Battista Alberti published the Italian version of his Latin treatise *On Painting* (1435), he added a prologue praising the great Florentine artists Donatello, Ghiberti, and Masaccio, and the architect Brunelleschi. These individuals, says Alberti, are responsible for returning to the study of nature as the source of art and have consequently brought great fame to Florence. In a passage that parallels Pericles' *Funeral Oration,* Alberti compares Florentine accomplishments in art to those of the ancients, reserving the greatest praise for the Florentines, since they had to create by first discovering the knowledge that the ancients had already attained.

This point of view stresses the sense of departure from the immediate past and that of courageous experiment and exploration that, to Alberti and his contemporaries, must have seemed characteristic of Florence in the mid-fifteenth century. Wealth, power, and the association of free people had produced the republic; these same conditions fostered the new forms and conventions in art and architecture.

Similarly, the successful artists of the fifteenth century had roots in Roman antiquity. Brunelleschi, Florence's architect, is reported to have visited Rome in the early 1400s, studying and measuring the remains of the Forum. He returned to create a conspicuously new architecture. Alberti, who knew Brunelleschi, was also an architect who studied ancient texts; he wrote about the ideals and intentions that made Roman and fifteenth-century architecture so different from that of the Middle Ages. His theory and Brunelleschi's practice were, as we will see, representative of the changes taking place in Florence and were largely responsible for the transmission of new ideas to the future.

The City of Florence

It is difficult to imagine the events of the fifteenth century without some feeling for the physical setting of Florence itself (Color Plate I). In the center of Italy, the city sits in a plain at the foothills of the Apennine Mountains, bisected by the Arno River. From almost any vantage point outside or within the

city, one's view is dominated by the red-tiled octagonal dome of Saint Mary of the Flowers, or the *Duomo*, the cathedral of the city. The feeling created by this cathedral and its place within the city is vastly different from that of Notre Dame at Chartres. The *Duomo* sits in its own square (*piazza*) but within a city of other squares that belong to equally important old Christian churches or civic and mercantile enterprises. The *Palazzo Vecchio* (the old city hall) with its battlements and tower reminds one of the Gothic period. It dominates the square where Michelangelo's *David* was originally placed.

The city has many centers of activity; there are distinguishable quarters for artisans, and the *Ponte Vecchio* (the old bridge) spanning the Arno still carries the many shops for luxury items that were there in the 1400s. Florence bustles with business activity—with the precious industries of gold, silver, silk, and leather still practiced today. The great food market near San Lorenzo and the small street stalls give the city an air of tantalizing fecundity.

Florence is dominated by narrow cobbled streets and the thick walls of palaces, banks, and apartments that rise three and four stories, keeping the blistering summer sun from the streets. In the winter the reds, yellows, browns, and tans of marble, stone, stucco, and brick glow wetly, contrasting with the black and white, gray, or green marble of the façades of many of the churches. The city has a this-worldly intensity, a presence of now that is surely both a condition and creation of its fifteenth-century efflorescence.

Florentine Architecture

The cathedral dome that dominates Florence was designed by Filippo Brunelleschi (1377–1446), who won a competition for the commission (Fig. 17–1). Although not the most significant of Brunelleschi's accomplishments, it introduces the scientist, inventor, and designer that Brunelleschi had become. Technically, he employed a system that suspended an interior shell from the exterior structure of ribs and concealed buttresses, which originated in Roman and Gothic technology. Of almost equal importance to the city fathers were the machines and devices that Brunelleschi invented to erect the dome without an enormous quantity of wooden centering (see Roman and Gothic architecture in Vol. 1, Chapters 6 and 9). The *lantern* (cupola) based on his design was put in place after his death. Brunelleschi's influence on architecture was enormous. We can better appreciate some of the new ideas and vitality he gave to the art by considering two other works: the interior of San Lorenzo and the Pazzi Chapel.

The Church of San Lorenzo

Brunelleschi designed a sacristy for the Medici family to be added to San Lorenzo, an essentially Gothic church. The Medici were so delighted with it that he was then commissioned to remodel the interior of the church (Fig. 17-2), a project that began in 1421 and went on for many years. San Lorenzo's great simplicity and directness emphasize the contrast between the Renaissance

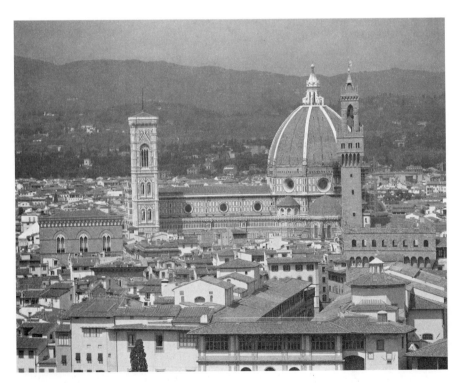

17-1 *View of Florence with Duomo. (Jon Arnold Images/Danita Delimont Stock)*

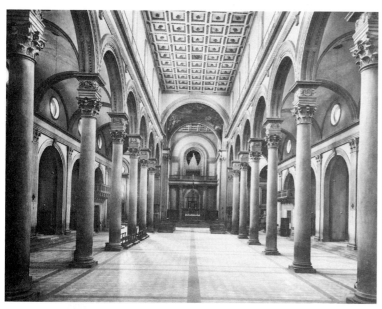

17-2 *Nave, San Lorenzo, Florence. (Alinari/Art Resource, NY)*

• Compare this nave, aisles, and clerestory with those at Chartres (see Vol. 1, Ch. 9). How do the spaces compare with or differ from those of the nave and aisles of San Vitale in Ravenna (Vol. 1, Fig. 8-5)? (W)

and the Middle Ages. The interior seems almost early Christian, but with a substantial difference. Imposed on the traditional plan of *nave* and aisles is a sense of mathematical harmony, the repetition of sizes and shapes that derive from, but achieve a form different from, those of Gothic or Roman buildings.

Perhaps the most significant obvious difference is the sense of definite measured units of space, individual and independent. The nave is separated from the aisles by arcades of smooth Corinthian columns that carry semicircular arches. Above the arches is an *entablature* marking off the *clerestory* walls, which are broken by arched windows centered above the arches. The columns, arches, and entablature are all in a gray stone that contrasts sharply with the smooth white plaster walls. The aisles are roofed by shallow *vaults*, and shallow side chapels line the walls. These have semicircular arched openings with a decorative *keystone* and are also flanked by pilasters with Corinthian capitals, thus repeating the column-arch combination of the nave arcade. The aisles are lit by small round windows, one centered above each side chapel.

The division of the wall planes of the aisles and the nave arcade is reinforced by the pavement, which is arranged in squares (see plan, Fig. 17-3)—thus, two squares form a *bay* of the nave and equal the height of a column; one square equals a bay of the aisle and one-half square a chapel. The *transept* is made of four large

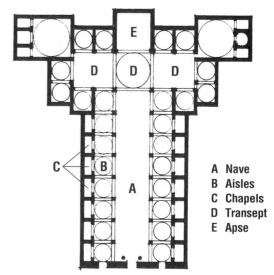

17-3 *Ground plan, San Lorenzo, Florence.*

A Nave
B Aisles
C Chapels
D Transept
E Apse

squares that are approximately equal to four square bays of the aisles. The nave roof is flat and decorated with square coffers.

Space in San Lorenzo is clear and limited, strongly directional but ordered into a rigorous sequence of bays. Each column, perfectly articulated, marks the beginning and end of a bay, a space. The light is dim but not mysterious. The transept is a specific and different space, as is the square *apse* at the east end. The feeling is one of intellectual control, not mystic transcendence.

Alberti, the architectural theorist, wrote that a church should induce contemplation through order and harmony, reflecting the mathematical perfection of the universe. It should, he said, be plain and encourage one to focus inward on control of the self for the attainment of right, Christian actions. Windows should be high, so that one could see only the sky and not be distracted by the external world. Brunelleschi seems to have anticipated these ideals.

The Pazzi Chapel

The Pazzi Chapel was commissioned by the wealthy Pazzi family for its own use and for the use of the monastery of which it is a part. Located in the cloister of Santa Croce, the chapel forms a strong contrast to the church, which is one of the few Gothic buildings in Florence. The façade, with its columns and portico, clearly recalls Roman architecture (Fig. 17-4).

Structurally, the interior of the chapel is also familiar. Brunelleschi has used a *post and lintel* and load-bearing wall system to carry barrel vaults and an arrangement of domes. The plan shows two major axes: that formed by the domical space of the *portico* (which is repeated in the dome over the apse) and that formed by the rectangular spaces of the barrel vaults that

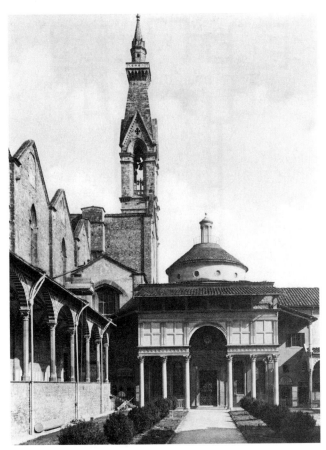

17-4 *Pazzi Chapel, exterior, Cloister of Santa Croce, Florence. (Alinari/Art Resource, NY)*

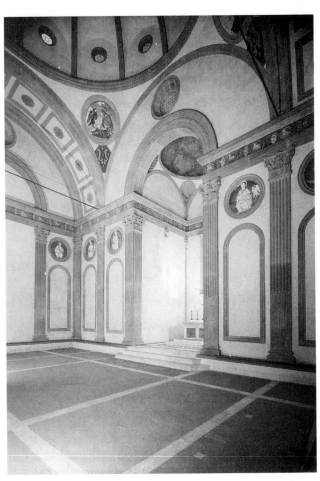

17-5 *Interior view of Pazzi Chapel by Filippo Brunelleschi. (Takashi Okamura) (W)*

support the central dome (Fig. 17-5). The directional quality of each axis is resolved under the great dome of the hall. The resultant feeling is one of quiet serenity reinforced by the articulation of the wall planes, windows, door, and apse opening. Applied pilasters rising from a base carry an entablature on which rest the arches of the vaults. These members, like the other decorative elements (the blind arches opposite the windows, for example), are made of *pietra serena*, the gray stone that is also used on the interior surfaces of San Lorenzo. They form a strong contrast with the white plastered walls and the terra-cotta plaques, which are predominantly blue and white. The impression of the interior is one of cool elegance, for each element is paired, or repeated, except for the central dome, which in its singularity acts to arrest all motion.

It is easy to understand how Brunelleschi's work must have appeared to his colleagues. With its order, clarity, and use of elements from the antique, it must have seemed like Rome revived. Yet it is not based on simply copying from ruins that Brunelleschi had seen, or from later uses of antique forms in early Christian and Romanesque buildings. Like Gothic art and architecture, the art and architecture of fifteenth-century Florence depend for their forms and ideals on a struc-

ture of knowledge and value, on a society that was not ignorant of the meaning to be found in building. Alberti's Latin treatise *On Architecture* presents some of the ideas and principles that he certainly believed capable of communication in building. The model for his treatise was the text by Vitruvius, the first-century B.C. Roman architect and engineer, but the book itself was very much the product of Alberti and fifteenth-century Florentine thought. It is another important way to understand the art and architecture of that century.

Leon Battista Alberti (1404–1472) and His Theory of Architecture

Alberti wrote that the architecture and the planning of cities should be based on a rational analysis of problems, needs, site, and climate. The city, he felt, would inspire its citizens through its propriety, order, harmony, and control. Buildings should be considered in a hierarchy based on significance. The ornaments of a city should be its churches. Of secondary importance would be buildings of civic and mercantile nature, like guild halls, bridges, and squares; finally, one should

consider housing. Private dwellings should constitute a self-effacing background for the public monuments to Christian and civic virtues.

Alberti not only advocated public housing for the lower classes but also admonished the city fathers to prevent conspicuous consumption. Rich people, he said, should not be permitted to call attention to themselves by the creation of lavish, individual buildings but should live in houses only somewhat better than the less fortunate city dwellers. Wealth should be used to create buildings that all could share, and buildings would contribute to the public good.

These ideas are consistent with Bruni's concept of a person as a civic being whose ambitions and skills, intellect and passion, should be turned to the benefit of the republic. Moreover, there is almost a parallel between the humanists' belief that eloquence should be cultivated to speak and persuade for the truth of Christian virtue and Alberti's idea that eloquent architecture, based on the great principles of nature, would enable a person to discover and lead a harmonious life.

In Alberti's text we find these proposals for eloquent architecture derived from a study of nature and of the antique. Human beings, Alberti says, are creatures of reason and appetite, of intellect and will. If they succumb only to the forces of appetite and will, they may enjoy their lives briefly but will not achieve goodness and virtue, the attributes of greatness. In fact, he says, it is only by use of reason and intellect that people can know how to act. These tools are sharpened and trained through the study of nature.

Perfection in architecture is achieved for Alberti by emulation of perfect forms—the square and circle—and by the application of the rules of harmony that govern music. Both geometrical and musical forms are divine in origin and occur throughout the universe. Beauty, says Alberti, is the result of the correct observation and application of rules of proportion derived from Pythagoras' system of musical harmony. Beauty is the creation of a whole to which nothing can be added and from which nothing can be subtracted without the destruction of that whole. Our minds, understanding that perfection intuitively, respond to harmony and order, producing actions that will grace life as monuments grace a city.

The belief that good buildings can make a good life is highly debatable. What cannot be denied is that the application of reason to art was one of the most powerful forces in the Renaissance. This will emerge more clearly as we study the other arts.

Sculpture in Florence in the Fifteenth Century

Sculpture, like architecture, was considered a preeminent manifestation of civil and religious pride. Like other artists, sculptors of this period drew inspiration from antiquity, nature, and thirteenth- and fourteenth-century achievements in their medium. There are many whose work might be considered—Brunelleschi, Ghiberti, Nanno di Banco, Luca della Robbia—but, as with painters, no single sculptor represents all the energy and accomplishment of this period. Donatello (1386–1466), however, created a body of work that covers the range of sculptural possibilities—low relief to freestanding sculpture in the round, carved marble and cast bronze, and a variety of subjects that provided enormous intellectual and psychological challenge. Because he was a powerful individual creator in his own right, Donatello was a natural forebear to Michelangelo.

Among his earliest commissions were two sculptures of saints, George and Mark, for niches on the exterior of a church, Orsanmichele (Fig. 17-6). These larger-than-life figures have the vitality and presence of particular, individual human beings. This effect is achieved through Donatello's clear articulation of the body under its clothing and the definite sense of personality carved in the face. These two elements are combined in the total composition of the body and its attire.

17-6 Saint Mark *by Donatello. Orsanmichele, Florence. (Alinari/Art Resource, NY)*

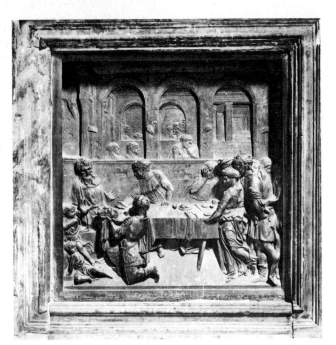

17-7 *Donatello,* The Feast of Herod, *c. 1425, gilded bronze relief, 23⅝ × 23⅝″, baptismal font, Cathedral of Siena. (Alinari/Art Resource, NY)*

• Compare the architecture of Herod's palace with that of San Lorenzo and the Pazzi Chapel. How does Donatello use the architecture in the relief to define space? Compare Donatello's figures with the figures in the frieze on the Parthenon and with Triani's figures in *The Triumph of Death.* What is the role of the space in each work? Compare these figures with Giotto's *Madonna and Child Enthroned* (Fig. 17-8) and with the figures in his *The Lamentation* (Color Plate II). What is the role of gesture?

Donatello's skill and innovative ability are no better exhibited than in his gilded bronze relief for the baptismal font of the cathedral of Siena, executed c. 1425. In *The Feast of Herod,* Donatello makes use of a new formal tool—one-point perspective—which will also be used by Masaccio and other painters and sculptors to render the illusion of three-dimensional space (Fig. 17-7). Organized in an architectural setting, which provides the diminution in space that creates the illusion of light and distance, this dramatic moment is presented in all its emotional horror and intensity. In the center of the composition is a vacuum, created as people scatter before the presentation of the severed head of John the Baptist. Donatello's observations of the human body in movement, of drapery, of emotion, are all demonstrated here.

Achievements like these surely convinced the Florentines of the dynamism of their own time and gave them a particular consciousness of their accomplishments and their shortcomings.

New Developments in Painting

Painting and sculpture in the Middle Ages depended on formulas and conventions for the presentation of visual equivalents of important ideas and beliefs. The makers of stained glass increased the size of significant persons in their glass and ignored any illusions of weight or volume in the representation of figures. The illuminators who made manuscript plates emphasized intense color, flat surfaces, complex linear patterns, and stylized gestures to create their pictures. Also, the size and location of figures were determined by their importance. Rarely do we feel that the rules for making—the formal conventions—are inappropriate to or detract from the information to be conveyed. Fifth-century-B.C. Athenians considered ideal representation of the human body as the best means of commemorating or perpetuating important events and beliefs. The sculptors of the Royal Portal at Chartres subordinated the visible world to symmetry, pattern, flatness, and distortion to teach and inform viewers of Christian dogma. At times the rules and their results may seem strange to us, but it is the successful marriage of means and ends that makes great art and architecture. In the art of fifteenth-century Florence we meet a new set of rules, of conventions for making, that were arrived at experimentally through trial and error, as were the other conventions we have studied. Alberti wrote about painting, describing the rules for making successful pictures. Giorgio Vasari (1511–1574), who was among the first biographers of artists and architects of the Renaissance, was also an important critic of the intentions and development of their art. Like Alberti, he praised artists for their return to, and successful conquest of, the representation of nature.

Giotto (1267?–1337)

If we follow the example of Vasari, the first artist who must be considered in the development of painting in Renaissance Florence is not a fifteenth-century painter at all but Giotto, who, as Dante noted in the *Purgatorio,* eclipsed Cimabue (1271–1302), who was considered the best painter of his day.

In painting Cimabue thought indeed
To hold the field; now Giotto has the cry,
So that the fame of the other few now heed.
(*Canto 11, 94–96*)

Legend has it that Cimabue saw the poor young shepherd Giotto drawing on a rock with a stone and was so impressed by his talent that he brought him to Florence, where he was apprenticed to a painter. In Florence, Giotto found himself in the cultural and artistic center of Europe, and after absorbing all he needed, he rose to fame as the inventor of a new style of painting.

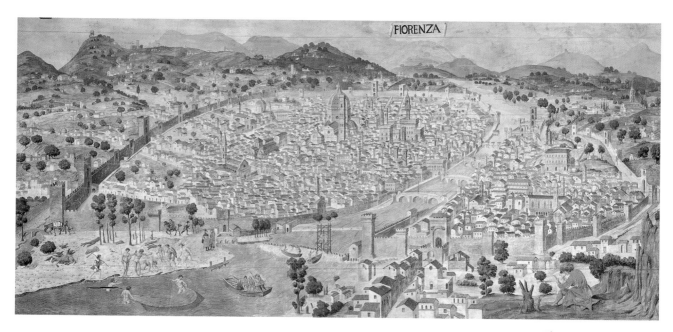

Plate I
Stefano Buonsignori,
Map of Florence
called "della Catena"
(c. 1480). Museo di
Firenze com'era.
(Scala/Art Resource, NY)

Plate II
Giotto, *The Lamentation* (1305–06).
Scrovegni Chapel,
Padua.
(Scala/Art Resource, NY)

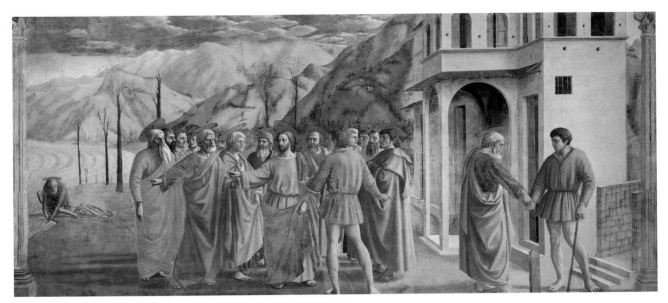

Plate III
Masaccio, *The Tribute Money* (1427). Brancacci Chapel, Florence.
(Scala/Art Resource, NY)

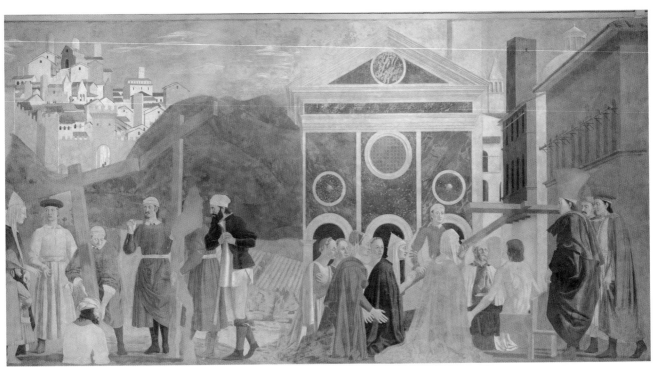

Plate IV
Piero della Francesca, *The Discovery and Proving of the True Cross* (c. 1455). Fresco. S. Francesco, Arezzo.
(Scala/Art Resource, NY)

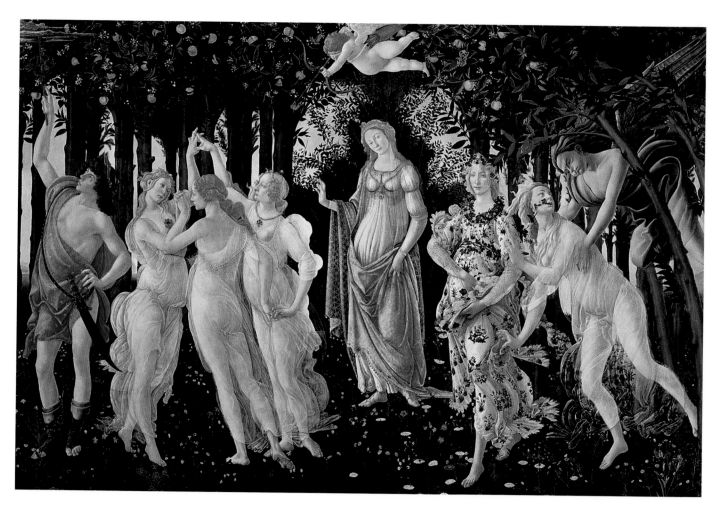

Plate V
Sandro Botticelli,
Primavera (c. 1478).
Galleria degli Uffizi,
Florence.
(Nicolo Orsi Battaglini/Art
Resource, NY)

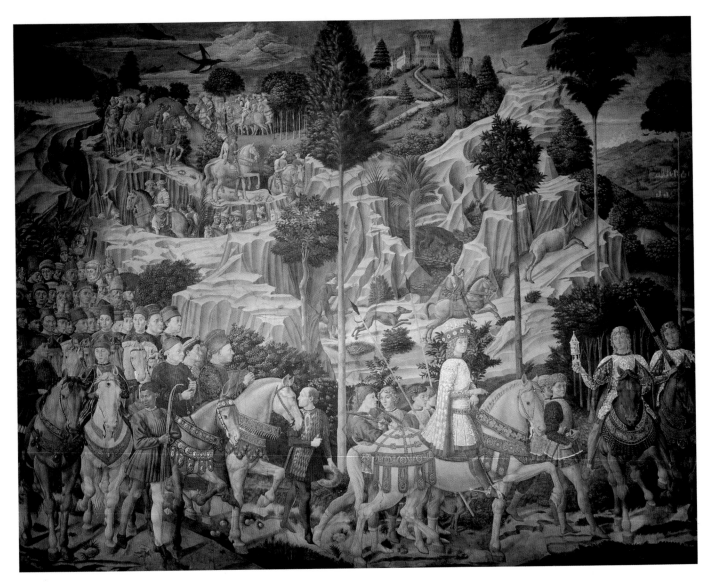

Plate VI
Benozzo Gozzoli, *The
Adoration of the Magi*
(1459). Palazzo Medici-
Riccardi, Florence.
(Erich Lessing/Art Resource, NY)

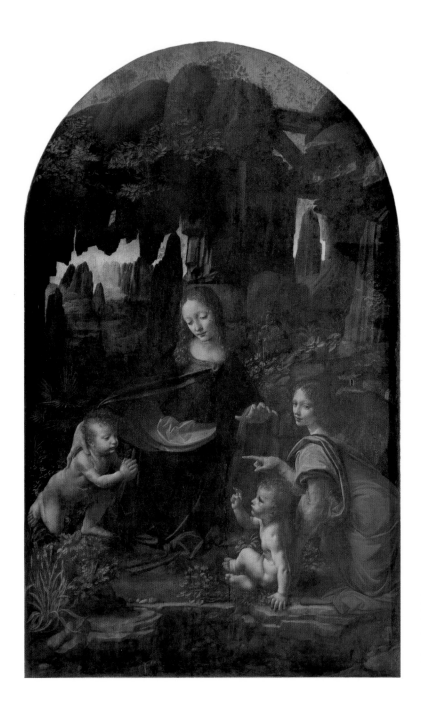

Plate VII
Leonardo da Vinci, *The Madonna of the Rocks* (c. 1483). The Louvre, Paris.

(Erich Lessing/Art Resource, NY)

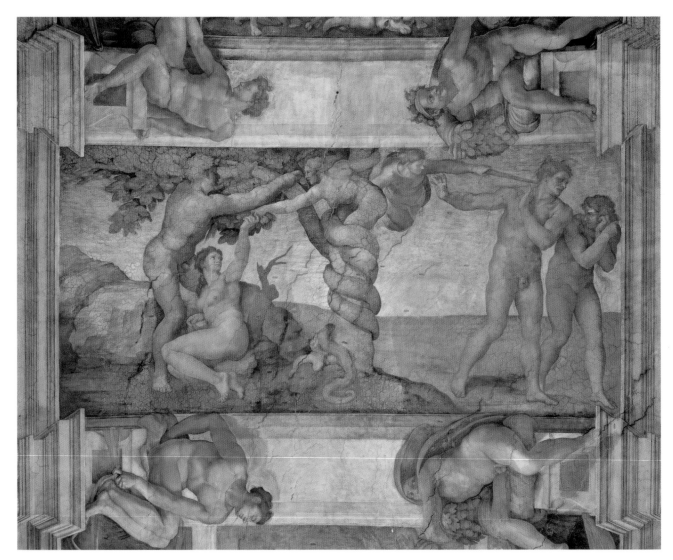

Plate VIII
Michelangelo, *The Fall of Man* and *The Expulsion from the Garden of Eden*, portion of the Sistine ceiling (1508–12). Fresco.

(Art Resource, NY)

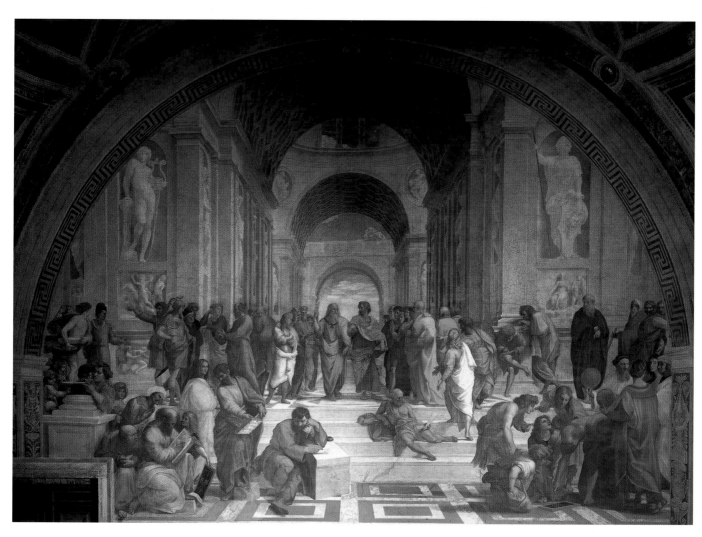

Plate IX
Raphael, *The School of Athens* (c. 1510–12). Stanza della Segnatura, Vatican Palace, Vatican State.
(Erich Lessing/Art Resource, NY)

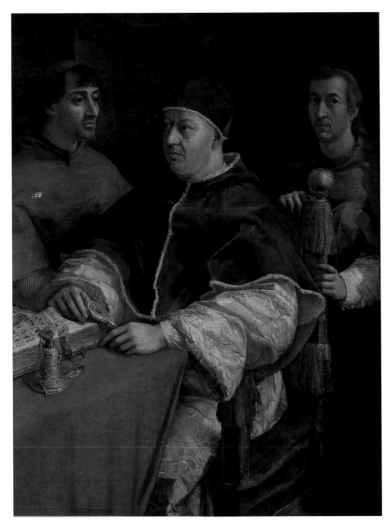

Plate X
Raphael, *Pope Leo X with Cardinals Giulio de' Medici and Luigi de' Rossi.* Panel Painting (c. 1517). Galleria degli Uffizi, Florence.
(Erich Lessing/Art Resource, NY)

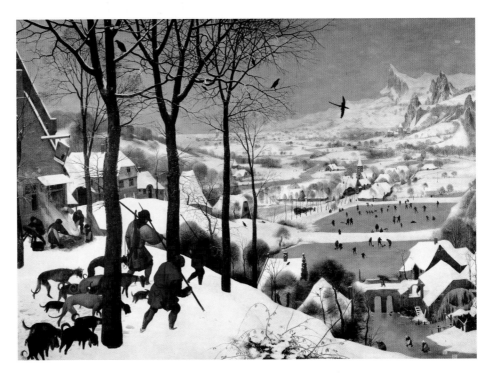

Plate XI
Pieter Bruegel, *The Return of the Hunters* (1565). Oil on panel. 46½ × 63¾".
(Kunsthistorisches Museum, Vienna/Erich Lessing/Art Resource, NY)

There was much for Giotto to absorb. In addition to the established late-medieval art of Florence, there were ideas from the East, from Christian Byzantium, and from the flowering of Gothic art in France. What Giotto seemed particularly successful in achieving, however, was a sense of drama, a moment stopped in real time, which the observer could then participate in for all time. Giotto combined a keen observation of human movement, gesture, and expression with a growing ability to depict figures whose weight, form, and pose convey a sense of space in which a drama is acted out.

When one first sees work by Giotto, the impact of his formal innovations is not immediately apparent. The *Madonna and Child Enthroned* (Fig. 17-8), painted (c. 1310) for the Church of the Ognissanti in Florence, has the kinds of discrepancies in scale that one expects in medieval painting. For example, the angels are one

17-8 *Giotto,* Madonna and Child Enthroned, *tempera on panel, 10'8" × 6'8¼", from the Church of the Ognissanti, Florence, c. 1310, Galleria degli Uffizi, Florence. (Alinari/Art Resource, NY)*

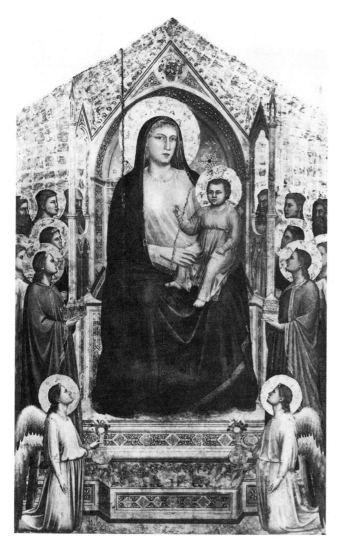

size, Mary and Jesus another. The figures are placed in front of a traditional gold ground, long used by both Byzantine artists and many medieval illuminators and painters. But a closer examination shows that Mary and the Child occupy a Gothic throne that sits heavily in space. Mary *sits;* her knees show under the folds of her robe, and the Baby, although not exactly a baby, is not a little old man, either. He is round and firm, and his cheeks are the fat cheeks of babyhood.

Vasari tells us that Giotto's accomplishments were based on his observation of nature and his abandonment of the existing formal language of tradition. Whether a result of nature, the influence of French art, or a combination of these, Giotto's achievement in the Arena Chapel cycle is evident.

The Arena Chapel in Padua is decorated with scenes from the life of the Virgin and the life of Christ, both traditional themes. The scenes painted in *fresco* on the walls are "living" tableaux, acted out in shallow constricted spaces, but they are spaces that are nonetheless based on observation of the experienced world. The participants, presented in simple drapery—the density of which seems to emphasize weight, gravity, and the physical body underneath—gesture, move, and give expression to the changing emotional content of each scene. The composition of each scene seems accidental—as if seen at a glance, and yet studied—as if designed to emphasize the significant action of the moment. In *The Lamentation* (Color Plate II) the action falls from the right to the lower left corner, where the Virgin cradles the head and shoulders of her dead Son on her knees. The actions and gestures of each of the figures and the shape of the landscape reinforce the movement into the corner, a movement that is both a visual and psychological decline and dead end. The mourners have the self-contained and controlled gestures of disbelieving grief, from the woman who tenderly holds Jesus' feet, to the stylized gesture of the standing figure (Saint John), whose arms fly back, to the onlooker who stands in the right corner, hands mutely folded. This exposition of the stages of grief acted out by heavy, somewhat lumpy figures is extraordinarily eloquent. Grief is presented as painful, timeless, and almost silent; yet the faces and hands tell us that folded into these bodies that cluster around the dead Christ is soft, muffled weeping. Then, looking into the sky, the viewer sees the angels who give themselves up to grief, wailing and keening. It is impossible to see these paintings and not be deeply moved. The stories of the Virgin and Christ are given a new humanity and a power that transcend this world by being so clearly of it.

The simple intensity and power of Giotto's work disguise the monumental effort required to break with tradition and to create new formal conventions. He is still far from using the paint, color, line, light, and shade one associates with the art of fifteenth- and sixteenth-

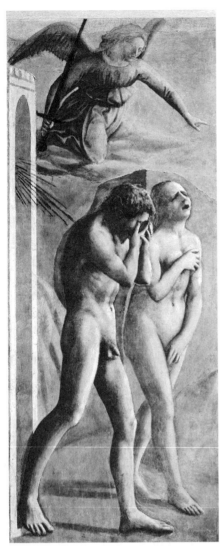

17-9 *Masaccio,* Expulsion from Eden, *fresco, c. 1425, Brancacci Chapel, Florence. (Scala/Art Resource, NY)* (**W**)

century Florence. His paintings reveal his limited knowledge of the rules of perspective, and his landscapes are as stylized as those of the older schools. None of his paintings has a secular theme. Nevertheless, no one can differ seriously with the judgment of Vasari, who traced the artistic revival that culminated in his day back to Giotto two hundred fifty years before, for it was he who led art back to "a path which may be called the true one." Although the path is not a direct one, his work is a major basis for the art of Masaccio.

Masaccio (1401–1428?)

Giotto's accomplishment, which filled his contemporaries with admiration, was dependent on the success with which he captured the human presence through bodily form, gesture, and emotion. A few visual clues placed the scenes in the experienced world, but his technique did not extend to creating a convincing facsimile of the light, shade, and space of the three-dimensional world in which people live. This was to be the accomplishment of the many painters of fifteenth-century Florence.

One of those painters was Masaccio, who painted expressive human bodies in palpable space. The work for which he is most famous is the series of *frescoes* for the Brancacci Chapel in Santa Maria delle Carmine in Florence. Recently cleaned and restored, these works reveal Masaccio's close observation of nature and of the human form. The *Expulsion from Eden* (Fig. 17-9) on a side wall of the chapel presents a powerfully human, sorrowful, nude Adam and Eve as they leave paradise. Adam covers his face, but Eve seems to wail. Their muscular, substantial bodies are depicted through contrasts of light, shade, and shadow. These figures have the presence of the nudes of antiquity.

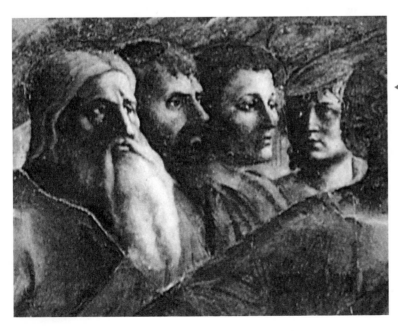

• What are the major compositional differences between Giotto's *Lamentation* and Masaccio's *Tribute Money*? In which work is there a greater illusion of space around and between the figures? What role does the landscape play? Where is the light coming from in each fresco? Is it day or night? Do the figures cast shadows? What difference does this make? Do the artists portray people with personalities or symbols of people? How do you tell the difference?

17-10 *Detail of Masaccio,* The Tribute Money, *Brancacci Chapel, Florence. (Alinari/Art Resource, NY)*

The central painting of the chapel, *The Tribute Money,* recounts a story from Christ's life as told in Matthew 17:24–27 (Color Plate III and detail, Fig. 17-10). A tax collector has approached Jesus, who then instructs Peter to catch a fish from the Sea of Galilee; in its mouth will be a coin sufficient for the tax to be paid. The action of the story is stretched out in the painting. Compare Giotto's *The Lamentation* (Color Plate II) with this work.

Masaccio, it would seem, has transformed the wall plane into a transparent curtain that reveals a stage space in which he can present a dramatic event. We see into the space where people move; light falls from the sky; figures cast shadows; people have personalities and are therefore like us, like the visible world of experienced reality. These people are also not self-conscious actors but are convincing as Adam and Eve, who notice neither angel nor audience in the pain of their degradation. As in Donatello's sculpture *David* (Fig. 17-11), the human body is expressive, sensuous, and filled with life.

Masaccio and Donatello both used the new artistic language that had been developed by Brunelleschi, the cathedral architect. *Linear perspective* is a tool for the accurate translation of three-dimensional space onto the two-dimensional plane of paper, panel, or wall (Fig.

17-11 *Donatello,* David, *c. 1430–1432. Bronze, height 62¼", Museo Nazionale, Florence. (Alinari/Art Resource, NY)*

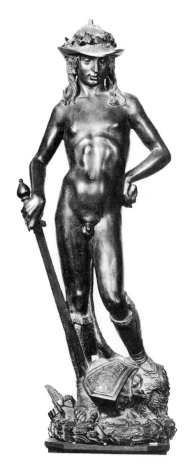

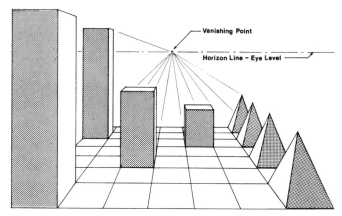

17-12 *Simplified single-point perspective (after Brunelleschi).*

17-12). Masaccio, learning from Giotto the importance of gesture and the feeling of weight, combined the two with his own ideas about shade and shadow, volume and location, to create his dramatic scenes. Obviously, Masaccio did not achieve this in one day (equally obviously, he was not alone in his endeavors), but he gives us scenes that seem suddenly familiar to us. His work both transforms and presents a series of new conventions, which we will explore further.

There is a close parallel between the development of perspective in painting and sculptural relief and the humanists' growing sense of the historical past. The fifteenth-century humanists were coming to understand the past as composed of a group of successive societies leading down to their own time. Increasingly, they became aware of the differences between pagan Roman society and Christian Rome and of the changes that had occurred in thinking in the Middle Ages. In a sense they viewed history as a series of temporal planes corresponding to the spatial planes defined by the linear perspective. Just as artists objectified space from the point of view of their eyes, so humanists defined the past in relationship to their own time. Similarly, the humanists used this objectified time for their own purposes, in their case the improvement of the present and the shaping of the future.

It is not enough, however, that we celebrate the conquest of illusion. To assume that this was the goal of Renaissance painting is to miss the point of this artistic development. Just as Brunelleschi and Alberti wanted to learn the principles of antique architecture in order to create new forms in response to new ideas, so perspective was a principle, a tool, to enhance the purpose of Christian art. The purpose of creating art with Christian subjects was to teach, enlighten, and persuade people in the ways of right moral action. Viewers are therefore expected not merely to *observe* an event but to be moved by it toward repentance and salvation. The illusion of weight and volume, and of the visible world itself, and the creation of splendid individuals all serve this purpose.

Piero della Francesca (1420–1492)

To fully appreciate the extent to which painters, sculptors, and other artisans served the church and their faith through their art, it is necessary to consider the work of other painters and the ways in which they explored the new ideas. One such painter was Piero della Francesca. Born in southeastern Tuscany, he came to Florence as a painter's apprentice. He left a few years later, never to return, but worked in the vicinity of his birth, Arezzo, Borgo San Sepolcro, and, finally, Urbino, a small but wealthy mountain principality. The origins of his art lie in Masaccio, but his intellectual capacity and artistic study created an art of severe harmony, clarity, and cool detachment.

Piero's fresco cycle for San Francesco in Arezzo recounts the Legend of the True Cross. Constantine's mother, Helena, visited the Holy Land to find the cross on which Christ was crucified. In this scene (Color Plate IV), *The Discovery and Proving of the True Cross*, the left side of the narrative shows the cross being uncovered; on the right side the cross proves its authenticity by resurrecting a dead man. The figures are organized like a deep bas-relief or frieze as they stand or kneel on a limited space in front of a brightly lit desert landscape, on the left, and a very urban "modern" cityscape, on the right.

The background helps to organize and focus attention on the action of the figures. Helena and her retainers are fully three-dimensional, weighty and grave. The clear unidirectional light gives their elaborate contemporary dress—hats, cloaks, head coverings—folds and shadows that emphasize their solidity and presence in space. Their expressions contain an intense piety engendered by the scene. The powerful emotional energy of Masaccio's Adam and Eve (Fig. 17-9) contrasts with the still psychological drama Piero presents.

Piero did many drawings for this and every work. His investigations led to a treatise in which he demonstrated the uses of perspective to delineate bodies and architectural forms. These he reduced to their most abstract geometrical components, seeing forms as variations on or combinations of spheres, cylinders, cones, cubes, and pyramids. Like Alberti, he sought nature's perfect forms, and like Leonardo after him, he learned much from that study.

Botticelli (1444–1510)

Sandro Botticelli was more interested in the expressive possibilities of a graceful and energetic line than in the structural problems of perspective. He had been apprenticed to an engraver, and from his experiences with those conventions came his reliance on draftsmanship. The favorite painter of the Medici family, Botticelli was very much interested in the ideas of humanism and Neoplatonism prevailing in the intellectual circles around Lorenzo. He was one of the first Florentine painters to represent subjects from classical mythology. Just as the humanists attempted to fuse Greco-Roman myths and ideas with Christian theology, Botticelli endowed his pagan subjects with a spirituality that derives from medieval painting and sculpture.

The large painting called *Primavera* (Springtime) or *The Realm of Venus* is an *allegory* of the rebirth of nature in spring under the power of love (Color Plate V). In the center stands Venus, who looks more like a madonna than a Greek love goddess. The fusion of the pagan goddess and the Christian saint would not have surprised the Neoplatonists, who believed that both could aid the soul in its ascent to God. Venus appears to give her blessing to the three Graces, who are dancing in a circle to her right. The rhythmical line for which Botticelli was so well known is nowhere more apparent than here. The folds of flowing drapery make one feel the movement of the dance. The seminude bodies are another classical inspiration—they could never have appeared in medieval art. Next to the Graces stands Mercury, raising his hand to the skies. To the viewer's right is Flora, in a dress abundantly covered with flowers, and another almost-nude nymph representing springtime, who is about to be seized by a young man personifying Zephyr, the wind. Above everyone flies the blindfolded Cupid with his bow and arrow.

What about the setting of this painting? Although the flowers are exact copies of flowers that grow around Tuscany, Botticelli has certainly not portrayed a realistic natural setting. What kind of nature is he portraying, and what is he attempting to suggest by it? How would you characterize the colors? Make a schematic drawing to show how the *composition* works. Are the various elements of the painting held together in some way? Does the right side of the painting convey a different sort of feeling from that conveyed by the left side? How? Compare your reactions to this painting with your reactions to Piero della Francesca's paintings.

Primavera, which decorated the Medici palace, captures in visual terms much of the spirit of the Florentine Renaissance under Lorenzo de' Medici. In this painting, Botticelli seems to have been inspired by parts of a long poem by Angelo Poliziano, another Medici associate. Poliziano wrote his "Stanzas for the Joust of Giuliano de' Medici" in honor of Lorenzo's younger brother after he had taken part in a joust. Rather than celebrating heroic exploits, as the title would indicate, much of the poem depicts youth, love, and spring with a kind of verbal painting similar in spirit to that of Botticelli. Here, for example, is the description of Giuliano's ladylove, Simonetta.

> Pure white is she, and white her dress
> But painted with roses and flowers and grass:
> The ringed hair of her golden head

Flows on her forehead, humbly proud.
The whole forest laughs around her,
Making her cares grow milder.
In her regal bearing she is gentle,
And calms the storms with a blink of her eyes.

An allegorical-descriptive scene contains some of the figures in the painting:

Venus, mother of Cupid, leads the band of her sons.
Zephyr bathes the meadow with dew,
Splashing a thousand fresh scents:

Wherever he flies, he clothes the countryside
With roses, lilies, violets, wildflowers;
The grasses grow marvels from his beauty;
White, sky-blue, pallid, and crimson.[1]

Such a visual depiction of the beauty of youth and spring attests to the unity of poetry and painting in this period. Both *Primavera* and the "Stanzas," however, contain underlying melancholy, reminding the viewer or reader that the joys they celebrate are transitory.

Looking at Paintings: Comparison of Color Plates IV and V

Writing or talking about paintings requires some use of artists' technical vocabulary, and many of these words are in italics in the text and defined in the glossary.

These terms, such as *composition* (the arrangement of the figures, landscape, or architecture on the canvas or wall), color, line, texture, light, and shade refer to elements used by artists to tell a story and convey emotions that engage the viewer. As you look at Piero della Francesca's *The Discovery and Proving* and Botticelli's *Primavera,* observe how the artists have exploited formal elements and describe how each plays a role in conveying the story.

The two paintings could not be more radically different in their subject matter, but they provide an opportunity to consider the ways in which the elements used by the artists emphasize the differences between the two works. Make a list of the characteristics that you would expect the artist to convey in *The Discovery and Proving,* such as surprise, seriousness, grief, triumph. What characteristics would you expect in a painting about spring? Lightness, joy, excitement? What is the mood of each work, and how does the artist use the color palette to convey the mood? Consider the placement of figures: What happens in the foreground, middleground, and background? Where do you, the viewer, stand? What is the role of the landscape? What is the role of space and of line? How does the artist use the *texture* of objects depicted in the work? Are the figures ideal or natural looking in appearance? How can you tell? Which work seems the more successful in conveying its subject and why?

[1] The translation is by Mary Ann Witt.

Summary Questions

1. Describe the role of Greek and Roman architecture in the development of Renaissance architecture.
2. How did the development of single- or one-point perspective aid the artists of the Renaissance?

3. According to Alberti, what role should nature play in the revitalization of art?
4. What elements do the paintings of Masaccio share with the sculpture of Donatello?

Key Terms

linear perspective

composition

fresco

texture

18

The End of the Florentine Renaissance: Machiavelli, Leonardo, Michelangelo, and Raphael

The death of Lorenzo the Magnificent in 1492 came in a very troubled time not only for Florence but for the whole of Italy (see map). In 1494 the French invaded Italy, sweeping the length of the peninsula with their powerful armies. This was only the first of a whole series of foreign invasions over the next fifty years, during which time Italy became the battleground between the two rising national monarchies, France and Spain. The Medici were toppled from power with the arrival of the French in 1494, and a republic under French rule was established. But the waning of French influence over Italy in the following decade spelled the doom of the new regime, and the Medici returned to power in 1512. Except for a three-year interruption (1527–1530), they were to remain rulers of Tuscany down to the eighteenth century.

Already by Lorenzo's last years, Florence was sharing its position of cultural dominance with Rome. From the early decades of the sixteenth century, moreover, France and northern Europe began to rival Italy's position of cultural leadership. The Florentine efflorescence was to be given new forms in art, architecture, and political thought. Four individuals—Niccolò Machiavelli, Leonardo da Vinci, Michelangelo Buonarotti, and Raffaello Sanzio—represent aspects of the transformation of the confidence of the fifteenth century into the doubt of the sixteenth century, when Italy was invaded and the papacy came under siege from Martin Luther and the princes of northern Europe.

Niccolò Machiavelli (1469–1527)

The ease with which the Italians succumbed to Spanish and French arms shocked Italian thinkers and caused them to seek explanations. Many focused on the chaotic political structure of the peninsula as the major factor in Italian weakness. This atmosphere of questioning produced one of the greatest political theorists of all time, the Florentine Niccolò Machiavelli (Fig. 18-1). Born in Florence in 1469, Machiavelli rose to a position of prominence in the republican government established in the city after 1495. Closely associated with that regime, Machiavelli fell into disfavor after the reestablishment of Medici power

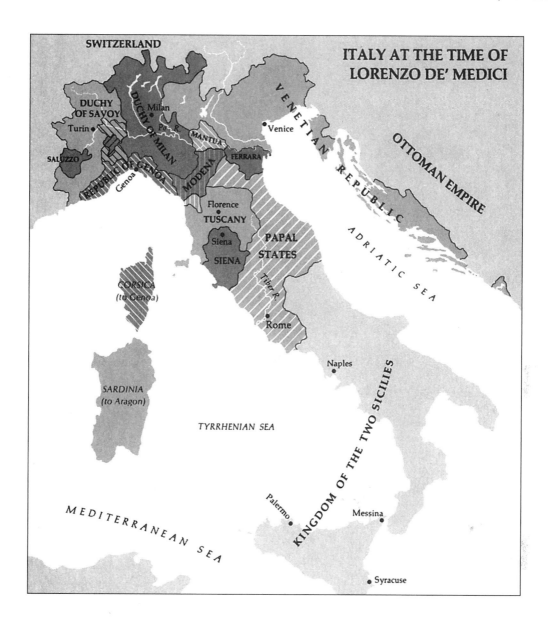

in 1512. He spent most of the last fifteen years of his life as a private citizen, composing his works on history and political theory.

At heart a republican, Machiavelli faced squarely the problem that confronts any political thinker: the conflict between liberty and order. To what extent can individuals be given freedom without disrupting authority? Although he would have liked to see Florence and other Italian states republican, he recognized that, given the corruption of Italian society, only a strong ruler was capable of establishing order; until order had been established, there was no hope of reforming the people to make them capable of self-government. He realized the risk: the kind of ruler ruthless enough to establish order was not likely to be the kind of prince willing to train the people in self-government. But in a peninsula divided into fifty to a hundred power centers, a prey to foreign invasions, strong authority had prior-

ity. Thus, although raised in the tradition of Florentine civic humanism derived from Bruni, Machiavelli gave first place to political realities.

Machiavelli's most famous work, *The Prince*, written in 1513, was designed to give lessons in statecraft to a prince with an eye to creating an authority capable of driving out the invaders and bringing peace to Italy. Although throughout the work Machiavelli appeals to the selfish desire of the prince for power, in the final chapter Machiavelli's own altruistic motives on behalf of Italian unity become manifest. *The Prince* is intended to be a revolutionary "mirror of the prince," based on a medieval form of literature designed to instruct the prince on how to be a good ruler. However, whereas the traditional mirror of the prince endeavored to make the prince conform to common principles of Christian morality in his rule, the thesis of *The Prince* is that the morality of the successful ruler is unlike that of the

18-1 Niccolò Machiavelli, *Santi di Tito. (Palazzo Vecchio, Florence, Italy, S0016714)*

private citizen; indeed, the conduct required of a prince would frequently be reprehensible in a private individual. Nevertheless, in the long run actions that would be immoral in an ordinary citizen may very well be the best means for achieving a goal that serves the common good.

When Machiavelli came to sketch the character of the ideal prince, he defined *virtù* as his essential quality. Not to be confused with virtue, the term was defined by Machiavelli as "the ability to measure oneself." At points in *The Prince* he appears to consider the *prince* as a kind of artist imposing a form (his particular regime) on matter (the people). The quality of *virtù* will help the prince to understand the nature of the particular matter he is working with and thus know the limits of what can be done with it. Realization of political ends, however, is not merely a product of executing a rationally determined course of action. The ability to measure oneself also entails taking account of the whims of *fortune*. Against its unpredictability, the prince can only construct dikes to protect himself when it rages. This does not mean that cautiousness is the best policy; rather, Machiavelli urges a bold attitude, modified by self-restraint.

That Machiavelli considered the ruthless Cesare Borgia (1475–1507), bastard son of Pope Alexander VI, something approaching the ideal prince shocked many in his own generation, as it does in ours. But the fascination of Machiavelli remains, for he is telling us something that might be true but that we cannot bear to hear. This is especially true for Americans, who have always nourished the belief that at some point public morality can be forced to coincide with private morality, that leaders can be judged by the same standards as average citizens. What Machiavelli tells us is that this will never be the case, nor ought it to be; there is a fun-

damental difference between the rules of the game of politics and those of ordinary life.

In Machiavelli's view the state was not a product of undirected growth of authority; rather, it was a work of art, the creation of the prince who skillfully imposed a form of political order on the people, who served as the matter for his work. This kind of imagery indeed reflects the Renaissance preoccupation with defining the nature of the artist and his or her activity. It was in this period that people first began to take the word *artist* seriously and to look on the artist with respect.

The Renaissance Artist

Who is an artist? Is the artist a maker, a thinker, a craftsperson, a technician, a manipulator of emotions, a teacher? Is he or she a worldly, extroverted, confident, sophisticated personality, or lonely, introverted, filled with self-doubt and scorn? These questions were asked by writers and artists in the Renaissance, and it is to them that we owe concepts of the artist and architect, as well as the inclusion of these arts in the "fine" or "liberal," as opposed to the mechanical, arts. Not only theory but also the works of the artists themselves produced these ideas. In the contrasts between two of the greatest figures of Italian Renaissance art, we find two very different images of the artist.

Leonardo da Vinci (1452–1519)

Both Leonardo and Michelangelo were Florentines, near contemporaries, and undeniable geniuses. Leonardo was splendidly handsome; Michelangelo was at times obsessed with his ugliness. When Leonardo offered his services to the duke of Milan, he gave primacy to his qualifications as a military and hydraulic engineer, architect, and sculptor, mentioning painting last. When Pope Julius II commanded Michelangelo to paint the frescoes on the ceiling of the Sistine Chapel (in the Vatican Palace), he replied that he was not a painter but a sculptor. Nevertheless, he fulfilled the commission and later became noted for his genius not only in painting and sculpture, but also in architecture. Both individuals seem to have possessed enormous ego and incredible versatility. In both we find characteristics that have contributed to our idea of the "Renaissance man"—a person of broad learning and skill.

Although Leonardo viewed painting as the least of his talents, until recently we knew him principally as painter and courtier. Now, since the discovery and publication of his notes and drawings, begun in the late nineteenth century, we can call him a scientist with equal correctness. Perhaps, above all, Leonardo was an investigator of nature through observation and practice. He was an architect, engineer, botanist, and musician; he studied hydraulics, geology, and human anatomy. The pages in his notebooks reveal a person

A Renaissance Banquet

In sixteenth-century Italy, both the nobility and the princes of the church were often seen parading through the streets or walking along the halls of their palaces dressed in silks, brocades, dyed woolens of the finest quality, and eye-dazzling jewelry. Appearance was important, for it declared quickly and publicly the ranking of individuals in the hierarchy of earthly affairs. People did their best to maintain the presumed level of their station at all times. Both social events and business gatherings required sumptuous feasts and a proper display of splendor, sartorial as well as artistic or intellectual. Banquets were crafted with this in mind. Though the poor had little, if anything, in the way of comfort or decoration, the superrich refined banqueting to an art, and on these occasions, hosts and guests were eager to outdo each other in a public display of wealth, learning, cultural accomplishments, and power.

In February 1515, a banquet was held in honor of Gian Galeazzo Sforza, duke of Milan, and his wife, Isabella of Aragon. A special wooden pavilion was constructed for this affair, and it was furnished and decorated with incomparable luxury—inlaid tables, silk tapestries, gold and silver serving dishes. It is likely that Leonardo da Vinci was present at the affair, for he was in the duke's employ and had earlier designed sets and stage machinery for some of Gian Galeazzo's musical productions. Franchinus Gaffurius, a great Renaissance musician and theorist, was also a servant of the duke, and he, too, may have overseen some of the evening's musical entertainment, perhaps composing a motet in honor of his prince and directing the choristers in its performance. The duke maintained twenty-two full-time singers in his chapel and eighteen more in his court choir, and he probably hired dozens more musicians for this occasion—especially instrumentalists who could play recorders, shawms, sackbuts, viols, and lutes (Renaissance flutes, oboes, trombones, and bowed and plucked string instruments) to accompany the singing and dancing, as well as play background music for the feast.

And what a feast it was. The meal took four hours to complete! Every guest was served individual dishes, course after course. Each was given a partridge, a pheasant, a lifelike fish or fowl made of marzipan (a sweet almond paste), eels, a trout, light wine, and hearty red wine, along with salad, nuts, vegetables, fruit, breads, and more. Between each course, servants brought every guest a finger bowl filled with scented water to cleanse the fingers and lips. During the meal, most likely, musicians played to accompany the eating and conversation. Many paintings of the period depict shawm and sackbut players—behind the table, or to one side in a corner, or on a balcony above the guests—blowing with gusto as the guests and servants go about their business. Dancing was normally part of an evening's entertainment, and these guests may have danced, too, but considering the great quantities of food and drink they must have consumed that night, it is probably not likely.

When the meal came to an end, an actor disguised as a jeweler came and presented his wares: extravagant necklaces, bracelets, and other items of jewelry set in the finest gold and silver. Choosing items he felt especially suited to the color or temperament of individual female guests, he praised both the ladies and the jewelry and explained that he might be willing to part with it if the price was right. Before the ladies' escorts had a chance to demonstrate their chivalry and their wealth, the prince of the house, and honoree at his own banquet, Gian Galeazzo Sforza, declared that these expensive items were party favors that he was graciously giving to his charming female friends.

Neither the poor nor those of Milan's middle class were invited, of course, and the servants, no matter how brilliant or talented, went back to their quarters tired after a long, hard day. Leftovers, however, were often distributed to the poor, a measure now interpreted as a political device to keep them quiet.

obsessed with nature's beauty, power, and functional complexity. He sought answers to his questions neither in the church nor in antiquity but in nature—that which was observable—and in the mind—that which asked and imagined. He studied the motion of water to capture its power to operate engines, but his drawings also reveal his respect for its awesome natural power in a flood or storm. He dissected bodies to understand human anatomy, which then became the source for the mighty bodies in a drawing or painting. But muscles were abstracted into the ropes of levers and pulleys just as the anatomy of birds' wings and the action of wind on fabric suggested possibilities for human flight. He drew the fetus in the womb (Fig. 18-2) and anticipated Harvey's discovery of the circulation of the blood. His botanical drawings created a style for scientific illustration, and the plants reappear, lovingly delineated, in his pictures. It is as if Leonardo could not satisfy a longing to know, to understand the principles of life—birth, transformation, change, and decay—operating in the natural world. It is as if what he saw constantly assailed him with its incredible diversity, beauty, simplicity, and ugliness; and he sought rationally to control, order, and understand the vast

18-2 Embryo in the Uterus, *c. 1511 by Leonardo da Vinci. (Royal Collection, Windsor, England/A.K.G., Berlin/Superstock)*

potentialities open to human experience. He *attended* to *his* world; he wanted nothing to escape that questing, loving eye.

In his lifetime Leonardo finished few paintings. The *Mona Lisa* (or *La Gioconda*), a portrait of the enigmatic lady of the sublime smile, is perhaps the most familiar. Even more enigmatic to many is *The Madonna of the Rocks* (1483)—a soft, slightly mist-filled representation of the Virgin with the Christ Child, who, supported by an angel, blesses the kneeling John the Baptist presented by the Virgin (Color Plate VII).

The Madonna of the Rocks Set in a curious cavelike opening on a ledge in a rocky landscape, the four figures interact with each other; yet the viewer is hard-pressed to define the interaction. The light is soft and vague, the landscape shadowy and moist. The edges of the figures, their drapery, and their expressions lack clear definition. We do not doubt their presence in space, for the figures have a weight and volume that originated with Masaccio; yet there is a sense of fragility that is shared with Botticelli's *Primavera*. Nor do these figures possess Piero's intense abstraction—we are not sure what to look at in them. We seem forced by gesture and glance to look from face to face. The landscape itself is ambivalent, rocky, yet filled with beautiful plants and flowers. Light penetrates from behind and falls in the foreground. Where are we? Precisely what do we see? Academically, we know the picture may deal with the doctrine of the virgin birth of Christ, but that knowledge does not begin to explain the picture. Rather it is almost a sacred conversation—a moment suspended in time that alludes to events years hence. Or is time, in a chronological sense, of any consequence? This is a picture rich in ambivalences. Its brilliant *illusionism* is dependent on the experienced world and on a technical mastery of the creation of subtle nuances of shade and shadow that was one of Leonardo's great accomplishments. Similarly, it is a knowledge of anatomy, the study of faces and gestures, of falling light, of air suffused with light, that makes the vision possible. But technical expertise cannot account for the experience of the picture—a profound religious silence—where children who are touchingly childlike imitate the roles of their adulthood, and a mother's protective gesture reaches all of us. This splendid vision is so rich in nuance and idea that it is ever fresh to the eye and imagination. This is the end attained by the means that the fifteenth-century Florentines made possible—an end so filled with resonances that we are still compelled to discuss the picture and we struggle to know the painter's mind.

The Madonna of the Rocks is one of the few almost finished paintings by Leonardo. It is because of such a painting that we study the complex, unfinished *Adora-*

tion of the Magi or the ruined *Last Supper*, hoping to reconstruct not just the means but also the purpose of an artist who presents both a final statement and a vision of potentiality, of transformation. The vision is complete by Alberti's definition, but also ever ready, like nature itself, to provide a new experience, to stimulate the imagination with fresh questions. It is as if reason, finally, is not enough. One can control the will, guide intuition, define problems, comprehend mathematical harmonies, and draw the structure of the body; but one cannot determine the source of the life force or define the power of experience. Nor can one rule the imagination as it seeks knowledge of the work through the world. In this capacity, humanity is godlike and transcendent, free of everything except death.

Leonardo's art raises some problems that are still with us. What is it in the combination of nature, imagination, skill, and communication that creates a successful or great painting or, for that matter, any work of art? How does a work of art evoke resonance and sympathy in the viewer? We may agree that a particular painting moves us, yet not on why that happens. With Masaccio's paintings, it may be the still drama, enacted in a space that we share. Piero della Francesca certainly presents clarified images, harmonized in a world that he has made both more abstract and orderly. Botticelli speaks to our sensitivities with delicate color and linear harmonies. The powerful visual experience evoked by *The Madonna of the Rocks* is more difficult to define precisely. Leonardo's predecessors and peers reinstated the nude, the portrait, and the landscape; moreover, they created conventions of form and technique to achieve the presentation of Christian and pagan themes for personal edification. The possibilities for the artist must have seemed unlimited to them, maybe frightening in their limitlessness. Perhaps, in Leonardo's mind, it was the limits imposed by sculpture that made this art seem inferior, yet it was his greatest peer, Michelangelo, who defined limits so wide and so demanding that they changed the course of sculpture.

Michelangelo Buonarotti (1475–1564)

In contrast to Leonardo, the handsome, graceful courtier with polished manners and mellifluous voice, Michelangelo seems like a difficult child. He was secretive, rude, dirty, and offensive. Leonardo passionately embraced nature, whereas Michelangelo seems to have embraced his own genius, then God, as the path to immortality (both concerns far removed from Leonardo's elevation of the artist to the status of the gentleman). But both artists shared the power to imagine, make, and move. Both used nature—the visible world—but they transformed it, filling the objects made with immediate and universal meaning.

David The squares of Florence were decorated by some of the city's great sculptors. The Loggia dei Lanzi, a great open porch to the right of the Palazzo Vecchio, is still filled with sculpture. To the left is the Neptune fountain, whose splashing water invigorates the humid summer air. Directly in front, on the raised terrace before the Palazzo, is a copy of Michelangelo's *David* (the original was moved inside a museum in 1873). Light is intense in the square, and the high walls and tower of the Palazzo Vecchio intensify the experience. The figure silently commands the busy space and challenges one's passage into the palace.

The *David* is marble, over thirteen feet tall (Fig. 18-3). The figure is completely nude; the limbs and torso, now aged by rain and sun, once had a smoothness that remains only on the surface of the face. Never painted or decorated, unlike the statuary of former times, its first impact is of intractable stone formed into a superhuman figure. But what is the boy like? His face is not symmetrical, the hands are enormous, and the arms and legs are too long. The body is awkward, like that of a tough youth, streetwise and confident. The brooding face is reticent but filled with a fierce courage. The body turns, a knee flexed; does the boy search the horizon for Goliath? The muscles of the neck and torso are tense, standing forth under the skin. The veins in arms, elbows, and hands rise to enliven the surface of the skin. The toes of one foot grasp the ground, and the toes of the other play over the rocky ledge. Has the stone been thrown, or does it lie in his curved fingers? Does he ready the sling, or does it lie on his shoulder, no longer useful, but used?

If you are unable to decide the precise moment or motivation, you have begun to experience the *David*—an experience deriving its power from ambiguity. He is splendidly beautiful without being idealized. The torso and limbs flow into his pose with ease and grace, yet show the tension of movement. He is youthful but confident, brooding but able to act. His face has an intellectual intensity, and his body is its physical complement. Over all lies a feeling of potential—to make, do, dream, and be—to live in the world, to challenge with mind and body the limits of our human nature. That is the enemy—not the giant Goliath but the struggle between intellect and will, self-interest and unselfishness, love and hate.

The *David* was placed before the entrance to the Florentine city hall in 1504, during the restoration of the republic, as a visible sign of courage and purpose—qualities that had made the republic possible. After the ascendancy of the Medici, it might have been a reminder of what had been and might be again. The shepherd boy became king, only to be destroyed by his pride.

Other Works Michelangelo populated Florence and Rome with giants like his *David*. He loved the stone

18-3 *Michelangelo, David. Accademia della Belle Arts, Florence. (Alinari/Art Resource, NY)*

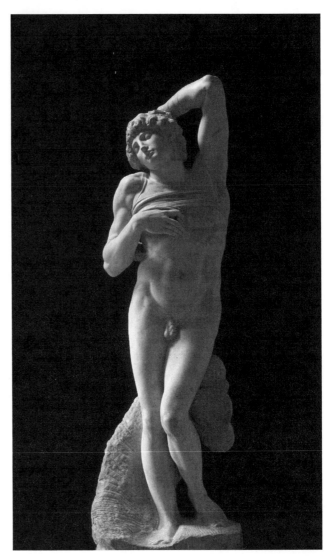

18-4 The Dying Slave *by Michelangelo. Made for the tomb of Pope Julius II, marble. (Louvre, Paris/Réunion des Musées Nationaux/Art Resource, NY)*

▲
• Why is the figure nude? Compare David's body with that of the *Kritios Boy* (Fig. 4-5) and of *The Spearbearer* (Fig. 4-9). Characterize the essential differences. Which figure is the most idealized? Examine hands, arms, and legs. Would you describe David as youthful or mature? Isn't the *Kritios Boy* a boy? What is different? Compare David's face with that of Augustus (Fig. 6-2). Which is the most noble and why?

that was his medium and hated the demands that it made. In his sonnets he writes of the conflict between his art, with its glorification of the human body, and his personal quest for the salvation of his soul, a quest that he felt his art contradicted. The great commissions produced in the sixty years after the *David* reflect stages not only in his art but also in the bent of his mind. There were the great papal commissions like the unfinished tomb for Julius II and the frescoes for the Sistine Chapel ceiling (1508–1512), as well as *The Last Judg-*

ment (1536–1541) behind its high altar. Although he became the architect for the new Saint Peter's, redesigned the Capitoline Hill, and executed other architectural and painted commissions, his greatest vehicle for expression was the human body. In some figures he was able to attain an almost Greek classicism (Color Plate VIII). In other figures, like the *Dying Slave* (1513–1516), whose body is still contained in the block, the imperfect stone seems expressive of those faults that must fall away if humanity is to become good and filled with grace (Fig. 18-4).

The Medici Chapel Michelangelo's projects were wide-ranging, as if he felt challenged by the solutions of the past and present. The commission for the Medici Chapel, to be added to Brunelleschi's San Lorenzo, began about 1524 and went on for fourteen years, at which point Michelangelo left Florence, never to return.

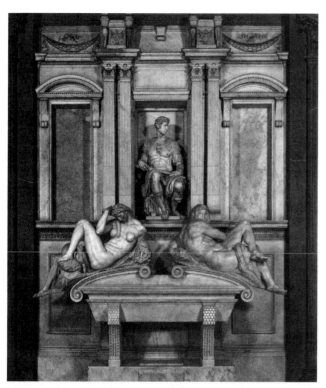

18-5 *Tomb of Giuliano de' Medici, Duc de Nemours by Michelangelo. Medici Chapels, San Lorenzo. (Scala/Art Resource, NY) (W)*

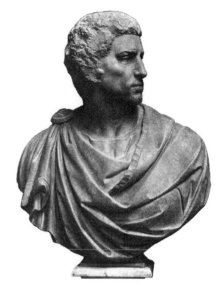

18-6 *Michelangelo,* Brutus. *(Alinari/Art Resource, NY)*

It was a very ambitious project, meant to house the tombs of Lorenzo the Magnificent and his brother, Giuliano, and two younger brothers, also Lorenzo and Giuliano. Michelangelo completed two of the tombs and the architectural setting.

The Tomb for Giuliano de' Medici (1524–1534, Fig. 18-5) nearly mirrors the other and demonstrates that even unfinished projects could contain the new, dramatic, and dynamic. The seated figure of Giuliano is barely contained in a very tight niche where pilasters, swags, flattened capitals, and a tight entablature try to hold the crowded architectural elements in check. The rounded tomb itself is based on antique types and, unlike common practice, displays no effigy of the deceased. Instead, heroically scaled nude figures of Day on the right (whose face was deliberately left unfinished) and Night on the left seem to recline precariously on the tomb top, perhaps representing life and death. These brooding figures could be compared to figures in the Fall of Adam and the Expulsion from the Garden in the Sistine Chapel cycle. The artist has attained a dramatic expressiveness that embodies body and soul in individual human forms.

In Michelangelo's unfinished works, like those of Leonardo, we sense the skill needed to manipulate the medium and the potential of the object for interpretations that reach beyond the accepted meaning. The bust of Brutus (the assassin of Julius Caesar), although made after 1537 (thus after the final demise of the republic and return of the Medici to power), seems to carry on the spirit of republican Florence (Fig. 18-6). The head and face are unfinished, the drape completed by one of Michelangelo's assistants. Compare it with similar works that we have seen. The ridges left by the chisel do not detract from the strong, heavy face. The folds of flesh that extend from the nostrils to the small but sensuous mouth, as well as the hollows of the cheeks, give the face a tension and purpose that come with age. The deep hollows of the simplified eyes hold shadow; they contrast with the broad ridge of the nose. This face could be that of any person with courage who has known fear, with purpose who has known discouragement. He is neither the purely detached imperial Augustus (Fig. 6-2) nor the political Arringatore (Fig. 6-1). He asks questions and seeks answers. He loves life but knows that death will come. He wants salvation but knows that it comes from sacrifice. Our responses to this face are varied, rich, and resonant. In it are recorded the marks of life and the need for meaning.

Raphael (1483–1520)

Raffaello Sanzio (anglicized as Raphael) was the youngest of these four individuals whose ideas were born and matured in the intensely creative, confident atmosphere of late-fifteenth-century Florence. Taught by his father, then by the painter Perugino in sophisticated, worldly Urbino, Raphael traveled to Florence, then to Rome. Raphael's vision of the nature of painting seems

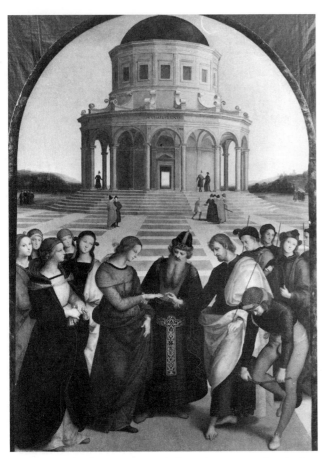

18-7 *Raphael,* Marriage of the Virgin, *panel painting, 1504. Pinacoteca di Brera, Milan. (Alinari/Art Resource, NY)* (W)

• Compare the architecture in this painting with that of the Church of San Lorenzo (Fig. 17-2) and the Pazzi Chapel (Figs. 17-4 and 17-5). What is similar? What role does the architecture play in the composition of the painting? Compare Raphael's figures with those in Masaccio's *The Tribute Money* (Color Plate III) and Botticelli's *Primavera* (Color Plate V). How would you describe the differences in the figures, and how are these differences conveyed?

to have been founded on a desire to make paintings that present an ideal and harmonious moment in which time and change are suspended. This vision contrasts sharply with the ideas of Michelangelo and Leonardo, but its presence emphasizes the rich possibilities inherent in Florentine art. Just as Giotto and Simone Martini represented alternatives in the fourteenth century, Raphael, with Leonardo and Michelangelo, presented alternatives that artists explored well into the nineteenth century.

Among Raphael's first important works, *The Marriage of the Virgin* (Fig. 18-7) was painted for the church in Città di Castello about 1504. The arch of the frame, almost touching the dome of the temple, is one curve in a repeating pattern of curves and rectangles, which focus attention on Joseph, who places a ring on the finger of the Virgin. Their bodies and heads incline inward toward each other, as do all the figures. Everything in the work quietly conspires to concentrate on this precise moment in time. The principal characters stand as silently as their attendants; their elegant profiles and the curves of their rich drapery repeat each other. The light in the piazza is clear and golden; figures in the middle distance and background move easily through this spacious, ordered world.

The successful marriage of figures with their setting was and remains a problem for the artist. The setting must reinforce the motif of the painting, but it must not be so contrived as to be incredible. Raphael's painting *The School of Athens* (Color Plate IX), executed for the Stanza della Segnatura in the papal apartments in Rome (1510–1511), presents another solution and one that should be compared with Michelangelo's Sistine Chapel ceiling frescoes (Color Plate VIII).

In *The School of Athens*, Raphael places the great philosophers of antiquity in a barrel-vaulted and domed hall lined with sculpture in niches, open to the air, and filled with light. Plato and Aristotle are framed by the central arches as they stand in the sunlight at the top of steps, between groups of auditors. In the upper left, Socrates holds the attention of some youth; in the lower left, Pythagoras computes on a slate. Euclid, lower right, draws a geometrical demonstration.

The groups of figures form a circle in the space and color, and gestures and overlapping figures move the eye around the composition in an even rhythm. In spite of all the movement, discussion, and implied noise, the painting seems to portray a dream of antiquity concentrated in a golden moment of time. The figures and the architecture are idealizations, like the subject itself, an occasion that could never have occurred.

On the opposite wall of the apartment, Raphael placed the complex *Disputation of the Sacrament*, an exposition of the doctrine of the Eucharist. These two subjects seem to symbolize Renaissance thought, which sought to reconcile antiquity and Christianity.

At the same time that Raphael was executing these frescoes, Michelangelo was working in the Sistine Chapel on the ceiling decorations that were to tell the story of Creation. These paintings are directly overhead, at quite a distance from the viewer. Michelangelo was faced with a problem. What could be seen—figures, setting, both? Discarding any but the barest architectural framework, the barest landscape, Michelangelo concentrated all his effort on creating a series of idealized, heroic figures, a canopy of giants. The ceiling is given over to the human body, which is the sole carrier of meaning. These are the figures of a sculptor, trans-

lated into painting. But the difference is more than one of the physical location of the work. Raphael was more interested in attaining a completely harmonious moment in a harmonized world, whereas Michelangelo was more interested in the human power of the narrative. (The cleaning of the Sistine Chapel frescoes, a massive project that has aroused controversy in the art world, has revealed Michelangelo's work in an entirely new light.)

Raphael, like Michelangelo, could not ignore the realities of this world, or the people in it. His stunning portrait of Pope Leo X (Color Plate X), painted about 1517, presents this Renaissance prelate in all his corpulent power. A shrewd man given to worldly things, Leo excommunicated Martin Luther in 1520. There was no golden moment to capture here, but there was the reality of earthly power. Raphael's ability to see this, along with the ideal, gave his art its lasting vitality.

Niccolò Machiavelli

from *The Prince*

Translation by Ninian Hill Thompson

Chapter XV

Of the qualities in respect of which men,
and most of all Princes,
are praised or blamed

It now remains for us to consider what ought to be the conduct and bearing of a Prince in relation to his subjects and friends. And since I know that many have written on this subject, I fear it may be thought presumptuous in me to write of it also; the more so, because in my treatment of it I depart widely from the views that others have taken.

But since it is my object to write what shall be useful to whosoever understands it, it seems to me better to follow the real truth of things than an imaginary view of them. For many Republics and Princedoms have been imagined that were never seen or known. It is essential, therefore, for a Prince who would maintain his position, to have learned how to be other than good, and to use or not to use his goodness as necessity requires.

Laying aside, therefore, all fanciful notions concerning a Prince, and considering those only that are true, I say that all men when they are spoken of, and Princes more than others from their being set so high, are noted for certain of those qualities which attach either praise or blame. Thus one is accounted liberal, another miserly (which word I use, rather than *avaricious*, to denote the man who is too sparing of what is his own, *avarice* being the disposition to take wrongfully what is another's); one is generous, another greedy; one cruel, another tender-hearted; one is faithless, another true to his word; one effeminate and cowardly, another high-spirited and courageous; one is courteous, another haughty; one lewd, another chaste; one upright, another crafty; one firm, another facile; one grave, another frivolous; one devout, another unbelieving; and the like. Every one, I know, will admit that it would be most laudable for a Prince to be endowed with all of the above qualities that are reckoned good; but since it is impossible for him to possess or constantly practise

them all, the conditions of human nature not allowing it, he must be discreet enough to know how to avoid the reproach of those vices that would deprive him of his government, and, if possible, be on his guard also against those which might not deprive him of it; though if he cannot wholly restrain himself, he may with less scruple indulge in the latter. But he need never hesitate to incur the reproach of those vices without which his authority can hardly be preserved; for if he well consider the whole matter, he will find that there may be a line of conduct having the appearance of virtue, to follow which would be his ruin, and that there may be another course having the appearance of vice, by following which his safety and well-being are secured.

Chapter XVII

Of Cruelty and Clemency,
and whether it is better to be Loved or Feared

Passing to the other qualities above mentioned, I say that every Prince should desire to be accounted merciful and not cruel. Nevertheless, he should be careful not to abuse this quality of mercy. Cesare Borgia was reputed cruel, yet his cruelty restored Romagna, united it, and brought it to order and obedience; so that if we look at things in their true light, it will be seen that he was in reality far more merciful than the people of Florence, who, to avoid the imputation of cruelty, suffered Pistoia to be destroyed by factions.[1]

A Prince should therefore disregard the reproach of cruelty where it enables him to keep his subjects united and faithful. For he who quells disorder by a very few signal examples will in the end be more merciful than he who from excessive leniency suffers things to take their course and so result in rapine and bloodshed; for these hurt the entire State, whereas the severities of the Prince injure individuals only.

And for a new Prince, above all others, it is impossible to escape a name for cruelty, since new States are full of dangers. Wherefore Virgil, by the mouth of Dido:—

[1] Florence attempted to govern Pistoia by encouraging the disputes between the two major factions. When in 1501–1502 it attempted finally to end the civil conflict, it caused untold bloodshed and destruction. [Translator's notes.]

"Res dura et regni novitas me talia cogunt
Moliri, et late fines custode tueri."[2]

Nevertheless, the new Prince should not be too ready of belief, nor too easily set in motion; nor should he himself be the first to raise alarms; but should so temper prudence with kindliness that too great confidence in others shall not throw him off his guard, nor groundless distrust render him insupportable.

And here comes in the question whether it is better to be loved rather than feared, or feared rather than loved. It might be answered that we should wish to be both; but since love and fear can hardly exist together, if we must choose between them, it is far safer to be feared than loved. For of men it may generally be affirmed that they are thankless, fickle, false, studious to avoid danger, greedy of gain, devoted to you while you confer benefits upon them, and ready, as I said before, while the need is remote, to shed their blood, and sacrifice their property, their lives, and their children for you; but when it comes near they turn against you. The Prince, therefore, who without otherwise securing himself builds wholly on their professions, is undone. For the friendships we buy with a price, and do not gain by greatness and nobility of character, though fairly earned are not made good, but fail us when we need them most.

Moreover, men are less careful how they offend him who makes himself loved than him who makes himself feared. For love is held by the tie of obligation, which, because men are a sorry breed, is broken on every prompting of self-interest; but fear is bound by the apprehension of punishment which never loosens its grasp.

Nevertheless a Prince should inspire fear in suchwise that if he do not win love he may escape hate. For a man may very well be feared and yet not hated, as will always be the case so long as he does not intermeddle with the property or with the women of his citizens and subjects. And if constrained to put any one to death, he should do so only when there is manifest cause or reasonable justification. But, above all, he must abstain from the property of others. For men will sooner forget the death of their father than the loss of their patrimony. Moreover, pretexts for confiscation are never to seek, and he who has once begun to live by rapine always finds reasons for taking what is not his; whereas reasons for shedding blood are fewer, and sooner exhausted.

But when a Prince is with his army, and has many soldiers under his command, he must entirely disregard the reproach of cruelty, for without such a reputation in its Captain, no army can be held together or kept ready for every emergency. Among other things remarkable in Hannibal[3] this has been noted, that having a very great army, made up of men of many different nations and brought to serve in a foreign country, no dissension ever arose among the soldiers themselves, nor any mutiny against their leader, either in his good or in his evil fortunes. This we can only ascribe to the transcendent cruelty, which, joined with numberless great qualities, rendered him at once venerable and terrible in the eyes of his soldiers; for without this reputation for cruelty his other virtues would not have effected the like results.

Unreflecting writers, indeed, while praising his achievements, have condemned the chief cause of them; but that his other merits would not by themselves have been so efficacious we may see from the case of Scipio,[4] one of the greatest Captains, not of his own time only but of all times whereof we have record, whose armies rose against him in Spain from no other cause than his excessive leniency in allowing them freedoms inconsistent with military discipline. With which weakness Fabius Maximus[5] taxed him in the Senate House, calling him the corrupter of the Roman soldiery. Again, when the Locrians were shamefully outraged by one of his lieutenants, he neither avenged them, nor punished the insolence of his officer;[6] and this from the natural easiness of his disposition. So that it was said in the Senate by one who sought to excuse him, that there were many who knew better how to refrain from doing wrong themselves than how to correct the wrong-doing of others. This temper, however, must in time have marred the name and fame even of Scipio, had he continued in it, and retained his command. But living as he did under the control of the Senate, this hurtful quality was not merely veiled, but came to be regarded as a glory.

Returning to the question of being loved or feared, I sum up by saying, that since his being loved depends upon his subjects, while his being feared depends upon himself, a wise Prince should build on what is his own, and not on what rests with others. Only, as I have said, he must do his best to escape hatred.

2 "A fate unkind, and newness in my reign/Compel me thus to guard a wide domain."

3 Hannibal (247–183 B.C.) almost succeeded in destroying Rome in the Second Carthaginian War. Machiavelli often uses him as an example of efficacious cruelty. He is compared with Scipio (236–184 B.C.), the Roman general, whose humanity was equally successful.

4 Scipio (see note above) defeated Hannibal decisively at Zama in 202 B.C.

5 Fabius Maximus, called the Delayer, wore Hannibal's army out by delaying tactics in 217 B.C., but, knowing his army was weak, refused to do open battle with him.

6 Locri, a Greek colony in southern Italy, was bled white by its supposed governor, Quintus Pleminus. Scipio, although knowing of his misdeeds, did nothing to punish his subordinate.

Chapter XIX

That a Prince should seek to escape Contempt and Hatred

Having now spoken of the chief of the qualities above referred to, the rest I shall dispose of briefly with these general remarks, that a Prince, as has already in part been said, should consider how he may avoid such courses as would make him hated or despised; and that whenever he succeeds in keeping clear of these, he has performed his part, and runs no risk though he incur other reproaches.

A Prince, as I have said before, sooner becomes hated by being rapacious and by interfering with the property and with the women of his subjects, than in any other way. From these, therefore, he should abstain. For so long as neither their property nor their honour is touched, the mass of mankind live contentedly, and the Prince has only to cope with the ambition of a few, which can in many ways and easily be kept within bounds.

A Prince is despised when he is seen to be fickle, frivolous, effeminate, pusillanimous, or irresolute, against which defects he ought therefore to guard most carefully, striving so to bear himself that greatness, courage, wisdom, and strength may appear in all his actions. In his private dealings with his subjects his decisions should be irrevocable, and his reputation such that no one would dream of over-reaching or cajoling him.

The Prince who inspires such an opinion of himself is greatly esteemed, and against one who is greatly esteemed conspiracy is difficult; nor, when he is known to be an excellent Prince and held in reverence by his subjects, will it be easy to attack him. For a Prince is exposed to two dangers, from within in respect of his subjects, from without in respect of foreign powers. Against the latter he will defend himself with good arms and good allies, and if he have good arms he will always have good allies; and when things are settled abroad, they will always be settled at home, unless disturbed by conspiracies; and even should there be hostility from without, if he has taken those measures, and has lived in the way I have recommended, and if he never despairs, he will withstand every attack; as I have said was done by Nabis the Spartan.[7]

As regards his own subjects, when affairs are quiet abroad, a Prince has to fear they may engage in secret plots; against which he best secures himself when he escapes being hated or despised, and keeps on good terms with his people; and this, as I have already shown at length, it is essential he should do. Not to be hated or despised by the body of his subjects, is one of the surest safeguards that a Prince can have against conspiracy. For he who conspires always reckons on pleasing the people by putting the Prince to death: but when he sees that instead of pleasing he will offend them, he cannot summon courage to carry out his design. For the difficulties that attend conspirators are infinite, and we know from experience that while there have been many conspiracies, few of them have succeeded.

He who conspires cannot do so alone, nor can he assume as his companions any save those whom he believes to be discontented; but so soon as you impart your design to a discontented man, you supply him with the means of removing his discontent, since by betraying you he can procure for himself every advantage; so that seeing on the one hand certain gain, and on the other a doubtful and dangerous risk, he must either be a rare friend to you, or the mortal enemy of the Prince, if he keep your secret.

To put the matter shortly, I say that on the side of the conspirator there are distrust, jealousy, and dread of punishment to deter him, while on the side of the Prince there are the laws, the majesty of the throne, the protection of friends and of the government to defend him; to which if the general goodwill of the people be added, it is hardly possible that any should be rash enough to conspire. For while in ordinary cases, the conspirator has ground for fear only before the execution of his villainy, in this case he has also cause to fear after, since he has the people for his enemy, and is thus cut off from all hope of shelter.

Of this, endless instances might be given, but I shall content myself with one that happened within the recollection of our fathers. Messer Annibale Bentivoglio, Lord of Bologna and grandsire of the present Messer Annibale, was conspired against and slain by the Canneschi, leaving behind none belonging to him save Messer Giovanni, then an infant in arms. Immediately upon the murder, the people rose and put all the Canneschi to death. This resulted from the goodwill then generally felt towards the House of the Bentivoglio in Bologna; which feeling was so strong, that when upon the death of Messer Annibale no one was left who could govern the State, there being reason to believe that a descendant of the family (who up to that time had been thought to be the son of a smith) was living in Florence, the citizens of Bologna went there to fetch him, and entrusted him with the government of their city; which he retained until Messer Giovanni was old enough to govern.

To be brief, a Prince has little to fear from conspiracies when his subjects are well affected towards him; but when they are hostile and hold him in abhorrence, he has then reason to fear everything and every one. And well ordered States and wise Princes have provided with extreme care that the nobility shall not be driven to desperation, and that the commons shall be kept satisfied and contented; for this is one of the most important matters that a Prince has to look to.

Among the well ordered and governed Kingdoms of our day is that of France, wherein we find an infinite number of wise institutions, upon which depend the freedom and security of the King, and of which the most im-

[7] He was tyrant of Sparta, 205–192 B.C.

portant are the Parliament and its authority. For he who gave its constitution to this Realm, knowing the ambition and arrogance of the nobles, and judging it necessary to bridle and restrain them, and on the other hand knowing the hatred, originating in fear, entertained against them by the commons, and desiring that they should be safe, was unwilling that the responsibility for this should rest on the King; and to relieve him of the ill-will which he might incur with the nobles by favouring the commons, or with the commons by favouring the nobles, appointed a third party to arbitrate, who without committing the King, might depress the nobles and uphold the commons. Nor could there be any better or wiser remedy than this, nor any surer safeguard for the King and Kingdom. And hence we may draw another notable lesson, namely, that Princes should devolve on others those matters which entail responsibility, and reserve to themselves those that relate to grace and favour. And again I say that a Prince should esteem the great, but must not make himself odious to the people. . . .

Chapter XXV

What Fortune can effect in human affairs, and how she may be withstood

I am not ignorant that many have been and are of the opinion that human affairs are so governed by Fortune and by God, that men cannot alter them by any prudence of theirs, and indeed have no remedy against them; and for this reason have come to think that it is not worth while to labour much about anything, but that they must leave everything to be determined by chance.

Sometimes when I turn the matter over, I am in part inclined to agree with this opinion, which has had the readier acceptance in our own times from the great changes in things which we have seen, and every day see, happen contrary to all human expectation. Nevertheless, that our free will be not wholly set aside, I think it may be the case that Fortune is the mistress of one half our actions, and yet leaves the control of the other half, or a little less, to ourselves. And I would liken her to one of those wild torrents which, when angry, overflow the plains, sweep away trees and houses, and carry off soil from one bank to throw it down upon the other. Every one flees before them, and yields to their fury without the least power to resist. And yet, though this be their nature, it does not follow that in seasons of fair weather, men cannot, by constructing weirs and moles, make such provision as will cause them when again in flood to pass off by some artificial channel, or at least prevent their course from being so uncontrolled and destructive. And so it is with Fortune, who displays her might where there is no prepared strength to resist her, and directs her onset where she knows there is neither barrier nor embankment to confine her.

And if you look at Italy, which has been at once the seat of these changes and their cause, you will perceive that it is a field without embankment or barrier. For if, like Germany, France, and Spain, it had been guarded with sufficient skill, this inundation, if it ever came upon us, would never have wrought the violent changes we have witnessed.

This I think enough to say generally touching resistance to Fortune. But confining myself more closely to the matter in hand, I note that one day we see a Prince prospering and the next overthrown, without detecting any change in his nature or conduct. This, I believe, comes chiefly from a cause already dwelt upon, namely, that the Prince who rests wholly on Fortune is ruined when she changes. Moreover, I believe that he will prosper most whose mode of acting best adapts itself to the character of the times; and conversely that he will be unprosperous, with whose mode of acting the times do not accord. For we see that men in those matters which lead to the end each has before him, namely, glory and wealth, proceed by different ways, one with caution, another with impetuosity, one with violence, another with subtlety, one with patience, another with its contrary; and that by one or other of these different courses each may succeed.

Again, of two who act cautiously, you shall find that one attains his end, the other not, and that two of different temperament, the one cautious, the other impetuous, are alike successful. All which happens from no other cause than that the character of the times accords or does not accord with their methods of acting. And hence it comes, as I have already said, that two operating differently arrive at the same result, and two operating similarly, the one succeeds, the other not. On this likewise depend the shifts of Fortune. For if to one who conducts himself with caution and patience, time and circumstance are propitious, so that his method of acting is good, he goes on prospering; but if these change he is ruined, because he does not change his method of acting.

For no man is found prudent enough to adapt himself to these changes, both because he cannot deviate from the course to which nature impels him, and because, having always prospered while pursuing one path, he cannot be persuaded that it would be well for him to leave it. And so when occasion requires the cautious man to act impetuously, he cannot do so and is undone: whereas, had he changed his nature with time and circumstances, his fortune would have been unchanged.

Pope Julius II acted with impetuosity in all his affairs, and found time and circumstance in such harmony with his mode of acting that he always obtained happy results. Witness his first expedition against Bologna, when Messer Giovanni Bentivoglio was yet living.[8] The

[8] Pope Julius attacked in 1506.

Venetians were not favourable to the enterprise; nor was the King of Spain. Negotiations respecting it with France were still open. Nevertheless, the Pope with his wonted hardihood and impetuosity marched in person on the expedition, and by this movement brought the King of Spain and the Venetians to a stay, the latter through fear, the former from his eagerness to recover the entire Kingdom of Naples; at the same time, he dragged after him the King of France, who, desiring to have the Pope for an ally in humbling the Venetians, and finding him already in motion, saw that he could not refuse him his soldiers without openly offending him. By the impetuosity of his movements, therefore, Julius effected what no other Pontiff endowed with the highest human prudence could. For had he, as any other Pope would have done, put off his departure from Rome until terms had been settled and everything duly arranged, he never would have succeeded. For the King of France would have found a thousand pretexts to delay him, and the others would have menaced him with a thousand alarms. I shall not touch upon his other actions, which were all of a like character, and all of which had a happy issue, since the shortness of his life did not allow him to experience reverses. But if times had overtaken him, rendering a cautious line of conduct necessary, his ruin must have been ensured, since he never would have deviated from those methods to which nature inclined him.

To be brief, I say that since Fortune changes and men stand fixed in their old ways, they are prosperous so long as there is congruity between them, and unprosperous when there is not. Of this, however, I am well persuaded, that it is better to be impetuous than cautious. For Fortune is a woman who to be kept under must be beaten and roughly handled; and we see that she suffers herself to be more readily mastered by those who so treat her than by those who are more timid in their approaches. And always, like a woman, she favours the young, because they are less scrupulous, and fiercer, and command her with greater audacity.

COMMENTS AND QUESTIONS

1. Do you consider Machiavelli's advice immoral or merely practical?

2. What is the author's opinion of human nature?

3. Why should the prince not fear being feared but avoid being hated?

4. To what extent can the prince conquer fortune?

Summary Questions

1. What characteristics do Machiavelli, Leonardo, Michelangelo, and Raphael have in common?

2. How do Leonardo and Michelangelo differ in their concept of the artist?

3. In what sense does Machiavelli consider the state to be "a work of art"?

4. What advice does Machiavelli give to the prince and why?

5. What important innovations did Leonardo, Michelangelo, and Raphael make in their respective arts?

Key Terms

virtù

prince

fortune

artist

illusionism

19 The Northern Renaissance and the Protestant Reformation

CENTRAL ISSUES

- Humanism in Italy and in northern Europe compared
- Causes and effects of the Protestant Reformation in Europe
- Catholic reform and counter-reform
- Music in Lutheranism and sixteenth-century Catholicism
- The great economic expansion of the sixteenth century
- Exploration in the New World and cultural relativism
- Shakespeare's *The Tempest* and its music

By 1500 humanism had northern European adherents. Generally speaking, northern humanism differed from the Italian variety in directing its attention to the ancient texts of the Christian religion rather than to the writings of Roman and Greek antiquity. Humanist philological techniques, developed in preparing editions of Cicero, Plato, and others, were now applied to editing the Bible and the writings of the Latin and Greek Church Fathers. Thus the humanists in the North were responsible for directing the attention of learned people to the early history of Christianity and the sources of the Christian faith.

Erasmus (1463–1536)

The leading northern humanist and doubtless the most important humanist of his generation was Desiderius Erasmus (Fig. 19-1). Although born in the Low Countries, Erasmus lived most of his mature life in France, England, and Switzerland. Like his Italian humanist predecessors, he believed that ethics was more important than elaborate systems of philosophy and theology. Coupled with his extremely critical attitude toward current Church abuses, this insistence on the primacy of moral action became a powerful weapon for the reform of Christian life.

In Erasmus's opinion, the Church had overemphasized rituals and outward manifestations of piety. It had made too sharp a distinction between the status of a cleric and that of a layperson. The central focus of Christianity should be on the spirit, on the cultivation of deep religious feeling, rather than on ceremonies. Although not attacking the principle of monasticism as evil, Erasmus nevertheless maintained that the lay life, doing God's work in the world, was just as effective in serving Christ as was the life of the cloistered monk. Moreover, the laity, too, needed and had the right to read and discuss the sources of their faith. In short, as Erasmus himself said at one point, "The world has become my monastery."

Like the texts of pagan antiquity, those of Christian antiquity were highly defective. Erasmus chose as his first task the preparation of a new edition of the Greek New Testament with Latin translation, which he published in 1516. It was a courageous task to undertake. Over a thousand years of Christian scholarship had been based on the Vulgate, composed of early translations of the books of the Bible; now Erasmus showed that some of the key passages on which countless interpretations had been made were not actually in the Greek original or were mistranslated. In the same year he published his nine-volume edition of the works of Saint Jerome. This was one of the first humanist editions of the complete works of a Church Father, but many were to follow.

Erasmus was the first great European writer to make use of an important invention, the printing press. Although printing had been developed before his time—the Gutenberg Bible first appeared in 1455—the earlier books were primarily luxury items. Erasmus distributed his editions and his polemical pamphlets throughout Europe. Writing in Latin, he could be read by educated people in all countries; thus he helped to create a culture of the printed word that has since dominated Western intellectual life.

Erasmus firmly believed that if all the sources of Christian truth could be published in an accurate form, the eloquence of the words, as they were originally written under the inspiration of the Holy Spirit,

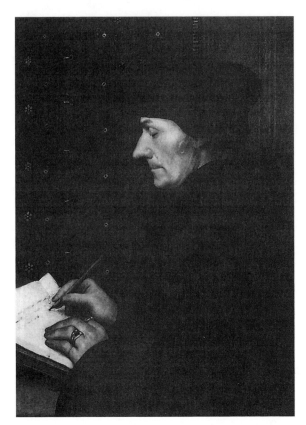

19-1 *Hans Holbein the Younger,* Erasmus Writing, *c. 1523. Oil on panel. 16¹/₂ × 12¹/₂″. The Louvre, Paris, France. (Giraudon/Art Resource, NY)* (**W**)

▲

• Compare this portrait with Raphael's *Pope Leo X* (Color Plate X). How can you tell that this is a likeness of a particular person? Compare these portraits with Cranach's drawing of Luther (Fig. 19-2). What is the effect of Cranach's work being a drawing rather than a painting? Which man is the most noble, and what aspects of each portrait make you think so?

could not fail to move people to become better Christians. The goal of Erasmus's Christian scholarship was therefore to reform both individual Christians and the Church itself. He did not attack the dogma of the Church, but he did attack the effort of theologians to elaborate on the dogma and to claim certainty for their deductions. For him there were only a few absolutely certain principles in the Bible, and these were all people needed to believe in order to be saved. What was important for him was that Christian belief be reflected in one's life. True Christians acted like Christians. This was Erasmus's "philosophy of Christ" in essence. Accordingly, he was exceedingly tolerant of differing views of theology but severely critical of evil conduct.

EUROPE AT THE TIME OF THE PROTESTANT REFORMATION

Erasmus remained a Catholic despite every effort of the Lutherans to convince him to join their sect. Nonetheless, the sweeping criticism he made of abuses in the Church had a devastating effect and has led some scholars to say that "Erasmus laid the egg that Luther hatched."

The Protestant Reformation

The reform tendencies present in Erasmus and other northern humanists were not unique to them. Rather, by 1500 in northern Europe a broad spirit of Christian reform prevailed, of which humanism was only one reflection (see map). Intensive efforts were under way to reform monastic orders, and new orders were founded devoted to strict enforcement of the monastic vows. Pietistic movements like the Brethren of the Common Life, which included both laity and clerics,

aimed at infusing in the daily life of all Christians a deep spirit of devotion. Against this background the Lutheran reform could be interpreted as only another manifestation of a universal concern. Martin Luther (Fig. 19-2) was different from the other reformers, however, in that he attacked not only abuses but doctrines as well.

Martin Luther (1483–1546)

For Luther, the Church for the past thousand and more years had distorted the truth found in the Bible. In practice the Church had exalted the pronouncements of Church councils, popes, and learned individuals to a level equal to that of Scripture. For him these "truths" were human ones; human beings made mistakes and only the Bible was unquestionably true. Hence, he rejected the authoritative interpretations that the Church

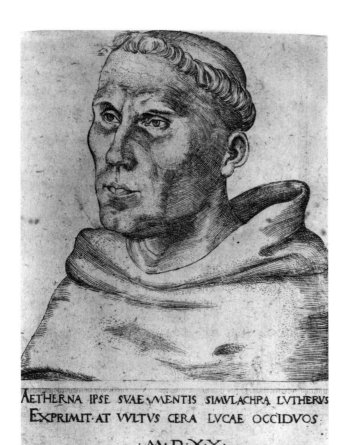

Luther that in his view no fair-minded person could differ with his interpretation. Accordingly, he was perfectly willing to persecute others who did not share his understanding of the basic principles found in the Bible.

Grace and Predestination A dominant tradition of the medieval Church had been the belief that people could cooperate with God's grace in earning their own salvation. Through a succession of good works, product of the joint efforts of human will and grace, the individual could build up enough merits to earn a place in heaven. The *sacraments* controlled by the Church hierarchy were viewed as the channels through which life-giving *divine grace* poured into believers. The clerics (the priests who administered the sacraments and had care of souls) and the monks and friars (who had taken special vows to devote their life to God) were considered as a group to be on a higher spiritual level than were the laity. Their average chances for entering heaven were considered better than those of nonclerics; they were more likely to build up merits because of their profession.

Luther attacked the central thesis of this belief. No human being can cooperate with God in his or her own salvation. Mortals are too sinful. God *predestines* some individuals from all eternity to salvation. These men and women know who they are because they have faith that Christ's merits have been imputed to them for their salvation. They themselves did absolutely nothing to win this salvation; it was a free gift of God. In saying this, Luther firmly believed that he was truly interpreting the words of Christ and Paul. Therefore, gone was the need for pilgrimages, penances, masses for the dead, and all the other rituals of the medieval Church designed to build up a sum of the good works requisite for salvation. Only after people are justified and know that Christ is their savior can they really begin to do good works. Yet these count nothing for salvation: they are merely the fruits of knowing that God has already chosen one to be saved. The good works pour out as a product of love for God and one's fellow mortals because Christ is at work in the depths of the soul.

Consequently, no one is saved because of what he or she does; a person receives *salvation by faith*. From this it follows that a shoemaker has just as good a chance of being saved as does the pope. In Luther's view, the whole spiritual hierarchy with bishops, archbishops, cardinals, and pope was a human construction. He denied that Christ in committing the keys to Peter intended to make the bishop of Rome the head of the whole Church. The present hierarchical Church was a work of humanity, not God; and since it was loaded with corruption and led by blind people, the edifice had to be destroyed. Luther's solution was that the territorial prince in each area should be the governor of the territorial Church.

19-2 Lucas Cranach the Elder, Portrait of Luther as a Dominican Friar, *engraving, 13.4 × 9.5 cm, 1520. (Courtesy of the Harvard University Art Museums. Francis Calley Gray Collection of Engravings)*

had placed on each passage of the Bible as concealing, rather than revealing, the Word of God found therein. Each person should have the power of coming to the text and reading it according to the dictates of his or her own conscience. When in 1521 Luther was called before the Catholic emperor, Charles V of Germany, at Augsburg to renounce his deviation from Catholic truth, he exalted the majesty of the individual human conscience in refusing:

> Since then Your Majesty and your lordships desire a simple reply, I will answer without horns and without teeth. Unless I am convicted by Scripture and plain reason—do not accept the authority of popes and councils, for they have contradicted each other—my conscience is captive to the Word of God. I cannot and I will not recant anything, for to go against conscience is neither right nor safe. God help me. Amen.

By this, however, he did not mean that everyone's opinion about religion should be respected. The truth on important issues of the faith was so evident for

Influences on Luther The sources for Luther's thought, in addition to the Bible, included Saint Augustine and northern European critics of medieval scholasticism. Unlike Thomas Aquinas, Luther had little faith in the ability of human reason to establish truths about the divine nature. Luther's God was primarily Will, and people had no power to know anything more of him than the Bible conveyed. The reformer's insistence on the importance of the inner life as opposed to ceremonies was perhaps in part an inheritance from northern mysticism, but humanists like Erasmus also exercised an influence here. To humanism Luther also owed his training in the three major ancient languages—Latin, Greek, and Hebrew—and his confidence in his critical powers when confronted with a text. Humanism placed at his disposal a set of philological tools and a tradition of independent judgment; Luther fearlessly applied these in an examination of the whole body of Christian doctrine.

Like Erasmus, Luther made extensive use of the medium of printing to distribute his ideas. The impact of his message was much greater, however, because whereas Erasmus wrote only in Latin, Luther championed his appeal to reform in eloquent German. To make the Bible more accessible to the layperson, he translated the whole of the Old and New Testaments, a translation that served as the basis for the modern German language.

Effects of Luther's Doctrine Whereas Luther embraced the doctrine of the freedom of conscience to interpret the Bible—confident that the Bible clearly supported his views—other reformers, using the same principle, held very different positions with similar certainty. For more than ten centuries the holy book of the Christian faith had been protected by authoritative commentaries on key words and phrases. And now Luther proclaimed a doctrine of interpretation that, contrary to his intention, encouraged religious anarchy.

Luther and Music Martin Luther was one of several reformers who believed that the Catholic Church had become too secular and was moving away from its primary religious mission of reaching the people and saving souls. A great lover of music and art, Luther did not want to remove music from the service of God but rather sought to make it more accessible to the entire congregation. Although at first he wished to retain Latin for the service, in 1526 he published a German mass, since German was the native language of his congregation. He also introduced the German chorale, a congregational hymn sung in the vernacular, into the regular Lutheran service. This music proved to be a popular and powerful weapon for winning converts to the Protestant faith. Indeed, Protestant church music became a major source of concern to the Catholic Church as it strove to counter the effects of the *Refor-*

mation. From the sixteenth through the eighteenth century, the Lutheran chorale developed and prospered. We will hear these chorales when we study the music of the greatest of all Lutheran composers, Johann Sebastian Bach (Chapter 22).

CD-2, 6

John Calvin (1509–1564)

Next to the Lutherans the single most important Protestant group was the Calvinists. John Calvin, a Frenchman, came to Geneva in Switzerland after the city had already converted from Catholicism; after 1540 under his able direction the city became the center of that variety of Protestantism bearing his name. A second-generation reformer, Calvin believed with Luther in God's predestination of the human soul either to heaven or to hell and in the uselessness of humanity's good works for salvation. But whereas Luther's preoccupation had been with the salvation of the sinner and its consequences for the individual, Calvin focused on the duty of the "elect" to glorify God in all their actions as instruments of God's work. The result of the difference was that, whereas Lutherans stressed the need of the saved to live as Christians in their daily lives, Calvinists viewed themselves as charged with responsibility to reform society so as to make it acceptable in the Lord's eyes. As exemplified in Geneva, Calvinism was against taverns, whorehouses, elaborate clothing, and any form of behavior that would detract from God's glory. For the same reason Calvinists proved much more active missionaries than did Lutherans. Moreover, although Calvin himself was politically conservative, his followers were born revolutionaries in countries where rulers were not Calvinists. After the founder's death, Calvinism was rapidly diffused in France and England as well as in eastern Europe, especially Poland.

There is no space here to discuss the multitude of more radical Protestant sects that sprang up in the sixteenth century along with Lutheranism and Calvinism. Suffice it to say that throughout the century Catholics and Protestants, conservative Protestants and radical Protestants, tortured and killed one another in the name of their religious convictions. Religious toleration would come in the next century only because most of the European population was tired of civil wars and of the anarchy created by religious struggle.

Reform and Counter-Reform

The causes of the religious upheaval in the early sixteenth century were many. The enormous demographic rise that began in the late fifteenth century brought a significant expansion of commerce and industry, but it also lowered wages, raised rents, and created a

discontented lower class anxious for change. At the same time, an increasingly educated population was less likely to tolerate corruption in the Church. Furthermore, humanists had questioned the traditional reading of some of the sacred texts, thus undercutting clerical authority in the name of individual judgment and inspiring debates about some of the basic tenets of the faith. Princes, for their part, were often eager to take up arms if they saw a possibility of gaining greater control over the churches in their territories.

By 1550 an objective observer of the European scene would perhaps have predicted the ultimate triumph of Protestantism over the old religion. England, which had broken with the Roman Church in 1534 primarily for political motives, was by this time a Protestant power. The Lutherans had gained half of Germany and were advancing; theirs had become the dominant religion in the Scandinavian peninsula. Calvinism was spreading rapidly in areas such as France, the Low Countries, and Poland.

Such a prophet, however, would have misjudged the determination of the most powerful country in Europe—Spain—and the continued vitality of the Catholic Church. After centuries of campaigning to drive the Muslims from the Iberian Peninsula, the Spanish, after their final victory at Granada in 1492, could at last play a role on the European scene. By the mid-sixteenth century, through a series of wars and accidents of birth and death, the king of Spain ruled an empire much greater in area than that of Rome at its height. Charles V was, at the time of his abdication in 1553, king of the combined monarchies of Castile and Aragon, inherited from his grandparents Ferdinand and Isabella. The Spanish inheritance included lands claimed by Castile in South, Central, and North America. As Holy Roman Emperor, he also governed Germany, the Low Countries, Austria, Bohemia, and Moravia, as well as large areas of France and more than half of Italy. The wealth of the silver mines of the New World allowed him to maintain the largest, most powerful army in Europe. Whereas Spain's nearest competitor, France, was riven by religious dissension, Charles and his immediate successors presided over a people whose Catholic faith had been successfully tested by centuries of crusading against the Spanish Muslims. The Spanish monarchs throughout the sixteenth and early seventeenth centuries were unquestionably the major champions of the faith throughout western Europe.

The success of the Catholic counteroffensive, or *Counter-Reformation,* was not, however, simply built on the power of the Spanish infantry. The Council of Trent, the Church council that met at Trent in northern Italy at various times between 1545 and 1563, laid the groundwork for a great church reform. The basic results of the Council of Trent were to define clearly what Catholics should believe, to make some crucial administrative reforms, and to provide for the creation of seminaries for the education of the clergy. Henceforth Catholics could no longer fall into heresy because they were not aware of the orthodox doctrines. The administrative reforms made the Church less vulnerable to criticism, and the steps to raise the educational level of the clergy resulted after decades in a new respect by laity for their priests. Therefore, while establishing a platform on which to base an attack on the Protestants, Trent also provided a program of reforms that would attract individual Christians back to the faith.

The new agencies of the Church (the Jesuit order founded in 1540 and the Holy Office of the Roman Inquisition established in 1542) played an extremely important part in seconding these efforts. Heresy or false belief had always been regarded as a disease that not only destroyed the soul of the heretic but also, if diffused, could corrupt the immortal souls of others. Once identified by a commission of experts, the *Inquisition,* the heretic was expected to abjure the errors for the good of the immortal soul. If he or she did not, or first abjured and then returned to the errors, the duty of the Inquisition was to have the person executed to prevent further infection of the community of believers.

The Inquisition

There had been various forms of inquisitions established over the centuries, mostly at the level of the bishopric or archbishopric. The most famous of all, however, was the Spanish Inquisition. It was set up in 1478 by Ferdinand and Isabella of Spain as a department of their government to ferret out *Conversos,* converted Jews and Moors who, although professing Christianity, remained faithful to Judaism or Islam. Independent of the papacy, this inquisition was introduced into North America along with the Spanish conquistadors.

By contrast, the Holy Office of the Roman Inquisition represented an effort of the papacy to concentrate investigation of heresy throughout the Catholic world at Rome. From that vantage point heresy could be pursued even among the princes of Europe and the Church. In the decades after its foundation more than one cardinal, for example, was forced to renounce a heretical or dangerous belief under threat of death or imprisonment. The efficiency of the new organization had the desired effect of preventing the diffusion of Protestantism as well as of more exotic beliefs among Catholic populations.

The Jesuits

Recognized as an order by the papacy in 1540, the Jesuits, founded by the Spanish knight Ignatius Loyola, were to become the right arm of the pope in the Counter-Reformation. Like previous religious orders,

the Jesuits took a vow of poverty, chastity, and obedience, but in their case the last vow included a promise of complete obedience to the papacy at all times. As Loyola wrote: "If we wish to proceed securely in all things, we must hold fast to the following principle: What seems to be white, I will believe black if the hierarchical Church so defines."

The Jesuits formed an elitist body, composed of men admitted because of their intelligence, finesse, physical stamina, and deep commitment. Given a superb university education, they were capable of holding their own in any situation or discussion. They actively promoted papal policies on the international level as diplomats. More humble but perhaps more important in the long run was their role as the prime educators of the middle and upper classes of Catholic Europe through the hundreds of schools that they established over the next century. Everywhere they diffused the brand of spirituality developed by their founder. In his effort to bring the believer to a higher state of religious awareness, Loyola focused on training and disciplining the will. All kinds of appeals were made, at least in the initial stages of development, to the senses, emotions, and imagination. As we will see, this type of spirituality was intimately related to the evolution in Catholic countries of the artistic styles called *baroque*.

Having in a sense experienced a revival of heart and conviction through the Council of Trent, resting on two powerful instruments for orthodoxy, the Inquisition and the Jesuits, and backed by the military power of the greatest European monarchy, the Church in the last forty years of the sixteenth century set off on its campaign to drive the Protestant menace back and eventually to destroy its heresies. By 1600 Poland had all but completely returned to the Catholic camp; in France the French Calvinists, the Huguenots, had already reached their maximum membership and their power was on the wane. In Germany as well, the Protestant advance was by this date turning into a retreat. The Catholic reform, relying there on two powerful German states, Austria and Bavaria, was meeting success in converting one city after another back to the old faith. Everywhere the Jesuits were leaders in the campaign.

Spanish Composer for the Roman Church: Cristóbal de Morales (c. 1500–1553)

Spain, as part of the Holy Roman Empire under the leadership of Holy Roman Emperor Charles V, was, even more than Rome itself, the model of Roman Catholic orthodoxy and conservatism, and these traits are manifest in music written for the Church by Spanish composers of the Renaissance. Prime among these musical artists was Cristóbal de Morales. Born in Seville and educated in his homeland, Morales was to achieve a reputation as the greatest Spanish composer of the early sixteenth century. His music not only diffused widely throughout Europe during his own lifetime, but it was also carried to the New World by Spanish priests intent on Christianizing the native population of the Western Hemisphere. There his music was copied into manuscripts and performed by priests and Native Americans several generations before Pilgrims set foot on Plymouth Rock in New England. A copy of his published book of masses of 1544 was carried to the New World, and we also know that his music was performed in Mexico in 1559 for a commemorative service for Charles V.

Morales composed music of great solemnity and sobriety for the Catholic services, and he enriched these liturgical and paraliturgical compositions with the passionate feelings and religious intensity deemed so characteristically Spanish. During his lifetime he worked both in Spain and in Italy: as a singer and composer in the service of Spanish cathedrals, where he was employed, and also in Rome as a member of the papal chapel.

His motet "Clamabat autem mulier Chananaea" (But the Canaanite woman cried out) displays both restraint and dramatic effect. It is a dialogue (based on Matt. 15:21–28) between the Canaanite mother

CD-2, 1

and Christ, when she seeks him out to heal her ailing daughter. The introductory words, "But the Canaanite woman cried out," are set in an even flow of music, one voice entering after another, and this is smoothly joined with her plea to Christ, which begins with several voices declaiming the text together. As the musicians sing her entreaty, "Lord Jesus Christ, Son of David, help me," one line builds upon another until the full five-voice *texture* is sounding. As is characteristic of Renaissance music of the period, these voice parts overlap, and one choir member sings one syllable while another sings a different one. The effect is mystical and ethereal, but this clouding of text soon became an issue within the Church as it sought clarity of text for the listener.

The musical texture of the motet thins as the mother explains her plight, "My daughter is sorely troubled with an evil spirit," and we emphatically feel her pain. The narrative continues, "The Lord replied and said to her," and this brief statement, a formality, really, is given little attention in the music, a quick statement in but two of the five voices of the choir. Then the dramatic first words of Jesus, which are meant to test her faith, receive the conservative, orthodox treatment of one voice after another: "I am sent to none but the lost sheep of the House of Israel." She, being a Canaanite and not an Israelite, is excluded. She should leave, but she won't let go. She moves up close to Christ and says, "Lord, help me." Morales first sets these words low, in the bottom three voices, repeats them in the upper two, adds the bottom three, and repeats them

again in all the parts. Thus the composer underscores the drama of the text by employing musical devices that create tension and release. To mark the reply, Morales uses a repeated three-note pattern to introduce the words of the sympathetic Lord, and here Christ answers with the sound of the full choir: "Woman, great is your faith. Let it be as you wish."

Hispanic music came early to the Americas, and it has persisted, in many forms, in an unbroken tradition on this continent longer than any other music save that of the indigenous North Americans. Morales was a composer of the traditional faith at the same time as Martin Luther was first gaining ground in his great Reformation of the Church. Founded on the tradition of Gregorian chant and medieval polyphony, Morales's music moves forward to embrace and exemplify the historic development of Christian church music from the psalms of its Jewish roots to the flowering of the Christian high-art music of the early sixteenth century.

Clamabat autem mulier Chananaea:	But the Canaanite woman cried out:
Domine Jesu Christe, Fili David,	Lord Jesus Christ, Son of David,
Adjuva me; filia mea male a daemonio vexatur.	Help me. My daughter is sorely troubled with an evil spirit.
Respondens ei Dominus dixit:	The Lord replied and said to her:
Non sum missus nisi ad oves quae perierunt domus Israel.	I am sent to none but the lost sheep of the House of Israel.
At illa venit et adoravit eum, dicens:	But she drew near and implored him, saying:
Domine adjuva me.	Lord, help me.
Respondens Jesus ait illi:	Jesus replied and said to her:
Mulier, magna est fides tua;	Woman, great is your faith.
Fiat tibi sicut vis.	Let it be as you wish.

CD-2, 1

Music and the Counter-Reformation: Palestrina (c. 1525–1594)

Giovanni Pierluigi da Palestrina holds a special place among Renaissance composers, for a legend sprang up during the seventeenth century and persists even today about his saving the music of the Roman Catholic Church from the decay and decadence into which it was believed to have fallen during the early years of the sixteenth century. Although his role in this process has been highly inflated, it is true that Church officials at the Council of Trent devised, among legislation dealing with every aspect of the Church, a broad policy of musical reform, and Palestrina became its leading advocate. In music, the principal issue was the excessive artifice of counterpoint employed by some Church composers of the day. Some sacred Catholic music of the High Renaissance apparently had become so florid

that Church officials forbade its use. Indeed, the bishop of Modena stopped polyphonic (multivoiced) singing in his church altogether in 1538 and insisted on plainchant. As a chronicler noted, the reason was that when the choir sang *polyphony*, only the musicians knew what they were singing about; when they sang chant, everyone understood the words.

Musicians did not always comprehend harmony, the agreeable-sounding confluence of several voices all singing together on different pitches. Melody clearly was the first step in the development of art music, and the earliest melodies were unaccompanied. In the West, primarily in central Europe during the Middle Ages, the art of taking one melody and combining it with another melody in such a way that the simultaneous performance of both sounded pleasing and interesting was called *counterpoint*—point counter point or note against note. By the time of the Renaissance, this skill was highly developed and was the principal method of composition used by all the great composers of the day. During the late Renaissance, Palestrina was considered to be one of the greatest masters of counterpoint, because he could skillfully weave many voices together in sweet-sounding combinations that allowed both the words to be understood and the music to sound with the religious purity of Gregorian chant.

According to a legend, one that might even be true, Palestrina composed his mass dedicated to Pope Marcellus, *Missa Papae Marcelli*, to convince the Council of Trent that sacred music could be written for choir in beautiful, reverent, and intelligible polyphony. Without question, Palestrina was dedicated to the propagation of Counter-Reformation ideals, and his style and his whole corpus of sacred works served as models for later composers in that century and for the next two hundred years. The Pope Marcellus Mass may or may not have had any specific relationship to the deliberations of the Trent or post-Trent reform councils, but Palestrina's music as a whole has earned him the reputation of "savior of church music." He was a supreme master of the art of Renaissance sacred polyphony.

Born in 1525 or 1526, probably at the town of Palestrina near Rome, he became *maestro* of the Cappella Giulia, the musical establishment of Saint Peter's in Rome, in 1551. As his ecclesiastic patrons changed over the years, he held other jobs as well, but all were important positions: maestro at the pope's private chapel, the Sistine Chapel; maestro at the Roman Church of Saint John Lateran; and maestro at the Roman Basilica of Santa Maria Maggiore. In all these posts he composed and performed a vast number of masses, motets, and other liturgical works. This music was disseminated widely through his pupils and the transmission of manuscripts and printed editions, influencing generation after generation of composers, even to the twentieth century. Although seldom known or acknowledged, his

musical interests, like those of all the great Renaissance musicians, extended beyond the Church. For some years of his life he was associated with the Este and Gonzaga families, two music-loving Renaissance dynasties that required music not only for their private chapels but also for their entertainment and social functions. Besides his sacred works, Palestrina composed over 140 madrigals, most of them secular polyphonic songs in Italian; they were probably first sung for the entertainment of his patrons and their guests.

Palestrina's choirs consisted of men and boys, and he wrote music that reflected the beauty of their individual vocal characteristics, as well as the resonance and reverberation of the spaces in which they sang. The smooth-flowing shape and seemingly effortless style of vocal production were typical of the performance of chant, and these became the hallmarks of his own melodic style. All the characteristics of chant—clarity of text, religious feeling, moderation, and aesthetic beauty—can be heard in both the masses and the motets.

In his motet "Surge, amica mea" (Arise, my love), Palestrina sets to music text from two verses of the Old Testament Song of Songs (12:13–14), also known as the Song of Solomon (see Chapter 7). It is **CD-2, 2** interesting to contemplate the place of these erotic love poems, which frankly celebrate physical passion, in the setting of the Christian Church at Rome during the Counter-Reformation. Most likely collected at the time of King Solomon, the son and successor of King David, these songs are historically compatible with a ruler remembered for both his wisdom and his many loves. However, Jewish interpreters in the following centuries have understood these poems to represent, allegorically, the relationship between God and his people, his "bride" Israel. Christian commentators read them similarly, as an expression of Christ's love for his bride, the Church. Given this interpretation, we can easily imagine Palestrina composing for the Church a work to underscore in music the message of the Counter-Reformation, "Arise, my love" in the sense of "grow strong, my Church."

The music of this motet is a blend of polyphony and chordal writing and incorporates the best elements of both musical worlds. Undulating melodic lines surge upward in the first phrase, "Surge, amica mea" (Arise, my love), and a chordal declamation of words describes a peaceful image of the Church, "Columba mea" (O my dove). Passing smoothly back and forth from one technique to the other, Palestrina alternates intelligible chordal declamation of sacred text with beautifully flowing melodic lines patterned on the melodic style of Gregorian chant.

The context of the lines from the Bible (based on text from the Revised Standard Version) that serve as text for Palestrina's motet is a dialogue in which the two speakers, one male and the other female, voice their affection for one another. At verse 10, the woman says, "My beloved speaks and says to me," and the man answers:

Arise, my love, my fair one, and come away;
for now the winter is past,
the rain is over and gone.
The flowers appear on the earth;
the time of singing has come,
and the voice of the turtle dove
is heard on our land.
The fig tree puts forth its figs,
and the vines are in blossom.
They give forth fragrance.[1]

At this point, the opening words are repeated, and that is the text set by Palestrina:

Surge, amica mea, speciosa mea, et veni: | Arise, my love, my fair one, and come away.
Columba mea, in foraminibus petrae,[2] in caverna maceriae, | O my dove, in the clefts of the rock,[2] in the shelter of the cliff,
Ostende mihi faciem tuam, | let me see your face,
Sonet vox tua in auribus meis; | let me hear your voice;
Vox enim tua dulcis, et facies tua decora. | for your voice is sweet And your face is lovely.

CD-2, 2

Economic Expansion

Part of the reason for the massive participation of Europeans in the religious wars of the sixteenth century can be traced to the economic development of the subcontinent in that century and to the enormous population increase that began about 1475, once the Black Death ceased. New diseases, syphilis and typhus, took its place as leading killers, but nothing could match the plague's lethality. The only previous Europeanwide religious phenomenon to match the Reformation was that of the Crusades in the twelfth and thirteenth centuries; perhaps not coincidentally, that was also the last great age of general economic boom and population increase. As then so in the sixteenth century the vigor of the expanding society found an outlet to an extent in religious warfare, this time within Europe itself.

The causes of the economic expansion were various. Certainly the population increase itself was a major factor. But one element that cannot be discounted was the enormous increase in bullion stocks, which multiplied the currency of Europe, causing a price rise

[1] The mention of winter could perhaps be interpreted as a reference to the first onslaughts of the Reformation, and "the voice of the turtle dove" might be an allusion to the decrees of the Council of Trent.

[2] *Petrus* = rock; *Petrus* = Peter, the disciple of Christ, the founder of the Church, and the first bishop of Rome (pope).

and stimulating production. From the early fourteenth century the Spanish and the Portuguese had been exploring the coast of Africa. By the end of the fifteenth century they managed to round the dangerous Cape of Good Hope and establish contact with the Far East. By the second half of that century significant supplies of gold were being imported into Europe from the gold mines south of the Sahara.

Through the voyages of Christopher Columbus from 1492 on, the crown of Castile laid claim to a whole new world beyond the Atlantic Ocean. In the sixteenth century the New World provided an almost unlimited stream of precious metals for Europe, raising prices and fueling the economy. Both agricultural and industrial production expanded. Although most of the industrial goods were still produced in homes and small shops, an increasing number of people were involved in their manufacture. In a few areas such as the manufacture of paper, glass, and cannon; the mining of coal; shipbuilding; and printing, significant investment was made in the modes of production. The forerunners of modern factories were constructed.

Impressive as this economic development may have been for Europe itself, it made surprisingly little impact on Europeans' economic relationship with Asia. When the Portuguese rounded the Cape in the late 1490s, they found themselves not in a New World but in a very old one, with well-established trading networks, harbors, and huge numbers of Indian, Chinese, and, especially, Arab ships. Europeans (first the Portuguese, then the Dutch, and then the English and French) had an important advantage in sea power, resulting from superior ship construction and the ability to fire shipboard guns. But whereas Europe had a large demand for goods from Asia (especially spices, which, in the absence of refrigeration, were needed to keep meat from spoiling), Europe was growing and making virtually nothing Asia needed or wanted.

Until the Industrial Revolution of the late eighteenth and early nineteenth centuries, which drove down prices and finally enabled European goods to compete in Asian markets, European ships sailed to Asia with bullion—mainly silver from America—which they used to pay for Asian goods for the return voyage. American silver, mined with very high mortality rates by forced native labor, thus helped finance Europe's trade with Asia. Although the increased trade greatly enriched Europe, most of the bullion wound up in China.

Other means of financing trade were just as ingenious. The first was revenue gained from taxing Asians. During the late eighteenth century the English East India Company, which had been founded in 1600, obtained from the Indian authorities the right to collect taxes in Bengal, in eastern India. The revenue enabled the company to pay for the costs of its army and administration, for dividends to its shareholders, and for some of its

trade. The second means was opium, grown in India, which the company monopolized and sold at great profit to China. The opium proceeds then financed purchases of silk and other Chinese commodities, on which the company made still more profit when they were sold in London. In short, the company had an incredibly lucrative triangular trade among India, China, and London.

Cultural Relativism

The new discoveries in Africa, Asia, and the Americas had profound cultural as well as economic effects on Europeans. Contact with different systems of religion, thought, and government, as well as with new customs, challenged their view of what was "natural" to human nature and undermined the belief in absolute standards supposedly derived from that nature. A small but increasing number of Europeans came to question the superiority of their culture over the cultures of other areas of the world. In short, exploration encouraged cultural relativism.

Montaigne (1533–1592)

The writings of one of the great minds of the late sixteenth century show the effects both of the geographical discoveries and of the religious wars. Michel de Montaigne came to doubt not only the possibility of establishing any certitude in religion, but also the power of reason to establish laws of nature and society in the world. He was one of the few thinkers in history up to his time who seriously raised the question *What do I know?* A relativist in philosophical as well as in social matters, Montaigne was one of the first Europeans to understand and portray the cultural relativism that the new travels and discoveries made possible.

The last half of Montaigne's life coincided with the French religious wars, which began in 1562 and ended in 1593 after his death. Led by members of the highest nobility, Protestant and Catholic factions frustrated all efforts of the royal government to bring about a settlement. The bitterness of the struggle only intensified after August 24, 1572—St. Bartholomew's Day—when in Paris, with the complicity of the king, the Catholic party slaughtered most of the Protestant leaders, who had come to the city under a truce arrangement (Fig. 19-3).

Son of a Catholic father and a Protestant-Jewish mother, Montaigne was alien to these religious passions. Although in his thirties he served for a time as mayor of the modest French city of Bordeaux, he preferred to remain away from the centers of power. His favorite place for his major activities—reading, writing, and thinking—was his book-lined study located in a tower. There he not only read and commented on classical philosophers but also, in a more modern vein,

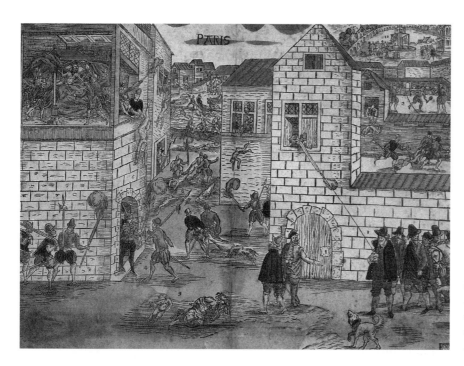

19-3 Massacre of Saint Bartholomew's Day *(massacre of French Huguenots). German sixteenth-century engraving. Bibliothèque de l'Histoire du Protestantisme, Paris, France. (Giraudon/Art Resource, NY)*

looked inward in an attempt to understand himself. He did this not because he considered himself an exceptional individual but because he thought that an understanding of oneself could lead to an understanding of the human predicament. He certainly had no intention of establishing laws for human beings. Reason could not do that; people were each one different from the other. But, at least by the last years of his life, he came to believe that nature through pain and pleasure gives us some guidance in the conduct of our lives. Although he relished his own peculiarities, he felt a kinship with other human beings and a need to communicate his thoughts to them: "Every man bears the whole form of the human condition."

Montaigne called his writings *essays,* by which he meant "trials" or "experiences." He does not claim to impose a lesson but rather to invite the reader to participate in his "tryouts," his observations, his experiences. The essays might be called the journal of a man seeking wisdom. Although each one has a definite subject, Montaigne does not hesitate to go off on tangents when his reflections so lead him. The subjects he chooses may be philosophical, personal, or social.

William Shakespeare (1564–1616) and the Late Renaissance

The world of Montaigne, fraught with religious dissension, stimulated and enlarged by travels and discoveries, was also fundamentally the world of Shakespeare, although England under the reign of Queen Elizabeth I had a dynamic culture very much its own. More has been written about Shakespeare (Fig. 19-4) than about

19-4 *Statue of Shakespeare in Stratford's Holy Trinity Church. (Bildarchiv Preussischer Kulturbesitz)*

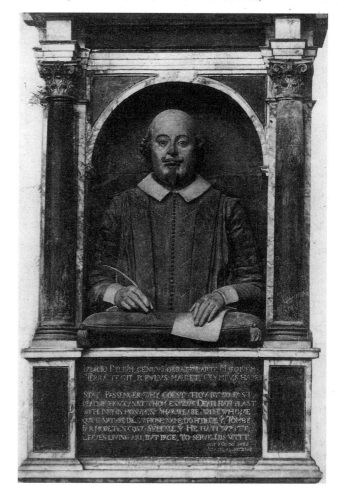

any other writer, and with good reason. The universality of his genius is such that it is difficult not to fall into what Bernard Shaw called "bardolatry" when discussing him. There are writers whose works are more unified, more even, certainly more "classical" than Shakespeare's; but the dramatic power, the philosophical depth, and the superb characterization in Shakespeare's major plays have never been equaled. For English-speaking people, the way in which his poetry has enriched and amplified our language ensures his place in our cultural roots. His language may seem difficult to us today; but as we read Shakespeare, we become aware of his enormous impact on our everyday speech and writing.

Shakespeare remains a writer for all times, but he was also very much a man of his time. Many of the cultural and intellectual trends that we have seen developing throughout the Renaissance are synthesized in this playwright of Elizabethan England. He shares Montaigne's skeptical and relativistic view of the human condition, and he often displays a deep pessimism and doubt that would have been impossible under the more unified, God-centered culture of the Middle Ages. Yet he had also been influenced by the earlier humanists' glorification of human beings. This passage from one of Hamlet's soliloquies illustrates the two tendencies:

> What a piece of work is a man! how noble in reason! how infinite in faculty! in form and moving how express and admirable! in action how like an angel! in apprehension how like a god! the beauty of the world! the paragon of animals! And yet, to me, what is this quintessence of dust? Man delights not me.

The whole span of Renaissance-Reformation culture is found in Shakespeare: the early humanistic confidence in human powers, bolstered by the revival of classical texts, and the doubt, deepened by the Reformation, that human endeavors amounted to very much at all.

Shakespeare's Sonnets

Shakespeare's vision of the human condition may be approached through his collection of 154 sonnets. In the wake of Petrarch (see Chapter 16) and the school of poets influenced by him in France, sonnet writing came into vogue in England during the sixteenth century. Many of these "sonneteers," as they were called, wrote in a derivative manner. Their sonnets were sterile imitations of love poems to imaginary golden-haired ladies resembling Laura. In Shakespeare's hands, however, the *sonnet* became an original and vital English form. Not only did he ridicule the conventional Petrarchan lover in his sonnets, proposing another, more earthly vision of love for a "dark lady" instead of an elusive blonde; he also used the sonnet form for meditations of a philosophical nature, most notably on the passage of time.

Shakespeare and the Theater

It is, of course, because of his plays that Shakespeare is now considered the greatest English writer in history. The era in which he lived, Elizabethan England, was a time in which broad interests and creativity could flourish. Although Elizabeth, the Protestant daughter of Henry VIII, came to the throne when there was great rivalry between Protestant and Catholic factions, she was beloved by her subjects and proved to be a powerful and able ruler. Under the reign of Elizabeth, England changed from an island kingdom to an expanding empire that controlled the seas after its naval defeat of the greatest European power, Spain. England grew rich through trade. Sixteenth-century English citizens traveled to the New World and to Africa. Music, dance, poetry, painting, and architecture flourished; but the art form in which Elizabethan England surpassed the rest of Europe (except perhaps Spain) was the theater.

The impact of the humanist resurrection of classical texts on Renaissance theater was great. Humanists in Italy translated Latin and Greek plays; then they wrote their own tragedies and comedies in the classical manner, first in Latin and later, by the sixteenth century, in Italian. French, German, and Spanish writers turned to the classical models. In England schools and universities began to produce comedies and tragedies by Plautus, Terence, and Seneca. In spite of a contemporary's remark that Shakespeare knew "a little Latin and less Greek," he was well grounded in the classical humanities through his own reading as well as through formal education. Certainly, he knew the Roman tragedies of Seneca and the comedies of Plautus, which served as models for his own drama. In characteristic Renaissance fashion, his interests ranged beyond book learning to practical knowledge of military strategy, seafaring, business affairs, and the new geographical discoveries, all evident in his plays.

Writers associated with the universities in England began to write plays in English that combined classical and medieval, Roman and English elements. Companies of "strolling players" who had specialized in morality plays began to stage the new plays. Professional actors, who had been viewed by English society as little better than vagrants or criminals, gradually came under the protection of the nobility. Licensed theater companies were formed; Shakespeare belonged to one of these, where in addition to his writing he acquired a wide experience in acting and theater management. Shakespeare knew his audience: his theater is addressed not just to the elite and the educated but to all segments of society.

Shakespeare's plays have been classified in four categories: comedies, histories, tragedies, and romances. None of these is a "pure" form. The tragedies, for example, nearly all contain elements of history and comedy, and the romances are sometimes seen as tragic or comic.

Theatergoing in Shakespeare's Time

As theatrical performances grew in popularity and public acceptance during the reign of Queen Elizabeth I, public theaters began to be built—among them the Swan and the Globe, where many of Shakespeare's plays were performed. Before the building of the theaters, plays were performed in the courtyards of inns, with the audience looking down from windows.

The early theaters reflected those origins. Built outside the city limits, along with other places of entertainment such as brothels and taverns, they were primarily outdoor and made to accommodate a wide spectrum of social and economic classes.

The Globe Theatre (Fig. 19-5), built in 1599, had a platform stage jutting out into a central courtyard. About half of the stage area was covered by a roof painted blue with stars to represent the sky. The roof also contained machinery to lower actors onto the stage at the appropriate time, just like the *deus ex machina* in Roman theater. At the back of the stage, there were openings for exits and entrances, as well as a room for costume changes. Because music was usually a significant part of the production, the musicians were on stage. Because performances were held in the daytime, there was no need for lighting.

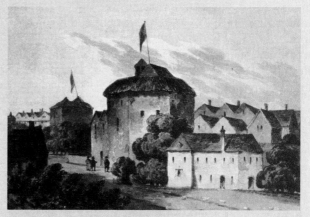

19-5 *Watercolor of Globe Theatre by G. Shepard, 1810, after M. Merian engraving, Frankfurt, 1638. (The Art Archive/British Museum/Eileen Tweedy)*

It cost only a penny to attend a play, but for more money one could have a comfortable or a better seat. The so-called groundlings, usually the poorer spectators, stood around the stage. Wealthier spectators could have a seat in the upper galleries or in more private spaces. As in ancient Greece and Rome, women were not allowed to act on the stage in the Elizabethan era. The parts of young women were played by boys and those of older women by male character actors.

We will concentrate here on the romance that is probably his last play, *The Tempest*.

The Tempest

Most scholars agree that the shipwreck represented in Shakespeare's last play (first performed in 1611 and first published in 1623) was loosely based on a real incident. In June 1609, ships from the Virginia Company sailed from Plymouth, England, toward the colony. One of them, however, ran aground on the island of Bermuda, where the sailors remained until their ship reached Virginia, almost a year later. Although Bermuda was reported to be an "Isle of Devils," the men found it to be delightful. Shakespeare probably read some of the reports published on this adventure.

Another important influence was Montaigne's "Of Cannibals," which Shakespeare read in John Florio's translation. Montaigne's portrayal of an idealized "primitive" society in the New World finds an echo in Gonzalo's description of a perfect "commonwealth," illiterate, innocent, and egalitarian, as opposed to European society (Act II, scene i, 148–157). The name of the slave Caliban would seem to be an anagram of "cannibal."

The true nature of Caliban's character has received much attention. For some, he represents all that is brutish and subhuman, and thus stands as a refutation of Montaigne's virtuous Indians. For others, he is a rebel and a threat to European colonialism. With the contrast between Caliban and Ariel, as well as the European characters in the play, Shakespeare poses questions about the fundamental traits of human nature.

The play thus reflects the spirit of the European explorations of the New World. Yet its realism is secondary to its fantastic quality, for the island is more than anything else a magical place, existing outside of time. The interplay between reality and illusion is one of *The Tempest*'s major themes. Prospero controls the entire life of the island through his magic, but renounces it in the end. Unlike the tragedies, this romance does not deal very much with philosophical questions on the nature of the powers that control human destiny, but rather focuses on the varieties of human nature and human illusions.

The Tempest is also unusual in Shakespeare's dramatic work in that its plot is very uncomplicated—in fact, there is very little plot—and in that it adheres to the "unities" claimed by neoclassical theorists in England and, later, especially in France, to have been prescribed by Aristotle. According to these rules, the action of a play should be uncomplicated, it should occur in not more than twenty-four hours, and it should be set in only one place. French neoclassical writers at the end of the seventeenth century, as we will see, claimed that Shakespeare consistently violated all of these rules, but that is not the case here. In another way, however, *The Tempest* does go against neoclassical canons. It is neither tragedy nor comedy, but rather a mixture of a variety of genres, blending tragic and comic elements with the fantastic.

Although it opens with a prose dialogue, most of *The Tempest* is written in poetry. Many of the lines are in *blank verse,* the verse line introduced in the sixteenth century and still considered the most natural to the English language. It consists of unrhymed lines in *iambic pentameter,* that is, five strong stresses and five weak stresses. Take, for example, the famous lines of wonder spoken by Miranda, from which Aldous Huxley took the title of his novel *Brave New World:*

> How many goodly creatures are there here!
> How beauteous mankind is! O brave new world
> That has such people in't! (Act V, scene i, 180–183)

The last verse line is completed by Prospero, but the other two can be scanned in the five "short-long" feet of iambic pentameter. The second line, however, is more irregular in rhythm than the first, and many of the lines of the play are more irregular still. Shakespeare seemed to take more poetic liberties in his last play.

Music in *The Tempest* Shakespeare made use of music in his dramas for many purposes: military fanfare and pageantry, accompaniment to dance, enhancement to a social setting, part of an intimate lyrical mood. Perhaps because of its magical quality, *The Tempest* contains more songs and instrumental pieces than any other play by Shakespeare. Although it is uncertain exactly how music was performed during a play at the Globe Theatre

or the Strand Theatre in Shakespeare's time, we do know that the conduct of the audience was more relaxed and informal than would be likely in a Shakespearean theater today. The atmosphere and behavior resembled those in a nightclub, and the play, as well as the music, was enjoyed purely as entertainment, not venerated as "high art." The most popular instrument in Elizabethan England was the lute, a plucked instrument similar to an acoustical guitar, and lute songs, melodies sung to the accompaniment of the lute, were similar in many ways to the English madrigal. The lutenist would play the music of the accompanying voices and at the same time sing the principal melodic line. The music was carefully adapted to the words, and when the opportunity arose, "madrigalisms," musical sounds that correspond to the meaning of particular words (for instance, a rising melody for "up to heaven," a wiggling melody for "running brook"), were incorporated into the music.

One of Queen Elizabeth's lutenists, Robert Johnson, continued in the service of James I and Charles I and also wrote music for the seventeenth-century theater. For *The Tempest,* he composed music to the lines that begin "Full Fathom Five," a song that pokes fun at the behavior of the royal court. Picture the lutenist-singer capturing his audience's attention as he sings of the death of a man lost at sea and uses a madrigalism to convey the essence of the bell tolling his demise.

CD-2, 3

> Full fathom five thy father lies,
> Of his bones are coral made,
> Those are pearls that were his eyes.
> Nothing of him that doth fade
> But doth suffer a sea change
> Into something rich and strange.
> Sea nymphs hourly ring his knell,
> Hark, now I hear them: ding dong bell.

The Madrigal in England

The Italian *madrigal* flourished during the sixteenth century. Its many composers came from France, Germany, and the Low Countries, in addition to Italy. The compositions consisted of part music (soprano, alto, tenor, bass) with Italian words that spoke of love, war, birth, and death. The music used poetry of the literati (Petrarch, Poliziano, Bembo, and Lorenzo the Magnificent) as well as vulgar words of street songs and bawdy houses to entertain in the great courts, on the streets, during carnivals and festivals, and in the homes of the growing merchant and artisan classes. The art of music profited from the invention of movable type, and printers made music available to the middle class at home and abroad.

Italian madrigals were first published in England by Nicholas Yonge in 1588 and became the rage almost overnight. Immediately, English composers followed the

model, and an English madrigal school flourished in the 1590s. Many English musicians became outstanding madrigal composers, men such as John Dowland, William Byrd, and Orlando Gibbons. One of the favorite works of all time, a genuine "hit song," if you will, is Thomas Morley's "Now Is the Month of Maying." With its perfect match of musical rhythm and text accent, with its catchy tune and "fa la la" refrain, it reflects the joy in life's pleasures savored by Elizabethan society. Each verse is divided in half and then repeated; each half has its own "fa la la" refrain.

CD-2, 4

Now is the month of maying,
when merry lads are playing.
Fa la la la la.

Each with his bonny lass
upon the greeny grass.
Fa la la la la.

The spring clad all in gladness
doth laugh at Winter's sadness.
Fa la la la la.
And to the bagpipe's sound
the Nymphs tread out their ground.
Fa la la la la.

Fie then, why sit we musing,
youth's sweet delight refusing?
Fa la la la la.
Say, dainty Nymphs and speak,
Shall we play barley break?
Fa la la la la.

DESIDERIUS ERASMUS

from *The Praise of Folly*

Translation by Betty Radice

In his most famous work, *The Praise of Folly* (1509), Erasmus gives folly the opportunity to make a speech mocking the serious, praising the foibles of humankind, and claiming that she is the means by which human beings can tolerate one another and which make life bearable. Some critics thought Erasmus was teaching immorality; others, who sensed that he had them in mind, denounced the work as disrespectful of authority. In his defense, Erasmus could reply that the speech did not express his own opinion but that of folly, and that whatever folly spoke had to be regarded as folly.

The voice of folly, however, is not consistent throughout the speech. Whereas in the early sections folly good-naturedly exposes the silliness of human conduct while defending it as vital to social life, the author's own voice breaks out in a middle section, where he seriously condemns the vices and errors of kings and Church prelates. A long passage follows in which the "foolishness" of Christianity is contrasted with the "wisdom" of the world, and the speech concludes with the return of the original voice of folly praising her powers. The following texts are taken from the first part of the oration, where folly is speaking in her own voice.[1]

Friendship, they're always saying, must come before everything. It is something even more essential than air, fire, and water, so delightful that if it were removed from their midst it would be like losing the sun, and finally, so respected (if this is at all relevant) that even the philosophers do not hesitate to mention it amongst the greatest of blessings. Here again I can show that of that greatest blessing I am both poop and prow. . . . Just think: winking at your friend's faults, passing over them, turning a blind eye, building up illusions, treating obvious faults as virtues which call for love and admi-

ration—isn't all that related to folly? One man showers kisses on his mistress's mole, another is charmed by the polypus in his mistress's mole, another is charmed by the polypus in his dear lamb's nose, a father talks about the wink in his son's squinting eye—what's that, please, but folly pure and simple? Let's have it repeated, three and four times over, it is folly, and the same folly, which alone makes friendships and keeps friends together.

I'm talking of ordinary mortals, none of whom is born faultless, and the best among them is the one with fewest faults. But among those Stoic philosopher-gods either no friendship forms at all, or else it is a sour and ungracious sort of relationship which exists only with very few men—I hesitate to say it doesn't exist at all, for most men have their foolish moments, or rather, everyone is irrational in various ways, and friendship joins like to like.[2] It's in man's nature for every sort of character to be prone to serious faults. Then there are wide variations of temperament and interests, as well as all the lapses and mistakes and accidents of mortal life. Consequently the delights of friendship couldn't last a single hour among such Argus-eyed folk[3] without the addition of what the Greeks aptly named 'good-nature', a word we can translate either as folly or as easy-going ways. Besides, isn't Cupid himself, who is responsible for creating all relationships, totally blind, so that to him 'ugliness looks like beauty'? And so he sees to it that each one of you finds beauty in what he has, and the old man loves his old woman as the boy loves his girl. This happens everywhere and meets with smiles, but nevertheless it's the sort of absurdity which is the binding force in society and brings happiness to life.

[20] What I've said about friendship is much more applicable to marriage, which is nothing other than an

[1] Erasmus, *Praise of Folly and Letter to Martin Dorp 1515*, trans. Betty Radice (Alsbury, Bucks: Penguin, 1983), pp. 90–95 and 104–105.

[2] Erasmus is referring here to the definition of friendship as developed by the Stoics, Cicero, and early Christian writers. In this view, friendship required both parties to have no motive for their relationship save love of the virtues of the other person. It was a union of wills free of desire and sensual attraction.

[3] Argus was a mythical dog that had eyes in the back of his head. Philosophers, Erasmus is saying, are so watchful in making sure that an individual is worthy of their friendship that they will never have friends for long.

inseparable union for life. Goodness me, what divorces or worse than divorces there would be everywhere if the domestic relations of man and wife were not propped up and sustained by the flattery, joking, complaisance, illusions and deceptions provided by my followers! Why, not many marriages would ever be made if the bridegroom made prudent inquiries about the tricks that little virgin who now seems so chaste and innocent was up to long before the wedding. And once entered on, even fewer marriages would last unless most of a wife's goings-on escaped notice through the indifference or stupidity of her husband. All this can properly be attributed to folly, for it's she who sees that a wife is attractive to her husband and a husband to his wife, that peace reigns in the home and their relationship continues. A husband is laughed at, cuckolded, called a worm and who knows what else when he kisses away the tears of his unfaithful wife, but how much happier it is for him to be thus deceived than to wear himself out with unremitting jealousy, strike a tragic attitude and ruin everything!

[21] In short, no association or alliance can be happy or stable without me. People can't long tolerate a ruler, nor can a master his servant, a maid her mistress, a teacher his pupil, a friend his friend or a wife her husband, a landlord his tenant, a soldier his comrade nor a party-goer his companion, unless they sometimes have illusions about each other, make use of flattery, and have the sense to turn a blind eye and sweeten life for themselves with the honey of folly. I daresay you think this is the last word on the subject, but there are more important things to come.

[22] Now tell me: can a man love anyone who hates himself? Can he be in harmony with someone else if he's divided in himself, or bring anyone pleasure if he's only a disagreeable nuisance to himself? No one, I fancy, would say he can unless there is someone more foolish than Folly. Remove me, and no one could put up with his neighbour, indeed, he'd stink in his own nostrils, find everything about himself loathsome and disgusting. The reason is that nature, more of a stepmother than a mother in several ways, has sown a seed of evil in the hearts of mortals, especially in the more thoughtful men, which makes them dissatisfied with their own lot and envious of another's. Consequently, all the blessings of life which should give it grace and charm are damaged and destroyed. What good is beauty, the greatest gift of the gods, if it is tainted by the canker of decay? Or youth, if it is soured and spoiled by the misery of advancing age? And finally, is there any duty throughout life which you can perform gracefully as regards yourself or others (for the importance of graceful performance extends beyond mere skills and covers every action) unless you have Self-love at hand to help you, Self-love who is so prompt to take my place on all occasions that she is rightly called my sister? What is so foolish as self-satisfaction and self-admiration? But then what agreeable, pleasant or graceful act can you perform if you aren't self-satisfied? Take away this salt of life and immediately the orator and his gestures will be a bore, the musician will please no one with his tunes, the actor and his posturings will be hissed off the stage, the poet be a laughing-stock along with his Muses, the painter and his works deemed valueless, and the doctor starve amidst his remedies. . . .

What's the point of this, someone will say. Hear how we'll develop the argument. If anyone tries to take the masks off the actors when they're playing a scene on the stage and show their true natural faces to the audience, he'll certainly spoil the whole play and deserve to be stoned and thrown out of the theatre for a maniac. For a new situation will suddenly arise in which a woman on the stage turns into a man, a youth is now old, and the king of a moment ago is suddenly Dama, the slave, while a god is shown up as a common little man. To destroy the illusion is to ruin the whole play, for it's really the illusion and make-up which hold the audience's eye. Now, what else is the whole life of man but a sort of play? Actors come on wearing their different masks and all play their parts until the producer orders them off the stage, and he can often tell the same man to appear in different costume, so that now he plays a king in purple and now a humble slave in rags. It's all a sort of pretence, but it's the only way to act out this farce.

At this point let us suppose some wise man dropped from heaven confronts me and insists that the man whom all look up to as god and master is not even human, as he is ruled by his passions, like an animal, and is no more than the lowest slave for serving so many evil masters of his own accord. Or again, he might tell someone else who is mourning his father to laugh because the dead man is only just beginning to live, seeing that this life of ours is nothing but a sort of death. Another man who boasts of his ancestry he might call low-born and bastard because he is so far removed from virtue, which is the sole source of nobility. If he had the same sort of thing to say about everyone else, what would happen? We should all think him a crazy madman. Nothing is so foolish as mistimed wisdom, and nothing less sensible than misplaced sense. A man's conduct is misplaced if he doesn't adapt himself to things as they are, has no eye for the main chance, won't even remember that convivial maxim 'Drink or depart', and asks for the play to stop being a play. On the other hand, it's a true sign of prudence not to want wisdom which extends beyond your share as an ordinary mortal, to be willing to overlook things along with the rest of the world and wear your illusions with a good grace. People say that this is really a sign of folly, and I'm not setting out to deny it—so long as they'll admit on their side that this is the way to play the comedy of life.

COMMENTS AND QUESTIONS

1. Why does folly think she is the guarantor of friendship?

2. Why does she attack the Stoic idea of friendship?

3. In what way does folly claim to facilitate all human relationships?

4. How does folly help us to love ourselves?

5. Why is illusion essential to human life?

6. What does Erasmus mean in the last paragraph when he writes, "Nothing is so foolish as mistimed wisdom, and nothing less sensible than misplaced sense"?

MICHEL DE MONTAIGNE

from the *Essays*

In his essay on cannibals, Montaigne uses a society from a newly discovered land—Indians in Brazil—to make one of his most daring social critiques. The *Essays*, translated into English by an Englishman of Italian extraction, John Florio, were widely read in England, most notably by Shakespeare. Florio's English has the robust, somewhat rambling quality of Montaigne's French. It is essentially the English of Shakespeare and the King James Bible. The spelling in the following selection has been modernized.

Of Cannibals

When King Pyrrhus came into Italy, after he had surveyed the marshalling of the army which the Romans sent against him, he said: "I know not what barbarous men these are" (for so the Greeks called all foreign nations) "but the disposition of this army, which I see, is nothing barbarous." . . . Thus should a man take heed, lest he follow vulgar opinions, which should be measured by the rule of reason, and not by the common report. I have had for a long time dwelling with me a man, who for the space of ten or twelve years had dwelt in that other world, which in our age was lately discovered in those parts where Villegaignon first landed, and surnamed Antarctic France.[1] The discovery of so infinite and vast a country seems worthy of great consideration. . . .[2]

This servant I had was a simple and rough-hewn fellow, a condition fit to yield a true testimony. For subtle people may indeed . . . observe things more

exactly, but they amplify and gloss them, the better to persuade. . . . They never represent things truly, but fashion and mask them according to the visage they saw them in. . . . I would have every man write what he knows, and no more. . . .

Now (to return to my purpose) I find (as far as I have been informed) there is nothing in that nation, that is either barbarous or savage, unless men call that barbarism which is not common to them. As indeed, we have no other measure of truth and reason, than the example and idea of the opinions and customs of the country we live in. There is ever the perfect religion, the perfect government, perfect and complete customs in all things. We call people savage, as we call fruits wild, which nature has produced by herself. Indeed, however, we should rather term savage those which we ourselves have altered by our artificial devices and diverted from their common order. In the former are the true and most profitable virtues, and natural properties most lively and vigorous, which in the latter we have bastardized, applying them to the pleasure of our corrupted taste. And if notwithstanding we find that the fruits of those lands that were never tilled are still more excellent, compared to ours, there is no reason why art should win the point of honor over our great and powerful mother nature. We have so much by our inventions surcharged the beauties and riches of her works that we have altogether overchoked her: yet wherever her purity shines, she makes our vain and frivolous enterprises wonderfully ashamed. . . . All our endeavor or wit cannot so much as represent the nest of the least little bird, its contexture, beauty, profit and use, nor even the web of a frail spider. "All things" (says Plato) "are produced, either by nature, by fortune, or by art. The greatest and fairest by one or other of the two first, the least and imperfect by the last."

Those nations therefore seem to me barbarous thus: they have received very little fashioning from human ingenuity, and are yet near their original natural state. The laws of nature do yet command them, but little bastardized by ours, and that with such purity, that I am sometimes grieved that the knowledge of it no sooner came to light, when men better than we could have judged of it. I am sorry that Lycurgus and Plato had it not, for it seems to me that what in those nations we see by experience . . . exceeds all the pictures with which poetry has embellished the golden age. . . . They could not imagine a genuineness so pure and simple as we see by experience, nor ever believe our society might be maintained by so little art and human combination. It is a nation, I would answer Plato, that has no kind of traffic, no knowledge of letters, no intelligence of numbers, no name of magistrate, nor of political superiority, no use of service, of riches or of poverty; no contracts, no successions, no partitions, no occupation but idle, no kinship but common, no apparel but natural, no manuring of lands, no use of wine, corn or metal. The very words

[1] Villegaignon landed in Brazil in 1557.

[2] In the passage omitted here, Montaigne recounts Plato's account of the "lost continent," Atlantis, and wonders if the "new world" could once have been connected with the old.

that import lying, falsehood, treason, dissimulations, covetousness, envy, belittling and pardon were never heard of amongst them. How different would he find his imaginary commonwealth from this perfection: *Men but recently born of the gods.*[3]

Furthermore, they live in a country of so exceeding pleasant and temperate situation, that as my testimonies have told me, it is very rare to see a sick body amongst them; and they have further assured me they never saw any man there, either shaking with the palsy, toothless, with eyes dropping, or crooked and stooped with age. They are situated along the sea coast.... They have great abundance of fish and flesh, that have no resemblance at all with ours, and eat them without any sauces, or skill of cookery, but plain boiled or broiled. The first man that brought a horse thither, although he had in many other voyages conversed with them, bred so great a horror in the land, that before they could take notice of him, they slew him with arrows.... They spend the whole day dancing. Their young men go hunting after wild beasts with bows and arrows. Their women busy themselves meanwhile with warming their drink—that is their main occupation. Some of their old men, in the morning before they go to eat, preach in common to all the household, walking from one end of the house to the other, repeating the same sentence many times.... The preacher commends but two things to his listeners: first, courage against their enemies, and second, lovingness to their wives.... They are shaven all over, much closer and cleaner than we are, with no other razors than of wood and stone. They believe their souls to be eternal, and those that have deserved well of their gods to be placed in that part of heaven where the sun rises, and the cursed ones toward the west. They have certain prophets and priests which normally live in the mountains and very seldom show themselves to the people. When they do come down, a great feast is prepared.... The prophet speaks to the people in public, exhorting them to embrace virtue and follow their duty. All their moral discipline contains but these two articles: first an undaunting resolution in war, and second an inviolable affection to their wives [Fig. 19-6]....

They war against the nations that lie beyond their mountains, to which they go naked, having no other weapons than bows, or wooden swords, sharp at one end as our broaches are. It is an admirable thing to see the constant resolution of their combats, which never end but by effusion of blood and murder, for they know not what fear and routs are. Every victor brings home the head of the enemy he has slain as a trophy of his victory, and fastens it to the entrance of his dwelling. After

19-6 *Watercolor of a chief's wife and daughter by John White. (Copyright The British Museum, London)*

they have treated their prisoners well for a long time, with all commodities, the master of them summons together a great assembly of his acquaintance, ties a cord to one of the prisoner's arms, by the end of which he holds him fast, though at some distance, for fear of being hurt. He then gives the other arm, bound in like manner, to his dearest friend, and both in the presence of all the assembly kill him with swords. This done, they roast and then eat him in common, and send some slices of him to their friends who are absent. It is not, as some imagine, to nourish themselves with it (as anciently the Scythians[4] used to do), but to represent an extreme revenge. We can prove it thus: some of them saw the Portuguese, who had allied themselves with their adversaries, use another kind of death when they took them prisoners, which was to bury them up to the middle, and shoot arrows against the upper part of the body, and then when they were almost dead to hang them. They supposed that these people of the other world, they who had sowed the knowledge of many vices among their neighbors, and were much more cunning in all kinds of

[3] Seneca, *Epistles*, XC, 44. Montaigne uses many classical quotations in this essay (as in his others), some of which are omitted here.

[4] An ancient, nomadic, and warlike people who lived in southeastern Europe and Asia.

evil and mischief, did not undertake this manner of revenge without cause, and that consequently it was more painful and cruel than theirs. Thereupon they began to leave their old fashion to follow this one.

I am not sorry that we note the barbarous horror of such an action, but grieved that in prying so narrowly into their faults we are so blinded in ours. I think there is more barbarism in eating men alive than to feed upon them being dead; to mangle by tortures and torments a body full of lively sense, to roast him in pieces, to make dogs and swine gnaw and tear him (as we have not only read, but seen very recently, not among ancient enemies, but among our neighbors and fellow citizens, and what is worse, under the pretext of piety and religion)[5] than to roast and eat him after he is dead. Chrysippus and Zeno, arch-pillars of the Stoic sect, thought that there was no harm at all, in time of need, to make use of our carrion bodies, and to feed upon them, as did our forefathers, who being besieged by Caesar in the City of Alexia, resolved to sustain the famine of the siege with the bodies of old men, women, and other persons unserviceable and unfit to fight.

> Gascons (as fame reports)
> Liv'd with meats of such sorts.[6]

... We may then well call these people barbarous in respect to the rules of reason, but not in respect to ourselves, who exceed them in all kinds of barbarism.

Their wars are noble and generous, and have as much excuse and as much beauty as this human infirmity can: they aim at nothing but rivalry in valor. They do not contend for the gaining of new lands, for to this day they still enjoy that natural abundance and fruitfulness which without laboring toil furnishes them in plenteous abundance with all necessary things so that they need not enlarge their limits. They are still in that happy state of desiring no more than their natural necessities: anything beyond is superfluous to them.

Those that are about the same age call each other brethren, those that are younger are called children, and the aged are esteemed as fathers to the rest. They leave full possession of goods in common, without division, to their heirs, and no other claim or title but that which nature gives to all creatures as she brings them into the world.

If their neighbors chance to come over the mountains to invade them and are victorious over them, the victors' conquest is glory and the advantage to be and remain superior in valor and virtue. Otherwise, they have nothing to do with the goods and spoils of the vanquished, and so return to their country where they are not lacking in any necessary thing, and know how to enjoy their condition happily and be content with what nature supplies them. The others do the same when their turn comes. They require no other ransom of their prisoners but an acknowledgement and confession that they are vanquished. But it is impossible to find one in a whole century who would not rather embrace death than either by word or countenance yield one jot from the grandeur of an invincible courage. There is not one who would not rather be slain and devoured than to beg for his life or show any fear. . . .

The reputation and worth of a man consists in his heart and will: therein lies true honor. Valor is in the strength, not of arms and legs, but of mind and courage; not in the spirit and courage of our horse, nor of our arms, but in our own. He who falls persistent in his courage, "If he slip or fall, he fights upon his knee."[7] He who, in danger of imminent death, is in no way daunted in his assuredness, he that in yielding up his ghost beholds his enemy with a scornful and fierce look, he is vanquished, not by us but by fortune; he is slain, but not conquered. The most valiant are often the most unfortunate. So are there triumphant losses that rival victories. . . .

To return to our story, the prisoners, no matter how they are dealt with, are so far from yielding that during the two or three months they are kept they always keep cheerful and urge and defy their keepers to hasten their trial. They upbraid them with their cowardliness and with the number of battles they have lost. I have a song made by a prisoner which contains this clause: "Let them boldly come together and flock in multitudes to feed on him; for with him they shall feed upon their fathers and grandfathers that heretofore have served his body for food and nourishment. These muscles, this flesh, these veins, are your own; fools that you are, know you not that the substance of your forefathers' limbs is still tied to ours? Taste them well, for in them you shall find the relish of your own flesh." This is an invention that shows no barbarism. Those who describe them dying say that when they are put to execution, the prisoners spit in their executioners' faces and scowl at them. Truly, as long as breath is in their body, they never cease to brave and defy them, both in speech and countenance. Surely, in respect to us these are very savage men, for either they must be so or we must be so. There is a wondrous difference between their style and ours.

Their men have many wives; the more valiant they are reputed to be, the greater the number. The manner and beauty of their marriages is wondrously strange and remarkable. Just as our wives jealously try to keep us from the love and affection of other women, theirs

[5] Montaigne refers to the tortures inflicted by both Protestants and Catholics on their enemies.

[6] Juvenal, *Satires*, XV, 93–94. The Gascons were a people of southwestern France (Montaigne's own region).

[7] Seneca, *On Providence*, II.

try to obtain it. Being more concerned for their husbands' honor than for anything else, they endeavor to have as many rivals as they possibly can, since that is a testimony to their husbands' valor. Our women would count it a wonder, but it is not so. It is a properly matrimonial virtue, of the highest kind. In the Bible, Leah, Rachel, Sarah, and Jacob's wives brought their fairest maidservants to their husbands' beds. . . . And lest anyone should think that this is done out of simple and servile duty to custom, . . . or because they are so blockish and dull spirited . . . I must cite an example of their abilities. Besides what I have said of one of their war songs, I have a love song which begins like this: "Adder stay, stay good adder, that my sister may by the pattern of thy many-colored coat draw the fashion and work of a rich lace for me to give unto my love; so may thy beauty, thy nimbleness and disposition be ever preferred before all other serpents." The first couplet is the refrain of the song. I am familiar enough with poetry that I may judge that this invention has no barbarism at all in it, but is altogether Anacreontic.[8] Their language is a kind of pleasant speech, and has a pleasing sound, and some affinity with Greek in its endings.

Three of that nation, ignorant of how costly the knowledge of our corruptions will one day be to their repose, security and happiness, and how their ruin shall proceed from this commerce, which I imagine is already well advanced (miserable as they are to have let themselves be so deceived by a desire for new-fangled novelties and to have left the calmness of their climate to come and see ours) were at Rouen at the time of our late King Charles the ninth,[9] who talked with them a great while. They were shown our fashions, our pomp, and the way a beautiful city looks. Afterwards, some demanded their opinion, and wished to know of them what noteworthy and admirable things they had observed among us. They answered three things, the last of which I have forgotten, and am very sorry for it, the other two I yet remember. They said that first they found it very strange that so many tall men with long beards, strong and well armed, around the person of the king (very likely they meant his Swiss guards) would submit themselves to obey a beardless child, and they wondered why we did not rather choose one among them to command the rest. Secondly, (they have a way of speaking whereby they call men "halves" of one another) they had perceived that there were men among us full gorged with all sorts of commodities, and others which hunger-starved, and bare with need and poverty, begged at their gates, and they found it strange that these needy "halves" could endure such an injustice, and that they did not take the others by the throat or set fire to their houses.

I talked a good while with one of them but had such a bad interpreter who understood my meaning so badly and was so foolish in his conceptions of my ideas, that I did not learn a great deal from him. When I asked him what good he received from the superior position he had among his countrymen (for he was a captain and our sailors called him king) he told me that it was to march foremost in any war charge. When I asked him how many men followed him, he showed me a space of ground to signify as many as might be contained there which I guessed to be about four or five thousand men. Moreover, I asked, when all wars were ended, did his authority expire? He answered that only this much was left, that when he visited the villages dependent on him, the inhabitants prepared paths across the hedges of their woods for him to pass through at ease. All this is not very bad, but what of that? They wear no kind of breeches nor hose.

COMMENTS AND QUESTIONS

1. What does Montaigne seem to mean by "nature"? Would a modern anthropologist agree with his observations on people in a "natural" state?

2. Montaigne uses a great deal of irony in contrasting the cannibals' "natural" state with the European "civilized" one. Point out some specific examples of irony.

3. What criticisms, implicit and explicit, does Montaigne make of his own culture? How does he convince the reader that cannibalism is a relative value rather than an absolute "barbarous" evil?

4. What seem to be Montaigne's positive values? His views on morality and religion? Would you call Montaigne a humanist?

5. What is the impact of the last sentence of the essay?

6. With Montaigne, we have obviously come a long way from Pico della Mirandola and Erasmus, with their faith in the achievements and potential of humanity in general and of European culture in particular. What specific differences can you point out between Montaigne and these earlier thinkers?

[8] Anacreon was a Greek lyric poet who lived about a century later than Sappho (c. 610–c. 580 B.C.).

[9] King Charles IX was only about twelve years old at the time of the incident related here.

WILLIAM SHAKESPEARE

from the *Sonnets*

The first two sonnets reprinted here are meditations on time; the third is a meditation on love and lust; and the fourth is an anti-Petrarchan sonnet using a

series of comparisons to describe the poet's ladylove. In reading these sonnets, compare Shakespeare's rhyme scheme and his use of the octave and the sestet with those of Petrarch.

15

When I consider everything that grows
Holds in perfection but a little moment,
That this huge stage presenteth nought but shows
Whereon the stars in secret influence comment;
When I perceive that men as plants increase, 5
Cheerèd and checked even by the selfsame sky,
Vaunt in their youthful sap, at height decrease,
And wear their brave state out of memory;
Then the conceit of this inconstant stay
Sets you most rich in youth before my sight, 10
Where wasteful Time debateth with Decay
To change your day of youth to sullied night;
 And, all in war with Time for love of you,
 As he takes from you, I ingraft you new.

60

Like as the waves make towards the pebbled shore,
So do our minutes hasten to their end;
Each changing place with that which goes before,
In sequent toil all forwards do contend.
Nativity, once in the main of light, 5
Crawls to maturity, wherewith being crowned,
Crookèd eclipses 'gainst his glory fight,
And Time that gave doth now his gift confound.
Time doth transfix the flourish set on youth
And delves the parallels in beauty's brow, 10
Feeds on the rarities of nature's truth,
And nothing stands but for his scythe to mow;
 And yet to times in hope my verse shall stand,
 Praising thy worth, despite his cruel hand.

129

Th' expense of spirit in a waste of shame
Is lust in action; and, till action, lust
Is perjured, murd'rous, bloody, full of blame,
Savage, extreme, rude, cruel, not to trust;
Enjoyed no sooner but despisèd straight; 5
Past reason hunted, and no sooner had,
Past reason hated, as a swallowed bait
On purpose laid to make the taker mad;
Mad in pursuit, and in possession so;
Had, having, and in quest to have, extreme; 10
A bliss in proof—and proved, a very woe;
Before, a joy proposed; behind, a dream.
 All this the world well knows; yet none knows well
 To shun the heaven that leads men to this hell.

130

My mistress' eyes are nothing like the sun;
Coral is far more red than her lips' red;
If snow be white, why then her breasts are dun;
If hairs be wires, black wires grow on her head.
I have seen roses damasked, red and white, 5
But no such roses see I in her cheeks;
And in some perfumes is there more delight
Than in the breath that from my mistress reeks.
I love to hear her speak, yet well I know
That music hath a far more pleasing sound. 10
I grant I never saw a goddess go:
My mistress when she walks treads on the ground;
 And yet by heaven I think my love as rare
 As any she belied with false compare.

COMMENTS AND QUESTIONS

1. What concept of time does Shakespeare express in these sonnets? How is it conveyed poetically?

2. How do paradox and contradiction function in Sonnet 129? What is its subject?

3. In what respects is Sonnet 130 anti-Petrarchan? (See Chapter 16.)

The Tempest

NAMES OF THE ACTORS
ALONSO, *King of Naples*
SEBASTIAN, *his brother*
PROSPERO, *the right Duke of Milan*
ANTONIO, *his brother, the usurping Duke of Milan*
FERDINAND, *son to the King of Naples*
GONZALO, *an honest old councillor*
ADRIAN *and* FRANCISCO, *lords*
CALIBAN, *a savage and deformed slave*
TRINCULO, *a jester*
STEPHANO, *a drunken butler*
MASTER OF A SHIP
BOATSWAIN
MARINERS
MIRANDA, *daughter to Prospero*
ARIEL, *an airy spirit*
IRIS
CERES
JUNO *spirits*
NYMPHS
REAPERS
[*Other* SPIRITS *attending on Prospero*]

THE SCENE: [*A ship at sea;*] *an uninhabited island*

ACT I, SCENE I

A tempestuous noise of thunder and lightning heard.

Enter a SHIP-MASTER *and a* BOATSWAIN.

MAST. Boatswain!

BOATS. Here, master; what cheer?

MAST. Good; speak to th' mariners. Fall to't,
yarely, or we run ourselves aground. Bestir, bestir.
Exit.

Enter MARINERS.

BOATS. Heigh, my hearts! cheerly, cheerly, my 5
hearts! yare, yare! Take in the topsail. Tend to th'
master's whistle.—Blow till thou burst thy wind, if
room enough!

Enter ALONSO, SEBASTIAN, ANTONIO, FERDINANDO,
GONZALO, *and others.*

ALON. Good botswain, have care. Where's the
master? Play the men. 10

BOATS. I pray now keep below.

ANT. Where is the master, bos'n?

BOATS. Do you not hear him? You mar our labor.
Keep your cabins; you do assist the storm.

GON. Nay, good, be patient. 15

BOATS. When the sea is. Hence! What cares these
roarers for the name of king? To cabin! silence!
trouble us not.

GON. Good, yet remember whom thou hast aboard.

BOATS. None that I more love than myself. You are
a councillor; if you can command these elements 21
to silence, and work the peace of the present, we will
not hand a rope more. Use your authority. If you can-
not, give thanks you have liv'd so long, and make
yourself ready in your cabin for the mischance of 25

the hour, if it so hap.—Cheerly, good hearts!—
Out of our way, I say. *Exit.*

GON. I have great comfort from this fellow. Methinks
he hath no drowning mark upon him, his complex-
ion is perfect gallows. Stand fast, good Fate, 30
to his hanging, make the rope of his destiny our cable,
for our own doth little advantage. If he be not born to
be hang'd, our case is miserable. *Exeunt.*

Enter BOATSWAIN.

BOATS. Down with the topmast! yare! lower, lower!
bring her to try with main-course. (*A cry within.*) 35
A plague upon this howling! they are louder than the
weather, or our office.

Enter SEBASTIAN, ANTONIO, *and* GONZALO.

Yet again? What do you here? Shall we give o'er and
drown? Have you a mind to sink? 39

SEB. A pox o' your throat, you bawling, blas-
phemous, incharitable dog!

BOATS. Work you then.

ANT. Hang, cur! hang, you whoreson, insolent
noisemaker! We are less afraid to be drown'd than
thou art. 45

GON. I'll warrant him for drowning, though the
ship were no stronger than a nutshell, and as leaky as
an unstanch'd wench.

BOATS. Lay her a-hold, a-hold! Set her two courses
off to sea again! Lay her off. 50

Enter MARINERS *wet.*

MARINERS. All lost! To prayers, to prayers! All
lost! [*Exeunt.*]

BOATS. What, must our mouths be cold?

GON. The King and Prince at prayers, let's assist
them,
For our case is as theirs.

SEB. I am out of patience. 55

ANT. We are merely cheated of our lives by
drunkards.

*Words and passages enclosed in square brackets in the text above are
either emendations of the copy-text or additions to it. The Textual
Notes immediately following the play cite the earliest authority for
every such change or insertion and supply the reading of the copy-
text wherever it is emended in this edition.*

Names of the Actors. **salvage:** savage.

I.i. Location: On a ship at sea.
3. **Good.** An acknowledgment of the boatswain's reply. The
punctuation differentiates this from the *good* in line 15, which
means "good fellow." 4. **yarely:** smartly, nimbly.
6. **Tend:** attend. 7–8. **Blow . . . enough.** He addresses the
storm. **if room enough:** so long as we have sea-room, i.e. space in which to
maneuver without going aground. 10. **Play:** ply, urge on (?).
17. **roarers:** (1) turbulent waves; (2) rowdies.
21. **councillor:** member of the King's council. 22. **the present:** the
present occasion; but *present* may be a mistake for *presence*, i.e. the
King's presence or presence chamber.

28–30. **Methinks . . . gallows.** Alluding to the proverb "He that is
born to be hanged need fear no drowning."
29–30. **complexion:** appearance (as reflecting his temperament).
31–32. **make . . . advantage:** make the rope that will hang him our
anchor chain, since our actual one now does us little good.
35. **bring . . . main-course:** keep her close to the wind by means of the
mainsail. 37. **office:** duties. 38. **give o'er:** give up.
46. **warrant him for:** guarantee him against. 49. **a-hold:** a-hull,
close to the wind. 49–50. **Set . . . sea:** i.e. set her mainsail and
foresail so as to get her out to sea. 56. **merely:** utterly.

This wide-chopp'd rascal—would thou mightst lie drowning
 The washing of ten tides!
GON. He'll be hang'd yet,
 Though every drop of water swear against it, 59
 And gape at wid'st to glut him.
 A confused noise within: "Mercy on us!"—
 "We split, we split!"—"Farewell, my wife and children!"—
 "Farewell, brother!"—"We split, we split, we split!"
 [*Exit* BOATSWAIN.]
ANT. Let's all sink wi' th' King. 63
SEB. Let's take leave of him. *Exit* [*with* ANTONIO].
GON. Now would I give a thousand furlongs of sea
 for an acre of barren ground, long heath, brown
 [furze], any thing. The wills above be done! but I
 would fain die a dry death. *Exit.* 68

SCENE II

Enter PROSPERO *and* MIRANDA.

MIR. If by your art, my dearest father, you have
 Put the wild waters in this roar, allay them.
 The sky it seems would pour down stinking pitch,
 But that the sea, mounting to th' welkin's cheek,
 Dashes the fire out. O! I have suffered 5
 With those that I saw suffer. A brave vessel
 (Who had, no doubt, some noble creature in her)
 Dash'd all to pieces! O, the cry did knock
 Against my very heart. Poor souls, they perish'd.
 Had I been any God of power, I would 10
 Have sunk the sea within the earth or ere
 It should the good ship so have swallow'd, and
 The fraughting souls within her.
PROS. Be collected,
 No more amazement. Tell your piteous heart
 There's no harm done.
MIR. O woe the day!
PROS. No harm: 15
 I have done nothing, but in care of thee
 (Of thee my dear one, thee my daughter), who

Art ignorant of what thou art, nought knowing
 Of whence I am, nor that I am more better
 Than Prospero, master of a full poor cell, 20
 And thy no greater father.
MIR. More to know
 Did never meddle with my thoughts.
PROS. 'Tis time
 I should inform thee farther. Lend thy hand,
 And pluck my magic garment from me. So,
 [*Lays down his mantle.*]
 Lie there, my art. Wipe thou thine eyes, have comfort. 25
 The direful spectacle of the wrack, which touch'd
 The very virtue of compassion in thee,
 I have with such provision in mine art
 So safely ordered that there is no soul—
 No, not so much perdition as an hair 30
 Betid to any creature in the vessel
 Which thou heardst cry, which thou saw'st sink. Sit down,
 For thou must now know farther.
MIR. You have often
 Begun to tell me what I am, but stopp'd
 And left me to a bootless inquisition, 35
 Concluding, "Stay: not yet."
PROS. The hour's now come,
 The very minute bids thee ope thine ear.
 Obey, and be attentive. Canst thou remember
 A time before we came unto this cell?
 I do not think thou canst, for then thou wast not 40
 Out three years old.
MIR. Certainly, sir, I can.
PROS. By what? by any other house, or person?
 Of any thing the image, tell me, that
 Hath kept with thy remembrance.
MIR. 'Tis far off;
 And rather like a dream than an assurance 45
 That my remembrance warrants. Had I not
 Four, or five, women once that tended me?
PROS. Thou hadst; and more, Miranda. But how is it
 That this lives in thy mind? What seest thou else

57. **wide-chopp'd:** wide-jawed. 58. **ten tides.** Pirates were hanged on shore and left until three tides had washed over them. 60. **gape . . . him:** open its mouth to the widest to gulp him down. 66. **heath . . . furze:** heather . . . gorse (plants that grow in poor soil). 67. **fain:** gladly.

I.ii. Location: An island. Before Prospero's cell. 1. **art:** magic. 4. **welkin's:** sky's. **cheek:** (1) face; (2) side of a grate. 6. **brave:** splendid. 11. **or ere:** before. 13. **fraughting:** forming the cargo. **collected:** composed. 14. **amazement:** terror. **piteous:** pitying.

19. **more better:** of higher rank (common Elizabethan double comparative). 20. **full:** very. 21. **no greater:** i.e. of no loftier position than is implied by his "full poor cell." 22. **meddle with:** mingle with, enter. 26. **wrack:** shipwreck. 27. **virtue:** essence. 28. **provision:** foresight. 29. **soul—.** The sentence changes its course in what follows, but the sense is plain. 30. **perdition:** loss. 31. **Betid:** happened. 35. **bootless inquisition:** useless inquiry. 38. **Obey:** i.e. listen. 41. **Out:** fully. 45. **assurance:** certainty. 46. **remembrance warrants:** memory guarantees.

In the dark backward and abysm of time? 50
If thou rem, remb'rest aught ere thou cam'st here,
How thou cam'st here thou mayst.
MIR. But that I do not.
PROS. Twelve year since, Miranda, twelve year
 since,
Thy father was the Duke of Milan and
A prince of power.
MIR. Sir, are not you my father? 55
PROS. Thy mother was a piece of virtue, and
She said thou wast my daughter; and thy father
Was Duke of Milan, and his only heir
And princess no worse issued.
MIR. O the heavens, 59
What foul play had we, that we came from thence?
Or blessed was't we did?
PROS. Both, both, my girl.
By foul play (as thou say'st) were we heav'd thence,
But blessedly holp hither.
MIR. O, my heart bleeds
To think o' th' teen that I have turn'd you to, 64
Which is from my remembrance! Please you,
 farther.
PROS. My brother and thy uncle, call'd Antonio—
I pray thee mark me—that a brother should
Be so perfidious!—he whom next thyself
Of all the world I lov'd, and to him put
The manage of my state, as at that time 70
Through all the signories it was the first,
And Prospero the prime duke, being so reputed
In dignity, and for the liberal arts
Without a parallel; those being all my study,
The government I cast upon my brother, 75
And to my state grew stranger, being transported
And rapt in secret studies. Thy false uncle—
Dost thou attend me?
MIR. Sir, most heedfully.
PROS. Being once perfected how to grant suits,
How to deny them, who t' advance, and who 80
To trash for overtopping, new created
The creatures that were mine, I say, or chang'd
 'em,
Or else new form'd 'em; having both the key
Of officer and office, set all hearts i' th' state
To what tune pleas'd his ear, that now he was 85

The ivy which had hid my princely trunk,
And suck'd my verdure out on't. Thou attend'st not!
MIR. O, good sir, I do.
PROS. I pray thee mark me.
I, thus neglecting worldly ends, all dedicated
To closeness and the bettering of my mind 90
With that which, but by being so retir'd,
O'er-priz'd all popular rate, in my false brother
Awak'd an evil nature, and my trust,
Like a good parent, did beget of him
A falsehood in its contrary, as great 95
As my trust was, which had indeed no limit,
A confidence sans bound. He being thus lorded,
Not only with what my revenue yielded,
But what my power might else exact—like one
Who having into truth, by telling of it, 100
Made such a sinner of his memory
To credit his own lie—he did believe
He was indeed the Duke, out o' th' substitution,
And executing th' outward face of royalty 104
With all prerogative. Hence his ambition growing—
Dost thou hear?
MIR. Your tale, sir, would cure deafness.
PROS. To have no screen between this part he
 play'd
And him he play'd it for, he needs will be
Absolute Milan—me (poor man) my library
Was dukedom large enough: of temporal
 royalties 110
He thinks me now incapable; confederates
(So dry he was for sway) wi' th' King of Naples
To give him annual tribute, do him homage,
Subject his coronet to his crown, and bend
The dukedom yet unbow'd (alas, poor Milan!) 115
To most ignoble stooping.
MIR. O the heavens!
PROS. Mark his condition, and th' event, then tell me
If this might be a brother.
MIR. I should sin
To think but nobly of my grandmother.
Good wombs have borne bad sons.
PROS. Now the condition.
This King of Naples, being an enemy 121
To me inveterate, hearkens my brother's suit,

50. **backward . . . time:** abyss of the past. 56. **piece:** masterpiece.
virtue: chastity. 59. **no worse issued:** no less noble in birth.
63. **blessedly holp:** providentially helped.
64. **teen:** sorrow, trouble. **turn'd you to:** reminded you of.
65. **from:** out of. 71. **signories:** city states.
72. **prime:** chief, first in rank. 79. **perfected:** expert in.
81 **trash for overtopping:** restrain from becoming too powerful. Two
images are combined here: *trash* = check a hunting dog from going
too fast; *overtopping* = growing too high. 82. **or:** either.
83. **key:** (1) key to office; (2) tuning key.

87. **verdure:** vigor, vitality. **on't:** of it. 90. **closeness:** seclusion.
92. **O'er-priz'd . . . rate:** had greater worth than any vulgar evalua-
tion would place upon it. 94. **good parent.** That a good parent
often bred a bad child was proverbial. 97. **sans:** without.
lorded: i.e. established in a position of power.
100. **into:** unto, against (*into truth* modifies *sinner*).
102. **To:** as to. 103. **out:** as a result.
107–8. **no . . . for:** i.e. no separation between acting as Duke and be-
ing Duke. 109. **Absolute Milan:** actual Duke of Milan.
110. **temporal royalties:** practical administration.
111. **confederates:** makes alliance. 112. **dry:** thirsty.
117. **condition:** compact. **event:** outcome.

Which was, that he in lieu o' th' premises,
Of homage, and I know not how much tribute,
Should presently extirpate me and mine 125
Out of the dukedom, and confer fair Milan
With all the honors on my brother; whereon,
A treacherous army levied, one midnight
Fated to th' purpose, did Antonio open
The gates of Milan, and i' th' dead of darkness 130
The ministers for th' purpose hurried thence
Me and thy crying self.
MIR. Alack, for pity!
I, not rememb'ring how I cried out then,
Will cry it o'er again. It is a hint 134
That wrings mine eyes to't.
PROS. Hear a little further,
And then I'll bring thee to the present business
Which now's upon 's; without the which this story
Were most impertinent.
MIR. Wherefore did they not
That hour destroy us?
PROS. Well demanded, wench; 139
My tale provokes that question. Dear, they durst
 not,
So dear the love my people bore me; nor set
A mark so bloody on the business; but
With colors fairer painted their foul ends.
In few, they hurried us aboard a bark,
Bore us some leagues to sea, where they
 prepared 145
A rotten carcass of a butt, not rigg'd,
Nor tackle, sail, nor mast, the very rats
Instinctively have quit it. There they hoist us,
To cry to th' sea, that roar'd to us; to sigh
To th' winds, whose pity, sighing back again, 150
Did us but loving wrong.
MIR. Alack, what trouble
Was I then to you!
PROS. O, a cherubin
Thou wast that did preserve me. Thou didst smile,
Infused with a fortitude from heaven,
When I have deck'd the sea with drops full salt, 155
Under my burthen groan'd, which rais'd in me
An undergoing stomach, to bear up
Against what should ensue.

MIR. How came we ashore?
PROS. By Providence divine.
Some food we had, and some fresh water, that 160
A noble Neapolitan, Gonzalo,
Out of his charity, who being then appointed
Master of this design, did give us, with
Rich garments, linens, stuffs, and necessaries,
Which since have steaded much; so of his
 gentleness,
Knowing I lov'd my books, he furnish'd me 166
From mine own library with volumes that
I prize above my dukedom.
MIR. Would I might
But ever see that man!
PROS. Now I arise. [*Puts on his robe.*]
Sit still, and hear the last of our sea-sorrow: 170
Here in this island we arriv'd, and here
Have I, thy schoolmaster, made thee more profit
Than other princes can, that have more time
For vainer hours, and tutors not so careful.
MIR. Heavens thank you for't! And now I pray
 you, sir, 175
For still 'tis beating in my mind, your reason
For raising this sea-storm?
PROS. Know thus far forth:
By accident most strange, bountiful Fortune
(Now my dear lady) hath mine enemies
Brought to this shore; and by my prescience 180
I find my zenith doth depend upon
A most auspicious star, whose influence
If now I court not, but omit, my fortunes
Will ever after droop. Here cease more questions.
Thou art inclin'd to sleep; 'tis a good dullness, 185
And give it way. I know thou canst not choose.
 [MIRANDA *sleeps.*]
Come away, servant, come; I am ready now,
Approach, my Ariel. Come.

Enter ARIEL.

ARI. All hail, great master, grave sir, hail! I come
To answer thy best pleasure; be 't to fly, 190
To swim, to dive into the fire, to ride

123. **lieu . . . premises:** return for the pledge. 125. **presently extirpate:** immediately remove. 131. **ministers:** agents. 134. **hint:** occasion. 135. **wrings:** (1) constrains; (2) extracts moisture from. 138. **impertinent:** irrelevant. 143. **With . . . ends:** i.e. undertook to accomplish the same end by less violent means. 144. **In few:** in short. 146. **butt:** tub. 151. **Did . . . wrong:** i.e. only added to our discomfort. 155. **deck'd:** (1) adorned; (2) covered. 156. **which:** i.e. Miranda's smile. 157. **undergoing stomach:** courage to endure.

165. **steaded:** been of use. **gentleness:** character proper to one of high birth and cultivation. 167. **volumes:** i.e. books of magic. 172. **more profit:** profit more. 173. **princes.** The title "prince" could be used to honor either sex. 176. **beating:** working violently. 179. **my dear lady:** i.e. favorable to me. 181. **zenith:** height of fortune. 182. **influence:** power (astrological term). 183. **omit:** ignore. 185. **good dullness:** timely sleepiness. 187. **Come away:** come here.

On the curl'd clouds. To thy strong bidding, task
Ariel, and all his quality.

PROS. Hast thou, spirit,
Perform'd to point the tempest that I bade thee?

ARI. To every article. 195
I boarded the King's ship; now on the beak,
Now in the waist, the deck, in every cabin,
I flam'd amazement. Sometime I'ld divide,
And burn in many places; on the topmast,
The yards and boresprit, would I flame
 distinctly, 200
Then meet and join. Jove's lightning, the precursors
O' th' dreadful thunder-claps, more momentary
And sight-outrunning were not; the fire and cracks
Of sulphurous roaring the most mighty Neptune
Seem to besiege, and make his bold waves tremble,
Yea, his dread trident shake.

PROS. My brave spirit! 206
Who was so firm, so constant, that this coil
Would not infect his reason?

ARI. Not a soul
But felt a fever of the mad, and play'd
Some tricks of desperation. All but mariners 210
Plung'd in the foaming brine, and quit the vessel;
Then all afire with me, the King's son, Ferdinand,
With hair up-staring (then like reeds, not hair),
Was the first man that leapt; cried, "Hell is empty,
And all the devils are here."

PROS. Why, that's my spirit! 215
But was not this nigh shore?

ARI. Close by, my master.

PROS. But are they, Ariel, safe?

ARI. Not a hair perish'd;
On their sustaining garments not a blemish,
But fresher than before; and as thou badst me,
In troops I have dispers'd them 'bout the isle. 220
The King's son have I landed by himself,
Whom I left cooling of the air with sighs,
In an odd angle of the isle, and sitting,
His arms in this sad knot.

PROS. Of the King's ship,
The mariners, say how thou hast dispos'd, 225
And all the rest o' th' fleet.

ARI. Safely in harbor
Is the King's ship, in the deep nook, where once
Thou call'dst me up at midnight to fetch dew
From the still-vex'd Bermoothes, there she's hid;
The mariners all under hatches stowed, 230
Who, with a charm join'd to their suff'red labor,
I have left asleep; and for the rest o' th' fleet
(Which I dispers'd), they all have met again,
And are upon the Mediterranean float
Bound sadly home for Naples, 235
Supposing that they saw the King's ship wrack'd,
And his great person perish.

PROS. Ariel, thy charge
Exactly is perform'd; but there's more work.
What is the time o' th' day?

ARI. Past the mid season.

PROS. At least two glasses. The time 'twixt six and
 now 240
Must by us both be spent most preciously.

ARI. Is there more toil? Since thou dost give me
 pains,
Let me remember thee what thou hast promis'd,
Which is not yet perform'd me.

PROS. How now? moody?
What is't thou canst demand?

ARI. My liberty. 245

PROS. Before the time be out? No more!

ARI. I prithee,
Remember I have done thee worthy service,
Told thee no lies, made thee no mistakings, serv'd
Without or grudge or grumblings. Thou didst promise
To bate me a full year.

PROS. Dost thou forget 250
From what a torment I did free thee?

ARI. No.

PROS. Thou dost; and think'st it much to tread the
 ooze
Of the salt deep,
To run upon the sharp wind of the north,
To do me business in the veins o' th' earth 255
When it is bak'd with frost.

ARI. I do not, sir.

PROS. Thou liest, malignant thing! Hast thou
 forgot
The foul witch Sycorax, who with age and envy
Was grown into a hoop? Hast thou forgot her?

193. **quality:** (1) skill; (2) cohorts, minor spirits under him.
194. **to point:** in detail. 196. **beak:** prow.
198. **flam'd amazement:** struck terror by appearing as the flamelike phenomenon called St. Elmo's fire or the corposant.
200. **boresprit:** bowsprit. **distinctly:** in separate places.
206. **brave:** splendid. 207. **coil:** uproar. 209. **of the mad:** such as madmen have. 212. **Then . . . me.** Many editors repunctuate lines 211–12 so as to make this phrase modify *vessel* rather than *son.*
213. **up-staring:** standing on end. 218. **sustaining garments:** garments that bore them up in the water. 224. **in . . . knot:** i.e. crossed thus (Ariel illustrates with a gesture). Crossed arms indicated melancholy.

227. **nook:** inlet, small bay. 229. **still-vex'd Bermoothes:** always stormy Bermuda islands. 231. **with a charm:** by means of a magic spell. **their suff'red labor:** the labor they have endured.
234. **float:** flood, sea. 239. **mid season:** noon. 240. **glasses:** hourglasses. 242. **pains:** duties, chores. 243. **remember:** remind. 250. **bate:** remit. 252. **ooze:** mud at sea-bottom.
255. **veins:** underground streams, which were thought to correspond to veins of the body. 256. **bak'd:** hardened. 258. **envy:** malice.

ARI. No, sir.

PROS. Thou hast. Where was she born?
 Speak. Tell me. 260

ARI. Sir, in Argier.

PROS. O, was she so? I must
 Once in a month recount what thou hast been,
 Which thou forget'st. This damn'd witch Sycorax,
 For mischiefs manifold, and sorceries terrible
 To enter human hearing, from Argier 265
 Thou know'st was banish'd; for one thing she did
 They would not take her life. Is not this true?

ARI. Ay, sir.

PROS. This blue-ey'd hag was hither brought with
 child,
 And here was left by th' sailors. Thou, my slave, 270
 As thou report'st thyself, was then her servant,
 And for thou wast a spirit too delicate
 To act her earthy and abhorr'd commands,
 Refusing her grand hests, she did confine thee,
 By help of her more potent ministers, 275
 And in her most unmitigable rage,
 Into a cloven pine, within which rift
 Imprison'd, thou didst painfully remain
 A dozen years; within which space she died, 279
 And left thee there, where thou didst vent thy
 groans
 As fast as mill-wheels strike. Then was this island
 (Save for the son that [she] did litter here,
 A freckled whelp, hag-born) not honor'd with
 A human shape.

ARI. Yes—Caliban her son.

PROS. Dull thing, I say so; he, that Caliban 285
 Whom now I keep in service. Thou best know'st
 What torment I did find thee in; thy groans
 Did make wolves howl, and penetrate the breasts
 Of ever-angry bears. It was a torment
 To lay upon the damn'd, which Sycorax 290
 Could not again undo. It was mine art,
 When I arriv'd and heard thee, that made gape
 The pine, and let thee out.

ARI. I thank thee, master.

PROS. If thou more murmur'st, I will rend an oak
 And peg thee in his knotty entrails till 295
 Thou hast howl'd away twelve winters.

ARI. Pardon, master,
 I will be correspondent to command
 And do my spriting gently.

PROS. Do so; and after two days
 I will discharge thee.

ARI. That's my noble master!
 What shall I do? say what? what shall I do? 300

PROS. Go make thyself like a nymph o' th' sea; be
 subject
 To no sight but thine and mine, invisible
 To every eyeball else. Go take this shape
 And hither come in't. Go. Hence with diligence!
 Exit [ARIEL].
 Awake, dear heart, awake! Thou hast slept well,
 Awake!

MIR. The strangeness of your story put 306
 Heaviness in me.

PROS. Shake it off. Come on,
 We'll visit Caliban my slave, who never
 Yields us kind answer.

MIR. 'Tis a villain, sir,
 I do not love to look on.

PROS. But as 'tis, 310
 We cannot miss him. He does make our fire,
 Fetch in our wood, and serves in offices
 That profit us. What ho! slave! Caliban!
 Thou earth, thou! speak.

CAL. (*Within.*) There's wood enough within.

PROS. Come forth, I say, there's other business for
 thee. 315
 Come, thou tortoise, when?

Enter ARIEL *like a water-nymph.*

 Fine apparition! My quaint Ariel,
 Hark in thine ear.

ARI. My lord, it shall be done. *Exit.*

PROS. Thou poisonous slave, got by the devil
 himself
 Upon thy wicked dam, come forth! 320

Enter CALIBAN.

CAL. As wicked dew as e'er my mother brush'd
 With raven's feather from unwholesome fen
 Drop on you both! A south-west blow on ye,
 And blister you all o'er!

PROS. For this, be sure, to-night thou shalt have
 cramps, 325

261. **Argier:** Algiers. 269. **blue-ey'd:** with dark circles around
the eyes. 272. **for:** because. 274. **hests:** commands.
281. **mill-wheels:** i.e. the clappers on mill-wheels.
292. **gape:** open wide. 295. **his:** its.
297. **correspondent:** obedient. 298. **do . . . gently:** perform my
tasks as a spirit ungrudgingly.

307. **Heaviness:** drowsiness. 311. **miss:** do without.
316. **when:** a common expression of impatience. s.d. **like:** in the
shape of. 317. **quaint:** clever, ingenious. 321. **wicked:**
harmful. 323. **south-west:** southwest wind, thought to bring
pestilence.

Side-stitches, that shall pen thy breath up; urchins
Shall, for that vast of night that they may work,
All exercise on thee; thou shalt be pinch'd
As thick as honeycomb, each pinch more stinging
Than bees that made 'em.

CAL. I must eat my dinner. 330
This island's mine by Sycorax my mother,
Which thou tak'st from me. When thou cam'st first,
Thou strok'st me and made much of me, wouldst give
 me
Water with berries in't, and teach me how
To name the bigger light, and how the less, 335
That burn by day and night; and then I lov'd thee
And show'd thee all the qualities o' th' isle,
The fresh springs, brine-pits, barren place and fertile.
Curs'd be I that did so! All the charms
Of Sycorax, toads, beetles, bats, light on you! 340
For I am all the subjects that you have,
Which first was mine own king; and here you sty me
In this hard rock, whiles you do keep from me
The rest o' th' island.

PROS. Thou most lying slave,
Whom stripes may move, not kindness! I have us'd
 thee 345
(Filth as thou art) with human care, and lodg'd thee
In mine own cell, till thou didst seek to violate
The honor of my child.

CAL. O ho, O ho, would't had been done!
Thou didst prevent me; I had peopled else 350
This isle with Calibans.

MIR. Abhorred slave,
Which any print of goodness wilt not take,
Being capable of all ill! I pitied thee,
Took pains to make thee speak, taught thee each hour
One thing or other. When thou didst not,
 savage, 355
Know thine own meaning, but wouldst gabble like
A thing most brutish, I endow'd thy purposes
With words that made them known. But thy vild race
(Though thou didst learn) had that in't which good
 natures
Could not abide to be with; therefore was thou 360
Deservedly confin'd into this rock,
Who hadst deserv'd more than a prison.

CAL. You taught me language, and my profit on't
Is, I know how to curse. The red-plague rid you
For learning me your language!

PROS. Hag-seed, hence! 365
Fetch us in fuel, and be quick, thou'rt best,
To answer other business. Shrug'st thou, malice?
If thou neglect'st, or dost unwillingly
What I command, I'll rack thee with old cramps,
Fill all thy bones with aches, make thee roar 370
That beasts shall tremble at thy din.

CAL. No, pray thee.
[*Aside.*] I must obey. His art is of such pow'r,
It would control my dam's god, Setebos,
And make a vassal of him.

PROS. So, slave, hence! *Exit* CALIBAN.

Enter FERDINAND; *and* ARIEL, *invisible, playing and singing.*

Ariel['s] Song

Come unto these yellow sands, 375
 And then take hands:
Curtsied when you have, and kiss'd,
 The wild waves whist:
Foot it featly here and there,
And, sweet sprites, [the burthen bear]. 380
Hark, hark!
 Burthen, dispersedly, [*within*]. Bow-wow.
The watch-dogs bark!
 [*Burthen, dispersedly, within.*] Bow-wow.
Hark, hark, I hear 385
The strain of strutting chanticleer:
 Cry [*within.*] Cock-a-diddle-dow.

FER. Where should this music be? I' th' air, or th'
 earth?
It sounds no more; and sure it waits upon
Some god o' th' island. Sitting on a bank, 390
Weeping again the King my father's wrack,
This music crept by me upon the waters,
Allaying both their fury and my passion

326. **urchins:** hedgehogs; here, goblins in the shape of hedgehogs.
327. **for . . . work:** during that long and desolate period of darkness during which they are permitted to perform their mischief. It was thought that malignant spirits lost their power with the coming of day.
330. **'em:** i.e. cells of the honeycomb. 345. **stripes:** lashes.
346. **human:** humane. 351. s.p. **Mir.** Some editors make Prospero the speaker. 358. **vild:** vile. **race:** nature.

364. **red-plague:** plague that produces red sores. **rid:** destroy.
365. **learning:** teaching. 366. **thou'rt best:** you had better.
369. **old:** i.e. such as old people have. 370. **aches.** Pronounced *aitches.* 374 s.d. **invisible.** Ariel is of course visible to the audience but he wears a costume which by convention makes him invisible to other persons on the stage, except Prospero.
378. **whist:** being hushed. 379. **featly:** nimbly.
380. **the burthen bear:** bear the burden, i.e. the bass undersong.
382. **dispersedly:** from several directions. 393. **passion:** sorrow.

With its sweet air; thence I have follow'd it,
Or it hath drawn me rather. But 'tis gone. 395
No, it begins again.

Ariel['s] Song

Full fadom five thy father lies,
 Of his bones are coral made:
Those are pearls that were his eyes:
 Nothing of him that doth fade, 400
But doth suffer a sea-change
Into something rich and strange.
Sea-nymphs hourly ring his knell:
 Burthen [*within*]. Ding-dong.
Hark now I hear them—ding-dong bell. 405

FER. The ditty does remember my drown'd father.
 This is no mortal business, nor no sound
 That the earth owes. I hear it now above me.
PROS. The fringed curtains of thine eye advance,
 And say what thou seest yond.
MIR. What, is't a spirit?
 Lord, how it looks about! Believe me, sir, 411
 It carries a brave form. But 'tis a spirit.
PROS. No, wench, it eats, and sleeps, and hath such
 senses
 As we have—such. This gallant which thou seest
 Was in the wrack; and but he's something stain'd
 With grief (that's beauty's canker), thou mightst call
 him 416
 A goodly person. He hath lost his fellows,
 And strays about to find 'em.
MIR. I might call him
 A thing divine, for nothing natural
 I ever saw so noble.
PROS. [*Aside.*] It goes on, I see, 420
 As my soul prompts it. Spirit, fine spirit, I'll free thee
 Within two days for this.
FER. Most sure, the goddess
 On whom these airs attend! Vouchsafe my pray'r
 May know if you remain upon this island,
 And that you will some good instruction give 425
 How I may bear me here. My prime request,
 Which I do last pronounce, is (O you wonder!)
 If you be maid, or no?
MIR. No wonder, sir,
 But certainly a maid.
FER. My language? heavens!
 I am the best of them that speak this speech, 430
 Were I but where 'tis spoken.
PROS. How? the best?
 What wert thou, if the King of Naples heard thee?
FER. A single thing, as I am now, that wonders
 To hear thee speak of Naples. He does hear me,
 And that he does I weep. Myself am Naples, 435
 Who with mine eyes (never since at ebb) beheld
 The King my father wrack'd.
MIR. Alack, for mercy!
FER. Yes, faith, and all his lords, the Duke of Milan
 And his brave son being twain.
PROS. [*Aside.*] The Duke of Milan
 And his more braver daughter could control
 thee, 440
 If now 'twere fit to do't. At the first sight
 They have chang'd eyes. Delicate Ariel,
 I'll set thee free for this.—A word, good sir,
 I fear you have done yourself some wrong; a word.
MIR. Why speaks my father so ungently? This
 Is the third man that e'er I saw; the first 446
 That e'er I sigh'd for. Pity move my father
 To be inclin'd my way!
FER. O, if a virgin,
 And your affection not gone forth, I'll make you
 The Queen of Naples.
PROS. Soft, sir, one word more. 450
 [*Aside.*] They are both in either's pow'rs; but this
 swift business
 I must uneasy make, lest too light winning
 Make the prize light.—One word more: I charge thee
 That thou attend me. Thou dost here usurp
 The name thou ow'st not, and hast put thyself 455
 Upon this island as a spy, to win it
 From me, the lord on't.
FER. No, as I am a man.
MIR. There's nothing ill can dwell in such a temple.
 If the ill spirit have so fair a house,
 Good things will strive to dwell with't.
PROS. Follow me.— 460
 Speak not you for him; he's a traitor.—Come,

I'll manacle thy neck and feet together.
Sea-water shalt thou drink; thy food shall be
The fresh-brook mussels, wither'd roots, and husks
Wherein the acorn cradled. Follow.
FER. No, 465
I will resist such entertainment till
Mine enemy has more pow'r.
 He draws, and is charmed from moving.
MIR. O dear father,
Make not too rash a trial of him, for
He's gentle, and not fearful.
PROS. What, I say,
My foot my tutor? Put thy sword up, traitor, 470
Who mak'st a show but dar'st not strike, thy
 conscience
Is so possess'd with guilt. Come, from thy ward,
For I can here disarm thee with this stick,
And make thy weapon drop.
MIR. Beseech you, father.
PROS. Hence! hang not on my garments.
MIR. Sir, have pity,
I'll be his surety.
PROS. Silence! one word more 476
Shall make me chide thee, if not hate thee. What,
An advocate for an impostor? Hush!
Thou think'st there is no more such shapes as he,
Having seen but him and Caliban. Foolish wench,
To th' most of men this is a Caliban, 481
And they to him are angels.
MIR. My affections
Are then most humble; I have no ambition
To see a goodlier man.
PROS. [*To* FERDINAND.] Come on, obey:
Thy nerves are in their infancy again 485
And have no vigor in them.
FER. So they are.
My spirits, as in a dream, are all bound up.
My father's loss, the weakness which I feel,
The wrack of all my friends, nor this man's threats
To whom I am subdu'd, are but light to me, 490
Might I but through my prison once a day
Behold this maid. All corners else o' th' earth
Let liberty make use of; space enough
Have I in such a prison.

PROS. [*Aside.*] It works. [*To* FERDINAND.] Come
 on.—
Thou hast done well, fine Ariel! [*To* FERDINAND.]
Follow me. 495
[*To* ARIEL.] Hark what thou else shalt do me.
MIR. Be of comfort,
My father's of a better nature, sir,
Than he appears by speech. This is unwonted
Which now came from him.
PROS. Thou shalt be as free
As mountain winds; but then exactly do 500
All points of my command.
ARI. To th' syllable.
PROS. [*To* FERDINAND.] Come, follow. [*To* MIRANDA.]
Speak not for him. *Exeunt.*

ACT II, SCENE I

Enter ALONSO, SEBASTIAN, ANTONIO, GONZALO,
ADRIAN, FRANCISCO, *and others.*

GON. Beseech you, sir, be merry; you have cause
(So have we all) of joy; for our escape
Is much beyond our loss. Our hint of woe
Is common: every day some sailor's wife,
The masters of some merchant, and the merchant 5
Have just our theme of woe; but for the miracle
(I mean our preservation), few in millions
Can speak like us. Then wisely, good sir, weigh
Our sorrow with our comfort.
ALON. Prithee peace.
SEB. He receives comfort like cold porridge. 10
ANT. The visitor will not give him o'er so.
SEB. Look, he's winding up the watch of his wit, by
 and by it will strike.
GON. Sir—
SEB. One. Tell. 15
GON. When every grief is entertain'd that's offer'd,
Comes to th' entertainer—
SEB. A dollar.
GON. Dolor comes to him indeed, you have spoken
 truer than you purpos'd. 20

496. **do me:** do for me.

II.i. Location: Another part of the island.
3. **hint:** occasion. 5. **masters . . . the merchant:** chief officers of
some merchant vessel, and the owner of it. 9. **with:** against.
10. **porridge:** broth. There is an underlying pun on *peace* (line 9) and
pease, i.e. peas, a common ingredient of porridge.
11. **visitor:** minister who visits the sick and bereaved, i.e. would-be
comforter. 15. **Tell:** count. 17. **entertainer:** sufferer. Sebastian
puns on the sense "innkeeper." 18. **dollar:** a continental coin.
19. **Dolor:** sorrow.

466. **entertainment:** treatment. 467 s.d. **charmed:** magically
prevented. 469. **gentle:** of high birth. **fearful:** cowardly.
470. **foot:** i.e. subordinate (Miranda). 472. **ward:** position of
defense. 473. **stick:** staff. 481. **To:** in comparison with.
482. **affections:** inclinations. 485. **nerves:** sinews. 487. **spirits:**
vital powers.

SEB. You have taken it wiselier than I meant you
 should.

GON. Therefore, my lord—

ANT. Fie, what a spendthrift is he of his tongue!

ALON. I prithee spare. 25

GON. Well, I have done. But yet—

SEB. He will be talking.

ANT. Which, of he or Adrian, for a good wager,
 first begins to crow?

SEB. The old cock. 30

ANT. The cock'rel.

SEB. Done. The wager?

ANT. A laughter.

SEB. A match!

ADR. Though this island seem to be desert— 35

SEB. Ha, ha, ha!

ANT. So: you're paid!

ADR. Uninhabitable, and almost inaccessible—

SEB. Yet—

ADR. Yet— 40

ANT. He could not miss't.

ADR. It must needs be of subtle, tender, and delicate
 temperance.

ANT. Temperance was a delicate wench. 44

SEB. Ay, and a subtle, as he most learnedly
 deliver'd.

ADR. The air breathes upon us here most sweetly.

SEB. As if it had lungs, and rotten ones.

ANT. Or, as 'twere perfum'd by a fen.

GON. Here is every thing advantageous to life. 50

ANT. True, save means to live.

SEB. Of that there's none, or little.

GON. How lush and lusty the grass looks! How
 green!

ANT. The ground indeed is tawny. 55

SEB. With an eye of green in't.

ANT. He misses not much.

SEB. No; he doth but mistake the truth totally.

GON. But the rariety of it is—which is indeed
 almost beyond credit— 60

SEB. As many vouch'd rarieties are.

GON. That our garments, being (as they were)
 drench'd in the sea, hold notwithstanding their fresh-
ness and glosses, being rather new dy'd than stain'd
with salt water. 65

ANT. If but one of his pockets could speak, would
 it not say he lies?

SEB. Ay, or very falsely pocket up his report.

GON. Methinks our garments are now as fresh as
 when we put them on first in Afric, at the marriage 70
 of the King's fair daughter Claribel to the King of
 Tunis.

SEB. 'Twas a sweet marriage, and we prosper well
 in our return.

ADR. Tunis was never grac'd before with such a
 paragon to their queen. 76

GON. Not since widow Dido's time.

ANT. Widow? a pox o' that! How came that
 widow in? Widow Dido!

SEB. What if he had said "widower Aeneas" too?
 Good Lord, how you take it! 81

ADR. "Widow Dido," said you? You make me
 study of that. She was of Carthage, not of Tunis.

GON. This Tunis, sir, was Carthage.

ADR. Carthage? 85

GON. I assure you, Carthage.

ANT. His word is more than the miraculous harp.

SEB. He hath rais'd the wall, and houses too.

ANT. What impossible matter will he make easy
 next? 90

SEB. I think he will carry this island home in his
 pocket, and give it his son for an apple.

ANT. And sowing the kernels of it in the sea,
 bring forth more islands.

GON. Ay. 95

ANT. Why, in good time.

GON. Sir, we were talking that our garments seem
 now as fresh as when we were at Tunis at the marriage
 of your daughter, who is now queen.

ANT. And the rarest that e'er came there. 100

SEB. Bate, I beseech you, widow Dido.

ANT. O, widow Dido? Ay, widow Dido.

GON. Is not, sir, my doublet as fresh as the first
 day I wore it? I mean, in a sort.

30. **old cock:** i.e. Gonzalo. 31. **cock'rel:** i.e. Adrian.

33. **laughter:** a laugh (perhaps with pun on the sense "a sitting of eggs," consistent with the poultry imagery).

35. **desert:** uninhabited. 36. **Ha, ha, ha.** Antonio wins the bet, since Adrian spoke first. The winner was entitled to laugh. Accordingly most editors reverse the speech prefixes for lines 36 and 37.

41. **miss't:** (1) escape saying "yet"; (2) avoid the island.

43. **temperance:** climate. Antonio puns on the word as a girl's name.

55. **tawny:** parched tan or yellow. 56. **eye:** spot.

59. **rariety.** Perhaps this spelling indicates an unusual pronunciation of the word by Gonzalo, which Sebastian mimics.

61. **vouch'd:** guaranteed true.

68. **pocket up:** conceal, suppress. One who failed to challenge a lie or an insult was said to "pocket up" the injury. 76. **to:** for.

78–79. **Widow . . . Dido.** Antonio's vigorous reaction has been variously explained. Dido was indeed a widow, and Aeneas a widower, when they met, and perhaps Antonio is laughing at what he considers Gonzalo's prudery in referring to her as widow rather than as Aeneas' mistress. *Widow* could also be used of a wife separated from or deserted by her husband, and Antonio may be laughing at Gonzalo for prudish evasion of the fact that the deserted Dido was not Aeneas' wife. 84. **This . . . Carthage.** Tunis and Carthage were separate cities, though not far apart. 87. **miraculous harp:** the legendary harp of Amphion, which raised the walls of Thebes. Gonzalo's error has created a whole new city. 93. **kernels:** seeds.

95. **Ay.** Probably a reassertion of the identity of the two cities. Antonio responds with a sarcastic expression of approbation.

101. **Bate:** except. 104. **in a sort:** comparatively.

ANT. That "sort" was well fish'd for. 105
GON. When I wore it at your daughter's marriage?
ALON. You cram these words into mine ears against
The stomach of my sense. Would I had never
Married my daughter there! for coming thence,
My son is lost and (in my rate) she too, 110
Who is so far from Italy removed
I ne'er again shall see her. O thou mine heir
Of Naples and of Milan, what strange fish
Hath made his meal on thee?
FRAN. Sir, he may live.
I saw him beat the surges under him, 115
And ride upon their backs. He trod the water,
Whose enmity he flung aside, and breasted
The surge most swoll'n that met him. His bold head
'Bove the contentious waves he kept, and oared
Himself with his good arms in lusty stroke 120
To th' shore, that o'er his wave-worn basis bowed,
As stooping to relieve him. I not doubt
He came alive to land.
ALON. No, no, he's gone.
SEB. Sir, you may thank yourself for this great loss,
That would not bless our Europe with your daughter,
But rather loose her to an African, 126
Where she, at least, is banish'd from your eye,
Who hath cause to wet the grief on't.
ALON. Prithee peace.
SEB. You were kneel'd to, and importun'd otherwise
By all of us, and the fair soul herself 130
Weigh'd between loathness and obedience, at
Which end o' th' beam should bow. We have lost
 your son,
I fear for ever. Milan and Naples have
Moe widows in them of this business' making
Than we bring men to comfort them. 135
The fault's your own.
ALON. So is the dear'st o' th' loss.
GON. My Lord Sebastian,
The truth you speak doth lack some gentleness,
And time to speak it in. You rub the sore,
When you should bring the plaster.
SEB. Very well. 140
ANT. And most chirurgeonly.
GON. It is foul weather in us all, good sir,
When you are cloudy.

SEB. Fowl weather?
ANT. Very foul.
GON. Had I plantation of this isle, my lord— 144
ANT. He'd sow't with nettle-seed.
SEB. Or docks, or mallows.
GON. And were the king on't, what would I do?
SEB. Scape being drunk, for want of wine.
GON. I' th' commonwealth I would, by contraries,
Execute all things; for no kind of traffic
Would I admit; no name of magistrate; 150
Letters should not be known; riches, poverty,
And use of service, none; contract, succession,
Bourn, bound of land, tilth, vineyard, none;
No use of metal, corn, or wine, or oil;
No occupation, all men idle, all; 155
And women too, but innocent and pure;
No sovereignty—
SEB. Yet he would be king on't.
ANT. The latter end of his commonwealth forgets
the beginning.
GON. All things in common nature should produce
Without sweat or endeavor: treason, felony, 161
Sword, pike, knife, gun, or need of any engine,
Would I not have; but nature should bring forth,
Of it own kind, all foison, all abundance,
To feed my innocent people. 165
SEB. No marrying 'mong his subjects?
ANT. None, man, all idle—whores and knaves.
GON. I would with such perfection govern, sir,
T' excel the golden age.
SEB. 'Save his Majesty! 169
ANT. Long live Gonzalo!
GON. And—do you mark me, sir?
ALON. Prithee no more; thou dost talk nothing to
me.
GON. I do well believe your Highness, and did it to
minister occasion to these gentlemen, who are of such
sensible and nimble lungs that they always use to
laugh at nothing. 175
ANT. 'Twas you we laugh'd at.
GON. Who, in this kind of merry fooling, am
nothing to you; so you may continue, and laugh at
nothing still.

107–8. **You . . . sense:** The image is of someone being fed against his will; *stomach* = appetite. 110. **rate:** opinion.
121. **his wave-worn basis:** its foundation hollowed by the action of the sea. 125. **That:** you who. 126. **loose.** With second (perhaps primary) sense "lose," often spelled *loose.* 131–32. **Weigh'd . . . bow:** weighed in the scale her unwillingness to marry and her duty of obedience to her father, to see which would prevail.
134. **Moe:** more. 136. **dear'st:** most heartfelt.
139. **time:** appropriate occasion.
141. **chirurgeonly:** like a surgeon.

143. **Fowl.** Sebastian's pun returns to the imagery of lines 28–31.
144. **plantation:** colonization, but the following speakers take up the word in the sense "planting." 148. **contraries:** the opposite of what is customary. 149. **traffic:** business, trade. 151. **Letters:** learning, literacy. 152. **service:** servanthood, serving of some by others. **succession:** inheritance, hereditary privilege. 153. **Bourn:** boundary, i.e. division of land among individual owners. **tilth:** tillage.
154. **corn:** grain. 162. **pike:** spear. **engine:** instruments of war.
164. **it:** its. **foison:** plenty. 169. **'Save:** God save.
173. **minister occasion:** give opportunity. 174. **sensible and nimble:** sensitive and lively.

ANT. What a blow was there given! 180
SEB. And it had not fall'n flat-long.
GON. You are gentlemen of brave mettle; you
 would lift the moon out of her sphere, if she would
 continue in it five weeks without changing.

Enter ARIEL [*invisible*], *playing solemn music.*

SEB. We would so, and then go a-batfowling.
ANT. Nay, good my lord, be not angry. 186
GON. No, I warrant you, I will not adventure my
 discretion so weakly. Will you laugh me asleep, for I
 am very heavy?
ANT. Go sleep, and hear us. 190
 [*All sleep except* ALONSO, SEBASTIAN, *and* ANTONIO.]
ALON. What, all so soon asleep! I wish mine eyes
 Would, with themselves, shut up my thoughts. I find
 They are inclin'd to do so.
SEB. Please you, sir,
 Do not omit the heavy offer of it.
 It seldom visits sorrow; when it doth, 195
 It is a comforter.
ANT. We two, my lord,
 Will guard your person while you take your rest,
 And watch your safety.
ALON. Thank you. Wondrous heavy.
 [ALONSO *sleeps. Exit* ARIEL.]
SEB. What a strange drowsiness possesses them!
ANT. It is the quality o' th' climate.
SEB. Why 200
 Doth it not then our eyelids sink? I find not
 Myself dispos'd to sleep.
ANT. Nor I, my spirits are nimble.
 They fell together all, as by consent;
 They dropp'd, as by a thunder-stroke. What might,
 Worthy Sebastian, O, what might—? No more—
 And yet methinks I see it in thy face, 206
 What thou shouldst be. Th' occasion speaks thee, and
 My strong imagination sees a crown
 Dropping upon thy head.
SEB. What? art thou waking?

ANT. Do you not hear me speak?
SEB. I do, and surely
 It is a sleepy language, and thou speak'st 211
 Out of thy sleep. What is it thou didst say?
 This is a strange repose, to be asleep
 With eyes wide open—standing, speaking, moving—
 And yet so fast asleep.
ANT. Noble Sebastian, 215
 Thou let'st thy fortune sleep—die, rather; wink'st
 Whiles thou art waking.
SEB. Thou dost snore distinctly,
 There's meaning in thy snores.
ANT. I am more serious than my custom; you
 Must be so too, if heed me; which to do, 220
 Trebles thee o'er.
SEB. Well; I am standing water.
ANT. I'll teach you how to flow.
SEB. Do so. To ebb
 Hereditary sloth instructs me.
ANT. O!
 If you but knew how you the purpose cherish
 Whiles thus you mock it! how, in stripping it, 225
 You more invest it! Ebbing men, indeed,
 Most often, do so near the bottom run
 By their own fear of sloth.
SEB. Prithee say on.
 The setting of thine eye and cheek proclaim
 A matter from thee; and a birth, indeed, 230
 Which throes thee much to yield.
ANT. Thus, sir:
 Although this lord of weak remembrance, this
 Who shall be of as little memory
 When he is earth'd, hath here almost persuaded
 (For he's a spirit of persuasion, only 235
 Professes to persuade) the King his son's alive,
 'Tis as impossible that he's undrown'd,
 As he that sleeps here swims.
SEB. I have no hope
 That he's undrown'd.
ANT. O, out of that no hope 239
 What great hope have you! No hope, that way, is
 Another way so high a hope that even

216. **wink'st**: keep your eyes shut. 221. **Trebles thee o'er**: triples your fortune. **standing water**: i.e. indecisive, going neither forward nor back. 223. **Hereditary sloth**: natural laziness.
224. **cherish**: enrich. 226. **invest**: dress up.
229. **setting**: fixed look. 231. **throes**: causes labor pains.
232. **this lord**: i.e. Gonzalo. **of weak remembrance**: having a short memory (perhaps alluding to Gonzalo's lapse in identifying Tunis with Carthage); with following shift to the sense "remembered only briefly after death." 234. **earth'd**: buried.
235–36. **only . . . persuade**: has no function except to persuade. Gonzalo is a privy councillor. 240. **that way**: i.e. with respect to Ferdinand's being undrowned.

181. **And**: if. **flat-long**: with the sword blade flat, not on edge.
185. **a-batfowling**: bird-hunting with sticks (*bats*) at night. He suggests that they would use the moon as their lantern.
187–88. **adventure . . . weakly**: risk my reputation for good sense by getting angry at such superficial fellows. 189. **heavy**: drowsy.
190. **hear us**: i.e. listen to our laughter. 194. **omit . . . offer**: neglect the opportunity sleepiness provides. 195. **visits**. See note to II.i.11. 207. **speaks thee**: calls upon you (to seize the opportunity).

Ambition cannot pierce a wink beyond,
But doubt discovery there. Will you grant with me
That Ferdinand is drown'd?

SEB. He's gone.

ANT. Then tell me,
Who's the next heir of Naples?

SEB. Claribel. 245

ANT. She that is Queen of Tunis; she that dwells
Ten leagues beyond man's life; she that from Naples
Can have no note, unless the sun were post—
The Man i' th' Moon's too slow—till new-born chins
Be rough and razorable; she that from whom 250
We all were sea-swallow'd, though some cast again
(And by that destiny) to perform an act
Whereof what's past is prologue, what to come
In yours and my discharge.

SEB. What stuff is this? How say you?
'Tis true, my brother's daughter's Queen of
 Tunis, 255
So is she heir of Naples; 'twixt which regions
There is some space.

ANT. A space whose ev'ry cubit
Seems to cry out, "How shall that Claribel
Measure us back to Naples? Keep in Tunis,
And let Sebastian wake." Say this were death 260
That now hath seiz'd them, why, they were no
 worse
Than now they are. There be that can rule Naples
As well as he that sleeps; lords that can prate
As amply and unnecessarily
As this Gonzalo; I myself could make 265
A chough of as deep chat. O that you bore
The mind that I do! what a sleep were this
For your advancement! Do you understand me?

SEB. Methinks I do.

ANT. And how does your content
Tender your own good fortune?

SEB. I remember 270
You did supplant your brother Prospero.

ANT. True.
And look how well my garments sit upon me,
Much feater than before. My brother's servants
Were then my fellows, now they are my men.

SEB. But, for your conscience? 275

ANT. Ay, sir; where lies that? If 'twere a kibe,

'Twould put me to my slipper; but I feel not
This deity in my bosom. Twenty consciences,
That stand 'twixt me and Milan, candied be they,
And melt ere they molest! Here lies your brother,
No better than the earth he lies upon, 281
If he were that which now he's like—that's dead,
Whom I with this obedient steel, three inches of it,
Can lay to bed for ever; whiles you, doing thus,
To the perpetual wink for aye might put 285
This ancient morsel, this Sir Prudence, who
Should not upbraid our course. For all the rest,
They'll take suggestion as a cat laps milk;
They'll tell the clock to any business that
We say befits the hour.

SEB. Thy case, dear friend, 290
Shall be my president: as thou got'st Milan,
I'll come by Naples. Draw thy sword. One stroke
Shall free thee from the tribute which thou payest,
And I the King shall love thee.

ANT. Draw together;
And when I rear my hand, do you the like, 295
To fall it on Gonzalo.

SEB. O, but one word. [*They talk apart.*]

Enter ARIEL [*invisible*], *with music and song.*

ARI. My master through his art foresees the danger
That you, his friend, are in, and sends me forth
(For else his project dies) to keep them living.
 Sings in GONZALO'*s ear.*
 While you here do snoring lie, 300
 Open-ey'd conspiracy
 His time doth take.
 If of life you keep a care,
 Shake off slumber, and beware.
 Awake, awake! 305

ANT. Then let us both be sudden.

GON. [*Waking.*] Now, good angels
Preserve the King! [*Wakes* ALONSO.]

ALON. Why, how now, ho! Awake? Why are
 you drawn?
Wherefore this ghastly looking?

GON. What's the matter?

SEB. Whiles we stood here securing your repose,
Even now, we heard a hollow burst of
 bellowing 311
Like bulls, or rather lions. Did't not wake you?
It strook mine ear most terribly.

242. **wink**: glimpse. 243. **doubt discovery there**: is uncertain of
seeing clearly even there. 247. **Ten . . . life**: thirty miles farther
than a lifetime's journey. 248. **note**: news. **post**: messenger.
250. **from**: coming from. 251. **cast**: (1) cast up; (2) cast as actors.
254. **discharge**: performance. 257. **cubit**: measure of about 20
inches. 259. **Measure us**: i.e. travel over the cubits.
260. **wake**: i.e. awake to fortune. 265–66. **make . . . chat**: train a
jackdaw to speak as wisely as he. Jackdaws were taught to speak.
269. **content**: inclination. 270. **Tender**: regard. 273. **feater**:
more gracefully. 276. **kibe**: chilblain. 277. **put me to**: make
me wear.

279. **Milan**: the dukedom of Milan. **candied**: sugared.
285. **wink**: sleep. 288. **suggestion**: evil prompting.
289. **tell . . . to**: i.e. agree that the time sorts with.
291. **president**: precedent. 296. **fall it**: let it fall.
302. **time**: opportunity. 310. **securing**: guarding.
313. **strook**: struck.

ALON. I heard nothing.
ANT. O, 'twas a din to fright a monster's ear,
 To make an earthquake; sure it was the roar 315
 Of a whole herd of lions.
ALON. Heard you this, Gonzalo?
GON. Upon mine honor, sir, I heard a humming
 (And that a strange one too) which did awake me.
 I shak'd you, sir, and cried. As mine eyes open'd,
 I saw their weapons drawn. There was a noise, 320
 That's verily. 'Tis best we stand upon our guard,
 Or that we quit this place. Let's draw our weapons.
ALON. Lead off this ground, and let's make further
 search
 For my poor son.
GON. Heavens keep him from these beasts!
 For he is sure i' th' island.
ALON. Lead away. 325
ARI. Prospero my lord shall know what I have
 done.
 So, King, go safely on to seek thy son. *Exeunt.*

SCENE II

Enter CALIBAN *with a burthen of wood. A noise of
thunder heard.*

CAL. All the infections that the sun sucks up
 From bogs, fens, flats, on Prosper fall, and make him
 By inch-meal a disease! His spirits hear me,
 And yet I needs must curse. But they'll nor pinch,
 Fright me with urchin-shows, pitch me i' th' mire, 5
 Nor lead me, like a fire-brand, in the dark
 Out of my way, unless he bid 'em; but
 For every trifle are they set upon me,
 Sometimes like apes that mow and chatter at me,
 And after bite me; then like hedgehogs which 10
 Lie tumbling in my barefoot way, and mount
 Their pricks at my footfall; sometime am I
 All wound with adders, who with cloven tongues
 Do hiss me into madness.

Enter TRINCULO.

 Lo, now lo,
 Here comes a spirit of his, and to torment me 15
 For bringing wood in slowly. I'll fall flat,
 Perchance he will not mind me.

TRIN. Here's neither bush nor shrub to bear off any
 weather at all. And another storm brewing, I hear it
 sing i' th' wind. Yond same black cloud, yond 20
 huge one, looks like a foul bumbard that would
 shed his liquor. If it should thunder as it did before,
 I know not where to hide my head. Yond same cloud
 cannot choose but fall by pailfuls. What have we
 here? a man or a fish? dead or alive? A fish, he
 smells like a fish; a very ancient and fish-like 25
 smell; a kind of, not-of-the-newest poor-John. A
 strange fish! Were I in England now (as once I was)
 and had but this fish painted, not a holiday fool
 there but would give a piece of silver. There would
 this monster make a man; any strange beast 30
 there makes a man. When they will not give a doit
 to relieve a lame beggar, they will lay out ten to see a
 dead Indian. Legg'd like a man; and his fins like
 arms! Warm, o' my troth! I do now let loose my
 opinion, hold it no longer: this is no fish, 35
 but an islander, that hath lately suffer'd by a
 thunder-bolt. [*Thunder.*] Alas, the storm is come
 again! My best way is to creep under his gaberdine;
 there is no other shelter hereabout. Misery acquaints
 a man with strange bedfellows; I will here shroud till
 the dregs of the storm be past. 41

Enter STEPHANO, *singing,* [*a bottle in his hand*].

STE. "I shall no more to sea, to sea,
 Here shall I die ashore—"
 This is a very scurvy tune to sing at a man's funeral.
 Well, here's my comfort. *Drinks.*
 (*Sings.*) "The master, the swabber, the boatswain,
 and I, 46
 The gunner and his mate,
 Lov'd Mall, Meg, and Marian, and Margery,
 But none of us car'd for Kate;
 For she had a tongue with a tang, 50
 Would cry to a sailor, 'Go hang!'
 She lov'd not the savor of tar nor of pitch,
 Yet a tailor might scratch her where e'er she did itch.
 Then to sea, boys, and let her go hang!"
 This is a scurvy tune too; but here's my comfort. 55
 Drinks.

319. **cried:** called out.

II.ii. Location: Another part of the island.
3. **By inch-meal:** inch by inch. Cf. *piecemeal.*
5. **urchin-shows:** sights of goblins in the shape of hedgehogs.
6. **like a fire-brand:** in the shape of a will-o'-the-wisp.
9. **mow:** make faces. 13. **wound:** twined about.
17. **mind:** notice.

18. **bear off:** ward off. 21. **bumbard:** bombard, leather bottle.
22. **his:** its. 27. **poor-John:** cheap dried fish.
29. **painted:** i.e. on a sign hung outside a booth at a fair to attract
customers, with the monster exhibited within.
30. **make a man:** make a man's fortune, with obvious punning sense
"be indistinguishable from an Englishman."
32. **doit:** coin of trifling value. 34. **o' my troth:** by my faith.
35. **hold it:** hold it back. 38. **gaberdine:** cloak.
40. **dregs:** lees (recurring to the image of the rain as liquor poured
from a jug).

CAL. Do not torment me! O!

STE. What's the matter? Have we devils here? Do you put tricks upon 's with salvages and men of Inde? Ha? I have not scap'd drowning to be afeard now of your four legs; for it hath been said, "As proper a 60
man as ever went on four legs cannot make him give ground"; and it shall be said so again while Stephano breathes at' nostrils.

CAL. The spirit torments me! O! 64

STE. This is some monster of the isle with four legs, who hath got (as I take it) an ague. Where the devil should he learn our language? I will give him some relief, if it be but for that. If I can recover him, and keep him tame, and get to Naples with him, he's a present for any emperor that ever trod on neat's-leather.

CAL. Do not torment me, prithee. I'll bring my wood home faster. 72

STE. He's in his fit now, and does not talk after the wisest. He shall taste of my bottle; if he have never drunk wine afore, it will go near to remove his fit. 75
If I can recover him, and keep him tame, I will not take too much for him; he shall pay for him that hath him, and that soundly.

CAL. Thou dost me yet but little hurt; thou wilt anon, I know it by thy trembling. Now Prosper works upon thee. 81

STE. Come on your ways. Open your mouth; here is that which will give language to you, cat. Open your mouth; this will shake your shaking, I can tell you, and that soundly. You cannot tell who's your friend. Open your chaps again.

[CALIBAN *drinks.*] 86

TRIN. I should know that voice; it should be—but he is drown'd; and these are devils. O, defend me!

STE. Four legs and two voices; a most delicate monster! His forward voice now is to speak well 90
of his friend; his backward voice is to utter foul speeches and to detract. If all the wine in my bottle will recover him, I will help his ague. Come. [CALIBAN *drinks again.*] Amen! I will pour some in thy other mouth. 95

TRIN. Stephano!

STE. Doth thy other mouth call me? Mercy, mercy! This is a devil, and no monster. I will leave him, I have no long spoon. 99

TRIN. Stephano! If thou beest Stephano, touch me, and speak to me; for I am Trinculo—be not afeard—thy good friend Trinculo.

STE. If thou beest Trinculo, come forth. I'll pull thee by the lesser legs. If any be Trinculo's legs, these are they. Thou art very Trinculo indeed! How 105
cam'st thou to be the siege of this moon-calf? Can he vent Trinculos?

TRIN. I took him to be kill'd with a thunder-stroke. But art thou not drown'd, Stephano? I hope now thou art not drown'd. Is the storm overblown? I hid 110
me under the dead moon-calf's gaberdine for fear of the storm. And art thou living, Stephano?
O Stephano, two Neapolitans scap'd!

STE. Prithee do not turn me about, my stomach is not constant. 115

CAL. [*Aside.*] These be fine things, and if they be not sprites.
That's a brave god, and bears celestial liquor.
I will kneel to him.

STE. How didst thou scape? How cam'st thou hither? Swear by this bottle how thou cam'st 120
hither—I escap'd upon a butt of sack which the sailors heav'd o'erboard—by this bottle, which I made of the bark of a tree with mine own hands since I was cast ashore. 124

CAL. I'll swear upon that bottle to be thy true subject, for the liquor is not earthly.

STE. Here; swear then how thou escap'dst.

TRIN. Swom ashore, man, like a duck. I can swim like a duck, I'll be sworn. 129

STE. Here, kiss the book. [*Passing the bottle.*]
Though thou canst swim like a duck, thou art made like a goose.

TRIN. O Stephano, hast any more of this?

STE. The whole butt, man. My cellar is in a rock by th' sea-side, where my wine is hid. How now, moon-calf? how does thine ague? 136

CAL. Hast thou not dropp'd from heaven?

STE. Out o' th' moon, I do assure thee. I was the Man i' th' Moon, when time was.

56. **Do . . . me.** Caliban takes Stephano for a spirit sent by Prospero to plague him. 58. **put tricks upon 's:** delude us with a conjuror's or showman's devices. **salvages:** savages. **Inde:** India.
60–61. **As . . . legs.** Stephano adapts a proverbial expression by substituting *four* for *two.* *Proper* = handsome. 63. **at':** at the.
68. **for that:** i.e. because he knows our language. **recover:** restore.
70. **neat's-leather:** cowhide. 76–77. **I will . . . much:** whatever I can take for him won't be too much. 77. **hath:** gets.
79–80. **thou wilt anon:** i.e. you will hurt me more very soon.
82–83. **here . . . cat.** Alluding to the proverb "Liquor will make a cat talk." 86. **chaps:** jaws. 89. **delicate:** ingenious.

99. **long spoon.** Alluding to the proverb "He must have a long spoon that will eat with the devil." 106. **siege:** excrement. **moon-calf:** monstrosity, creature born misshapen because of lunary influence.
107. **vent:** emit. 116. **and if:** if. 121. **butt of sack:** barrel of Spanish wine. 128. **Swom:** swam. 130. **kiss the book.** Trinculo has taken his oath on the bottle, not on the customary Bible. Stephano means "Take a drink." 139. **when time was:** once upon a time.

CAL. I have seen thee in her, and I do adore thee.
My mistress show'd me thee, and thy dog, and thy
 bush. 141
STE. Come, swear to that; kiss the book. I will
furnish it anon with new contents. Swear.
 [Caliban drinks.]
TRIN. By this good light, this is a very shallow
monster! I afeard of him? A very weak monster! 145
The Man i' th' Moon? A most poor credulous mon-
ster! Well drawn, monster, in good sooth!
CAL. I'll show thee every fertile inch o' th' island;
And I will kiss thy foot. I prithee be my god.
TRIN. By this light, a most perfidious and drunken
monster! When 's god's asleep, he'll rob his
bottle. 151
CAL. I'll kiss thy foot. I'll swear myself thy subject.
STE. Come on then; down, and swear.
TRIN. I shall laugh myself to death at this puppy-
headed monster. A most scurvy monster! I could find
in my heart to beat him— 156
STE. Come, kiss.
TRIN. But that the poor monster's in drink. An
abominable monster!
CAL. I'll show thee the best springs; I'll pluck thee
berries; 160
I'll fish for thee, and get thee wood enough.
A plague upon the tyrant that I serve!
I'll bear him no more sticks, but follow thee,
Thou wondrous man.
TRIN. A most ridiculous monster, to make a wonder
of a poor drunkard! 166
CAL. I prithee let me bring thee where crabs grow;
And I with my long nails will dig thee pig-nuts,
Show thee a jay's nest, and instruct thee how
To snare the nimble marmazet. I'll bring thee 170
To clust'ring filberts, and sometimes I'll get thee
Young scamels from the rock. Wilt thou go with me?
STE. I prithee now lead the way without any more
talking. Trinculo, the King and all our company else
being drown'd, we will inherit here. Here! bear 175
my bottle. Fellow Trinculo, we'll fill him by and by
again.
CAL. [*Sings drunkenly.*} Farewell, master; fare-
well, farewell!

TRIN. A howling monster; a drunken monster!
CAL. No more dams I'll make for fish, 180
Nor fetch in firing
 At requiring,
Nor scrape trenchering, nor wash dish.
 'Ban, 'Ban, Ca-Caliban
Has a new master, get a new man. 185
Freedom, high-day! high-day, freedom! freedom, high-
day, freedom!
STE. O brave monster! lead the way. *Exeunt.*

ACT III, SCENE I

Enter FERDINAND *bearing a log.*

FER. There be some sports are painful, and their
 labor
Delight in them [sets] off; some kinds of baseness
Are nobly undergone; and most poor matters
Point to rich ends. This my mean task
Would be as heavy to me as odious, but 5
The mistress which I serve quickens what's dead,
And makes my labors pleasures. O, she is
Ten times more gentle than her father's crabbed;
And he's compos'd of harshness. I must remove
Some thousands of these logs, and pile them up, 10
Upon a sore injunction. My sweet mistress
Weeps when she sees me work, and says such baseness
Had never like executor. I forget;
But these sweet thoughts do even refresh my
 labors, 14
Most [busil'est] when I do it.

Enter MIRANDA, *and* PROSPERO [*at a distance, unseen*].

MIR. Alas, now pray you
Work not so hard. I would the lightning had
Burnt up those logs that you are enjoin'd to pile!
Pray set it down, and rest you. When this burns,
'Twill weep for having wearied you. My father
Is hard at study; pray now rest yourself, 20
He's safe for these three hours.
FER. O most dear mistress,
The sun will set before I shall discharge
What I must strive to do.

183. **trenchering:** trenchers, wooden plates.

III.i. Location: Before Prospero's cell.

1. **are painful:** that are laborious.

1–2. **their . . . off:** their laboriousness increases our pleasure in them
(?) or our pleasure in them offsets their laboriousness (?).

2. **baseness:** menial activity. 6. **quickens:** brings to life.

11. **sore injunction:** harsh command. 13. **like:** such, i.e. such a
noble. 15. **Most . . . it:** when I am working hardest. 19. **weep:**
i.e. exude resin.

141. **dog . . . bush.** The man in the moon was placed there in punish-
ment for gathering firewood on Sunday. 147. **Well drawn:** that's a
good long draught you've taken. **sooth:** truth. 167. **crabs:** crab
apples. 168. **pig-nuts:** peanuts. 170. **marmazet:** marmoset (a
small monkey). 172. **scamels.** Meaning unknown, but apparently
either shellfish or rock-inhabiting birds. Some editors emend to *sea-
mels,* i.e. sea-mews.

MIR. If you'll sit down,
 I'll bear your logs the while. Pray give me that,
 I'll carry it to the pile.
FER. No, precious creature, 25
 I had rather crack my sinews, break my back,
 Than you should such dishonor undergo,
 While I sit lazy by.
MIR. It would become me
 As well as it does you; and I should do it
 With much more ease, for my good will is to it, 30
 And yours it is against.
PROS. [*Aside.*] Poor worm, thou art infected!
 This visitation shows it.
MIR. You look wearily.
FER. No, noble mistress, 'tis fresh morning with me
 When you are by at night. I do beseech you—
 Chiefly that I might set it in my prayers— 35
 What is your name?
MIR. Miranda.—O my father,
 I have broke your hest to say so.
FER. Admir'd Miranda,
 Indeed the top of admiration! worth
 What's dearest to the world! Full many a lady
 I have ey'd with best regard, and many a time 40
 Th' harmony of their tongues hath into bondage
 Brought my too diligent ear. For several virtues
 Have I lik'd several women, never any
 With so full soul but some defect in her
 Did quarrel with the noblest grace she ow'd, 45
 And put it to the foil. But you, O you,
 So perfect and so peerless, are created
 Of every creature's best!
MIR. I do not know
 One of my sex; no woman's face remember,
 Save, from my glass, mine own; nor have I seen 50
 More that I may call men than you, good friend,
 And my dear father. How features are abroad
 I am skilless of; but by my modesty
 (The jewel in my dower), I would not wish
 Any companion in the world but you; 55
 Nor can imagination form a shape,
 Besides yourself, to like of. But I prattle
 Something too wildly, and my father's precepts
 I therein do forget.
FER. I am, in my condition,
 A prince, Miranda; I do think, a king 60
 (I would, not so!), and would no more endure
This wooden slavery than to suffer
 The flesh-fly blow my mouth. Hear my soul speak:
 The very instant that I saw you, did
 My heart fly to your service, there resides, 65
 To make me slave to it, and for your sake
 Am I this patient log-man.
MIR. Do you love me?
FER. O heaven, O earth, bear witness to this sound,
 And crown what I profess with kind event
 If I speak true! if hollowly, invert 70
 What best is boded me to mischief! I,
 Beyond all limit of what else i' th' world,
 Do love, prize, honor you.
MIR. I am a fool
 To weep at what I am glad of.
PROS. [*Aside.*] Fair encounter
 Of two most rare affections! Heavens rain grace 75
 On that which breeds between 'em!
FER. Wherefore weep you?
MIR. At mine unworthiness, that dare not offer
 What I desire to give; and much less take
 What I shall die to want. But this is trifling,
 And all the more it seeks to hide itself, 80
 The bigger bulk it shows. Hence, bashful cunning,
 And prompt me, plain and holy innocence!
 I am your wife, if you will marry me;
 If not, I'll die your maid. To be your fellow
 You may deny me, but I'll be your servant, 85
 Whether you will or no.
FER. My mistress, dearest,
 And I thus humble ever.
MIR. My husband then?
FER. Ay, with a heart as willing
 As bondage e'er of freedom. Here's my hand.
MIR. And mine, with my heart in't. And now fare-
 well 90
 Till half an hour hence.
FER. A thousand, thousand!
 Exeunt [FERDINAND *and* MIRANDA *severally*].
PROS. So glad of this as they I cannot be,
 Who are surpris'd [withal]; but my rejoicing
 At nothing can be more. I'll to my book,
 For yet ere supper-time must I perform 95
 Much business appertaining. *Exit.*

32. **visitation:** (1) visit; (2) attack of plague (carrying on the medical figure in *infected*). 37. **hest:** command. **Admir'd Miranda.** A pun, since *Miranda* = admired, i.e. wondered at. 40. **best regard:** highest approval. 42, 43. **several:** particular. 45. **ow'd:** owned. 46. **foil:** (1) contrast; (2) defeat. 52. **abroad:** elsewhere. 53. **skilless:** ignorant. 59. **condition:** rank.

62. **wooden slavery:** being compelled to carry wood. 63. **blow:** defile. 69. **kind event:** favorable outcome. 70. **hollowly:** insincerely. 70–71. **invert . . . to mischief:** turn . . . to ill fortune. 71. **boded:** destined. 79. **want:** be without. 81. **bashful cunning:** coyness. 84. **maid:** handmaiden. **fellow:** mate. 91. **thousand:** i.e. thousand farewells. 93. **withal:** with it, i.e. by it.

SCENE II

Enter CALIBAN, STEPHANO, *and* TRINCULO.

STE. Tell not me. When the butt is out, we will
drink water—not a drop before; therefore bear up and
board 'em. Servant-monster, drink to me.

TRIN. Servant-monster? the folly of this island!
They say there's but five upon this isle: we are 5
three of them; if th' other two be brain'd like us,
the state totters.

STE. Drink, servant-monster, when I bid thee.
Thy eyes are almost set in thy head. 9

TRIN. Where should they be set else? He were a
brave monster indeed if they were set in his tail.

STE. My man-monster hath drown'd his tongue in
sack. For my part, the sea cannot drown me; I swam,
ere I could recover the shore, five and thirty leagues
off and on. By this light, thou shalt be my lieutenant,
monster, or my standard. 16

TRIN. Your lieutenant if you list, he's no standard.

STE. We'll not run, Monsieur Monster.

TRIN. Nor go neither; but you'll lie like dogs, and
yet say nothing neither. 20

STE. Moon-calf, speak once in thy life, if thou beest
a good moon-calf.

CAL. How does thy honor? Let me lick thy shoe.
I'll not serve him, he is not valiant. 24

TRIN. Thou liest, most ignorant monster, I am in
case to justle a constable. Why, thou debosh'd fish
thou, was there ever man a coward that hath drunk so
much sack as I to-day? Wilt thou tell a monstrous lie,
being but half a fish and half a monster? 29

CAL. Lo, how he mocks me! Wilt thou let him, my
lord?

TRIN. "Lord," quoth he? That a monster should be
such a natural! 33

CAL. Lo, lo again. Bite him to death, I prithee.

STE. Trinculo, keep a good tongue in your head. If
you prove a mutineer—the next tree! The poor mon-
ster's my subject, and he shall not suffer indignity.

CAL. I thank my noble lord. Wilt thou be pleas'd to
hearken once again to the suit I made to thee? 39

STE. Marry, will I; kneel, and repeat it. I will stand,
and so shall Trinculo.

Enter ARIEL, *invisible.*

CAL. As I told thee before, I am subject to a tyrant,
A sorcerer, that by his cunning hath
Cheated me of the island. 44

ARI. Thou liest.

CAL. Thou liest, thou jesting monkey thou!
I would my valiant master would destroy thee.
I do not lie.

STE. Trinculo, if you trouble him any more in 's
tale, by this hand, I will supplant some of your teeth.

TRIN. Why, I said nothing. 50

STE. Mum then, and no more.—Proceed.

CAL. I say by sorcery he got this isle;
From me he got it. If thy greatness will
Revenge it on him—for I know thou dar'st,
But this thing dare not— 55

STE. That's most certain.

CAL. Thou shalt be lord of it, and I'll serve thee.

STE. How now shall this be compass'd? Canst thou
bring me to the party? 59

CAL. Yea, yea, my lord. I'll yield him thee asleep,
Where thou mayst knock a nail into his head.

ARI. Thou liest, thou canst not.

CAL. What a pied ninny's this! Thou scurvy patch!
I do beseech thy greatness, give him blows,
And take his bottle from him. When that's gone, 65
He shall drink nought but brine, for I'll not show him
Where the quick freshes are.

STE. Trinculo, run into no further danger; interrupt
the monster one word further, and by this hand, 69
I'll turn my mercy out o' doors, and make a stock-fish
of thee.

TRIN. Why, what did I? I did nothing. I'll go
farther off.

STE. Didst thou not say he lied?

ARI. Thou liest. 75

STE. Do I so? Take thou that. [*Beats* TRINCULO.]
As you like this, give me the lie another time.

TRIN. I did not give the lie. Out o' your wits, and
hearing too? A pox o' your bottle! this can sack 79
and drinking do. A murrain on your monster, and the
devil take your fingers!

CAL. Ha, ha, ha!

STE. Now forward with your tale.—Prithee stand
further off.

III.ii. Location: Another part of the island.
1. **out:** empty. 2–3. **bear . . . 'em:** stand firm and attack. Stephano
uses naval jargon as an encouragement to drink.
4. **folly of:** low level of intellect on. 9. **set:** sunk out of sight.
Trinculo puns on the sense "placed."
16. **standard:** standard-bearer. 17. **no standard:** i.e. unable to
stand. 18. **run:** i.e. run from the enemy. 19. **go:** walk. **lie:** (1)
lie down; (2) tell lies; (3) excrete (with a backward glance at *run* in the
sense "urinate" and perhaps at *standard* in the sense "conduit").
26. **case:** fit condition. **debosh'd:** debauched. 33. **natural:** idiot.
The point is that a monster is by definition "unnatural."

40. **Marry:** indeed (originally the name of the Virgin Mary used as
an oath). 55. **this thing:** i.e. Trinculo. 63. **pied . . . patch:**
foolish . . . fool (from the multicolored garb of the professional fool).
67. **quick freshes:** fresh-water springs. 70. **stock-fish:** dried cod,
so stiff it had to be beaten before cooking. 80. **murrain:** a disease
of cattle.

CAL. Beat him enough. After a little time 85
I'll beat him too.
STE. Stand farther.—Come, proceed.
CAL. Why, as I told thee, 'tis a custom with him
I' th' afternoon to sleep. There thou mayst brain him,
Having first seiz'd his books; or with a log
Batter his skull, or paunch him with a stake, 90
Or cut his wezand with thy knife. Remember
First to possess his books; for without them
He's but a sot, as I am; nor hath not
One spirit to command: they all do hate him
As rootedly as I. Burn but his books. 95
He has brave utensils (for so he calls them)
Which when he has a house, he'll deck withal.
And that most deeply to consider is
The beauty of his daughter. He himself
Calls her a nonpareil. I never saw a woman 100
But only Sycorax my dam and she;
But she as far surpasseth Sycorax
As great'st does least.
STE. Is it so brave a lass?
CAL. Ay, lord, she will become thy bed, I warrant,
And bring thee forth brave brood. 105
STE. Monster, I will kill this man. His daughter
and I will be king and queen—save our Graces! and
Trinculo and thyself shall be viceroys. Dost thou like
the plot, Trinculo?
TRIN. Excellent. 110
STE. Give me thy hand. I am sorry I beat thee; but
while thou liv'st keep a good tongue in thy head.
CAL. Within this half hour will he be asleep.
Wilt thou destroy him then?
STE. Ay, on mine honor.
ARI. This will I tell my master. 115
CAL. Thou mak'st me merry; I am full of pleasure,
Let us be jocund. Will you troll the catch
You taught me but while-ere?
STE. At thy request, monster, I will do reason, any
reason. Come on, Trinculo, let us sing. *Sings.* 120
"Flout 'em and [scout] 'em,
And scout 'em and flout 'em!
Thought is free."
CAL. That's not the tune.

ARIEL plays the tune on a tabor and pipe.

STE. What is this same? 125
TRIN. This is the tune of our catch, play'd by the
picture of Nobody.

STE. If thou beest a man, show thyself in thy like-
ness. If thou beest a devil, take't as thou list.
TRIN. O, forgive me my sins! 130
STE. He that dies pays all debts. I defy thee. Mercy
upon us!
CAL. Art thou afeard?
STE. No, monster, not I.
CAL. Be not afeard, the isle is full of noises, 135
Sounds, and sweet airs, that give delight and hurt not.
Sometimes a thousand twangling instruments
Will hum about mine ears; and sometime voices,
That if I then had wak'd after long sleep,
Will make me sleep again, and then in dreaming, 140
The clouds methought would open, and show riches
Ready to drop upon me, that when I wak'd
I cried to dream again.
STE. This will prove a brave kingdom to me, where
I shall have my music for nothing. 145
CAL. When Prospero is destroy'd.
STE. That shall be by and by. I remember the story.
TRIN. The sound is going away. Let's follow it,
and after do our work. 149
STE. Lead, monster, we'll follow. I would I could
see this taborer; he lays it on.
TRIN. Wilt come? I'll follow Stephano. *Exeunt.*

SCENE III

Enter ALONSO, SEBASTIAN, ANTONIO, GONZALO,
ADRIAN, FRANCISCO, *etc.*

GON. By'r lakin, I can go no further, sir,
My old bones aches. Here's a maze trod indeed
Through forth-rights and meanders! By your patience,
I needs must rest me.
ALON. Old lord, I cannot blame thee,
Who am myself attach'd with weariness 5
To th' dulling of my spirits. Sit down, and rest.
Even here I will put off my hope, and keep it
No longer for my flatterer. He is drown'd
Whom thus we stray to find, and the sea mocks
Our frustrate search on land. Well, let him go. 10
ANT. [*Aside to* SEBASTIAN.] I am right glad that he's
so out of hope.
Do not for one repulse forgo the purpose
That you resolv'd t' effect.

90. **paunch:** stab in the belly. 91. **wezand:** windpipe.
93. **sot:** fool. 96. **utensils:** furnishings. 97. **withal:** with.
117. **troll the catch:** sing the round. 118. **but while-ere:** a short
time ago. 121. **Flout:** deride. **scout:** jeer at.
124 s.d. **tabor:** small drum. 127. **picture of Nobody:** traditional
image of a man with arms and legs but no torso; but Trinculo means
an invisible agency.

129. **take't . . . list:** do as you please (a challenge).
135. **noises:** musical sounds. 137. **twangling.** An invented word.
147. **by and by:** immediately.

III.iii. Location: Another part of the island.
1. **By'r lakin:** by our Ladykin, i.e. the Virgin Mary.
3. **forth-rights:** straight paths. 5. **attach'd:** seized. 8. **for:** as.
12. **for:** because of.

SEB. [*Aside to* ANTONIO.] The next advantage
 Will we take throughly.
ANT. [*Aside to* SEBASTIAN.] Let it be to-night,
 For now they are oppress'd with travail, they 15
 Will not, nor cannot, use such vigilance
 As when they are fresh.
SEB. [*Aside to* ANTONIO.] I say to-night. No more.

Solemn and strange music; and PROSPER *on the top, invisible.*

ALON. What harmony is this? My good friends,
 hark!
GON. Marvellous sweet music!

Enter several strange SHAPES, *bringing in a banket; and
dance about it with gentle actions of salutations; and
inviting the* KING, *etc., to eat, they depart.*

ALON. Give us kind keepers, heavens! what were
 these? 20
SEB. A living drollery. Now I will believe
 That there are unicorns; that in Arabia
 There is one tree, the phoenix' throne, one phoenix
 At this hour reigning there.
ANT. I'll believe both;
 And what does else want credit, come to me, 25
 And I'll be sworn 'tis true. Travellers ne'er did lie,
 Though fools at home condemn 'em.
GON. If in Naples
 I should report this now, would they believe me?
 If I should say I saw such [islanders]
 (For, certes, these are people of the island), 30
 Who though they are of monstrous shape, yet note
 Their manners are more gentle, kind, than of
 Our human generation you shall find
 Many, nay, almost any.
PROS. [*Aside.*] Honest lord,
 Thou hast said well; for some of you there present
 Are worse than devils.
ALON. I cannot too much muse 36
 Such shapes, such gesture, and such sound expressing
 (Although they want the use of tongue) a kind
 Of excellent dumb discourse.
PROS. [*Aside.*] Praise in departing.
FRAN. They vanish'd strangely.

SEB. No matter, since
 They have left their viands behind; for we have
 stomachs. 41
 Will't please you taste of what is here?
ALON. Not I.
GON. Faith, sir, you need not fear. When we were
 boys,
 Who would believe that there were mountaineers,
 Dew-lapp'd, like bulls, whose throats had hanging at
 'em 45
 Wallets of flesh? or that there were such men
 Whose heads stood in their breasts? which now we
 find
 Each putter-out of five for one will bring us
 Good warrant of.
ALON. I will stand to, and feed,
 Although my last, no matter, since I feel 50
 The best is past. Brother, my lord the Duke,
 Stand to, and do as we.

Thunder and lightning. Enter ARIEL, *like a harpy, claps
his wings upon the table, and with a quaint device the
banquet vanishes.*

ARI. You are three men of sin, whom Destiny,
 That hath to instrument this lower world
 And what is in't, the never-surfeited sea 55
 Hath caus'd to belch up you; and on this island
 Where man doth not inhabit—you 'mongst men
 Being most unfit to live. I have made you mad;
 And even with such-like valor men hang and drown
 Their proper selves.
 [ALONSO, SEBASTIAN, *etc. draw their swords.*]
 You fools! I and my fellows 60
 Are ministers of Fate. The elements,
 Of whom your sword are temper'd, may as well
 Wound the loud winds, or with bemock'd-at stabs
 Kill the still-closing waters, as diminish
 One dowle that's in my plume. My fellow ministers

41. **stomachs:** appetites. 45. **Dew-lapp'd:** with pouches of skin hanging from the neck (probably alluding to travellers' tales about goiter among Swiss mountaineers). 46–47. **men . . . breasts.** A common travellers' tale. See *Othello*, I.iii.144–45. 48. **Each . . . one.** Travellers deposited a sum of money at home to be repaid five-fold if they returned, forfeited if they did not. 49. **stand to:** take the risk. 51. **best:** i.e. best part of life. 52 s.d. **like a harpy:** in the shape of a harpy, a rapacious monster with the face of a woman and the wings and claws of a bird of prey. **with . . . device:** by means of an ingenious stage mechanism. 54. **to:** for. 59. **such-like valor:** i.e. the valor of madness, very different from true courage. 60. **proper:** own. 62. **whom:** which. 64. **still-closing:** always closing as soon as parted. 65. **dowle:** small feather.

14. **throughly:** thoroughly. 17 s.d. **top.** Probably the third level of the tiring-house. 19 s.d. **banket:** banquet, i.e. light repast. 20. **kind keepers:** guardian angels. 21. **living drollery:** puppet show with live actors. 25. **want credit:** lack credence. 30. **certes:** certainly. 31. **monstrous:** abnormal, unnatural. 36. **muse:** wonder at. 39. **Praise in departing:** i.e. don't judge until you see the conclusion (proverbial).

Are like invulnerable. If you could hurt, 66
Your swords are now too massy for your strengths,
And will not be uplifted. But remember
(For that's my business to you) that you three
From Milan did supplant good Prospero, 70
Expos'd unto the sea (which hath requit it)
Him, and his innocent child; for which foul deed
The pow'rs, delaying (not forgetting), have
Incens'd the seas and shores—yea, all the creatures,
Against your peace. Thee of thy son, Alonso, 75
They have bereft; and do pronounce by me
Ling'ring perdition (worse than any death
Can be at once) shall step by step attend
You and your ways, whose wraths to guard you
 from—
Which here, in this most desolate isle, else falls 80
Upon your heads—is nothing but heart's sorrow,
And a clear life ensuing.

He vanishes in thunder; then, to soft music, enter the
SHAPES *again, and dance, with mocks and mows, and*
carrying out the table.

PROS. Bravely the figure of this harpy hast thou
Perform'd, my Ariel; a grace it had, devouring.
Of my instruction hast thou nothing bated 85
In what thou hadst to say; so with good life,
And observation strange, my meaner ministers
Their several kinds have done. My high charms work,
And these, mine enemies, are all knit up
In their distractions. They now are in my pow'r; 90
And in these fits I leave them, while I visit
Young Ferdinand, whom they suppose is drown'd,
And his and mine lov'd darling. [*Exit above.*]
GON. I' th' name of something holy, sir, why stand
 you
In this strange stare?
ALON. O, it is monstrous! monstrous!
Methought the billows spoke, and told me of it; 96
The winds did sing it to me, and the thunder,
That deep and dreadful organ-pipe, pronounc'd
The name of Prosper; it did base my trespass.
Therefore my son i' th' ooze is bedded; and 100

I'll seek him deeper than e'er plummet sounded,
And with him there lie mudded. *Exit.*
SEB. But one fiend at a time,
I'll fight their legions o'er.
ANT. I'll be thy second.
 Exeunt [SEBASTIAN *and* ANTONIO].
GON. All three of them are desperate: their great
 guilt
(Like poison given to work a great time after) 105
Now gins to bite the spirits. I do beseech you
(That are of suppler joints) follow them swiftly,
And hinder them from what this ecstasy
May now provoke them to.
PROS. Follow, I pray you. *Exeunt omnes.*

ACT IV, SCENE I

Enter PROSPERO, FERDINAND, *and* MIRANDA.

PROS. If I have too austerely punish'd you,
Your compensation makes amends, for I
Have given you here a third of mine own life,
Or that for which I live; who once again
I tender to thy hand. All thy vexations 5
Were but my trials of thy love, and thou
Hast strangely stood the test. Here, afore heaven,
I ratify this my rich gift. O Ferdinand,
Do not smile at me that I boast her [off],
For thou shalt find she will outstrip all praise 10
And make it halt behind her.
FER. I do believe it
Against an oracle.
PROS. Then, as my [gift], and thine own acquisition
Worthily purchased, take my daughter. But
If thou dost break her virgin-knot before 15
All sanctimonious ceremonies may
With full and holy rite be minist'red,
No sweet aspersion shall the heavens let fall
To make this contract grow; but barren hate,
Sour-ey'd disdain, and discord shall bestrew 20

103. **o'er:** one after another. 106. **gins . . . spirits:** begins to cause mental anguish. 108. **ecstasy:** fit of madness.

IV.i. Location: Before Prospero's cell.
3. **a third . . . life.** Various explanations have been put forward: for example, that the other two parts have been his dukedom and his books, or his late wife and his personal interests; or that Miranda represents his future, the other two parts being his past and his present; or that he has spent a third of his life on Miranda's education.
7. **strangely:** wonderfully well. 9. **boast her off:** i.e. praise her so highly. 11. **halt:** limp. 12. **Against an oracle:** even if an oracle should declare otherwise. 16. **sanctimonious:** sacred, holy.
18. **aspersion:** i.e. blessing; literally, sprinkling, as of rain that promotes fertility and growth. 19. **grow:** be fruitful (as contrasted with *barren*).

66. **like:** similarly. 71. **requit it:** repaid the act (by casting you up here). 77. **perdition:** ruin. 79. **whose:** i.e. those of the "pow'rs" of line 73. 81. **is . . . sorrow:** there is no means except repentance. 82. **clear:** sinless. s.d. **mocks and mows:** mocking gestures and grimaces. 84. **devouring:** i.e. making the banquet disappear. 85. **bated:** omitted. 86. **life:** realism.
87. **observation strange:** exceptional care. **meaner:** i.e. inferior to Ariel. 88. **several kinds:** individual parts.
89–90. **knit . . . distractions:** entangled in their madness.
94–95. **why . . . stare.** Gonzalo has not heard Ariel's speech.
96. **it:** i.e. my sin. 99. **base:** bass, i.e. utter in a deep voice.
100. **Therefore:** therefor, i.e. in consequence of his trespass.

The union of your bed with weeds so loathly
That you shall hate it both. Therefore take heed,
As Hymen's lamps shall light you.
FER. As I hope
 For quiet days, fair issue, and long life,
 With such love as 'tis now, the murkiest den, 25
 The most opportune place, the strong'st suggestion
 Our worser genius can, shall never melt
 Mine honor into lust, to take away
 The edge of that day's celebration, 29
 When I shall think or Phoebus' steeds are founder'd
 Or Night kept chain'd below.
PROS. Fairly spoke.
 Sit then and talk with her, she is thine own.
 What, Ariel! my industrious servant, Ariel!

Enter ARIEL.

ARI. What would my potent master? here I am.
PROS. Thou and thy meaner fellows your last
 service 35
 Did worthily perform; and I must use you
 In such another trick. Go bring the rabble
 (O'er whom I give thee pow'r) here to this place.
 Incite them to quick motion, for I must
 Bestow upon the eyes of this young couple 40
 Some vanity of mine art. It is my promise,
 And they expect it from me.
ARI. Presently?
PROS. Ay, with a twink.
ARI. Before you can say "come" and "go,"
 And breathe twice, and cry "so, so," 45
 Each one, tripping on his toe,
 Will be here with mop and mow.
 Do you love me, master? no?
PROS. Dearly, my delicate Ariel. Do not approach
 Till thou dost hear me call.
ARI. Well; I conceive. *Exit.*
PROS. Look thou be true; do not give dalliance 51
 Too much the rein. The strongest oaths are straw

To th' fire i' th' blood. Be more abstenious,
Or else good night your vow!
FER. I warrant you, sir,
 The white cold virgin snow upon my heart 55
 Abates the ardor of my liver.
PROS. Well.
 Now come, my Ariel, bring a corollary,
 Rather than want a spirit. Appear, and pertly!
 No tongue! all eyes! Be silent. *Soft music.*

Enter IRIS.

IRIS. Ceres, most bounteous lady, thy rich leas 60
 Of wheat, rye, barley, fetches, oats, and pease;
 Thy turfy mountains, where live nibbling sheep,
 And flat meads thatch'd with stover, them to keep;
 Thy banks with pioned and twilled brims,
 Which spungy April at thy hest betrims, 65
 To make cold nymphs chaste crowns; and thy broom-
 groves,
 Whose shadow the dismissed bachelor loves,
 Being lass-lorn; thy pole-clipt vineyard,
 And thy sea-marge, sterile and rocky-hard, 69
 Where thou thyself dost air—the Queen o' th' sky,
 Whose wat'ry arch and messenger am I,
 Bids thee leave these, and with her sovereign Grace,
 Here on this grass-plot, in this very place,
 To come and sport. [Her] peacocks fly amain.
 JUNO *descends [slowly in her car]*.
 Approach, rich Ceres, her to entertain. 75

Enter CERES.

CER. Hail, many-colored messenger, that ne'er
 Dost disobey the wife of Jupiter;
 Who with thy saffron wings upon my flow'rs
 Diffusest honey-drops, refreshing show'rs,
 And with each end of thy blue bow dost crown 80
 My bosky acres and my unshrubb'd down,

53. **abstenious:** abstemious. 56. **liver.** Supposed seat of the passions. 57. **corollary:** extra. 58. **want:** lack. **pertly:** briskly.
59. **No tongue.** Any speech from the spectators would make the spirits vanish. Cf. lines 126–27. s.d. **Iris:** goddess of the rainbow and Juno's messenger. 60. **Ceres:** goddess of agriculture. **leas:** meadows, cultivated land. 61. **fetches:** vetch, a fodder plant.
63. **stover:** hay for winter use. 64. **pioned and twilled:** undercut by the stream and retained by interwoven branches.
65. **spungy:** spongy, i.e. wet. 66. **cold:** chaste. **broom:** a kind of shrub bearing yellow flowers. 67. **dismissed bachelor:** rejected suitor. 68. **pole-clipt:** poll-clipped, i.e. with top growth pruned back (?). If *clipt* means (as often) "embraced," the sense could be "enclosed by a fence of poles" or "with poles entwined by the vines."
70. **Queen . . . sky:** Juno. 74. **peacocks.** Juno's sacred birds, which drew her chariot. **amain:** swiftly. 75. **entertain:** receive.
81. **bosky:** wooded. **down:** upland.

21. **weeds.** Instead of the flowers with which the marriage bed was customarily strewn. 23. **As . . . you:** i.e. as you desire happiness in your marriage. The symbolic torch of Hymen, god of marriage, was supposed to promise happiness if it burned with a clear flame, the opposite if it smoked. 26. **suggestion:** temptation. 27. **Our . . . can:** our bad angel is capable of. 30. **or . . . founder'd:** either the sun-god's horses have gone lame (because the day is so long). 37. **trick:** ingenious device (technical term in pageantry). **rabble:** troop of inferior spirits. 41. **vanity:** show, delusive appearance.
42. **Presently:** immediately. 43. **with a twink:** in a twinkling.
47. **mop and mow:** gesture and grimace. 50. **conceive:** understand.

Rich scarf to my proud earth—why hath thy Queen
Summon'd me hither, to this short-grass'd green?
IRIS. A contract of true love to celebrate,
And some donation freely to estate 85
On the bless'd lovers.
CER. Tell me, heavenly bow,
If Venus or her son, as thou dost know,
Do now attend the Queen? Since they did plot
The means that dusky Dis my daughter got,
Her and her blind boy's scandall'd company 90
I have forsworn.
IRIS. Of her society
Be not afraid. I met her Deity
Cutting the clouds towards Paphos; and her son
Dove-drawn with her. Here thought they to have done
Some wanton charm upon this man and maid, 95
Whose vows are, that no bed-right shall be paid
Till Hymen's torch be lighted; but in vain,
Mars's hot minion is return'd again;
Her waspish-headed son has broke his arrows,
Swears he will shoot no more, but play with
 sparrows,
And be a boy right out.

[JUNO *alights*.]

CER. Highest Queen of state, 101
Great Juno, comes, I know her by her gait.
JUNO. How does my bounteous sister? Go with me
To bless this twain, that they may prosperous be,
And honor'd in their issue. *They sing.* 105
JUNO. Honor, riches, marriage-blessing,
 Long continuance, and increasing,
 Hourly joys be still upon you!
 Juno sings her blessings on you.
[CER.] Earth's increase, foison plenty, 110
 Barns and garners never empty;
 Vines with clust'ring bunches growing,
 Plants with goodly burthen bowing;
 Spring come to you at the farthest
 In the very end of harvest! 115

Scarcity and want shall shun you,
Ceres' blessing so is on you.
FER. This is a most majestic vision, and
Harmonious charmingly. May I be bold
To think these spirits?
PROS. Spirits, which by mine art 120
I have from their confines call'd to enact
My present fancies.
FER. Let me live here ever;
So rare a wond'red father and a wise
Makes this place Paradise.
JUNO *and* CERES *whisper, and send Iris on employment.*
PROS. Sweet now, silence!
Juno and Ceres whisper seriously; 125
There's something else to do. Hush and be mute,
Or else our spell is marr'd.
IRIS. You nymphs, call'd Naiades, of the windring
 brooks,
With your sedg'd crowns and ever-harmless looks,
Leave your crisp channels, and on this green
 land 130
Answer your summons; Juno does command.
Come, temperate nymphs, and help to celebrate
A contract of true love; be not too late.

Enter certain NYMPHS.

You sunburn'd sicklemen, of August weary,
Come hither from the furrow and be merry. 135
Make holiday; your rye-straw hats put on,
And these fresh nymphs encounter every one
In country footing.

Enter certain REAPERS, *properly habited: they join with
the* NYMPHS *in a graceful dance, towards the end
whereof* PROSPERO *starts suddenly, and speaks; after
which, to a strange, hollow, and confused noise, they
heavily vanish.*

PROS. [*Aside.*] I had forgot that foul conspiracy
Of the beast Caliban and his confederates 140
Against my life. The minute of their plot
Is almost come. [*To the* SPIRITS.] Well done, avoid;
 no more.
FER. This is strange. Your father's in some passion
That works him strongly.

85. **estate:** bestow. 87. **son:** Cupid, the "blind boy" of line 90.
89. **Dis:** Pluto, ruler of the underworld (hence *dusky*), who carried
off Ceres' daughter Proserpine to be his queen.
90. **scandall'd:** scandalous. 93. **Paphos:** place in Cyprus sacred
to Venus. 94. **Dove-drawn.** Venus' chariot was drawn by her
sacred doves. 94–95. **done . . . charm:** cast some unchaste spell.
98. **hot minion:** lustful mistress. Venus and Mars were lovers.
return'd: i.e. to Paphos. 99. **waspish-headed:** peevish.
100. **sparrows.** Like doves, sacred to Venus. Sparrows were prover-
bially lecherous. 101. **right out:** outright. **Highest . . . state:** most
majestic queen. 102. **gait:** i.e. regal bearing.
108. **still:** always. 110. **foison plenty:** plentiful abundance.
115. **In . . . harvest:** i.e. without intervening winter.

119. **charmingly:** enchantingly, magically. 123. **wond'red:** (1) to
be wondered at; (2) able to perform wonders; (3) possessed of that
wonder, Miranda (see note to III.i.37). 124. **Sweet now, silence.**
Addressed to Miranda, who is about to speak. 128. **windring:**
winding and wandering (apparently a coinage of Shakespeare's).
129. **ever-harmless:** ever-innocent. 130. **crisp:** rippling.
132. **temperate:** chaste. 137. **fresh:** young and beautiful. **en-
counter:** meet. 138. **footing:** dance. s.d. **heavily:** reluctantly.
142. **avoid:** be gone. 144. **works:** agitates.

MIR. Never till this day
 Saw I him touch'd with anger, so distemper'd. 145
PROS. You do look, my son, in a mov'd sort,
 As if you were dismay'd; be cheerful, sir.
 Our revels now are ended. These our actors
 (As I foretold you) were all spirits, and
 Are melted into air, into thin air, 150
 And like the baseless fabric of this vision,
 The cloud-capp'd tow'rs, the gorgeous palaces,
 The solemn temples, the great globe itself,
 Yea, all which it inherit, shall dissolve,
 And like this insubstantial pageant faded 155
 Leave not a rack behind. We are such stuff
 As dreams are made on; and our little life
 Is rounded with a sleep. Sir, I am vex'd;
 Bear with my weakness, my old brain is troubled.
 Be not disturb'd with my infirmity. 160
 If you be pleas'd, retire into my cell,
 And there repose. A turn or two I'll walk
 To still my beating mind.
FER., MIR. We wish your peace.
PROS. [*To* ARIEL.] Come with a thought.
 [*To* FERDINAND *and* MIRANDA.] I thank thee.
 Exeunt [FERDINAND *and* MIRANDA].
 Ariel! come.

Enter ARIEL.

ARI. Thy thoughts I cleave to. What's thy
 pleasure?
PROS. Spirit, 165
 We must prepare to meet with Caliban.
ARI. Ay, my commander. When I presented
 Ceres,
 I thought to have told thee of it, but I fear'd
 Lest I might anger thee.
PROS. Say again, where didst thou leave these
 varlots? 170
ARI. I told you, sir, they were red-hot with
 drinking,
 So full of valor that they smote the air
 For breathing in their faces; beat the ground
 For kissing of their feet; yet always bending
 Towards their project. Then I beat my tabor, 175

At which like unback'd colts they prick'd their ears,
Advanc'd their eyelids, lifted up their noses
 As they smelt music. So I charm'd their ears
 That calf-like they my lowing follow'd through
 Tooth'd briers, sharp furzes, pricking goss, and
 thorns,
 Which ent'red their frail shins. At last I left them
 I' th' filthy-mantled pool beyond your cell, 182
 There dancing up to th' chins, that the foul lake
 O'erstunk their feet.
PROS. This was well done, my bird.
 Thy shape invisible retain thou still. 185
 The trumpery in my house, go bring it hither,
 For stale to catch these thieves.
ARI. I go, I go. *Exit.*
PROS. A devil, a born devil, on whose nature
 Nurture can never stick; on whom my pains,
 Humanely taken, all, all lost, quite lost; 190
 And as with age his body uglier grows,
 So his mind cankers. I will plague them all,
 Even to roaring.

Enter ARIEL, *loaden with glistering apparel, etc.*

 Come, hang [them on] this line.

[PROSPERO *and* ARIEL *remain, invisible.*] *Enter* CALIBAN,
STEPHANO, *and* TRINCULO, *all wet.*

CAL. Pray you tread softly, that the blind mole may
 not
 Hear a foot fall; we now are near his cell. 195
STE. Monster, your fairy, which you say is a harm-
 less fairy, has done little better than play'd the Jack
 with us.
TRIN. Monster, I do smell all horse-piss, at which
 my nose is in great indignation. 200
STE. So is mine. Do you hear, monster? If I should
 take a displeasure against you, look you—
TRIN. Thou wert but a lost monster.
CAL. Good my lord, give me thy favor still.
 Be patient, for the prize I'll bring thee to 205
 Shall hoodwink this mischance; therefore speak softly,
 All's hush'd as midnight yet.
TRIN. Ay, but to lose our bottles in the pool—

146. **mov'd sort:** troubled state. 148. **revels:** festivity,
entertainment. 151. **baseless fabric:** structure without physical
foundation. 154. **which it inherit:** who occupy it.
155. **insubstantial:** without material substance.
156. **rack:** wisp of cloud. 157. **on:** of.
158. **rounded:** surrounded. 164. **with:** at the summons of.
167. **presented:** represented, took the part of (?).
170. **varlots:** varlets, ruffians. 174–75. **bending . . . project:** pur-
suing their purpose—the murder of Prospero.

176. **unback'd:** never ridden, unbroken. 177. **Advanc'd:** raised.
178. **As:** as if. 180. **goss:** gorse. 182. **filthy-mantled:** covered
with dirty scum. 186. **trumpery:** showy finery (the "glistering ap-
parel" of line 193 s.d.). 187. **stale:** bait.
192. **cankers:** becomes malignant. 193. **line:** lime tree, linden.
194. **mole.** Thought to have sensitive hearing.
197. **Jack:** (1) knave; (2) jack-o'-lantern, i.e. will-o'-the-wisp.
206. **hoodwink:** make you blind to.

STE. There is not only disgrace and dishonor in that,
 monster, but an infinite loss. 210

TRIN. That's more to me than my wetting; yet this
 is your harmless fairy, monster!

STE. I will fetch off my bottle, though I be o'er ears
 for my labor.

CAL. Prithee, my king, be quiet. Seest thou here,
 This is the mouth o' th' cell. No noise, and enter. 216
 Do that good mischief which may make this island
 Thine own for ever, and I, thy Caliban,
 For aye thy foot-licker.

STE. Give me thy hand. I do begin to have bloody
 thoughts. 221

TRIN. O King Stephano! O peer! O worthy
 Stephano! look what a wardrobe here is for thee!

CAL. Let it alone, thou fool, it is but trash.

TRIN. O, ho, monster! we know what belongs to a
 frippery. O King Stephano! 226

STE. Put off that gown, Trinculo. By this hand,
 I'll have that gown.

TRIN. Thy Grace shall have it.

CAL. The dropsy drown this fool! what do you
 mean 230
 To dote thus on such luggage? Let['t] alone
 And do the murther first. If he awake,
 From toe to crown he'll fill our skins with pinches,
 Make us strange stuff. 234

STE. Be you quiet, monster. Mistress line, is not
 this my jerkin? Now is the jerkin under the line. Now,
 jerkin, you are like to lose your hair, and prove a bald
 jerkin.

TRIN. Do, do; we steal by line and level, and't like
 your Grace. 240

STE. I thank thee for that jest; here's a garment
 for't. Wit shall not go unrewarded while I am king of
 this country. "Steal by line and level" is an excellent
 pass of pate; there's another garment for't. 244

TRIN. Monster, come put some lime upon your
 fingers, and away with the rest.

CAL. I will have none on't. We shall lose our time,
 And all be turn'd to barnacles, or to apes
 With foreheads villainous low.

STE. Monster, lay-to your fingers. Help to bear this
 away where my hogshead of wine is, or I'll turn you
 out of my kingdom. Go to, carry this. 252

TRIN. And this.

STE. Ay, and this.

A noise of hunters heard. Enter divers SPIRITS *in shape
of dogs and hounds, hunting them about;* PROSPERO *and*
ARIEL *setting them on.*

PROS. Hey, Mountain, hey! 255

ARI. Silver! there it goes, Silver!

PROS. Fury, Fury! there, Tyrant, there! hark, hark!
[CALIBAN, STEPHANO, *and* TRINCULO *are driven out.*]
 Go, charge my goblins that they grind their joints
 With dry convulsions, shorten up their sinews
 With aged cramps, and more pinch-spotted make
 them
 Than pard or cat o' mountain.

ARI. Hark, they roar! 261

PROS. Let them be hunted soundly. At this hour
 Lies at my mercy all mine enemies.
 Shortly shall all my labors end, and thou
 Shalt have the air at freedom. For a little 265
 Follow, and do me service. *Exeunt.*

ACT V, SCENE I

Enter PROSPERO *in his magic robes, and* ARIEL.

PROS. Now does my project gather to a head:
 My charms crack not; my spirits obey; and Time
 Goes upright with his carriage. How's the day?

ARI. On the sixt hour, at which time, my lord,
 You said our work should cease.

PROS. I did say so, 5
 When first I rais'd the tempest. Say, my spirit,
 How fares the King and 's followers?

222. **peer.** Referring to the old ballad "King Stephen was a worthy
peer," quoted in *Othello*, II.iii.89–96. 226. **frippery:** secondhand-
clothes shop. 230. **drown:** suffocate. 231. **luggage:** encumber-
ing trash. 236. **jerkin:** a kind of jacket. **under the line.** With pun
on the sense "south of the equator." The joke involves the popular
idea that travellers to tropical countries lost their hair through fevers,
or from scurvy resulting from lack of fresh food on the long voyage.
239. **Do, do:** an expression of approval, equivalent to "bravo." **by
. . . level:** with plumb-line and carpenter's level, i.e. with professional
skill (continuing the puns on *line*). **and't like:** if it please. 244.
pass: thrust (a fencing term). **pate:** i.e. wit. 245. **lime:** sticky sub-
stance; thieves were jokingly said to have lime on their fingers.
248. **barnacles:** a kind of geese traditionally supposed to develop
from the shellfish so named. 249. **villainous:** wretchedly.

252. **Go to:** expression of exhortation or reproof, equivalent to
"come, come!" 257. **hark:** "sic 'em!" 259. **dry convulsions.**
Precisely what sort of painful seizure is meant here is uncertain.
260. **aged:** such as old people have. 261. **pard:** leopard. **cat o'
mountain:** catamount, wildcat.

V.i. Location: Before Prospero's cell.
3. **Goes . . . carriage:** walks upright under what he is carrying
(because his burden of coming events has been greatly lightened).
4. **On:** approaching. **sixt:** sixth. On the time, see I.ii.240–41.

ARI. Confin'd together
In the same fashion as you gave in charge,
Just as you left them; all prisoners, sir,
In the line-grove which weather-fends your cell; 10
They cannot boudge till your release. The King,
His brother, and yours, abide all three distracted,
And the remainder mourning over them,
Brimful of sorrow and dismay; but chiefly
Him that you term'd, sir, "the good old Lord
 Gonzalo,"
His tears runs down his beard like winter's drops 16
From eaves of reeds. Your charm so strongly works
 'em
That if you now beheld them, your affections
Would become tender.
PROS. Dost thou think so, spirit?
ARI. Mine would, sir, were I human.
PROS. And mine shall.
Hast thou, which art but air, a touch, a feeling 21
Of their afflictions, and shall not myself,
One of their kind, that relish all as sharply
Passion as they, be kindlier mov'd than thou art?
Though with their high wrongs I am strook to th'
 quick, 25
Yet, with my nobler reason, 'gainst my fury
Do I take part. The rarer action is
In virtue than in vengeance. They being penitent,
The sole drift of my purpose doth extend
Not a frown further. Go, release them, Ariel. 30
My charms I'll break, their senses I'll restore,
And they shall be themselves.
ARI. I'll fetch them, sir.
 Exit. [PROSPERO *traces a magic circle with his staff.*]
PROS. Ye elves of hills, brooks, standing lakes, and
 groves,
And ye that on the sands with printless foot
Do chase the ebbing Neptune, and do fly him 35
When he comes back; you demi-puppets that
By moonshine do the green sour ringlets make,
Whereof the ewe not bites; and you whose pastime
Is to make midnight mushrumps, that rejoice

To hear the solemn curfew: by whose aid 40
(Weak masters though ye be) I have bedimm'd
The noontide sun, call'd forth the mutinous winds,
And 'twixt the green sea and the azur'd vault
Set roaring war; to the dread rattling thunder
Have I given fire, and rifted Jove's stout oak 45
With his own bolt; the strong-bas'd promontory
Have I made shake, and by the spurs pluck'd up
The pine and cedar. Graves at my command
Have wak'd their sleepers, op'd, and let 'em forth
By my so potent art. But this rough magic 50
I here abjure; and when I have requir'd
Some heavenly music (which even now I do)
To work mine end upon their senses that
This airy charm is for, I'll break my staff,
Bury it certain fadoms in the earth, 55
And deeper than did ever plummet sound
I'll drown my book. *Solemn music.*

Here enters ARIEL *before; then* ALONSO, *with a frantic
gesture, attended by* GONZALO; SEBASTIAN *and*
ANTONIO *in like manner, attended by* ADRIAN *and*
FRANCISCO. *They all enter the circle which* PROSPERO
had made, and there stand charm'd; which PROSPERO
observing, speaks.

A solemn air, and the best comforter
To an unsettled fancy, cure thy brains,
Now useless, [boil'd] within thy skull! There stand,
For you are spell-stopp'd. 61
Holy Gonzalo, honorable man,
Mine eyes, ev'n sociable to the show of thine,
Fall fellowly drops. The charm dissolves apace,
And as the morning steals upon the night, 65
Melting the darkness, so their rising senses
Begin to chase the ignorant fumes that mantle
Their clearer reason. O good Gonzalo,
My true preserver, and a loyal sir
To him thou follow'st! I will pay thy graces 70
Home both in word and deed. Most cruelly
Didst thou, Alonso, use me and my daughter;
Thy brother was a furtherer in the act.

10. **weather-fends:** serves as windbreak for. 11. **boudge:** budge,
stir. **your release:** i.e. their release by you. 12. **distracted:** out of
their wits. 17. **eaves of reeds:** thatched roofs.
18. **affections:** inclinations, bent of mind. 21. **touch.** Synonymous
with *feeling.* 23. **relish:** experience. **all:** quite.
24. **kindlier:** (1) more sympathetically; (2) more naturally (as "one of
their kind"). 27. **take part:** side. **rarer:** finer, nobler.
36. **demi-puppets:** quasi-puppets, i.e. creatures of small size.
37. **green sour ringlets:** so-called "fairy rings" in grass, actually
caused by mushrooms. 39. **mushrumps:** mushrooms, supposed
because of their rapid growth to be made by elves during the night.

40. **curfew.** Supposedly spirits could be abroad only between curfew
(9 p.m.) and the first cockcrow; cf. I.ii.327. 41. **Weak:** i.e. as
compared with the powerful demons summoned up by black magic.
45. **rifted:** split. 47. **spurs:** roots. 50. **rough:** i.e. capable of
producing the violent effects just described (?). 51. **requir'd:**
requested. 53. **their senses that:** the senses of those whom.
54. **airy charm:** i.e. the music. 57 s.d. **frantic gesture:** insane
demeanor. 58. **and:** i.e. which is. 59. **thy brains.** The first
sentence is addressed to Alonso, the next to all six now within the
circle. 60. **boil'd:** i.e. made useless by passion.
63. **sociable:** sympathetic. **show:** appearance. 64. **Fall:** let fall.
67. **ignorant fumes:** fumes that make them uncomprehending.
70–71. **pay . . . Home:** reward your favors fully.

Thou art pinch'd for't now, Sebastian. Flesh and
　blood,
You, brother mine, that [entertain'd] ambition, 75
Expell'd remorse and nature, whom, with Sebastian
(Whose inward pinches therefore are most strong),
Would here have kill'd your king, I do forgive thee,
Unnatural though thou art.—Their understanding
Begins to swell, and the approaching tide 80
Will shortly fill the reasonable [shores]
That now lie foul and muddy. Not one of them
That yet looks on me, or would know me! Ariel,
Fetch me the hat and rapier in my cell.
　　　　　[*Exit* ARIEL, *and returns immediately.*]
I will discase me, and myself present 85
As I was sometime Milan. Quickly, spirit,
Thou shalt ere long be free.
　　　　　ARIEL *sings and helps to attire him.*
[ARI.]　Where the bee sucks, there suck I,
　　In a cowslip's bell I lie;
　　There I couch when owls do cry. 90
　　On the bat's back I do fly
　　After summer merrily.
　Merrily, merrily shall I live now,
　Under the blossom that hangs on the bough.
PROS.　Why, that's my dainty Ariel! I shall miss
　　thee, 95
But yet thou shalt have freedom. So, so, so.
To the King's ship, invisible as thou art;
There shalt thou find the mariners asleep
Under the hatches. The master and the boatswain
Being awake, enforce them to this place; 100
And presently, I prithee.
ARI.　I drink the air before me, and return
Or ere your pulse twice beat.　　　　*Exit.*
GON.　All torment, trouble, wonder, and amazement
Inhabits here. Some heavenly power guide us 105
Out of this fearful country!
PROS.　　　　　　　　Behold, sir King,
The wronged Duke of Milan, Prospero.
For more assurance that a living prince
Does now speak to thee, I embrace thy body,
And to thee and thy company I bid 110
A hearty welcome.

ALON.　　　　　　　Whe'er thou beest he or no,
Or some enchanted trifle to abuse me
(As late I have been), I not know. Thy pulse
Beats as of flesh and blood; and since I saw thee,
Th' affliction of my mind amends, with which 115
I fear a madness held me. This must crave
(And if this be at all) a most strange story.
Thy dukedom I resign, and do entreat
Thou pardon me my wrongs. But how should
　Prospero
Be living, and be here?
PROS.　　　　　　[*To* GONZALO.] First, noble friend,
Let me embrace thine age, whose honor cannot 121
Be measur'd or confin'd.
GON.　　　　　　　Whether this be,
Or be not, I'll not swear.
PROS.　　　　　　You do yet taste
Some subtleties o' th' isle, that will [not] let you
Believe things certain. Welcome, my friends all!
[*Aside to* SEBASTIAN *and* ANTONIO.] But you, my
　brace of lords, were I so minded, 126
I here could pluck his Highness' frown upon you
And justify you traitors. At this time
I will tell no tales.
SEB.　　　[*Aside.*] The devil speaks in him.
PROS.　　　　　　　　　　　　No.
For you, most wicked sir, whom to call brother 130
Would even infect my mouth, I do forgive
Thy rankest fault—all of them; and require
My dukedom of thee, which perforce, I know
Thou must restore.
ALON.　　　　　If thou beest Prospero,
Give us particulars of thy preservation, 135
How thou hast met us here, whom three hours since
Were wrack'd upon this shore; where I have lost
(How sharp the point of this remembrance is!)
My dear son Ferdinand.
PROS.　　　　　　　　I am woe for't, sir.
ALON.　Irreparable is the loss, and patience 140
Says, it is past her cure.
PROS.　　　　　　　I rather think
You have not sought her help, of whose soft grace
For the like loss I have her sovereign aid,
And rest myself content.

76. **remorse:** pity. **nature:** natural feeling.　77. **therefore:** therefor,
to that end.　81. **reasonable shores:** shores of reason, i.e. minds.
85. **discase me:** take off my magician's robe.
86. **As . . . Milan:** dressed as I formerly was as Duke of Milan.
96. **So, so, so.** Probably an expression of approval as Ariel finishes
attiring him.　101. **presently:** at once.　108. **a living prince:** i.e.
not a spirit.

112. **enchanted trifle:** trick of magic. **abuse:** deceive.
116–17. **This . . . story:** this demands, if it is really taking place, an
extraordinary explanation.　121. **thine age:** i.e. thy reverend self.
121–22. **cannot . . . confin'd:** i.e. is immeasurable and boundless.
124. **subtleties:** illusions, with play (as *taste* suggests) on the word as
applied to fancy confections representing actual objects or allegorical
figures.　128. **justify:** prove.　142. **of . . . grace:** by whose
mercy.

ALON. You the like loss?

PROS. As great to me as late, and supportable 145
 To make the dear loss, have I means much weaker
 Than you may call to comfort you; for I
 Have lost my daughter.

ALON. A daughter?
 O heavens, that they were living both in Naples,
 The King and Queen there! That they were, I wish
 Myself were mudded in that oozy bed 151
 Where my son lies. When did you lose your daughter?

PROS. In this last tempest. I perceive these lords
 At this encounter do so much admire
 That they devour their reason, and scarce think 155
 Their eyes do offices of truth, their words
 Are natural breath; but howsoev'r you have
 Been justled from your senses, know for certain
 That I am Prospero, and that very duke 159
 Which was thrust forth of Milan, who most strangely
 Upon this shore (where you were wrack'd) was
 landed,
 To be the lord on't. No more yet of this,
 For 'tis a chronicle of day by day,
 Not a relation for a breakfast, nor
 Befitting this first meeting. Welcome, sir; 165
 This cell's my court. Here have I few attendants,
 And subjects none abroad. Pray you look in.
 My dukedom since you have given me again,
 I will requite you with as good a thing,
 At least bring forth a wonder, to content ye 170
 As much as me my dukedom.

Here PROSPERO *discovers* FERDINAND *and* MIRANDA *playing at chess.*

MIR. Sweet lord, you play me false.

FER. No, my dearest love,
 I would not for the world.

MIR. Yes, for a score of kingdoms you should
 wrangle,
 And I would call it fair play.

ALON. If this prove 175
 A vision of the island, one dear son
 Shall I twice lose.

SEB. A most high miracle!

FER. Though the seas threaten, they are merciful;
 I have curs'd them without cause. [*Kneels.*]

ALON. Now all the blessings
 Of a glad father compass thee about! 180
 Arise, and say how thou cam'st here.

MIR. O wonder!
 How many goodly creatures are there here!
 How beauteous mankind is! O brave new world
 That has such people in't!

PROS. 'Tis new to thee.

ALON. What is this maid with whom thou wast at
 play? 185
 Your eld'st acquaintance cannot be three hours.
 Is she the goddess that hath sever'd us,
 And brought us thus together?

FER. Sir, she is mortal;
 But by immortal Providence she's mine.
 I chose her when I could not ask my father 190
 For his advice, nor thought I had one. She
 Is daughter to this famous Duke of Milan,
 Of whom so often I have heard renown,
 But never saw before; of whom I have
 Receiv'd a second life; and second father 195
 This lady makes him to me.

ALON. I am hers.
 But O, how oddly will it sound that I
 Must ask my child forgiveness!

PROS. There, sir, stop.
 Let us not burthen our remembrances with
 A heaviness that's gone.

GON. I have inly wept, 200
 Or should have spoke ere this. Look down, you gods,
 And on this couple drop a blessed crown!
 For it is you that have chalk'd forth the way
 Which brought us hither.

ALON. I say amen, Gonzalo! 204

GON. Was Milan thrust from Milan, that his issue
 Should become kings of Naples? O, rejoice
 Beyond a common joy, and set it down
 With gold on lasting pillars: in one voyage
 Did Claribel her husband find at Tunis,
 And Ferdinand, her brother, found a wife 210
 Where he himself was lost; Prospero, his dukedom
 In a poor isle; and all of us, ourselves,
 When no man was his own.

ALON. [*To* FERDINAND *and* MIRANDA.] Give
 me your hands.
 Let grief and sorrow still embrace his heart
 That doth not wish you joy!

146. **dear:** deeply felt. 150. **That:** provided that.
154. **admire:** marvel. 155. **devour their reason.** Presumably referring to the open-mouthed astonishment in which their rational powers are lost. 156. **do . . . truth:** function accurately. 160. **of:** from. 167. **abroad:** i.e. elsewhere on the island. 171 s.d. **discovers:** discloses (by pulling aside a curtain). 174. **Yes . . . wrangle:** i.e. certainly you should do so for the world; in fact, for less than the world—for twenty kingdoms you ought to do your utmost against me. 176. **vision:** i.e. illusion.

186. **eld'st:** longest possible. 200. **heaviness:** grief.
205. **Milan . . . Milan:** the Duke . . . the city. 212–13. **all . . . own:** we all found ourselves when every man was deluded.
214. **still:** ever. 214–15. **his heart That:** the heart of anyone who.

GON. Be it so, amen! 215

Enter ARIEL, *with the* MASTER *and* BOATSWAIN
amazedly following.

 O, look, sir, look, sir, here is more of us.
 I prophesied, if a gallows were on land,
 This fellow could not drown. Now, blasphemy,
 That swear'st grace o'erboard, not an oath on shore?
 Hast thou no mouth by land? What is the news? 220
BOATS. The best news is, that we have safely found
 Our king and company; the next, our ship—
 Which, but three glasses since, we gave out split—
 Is tight and yare, and bravely rigg'd as when 224
 We first put out to sea.
ARI. [*Aside to* PROSPERO.] Sir, all this service
 Have I done since I went.
PROS. [*Aside to* ARIEL.] My tricksy spirit!
ALON. These are not natural events, they strengthen
 From strange to stranger. Say, how came you
 hither?
BOATS. If I did think, sir, I were well awake,
 I'd strive to tell you. We were dead of sleep, 230
 And (how we know not) all clapp'd under hatches,
 Where, but even now, with strange and several
 noises
 Of roaring, shrieking, howling, jingling chains,
 And moe diversity of sounds, all horrible,
 We were awak'd; straightway, at liberty; 235
 Where we, in all our trim, freshly beheld
 Our royal, good, and gallant ship; our master
 Cap'ring to eye her. On a trice, so please you,
 Even in a dream, were we divided from them,
 And were brought moping hither.
ARI. [*Aside to* PROSPERO.] Was't well done?
PROS. [*Aside to* ARIEL.] Bravely, my diligence.
 Thou shalt be free. 241
ALON. This is as strange a maze as e'er men trod,
 And there is in this business more than nature
 Was ever conduct of. Some oracle
 Must rectify our knowledge.

PROS. Sir, my liege, 245
 Do not infest your mind with beating on
 The strangeness of this business. At pick'd leisure,
 Which shall be shortly, single I'll resolve you
 (Which to you shall seem probable) of every
 These happen'd accidents; till when, be cheerful 250
 And think of each thing well. [*Aside to* ARIEL.]
 Come
 hither, spirit.
 Set Caliban and his companions free;
 Untie the spell. [*Exit* ARIEL.] How fares my gracious
 sir?
 There are yet missing of your company
 Some few odd lads that you remember not. 255

Enter ARIEL, *driving in* CALIBAN, STEPHANO, *and*
TRINCULO *in their stol'n apparel.*

STE. Every man shift for all the rest, and let no man
 take care for himself; for all is but fortune. *Coraggio,*
 bully-monster, *coraggio!*
TRIN. If these be true spies which I wear in my
 head, here's a goodly sight. 260
CAL. O Setebos, these be brave spirits indeed!
 How fine my master is! I am afraid
 He will chastise me.
SEB. Ha, ha!
 What things are these, my Lord Antonio?
 Will money buy 'em?
ANT. Very like; one of them 265
 Is a plain fish, and no doubt marketable.
PROS. Mark but the badges of these men, my lords,
 Then say if they be true. This misshapen knave—
 His mother was a witch, and one so strong
 That could control the moon, make flows and
 ebbs,
 And deal in her command without her power. 271
 These three have robb'd me, and this demi-devil
 (For he's a bastard one) had plotted with them
 To take my life. Two of these fellows you

215 s.d. **amazedly:** as in a maze, in bewilderment.
218. **blasphemy:** blasphemous fellow. Cf. *diligence* (= diligent crea-
ture) in line 241. 219. **That . . . o'erboard:** who are profane
enough to make heavenly grace forsake the ship.
223. **glasses:** i.e. hours. **gave out:** reported.
224. **yare:** shipshape. 226. **tricksy:** ingenious, adroit.
227–28. **strengthen . . . stranger:** increase in strangeness.
230. **of sleep:** asleep. 234. **moe:** more. 235. **at liberty:** i.e. no
longer under hatches. 238. **On:** in. 240. **moping:** in a daze.
244. **conduct:** conductor.

245. **liege:** sovereign. 246. **infest:** annoy. 247. **pick'd:** i.e. con-
venient. 248. **single:** by myself (without an oracle).
249. **probable:** satisfactory. 250. **accidents:** occurrences.
255. **odd:** unaccounted for. 256. **Every . . . rest.** Stephano drunk-
enly inverts the proverbial "Every man for himself." 257. **Corag-
gio:** courage (Italian). 259. **true spies:** reliable observers (eyes).
262. **fine:** splendidly dressed (in his ducal robes). 267. **badges:**
insignia for servants, indicating what master they served. Stephano
and Trinculo are of course dressed in stolen garments. 268. **true:**
honest. 271. **her command:** i.e. the moon's authority. **without her
power:** beyond the moon's influence.

Must know and own, this thing of darkness I 275
Acknowledge mine.

CAL. I shall be pinch'd to death.

ALON. Is not this Stephano, my drunken butler?

SEB. He is drunk now. Where had he wine?

ALON. And Trinculo is reeling ripe. Where should
 they
Find this grand liquor that hath gilded 'em? 280
How cam'st thou in this pickle?

TRIN. I have been in such a pickle since I saw you
 last that I fear me will never out of my bones. I shall
 not fear fly-blowing.

SEB. Why, how now, Stephano? 285

STE. O, touch me not, I am not Stephano, but a
 cramp.

PROS. You'ld be king o' the isle, sirrah?

STE. I should have been a sore one then.

ALON. This is a strange thing as e'er I look'd on. 290
 [*Pointing to* CALIBAN.]

PROS. He is as disproportion'd in his manners
 As in his shape. Go, sirrah, to my cell;
 Take with you your companions. As you look
 To have my pardon, trim it handsomely.

CAL. Ay, that I will; and I'll be wise hereafter,
 And seek for grace. What a thrice-double ass 296
 Was I to take this drunkard for a god,
 And worship this dull fool!

PROS. Go to, away!

ALON. Hence, and bestow your luggage where you
 found it.

SEB. Or stole it, rather. 300
 [*Exeunt* CALIBAN, STEPHANO, *and* TRINCULO.]

PROS. Sir, I invite your Highness and your train
 To my poor cell, where you shall take your rest
 For this one night; which, part of it, I'll waste
 With such discourse as, I not doubt, shall make it
 Go quick away—the story of my life, 305
 And the particular accidents gone by
 Since I came to this isle. And in the morn
 I'll bring you to your ship, and so to Naples,
 Where I have hope to see the nuptial
 Of these our dear-belov'd solemnized, 310
 And thence retire me to my Milan, where
 Every third thought shall be my grave.

ALON. I long
 To hear the story of your life, which must
 Take the ear strangely.

PROS. I'll deliver all,
 And promise you calm seas, auspicious gales, 315
 And sail so expeditious, that shall catch
 Your royal fleet far off. [*Aside to Ariel.*] My Ariel,
 chick,
 That is thy charge. Then to the elements
 Be free, and fare thou well!—Please you draw near.
 Exeunt omnes.

EPILOGUE

Spoken by PROSPERO.

Now my charms are all o'erthrown,
And what strength I have's mine own,
Which is most faint. Now 'tis true,
I must be here confin'd by you,
Or sent to Naples. Let me not, 5
Since I have my dukedom got,
And pardon'd the deceiver, dwell
In this bare island by your spell,
But release me from my bands
With the help of your good hands. 10
Gentle breath of yours my sails
Must fill, or else my project fails,
Which was to please. Now I want
Spirits to enforce, art to enchant,
And my ending is despair, 15
Unless I be reliev'd by prayer,
Which pierces so, that it assaults
Mercy itself, and frees all faults.
 As you from crimes would pardon'd be,
 Let your indulgence set me free. *Exit.* 20

COMMENTS AND QUESTIONS

1. For what different purposes does Shakespeare use
 blank verse, prose, rhymed verse, and music in *The
 Tempest*?

2. Trace the theme of reality versus illusion as it de-
 velops in the play.

3. Compare Shakespeare's concept of "nature" here
 to that of Montaigne.

4. Contrast the characters of Caliban and Ariel.

280. **gilded 'em:** flushed their faces (a common connection between blood and gold). Possibly *grand liquor* contains an alchemical allusion to the long-sought elixir that could transform base substances to gold. 281. **pickle:** predicament. 282. **pickle:** preservative (the horse urine of the pool being equivalent to vinegar).
284. **fly-blowing:** infestation by maggots (to which unpickled meat would be subject). 288. **sirrah:** form of address to an inferior.
289. **sore:** (1) harsh; (2) pain-wracked. 303. **waste:** use up.
314. **Take:** enchant.

314. **deliver:** report. 316. **sail:** voyage.
319. **draw near:** i.e. enter the cell.

Epi. 9. **bands:** bonds.
10. **hands:** i.e. applause. The noise of clapping would break the charm. 11. **Gentle breath:** a favorable breeze (produced by hands clapping). 13. **want:** lack. 16. **prayer:** i.e. this petition.
17. **assaults:** storms the ear of. 18. **frees:** remits.
19. **crimes:** sins.

5. Do you agree with the interpretation of Caliban as a colonial subject oppressed by European settlers? Why or why not?

6. What are the real and illusory characteristics of the "brave new world"?

7. Outline the plot of *The Tempest*. How important is it?

8. What elements of spectacle appear in the play, and what is their function?

9. What is the role of magic in the play? What seems to be Shakespeare's attitude toward it?

10. Describe the nature of the relationship between Ferdinand and Miranda.

Summary Questions

1. How did northern humanism differ from Italian humanism?

2. On what basic issues did Luther differ with the Church authorities?

3. What was the importance of the invention of the printing press for the success of the Reformation?

4. How does Calvin's theology differ from Luther's?

5. What was the Inquisition, and what effects did it have?

6. How do you explain the success of the Catholic Church in recouping many of its losses by 1600?

7. What role did music play in the Reformation and in the Counter-Reformation?

8. What were the causes of the economic expansion of Europe in the sixteenth century?

9. How do Montaigne and Shakespeare reflect cultural relativism?

10. To what extent does *The Tempest* reflect late Renaissasnce ideals?

Key Terms

sacraments

divine grace

predestination

salvation by faith

Reformation

Counter-Reformation

Inquisition

Conversos

Jesuits

counterpoint

polyphony

essay

Shakespearean sonnet

blank verse

iambic pentameter

madrigal

irony

Renaissance and Reformation

The death and dislocation of fourteenth-century Europe served as a catalyst for the birth of the modern age. This century of crisis tended to privilege certain intellectual tendencies that led over time to the formation of a new culture distinct from that of the Middle Ages. In our discussion of the Italian Renaissance we focused on its beginnings in the fourteenth and fifteenth centuries rather than on its "high" (early-sixteenth-century) phase in Rome. It is in Florence in this early period that we can best witness the radical departures from medieval mentality; the innovations in art, life, and thought; and the new fusion of Christian and classical traditions that laid the basis for much of our modern art, thought, and institutions. The roots of the humanities as we know them are certainly there. We have seen how Florentine humanism spread to northern Europe, influencing the development of a literature at least equal to its own, and how its original self-confidence underwent a crisis that is still with us.

Individualism

"The discovery of the individual was made in early fifteenth-century Florence," proclaims Kenneth Clark in his *Civilization* series. "Nothing can alter that fact." Certainly, when one looks at the portraits of Renaissance Florentines (the art of the portrait had been lost in Europe since Roman times!), or when one reads about their lives or views the different styles of each artist, one senses an individuality that was not present in the more collective and symbolic arts of the Middle Ages. The development of a more naturalistic way of portraying individual characters and their natural surroundings is part of this trend—we see its beginnings in the fourteenth century with Giotto.

Civic Sense

If fifteenth-century Florentines were highly conscious of themselves as individuals, they were also very much aware of being part of a community. Florence in many ways resembled a Greek city-state; and like the ancient Athenians, the Florentines believed that participation in the affairs of state was essential for the realization of one's full humanity. But the people of the Renaissance needed to justify this classical value in Christian terms. Whereas medieval people believed that the contemplative life, or the life devoted to God, was of highest value, the fifteenth-century Florentines believed that Christian ideals could be served just as well in a secular, active life. Their political ideal of republicanism, rule by a body of citizens, has served as a basis for modern political theory. Although the modern state developed out of the medieval monarchies, since the nineteenth century these states have been on the whole republican.

By the last half of the fifteenth century, Florence came under the more autocratic rule of the Medici family. An ardent republican, Machiavelli nevertheless saw that by this time the ideal form of government was no longer practical for Florence. Yet through the early sixteenth century the spirit of republicanism, as seen in Michelangelo's *David*, with his proud, youthful defiance of tyranny, and his *Brutus*, the defender of Roman liberty, remained identified with the city. Republicanism was a part of the civic humanism of which Florentines were proud. The Florentines, with their urban-centered lifestyle, created a city whose physical aspect expressed their values. The architecture and sculpture, which even today give Florence its distinctive character, reflect a sense of beauty and proportion keyed to the measure of humankind. City planning as we know it today was born in Florence with the treatises of Leon Battista Alberti.

Visual and Verbal Eloquence

Beautiful architecture was for the practitioner Brunelleschi and the theoretician Alberti what beautiful speech was for the Florentine humanists. Visual and verbal eloquence was the means of using newly redis-

covered classical values in the service of Christian truth. Brunelleschi and (after him) Michelangelo observed closely the remains of Roman buildings and statues; Petrarch, Salutati, and Bruni edited and studied Latin, and eventually Greek, texts. The use of language was for the humanists the art that made people most truly human; consequently, the studies that they called the humanities focused on literature.

Historical and Visual Perspective

In their study of ancient rhetoric, the humanists observed a truth that the medieval mind seemed not to realize: language and other human customs, institutions, and ideas change; they have a history. The notion of seeing oneself and one's culture in historical perspective, as part of a continuum of time, has become a habit with us; it has its origins in the humanists' new way of thought.

Intimately connected with this sense of historical perspective was the humanists' awareness that humanity constructed its own history. This led them to view the past, particularly the ancient pagan and early Christian past, as providing cultural alternatives to their contemporary world. This helps to explain the humanists' concern for introducing moral, political, and religious reforms into their society. Their efforts were predicated on the belief that it was possible to bring society back to better and purer times. This same commitment to the idea that human beings can shape the future has come to characterize the modern world. Now, however, the models we use are rarely drawn from societies that have actually existed but rather from those we envision in our mind's eye.

The ability to see with the perspective of time has its artistic parallel in the ability to see, and to draw, with the perspective of space. There is no doubt that the technical development permitting artists to give the illusion of three dimensions on the flat surface of a canvas was a major step in the history of art. Renaissance painters established a formal visual language for their art that remained until recently the official standard of all Western art academies. Yet *perspective*, it must be remembered, was a means, not an end in itself. It permitted artists to represent what they observed, rather than to create symbols of the unseen. The sources of their observation were primarily two: nature (inanimate, animate, and human) and antiquity. From these they derived an art centered on the human being and the here-and-now; yet, like the humanists, they wished to put these new modes of expression to the service of Christian values. Leonardo, who stressed the scientific nature of painting and its worthiness to be placed among the liberal arts, created one of the most mystical Virgins ever painted.

Practicality

Leonardo was also a creator of tools and devices by which human beings could control their natural surroundings. In this he reflects the tendency in the Renaissance for the theoretical to become increasingly united with the practical. The great scientific advances of the seventeenth century would have been impossible without the creation of better instrumentation with which to measure, view, and manipulate the material world. Incidentally, as we will explain in the discussion of the Scientific Revolution, the development of Neoplatonism in the fifteenth century led to a new concern with mathematics, which also made a fundamental contribution to new approaches in natural science.

Developments in Music

In secular music, too, nature and antiquity were sources that helped new forms to flourish. Renaissance composers were not acquainted with the actual musical works of the Greeks and Romans, but they read their musical theory and were interested in the ways in which music could be wedded to words. Much of Renaissance music was religious, but secular music gained prominence at this time. The madrigal, which developed in the sixteenth century, exemplifies one type of secular music.

Religious music, however, became extremely important during the Reformation and Counter-Reformation. Luther's hymns had an enormous effect both on the Protestant worship service and on the music of Bach (see Chapter 22). At the Council of Trent the Catholic Church called on its composers to write music that was purged of secular elements and that instead maintained the elegant simplicity and reverential character of Gregorian chant, did not rely excessively on the use of instruments, and made the sung words understandable. One composer above all others, Giovanni Pierluigi da Palestrina, carried out this program in his beautiful sacred works. He became known as "the savior of church music." The Spanish Counter-Reformation composer Cristóbal de Morales enriched Catholic liturgy both in the Old World and the New, as his music had a great impact on the Americas.

Non-Christian Subject Matter

The use of pagan, classical subjects in painting, sculpture, secular music, and literature represents a radical break with medieval culture. For instance, rather than being a symbol of the divine, Petrarch's Laura fuses love and nature. Much of this "pagan" art developed under the influence of Lorenzo de' Medici and the circle of Neoplatonic scholars around him. The lyrical Venuses

and nymphs of Botticelli represent joy in this world but also an underlying melancholy. One senses in them a spiritual world beyond the visible forms.

Human Dignity

One of Lorenzo's Neoplatonic acquaintances, Pico della Mirandola, made what is considered by many to be the most extreme Renaissance statement on human dignity and grandeur. Pico's success at fusing the Judeo-Christian and Greco-Roman ways of thinking is problematic: although he recognized Christianity as the truest of all religions, he nonetheless endowed humanity with creative powers exceeding those of celestial beings, thus sounding a note that had not been heard since antiquity. Yet, when this brilliant, handsome prince of Mirandola died in Florence of fever at the age of thirty-one, he met death wrapped in the robes of a Dominican friar.

The Italian humanists' conception of the dignity of man, however, was severely limited in its failure to recognize that women shared equally with men in human nature. Learned women such as Laura Cereta vigorously asserted their equality but were largely ignored. Though unheeded in their own generations, they nonetheless anticipate later developments in feminism.

Northern Humanism

When Italian humanism spread to northern Europe, its Christian aspect was emphasized more than its pagan one. Humanists such as Erasmus read and delighted in the classical authors but turned their attention toward the study and editing of Greek and Latin Christian texts. Erasmus believed strongly in the value of reading and study: through knowledge and the development of inner piety, individual Christians could help to dispel the ignorance and reduce the emphasis on externals that pervaded the Church, especially its monasteries.

Northern Europe made its greatest contribution to our culture through the printed word. Ever since the development of printing we have relied on communications media for the circulation of news and ideas. Radio, television, and computers have, of course, speeded up the process enormously. Film has come to fuse visual with literary statements, but we still rely heavily on books for the dissemination of intellectual developments and for knowledge of the past. Books, such as those published by Erasmus, enabled more people to form intelligent opinions and thus to question authority. Humanistic educators still share Erasmus's faith in the printed word's capacity to aid in the process of creating well-informed, soundly reasoning, independently thinking human individuals.

Reformation and Counter-Reformation

Martin Luther pushed Erasmus's emphasis on the study of texts and rejection of authority to what Erasmus considered a radical extreme. Trained in humanistic methods, Luther used his extensive knowledge of Hebrew, Greek, and Latin to study the Bible directly, without the official interpretations of the Church, and to translate it into German, thus making it available to his fellow citizens. Luther's studies led him to believe that the original message of Christ had been distorted over the centuries. Given this insight, he felt compelled to reject "on conscience" certain doctrines and practices of the Church and, with many other contributing factors, launched the Reformation. Although Luther became as doctrinaire as the authorities he had rejected, the impetus he gave to thinking independently of authority has had far-reaching influences on the culture of the modern world. There is a direct line from Luther to the sense of isolation and confusion in a tangle of conflicting values that many individuals experience today.

Luther's religious reform became contagious. However, unable to control the movement he started, he watched helplessly as other reformers constructed their own theological systems; they often borrowed key ideas from him and sought followers among Catholics and dissatisfied Lutherans. The Church of Rome was not idle. While it strove to retain its followers by enacting many reforms of its institutions, it also endeavored to suppress the religious dissidents, whom it considered heretics. The result was bitter religious warfare between Catholics and Protestants throughout much of the century.

Exploration and Cultural Relativism

In the course of the fourteenth century, with the ascent of the hostile Ming dynasty in China and the territorial conquests of the Muslims against the Byzantine Empire, Europe lost much of its direct contact with the East. The effort to renew relations with China beginning late in the fifteenth century not only opened the way to the East around Africa, but also led to widespread exploration of the Atlantic and Pacific Oceans and to Europeans' discovery of new continents. If trade with these newly discovered areas was as yet unimportant compared with trade within Europe, the supply of precious metals from exploitation of mines in the New World at least contributed to a tremendous economic boom beginning around 1500.

A period of intense religious concerns and conflicts, the sixteenth century was also a time of rapid economic development and demographic increase.

Swift change, population growth, and rapidly rising prices probably added to the unsettling atmosphere created by religious controversy. On the intellectual level, individuals such as Montaigne reflected a new and very modern feeling that truth and belief are relative rather than absolute.

Cultural relativism became during the sixteenth century a corollary to relativism in matters of opinion. In this era of travel and exploration, Europeans discovered in America, Africa, and Asia people who lived with customs and institutions very different from theirs. Just as Mediterranean peoples had once viewed Europeans as barbaric, many Europeans now thought the newly discovered cultures uncivilized and vastly inferior to their own. Intelligent observers such as Montaigne used the different cultural values to reflect what was corrupt and unjust in European society. Cultural relativism has served self-criticism and social satire ever since.

Shakespeare

Montaigne's interest in the new world discoveries and resultant cultural relativism continues in the work of William Shakespeare, particularly in the "brave new world" he portrays in *The Tempest*. William Shakespeare embodies nearly all of the currents that we have witnessed in the Renaissance-Reformation period. Like Leonardo, Michelangelo, and Luther, he was a giant in an age of geniuses—one who discovered and mastered new worlds of thought and expression. His characters demonstrate a range of feeling from the early humanists' confidence in humanity's abilities and powers to late Renaissance skepticism and relativism and the Reformation's doubt that human beings can accomplish much of anything on their own. Shakespeare combined the medieval and the classical traditions to lay the basis for the modern theater.

PART VII

Science and Splendor: The Seventeenth Century

20 The Consolidation of Modernity

CENTRAL ISSUES

- The last major religious war of Europe, the Thirty Years' War
- The Scientific Revolution
- The continuing economic expansion of Europe in the seventeenth century
- The causes of absolutism in the seventeenth century and the means by which rulers attained absolute power
- Hobbes's theory of absolutism and Locke's response

Many of the tendencies we recognize as modern, the beginnings of which we have identified in preceding centuries, became embodied in institutions and daily life by 1650. By this time religious issues had ceased to be matters of life and death, religion had become detached from politics, and life was secular six days a week. Literature, painting, and sculpture increasingly depicted secular subjects; the palace and the theater exerted immense influence on the architectural, artistic, and ceremonial forms of the churches.

The centralized state resting on a bureaucracy, a standing army, and a system of taxation developed into the dominant form of European government in the seventeenth century. These relatively stronger governments (which had their roots in the Middle Ages) endeavored to control and expand the economic life of

DAILY LIVES

The Suffering of Ordinary People in the Thirty Years' War

In his novel *Simplicius simplicissimus* (1668), Hans Jakob Grimmelshausen (1622?–1676) realistically described the adventures of a young man caught in the horrors of the Thirty Years' War. Much of the novel is a thinly veiled autobiography. Like that of the boy in the excerpt here, Grimmelshausen's home had been invaded and ransacked by a group of mercenary soldiers; his mother and father were killed, and he himself was taken prisoner.

The first thing these troopers did was, that they stabled their horses: thereafter each fell to his appointed task: which task was neither more nor less than ruin and destruction. For though some began to slaughter and to boil and to roast so that it looked as if there should be a merry banquet forward, yet others there were who did but storm through the house above and below stairs. Others stowed together great parcels of cloth and apparel and all manner of household stuff, as if they would set up a frippery market. All that they had no mind to take with them they cut in pieces. Some thrust their swords through the hay and straw as if they had not enough sheep and swine to slaughter: and some shook the feathers out of the beds and in their stead stuffed in bacon and other dried meat and provisions as if such were better and softer to sleep upon. Others broke the stove and the windows as if they had a never-ending summer to promise. Houseware of copper and tin they beat flat, and packed such vessels, all bent and spoiled, in with the rest. Bedsteads, tables, chairs, and benches they burned, though there lay many cords of dry wood in the yard. Pots and pipkins must all go to pieces, either because they would eat none but roast flesh, or because their purpose was to make there but a single meal.

Our maid was so handled in the stable that she could not come out; which is a shame to tell of. Our man they laid bound upon the ground, thrust a gag into his mouth, and poured a pailful of filthy water into his body: and by this, which they called a Swedish draught, they forced him to lead a party of them to another place where they captured men and beasts, and brought them back to our farm, in which company were my dad, my mother, and our Ursula.

And now they began: first to take the flints out of their pistols and in place of them to jam the peasants' thumbs in and so to torture the poor rogues as if they had been about the burning of witches: for one of them they had taken they thrust into the baking oven and there lit a fire under him, although he had as yet confessed no crime: as for another, they put a cord round his head and so twisted it tight with a piece of wood that the blood gushed from his mouth and nose and ears. In a word each had his own device to torture the peasants, and each peasant his several torture.

Hans Jakob Grimmelshausen, *Adventures of a Simpleton*, trans. A. T. S. Goodrick (New York: E. P. Dutton & Co., 1924), pp. 8–9.

their respective countries, fostering in the process the conception of a national economy in competition with other national economies for the world's riches. Importation of gold and spices from other continents had been important for European commerce before 1600, and the development of the plantation system in the Americas (tied to the African slave trade and the establishment of elaborate networks of trading posts on the coasts of Africa and Asia) reflected the existence of a worldwide market by the late seventeenth century. To meet the demands of such expanded economic horizons, Europeans devised financial and business institutions such as the national bank and the *joint-stock company*, a business owned by stockholders in shares which each may sell or transfer independently. At the same time that Europe set out to dominate the rest of the world through its stronger political and economic structures, its scientists turned their attention as never before to mastering nature for human use. This attitude, which was born in the so-called *Scientific Revolution*, eventually made possible immense material improvements in the human condition and has become the dominant goal—for good or ill—not only of Europeans but of the rest of the world as well.

The Thirty Years' War and Its Aftermath

The German Catholic campaign of the Counter-Reformation was to precipitate one of the bloodiest wars in modern times. The German Thirty Years' War between 1618 and 1648 began directly as a response of Bohemian

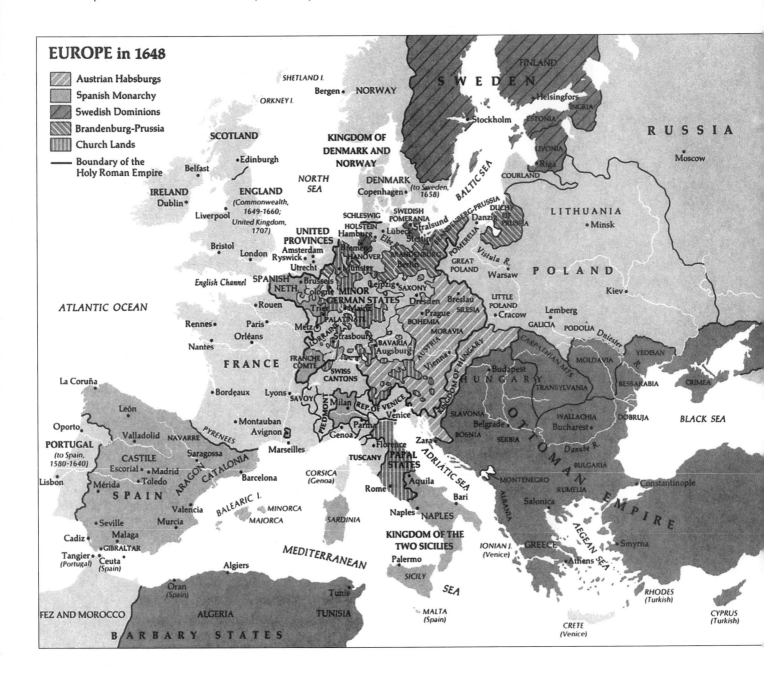

EUROPE in 1648

- ///// Austrian Habsburgs
- Spanish Monarchy
- Swedish Dominions
- Brandenburg-Prussia
- Church Lands
- —— Boundary of the Holy Roman Empire

Protestants to the efforts of their Catholic king (who was also the ruler of Austria) to suppress the Protestant faith in their country. After the Bohemians revolted, the war gradually spread to the whole empire; no one could safely remain neutral. The war was fought on both sides by large mercenary armies over which the German princes had little control. These armies had no interest in peace; wherever they went, they brought death and devastation. Moreover, after the first few years the war in Germany became the focus for international rivalries, and the provinces of the empire served as a battlefield for invading armies of Denmark, Sweden, Spain, and France.

By 1648 when the *Peace of Westphalia* was finally signed, Germany was ruined from one end to the other. In effect the peace treaty reestablished the religious pol-

icy that had dominated Germany in the seventy years prior to the war: each German prince had the right to determine the religion of his state. The advance of the Counter-Reformation was, for all practical purposes, stopped. Spain, the bulwark of the Catholic offensive, was financially exhausted and in the grip of a serious demographic decline, and from 1648 on ceased to play a central role in European politics.

The Thirty Years' War, at least in the beginning a religious struggle, constitutes the last major European war fought for motives of religion. Europe had had its orgy of religious passion; now each side sensibly recognized the sphere of influence held by the other. The lines separating Catholics in southern Europe from Protestants in the northern areas (see map) have remained

fairly stable from that time on. Although religious persecution of minorities might continue within individual countries, even at this level a new sense of toleration was developing. King Louis XIV's revocation of the Protestant rights to worship in 1685 and his expulsion of Protestants from France were perhaps the last grand gestures of the Counter-Reformation.

By the end of the Thirty Years' War Europeans generally realized the senselessness of such struggles and the misery that they produced. But beneath the apparent tolerance of religious dissent also lay a growing religious indifference. Europeans on the whole no longer felt the need to judge their experience and to set their goals within a Christian frame of reference. Well might the student of European culture after 1650 ask, "What happened to God?"

The Scientific Revolution

So enormous and dazzling was the progress made in the course of the seventeenth century toward the understanding of the human body, the earth, and the heavens that it is not too much to say that by 1700 a radical change was taking place in the attitude of Europeans toward the interrelationship among humanity, God, and nature. At least in its initial stages this progress consisted in a rejection of the "commonsense" approach of ancient and medieval science. The European view of the universe in 1500 was substantially the same as that of Dante in 1300. The earth was at rest in the center, just as it appears, and the heavens rotated around it. These heavens—beginning with the moon, the sun, the planets out to the fixed stars—were either nine or ten in number. Beyond the outermost heaven, or the "first mover" that gave motion to everything in the universe, lay the region of God and the blessed. This universe was finite. God made the earth of heavy inferior substance, placing the finer heavenly bodies above the earth in ascending order of perfection. Since ancient times, however, astronomers had recognized a good deal of irregularity in the movement of the heavens. To make this conception fit the appearances, the astronomers had to add a whole series of special movements for individual bodies.

Although medieval and early Renaissance scholars were often very dedicated to the investigation of nature, they worked within the shadow of the ancients. The diffusion of knowledge of Greek in the fifteenth century, moreover, made available to Europeans a great number of ancient scientific writings not hitherto known, and this new scientific literature had to be absorbed. By the beginning of the sixteenth century, however, that process was completed. The translated works of Plato and his followers suggested to Europeans the idea that all physical objects could be reduced to numbers and that mathematics was the key to understanding nature. This approach differed considerably from the medieval conception of science that investigated nature in terms of qualities: heavy or light, colored or transparent, voluntary or natural in movement, and the like. The increased cooperation during the Renaissance between workers skilled with their hands and scholars laid the basis for a joint effort in making new instruments for observing and calculating nature's operations. The methodology of ancient philosophers could be useful, but their authority now had to be tested against experience.

Copernicus (1473–1543) and Kepler (1571–1630)

The first fruit of the new concern with mathematics and experimentation was the work of the Polish priest and astronomer Nicholas Copernicus, who in fact had no intention of making an aggressive attack on the received ideas of his day. In his *On the Revolution of the Heavenly Bodies,* published in 1543 and dedicated to the pope, Copernicus generally accepted the traditional conception of a finite universe characterized by a series of heavens, the moon, the planets, and the fixed stars. Copernicus's innovation was to substitute the sun for the earth at the center of the universe. For him the earth became one of the planets and, like other bodies, circulated around the center.

Copernicus's primary reason for switching the position of the sun and earth was that this conception furnished a better explanation of the observed motions of the heavens, reducing the need to ascribe exceptional movements to individual bodies as in the earth-centered theory. According to the deeply religious Copernicus, the ability of his sun-centered theory to explain the appearances and to show heavenly motion to be simple and regular magnified the perfection of the divine creator.

Copernicus presented his ideas as a hypothesis; but over succeeding decades, as new observations were recorded and found to support it, some thinkers came to insist that the theory was proved. The ancient picture of the universe gradually disintegrated. Although embracing the finitude of the universe, Copernicus's theory laid the foundation for the idea of the infinite nature of God's creation. Whereas the earth-centered view of the universe maintained an absolute up and down, potentially Copernicus's theory suggested that space was relative. Even though the Copernican earth circulated around the sun, heavy bodies still fell to the earth. If the sun, which all agreed was a nobler body than the earth, was at the center of the universe, then the old view (that, beginning with the earth, other heavenly bodies increased in perfection as they came nearer to the outermost sphere) made no sense at all. Finally, the fact that mathematics played such a primary role in Copernicus's original analysis and in subsequent efforts to test it made mathematics appear as a key to scientific truth.

It fell to the mathematician-astronomer Johannes Kepler to discover that the orbit of the planets around the sun, including that of the earth, took the form of an ellipse. Kepler worked out a single set of mathematical formulas that could be applied to every planet. Although he could not say why the planets moved in this way, he was finally able to make sense of the appearance of planetary motion with his simple equations.

Galileo (1564–1642)

An aggressive publicist of the Scientific Revolution and one of its greatest contributors was a Florentine, Galileo Galilei. Both Copernicus and Kepler had worked with the naked eye. Galileo, informed of a new optical instrument developed in the Netherlands, the telescope, constructed one for himself and turned it toward the heavens. Through the lens of this fantastic instrument (Fig. 20-1) he was the first human being to see that Jupiter had moons like the earth's, and that the earth's own moon was made of material similar to that found on earth. The momentous conclusion was that heavenly bodies were not made of more perfect material. Rather,

20-1 *Telescopes, c. 1609, by Galileo Galilei. Museo di Fisica e Storia Naturale. (Alinari/Art Resource, NY)*

they resembled the earth and were governed by the same laws.

Galileo's conclusions were equally revolutionary when he turned to consider the behavior of bodies in motion. Traditional theories of dynamics, geared to the assumption that the natural state of a body was at rest, attempted to explain what caused motion to occur. For Galileo there was no "natural" motion of the body; rather, if a body was in motion, it would continue in a straight line at the same speed forever unless deflected, quickened, or retarded by another force—illustrating the principle of inertia. Thus what concerned Galileo was not why things move but why changes in motion occur and how one describes these changes mathematically. His formula for the acceleration of a freely falling body in terms of time and space represents the kind of solutions he had in mind.

A magnificent stylist, courageous to the point of rashness, Galileo trumpeted his discoveries in a series of eloquent works that brought him to the attention of the Inquisition. The Inquisition found his teachings dangerous in that they not only reduced the eternal heavens to the level of the earth but also specifically contradicted passages of Scripture. After a period of imprisonment Galileo was forced to live under house arrest in Florence until his death. Although he was forbidden to work on astronomy, he was allowed to continue his researches on motion. In 1638 his *Discourse on Two New Sciences,* which provided the foundation for modern physics, was published in the Dutch republic.

Bacon (1561–1626)

Like his contemporary Galileo, the Englishman Francis Bacon was a gifted writer. Recognized as an outstanding essayist, Bacon has also been curiously designated by some scholars as the true author of the plays attributed to William Shakespeare. An ambitious and unscrupulous politician, he was lord chancellor of England between 1618 and 1621, under James I of England. Convicted of accepting bribes, he was dismissed and died in disgrace. Bacon is perhaps best remembered, however, as an early propagandist for the Scientific Revolution. His *New Organon* (1620), designed to replace Aristotle's logical works collectively known as the *Organon,* called for a new approach to the study of nature. Science for Bacon was the means by which human beings could gain power over nature and use it for their own purposes. To do this, they needed a new instrument, a new method of approach. This new method was *empiricism.*

As far back as Aristotle, scholars had discussed the inductive method, but Bacon gave it a systematic presentation and is generally credited with being the founder of empiricism. The empirical method, which has profoundly influenced English and American thought ever

since, relies on observation and experience as the roads to truth. Bacon held that we must begin by closer observation of nature, because every generalization has to be controlled by reference to specific instances.

The great shortcoming of Bacon's conception of science was his failure to appreciate the need to establish hypotheses in research and the value of mathematics. Rather than develop a hypothesis and then test it by experiment, Bacon believed that if one inspected every instance of the occurrence of a particular natural phenomenon, the cause of the phenomenon would become clear. Although ultimately applicable to fields such as biology and chemistry, his methodology was of little use in the fields of physics and astronomy, in which the most spectacular advances were made in the seventeenth century. Closer observation furnished data in these fields, but scientists employed mathematics for their interpretation of the data; thus they were essentially working by *deduction*. Nevertheless, Bacon's far-reaching criticism of contemporary natural science, his reliance on the independent judgment of the scientist based on personal observation, and his vision of the enormous benefits accruing to humanity from the scientific enterprise proved fundamental in the formation of a new attitude toward the study of nature.

20-2 *Frans Hals,* René Descartes *(Statens Museum fur Kunst, Copenhagen, Denmark. Photo by Hans Peterson)*

Descartes (1596–1650)

Applying mathematics to the study of the natural world had led Galileo and Kepler to make dramatic discoveries in physics and astronomy. By the mid-seventeenth century, René Descartes (Fig. 20-2) gave this use of mathematics tremendous impetus through his conception of the universe of extended matter as entirely reducible to mathematical equations. Almost paradoxically, he arrived at this conception as a result of initially resolving to doubt everything he thought he knew.

The wars of religion that divided France between 1562 and 1594, with Protestants and Catholics killing each other in the name of divine truth, encouraged the skeptical position that neither side could prove its conviction and that the scope of human knowledge was extremely limited. Like Montaigne, though a half century later, Descartes took himself as the object of his pursuit of truth. However, whereas Montaigne was reluctant to generalize from his own experience, Descartes fashioned his method of introspection into a means of establishing absolute truths.

He began his investigation by systematically applying the principle of doubt to all knowledge—that is, he refused to accept any authority without careful verification. His introspection led him to conclude that he could unquestionably know only one thing: that he was doubting. Because the act of doubting meant that he was thinking—and thinking meant that he existed—he concluded: "I think, therefore I am." This idea was not

derived from a chain of logical proofs, but from a simple act of mental vision. He then inspected the idea to ascertain what made him convinced that the idea was true. He concluded that his conviction derived from its clarity and distinctness. Even if God were a deceiving God who only made him think that the idea was clear and distinct, he would still be thinking. Consequently, of this one fundamental truth there could be no doubt.

But could he go beyond the knowledge of his own existence to prove anything else? Inspecting the full range of ideas, Descartes concluded that all of them except one could have been self-generated. The one exception was the idea of the infinite perfection of the being we call God. Because he, Descartes, was finite, he could not have been responsible for generating the idea of infinite perfection. It had to come from outside, and had to resemble the reality of which it was the idea. Because this perfection called God could not possibly be a deceiver, Descartes concluded that all that we can perceive clearly and distinctly was true. Thereupon, examining one by one the ideas he held that were clear and distinct, he proceeded to establish the existence of bodies outside the mind, the validity of mathematical principles, and their relevance for determining the structure of the universe.

Newton (1642–1727)

Although Bacon's empirical method was important in the formation of a scientific attitude toward exploring nature, he made no significant scientific discoveries. But

another Englishman, Isaac Newton, accomplished the most dazzling feat of the seventeenth century. Working on Descartes's conception that all matter was subject to mathematics, he brought together Galileo's laws of inertia, Kepler's laws of celestial mechanics, and his own theory of gravitational force into a monumental system of physical principles and mathematical formulas by which every physical movement in the universe could potentially be described. Newton came to see that every body in the universe attracted every other body with a force proportional to the product of the two masses and inversely proportional to the square of the distance between them. Galileo's law that a moving body would fly off in a straight line unless affected by an external force held true for the heavens as for the earth. A planet moved in an elliptical motion around the sun, and the moon in similar fashion around the earth, because the mutual attraction of the two bodies drew the smaller in toward the larger and deflected the motion of the smaller into an orbit. The shape of the orbit and its velocity could be described by Galileo's formula for falling bodies.

Other Scientific Discoveries and Their Effects

Newton's findings, published in his *Mathematical Principles of Natural Philosophy* in 1687, marked the high point of the Scientific Revolution of the seventeenth century. But if less spectacular, the discoveries in other areas of science were nonetheless important. In 1628 William Harvey (1578–1657) demonstrated the circulation of the blood, and at mid-century Anton van Leeuwenhoek (1632–1723) had developed the microscope, thus revealing a whole world hidden from the naked eye. Scientists such as Robert Boyle (1627–1691) were in subsequent decades involved in investigating the action of gases.

No longer working in isolation, the scientists of this "revolution" developed communities. Societies like the Royal Society of London, founded in 1662, not only helped the diffusion of information among scientists but also brought their work to the attention of an educated public. For many, there were great expectations of a new era when, through the use of reason and new instruments, the human race would gradually eliminate the area of the unknown. But if the new discoveries brought confidence to some, others felt uncertain and confused. The Inquisition had justifiably regarded Galileo's doctrines as dangerous: people now had to deal with an order of truth appearing to contradict the Bible at several points. More than this, whereas the God of the Christian Middle Ages had been a God intimately connected with the human world, scientists such as Galileo and Newton approached the universe as if, after creating it, God had stepped aside and let nature run itself. The French philosopher Blaise Pascal phrased it: "The eternal silence of infinite spaces terrifies me."

Economic Life

Historians tend to date the birth of modern capitalism to the late sixteenth and early seventeenth centuries, but to understand what actually occurred, an important distinction must be made. There are basically two types of capitalism: commercial and industrial. In *commercial capitalism* the capitalist is usually a merchant who invests money both in buying the raw material and in marketing the finished product once produced. In the case of wool cloth, for example, the merchant buys the raw wool; then either the merchant or an agent carries the wool to artisans who spin, weave, and dye it in their shops or homes. They usually work by the piece and own or rent their equipment. When the cloth is finished, the merchant then sells the product; the merchant's profit lies in the difference between what the cloth cost to produce and market and the purchase price of the finished goods.

This form of capitalism, with the merchant as the capitalist, began in the Middle Ages and remained the dominant form for the production of industrial goods down to the eighteenth century. The economic boom of the sixteenth century did not significantly affect the way that goods were produced; what did change was the number of people engaged in producing. The production of industrial goods significantly increased in the sixteenth century because so many more independent producers were working for the merchant.

Industrial capitalism, on the other hand, refers to investment in the modes or means of production. In this case the capitalist is not the merchant but the factory or mine owner. Investment in machines means more productivity per worker and more variety in products. To print books, for example, a significant investment must be made in a printing press. In the sixteenth century a rapid surge in the amount of investment in machinery occurred in areas such as metalworking, glass making, paper production, coal mining, and firearms manufacture. Although the output of goods provided by industrial capitalism climbed significantly after 1550, until the end of the eighteenth century commercial capitalism was responsible for most of the industrial production of Europe.

By 1550 European observers demonstrated an awareness of a long-term rise in prices that had begun by the end of the fifteenth century. Initially, the price rise came mainly in food products, testifying to the beginnings of a population increase after a century of demographic stagnation. But clearly the price rise was reinforced by the tremendous quantities of bullion pouring into Europe from the Spanish silver mines in the New World. In the long-term price rise, so favorable for investment, is to be found the major cause of the tremendous economic development that took place in most of Europe by the mid-sixteenth century.

In Spain, however—the prime source for the bullion—an expensive policy of conquest and an oppressive taxation policy falling on all but the upper classes combined to strangle both commercial and economic development. In an increasingly stratified society, the military, government service, and religion became the only valued professions. Spanish silver spread throughout Europe in the sixteenth century in three ways. Spain used it to cover its military expenditures abroad; to pay for imported goods that its own investment-starved economy could not provide; and to settle its ever-growing debts to foreign bankers.

In contrast with Spain's experience, the sixteenth century had proven highly profitable for Italy, the other major southern European country and the traditional economic center of Europe. The seventeenth century, however, witnessed a definitive movement of that center to the North Atlantic countries: France, England, and Holland. The two latter countries, both dominated by Protestants, were the leading sea powers of Europe. Both were also advanced in developing organizational forms of business capable of collecting large amounts of capital. The rest of Europe was characterized by family businesses until the nineteenth century, but these two countries used the joint-stock company to attract money into business ventures. Amsterdam was the center of a thriving stock exchange. In England and especially in Holland, banking arrangements so developed that businesses and private individuals were able to borrow large sums of money on credit.

These relatively enormous financial assets available for commercial investment meant that the Dutch and English would play a preponderant role in business ventures overseas. The plantation economy of the New World was in large part a product of this flow of capital that brought the slaves from Africa; purchased the sugar, rice, coffee, tobacco, and other commodities that the slaves produced; and marketed the goods in Europe. Even French, Spanish, and Portuguese planters depended for their survival on Dutch willingness to extend credit on purchases from harvest to harvest, a convenience not provided in their own countries.

The Age of Absolutism

The last half of the seventeenth century and most of the eighteenth have come to be recognized as the age of "absolute" monarchs. Although kings and queens had all kinds of practical limitations on what they could do without provoking a rebellion, they were absolute in the sense that there were no legal restraints or alternative constitutional institutions that could block the monarch's will. Of course, even in France, the ideal absolute monarchy, there were law courts and some provincial assemblies that could lawfully impede the royal decrees for a time; but eventually, if the king was willing to pay the price for publicizing the opposition, he could have his way.

By 1650 such investment of power in the royal office appeared to most observers the only way that the centralized state could advance against forces of decentralization such as the great nobility, the provincial government, and the autonomous cities. The two notable exceptions to this situation were the Dutch and the English. The fact that the Dutch had a small country, densely populated, with good communications and a weak nobility, made their republican government feasible. The development of constitutional monarchy in England must be explained in the light of its small size and its early centralization and development of Parliament.

Whereas the English Parliament had established a tradition of consultation with the monarch, assemblies in France, Spain, Germany, and elsewhere brought together forces of localism opposed to concentration of power. Since the Middle Ages these were the elements that, in moments when the monarchy was weak, seized the opportunity to destroy the carefully accumulated powers of the state over its territories. The religious wars of the sixteenth and early seventeenth centuries had created an ideal situation for subjects of one religion to revolt against their king who had another. For instance, although some of the highest French nobility rebelled in the sixteenth century in the name of the Protestant faith, their revolt was unquestionably also motivated by political ambitions. Consequently, monarchs and their advisers came to believe that only by taking legal authority out of the hands of cities, provinces, and the nobility and instead centering it in the monarch's hands could their countries ever experience domestic peace. In large part this policy was also supported by intellectuals and by the common people, who had to choose between this or institutionalized anarchy.

Yet the monarch could not make a frontal attack on political privileges without provoking massive revolt. Basically, the European social structure was divided into three general classes: the nobility, the peasants (both in the countryside), and the bourgeoisie in the towns and cities. The last class included groups as far apart as humble shoemakers and wealthy bankers. Consequently, we must distinguish the upper bourgeoisie, who controlled the cities, from the lower bourgeoisie, who often were economically not superior to the peasants.

From the sixteenth century in Spain and France and a century later in other parts of the continent, the monarchy developed a policy of compromise with the privileged middle classes in the cities and with the nobility. In return for sanctioning the political domination of the king and accepting the extension of his authority, the powerful interest groups were promised exemption from many of the burdens imposed. The king guaranteed the nobility and the upper bourgeoisie that they would not have to pay many of the new taxes and that

the heaviest impositions would fall on the poor. Besides, the king acknowledged the monopoly of the nobility over the officer corps in the army and over the great ceremonial posts at court. By dazzling the bourgeoisie with the prospect of offices in the expanded central bureaucracy, the absolute monarch of the seventeenth century had the means to incorporate families of new wealth into the establishment and thus to render them supporters of the system; otherwise they would have constituted a disgruntled and potentially subversive bourgeois leadership.

Farther to the east, in countries such as Brandenburg-Prussia and Austria, the monarchies had emerged from the Middle Ages much weaker and more unstable than those in the west; as a result, eastern rulers were forced to go even further to obtain absolute political power. They granted the nobility (the middle class was insignificant in numbers) the right to reduce the local rural populations to the status of serfs. In Brandenburg-Prussia, moreover, the *Junkers*, or nobility, were made the only class legally allowed to own land.

As a result of these different compromises across Europe, the class structure in the various countries became more clearly defined: each class had a legal relationship with the central government. At the same time, the monarch became the sole judge of who would be admitted to the privileged classes, especially to the nobility. This right proved a great financial asset to the royal treasury, as most offices in the government were sold at a fixed price. The buyer earned only a small yearly salary from the government but was expected to make profits from those who needed the buyer's services in that position. Some of the higher government offices—and naturally the most expensive—carried with them a patent of nobility, ennobling forever the buyer and the buyer's descendants. This system permitted humble people who had money to put their families into the upper class. If an unlikely way to staff a bureaucracy, the method proved a good means of permitting social mobility.

But the concentration of power in the hands of monarchs, although affording domestic peace, had a different effect on international relations. More powerful monarchs with money to spend presided over larger armies and more far-ranging wars. In the Middle Ages and Renaissance, war was fought with troops raised for short periods of time; even the Hundred Years' War between France and England primarily consisted of a long series of summer campaigns spread out over more than a century. With the greater taxing power of the seventeenth-century monarchies, however, kings could afford to keep an army in the field for years at a time and to do so at a distance from the sources of supply. Consequently, there was a danger that one country might try to take over the whole of Europe, and monarchs felt it vital to their interests to know what their colleagues were about. This led to the increasing importance of diplomacy and to wars fought on the basis of international alliances.

Furthermore, as Europe became a political system based on a balance-of-power concept, in this century Europeans spread their rivalries to the rest of the world: to the Americas, Africa, and Asia. An important consequence of the increase in royal power was that the central government assumed the responsibility of regulating the economic life of the country and a commitment to fostering its development. Thus, more than ever before, hostilities between European powers appeared to be dictated by economic concerns: having influence in other areas of the world was regarded as significant for prosperity at home.

Hobbes (1588–1679)

The *Leviathan* of Thomas Hobbes was the first attempt to develop a political theory that emulated the dominant tendencies of the Scientific Revolution. Hobbes was deeply affected by the revolt of antiroyalists led by Parliament against Charles I (who ruled from 1625 to 1649)—a revolt capped by the execution of the king in 1649. Hobbes fled into exile, worked as tutor for the future Charles II (the monarchy was restored in 1660), and wrote his great work on government as a way of preventing revolutions. Despite what contemporary scientists said, Hobbes saw that they approached nature as if it were a purely mechanical system in which all could be explained by applying mathematics to the movements of bodies relative to one another. Taking geometry as his mathematical model, he started by examining the simplest elements and, by using self-evident principles, moved forward to the analysis of problems of greater complexity. He believed that each human being, like the rest of the universe, consisted of a series of motions. The center of each series was the heart, the source of vital motion in the body. Increases and decreases in this vital motion were transmitted through the sense organs, giving rise to two basic emotions, desire and aversion—movement toward that which heightened vitality and retreat from that which threatened it. The movement of other bodies stimulated one emotion or the other, depending on whether they favored or menaced the life force. Thus Hobbes's analysis rises from the study of the movement of bodies (physics) to that of the psychology and physiology of human beings.

The basic instinct of all people is the maintenance and, if possible, the heightening of the vital force. The desire for self-preservation leads to the pursuit of power, because one can never be secure enough:

> I put for a general inclination of all mankind a perpetual and restless desire of power after power, that ceases only in death . . . because he [man] cannot assure the power and means to live well, which he has present, without the acquisition of more.

Humanity existing in the state of nature, before the existence of government, experienced almost constant war. In a phrase that was to become classic, Hobbes described the human condition in this state as "solitary, poor, nasty, brutish, and short." It is improbable that Hobbes believed that there ever had been such a time, but consistent with his geometrical model, he (and subsequent philosophers) used the conception of a state of nature to get a clear focus on what *human* nature was like. Hobbes viewed people as essentially isolated, selfish beings. Given the misery of their circumstances, they could live in peace only after surrendering their freedom to an artificially created unitary will (Leviathan) with absolute power to rule. With the creation of Leviathan, both government and civil society came into existence.

Hobbes wrote his book in the belief that his theories would bolster the cause of monarchical *absolutism*, but he and his ideas were shunned by those he meant to defend. Whereas seventeenth-century monarchs justified their power as based on divine right, Hobbes saw it as deriving from utilitarian needs: the alternative to royal absolutism was anarchy. His materialism, atheism, and denial that there was any absolute right or wrong also shocked his generation and earned him the epithet "the Monster of Malmesbury."

Locke (1632–1704)

Late in his reign, Charles II (1660–1685) began to show signs of wanting to follow the model of continental absolutism, and his brother, James II, who succeeded him in 1685, was even more dedicated to this goal. Reluctant to inspire another revolution, the Parliament acted to replace the unpopular king with his daughter, Mary, wife of the Dutch prince, William of Orange. When William disembarked on English shores late in 1688, James II fled. William and Mary were granted the crown by Parliament early in 1689 only on the condition that they sign the Bill of Rights, which enumerated the civil liberties of Englishmen and required the ruler to act only with the consent of Parliament.

John Locke, whose father had championed the parliamentary cause against Charles I, sided with Parlia-

ment against James II. In 1690 he published his *Two Treatises on Government*, justifying what had occurred in 1688–1689. His treatise on human nature, *Essay Concerning Human Understanding*, written several years earlier, also appeared that same year.

In the tradition of Bacon, Locke held in his *Essay* that all knowledge comes from sense perception. The mind begins as a blank slate, a *tabula rasa*, and what the mind comes to know is a product of combining perceptions and reflection on those combinations. What this in effect meant was that people were products of their environment: change the environment and the person is changed. Inspired in his turn by scientific discoveries taking place in his time, Locke attempted to establish laws of human behavior by *inductive* means.

Like Hobbes's *Leviathan*, Locke's political writings postulated a state of nature, but in contrast with that of Hobbes, Locke's state of nature was already a rational society, and not a jungle where individuals struggled against one another for self-preservation. Locke hypothesized that individuals in his state of nature would not be so desperate as to give over all their freedom to a government: their lives were uncertain in a world where each one had the right to take the law into his own hands, but men usually worked together to prevent violence. Consequently, they needed to create a state with limited powers, specifically one that would establish just laws to protect the individual from physical harm, but with minimal responsibility for other aspects of life.

This state would be governed by the elected representatives of the citizen body and would be responsible to it at all times. If the governors contravened the law and began to infringe on the liberties of the citizens, the citizens had the right to replace them with others who were more responsible. Whereas for Hobbes dissolution of the state meant a return to the savagery of the state of nature—that is, a return to being a collection of isolated, fearful individuals—for Locke, the only consequence of changing governments was that the society would be temporarily deprived of a ruling head. As we shall see in Chapter 24, while Locke's psychological theories strongly appealed to the French *philosophes* of the eighteenth century, his political theory strongly attracted Americans seeking to establish their own government (Chapter 25).

René Descartes

from the *Discourse on Method*

Translation by Laurence J. Lafleur

The following selections are taken from Descartes's *Discourse on Method,* first published in 1637. In them Descartes explains his method of systematic doubt and affirms the undeniable truth of his own existence, the affirmation that lies at the basis of the elaborate philosophical structure he intends to create.

Part 1

From my childhood I lived in a world of books, and since I was taught that by their help I could gain a clear and assured knowledge of everything useful in life, I was eager to learn from them. But as soon as I had finished the course of studies that usually admits one to the ranks of the learned, I changed my opinion completely. For I found myself saddled with so many doubts and errors that I seemed to have gained nothing in trying to educate myself unless it was to discover more and more fully how ignorant I was.

Nevertheless I had been in one of the most celebrated schools in all of Europe, where I thought there should be wise men if wise men existed anywhere on earth. I had learned there everything that others learned, and, not satisfied with merely the knowledge that was taught, I had perused as many books as I could find which contained more unusual and recondite knowledge. I also knew the opinions of others about myself, and that I was in no way judged inferior to my fellow students, even though several of them were preparing to become professors. And finally, it did not seem to me that our own times were less flourishing and fertile than were any of the earlier periods. All this led me to conclude that I could judge others by myself, and to decide that there was no such wisdom in the world as I had previously hoped to find. . . .

I revered our theology, and hoped as much as anyone else to get to heaven, but having learned on great authority that the road was just as open to the most ignorant as to the most learned, and that the truths of revelation which lead thereto are beyond our understanding, I would not have dared to submit them to the weakness of my reasonings. I thought that to succeed in their examination it would be necessary to have some extraordinary assistance from heaven, and to be more than a man.

I will say nothing of philosophy except that it has been studied for many centuries by the most outstanding minds without having produced anything which is not in dispute and consequently doubtful and uncertain. I did not have enough presumption to hope to succeed better than the others; and when I noticed how many different opinions learned men may hold on the same subject, despite the fact that no more than one of them can ever be right, I resolved to consider almost as false any opinion which was merely plausible. . . .

This is why I gave up my studies entirely as soon as I reached the age when I was no longer under the control of my teachers. I resolved to seek no other knowledge than that which I might find within myself, or perhaps in the great book of nature. . . .

Part 2

As far as the opinions which I had been receiving since my birth were concerned, I could not do better than to reject them completely for once in my lifetime, and to resume them afterwards, or perhaps accept better ones in their place, when I had determined how they fitted into a rational scheme. And I firmly believed that by this means I would succeed in conducting my life much better than if I built only upon the old foundations and gave credence to the principles which I had acquired in my childhood without ever having examined them to see whether they were true or not. Never has my intention been more than to try to reform my own ideas, and rebuild them on foundations that would be wholly mine. If my building has pleased me sufficiently to display a model of it to the public, it is not because I advise anyone to copy it. Those whom God has more bountifully endowed will no doubt have higher aims; there are others, I fear, for whom my own are too adventurous. . . .

As for myself, I should no doubt have belonged in the last class if I had had but a single teacher or if I had

not known the differences which have always existed among the most learned. I had discovered in college that one cannot imagine anything so strange and unbelievable but that it has been upheld by some philosopher; and in my travels I had found that those who held opinions contrary to ours were neither barbarians nor savages, but that many of them were at least as reasonable as ourselves. I had considered how the same man, with the same capacity for reason, becomes different as a result of being brought up among Frenchmen or Germans than he would be if he had been brought up among Chinese or Americans or cannibals; and how, in our fashions, the thing which pleased us ten years ago and perhaps will please us again ten years in the future, now seems extravagant and ridiculous; and felt that in all these ways we are much more greatly influenced by custom and example than by any certain knowledge. Faced with this divergence of opinion, I could not accept the testimony of the majority, for I thought it worthless as a proof of anything somewhat difficult to discover, since it is much more likely that a single man will have discovered it than a whole people. Nor, on the other hand, could I select anyone whose opinions seemed to me to be preferable to those of others, and I was thus constrained to embark on the investigation for myself.

Nevertheless, like a man who walks alone in the darkness, I resolved to go so slowly and circumspectly that if I did not get ahead very rapidly I was at least safe from falling. Also, just as the occupants of an old house do not destroy it before a plan for a new one has been thought out, I did not want to reject all the opinions which had slipped irrationally into my consciousness since birth, until I had first spent enough time planning how to accomplish the task which I was then undertaking, and seeking the true method of obtaining knowledge of everything which my mind was capable of understanding.

[Rejecting all other rules], I would have enough with the four following ones, provided that I made a firm and unalterable resolution not to violate them even in a single instance.

The first rule was never to accept anything as true unless I recognized it to be certainly and evidently such: that is, carefully to avoid all precipitation and prejudgment, and to include nothing in my conclusions unless it presented itself so clearly and distinctly to my mind that there was no reason or occasion to doubt it.

The second was to divide each of the difficulties which I encountered into as many parts as possible, and as might be required for an easier solution.

The third was to think in an orderly fashion when concerned with the search for truth, beginning with the things which were simplest and easiest to understand, and gradually and by degrees reaching toward more complex knowledge, even treating, as though ordered, materials which were not necessarily so.

The last was always to make enumerations so complete, and reviews so general, that I would be certain that nothing was omitted. . . .

What pleased me most about this method was that it enabled me to reason in all things, if not perfectly, at least as well as was in my power. In addition, I felt that in practicing it my mind was gradually dissipating its uncertainties and becoming accustomed to conceive its objects more clearly and distinctly. . . .

Part 4

I had noticed for a long time that in practice it is sometimes necessary to follow opinions which we know to be very uncertain, just as though they were indubitable, as I state before; but inasmuch as I desired to devote myself wholly to the search for truth, I thought that I should take a course precisely contrary, and reject as absolutely false anything of which I could have the least doubt, in order to see whether anything would be left after this procedure which could be called wholly certain. Thus, as our senses deceive us at times, I was ready to suppose that nothing was at all the way our senses represented them to be. As there are men who make mistakes in reasoning even on the simplest topics in geometry, I judged that I was as liable to error as any other, and rejected as false all the reasoning which I had previously accepted as valid demonstration. Finally, as the same percepts which we have when awake may come to us when asleep without their being true, I decided to suppose that nothing that had ever entered my mind was more real than the illusions of my dreams. But I soon noticed that while I thus wished to think everything false, it was necessarily true that I who thought so was something. Since this truth, *I think, therefore I am, or exist,* was so firm and assured that all the most extravagant suppositions of the sceptics were unable to shake it, I judged that I could safely accept it as the first principle of the philosophy I was seeking.

COMMENTS AND QUESTIONS

1. On what basis did Descartes come to the conclusion as a young man that there was no wisdom in the world?

2. How does he defend himself in advance from the charge of being skeptical about religion?

3. Why did Descartes decide to embark on his investigation of the truth by himself?

4. What were the four rules by which he guided his investigation?

5. Why was Descartes so firm and assured that his thinking meant he existed?

Thomas Hobbes

from *Leviathan*

Of the Difference of Manners

In the first place, I put for a general inclination of all mankind a perpetual and restless desire of power after power that ceases only in death. And the cause of this is not always that a man hopes for a more intensive delight than he has already attained to, or that he cannot be content with a moderate power, but because he cannot assure the power and means to live well which he has present without the acquisition of more.

Of the Natural Condition of Mankind as Concerning Their Felicity and Misery

Nature has made men so equal in the faculties of the body and mind as that, though there be found one man sometimes manifestly stronger in body or of quicker mind than another, yet, when all is reckoned together, the difference between man and man is not so considerable as that one man can thereupon claim to himself any benefit to which another may not pretend as well as he. For as to the strength of body, the weakest has strength enough to kill the strongest, either by secret machination or by confederacy with others that are in the same danger with himself. . . .

Hereby it is manifest that, during the time men live without a common power to keep them all in awe, they are in that condition which is called war, and such a war as is of every man against every man. For WAR consists not in battle only, or the act of fighting, but in a tract of time wherein the will to contend by battle is sufficiently known; and therefore the notion of *time* is to be considered in the nature of war as it is in the nature of weather. For as the nature of foul weather lies not in a shower or two of rain but in an inclination thereto of many days together, so the nature of war consists not in actual fighting but in the known disposition thereto during all the time there is no assurance to the contrary. All other time is PEACE.

Whatsoever, therefore, is consequent[1] to a time of war where every man is enemy to every man, the same is consequent to the time wherein men live without other security than what their own strength and their own invention shall furnish them withal. In such condition there is no place for industry, because the fruit thereof is uncertain: and consequently no culture of the

earth; no navigation nor use of the commodities that may be imported by sea; no commodious building; no instruments of moving and removing such things as require much force; no knowledge of the face of the earth; no account of time; no arts; no letters; no society; and, which is worst of all, continual fear and danger of violent death; and the life of man solitary, poor, nasty, brutish, and short. . . .

To this war of every man against every man, this also is consequent: that nothing can be unjust. The notions of right and wrong, justice and injustice, have there no place. Where there is no common power, there is no law; where no law, no injustice. Force and fraud are in war the two cardinal virtues. Justice and injustice are none of the faculties neither of the body nor mind. If they were, they might be in a man that were alone in the world, as well as his senses and passions. They are qualities that relate to men in society, not in solitude. It is consequent also to the same condition that there be no property, no dominion, no *mine* and *thine* distinct; but only that to be every man's that he can get, and for so long as he can keep it. And thus much for the ill condition which man by mere nature is actually placed in, though with a possibility to come out of it consisting partly in the passions, partly in his reason. . . .

The passions that incline men to peace are fear of death, desire of such things as are necessary to commodious living, and a hope by their industry to obtain them. And reason suggests convenient articles of peace, upon which men may be drawn to agreement. These articles are they which otherwise are called the Laws of Nature.

Of the First and Second Natural Laws, and of Contracts

The RIGHT OF NATURE . . . is the liberty each man has to use his own power, as he will himself, for the preservation of his own nature—that is to say, of his own life—and consequently of doing anything which, in his own judgment and reason, he shall conceive to be the aptest means thereunto. . . .

A LAW OF NATURE . . . is a precept or general rule, found out by reason, by which a man is forbidden to do that which is destructive of his life or takes away the means of preserving the same. . . .

And because the condition of man, as has been declared in the precedent chapter, is a condition of war of every one against every one—in which case everyone is governed by his own reason and there is nothing he can make use of that may not be a help unto him in preserving his life against his enemies—it follows that in such a condition every man has a right to everything, even to one another's body. And therefore, as long as this natural right of every man to everything endures, there can be no security to any man, how strong or wise soever he

[1] Attributed.

be, of living out the time which nature ordinarily allows men to live. And consequently it is a precept or general rule of reason *that every man ought to endeavor peace, as far as he has hope of obtaining it; and when he cannot obtain it, that he may seek and use all helps and advantages of war.* The first branch of which rule contains the first and fundamental law of nature, which is *to seek peace and follow it.* The second, the sum of the right of nature, which is, *by all means we can to defend ourselves.*

From this fundamental law of nature, by which men are commanded to endeavor peace, is derived this second law: *that a man be willing, when others are so too, as far forth as for peace and defense of himself he shall think it necessary, to lay down this right to all things, and be contented with so much liberty against other men as he would allow other men against himself.* For as long as every man holds this right of doing anything he likes, so long are all men in the condition of war. But if other men will not lay down their right as well as he, then there is no reason for anyone to divest himself of his, for that were to expose himself to prey, which no man is bound to, rather than to dispose himself to peace. This is that law of the gospel: *whatsoever you require that others should do to you, that do ye to them.*

Of the Causes, Generation, and Definition of a Commonwealth

The final cause, end, or design of men, who naturally love liberty and dominion over others, in the introduction of that restraint upon themselves in which we see them live in commonwealths is the foresight of their own preservation, and of a more contented life thereby—that is to say, of getting themselves out from that miserable condition of war which is necessarily consequent . . . to the natural passions of men when there is no visible power to keep them in awe and tie them by fear of punishment to the performance of their covenants and observation of those laws of nature. . . .

For the laws of nature—as *justice, equity, modesty, mercy,* and, in sum, *doing to others as we would be done to*—of themselves, without the terror of some power to cause them to be observed, are contrary to our natural passions, that carry us to partiality, pride, revenge, and the like. And covenants without the sword are but words, and of no strength to secure a man at all. . . .

The only way to erect such a common power as may be able to defend them from the invasion of foreigners and the injuries of one another, and thereby to secure them in such sort as that by their own industry and by the fruits of the earth they may nourish themselves and live contentedly, is to confer all their power and strength upon one man, or upon one assembly of men that may reduce all their wills, by plurality of voices, unto one will; which is as much as to say, to appoint one man or assembly of men to bear their person, and everyone to own and acknowledge himself to be author of whatsoever he that so bears their person shall act or cause to be acted in those things which concern the common peace and safety, and therein to submit their wills every one to his will, and their judgments to his judgment. This is more than consent or concord; it is a real unity of them all in one and the same person, made by covenant of every man with every man, in such manner as if every man should say to every man, *I authorize and give up my right of governing myself to this man, or to this assembly of men, on this condition, that you give up your right to him and authorize all his actions in like manner.* This done, the multitude so united in one person is called a COMMONWEALTH, in Latin CIVITAS. This is the generation of that great LEVIATHAN (or rather, to speak more reverently, of that *mortal god*) to which we owe, under the *immortal God,* our peace and defense. For by this authority, given him by every particular man in the commonwealth, he has the use of so much power and strength conferred on him that, by terror thereof, he is enabled to form the wills of them all to peace at home and mutual aid against their enemies abroad. And in him consists the essence of the commonwealth, which, to define it, is *one person, of whose acts a great multitude, by mutual covenants one with another, have made themselves every one the author, to the end he may use the strength and means of them all as he shall think expedient for their peace and common defense.* And he that carries this person is called SOVEREIGN and said to have *sovereign power;* and everyone besides, his SUBJECT.

The attaining to this sovereign power is by two ways. One, by natural force, as when a man makes his children to submit themselves and their children to his government, as being able to destroy them if they refuse, or by war subdues his enemies to his will, giving them their lives on that condition. The other is when men agree among themselves to submit to some man or assembly of men voluntarily, on confidence to be protected by him against all others. This latter may be called a political commonwealth, or commonwealth by *institution,* and the former a commonwealth by *acquisition.*

Of the Office of the Sovereign Representative

The office of the sovereign, be it a monarch or an assembly, consists in the end for which he was trusted with the sovereign power, namely, the procuration of *the safety of the people;* to which he is obliged by the law of nature, and to render an account thereof to God, the author of that law, and to none but him. But by safety here is not meant a bare preservation but also all

other contentments of life which every man by lawful industry, without danger or hurt to the commonwealth, shall acquire to himself. . . .

To the care of the sovereign belongs the making of good laws. But what is a good law? By a good law I mean not a just law, for no law can be unjust. The law is made by the sovereign power, and all that is done by such power is warranted and owned by every one of the people; and that which every man will have so, no man can say is unjust. It is in the laws of a commonwealth as in the laws of gaming: whatsoever the gamesters all agree on is injustice to none of them. A good law is that which is *needful* for the *good of the people,* and withal *perspicuous.*

For the use of laws, which are but rules authorized, is not to bind the people from all voluntary actions but to direct and keep them in such a motion as not to hurt themselves by their own impetuous desires, rashness, or indiscretion—as hedges are set, not to stop travelers, but to keep them in their way. And therefore a law that is not needful, having not the true end of a law, is not good. A law may be conceived to be good when it is for the benefits of the sovereign though it be not necessary for the people; but it is not so. For the good of the sovereign and people cannot be separated. It is a weak sovereign that has weak subjects, and a weak people whose sovereign wants power to rule them at his will. . . .

It belongs also to the office of the sovereign to make a right application of punishments and rewards. And seeing the end of punishing is not revenge and discharge of choler[2] but correction, either of the offender or of others by his example, the severest punishments are to be inflicted for those crimes that are of most danger to the public: such as are those which proceed from malice to the government established; those that spring from contempt of justice; those that provoke indignation in the multitude; and those which, unpunished, seem authorized, as when they are committed by sons, servants, or favorites of men in authority. For indignation carries men not only against the actors and authors of injustice, but against all power that is likely to protect them: as in the case of Tarquin,[3] when for the insolent act of one of his sons he was driven out of Rome and the monarchy itself dissolved. But crimes of infirmity—such as are those which proceed from great provocation, from great fear, great need, or from ignorance . . .—there is place many times for lenity without prejudice to the commonwealth; and lenity, when

there is such place for it, is required by the law of nature. The punishment of the leaders and teachers in a commotion, not the poor seduced people, when they are punished, can profit the commonwealth by their example. To be severe to the people is to punish that ignorance which may in great part be imputed to the sovereign, whose fault it was that they were no better instructed. . . .

Concerning the offices of one sovereign to another, which are comprehended in that law which is commonly called the *law of nations,* I need not say anything in this place because the law of nations and the law of nature is the same thing. And every sovereign has the same right in procuring the safety of his people that any particular man can have in procuring the safety of his own body. And the same law that dictates to men that have no civil government what they ought to do and what to avoid in regard of one another dictates the same to commonwealths—that is, to the consciences of sovereign princes and sovereign assemblies, there being no court of natural justice but in the conscience only, where not man but God reigns, whose laws, such of them as oblige all mankind, in respect of God as he is the author of nature are *natural,* and in respect of the same God as he is King of kings are *laws.*

COMMENTS AND QUESTIONS

1. Why does the fact that all people are roughly equal lead in the state of nature to continual insecurity and warfare?

2. Why does Hobbes believe there can be no sin or injustice before there is law?

3. What are the roles of passion and reason in helping people escape from the state of nature?

4. People never lose the right of nature (the right of self-defense) even when living in our organized state, but reason tells them that the best way to defend themselves is through the first law of nature (the pursuit of peace). In what way does the second law of nature follow from the first?

5. For Hobbes the state and society come into existence at the same time and are really the same entity. They are the artificial creation of a covenant sworn to by each isolated individual. What does each individual swear to do?

6. Why can no law be unjust and yet some laws can be bad? Although Leviathan can do as he pleases, does Hobbes see him as a tyrant?

7. Why are sovereign powers in the state of nature in relationship to one another?

[2] Anger.
[3] According to legend, Tarquin, the last Roman king, was driven from the city (510 B.C.) by a popular rising after his son had raped—and thereby occasioned the suicide of—the virtuous Lucretia (Livy I).

JOHN LOCKE

from the *Second Treatise of Civil Government*[1]

In 1690 Locke composed two treatises designed to justify the expulsion of James II and the establishment of government in which the monarch had severely limited powers. In the first of these treatises Locke attacked the principle of absolutism, and in the second he offered his vision of a state in which individual freedoms were maximized. The sphere of governmental powers was limited mainly to protecting the lives and property of citizens; all members of society were considered equal; all religions were tolerated; and the press was free. In Locke's state, the attempt of the governors to extend their power could justifiably be resisted by revolution.

Chapter I: Introduction

Political power, then, I take to be a right of making laws with penalties of death, and consequently all less penalties, for the regulating and preserving of property, and of employing the force of the community, in the execution of such laws, and in the defence of the commonwealth from foreign injury; and all this only for the public good.

Chapter II: Of the State of Nature

To understand political power . . . we must consider what state all men are naturally in, and that is, a state of perfect freedom to order their actions and dispose of their possessions and persons, as they think fit, within the bounds of the law of nature; without asking leave, or depending upon the will of any other man.

A state also of equality, wherein all the power and jurisdiction is reciprocal, no one having more than another; there being nothing more evident, than that creatures of the same species and rank, promiscuously born to all the same advantages of nature, and the use of the same faculties, should also be equal one amongst another without subordination or subjection; unless the lord and master of them all should, by any manifest declaration of his will, set one above another, and confer on him, by an evident and clear appointment, an undoubted right to dominion and sovereignty. . . .

But though this be a state of liberty, yet it is not a state of license: though man in that state has an uncontrollable liberty to dispose of his person or possessions,

yet he has no liberty to destroy himself, or so much as any creature in his possession, but where some nobler use than its bare preservation call for it. The state of nature has a law of nature to govern it, which obliges every one: one reason, which is that law, teaches all mankind, who will but consult it, that being equal and independent, no one ought to harm another in his life, health, liberty, or possessions for men being all the workmanship of one omnipotent and infinitely wise Maker; all the servants of one sovereign master, sent into the world by his order, and about his business; they are his property, whose workmanship they are, made to last during his, not another's pleasure: and being furnished with like faculties, sharing all in one community of nature, there cannot be supposed any such subordination among us, that may authorize us to destroy another, as if we were made for one another's uses, as the inferior ranks of creatures are for ours. Every one, as he is bound to preserve himself, . . . ought he, as much as he can, to preserve the rest of mankind, and may not, unless it be to do justice to an offender, take away or impair the life, or what tends to the preservation of life, the liberty, health, limb, or goods of another.

Chapter VIII: Of the Beginning of Political Societies

Men being, as has been said by nature, all free, equal, and independent, no one can be put out of this estate, and subjected to the political power of another, without his own consent. The only way, whereby any one divests himself of his natural liberty, and puts on the bonds of civil society, is by agreeing with other men to join and unite into a community, for their comfortable, safe, and peaceable living one amongst another, in a secure enjoyment of their properties, and a greater security against any, that are not of it. This any number of men may do, because it injures not the freedom of the rest; they are left as they were in the liberty of the state of nature. When any number of men have so consented to make one community or government they are thereby presently incorporated, and make one body politic, wherein the majority have a right to act and conclude the rest.

For, when any number of men have, by the consent of every individual, made a community, they have thereby made that community one body, with a power to act as one body, which is only by the will and determination of the majority: . . . or else it is impossible that it should act or continue as one body, one community, which the consent of every individual that united into it, agreed that it should; and so every one is bound by that consent to be concluded by the majority. . . .

And thus every man, by consenting with others to make one body politic under one government, puts himself under an obligation, to every one of that society,

[1] The selections are taken from John Locke, "Second Treatise of Civil Government" in *The Treatise of Government* (London, 1694), pp. 219–224, 316–317, 345–346, 441–442, 453.

to submit to the determination of the majority, and to be concluded by it; or else this original compact, whereby he with others incorporate into one society, would signify nothing, and be no compact, if he be left free, and under no other ties than he was in before in the state of nature.

Chapter IX: Of the Ends of Political Society and Government

If man in the state of nature be so free, as has been said: if he be absolute lord of his own person and possessions, equal to the greatest, and subject to nobody, why will he part with his freedom? why will he give up his empire, and subject himself to the dominion and control of any other power? To which it is obvious to answer, that though in the state of nature he hath such a right, yet the enjoyment of it is very uncertain, and constantly exposed to the invasion of others; for all being kings as much as he, every man his equal, and the greater part no strict observers of equity and justice, the enjoyment of the property he has in this state is very unsafe, very unsecure. This makes him willing to quit a condition, which however free, is full of fears and continual dangers: and it is not without reason, that he seeks out, and is willing to join in society with others, who are already united, or have a mind to unite, for the mutual preservation of their lives, liberties, and estates, which I call by the general name, property.

The great and chief end, therefore, of men's uniting into commonwealths, and putting themselves under government, is the preservation of their property. To which in the state of nature there are many things wanting. . . .

Chapter XIX: Of the Dissolution of Government

The reason why men enter into society, is the preservation of their property; and the end why they choose and authorize a legislative, is, that there may be laws made, and rules set, as guards and fences to the properties of all the members of the society: to limit the power, and moderate the dominion, of every part and member of the society: for since it can never be supposed to be the will of the society, that the legislative should have a power to destroy that which every one designs to secure by entering into society, and for which the people submitted themselves to legislators of their own making; whenever the legislators endeavour

to take away and destroy the property of the people, or to reduce them to slavery under arbitrary power, they put themselves into a state of war with the people, who are thereupon absolved from any further obedience, and are left to the common refuge, which God hath provided for all men, against force and violence. Whensoever therefore the legislative shall transgress this fundamental rule of society; and either by ambition, fear, folly or corruption, endeavour to grasp themselves, or put into the hands of any other, an absolute power over the lives, liberties, and estates of the people, by this breach of trust they forfeit the power the people had put into their hands for quite contrary ends, and it devolves to the people, who have a right to resume their original liberty, and, by the establishment of a new legislative, (such as they shall think fit) provide for their own safety and security, which is the end for which they are in society. What I have said here, concerning the legislative in general holds true also concerning the supreme executor, who having a double trust put in him, both to have a part in the legislative, and the supreme execution of the law, acts against both, when he goes about to set up his own arbitrary will as the law of the society. . . .

Whosoever uses force without right, as every one does in society, who does it without law, puts himself into a state of war with those against whom he so used it; and in that state all former ties are cancelled, all other rights cease, and every one has a right to defend himself, and to resist the aggressor.

COMMENTS AND QUESTIONS

1. What is the purpose of political power?
2. What rights do individuals have in the state of nature?
3. What prevents men in the state of nature from killing other men and robbing them of their possessions?
4. How is government created?
5. Why do men leave the state of nature and create a government?
6. What causes the dissolution of government?
7. Why do men in society have a right to revolt against an oppressive government?

Summary Questions

1. What three elements were absolutely essential to the centralized state?
2. What were the end results of the Thirty Years' War?
3. Contrast the medieval approach to science with the early modern one.
4. How does Bacon's approach to science contrast with that of Galileo and Kepler? Did it contribute anything to the development of science?
5. Why do historians date the birth of modern capitalism in the decades around 1600?
6. Why would absolutism be regarded as the modern approach to centralized government?
7. To what extent does the conception of the state of nature in the thought of Hobbes and Locke determine the kind of government they argue for?
8. What was Descartes's contribution to the Scientific Revolution?

Key Terms

joint-stock company

Scientific Revolution

Peace of Westphalia

empiricism

deduction

commercial capitalism

industrial capitalism

absolutism

21 The Baroque Style in Art and Literature

The social, religious, intellectual, and economic upheavals that characterized the late sixteenth and early seventeenth centuries were accompanied by a new style in the arts. The High Renaissance conventions of human beauty expressed in ideal proportions seemed to lead to a dead end. Luther and Calvin took to task the whole Catholic tradition of visual art in the service of religion, and they found Italian religious painting of the sixteenth century completely pagan. In literature and in music, too, Protestant doctrine demanded an art form less tied to classical antiquity and formal standards and more suitable to individualistic piety. Some of the best poetry and music of seventeenth-century Protestant Europe took the form of hymns. Catholics, zealous to defend their faith after the Council of Trent, found High Renaissance art inadequate for other reasons. In contrast to the Protestants, they vigorously reaffirmed the importance of rich visual and auditory imagery in churches and worship rituals. The intellectual and classical qualities of Renaissance art were found wanting in emotional appeal. Catholics wanted art that could enrapture the viewer, listener, or reader, appealing to the spirit through the senses and serving as an instrument of conversion.

Political and economic changes also had their effect on the development of new artistic forms. If the Protestant capitalists discouraged the decoration of churches, they encouraged paintings of themselves and the material objects surrounding them. Absolutist monarchy created a style of its own. Catholic monarchs liked to be shown in opulence and splendor, thus also encouraging a sensuous exploration of reality. One of the persistent characteristics of the new style in visual arts, literature, and music was a heightened sensuality combined with spirituality. Perhaps the long-lived disasters of the religious wars gave human beings zest for a life that seemed precarious and, at the same time, fervor for the life to come. Expanded trade and colonization in Africa and the New World gave artists wealth, more exotic themes, and an enlarged sense of space. The scientific and philosophical revolutions inevitably influenced artists'

portrayals of reality. The shift from an authoritarian view of nature to an experimental one also encouraged artists to portray what they actually saw.

On the other hand, the new knowledge that the earth was not the center of the universe led artists to seek a depiction of enlarged space in contrast to the ordered, limited space suggested by Renaissance conventions. Seventeenth-century church architects and painters loved to give illusions of infinite space; musicians enlarged their tonal space to echo an illusion of infinity; poets and playwrights became preoccupied with the idea that life on earth is transient and precarious, or as the title of Calderón de la Barca's famous play states, *La vida es sueño;* life is a dream, an illusion. An English poet of the new age, John Donne, captured something of the effect of the Scientific Revolution on people's minds and spirits in a poem called "An Anatomie of the World."

> And new Philosophy calls all in doubt,
> The element of fire is quite put out;
> The Sun is lost, and th'earth, and no man's wit
> Can well direct him where to looke for it.
> And freely men confess that this world's spent,
> When in the Planets, and the Firmament
> They seeke so many new; they see that this
> Is crumbled out againe to his Atomies.
> 'Tis all in peeces, all coherence gone;
> All just supply, and all Relation.

The sense of being on a little planet in space rather than on firm earth is accompanied by a kind of breathless vertigo that is characteristic of much of seventeenth-century art. Yet the sense of earthly life as an illusion often appears along with a realistic depiction of it. This is one of the many contradictions of the period.

Historians of Spanish, Dutch, French, and, sometimes, English culture call the seventeenth century the "great century" or the "golden century." The power attained by these countries was accompanied by a great cultural outpouring in all fields. Italy, although waning in prominence, took an early lead in architecture, painting, music, and poetry, and Germany, toward the end of the century, produced the period's greatest musicians. Yet this period of rich productivity in the arts shows a diversity of style that makes it hard to classify. The stylistic terms most often used now to describe all of the arts in this century are taken from the vocabulary of visual arts: *baroque* and *neoclassical.*

Some cultural historians like to divide the century into two neat parts: the first, until roughly 1680, politically and religiously chaotic, is characterized as baroque, and the late part, a period of relative stability, as neoclassical. This may be approximately true of literature and art in most Western countries, but the great period of baroque music did not end until the middle of the eighteenth century, and in the Slavic countries the baroque style in all the arts continued through that period. Even in France, where neoclassicism as a doctrine prevailed during the late-seventeenth-century reign of Louis XIV, certain elements of the baroque can still be found in the arts. We will focus on the reign of the "sun king" in Chapter 23. For now we will attempt to define some aspects of the baroque in the late sixteenth and early seventeenth centuries in the visual arts and poetry and, in Chapter 22, in the seventeenth and early eighteenth centuries in music.

Baroque in the Visual Arts

The rather strange word *baroque* (from Italian *barocco*) originally meant a logical process that was contorted or involuted. In Portuguese, *perola barroca* was a term used by jewelers to designate a rough or irregularly shaped pearl. The French, by the eighteenth century, used the word *baroque* to mean "a painting . . . in which the rules of proportion are not observed and everything is represented according to the artist's whim." All of these meanings were, like "Gothic," originally pejorative. What these definitions share in common is the sense of divergence from an established, accepted ideal. As art history and criticism evolved and the seventeenth century was revalued, *baroque* appeared to be the opposite of *classical,* in reference either to antiquity or to the High Renaissance. In this sense the term suggested art that was naturalistic rather than ideal, and emotional rather than rational. Translated visually, this would produce an art of movement, vitality, and brilliant color. Subjects could be chosen from daily life, as well as antiquity and the Bible, and presented to achieve maximum emotional impact or intense, detached observation.

Baroque Painting

Artists of the Renaissance fashioned an artistic revolution with new tools and strategies for dealing with the visual landscape. All over Europe artists responded to this new way of visual thinking and making. As the Italian accomplishments were disseminated north and west, they married with the explorations, ideas, and traditions of France, Spain, England, and the Netherlands. Artists in these countries created new work based on the particular needs, ideals, and beliefs of their patrons. For example, Dutch and German artists chose to paint scenes from daily life—farmers, skaters, hunters, and village celebrations.

Pieter Bruegel the Elder (born in Flanders, c. 1525–1569) was a genius whose "simple" scenes seem filled with meaning. *The Return of the Hunters* (Color Plate XI; 1565) appears to report on a daily incident in the life and in this season, one of at least four, of a village. The four trees that lead into the composition move

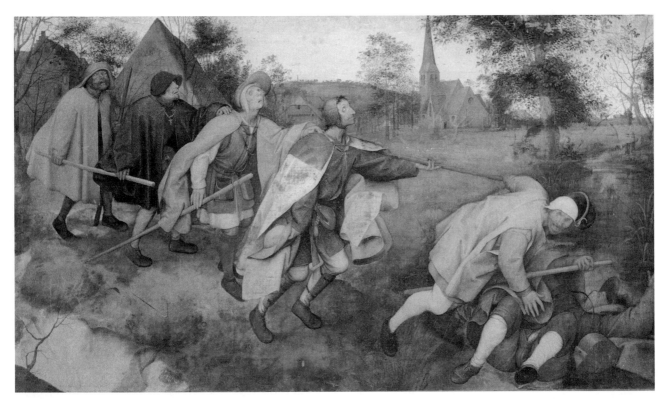

21-1 The Blind Leading the Blind, *1568, by Peter Bruegel the Elder. (Museo Nazionale di Capodimonte, Naples/Erich Lessing/Art Resource, NY)*

the space deeply into the frozen and snowy landscape, where hunters stride empty-handed, their shoulders hunched. It is a cold and frozen world; skaters, fishermen, and a wood carrier move in a gray-green atmosphere. An uncurling scrub in the foreground may presage spring. Bruegel seemed to view life with a careful distrust. *The Blind Leading the Blind* (Fig. 21-1, c. 1568) shows a cruel close-up of what must have been a common sight. The proverb alluded to is borne out as the leader falls down, sure to take the rest of the walkers with him. The church sits silently in the background.

In contrast, the work of El Greco (born Domenikos Theotokopoulos in Crete, 1541–1614), a student in Italy and a successful artist in Spain at the end of the sixteenth century, seems both courtly and intensely mystical. The *Burial of Count Orgaz* (1586) (Fig. 21-2) uses a vocabulary of form and color whose sources are Italian painting but whose feeling is uniquely El Greco's. The interment of the saintly Orgaz, being laid to rest by priests and friends, fills the lower half of the large canvas; the upper half is aswirl with saints, angels, Christ, and the Virgin, who welcome his soul to heaven. The expressive faces of the noblemen who attend Orgaz, the glittering surface of objects rendered vividly, have a life and energy far different from work by

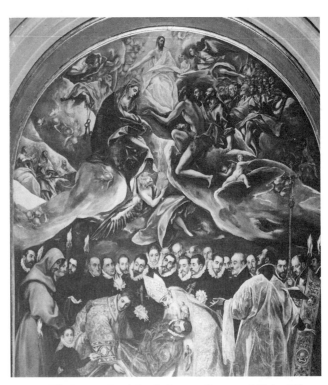

21-2 *El Greco,* Burial of Count Orgaz, *1586. Oil on canvas, 16′ × 11′10″, S. Tomé, Toledo, Spain. (Alinari/Art Resource, NY)*

Raphael and his peers. By 1600, when El Greco painted his *View of Toledo* (Color Plate XII), sky, earth, and air take on unearthly tones of light and movement that seem to be the product of an intensely personal experience and artistic language. El Greco's painting speaks of an independent vision, an individual soul.

By the end of the sixteenth century, the artistic vocabulary of Europe had expanded to create masterpieces removed both visually and emotionally from the art of the preceding one hundred years. It was this legacy, a vast body of paintings, prints, sculpture, and architecture, that provided the artists of the seventeenth century with unlimited resources for their own personal development. And the general term *baroque*, which is used to characterize their work, must always be qualified by reference to time, artist, and place of its production. Painters from France, Italy, the Netherlands, and Spain created works that demonstrate both the diversity and the shared characteristics of painting in the seventeenth century.

Caravaggio (1573–1610)

Born Michelangelo Merisi, Caravaggio took the name of his hometown in Lombardy. He arrived in Rome in his late teens and lived there like a rebel. His violence caused him to be accused of murder, and he fled the city about 1606. His anger suffused his artistic style, and like many artists in this period, he translated the accomplishments of the sixteenth century into highly dramatic and sometimes shocking paintings. *The Conversion of St. Paul* (1601), which at first glance seems to be about a very large horse, derives its drama from the choice of moment (Fig. 21-3). Caravaggio focuses on the moment when Paul, blinded by the light of Christ, falls from his horse. In *The Calling of Saint Matthew* (1599–1600) (Color Plate XIII), the artist uses many of the same techniques to create a sense of mystery, drama, and intense reality filled with human conflict and confusion. He uses ordinary daily settings to make the earthly divine.

Artemisia Gentileschi (1593–1652/53)

Artemisia Gentileschi was one of many women artists who emerged when master painters, who apprenticed emerging painters, began to recognize that women might be as talented as men. Gentileschi, like some other women artists (Bach's daughters come to mind), was trained by her painter father. Like her father, she was influenced by Caravaggio, but as she matured, she found her own style. Among her favorite subjects was the biblical heroine Judith, who beheaded the Assyrian general Holofernes to save her people. In the example here (Color Plate XIV) the artist has resisted showing the actual beheading and instead shows Judith in a dramatic and suspenseful moment, as if hearing a sound or a threat while the maid stuffs the head in a bag. The

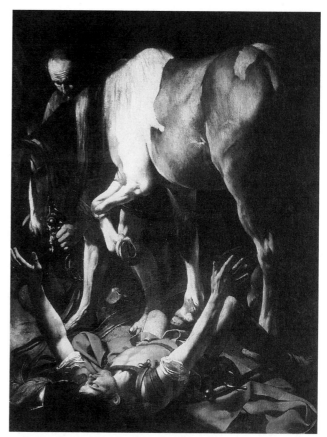

21-3 *Caravaggio,* The Conversion of St. Paul, *c. 1601. Oil on canvas, approx. 90¹⁄₂″ × 68⁷⁄₈″. Santa Maria del Popolo, Rome, Italy. (Canali Photo Bank, Milan/Superstock)*

• Where do the events in *The Conversion of St. Paul* and *The Calling of Saint Matthew* (Color Plate XIII) take place? What characteristics do they have in common? Where is Christ in *The Conversion* and in *The Calling*? How does light function in the two paintings? Where does the viewer stand? What is the effect of this position? Does the texture of material, the surface of skin, the body of the horse convince you that what you see is powerful?

wavering candle and the diagonals of raised arm against the sword in the hand beneath, like the two profiled faces, create a sense of tension filled with complex emotion. The careful rendering of delicate skin, hair, clothing, and other textures provides a foil for the terrible act of murder.

Peter Paul Rubens (1577–1640)

Peter Paul Rubens's early life, like his career as painter, diplomat, and collector, embodied the conflicts that characterized Europe in the late sixteenth and the seventeenth centuries. The son of a wealthy Antwerp Protestant, his flight from the Catholics who came to

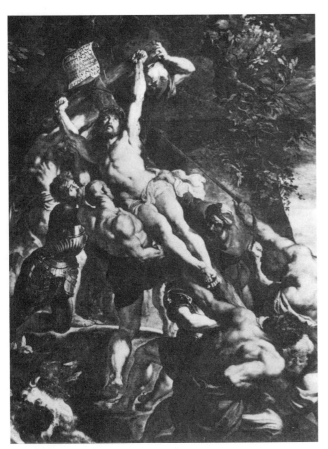

21-4 *Peter Paul Rubens,* The Raising of the Cross *(center panel of a triptych), 1609–1610, 15'2" × 11'2". Cathedral of Antwerp. (Copyright A.C.L.—Bruxelles; Institut Royal du Patrimoine Artistique)*

▲
• Compare Rubens's composition with Caravaggio's *Conversion* (Fig. 21-3). How does he convey the nobility of Christ? Compare the figures who raise the cross with those in Caravaggio's *The Calling of Saint Matthew* (Color Plate XIII) and with the figures in Bruegel's *The Return of the Hunters* (Color Plate XI). What is the purpose of the dog in the foreground?

control the Netherlands ended after his father's death, when the family returned to Antwerp and Rubens became a Catholic. Rubens was amiable, handsome, energetic, and talented. He traveled to Italy in 1600, and by the time he returned to Antwerp, in 1608, he had learned much from the painters of the fifteenth century. He had been introduced to the drama of Caravaggio's works and had studied Leonardo, Michelangelo, and Raphael. From these sources he created his own distinctive, optimistic, and visually rich view of the world.

Like many important artists, Rubens had his own workshop, where, in his absence, which was not infrequent, the commissions that flowed in could be carried out to his designs by his many assistants and reviewed and completed upon his return.

The Raising of the Cross (1609–1610) represents Rubens's new style (Fig. 21-4). It is the central panel of a triptych—a three-part altarpiece—executed for the cathedral in Antwerp. In his triangular composition, Rubens offers a dramatic moment filled with energy as the soldiers raise the cross bearing Christ's muscular, athletic body. Strong contrasts of light and shadow play over the forms, and Rubens's use of color and texture intensifies the sense of movement and emotion. Like those of many artists, Rubens's religious paintings were designed to convince and convert through the power of the image.

Rubens received many important secular commissions that, like his work for the church, were designed not only to convey a narrative of importance, but also to reinforce the power of the nobility and royalty whom he portrayed. The series of twenty-one canvases he painted to celebrate the career of Marie de' Medici (1573–1642), France's regent during the minority of her son Louis XIII (1601–1643), transforms this vainglorious, unscrupulous older woman into the personification of royalty through the linking of myth, fact, history, and allegory. For example, Marie's arrival at Marseilles (Fig. 21-5) shows her being greeted by helmeted France, attended by Fame and Neptune, whose court rises from the water at

21-5 *Peter Paul Rubens,* Arrival of Marie de' Medici at Marseilles, *Louvre, Paris. (Copyright 1996 ARS, NY/SPADEM, Paris)*

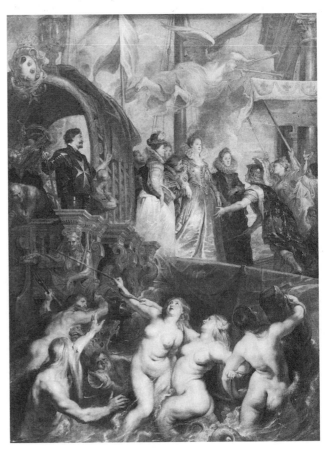

boat side. The rich colors, textures, and materials and the golden light glorify both Marie and the French monarchy, a monarchy whose power under Louis XIV would achieve new levels of wealth and absolute control.

Rubens was adept at creating images suitable for adulation whether of church or state, but it is important to remember that he was also a great painter who was captivated by life and by the people and objects he loved.

Garden of Love, painted in 1638, was inspired by Rubens's second marriage (Color Plate XV). Rubens and his young wife, Helene, at the far left, join a group of obviously loving couples in the garden of the painter's home in Antwerp. A statue of Venus and mischievous cupids complete this vision. The courtly man in the broad-brimmed hat introduces us to a world that will be, more and more, the subject of art—a golden time without pain or anxiety.

Rembrandt van Rijn (1606–1669)

Born in Leiden, near Amsterdam, Rembrandt spent his life in the more sober, restrained Protestant society of Holland. The churches were not great patrons of the arts, but the country was filled with a growing class of prosperous Dutch Calvinists and Lutherans. These industrious antiroyalists established a worldwide commercial empire that enabled people to want and to acquire art to adorn their houses. Travelers in Holland in the seventeenth century noted that almost every family owned at least one original work of art. For the first time in history, many painters made their livelihood in a free market. Paintings and prints of the flat country of land and water, with its huge cloud-filled sky, and of rich and sumptuous interiors of private homes were very popular, as were delicious still-life pictures. *The Three Trees,* an etching made by Rembrandt about 1643 (Fig. 21-6), depicts the Dutch landscape. His work also celebrates the material possessions, personal success, and pietistic faith of the independent Dutch.

Seated around a table covered with a magnificent red oriental rug, attended by a servant, the black-coated *Syndics of the Drapers' Guild* discuss the affairs of the guild (Color Plate XVI). Yet the moment is not altogether public, for they seem to have been caught in a quiet conversation. One man rises from his seat to greet someone who has come into the room, and all eyes focus on that person. The intruder is, of course, the viewer, and this is one of the qualities that give the picture its life. The men, who seem completely unposed, become the focus of our attention through their glances, their alert faces, the direction of light, and their white collars and broad-brimmed hats.

Rembrandt's sympathy with his patrons and their view of life grew from his own experience. His subject is always humankind, and the face, costume, and demeanor become a means to explore the internal life, with its pain, power, and pride. Thus, in his self-portraits, his own face becomes a vehicle for exploring the changes that life leaves on the body and the soul. One can follow his transformation from a foppish, well-dressed young man in the *Self-Portrait with Saskia* (his first wife) (Fig. 21-7), painted about 1635, to a mature, introspective man (Fig. 21-8), to a balding and turbaned artist holding his palette (Color Plate XVII).

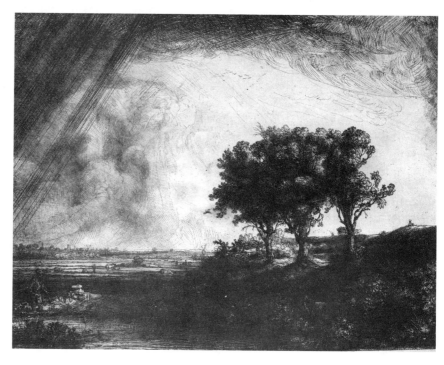

21-6 *Rembrandt,* The Three Trees, *etching, 1643. (The Metropolitan Museum of Art, bequest of Mrs. H. O. Havemeyer, 1929. The H. O. Havemeyer Collection.)*

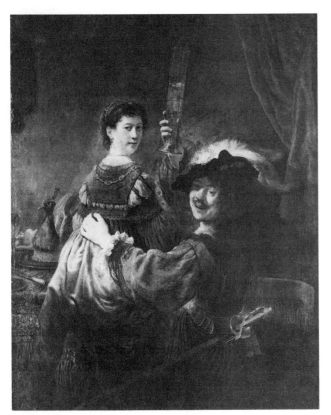

21-7 *Rembrandt,* Self-Portrait with Saskia, *c. 1635. (Staatliche Kunstsammlungen, Dresden)*

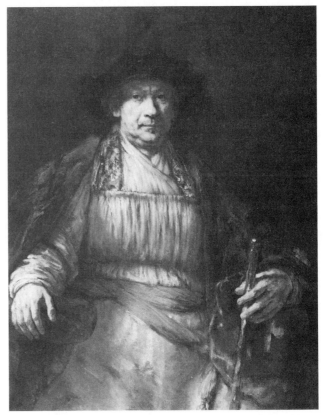

21-8 *Rembrandt,* Self-Portrait, *1658. (The Frick Collection, New York)*

Rembrandt's genius, like that of Rubens, lay in the unity of composition achieved by light and by the revelation of surface features, textures, and colors in light. Renaissance painting developed conventions in which light was generally clear, even, and uniformly revealing. Masaccio, Piero, Botticelli, Raphael, and Leonardo all employed a representation of light that is not intrusive. It is a steady light that has been studied in nature but controlled in the studio. It may be slightly *warm*—that is, tending to emphasize the warm reds, yellows, and oranges of the spectrum—or it may be *cool*—emphasizing the cool blues, greens, and purples of the spectrum—but, above all, it is consistent. Along with this convention of uniform light, the Renaissance painters used another by designating *shade* or *shadow* with gray, brown, or black layers of paint. This is not the way that shades and shadows are colored in nature, but it is the way that they were conventionally depicted. Without shade and shadow there is little or no sense of volume and space. Showing shade and shadow as an absence of color gives a great sense of uniformity to a picture, particularly uniformity of light.

Just as Caravaggio used light in a new way, so, too, did Rubens and Rembrandt, who experimented with and elaborated on the conventions that had defined the way light would be rendered in fifteenth- and sixteenth-century painting. Rubens, like Caravaggio, used light dramatically to reveal and focus on objects, but unlike Caravaggio, whose light usually revealed the harsh reality of things, Rubens used light to reveal color and texture and to enliven and enhance objects. Rembrandt used light to create much sharper contrasts between figures and objects in space. In deep shadows and shadowed faces we find that same mystery of life and death, pain and joy. Although these themes are present in Rubens's work, Rembrandt portrays them without explosive theatricality. The drama becomes more personal and introspective; it is not something that we witness, but rather something that we experience.

Return of the Prodigal Son (c. 1669) (Color Plate XVIII) is such a shadowy, soundless, but deeply moving painting. The differences between Rembrandt and Rubens and between their styles and that of the previous century can be seen here just as one can see the contrast between the theatricality of Counter-Reformation Catholicism and the individual piety of the Protestant north.

Jan Vermeer (1632–1675)

The ability to make paint give the illusion of reality has almost no limits. The Dutch landscape painters of the

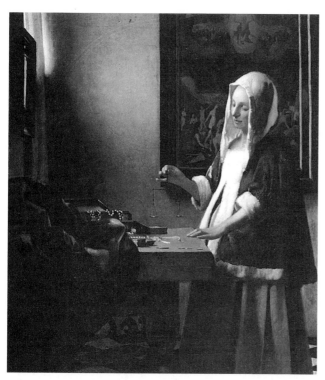

21-9 Woman Holding a Balance, *by Johannes Vermeer. (National Gallery of Art, Washington. Widener Collection. Photo by Richard Carafelli)* (W)

sixteenth century created a means of capturing feelings of space and air, of light and movement, that offered remarkable windows into the world, but the painting still remained a picture that was ordered and controlled. Vermeer of Delft used his experience of the natural world to fashion visions that seem to be fragmentary moments of real time captured in his apparently simple subjects. Domestic scenes such as his *Woman Holding a Balance* (Fig. 21-9) had been popular for many generations of painters, but in the work of Vermeer these transient moments are rendered permanent.

In *The Kitchenmaid* (Color Plate XIX), a maidservant stands before a window pouring milk from a pitcher into a basin. The light from the window is cool and subdued; the colors of her sleeves, apron, and the tablecloth are also cool. The pottery basin and bowl, the cut bread, the basket, the gold of her bodice, and the red of her skirt challenge the cool, quiet northern light that falls from the window above her head. The woman is unself-conscious and unremarkable, solid and three-dimensional; her weight and volume act as a fulcrum for all the objects in the room. The milk falls of its own weight into the basin.

What is so remarkable about this painting? The original, more than a reproduction, emits an incredible transparency and glow. It is possible to imagine that, should the light be gone from the room, the painting itself would provide light—so natural and convincing

is its revelation of every surface, fold, and wrinkle. The colors themselves vibrate; shadows and folds are not rendered in gray, brown, or black but in thin layers of color itself—deeper blue in her apron, deeper golden red on the basin.

Light, of course, is the most essential and most recalcitrant element that artists have captured in a variety of ways by controlling it in paintings. Raphael's even, harmonious light; Rubens's and Gentileschi's dramatic spotlight effects; and Rembrandt's reflected light are examples of different ways to render light. Vermeer, however, by confining his subjects almost exclusively to figures before windows, proclaims his interest in the transient cool light that comes from outside and is subject to constant change. Yet change cannot occur in the painting: the subject is "real," but it is not. Up until this time painters have used light to reveal figures and forms, but there is no attempt to make us think that it is the kind of light we experience. Vermeer suggests the brevity of life and light in his paintings, which capture the temporary nature of living actions.

Diego Rodríguez de Silva y Velázquez (1599–1660)

It is perhaps curious that of all the acknowledged masters of the seventeenth century, a painter at the court of Philip IV, in the period of Spain's decline, could have created a highly original and personal style based on pure sensibility and perceptual experience. During the same years that Rubens executed great religious paintings, and Ribera and Zurbarán, Spanish contemporaries of Velázquez, made deeply moving and powerful religious pictures for Spanish patrons and the Church, the court painter (he had joined the court in 1623, remained there, and was made court chamberlain in 1652) produced few religious subjects. Rather, his fame grew from his stunning portraits and scenes of classical allegory and myth. Visiting Italy twice provided inspiration but did not essentially alter his manner. Velázquez's manner is most comparable to that of Vermeer. Like Vermeer, he was fascinated by light on objects, the light that reveals and conceals the images the artist sees and reproduces. Thus the actual surfaces of Velázquez's paintings reveal an elegant and systematic brushwork that depicts objects as fragments of light and shade, of colors placed side by side. The edges of objects are slightly indeterminate; the surface is never harsh or crisp but rather seems perpetually modulated by the movement of air and light. The most telling experience is to see a painting by Velázquez and to stalk it silently in an attempt to discover the precise moment at which the surface dissolves into the fragments, layers, and dots that constitute the source of the painted image. This is difficult, however, for the moment of dissolution is so close to the moment of seeing the image as a complete whole.

This kind of painting seems to lend itself to speculations about kinds of reality—the reality of image, of surface, of object. Yet like Vermeer's paintings, Velázquez's works do not suggest speculation; rather, they seem truly to depict reality. His most famous work, *Las Meninas* (The Ladies-in-Waiting), painted in 1656, typifies his greatest work (Color Plate XX).

In the center of the large canvas, near the front edge, stands the five-year-old princess who has come to visit the painter in his studio. To the left stands Velázquez, a very large canvas on his easel. The ladies-in-waiting attend the princess, and to the right are two dwarfs, whose plainness plays against the glitter of royalty. A dog lies quietly in the foreground; a court official enters a lighted doorway at the back of the room. It is then that the viewer sees, or is shown, the images of the king and queen, reflected by a mirror at the back of the room. They, too, have come to the studio of their painter, who must be working on a painting of the royal family.

The light in this painting seems to fall into the room from an unseen window to the left. It lights the figures, the foreground, and the king and queen, who stand where the viewer might be. As with Vermeer's painting, it is possible to imagine that one could see into the painting in the dark, because it seems to contain its own light. The surface is fairly smooth, but rich with the paints that so carefully re-create the varying surfaces of hair, skin, fabric, fur, embroidery, jewelry. It is a remarkable achievement; the painting seems to breathe with a life drawn from experienced reality, captured on canvas.

Rubens, Rembrandt, and Caravaggio, each in his own way, explore human emotions with power, drama, and, sometimes, the rhetoric of experience. Vermeer and Velázquez, on the other hand, seem to explore the experienced world in a direct and candid way, sacrificing nothing to give an account of the essentials of seeing, yet creating an extraordinary series of masterpieces that are, in fact, as carefully considered, composed, and conceptualized as the work of their predecessors or their peers.

Baroque Architecture and Sculpture in Rome: Gian Lorenzo Bernini

It was in a Rome dominated by the papacy and the militant Counter-Reformation that the baroque style in architecture began. In the late sixteenth century the popes began to transform the city. A system of wide thoroughfares and squares united the major churches and sites of the pilgrim processional. There was innovative accommodation for wheeled and pedestrian traffic. There was also a sense of order to the city, recalling that produced by the ancient Forum. The pope's cathedral, Saint Peter's, was begun in the early sixteenth century (Fig. 21-10); the dome and east end, carried forth under Michelangelo, were brought to completion and aggrandized by a succession of powerful popes. Gian Lorenzo Bernini (1598–1680), the greatest sculptor of the seventeenth century, was commissioned to finish the interior. He designed the great canopy that stands over the high altar; the enormous elevated throne, the Chair of Saint

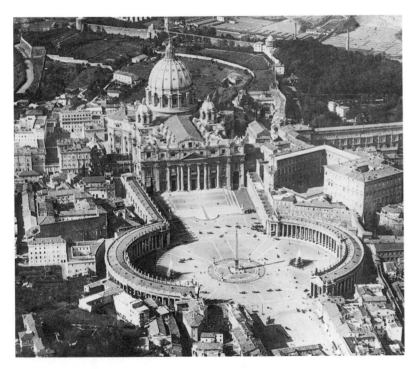

21-10 *Saint Peter's Basilica, Rome, aerial view. (Alinari/Art Resource, NY)*

The colonnade, for example, is four columns deep. Decorated with fountains and an Egyptian obelisk, this piazza—and others like it opened in Rome and decorated by Bernini and his peers—became important in the development of urban planning. Rome itself was adorned with new churches and palaces. In their interiors are still found paintings and sculptures that represent persuasive, powerful propaganda for the faith.

In contrast to the vast adornments of Saint Peter's, Bernini planned other, more intimate decorative schemes that were focused on his magnificent sculptures. Such a scheme is the Cornaro Chapel at Santa Maria della Vittoria in Rome (1645–1652) (Fig. 21-13). An anonymous eighteenth-century painting of the chapel gives us the best idea of the ensemble, whose subject is the ecstasy of Saint Teresa of Ávila. The ceiling of the vaulted chapel seems to disappear as angels greet the dove of the Holy Spirit in a burst of divine, heavenly light. The architectural frame swells out to create a stage for the cloud with its burden of a limp, sagging Saint Teresa and a beautiful, smiling angel who holds an arrow in his upraised hand and with the other gently raises her habit to reveal her heart. In her autobiography Saint Teresa had described this vision in which an angel with a flaming golden arrow pierced her heart. "The pain was so great that I screamed aloud, but simultaneously felt such infinite sweetness that I wished the pain to last eternally. It was the sweetest caressing of the soul by

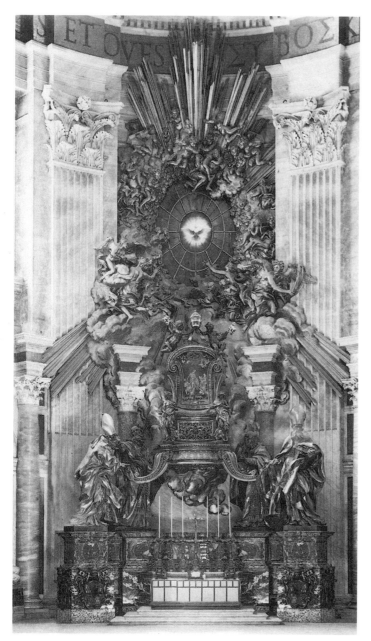

21-11 *Bernini, Chair of Saint Peter, St. Peter's Basilica, Rome. (Alinari/Art Resource, NY)* **(W)**

Peter, in the east end (Fig. 21-11); and the magnificent staircase that connects the papal apartments with the west front of the church.

All these features seem like sets for a grand spectacle, but none more so than the great plaza and colonnade set before the church to provide the necessary vista for a view of the great hovering dome of Saint Peter's. The arms of the Tuscan Doric colonnade reach down from the ends of the church façade, compress slightly, and then swell into the curved arms of the oval that welcomes the pilgrim to Saint Peter's (Fig. 21-12). The architectural vocabulary is that of Rome and the Renaissance but employed on a massive, monumental scale.

21-12 *Ground plan, Saint Peter's Square.*

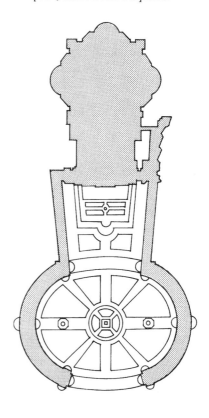

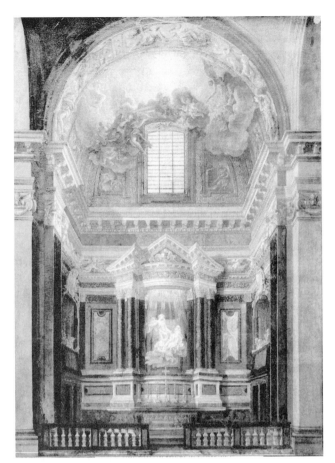

21-13 *Anonymous,* The Cornaro Chapel, *17th-century painting. (Staatliches Museum, Schwerin, Germany)*

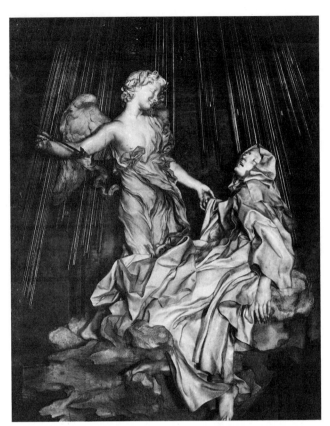

21-14 *Bernini,* The Ecstasy of Saint Teresa, *c. 1645–1652, marble, height of group 11′6″, Cornaro Chapel, Santa Maria della Vittoria, Rome. (Art Resource, NY)* (**W**)

God." The saint's mouth is open, as if to cry out, but the movement of her complex drapery contrasts with her thrown-back head and arm so that she seems to move both away from and toward this awesome divine love (Fig. 21-14). There is a distinctly erotic tone to pose and gesture, which is enhanced by the realistic rendition of hands, feet, and face of the saint and the angel's soft feathered wings and curls. The bronze rays falling behind the group reinforce the real light, and the marble paneling of the wall is continuous with that in the rest of the chapel. We observe from the ground, but members of the Cornaro family are in boxes on either side—these are also part of the total ensemble of sculpted and painted decoration, for the figures are marble reliefs. It is significant that many Catholics, including Bernini, practiced exercises of prayer and self-denial that were designed to induce suffering and delight comparable to that of Christ and the saints.

It was in Rome, then, that some of the greatest monuments of the seventeenth century were produced. It was from Rome also that the baroque was carried to other artistic centers. Baroque in the visual arts thus includes a rich diversity of styles and cultural patterns from the Catholic south to the Protestant north.

Literary Baroque

Although some scholars still dispute its usage, the term *baroque* has in recent decades been applied to literature as well as to the other arts. Late-sixteenth- and early-seventeenth-century drama and poetry, as well as some fiction, in all European languages do indeed show some characteristics similar to those we have seen in the visual arts: conflict, paradox and contrast, metaphysical concern, and a heightened spirituality, combined with a lively sensuality and ultrarealism. Like the baroque style in art, literary baroque also had Catholic and Protestant representatives. German Lutheran hymns, Spanish Catholic devotional poetry, Italian erotic verse, and English "metaphysical poetry" all display aspects of this multifaceted style. Here we will limit our examples to a few poems from the country that produced the earliest and perhaps the greatest baroque writers, Spain, and to an important group of early-seventeenth-century poets in England.

The Origins of Spanish Baroque

The names of the novelist and playwright Miguel de Cervantes (1547–1616), the dramatists Pedro Calderón

de la Barca (1600–1681) and Lope de Vega (1562–1635), and the poet Luis de Góngora y Argote (1561–1627) remind us that the seventeenth century was Spain's "golden age," a time that produced writers who were to have an impact on world literature comparable to the impact of Spanish civilization on the New World. To understand the flowering of the Spanish baroque, it is important to look at some late-sixteenth-century precursors.

The widespread sense of disillusionment felt in late-sixteenth-century Spain was in part a manifestation of the widening gap between the ideals of a great Catholic power and reality. Ambitious military enterprises such as that of the Armada forced the monarchy to live from hand to mouth and to declare periodic bankruptcies. Religious conformity discouraged independent thinking and encouraged hypocrisy. The aristocratic values of the society tended to divide the population into masters and servants.

As early as 1554, the tale of Lazarillo de Tormes presents a revealing picture of this world. In a short first-person narrative, the anonymous author vents a constant aggressiveness against the prevailing social values in a realistic style that contrasts sharply with the idealized approach of the then-popular sentimental novels and romances of chivalry. It is an irreverent work, antiestablishment, anticlerical, bitterly satirical, attacking religious orthodoxy, purity of blood, and aristocratic "virtue."

The story of Lazarillo, whose parents are members of the very lowest social stratum, is one of corruption in which the hero, or more accurately the antihero, rises in the social scale as the prevailing social values force him to sink progressively into personal and moral degradation. This tale poses unambiguously the aesthetic values of what will years later become the very basis of baroque literature—that is, the dialectical relation between appearance and reality, between *engaño* (illusion) and its opposite, *desengaño*, which is not disillusionment but rather the process of arriving at the acceptance of truth, which is usually bitter and at odds with conventional wisdom.

Saint Teresa of Ávila (1515–1582) and Spanish Mysticism

Chronologically closer to the full-fledged baroque are the mystics and mystic poets who flourished in the second half of the sixteenth century. Undoubtedly, the Spanish mystics must have been influenced by the same weariness with conflict and turmoil that had caused the satirical outbursts in *Lazarillo*. In opting for a life of seclusion, a contemplative rather than an active life, they were expressing both their disdain for worldly ambition and their condemnation of the ideological oppression and the corruption that had gripped Spanish

society. Many of them, including the Carmelite nun and mystical writer Saint Teresa of Ávila and her disciple the poet Saint John of the Cross, fell afoul of the Inquisition.

Teresa de Ahumada y Cepeda—later canonized as Saint Teresa of Jesus—was born in Ávila to Doña Beatriz de Ahumada, from an old Catholic family of Ávila, and Alonso Sánchez de Cepeda, the son of a *Converso* merchant, who had been punished by the Inquisition for secretly practicing Judaism. Raised in a strict Catholic household, Teresa as a young girl loved to read chivalric romances and saints' lives but had no thought of becoming a nun. When Teresa was thirteen years old, her mother died and her father sent her to a convent to pursue her education. Much impressed by the strong commitment and seriousness of the nuns, Teresa decided to enter a Carmelite convent. During the remaining years of her life, Teresa demonstrated her remarkable gifts as a mystic visionary, a prolific and noteworthy writer, and a practical reformer who braved numerous struggles to found her own convent at San Jose.

Perhaps the most interesting of Saint Teresa's writings for the modern reader is the autobiographical *Book of Her Life*, written when she was about fifty years old. She describes there in vivid detail her pains, tribulations, and joys, both in combating her own doubts and those of others about the authenticity of her mystic visions and in struggling against church hierarchy and community opposition to found her convent. *Mysticism* involves the experience of the union of the soul with God through visions. Such experiences transcend human reference and cannot therefore be rationally explained. Teresa herself, as well as her detractors, sometimes questioned whether her visions came from the devil rather than from God. However, she found the means to define and distinguish true from false visions, as well as a poetic language in which to express something of the nature of the mystic experience.

In her convent reform projects, she was inspired by Saint Francis of Assisi's ideal of voluntary poverty. Whereas most Spanish convents allowed nuns to retain their social class distinction, as well as their property, including slaves, Teresa believed in strict equality for the nuns and in a cloistered life of austerity—though not deprivation—financed by alms. She believed that an ascetic life, removed as far as possible from the concerns of the world, would ultimately lead to greater spiritual freedom for the nuns. In her own case, at least, this seems to have been true. She was ultimately successful in founding and heading her convent and in winning the respect and support of the Church and the community. Teresa's mystic visions inspired several baroque artists, most notably, as we have seen, Gian Lorenzo Bernini (Fig. 21-14).

The Baroque Style in Spain

The full flowering of Spanish baroque comes in the early seventeenth century. The term *barroco* denotes, in Spanish life, literature, and fine arts, a clearly defined attitude to the external world as well as a stage in artistic development. It is an attitude conditioned by the concept of *desengaño*. In a world in which all values were found to be inconstant and deceptive, the nature of life itself was subjected to constant questioning. That is the quandary of Segismundo, a sort of Everyman in Calderón's play *Life Is a Dream*. He expresses it at the end of Act II: "We are in such a singular world that to live is but to dream; I have learned, in my experience, that, in living, man but dreams what he is until he wakes." There is, of course, no knowing when the awakening will come.

This view of the deceptive nature of human experience gave rise to a preoccupation with death on the one hand and with corruptible human flesh on the other. Artists resorted to overornamentation to extract from nature the beauty that seemed (as in the painting of Velázquez) to dissolve and disappear precisely as the artist struggled to record it. Nature has lost out, they seem to be saying, and meaning has to be sought in the painful and painstaking accumulation of artifice. The most disparate notions are brought together by violence to create a new kind of aesthetic. The paintings of El Greco (Spanish for "the Greek"), although not considered baroque by all art historians, demonstrate the expressive distortion of human anatomy and of spatial relations and the violent emotion characteristic of the period (see Fig. 21-2 and Color Plate XII). In literature, the baroque style takes the form of extravagant metaphors, violent paradoxes, and an abstruse and learned vocabulary.

Sor Juana Inés de la Cruz (1651–1695)

The Spanish baroque poet Góngora found many followers in the overseas Spanish possessions. The viceregal courts of Mexico and Lima, for instance, were known as sophisticated centers of learning in which writing and the fine arts flourished. Inés Ramírez de Asbaje had become known at an early age in Mexico for her unusual aptitude and thirst for learning. Society, however, frowned on learned women. In taking vows at the age of nineteen in the order of Saint Jerome, assuming the name of Sor (Sister) Juana Inés de la Cruz, she was led by the sincere belief that in withdrawing from the secular world, in which she found herself "sought as a beautiful woman and unhappy in her wisdom," she would be able to pursue a life of study and contemplation. As she found out, she was only partly right. Nonetheless, she managed to leave a remarkable written record as poet, playwright, and essayist.

In her quest for mystic experience, Sor Juana considered herself to be a daughter and disciple of the great Saint Teresa. Yet she differed from the saint by defending for herself and for other women the right to pursue secular as well as sacred learning. Her letter "Response to Sor Filotea" is considered to be the first written document from the Americas that defends a woman's right to a humanistic education. Sor Juana composed more than two hundred poems—many of them sonnets—as well as songs, devotional exercises, and plays. The *tone* of her poetry is enormously varied: she wrote tender poems of friendship and love, satirical epigrams, and rich, complex, "baroque" poems, full of imagery, complex rhetoric, and classical allusions. She wrote at least one poem in Nahuatl, a Native American language. Although she fervently espoused the conversion of the Indians to Catholicism, Sor Juana also defended their rights as a people.

Don Quixote and Don Juan

The most justly famous of all of the literary works of Spain's golden age is Cervantes's *Don Quixote*, published in 1605. The adventures of the country gentleman who tries to impose an outmoded code of chivalry on the modern world play with the baroque themes of reality and illusion and have delighted millions of readers. But another *don* (a Spanish form of address denoting a high social status) conceived in the baroque era has had an even greater effect on the Western imagination: the figure of Don Juan.

The original Don Juan Tenorio may or may not have been a real person but was certainly a figure in Andalusian legend and oral literature when Tirso de Molina (1571?–1648) composed the first literary work about him, *El burlador de Sevilla y su convidado de piedra* (The trickster of Seville and his guest of stone), around 1630. Tirso's Don Juan is a spoiled child of privilege, an overweening young aristocrat who, confident in his social status, consciously sets out to break all rules of conduct, divine as well as human, to gratify his insatiable desire to seduce women. It is not love, and not even lust, that prompts him so much as the game itself, the desire for conquest. Don Juan replaces the courtly adoration of the lady with a cynical and mocking belief in the fallibility of woman. He shows cavalier disregard for polity and morality, trusting to a distant day of reckoning as well as to God's infinite and all-encompassing grace. Catholic Spain, however, believed not in predestination but in humanity's proving itself worthy of salvation through the exercise of free will. Don Juan fails the test. His life is cut short and he is therefore condemned to eternal damnation. In his own way, Don Juan thus became one of the most compelling symbols of this period of despair as well as of the intense sensory and religious experience that was the

Spanish baroque. We will study the most famous incarnation of Don Juan in Mozart's opera *Don Giovanni* in Chapter 26.

English "Metaphysical" Poetry

One group of poets in mid-seventeenth-century England, including John Donne, George Herbert, Richard Crashaw, and Andrew Marvell, was disparagingly dubbed "metaphysical" (meaning abstract and difficult) by the critic Dryden. Although inadequate to describe this school of poetry, the term has stuck. In recent years, however, Continental critics and even some English critics have begun to see affinities between this school of poets and the baroque sensibility that prevailed throughout Europe. Frank Kermode, while granting that "metaphysical" may be a subdepartment of "baroque," urges caution:

> When we think of metaphysical, we do not think at once of St. Ignatius or Bernini or Marino, though we may do so a little later. We think first of a special moment in English poetry, a moment of plain but witty magniloquence, of a passionate poetry ballasted with learning and propelled by a skeptical ingenuity that may strike us as somehow very modern.[1]

This succinct definition does express the most salient qualities of "metaphysical" poetry. We will briefly discuss here two of these poets who combined the spiritual with the sensual in ways that relate them to Continental baroque poets and artists.

Crashaw (1612–1649) Perhaps the most baroque of all the seventeenth-century English poets was Richard Crashaw. Crashaw was raised in the Puritan tradition—

his father was a preacher—but he converted to Roman Catholicism and spent the last years of his life in Rome. He was greatly attracted to mysticism and especially to female saints; three of his best-known poems are on Saint Teresa of Ávila. Although it is unlikely that Crashaw saw Bernini's famous statue before writing the poems, they share its spirit. In the last part of the third poem in the series, entitled "The Flaming Heart," Crashaw criticizes conventional pictorial representations of the saint (where she usually appears as a rather placid nun). He then describes how she should be represented. First, he says that she, not the seraph beside her, should hold the dart. He then concedes to the angel "the bravery of all those Bright things," including "the radiant dart," and asks that Teresa be left only "the flaming heart."

Donne (1572–1631) In contrast to Crashaw, John Donne was brought up as a Catholic but became an Anglican. He became, in fact, one of the most successful preachers of his age, and his sermons are still read for their force and brilliant style. At the same time, Donne was a worldly man, fond of women and involved in several passionate love affairs. He was thus suited to the baroque combination of the ardently religious and the ardently erotic; his best poems successfully combine the two. His "holy sonnets" are often like prayers, comparable to Bernini's and to Crashaw's Saint Teresa in their use of erotic and violent imagery to describe mystic experience. The famous poem "To His Mistress Going to Bed" is frankly erotic, but in it the poet speaks of the bed as "love's hallowed temple" and of women as angels and "mystic books." Another type of poem, "The Flea," is set up as an argument for seduction. Centered on a tiny, apparently insignificant object (a flea), it makes use of extreme detail to portray matters of larger significance; in this sense it is more comparable to the Dutch than to the Italian baroque style in art.

[1] Frank Kermode, ed., *The Metaphysical Poets* (New York: Fawcett, 1969), p. 32.

Saint Teresa of Ávila

from *The Book of Her Life*

Translation by Kieran Kavanaugh and Otilio Rodriguez

In the first selection, Chapter 29, Teresa depicts the famous vision that inspired both Bernini's statue and Crashaw's poem. The second selection, from Chapter 36, describes the founding of Teresa's convent.

Chapter 29

13. The Lord wanted me while in this state to see sometimes the following vision: I saw close to me toward my left side an angel in bodily form. I don't usually see angels in bodily form except on rare occasions; although many times angels appear to me, but without my seeing them, as in the intellectual vision I spoke about before. This time, though, the Lord desired that I see the vision in the following way: the angel was not large but small; he was very beautiful, and his face was so aflame that he seemed to be one of those very sublime angels that appear to be all afire. They must belong to those they call the cherubim, for they didn't tell me their names. But I see clearly that in heaven there is so much difference between some angels and others and between these latter and still others that I wouldn't know how to explain it. I saw in his hands a large golden dart and at the end of the iron tip there appeared to be a little fire. It seemed to me this angel plunged the dart several times into my heart and that it reached deep within me. When he drew it out, I thought he was carrying off with him the deepest part of me; and he left me all on fire with great love for God. The pain was so great that it made me moan, and the sweetness this greatest pain caused me was so superabundant that there is no desire capable of taking it away; nor is the soul content with less than God. The pain is not bodily but spiritual, although the body doesn't fail to share in some of it, and even a great deal. The loving exchange that takes place between the soul and God is so sweet that I beg Him in His goodness to give a taste of this love to anyone who thinks I am lying.

14. On the days this lasted I went about as though stupefied. I desired neither to see nor to speak, but to clasp my suffering close to me, for to me it was greater glory than all creation.

Sometimes it happened—when the Lord desired—that these raptures were so great that even though I was among people I couldn't resist them; to my deep affliction they began to be made public. After I experience them I don't feel this suffering so strongly; rather I experience what I mentioned before in that other part—I don't recall which chapter—which is very different in many respects and more valuable. But when this pain I'm now speaking of begins, it seems the Lord carries the soul away and places it in ecstasy; thus there is no room for pain or suffering, because joy soon enters in.

May He be blessed forever who grants so many favors to one who responds so poorly to gifts as great as these.

Chapter 36

24. Before entering the new monastery, while in prayer outside in the church, being almost in rapture, I saw Christ who seemed to be receiving me with great love and placing a crown on my head and thanking me for what I did for His Mother.

Another time while all were at prayer in choir after compline, I saw our Lady in the greatest glory clothed in a white mantle; it seemed she was sheltering us all under it. I understood how high a degree of glory the Lord would give to those living in this house.

25. Once the liturgical Offices were initiated the people began to grow very devoted to this house. More nuns were accepted, and the Lord started to inspire our most vigorous persecutors to show us much favor; and they gave us alms. So they approved of what they had so greatly disapproved. Little by little they abandoned the lawsuit and said that now they knew the house was a work of God since in spite of so much opposition His Majesty desired the foundation to go forward. And there isn't anyone at present who doesn't think it was right to let the house be founded. Thus they are so careful about providing us with alms that, without our asking or begging from anyone, the Lord stirs them to send alms to us. We get along without any lack of necessities, and I hope in the Lord things will always be like this. Since the nuns are few in

number, if they do what they are obliged to, as His Majesty now gives them the grace to do, I am sure they won't lack anything or have need to be anxious or to importune anyone. The Lord will take care of them as He has up to now.

26. It is the most wonderful consolation for me to be able to live with souls so detached. Their conversation is about how they can make progress in the service of God. Solitude is their comfort, and the thought of seeing others (when doing so is not a help toward an enkindling within them of a greater love of their Spouse) is a burden to them even though these others may be relatives. As a result no one comes to this house save those who speak about this love, for otherwise neither are the nuns satisfied nor are their visitors. Their language allows them to speak only to God, and so they only understand one who speaks the same language; nor would they in turn be understood by anyone who doesn't. We observe the rule of our Lady of Mt. Carmel and keep it without mitigation. . . .

27. It seems to me that all the trials suffered were well worth it. Now, although there is some austerity because meat is never eaten without necessity and there is an eight-month fast and other things, as are seen in the first rule, this is still in many respects considered small by the sisters; and they have other observances which seemed to us necessary in order to observe the rule with greater perfection. I hope in the Lord that what has been begun will prosper, as His Majesty has told me it would.

29. . . . Since the Lord has desired so particularly to show His favor toward the establishment of this house, it seems to me that one would be doing a great wrong and would be punished by God were one to begin to mitigate the way of perfection that the Lord has initiated here and so favored that it can be borne with such great ease; it is very clearly seen to be bearable and can be carried out calmly. The main disposition required for always living in this calm is the desire to rejoice solely in Christ, one's Spouse. This is what they must always have as their aim: to be alone with Him alone. And there should be no more than thirteen in the house, for after much advice I have learned that this is a fitting number; and I've also found it out through experience. To live the spiritual life as we do, as well as from alms, without begging, does not allow for a larger number. Let them always have greater trust in the one who through many trials and the prayer of many persons strove for what would be better. And by the great happiness and joy and small amount of hardship we have had during these years spent in this house, in which we find that all of us have had much better health than usual, it is obvious that this number is what is fitting. Those who think the life harsh should blame their own lack of spirituality and not what is observed here, for they should be able to live it since persons who are sickly or have delicate health live it with such ease; they should go to another monastery where they can be saved in a way conformable to their own spirituality.

COMMENTS AND QUESTIONS

1. What kinds of vocabulary and images does Teresa use to describe mystical experience?

2. Compare Teresa's vision of the angel with Bernini's representation of it. Has the sculptor emphasized or exaggerated certain aspects?

3. How does Teresa show that she is a practical organizer as well as a mystic visionary? Describe her plan for her convent.

SOR JUANA INÉS DE LA CRUZ

The first poem is from Sor Juana's "Redondillas"—quatrains of eight-syllable lines, generally with an abba *rhyme. In them she displays her talent for satire, usually directed against the follies of men. The second poem, a sonnet, treats in a baroque style the baroque theme of illusion. Here we have also given the originals of the shorter poems.*

Sátira filosófica

Arguye de inconsecuentes el gusto y la censura de los hombres
que en las mujeres acusan lo que causan.

Hombres necios que acusáis
a la mujer sin razón,
sin ver que sois la ocasión
de lo mismo que culpáis:
 si con ansia sin igual
solicitáis su desdén,
¿por qué queréis que obren bien

A Philosophical Satire

Translation by Margaret Sayers Peden

She proves the inconsistency of the caprice and criticism of men
who accuse women of what they cause

Misguided men, who will chastize
a woman when no blame is due,
oblivious that it is you
who prompted what you criticize;
 if your passions are so strong
that you elicit their disdain,
how can you wish that they refrain

si las incitáis al mal?

Combatís su resistencia
y luego, con gravedad,
decís que fue liviandad
lo que hizo la diligencia.

Parecer quiere el denuedo
de vuestro parecer loco,
al niño que pone el coco
y luego le tiene miedo.

Queréis, con presunción necia,
hallar a la que buscáis,
para prentendida, Thais,
y en la posesión, Lucrecia.

¿Qué humor puede ser más raro
que el que, falto de consejo,
él mismo empaña el espejo,
y siente que no esté claro?

when you incite them to do wrong?

You strive to topple their defense,
and then, with utmost gravity,
you credit sensuality
for what was won with diligence.

Your daring must be qualified,
your sense is no less senseless than
the child who calls the boogeyman,
then weeps when he is terrified.

Your mad presumption knows no bounds,
though for a wife you want Lucrece,[1]
in lovers you prefer Thaïs,[2]
thus seeking blessings to compound.

If knowingly one clouds a mirror
—was ever humor so absurd
or good counsel so obscured?—
can he lament it is not clearer?

[1] Lucretia, an example of the virtuous, honorable Roman wife.
[2] A well-known Greek prostitute.

COMMENTS AND QUESTIONS

1. Even if you do not know Spanish, you should be able to discern the *meter* and the *rhyme scheme* in the original. What are they? How has the translator rendered them?

2. Of what, exactly, does Sor Juana accuse men here? How does she demonstrate their lack of logic?

3. How does the image of the clouded mirror in the last four lines help to convey the poem's meaning?

4. How effective, in your opinion, is Sor Juana's satire?

Soneto sobre un retrato de sí misma

Sonnet on a Portrait of Herself

Translation by Margaret Sayers Peolen

She Attempts to Mimimize the Praise Occasioned by a Portrait of Herself Inscribed by Truth—Which She Calls Ardor

Este, que ves, engaño colorido,
que del arte ostentando los primores,
con falsos silogismos de colores
es cauteloso engaño del sentido;

éste, en quien la lisonja ha pretendido
excusar de los años los horrores,
y, venciendo del tiempo los rigores
triunfar de la vejez y del olvido,

es un vano artificio del cuidado,
es una flor al viento delicada,
es un resguardo inútil para el hado;

es una necia diligencia errada,
es un afán caduco y, bien mirado,
es cadáver, es polvo, es sombra, es nada.

This,[1] that you see, colorful deceit,
that so immodestly display art's favors,
with its fallacious argumnets of colors
is to the senses cunning counterfeit;

this on which kindness practiced is deleted
from cruel years accumulated horrors,
constraining time to mitigrate its rigors,
and thus oblivion and age defeat,

is but an artifice, a sop to vanity,
is but a flower by the breezes bowed,
is but a ploy to counter destiny;

is but foolish labor, ill-employed,
is but a fancy, and, as all may see,
is but cadaver, ashes, shadow, void.

[1] The portrait of herself.

COMMENTS AND QUESTIONS

1. How would you characterize Sor Juana's attitude toward her portrait? What spiritual truth does this attitude represent?

2. What differences in tone and meaning are there between the *octave* and the *sestet* of this sonnet?

RICHARD CRASHAW

from *The Flaming Heart*

(Spelling modernized)

Leave Her alone The Flaming Heart.
 Leave her that; and thou shalt leave her
Not one loose shaft but love's whole quiver.
For in love's field was never found
A nobler weapon than a Wound.
Love's passives are his activ'st part.
The wounded is the wounding heart.
O Heart! the equal poise of love's both parts
Big alike with wounds and darts.
Live in these conquering leaves; live all the same;
And walk through all tongues one triumphant
 Flame.
Live here, great Heart; and love and die and kill;
And bleed and wound; and yield and conquer still.
Let this immortal life where'er it comes
Walk in a crowd of loves and Martyrdoms.
Let mystic Deaths wait on it; and wise souls be
The love-slain witnesses of this life of thee.
O sweet incendiary! show here thy art,
Upon this carcass of a hard, cold hart,
Let all thy scatter'd shafts of light, that play
Among the leaves of thy large books of day,
Combin'd against this Breast at once break in
And take away from me my self and sin,
This gracious Robbery shall thy bounty be;
And my best fortunes such fair spoils of me.
O thou undaunted daughter of desires!
By all thy dower of Lights and Fires;
By all the eagle in thee, all the dove;
By all thy lives and deaths of love;
By thy large draughts of intellectual day,
And by thy thirsts of love more large than they;
By all thy brim-fill'd Bowls of fierce desire
By thy last Morning's draught of liquid fire;
By the full kingdom of that final kiss
That seiz'd thy parting Soul, and seal'd thee his;
By all the heav'ns thou hast in him
(Fair sister of the Seraphim!)
By all of Him we have in Thee;
Leave nothing of my Self in me.
Let me so read thy life, that I
Unto all life of mine may die.

COMMENTS AND QUESTIONS

1. Baroque poets, like baroque artists, loved extreme contrasts; they expressed these with the rhetorical figures known as *oxymoron* (the juxtaposition of words with opposing meanings) and *antithesis* (the balance of parallel word groups conveying opposing ideas). An example of oxymoron here is the phrase "sweet in-cendiary." An example of antithesis is "Love's passives are his activ'st part. / The wounded is the wounding heart." What other examples of these figures can you find? How do they serve the poet's purpose here?

2. Another characteristic of baroque poetry is the extended use of *metaphor*. Renaissance poets tended to make more use of the *simile*, which makes a comparison between two things on an intellectual level; but the baroque sensibility preferred the more emotional fusion and identification that the metaphor provided. In this poem the poet does not compare himself to a deer but suddenly *becomes* "this carcass of a hard, cold hart." (Plays on words like *heart/hart* were also dear to baroque poets.) What other metaphors does Crashaw use here?

3. Baroque poems often tend to have a cumulative effect, comparable to the rich profusion of matter in baroque art. One way of achieving this is through the rhetorical device of *anaphora* (the repetition of the same word to introduce two or more clauses or lines). Notice here the number of lines that begin with "By all." What is the effect of this device?

4. How would you describe Crashaw's interpretation of the mystical experience of Saint Teresa? Compare it with Bernini's statue *The Ecstasy of Saint Teresa.*

5. Do this style and sensibility appeal to you? What in your own personality makes you answer negatively or positively?

JOHN DONNE

from *Holy Sonnets*

(Spelling modernized)

Sonnet 14

Batter my heart, three-personed God; for you
As yet but knock, breathe, shine, and seek to mend;
That I may rise, and stand, o'erthrow me, and bend
Your force, to break, blow, burn, and make me new.
I, like an usurped° town, to another due, 5
Labor to admit you, but Oh, to no end,
Reason your viceroy° in me, me should defend,
But is captived, and proves weak or untrue.
Yet dearly I love you, and would be loved fain,°
But am betrothed unto your enemy: 10
Divorce me, untie, or break that knot again,
Take me to you, imprison me, for I
Except you enthral me, never shall be free,
Nor ever chaste, except you ravish me.

5. Captured. 7. Representative. 9. Gladly.

COMMENTS AND QUESTIONS

1. How do the characteristics of contrast and repetition appear in this poem?

2. Are there extreme contrasts in the rhythm of the lines as well? How is this achieved?

3. How are the war metaphor and the sexual metaphor worked in together?

4. Compare Donne's expression of a human being overwhelmed by God with that of Caravaggio in *The Conversion of St. Paul* (Fig. 21-3).

from *Elegies*

(Spelling modernized)

Elegy XIX
To His Mistress
Going to Bed

Come, madam, come, all rest my powers defy,
Until I labor, I in labor lie.
The foe oft-times having the foe in sight,
Is tired with standing though he never fight.
Off with that girdle,° like heaven's zone glistering, 5
But a far fairer world encompassing.
Unpin that spangled breastplate which you wear,
That th' eyes of busy fools may be stopped there.
Unlace yourself, for that harmonious chime
Tells me from you that now it is bed time. 10
Off with that happy busk,° which I envy,
That still can be, and still can stand so nigh.
Your gown, going off, such beauteous state reveals,
As when from flowry meads th' hill's shadow steals.
Off with that wiry coronet and show 15
The hairy diadem which on you doth grow:
Now off with those shoes, and then safely tread
In this love's hallowed temple, this soft bed.
In such white robes, heaven's angels used to be
Received by men; thou, Angel, bring'st with thee 20
A heaven like Mahomet's Paradise,° and though

5. Belt. 11. Undergarment worn over the breast. 21. The Muslim idea of paradise includes beautiful women.

Ill spirits walk in white, we easily know
By this these angels from an evil sprite:
Those set our hairs, but these our flesh upright.
 License my roving hands, and let them go 25
Before, behind, between, above, below.
O my America! my new-found-land,
My kingdom, safeliest when with one man manned,
My mine of precious stones, my empery,
How blest am I in this discovering thee! 30
To enter in these bonds is to be free;
Then where my hand is set, my seal shall be.
 Full nakedness! All joys are due to thee,
As souls unbodied, bodies unclothed must be
To taste whole joys. Gems which you women use 35
Are like Atalanta's balls,° cast in men's views,
That when a fool's eye lighteth on a gem,
His earthly soul may covet theirs, not them.
Like pictures, or like books' gay coverings made
For lay-men, are all women thus arrayed; 40
Themselves are mystic books, which only we
(Whom their imputed grace will dignify)
Must see revealed. Then, since that I may know,
As liberally as to a midwife, show
Thyself: cast all, yea, this white linen hence, 45
There is no penance due to innocence.
 To teach thee, I am naked first; why then,
What needst thou have more covering than a man?

COMMENTS AND QUESTIONS

1. Why does Donne spend so much time describing each article of clothing that he wants the woman to take off? What is the effect of this "slow motion"?

2. Could you compare the enumeration here with the numbers of sensuously depicted objects in baroque painting?

3. What use does Donne make here of the "new world" discoveries? What is the effect of this metaphor?

36. Atalanta agreed to marry Hippomenes if he could defeat her in a foot race. As she was about to overtake him, he cast in her path three golden apples given to him by Venus. Distracted by their beauty, Atalanta stopped to retrieve them, and Hippomenes won the race.

Summary Questions

1. What characterizes the originality of Caravaggio and Artimesia Gentileschi?
2. What major similarities and differences do you find between the Italian baroque painters and their Dutch or Flemish counterparts?
3. What effects did the Reformation and Counter-Reformation have on these painters?
4. How does the baroque fusion of sensuality and spirituality manifest itself in poetry and in painting?
5. Who was Saint Teresa, and how was she depicted by Bernini and Crashaw?
6. In what ways was Sor Juana Inés de la Cruz an extraordinary woman for her time?
7. What characterizes "metaphysical" poetry?

Key Terms

baroque

mysticism

oxymoron

metaphor

anaphora

22 Two Masters of Baroque Music: Handel and Bach

The artistic skies of the seventeenth and eighteenth centuries were spangled with musical lights of great magnitude: Monteverdi, Corelli, Alessandro Scarlatti, and Vivaldi in Italy; Domenico Scarlatti in Spain; Rameau, Lully, and Couperin in France; Purcell in England; Schütz, Buxtehude, and Johann Sebastian Bach in Germany; and a figure of international fame and travels, George Frederick Handel.

The centuries have taught us that the latter two composers—Bach and Handel—rise above all the others. Each has left us a vast store of musical riches that span the compass from small to large, easy to difficult, sacred to secular, instrumental to vocal, incidental to monumental. No single work can adequately represent either of these musical geniuses, but two have retained their universal appeal over the centuries: Handel's English masterpiece, *Messiah*, and Bach's *Christmas Oratorio*.

George Frederick Handel (1685–1759): *Messiah*

Handel began his career in Germany, traveled and worked in Italy, and eventually emigrated to London. Although this German musician first established his reputation in England as a composer of Italian operas, the masterwork from his pen that has endeared him to the hearts of all English-speaking Christians is his sacred oratorio *Messiah*, a work created in response to an invitation from the duke of Devonshire, the Lord Lieutenant of Ireland, to present some concerts for the benefit of the Charitable Musical Society of Dublin. Composed in twenty-four days, it was first performed in Dublin in 1742 and was an immediate artistic and popular success. According to popular legend, the tradition of standing for the Hallelujah Chorus began with the first London performance in 1743 when King George II, wakened from a nap by the opening chords of the chorus, rose to his feet—followed, of course, by all his subjects. *Messiah* was, and remains, popular with people from all walks of life. Although written more than 250 years ago, *Messiah* is available to most Americans through live performance or live broadcast at least twice a year, at Christmas and Easter. Universal recognition is not the only criterion for greatness in music, but it is clear that no other musical composition has captured the sincere affection of the English-speaking world more completely. In every aspect of its existence—concept, design, scale, quality—it is a monumental work, a superb pinnacle of artistic creation, a masterpiece that brought tears to the eyes of the composer himself and caused him to say, "I did think I did see all Heaven before me and

CENTRAL ISSUES

- Perceiving essential elements of musical compositions

- Affect in music: arousing emotions through musical sounds

- Similarities and differences between Handel's *Messiah* and Bach's *Christmas Oratorio*

- Understanding selected musical forms: recitative, aria, overture, chorale, toccata, and fugue

- The relationships of word and music

- Meaning in absolute music: musical logic and the exposition and development of musical ideas

the great God Himself." In spite of all the technical accounts of how this grand work was organized and composed with borrowed material and practical concerns for particular singers' voice ranges and abilities, nothing can detract from the fact that it was an inspired work completed in feverish haste by a musical genius of the first rank.

Messiah speaks to modern ears with the same honesty of religious expression that has stirred fervent emotions in listeners for more than two centuries. It is one of the greatest expressions of the Protestant *baroque*. It is not enough to deal with this *oratorio* as a musical composition only, for it is first and foremost a religious piece, a remarkable setting of biblical texts dealing with the redemption of humanity from sin through the intervention of the Messiah. The *libretto* is a compilation of verses from the Bible, a selection that draws from both the Old and the New Testaments. The organization and unity of the work are primarily text-centered, for, like three acts of an opera, the three large divisions of the oratorio reveal the following plan: PART I. A messianic prophecy, the coming and birth of Christ. The revelation of God's plan to save humankind by the coming of the Messiah. PART II. The suffering and death of Christ; the defeat of humanity, which rejects God's offer; and the spread of his doctrine. PART III. The redemption of humanity through faith, the final overthrow of death, and a hymn of thanksgiving.

With this large framework in mind, Handel fleshed out a massive construct for soloists, chorus, and orchestra by using standard forms that were second nature to him and were a regular part of the fully developed operatic style of the baroque era. He sets the spell for the entire work by opening with an orchestral *overture* with the same characteristics as the French overture developed by Lully decades before: a slow, majestic first movement (**a**) in jagged *rhythms*, duple *meter*, and *chordal texture*, followed by a lively, *fugal* second movement (**b**) with an impressive *contrapuntal* display.[1]

The *fugue* impresses the listener because the composer successfully takes a melody and uses it against itself, or in conjunction with itself, to create logical and beautiful harmonies. Exquisite fugues are a hallmark of the baroque masters, who displayed their melodic inventiveness through this process of imitating short and distinctive melodies in succession.

The fugal process was one of the most compelling in the repertoire of the baroque composers, for

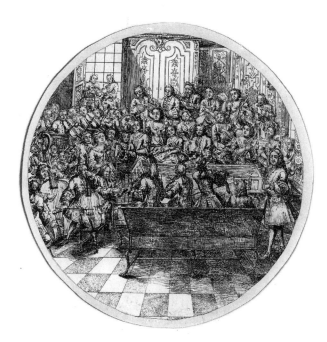

22-1 *Performance of an oratorio with Handel conducting. Woodcut. (The Fotomas Index)*

although its texture is lighter in "weight" than most *chordal*, or *homophonic*, compositions, it has a forward-driving rhythm and additive layering-of-melody effect that propels the listener to the final release of the closing chords. Handel was a master of this mature form of the late baroque, and we can see its dramatic effect in the vocal fugues that he favors for climactic moments.

The overall design of the first part of *Messiah* can be seen in the chart at the bottom of the following page. The regularity, or symmetry, and the simplicity of the design are in fact *classical*, and we must keep in mind that Handel was working at the culmination of an age, a period in which the influences of new ideas in opposition to the norms of the baroque were beginning to make themselves felt. Simplicity of design is of great advantage in the function of a work that depends heavily upon text, for unnecessary complexity detracts by drawing attention to itself. No one was more aware of this than Handel himself, for he understood better than any other composer of his time how to employ the operatic forms of *recitative* and *aria* to communicate the inner message of the text.

A *recitative* is a musical form that has almost no melodic interest; consequently, a great store of information can be related to the listener in a short time. Those points in the narrative where several ideas await telling, where people need adequate introduction, where details of plot need to be unfolded quickly, and in general where there are a great many words to be dealt with are the proper domain of the recitative. Still, within that

[1] Any number of excellent recordings of the complete *Messiah* are available, but the reader is advised to find a recent recording that seeks to approximate Handel's original scoring for small orchestra and modest chorus. The loss in dramatic power supplied by a romantic orchestra and gigantic chorus is amply compensated for by the increased clarity of line and decreased ponderosity.

general plan, certain points need emphasis; Handel uses chord change and chord selection as well as slight *melodic elaboration* to achieve dramatic emphasis of particular words or propulsion of the plot.

Other devices are available to him too, such as *orchestration*, but the essential concept that the recitative should be used to carry a high volume of words per unit of time is not disturbed. In one recitative, Handel employs an interesting musical device to achieve affective power over his audience. On the statement of the word "shake," Handel literally shakes the music. He rapidly wiggles the notes back and forth, a visual effect for the performer and an aural effect for the listener.

Handel uses similar musical devices for the chorus; for instance, as it sings "All we like sheep have gone astray," the melodic lines diverge; with "we have turned," a quickly twisting and turning figure is introduced; and with "every one to his own way," a single note is stubbornly repeated.

The *aria*, or "air," has a purpose almost diametrically opposed to that of the recitative. An aria usually contains two ideas often expressed in two sentences. It is an opportunity for the soloist (or composer) to wax eloquent, to spin out gradually a thought that grows fuller in meaning as the music progresses. It is usually somewhat introspective, personal to the character of the person portrayed by the soloist. The second idea is related to the first, but it casts a slightly different light on the subject or adds to it in some contrasting way.

Most Handelian airs are cast in the mold of the *da capo aria*, the *ABA* form that returns to the beginning to reiterate the message of the first idea in the new light of the second statement. The bass aria "But who may abide" is a demonstration of this principle. The soloist asks the questions "But who may abide the day of His coming, and who shall stand when He appeareth?" In response, the listener might ask, "Why does he ask, for

would we not all stand to greet the Lord?" In the B section of the aria, the soloist states the difficulty: "For He is like a refiner's fire." God is judge and he will separate the righteous from the sinful. He is like the refiner who smelts metal from ore and separates the gold or silver from the rock. When the bass returns to his initial question of who shall stand, the listener might reconsider whether he or she dares be among those who rise to meet God eyeball to eyeball. And the mighty chorus, like impartial observers from another world, responds in a frightening tone, "And He shall purify the sons of Levi, that they may offer unto the Lord an offering in righteousness."

The plan of the specific recitative-aria-chorus combination serves as the model for all the subsections of the entire work: develop an idea rapidly (recitative), elaborate a single aspect (aria), and hammer the message home (chorus). After four exact repetitions of the plan, Handel, of course, varies the scheme by omitting, inverting, or repeating the three basic elements—recitative, aria, and chorus—but the affective function of each always remains the same. Thus listeners gear their expectations to the type of music offered.

The second and third parts of the *oratorio* are naturally similar in format to the first. The tone of the second part is sorrowful, for it accompanies the music of the Passion and, only toward the end, Easter. The libretto tells vividly how Christ was despised: "He hid not His face from shame and spitting"; "He was bruised for our iniquities"; "All they that see Him laugh Him to scorn"; "He was cut off out of the land of the living." This intense, doleful atmosphere is relieved briefly with words and music promising the Resurrection: "But Thou didst not leave His soul in hell" and "Lift up your heads . . . the King of Glory shall come in"; but it quickly returns to a drama of death and fear when the people are reminded of their shortcomings:

Subject	Sinfonia	God's Promise			Distance Between God and Man			Message of Joy			Fulfillment Through Christ's Birth	
Selection Number	1	2	3	4	5	6	7	7a	8	8a	9	10 11
Form	O	R	A	C	R	A	C	R	A	C	R	A C

Subject	"Pastoral" Sinfonia			Christmas Story			Rapture at the Lord's Coming			
Selection Number	12	12a	13	13a	14	15	16	16a	17	18
Form	O	R	A	R	R	C	A	R	AA	C

O = Orchestra; R = Recitative; A = Air; AA = Air (Duet); C = Chorus
Messiah, Part I. Overall design.

"Why do the nations so furiously rage together?" and "He that dwelleth in heaven shall laugh them to scorn." In other words, a religious drama is taking place; the listeners are no longer observers but participants. They do not have to identify with characters on stage as they would at the theater or opera house; they are being explicitly identified themselves as the words of the Bible preach to them. And when the words are completely damning and reduce the attentive listener to dust— "Thou shalt break them with a rod of iron, Thou shalt dash them in pieces like a potter's vessel"—then Handel steps in and saves the victory with one of the most exultant choruses of all time: "Hallelujah! for the Lord God Omnipotent reigneth." The Hallelujah Chorus alone would have brought fame to George Frederick Handel, for it is one of those resounding strokes of genius that is able in itself to embody the concept of a victorious Lord.

CD-2, 5

The Hallelujah Chorus creates a problem for the composer. In it he achieves an artistic peak, making material that follows necessarily anticlimactic. But the oratorio is not yet over. In this hurried world of the twenty-first century, one still finds *Messiah* concerts that cut off the work at this point. Musically, one comes to a satisfactory conclusion at the end of the Hallelujah Chorus, but spiritually one has missed the message of the text if the portion dealing with individual redemption through faith is left out. The only possible, or impossible, solution, of course, was to write an even more stirring and more climactic chorus for the final portion; unbelievably, Handel was able to do this. The Amen Chorus, which acts as finale to the third part and the work as a whole, is one of the most awesome choral fugues ever conceived. It grows and swells, piling layer on layer in a surprisingly brief sprint to the finish.

An alternation of slow and fast chordal passages sets the stage: "Worthy is the Lamb . . . to receive power . . . worthy is the Lamb . . . to receive power. . . ." This introduction is followed by a fugue whose vocal entrances rise successively from the low range of the men's voices to the upper register of the sopranos': "Blessing and honour, glory and pow'r be unto Him that sitteth on the throne." A fugal device called *stretto* collapses the interval of time between successive entrances so that the music, which seemed to work only at greater length and expansiveness, suddenly feels to be moving faster—to be propelling forward with less caution but no greater recklessness. The voices begin to pair and rise together; suddenly they join in a unison line that reduces the texture to a penetrating knife edge. Expanding again, the voices move into a series of high, sustained chords that virtually teeter on the brink of a musical chasm. Then, at last, the voices begin to move and gain momentum in the final *fugue* to the single word "Amen." The sense of completion is achieved; the

restoration of balance is accomplished; the work is consummated.

Strangely enough, *Messiah* was not composed for a church service. Handel was a bankrupt impresario-composer who was currently out of favor as a local opera composer. He seized an opportunity to perform "some of his choicest Musick" for the benefit of Mercer's Hospital in Dublin. On April 12, 1742, he performed his new oratorio in public for the first time. With its baroque harmonies and standardized forms, it reflected ideas seen emerging out of the past with a steady linkage back to the Renaissance through the operas of Lully to the congregational sacred music of Saint Philip Neri in Rome. In its expansiveness and classical balance, in its communication with a growing middle class, and in its seeming power to attract listeners from all walks of life in the modern world, *Messiah* is a searching tendril that stretches upward to the future. Many works of art seem to be understood fully only within the context of the age in which they were created. Handel's *Messiah* is an exception to this rule, for it seems to have had an immediacy and direct impact on musicians and laity alike from its origin in 1742 to the present day. It is perhaps the most substantial monument of Western musical art of all time.

Johann Sebastian Bach (1685–1750): *Christmas Oratorio* and *Toccata and Fugue in D Minor*

The baroque era was certainly an age of contrast, and the lives and music of Handel and Bach illustrate this principle vividly. Bach (Fig. 22-2) led a relatively uneventful musical career that saw him employed as one of a number of musical functionaries who served at court and church in Protestant Germany. Virtually his entire life was spent within sixty miles of his birthplace. Handel, on the other hand, developed his profession in the company of the leading musical patrons of Germany, Italy, and England. His music was composed for the contemporary international taste, and the last years of his life were filled with great public acclaim and financial success. Still, it was only in 1968 that a painted image of Bach looked out from the cover of *Time* magazine—a cover that proclaimed, "Johann Sebastian Bach: Music from the Fifth Evangelist." Media hype or a truth worthy of investigation? Inside, the five-page feature article reported, "Today, of course, Bach is universally ranked among the transcendent creators of Western civilization."[2] A transcendent creator, not just of Western *music* but of Western *civilization*! What, then, is the magic of the composer from Eisenach?

2 "A Composer for All Seasons (But Especially for Christmas)," *Time* (December 27, 1968), p. 35.

Bach, although well known as a virtuoso organist, saw few of his works published during his lifetime, and his music found almost total neglect immediately after his death. However, great composers of subsequent generations would not allow his music to die. Haydn owned a copy of the Mass in B Minor, Mozart studied Bach's motets and *The Art of Fugue*, and Mendelssohn resurrected Bach's music for the larger public with his revival of the *St. Matthew Passion* in 1829, seventy-nine years after the composer's death. Regardless of his provincial life, and regardless of the superlative creations of other masters, including his famous contemporary Handel, Bach's surviving works are so various, inventive, intellectual, and beautiful that it is difficult to name his equal among composers of any age! Today, Bach societies and Bach choirs thrive throughout the world. Organists know his music as the principal repertoire for the instrument, and violinists and cellists learn his solo sonatas, partitas, and suites as the tests that separate professional from beginner, master from novice. All serious keyboard players learn with the Inventions, mature with *The Well-Tempered Clavier*, and strive for the Goldberg Variations and the *Chromatic Fantasia and Fugue*. And today's composers study and marvel at the sheer genius displayed in the contrapuntal intricacies of *The Art of Fugue* and the *Musical Offering*. But the master composer's profound religious convictions come triumphantly to light in his vocal compositions, especially those for chorus, soloists, and orchestra in combination—cantatas, passions, masses, Magnificat settings, and oratorios.

For the last twenty-seven years of his life, Bach was a Lutheran church musician in Leipzig. For the Christmas services of 1734, he composed a mammoth work in six parts, the *Christmas Oratorio* (Fig. 22-1). Written for the six feast days or Sundays of the holiday season (1734–1735)—the three days of Christmas (December 25–27), New Year's Day, the Sunday after New Year, and Epiphany (the manifestation of the Savior to the Gentiles, or the coming of the Magi)—each part is like a complete cantata in itself and lasts about thirty minutes. An unusual feature of the first performance was the publication of the entire libretto in advance, so that members of the congregation could not only understand the words more readily but also see the totality of the work. Because only one of the six portions was performed at each of the six services, it was important for the congregation to review the significance of the day's setting within the context of the whole.

The first three parts are built on the story of Christmas as reported in the Gospel of Luke; the fourth deals with the circumcision and naming of Jesus; the fifth tells of the flight into Egypt; and the sixth deals with the story of the Three Wise Men from the East. Unlike Handel's *Messiah*, Bach's *Christmas Oratorio* places great emphasis on reflection and downplays the dramatic element. In

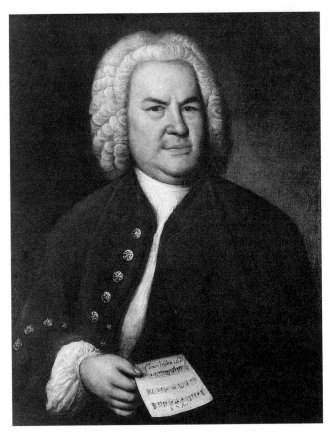

22-2 *Elias Gottlob Haussmann,* Portrait of Johann Sebastian Bach, 1746. *Oil on canvas. (A.K.G. Berlin/ Superstock)*

addition to using German prose from Luther's translation of the Bible, Bach combines introspective poetry from an unknown librettist, possibly Picander (Friedrich Henrici). Like Handel and most of the other composers of his day, Bach reused much musical material he had composed earlier, but he constantly strove for a unified total work that was true and complete unto itself, a work that displayed perfect craftsmanship in every element.

The oratorio is a collection of biblical texts and poetic meditations underscored by sixty-four separate musical movements. Bach's composition and orchestration are superlative, and he avails himself of a rich palette of musical resources, an orchestra of organ, strings, flutes, oboes, oboes *d'amore*, oboes and horns *da caccia*,[3] bassoon, trumpets, and timpani; a chorus; and four solo voices. A tenor assumes the role of the Evangelist and narrates the Bible story. The other three—soprano, alto, and bass—sometimes sing the role of a biblical character—Herod, Angel—and sometimes merely elaborate and reflect on a text. There is ample opportunity for virtuosic display by both singer

[3] The oboe *d'amore*, or oboe of love, was a baroque oboe whose tone was considered sweeter than the regular soprano oboe. The horns *da caccia*, or hunting horns, were valveless natural horns that had, in the early eighteenth century, a more trumpetlike sound.

and instrumentalist, but the use of this and every other musical device is always subordinated to the primary purpose of underscoring the meaning of the text, never of seeking to impress a concert audience. The music was created to help a congregation join professional musicians in musical worship.

Fourteen times in the course of the six services a chorale is inserted into the musical tapestry, and these are the congregational hymns that Bach's Lutheran parishioners knew, loved, and felt with deep emotion.

CD-2, 6

The first-used chorale tune, "Wie soll ich dich emp-fangen?" (How Best Can I Receive Thee?), piece #5 of the sixty-four, is also the chorale that closes the entire cycle, piece #64. In Bach's day it was known as the Passion Chorale, "O Haupt voll Blut und Wunden" (O Sacred Head Sore Wounded). Bach had used several settings of this chorale in his *St. Matthew Passion* five years earlier, and its use here, with the Christmas texts, #5 ("How Best Can I Receive Thee?") and #64 ("Now Christ Will Avenge Our Satanic Foes"), can also be interpreted as Bach's way of suggesting that the birth of Christ must also be interpreted as a foreshadowing of his death on the cross if it is to have religious significance as well as musical or other artistic significance.

The musical forms and techniques displayed in this work are as diverse as the orchestral and vocal resources already mentioned. Some important and obvious features will help interpretation and understanding. Similarities to Italian and French opera, as well as to Handel's *Messiah*, exist in the recitatives and arias. The same principles of *exposition* of text in recitatives and reflection on one or two thoughts in an aria hold true. The same principles of tonal organization for individual pieces, daily sections, and the complete work operate here to give formal unity and variety to each part:

THE ORATORIO COMPLETE

The six days:	I	II	III	IV	V	VI
Keys of each part:	D	G	D	F	A	D

The key of D major establishes the base, or tonic, of the entire work. In the affective theory of the day, D major is considered a key of strength and joy.

At the next level, the individual service, we see the same principles at work. For example,

DAY ONE
CHRISTMAS DAY

Pieces:	1	2	3	4	5	6	7	8	9
Key of each:	D	to E	A	a	a	to D	G	D	D

For the nonmusician, the exposition of these keys and their relationships may seem meaningless, but these key relationships have their effect on all listeners, whether or not the listener is conscious of their presence or technically competent to describe their intricacies. Bach knew that D major had affective power on his listener, that it instilled a sense of joy and exuberance that was absolute and intrinsic to the sound itself. Therefore, to set the Christmas story with its joyful opening

Praise, joy and gladness be blended in one!
Tell what the Father Almighty has done!

in the key of D was almost a requirement of the doctrine of affections that governed baroque composition. We respond to the jubilant trumpets, the energetic voices, the rush of notes, and the instrumental colors, but Bach also believed that we would react to D major, the key of gladness and strength.

The *Christmas Oratorio* can be listened to in one sitting, of course, but the composer's original intent was to provide music for services spanning two weeks. Therefore, let us study and listen to the music for December 25, Christmas Day, as one complete unit. The opening chorus is a massive three-part structure in *da capo* format. Using the full resources of the orchestra and chorus, it has a monumental grandeur. In contrapuntal style, the forces pile one on the other, creating an effect of both solidity and motion. The basic melodic motive is embellished, and it appears over and over in a series of fugal entries. The orchestra leads the way, and the voices proclaim the message "Praise, joy, and gladness be blended in one!"

There is a middle, contrasting section. Its hushed tones reflect the awe of the singers as they say, "Worship the Highest and fall down before him."

The music gradually builds again, and the *da capo* returns us to the beginning for a repeat of the entire first section.

Pieces #2 and #3 are both recitatives, but they are quite different. The first is unaccompanied except by continuo (keyboard and a bass instrument or two), and the tenor sings the biblical prose from Luke, "And it came to pass in those days, that there went out a decree from Caesar Augustus. . . ."

The second recitative, #3, is accompanied by two oboes *d'amore*, and it almost has the quality of an arioso. The alto sings the words of the poet,

Behold the Bridegroom, Love Divine,
Behold the hope of David's line. . . .

She then sings her aria in A minor ("Prepare yourself, Zion, with tender desire"), which, even though it is structured in the *da capo* format, is composed as a trio sonata, a contrapuntal work for three equal melodic lines, usually for two melodic instruments and continuo. The first melodic line is played by violin and

oboe *d'amore* in unison; the second melodic line is sung by the alto; and the third line is performed by continuo—keyboard (organ), cello, and bassoon doubling the bass melody. It was also standard practice for the keyboard player to improvise a simple chordal accompaniment with the right hand while the left hand or pedal played the bass melody. This aria is typical of one aspect of Bach's idiom. The structure is clear and balanced, the counterpoint is obvious and fascinating, and the music moves along relentlessly through the persistent baroque rhythm. Even though it has these features of master craftsmanship, the work is tender and expressive. The master craftsman oversteps neither the artist nor the devout Lutheran.

The choir and instruments respond with a simple setting of the chorale usually associated with the Crucifixion:

> How best can I receive Thee and best encounter Thee?
> O most desired of nations, adornment of my soul!

CD-2, 6

Its tentative, inconclusive ending on the dominant (E in the key of A minor) might be attributed to the composer's supposed attempt to express a foreshadowing of future tragedy, or it might simply be the result of a modal melody that begins and ends on E. Either way, the Lutheran congregation cannot help but respond sympathetically to its depth and beauty.

The Evangelist returns with the biblical text "And she brought forth her firstborn Son . . . ," and this is immediately followed by an accompanied chorale setting in which the bass soloist intersperses devotional, meditative statements in recitative style. This time the chorale ("He came to earth a pauper") is not harmonized but sung as a unison line by the sopranos (normally boys). This melody, less familiar to us today than it was to Lutherans in 1734, is set against the melodic layers of the two oboes *d'amore*.

A final aria shifts the mood from contemplation to one of celebration as the sounds of the opening return to continue the birthday celebration. The syncopation between trumpet and orchestra is a prominent feature of this opening, and the bass enters to proclaim:

> Sovereign Lord and King Almighty,
> Savior dear, behold how lightly
> Holdest Thou all pride and state.

Finally, the chorus returns singing to the tune of the Christmas chorale, "Vom Himmel hoch" (From Heaven High), the words "Ah, my dearest Jesus child . . ."

Two centuries before Bach labored as a church musician in his beloved homeland, Martin Luther had chosen the chorale as the most appropriate

vehicle for the congregation's communal expression of faith. Early in his career, Bach stated his goal of creating "a well-regulated church music to the honor of God." Like a preacher, he interpreted the texts he compiled with all the craft and art at his disposal. Taking the Lutheran chorale as his *cantus prius factus*, his preexistent sacred melody, and coupling it with his skill, genius, and pious dedication, he composed works expressive of his age and for ours. Why he was held in no great esteem as a composer during his lifetime is a mystery that may never be solved, but it matters little to those of us today who have the opportunity of sharing his music in a way not possible at any other time in history. The *Christmas Oratorio* is both typical and unique, an example of his sacred music and an incomparable masterpiece.

Among the instruments of the world, the organ (Fig. 22-3) is king, and among the organists and organ composers of all time, Bach reigns supreme. The German organ of Bach's day was probably the most complicated mechanical instrument built before the Industrial Revolution, and thousands of pipes could be called to attention individually or in combination at the touch of a finger. Without electricity, this huge machine of widely dispersed chests of varied pipes was connected by sticks, rollers, and strings to a wind chest and a console of two or more keyboards and a pedal keyboard. This king of instruments lived primarily in the largest, most prestigious, and most beautiful spaces of the eighteenth-century German cities, the main churches and cathedrals, and the church served not only as the concert hall for organ performance but also as the resonant sounding board of the instrument itself. In the hands of Bach, the music and the instrument became one. Among his best-known compositions for this instrument, most of which were intended as aids to worship in the Lutheran services, his *Toccata and Fugue in D Minor* is probably the most famous of all.

Toccata, from the Italian *toccare*, "to touch," refers to pieces that run the fingers all over the instrument at the beginning of a performance to test the instrument and see that everything is in order. After all, the hundreds of thousands of moving parts in this mechanical colossus lived in buildings with no climate control, collected and dispensed wind in leather bellows that were attractive to mice and insects, and used carefully fitted pieces of sliding wood that might stick if moisture caused undue swelling. Toccatas were not only test pieces for the organ but also virtuoso "trial by fire" pieces for the organist. Bach's *Toccata in D Minor* begins with a brief exploratory statement high upon the instrument, descends by octaves like a crash of lightning, and explodes in an immense chord that shakes the instrument and the building. With all in or-

CD-2, 8

CD-2, 7

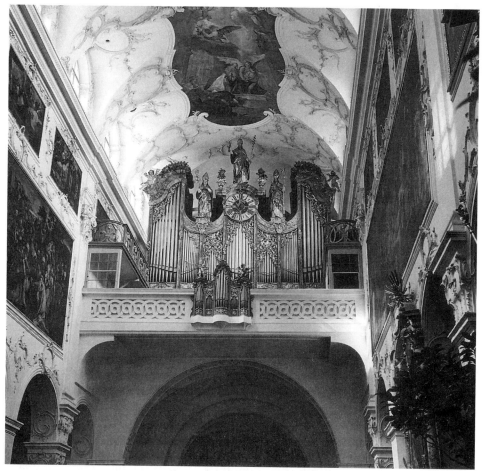

22-3 *Organ played by Wolfgang Amadeus Mozart (1756–1791). Church of St. Peter, Salzburg, Austria. (Roger Viollet, Paris/Bridgeman Art Library)*

der to that point, the music proceeds in a dizzying swirl of notes that alternate, climb, descend, join, and separate in a bravura journey through the instrument and through the music.

The *Toccata* serves as an introduction or prelude to the *Fugue*, a contrapuntal masterpiece based on the rhetorical principles taught in the schools and universities.[4] Not a form but a process, the ideal fugue demonstrates the same intellectual process at work as that in a fine speech, a Shakespearean tragedy, a scientific theorem, or a legal brief:

1. The *exposition* of the subject or melodic idea, the opening statement of fact

2. The continuing *narration* of the subject (or argument, or story) that fills in the details or background for the music (or plot) to come

3. The *proposition*, or declaration of musically innovative ideas (a thesis)

4. The *confutation*, or presentation of opposing ideas or arguments (antithesis)

5. A resolution, or *confirmation* of the ideas that unify the piece of music (by supporting the thesis; the identity scene in tragedy)

6. A *peroration*, or coda, that concludes the work and lets it come to rest

A fugue is thus exposition, narration, proposition, confutation, confirmation, and peroration. As you listen to Bach's *Fugue in D Minor*, identify the rhetorical elements of the piece as it moves from beginning to ending, from exposition to coda.

CD-2, 9

[4] See the previous discussion of Handel's fugue, and compare that description with this one. Vocal and with words, or instrumental only, the process is the same.

Summary Questions

1. How are Handel's *Messiah* and Bach's *Christmas Oratorio* similar and different?

2. In what ways were Handel's and Bach's audiences, in their own time, similar and different?

3. Is the musical progress of an instrumental work, such as the *Messiah* Overture or the Bach organ fugue, the same as or different from the musical progress of a work with words?

4. Were *Messiah, Christmas Oratorio,* and *Toccata and Fugue* works of functional music or compositions intended for concert audiences? Were they popular? Are they popular music?

5. What is art music?

6. Does a twenty-first-century concertgoer hear Bach's and Handel's music differently from the way an eighteenth-century listener would have heard it?

7. What effect do twenty-first-century concert halls have on eighteenth-century music? Also, what effect has sound recording had on the preservation, distribution, and distortion of early music?

Key Terms

baroque

oratorio

overture

fugal

fugue

classical

recitative

aria

da capo

exposition

narration

proposition

confutation

confirmation

peroration

23 The Arts at the Court of Louis XIV

Because the high point of baroque music came in the early eighteenth century, later than that of the other arts, we have temporarily stepped out of chronological order. We now return to France in the late seventeenth century to examine aspects of a culture that fused the baroque aesthetic with an espousal of reason, order, and clarity, as found in classical (Greco-Roman) art, a culture that came to be called *neoclassical*.

Louis XIV (1638–1715) and Absolutism

The most populous country in western Europe, reunited after divisive religious wars of the late sixteenth century, sharing with England and Holland in the flourishing Atlantic trade, France was the most powerful country in Europe from the mid-seventeenth to the early nineteenth century. Under Louis XIV, France became dominant not only in politics but in cultural life as well. It was, however, a culture with a narrow base, created by and for the aristocracy and upper bourgeoisie, always oriented around the monarch, but one that impressed people from all social classes. This culture developed from the king's lifestyle at his court.

Absolutism as a form of government (manifested as absolute monarchy) began to take shape under Louis's predecessors, Henry IV and Louis XIII, but Louis XIV made it an unchangeable fact. He managed to transform France's traditionally restless, independent nobles into fawning courtiers eager to catch the smile of their king. As a child, Louis had witnessed the evils that seditious upper classes could inflict on society; now the central aim of his life was to transform these elements into loyal servants of the crown. A master showman, he created around him such an aura of grandeur that he became known as the Great Monarch. The upper nobility were expected to live at court, rather than in their own castles on their own lands. Louis moved his court from the palace of the Louvre in Paris to Versailles, twelve miles outside. There he built up a somewhat insulated world where he could entertain the nobles and keep an eye on them. Members of the bourgeoisie, eager to buy their way into the nobility and to be presented at court, were not likely to cause any trouble; and the peasants and lower classes were so heavily taxed that they remained in an almost feudal state of dependence. Louis saw to it that the monarchy became the primary source of privilege and honor in the society so that people would look to him as to the light. The *Sun King* was extolled as the center and source of all power, just as the sun was the center of the universe.

Versailles

The art and architecture of Versailles provided the setting for the spectacle of the monarchy of Louis XIV. It remains as the example of a place designed and refined to enhance the ideal of kingship and power.

The transformation of the medieval castle, secure from attack with its high walls and battlements, into an open palace tells the story of the transformation from a feudal way of life to the ascendancy of one ruler. When the court had an urban location, the rich and powerful built in the city. By the sixteenth century, however, in both Italy and France wealthy nobility and gentry had begun to build splendid country houses. In Italy the Venetian architect Andrea Palladio was the greatest designer of this type of residence (Fig. 23-1). In France sixteenth-century palatial architecture tended to grow from the local traditions, with some influence from Renaissance Italy.

By the early seventeenth century the great country house, the château, had become a magnificent retreat for the summer; for hunting, games, and entertainments; and for escape from life at the royal court. Louis XIII and his ministers had established a pattern that Louis XIV accepted and transformed. Vaux-le-Vicomte (1657–1661), built by Louis Le Vau for one of Louis's ministers, was the most splendid and sumptuous of these residences (Fig. 23-2). With this (and the beautiful Louise de la Vallière) in mind, Louis XIV decided to enlarge the small hunting lodge at Versailles that had served Louis XIII. This extravaganza is based on the

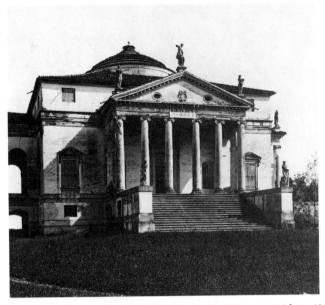

23-1 *Andrea Palladio, Villa Rotonda, Vicenza. (Alinari/ Art Resource, NY)* (**W**)

adaptation of the architectural language of Rome and the Renaissance.

The *palace* of Versailles was begun in 1669 by Le Vau, who incorporated the old brick and stone lodge into the new designs. Originally, the building was a three-sided rectangle with the chief entrance on the east and the garden façade on the west with its courtyard (Fig. 23-3). Le Vau extended the wings east to create a

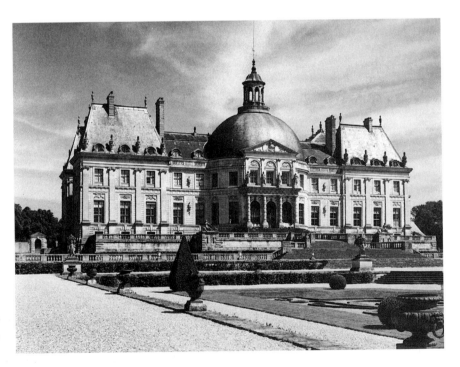

23-2 *Louis Le Vau, Villa Vaux-le-Vicomte. (Giraudon/Art Resource, NY)*

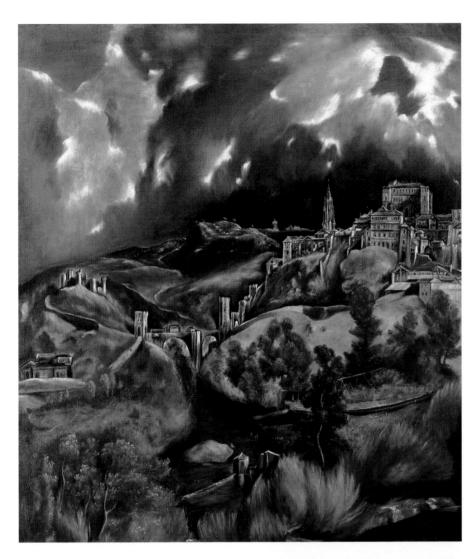

Plate XII
El Greco, *View of Toledo*
(c. 1597). Oil on canvas.
47¾ × 42¾".

(The Metropolitan Museum of
Art, Bequest of Mrs. H. O.
Havemeyer, 1929. The H. O.
Havemeyer Collection)

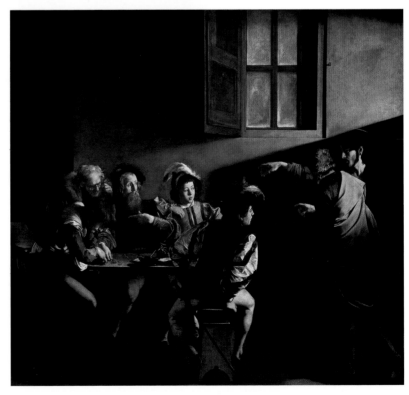

Plate XIII
Caravaggio, *The Calling of
Saint Matthew* (c. 1598).
San Luigi dei Francesi,
Rome.

(Scala/Art Resource, NY)

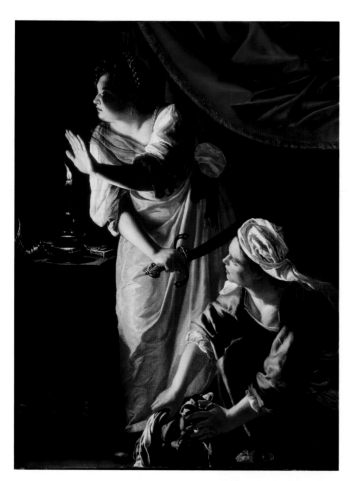

Plate XIV
Artemisia Gentileschi, *Judith and Maidservant with the Head of Holofernes* (c. 1625).

(Photograph © 1995 The Detroit Institute of Arts. Gift of Mr. Leslie H. Green.)

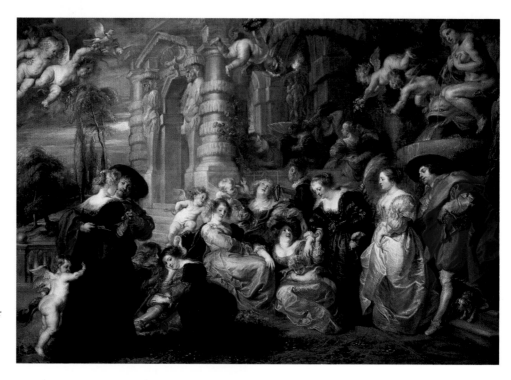

Plate XV
Peter Paul Rubens, *Garden of Love* (c. 1638). Oil on canvas, 78 × 111⅜".

(Museo del Prado, Madrid)

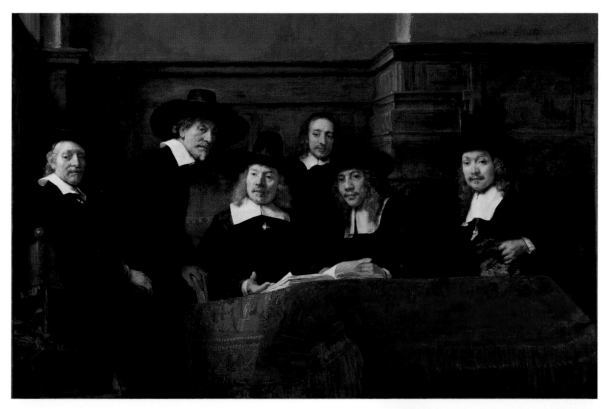

Plate XVI Rembrandt, *The Syndics of the Drapers' Guild*
(1662) after restoration. Canvas. 75 1/2 × 110″.
(Rijksmuseum, Amsterdam)

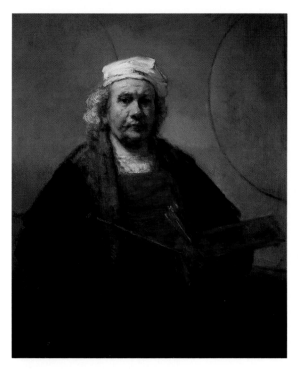

Plate XVII Rembrandt, *Portrait of the Artist*
(c. 1660).

(The Iveagh Bequest, Kenwood/English Heritage)

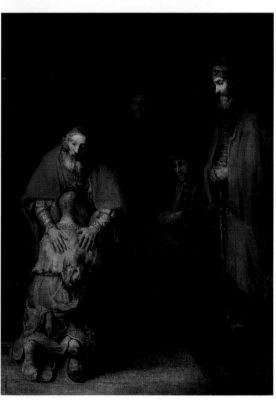

Plate XVIII Rembrandt, *Return of the Prodigal Son*
(c. 1669). Oil on canvas. 103 × 81″. The Hermitage,
St. Petersburg, Russia. (Scala/Art Resource, NY)

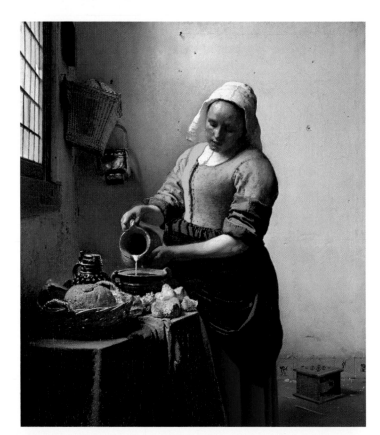

Plate XIX
Jan Vermeer,
The Kitchenmaid
(c. 1658) after
restoration. Canvas.
18 × 16″.
(Rijksmuseum, Amsterdam)

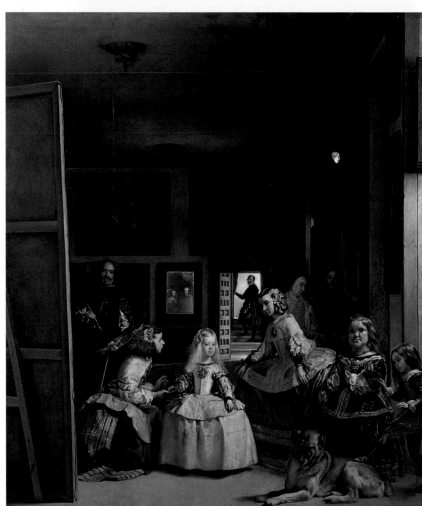

Plate XX
Diego Velázquez, *Las
Meninas* (1656). Oil on
canvas. 125″ × 108½″.
(Museo del Prado, Madrid)

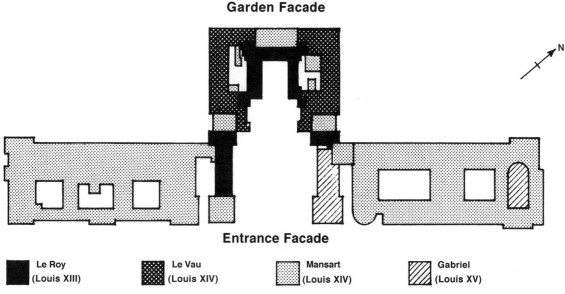

Garden Facade

N

Entrance Facade

| ■ | Le Roy (Louis XIII) | ▨ | Le Vau (Louis XIV) | ▦ | Mansart (Louis XIV) | ▨ | Gabriel (Louis XV) |

23-3 *Versailles (plan)*

courtyard on the entrance side; on the west garden façade he encased the building in the same pale, warm marble of the other sides, centering the courtyard with a six-columned portico and the ends of the flanking wings with smaller porticoes with paired columns. When Le Vau died in 1670, he was replaced by Jules Hardouin-Mansart. It was Mansart who gave the palace its present scale.

On the east side Mansart focused attention on the entrance by the convergence of three great avenues (Fig. 23-4). In the angles were the horseshoe-shaped stables. He also added the long flanking wings that run north and south. On the garden façade (Fig. 23-5) Mansart joined the wings with the Hall of Mirrors, and the façade became an unbroken expanse, punctuated by a central portico, like the original one.

As the garden façade was meant as the principal view, it is appropriate to examine it more closely. The ground floor has a deep, substantial base and round arches for the windows. The masonry is fairly smooth, but deep grooves run parallel to the ground and break to create the curved *voussoirs* of the arches. The only other decoration is on the *keystones* of the arches: each has the relief of a head; the sequence depicts the ages of humanity. On the next level, which is slightly taller than the first, the arched windows are repeated and are separated by Ionic *pilasters* on bases that support the *entablature*. Each window is also framed by other pilasters and a profiled molding with decorative keystone. The central portico and those on either side have Ionic columns and freestanding sculpture above the entablature. The masonry is smooth, the joints filled even with the surface. The third, attic story is lower in height; its

rectangular windows with simple molding, pilaster, and balustrade with urns and sculpture act as a *cornice*, weighing down the whole flat-roofed block. All the details are familiar from the Greek, Roman, and Renaissance vocabularies. Their elaborate combination gives the wall rhythm and interest but only begins to suggest the complexity of weight, load, and plan that lies behind. In the wall's strict continuity and order it also disguises scale. It is difficult to know how big the building is, how tall, wide, or long. One cannot easily relate to its size, which is even more impressive as one walks around it. The exterior detailing is essentially continuous, and if one walks from long end to end, the distance is some six hundred yards, or six football fields. From his bedroom on the east, facing the rising sun, the Sun King had an unimpeded view of three miles.

Begun with the work on the palace, the gardens were designed as its setting. André Le Notre, their designer, combined plantings, ponds, canals, fountains, and falls to enhance and repeat the symmetry and order of the palace. The long tree-lined or hedged walks and the intricately planted beds of brilliantly colored flowers provided the vistas, reflections, and light of outdoor rooms. Everywhere the court's formality was recalled in the total subjugation of nature to order and design, a formality that showed absolute control. Everywhere the Sun King's magnificence was proclaimed. The garden façade faced two great fountains: one featured the ancestors of Apollo; the other, on axis with the Hall of Mirrors and the long canal, was dedicated to Apollo himself, the god of light and sun (Fig. 23-6).

The *Hall of Mirrors,* which fills the central block of the west side, was the gathering place for the court and

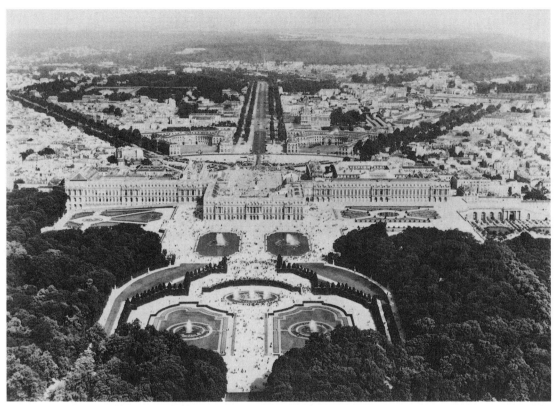

23-4 *Versailles, aerial view. (French Government Tourist Office)*

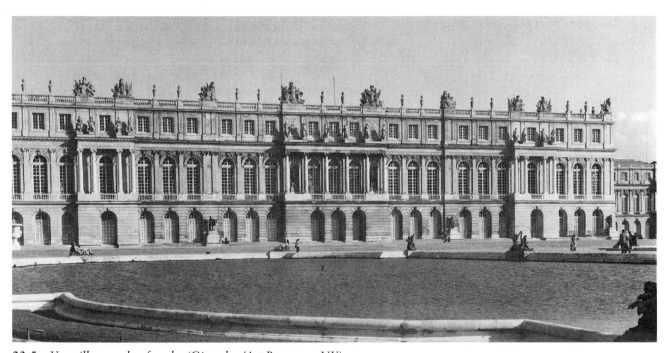

23-5 *Versailles, garden façade. (Giraudon/Art Resource, NY)*

• Compare the palace at Versailles with Saint Peter's Basilica in Rome (Fig. 21-10). What are the dominant features of each, and how are they used to convey a sense of the power and importance of each? Consider especially size and scale, materials, and repetition. What role does the landscape play?

DAILY LIVES

Rituals at Versailles

The following excerpt from the memoirs of a young contemporary of Louis XIV, the duke of Saint-Simon, provides a glimpse into the rituals created by the king to govern every aspect of life at Versailles. By this means Louis XIV succeeded in reducing the haughty, often unruly nobility of his father's reign to the status of dependent courtiers competing for royal favor.

At eight o'clock the chief valet de chambre on duty, who alone had slept in the royal chamber, and who had dressed himself, awoke the King. The chief physician, the chief surgeon, and the nurse (as long as she lived), entered at the same time. The latter kissed the King; the others rubbed and often changed his shirt, because he was in the habit of sweating a great deal. At the quarter, the grand chamberlain was called (or, in his absence, the first gentleman of the chamber), and those who had, what was called the *grandes entrées*. The chamberlain (or chief gentleman) drew back the curtains which had been closed again, and presented the holy water from the vase, at the head of the bed. These gentlemen stayed but a moment, and that was the time to speak to the King, if any one had anything to ask of him; in which case the rest stood aside. When, contrary to custom, nobody had aught to say, they were there but for a few moments. He who had opened the curtains and presented the holy water, presented also a prayer-book. Then all passed into the cabinet of the council. A very short religious service being over, the King called, they re-entered. The same officer gave him his dressing-gown; immediately after, other privileged courtiers entered, and then everybody, in time to find the King putting on his shoes and stockings, for he did almost everything himself and with address and grace. Every other day we saw him shave himself; and he had a little short wig in which he always appeared, even in bed, and on medicine days. He often spoke of the chase, and sometimes said a word to somebody. No toilette table was near him; he had simply a mirror held before him.

As soon as he was dressed, he prayed to God, at the side of his bed, where all the clergy present knelt, the cardinals without cushions, all the laity remaining standing; and the captain of the guards came to the balustrade during the prayer, after which the King passed into his cabinet.

He found there, or was followed by all who had the entrée, a very numerous company, for it included everybody in any office. He gave orders to each for the day; thus within a half a quarter of an hour it was known what he meant to do; and then all this crowd left directly. The bastards, a few favourites, and the valets alone were left. It was then a good opportunity for talking with the King; for example, about plans of gardens and buildings; and conversation lasted more or less according to the person engaged in it.

The Memories of the Duke of Saint-Simon on the Reign of Louis XIV. And the Regency, trans. Bayle St. John, 3 vols. (London, 1891), pp. 21–22.

the site for balls and other performances (Fig. 23-7). Its great windows drew light from the expansive open vistas, and its mirrors reflected that light. At night, filled with candles, it glittered icily. On either end of this opulent vast room are the Salons of War and Peace. The ceilings and walls are decorated with allegorical paintings celebrating the deeds of Louis XIV. Le Brun, chief painter at the court, was responsible for this and for all the interior decoration. The paintings themselves, executed by swarms of assistants, are a bit mechanical and cold. Rather, the rich marble-paneled walls, inlaid floors, and gilded pilasters and moldings attract our attention.

The Royal Chapel, added by Mansart between 1689 and 1710, gives us another experience of the palace (Fig. 23-8). Already the Sun King's power was waning; battles were lost, treasure spent. In his old age, when religion became more important to him, Louis abandoned all building except for this light, very beautiful chapel. Its great height (lower floor for the court, gallery level for royalty) recalls the Gothic style, although the architectural members and details have their origin in antiquity and the Renaissance. Compare this with Brunelleschi's interior at San Lorenzo. (See Chapter 17.) What are the most significant departures from his ideals? Compare this with the Cornaro chapel. (See Chapter 21.)

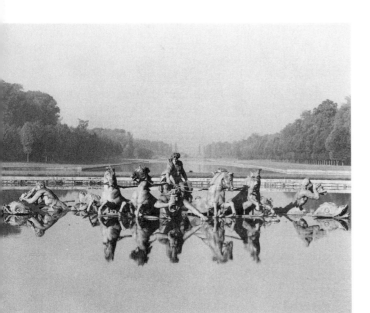

23-6 *Versailles, Fountain of Apollo. (Giraudon/Art Resource, NY)*

23-7 *Versailles, Hall of Mirrors. (Giraudon/Art Resource, NY)* **(W)**

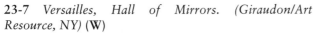
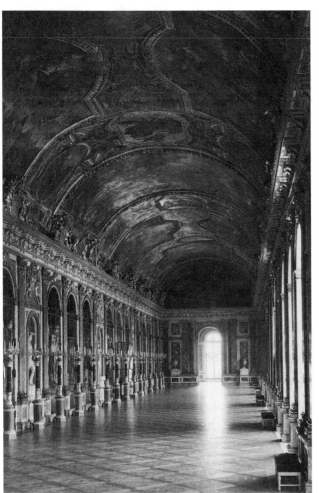

23-8 *Jules Hardouin-Mansart, Royal Chapel, Palace of Versailles. (Giraudon/Art Resource, NY)*

The marble, gilded, painted, and paneled rooms of Versailles echoed with the feet of courtiers, ambassadors, and kings of France until the French Revolution. Bernini's model for an equestrian statue shows Louis XIV shortly after his ascension (Fig. 23-9). The sensuous hair and mouth, the sharp-eyed gravity, the swirling drapery glorify the Sun King. The later portrait by Hyacinthe Rigaud gives us a better idea of the pomp and ceremony that defined the formal court (Fig. 23-10).

The overwhelming feeling at Versailles is domination: domination by order, symmetry, balance, and repetition; domination achieved by forcing grass, flowers, hedges, and trees into intricate patterns and by channeling water into pools, fountains, and falls, subduing nature itself to Louis's ego. This architectural complex created by the classical vocabulary contradicts the intent of the vocabulary by its vast scale and its disregard for restraint and simplicity. In a similar way there is a conflict in our response to Versailles. It vacillates between respect for, and delight in, the intricate workmanship and a kind of horrified awe at the vast scale

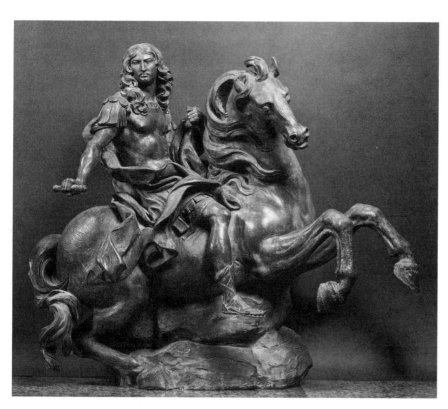

23-9 *Equestrian statue of Louis XIV by Gian Lorenzo Bernini, Galleria Borghese, Rome. (Scala/Art Resource, NY)*

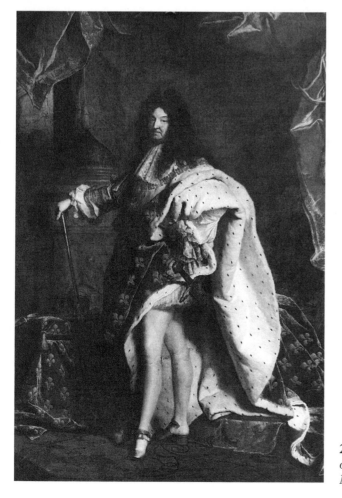

- Compare Rigaud's portrait of Louis XIV with Rubens's painting of Marie de' Medici's arrival in France (Fig. 21-5). Rigaud uses no mythological or allegorical figures, so how does he convey Louis XIV's importance?

23-10 *Hyacinthe Rigaud*, Portrait of Louis XIV, *1701, oil on canvas, 9'2" × 7'10¾" (detail), Louvre, Paris. (Cliché des Musées Nationaux)*

and richness, at this complex produced at great expense to the people of France. We sense that the glittering spectacle could not endure or be endured. Art and architecture had to become more and more accessible and essential to the rising bourgeoisie.

French Court Ballet and the Origins of Modern Theatrical Dancing

The showy, dramatic qualities of the palace at Versailles were appropriate to the highly theatrical rituals constituting life at court. Central to this life were the great festivals given in the gardens and halls at Versailles, where the nobles staged their own shows. It is then hardly surprising that in this world theatrical spectacles were the favorite form of entertainment and that the arts of ballet, opera, tragedy, and comedy reached new heights in France in the reign of Louis XIV.

Around the same time that baroque opera was developing in Italy, another new baroque art form was taking shape in France. The *court ballet* (*ballet de cour*) developed at the French court in the early seventeenth century but had its most splendid age under Louis XIV, who was himself an excellent dancer and took the starring role in a number of performances. The court ballet, although a short-lived art form, is nonetheless a crucial one because it is one of the important roots of both our social and our theatrical dancing. It demonstrates not only another facet of seventeenth-century art but also something of the nature of dance itself.

Court dancing as a form of entertainment probably began in Italy. Manuals by dancing masters published in the fifteenth and sixteenth centuries make it clear that dancing was considered an essential social grace for courtiers. Since the young nobles spent so much of their time learning to dance well, there was little need to hire professional dancers for entertainment. Nobles entertained each other with "dinner ballets"—great feasts of several courses with a dance between each course. Balls became popular in all the courts of Europe, and nobles raged to learn the latest dances from Italy. A few, like "La Volta," scandalous to many because the gentleman lifted his lady in the air (but nonetheless danced by Queen Elizabeth), were couple dances (Fig. 23-11). Most, however, were dances for couples in large groups, intended to be danced as processions or in circles, lines, or other formations.

When Catherine de' Medici, great-granddaughter of Lorenzo, became queen of France through her marriage to Henry II, she brought many aspects of Italian culture to her new country. She was especially fond of dancing and feasts. Dancing masters at Catherine's court discovered that they could make dancers move in geometric patterns; they also experimented with imitative dances that mimed dramatic actions. As musicians, poets, and stage designers worked with dancing masters, the lavish spectacles known as court ballets were born.

The court ballet continued to grow in appeal throughout the seventeenth century. The prime minister under Louis XIII and Louis XIV, Cardinal Mazarin,

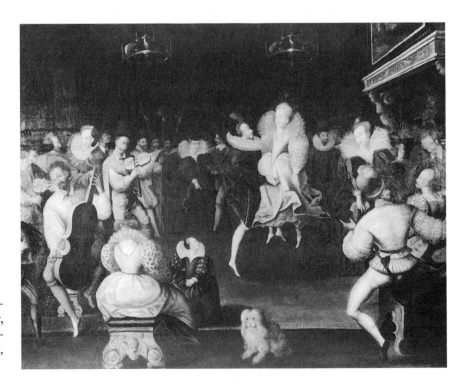

23-11 *Lord de L'Isle,* Queen Elizabeth I Dancing with Robert Dudley, Earl of Leicester. *(Reproduced by permission of Viscount de L'Isle, VC, KG, from his private collection)*

used this popularity for political purposes by impressing on the court the royal authority of the young Louis XIV through his performances. At the age of fifteen, Louis made his most celebrated appearance in the role of Apollo, the sun god, in *The Royal Ballet of Night* (1653). This is a typical piece of baroque theater in its mixtures of tones and genres, its extravagant scenery and costumes, its use of machines and surprises, and its ballet within a ballet, similar to a play within a play. The *entrées* (the term comes from the dinner ballet) included serious mythology, magical allegory, court dances, and comic and burlesque characters. A loose plot concerned with the events of a night holds it together. In the end the political purpose is manifest, for Louis appears to dance as the rising sun while the cast sings the glories of his realm. His title of Sun King derived from this role and the splendid costume that he wore (Fig. 23-12) while playing it.

Development of the Comedy-Ballet

As he grew to maturity, Louis continued both to dance himself and to encourage the production of more bal-

23-12 *Louis XIV as the Sun King in the* Ballet de la Nuit. *(Bibliothèque Nationale, Paris)*

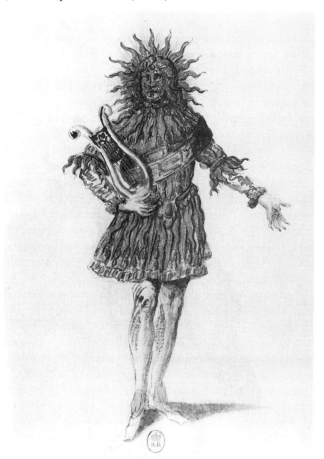

lets. He was also an accomplished guitar player and fond of poetry and drama, but dance was his favorite of the arts. His dancing master was Pierre Beauchamps; his court musician, the former Florentine Jean-Baptiste Lully. They collaborated on some opera-ballets, but eventually these two arts separated. In 1661 Louis founded the Royal Academy of Dance and in 1669 the Royal Academy of Music, which became the Paris Opera. The dance academy was primarily for noble amateurs, but in 1672 Louis founded a school to train professional dancers; this date marks the beginning of stage dancing as we know it today. Beauchamps codified the five positions and other steps still taught in ballet classes. Dance in the ballroom and dance in the theater from then on went their separate ways.

Beauchamps and Lully did collaborate with the actor-director-playwright Molière in another type of production that flourished at the end of the century: the "comedy-ballet," exemplified by *Le Bourgeois Gentilhomme* (The Middle-Class Gentleman). Molière is justly considered the father of modern comedy. To understand this art form, we must know something about drama in seventeenth-century France.

French Neoclassical Drama

Drama in France, in the early part of the seventeenth century, resembled the court ballet in its mixture of genres (tragedy, comedy, pastoral, and so on), its extravagant and complicated plots, and its sometimes unwieldy length. Later in the century, however, theoreticians and practitioners of the theater reacted against what they viewed as unbridled exuberance and attempted, in conformity with the reigning political absolutism, to impose universal standards on drama. Yet as in the palace at Versailles, classical standards of clarity, order, and harmony were often used in the service of qualities such as extremes of emotion, extravagance, *grandeur*, and high-flown rhetoric that we might call baroque.

Classicism as an aesthetic first appeared in tragedy and in theories of tragedy. Basing their ideas on the Italian humanists' revival and imitations of Greek and Roman tragedy, French writers found rules that they believed must be followed to produce good tragedy. The rules that they set down became a kind of standard doctrine after they were accepted by the French Academy, founded in 1635. The academy, still in operation today, was charged with putting together theoretical works of importance to the French language: dictionaries, grammars, and treatises on rhetoric and poetics. It became in fact a kind of watchdog over matters of style and usage. Its members standardized the rules for tragedy when they pronounced judgment on the first important tragedy by Pierre Corneille, based on a

Spanish work, entitled *Le Cid* (1637). The members of the academy found the tragedy basically a good one but lacking in certain points. What were the standards by which they judged?

Most important to the "classical" ideal of *tragedy* were the so-called *three unities*: unity of time, place, and action. The tragedy was to take place in no more than twenty-four hours, was to occur in the same setting, and was to have only one plot. Related to these three basic unities was unity of tone—tragedy and comedy were not to appear in the same play. The characters of tragedy were to be nobles, kings, and queens, who would speak in a dignified manner. No vulgar realism and no violent action could appear on the stage: such events necessary to the plot could be related by a messenger. Also, the events and characters could not be contemporary: they had to be far away either in time or in space. In fact, most of the French classical tragedies were based on Greek or Roman history or mythology. And yet the plots were to follow the rule of *verisimilitude*. They were not to be fantasies but to seem as if they could actually happen.

One can see how these rules might be applied to a Greek tragedy such as *Oedipus Rex*, but the French were in fact stricter than the Athenians; many Greek tragedies do not fit these standards. Certainly, every play by Shakespeare would fail the French Academy's test. It is hard for us to understand now how such strict rules could be effectively applied to art; but French classicism did produce two great tragedians: Pierre Corneille (1606–1684), who admittedly did have some trouble with the rules; and Jean Racine (1639–1699), whose pure, compressed works seem to have benefited by the limits imposed on them. The grandeur and magnificence characteristic of all art in the era of Louis XIV are evident in the tragedies of these two writers.

Corneille and Racine were (and are) considered by many to be the glories of their age; but when the influential literary critic Boileau was asked by Louis XIV to name the greatest contemporary dramatist, he replied, "Molière, Sire." Most people today would concur with that judgment, for although the two tragedians seem particularly French, the comedy writer Molière is universal. Yet Molière, too, was obliged to write in conformity with the standards of his day and, especially, for the pleasure of the king.

Molière (1622–1673), a Genius of Comedy

Jean-Baptiste Poquelin, who later assumed the stage name of Molière, was born to a solidly bourgeois Parisian family. After receiving a good education, he abandoned a possible career in law to pursue two passions—the theater and the actress Madeleine Béjart. Molière and Mlle. Béjart together founded a company

of actors, the *Illustre Théâtre*, in 1643. During the years in which the company toured France, Molière gained valuable experience as an actor, director, and manager. He also wrote and produced two of his own comedies, heavily influenced by the Italian *commedia dell'arte*, with its improvisations on stock characters, which he often saw during his travels. Like Shakespeare, Molière was not just a writer but a complete man of the theater.

The great breakthrough for the *Illustre Théâtre* came when the company pleased the king, performing before him at the Louvre. Louis then offered them a theater to play in, the Petit Bourbon, which they were to share with an Italian company. From then on, Molière turned more seriously to writing, although he continued to act in his own comedies throughout his lifetime (in fact, he died during a performance). Continuing to enjoy the protection and interest of the king, Molière staged his comedies not only at the Louvre but also at the palace at Versailles and at other castles. He thus became intimately involved in the atmosphere of festivity surrounding the court of Louis XIV, but his comedies reached a much wider audience. Common people as well as bourgeois and nobles attended them with great enthusiasm when they played in Paris. Molière was accused by certain purists of catering to the vulgar element of the audience, but it is exactly his wide human experience and his refusal to become too refined that helped to make him a great writer of *comedy*.

Molière's comedies range from rather gross farces, based on the stock character of the ridiculous dupe and almost slapstick effects, to subtle analyses of human character that are close to serious drama. His greatest originality lay in his ability to observe keenly the society and the people around him and to create from them characters both of their time and for all times and places. On the whole his comedies observe the classical three unities originally laid down for tragedy, as well as other classical canons such as simplicity and verisimilitude, yet Molière did not hesitate to deviate from the rules when it suited his purposes. The only really important rule, he maintained, was to *please*. Audiences, not theoreticians, were the best judges. It was necessary, too, to please the king. Luckily, Louis was not a person of narrow tastes.

One of Molière's greatest comedies was written for a great festival at Versailles called "The Pleasures of the Enchanted Island" in 1664. The title character of the play *Tartuffe* is a religious hypocrite, and the proposed moral clearly favors good common sense against fanaticism. The play so shocked the religious elements of the court that the archbishop used his influence to persuade Louis to ban it; not until five years later was Molière free to produce it. Another of his most admired plays, *The Misanthrope*, is about a man who hates the preten-

sions and superficiality of upper-class society but is in love with a woman who accepts them fully. Both of these plays are centered around a complex character and are satirical studies of human life in society.

Marie de la Vergne de La Fayette (1634–1693) and the Origins of the Modern Novel

Although the court at Versailles lent itself to theatricality, other literary forms flourished in seventeenth-century France as well. *Romances,* or long fantastic tales, and love poetry enjoyed popularity in both city and court. Toward the end of the century, a highly original and talented French writer helped to shape the course of modern fiction as we know it.

It is now generally agreed that the first authors of what we can call the early modern *novel* were women. The epistolary novel (based on letters) and other novels emphasizing analysis of feeling and sentiment flourished among women writers in England and France early in the eighteenth century. Their predecessor, however, was the masterpiece of Madame de La Fayette, *The Princess of Clèves.*

The author, Marie-Madelaine de la Vergne, married the count of La Fayette at the age of twenty-two and went to live with him in the country, where she bore two sons. At the age of twenty-five, however, she returned to live primarily in Paris, where she had close associates both in literary society and at court. She had a successful writing career, publishing five novels and a book of memoirs on court life.

Probably because women writers were still viewed with some suspicion, Madame de La Fayette (Fig. 23-13) published *The Princess of Clèves* anonymously, in 1678. It was an immediate success. Set in the sixteenth-century French court of Henry II and using actual historical figures, it nonetheless reflects many aspects of the court of the Sun King. Its real interest, however, lies not so much in social or historical observations as in its subtle analysis of character and psychological states. Like Molière, and like writers in the Enlightenment, the

24-13 *Marie-Madelaine Comtesse de La Fayette (Madame de La Fayette), 1634–1693. (Giraudon/Art Resource, NY)*

author of *The Princess of Clèves* believed in a universal, fundamentally unchanging human nature, and it is this nature, particularly regarding relations between men and women, that she sets out to study.

The novel's plot is quite simple. It concerns a young noblewoman whose mother, fearing the dangers and seductions of court life, raises her daughter with strict notions of virtue, honor, and chastity. Even though she feels only admiration and esteem for him, the daughter marries the man her mother chooses, the prince of Clèves. When she meets the young and charming duke of Nemours, however, she understands what it means to fall in love. The rest of the novel concerns the deepening of her feelings toward the duke, her efforts to resist him, her (shocking, to her readers) confession of her feelings to her husband, and her final renouncement of the court and the duke even after her husband's death. Although the novel could be seen as a portrayal of female self-sacrifice, it is rather a tale of female courage and moral strength.

MOLIÈRE

Tartuffe

Translation by Richard Wilbur

CHARACTERS

MME. PERNELLE, *Orgon's mother*
ORGON, *Elmire's husband*
ELMIRE, *Orgon's wife*
DAMIS, *Orgon's son, Elmire's stepson*
MARIANE, *Orgon's daughter, Elmire's stepdaughter, in love with Valère*
VALÈRE, *in love with Mariane*
CLÉANTE, *Orgon's brother-in-law*
TARTUFFE, *a hypocrite*
DORINE, *Mariane's lady's-maid*
M. LOYAL, *a bailiff*
A POLICE OFFICER
FLIPOTE, *Mme. Pernelle's maid*

The scene throughout: ORGON's *house in Paris*

ACT I, SCENE ONE

MADAME PERNELLE *and* FLIPOTE, *her maid,* ELMIRE, MARIANE, DORINE, DAMIS, CLÉANTE

MADAME PERNELLE Come, come, Flipote; it's time I
 left this place.
ELMIRE I can't keep up, you walk at such a pace.
MADAME PERNELLE Don't trouble, child; no need to
 show me out.
 It's not your manners I'm concerned about.
ELMIRE We merely pay you the respect we owe.
 But, Mother, why this hurry? Must you go?
MADAME PERNELLE I must. This house appals me.
 No one in it
Will pay attention for a single minute.
Children, I take my leave much vexed in spirit.
I offer good advice, but you won't hear it.
You all break in and chatter on and on.
It's like a madhouse with the keeper gone.
DORINE If . . .
MADAME PERNELLE Girl, you talk too much, and
 I'm afraid

You're far too saucy for a lady's-maid.
You push in everywhere and have your say.
DAMIS But . . .
MADAME PERNELLE You, boy, grow more foolish
 every day.
To think my grandson should be such a dunce!
I've said a hundred times, if I've said it once,
That if you keep the course on which you've started,
You'll leave your worthy father broken-hearted.
MARIANE I think . . .
MADAME PERNELLE And you, his sister, seem so
 pure,
So shy, so innocent, and so demure.
But you know what they say about still waters.
I pity parents with secretive daughters.
ELMIRE Now, Mother . . .
MADAME PERNELLE And as for you, child, let me
 add
That your behavior is extremely bad,
And a poor example for these children, too.
Their dear, dead mother did far better than you.
You're much too free with money, and I'm distressed
To see you so elaborately dressed.
When it's one's husband that one aims to please,
One has no need of costly fripperies.
CLÉANTE Oh, Madam, really . . .
MADAME PERNELLE You are her brother, Sir,
And I respect and love you; yet if I were
My son, this lady's good and pious spouse,
I wouldn't make you welcome in my house.
You're full of worldly counsels which, I fear,
Aren't suitable for decent folk to hear.
I've spoken bluntly, Sir; but it behooves us
Not to mince words when righteous fervor moves us.
DAMIS Your man Tartuffe is full of holy speeches . . .
MADAME PERNELLE And practises precisely what he
 preaches.
He's a fine man, and should be listened to.
I will not hear him mocked by fools like you.
DAMIS Good God! Do you expect me to submit
 To the tyranny of that carping hypocrite?
 Must we forgo all joys and satisfactions
 Because that bigot censures all our actions?
DORINE To hear him talk—and he talks all the
 time—

There's nothing one can do that's not a crime.
He rails at everything, your dear Tartuffe.
MADAME PERNELLE Whatever he reproves deserves
 reproof.
He's out to save your souls, and all of you
Must love him, as my son would have you do.
DAMIS Ah no, Grandmother, I could never take
To such a rascal, even for my father's sake.
That's how I feel, and I shall not dissemble.
His every action makes me seethe and tremble
With helpless anger, and I have no doubt
That he and I will shortly have it out.
DORINE Surely it is a shame and a disgrace
To see this man usurp the master's place—
To see this beggar who, when first he came,
Had not a shoe or shoestring to his name
So far forget himself that he behaves
As if the house were his, and we his slaves.
MADAME PERNELLE Well, mark my words, your
 souls would fare far better
If you obeyed his precepts to the letter.
DORINE You see him as a saint. I'm far less awed;
In fact, I see right through him. He's a fraud.
MADAME PERNELLE Nonsense!
DORINE His man Laurent's the same, or worse;
I'd not trust either with a penny purse.
MADAME PERNELLE I can't say what his servant's
 morals may be;
His own great goodness I can guarantee.
You all regard him with distaste and fear
Because he tells you what you're loath to hear,
Condemns your sins, points out your moral flaws,
And humbly strives to further Heaven's cause.
DORINE If sin is all that bothers him, why is it
He's so upset when folk drop in to visit?
Is Heaven so outraged by a social call
That he must prophesy against us all?
I'll tell you what I think: if you ask me,
He's jealous of my mistress' company.
MADAME PERNELLE Rubbish!

(*To* ELMIRE.)

He's not alone, child, in complaining
Of all of your promiscuous entertaining.
Why, the whole neighborhood's upset, I know,
By all these carriages that come and go,
With crowds of guests parading in and out
And noisy servants loitering about.
In all of this, I'm sure there's nothing vicious;
But why give people cause to be suspicious?
CLÉANTE They need no cause; they'll talk in any
 case.
Madam, this world would be a joyless place
If, fearing what malicious tongues might say,
We locked our doors and turned our friends away.
And even if one did so dreary a thing,

D'you think those tongues would cease their
 chattering?
One can't fight slander; it's a losing battle;
Let us instead ignore their tittle-tattle.
Let's strive to live by conscience' clear decrees,
And let the gossips gossip as they please.
DORINE If there is talk against us, I know the source:
It's Daphne and her little husband, of course.
Those who have greatest cause for guilt and shame
Are quickest to besmirch a neighbor's name.
When there's a chance for libel, they never miss it;
When something can be made to seem illicit
They're off at once to spread the joyous news,
Adding to fact what fantasies they choose.
By talking up their neighbor's indiscretions
They seek to camouflage their own transgressions,
Hoping that others' innocent affairs
Will lend a hue of innocence to theirs,
Or that their own black guilt will come to seem
Part of a general shady color-scheme.
MADAME PERNELLE All that is quite irrelevant. I
 doubt
That anyone's more virtuous and devout
Than dear Orante; and I'm informed that she
Condemns your mode of life most vehemently.
DORINE Oh, yes, she's strict, devout, and has no
 taint
Of worldliness; in short, she seems a saint.
But it was time which taught her that disguise;
She's thus because she can't be otherwise.
So long as her attractions could enthrall,
She flounced and flirted and enjoyed it all,
But now that they're no longer what they were
She quits a world which fast is quitting her,
And wears a veil of virtue to conceal
Her bankrupt beauty and her lost appeal.
That's what becomes of old coquettes today:
Distressed when all their lovers fall away,
They see no recourse but to play the prude,
And so confer a style on solitude.
Thereafter, they're severe with everyone,
Condemning all our actions, pardoning none,
And claiming to be pure, austere, and zealous
When, if the truth were known, they're merely
 jealous,
And cannot bear to see another know
The pleasures time has forced them to forgo.
MADAME PERNELLE (*Initially to* ELMIRE.)
That sort of talk is what you like to hear;
Therefore you'd have us all keep still, my dear,
While Madam rattles on the livelong day.
Nevertheless, I mean to have my say.
I tell you that you're blest to have Tartuffe
Dwelling, as my son's guest, beneath this roof;
That Heaven has sent him to forestall its wrath
By leading you, once more, to the true path;

That all he reprehends is reprehensible,
And that you'd better heed him, and be sensible.
These visits, balls, and parties in which you revel
Are nothing but inventions of the Devil.
One never hears a word that's edifying:
Nothing but chaff and foolishness and lying,
As well as vicious gossip in which one's neighbor
Is cut to bits with epee, foil, and saber.
People of sense are driven half-insane
At such affairs, where noise and folly reign
And reputations perish thick and fast.
As a wise preacher said on Sunday last,
Parties are Towers of Babylon, because
The guests all babble on with never a pause;
And then he told a story which, I think . . .

(*To* CLÉANTE.)

I heard that laugh, Sir, and I saw that wink!
Go find your silly friends and laugh some more!
Enough; I'm going; don't show me to the door.
I leave this household much dismayed and vexed;
I cannot say when I shall see you next.

(*Slapping* FLIPOTE.)

Wake up, don't stand there gaping into space!
I'll slap some sense into that stupid face.
Move, move, you slut.

SCENE TWO

CLÉANTE, DORINE

CLÉANTE I think I'll stay behind;
I want no further pieces of her mind.
How that old lady . . .
DORINE Oh, what wouldn't she say
If she could hear you speak of her that way!
She'd thank you for the *lady,* but I'm sure
She'd find the *old* a little premature.
CLÉANTE My, what a scene she made, and what a din!
And how this man Tartuffe has taken her in!
DORINE Yes, but her son is even worse deceived;
His folly must be seen to be believed.
In the late troubles, he played an able part
And served his king with wise and loyal heart,
But he's quite lost his senses since he fell
Beneath Tartuffe's infatuating spell.
He calls him brother, and loves him as his life,
Preferring him to mother, child, or wife.
In him and him alone will he confide;
He's made him his confessor and his guide;
He pets and pampers him with love more tender
Than any pretty mistress could engender,
Gives him the place of honor when they dine,
Delights to see him gorging like a swine,

Stuffs him with dainties till his guts distend,
And when he belches, cries "God bless you, friend!"
In short, he's mad; he worships him; he dotes;
His deeds he marvels at, his words he quotes,
Thinking each act a miracle, each word
Oracular as those that Moses heard.
Tartuffe, much pleased to find so easy a victim,
Has in a hundred ways beguiled and tricked him,
Milked him of money, and with his permission
Established here a sort of Inquisition.
Even Laurent, his lackey, dares to give
Us arrogant advice on how to live;
He sermonizes us in thundering tones
And confiscates our ribbons and colognes.
Last week he tore a kerchief into pieces
Because he found it pressed in a *Life of Jesus:*
He said it was a sin to juxtapose
Unholy vanities and holy prose.

SCENE THREE

ELMIRE, MARIANE, DAMIS, CLÉANTE, DORINE

ELMIRE.

(*To* CLÉANTE.)

You did well not to follow; she stood in the door
And said *verbatim* all she'd said before.
I saw my husband coming. I think I'd best
Go upstairs now, and take a little rest.
CLÉANTE I'll wait and greet him here; then I must go.
I've really only time to say hello.
DAMIS Sound him about my sister's wedding, please.
I think Tartuffe's against it, and that he's
Been urging Father to withdraw his blessing.
As you well know, I'd find that most distressing.
Unless my sister and Valère can marry,
My hopes to wed *his* sister will miscarry,
And I'm determined. . . .
DORINE He's coming.

SCENE FOUR

ORGON, CLÉANTE, DORINE

ORGON Ah, Brother, good-day.
CLÉANTE Well, welcome back. I'm sorry I can't stay.
How was the country? Blooming, I trust, and green?
ORGON Excuse me, Brother; just one moment.

(*To* DORINE.)

 Dorine . . .

(*To* CLÉANTE.)

To put my mind at rest, I always learn
The household news the moment I return.

(*To* Dorine.)

Has all been well, these two days I've been gone?
How are the family? What's been going on?

Dorine Your wife, two days ago, had a bad fever,
And a fierce headache which refused to leave her.

Orgon Ah. And Tartuffe?

Dorine Tartuffe? Why, he's round and red,
Bursting with health, and excellently fed.

Orgon Poor fellow!

Dorine That night, the mistress was unable
To take a single bite at the dinner-table.
Her headache-pains, she said, were simply hellish.

Orgon Ah. And Tartuffe?

Dorine He ate his meal with relish,
And zealously devoured in her presence
A leg of mutton and a brace of pheasants.

Orgon Poor fellow!

Dorine Well, the pains continued strong,
And so she tossed and tossed the whole night long,
Now icy-cold, now burning like a flame.
We sat beside her bed till morning came.

Orgon Ah. And Tartuffe?

Dorine Why, having eaten, he rose
And sought his room, already in a doze,
Got into his warm bed, and snored away
In perfect peace until the break of day.

Orgon Poor fellow!

Dorine After much ado, we talked her
Into dispatching someone for the doctor.
He bled her, and the fever quickly fell.

Orgon Ah. And Tartuffe?

Dorine He bore it very well.
To keep his cheerfulness at any cost,
And make up for the blood *Madame* had lost,
He drank, at lunch, four beakers full of port

Orgon Poor fellow!

Dorine Both are doing well, in short.
I'll go and tell *Madame* that you've expressed
Keen sympathy and anxious interest.

SCENE FIVE

Orgon, Cléante

Cléante That girl was laughing in your face, and though
I've no wish to offend you, even so
I'm bound to say that she had some excuse.
How can you possibly be such a goose?
Are you so dazed by this man's hocus-pocus
That all the world, save him, is out of focus?
You've given him clothing, shelter, food, and care;
Why must you also . . .

Orgon Brother, stop right there.
You do not know the man of whom you speak.

Cléante I grant you that. But my judgement's not so weak
That I can't tell, by his effect on others. . . .

Orgon Ah, when you meet him, you two will be like brothers!
There's been no loftier soul since time began.
He is a man who . . . a man who . . . an excellent man.
To keep his precepts is to be reborn,
And view this dunghill of a world with scorn.
Yes, thanks to him I'm a changed man indeed.
Under his tutelage my soul's been freed
From earthly loves, and every human tie:
My mother, children, brother, and wife could die,
And I'd not feel a single moment's pain.

Cléante That's a fine sentiment, Brother; most humane.

Orgon Oh, had you seen Tartuffe as I first knew him,
Your heart, like mine, would have surrendered to him.
He used to come into our church each day
And humbly kneel nearby, and start to pray.
He'd draw the eyes of everybody there
By the deep fervor of his heartfelt prayer;
He'd sigh and weep, and sometimes with a sound
Of rapture he would bend and kiss the ground;
And when I rose to go, he'd run before
To offer me holy-water at the door.
His serving-man, no less devout than he,
Informed me of his master's poverty;
I gave him gifts, but in his humbleness
He'd beg me every time to give him less.
"Oh, that's too much," he'd cry, "too much by twice!
I don't deserve it. The half, Sir, would suffice."
And when I wouldn't take it back, he'd share
Half of it with the poor, right then and there.
At length, Heaven prompted me to take him in.
To dwell with us, and free our souls from sin.
He guides our lives, and to protect my honor
Stays by my wife, and keeps an eye upon her;
He tells me whom she sees, and all she does,
And seems more jealous than I ever was!
And how austere he is! Why, he can detect
A mortal sin where you would least suspect;
In smallest trifles, he's extremely strict.
Last week, his conscience was severely pricked
Because, while praying, he had caught a flea
And killed it, so he felt, too wrathfully.

Cléante Good God, man! Have you lost your common sense—
Or is this all some joke at my expense?
How can you stand there and in all sobriety . . .

Orgon Brother, your language savors of impiety.
Too much free-thinking's made your faith unsteady,

And as I've warned you many times already,
'Twill get you into trouble before you're through.
CLÉANTE So, I've been told before by dupes like you:
 Being blind, you'd have all others blind as well;
 The clear-eyed man you call an infidel,
 And he who sees through humbug and pretense
 Is charged, by you, with want of reverence.
 Spare me your warnings, Brother; I have no fear
 Of speaking out, for you and Heaven to hear,
 Against affected zeal and pious knavery.
 There's true and false in piety, as in bravery,
 And just as those whose courage shines the most
 In battle, are the least inclined to boast,
 So those whose hearts are truly pure and lowly
 Don't make a flashy show of being holy.
 There's a vast difference, so it seems to me,
 Between true piety and hypocrisy:
 How do you fail to see it, may I ask?
 Is not a face quite different from a mask?
 Cannot sincerity and cunning art,
 Reality and semblance, be told apart?
 Are scarecrows just like men, and do you hold
 That a false coin is just as good as gold?
 Ah, Brother, man's a strangely fashioned creature
 Who seldom is content to follow Nature,
 But recklessly pursues his inclination
 Beyond the narrow bounds of moderation,
 And often, by transgressing Reason's laws,
 Perverts a lofty aim or noble cause.
 A passing observation, but it applies.
ORGON I see, dear Brother, that you're profoundly
 wise;
 You harbor all the insight of the age.
 You are our one clear mind, our only sage,
 The era's oracle, its Cato too,
 And all mankind are fools compared to you.
CLÉANTE Brother, I don't pretend to be a sage,
 Nor have I all the wisdom of the age.
 There's just one insight I would dare to claim:
 I know that true and false are not the same;
 And just as there is nothing I more revere
 Than a soul whose faith is steadfast and sincere,
 Nothing that I more cherish and admire
 Than honest zeal and true religious fire,
 So there is nothing that I find more base
 Than specious piety's dishonest face—
 Than these bold mountebanks, these histrios
 Whose impious mummeries and hollow shows
 Exploit our love of Heaven, and make a jest
 Of all that men think holiest and best;
 These calculating souls who offer prayers
 Not to their Maker, but as public wares,
 And seek to buy respect and reputation
 With lifted eyes and sighs of exaltation;
 These charlatans, I say, whose pilgrim souls
 Proceed, by way of Heaven, toward earthly goals,
 Who weep and pray and swindle and extort,

Who preach the monkish life, but haunt the court,
Who make their zeal the partner of their vice—
Such men are vengeful, sly, and cold as ice,
And when there is an enemy to defame
They cloak their spite in fair religion's name,
Their private spleen and malice being made
To seem a high and virtuous crusade,
Until, to mankind's reverent applause,
They crucify their foe in Heaven's cause.
Such knaves are all too common; yet, for the wise,
True piety isn't hard to recognize,
And, happily, these present times provide us
With bright examples to instruct and guide us.
Consider Ariston and Périandre;
Look at Oronte, Alcidamas, Clitandre;
Their virtue is acknowledged; who could doubt it?
But you won't hear them beat the drum about it.
They're never ostentatious, never vain,
And their religion's moderate and humane;
It's not their way to criticize and chide:
They think censoriousness a mark of pride,
And therefore, letting others preach and rave,
They show, by deeds, how Christians should behave.
They think no evil of their fellow man,
But judge of him as kindly as they can.
They don't intrigue and wangle and conspire;
To lead a good life is their one desire;
The sinner wakes no rancorous hate in them;
It is the sin alone which they condemn;
Nor do they try to show a fiercer zeal
For Heaven's cause than Heaven itself could feel.
These men I honor, these men I advocate
As models for us all to emulate.
Your man is not their sort at all, I fear:
And, while your praise of him is quite sincere,
I think that you've been dreadfully deluded.
ORGON Now then, dear Brother, is your speech
 concluded?
CLÉANTE Why, yes.
ORGON Your servant, Sir.

(*He turns to go.*)

CLÉANTE No, Brother; wait.
 There's one more matter. You agreed of late
 That young Valère might have your daughter's hand.
ORGON I did.
CLÉANTE And set the date, I understand.
ORGON Quite so.
CLÉANTE You've now postponed it; is that true?
ORGON No doubt.
CLÉANTE The match no longer pleases you?
ORGON Who knows?
CLÉANTE D'you mean to go back on your word?
ORGON I won't say that.
CLÉANTE Has anything occurred
 Which might entitle you to break your pledge?
ORGON Perhaps.

CLÉANTE Why must you hem, and haw, and hedge?
 The boy asked me to sound you in this affair. . . .
ORGON It's been a pleasure.
CLÉANTE But what shall I tell Valère?
ORGON Whatever you like.
CLÉANTE But what have you decided?
 What are your plans?
ORGON I plan, Sir, to be guided
 By Heaven's will.
CLÉANTE Come, Brother, don't talk rot.
 You've given Valère your word; will you keep it, or
 not?
ORGON Good day.
CLÉANTE This looks like poor Valère's undoing;
 I'll go and warn him that there's trouble brewing.

ACT II, SCENE ONE

ORGON, MARIANE

ORGON Mariane.
MARIANE Yes, Father?
ORGON A word with you; come here.
MARIANE What are you looking for?
ORGON (*Peering into a small closet.*)
 Eavesdroppers, dear.
 I'm making sure we shan't be overheard.
 Someone in there could catch our every word.
 Ah, good, we're safe. Now, Mariane, my child,
 You're a sweet girl who's tractable and mild,
 Whom I hold dear, and think most highly of.
MARIANE I'm deeply grateful, Father, for your love.
ORGON That's well said, Daughter; and you can
 repay me
 If, in all things, you'll cheerfully obey me.
MARIANE To please you, Sir, is what delights me
 best.
ORGON Good, good. Now, what d'you think of
 Tartuffe, our guest?
MARIANE I, Sir?
ORGON Yes. Weigh your answer; think it through.
MARIANE Oh, dear. I'll say whatever you wish me to.
ORGON That's wisely said, my Daughter. Say of him,
 then,
 That he's the very worthiest of men,
 And that you're fond of him, and would rejoice
 In being his wife, if that should be my choice.
 Well?
MARIANE What?
ORGON What's that?
MARIANE I . . .
ORGON Well?
MARIANE Forgive me, pray.
ORGON Did you not hear me?
MARIANE Of *whom*, Sir, must I say
 That I am fond of him, and would rejoice
 In being his wife, if that should be your choice?

ORGON Why, of Tartuffe.
MARIANE But, Father, that's false, you know.
 Why would you have me say what isn't so?
ORGON Because I am resolved it shall be true.
 That it's my wish should be enough for you.
MARIANE You can't mean, Father . . .
ORGON Yes, Tartuffe shall be
 Allied by marriage to this family,
 And he's to be your husband, is that clear?
 It's a father's privilege. . . .

SCENE TWO

DORINE, ORGON, MARIANE

ORGON (*To* DORINE.)
 What are you doing in here?
 Is curiosity so fierce a passion
 With you, that you must eavesdrop in this fashion?
DORINE There's lately been a rumor going about—
 Based on some hunch or chance remark, no doubt—
 That you mean Mariane to wed Tartuffe.
 I've laughed it off, of course, as just a spoof.
ORGON You find it so incredible?
DORINE Yes. I do.
 I won't accept that story, even from you.
ORGON Well, you'll believe it when the thing is done.
DORINE Yes, yes, of course. Go on and have your
 fun.
ORGON I've never been more serious in my life.
DORINE Ha!
ORGON Daughter, I mean it; you're to be his wife.
DORINE No, don't believe your father; it's all a hoax.
ORGON See here, young woman . . .
DORINE Come, Sir, no more jokes;
 You can't fool us.
ORGON How dare you talk that way?
DORINE All right, then; we believe you, sad to say.
 But how a man like you, who looks to wise
 And wears a moustache of such splendid size,
 Can be so foolish as to . . .
ORGON Silence, please!
 My girl, you take too many liberties.
 I'm master here, as you must not forget.
DORINE Do let's discuss this calmly; don't be upset.
 You can't be serious, Sir, about this plan.
 What should that bigot want with Mariane?
 Praying and fasting ought to keep him busy.
 And then in terms of wealth and rank, what is he?
 Why should a man of property like you
 Pick out a beggar son-in-law?
ORGON That will do.
 Speak of his poverty with reverence.
 His is a pure and saintly indigence
 Which far transcends all worldly pride and pelf.
 He lost his fortune, as he says himself,
 Because he cared for Heaven alone, and so

Was careless of his interests here below.
I mean to get him out of his present straits
And help him to recover his estates—
Which, in his part of the world, have no small fame.
Poor though he is, he's a gentleman just the same.

DORINE Yes, so he tells us; and, Sir, it seems to me
Such pride goes very ill with piety.
A man whose spirit spurns this dungy earth
Ought not to brag of lands and noble birth;
Such worldly arrogance will hardly square
With meek devotion and the life of prayer.
. . . But this approach, I see, has drawn a blank;
Let's speak, then, of his person, not his rank.
Doesn't it seem to you a trifle grim
To give a girl like her to a man like him?
When two are so ill-suited, can't you see
What the sad consequence is bound to be?
A young girl's virtue is imperilled, Sir,
When such a marriage is imposed on her;
For if one's bridegroom isn't to one's taste,
It's hardly an inducement to be chaste,
And many a man with horns upon his brow
Has made his wife the thing that she is now.
It's hard to be a faithful wife, in short,
To certain husbands of a certain sort,
And he who gives his daughter to a man she hates
Must answer for her sins at Heaven's gates.
Think, Sir, before you play so risky a role.

ORGON This servant-girl presumes to save my soul!

DORINE You would do well to ponder what I've said.

ORGON Daughter, we'll disregard this dunderhead.
Just trust your father's judgement. Oh, I'm aware
That I once promised you to young Valère;
But now I hear he gambles, which greatly shocks me.
What's more, I've doubts about his orthodoxy.
His visits to church, I note, are very few.

DORINE Would you have him go at the same hours
as you,
And kneel nearby, to be sure of being seen?

ORGON I can dispense with such remarks, Dorine.

(*To* MARIANE.)

Tartuffe, however, is sure of Heaven's blessing,
And that's the only treasure worth possessing.
This match will bring you joys beyond all measure;
Your cup will overflow with every pleasure;
You two will interchange your faithful loves
Like two sweet cherubs, or two turtle-doves.
No harsh word shall be heard, no frown be seen,
And he shall make you happy as a queen.

DORINE And she'll make him a cuckold, just wait
and see.

ORGON What language!

DORINE Oh, he's a man of destiny;
He's *made* for horns, and what the stars demand
Your daughter's virtue surely can't withstand.

ORGON Don't interrupt me further. Why can't you
learn
That certain things are none of your concern?

DORINE It's for your own sake that I interfere.

(*She repeatedly interrupts* ORGON *just as he is turning to speak to his daughter.*)

ORGON Most kind of you. Now, hold your tongue,
d'you hear?

DORINE If I didn't love you . . .

ORGON Spare me your affection.

DORINE I'll love you, Sir, in spite of your objection.

ORGON Blast!

DORINE I can't bear, Sir, for your honor's sake,
To let you make this ludicrous mistake.

ORGON You mean to go on talking?

DORINE If I didn't protest
This sinful marriage, my conscience couldn't rest.

ORGON If you don't hold your tongue, you little
shrew . . .

DORINE What, lost your temper? A pious man like
you?

ORGON Yes! Yes! You talk and talk. I'm maddened
by it.
Once and for all, I tell you to be quiet.

DORINE Well, I'll be quiet. But I'll be thinking hard.

ORGON Think all you like, but you had better guard
That saucy tongue of yours, or I'll . . .

(*Turning back to* MARIANE.)

 Now, child,
I've weighed this matter-fully.

DORINE (*Aside.*)
 It drives me wild
That I can't speak.

(ORGON *turns his head, and she is silent.*)

ORGON Tartuffe is no young dandy,
But, still, his person . . .

DORINE (*Aside.*)
 Is as sweet as candy.

ORGON Is such that, even if you shouldn't care
For his other merits . . .

(*He turns and stands facing* DORINE, *arms crossed.*)

DORINE (*Aside.*)
 They'll make a lovely pair.
If I were she, no man would marry me
Against my inclination, and go scot-free.
He'd learn, before the wedding-day was over,
How readily a wife can find a lover.

ORGON

(*To* DORINE.)

It seems you treat my orders as a joke.

DORINE Why, what's the matter? 'Twas not to you I
spoke.

ORGON What *were* you doing?
DORINE Talking to myself, that's all.
ORGON Ah!

(*Aside.*)

One more bit of impudence and gall,
And I shall give her a good slap in the face.

(*He puts himself in position to slap her;* DORINE, *whenever he glances at her, stands immobile and silent.*)

Daughter, you shall accept and with good grace,
The husband I've selected. . . . Your wedding-day . . .

(*To* DORINE.)

Why don't you talk to yourself?
DORINE I've nothing to say.
ORGON Come, just one word.
DORINE No thank you, Sir. I pass.
ORGON Come, speak; I'm waiting.
DORINE I'd not be such an ass.
ORGON (*Turning to* MARIANE)
In short, dear Daughter, I mean to be obeyed,
And you must bow to the sound choice I've made.
DORINE (*Moving away.*)
I'd not wed such a monster, even in jest.

(ORGON *attempts to slap her, but misses.*)

ORGON Daughter, that maid of yours is a thorough
 pest;
She makes me sinfully annoyed and nettled.
I can't speak further; my nerves are too unsettled.
She's so upset me by her insolent talk,
I'll calm myself by going for a walk.

SCENE THREE

DORINE, MARIANE

DORINE (*Returning.*)
Well, have you lost your tongue, girl? Must I play
Your part, and say the lines you ought to say?
Faced with a fate so hideous and absurd,
Can you not utter one dissenting word?
MARIANE What good would it do? A father's power
 is great.
DORINE Resist him now, or it will be too late.
MARIANE But . . .
DORINE Tell him one cannot love at a father's whim;
That you shall marry for yourself, not him;
That since it's you who are to be the bride,
It's you, not he, who must be satisfied;
And that if his Tartuffe is so sublime,
He's free to marry him at any time.
MARIANE I've bowed so long to Father's strict control,
I couldn't oppose him now, to save my soul.
DORINE Come, come, Mariane. Do listen to reason,
 won't you?

Valère has asked your hand. Do you love him, or
 don't you?
MARIANE Oh, how unjust of you! What can you
 mean
By asking such a question, dear Dorine?
You know the depth of my affection for him;
I've told you a hundred times how I adore him.
DORINE I don't believe in everything I hear;
Who knows if your professions were sincere?
MARIANE They were, Dorine, and you do me wrong
 to doubt it;
Heaven knows that I've been all too frank about it.
DORINE You love him, then?
MARIANE Oh, more than I can express.
DORINE And he, I take it, cares for you no less?
MARIANE I think so.
DORINE And you both, with equal fire,
Burn to be married?
MARIANE That is our one desire.
DORINE What of Tartuffe, then? What of your
 father's plan?
MARIANE I'll kill myself, if I'm forced to wed that
 man.
DORINE I hadn't thought of that recourse. How
 splendid!
Just die, and all your troubles will be ended!
A fine solution. Oh, it maddens me
To hear you talk in that self-pitying key.
MARIANE Dorine, how harsh you are! It's most
 unfair.
You have no sympathy for my despair.
DORINE I've none at all for people who talk drivel
And, faced with difficulties, whine and snivel.
MARIANE No doubt I'm timid, but it would
 be wrong . . .
DORINE True love requires a heart that's firm
 and strong.
MARIANE I'm strong in my affection for Valère,
But coping with my father is his affair.
DORINE But if your father's brain has grown so
 cracked
Over his dear Tartuffe that he can retract
His blessing, though your wedding-day was named,
It's surely not Valère who's to be blamed.
MARIANE If I defied my father, as you suggest,
Would it not seem unmaidenly, at best?
Shall I defend my love at the expense
Of brazenness and disobedience?
Shall I parade my heart's desires, and flaunt . . .
DORINE No, I ask nothing of you. Clearly you want
To be Madame Tartuffe, and I feel bound
Not to oppose a wish so very sound.
What right have I to criticize the match?
Indeed, my dear, the man's a brilliant catch.
Monsieur Tartuffe! Now, there's a man of weight!
Yes, yes, Monsieur Tartuffe, I'm bound to state,

Is quite a person; that's not to be denied;
'Twill be no little thing to be his bride.
The world already rings with his renown;
He's a great noble—in his native town;
His ears are red, he has a pink complexion,
And all in all, he'll suit you to perfection.

MARIANE Dear God!

DORINE Oh, how triumphant you will feel
At having caught a husband so ideal!

MARIANE Oh, do stop teasing, and use your
 cleverness
To get me out of this appalling mess.
Advise me, and I'll do whatever you say.

DORINE Ah no, a dutiful daughter must obey
Her father, even if he weds her to an ape.
You've a bright future; why struggle to escape?
Tartuffe will take you back where his family lives,
To a small town aswarm with relatives—
Uncles and cousins whom you'll be charmed to meet.
You'll be received at once by the elite,
Calling upon the bailiff's wife, no less—
Even, perhaps, upon the mayoress,
Who'll sit you down in the *best* kitchen chair.
Then, once a year, you'll dance at the village fair
To the drone of bagpipes—two of them, in fact—
And see a puppet-show, or an animal act.
Your husband . . .

MARIANE Oh, you turn my blood to ice!
Stop torturing me, and give me your advice.

DORINE (*Threatening to go.*)
Your servant, Madam.

MARIANE Dorine, I beg of you . . .

DORINE No, you deserve it; this marriage must go
 through.

MARIANE Dorine!

DORINE No.

MARIANE Not Tartuffe! You know I think him . . .

DORINE Tartuffe's your cup of tea, and you shall
 drink him.

MARIANE I've always told you everything, and
 relied . . .

DORINE No. You deserve to be tartuffified.

MARIANE Well, since you mock me and refuse
 to care,
I'll henceforth seek my solace in despair:
Despair shall be my counsellor and friend,
And help me bring my sorrows to an end.

(*She starts to leave.*)

DORINE There now, come back; my anger has
 subsided.
You do deserve some pity, I've decided.

MARIANE Dorine, if Father makes me undergo
This dreadful martyrdom, I'll die, I know.

DORINE Don't fret; it won't be difficult to discover

Some plan of action. . . . But here's Valère, your
 lover.

SCENE FOUR

VALÈRE, MARIANE, DORINE

VALÈRE Madam, I've just received some wondrous
 news
Regarding which I'd like to hear your views.

MARIANE What news?

VALÈRE You're marrying Tartuffe.

MARIANE I find
That Father does have such a match in mind.

VALÈRE Your father, Madam . . .

MARIANE . . . has just this minute said
That it's Tartuffe he wishes me to wed.

VALÈRE Can he be serious?

MARIANE Oh, indeed he can;
He's clearly set his heart upon the plan.

VALÈRE And what position do you propose to take,
 Madam?

MARIANE Why—I don't know.

VALÈRE For heaven's sake—
You don't know?

MARIANE No.

VALÈRE Well, well!

MARIANE Advise me, do.

VALÈRE Marry the man. That's my advice to you.

MARIANE That's your advice?

VALÈRE Yes.

MARIANE Truly?

VALÈRE Oh, absolutely.
You couldn't choose more wisely, more astutely.

MARIANE Thanks for this counsel; I'll follow it, of
 course.

VALÈRE Do, do; I'm sure 'twill cost you no remorse.

MARIANE To give it didn't cause your heart to break.

VALÈRE I gave it, Madam, only for your sake.

MARIANE And it's for your sake that I take it, Sir.

DORINE (*Withdrawing to the rear of the stage.*)
Let's see which fool will prove the stubborner.

VALÈRE So! I am nothing to you, and it was flat
Deception when you . . .

MARIANE Please, enough of that.
You've told me plainly that I should agree
To wed the man my father's chosen for me,
And since you've deigned to counsel me so wisely,
I promise, Sir, to do as you advise me.

VALÈRE Ah, no, 'twas not by me that you were
 swayed.
No, your decision was already made;
Though now, to save appearances, you protest
That you're betraying me at my behest.

MARIANE Just as you say.

VALÈRE Quite so. And I now see
That you were never truly in love with me.

MARIANE Alas, you're free to think so if you choose.

VALÈRE I choose to think so, and here's a bit of news:
You've spurned my hand, but I know where to turn
For kinder treatment, as you shall quickly learn.

MARIANE I'm sure you do. Your noble qualities
Inspire affection. . . .

VALÈRE Forget my qualities, please.
They don't inspire you overmuch, I find.
But there's another lady I have in mind
Whose sweet and generous nature will not scorn
To compensate me for the loss I've borne.

MARIANE I'm no great loss, and I'm sure that you'll
 transfer
Your heart quite painlessly from me to her.

VALÈRE I'll do my best to take it in my stride.
The pain I feel at being cast aside
Time and forgetfulness may put an end to.
Or if I can't forget, I shall pretend to.
No self-respecting person is expected
To go on loving once he's been rejected.

MARIANE Now, that's a fine, high-minded sentiment.

VALÈRE One to which any sane man would assent.
Would you prefer it if I pined away
In hopeless passion till my dying day?
Am I to yield you to a rival's arms
And not console myself with other charms?

MARIANE Go then: console yourself, don't hesitate.
I wish you to; indeed, I cannot wait.

VALÈRE You wish me to?

MARIANE Yes.

VALÈRE That's the final straw.
Madam, farewell. Your wish shall be my law.

(He starts to leave, and then returns: this repeatedly:)

MARIANE Splendid.

VALÈRE *(Coming back again.)*
 This breach, remember, is of your making;
It's you who've driven me to the step I'm taking.

MARIANE Of course.

VALÈRE *(Coming back again.)*
 Remember, too, that I am merely
Following your example.

MARIANE I see that clearly.

VALÈRE Enough. I'll go and do your bidding, then.

MARIANE Good.

VALÈRE *(Coming back again.)*
 You shall never see my face again.

MARIANE Excellent.

VALÈRE *(Walking to the door, then turning about.)*
 Yes?

MARIANE What?

VALÈRE What's that? What did you say?

MARIANE Nothing. You're dreaming.

VALÈRE Ah. Well, I'm on my way.
Farewell, *Madame*.

(He moves slowly away.)

MARIANE Farewell.

DORINE *(To* MARIANE.*)*
 If you ask me,
Both of you are as mad as mad can be.
Do stop this nonsense, now. I've only let you
Squabble so long to see where it would get you
Whoa there, Monsieur Valère!

(She goes and seizes VALÈRE *by the arm; he makes a great show of resistance.)*

VALÈRE What's this, Dorine?

DORINE Come here.

VALÈRE No, no, my heart's too full of spleen.
Don't hold me back; her wish must be obeyed.

DORINE Stop!

VALÈRE It's too late now; my decision's made.

DORINE Oh, pooh!

MARIANE *(Aside.)*
 He hates the sight of me, that's plain.
I'll go, and so deliver him from pain.

DORINE *(Leaving* VALÈRE, *running after* MARIANE*)*
And now *you* run away! Come back.

MARIANE No, no.
Nothing you say will keep me here. Let go!

VALÈRE *(Aside.)*
She cannot bear my presence, I perceive.
To spare her further torment, I shall leave.

DORINE *(Leaving* MARIANE, *running after* VALÈRE*)*
Again! You'll not escape, Sir; don't you try it.
Come here, you two. Stop fussing, and be quiet.

(She takes VALÈRE *by the hand, then* MARIANE, *and draws them together.)*

VALÈRE *(To* DORINE.*)*
What do you want of me?

MARIANE *(To* DORINE.*)*
 What is the point of this?

DORINE We're going to have a little armistice.

(To VALÈRE.*)*

Now, weren't you silly to get so overheated?

VALÈRE Didn't you see how badly I was treated?

DORINE *(To* MARIANE*)*
Aren't you a simpleton, to have lost your head?

MARIANE Didn't you hear the hateful things he said?

DORINE *(To* VALÈRE*)*
You're both great fools. Her sole desire, Valère,
Is to be yours in marriage. To that I'll swear.

(*To* MARIANE.)

He loves you only, and he wants no wife
But you, Mariane. On that I'll stake my life.
MARIANE (*To* VALÈRE.)
Then why you advised me so, I cannot see.
VALÈRE (*To* MARIANE.)
On such a question, why ask advice of *me*?
DORINE Oh, you're impossible. Give me your hands,
 you two.

(*To* VALÈRE.)

Yours first.
VALÈRE (*Giving* DORINE *his hand.*)
 But why?
DORINE (*To* MARIANE.)
 And now a hand from you
MARIANE (*Also giving* DORINE *her hand.*)
 What are you doing?
DORINE There: a perfect fit.
 You suit each other better than you'll admit.

(VALÈRE *and* MARIANE *hold hands for some time without looking at each other.*)

VALÈRE (*Turning toward* MARIANE.)
 Ah, come, don't be so haughty. Give a man
 A look of kindness, won't you, Mariane?

(MARIANE *turns toward* VALÈRE *and smiles.*)

DORINE I tell you, lovers are completely mad!
VALÈRE (*To* MARIANE.)
 Now come, confess that you were very bad
 To hurt my feelings as you did just now.
 I have a just complaint, you must allow.
MARIANE *You* must allow that you were most
 unpleasant. . . .
DORINE Let's table that discussion for the present;
 Your father has a plan which must be stopped.
MARIANE Advise us, then; what means must we
 adopt?
DORINE We'll use all manner of means, and all at
 once.

(*To* MARIANE.)

Your father's addled; he's acting like a dunce.
Therefore you'd better humor the old fossil.
Pretend to yield to him, be sweet and docile,
And then postpone, as often as necessary,
The day on which you have agreed to marry.
You'll thus gain time, and time will turn the trick.
Sometimes, for instance, you'll be taken sick,
And that will seem good reason for delay;
Or some bad omen will make you change the day—
You'll dream of muddy water, or you'll pass
A dead man's hearse, or break a looking-glass.
If all else fails, no man can marry you

Unless you take his ring and say "I do."
But now, let's separate. If they should find
Us talking here, our plot might be divined.

(*To* VALÈRE.)

Go to your friends, and tell them what's occurred,
And have them urge her father to keep his word.
Meanwhile, we'll stir her brother into action,
And get Elmire, as well, to join our faction.
Good-bye.
VALÈRE (*To* MARIANE.)
 Though each of us will do his best,
 It's your true heart on which my hopes shall rest.
MARIANE (*To* VALÈRE.)
 Regardless of what Father may decide,
 None but Valère shall claim me as his bride.
VALÈRE Oh, how those words content me! Come
 what will. . .
DORINE Oh, lovers, lovers! Their tongues are never
 still.
 Be off, now.
VALÈRE (*Turning to go, then turning back.*)
 One last word . . .
DORINE No time to chat:
 You leave by this door; and *you* leave by that.

(DORINE *pushes them, by the shoulders, toward opposing doors.*)

ACT III, SCENE ONE

DAMIS, DORINE

DAMIS May lightning strike me even as I speak,
 May all men call me cowardly and weak,
 If any fear or scruple holds me back
 From settling things, at once, with that great quack!
DORINE Now, don't give way to violent emotion.
 Your father's merely talked about this notion,
 And words and deeds are far from being one.
 Much that is talked about is left undone.
DAMIS No, I must stop that scoundrel's
 machinations;
 I'll go and tell him off; I'm out of patience.
DORINE Do calm down and be practical. I had rather
 My mistress dealt with him—and with your father.
 She has some influence with Tartuffe, I've noted.
 He hangs upon her words, seems most devoted,
 And may, indeed, be smitten by her charm.
 Pray Heaven it's true! 'Twould do our cause no
 harm.
 She sent for him, just now, to sound him out
 On this affair you're so incensed about;
 She'll find out where he stands, and tell him, too,
 What dreadful strife and trouble will ensue
 If he lends countenance to your father's plan.

I couldn't get in to see him, but his man
Says that he's almost finished with his prayers.
Go, now. I'll catch him when he comes downstairs.
DAMIS I want to hear this conference, and I will.
DORINE No, they must be alone.
DAMIS Oh, I'll keep still.
DORINE Not you. I know your temper. You'd start a brawl,
And shout and stamp your foot and spoil it all.
Go on.
DAMIS I won't; I have a perfect right. . . .
DORINE Lord, you're a nuisance! He's coming; get out of sight.

(DAMIS *conceals himself in a closet at the rear of the stage.*)

SCENE TWO

TARTUFFE, DORINE

TARTUFFE (*Observing* DORINE, *and calling to his manservant offstage.*)

Hang up my hair-shirt, put my scourge in place,
And pray, Laurent, for Heaven's perpetual grace.
I'm going to the prison now, to share
My last few coins with the poor wretches there.
DORINE (*Aside.*)
Dear God, what affectation! What a fake!
TARTUFFE You wished to see me?
DORINE Yes . . .
TARTUFFE (*Taking a handkerchief from his pocket.*)
 For mercy's sake,
Please take this handkerchief, before you speak.
DORINE What?
TARTUFFE Cover that bosom, girl. The flesh is weak,
And unclean thoughts are difficult to control.
Such sights as that can undermine the soul.
DORINE Your soul, it seems, has very poor defenses,
And flesh makes quite an impact on your senses.
It's strange that you're so easily excited;
My own desires are not so soon ignited,
And if I saw you naked as a beast,
Not all your hide would tempt me in the least.
TARTUFFE Girl, speak more modestly; unless you do,
I shall be forced to take my leave of you.
DORINE Oh, no, it's I who must be on my way;
I've just one little message to convey.
Madame is coming down, and begs you, Sir,
To wait and have a word or two with her.
TARTUFFE Gladly.
DORINE (*Aside.*)
 That had a softening effect!
I think my guess about him was correct.
TARTUFFE Will she be long?

DORINE No: that's her step I hear.
Ah, here she is, and I shall disappear.

SCENE THREE

ELMIRE, TARTUFFE

TARTUFFE May Heaven, whose infinite goodness we adore,
Preserve your body and soul forevermore,
And bless your days, and answer thus the plea
Of one who is its humblest votary.
ELMIRE I thank you for that pious wish. But please,
Do take a chair and let's be more at ease.

(*They sit down.*)

TARTUFFE I trust that you are once more well and strong?
ELMIRE Oh, yes: the fever didn't last for long.
TARTUFFE My prayers are too unworthy, I am sure,
To have gained from Heaven this most gracious cure;
But lately, Madam, my every supplication
Has had for object your recuperation.
ELMIRE You shouldn't have troubled so. I don't deserve it.
TARTUFFE Your health is priceless, Madam, and to preserve it
I'd gladly give my own, in all sincerity.
ELMIRE Sir, you outdo us all in Christian charity.
You've been most kind. I count myself your debtor.
TARTUFFE 'Twas nothing, Madam. I long to serve you better.
ELMIRE There's a private matter I'm anxious to discuss.
I'm glad there's no one here to hinder us.
TARTUFFE I too am glad; it floods my heart with bliss
To find myself alone with you like this.
For just this chance I've prayed with all my power—
But prayed in vain, until this happy hour.
ELMIRE This won't take long, Sir, and I hope you'll be
Entirely frank and unconstrained with me.
TARTUFFE Indeed, there's nothing I had rather do
Than bare my inmost heart and soul to you.
First, let me say that what remarks I've made
About the constant visits you are paid
Were prompted not by any mean emotion,
But rather by a pure and deep devotion,
A fervent zeal . . .
ELMIRE No need for explanation.
Your sole concern, I'm sure, was my salvation.
TARTUFFE (*Taking* ELMIRE's *hand and pressing her fingertips.*)
Quite so; and such great fervor do I feel. . . .
ELMIRE Ooh! Please! You're pinching!

TARTUFFE 'Twas from excess of zeal.
 I never meant to cause you pain, I swear.
 I'd rather . . .

(*He places his hand on* ELMIRE's *knee.*)

ELMIRE What can your hand be doing there?
TARTUFFE Feeling your gown; what soft, fine-woven
 stuff!
ELMIRE Please, I'm extremely ticklish. That's enough.

(*She draws her chair away;* TARTUFFE *pulls his after her.*)

TARTUFFE (*Fondling the lace collar of her gown.*)
 My, my, what lovely lacework on your dress!
 The workmanship's miraculous, no less.
 I've not seen anything to equal it.
ELMIRE Yes, quite. But let's talk business for a bit.
 They say my husband means to break his word
 And give his daughter to you, Sir. Had you heard?
TARTUFFE He did once mention it. But I confess
 I dream of quite a different happiness.
 It's elsewhere, Madam, that my eyes discern
 The promise of that bliss for which I yearn.
ELMIRE I see: you care for nothing here below.
TARTUFFE Ah, well—my heart's not made of stone,
 you know.
ELMIRE All your desires mount heavenward, I'm
 sure,
 In scorn of all that's earthly and impure.
TARTUFFE A love of heavenly beauty does not
 preclude
 A proper love for earthly pulchritude;
 Our senses are quite rightly captivated
 By perfect works our Maker has created.
 Some glory clings to all that Heaven has made;
 In you, all Heaven's marvels are displayed.
 On that fair face, such beauties have been lavished,
 The eyes are dazzled and the heart is ravished;
 How could I look on you, O flawless creature,
 And not adore the Author of all Nature,
 Feeling a love both passionate and pure
 For you, his triumph of self-portraiture?
 At first, I trembled lest that love should be
 A subtle snare that Hell had laid for me;
 I vowed to flee the sight of you, eschewing
 A rapture that might prove my soul's undoing;
 But soon, fair being, I became aware
 That my deep passion could be made to square
 With rectitude, and with my bounden duty.
 I thereupon surrendered to your beauty.
 It is, I know, presumptuous on my part
 To bring you this poor offering of my heart,
 And it is not my merit, Heaven knows,
 But your compassion on which my hopes repose.
 You are my peace, my solace, my salvation;
 On you depends my bliss—or desolation;
 I bide your judgement and, as you think best,
 I shall be either miserable or blest.
ELMIRE Your declaration is most gallant, Sir,
 But don't you think it's out of character?
 You'd have done better to restrain your passion
 And think before you spoke in such a fashion.
 It ill becomes a pious man like you. . . .
TARTUFFE I may be pious, but I'm human too:
 With your celestial charms before his eyes,
 A man has not the power to be wise.
 I know such words sound strangely, coming from
 me,
 But I'm no angel, nor was meant to be,
 And if you blame my passion, you must needs
 Reproach as well the charms on which it feeds.
 Your loveliness I had no sooner seen
 Than you became my soul's unrivalled queen;
 Before your seraph glance, divinely sweet,
 My heart's defenses crumbled in defeat,
 And nothing fasting, prayer, or tears might do
 Could stay my spirit from adoring you.
 My eyes, my sighs have told you in the past
 What now my lips make bold to say at last,
 And if, in your great goodness, you will deign
 To look upon your slave, and ease his pain,—
 If, in compassion for my soul's distress,
 You'll stoop to comfort my unworthiness,
 I'll raise to you, in thanks for that sweet manna,
 An endless hymn, an infinite hosanna.
 With me, of course, there need be no anxiety,
 No fear of scandal or of notoriety.
 These young court gallants, whom all the ladies
 fancy,
 Are vain in speech, in action rash and chancy;
 When they succeed in love, the world soon
 knows it;
 No favor's granted them but they disclose it
 And by the looseness of their tongues profane
 The very altar where their hearts have lain.
 Men of my sort, however, love discreetly,
 And one may trust our reticence completely.
 My keen concern for my good name insures
 The absolute security of yours;
 In short, I offer you, my dear Elmire,
 Love without scandal, pleasure without fear.
ELMIRE I've heard your well-turned speeches to the
 end,
 And what you urge I clearly apprehend.
 Aren't you afraid that I may take a notion
 To tell my husband of your warm devotion,
 And that, supposing he were duly told,
 His feeling toward you might grow rather cold?
TARTUFFE I know, dear lady, that your exceeding
 charity
 Will lead your heart to pardon my temerity;
 That you'll excuse my violent affection
 As human weakness, human imperfection;

And that—O fairest!—you will bear in mind
That I'm but flesh and blood, and am not blind.
ELMIRE Some women might do otherwise, perhaps,
But I shall be discreet about your lapse;
I'll tell my husband nothing of what's occurred
If, in return, you'll give your solemn word
To advocate as forcefully as you can
The marriage of Valère and Mariane,
Renouncing all desire to dispossess
Another of his rightful happiness,
And . . .

SCENE FOUR

DAMIS, ELMIRE, TARTUFFE

DAMIS (*Emerging from the closet where he has been
 hiding.*)
 No! We'll not hush up this vile affair;
I heard it all inside that closet there,
Where Heaven, in order to confound the pride
Of this great rascal, prompted me to hide.
Ah, now I have my long-awaited chance
To punish his deceit and arrogance,
And give my father clear and shocking proof
Of the black character of his dear Tartuffe.
ELMIRE Ah no, Damis; I'll be content if he
Will study to deserve my leniency.
I've promised silence—don't make me break my
 word;
To make a scandal would be too absurd.
Good wives laugh off such trifles, and forget them;
Why should they tell their husbands, and upset
 them?
DAMIS You have your reasons for taking such a
 course,
And I have reasons, too, of equal force.
To spare him now would be insanely wrong.
I've swallowed my just wrath for far too long
And watched this insolent bigot bringing strife
And bitterness into our family life.
Too long he's meddled in my father's affairs,
Thwarting my marriage-hopes, and poor Valère's.
It's high time that my father was undeceived,
And now I've proof that can't be disbelieved—
Proof that was furnished me by Heaven above.
It's too good not to take advantage of.
This is my chance, and I deserve to lose it
If, for one moment, I hesitate to use it.
ELMIRE Damis . . .
DAMIS No, I must do what I think right.
Madam, my heart is bursting with delight,
And, say whatever you will, I'll not consent
To lose the sweet revenge on which I'm bent.
I'll settle matters without more ado;
And here, most opportunely, is my cue.

SCENE FIVE

ORGON, DAMIS, TARTUFFE, ELMIRE

DAMIS Father, I'm glad you've joined us. Let us
 advise you
Of some fresh news which doubtless will surprise
 you.
You've just now been repaid with interest
For all your loving-kindness to our guest.
He's proved his warm and grateful feelings toward
 you;
It's with a pair of horns he would reward you.
Yes, I surprised him with your wife, and heard
His whole adulterous offer, every word.
She, with her all too gentle disposition,
Would not have told you of his proposition;
But I shall not make terms with brazen lechery,
And feel that not to tell you would be treachery.
ELMIRE And I hold that one's husband's peace of
 mind
Should not be spoilt by tattle of this kind.
One's honor doesn't require it: to be proficient
In keeping men at bay is quite sufficient.
These are my sentiments, and I wish, Damis,
That you had heeded me and held your peace.

SCENE SIX

ORGON, DAMIS, TARTUFFE

ORGON Can it be true, this dreadful thing I hear?
TARTUFFE Yes, Brother, I'm a wicked man, I fear:
A wretched sinner, all depraved and twisted,
The greatest villain that has ever existed.
My life's one heap of crimes, which grows each
 minute;
There's naught but foulness and corruption in it;
And I perceive that Heaven, outraged by me,
Has chosen this occasion to mortify me.
Charge me with any deed you wish to name;
I'll not defend myself, but take the blame.
Believe what you are told, and drive Tartuffe
Like some base criminal from beneath your roof;
Yes, drive me hence, and with a parting curse:
I shan't protest, for I deserve far worse.
ORGON (*To* DAMIS)
Ah, you deceitful boy, how dare you try
To stain his purity with so foul a lie?
DAMIS What! Are you taken in by such a bluff?
Did you not hear . . . ?
ORGON Enough, you rogue, enough!
TARTUFFE Ah, Brother, let him speak: you're being
 unjust.
Believe his story; the boy deserves your trust.
Why, after all, should you have faith in me?

How can you know what I might do, or be?
Is it on my good actions that you base
Your favor? Do you trust my pious face?
Ah, no, don't be deceived by hollow shows;
I'm far, alas, from being what men suppose;
Though the world takes me for a man of worth,
I'm truly the most worthless man on earth.

(*To* Damis.)

Yes, my dear son, speak out now; call me the chief
Of sinners, a wretch, a murderer, a thief;
Load me with all the names men most abhor;
I'll not complain; I've earned them all, and more;
I'll kneel here while you pour them on my head.
As a just punishment for the life I've led.
Orgon (*To* Tartuffe.)
 This is too much, dear Brother.

(*To* Damis.)

 Have you no heart?
Damis Are you so hoodwinked by this rascal's
 art . . . ?
Orgon Be still, you monster.

(*To* Tartuffe.)

 Brother, I pray you, rise.

(*To* Damis.)

 Villain!
Damis But . . .
Orgon Silence!
Damis Can't you realize . . . ?
Orgon Just one word more, and I'll tear you limb
 from limb.
Tartuffe In God's name, Brother, don't be harsh
 with him.
 I'd rather far be tortured at the stake
 Than see him bear one scratch for my poor sake.
Orgon (*To* Damis.)
 Ingrate!
Tartuffe If I must beg you, on bended knee,
 To pardon him . . .
Orgon (*Falling to his knees, addressing* Tartuffe)
 Such goodness cannot be!

(*To* Damis.)

 Now, *there's* true charity!
Damis What, you . . . ?
Orgon Villain, be still!
 I know your motives; I know you wish him ill:
 Yes, all of you—wife, children, servants, all—
 Conspire against him and desire his fall,
 Employing every shameful trick you can
 To alienate me from this saintly man.
 Ah, but the more you seek to drive him away,
 The more I'll do to keep him. Without delay,

I'll spite this household and confound its pride
By giving him my daughter as his bride.
Damis You're going to force her to accept his hand?
Orgon Yes, and this very night, d'you understand?
 I shall defy you all, and make it clear
 That I'm the one who gives the orders here.
 Come, wretch, kneel down and clasp his blessed feet,
 And ask his pardon for your black deceit.
Damis I ask that swindler's pardon? Why, I'd
 rather . . .
Orgon So! You insult him, and defy your father!
 A stick! A stick!

(*To* Tartuffe.)

 No, no—release me, do.

(*To* Damis.)

 Out of my house this minute! Be off with you,
 And never dare set foot in it again.
Damis Well, I shall go, but . . .
Orgon Well, go quickly, then.
 I disinherit you; an empty purse
 Is all you'll get from me—except my curse!

SCENE SEVEN

Orgon, Tartuffe

Orgon How he blasphemed your goodness! What a
 son!
Tartuffe Forgive him, Lord, as I've already done.

(*To* Orgon.)

 You can't know how it hurts when someone tries
 To blacken me in my dear Brother's eyes.
Orgon Ahh!
Tartuffe The mere thought of such ingratitude
 Plunges my soul into so dark a mood. . . .
 Such horror grips my heart. . . . I gasp for breath,
 And cannot speak, and feel myself near death.
Orgon (*He runs, in tears, to the door through
 which he has just driven his son.*)
 You blackguard! Why did I spare you? Why did I
 not
 Break you in little pieces on the spot?
 Compose yourself, and don't be hurt, dear friend.
Tartuffe These scenes, these dreadful quarrels, have
 got to end.
 I've much upset your household, and I perceive
 That the best thing will be for me to leave.
Orgon What are you saying!
Tartuffe They're all against me here:
 They'd have you think me false and insincere.
Orgon Ah, what of that? Have I ceased believing in
 you?
Tartuffe Their adverse talk will certainly continue,

And charges which you now repudiate
You may find credible at a later date.
ORGON No, Brother, never.
TARTUFFE Brother, a wife can sway
Her husband's mind in many a subtle way.
ORGON No, no.
TARTUFFE To leave at once is the solution;
Thus only can I end their persecution.
ORGON No, no, I'll not allow it; you shall remain.
TARTUFFE Ah, well; 'twill mean much martyrdom
and pain,
But if you wish it . . .
ORGON Ah!
TARTUFFE Enough; so be it.
But one thing must be settled, as I see it.
For your dear honor, and for our friendship's sake,
There's one precaution I feel bound to take.
I shall avoid your wife, and keep away. . . .
ORGON No, you shall not, whatever they may say.
It pleases me to vex them, and for spite
I'd have them see you with her day and night.
What's more, I'm going to drive them to despair
By making you my only son and heir;
This very day, I'll give to you alone
Clear deed and title to everything I own.
A dear, good friend and son-in-law-to-be
Is more than wife, or child, or kin to me.
Will you accept my offer, dearest son?
TARTUFFE In all things, let the will of Heaven be
done.
ORGON Poor fellow! Come, we'll go draw up the
deed.
Then let them burst with disappointed greed!

ACT IV, SCENE ONE

CLÉANTE, TARTUFFE

CLÉANTE Yes, all the town's discussing it, and truly,
Their comments do not flatter you unduly.
I'm glad we've met, Sir, and I'll give my view
Of this sad matter in a word or two.
As for who's guilty, that I shan't discuss;
Let's say it was Damis who caused the fuss;
Assuming, then, that you have been ill-used
By young Damis, and groundlessly accused,
Ought not a Christian to forgive, and ought
He not to stifle every vengeful thought?
Should you stand by and watch a father make
His only son an exile for your sake?
Again I tell you frankly, be advised:
The whole town, high and low, is scandalized;
This quarrel must be mended, and my advice is
Not to push matters to a further crisis.
No, sacrifice your wrath to God above,
And help Damis regain his father's love.

TARTUFFE Alas, for my part I should take great joy
In doing so. I've nothing against the boy.
I pardon all, I harbor no resentment;
To serve him would afford me much contentment.
But Heaven's interest will not have it so:
If he comes back, then I shall have to go.
After his conduct—so extreme, so vicious—
Our further intercourse would look suspicious.
God knows what people would think! Why, they'd
describe
My goodness to him as a sort of bribe;
They'd say that out of guilt I made pretense
Of loving-kindness and benevolence—
That, fearing my accuser's tongue, I strove
To buy his silence with a show of love.
CLÉANTE Your reasoning is badly warped and
stretched,
And these excuses, Sir, are most far-fetched.
Why put yourself in charge of Heaven's cause?
Does Heaven need our help to enforce its laws?
Leave vengeance to the Lord, Sir; while we live,
Our duty's not to punish, but forgive;
And what the Lord commands, we should obey
Without regard to what the world may say.
What! Shall the fear of being misunderstood
Prevent our doing what is right and good?
No, no, let's simply do what Heaven ordains,
And let no other thoughts perplex our brains.
TARTUFFE Again, Sir, let me say that I've forgiven
Damis, and thus obeyed the laws of Heaven;
But I am not commanded by the Bible
To live with one who smears my name with libel.
CLÉANTE Were you commanded, Sir, to indulge the
whim
Of poor Orgon, and to encourage him
In suddenly transferring to your name
A large estate to which you have no claim?
TARTUFFE 'Twould never occur to those who know
me best
To think I acted from self-interest.
The treasures of this world I quite despise;
Their specious glitter does not charm my eyes;
And if I have resigned myself to taking
The gift which my dear Brother insists on making,
I do so only, as he well understands,
Lest so much wealth fall into wicked hands,
Lest those to whom it might descend in time
Turn it to purposes of sin and crime,
And not, as I shall do, make use of it
For Heaven's glory and mankind's benefit.
CLÉANTE Forget these trumped-up fears. Your
argument
Is one the rightful heir might well resent;
It *is* a moral burden to inherit
Such wealth, but give Damis a chance to bear it.
And would it not be worse to be accused

Of swindling, than to see that wealth misused?
I'm shocked that you allowed Orgon to broach
This matter, and that you feel no self-reproach;
Does true religion teach that lawful heirs
May freely be deprived of what is theirs?
And if the Lord has told you in your heart
That you and young Damis must dwell apart,
Would it not be the decent thing to beat
A generous and honorable retreat,
Rather than let the son of the house be sent,
For your convenience, into banishment?
Sir, if you wish to prove the honesty
Of your intentions . . .

TARTUFFE Sir, it is half-past three.
I've certain pious duties to attend to,
And hope my prompt departure won't offend you.

CLÉANTE (*Alone.*)
Damn.

SCENE TWO

ELMIRE, MARIANE, CLÉANTE, DORINE

DORINE Stay, Sir, and help Mariane, for Heaven's
 sake!
She's suffering so, I fear her heart will break.
Her father's plan to marry her off tonight
Has put the poor child in a desperate plight.
I hear him coming. Let's stand together, now,
And see if we can't change his mind, somehow,
About this match we all deplore and fear.

SCENE THREE

ORGON, ELMIRE, MARIANE, CLÉANTE, DORINE

ORGON Hah! Glad to find you all assembled here.

(*To* MARIANE.)

This contract, child, contains your happiness,
And what it says I think your heart can guess.

MARIANE (*Falling to her knees.*)
Sir, by that Heaven which sees me here distressed,
And by whatever else can move your breast,
Do not employ a father's power, I pray you,
To crush my heart and force it to obey you,
Nor by your harsh commands oppress me so
That I'll begrudge the duty which I owe—
And do not so embitter and enslave me
That I shall hate the very life you gave me.
If my sweet hopes must perish, if you refuse
To give me to the one I've dared to choose,
Spare me at least—I beg you, I implore—
The pain of wedding one whom I abhor;
And do not, by a heartless use of force,
Drive me to contemplate some desperate course.

ORGON (*Feeling himself touched by her.*)
Be firm, my soul. No human weakness, now.

MARIANE I don't resent your love for him. Allow
Your heart free rein, Sir; give him your property,
And if that's not enough, take mine from me;
He's welcome to my money; take it, do,
But don't, I pray, include my person too.
Spare me, I beg you; and let me end the tale
Of my sad days behind a convent veil.

ORGON A convent! Hah! When crossed in their
 amours,
All lovesick girls have the same thought as yours.
Get up! The more you loathe the man, and dread
 him,
The more ennobling it will be to wed him.
Marry Tartuffe, and mortify your flesh!
Enough; don't start that whimpering afresh.

DORINE But why . . . ?

ORGON Be still, there. Speak when you're spoken to.
Not one more bit of impudence out of you.

CLÉANTE If I may offer a word of counsel here . . .

ORGON Brother, in counseling you have no peer;
All your advice is forceful, sound, and clever;
I don't propose to follow it, however.

ELMIRE (*To* ORGON.)
I am amazed, and don't know what to say;
Your blindness simply takes my breath away.
You are indeed bewitched, to take no warning
From our account of what occurred this morning.

ORGON Madam, I know a few plain facts, and one
Is that you're partial to my rascal son;
Hence, when he sought to make Tartuffe the victim
Of a base lie, you dared not contradict him.
Ah, but you underplayed your part, my pet;
You should have looked more angry, more upset.

ELMIRE When men make overtures, must we reply
With righteous anger and a battle-cry?
Must we turn back their amorous advances
With sharp reproaches and with fiery glances?
Myself, I find such offers merely amusing,
And make no scenes and fusses in refusing;
My taste is for good-natured rectitude,
And I dislike the savage sort of prude
Who guards her virtue with her teeth and claws,
And tears men's eyes out for the slightest cause:
The Lord preserve me from such honor as that,
Which bites and scratches like an alley-cat!
I've found that a polite and cool rebuff
Discourages a lover quite enough.

ORGON I know the facts, and I shall not be shaken.

ELMIRE I marvel at your power to be mistaken.
Would it, I wonder, carry weight with you
If I could *show* you that our tale was true?

ORGON Show me?

ELMIRE Yes.

ORGON Rot.

ELMIRE Come, what if I found a way
 To make you see the facts as plain as day?
ORGON Nonsense.
ELMIRE Do answer me; don't be absurd.
 I'm not now asking you to trust our word.
 Suppose that from some hiding-place in here
 You learned the whole sad truth by eye and ear—
 What would you say of your good friend, after that?
ORGON Why, I'd say . . . nothing, by Jehoshaphat!
 It can't be true.
ELMIRE You've been too long deceived,
 And I'm quite tired of being disbelieved.
 Come now: let's put my statements to the test,
 And you shall see the truth made manifest.
ORGON I'll take that challenge. Now do your
 uttermost.
 We'll see how you make good your empty boast.
ELMIRE (*To* DORINE)
 Send him to me.
DORINE He's crafty; it may be hard
 To catch the cunning scoundrel off his guard.
ELMIRE No, amorous men are gullible. Their conceit
 So blinds them that they're never hard to cheat.
 Have him come down.

(*To* CLÉANTE *and* MARIANE.)

 Please leave us, for a bit.

SCENE FOUR

ELMIRE, ORGON

ELMIRE Pull up this table, and get under it.
ORGON What?
ELMIRE It's essential that you be well-hidden.
ORGON Why there?
ELMIRE Oh, Heavens! Just do as you are bidden.
 I have my plans; we'll soon see how they fare.
 Under the table, now; and once you're there,
 Take care that you are neither seen nor heard.
ORGON Well, I'll indulge you, since I gave my word
 To see you through this infantile charade.
ELMIRE Once it is over, you'll be glad we played.

(*To her husband, who is now under the table.*)

 I'm going to act quite strangely, now, and you
 Must not be shocked at anything I do.
 Whatever I may say, you must excuse
 As part of that deceit I'm forced to use.
 I shall employ sweet speeches in the task
 Of making that imposter drop his mask;
 I'll give encouragement to his bold desires,
 And furnish fuel to his amorous fires.
 Since it's for your sake, and for his destruction,
 That I shall seem to yield to his seduction,
 I'll gladly stop whenever you decide

That all your doubts are fully satisfied.
 I'll count on you, as soon as you have seen
 What sort of man he is, to intervene,
 And not expose me to his odious lust
 One moment longer than you feel you must.
 Remember: you're to save me from my plight
 Whenever . . . He's coming! Hush! Keep out of sight!

SCENE FIVE

TARTUFFE, ELMIRE, ORGON

TARTUFFE You wish to have a word with me, I'm
 told.
ELMIRE Yes. I've a little secret to unfold.
 Before I speak, however, it would be wise
 To close that door, and look about for spies.

(TARTUFFE *goes to the door, closes it, and returns.*)

 The very last thing that must happen now
 Is a repetition of this morning's row.
 I've never been so badly caught off guard.
 Oh, how I feared for you! You saw how hard
 I tried to make that troublesome Damis
 Control his dreadful temper, and hold his peace.
 In my confusion, I didn't have the sense
 Simply to contradict his evidence;
 But as it happened, that was for the best,
 And all has worked out in our interest.
 This storm has only bettered your position;
 My husband doesn't have the least suspicion,
 And now, in mockery of those who do,
 He bids me be continually with you.
 And that is why, quite fearless of reproof,
 I now can be alone with my Tartuffe,
 And why my heart—perhaps too quick to yield—
 Feels free to let its passion be revealed.
TARTUFFE Madam, your words confuse me. Not long
 ago,
 You spoke in quite a different style, you know.
ELMIRE Ah, Sir, if that refusal made you smart,
 It's little that you know of woman's heart,
 Or what that heart is trying to convey
 When it resists in such a feeble way!
 Always, at first, our modesty prevents
 The frank avowal of tender sentiments;
 However high the passion which inflames us,
 Still, to confess its power somehow shames us.
 Thus we reluct, at first, yet in a tone
 Which tells you that our heart is overthrown,
 That what our lips deny, our pulse confesses,
 And that, in time, all noes will turn to yesses.
 I fear my words are all too frank and free,
 And a poor proof of woman's modesty;
 But since I'm started, tell me, if you will—
 Would I have tried to make Damis be still,

Would I have listened, calm and unoffended,
Until your lengthy offer of love was ended,
And been so very mild in my reaction,
Had your sweet words not given me satisfaction?
And when I tried to force you to undo
The marriage-plans my husband has in view,
What did my urgent pleading signify
If not that I admired you, and that I
Deplored the thought that someone else might own
Part of a heart I wished for mine alone?

TARTUFFE Madam, no happiness is so complete
As when, from lips we love, come words so sweet;
Their nectar floods my every sense, and drains
In honeyed rivulets through all my veins.
To please you is my joy, my only goal;
Your love is the restorer of my soul;
And yet I must beg leave, now, to confess
Some lingering doubts as to my happiness.
Might this not be a trick? Might not the catch
Be that you wish me to break off the match
With Mariane, and so have feigned to love me?
I shan't quite trust your fond opinion of me
Until the feelings you've expressed so sweetly
Are demonstrated somewhat more concretely,
And you have shown, by certain kind concessions,
That I may put my faith in your professions.

ELMIRE (*She coughs, to warn her husband.*)
Why be in such a hurry? Must my heart
Exhaust its bounty at the very start?
To make that sweet admission cost me dear,
But you'll not be content, it would appear,
Unless my store of favors is disbursed
To the last farthing, and at the very first.

TARTUFFE The less we merit, the less we dare to hope,
And with our doubts, mere words can never cope.
We trust no promised bliss till we receive it;
Not till a joy is ours can we believe it.
I, who so little merit your esteem,
Can't credit this fulfillment of my dream,
And shan't believe it, Madam, until I savor
Some palpable assurance of your favor.

ELMIRE My, how tyrannical your love can be,
And how it flusters and perplexes me!
How furiously you take one's heart in hand,
And make your every wish a fierce command!
Come, must you hound and harry me to death?
Will you not give me time to catch my breath?
Can it be right to press me with such force,
Give me no quarter, show me no remorse,
And take advantage, by your stern insistence,
Of the fond feelings which weaken my resistance?

TARTUFFE Well, if you look with favor upon my love,
Why, then, begrudge me some clear proof thereof?

ELMIRE But how can I consent without offense
To Heaven, toward which you feel such reverence?

TARTUFFE If Heaven is all that holds you back, don't worry.
I can remove that hindrance in a hurry.
Nothing of that sort need obstruct our path.

ELMIRE Must one not be afraid of Heaven's wrath?

TARTUFFE Madam, forget such fears, and be my pupil,
And I shall teach you how to conquer scruple.
Some joys, it's true, are wrong in Heaven's eyes;
Yet Heaven is not averse to compromise;
There is a science, lately formulated,
Whereby one's conscience may be liberated,
And any wrongful act you care to mention
May be redeemed by purity of intention.
I'll teach you, Madam, the secrets of that science;
Meanwhile, just place on me your full reliance.
Assuage my keen desires, and feel no dread:
The sin, if any, shall be on my head.

(ELMIRE *coughs, this time more loudly.*)

You've a bad cough.

ELMIRE Yes, yes. It's bad indeed.

TARTUFFE (*Producing a little paper bag.*)
A bit of licorice may be what you need.

ELMIRE No, I've a stubborn cold, it seems. I'm sure it
Will take much more than licorice to cure it.

TARTUFFE How aggravating.

ELMIRE Oh, more than I can say.

TARTUFFE If you're still troubled, think of things this way:
No one shall know our joys, save us alone,
And there's no evil till the act is known;
It's scandal, Madam, which makes it an offense,
And it's no sin to sin in confidence.

ELMIRE (*Having coughed once more.*)
Well, clearly I must do as you require,
And yield to your importunate desire.
It is apparent, now, that nothing less
Will satisfy you, and so I acquiesce.
To go so far is much against my will;
I'm vexed that it should come to this; but still,
Since you are so determined on it, since you
Will not allow mere language to convince you,
And since you ask for concrete evidence, I
See nothing for it, now, but to comply.
If this is sinful, if I'm wrong to do it,
So much the worse for him who drove me to it.
The fault can surely not be charged to me.

TARTUFFE Madam, the fault is mine, if fault there be,
And . . .

ELMIRE Open the door a little, and peek out;
I wouldn't want my husband poking about.

TARTUFFE Why worry about the man? Each day he grows
More gullible; one can lead him by the nose.
To find us here would fill him with delight,

And if he saw the worst, he'd doubt his sight.
ELMIRE Nevertheless, do step out for a minute
Into the hall, and see that no one's in it.

SCENE SIX

ORGON, ELMIRE

ORGON (*Coming out from under the table.*)
That man's a perfect monster, I must admit!
I'm simply stunned. I can't get over it.
ELMIRE What, coming out so soon? How premature!
Get back in hiding, and wait until you're sure.
Stay till the end, and be convinced completely;
We mustn't stop till things are proved concretely.
ORGON Hell never harbored anything so vicious!
ELMIRE Tut, don't be hasty. Try to be judicious.
Wait, and be certain that there's no mistake.
No jumping to conclusions, for Heaven's sake!

(*She places* ORGON *behind her, as* TARTUFFE *re-enters.*)

SCENE SEVEN

TARTUFFE, ELMIRE, ORGON

TARTUFFE (*Not seeing* ORGON)
Madam, all things have worked out to perfection;
I've given the neighboring rooms a full inspection;
No one's about; and now I may at last . . .
ORGON (*Intercepting him.*)
Hold on, my passionate fellow, not so fast!
I should advise a little more restraint.
Well, so you thought you'd fool me, my dear saint!
How soon you wearied of the saintly life—
Wedding my daughter, and coveting my wife!
I've long suspected you, and had a feeling
That soon I'd catch you at your double-dealing.
Just now, you've given me evidence galore;
It's quite enough; I have no wish for more.
ELMIRE (*To* TARTUFFE)
I'm sorry to have treated you so slyly,
But circumstances forced me to be wily.
TARTUFFE Brother, you can't think . . .
ORGON No more talk from you;
Just leave this household, without more ado.
TARTUFFE What I intended . . .
ORGON That seems fairly clear.
Spare me your falsehoods and get out of here.
TARTUFFE No, I'm the master, and you're the one
to go!
This house belongs to me, I'll have you know,
And I shall show you that you can't hurt *me*
By this contemptible conspiracy,
That those who cross me know not what they do,
And that I've means to expose and punish you,

Avenge offended Heaven, and make you grieve
That ever you dared order me to leave.

SCENE EIGHT

ELMIRE, ORGON

ELMIRE What was the point of all that angry chatter?
ORGON Dear God, I'm worried. This is no laughing
matter.
ELMIRE How so?
ORGON I fear I understood his drift.
I'm much disturbed about that deed of gift.
ELMIRE You gave him . . . ?
ORGON Yes, it's all been drawn and signed.
But one thing more is weighing on my mind.
ELMIRE What's that?
ORGON I'll tell you; but first let's see if there's
A certain strong-box in his room upstairs.

ACT V, SCENE ONE

ORGON, CLÉANTE

CLÉANTE Where are you going so fast?
ORGON God knows!
CLÉANTE Then wait;
Let's have a conference, and deliberate
On how this situation's to be met.
ORGON That strong-box has me utterly upset;
This is the worst of many, many shocks.
CLÉANTE Is there some fearful mystery in that box?
ORGON My poor friend Argas brought that box
to me
With his own hands, in utmost secrecy;
'Twas on the very morning of his flight.
It's full of papers which, if they came to light,
Would ruin him—or such is my impression.
CLÉANTE Then why did you let it out of your
possession?
ORGON Those papers vexed my conscience, and it
seemed best
To ask the counsel of my pious guest.
The cunning scoundrel got me to agree
To leave the strong-box in his custody,
So that, in case of an investigation,
I could employ a slight equivocation
And swear I didn't have it, and thereby,
At no expense to conscience, tell a lie.
CLÉANTE It looks to me as if you're out on a limb.
Trusting him with that box, and offering him
That deed of gift, were actions of a kind
Which scarcely indicate a prudent mind.
With two such weapons, he has the upper hand,
And since you're vulnerable, as matters stand,
You erred once more in bringing him to bay.

You should have acted in some subtler way.
ORGON Just think of it: behind that fervent face,
A heart so wicked, and a soul so base!
I took him in, a hungry beggar, and then . . .
Enough, by God! I'm through with pious men:
Henceforth I'll hate the whole false brotherhood,
And persecute them worse than Satan could.
CLÉANTE Ah, there you go—extravagant as ever!
Why can you not be rational? You never
Manage to take the middle course, it seems,
But jump, instead, between absurd extremes.
You've recognized your recent grave mistake
In falling victim to a pious fake;
Now, to correct that error, must you embrace
An even greater error in its place,
And judge our worthy neighbors as a whole
By what you've learned of one corrupted soul?
Come, just because one rascal made you swallow
A show of zeal which turned out to be hollow,
Shall you conclude that all men are deceivers,
And that, today, there are no true believers?
Let atheists make that foolish inference;
Learn to distinguish virtue from pretense,
Be cautious in bestowing admiration,
And cultivate a sober moderation.
Don't humor fraud, but also don't asperse
True piety; the latter fault is worse,
And it is best to err, if err one must,
As you have done, upon the side of trust.

SCENE TWO

DAMIS, ORGON, CLÉANTE

DAMIS Father, I hear that scoundrel's uttered threats
Against you; that he pridefully forgets
How, in his need, he was befriended by you,
And means to use your gifts to crucify you.
ORGON It's true, my boy. I'm too distressed for tears.
DAMIS Leave it to me, Sir; let me trim his ears.
Faced with such insolence, we must not waver.
I shall rejoice in doing you the favor
Of cutting short his life, and your distress.
CLÉANTE What a display of young hotheadedness!
Do learn to moderate your fits of rage.
In this just kingdom, this enlightened age,
One does not settle things by violence.

SCENE THREE

MADAME PERNELLE, MARIANE, ELMIRE, DORINE, DAMIS,
ORGON, CLÉANTE

MADAME PERNELLE I hear strange tales of very
strange events.

ORGON Yes, strange events which these two eyes
beheld.
The man's ingratitude is unparalleled.
I save a wretched pauper from starvation,
House him, and treat him like a blood relation,
Shower him every day with my largesse,
Give him my daughter, and all that I possess;
And meanwhile the unconscionable knave
Tries to induce my wife to misbehave;
And not content with such extreme rascality,
Now threatens me with my own liberality,
And aims, by taking base advantage of
The gifts I gave him out of Christian love,
To drive me from my house, a ruined man,
And make me end a pauper, as he began.
DORINE Poor fellow!
MADAME PERNELLE No, my son, I'll never bring
Myself to think him guilty of such a thing.
ORGON How's that?
MADAME PERNELLE The righteous always were
maligned.
ORGON Speak clearly, Mother. Say what's on your
mind.
MADAME PERNELLE I mean that I can smell a rat,
my dear.
You know how everybody hates him, here.
ORGON That has no bearing on the case at all.
MADAME PERNELLE I told you a hundred times,
when you were small,
That virtue in this world is hated ever;
Malicious men may die, but malice never.
ORGON No doubt that's true, but how does it apply?
MADAME PERNELLE They've turned you against him
by a clever lie.
ORGON I've told you, I was there and saw it done.
MADAME PERNELLE Ah, slanderers will stop at
nothing, Son.
ORGON Mother, I'll lose my temper. . . . For the last
time,
I tell you I was witness to the crime.
MADAME PERNELLE The tongues of spite are busy
night and noon,
And to their venom no man is immune.
ORGON You're talking nonsense. Can't you realize
I saw it; saw it; saw it with my eyes?
Saw, do you understand me? Must I shout it
Into your ears before you'll cease to doubt it?
MADAME PERNELLE Appearances can deceive, my
son. Dear me,
We cannot always judge by what we see.
ORGON Drat! Drat!
MADAME PERNELLE One often interprets things
awry;
Good can seem evil to a suspicious eye.
ORGON Was I to see his pawing at Elmire
As an act of charity?

MADAME PERNELLE Till his guilt is clear,
A man deserves the benefit of the doubt.
You should have waited, to see how things turned
out.
ORGON Great God in Heaven, what more proof did I
need?
Was I to sit there, watching, until he'd . . .
You drive me to the brink of impropriety.
MADAME PERNELLE No, no, a man of such
surpassing piety
Could not do such a thing. You cannot shake me.
I don't believe it, and you shall not make me.
ORGON You vex me so that, if you weren't my
mother,
I'd say to you . . . some dreadful thing or other.
DORINE It's your turn now, Sir, not to be listened to;
You'd not trust us, and now she won't trust you.
CLÉANTE My friends, we're wasting time which
should be spent
In facing up to our predicament.
I fear that scoundrel's threats weren't made in sport.
DAMIS Do you think he'd have the nerve to go to
court?
ELMIRE I'm sure he won't: they'd find it all too crude
A case of swindling and ingratitude.
CLÉANTE Don't be too sure. He won't be at a loss
To give his claims a high and righteous gloss;
And clever rogues with far less valid cause
Have trapped their victims in a web of laws.
I say again that to antagonize
A man so strongly armed was most unwise.
ORGON I know it; but the man's appalling cheek
Outraged me so, I couldn't control my pique.
CLÉANTE I wish to Heaven that we could devise
Some truce between you, or some compromise.
ELMIRE If I had known what cards he held, I'd not
Have roused his anger by my little plot.
ORGON (*To* DORINE, *as* M LOYAL *enters.*)
What is that fellow looking for? Who is he?
Go talk to him—and tell him that I'm busy.

SCENE FOUR

MONSIEUR LOYAL, MADAME PERNELLE, ORGON, DAMIS,
MARIANE, DORINE, ELMIRE, CLÉANTE

MONSIEUR LOYAL Good day, dear sister. Kindly let
me see
Your master.
DORINE He's involved with company,
And cannot be disturbed just now, I fear.
MONSIEUR LOYAL I hate to intrude; but what has
brought me here
Will not disturb your master, in any event.
Indeed, my news will make him most content.
DORINE Your name?

MONSIEUR LOYAL Just say that I bring greetings
from
Monsieur Tartuffe, on whose behalf I've come.
DORINE (*To* ORGON.)
Sir, he's a very gracious man, and bears
A message from Tartuffe, which, he declares,
Will make you most content.
CLÉANTE Upon my word,
I think this man had best be seen, and heard.
ORGON Perhaps he has some settlement to suggest.
How shall I treat him? What manner would be best?
CLÉANTE Control your anger, and if he should
mention
Some fair adjustment, give him your full attention.
MONSIEUR LOYAL Good health to you, good Sir.
May Heaven confound
Your enemies, and may your joys abound.
ORGON (*Aside, to* CLÉANTE.)
A gentle salutation: it confirms
My guess that he is here to offer terms.
MONSIEUR LOYAL I've always held your family most
dear;
I served your father, Sir, for many a year.
ORGON Sir, I must ask your pardon; to my shame,
I cannot now recall your face or name.
MONSIEUR LOYAL Loyal's my name; I come from
Normandy,
And I'm a bailiff, in all modesty.
For forty years, praise God, it's been my boast
To serve with honor in that vital post,
And I am here, Sir, if you will permit
The liberty, to serve you with this writ. . . .
ORGON To—*what?*
MONSIEUR LOYAL Now, please, Sir, let us have no
friction:
It's nothing but an order of eviction.
You are to move your goods and family out
And make way for new occupants, without
Deferment or delay, and give the keys. . . .
ORGON I? Leave this house?
MONSIEUR LOYAL Why yes, Sir, if you please.
This house, Sir, from the cellar to the roof,
Belongs now to the good Monsieur Tartuffe,
And he is lord and master of your estate
By virtue of a deed of present date,
Drawn in due form, with clearest legal phrasing. . . .
DAMIS Your insolence is utterly amazing!
MONSIEUR LOYAL Young man, my business here is
not with you,
But with your wise and temperate father, who,
Like every worthy citizen, stands in awe
Of justice, and would never obstruct the law.
ORGON But. . .
MONSIEUR LOYAL Not for a million, Sir, would you
rebel
Against authority; I know that well.

You'll not make trouble, Sir, or interfere
 With the execution of my duties here.
DAMIS Someone may execute a smart tattoo
 On that black jacket of yours, before you're through.
MONSIEUR LOYAL Sir, bid your son be silent. I'd
 much regret
 Having to mention such a nasty threat
 Of violence, in writing my report.
DORINE (*Aside.*)
 This man Loyal's a most disloyal sort!
MONSIEUR LOYAL I love all men of upright character,
 And when I agreed to serve these papers, Sir,
 It was your feelings that I had in mind.
 I couldn't bear to see the case assigned
 To someone else, who might esteem you less
 And so subject you to unpleasantness.
ORGON What's more unpleasant than telling a man
 to leave
 His house and home?
MONSIEUR LOYAL You'd like a short reprieve?
 If you desire it, Sir, I shall not press you,
 But wait until tomorrow to dispossess you.
 Splendid. I'll come and spend the night here, then,
 Most quietly, with half a score of men.
 For form's sake, you might bring me, just before
 You go to bed, the keys to the front door.
 My men, I promise, will be on their best
 Behavior, and will not disturb your rest.
 But bright and early, Sir, you must be quick
 And move out all your furniture, every stick:
 The men I've chosen are both young and strong,
 And with their help it shouldn't take you long.
 In short, I'll make things pleasant and convenient,
 And since I'm being so extremely lenient,
 Please show me, Sir, a like consideration,
 And give me your entire cooperation.
ORGON (*Aside.*)
 I may be all but bankrupt, but I vow
 I'd give a hundred louis, here and now,
 Just for the pleasure of landing one good clout
 Right on the end of that complacent snout.
CLÉANTE Careful; don't make things worse.
DAMIS My bootsole itches
 To give that beggar a good kick in the breeches.
DORINE Monsieur Loyal, I'd love to hear the whack
 Of a stout stick across your fine broad back.
MONSIEUR LOYAL Take care: a woman too may go
 to jail if
 She uses threatening language to a bailiff.
CLÉANTE Enough, enough, Sir. This must not go on.
 Give me that paper, please, and then begone.
MONSIEUR LOYAL Well, *au revoir.* God give you all
 good cheer!
ORGON May God confound you, and him who sent
 you here!

SCENE FIVE

ORGON, CLÉANTE, MARIANE, ELMIRE, MADAME PERNELLE,
DORINE, DAMIS

ORGON Now, Mother, was I right or not? This writ
 Should change your notion of Tartuffe a bit.
 Do you perceive his villainy at last?
MADAME PERNELLE I'm thunderstruck. I'm utterly
 aghast.
DORINE Oh, come, be fair. You mustn't take offense
 At this new proof of his benevolence.
 He's acting out of selfless love, I know.
 Material things enslave the soul, and so
 He kindly has arranged your liberation
 From all that might endanger your salvation.
ORGON Will you not ever hold your tongue, you
 dunce?
CLÉANTE Come, you must take some action, and at
 once.
ELMIRE Go tell the world of the low trick he's tried.
 The deed of gift is surely nullified
 By such behavior, and public rage will not
 Permit the wretch to carry out his plot.

SCENE SIX

VALÈRE, ORGON, CLÉANTE, ELMIRE, MARIANE, MADAME
PERNELLE, DAMIS, DORINE

VALÈRE Sir, though I hate to bring you more bad
 news,
 Such is the danger that I cannot choose.
 A friend who is extremely close to me
 And knows my interest in your family
 Has, for my sake, presumed to violate
 The secrecy that's due to things of state,
 And sends me word that you are in a plight
 From which your one salvation lies in flight.
 That scoundrel who's imposed upon you so
 Denounced you to the King an hour ago
 And, as supporting evidence, displayed
 The strong-box of a certain renegade
 Whose secret papers, so he testified,
 You had disloyally agreed to hide.
 I don't know just what charges may be pressed,
 But there's a warrant out for your arrest;
 Tartuffe has been instructed, furthermore,
 To guide the arresting officer to your door.
CLÉANTE He's clearly done this to facilitate
 His seizure of your house and your estate.
ORGON That man, I must say, is a vicious beast!
VALÈRE Quick, Sir; you mustn't tarry in the least.
 My carriage is outside, to take you hence;
 This thousand louis should cover all expense.

Let's lose no time, or you shall be undone;
The sole defense, in this case, is to run.
I shall go with you all the way, and place you
In a safe refuge to which they'll never trace you.
ORGON Alas, dear boy, I wish that I could show you
My gratitude for everything I owe you.
But now is not the time; I pray the Lord
That I may live to give you your reward.
Farewell, my dears; be careful . . .
CLÉANTE Brother, hurry.
We shall take care of things; you needn't worry.

SCENE SEVEN

THE OFFICER, TARTUFFE, VALÈRE, ORGON, ELMIRE,
MARIANE, MADAME PERNELLE, DORINE, CLÉANTE,
DAMIS

TARTUFFE Gently, Sir, gently; stay right where you
are.
No need for haste; your lodging isn't far.
You're off to prison, by order of the Prince.
ORGON This is the crowning blow, you wretch; and
since
It means my total ruin and defeat,
Your villainy is now at last complete.
TARTUFFE You needn't try to provoke me; it's no use.
Those who serve Heaven must expect abuse.
CLÉANTE You are indeed most patient, sweet, and
blameless.
DAMIS How he exploits the name of Heaven! It's
shameless.
TARTUFFE Your taunts and mockeries are all for
naught;
To do my duty is my only thought.
MARIANE Your love of duty is most meritorious,
And what you've done is little short of glorious.
TARTUFFE All deeds are glorious, Madam, which
obey
The sovereign prince who sent me here today.
ORGON I rescued you when you were destitute;
Have you forgotten that, you thankless brute?
TARTUFFE No, no, I well remember everything;
But my first duty is to serve my King.
That obligation is so paramount
That other claims, beside it, do not count;
And for it I would sacrifice my wife,
My family, my friend, or my own life.
ELMIRE. Hypocrite!
DORINE All that we most revere, he uses
To cloak his plots and camouflage his ruses.
CLÉANTE If it is true that you are animated
By pure and loyal zeal, as you have stated,
Why was this zeal not roused until you'd sought
To make Orgon a cuckold, and been caught?

Why weren't you moved to give your evidence
Until your outraged host had driven you hence?
I shan't say that the gift of all his treasure
Ought to have damped your zeal in any measure;
But if he is a traitor, as you declare,
How could you condescend to be his heir?
TARTUFFE (*To the* OFFICER)
Sir, spare me all this clamor; it's growing shrill.
Please carry out your orders, if you will.
OFFICER Yes, I've delayed too long, Sir. Thank you
kindly.
You're just the proper person to remind me.
Come, you are off to join the other boarders
In the King's prison, according to his orders.
TARTUFFE Who? I, Sir?
OFFICER Yes.
TARTUFFE To prison? This can't be true!
OFFICER I owe an explanation, but not to you.

(*To* ORGON.)

Sir, all is well; rest easy, and be grateful.
We serve a Prince to whom all sham is hateful,
A Prince who sees into our inmost hearts,
And can't be fooled by any trickster's arts.
His royal soul, though generous and human,
Views all things with discernment and acumen;
His sovereign reason is not lightly swayed,
And all his judgments are discreetly weighed.
He honors righteous men of every kind,
And yet his zeal for virtue is not blind,
Nor does his love of piety numb his wits
And make him tolerant of hypocrites.
'Twas hardly likely that this man could cozen
A King who's foiled such liars by the dozen.
With one keen glance, the King perceived the whole
Perverseness and corruption of his soul,
And thus high Heaven's justice was displayed:
Betraying you, the rogue stood self-betrayed.
The King soon recognized Tartuffe as one
Notorious by another name, who'd done
So many vicious crimes that one could fill
Ten volumes with them, and be writing still.
But to be brief: our sovereign was appalled
By this man's treachery toward you, which he called
The last, worst villainy of a vile career,
And bade me follow the imposter here
To see how gross his impudence could be,
And force him to restore your property.
Your private papers, by the King's command,
I hereby seize and give into your hand.
The King, by royal order, invalidates
The deed which gave this rascal your estates,
And pardons, furthermore, your grave offense
In harboring an exile's documents.
By these decrees, our Prince rewards you for

Your loyal deeds in the late civil war,
And shows how heartfelt is his satisfaction
In recompensing any worthy action,
How much he prizes merit, and how he makes
More of men's virtues than of their mistakes.
DORINE Heaven be praised!
MADAME PERNELLE I breathe again, at last.
ELMIRE We're safe.
MARIANE I can't believe the danger's past.
ORGON (*To* TARTUFFE.)
Well, traitor, now you see . . .
CLÉANTE Ah, Brother, please,
Let's not descend to such indignities.
Leave the poor wretch to his unhappy fate,
And don't say anything to aggravate
His present woes; but rather hope that he
Will soon embrace an honest piety,
And mend his ways, and by a true repentance
Move our just King to moderate his sentence.
Meanwhile, go kneel before your sovereign's throne
And thank him for the mercies he has shown.
ORGON Well said: let's go at once and, gladly
 kneeling,
Express the gratitude which all are feeling.
Then, when that first great duty has been done,
We'll turn with pleasure to a second one,
And give Valère, whose love has proven so true,
The wedded happiness which is his due.

COMMENTS AND QUESTIONS

1. Show how this comedy follows the classical dramatic divisions: exposition, development, crisis, and resolution.

2. At the beginning of the play, the characters seem to be divided into two "camps" according to their opinion of Tartuffe. Who is in each, and what are their arguments for and against Tartuffe?

3. Who are the "reasonable" characters in the play, and why?

4. In Molière's comedy, servants are often smarter than their masters. How does Dorine manipulate the situation?

5. Are the characters of the young lovers fully developed? Are they comic characters? Note that in comedy, conventionally, the young win out over the old. How is this convention handled here?

6. To what extent is the character of Tartuffe comic, and to what extent is he sinister?

7. Do you see any justification for the accusations that the play is antireligious?

8. In your opinion, what is the true target of Molière's satire here?

MARIE DE LA VERGNE DE LA FAYETTE

from *The Princess of Clèves*
Translation by Thomas Sergeant Perry

The first two passages, which occur early in the novel, introduce the central character and reveal how her mother's moral lessons stand in contrast to life at court.

At that moment there appeared at court a young lady to whom all eyes were turned, and we may well believe that she was possessed of faultless beauty, since she aroused admiration where all were well accustomed to the sight of handsome women. Of the same family as the Vidame of Chartres, she was one of the greatest heiresses in France. Her father had died young, leaving her under the charge of his wife, Madame de Chartres, whose kindness, virtue, and worth were beyond praise. After her husband's death she had withdrawn from court for many years; during this period she had devoted herself to the education of her daughter, not merely cultivating her mind and her beauty, but also seeking to inspire her with the love of virtue and to make her attractive. Most mothers imagine that it is enough never to speak of gallantry to their daughters to guard them from it forever. Madame de Chartres was of a very different opinion; she often drew pictures of love to her daughter, showing her its fascinations, in order to give her a better understanding of its perils. She told her how insincere men are, how false and deceitful; she described the domestic miseries which illicit love-affairs entail, and, on the other hand, pictured to her the peaceful happiness of a virtuous woman's life, as well as the distinction and elevation which virtue gives to a woman of rank and beauty. She taught her, too, how hard it was to preserve this virtue without extreme care, and without that one sure means of securing a wife's happiness, which is to love her husband and to be loved by him.

This heiress was, then, one of the greatest matches in France, and although she was very young, many propositions of marriage had been made to her. Madame de Chartres, who was extremely proud, found almost nothing worthy of her daughter, and the girl being in her sixteenth year, she was anxious to take her to court. The Vidame went to welcome her on her arrival, and was much struck by the marvellous beauty of Mademoiselle de Chartres,—and with good reason: her delicate complexion and her blond hair gave her a unique brilliancy; her features were regular, and her face and person were full of grace and charm.

Madame de Chartes, who had already taken such pains to fill her daughter with a love of virtue, did

not remit them in this place where they were still so necessary, and bad examples were so frequent. Ambition and gallantry were the sole occupation of the court, busying men and women alike. There were so many interests and so many different intrigues in which women took part that love was always mingled with politics, and politics with love. No one was calm or indifferent; every one sought to rise, to please, to serve, or to injure; no one was weary or idle, every one was taken up with pleasure or intrigue. The ladies had their special interest in the queen, in the crown princess, in the Queen of Navarre, in Madame the king's sister, or in the Duchess of Valentinois, according to their inclinations, their sense of right, or their humor. Those who had passed their first youth and assumed an austere virtue, were devoted to the queen; those who were younger and sought pleasure and gallantry, paid their court to the crown princess. The Queen of Navarre had her favorites; she was young, and had much influence over her husband the king[1] who was allied with the constable, and hence highly esteemed. Madame the king's sister still preserved some of her beauty, and gathered several ladies about herself. The Duchess of Valentinois was sought by all those whom she deigned to regard; but the women she liked were few, and with exception of those who enjoyed her intimacy and confidence, and whose disposition bore some likeness to her own, she received only on the days when she assumed to hold a court like the queen.

All these different cliques were separated by rivalry and envy. Then, too, the women who belonged to each one of them were also jealous of one another, either about their chances of advancement, or about their lovers; often their interests were complicated by other pettier, but no less important questions. Hence there was in this court a sort of well-ordered agitation, which rendered it very charming, but also very dangerous, for a young woman. Madame de Chartres saw this peril, and thought only of protecting her daughter from it. She besought her, not as a mother, but as a friend, to confide to her all the sweet speeches that might be made to her, and promised her aid in all those matters which so often embarrass the young.

> In the next passage, Mademoiselle de Chartres, now married, and Madame de Clèves (we never know anyone's first name!) meet the duke of Nemours at a ball given by the king and queen.

Madame de Clèves spent the day of the betrothal at home dressing herself for the ball in the evening at the Louvre. When she made her appearance, her beauty and the splendor of her dress aroused general admiration. The ball opened, and while she was dancing with Monsieur de Guise, there was a certain commotion at the door of the ballroom, as if some one were entering for whom way was being made. Madame de Clèves finished her dance, and while she was looking about for another partner, the king called out to her to take the gentleman who had just arrived. She turned, and saw a man, who she thought must be Monsieur de Nemours, stepping over some seats to reach the place where the dancing was going on. No one ever saw this prince for the first time without amazement; and this evening he was more striking than ever in the rich attire which set off his natural beauty to such a great advantage; and it was also hard to see Madame de Clèves for the first time without astonishment.

Monsieur de Nemours was so amazed by her beauty that when he drew near her and bowed to her he could not conceal his wonder and delight. When they began their dance, a murmur of admiration ran through the ball-room. The king and the queens remembered that the pair had never met, and saw how strange it was that they should be dancing together without being acquainted. They summoned them when they had finished the set, and without giving them a chance to speak to any one, asked if each would not like to know who the other was, and whether either had any idea.

"As for me, Madame," said Monsieur de Nemours, "I have no doubts; but since Madame de Clèves has not the same reasons for guessing who I am that I have for recognizing her, I must beg your Majesty to be good enough to tell her my name."

"I fancy," said the dauphiness, "that she knows it as well as you know hers."

"I assure you, Madame," said Madame de Clèves, who seemed a little embarrassed, "that I cannot guess so well as you think."

"You can guess very well," replied the dauphiness, "and you are very kind to Monsieur de Nemours in your unwillingness to acknowledge that you recognize him without ever having seen him before."

The queen interrupted the conversation, that the ball might go on, and Monsieur de Nemours danced with the dauphiness. This lady was a perfect beauty, and had always appeared to be one in the eyes of Monsieur de Nemours before he went to Flanders; but all that evening he admired no one but Madame de Clèves.

> The following scene, the most original and daring for the novel's first readers, depicts the prince and princess of Clèves in the summerhouse on their country estate. Partly by chance and partly by design, the duke of Nemours is hidden in a closet, listening to their conversation.

[1] Antoine de Bourbon, King of Navarre (1518–1562), father of Henri IV of France.

He heard Monsieur de Clèves say to his wife: "But why don't you wish to return to Paris? What can keep you in the country? For some time you have had a taste for solitude which surprises me and pains me, because it keeps us apart. I find you in even lower spirits than usual, and I am afraid something distresses you."

"I have nothing on my mind," she answered, with some embarrassment; "but the bustle of a court is so great, and our house is always so thronged, that it is impossible for mind and body not to be tired and to need rest."

"Rest," he answered, "is not needed by persons of your age. Neither at home nor at court do you get tired, and I should be rather inclined to fear that you are glad to get away from me."

"If you thought that, you would do me great injustice," she replied, with ever-growing embarrassment; "but I beg of you to leave me here. If you could stay too I should be very glad, provided you would stay alone, and did not care for the throng of people who almost never leave you."

"Ah, Madame," exclaimed Monsieur de Clèves, "your air and your words show me that you have reasons for wishing to be alone which I don't know, and which I beg of you to tell me."

For a long time the prince besought her to tell him the reason, but in vain; and after she had refused in a way that only redoubled his curiosity, she stood for a time silent, with eyes cast down; then, raising her eyes to his, she said suddenly,—

"Don't compel me to confess something which I have often meant to tell you, but had not the strength. Only remember that prudence does not require that a woman of my age, who is mistress of her actions, should remain exposed to the temptations of the court."

"What is it you suggest, Madame?" exclaimed Monsieur de Clèves. "I should not dare to say, for fear of offending you."

Madame de Clèves did not answer, and her silence confirming her husband's suspicions, he went on,—

"You are silent, and your silence tells me I am not mistaken."

"Well, sir," she answered, falling on her knees, "I am going to make you a confession such as no woman has ever made to her husband; the innocence of my actions and of my intentions gives me strength to do so. It is true that I have reasons for keeping aloof from the court, and I wish to avoid the perils that sometimes beset women of my age. I have never given the slightest sign of weakness, and I should never fear displaying any, if you would leave me free to withdraw from court, or if Madame de Chartres still lived to guide my actions. Whatever the dangers of

the course I take, I pursue it with pleasure, in order to keep myself worthy of you. I beg your pardon a thousand times if my feelings offend you; at any rate I shall never offend you by my actions. Remember that to do what I am now doing requires more friendship and esteem for a husband than any one has ever had. Guide me, take pity on me, love me, if you can."

All the time she was speaking, Monsieur de Clèves sat with his head in his hands; he was really beside himself, and did not once think of lifting his wife up. But when she had finished, and he looked down and saw her, her face wet with tears, and yet so beautiful, he thought he should die of grief. He kissed her, and helped her to her feet.

"Do you, Madame, take pity on me," he said, "for I deserve it; and excuse me if in the first moments of a grief so poignant as mine I do not respond as I should to your appeal. You seem to me worthier of esteem and admiration than any woman that ever lived; but I also regard myself as the unhappiest of men. The first moment that I saw you, I was filled with love of you; neither your indifference to me nor the fact that you are my wife has cooled it: it still lives. I have never been able to make you love me, and I see that you fear you love another. And who, Madame, is the happy man that inspires this fear? Since when has he charmed you? What has he done to please you? What was the road he took to your heart? I found some consolation for not having touched it in the thought that it was beyond any one's reach; but another has succeeded where I have failed. I have all the jealousy of a husband and of a lover; but it is impossible to suffer as a husband after what you have told me. Your noble conduct makes me feel perfectly secure, and even consoles me as a lover. Your confidence and your sincerity are infinitely dear to me; you think well enough of me not to suppose that I shall take any unfair advantage of this confession. You are right, Madame,—I shall not; and I shall not love you less. You make me happy by the greatest proof of fidelity that a woman ever gave her husband; but, Madame, go on and tell me who it is you are trying to avoid."

"I entreat you, do not ask me," she replied; "I have determined not to tell you, and I think that the more prudent course."

"Have no fear, Madame," said Monsieur de Clèves; "I know the world too well to suppose that respect for a husband ever prevents men falling in love with his wife. He ought to hate those who do so, but without complaining; so once more, Madame, I beg of you to tell me what I want to know."

"You would urge me in vain," she answered; "I have strength enough to keep back what I think I ought not to say. My avowal is not the result of weakness, and

it requires more courage to confess this truth than to undertake to hide it."

Monsieur de Nemours lost not a single word of this conversation, and Madame de Clèves' last remark made him quite as jealous as it made her husband. He was himself so desperately in love with her that he supposed every one else was just as much so. It was true in fact that he had many rivals, but he imagined even more than there were; and he began to wonder whom Madame de Clèves could mean. He had often believed that she did not dislike him, and he had formed this opinion from things which now seemed so slight that he could not imagine he had kindled a love so intense that it called for this desperate remedy. He was almost beside himself with excitement, and could not forgive Monsieur de Clèves for not insisting on knowing the name his wife was hiding.

COMMENTS AND QUESTIONS

1. Note that—in contrast to later, realistic novels—not only do we not know the first names of the characters, but we also are given merely a very general notion of their physical appearance. What is the effect of this on the reader?

2. Does the princess seem to be lying when she tells the king and queen that she does not know the duke of Nemours? How do you know?

3. According to these passages, how would you define the moral principles of Madame de Chartres and her daughter? How do these contrast with standards at court?

4. How does Madame de La Fayette analyze and portray the feelings of the three characters involved in the last scene?

Summary Questions

1. What is meant by royal absolutism, and how did the court of Louis XIV exemplify it?

2. In what ways does the palace at Versailles display the absolutist ideal?

3. What are the neoclassical and what are the baroque features of Versailles?

4. How did dancing evolve from a social entertainment to an art form at the court of Louis XIV?

5. In what ways did French neoclassical tragedy resemble and differ from Greek classical tragedy?

6. What aspects of his own society does Molière satirize in *Tartuffe*?

7. What aspects of Molière's comedy are still relevant to our own time?

8. What was Madame de La Fayette's primary contribution to the development of the modern novel?

9. What impression of court life do you have from *The Princess of Clèves*?

Key Terms

absolutism

Sun King

palace

Hall of Mirrors

court ballet (ballet de cour)

tragedy

three unities

verisimilitude

comedy

romance

novel

The Seventeenth Century

No historical period is more complex and contradictory than the one we have just studied. Every general statement made about seventeenth-century culture almost seems to generate an equally valid opposite. Perhaps this is because the first half of the century, at least, was a time of tremendous change, of birth and growth. By the second half of the century, Europe was established as a world power and had become more stable at home, culturally as well as politically. Let us review briefly some of the often conflicting aspects of the seventeenth century and their significance.

Religion

In the area of religion, Europe by 1650 was divided into Catholic and Protestant territories, which have more or less survived as such into the present. Protestantism evolved from a revolutionary movement into an establishment or series of establishments, each with its own set of orthodox beliefs. With the subsidence of religious warfare came a growing indifference to religion and a secular view of the world. Attempts by new reform movements among Catholics and Protestants could not halt the trend.

Still, even though the secularism that dominates the West today began in the seventeenth century, one should not discount the importance of both Protestant and Catholic religious fervor throughout the 1600s. The life of Saint Teresa of Ávila demonstrates the saliency and influence of mystic experience—the direct union of soul with God—during this period. Bernini's sculpture of Saint Teresa, as well as the poetry of Richard Crashaw and John Donne, exemplifies the often close relation between eroticism and religious mysticism in baroque art.

Science

The rapid developments in science were in part responsible for the increasingly nonreligious view of the world. First the revolutionary Copernican theory and then experiments conducted by scientists such as Newton and Galileo taught people to trust their own minds or senses rather than the decrees of authority. Bacon condemned what he conceived of as the traditional deductive approach to nature and called for a new inductive approach based on an exhaustive observation of as many occurrences of the phenomenon under investigation as possible. By use of this method, he believed, a new age of discovery would begin. His failure to see scientific research as a testing of hypotheses and his failure to appreciate the role of mathematics meant that his method would make little contribution to the study of physics and astronomy, where the most exciting scientific work of the century was being done. The deductive method of his young contemporary Descartes may not have produced many discoveries in these areas of science; nonetheless, his view of space and all matter in it as reducible to mathematical equations prepared the way for Newton, who was able to describe by mathematical formulas every movement occurring in the physical universe.

By the end of the century natural science became something of a hobby for learned men and women across the Continent, and in England societies were formed to promote the advancement of science. In practice, at least, many educated people came to think of nature itself as a self-regulating, autonomous machine: God was needed only to explain how the world came into being in the first place. Once created, the world ran as did a clock. Some thinkers, however, felt uneasy about living in such a world. A few experienced a kind of terror. If earth was no longer perceived as the center of the universe, the position of humanity also had to be rethought.

Economics

The seventeenth century witnessed a new stage in the development of a highly important modern economic institution: industrial capitalism. The desire for world

markets and wealth led to the exploitation of African and American cultures by Europeans. Whereas in the sixteenth century, America had furnished Europe primarily with precious metals, in the seventeenth the American colonies supplied important agricultural products and raw materials. The colonies became an important outlet for European investment. Slaves were a significant cost factor here. In its turn, trade with the New World and Africa stimulated intracontinental trade in Europe as well. The new economic interests were another influence in the growth of secularism.

Politics

The rapid accumulation of wealth allowed many wealthy middle-class people, or bourgeois, literally to buy their way into the nobility. After very unsettled political conditions in the first half of the century, the European monarchs (most strikingly Louis XIV) learned how to keep the upper classes politically subservient; royal absolutism became the political order of the day. Absolutism was the means by which strong central government was established in most of Continental Europe. Accordingly, the modern political state perhaps owes more to absolutism than to republican or constitutional monarchical forms.

Drawing on the mechanistic model prevalent in the new sciences and terrified of anarchy, Hobbes intended to come to the aid of absolutism with his *Leviathan*. Only by surrendering their individual wills to a will jointly created through a common covenant could humankind know the peace and security sought by the life force in each person. The justification for Leviathan's absolute power was purely utilitarian: he could claim obedience only so long as he provided the security for which he had been created.

Hobbes's insistence on the need for a superior will with absolute power was an almost necessary counterpoise to his strong sense of individualism: it was in the subject's interest to obey in order to avoid returning to the terrible state of nature. Contemporary defenders of absolutism, who based absolutism on the legitimate claim to rule and the natural love owed the monarch by his people, rejected this view. But in basing political theory on enlightened self-interest, Hobbes was clearly a pioneer of the modern age, which recognizes self-interest as the basic motive for human action.

His fellow Englishman John Locke countered Hobbes's pessimism about human selfishness with the optimistic thesis that human beings were largely determined by their environment. This was a view of human nature that strongly attracted social and political reformers of the next century, especially in France. At the same time, in apparent contradiction to his denial of in-

nate qualities, Locke insisted on the intrinsic rationality of human beings and argued against Hobbes that even in the state of nature people had been sufficiently rational to form societies, although these societies were unstable for lack of a government.

When human beings did create a government, they confined its power to protecting individuals and their property from internal and external aggression. Established by the agreement of all the male adults of the society, the government was elected by them. Its operations were carefully watched so as to prevent infringement of individual liberties not required in order to realize the purpose for which the government was created. Whereas absolutist political theories inspired most of the governments on the European continent in the eighteenth century, Lockean republicanism had wide appeal in England and the American colonies. Indeed, it was instrumental in the drafting of the U.S. Constitution.

Art, Architecture, and Literature

The Baroque Style

The baroque style, which permeated the visual arts and literature of the early seventeenth century, in many ways reflects the turmoil, contradictions, and dynamism of the age. Exuberance is perhaps its overriding quality. Often this style is characterized by intense sensuality combined with intense spirituality, by a realistic depiction of everyday life linked with a love of fantasy and illusion, and by a delight in the material aspects of life commingled with a sense of the impermanence of earthly existence. The poetry of Sor Juana Inés de la Cruz, Crashaw, and Donne; the paintings of Caravaggio, Rubens, and Rembrandt; and the sculpture of Bernini show the diversity of baroque art. In architecture and city planning, Bernini's transformation of Rome from a medieval town to a dazzling theatrical setting for the power of the popes is perhaps the most stunning example of the baroque.

The Neoclassical Style

The neoclassical style incorporated many aspects of the baroque, notably its magnificence and grandeur. But its aesthetic was more orderly and controlled—and hence better suited to the reign of royal absolutism in the second half of the seventeenth century. The palace and the gardens at Versailles demonstrate visually the power and control that the Sun King held over his court and his subjects. The comedies of Molière, the tragedies of Corneille and Racine, and the novels of Madame de La Fayette show a concern for classical

balance, clarity, and harmony, along with a keen penetration of human psychology that makes them still highly readable today.

Music and Performing Arts

The baroque style in music, like that in the visual arts and in literature, had its origins in late Renaissance Italy. Humanism, the same cultural and intellectual movement that used the ideas and ideals of Greece and Rome as models for contemporary artistic creation (and to a great degree gave rise to the Renaissance itself), was also largely responsible for creating a new or "second practice" at the height of the Renaissance period.

Well before the end of the sixteenth century, musicians in Italy tried to resurrect the affective power of Greek drama: they began to experiment with *dramma per musica,* theatrical genres that developed and were later named opera and oratorio. A whole theory of *affects* became a doctrine of the baroque, a method whereby a composer could invoke specific emotional responses in an audience by employing specific musical devices. As Plato's Dorian mode stirred manly feelings in the youth of Greece, Bach's and Handel's D-major trumpet parts evoked victorious martial responses in the listeners of the eighteenth, nineteenth, and twentieth centuries.

In general, theatrical arts gained prominence during the seventeenth century, perhaps because so much in society became more theatrical. Just as Bernini's churches resembled theaters, so the Catholic mass became more like a show. Louis XIV, the master showman, built his own showplace in Versailles and ran his court ritual somewhat like the ballet that developed there.

The first theaters that we can call modern were built in Italy and influenced those in other parts of Europe. Two forms of modern stage entertainment, the opera and the ballet, came into being in the seventeenth century. Greek and Roman tragedies were reborn in neoclassical form with the dramas of Corneille and Racine. Molière, with his ability to depict characters both everyday and universal, created the first truly modern comedies in which laughter serves to create incisive commentaries on human nature.

Musical baroque flourished well into the eighteenth century, and Handel developed the *oratorio* into a form that could be used for a popular show. Nowhere, however, are the grandeur, magnificence, and exuberance that characterize the baroque style more apparent than in Handel's *Messiah.* Yet many knowing musicians turn to Bach, not Handel, as the culmination of the era. In truth, both composers, and their works, are at the same time typical and extraordinary.

The early eighteenth century, which saw a flowering of great religious music, was on the whole a most nonreligious time for the other humanities. We will see the secular spirit that began in the fourteenth and developed throughout the seventeenth century take a more profound hold on Western culture in the eighteenth as the larger-than-life dimensions of baroque art are reduced to a more "reasonable" level.

PART VIII

Reason, Revolution,
Romanticism: The
Eighteenth and Early
Nineteenth Centuries

24 The European Enlightenment

CENTRAL ISSUES

- The French *philosophes* and their impact on society and thought
- The growing cultural importance of women in the eighteenth century
- Mary Wollstonecraft's contribution to feminism
- The rococo style in the arts
- Genre painting as an expression of social concerns

A Prerevolutionary Movement

The thinkers formed by the Scientific Revolution taught reliance on individual experience or reason rather than on authority and tradition. Within the age of absolutism, seeds were being planted for a cultural, and eventually political, revolution that would destroy everything the age stood for. France, which dominated Europe culturally and politically throughout the eighteenth century (see map), began the period with Louis XIV, king by the grace of God, and ended it with General Napoleon, sovereign by popular support. In the interim Louis's royal line, the Bourbon family, was swept away by the earth-shaking revolution of 1789, which toppled in its turn one European crowned head after another. The ideas originating in France also had a profound impact on the formation of a new republic across the Atlantic.

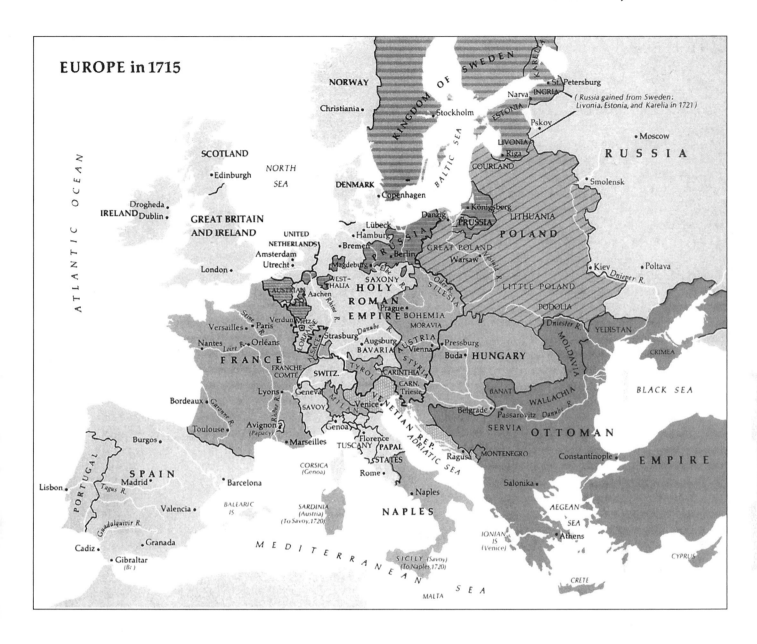

The Philosophes

The intellectual movement that came to be known as the Enlightenment was led by a group of diverse, individualistic Frenchmen who are usually labeled together as the *philosophes*. Although the word literally means "philosopher," these people were not on the whole creators of new philosophical systems. Rather, they were propagandists for a general set of ideas that they believed would bring "light" to their generation and so improve the life of the human race as a whole. Primarily middle-class, skilled, and prolific writers, the philosophes reached their public through the burgeoning printed media—not only books and pamphlets but also the newly introduced weekly newspapers and monthly journals. Their mission would have been impossible in prior centuries, when the level of literacy was low even in the upper class. The philosophes were able to reach a wide, literate, upper- and middle-class public, but not the poor. The lower classes throughout the eighteenth century remained, in general, as oppressed as before, although they joined the bourgeoisie at the end to overthrow the monarchy and to enthrone the goddess of reason. The philosophes had a rather abstract, if genuine, concern for the poor, but they associated primarily with the polished, witty, urbane men and women who frequented the Parisian *salons*. Paris was now replacing Versailles as the center of cultural life.

The Salon

The Hôtel de Soubise, designed by Germain Boffrand and begun in 1732, is an example of the smaller and more intimate quarters fashioned for the nobility in

24-1 *Germain Boffrand, Salon de la Princesse, Hôtel de Soubise, Paris. (Giraudon/Art Resource, NY)* (**W**)

Paris (Fig. 24-1). Located on small and sometimes awkwardly shaped urban sites, these buildings had a fairly simple exterior; the architects and clients concentrated on the interiors, where the salon was used for small gatherings that replaced the great festivities of the court. The salons were run primarily by women—Madame du Deffand and Madame Geoffrin were two of the most celebrated—and the sexes conversed and exchanged ideas on an equal footing. These conversations were also means for spreading ideas. As the century progressed, educated men and women everywhere strove to be recognized as "enlightened"; even the sovereigns of Europe sought to win the title of "enlightened monarch."

Foundations of the Enlightenment: John Locke (1632–1704)

How did the *Enlightenment* develop, and what were its common tenets? Essentially, the French philosophes' con-

ceptions of the sources of knowledge were confused. They claimed to be *empiricists*, deriving their ideas from experience, but they also espoused a belief in natural rights determined by examination of the human conscience. In *rationalist* fashion they used these natural rights as criteria for judging both the society and government of their time. The confusions in their thought, however, were in a sense inherited from the late-seventeenth-century English philosopher Locke, from whom they took much of the methodological approach. As shown in Chapter 20, Locke joined a belief that human beings were formed by their experience with a belief in natural rights to life, liberty, and property. These natural rights could not be proved by experience but were deduced by an examination of the conscience.

The Philosophes' Political and Religious Doctrines

Empiricism and a rationalistic doctrine of natural rights formed the core of the Enlightenment. With a few exceptions, the philosophes believed that all people were essentially equal, because they all possessed reason. As a creature of reason and equal to every other person by nature, every individual had the right to life, liberty, and a chance at happiness. Associated with these natural rights were others like the right to freedom of speech and to religious liberty. The philosophes deplored the intolerance to Protestants still practiced by the Catholic Church in France; in fact, they viewed the Church itself as a source of superstition, ignorance, and subservience. Priests and others in the hierarchy served to benight, rather than to enlighten, the multitudes. A philosophe motto, "Crush the infamous!" (*Écrasez l'infâme*), referred to all irrational and superstitious forces but was directed primarily against the Church.

Although the philosophes supported tolerance for Protestants, they had little respect for any Christian doctrines. They called their own form of religion *deism*. Drawing heavily on the conception of God fostered by Descartes and the Scientific Revolution, they held that God had created the world and set it running on its own, as a watchmaker makes a watch. Heaven and hell were not to be found in the hereafter but on this earth. If human beings would follow their God-given reason rather than their momentary passions, they could create a world in which everyone would enjoy felicity and peace.

Although their ideas were to influence the revolution, the majority of the philosophes politically were proponents of *despotism*, or rule by one enlightened person, harking back to Plato's notion of the philosopher-king. Robert Turgot (1727–1781), a philosophe and one of Louis XV's ministers, declared, "Give me five years of despotism and I will make France free." Given the situation in France, the greatest concern was to es-

tablish a basic equality among the classes and to eliminate privilege; the only way to do this practically was to give the central government absolute control of reform. In England, where, despite the existence of classes, there was a basic equality before the law, Locke stressed constitutional monarchy; in France the worst source of oppression came from the privileged classes and groups. If there were to be toleration and freedom of the press in France, they would have to come from the king: the Church and other interest groups were violently opposed to such freedoms.

The reason that the French did not enjoy natural rights in the present was the fault of evil institutions. People are good, but corrupted institutions have damaged them. Reform the institutions and people will improve. Indeed, the philosophes believed that if the proper institutions could be designed, people might eventually perfect themselves. Thus the philosophes introduced a doctrine of progress. They placed great hope in the reform of the state because they saw it as a central means for reforming all the other institutions of society.

Diderot (1713–1784) and the Encyclopedia

The philosophes were the first to broadcast an idea both widely accepted and under attack today: progress through education. If human beings are to be enlightened, to be able to use their reason to unmask lies and superstitions, then they must *know*. To this end one of the most intelligent and versatile of their number, Denis Diderot, conceived and directed the compiling of a vast encyclopedia called *Dictionnaire Raisonné des Sciences, des Arts et des Métiers*. French authorities saw the whole idea as dangerous—twice they suppressed the Encyclopedia. It contained articles, written by philosophes and others, on everything from how to make wallpaper to the definition of God. It was full of information on science and technology. Eighteenth-century socialites, as well as the philosophes, were passionate amateur scientists, often performing experiments for company after dinner in their elegant salons.

Voltaire (1694–1778)

A contributor to the Encyclopedia and the giant of the French Enlightenment was François-Marie Arouet, better known by his pen name Voltaire. Probably no other writer was so adored and so hated during his lifetime. Not a profoundly original thinker, he was endowed with an ability to see through hypocrisy and delusion as well as with a witty, satiric style that he used mercilessly against his enemies and anti-Enlightenment forces.

By birth a bourgeois (his father was a lawyer), the young Voltaire wanted nothing so much as to ingratiate himself with the court nobility; with his wit, intelligence, and good education, he accomplished this. Be-

coming well known as a writer of neoclassical tragedies, he discovered that in spite of his talents, he was not socially equal to aristocrats when one of them had him publicly beaten and then thrown into the infamous French prison, the Bastille. He also suffered from an inefficient censorship law, which arbitrarily swooped down on a victim and punished him with imprisonment or exile. After his release from the Bastille, Voltaire was sent into exile in England, where he found a constitutional government, an enlightened noble class that obeyed the law, a tolerant spirit, and the works of John Locke. It was Voltaire who introduced Locke's ideas into France. He also brought back to France the idea that its government and society could, indeed should, be changed. But Voltaire's *Philosophical Letters* (1734) on his impressions of England were seized by the French censors. Voltaire had portrayed England, in contrast to France, as a sane and rational place, where tolerance reigned. In a similar fashion, in his *Philosophical Dictionary* (1764), Voltaire used China as a kind of mirror with which to expose France's faults. According to him, China was a thoroughly civilized country, where a reasonable morality reigned and superstitious religious bigots did not persecute people who happened to disagree with them.

With the censoring of the *Philosophical Letters*, Voltaire sought a safe haven in northeastern France at Cirey with his friend and mistress for the next ten years, Gabrielle Emilie du Châtelet. Madame du Châtelet herself deserves attention as one of the liberated women of eighteenth-century France. Her portrait (Fig. 24-2), by a woman, Marianne Loir, reveals a subtle intelligence and love of learning coupled with a smile—typical features of the Enlightenment. Forced into an early marriage with an unintellectual nobleman, she astonished Parisian society by exiling herself to a small town to devote herself to intellectual pursuits. She was a mathematician who wrote several treatises on natural philosophy as well as mathematics. While Voltaire lived with her, they observed a rigid schedule filled with scientific experiments, studies, and theatrical performances put on by themselves and their visitors. Another of Voltaire's ambitions while at Cirey was to write history in a manner worthy of a scientific age. With the desire to create a record of the advance of civilization and to deal with all of the creations of the human mind—art, literature, science, business, and politics—Voltaire composed *The Century of Louis XIV*, still a classic of its kind.

In 1750 Voltaire left his country haven to live at the court of Frederick the Great of Prussia, a man whom many of the philosophes saw as the prototype of the "enlightened despot." Eventually he settled on an estate that he bought at Ferney, just outside Geneva but in France, where he became an enthusiastic farmer. It is there that he wrote, apparently with astounding speed,

24-2 *Marianne Loir,* Portrait de Gabrielle Emilie Le Tonnelier de Breteuil, Marquise du Châtelet. *Musée des Beaux-Arts de la Ville de Bordeaux. (Copyright Cliché du Musée des Beaux-Arts de Bordeaux)*

24-3 Seated Voltaire, *by Jean Antoine Houdon. Musée Fabre Montpellier. (Bridgeman-Giraudon/Art Resource, NY)*

the most famous of what he called his "philosophical tales," *Candide.* Voltaire devoted the rest of his life not only to farming and writing but also to espousing various causes in the name of enlightened justice. He exposed some of the miseries of the French peasants who lived around him and took up the cause of Jean Calas, an aged French Protestant executed by torture after being falsely charged with murdering his son because he had converted to Catholicism. Voltaire exposed the facts of the scandal in his *Treatise on Toleration,* which concludes with "An Address to the Deity." A deist, Voltaire made a plea for tolerance in matters of religion, along with a demand for social justice, a constant throughout his life.

The old Voltaire, admirably portrayed by the sculptor Houdon (Fig. 24-3), was confident that he had witnessed the triumph of reason in his lifetime. "It is certain," he wrote, "that the knowledge of nature, the skeptical attitude toward old fables dignified by the name of history, a healthy metaphysic freed from the absurdities of the schools, are the fruits of that century when reason was perfected."

He was to see Paris only once more, and to die there, but because he would not "retract his errors" to a priest, his body was not allowed to be buried in consecrated ground. Thirteen years after his death, after the revolution that he did not live to see, his body was

brought back to Paris and interred in the Pantheon. Skeptical and cynical as he was, he undoubtedly would not have approved of the revolution. Yet the crowds that came to honor him in 1790 inscribed on his tomb, "He taught us to be free."

Voltaire's life was thus an active one that spanned almost the entire eighteenth century. The products of his pen were many: poetry, philosophy, history, tragedies, pamphlets, essays, and the genre for which he is now best remembered, the philosophical tale. Characteristic of the Enlightenment, his talents were best suited to forms in which he could exercise his quick, sharp style and especially his gift for *satire.* The progress of Voltaire's thought may be roughly divided into the periods before and after 1755, when a significant event occurred. The earthquake at Lisbon on November 1, the worst natural disaster in Europe in centuries, killed an estimated fifty thousand people. If Voltaire's earlier thought had been characterized by an unshakable belief in progress and in the benefits of civilization, he was now forced to reevaluate his position. His "Poem on the Disaster of Lisbon" expresses compassion for the suffering of humanity but disgust for the proponents of the doctrine of optimism. He was to develop this vision more fully in *Candide,* written in 1758 and published in 1759.

One of Voltaire's philosophical tales, *Micromegas,* written in 1739, might be considered an early work of science fiction. If it is fiction, however, it is also very much concerned with contemporary developments in science—and with contemporary ignorance. Written with satiric verve, it is a tale of the Enlightenment, influenced by the Scientific Revolution and the ideas of Locke.

Montesquieu (1689–1755)

One of the greatest objections leveled against the philosophes by later generations is that they had no appreciation for the effect of history on humankind. Too analytical, they saw humanity in the abstract and were therefore unable to effect reform within a historical context. One perceptive critic of the eighteenth century, Charles-Louis de Secondat, the baron de Montesquieu, attacked this neglect of history on the very same grounds. His belief was that people are basically a product of history and that constitutions must be tailored to meet the conditions and historical traditions of the particular society. Like Voltaire, Montesquieu used partly fictitious portraits of other regions of the world as a way to expose the faults of France. His delightful *Persian Letters,* published in 1721, purports to be a collection of the letters sent home by a Persian visitor to France, who comments on what appear to him to be the strange customs of the host country. Through the eyes of the fictitious Persian observer, Montesquieu is able to satirize many of the habits of action and thought that his compatriots assumed were universal.

Despite his historical interests, Montesquieu is usually regarded as a philosophe. Like most of the others in the movement, he was a deist, a believer in natural rights, and a reformer, especially of the penal code. Although he was also an empiricist, he included history as a vital part of the human experience; his insistence on history as an important factor when considering reforms of society and government led him to be politically conservative. A member of the privileged provincial nobility, he was by both self-interest and conviction antagonistic to political reforms predicated on the belief that the past could simply be wiped away. Frankly fearing for personal liberty in a state ruled by a despot, no matter how enlightened, he found Locke's theory of an executive checked by a legislature very appealing. Admiring English government but basically misunderstanding its constitutional machinery, Montesquieu developed a theory of separation of powers among legislative, judicial, and executive agencies; he insisted that the individual could be free only when the power of one of these branches of government was checked by the other two. Of almost no importance in France, the theory had tremendous influence in the conception of the United States Constitution.

An issue dealt with by Montesquieu in *The Spirit of the Laws,* which had no resonance in America until much later, was the question of slavery. Seventeenth-century absolutists and capitalists had accepted slavery in the course of their trade; Montesquieu and other philosophes, scrutinizing the institution under the light of reason, found it unnatural and evil. It is clear that slavery would be abhorrent to those who believe in the natural rights of human beings. (We will examine the paradox of its continuation in the new, "enlightened" United States in the next chapter.)

Rousseau (1712–1778)

Jean-Jacques Rousseau was a paradoxical figure who in some ways belongs with the philosophes and in others may be seen as a precursor of romanticism. Of humble origins, Rousseau was born in the city-state of Geneva, in Switzerland; he came to Paris at the age of thirty after fifteen years of living a vagabond existence. An insecure, unhappy man, suffering from a sense of persecution and an embarrassing urinary problem, Rousseau found the source of his difficulties in the artificiality of society. Among the many contradictions of his life was his writing in praise of the simple, virtuous life in Geneva while he continued to live in Paris.

In two essays that brought him his first literary honors, the *Discourse on the Sciences and Arts* (1749) and *On the Origin of Inequality Among Men* (1755), he attacked the corruptions of society and characterized the progress that people had made in the arts and sciences as contributing to this degeneration. Accordingly, he idealized the state of nature, the time when people were originally free. Although he did not deny the rational capacity of humanity, Rousseau believed that the deepest part of the human being was at the level of the instincts and that by nature people were loving, sympathetic, and kind. When Voltaire finished reading *On the Origin,* he commented that Rousseau's work made him feel like getting down on four legs.

In the society of his own time Rousseau idealized the lower classes, which seemed to him to be living closest to the natural life. In works like *Émile,* a treatise on "natural" education, and his novel, *The New Heloise,* he depicted the beauties of the simple life led amid nature. So popular were these works by the last quarter of the century that all over France the upper classes, including the queen herself, entertained themselves by dressing as shepherds and peasants, picnicking and playing in the woods and fields. It became fashionable to speak of one's feelings in public, to act "naturally," and to idealize the poor.

Rousseau's most important work on political theory, *The Social Contract* (1762), reflects the contradictions found in this tortured genius who endeavored to reconcile into a system the philosophe inheritance with

his own intense experience of life. Terminology like "contract" and "state of nature" is that of Locke and Voltaire. On humanity's emerging from the state of nature to set up a government, the philosophes commonly spoke of a contract being made among the members of the society and the government that they created. This contract was to stipulate the duties and limitations of the government and to afford a legal basis for destroying the government if it violated the terms.

Using the "state of nature" as a model for prehistory in order to explain the origins and nature of government was not new; Hobbes and Locke had both done that. Nor was it unusual to find simple, so-called primitive, societies attractive. The Noble Savage was an important theme of the Enlightenment. Yet Rousseau portrayed "savage society" as a functioning, interacting reality rather than as an abstraction. He has therefore been called an important founder of modern (especially French) anthropology.

In Rousseau's hands the language of the Enlightenment remains, but the meanings are very different. Whereas previously he had seen humanity as good in the state of nature and subsequently corrupted by evil institutions, in this work human beings in nature are depicted as brutes driven by their impulses and appetites. The individual, however, is less self-conscious and rational in Rousseau's state of nature than in Hobbes's, and the transformation of the personality once society has been formed is much greater. For Rousseau, a person becomes truly human only when living in a civil society: "By dint of being exercised, his sentiments become ennobled and his whole soul becomes so elevated that, but for the fact that misuse of the new conditions still, at times, degrades him to a point below that from which he has emerged, he would unceasingly bless the day which freed him for ever from his ancient state, and turned him from a limited and stupid animal into an intelligent being and a man." Against his own earlier view and that of earlier philosophes, Rousseau maintains that the state is not a creation of fully formed human beings, but rather that people become human only by living in a community. There is no interest in returning to a state of nature; the task is to create a better society where one's humanity can be fully realized.

Moreover, for Rousseau the contract is an agreement not between a society and its government but among the various free individuals in the state of nature to create the society itself. Driven by the desire for self-preservation, brutish and lonely people unite themselves out of fear and voluntarily surrender their natural freedom in exchange for the benefits of social life. Merging their individual wills into a "general will," they agree to obey everything that "will" decrees. Rousseau's ideal society is small enough so that the collective body of the citizens can assemble to express the general will, which

rules that state. The actual government consists just of administrators who carry out its orders. Rousseau probably had in mind a society like the city-state of Geneva where he grew up. But whereas Geneva was governed by an *aristocracy*, Rousseau's ideal state was a *democracy*.

What is the general will? One thing is clear: for Rousseau it is not the will of the majority. Often the vote of the multitude reflects only the combined self-interest of every individual and not the public interest. For Rousseau the general will is mysteriously found in each citizen below the level of his individual selfish will. It is the common will that seeks the good of the whole community; when it speaks, it reflects the true interests even of those citizens who violently opposed its decision. In the case of citizens who differ with the general will, they are literally forced to be free, that is, to accept what the deepest part of their being really wants.

Voltaire and other philosophes envisaged people as atoms of rationality that were alike all over the earth. Rousseau saw human beings rather as essentially bundles of feelings and instincts determined to a large extent by the society in which they live. For Rousseau an individual's community was not simply a convenience; rather, it provided the framework in which the individual realized himself or herself. But for full personal development to occur, every member of the community had to participate in deliberations. Only in this way could the collective, or general, will be expressed and the good of all best be served. Of course, by maintaining that even the will of the majority does not necessarily express that will, he left the door open for the rise of a demagogue who knew better what the people needed than they did themselves. At various times, and with valid reasons, Rousseau has been called the father of democracy, socialism, communism, nationalism, and fascism.

Enlightenment Feminism: Mary Wollstonecraft (1759–1797)

We have seen that aristocratic and some upper-middle-class women played an influential role in the salons and other intellectual circles of eighteenth-century society, particularly in France. It is clear, however, that the educated woman who considered herself equal to men remained the exception rather than the rule and that in general women were expected to limit their education to domestic arts along with a few "accomplishments," such as singing; to interest themselves primarily in fashion, gossip, and flirtation; and not to meddle in the affairs of men. Rousseau, the radical thinker whose ideas challenged so many of the fundamental assumptions of his society, remained fundamentally conventional in his attitudes toward women. In his treatise on education entitled *Émile*, in which he proposes many of the theo-

ries that underlie modern ideas on "progressive" education with regard to boys, he maintains that women's role is to be subservient to men and that women's education should be structured accordingly:

> For this reason the education of women should always be relative to men. To please, to be useful to us, to make us love and esteem them, to educate us when young, and take care of us when grown up, to advise us, to console us, to render our lives easy and agreeable—these are the duties of women at all times, and what they should be taught in their infancy.[1]

Despite the fact that Rousseau's attitude represented the norm, the eighteenth century witnessed several challenges to the inferior status of women. In England, Lady Mary Wortley, whose pen name was Sophia, referred to women's social position as one of "slaves" and argued for better education and more independence for her sex. The rhetoric of the French Revolution supplied fuel for the feminist fire. In France, Olympe de Gouges (1748–1793) attempted to extend the revolution's doctrine of the Rights of Man by publishing a pamphlet entitled *Declaration of the Rights of Woman and of the Female Citizen* in 1791. Advocates for better education for women included the philosophe Condorcet, the English writer Catherine Macaulay, and Mary Wollstonecraft.

Wollstonecraft's *A Vindication of the Rights of Woman*, published in 1792, in many ways prefigures some of the *feminist* ideas that have become common in our own time. A middle-class woman who shared the Enlightenment thinkers' disdain for the "decadent" aristocracy, Wollstonecraft worked as a governess and a teacher, attempted to found a school, and lived for a while in Paris, where she fell in love with an American. She eventually married her old friend, the English social thinker William Godwin, and had with him a daughter, Mary Wollstonecraft Godwin. She died of "childbed fever" at the age of thirty-eight. Wollstonecraft's stated aim in her treatise was "to persuade women to endeavour to acquire strength, both of mind and body." Incorporating revolutionary ideas, she paints a rather dismal portrayal of the lives of contemporary women while advocating both domestic virtue and educational and professional achievement.

Aspects of Painting in the Enlightenment

Many of the tendencies found in the philosophes—the movement from the nobility to the bourgeois, from the grandiose to the petite, and from tragedy to satire, as well as the interests in science and society—are embodied in the art of the first half of the eighteenth century. In both England and France, painters turned to scenes from contemporary life as means to explore the world and to communicate with their audiences.

William Hogarth (1692–1764) and Joseph Wright of Derby (1734–1797) explored different aspects of English life. Like the novelists Smollet and Fielding, Hogarth was interested in recording the foibles and failings of the English and their manners and morals. These paintings, which were then reproduced as engravings and circulated, contributed to his popularity and the recognition Hogarth achieved. His painting *Signing the Contract* (Fig. 24-4) from the *Marriage à la Mode* series portrays the rising middle class in its attempts to rise still higher. The scene, placed in the tastefully decorated drawing room of a London townhouse, features the wealthy father who counts gold coins for his daughter's dowry and discusses the family tree that will be improved when he adds a titled lord. The foppish young nobleman, now bankrupt from building his new Palladian house (shown outside the window), admires himself in the mirror. The proposed young bride is chatting with the attorney. Paintings, a fine cornice molding, flamboyant clothing, and elegant poses do not cover the emptiness of the arrangement that, in subsequent paintings, depicts the potential decadence of abundance.

In contrast, Wright's *Experiment with the Air-Pump* (Fig. 24-5) reflects an earnest middle-class interest in science and experimentation at home. Exhibited in London, it would have appealed to Diderot and Voltaire because it records a scientific experiment in explicit detail. The air pump, on a table in the center of the composition, has been purchased by a prosperous bourgeois to entertain and to educate. The glass globe contains a dove that will die when the air is pumped from the globe to create a vacuum. The two young girls are sad, but the others, youths and elders, watch with interest. The surfaces and textures of the objects are rendered with extreme verisimilitude—the painter is as observant as the scientist.

Paintings such as this also record the decline of court art. Far more intimate and sensual, the *rococo* style replaced the classicism of Le Brun and his school. *Pilgrimage to Cythera* (1717) (Color Plate XXI) by Jean Antoine Watteau (1684–1721) is thematically the progeny of Rubens's *Garden of Love* (Color Plate XV). Yet these couples who move through the forest of the enchanted island of Venus are not arriving, but leaving, to return to the real world. Watteau has given a sense of melancholy to the beautiful but shallow world of entertainments and parties that seemed more and more to occupy the life of the nobility.

François Boucher (1703–1770), who followed Watteau, continued the decorative and intimate character of

[1] Jean-Jacques Rousseau, *Émile or A Treatise on Education*, ed. W. H. Payne (New York, 1906), p. 263.

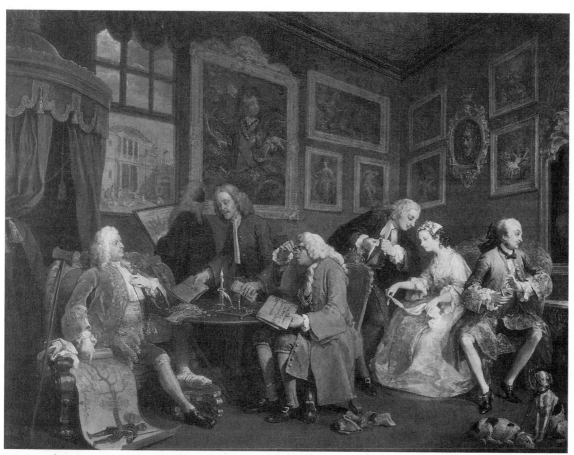

24-4 *William Hogarth*, Marriage à la Mode, Signing the Contract, *1743–1745. Oil on canvas. 28 × 35⅞″.*
(National Gallery, London)

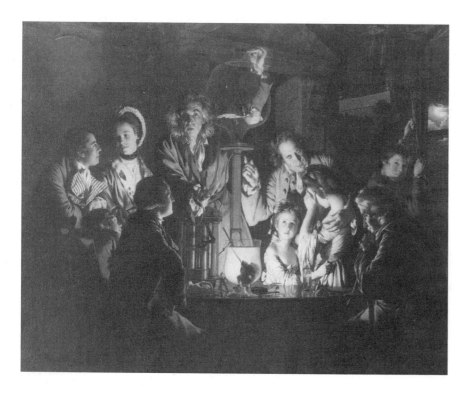

24-5 *Joseph Wright,* Experiment with the Air-Pump. *(Reproduced by the courtesy of the Trustees, The National Gallery, London)*

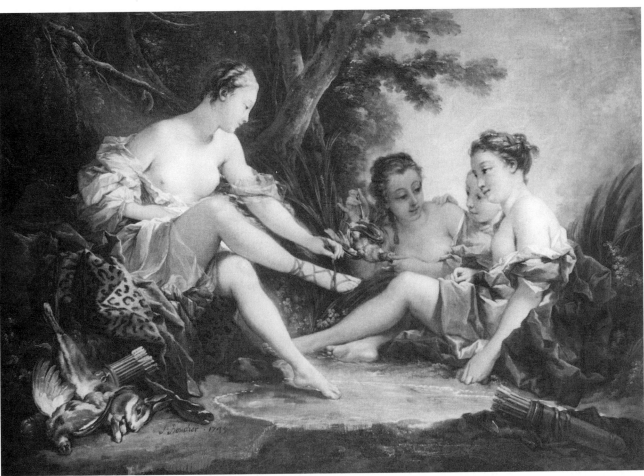

24-6 *François Boucher,* Diana After the Hunt. *(Musée Cognacq-Jay/Photographie Bulloz, Paris)*

rococo art, but added more sexual, sensuous content (Fig. 24-6). The golden colors, the flesh tones and textures, and the delightful abandon of these figures are the subject. Mythological or other themes are only an excuse for these handsome paintings that celebrate the life of the senses.

The philosophe Denis Diderot, who also wrote essays on contemporary art, was not impressed by these frivolous objects. Diderot's taste ran rather toward *genre* painting—scenes from everyday life among the peasants and the lower classes. In particular he praised Jean-Baptiste Siméon Chardin (1697–1779) and Jean-Baptiste Greuze (1725–1805), two painters whose works have only the most superficial elements in common. Chardin imparts to his subjects, whether a maid, a mother and child, or a still life, a monumental and quiet objectivity that recalls Vermeer (Color Plate XIX). Chardin's pictures of still-life subjects seem constructed from a careful, loving observation of nature that renders textures, surfaces, and light with verisimilitude. Order and harmony are extracted from the simple events and objects of the middle classes. We know that Chardin meant his pictures to educate and to instruct in virtue, but the depiction of objects seems to mean as much to him as the portrayal of a moral. It was Chardin's naturalism that so appealed to Diderot; yet, in contrast to Vermeer, Chardin's paint has a creamy sensual surface that is as covertly appealing as his subjects.

Greuze's work appealed to Diderot because his scenes suggested narratives that praised virtue or had a didactic moral. Too frequently, these scenes also had a marked sentimentalizing attitude toward the event. *The Village Bride,* shown in the Salon of 1761, is a sample of his work. A youthful bride watches while the dowry is negotiated, the grandfather admonishes, the mother is pensive, the hen in the foreground protects her chicks (Fig. 24-7). These sweet, clean, honest, virtuous, natural peasants provide a vivid contrast to what we know of life. But these pictures appealed to the upper bourgeoisie of the mid-eighteenth century, who saw in these peasants natural virtue.

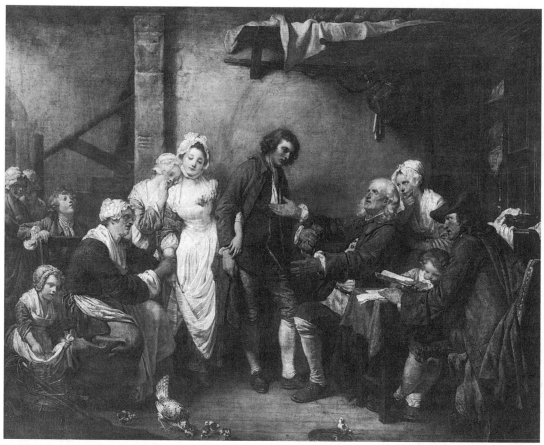

24-7 *Jean-Baptiste Greuze,* The Village Bride, *1761, Louvre, Paris. (Copyright 1996 ARS, NY/ SPADEM, Paris)*

• Hogarth's *Signing the Contract* (Fig. 24-4) and this painting by Greuze present similar events. Compare the composition in each, especially with regard to focus and the dress and attitudes of the potential brides and grooms. Compare also the different architecture of the two rooms. What are the effects of the differences? Why does Hogarth include dogs in the foreground, and why does Greuze show chickens instead? Which painting, in your opinion, is the most convincing in the way it portrays classes in society? With which are you in more sympathy and why?

As we have seen in this chapter, the art of the Enlightenment expressed many ideas embodied in different forms. "Rococo" was light, decorative, and sensual; its subjects were the pleasures of the court and the salon. Chardin and Greuze drew subjects from daily life and worked in a much more naturalistic style. Genre painting as these latter are called, like still-life painting that celebrated the ordinary, frequently carried moral messages as well (about life, death, loyalty, and sacrifice). In some ways painters in both schools seemed to anticipate the end of the Enlightenment's optimism.

VOLTAIRE

Micromegas
Translation by William Fleming

I

A Voyage to the Planet Saturn by a Native of Sirius

In one of the planets that revolve round the star known by the name of Sirius, was a certain young gentleman of promising parts, whom I had the honor to be acquainted with in his last voyage to this our little ant-hill. His name was Micromegas,[1] an appellation admirably suited to all great men, and his stature amounted to eight leagues in height, that is, twenty-four thousand geometrical paces of five feet each.[2]

Some of your mathematicians, a set of people always useful to the public, will, perhaps, instantly seize the pen, and calculate that Mr. Micromegas, inhabitant of the country of Sirius, being from head to foot four and twenty thousand paces in length, making one hundred and twenty thousand royal feet, that we, denizens of this earth, being at a medium little more than five feet high, and our globe nine thousand leagues in circumference: these things being premised, they will then conclude that the periphery of the globe which produced him must be exactly one and twenty millions six hundred thousand times greater than that of this our tiny ball. Nothing in nature is more simple and common. The dominions of some sovereigns of Germany or Italy, which may be compassed in half an hour, when compared with the empires of Ottoman, Russia, or China, are no other than faint instances of the prodigious difference that nature hath made in the scale of beings. The stature of his excellency being of these extraordinary dimensions, all our artists will agree that the measure around his body might amount to fifty thousand royal feet,—a very agreeable and just proportion.

His nose being equal in length to one-third of his face, and his jolly countenance engrossing one-seventh part of his height, it must be owned that the nose of this same Sirian was six thousand three hundred and thirty-three royal feet to a hair, which was to be demonstrated. With regard to his understanding, it is one of the best cultivated I have known. He is perfectly well acquainted with abundance of things, some of which are of his own invention; for, when his age did not exceed two hundred and fifty years, he studied, according to the custom of the country, at the most celebrated university of the whole planet, and by the force of his genius discovered upwards of fifty propositions of Euclid, having the advantage by more than eighteen of Blaise Pascal,[3] who, (as we are told by his own sister,) demonstrated two and thirty for his amusement and then left off, choosing rather to be an indifferent philosopher than a great mathematician.

About the four hundred and fiftieth year of his age, or latter end of his childhood, he dissected a great number of small insects not more than one hundred feet in diameter, which are not perceivable by ordinary microscopes, of which he composed a very curious treatise, which involved him in some trouble. The mufti[4] of the nation, though very old and very ignorant, made shift to discover in his book certain lemmas that were suspicious, unseemly, rash, heretic, and unsound, and prosecuted him with great animosity; for the subject of the author's inquiry was whether, in the world of Sirius, there was any difference between the substantial forms of a flea and a snail.

Micromegas defended his philosophy with such spirit as made all the female sex his proselytes; and the process lasted two hundred and twenty years; at the end of which time, in consequence of the mufti's interest, the book was condemned by judges who had never read it, and the author expelled from court for the term of eight hundred years.

[1] Two Greek words meaning "little-great."

[2] That is, 38.880 km.

[3] French philosopher and scientist (1623–1662). Voltaire deplored his religious philosophy.

[4] Member of the Muslim clergy charged with enforcing the religious laws. Voltaire has in mind his own difficulties with censorship.

Not much affected at his banishment from a court that teemed with nothing but turmoils and trifles, he made a very humorous song upon the mufti, who gave himself no trouble about the matter, and set out on his travels from planet to planet, in order (as the saying is) to improve his mind and finish his education. Those who never travel but in a postchaise or berlin, will, doubtless, be astonished at the equipages used above; for we that strut upon this little mole-hill are at a loss to conceive anything that surpasses our own customs. But our traveler was a wonderful adept in the laws of gravitation, together with the whole force of attraction and repulsion, and made such seasonable use of his knowledge, that sometimes by the help of a sunbeam, and sometimes by the convenience of a comet, he and his retinue glided from sphere to sphere, as the bird hops from one bough to another.[5] He in a very little time posted through the milky way, and I am obliged to own he saw not a twinkle of those stars supposed to adorn that fair empyrean, which the illustrious Dr. Derham brags to have observed through his telescope. Not that I pretend to say the doctor was mistaken. God forbid! But Micromegas was upon the spot, an exceeding good observer, and I have no mind to contradict any man. Be that as it may, after many windings and turnings, he arrived at the planet Saturn; and, accustomed as he was to the sight of novelties, he could not for his life repress a supercilious and conceited smile, which often escapes the wisest philosopher, when he perceived the smallness of that globe, and the diminutive size of its inhabitants; for really Saturn is but about nine hundred times larger than this our earth, and the people of that country mere dwarfs, about a thousand fathoms high. In short, he at first derided those poor pigmies, just as an Italian fiddler laughs at the music of Lully,[6] at his first arrival in Paris: but as this Sirian was a person of good sense, he soon perceived that a thinking being may not be altogether ridiculous, even though he is not quite six thousand feet high; and therefore he became familiar with them, after they had ceased to wonder at his extraordinary appearance. In particular, he contracted an intimate friendship with the secretary of the Academy of Saturn, a man of good understanding, who, though in truth he had invented nothing of his own, gave a very good account of the inventions of others, and enjoyed in peace the reputation of a little poet and great calculator. And here, for the edification of the reader, I will repeat a very singular conversation that one day passed between Mr. Secretary and Micromegas.

II

The Conversation Between Micromegas and the Inhabitant of Saturn

His excellency having laid himself down, and the secretary approached his nose:

"It must be confessed," said Micromegas, "that nature is full of variety."

"Yes," replied the Saturnian, "nature is like a bed, whose flowers—"

"Pshaw!" cried the other, "a truce with your flower beds."

"It is," resumed the secretary, "like an assembly of fair and brown women, whose dresses—"

"What a plague have I to do with your brunettes?" said our traveler.

"Then it is like a gallery of pictures, the strokes of which—"

"Not at all," answered Micromegas, "I tell you once for all, nature is like nature, and comparisons are odious."[7]

"Well, to please you," said the secretary—

"I won't be pleased," replied the Sirian, "I want to be instructed; begin, therefore, without further preamble, and tell me how many senses the people of this world enjoy."

"We have seventy and two," said the academician, "but we are daily complaining of the small number, as our imagination transcends our wants, for, with the seventy-two senses, our five moons and ring, we find ourselves very much restricted; and notwithstanding our curiosity, and the no small number of those passions that result from these few senses, we have still time enough to be tired of idleness."

"I sincerely believe what you say," cried Micromegas, "for, though we Sirians have near a thousand different senses, there still remains a certain vague desire, an unaccountable inquietude incessantly admonishing us of our own unimportance, and giving us to understand that there are other beings who are much our superiors in point of perfection. I have traveled a little, and seen mortals both above and below myself in the scale of being, but I have met with none who had not more desire than necessity, and more want than gratification. Perhaps I shall one day arrive in some country where nought is wanting, but hitherto I have had no certain information of such a happy land."

The Saturnian and his guest exhausted themselves in conjectures upon this subject, and after abundance of argumentation equally ingenious and uncertain, were fain to return to matter of fact.

"To what age do you commonly live?" said the Sirian.

[5] Voltaire makes an imaginative, poetic use of the recently discovered law of gravity.

[6] Lully was by this time considered the chief of the "French style" in music.

[7] What sort of style is Voltaire mocking here? What does this tell us about his own beliefs in matters of style?

"Lack-a-day! a mere trifle," replied the little gentleman.

"It is the very same case with us," resumed the other, "the shortness of life is our daily complaint, so that this must be an universal law in nature."

"Alas!" cried the Saturnian, "few, very few on this globe outlive five hundred great revolutions of the sun; (these, according to our way of reckoning, amount to about fifteen thousand years). So, you see, we in a manner begin to die the very moment we are born: our existence is no more than a point, our duration an instant, and our globe an atom. Scarce do we begin to learn a little, when death intervenes before we can profit by experience. For my own part, I am deterred from laying schemes when I consider myself as a single drop in the midst of an immense ocean. I am particularly ashamed, in your presence, of the ridiculous figure I make among my fellow-creatures."

To this declaration, Micromegas replied:

"If you were not a philosopher, I should be afraid of mortifying your pride by telling you that the term of our lives is seven hundred times longer than the date of your existence: but you are very sensible that when the texture of the body is resolved, in order to reanimate nature in another form, which is the consequence of what we call death—when that moment of change arrives, there is not the least difference betwixt having lived a whole eternity, or a single day. I have been in some countries where the people live a thousand times longer than with us, and yet they murmured at the shortness of their time. But one will find everywhere some few persons of good sense, who know how to make the best of their portion, and thank the author of nature for his bounty.[8] There is a profusion of variety scattered through the universe, and yet there is an admirable vein of uniformity that runs through the whole: for example, all thinking beings are different among themselves, though at bottom they resemble one another in the powers and passions of the soul. Matter, though interminable, hath different properties in every sphere. How many principal attributes do you reckon in the matter of this world?"

"If you mean those properties," said the Saturnian, "without which we believe this our globe could not subsist, we reckon in all three hundred, such as extent, impenetrability, motion, gravitation, divisibility, et caetera."

"That small number," replied the traveler, "probably answers the views of the creator on this your narrow sphere. I adore his wisdom in all his works. I see infinite variety, but everywhere proportion. Your globe is small: so are the inhabitants. You have few sensations; because your matter is endued with few properties. These are the works of unerring providence. Of what color does your sun appear when accurately examined?"

"Of a yellowish white," answered the Saturnian, "and in separating one of his rays we find it contains seven colors."

"Our sun," said the Sirian, "is of a reddish hue, and we have no less than thirty-nine original colors. Among all the suns I have seen there is no sort of resemblance, and in this sphere of yours there is not one face like another."

After divers questions of this nature, he asked how many substances, essentially different, they counted in the world of Saturn; and understood that they numbered but thirty: such as God; space; matter; beings endowed with sense and extension; beings that have extension, sense, and reflection; thinking beings who have no extension; those that are penetrable; those that are impenetrable, and also all others. But this Saturnian philosopher was prodigiously astonished when the Sirian told him they had no less than three hundred, and that he himself had discovered three thousand more in the course of his travels. In short, after having communicated to each other what they knew, and even what they did not know, and argued during a complete revolution of the sun, they resolved to set out together on a small philosophical tour.

III

The Voyage of These Inhabitants of Other Worlds

Our two philosophers were just ready to embark for the atmosphere of Saturn, with a large provision of mathematical instruments, when the Saturnian's mistress, having got an inkling of their design, came all in tears to make her protests. She was a handsome brunette, though not above six hundred and threescore fathoms high; but her agreeable attractions made amends for the smallness of her stature.

"Ah! cruel man," cried she, "after a courtship of fifteen hundred years, when at length I surrendered, and became your wife, and scarce have passed two hundred more in thy embraces, to leave me thus, before the honeymoon is over, and go a rambling with a giant of another world! Go, go, thou art a mere virtuoso, devoid of tenderness and love! If thou wert a true Saturnian, thou wouldst be faithful and invariable. Ah! whither art thou going? what is thy design? Our five moons are not so inconstant, nor our ring so changeable as thee! But take this along with thee, henceforth I ne'er shall love another man."

The little gentleman embraced and wept over her, notwithstanding his philosophy; and the lady, after having swooned with great decency, went to console herself with more agreeable company.

[8] Here Voltaire gets in some jibes at the whole Christian tradition that views heaven as the proper end of man after death.

Meanwhile our two virtuosi set out, and at one jump leaped upon the ring, which they found pretty flat, according to the ingenious guess of an illustrious inhabitant of this our little earth. From thence they easily slipped from moon to moon; and a comet chancing to pass, they sprang upon it with all their servants and apparatus. Thus carried about one hundred and fifty million of leagues, they met with the satellites of Jupiter, and arrived upon the body of the planet itself, where they continued a whole year; during which they learned some very curious secrets, which would actually be sent to the press, were it not for fear of the gentlemen inquisitors, who have found among them some corollaries very hard of digestion.

But to return to our travelers. When they took leave of Jupiter, they traversed a space of about one hundred millions of leagues, and coasting along the planet Mars, which is well known to be five times smaller than our little earth, they descried two moons subservient to that orb, which have escaped the observation of all our astronomers. . . . Be that as it may, our gentlemen found the planet so small, that they were afraid they should not find room to take a little repose; so that they pursued their journey like two travelers who despise the paltry accommodation of a village, and push forward to the next market town. But the Sirian and his companion soon repented of their delicacy; for they journeyed a long time without finding a resting place, till at length they discerned a small speck, which was the Earth. Coming from Jupiter, they could not but be moved with compassion at the sight of this miserable spot, upon which, however, they resolved to land, lest they should be a second time disappointed. They accordingly moved toward the tail of the comet, where, finding an Aurora Borealis ready to set sail, they embarked, and arrived on the northern coast of the Baltic on the fifth day of July, new style, in the year 1737.

IV

What Befell Them upon This Our Globe

Having taken some repose, and being desirous of reconnoitering the narrow field in which they were, they traversed it at once from north to south. Every step of the Sirian and his attendants measured about thirty thousand royal feet: whereas, the dwarf of Saturn, whose stature did not exceed a thousand fathoms, followed at a distance quite out of breath; because, for every single stride of his companion, he was obliged to make twelve good steps at least. The reader may figure to himself, (if we are allowed to make such comparisons,) a very little rough spaniel dodging after a captain of the Prussian grenadiers.

As those strangers walked at a good pace, they compassed the globe in six and thirty hours; the sun, it is true, or rather the earth, describes the same space in the course of one day; but it must be observed that it is much easier to turn upon an axis than to walk a-foot. Behold them then returned to the spot from whence they had set out, after having discovered that almost imperceptible sea, which is called the Mediterranean; and the other narrow pond that surrounds this mole-hill, under the denomination of the great ocean; in wading through which the dwarf had never wet his mid-leg, while the other scarce moistened his heel.[9] In going and coming through both hemispheres, they did all that lay in their power to discover whether or not the globe was inhabited. They stooped, they lay down, they groped in every corner; but their eyes and hands were not at all proportioned to the small beings that crawl upon this earth; and, therefore, they could not find the smallest reason to suspect that we and our fellow-citizens of this globe had the honor to exist.

The dwarf, who sometimes judged too hastily, concluded at once that there was no living creatures upon earth; and his chief reason was, that he had seen nobody. But Micromegas, in a polite manner, made him sensible of the unjust conclusion:

"For," said he, "with your diminutive eyes you cannot see certain stars of the fiftieth magnitude, which I easily perceive; and do you take it for granted that no such stars exist?"

"But I have groped with great care," replied the dwarf.

"Then your sense of feeling must be bad," said the other.

"But this globe," said the dwarf, "is ill contrived; and so irregular in its form as to be quite ridiculous. The whole together looks like a chaos. Do but observe these little rivulets; not one of them runs in a straight line: and these ponds which are neither round, square, nor oval, nor indeed of any regular figure; together with these little sharp pebbles, (meaning the mountains,) that roughen the whole surface of the globe, and have torn all the skin from my feet. Besides, pray take notice of the shape of the whole, how it flattens at the poles, and turns round the sun in an awkward oblique manner, so as that the polar circles cannot possibly be cultivated. Truly, what makes me believe there is no inhabitant on this sphere, is a full persuasion that no sensible being would live in such a disagreeable place."

"What then?" said Micromegas, "perhaps the beings that inhabit it come not under that denomination; but, to all appearance, it was not made for nothing. Everything here seems to you irregular; because you fetch all your comparisons from Jupiter or Saturn. Perhaps this is the very reason of the seeming confusion which you condemn; have I not told you, that in the course of my travels I have always met with variety?"

[9] Voltaire had no idea of the depth of the Atlantic Ocean.

The Saturnian replied to all these arguments; and perhaps the dispute would have known no end, if Micromegas, in the heat of the contest, had not luckily broken the string of his diamond necklace, so that the jewels fell to the ground; they consisted of pretty small unequal karats, the largest of which weighed four hundred pounds, and the smallest fifty. The dwarf, in helping to pick them up, perceived, as they approached his eye, that every single diamond was cut in such a manner as to answer the purpose of an excellent microscope. He therefore took up a small one, about one hundred and sixty feet in diameter, and applied it to his eye, while Micromegas chose another of two thousand five hundred feet. Though they were of excellent powers, the observers could perceive nothing by their assistance, so they were altered and adjusted. At length, the inhabitant of Saturn discerned something almost imperceptible moving between two waves in the Baltic. This was no other than a whale, which, in a dexterous manner, he caught with his little finger, and, placing it on the nail of his thumb, showed it to the Sirian, who laughed heartily at the excessive smallness peculiar to the inhabitants of this our globe. The Saturnian, by this time convinced that our world was inhabited, began to imagine we had no other animals than whales; and being a mighty debater, he forthwith set about investigating the origin and motion of this small atom, curious to know whether or not it was furnished with ideas, judgment, and free will. Micromegas was very much perplexed upon this subject. He examined the animal with the most patient attention, and the result of his inquiry was, that he could see no reason to believe a soul was lodged in such a body. The two travelers were actually inclined to think there was no such thing as mind in this our habitation, when, by the help of their microscope, they perceived something as large as a whale floating upon the surface of the sea. It is well known that, at this period, a flight of philosophers were upon their return from the polar circle,[10] where they had been making observations, for which nobody has hitherto been the wiser. The gazettes record, that their vessel ran ashore on the coast of Bothnia and that they with great difficulty saved their lives; but in this world one can never dive to the bottom of things. For my own part, I will ingenuously recount the transaction just as it happened, without any addition of my own; and this is no small effort in a modern historian.

V

The Travelers Capture a Vessel

Micromegas stretched out his hand gently toward the place where the object appeared, and advanced two fingers, which he instantly pulled back, for fear of being disappointed, then opening softly and shutting them all at once, he very dexterously seized the ship that contained those gentlemen, and placed it on his nail, avoiding too much pressure, which might have crushed the whole in pieces.

"This," said the Saturnian dwarf, "is a creature very different from the former."

Upon which the Sirian placing the supposed animal in the hollow of his hand, the passengers and crew, who believed themselves thrown by a hurricane upon some rock, began to put themselves in motion. The sailors having hoisted out some casks of wine, jumped after them into the hand of Micromegas: the mathematicians having secured their quadrants, sectors, and Lapland servants, went overboard at a different place, and made such a bustle in their descent, that the Sirian at length felt his fingers tickled by something that seemed to move. An iron bar chanced to penetrate about a foot deep into his forefinger; and from this prick he concluded that something had issued from the little animal he held in his hand; but at first he suspected nothing more: for the microscope, that scarce rendered a whale and a ship visible, had no effect upon an object so imperceptible as man.

I do not intend to shock the vanity of any person whatever; but here I am obliged to beg your people of importance to consider that, supposing the stature of a man to be about five feet, we mortals make just such a figure upon the earth, as an animal the sixty thousandth part of a foot in height, would exhibit upon a bowl ten feet in circumference. When you reflect upon a being who could hold this whole earth in the palm of his hand, and is provided with organs proportioned to those we possess, you will easily conceive that there must be a great variety of created substances;—and pray, what must such beings think of those battles by which a conqueror gains a small village, to lose it again in the sequel?

I do not at all doubt, but if some captain of grenadiers should chance to read this work, he would add two large feet at least to the caps of his company; but I assure him his labor will be in vain; for, do what he will, he and his soldiers will never be other than infinitely diminutive and inconsiderable.

What wonderful address must have been inherent in our Sirian philosopher, that enabled him to perceive those atoms of which we have been speaking. When Leeuwenhoek and Hartsoecker[11] observed the first rudiments of which we are formed, they did not make such an astonishing discovery. What pleasure, therefore, was the portion of Micromegas, in observing the motion of those little machines, in examining all their

[10] Expedition to the North Pole organized by Maupertius in 1736. The ship was wrecked during its return in 1737.

[11] Dutch scientists. Leeuwenhoek invented the microscope.

pranks, and following them in all their operations! With what joy did he put his microscope into his companion's hand; and with what transport did they both at once exclaim:

"I see them distinctly,—don't you see them carrying burdens, lying down and rising up again?"

So saying, their hands shook with eagerness to see, and apprehension to lose such uncommon objects. The Saturnian, making a sudden transition from the most cautious distrust to the most excessive credulity, imagined he saw them engaged in their devotions and cried aloud in astonishment.

Nevertheless, he was deceived by appearances: a case too common, whether we do or do not make use of microscopes.

VI

What Happened in Their Intercourse with Men

Micromegas being a much better observer than the dwarf, perceived distinctly that those atoms spoke; and made the remark to his companion, who was so much ashamed of being mistaken in his first suggestion, that he would not believe such a puny species could possibly communicate their ideas: for, though he had the gift of tongues, as well as his companion, he could not hear those particles speak; and therefore supposed they had no language.

"Besides, how should such imperceptible beings have the organs of speech? and what in the name of Jove can they say to one another? In order to speak, they must have something like thought, and if they think, they must surely have something equivalent to a soul. Now, to attribute anything like a soul to such an insect species appears a mere absurdity."

"But just now," replied the Sirian, "you believed they were engaged in devotional exercises; and do you think this could be done without thinking, without using some sort of language, or at least some way of making themselves understood? Or do you suppose it is more difficult to advance an argument than to engage in physical exercise? For my own part, I look upon all faculties as alike mysterious."

"I will no longer venture to believe or deny," answered the dwarf: "in short I have no opinion at all. Let us endeavor to examine these insects, and we will reason upon them afterward."[12]

"With all my heart," said Micromegas, who, taking out a pair of scissors which he kept for paring his nails, cut off a paring from his thumb nail, of which he immediately formed a large kind of speaking trumpet, like a vast tunnel, and clapped the pipe to his ear: as the cir-

cumference of this machine included the ship and all the crew, the most feeble voice was conveyed along the circular fibres of the nail; so that, thanks to his industry, the philosopher could distinctly hear the buzzing of our insects that were below. In a few hours he distinguished articulate sounds, and at last plainly understood the French language. The dwarf heard the same, though with more difficulty.

The astonishment of our travelers increased every instant. They heard a nest of mites talk in a very sensible strain: and that *Lusus Naturae* seemed to them inexplicable. You need not doubt but the Sirian and his dwarf glowed with impatience to enter into conversation with such atoms. Micromegas being afraid that his voice, like thunder, would deafen and confound the mites, without being understood by them, saw the necessity of diminishing the sound; each, therefore, put into his mouth a sort of small toothpick, the slender end of which reached to the vessel. The Sirian setting the dwarf upon his knees, and the ship and crew upon his nail, held down his head and spoke softly. In fine, having taken these and a great many more precautions, he addressed himself to them in these words:

"O ye invisible insects, whom the hand of the Creator hath deigned to produce in the abyss of infinite littleness! I give praise to his goodness, in that he hath been pleased to disclose unto me those secrets that seemed to be impenetrable."

If ever there was such a thing as astonishment, it seized upon the people who heard this address, and who could not conceive from whence it proceeded. The chaplain of the ship repeated exorcisms, the sailors swore, and the philosophers formed a system: but, notwithstanding all their systems, they could not divine who the person was that spoke to them. Then the dwarf of Saturn, whose voice was softer than that of Micromegas, gave them briefly to understand what species of beings they had to do with. He related the particulars of their voyage from Saturn, made them acquainted with the rank and quality of Monsieur Micromegas; and, after having pitied their smallness, asked if they had always been in that miserable state so near akin to annihilation; and what their business was upon that globe which seemed to be the property of whales. He also desired to know if they were happy in their situation? if they were inspired with souls? and put a hundred questions of the like nature.

A certain mathematician on board, braver than the rest, and shocked to hear his soul called in question, planted his quadrant,[13] and having taken two observations of this interlocutor, said: "You believe then, Mr. what's your name, that because you measure from head to foot a thousand fathoms—"

[12] The "scientific method."

[13] Instrument for measuring distant objects.

"A thousand fathoms!" cried the dwarf, "good heavens! How should he know the height of my stature? A thousand fathoms! My very dimensions to a hair. What, measured by a mite! This atom, forsooth, is a geometrician, and knows exactly how tall I am: while I, who can scarce perceive him through a microscope, am utterly ignorant of his extent!"

"Yes, I have taken your measure," answered the philosopher, "and I will now do the same by your tall companion."

The proposal was embraced: his excellency reclined upon his side; for, had he stood upright, his head would have reached too far above the clouds. Our mathematicians planted a tall tree near him, and then, by a series of triangles joined together, they discovered that the object of their observation was a strapping youth, exactly one hundred and twenty thousand royal feet in length. In consequence of this calculation, Micromegas uttered these words:

"I am now more than ever convinced that we ought to judge of nothing by its external magnitude. O God! who hast bestowed understanding upon such seemingly contemptible substances, thou canst with equal ease produce that which is infinitely small, as that which is incredibly great: and if it be possible, that among thy works there are beings still more diminutive than these, they may nevertheless be endued with understanding superior to the intelligence of those stupendous animals I have seen in heaven, a single foot of whom is larger than this whole globe on which I have alighted."

One of the philosophers assured him that there were intelligent beings much smaller than men, and recounted not only Virgil's whole fable of the bees; but also described all that Swammerdam hath discovered, and Reaumur dissected. In a word, he informed him that there are animals which bear the same proportion to bees, that bees bear to man; the same as the Sirian himself compared to those vast beings whom he had mentioned; and as those huge animals as to other substances, before whom they would appear like so many particles of dust. Here the conversation became very interesting, and Micromegas proceeded in these words:

"O ye intelligent atoms, in whom the Supreme Being hath been pleased to manifest his omniscience and power, without all doubt your joys on this earth must be pure and exquisite: for, being unincumbered with matter, and, to all appearance, little else than soul, you must spend your lives in the delights of pleasure and reflection, which are the true enjoyments of a perfect spirit. True happiness I have no where found, but certainly here it dwells."

At this harangue all the philosophers shook their heads, and one among them, more candid than his brethren, frankly owned, that excepting a very small number of inhabitants who were very little esteemed by their fellows, all the rest were a parcel of knaves, fools, and miserable wretches.

"We have matter enough," said he, "to do abundance of mischief, if mischief comes from matter; and too much understanding, if evil flows from understanding. You must know, for example, that at this very moment, while I am speaking, there are one hundred thousand animals of our own species, covered with hats, slaying an equal number of their fellow-creatures, who wear turbans; at least they are either slaying or being slain; and this hath usually been the case all over the earth from time immemorial."[14]

The Sirian, shuddering at this information, begged to know the cause of those horrible quarrels among such a puny race; and was given to understand that the subject of the dispute was a pitiful mole-hill no larger than his heel. Not that any one of those millions who cut one another's throats pretends to have the least claim to the smallest particle of that clod. The question is, whether it shall belong to a certain person who is known by the name of Sultan, or to another whom (for what reason I know not) they dignify with the appellation of Tsar. Neither the one nor the other has seen or ever will see the pitiful corner in question; and probably none of these wretches, who so madly destroy each other, ever beheld the ruler on whose account they are so mercilessly sacrificed!

"Ah, miscreants!" cried the indignant Sirian, "such excess of desperate rage is beyond conception. I have a good mind to take two or three steps, and trample the whole nest of such ridiculous assassins under my feet."

"Don't give yourself the trouble," replied the philosopher, "they are industrious enough in procuring their own destruction. At the end of ten years the hundredth part of those wretches will not survive; for you must know that, though they should not draw a sword in the cause they have espoused, famine, fatigue, and intemperance, would sweep almost all of them from the face of the earth. Besides, the punishment should not be inflicted upon them, but upon those sedentary and slothful barbarians, who, from their palaces, give orders for murdering a million of men and then solemnly thank God for their success."

Our traveler was moved with compassion for the entire human race, in which he discovered such astonishing contrast. "Since you are of the small number of the wise," said he, "and in all likelihood do not engage yourselves in the trade of murder for hire, be so good as to tell me your occupation."

"We anatomize flies," replied the philosopher, "we measure lines, we make calculations, we agree upon

[14] Reference to the war between the Russians and the Turks over Crimea.

two or three points which we understand, and dispute upon two or three thousand that are beyond our comprehension."

"How far," said the Sirian, "do you reckon the distance between the great star of the constellation Gemini and that called Caniculae?"

To this question all of them answered with one voice: "Thirty-two degrees and a half."

"And what is the distance from hence to the moon?"

"Sixty semi-diameters of the earth."

He then thought to puzzle them by asking the weight of the air; but they answered distinctly, that common air is about nine hundred times specifically lighter than an equal column of the lightest water, and nineteen hundred times lighter than current gold. The little dwarf of Saturn, astonished at their answers, was now tempted to believe those people sorcerers, who, but a quarter of an hour before, he would not allow were inspired with souls.

"Well," said Micromegas, "since you know so well what is without you, doubtless you are still more perfectly acquainted with that which is within. Tell me what is the soul, and how do your ideas originate?"

Here the philosophers spoke altogether as before; but each was of a different opinion. The eldest quoted Aristotle; another pronounced the name of Descartes; a third mentioned Malebranche; a fourth Leibnitz; and a fifth Locke. An old peripatecian lifting up his voice, exclaimed with an air of confidence. "The soul is perfection and reason, having power to be such as it is, as Aristotle expressly declares, page 633, of the Louvre edition:

"Εντελεχεια τις εςι, και λογος τ8 δυναμιν εχοντθς τοι8δι ειται."

"I am not very well versed in Greek," said the giant.

"Nor I either," replied the philosophical mite.

"Why then do you quote that same Aristotle in Greek?" resumed the Sirian.

"Because," answered the other, "it is but reasonable we should quote what we do not comprehend in a language we do not understand."

Here the Cartesian interposed: "The soul," said he, "is a pure spirit or intelligence, which hath received before birth all the metaphysical ideas; but after that event it is obliged to go to school and learn anew the knowledge which it hath lost."[15]

"So it was necessary," replied the animal of eight leagues, "that thy soul should be learned before birth, in order to be so ignorant when thou hast got a beard upon thy chin. But what dost thou understand by spirit?"

"I have no idea of it," said the philosopher, "indeed it is supposed to be immaterial."

"At least, thou knowest what matter is?" resumed the Sirian.

"Perfectly well," answered the other. "For example: that stone is gray, is of a certain figure, has three dimensions, specific weight, and divisibility."

"I want to know," said the giant, "what that object is, which, according to thy observation, hath a gray color, weight, and divisibility. Thou seest a few qualities, but dost thou know the nature of the thing itself?"

"Not I, truly," answered the Cartesian.

Upon which the Sirian admitted that he also was ignorant in regard to this subject. Then addressing himself to another sage, who stood upon his thumb, he asked "what is the soul? and what are her functions?"

"Nothing at all," replied this disciple of Malebranche; "God hath made everything for my convenience. In him I see everything, by him I act; he is the universal agent, and I never meddle in his work."

"That is being a nonentity indeed," said the Sirian sage; and then, turning to a follower of Leibnitz, he exclaimed: "Hark ye, friend, what is thy opinion of the soul?"

"In my opinion," answered this metaphysician, "the soul is the hand that points at the hour, while my body does the office of the clock; or, if you please, the soul is the clock, and the body is the pointer; or again, my soul is the mirror of the universe, and my body the frame. All this is clear and uncontrovertible."

A little partisan of Locke who chanced to be present, being asked his opinion on the same subject, said: "I do not know by what power I think; but well I know that I should never have thought without the assistance of my senses. That there are immaterial and intelligent substances I do not at all doubt; but that it is impossible for God to communicate the faculty of thinking to matter, I doubt very much. I revere the eternal power, to which it would ill become me to prescribe bounds. I affirm nothing, and am contented to believe that many more things are possible than are usually thought so."

The Sirian smiled at this declaration, and did not look upon the author as the least sagacious of the company: and as for the dwarf of Saturn, he would have embraced this adherent of Locke, had it not been for the extreme disproportion in their respective sizes. But unluckily there was another animalcule in a square cap,[16] who, taking the word from all his philosophical brethren, affirmed that he knew the whole secret. He surveyed the two celestial strangers from top to toe, and maintained to their faces that their persons, their fashions, their suns and their stars, were created solely for

[15] Descartes believed in innate ideas.

[16] A theologian.

the use of man. At this wild assertion our two travelers were seized with a fit of that uncontrollable laughter, which (according to Homer) is the portion of the immortal gods: their bellies quivered, their shoulders rose and fell, and during these convulsions, the vessel fell from the Sirian's nail into the Saturnian's pocket, where these worthy people searched for it a long time with great diligence. At length, having found the ship and set everything to rights again, the Sirian resumed the discourse with those diminutive mites, and promised to compose for them a choice book of philosophy which would demonstrate the very essence of things. Accordingly, before his departure, he made them a present of the book, which was brought to the Academy of Sciences at Paris, but when the old secretary came to open it he saw nothing but blank paper.

"Ay, ay," said he, "this is just what I suspected."

COMMENTS AND QUESTIONS

1. Voltaire's tale is a good example of the "philosophical" combination of critical reason, admiration for science, and fantasy. Find instances of Voltaire's use of all of these.

2. Where, specifically, does Voltaire say what he does not mean so that the reader will infer the opposite (*irony*)?

3. Against what ideas and what people is his *satire* directed?

4. Blaise Pascal concluded from the new scientific discoveries that man's place between the infinitely large and the infinitely small is a terrifying one, and that man can be saved only by God's grace. What is Voltaire's opinion of this view?

5. Do you as a modern reader find it easy to enter into the spirit of this tale of giants? Is the story still lively, amusing, and relevant?

from the *Philosophical Dictionary*

Translation by William F. Fleming

China

Section I

We have frequently observed elsewhere, how rash and injudicious it is to controvert with any nation, such as the Chinese, its authentic pretensions. There is no house in Europe, the antiquity of which is so well proved as that of the Empire of China. . . .

Many of the learned of our northern climes have felt confounded at the antiquity claimed by the Chinese.

The question, however, is not one of learning. Leaving all the Chinese literati, all the mandarins, all the emperors, to acknowledge Fo-hi as one of the first who gave laws to China, about two thousand five hundred years before our vulgar era; admit that there must be people before there are kings. Allow that a long period of time is necessary before a numerous people, having discovered the necessary arts of life, unite in the choice of a common governor. But if you do not make these admissions, it is not of the slightest consequence. Whether you agree with us or not, we shall always believe that two and two make four.

In a western province, formerly called Celtica, the love of singularity and paradox has been carried so far as to induce some to assert that the Chinese were only an Egyptian, or rather perhaps a Phoenician colony. It was attempted to prove, in the same way as a thousand other things have been proved, that a king of Egypt, called Menes by the Greeks, was the Chinese King Yu; and that Atoes was Ki, by the change of certain letters. In addition to which, the following is a specimen of the reasoning applied to the subject:

The Egyptians sometimes lighted torches at night. The Chinese light lanterns: the Chinese are, therefore, evidently a colony from Egypt. The Jesuit Parennin who had, at the time, resided five and twenty years in China, and was master both of its language and its sciences, has rejected all these fancies with a happy mixture of elegance and sarcasm. All the missionaries, and all the Chinese, on receiving the intelligence that a country in the extremity of the west was developing a new formation of the Chinese Empire, treated it with a contemptuous ridicule. Father Parennin replied with somewhat more seriousness: "Your Egyptians," said he, "when going to people China, must evidently have passed through India." Was India at that time peopled or not? If it was, would it permit a foreign army to pass through it? If it was not, would not the Egyptians have stopped in India? Would they have continued their journey through barren deserts, and over almost impracticable mountains, till they reached China, in order to form colonies there, when they might so easily have established them on the fertile banks of the Indus or the Ganges?

The compilers of a universal history, printed in England, have also shown a disposition to divest the Chinese of their antiquity, because the Jesuits were the first who made the world acquainted with China. This is unquestionably a very satisfactory reason for saying to a whole nation—"You are liars."

It appears to me a very important reflection, which may be made on the testimony given by Confucius, to the antiquity of his nation; and which is, that Confucius had no interest in falsehood: he did not pretend to be a prophet; he claimed no inspiration: he taught no new religion; he used no delusions; flattered not the emperor

under whom he lived: he did not even mention him. In short, he is the only founder of institutions among mankind who was not followed by a train of women.

I knew a philosopher who had no other portrait than that of Confucius in his study. At the bottom of it were written the following lines:

Without assumption he explored the mind,
Unveiled the light of reason to mankind;
Spoke as a sage, and never as a seer,
Yet, strange to say, his country held him dear.

I have read his books with attention; I have made extracts from them; I have found in them nothing but the purest morality, without the slightest tinge of charlatanism. He lived six hundred years before our vulgar era. His works were commented on by the most learned men of the nation. If he had falsified, if he had introduced a false chronology, if he had written of emperors who never existed, would not some one have been found, in a learned nation, who would have reformed his chronology? One Chinese only has chosen to contradict him, and he met with universal execration.

Were it worth our while, we might here compare the great wall of China with the monuments of other nations, which have never even approached it; and remark, that, in comparison with this extensive work, the pyramids of Egypt are only puerile and useless masses. We might dwell on the thirty-two eclipses calculated in the ancient chronology of China, twenty-eight of which have been verified by the mathematicians of Europe. We might show, that the respect entertained by the Chinese for their ancestors is an evidence that such ancestors have existed; and repeat the observation, so often made, that this reverential respect has in so small degree impeded, among this people, the progress of natural philosophy, geometry, and astronomy.

It is sufficiently known, that they are, at the present day, what we all were three hundred years ago, very ignorant reasoners. The most learned Chinese is like one of the learned of Europe in the fifteenth century, in possession of his Aristotle. But it is possible to be a very bad natural philosopher, and at the same time an excellent moralist. It is, in fact, in morality, in political economy, in agriculture, in the necessary arts of life, that the Chinese have made such advances towards perfection. All the rest they have been taught by us: in these we might well submit to become their disciples.

Of the Expulsion of the Missionaries from China

Humanly speaking, independently of the service which the Jesuits might confer on the Christian religion, are they not to be regarded as an ill-fated class of men, in having travelled from so remote a distance to introduce trouble and discord into one of the most extended and best-governed kingdoms of the world? And does not their conduct involve a dreadful abuse of the liberality and indulgence shown by the Orientals, more particularly after the torrents of blood shed, through their means, in the empire of Japan? A scene of horror, to prevent the consequence of which the government believed it absolutely indispensable to shut their ports against all foreigners.

The Jesuits had obtained permission of the emperor of China, Cam-hi, to teach the Catholic religion. They made use of it, to instil into the small portion of the people under their direction, that it was incumbent on them to serve no other master than him who was the vicegerent of God on earth, and who dwelt in Italy on the banks of a small river called the Tiber; that every other religious opinion, every other worship was an abomination in the sight of God, and whoever did not believe the Jesuits would be punished by Him to all eternity; that their emperor and benefactor, Cam-hi, who could not even pronounce the name of Christ, as the Chinese language possesses not the letter "r," would suffer eternal damnation; that the Emperor Youtchin would experience, without mercy, the same fate; that all the ancestors, both of Chinese and Tartars, would incur a similar penalty; that their descendants would undergo it also, as well as the rest of the world; and that the reverend fathers, the Jesuits, felt a sincere and paternal commiseration for the damnation of so many souls.

COMMENTS AND QUESTIONS

1. How does Voltaire go about proving that China could not have been a colony of the Egyptians? Why is this important to him?

2. What is Voltaire's view of Confucius? What implicit and explicit contrasts does he make between Confucius and European philosophers?

3. What are, according to Voltaire, the strengths and the weaknesses of modern Chinese culture? What should Europe learn from China?

4. In the final section, how does Voltaire go about satirizing the Jesuits? What does this tell us about his views on religion?

5. One of the major values advocated by Voltaire and by the philosophes generally was that of *tolerance* of other cultures, races, religions, and political systems. To what extent is tolerance an ideal and a reality in our own society? What, if any, limits should be put on the ideal of tolerance? How can you justify them?

MONTESQUIEU

from *The Persian Letters*

Translation by J. Robert Loy

Montesquieu's satires cover a wide range of contemporary life. In the following selections purportedly written by Persian emissaries, Usbek and Rica try to explain to their compatriots two of the prime institutions of the West: the Roman papacy and the French monarchy.

Letter XXIX

Rica to Ibben in Smyrna

The Pope is the head of the Christians. He is an old idol worshiped out of habit. Formerly he was to be feared even by kings, for he deposed them as easily as our magnificent sultans depose the kings of Imirette and Georgia.[1] But now he is no longer feared. He claims that he is the successor of one of the first Christians, who is called Saint Peter, and his is most certainly a rich succession, for he has immense treasures and a great country under his domination.

Bishops are lawyers subordinate to him, and they have, under his authority, two quite different functions. When they are assembled together they create, as does he, articles of faith. When they are acting individually they have scarcely any other function except to give dispensation from fulfilling the law. For you must know that the Christian religion is weighed down with an infinity of very difficult practices. And since it has been decided that it is less easy to fulfill these duties than to have bishops around who can dispense with them, this last alternative was chosen out of a sense of common good. In this way, if you don't wish to keep Ramadan, if you don't choose to be subjected to the formalities of marriage, if you wish to break your vows, if you would like to marry in contravention of the prohibitions of the law, even sometimes if you want to break a sworn oath—you go to the bishop or the Pope and you are given immediate dispensation.

Bishops do not create articles of faith by their own decision. There are countless doctors, most of them dervishes, who introduce among themselves thousands of new questions touching upon religion.[2] They are allowed to dispute at great length, and the war goes on until a decision comes along to finish it.

And thus I can assure you that there never has been a kingdom where there are so many civil wars as in the Kingdom of Christ.

Those who propose some new proposition are called at first *heretics*. Each heresy has its own name, and this name becomes for those who are involved, something like a rallying cry. But no one has to be a heretic. One needs only split the difference in half and give some distinction[3] to those who make accusations of heresy, and whatever the distinction—logical or not—it makes a man white as snow, and he may have himself called *orthodox*.

What I am telling you is valid for France and Germany, for I have heard it said that in Spain and Portugal there are certain dervishes who stand for no nonsense and will have a man burned as if he were straw.[4] When people fall into the hands of those fellows, happy is he who has always prayed to God with little wooden beads in his hand, who has worn on his person two strips of cloth attached to two ribbons, or who has at some time been in a province called Galicia.[5] Without that, the poor devil is in bad straits. Even should he swear like a pagan that he is orthodox, they might quite possibly disagree with him on his qualifications and burn him for a heretic. He could talk all he likes of distinctions to be made—there is no distinction, for he would be in ashes before they even considered listening to him.

Other judges assume that an accused man is innocent until proved guilty; these judges always assume him guilty. When in doubt, they have as their rule always to decide on the side of severity, apparently because they believe men to be bad. But then, from another point of view, they have such a good opinion of men that they never judge them capable of lying, for they receive the testimony of professed enemies, of women of evil repute, of those who ply an infamous profession.[6] In their sentences they include a little compliment for those clad in the brimstone shirt by telling them that they are very vexed to see them so badly dressed, that they as judges are gentle people and abhor blood and are truly grieved to have condemned them. However, to console

[1] States alternately under Turkish and Persian rule.

[2] Scholastic theologians are meant.

[3] Distinction is a term of dialectic: using the several meanings of a proposition in order to escape difficulties.

[4] The Spanish Inquisition, controlled by the Spanish monarch, was regarded as very harsh.

[5] Two ribbons refers to the scapulary carried around the neck of a priest. Galicia is the Spanish province where a famous pilgrimage objective, Santiago de Compostela, is located.

[6] According to Montesquieu, the testimony of anyone willing to testify to the accused's heretical beliefs is accepted.

their grief, they confiscate all the property of these wretches to their own advantage.[7]

Happy the land inhabited by the sons of the prophets! These sad spectacles are unknown there.[8] The holy religion brought to that land by the angels is protected by its very truth; it needs none of these violent means to preserve itself.

> From Paris, the 4th of the
> Moon of Shalval, 1712.

Letter XXXVII

Usbek to Ibben in Smyrna

The King of France is old.[1] We have no example in our history books of a monarch who has reigned so long. It is said that he possesses a high degree of talent for making himself obeyed. He governs with equal talent his family, his court, and his state. People have often heard him say that, of all the governments in the world, that of the Turks, or that of our august sultan would please him best—so much significance does he attach to Oriental politics.

I have studied his character and I find in it contradictions impossible for me to resolve. For example, he has a minister who is only eighteen years old, and a mistress who is eighty.[2] He loves his religion, and yet he cannot stand those who say that religion should be observed to the last letter.[3] Although he flees the tumult of cities and is not very communicative, still he is concerned from morning to night only with having himself talked about. He likes triumphs and victories but he is just as afraid of having a good general at the head of his own troops as he would be to have him at the head of an enemy army. To be at once weighed down with more riches than any prince could hope for and cursed with poverty that an individual could not support, has happened, I believe, only to him.[4]

He likes to reward those who serve him, yet he pays just as liberally for the constant attendance, or rather, the idleness of his courtiers as for the hard-fought campaigns of his captains. Often he shows preferment to a man who undresses him or who hands him his napkin when he sits down to table over some other who takes cities for him and wins battles. He does not feel that sovereign grandeur should be bothered with the doling out of favors, and without ever inquiring whether the man he showers with wealth is deserving, believes that his choosing him will make him so. Thus, he has been known to give a small pension to a man who fled two leagues in battle and a handsome governorship to another who fled four.

He is magnificent, particularly in his buildings. There are more statues in the gardens of his palace than there are citizens in a big city. His personal guard is as strong as the guard of that prince before whom all thrones topple.[5] His armies are just as large, his resources just as great, and his finances just as limitless.

> From Paris, the 7th of the
> Moon of Maharram, 1713.

COMMENTS AND QUESTIONS

1. How does the Church's power of dispensation make it possible for people to live with the Christian religion and its strict practices?

2. What criticism does the author make of the Spanish Inquisition, and what is his purpose in doing so?

3. Why does he claim that his own religion does not need an inquisition? What implication is this intended to have for Christians who believe in the truth of their faith?

4. What approach does Montesquieu use as a way of satirizing Louis XIV?

JEAN-JACQUES ROUSSEAU

from *The Social Contract*

Translation by Henry J. Tozer

The Social Pact

I assume that men have reached a point at which the obstacles that endanger their preservation in the state of nature overcome by their resistance the forces which each individual can exert with a view to maintaining himself in that state. Then this primitive condition can no longer subsist, and the human race would perish unless it changed its mode of existence.

[7] The property of an individual condemned for heresy was forfeited to the government, and the family of the condemned could not inherit.

[8] The Persians were considered by the Muslims most tolerant of other faiths.

[1] The letter, dated 1713, refers to the aged Louis XIV.

[2] The youngest minister of Louis XIV was Barbézieux, who was secretary of state in 1691 at the age of twenty-three. Mme. de Maintenon, first the king's mistress and then his wife, was seventy-eight at the date of this letter.

[3] He vigorously opposed the Jansenists, a group of Catholics who insisted on a strict Catholicism.

[4] Although the king had large revenues, his expenses always exceeded his income.

[5] The reference here is to the sultan of Persia.

Now, as men cannot create any new forces, but only combine and direct those that exist, they have no other means of self-preservation than to form by aggregation a sum of forces which may overcome the resistance, to put them in action by a single motive power, and to make them work in concert.

This sum of forces can be produced only by the combination of many; but the strength and freedom of each man being the chief instruments of his preservation, how can he pledge them without injuring himself, and without neglecting the cares which he owes to himself? This difficulty, applied to my subject, may be expressed in these terms:

"To find a form of association which may defend and protect with the whole force of the community the person and property of every associate, and by means of which each, coalescing with all, may nevertheless obey only himself, and remain as free as before." Such is the fundamental problem of which the social contract furnishes the solution.

The clauses of this contract are so determined by the nature of the act that the slightest modification would render them vain and ineffectual; so that, although they have never perhaps been formally enunciated, they are everywhere the same, everywhere tacitly admitted and recognised, until, the social pact being violated, each man regains his original rights and recovers his natural liberty, whilst losing the conventional liberty for which he renounced it.

These clauses, rightly understood, are reducible to one only, viz. The total alienation to the whole community of each associate with all rights; for, in the first place, since each gives himself up entirely, the conditions are equal for all; and, the conditions being equal for all, no one has any interest in making them burdensome to others.

Further, the alienation being made without reserve, the union is as perfect as it can be, and an individual associate can no longer claim anything; for, if any rights were left to individuals, since there would be no common superior who could judge between them and the public, each being on some point his own judge, would soon claim to be so on all; the state of nature would still subsist, and the association would necessarily become tyrannical or useless.

In short, each giving himself to all, gives himself to nobody; and as there is not one associate over whom we do not acquire the same rights which we concede to him over ourselves, we gain the equivalent of all that we lose, and more power to preserve what we have.

If, then, we set aside what is not of the essence of the social contract, we shall find that it is reducible to the following terms: "Each of us puts in common his person and his whole power under the supreme direction of the general will; and in return we receive every member as an indivisible part of the whole."

Forthwith, instead of the individual personalities of all the contracting parties, this act of association produces a moral and collective body, which is composed of as many members as the assembly has voices, and which receives from this same act its unity, its common self, its life, and its will. This public person, which is thus formed by the union of all the individual members, formerly took the name of "city" and now takes that of "republic" or "body politic," which is called by its members "State" when it is passive, "sovereign" when it is active, "power" when it is compared to similar bodies. With regard to the associates, they take collectively the name of "people," and are called individually "citizens," as participating in the sovereign power, and "subjects," as subjected to the laws of the State. But these terms are often confused and are mistaken one for another; it is sufficient to know how to distinguish them when they are used with complete precision.

COMMENTS AND QUESTIONS

1. What societies do not have a social contract? Why?

2. Why must the individual give up all his rights on entering the contract?

3. Why, after the creation of the social contract, does each individual remain as free as before?

4. What limitations are there on the actions of the community in regard to the individual? What kind of laws can the community not make?

Whether the General Will Can Err

It follows from what precedes that the general will is always right and always tends to the public advantage; but it does not follow that the resolutions of the people have always the same rectitude. Men always desire their own good, but do not always discern it; the people are never corrupted, though often deceived, and it is only then that they seem to will what is evil.

There is often a great deal of difference between the will of all and the general will; the latter regards only the common interest, while the former has regard to private interests, and is merely a sum of particular wills; but take away from these same wills the pluses and minuses which cancel one another, and the general will remains as the sum of the differences.

If the people came to a resolution when adequately informed and without any communication among the citizens, the general will would always result from the great number of slight differences, and the resolution would always be good. But when factions, partial associations, are formed to the detriment of the whole society, the will of each of these associations becomes

general with reference to its members, and particular with reference to the State; it may then be said that there are no longer as many voters as there are men, but only as many voters as there are associations. The differences become less numerous and yield a less general result. Lastly, when one of these associations becomes so great that it predominates over all the rest, you no longer have as the result a sum of small differences, but a single difference; there is then no longer a general will, and the opinion which prevails is only a particular opinion.

It is important, then, in order to have a clear declaration of the general will, that there should be no partial association in the State, and that every citizen should express only his own opinion.

COMMENTS AND QUESTIONS

1. Why does Rousseau feel as he does about political parties?
2. How did most philosophes regard such organizations? Why?
3. What does Rousseau mean by natural rights? Who determines the limits of these rights in society?

MARY WOLLSTONECRAFT

from *A Vindication of the Rights of Woman*

Chapter IX

Of the Pernicious Effects Which Arise from the Unnatural Distinctions Established in Society

From the respect paid to property[1] flow, as from a poisoned fountain, most of the evils and vices which render this world such a dreary scene to the contemplative mind. For it is in the most polished society that noisome reptiles and venomous serpents lurk under the rank herbage; and there is voluptuousness pampered by the still sultry air, which relaxes every good disposition before it ripens into virtue. . . .

It is vain to expect virtue from women till they are, in some degree, independent of men; nay, it is vain to expect that strength of natural affection, which would make them good wives and mothers. Whilst they are absolutely dependent on their husbands they will be cunning, mean, and selfish, and the men who can be gratified by the fawning fondness of spaniel-like affection, have not much delicacy, for love is not

to be bought, in any sense of the words, its silken wings are instantly shrivelled up when any thing beside a return in kind is sought. Yet whilst wealth enervates men; and women live, as it were, by their personal charms, how can we expect them to discharge those ennobling duties which equally require exertion and self-denial? . . .

To illustrate my opinion, I need only observe, that when a woman is admired for her beauty, and suffers herself to be so far intoxicated by the admiration she receives, as to neglect to discharge the indispensable duty of a mother, she sins against herself by neglecting to cultivate an affection that would equally tend to make her useful and happy. True happiness, I mean all the contentment, and virtuous satisfaction, that can be snatched in this imperfect state, must arise from well-regulated affections; and an affection includes a duty. Men are not aware of the misery they cause, and the vicious weakness they cherish, by only inciting women to render themselves pleasing; they do not consider that they thus make natural and artificial duties clash, by sacrificing the comfort and respectability of a woman's life to voluptuous notions of beauty, when in nature they all harmonize.

Cold would be the heart of a husband, were he not rendered unnatural by early debauchery, who did not feel more delight at seeing his child suckled by its mother, than the most artful wanton tricks could ever raise; yet this natural way of cementing the matrimonial tie, and twisting esteem with fonder recollections, wealth leads women to spurn. To preserve their beauty, and wear the flowery crown of the day, which gives them a kind of right to reign for a short time over the sex, they neglect to stamp impressions on their husbands' hearts, that would be remembered with more tenderness when the snow on the head began to chill the bosom, than even their virgin charms. The maternal solicitude of a reasonable affectionate woman is very interesting, and the chastened dignity with which a mother returns the caresses that she and her child receive from a father who has been fulfilling the serious duties of his station, is not only a respectable, but a beautiful sight. . . .

The preposterous distinctions of rank, which render civilization a curse, by dividing the world between voluptuous tyrants, and cunning envious dependents, corrupt, almost equally, every class of people, because respectability is not attached to the discharge of the relative duties of life, but to the station, and when the duties are not fulfilled the affections cannot gain sufficient strength to fortify the virtue of which they are the natural reward. Still there are some loop-holes out of which a man may creep, and dare to think and act for himself; but for a woman it is an herculean task, because she has difficulties peculiar to her sex to overcome, which require almost superhuman powers.

[1] Note that Wollstonecraft shares with Rousseau the idea that social ills are caused by private property.

A truly benevolent legislator always endeavours to make it the interest of each individual to be virtuous; and thus private virtue becoming the cement of public happiness, an orderly whole is consolidated by the tendency of all the parts towards a common centre. But, the private or public virtue of woman is very problematical; for Rousseau, and a numerous list of male writers, insist that she should all her life be subjected to a severe restraint, that of propriety. Why subject her to propriety—blind propriety, if she be capable of acting from a nobler spring, if she be an heir of immortality? Is sugar always to be produced by vital blood? Is one half of the human species, like the poor African slaves, to be subject to prejudices that brutalize them, when principles would be a surer guard, only to sweeten the cup of man? Is not this indirectly to deny woman reason? for a gift is a mockery, if it be unfit for use.

Women are, in common with men, rendered weak and luxurious by the relaxing pleasures which wealth procures; but added to this they are made slaves to their persons, and must render them alluring that man may lend them his reason to guide their tottering steps aright. Or should they be ambitious, they must govern their tyrants by sinister tricks, for without rights there cannot be any incumbent duties. The laws respecting woman, . . . make an absurd unit of a man and his wife;[2] and then, by the easy transition of only considering him as responsible, she is reduced to a mere cypher. . . .

I know that, as a proof of the inferiority of the sex, Rousseau has exultingly exclaimed, How can they leave the nursery for the camp!—And the camp has by some moralists been termed the school of the most heroic virtues; though, I think, it would puzzle a keen casuist to prove the reasonableness of the greater number of wars that have dubbed heroes. I do not mean to consider this question critically; because, having frequently viewed these freaks of ambition as the first natural mode of civilization, when the ground must be torn up, and the woods cleared by fire and sword, I do not choose to call them pests; but surely the present system of war has little connection with virtue of any denomination, being rather the school of *finesse* and effeminacy, than of fortitude.

Yet, if defensive war, the only justifiable war, in the present advanced state of society, where virtue can shew its face and ripen amidst the rigours which purify the air on the mountain's top, were alone to be adopted as just and glorious, the true heroism of antiquity might again animate female bosoms.—But fair and softly, gentle reader, male or female, do not alarm thyself, for

though I have compared the character of a modern soldier with that of a civilized woman, I am not going to advise them to turn their distaff into a musket, though I sincerely wish to see the bayonet converted into a pruning-hook. I only recreated an imagination, fatigued by contemplating the vices and follies which all proceed from a feculent stream of wealth that has muddied the pure rills of natural affection, by supposing that society will some time or other be so constituted, that man must necessarily fulfil the duties of a citizen, or be despised, and that while he was employed in any of the departments of civil life, his wife, also an active citizen, should be equally intent to manage her family, educate her children, and assist her neighbours.

But, to render her really virtuous and useful, she must not, if she discharge her civil duties, want, individually, the protection of civil duties, want, individually, the protection of civil laws; she must not be dependent on her husband's bounty for her subsistence during his life, or support after his death—for how can a being be generous who has nothing of its own? or, virtuous, who is not free? The wife, in the present state of things, who is faithful to her husband, and neither suckles nor educates her children, scarcely deserves the name of a wife, and has no right to that of a citizen. But take away natural rights, and duties become null.

Women then must be considered as only the wanton solace of men, when they become so weak in mind and body, that they cannot exert themselves, unless to pursue some frothy pleasure, or to invent some frivolous fashion. What can be a more melancholy sight to a thinking mind, than to look into the numerous carriages that drive helter-skelter about this metropolis in a morning full of pale-faced creatures who are flying from themselves. I have often wished, with Dr. Johnson, to place some of them in a little shop with half a dozen children looking up to their languid countenances for support. I am much mistaken, if some latent vigour would not soon give health and spirit to their eyes, and some lines drawn by the exercise of reason on the blank cheeks, which before were only undulated by dimples, might restore lost dignity to the character, or rather enable it to attain the true dignity of its nature. Virtue is not to be acquired even by speculation, much less by the negative supineness that wealth naturally generates.

Besides, when poverty is more disgraceful than even vice, is not morality cut to the quick? Still to avoid misconstruction, though I consider that women in the common walks of life are called to fulfil the duties of wives and mothers, by religion and reason, I cannot help lamenting that women of a superiour cast have not a road open by which they can pursue more extensive plans of usefulness and independence. I may excite laughter, by dropping an hint, which I mean to pursue, some future time, for I really think that women ought to have representatives, instead of being arbitrarily

[2] According to English law at the time, the husband was the only legally responsible person in a family unit.

governed without having any direct share allowed them in the deliberations of government. . . .

But what have women to do in society? I may be asked, but to loiter with easy grace; surely you would not condemn them all to suckle fools and chronicle small beer![3] No. Women might certainly study the art of healing, and be physicians as well as nurses. And midwifery, decency seems to allot to them, though I am afraid the word midwife, in our dictionaries, will soon give place to *accoucheur*,[4] and one proof of the former delicacy of the sex be effaced from the language.

They might, also, study politics, and settle their benevolence on the broadest basis; for the reading of history will scarcely be more useful than the perusal of romances, if read as mere biography; if the character of the times, the political improvements, arts, &c. be not observed. In short, if it be not considered as the history of man; and not of particular men, who filled a niche in the temple of fame, and dropped into the black rolling stream of time, that silently sweeps all before it, into the shapeless void called—eternity.—For shape, can it be called, "that shape hath none"?[5]

Business of various kinds, they might likewise pursue, if they were educated in a more orderly manner, which might save many from common and legal prostitution. Women would not then marry for a support, as men accept of places under government, and neglect the implied duties; nor would an attempt to earn their own subsistence, a most laudable one! sink them almost to the level of those poor abandoned creatures who live by prostitution. For are not milliners and mantua-makers[6] reckoned the next class? The few employments open to women, so far from being liberal, are menial; and when a superiour education enables them to take charge of the education of children as governesses, they are not treated like the tutors of sons, though even clerical tutors are not always treated in a manner calculated to render them respectable in the eyes of their pupils, to say nothing of the private comfort of the individual. But as women educated like gentlewomen, are never designed for the humiliating situation which necessity sometimes forces them to fill; these situations are considered in the light of a degradation; and they know little of the human heart, who need to be told, that nothing so painfully sharpens sensibility as such a fall in life.

Some of these women might be restrained from marrying by a proper spirit or delicacy, and others may not have had it in their power to escape in this pitiful way from servitude; is not that government then very defective, and very unmindful of the happiness of one half of its members, that does not provide for honest, independent women, by encouraging them to fill respectable stations? But in order to render their private virtue a public benefit, they must have a civil existence in the state, married or single; else we shall continually see some worthy woman, whose sensibility has been rendered painfully acute by undeserved contempt, droop like "the lily broken down by a plow-share."

It is a melancholy truth; yet such is the blessed effect of civilization! the most respectable women are the most oppressed; and, unless they have understandings far superiour to the common run of understandings, taking in both sexes, they must, from being treated like contemptible beings, become contemptible. How many women thus waste life away the prey of discontent, who might have practised as physicians, regulated a farm, managed a shop, and stood erect, supported by their own industry, instead of hanging their heads surcharged with the dew of sensibility, that consumes the beauty to which it at first gave lustre; nay, I doubt whether pity and love are so near akin as poets feign, for I have seldom seen much compassion excited by the helplessness of females, unless they were fair; then, perhaps, pity was the soft handmaid of love, or the harbinger of lust.

How much more respectable is the woman who earns her own bread by fulfilling any duty, than the most accomplished beauty!—beauty did I say?—so sensible am I of the beauty of moral loveliness, or the harmonious propriety that attunes the passions of a well-regulated mind, that I blush at making the comparison; yet I sigh to think how few women aim at attaining this respectability by withdrawing from the giddy whirl of pleasure, or the indolent calm that stupefies the good sort of women it sucks in. . . .

Would men but generously snap our chains, and be content with rational fellowship instead of slavish obedience, they would find us more observant daughters, more affectionate sisters, more faithful wives, more reasonable mothers—in a word, better citizens. We should then love them with true affection, because we should learn to respect ourselves; and the peace of mind of a worthy man would not be interrupted by the idle vanity of his wife, nor the babes sent to nestle in a strange bosom,[7] having never found a home in their mother's.

COMMENTS AND QUESTIONS

1. How does Wollstonecraft's concept of "unnatural distinctions" reveal Enlightenment thinking? In what respects is she a romantic?

[3] Shakespeare, *Othello* II.i.160.

[4] "The birther," a male doctor.

[5] Milton, *Paradise Lost* II.666–667.

[6] Dressmakers.

[7] That of a wet-nurse.

2. Why does Wollstonecraft place so much importance on women nursing their own children?

3. What accounts for women's inferior status in society? What are Wollstonecraft's remedies?

4. Does Wollstonecraft seem too hard on the women of her own time?

5. Compare Wollstonecraft's views with those of present-day feminists.

Summary Questions

1. What are the main characteristics of the rococo style in the arts and of genre painting?

2. What were the primary influences of John Locke on the Enlightenment in France?

3. What was the religion of most of the philosophes?

4. What were the political beliefs of the philosophes?

5. How does Voltaire's *Micromegas* attack traditional Christian beliefs? What scientific discoveries brought these beliefs into question?

6. What does Rousseau mean by "the social contract"?

7. How does Wollstonecraft use Enlightenment ideas?

Key Terms

philosophe

salon

Enlightenment

rationalism

deism

despotism

Encyclopedia

satire

feminism

rococo

irony

25

The Enlightenment in the United States

Political events in North America in the last four decades of the eighteenth century fascinated European observers. While the French philosophes were forced to adapt their goals for improving the human condition to the circumstances of a very traditional social and political structure, English-speaking North America presented the situation of a new people in an underdeveloped land largely untrammeled by the weight of past institutions. Once the colonists had thrown off the control imposed on their society by the imperial system of the mother country, the possibilities for political creativity and experimentation seemed limitless. As the new nation emerged from the endless deliberations of the political leadership, European intellectuals watched intently for signs to determine whether the American republic, the most populous and geographically extensive republican government in the history of the world, would succeed or fail.

The history of the creation of the United States, following more than a century of colonial development, can be divided into three basic phases. The first phase began with the defeat of French armies in the New World by combined British and colonial forces, part of a worldwide struggle between rival European powers. When British officials then tried to impose increased taxes on the growing colonies to help cover the rising military and administrative costs of the empire, the colonists resisted in increasing numbers and finally declared themselves politically independent in 1776. The second phase comprises the period from the first years of the war until the creation of the Constitution in 1787, when the dominant minds in America attempted to devise some sort of lasting union among the thirteen loosely confederated states. The final period is that of the first decades after ratification of the Constitution (which went into effect in 1789) as Americans endeavored to make the new government work in the face of forces for decentralization that threatened at times to pull the new federal structure apart.

American Religion

Christianity in prerevolutionary America was the most important cultural and intellectual force in colonial life. Among whites, the predominant allegiance of the colonists was to some form of Protestantism. Even in Maryland, originally

founded as a Catholic refuge, Protestants were in the vast majority. The few Jews in the colonies resided largely in the coastal towns. Missionary associations of various churches had achieved little success with the rapidly dwindling Native American population, but from the 1730s on African Americans converted in large numbers. By the revolution, conversion among the enslaved population, now principally being carried out by blacks themselves, created a significant mass of black Christians in the colonies. The African American churches, however, retained many elements of religious practices from the African religious heritage.

The beginning of the conversion of blacks on a large scale in the 1730s was only one aspect of a great religious revival that swept the English colonies in that and the succeeding decade. Known as the *Great Awakening,* the movement started in New Jersey; was taken up by Jonathan Edwards (1703–1758), a Congregational minister in Northampton, Massachusetts; and within the next few years was spread by a series of fiery preachers the entire length of the Atlantic coast.

Americans in these years were responding to a deeply felt sense that their churches were becoming too institutionalized and too committed to doctrine while the passion of belief that nourished the emotional life of the believer was draining away. By arousing religious feelings at the expense of catechisms and using emotion rather than reasoned argument, the preachers of the Great Awakening, a movement that cut across all doctrinal lines, appealed enormously to those with little education. The spiritual malaise was so general, however, that large numbers from all classes were attracted to the revival movement.

Effect of the Great Awakening

The Great Awakening had a tremendously disruptive effect on established religion in the colonies, dividing congregations into Old Light and New Light groups. The activity of itinerant preachers tended to destroy the identification of churches with particular territories, and because the preachers of the Awakening were marked more by charismatic gifts than by education or status, it undermined the authority of the traditional clergy. The intensity of the Great Awakening abated after 1750, but its effects on American religion were long lasting.

This revival movement contributed to bringing into question two fundamental beliefs of traditional Christianity: that religious conformity was necessary and that the state should lend financial and other support to a particular church. Although some states continued to use tax money to support a designated church or churches, the competition for membership in the spiritual market in the second half of the eighteenth century could not be prevented, and in practice freedom of conscience for all religions became the rule. Unlike European countries, in which the established church had a guaranteed membership and religion tended to be taken for granted, in the British colonies the competition for souls fostered an almost continual spirit of revival and a rich variety of choices. Consequently, by the time of the revolution the Christian churches were highly decentralized and largely voluntary in membership, and reflected the evolution of republican feeling in a broad sector of the population.

The American Revolution

The American Revolution arose out of the resistance of American colonists to taxation levied on them in the twelve years following the end of the Seven Years' War (1756–1763). Although in Europe a war between Britain and Prussia against Australia, France, and Russia, the Seven Years' War in America was a struggle between the British on one side and the French and their Indian allies on the other. When the war ended in 1763, the British had possession of Canada, but they won it on their own. Throughout the conflict the American colonists had largely depended on the regular army to defend them, maintaining all the while a brisk trade with the enemy.

The war left Britain with an enormous war debt, which Parliament was loath to reduce through taxation of the population of the British Isles. Rather, it was felt that because so much of the debt was owed to the mother country's efforts to defend the colonies, the colonists should be made to bear the costs. Until this time, taxation of the colonies had been light and control of payment weak; colonists normally paid only those taxes imposed by local governments for local purposes. With the passing of the Stamp Act of 1765, which required that a tax stamp be attached to every printed document, such as a bill of sale for land, a newspaper, or a will, Parliament endeavored to impose a tax on the colonists that was already operative in the British Isles. The tax created an uproar in the colonies and led to a stamp tax congress that challenged the right of the British government to levy a tax without the consent of those being taxed. Parliament repealed the tax in 1766, while affirming its absolute right to establish laws and levy taxes on the colonies. In 1767, still seeking a way to reduce the debts of the royal treasury, Parliament again voted a series of taxes, this time on imports to the colonies. As before, however, Parliament bowed before a wave of protest and in 1770 repealed all duties except for a tax on the importation of tea.

An uneasy truce followed until 1773, when the East India Company, a large, private British trading enterprise, requested permission of Parliament to sell tea directly to merchants at the local level rather than auctioning the tea in London to big American merchants, who imported it in the colonies. Parliament's accession to the company's

petition was a signal to the American colonists that Parliament was prepared to favor British business over colonial interests. The result was the Boston Tea Party: a group of men disguised as Indians boarded the company's ships in Boston Harbor and threw the tea into the water. In response, the British government closed the port of Boston and repressed local government in the Massachusetts Bay Colony. To the colonists British designs immediately became clear: taxation without representation appeared now as only one dimension of Parliament's effort to centralize political power and assert control over the economy of the colonies.

In 1774 in Philadelphia, a "continental congress," composed of delegates elected by independent groups of concerned citizens from various colonies, called for a general boycott on British goods. The peaceful response turned violent the following year, however, when a detachment of British soldiers sent to seize unauthorized weapons at Concord outside Boston was met at Lexington by a small group of armed colonists, who called themselves "minute men." The Second Continental Congress, which convened at Philadelphia a few weeks later, took the fateful steps of creating an American army and seeking an alliance with Britain's archrival, France. Succeeding events made it evident to most Americans that the thirteen colonies must seek their independence from the mother country. On July 4, 1776, Congress officially declared independence from Britain.

British difficulties with their colonials obviously delighted the other European powers, some of whom were still smarting from their defeat in the Seven Years' War. Over the next two years France covertly funneled weapons and ammunition to the colonists and in 1778 declared war against the British. Spain and Holland followed suit. Heavily dependent on the French navy and a French expeditionary force of six thousand men, the badly trained and faction-ridden American army ultimately proved a match for the British professional army. Although the surrender of the main British army under General Cornwallis to the French and American commanders at Yorktown in 1781 marked the end of hostilities, peace was concluded two years later at Paris. While Britain retained Canada, the boundaries of the new American republic were recognized as extending as far as the Mississippi River.

European Influences

The American Revolution and its immediate aftermath reflected the impact of English ideas on a pioneering society. The *empiricism* of English thinkers like Bacon and Newton exercised a strong influence on Americans, and theory was reinforced by a pioneer culture that respected labor and practical know-how. Products of a highly mobile society with a flexible social structure, the colonists worked well together at the local level in meeting their common needs. The validity of Locke's doctrine of the natural rights of humankind seemed borne out by their experience.

Beginning as they did in a new environment, the colonists tended to view critically any limitation on their freedom of action unless it could be justified in terms of personal advantage. With the executive power firmly in the hands of the British governors, they also found Locke's emphasis on the duty of legislative assemblies to supervise the executive authority to their liking. Characteristically, the Declaration of Independence, which claimed rights to life, liberty, and the pursuit of happiness to be self-evident, justified severing ties with Great Britain on the grounds of George III's tyranny, not because of oppression by Parliament. Furthermore, the Declaration of Independence and the Constitution echo Locke in their statements that governments derive their just powers from the consent of the governed and that when governments exceed their power, the people have the right to institute new governments.

French philosophes were, on the whole, ardent supporters of the American Revolution. They admired versatile diplomats such as Benjamin Franklin and Thomas Jefferson, both of whom lived for long periods in France, as the kind of "enlightened" individuals that the New World could produce. People like Turgot, a philosophe minister of Louis XV, used their influence at court to bring the French government into the war on the rebels' side in 1778. As has been noted, French intervention was decisive.

Montesquieu had a significant influence on American political thought, especially late in the revolution and its aftermath. His conception of a balance of power among the legislative, executive, and judicial branches of government suited the American distrust of the executive and made the Constitution more attractive to many who looked on a strong executive as a potential threat to their individual freedom. In the 1780s and 1790s, however, Rousseau's democratic theories provided ammunition against elitist conceptions of political authority held by most American thinkers. For example, property qualifications for voting rights were reduced at this time.

To an extent, the ease with which Americans accepted the ideas of the philosophes stemmed from the fact that much of the philosophy of the French thinkers had been inspired by the English political experience, which Americans had inherited. But more than this, the increasingly voluntaristic character of American religion made Christianity in the colonies compatible with most of their ideas. In France, as we have seen, intellectuals attacked the privileged Church as obscurantist and as the champion of political oppression. Religion itself became tainted by association. On the other hand, in religiously pluralistic America, the Enlightenment lost its antireligious bias. Whereas in France the

25-1 *Great Seal of the United States. (Bureau of Engraving and Printing, U.S. Department of the Treasury)*

Enlightenment doctrine of religious toleration aimed at subverting the hold of the Catholic Church on French culture, in America this doctrine was introduced to justify a practical situation created by the existence of conflicting religious groups.

American Federalism

Federalism, perhaps the United States' most original contribution to the theory and practice of republican government, owed little to either the French or the English; it was born of necessity. Under no circumstances able to induce strong, independent state governments to become mere agencies of the central government, the writers of the Constitution established a principle of separation of powers between the central government and the states. Such a system of power division was to have a great future because it permitted unification of large areas of land and supported regional diversity while still limiting the power of local opposition.

The Heritage of Ancient Rome

No account of the ideology of the American revolutionary epoch would be complete without acknowledging the extent to which these patriots thought of themselves and were considered by their European sympathizers as the heirs to the *republican tradition of ancient Rome*. Since the Renaissance the educated class of the Western world had been deeply imbued with classical culture; one aspect of that culture, clearly defined since the early fifteenth century, was its *republican* tradition. The leaders of the revolution appeared to contemporaries as the simple, honest descendants of Roman leaders like Cato,

or the general Cincinnatus, who left his own plow to lead an army against the enemies of the Roman Republic. Americans often signed their letters of protest against English tyranny with Roman names, and Washington and other officers of the revolutionary army took part in a controversial Society of Cincinnatus. In their struggle for liberty, the patriots (from Latin *patria*—homeland) seemed to be the modern counterparts of Roman heroes like Horatio and Brutus. The architects of the Constitution drew on words of Latin derivation like *president* and *senate,* and the Great Seal of the new nation and its coinage were marked with Latin phrases and classical emblems (Fig. 25-1). Houdon's statue of Washington in the capitol at Richmond dramatically illustrates these associations of the new republic with the old. In 1786 the French sculptor represented the future president of the United States in modern dress; but he stands beside the Roman *fasces,* a bundle of rods symbolic of power and union, in a pose based on that of a classical statue (Fig. 25-2).

25-2 *Jean Antoine Houdon,* George Washington, *1788–1792. Marble, height 74″, State Capitol, Richmond. (The Library of Virginia)*

25-3 *Thomas Jefferson, Monticello, west front. (Thomas Jefferson Memorial Foundation Inc.)*

Thomas Jefferson (1743–1826)

The figure who best represents the American Enlightenment is Thomas Jefferson. Jefferson combined the Old World's tradition of scholarship and philosophy with the New World's practicality and readiness to experiment. Both philosopher and plantation manager, he was at home in the salons of Paris and the still untamed parts of Virginia. Like the French philosophes, he combined wide learning in the classical humanities with a lively interest in recent scientific developments. He regarded the republic of letters and ideas as an international one.

In addition to his career as a politician, Jefferson was an excellent writer, an educator, a farmer, and an architect. One of his masterpieces is his home near Charlottesville, Virginia, which he called Monticello ("little mountain"; see Fig. 25-3). The house itself is symbolic of the nature of the American Enlightenment. Jefferson used the *Palladian villa* rotunda as his model (Fig. 23-1), but the plan of the interior exhibits a functional adaptation of the symmetrical plan to his own particular needs. Similarly, the building, originally designed for stone ex-

ecution, is rendered in red brick with white wooden trim—an elegant, rich contrast to the building's general simplicity of shape. These adaptations to use and surroundings do not, however, detract from the *portico* and *dome*, the two architectural forms that link it with those of democratic Greece and republican Rome. Facing westward, to the wilderness, dominating but sympathetic to the landscape, the house is almost a metaphor for the man—aristocratic, cosmopolitan, inventive, practical—a farmer and a philosopher.

Designing his own tomb for the grounds at Monticello, Jefferson composed the following inscription: "Here was buried Thomas Jefferson, author of the Declaration of American Independence, of the Statute of Virginia for Religious Freedom, and Father of the University of Virginia." He apparently did not consider that being the third president of the United States was among his most significant accomplishments. Those that he lists are excellent examples of the application of the principles of the Enlightenment to the American experience.

The Declaration of Independence The Declaration, written largely by Jefferson and approved by the Continental Congress on July 4, 1776, is a statement of political philosophy as well as an act of rebellion. It is in fact typical of the American Enlightenment that theory and its practical application are combined in the same document. The Declaration may be divided into two distinct parts. The first sets forth principles of democratic government and proves, in the abstract, philosophical terms of the Enlightenment, the right of the colonies to rebel. The second part is a specific list of grievances against the king of Great Britain, George III.

A close reading of the first two paragraphs of the Declaration reveals the purpose of the document and a theoretical basis for rebellion.

> When, in the course of human events, it becomes necessary for one people to dissolve the political bands which have connected them with another, and to assume, among the powers of the earth, the separate and equal station to which the laws of nature and of nature's God entitle them, a decent respect to the opinions of mankind requires that they should declare the causes which impel them to the separation.
>
> We hold these truths to be self-evident: That all men are created equal; that they are endowed by their Creator with certain unalienable rights; that among these are life, liberty & the pursuit of happiness; that to secure these rights governments are instituted among men, deriving their just powers from the consent of the governed; that whenever any form of government becomes destructive of these ends, it is the right of the people to alter or to abolish it, and to institute new government, laying its foundation on such principles and organizing its powers in such form, as to them shall seem most likely to effect their safety and happiness.

COMMENTS AND QUESTIONS

1. Is there any religious basis for the rebellion? Does it seem to be Christian?

2. How do the expressions "laws of nature," "nature's God," and "truths" that are "self-evident" reflect values of the Enlightenment?

3. Did the American political system in fact guarantee the "unalienable rights" that Jefferson lists? What do you think that he meant by "the pursuit of happiness"? By "all men are created equal"?

4. How do Jefferson's political ideals differ from, or resemble, those of Thucydides? (See Volume 1, Chapter 4.)

5. Do the principles of the Enlightenment found here (such as self-evident truths) seem a valid basis from which to argue legal and moral questions today?

The questions raised here may be applied to the entire Declaration. The second part of the document purports to show, by the list of grievances, that George III deliberately and malevolently attempted to establish an "absolute tyranny" over the colonies. It is consistent with Jefferson's idea of a government that derives its powers from the "consent of the governed" that he blames all sorts of evils on the tyrannical will of the king. The last of Jefferson's charges, omitted by the Congress in the final draft of the Declaration, was an indictment against the enslavement of Africans.

> He has waged cruel war against human nature itself, violating its most sacred rights of life and liberty in the persons of a distant people who never offended him, captivating and carrying them into slavery in another hemisphere, or to incur miserable death in their transportation thither. This piratical warfare, the opprobrium of *infidel* powers, is the warfare of the *Christian* king of Great Britain. Determined to keep open a market where MEN should be bought and sold, he has prostituted his negative[1] for suppressing every legislative attempt to prohibit or to restrain this execrable commerce; and that this assemblage of horrors might want no fact of distinguished die,[2] he is now exciting these very people to rise in arms among us, and to purchase that liberty of which *he* deprived them, by murdering the people upon whom *he* also obtruded them; thus paying off former crimes committed against the *liberties* of one people, with crimes which he urges them to commit against the *lives* of another.

COMMENTS AND QUESTIONS

1. How does Jefferson apply the principles of the Enlightenment to the question of slavery here?

2. Does it make good historical sense to blame the existence of slavery and the slave trade on George III?

3. What important factors does Jefferson omit?

Jefferson's own position on slavery was fraught with ambiguity. He owned many slaves on his plantation at Monticello and apparently had children by one of them, Sally Hemings. He seems to have been tormented by his contradictory feelings that slavery was a moral wrong and would eventually be abolished, but that the time was not yet ripe for black Americans to be free. He at times even argued in favor of the enslavement of Africans.

[1] That is, he has conceded to other interests by vetoing.

[2] That is, might be made clear.

25-4 *Thomas Jefferson, University of Virginia, 1856 engraving by C. Bohn. (University of Virginia Library)*

The Virginia Statute and the University of Virginia
The second accomplishment on which Jefferson prided himself, the Virginia Statute of Religious Liberty (October 1785), is in the spirit of Voltaire's *Treatise on Toleration*. The statute was part of the constitution of the state of Virginia, which served as a model for other state constitutions.

Jefferson remained a nominal Anglican until the end of his life but continued to combat what he considered to be superstitions and unnecessary dogmas in Christianity. He respected Jesus as a great moral teacher but did not necessarily believe him to be divine. He made his own edition of the Bible, cutting out references to miracles. *Unitarians* today consider Jefferson one of their forefathers. In an "unenlightened" age a century or two earlier, he would have been arrested as a heretic.

In keeping with Jefferson's beliefs, his third monumental project, the University of Virginia, was the only early university not to be associated with a church. Jefferson viewed this *academical village* as an opportunity not only to create an ideal educational environment but also to improve the tastes of the Americans who would be educated there (Fig. 25-4).

Jefferson had always scorned the architecture of Williamsburg, where he was educated, and had tried to mold taste with his designs for the capitol of Virginia at Richmond (Fig. 25-5). He used no Renaissance models or sources. Having seen engravings of the Maison Carrée in Nîmes, he adopted the plan of that building for the new capitol.

25-5 *Thomas Jefferson, Capitol, Richmond. (The Library of Virginia)*

DAILY LIVES

Education in a Moravian School for Girls

While the University of Virginia represented the new American ideal of higher education, private boarding schools (these were not public schools) offered secondary education for American children whose families had financial means. Some of the best were run by American Moravians, a religious community whose members immigrated to Pennsylvania and the Carolinas from Germany and Bohemia. These schools admitted non-Moravian students. One such, a twelve-year-old girl from Connecticut, wrote a letter home to her family telling of her experiences at school. The importance of music in the curriculum is noteworthy. The letter was printed in a New Haven newspaper in 1788, and it said:

> In the apartment where I reside, at the boarding school for Misses, there are about thirty little girls of my age. Here I am taught music, both vocal and instrumental. I play the guitar twice a day—am taught the spinnet and forte-piano; and sometimes I play the organ. . . . Our morning and evening prayers are playing on our guitars (which we join with our voices) a few religious verses. This chapel no man or boy ever enters. At seven we go to breakfast, at eight

school begins, in which we are taught reading and grammar, both English and German, for those who choose; writing, arithmetic, history, geography, composition, etc. till eleven; when we go into a large chapel, which also joins this house, where there is an organ. Here we see three gentlemen—the person who delivers a short lecture on divinity and morality—the organist, who plays a hymn, in which we join with our voices—and the boys' schoolmaster. In this meeting the boys attend with us. At three quarters after eleven we dine; and at one school begins. In the afternoon we are taught needle-work, tambour [embroidery], drawing, music, etc. till three when school is out, after which we walk, or divert ourselves as we please. At six we sup, then play on some musical instruments, or do as we please till half after seven, when we retire for evening prayers, at eight we go to bed. We sleep in a large chamber with windows on both sides in which a lamp burns during the whole night. After we are in bed, one of the ladies, with her guitar and voice, serenades us to sleep.[a]

a. Quoted in Edward A. Berlin, "The Moravians and Their Music," *The Flowering of Vocal Music in America*, vol. 1 [liner notes] (New World Records, NW 230).

That the pure temple form was not immediately adopted nationally can be seen by comparing the Virginia state capitol with the Massachusetts state house in Boston, designed by Charles Bulfinch in 1795 (Fig. 25-6). The sources of the state house are from the English Renaissance as well as from Rome. Both buildings, however, provided strong images of the state.

This belief, that art and architecture reinforce and perpetuate strong, appropriate images for ideals, was much in Jefferson's mind when the university was laid out. The heart of the university is a rectangular quadrangle bounded on each of its long sides by a one-story covered colonnade broken at intervals by the two-story houses of the professors. Students lived in rooms off the colonnades; professors held classes downstairs in their living quarters (Fig. 25-7). The east end of the quadrangle is closed by the library, a domed, porticoed rotunda, modeled on the Pantheon, that was the focus and capstone of the ensemble (Fig. 25-8). The west end of the

campus was open to the mountains. The regularity of the pattern was relieved by dining rooms, kitchens, and other service facilities located behind the two parallel colonnades. Gardens (which students were supposed to help work), pathways, and walks connected the students to nature and to opportunities for meditation and contemplation.

The rotunda and professors' houses were carefully detailed with what Jefferson considered the best of the classical orders; all were used in correct proportion and in proper relation so one could learn about the architecture of ancient Greece and Rome while living in it.

The architecture of the campus reflects the two areas in which students were supposed to grow to become successful adults—the active and the contemplative life. Conspicuously absent is a chapel or church since religion was to be a personal, private affair. Unlike Harvard, Yale, or Princeton, this early university of the new republic was a monument to free thought.

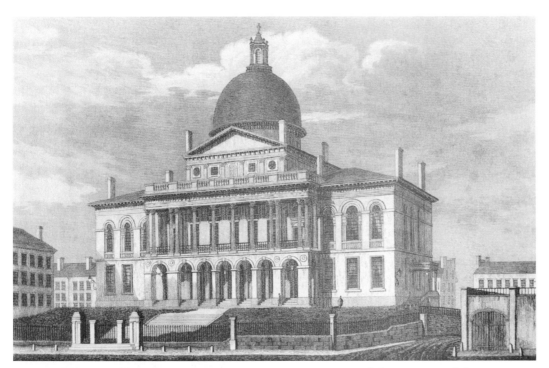

25-6 *Charles Bulfinch, Massachusetts State House. (Courtesy of the Trustees of the Public Library of the City of Boston)*

- What elements do the capitol at Richmond (Fig. 25-5) and Bulfinch's Massachusetts state house have in common? Compare them with the Maison Carrée, Nîmes (Vol. One, Fig. 6-8). What has Bulfinch changed so radically? What other classical structures might have influenced Bulfinch? Compare these buildings with Jefferson's rotunda (Fig. 25-8). What are three ways in which the buildings are similar and three ways in which they are each different from the other two in design? Does the design reflect the building's function?

25-8 *Thomas Jefferson, University of Virginia, Rotunda. (University of Virginia Library)* **(W)**

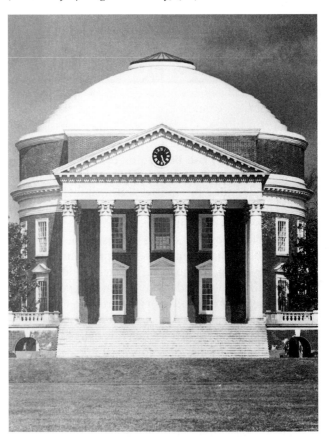

25-7 *Thomas Jefferson, University of Virginia, Pavilion and Colonnade. (University of Virginia Library)*

The ideal behind the University of Virginia was, in typical Enlightenment fashion, universal. "Enlighten the people generally," Jefferson wrote, "and oppressions of body and mind will vanish like evil spirits at the dawn of day." Practically, however, because of the nature of the education planned, it could accommodate only an elite few. Women of all races, African Americans, Native Americans, and white males from poor families were excluded. Jefferson, though he educated his daughters, held in fact very conventional ideas regarding women: they should not mix in politics or public meetings or be outspoken in any way; their proper place was in the domestic sphere. The educated elite, who alone were fit to rule the American nation in Jefferson's view, would have been limited to white men of some means if his plan had remained the pattern. Fortunately, as is the case with most important thinkers, Jefferson's ideas outgrew his era's limitations and eventually served the causes of struggles for civil rights in which we are still involved.

The product of Jefferson's old age and retirement years, the University of Virginia opened its doors in 1824, when its founder was eighty-one. It was perhaps natural that the revolutionary, politician, and diplomat should retire into creating an ideal world on a reduced scale. This edifice for the education of the New World elite stands today as an example of his interpretation of the styles and ideals of the Enlightenment.

From European Classicism to an "American Style"

Just as Jefferson and his colleagues in government and in architecture sought to create new forms that would embody the culture and values of the new republic, so artists sought to make the language of painting and sculpture appropriate to revolutionary ideals. The interest in science and nature that engaged Jefferson and the philosophers of the Enlightenment became a major subject for the new "American" art.

The colonies were hosts to various artists, from itinerant and awkward folk painters to artists of great accomplishment, such as Benjamin West, John Singleton Copley, and Gilbert Stuart, all of whom studied abroad. But it was artists such as Charles Willson Peale (1741–1827) of Philadelphia, founder of one of the country's first museums, who gave Americans images of themselves as successful inhabitants of the continent. Peale, posed with a kind of elegance, raises the curtain and invites the public to see the wonders of his museum, the wonders of America (Fig. 25-9).

Samuel F.B. Morse (1791–1872), who also invented the telegraph, decorated the walls and dome of the new capitol in Washington with scenes that combined myth,

25-9 *Charles Willson Peale,* The Artist in His Museum, *1822, oil, 103½ × 79⅞". (Owned by The Pennsylvania Academy of the Fine Arts, Philadelphia, Pa.)*

allegory, and the representatives of the new government. He then painted *Congress Hall: Old House of Representatives* in 1821 (Fig 25-10). There are echoes of European painting in his choice of the dramatic moment of lighting the lamps, but the overall impression generated by the room, the space, and the mood helped reinforce the American sense of independence from the routines and usages of Europe.

Paintings of the American landscapes showed another, inspiring aspect of the new country. Thomas Cole (1801–1848) created paintings with themes like the voyage of life, but *Schroon Mountain,* the Adirondacks, presented images that tantalized and pleased his audiences (Fig. 25-11). Likewise, his colleague Washington Allston (1779–1843) created paintings with classical themes, but *Landscape, American Scenery: Time, Afternoon, with a Southwest Haze* used views to present ideas of the transcendent and untouched glory of

25-10 *Samuel F.B. Morse,* Congress Hall: Old House of Representatives, *1821, oil, 87 × 131¼". (Owned by The Corcoran Gallery of Art, Washington, D.C.)*

25-11 *Thomas Cole,* Schroon Mountain, *1833. Oil on canvas, 39 ⅜ × 63". (Cleveland Museum of Art)*

25-12 *Washington Allston,* Landscape, American Scenery: Time, Afternoon, with a Southwest Haze, *1835. Oil on canvas, 18½ × 24¾". (Museum of Fine Arts, Boston)*

the new land (Fig. 25-12). All these artists owed much to European painting, but the radically different nature of the country, like its new government, would continue to engage and inform American artists until it was clear that theirs was a new way of seeing and expressing the world.

African American Voices in the Enlightenment

Phillis Wheatley (1753?–1784)

The paradox of the continued existence of *slavery* in a nation founded on the revolutionary principles of liberty and equality was not lost on African Americans (Fig. 25-13). Among the few who had had the opportunity to learn to read and write English was a young woman, Phillis Wheatley, who is now considered to be the founder of African American written literature. Brought from West Africa to America at the age of twelve, in 1761, and named for the ship she sailed on, Phillis was purchased by the Bostonian John Wheatley and his wife as a domestic servant. Studying at home

with the couple, she learned to read English, Latin, and Greek and began to write poetry while still quite young. John Wheatley, who emancipated her in 1773, encouraged her writing and helped her to publish. Wheatley's poetry, which often contains classical references, is written in the style prevalent in eighteenth-century English poetry, but she uses original images from her own life experience. Although she was hardly a militant, some of her poetry does apply the revolutionary ideals of liberty, justice, and equality to the abhorrent reality of slavery.

David Walker (1785–1830)

Much more militant and outspoken a writer was the North Carolinian David Walker. Born free in Wilmington the year after Phillis Wheatley died, he moved to Boston in 1827, where he married a fugitive slave. He became a leader in the antislavery movement in the black community in Boston, but his writings shocked many whites, and southern slaveholders were particularly anxious to keep them away from their slaves. His

25-13 *Taylor,* American Slave Market, *1852. (Chicago Historical Society)*

most famous work, *David Walker's Appeal in Four Articles; Together with a Preamble, to the Coloured Citizens of the World,* was purposely modeled on the U.S. Constitution. In it, Walker confronts, in a direct and outspoken manner, the glaring contradictions between the ideals of American liberty and the institution of slavery. Although Walker's writing belongs to the early nineteenth, rather than the eighteenth, century, we have included it here because it deals with ideas from the Enlightenment and from Thomas Jefferson.

JONATHAN EDWARDS

from *A Faithful Narrative of the Surprising Work of God*

In the following excerpt from *A Faithful Narrative of the Surprising Work of God* (1737), Edwards first describes the effect of his revivalist preaching on his congregation and then the diffusion of its effect to the surrounding countryside in the Connecticut River valley. Edwards tells us that he had resolved to preach unambiguously from the pulpit that humanity is saved by faith alone, and that human beings have absolutely no power to ensure, or even to cooperate in, their own salvation. These sermons had a dazzling and surprising effect, which Edwards describes as a "great awakening."

Although great fault was found with meddling with the controversy in the pulpit, by such a person, at that time, and though it was ridiculed by many elsewhere; yet it proved a word spoken in season here; and was most evidently attended with a very remarkable blessing of heaven to the souls of the people in this town. They received thence a general satisfaction with respect to the main thing in question, which they had in trembling doubts and concern about; and their minds were engaged the more earnestly to seek that they might come to be accepted of God, and saved in the way of the gospel, which had been made evident to them to be the true and only way. And then it was, in the latter part of December [1734], that the Spirit of God began extraordinarily to set in, and wonderfully to work amongst us; and there were, to all appearance, savingly converted, and some of them wrought upon in a very remarkable manner.

Particularly, I was surprised with the relation of a young woman, who had been one of the greatest company keepers in the whole town: when she came to me, I had never heard that she was become in any wise serious, but by the conversation I then had with her, it appeared to me, that what she gave an account of, was a glorious work of God's infinite power and sovereign grace; and that God had given her a new heart, truly broken and sanctified. I could not then doubt of it, and have seen much in my acquaintance with her since to confirm it.

Though the work was glorious, yet I was filled with concern about the effect it might have upon others: I was ready to conclude (though too rashly) that some would be hardened by it, in carelessness and looseness of life; and would take occasion from it to open their mouths, in reproaches of religion.[1] But the event was the reverse, to a wonderful degree; God made it, I suppose, the greatest occasion of awakening to others, of any thing that ever came to pass in the town. I have had abundant opportunity to know the effect it had, by my private conversation with many. The news of it seemed to be almost like a flash of lightning, upon the hearts of young people, all over the town, and upon many others. Those persons amongst us, who used to be farthest from seriousness, and that I most feared would make an ill improvement of it, seemed greatly to be awakened with it; many went to talk with her, concerning what she had met with; and what appeared in her seemed to be to the satisfaction of all that did so.

Presently upon this, a great and earnest concern about the great things of religion, and the eternal world, became universal in all parts of the town, and among persons of all degrees, and all ages; the noise amongst the dry bones waxed louder and louder: all other talk but about spiritual and eternal things was soon thrown by; all the conversation in all companies, and upon all occasions, was upon these things only, unless so much as was necessary for people carrying on their ordinary secular business. Other discourse than of the things of religion, would scarcely be tolerated in any company. The minds of people were wonderfully taken off from the world; it was treated amongst us as a thing of very little consequence: they seem to follow their worldly business, more as a part of their duty, than from any disposition they had to it; the temptation now seemed to be on that hand, to neglect worldly affairs too much, and to spend too much time in the immediate exercise of religion:

[1] Edwards feared that when people were told that they could do nothing to help in their own salvation, they would abandon themselves to pleasure or curse God for his injustice in robbing them of the power of their will.

which thing was exceedingly misrepresented by reports that were spread in distant parts of the land, as though the people here had wholly thrown by all worldly business, and betook themselves entirely to reading and praying, and such like religious exercises. . . .

This work of God, as it was carried on, and the number of true saints multiplied, soon made a glorious alteration in the town; so that in the spring and summer following, anno 1735, the town seemed to be full of the presence of God: it never was so full of love, nor so full of joy; and yet so full of distress as it was then. There were remarkable tokens of God's presence in almost every house. It was a time of joy in families on the account of salvation's being brought unto them; parents rejoicing over their children as new born, and husbands over their wives, and wives over their husbands. *The goings of God were then seen in his sanctuary, God's day was a delight, and his tabernacles were amiable.* Our public assemblies were then beautiful; the congregation was alive in God's service, every one earnestly intent on the public worship, every hearer eager to drink in the words of the minister as they came from his mouth; the assembly in general were, from time to time, in tears while the word was preached; some weeping with sorrow and distress, others with joy and love, others with pity and concern for the souls of their neighbors. . . .

This remarkable pouring out of the Spirit of God, which thus extended from one end to the other of this country, was not confined to it, but many places in Connecticut have partook in the same mercy: as for instance, the first parish in Windsor, under the pastoral care of the Reverend Mr. Marsh, was thus blest about the same time, as we in Northampton, while we had no knowledge of each other's circumstances. . . .

But this shower of Divine blessing has been yet more extensive: there was no small degree of it in some parts of the Jerseys; as I was informed when I was at New-York (in a long journey I took at that time of the year for my health), by some people of the Jerseys, whom I saw: especially the Rev. Mr. William Tennent, a minister, who seemed to have such things much at heart, told me of a very great awakening of many in a place called the Mountains, under the ministry of one Mr. Cross; and of a very considerable revival of religion in another place under the ministry of his brother the Rev. Mr. Gilbert Tennent; and also at another place, under the ministry of a very pious young gentleman, a Dutch minister, whose name as I remember, was Freelinghousen.

COMMENTS AND QUESTIONS

1. What is meant by "saved by faith alone"? Compare Luther's position in Chapter 19.

2. What are the signs of the "great awakening"? How does Edwards explain it?

3. How would you characterize Edwards's writing style? How do you imagine him as a preacher?

THOMAS JEFFERSON

The Virginia Statute of Religious Liberty

An Act for Establishing Religious Freedom

I. Whereas Almighty God hath created the mind free; that all attempts to influence it by temporal punishments or burthens, or by civil incapacitations, tend only to beget habits of hypocrisy and meanness, and are a departure from the plan of the Holy author of our religion, who being Lord both of body and mind, yet chose not to propagate it by coercions on either, as was in his Almighty power to do; that the impious presumption of legislators and rulers, civil as well as ecclesiastical, who being themselves but fallible and uninspired men, have assumed dominion over the faith of others, setting up their own opinions and modes of thinking as the only true and infallible, and as such endeavouring to impose them on others, hath established and maintained false religions over the greatest part of the world, and through all time; that to compel a man to furnish contributions of money for the propagation of opinions which he disbelieves, is sinful and tyrannical; that even the forcing him to support this or that teacher of his own religious persuasion, is depriving him of the comfortable liberty of giving his contributions to the particular pastor whose morals he would make his pattern, and whose powers he feels most persuasive to righteousness, and is withdrawing from the ministry those temporary rewards, which proceeding from an approbation of their personal conduct, are an additional incitement to earnest and unremitting labours for the instruction of mankind; that our civil rights have no dependence on our religious opinions, any more than our opinions in physics or geometry; that therefore the proscribing any citizen as unworthy the public confidence by laying upon him an incapacity of being called to offices of trust and emolument, unless he profess or renounce this or that religious opinion, is depriving him injuriously of those privileges and advantages to which in common with his fellow-citizens he has a natural right; that it tends only to corrupt the principles of that religion it is meant to encourage, by bribing with a monopoly of worldly honours and emoluments, those who will externally profess and conform to it; that though indeed these are

criminal who do not withstand such temptation, yet neither are those innocent who lay the bait in their way; that to suffer the civil magistrate to intrude his powers into the field of opinion, and to restrain the profession or propagation of principles on supposition of their ill tendency, is a dangerous fallacy, which at once destroys all religious liberty, because he being of course judge of that tendency will make his opinions the rule of judgment, and approve or condemn the sentiments of others only as they shall square with or differ from his own; that it is time enough for the rightful purposes of civil government, for its officers to interfere when principles break out into overt acts against peace and good order; and finally, that truth is great and will prevail if left to herself, that she is the proper and sufficient antagonist to error, and has nothing to fear from the conflict, unless by human interposition disarmed of her natural weapons, free argument and debate, errors ceasing to be dangerous when it is permitted freely to contradict them.

II. Be it enacted by the General Assembly, that no man shall be compelled to frequent or support any religious worship, place or ministry whatsoever, nor shall be enforced, restrained, molested, or burthened in his body or goods, nor shall otherwise suffer on account of his religious opinions or belief; but that all men shall be free to profess, and by argument to maintain, their opinions in matters of religion, and that the same shall in no wise diminish, enlarge or affect their civil capacities.

III. And though we well know that this Assembly, elected by the people for the ordinary purposes of legislation only, have no power to restrain the acts of succeeding Assemblies, constituted with powers equal to our own, and that therefore to declare this Act to be irrevocable would be of no effect in law; yet as we are free to declare, and do declare, that the rights hereby asserted are of the natural rights of mankind, and that if any Act shall hereafter be passed to repeal the present, or to narrow its operation, such Act will be an infringement of natural right.

COMMENTS AND QUESTIONS

1. On what basis does Jefferson seek to establish religious tolerance?

2. Is he critical of Christianity? How?

3. What does Jefferson mean by "truth," and what are his criteria for determining what is true?

4. Does his optimistic belief that truth will inevitably triumph over error strike you as typical of the Enlightenment? As typically American?

5. What specific human rights does Jefferson consider "natural"?

PHILLIS WHEATLEY

The first selection (1773) is dedicated to William Legge, Lord Dartmouth, who became secretary in charge of the American colonies in August 1772. Wheatley pleads with him to be more sympathetic to the demands of Americans for greater liberty in the colonies, using her own experience of captivity as an example. The second selection is not from the *Poems* but is a letter written in 1774 to Samson Occom (1723–1792), a Mohegan Indian and Presbyterian minister who had written a strong criticism of slaveholding Christian ministers.[1]

from *Poems on Various Subjects, Religious and Moral*

To the Right Honourable William, Earl of Dartmouth, His Majesty's Principal Secretary of State for North-America, Etc.

Hail, happy day, when, smiling like the morn,
Fair *Freedom* rose *New-England* to adorn:
The northern clime[2] beneath her genial ray,
Dartmouth, congratulates thy blissful sway:
Elate with hope her race no longer mourns,
Each soul expands, each grateful bosom burns,
While in thine hand with pleasure we behold
The silken reins, and *Freedom's* charms unfold.
Long lost to realms beneath the northern skies
She shines supreme, while hated *faction*[3] dies: 10
Soon as appear'd the *Goddess* long desir'd,
Sick at the view, she[4] languish'd and expir'd;
Thus from the splendors of the morning light
The owl in sadness seeks the caves of night.

No more, *America,* in mournful strain 15
Of wrongs, and grievance unredress'd complain,
No longer shalt thou dread the iron chain,
Which wanton *Tyranny* with lawless hand
Had made, and with it meant t' enslave the land.

Should you, my lord, while you peruse my song, 20
Wonder from whence my love of *Freedom* sprung,
Whence flow these wishes for the common good,
By feeling hearts alone best understood,
I, young in life, by seeming cruel fate

[1] This information comes from Henry Louis Gates Jr. and Nellie Y. McKay, eds., *The Norton Anthology of African American Literature* (New York: W. W. Norton, 1997), pp. 164–167, 170, 172, 176, 178.

[2] Region.

[3] I.e., internal conflict.

[4] "The Goddess": freedom.

Was snatch'd from *Afric's* fancy'd happy seat:[5] 25
What pangs excruciating must molest,
What sorrows labour in my parent's breast?
Steel'd was that soul and by no misery mov'd
That from a father seiz'd his babe belov'd:
Such, such my case. And can I then but pray 30
Others may never feel tyrannic sway?

 For favours past, great Sir, our thanks are due,
And thee we ask thy favours to renew,
Since in thy pow'r, as in thy will before,
To sooth the griefs, which thou did'st once deplore. 35
May heav'nly grace the sacred sanction give
To all thy works, and thou for ever live
Not only on the wings of fleeting *Fame*,
Though praise immortal crowns the patriot's name,
But to conduct to heav'ns refulgent fane,[6] 40
May fiery coursers[7] sweep th' ethereal plain,
And bear thee upwards to that blest abode,
Where, like the prophet,[8] thou shalt find thy God.

Letter to Samson Occom

Rev'd and honor'd Sir,

 I have this Day received your obliging kind Epistle, and am greatly satisfied with your Reasons respecting the Negroes, and think highly reasonable what you offer in Vindication of their natural Rights: Those that invade them cannot be insensible that the divine Light is chasing away the thick Darkness which broods over the Land of Africa; and the Chaos which has reign'd so long, is converting into beautiful Order, and [r]eveals more and more clearly, the glorious Dispensation of civil and religious Liberty, which are so inseparably united, that there is little or no Enjoyment of one without the other: Otherwise, perhaps, the Israelites had been less solicitous for their Freedom from Egyptian slavery; I do not say they would have been contented without it, by no means, for in every human Breast, God has implanted a Principle, which we call Love of Freedom; it is impatient of Oppression, and pants for Deliverance; and by the Leave of our modern Egyptians I will assert, that the same Principle lives in us. God grant Deliverance in his own Way and Time, and get him honour upon all those whose Avarice impels them to countenance and help forward the Calamities of their fellow Creatures. This I desire not for their Hurt, but to convince them of the strange Absurdity of their Conduct whose Words and Actions are

so diametrically opposite. How well the Cry for Liberty, and the reverse Disposition for the exercise of oppressive Power over others agree,—I humbly think it does not require the Penetration of a Philosopher to determine.—

COMMENTS AND QUESTIONS

1. By what poetic means does Wheatley portray freedom?

2. What connection does she make between her experience and the colonists' concerns?

3. What role does religion play in the poem?

4. Summarize Wheatley's main point in the letter. By what devices does she express her main point effectively?

5. What seems to be her view of Africa in the letter? Does it contrast with her view of Africa in the poem?

6. What attitude does she express toward colonial slaveholders?

DAVID WALKER

from *David Walker's Appeal in Four Articles; Together with a Preamble, to the Coloured Citizens of the World*

Preamble

My dearly beloved Brethren and Fellow Citizens.

 Having travelled over a considerable portion of these United States, and having, in the course of my travels, taken the most accurate observations of things as they exist—the result of my observations has warranted the full and unshaken conviction, that we, (coloured people of these United States,) are the most degraded, wretched, and abject set of beings that ever lived since the world began; and I pray God that none like us ever may live again until time shall be no more. They tell us of the Israelites in Egypt, the Helots[1] in Sparta, and of the Roman Slaves, which last were made up from almost every nation under heaven, whose sufferings under those ancient and heathen nations, were, in comparison with ours, under this enlightened and Christian nation, no more than a cypher[2]—or, in other words, those heathen nations of antiquity, had but little more among them than the name and form of slavery;

[5] Abode or home. "Fancy'd": imagined.

[6] "Refulgent fane": shining temple.

[7] Horses.

[8] Elijah, who was carried to heaven in a chariot of fire (2 Kings 2:11).

[1] A state-owned serf in the ancient Greek city-state of Sparta.

[2] Something of no consequence.

while wretchedness and endless miseries were reserved, apparently in a phial, to be poured out upon our fathers, ourselves and our children, by *Christian* Americans!

These positions I shall endeavour, by the help of the Lord, to demonstrate in the course of this *Appeal,* to the satisfaction of the most incredulous mind—and may God Almighty, who is the Father of our Lord Jesus Christ, open your hearts to understand and believe the truth. . . .

. . . I will ask one question here.—Can our condition be any worse?—Can it be more mean and abject? If there are any changes, will they not be for the better, though they may appear for the worst at first? Can they get us any lower? Where can they get us? They are afraid to treat us worse, for they know well, the day they do it they are gone. But against all accusations which may or can be preferred against me, I appeal to Heaven for my motive in writing—who knows that my object is, if possible, to awaken in the breasts of my afflicted, degraded and slumbering brethren, a spirit of inquiry and investigation respecting our miseries and wretchedness in this *Republican Land of Liberty!!!!!!* . . .

. . . And those enemies who have for hundreds of years stolen our *rights,* and kept us ignorant of Him and His divine worship, he [God] will remove. Millions of whom, are this day, so ignorant and avaricious, that they cannot conceive how God can have an attribute of justice, and show mercy to us because it pleased Him to make us black—which colour, Mr. Jefferson calls unfortunate!!!!!! As though we are not as thankful to our God, for having made us as it pleased himself, as they, (the whites) are for having made them white. They think because they hold us in their infernal chains of slavery, that we wish to be white, or of their color—but they are dreadfully deceived—we wish to be just as it pleased our Creator to have made us, and no avaricious and unmerciful wretches have any business to make slaves of or hold us in slavery. How would they like us to make slaves of, and hold them in cruel slavery, and murder them as they do us?—But is Mr. Jefferson's assertion true? viz. "that it is unfortunate for us that our Creator has been pleased to make us *black.*" We will not take his say so, for the fact. The world will have an opportunity to see whether it is unfortunate for us, that our Creator *has made us* darker than the *whites.* . . .

The world knows, that slavery as it existed among the Romans, (which was the primary cause of their destruction) was, comparatively speaking, no more than a *cypher,* when compared with ours under the Americans. Indeed I should not have noticed the Roman slaves, had not the very learned and penetrating Mr. Jefferson said, "when a master was murdered, all his slaves in the same house, or within hearing, were condemned to death."—Here let me ask Mr. Jefferson, (but he is gone to answer at the bar of God, for the deeds done in his body while living,) I therefore ask the whole American people, had

I not rather die, or be put to death, than to be a slave to any tyrant, who takes not only my own, but my wife and children's lives by the inches? Yea, would I meet death with avidity far! far!! in preference to such *servile submission* to the murderous hands of tyrants. Mr. Jefferson's very severe remarks on us have been so extensively argued upon by men whose attainments in literature, I shall never be able to reach, that I would not have meddled with it, were it not to solicit each of my brethren, who has the spirit of a man, to buy a copy of Mr. Jefferson's "Notes on Virginia," and put it in the hand of his son. For let no one of us suppose that the refutations which have been written by our white friends are enough—they are *whites*—we are *blacks.* We, and the world wish to see the charges of Mr. Jefferson refuted by the blacks *themselves,* according to their chance; for we must remember that what the whites have written respecting this subject, is other men's labours, and did not emanate from the blacks. I know well, that there are some talents and learning among the coloured people of this country, which we have not a chance to develope, in consequence of oppression; but our oppression ought not to hinder us from acquiring all we can. For we will have a chance to develope them by and by. God will not suffer us, always to be oppressed. Our sufferings will come to an *end,* in spite of all the Americans this side of *eternity.* Then we will want all the learning and talents among ourselves, and perhaps more, to govern ourselves.—"Every dog must have its day," the American's is coming to an end.

But let us review Mr. Jefferson's remarks respecting us some further. Comparing our miserable fathers, with the learned philosophers of Greece, he says: "Yet notwithstanding these and other discouraging circumstances among the Romans, their slaves were often their rarest artists. They excelled too, in science, insomuch as to be usually employed as tutors to their master's children; Epictetus, Terence and Phædrus,[3] were slaves,—but they were of the race of whites. It is not their *condition* then, but *nature,* which has produced the distinction." See this, my brethren!! Do you believe that this assertion is swallowed by millions of the whites? Do you know that Mr. Jefferson was one of as great characters as ever lived among the whites? See his writings for the world, and public labours for the United States of America. Do you believe that the assertions of such a man, will pass away into oblivion unobserved by this people and the world? If you do you are much mistaken—See how the American people treat us—have we souls in our bodies? Are we men who have any spirits at all? I know that there are many *swell-bellied* fellows among us, whose greatest object is to fill their stomachs. Such I do

[3] A classical Roman philosopher, a dramatist, and an author of fables, respectively, each one born in slavery.

not mean—I am after those who know and feel, that we are MEN, as well as other people; to them, I say, that unless we try to refute Mr. Jefferson's arguments respecting us, we will only establish them.

But the slaves among the Romans. Every body who has read history, knows, that as soon as a slave among the Romans obtained his freedom, he could rise to the greatest eminence in the State, and there was no law instituted to hinder a slave from buying his freedom. Have not the Americans instituted laws to hinder us from obtaining our freedom? Do any deny this charge? Read the laws of Virginia, North Carolina, etc. Further: have not the Americans instituted laws to prohibit a man of colour from obtaining and holding any office whatever, under the government of the United States of America? Now, Mr. Jefferson tells us, that our condition is not so hard, as the slaves were under the Romans!!!!!!

It is time for me to bring this article to a close. But before I close it, I must observe to my brethren that at the close of the first Revolution in this country, with Great Britain, there were but thirteen States in the Union, now there are twenty-four, most of which are slave-holding States, and the whites are dragging us around in chains and in handcuffs, to their new States and Territories to work their mines and farms, to enrich them and their children—and millions of them believing firmly that we being a little darker than they, were made by our Creator to be an inheritance to them and their children for ever—the same as a parcel of *brutes*.

Are we MEN!!—I ask you, O my brethren! are we MEN? Did our Creator make us to be slaves to dust and ashes like ourselves? Are they not dying worms as well as we? Have they not to make their appearance before the tribunal of Heaven, to answer for the deeds done in the body, as well as we? Have we any other Master but Jesus Christ alone? Is he not their Master as well as ours?—What right then, have we to obey and call any other Master, but Himself? How we could be so *submissive* to a gang of men, whom we cannot tell whether they are *as good* as ourselves or not, I never could conceive. However, this is shut up with the Lord, and we cannot precisely tell—but I declare, we judge men by their works. . . .

COMMENTS AND QUESTIONS

1. Describe Walker's style and its effect.
2. What distinction does the author make between slavery in antiquity and "modern" slavery?
3. Why does he draw on Enlightenment ideas and on the moral teachings of Christianity?
4. What is his criticism of Thomas Jefferson? Is it justified?
5. What does Walker see as the goal of the "coloured citizens of the world"?

Summary Questions

1. How did Americans adopt and alter the ideas of the European Enlightenment in political thought, art, and literature?
2. What role did religion play in the American colonies?

3. What impact did ancient Rome have on revolutionary and postrevolutionary America?
4. What were the causes of the American Revolution?
5. How did a specifically American style of painting evolve from European models?
6. How did African American writers apply Enlightenment ideals to the problem of slavery?

Key Terms

Great Awakening

empiricism

federalism

republican tradition of ancient Rome

Palladian villa

portico

dome

Unitarian

academical village

slavery

26

The Classical Style in Music, the Development of Opera, and Mozart's *Don Giovanni*

The baroque style in music, as stated earlier, lasted well into the eighteenth century, but the second half of the century saw the development of a musical style better suited to the ideals of the Enlightenment. This period of calming, lightening, balancing, and simplifying—this brief and splendid era—is one that music historians have labeled *classic*. It reached its height in the works of two towering geniuses: Josef Haydn and Wolfgang Amadeus Mozart. The compositions of Haydn consistently employed distinct phrases and sections in new structures that achieved unity and balance through readily perceived contrasts of melodies and harmonies. The music of Mozart forsook the intricate counterpoint and long-winded phrases of the baroque master Bach.

Composers seemed to find a regularity in their musical language that brought a logical coherence to works both tiny and grandiose. They worked primarily with the short, articulated phrase; they strove for structural symmetry; and they contrasted the rhythmic activities of the melody and the harmony in such a way that "tune" and "harmony" became distinct entities. New instruments developed, as they always had in the past; but, more importantly, old instruments changed character so that eventually the piano would replace the harpsichord and clavichord and the violin would replace the viol. This came about because the new bourgeoisie created a market for music, calling it from the patron's chamber to the public concert hall. As *dynamics* became louder, the music became more appropriate for performance before large audiences. At this time the symphony orchestra emerged as a primary musical medium through which compositional ideas might be sounded in concert.

We will study the form of the classical symphony in the next chapter as we look at a work that breaks the classical limits to announce the romantic style: Beethoven's Ninth Symphony. Here we intend to focus on one of the greatest operas ever written. First, however, it is necessary to understand the development of this art form combining drama, spectacle, and music.

Opera

Opera as we know it today has a long, continual history that dates back to a group of Florentine aristocrats who met at the home of Count Giovanni de' Bardi in the late sixteenth century. He was host to a set of Italian humanists known as the Camerata, a group of friends who met as an intellectual club to discuss cultural—primarily literary—matters. However, most of the members were musical amateurs, and three—Vincenzo Galilei, Giulio Caccini, and Pietro Strozzi—were musicians of the highest order. In the Camerata's attempt to understand classical Greek drama and the power music apparently held to sway the emotions of the ancient Greeks, the group laid the groundwork for the development of a music drama soon to be called *opera*. The search for cultural roots brought the group back to classical Greece, but one must not overlook the fact that there had been a continual interest in the West in the relationship of musical matters (appropriate themes, modes, rhythms, and so forth) to textual significance and dramatic events.

Even Gregorian chants may be seen as a musical amplification and ornamentation of the drama of the liturgy. The mass, after all, is the repeated symbolic action of the last days of Christ on earth. In the later Middle Ages, we saw that more overt musical drama developed within the Church when we studied *The Play of Daniel* (Chapter 9). Then, in the Renaissance, the development of oratorio and opera heralded the dawn of the baroque period. The music of the first opera that resulted from the efforts of the Camerata is lost, but an example of the declamatory style developed to "imitate" Greek music drama can be found in Jacopo Peri's *Euridice*, the earliest opera (1600) for which complete music has survived. The first masterpiece in this genre, Claudio Monteverdi's *L'Orfeo* (1607), followed soon after, and the next two centuries saw a rapid expansion of interest and remarkable growth, change, and development in nearly all technical aspects of the genre: libretto, scenery, costume, dance, and music—orchestration, forms, vocal virtuosity, and so on. The growth of opera took place throughout Europe, not just in Italy, and important contributors were Jean-Baptiste Lully in France (for example, *Le Bourgeois Gentilhomme*), Henry Purcell in England, Giovanni Pergolesi and Alessandro Scarlatti in Italy, and George Frederick Handel in Germany and England (for example, *Messiah*). Even though he was German and wrote for German audiences, Handel composed Italian operas in the Italian style.

The word *opera* comes from the Italian *opera in musica* (work in music), and it may be defined as a drama, either tragic or comic, sung throughout and presented on stage with scenery and action. The emphasis is on the solo voice, and, like the oratorio, which borrowed the forms from opera, it employs *arias* and *recitatives*. Because opera, of all the musical or dramatic forms, is the most difficult and expensive to produce, it has always been associated with the upper strata of social life. Often, the satisfaction of being able to support an operatic production—that is, sponsor a big, ostentatious display—has been compensation enough for a great many noble and wealthy patrons. Likewise, to be able to understand and appreciate this art form has been, and still is, a prestige symbol with the general public.

The successful composer and producer of opera have also traditionally received special rewards because of its difficulty, expense, and elite clientele. In the second half of the eighteenth century, such a composer was Wolfgang Amadeus Mozart—child prodigy, court figure, true genius, and perhaps the most universal composer in the history of Western music. In 1769, Sigismund, count of Schrattenbach and archbishop of Salzburg, gave orders for Mozart's first opera, *La Finta Semplice,* to be performed in the palace. Wolfgang was thirteen and had written it when he was twelve! After the performance, Sigismund appointed the young Mozart to be Kapellmeister, an important court position. This opera was not Mozart's first stage composition, for he had composed the *Singspiel* (operetta) *Bastien und Bastienne* a year earlier. As fine as these early compositions are, they are still youthful works and serve only as a prelude to the towering monuments of his mature years. The opera *Don Giovanni* (Don Juan) is one such masterpiece.

By 1787, the year of *Don Giovanni,* opera was a popular *form* among the elite of Austria, and Mozart was riding on the success of *Le Nozze di Figaro* (The Marriage of Figaro), produced in Prague the preceding winter. The classical style in music was established, and opera as a formal structure was well defined and commonly understood. When Mozart asked his librettist, Lorenzo da Ponte, for a new opera to follow *Figaro,* da Ponte was already busy with two other commissions. It may have been for this reason that he seized on the story of Don Juan, for he could rework a well-known tale more quickly than compose a new one.

The Don Juan Theme

Tirso de Molina's *The Trickster of Seville* fired the imaginations of many imitators, notably in the Italian *commedia dell'arte* (see the section on Molière, Chapter 23), in which Don Juan began to appear not so much as an overconfident aristocrat but more as a wicked and scheming character in revolt against both society and religion. His next important literary incarnation is in Molière's play *Don Juan* (1665). There the

hero appears as a character type prevalent in the French neoclassical period: the libertine. Refined and sophisticated, a cynical philosopher of free love rather than an unrepentant deceiver, Molière's Don Juan apparently has no religious beliefs. The eighteenth century, a time of increased freedom between the sexes, saw portrayals of a scheming seducer who pursued women as if in a military campaign and who cared for nothing but his own pleasure. By then Don Juan had a real-life counterpart in Italy—the famous Casanova.

Da Ponte and Mozart's collaborative work was not the first opera on Don Juan (Giovanni is the Italian equivalent of John or Juan), but it is the one that has made the legend immortal. Da Ponte was able to combine the vitality and passion of Tirso's hero with the wit and scheming intelligence of the Don Juans of Molière and his successors. Although the basic story line of Tirso's play remains, da Ponte has added some characters and events, eliminated some, and changed almost everyone's name. With his development of the character of the Don's servant, now called Leporello, he was able to merge the comic with the serious in original ways (as when Leporello sings under the table during Don Giovanni's supper with the statue). It is true that, as in most operas, there are some improbable incidents and the action does not always follow smoothly. This is more than compensated for, however, by the genius of Mozart.

In *Don Giovanni* perhaps even more than in his earlier operas, Mozart shows his ability to assume the personality and state of mind of his principal characters and his genius to create music suitable to each. Indeed, the music changes mood and character, reflecting the attitude and frame of mind of the singer. Mozart creates character in musical terms in the same way that Shakespeare does with vocabulary and poetic structures. This is remarkable enough in the parts in which only one character appears on stage at a time, but his virtuosity is particularly striking in the scenes in which several characters appear together, usually in conflict. At these times the element of "symphonic development" enters as an important ingredient in Mozart's style: through this polyphonic interweaving of the voice and orchestra the characterization comes to life.

WOLFGANG AMADEUS MOZART[1] AND LORENZO DA PONTE

Don Giovanni: The Rake Punished

A Comic Opera in Two Acts

Don Giovanni (baritone) is a Spanish nobleman who is both courageous and self-indulgent. With bravado he defies convention, propriety, and established authority, and with gusto he pursues, seduces, and subsequently abandons all women who cross his path. This opera represents the end of a dazzlingly successful career of seduction. It portrays not Don Giovanni's successes but rather his failures, and it ends with a heroic rejection of compromise, along with the terrible penalty exacted for the Don's refusal of penitence.

We learn that before the story begins, *Donna Anna* (soprano) was successful in rejecting the forceful advances of Don Giovanni, but because this event took place in the dark, she is unaware of the identity of her assailant. Don Giovanni is served by *Leporello* (bass), a resourceful but cowardly scoundrel. In contrast to Don Giovanni, Donna Anna's fiancé, *Don Octavio* (tenor), is a somewhat pale character. But *Donna Elvira* (soprano) is not. She is a lady from Burgos who truly loves Don Giovanni and vainly hopes to reform him. Despite the pain of having been loved and deserted by the Don, she tries to win him back and save his soul. Donna Elvira is almost as striking a character as the Don himself, for she refuses to accept the code of conduct laid down by society. Even though she is of nobility and has been wronged by Don Giovanni, she considers herself to be his wife, follows him around, and tries to save him, not from the mores of society but from the evil within himself.

Three lesser but important roles complete the cast of characters. The *Commendatore* (bass), Donna Anna's father, is killed in the first scene by Don Giovanni while trying to avenge his daughter's honor. *Zerlina* (soprano), just one more conquest for the Don, is an attractive peasant girl who is seduced on the very eve of her wedding day. *Masetto* (bass) is the country bumpkin to whom she is engaged. Mozart also gives dramatic substance to the *Chorus,* which sings and dances as peasants in Act I and which personifies devils in Act II.

The opera begins with an orchestral *overture,* a symphonic composition in its own right. An opera overture is the independent orchestral piece, usually of moderate length, that precedes the opera and prepares the audience for the musical drama which follows. Sometimes it introduces melodies from the opera, but often it is used primarily to catch the listeners' attention and establish the mood of the comedy or tragedy. Mozart's overture to *Don Giovanni* has a slow (andante) introduction. The massive opening chords establish the key of D minor and use a syncopated rhythm to begin the forward motion and give the listener a feeling of disquiet. Soon the syncopations move at twice the speed, and the forward movement becomes more intense. Shifting harmonies, expressive dissonances, and the hypnotic syncopated figure help set the mood for the music that follows. The notes are subdivided again, and the speed increases with running passages that crescendo and decrescendo (grow louder and softer) in sequence.

[1] Mozart himself conducted the first performance in Prague in 1787, and the audience responded with cheers.

Suddenly the tempo changes, the mood becomes more lively as the mode shifts to major, and the principal theme is introduced. This is the exposition section, and Mozart displays his musical prowess in sonata form, a musical construction in three sections—exposition, development, and recapitulation—in which two contrasting musical ideas are pitted against each other, developed, and brought together for resolution. The rising first theme is followed by a descending and less lyrical second theme.

The conflicting personalities of the music in this opening movement undergo a dramatic development not unlike the drama that will take place on the stage later. In music, the development involves changes of key, interworkings of themes and fragments of themes, orchestration changes, contrasts of dynamics, and the general interplay of musical elements that give life to an extended composition. The overture is a beginning, and before the final resolution it flows without pause into the opening song of Leporello. The curtain rises on the Don's servant, wrapped in his cloak and pacing back and forth in the darkness outside the house of Donna Anna.

LEPORELLO:

Notte e giorno faticar	ˊ ˘ ˊ ˘ ˊ ˘ ˊ	[-car]
Per chi nulla sa gradir;	˘ ˘ ˊ ˘ ˘ ˊ ˘ ˊ	[-dir]
Pioggia e vento sopportar,	ˊ ˘ ˊ ˘ ˘ ˊ ˘ ˊ	[-tar]
Mangiar male e mal dormir!	ˊ ˘ ˊ ˘ ˊ ˘ ˘ ˊ	[-mir]

Night and day I slave away
For one who's never pleased.
Through wind and rain I earn my pay
Of rotten food and troubled sleep.

Don Giovanni suddenly appears, having been forced to make a hasty exit from the house of Donna Anna. She pursues him, and the commotion wakes her father, the Commandant. He challenges Don Giovanni who, at first reluctant to duel the old man, succumbs to vanity and murders him. Others rush to the scene of the crime, but Don Giovanni and Leporello escape. The scene closes with Don Octavio promising to avenge the deed.

The scene changes to another street, where the Don and Leporello chatter about his habits. An angry Donna Elvira appears, and we learn that she pursues him because he seduced her with a promise of marriage. She sings her aria:

DONNA ELVIRA:

Ah! chi mi dice mai	ˊ ˘ ˘ ˊ ˘ ˊ ˘	[-i]
Quel barbaro dov'è,	ˊ ˊ ˘ ˊ ˘ ˊ ˘	[-v'è]
Che per mio scorno amai	ˊ ˘ ˘ ˊ ˘ ˊ ˘	[-i]
Che mi mancò di fè?	ˊ ˘ ˊ ˊ ˘ ˊ ˘	[-fè]

Oh, who can tell me now
Where to find the cad I seek,
Whom, to my shame, I gave my love,
Who betrayed and left me there?

Don Giovanni slips out, leaving Leporello to explain the facts of his master's life to her. In a rollicking song he points out that, to date, his master has already seduced 2,065 women, 1,003 of them in Spain. In spite of the seriousness of the crime, rape, the audience cannot help smiling, because the composer seduces the listener with his music, and the librettist with his words. This is *opera buffa* at its best, a tradition reaching back to seventeenth-century Italy and forward at least as far as Gilbert and Sullivan. For those who know *The Mikado*, it becomes obvious that Leporello's aria serves as the model for Pooh Bah's "I've got a little list!" Still, the astute drama critic would realize that this gesture of open confession is somewhat out of character for the trusted servant.

LEPORELLO:

Madamina, il catalogo è questo
Delle belle che amò il padron mio:
Un catalogo egli è che ho fatt'io;
Osservate, leggete con me.
In Italia seicentoquaranta,
In Alemagna duecentotrentuna,
Cento in Francia, in Turchia novantuna,
Ma in Ispagna son già mille e tre.
V'han fra queste contadine,
Cameriere, cittadine,
V'han contesse, baronesse,
Marchesane, principesse,
E v'han donne d'ogni grado,
D'ogni forma, d'ogni età.

> Little lady, this is a list
> Of the beauties my master loved:
> A catalogue I compiled;
> Take a look, read along with me.
> In Italy, six hundred and forty,
> In Germany, two hundred thirty-one.
> One hundred in France, ninety-one in Turkey,
> But in Spain, already one thousand and three.
> Among these are peasant girls,
> Maidservants, city girls,
> Countesses, baronesses,
> Noble ladies, even princesses.
> Women of every rank,
> Of every size, of every age.

Nella bionda egli ha l'usanza
Di lodar la gentilezza;
Nella bruna la costanza;
Nella bianca la dolcezza;
Vuol d'inverno la grassotta,
Vuol d'estate la magrotta;
È la grande maestosa,
La piccina è ognor vezzosa;
Delle vecchie fa conquista
Pel piacer di porle in lista;
Sua passion predominante
È la giovin principiante;
Non si picca se sia ricca,

Se sia brutta, se sia bella;
Purchè porti la gonnella,
Voi sapete quel che fa.

> With blonds, it is his habit
> To praise their kindness;
> With brunettes their faithfulness;
> Or the white-haired's sweetness.
> In the winter he likes fat ones,
> In the summer, he likes them thin.
> He calls the tall ones stately,
> A tiny one always dainty;
> Even the elderly he seduces for
> The pleasure of adding to the list.
> His greatest passion
> Is the young beginner;
> It doesn't matter if she's rich,
> If she's ugly or a beauty;
> Because if she wears a skirt,
> You know what he does.

The scene changes. A group of gay young country people are celebrating the forthcoming marriage of Zerlina and Masetto. When Don Giovanni and Leporello join the group, the Don loses no time in beginning his seduction of Zerlina. He promises a party at the villa and orders Masetto to lead the others there. He, of course, will escort the bride-to-be. Masetto is not fooled, but he fears disobeying the nobleman. As soon as they are gone, Don Giovanni promises, in a lovely duet, to marry Zerlina. Mozart's mastery of both the classical principles of formal balance and the dramatist's need to set the words of a love duet for a simple country maid in appropriate sounds is clearly demonstrated here. The duet's formal scheme of A–B–A–C is combined with simple melodies, clear harmonies, and uncomplicated rhythms.

A

DON GIOVANNI:
Là ci darem la mano,
Là mi dirai di sì
Vedi, non è lontano,
Partiam, ben mio, da qui.

> There we'll hold hands,
> There you'll whisper "yes,"
> See, it's not far,
> Let's go there, my dear.

CD-2, 10

ZERLINA:
Vorrei, e non vorrei . . .
Mi trema un poco il cor . . .
Felice, è ver, sarei:
Ma può burlarmi ancor.

> I'd like to but I dare not,
> My heart trembles a bit,
> It's true, I would be happy:
> But might he be tricking me?

DON GIOVANNI:
Vieni, mio bel diletto!

> Come, my dearly beloved!

B

ZERLINA:
Mi fa pietà Masetto!

> I'm sorry for Masetto!

DON GIOVANNI:
Io cangerò tua sorte.

> I'll change your way of life.

ZERLINA:
Presto . . . non son più forte.

> Quickly . . . I'm not very strong.

[repeat of beginning in dialogue form]

C

TOGETHER:
Andiam, andiam, mio bene,
A ristorar le pene
D'un innocent amor!

> Let's go, let's go, my dearest,
> To soothe the ache
> Of an innocent love!

Before the two can slip away, Donna Elvira appears and exposes the Don's real intentions. She takes the girl with her, and Donna Anna and Don Octavio enter to enlist Don Giovanni's aid in the search for her father's murderer. Donna Elvira returns to expose her faithless lover again, and Donna Anna begins to suspect the possible guilt of Don Giovanni.

Donna Elvira leaves, and she is followed by a much-irritated Don Giovanni. Donna Anna confides her suspicions to Don Octavio, and they talk the circumstances through in a recitative.

DONNA ANNA:
Don Ottavio . . . son morta!

> Don Octavio, I shall die!

DON OCTAVIO:
Cos'è stato?

> What's happened?

DONNA ANNA:
Per pietà, soccorretemi.

> For pity's sake, help me.

DON OCTAVIO:
Mio bene, fate coraggio.

> My dearest, be brave.

DONNA ANNA:
O Dei! quegli è il carnefice del padre mio!

> Oh God! There goes my father's executioner!

DON OCTAVIO:
Che dite?

> What did you say?

DONNA ANNA:

Non dubitate più. Gli ultimi accenti, che l'empio pro-
ferì, tutta la voce richiamà nel cor mio di quell'in-
degno che nel mio appartamento . . .

> There's no doubt about it. His parting words, the
> quality of his voice, bring back the memory of
> that vile beast who, in my chamber . . .

DON OCTAVIO:

Oh ciel! possibile che sotto il sacro manto d'ami-
cizia . . .
Ma come fu, narratemi lo strano avvenimento.

> Oh heaven! Could it be that under the sacred cloak
> of friendship . . .
> But what happened? Describe this bizarre affair.

DONNA ANNA:

Era già alquanto avanzata la notte, quando nelle mie
stanze, ove soletta mi trovai per sventura, entrar io
vidi in un mantello avvolto un uom che al primo is-
tante avea preso per voi; ma riconobbi poi che un
inganno era il mio . . .

> It was already quite late when into my room, where
> unluckily I happened to be alone, I saw a man enter
> all wrapped in a cloak. At first, I mistook him for
> you: But I soon found out how mistaken I was . . .

DON OCTAVIO:

Stelle; seguite.

> Great heavens! Go on.

DONNA ANNA:

Tacito a me s'appressa, e mi vuol abbracciar; scio-
gliermi cerco, ei più mi stringe; io grido; non vien al-
cun; con una mano cerca d'impedire la voce, e coll'-
altra m'afferra stretta cosi, che già mi credo vinta.

> Silently he came next to me, and drew me to him: I
> tried to free myself, but he only drew me closer. I
> screamed, but no one came: With one hand, he
> tried to stifle my voice, and with the other, he
> held me so tight I thought I must die.

DON OCTAVIO:

Perfido! E alfin?

> Horrible! And then?

DONNA ANNA:

Alfine il duol, l'orrore dell'infame attentato accìrebbe
sì la lena mia che a forza di svincolarmi, torcermi e
piegarmi, da lui mi sciolsi.

> Finally, the shame, the horror of this vile affront, so
> strengthened me that by struggling, twisting, and
> turning I was able to break loose from him.

DON OCTAVIO:

Ahimè! Respiro.

> Thank God! I can breathe again.

DONNA ANNA:

Allora rinforzo i stridi miei, chiamo soccorso, fugge il
fellon; arditamente il seguo fin nella strada per fer-
marlo, e sono assalitrice ed assalita: il padre v'ac-
corre, vuol conoscerlo, e l'indegno che del povero
vecchio era più forte, compie il misfatto suo col
dargli morte.

> Then I redoubled my screaming. I yelled for help,
> and the criminal raced out: boldly I chased him
> out to the street to stop him and began hitting
> my assailant: my father challenged him, wanting
> to know his identity. But the wretch, who was
> stronger than my poor old father, ended his night
> of crime by killing him.

She then cries for vengeance in a mag-
nificent *da capo* aria, with coda. (*Da capo*
means "go back to the beginning.") There-
fore, the aria, which has two musical sec-
tions (A–B), gains its classical, rounded
binary form when the first section is re-
peated (A–B–A). Then, with a little exten-
sion (coda), it closes.

CD-2, 11

DONNA ANNA:

A
> Or sai chi l'onore
> Rapire a me volse:
> Chi fu il traditore,
> Che il padre mi tolse:
> Vendetta ti chiedo,
> La chiede il tuo cor.
>
>> Now you know who tried
>> To take from me my honor,
>> Who was my betrayer,
>> Who took my father's life:
>> I ask you for vengeance,
>> Your heart asks it too.

B
> Rammenta la piaga
> Del misero seno:
> Rimira di sangue
> Coperto il terreno,
> Se l'ira in te langue
> D'un giusto furor.
>
>> Remember the wound
>> In his poor breast:
>> If the wrath of a just fury
>> Ever weakens in you,
>> Remember the pool of blood
>> Covering the ground.

[D.C. (*da capo*—A again) and coda]

Donna Anna leaves, and Don Octavio sings of his
love for her as well as his determination to discover the
truth. He must either redeem his friend Don Giovanni
or avenge his love.

In the next scene, the Don is fully recovered and
goes on as though nothing has happened. He is prepar-

ing the party for Masetto and Zerlina, and he is laying plans for his next conquest.

DON GIOVANNI:
Fin ch'han dal vino
Calda la testa,
Una gran festa
Fa preparar.
Se trovi in piazza
Qualche ragazza,
Teco ancor quella
Cerca menar.
Senza alcun ordine
La danza sia:
Chi il minuetto,
Chi la follia,
Chi l'alemanna
Farai ballar.
Ed io frattanto
Dall'altro canto
Con questa e quella
Vo' amoreggiar.
Ah! La mia lista
Doman mattina
D'una decina
Devi aumentar.

Go and prepare
A lavish affair
With plenty of wine
To make the heads spin.
If you find some young lady
Standing out in the square
Invite her too,
Try to bring her along.
Let the dancing be
Free and unrestricted:
Let them dance
Here a minuet,
Here a folia,
There an allemande.
And in the meantime,
To a different song,
I'll make love
To this one and that one.
Ah! Tomorrow morning
You will have to add
A dozen names
To my little list.

In the garden, Masetto scolds Zerlina and she begs his forgiveness. He is not thoroughly convinced of her faithfulness, but Don Giovanni turns the tables by reproaching Masetto for having left his bride. The three enter the house, and Donna Anna, Donna Elvira, and Don Octavio appear, masked. Leporello invites them to the party and then engages Masetto so that the Don can try once again to seduce Zerlina. They move into another room, but she begins to scream. The Don tries to bluff his way out by rushing from the room, sword in

hand, pretending it was Leporello who was annoying her. No one believes the story this time, but the fearless Don brazens his way out through the crowd, pushing Leporello in front of him.

Act II opens with Don Giovanni and Leporello standing before the inn in which Donna Elvira is staying. The Don, who now wants to seduce Donna Elvira's maid, has a mandolin in his hand. Knowing that Donna Elvira still loves him, he disguises Leporello as himself by exchanging clothes with his servant. Leporello then leads her off, leaving him a little free time with the maid. Don Giovanni serenades her with one of the most charming songs in the opera.

DON GIOVANNI:
Deh! vieni alla finestra,
 o mio tesoro.
Deh, vieni a consolar
 il pianto mio.
Se neghi a me di dar
 qualche ristoro,
Davanti agli occhi tuoi
 morir vogl'io.

O come to the window,
 my treasure,
O come and dispel
 my tears.
If you refuse
 to save me,
I will die
 before your eyes.

Tu ch'hai la bocca dolce
 più del miele,
Tu che il zucchero porti
 in mezzo al core,
Non esser, gioia mia,
 con me crudele,
Lasciati almen vedere,
 o bell'amore!

Your lips are sweeter
 than honey,
Your heart, the essence
 of sweet,
Do not be cruel,
 my gladness,
At least let me see you,
 my love.

But the Don is doomed to yet another failure, for before she can come to him, Masetto returns with a band of armed friends. Pretending to be Leporello, the Don sends Masetto's companions off on a wild goose chase, then tricks the not-too-bright Masetto into giving him his weapons and beats him severely before making an escape. Zerlina returns, comforts her bruised fiancé, and promises never to be unfaithful again.

The scene changes to a dark courtyard before Donna Anna's house. Donna Elvira tries to make love

to Leporello, whom she believes to be Don Giovanni, and Leporello seeks a way to escape. Suddenly, he is cornered by all of the Don's enemies, and he reveals his identity to save himself. They are irate at discovering that they have been tricked again, and seizing the opportunity, Leporello bolts away from them. Finally, Don Octavio promises to avenge them all and sings of his love for Donna Anna.

Although most of the drama of this scene is second-rate—few in the audience really believe that Leporello can imitate Don Giovanni well enough to deceive the one woman who knows, understands, and truly loves him, or that Leporello could simply run away from this furious group of armed men—the music is not. Following a brief recitative, each of the characters, in turn, expresses his or her thoughts with a brief melodic line characteristic of that particular personage. Gradually, the parts begin to combine until the five—Donna Anna, Zerlina, Donna Elvira, Don Octavio, and Masetto—group their musical forces against the line of Leporello in a sextet that is excellent musical drama. As they blend together in song, each maintains a distinct musical identity.

LEPORELLO (RECITATIVE):
Di molte faci il lume s'avvicina. . . .

See the lights of torches coming near. . . .

DONNA ELVIRA (1ST SOLO IN SEXTET):
Sola, sola in buio loco, palpitar il cor mi sento. . . .

All alone in this dark spot I feel the beating of my heart. . . .

LEPORELLO (2ND SOLO IN SEXTET):
Più che cerco, men ritrovo
Questa porta sciaguarata? . . .

The more I search, the less I find.
Where is this stupid doorway? . . .

DON OCTAVIO (3RD SOLO IN SEXTET):
Tergi il ciglio, o vita mia!
E da calma al tuo dolore. . . .

Stop your crying, my beloved,
And calm your sadness. . . .

In time, Zerlina and Masetto are introduced into the fabric too. When all are properly entered, the five side against Leporello.

LEPORELLO:
. . .
Viver lasciatemi, per carità!

. . .
Let me live, I beg you!

THE OTHERS:
Dei! Leporello!
Che inganno è questo? . . .

What? Leporello!
What trick is this? . . .

Also, when the group is about to punish Leporello, he stops the action with an aria that both seeks their pity and gives him time to move toward a convenient gate.

LEPORELLO:
Ah! Pietà signori miei!
Do ragione a voi . . . a lei . . .
Ma il delitto mio non è.
Il padron con prepotenza
L'innocenza mi rubò.
Donna Elvira! Compatite;
Già capite come andò.
Di Masetto non so nulla,
Vel dirà questa fanciulla;
E un'oretta circum circa
Che con lei girando vo.
A voi, signore, non dico niente.
Certo timore . . . certo accidente . . .
Di fuori chiaro . . . di dentro scuro. . . .
Non c'è riparo . . . la porta, il muro . . .
Io me ne vo da quel lato. . . .
Poi qui celato, l'affar si sa. . . .
Ma s'io sapeva, fuggia per qua! . . .

Oh! Have mercy my lords!
You are right, sir . . . and you . . .
But the real fault is not mine.
My master, with threats,
Robbed me of my innocence.
Donna Elvira! Forgive me!
You know what happened.
Of Masetto, I know nothing.
This lady can confirm it:
For about an hour
I've been walking with her.
To you, sir, I can say nothing.
Partly fear . . . partly chance . . .
It was light out but dark here.
No way out, the door, the wall,
I couldn't get out of here. . . .
Then I hid myself, you know all.
But had I known this, I'd have run from here! [flees]

Even though we are no more likely to believe that Don Octavio will live up to his word this time, since he has failed in the past, his sincerity, and his lovely tenor voice, are beautifully displayed in his aria.

DON OCTAVIO:
Il mio tesoro intanto
Andate a consolar:
E del bel ciglio il pianto
Cercate d'asciugar.
Ditele che i suoi torti
A vendicar io vado;
Che sol di stragi e morti
Nunzio voglio tornar.

Meanwhile, go and console
My dearest treasure:
And from her beautiful eyes,
Try and dry the tears.
Tell her I go
To avenge her wrongs:
I will return to announce
His punishment and death.

The scene changes to an enclosed cemetery with several equestrian statues, including that of the Commendatore. Don Giovanni enters, laughing about the night's events, and is quickly followed by a distressed Leporello. The Don chides him and tells about another escapade with a girl on his escape route. She mistook him for Leporello, showed affection, and was just about to be compromised by the Don when he heard pursuers coming and decided to run. Leporello is serious, but the Don is clever and unconcerned. Leporello says:

LEPORELLO:
Ma se fosse costei stata mia moglie?

But supposing she had been my wife?

And the Don laughingly replies:

DON GIOVANNI:
Meglio ancora!

Better still!

Then one of the most dramatic moments in the opera takes place, for the statue speaks!

COMMENDATORE:
Di rider finirai prima dell'aurora.

Your laughter will be silenced before morning.

From this moment on, the intense conflict between Don Giovanni's personal libertine philosophy and the morality of heaven and earth is personified in the struggle between the Don and the Commendatore. Leporello is frightened beyond reason when the marble statue speaks and nods, but Don Giovanni disdainfully commands his servant to invite the statue to dinner.

A brief respite takes place when the scene changes to a room in Donna Anna's house. Don Octavio tells her to calm down; the murder will be avenged. They should bow to the will of Providence, and she should soothe his longings by marrying him tomorrow. Donna Anna is affronted, Don Octavio calls her cruel, and she sets him straight in her recitative and aria.

DONNA ANNA (RECITATIVE):
Crudele? Ah no! mio bene! . . .

I cruel? Oh no, my dear! . . .

(aria)
Non mi dir, bell'idol mio,
Che son io crudel con te. . . .

Don't tell me, my love,
That I am cruel to you. . . .

Dramatically, there is not much point to this scene, other than providing time for a set change to Don Giovanni's dining hall. But musically, this aria gives Donna Anna an opportunity to display her coloratura vocal wares for the last time before the finale.

DONNA ANNA:
Forse un giorno il cielo ancora
Sentirà pietà di me.

Perhaps, one day, heaven will again
Feel merciful for me.

In the next scene, the curtain rises to show the dining room in Don Giovanni's house. The table is laid, and the Don, Leporello, servants, and a few musicians await the guest. Don Giovanni begins eating and jokes with Leporello and the musicians. Donna Elvira enters, pleads her love, and asks him to change. He only mocks her. Fearful screaming outside announces the approach of the invited guest. Leporello hides under the table while the Don opens the door. He invites the Commendatore to the table, and the statue slowly and grotesquely moves upstage. After a brief verbal repartee, the statue speaks.

COMMENDATORE:
Tu m'invitasti a cena:
Il tuo dovere or sai,
Rispondimi; verrai
Tu a cenar meco?

You invited me to supper;
You know what you must do,
So answer me: will you
Come and dine with me?

Don Giovanni is no coward. He takes the hand offered by the statue, and he is trapped. The statue demands repentance; Don Giovanni refuses. Flames leap up, a chasm opens, and the trombone voices of hell speak out. Before he is pulled to the torments of the underworld, Don Giovanni cries out:

DON GIOVANNI:
Chi l'anima mi lacera!
Chi m'agita le viscere!
Che strazio! ohimè! che smania!
Che inferno! che terror!

My soul is torn in agony!
My body is in torture!
What torment! Ah, what madness!
The fires of hell! The terror!

The flames rise and the chorus sings.

CHORUS:
Tutto a tue colpe è poco:
Vieni; c'è un mal peggior.

For all your sins, this is nothing:
Come! worse torments await below!

Were the opera to end here, it would have the elements of tragedy. The hero, Don Giovanni, recognizes his sins and goes to pay the price. But Mozart and da Ponte did not set out to moralize, but to entertain a pleasure-seeking audience. And with their final scene, they turn the drama from tragedy to comedy. As Don Giovanni disappears from the stage into the great abyss, all the principals emerge on the stage with officials and the entire cast. They ask for the criminal, learn of his fate, and quickly proceed to announce:

DON OCTAVIO:
 I want to get married.

DONNA ANNA:
 Give me a year.

DONNA ELVIRA:
 I'm off to a convent.

ZERLINA AND MASETTO:
 Let's go home to dinner.

LEPORELLO:
 I'll go to the Inn and find a better master.

And together, everyone sings and dances the moral of the tale:

TUTTI:
 Questo è il fin di chi fa mal!
 E de' perfidi la morte
 Alla vita è sempre ugual.
 This is the evil doer's end.
 Death is the payment for great sin.
 Always was and always will be.

Created toward the end of the Enlightenment and on the eve of the French Revolution, *Don Giovanni*

reflects the Enlightenment's reliance on reason and individual experience rather than on authority and tradition. Despite the final outcome, the opera is not without sympathy for the hero, for it balances the comic and tragic aspects of real human experience. Yet in presenting Don Giovanni as a man who lives without restraint and who views the well-being of others as incidental to the pleasure-seeking principle, Mozart and da Ponte seem to warn against the perils of supreme individualism. In keeping with the spirit of an age that could produce a treatise on toleration and the American Declaration of Independence and Constitution, the composer and the poet acknowledge the responsibilities of the individual and the possibility of retribution for acts that deny the rights of other individuals. Don Giovanni portrays this dilemma, a situation modern psychology would call the conflict of the id and superego, the struggle between immediate gratification and deferred pleasure for the greater good of both society and the individual. Yet it is not a sermon, but a work of art and an entertainment, a masterpiece of music and poetry by Wolfgang Amadeus Mozart and Lorenzo da Ponte.[2]

[2] Many fine recordings of *Don Giovanni* are, and will always be, available. One that can be recommended for both its fine performance and technical brilliance, as well as the quality of the book that accompanies the set, is produced by Deutsche Grammophon (419179-1 GH3; compact disk 419179-2 GH3). This performance is conducted by Herbert von Karajan and stars Kathleen Battle. It was recorded, mixed, and edited with the latest digital technology, and the resulting quality of sound is exquisite. Several films of the opera are now available on videocassette; the Glyndebourne Festival production by Peter Hall is one of the best (two cassettes, V69005, available from Media for the Arts, P.O. Box 1011, Newport, RI 02840).

Summary Questions

1. Is Don Giovanni a hero or a villain?
2. Does Leporello have a life of his own?
3. How are Donna Anna and Donna Elvira similar and different?
4. Why is Masetto so compliant to the Don's wishes?
5. Is Zerlina stupid? Innocent?
6. Is there a difference in the portrayal of rich nobility and poor working-class peasants?
7. What elements of authority and tradition and what elements of reason and individual experience are incorporated in the opera?
8. Would this opera be an effective stage drama without the music?

Key Terms

classic

opera

aria

recitative

form

overture

da capo

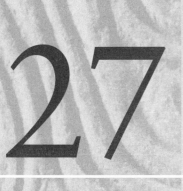

27

From Revolution to Romanticism

The French Revolution

The delicate balance between the demands of enlightened reason and those of passionate individualism was not to have a long supremacy in European culture. The philosophes' demands for a more just and equal society were to culminate in an upheaval of which they probably would not have approved: the French Revolution. It was an upheaval that changed the face of Europe forever.

The American Revolution, far less bloody, had in a sense served as a prelude to the French one. The American experiment demonstrated to Europeans that Enlightenment ideas could be realized in practice. The Declaration of Independence and the Virginia Statute of Religious Liberty were not abstract treatises but statements by a government of its official beliefs and policies. Heretofore, the principles of limited government and a system of checks endorsed by the U.S. Constitution had been considered by most Europeans to be connected with feudal privilege and aristocratic domination. This is why many of the philosophes had espoused absolute monarchy. America seemed to prove that this kind of constitutional structure could in fact foster the freedom and equality sought by Enlightenment thinkers.

Causes of the Revolution

The American example was particularly important for France. The most populous country in Europe and among the most prosperous, France in the last half of the eighteenth century was a troubled society. The death of Louis XIV in 1715 had brought to the throne a five-year-old boy, Louis XV (1710–1774). Largely unconcerned with government, Louis was primarily interested in women, eating, and lock making. His son, Louis XVI (1754–1793), although well meaning, was weak and popularly seen as dominated by his wife, Marie Antoinette.

Consequently, neither of these monarchs played a guiding role in the political life of the nation. A succession of ministers of varying ability governed the country, and policy lacked the consistency that an active monarch could have given it. Indicative of the shift in political focus was the increasing marginalization of Versailles as the center of French culture and the return of Paris to that position.

In retrospect, historians after the French Revolution came to speak of France in the eighteenth century as the *ancien régime* (the old order). All phases

CENTRAL ISSUES

- Causes and significance of the French Revolution
- The career and impact of Napoleon Bonaparte
- Relations between the revolution and romanticism
- Beethoven's Ninth Symphony and the transition between classicism and romanticism in music
- Aspects of the romantic hero and the romantic woman
- Romantic themes of individualism, nature, and love in lyric poetry, painting, music, and dance

of French life were dominated by an outmoded social structure that endured primarily because it was legally defined and protected. All French citizens except the royal family were divided into three classes: the clergy, the nobility, and the *third estate,* by far the largest of the three, comprising the peasants, the artisans of the towns, and the middle class, or *bourgeois.* Of France's twenty-four million people, only about 2 percent belonged to the clergy and nobility. Yet in a society in which land remained the greatest form of wealth, the other 98 percent owned only 60 percent of the landed property. This social group was the greatest force in causing the revolution.

But there was a greater source of discontent among the third estate. The clergy and nobility paid almost no taxes. Moreover, while giving little or nothing to support it, the nobility enjoyed all the highest offices in the government; they also constituted the officer corps of the army. As for the clergy, this class had the right to levy a tax, for its maintenance, on all agricultural goods produced by the third estate.

What made the situation volatile was that for most of the eighteenth century the economy was expanding. Bankers, merchants, and other members of the middle class had accumulated great wealth, and many of the peasants were prosperous. Traditionally, there had been various avenues by which successful members of the third estate could work their way into the nobility, but in the course of the eighteenth century these avenues had gradually been shut off by an aristocracy resolved not to dilute its membership further. The upper bourgeois, therefore, felt excluded from the social and financial privileges to which their success entitled them.

Economic prosperity also entailed rising prices and higher living costs. The nobility and clergy, barred by law from entering commerce or industry to reap the profits of the boom, increasingly came to insist on their economic rights over the third estate. Indeed, this was the heyday of lawyers employed by the upper classes to dredge up old, long-neglected rights over the peasantry. Moreover, although the bourgeoisie and the upper peasantry were profiting throughout most of the eighteenth century, the lower classes, at least in the last half of the century, saw their wages rise more slowly than prices and their standard of living fall.

The most immediate cause of the revolution, which began in the summer of 1789, was the government's financial crisis. Because some of the wealthiest elements in the country were exempt from taxation, the state could not balance its budget. An important element in the French public debt was the expense incurred by helping the Americans in their revolt against England. For years the enlightened advisers of the French king had endeavored to abolish the tax privileges of the clergy and the nobility, but these two orders had solidly resisted the effort. The king could proclaim the necessary laws, but the courts, completely controlled by the nobility, would never enforce them. Finally, in 1788, the royal government simply abolished the old court system and created a new one.

The result was an aristocratic revolt: the army officers and the king's officials at Paris and in the provinces refused to serve, and the whole state was brought to a halt. Unable to persevere in the attempt at reform, the king (Louis XVI) acceded to the nobility's demands that, for the first time since 1614, a national assembly be called to settle the nation's problems. The nobility clearly intended to gain more control over the king's government through an assembly that, by tradition, gave it and the clergy (dominated by the aristocracy) two votes, against one for the third estate.

Beginning of the Revolution

The Assembly met in May 1789 at Versailles, but in the months preceding the meeting, the third estate, growing conscious of its massive power, resolved to use the Assembly as a means of abolishing legal classes. Refusing their places in the Royal Assembly, where they were given one of the three votes, the delegates of the third estate declared themselves to be the Assembly of the Nation and defied the monarchy. Although Louis XVI called troops to Versailles at the end of June, he hesitated to arrest the disobedient delegates. In the atmosphere of tension prevailing over the next weeks, the common people of Paris rose on July 14, 1789, stormed and captured the Bastille (the king's prison in the city), and the revolution was on. The terrified king ordered the nobility and clergy to join with the third estate; those who had not already joined out of sympathy or gone home did so.

One of the first steps of the new one-house National Assembly was the publication of the Declaration of the Rights of Man and of the Citizen on August 26, 1789. Like the American Bill of Rights, its provisions emphasized the freedom and equality of every man. Subsequently, all privilege was abolished and the Church's property confiscated; henceforth, the clergy were to receive salaries from the state. The leaders of the Assembly at this stage were determined to make France a constitutional monarchy like that of England. Before the new constitution could be approved, however, the would-be constitutional monarch, Louis XVI, fled in June 1791. Despite his capture, the position of the leadership was undercut, and the *Jacobins,* or republicans, seized power in the National Assembly in September 1791. The king, however, was not officially deposed until August 1792, when France was declared a republic.

The Jacobins

The Jacobins were interested in more than transforming the French monarchy into a republic; they also wished to topple the crowned heads all over Europe and republicanize the subcontinent. Their rise to power naturally brought on conflict with the rest of Europe, and from the spring of 1792 France was at war. When the war began badly and the politicians blamed the defeat of the army on treachery behind the lines, the pursuit of traitors was under way. Starting in May 1793, the radical Jacobins, a group of ruthless idealists, displaced the more moderate leadership.

Maximilien Robespierre (1754–1794)

Whereas the moderate Jacobins had aimed at establishing a republic governed by an electorate with modest property qualifications, the radical Jacobins wanted an eventual democratic republic. Their leader, Maximilien Robespierre, believed that, before this could be brought about, a dictatorship representing Rousseau's general will must destroy all the reactionaries. His dictatorship took the form of an executive committee of twelve men called the Committee of Public Safety. He introduced the Reign of Terror, which lasted over a year. A new device, the guillotine, was introduced to expedite the execution of traitors to the revolution, including the king and queen. Nevertheless, by July 1794, France was tired of blood, and the Assembly, now called the National Convention, had Robespierre arrested and guillotined.

The government emerging from the reaction was dominated by large property owners. The fragility of its control, with radicals to the left and royalists on the right, was to an extent balanced by the success that French armies were having on the battlefield. Actually, after a bad start, the French by the fall of 1792 were winning one victory after another. By mid-1794 they had occupied what is now Belgium, the Netherlands, and Germany up to the Rhine as well as parts of northern Italy. In large part their success derived from the fact that the volunteer armies were enormous as opposed to the small professional armies of their opponents. Under the command of officers who held their commissions because of merit rather than family position, highly motivated by intense patriotic zeal, the French soldiers were irresistible. Everywhere they went they were welcomed by revolutionaries opposed to the local regime of despotism and privilege. French conquest meant the abolition of a legal class system and the establishment of a more equitable law code and social system.

Napoleon Bonaparte (1769–1821)

By 1796 one of the revolutionary generals, Napoleon Bonaparte, had distinguished himself above the others by a brilliant invasion of Italy and a swift capture of most of the northern part of the peninsula. Born in 1769 of minor Corsican nobility, Napoleon would probably never have risen above the rank of captain in the old aristocratic French army, but in the new army, he was a general by the age of twenty-five. Not only a military genius but a brilliant politician as well, Napoleon in 1797 purged the leadership of the conservative government that had come in after the Reign of Terror. In 1799, after an invasion of Egypt that stirred the imagination of all Europe, Napoleon abolished the whole government and declared himself the First Consul of France.

Napoleon had been deeply influenced by the Enlightenment. He has been referred to as "the last of the Enlightened despots," and he once said of himself, "I am the revolution." Napoleon believed that the real concern of the French was not so much political liberty as social equality. Political participation was for them secondary to their desire for a society where all people were equal before the law and where advancement derived from merit. Although Napoleon's constitution provided for a parliamentary government with universal male suffrage, there could be no question that Napoleon governed France.

Napoleon established a meritocracy in the bureaucracy and army, and he reformed laws to create greater equality before the law. His fiscal system was run by professionals, and there were no tax exemptions. On the whole, it is fair to say that Napoleon realized in his government most of the goals of the Enlightenment: those dealing with political freedom had always been secondary in any case.

Between 1799 and 1814 Napoleon, who took the title of emperor of the French in 1802, almost succeeded in conquering all of continental Europe (see map). But when he penetrated Russia as far as Moscow in 1812, the invasion cost him dearly; five hundred thousand soldiers never returned, and from this point on, his fortune waned.

With the heavy loss in troops and resistance to French war taxation growing among the subject peoples, Napoleon decided to surrender to an allied coalition of England, Austria, Russia, and Prussia. He abdicated and was sent in exile to Elba off the Italian coast in 1814. With hopes of turning the tables, he appeared again in France early in 1815. The French rallied, his old soldiers gathered again, and in the spring of 1815 he fought and lost the great battle of Waterloo. Defeated, he was exiled this time to Saint Helena in the Atlantic Ocean. The monarchy was then restored in France, with a brother of Louis XVI made king by the allies.

Effects of the Revolution

The French Revolution and its aftermath, however, left a lasting mark on western Europe. No longer

THE EMPIRE OF NAPOLEON AT ITS HEIGHT

Areas of French Influence

could rulers fight with the small professional armies of the past: the levy *en masse* was an absolute necessity in a new age of war. Rulers had to put arms in the hands of their subjects. Despite their conservative temper and fear of reform, kings, including the new French monarch, could not reimpose the old legal class structure where it had been abolished. The law codes destroying legal privilege in these areas were permanent. Moreover, French nationalism had proven infectious. At first welcomed as liberators by many in the conquered countries, the French ended by creating a national feeling directed against them in Germany, Italy, Spain, and elsewhere. Until later in the nineteenth century, however, nationalism would be considered the property of liberals wishing to imitate the French. After that time monarchs would learn how to use it for their own purposes. Although the allies reduced France to its boundaries before 1789, the French were considered the most dangerous people of Europe until 1870. The figure of Napoleon, the keen rationalist, became a symbol of the creative, mysterious, and at times demonic personality that fascinated the first generation of the nineteenth century.

The Art of the French Revolution: Jacques-Louis David (1748–1825)

Just as the leaders of the American Revolution instigated the search for a new visual and architectural language for the new republic, so the French Revolution and its aftermath profoundly affected art in France and England. The foremost painter of the revolutionary and Napoleonic eras was Jacques-Louis David. David revolted strongly against the sensual elegance of the court style as exemplified by the paintings of Boucher (Fig. 24-6) and

Fragonard. He sought to renew art by contact with the art of Rome and the Italian High Renaissance. While in Italy he painted his first important picture in this fresh style. *The Oath of the Horatii* (1784–1785) (Fig. 27-1) combined qualities from the sixteenth and seventeenth centuries to convey what some saw as revolutionary sentiments. Based on a story from Livy, *The Oath* places loyalty to the state above all other concerns, even those of family. The painting shows heroic male figures in a stark architectural setting. As in the *Death of Marat* (1793; Fig. 27-2), the figures are idealized but retain a degree of intense realism through an almost photographic rendering of flesh and muscle. Such detail makes them highly convincing. Colors are cool; the harsh light isolates form and gesture. Crisp and clear, the figures seem like a sculpted bas-relief.

Returning to Paris, where his style was immediately recognized as revolutionary, although not necessarily politically so, David in *The Death of Socrates* (1787) explored the theme of injustice by a government fearing the truth. This picture and others like it were manifestos of those virtues most lacking in monarchal France, and their artist became a leading revolutionary painter.

David was commissioned by the Committee of Public Safety to make three paintings of revolutionary he- roes; only one of them was finished, the *Death of Marat* (Fig. 27-2). It portrays the murder of the Jacobin Marat by Charlotte Corday, from a rival revolutionary group. Sending a note to Marat, she gained access to him while, seated in a medicinal bath, he received petition- ers. She stabbed him when he could offer no resistance. An almost ludicrous scene is transformed by David into the final act of a great tragedy. The dead revolutionary still lies in his draped tub, the focus of a cold, dramatic light. His wound gapes, blood stains his drapery and the water, and his limp arm and hand fall to the floor, his pen permanently stilled. The body bears no marks of the skin disease that forced him to sit in the tub. In the contrast between reality and abstraction, David cre- ates a magnificent tension—a tension like that between reason and intuition, calculation and passion.

Recognizing this formidable talent, Napoleon made David the pageant master of the consular government and then of the empire. In his *Napoleon Crossing the Alps* (Fig. 27-3) David's abstract clarity has given way to an ideal image. The youthful general, astride a rearing horse, his cloak blowing in the wind as he gestures for- ward, has become a romantic hero comparable to Han- nibal and Charlemagne, whose names are carved in the rocks. This is not a real general; it is how all generals might see themselves—indeed how people might envision

27-1 *Jacques-Louis David,* Oath of the Horatii, *1784–1785. Oil on canvas, 10′8.25″ × 14′. (The Louvre, Paris)*

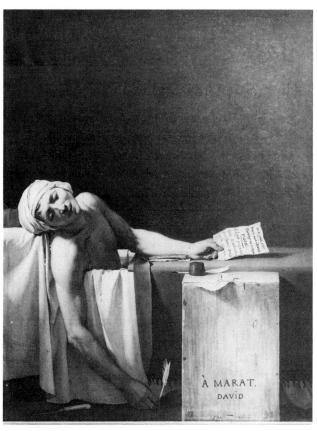

27-2 *Jacques-Louis David,* Death of Marat, 1793. *Oil on canvas, 63¾″ × 49⅛″. (Musées Royaux des Beaux-Arts, Brussels/Art Resource, NY)* (**W**)

▲
- What does *Marat* have in common with *The Oath of the Horatii*? How does David make this modern event "tragic"? Consider light source, his treatment of surfaces, and the figure of Marat himself.

a hero—commanding, youthful, virile, clean, shiny, and dry, in spite of cold, snow, and the hell of war.

The revolution in style begun by David would take on new forms with the birth of the sensibility called *romanticism.*

Romanticism: A Revolutionary Movement

The two great revolutions of the eighteenth century, the American and the French, were followed not only by upheavals altering the course of European politics but also by rapid changes in other spheres of life: taste, feeling, thought, behavior, and social and domestic relations. The varied, often contradictory cultural movement that swept over Europe and America and became known as romanticism had profound effects on the humanities—effects still very much felt in the contemporary world. The individualism, sense of isolation, and alienation of which we are now so aware have their roots in the Ren-

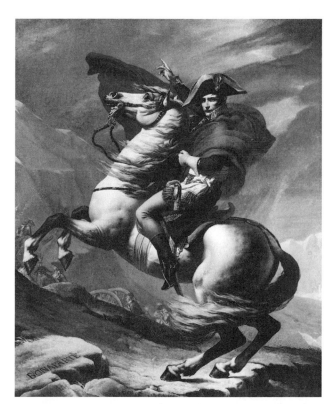

27-3 *Jacques-Louis David,* Napoleon Crossing the Alps, *Versailles Museum. (Réunion des Musées Nationaux)*

aissance and Reformation period, but they were cultivated and brought to flower by the romantics.

Romanticism as a movement may be said to have originated in Germany, but the word *romantic* first appeared in England in the mid-eighteenth century. It originated from an association with medieval "romances," the (predominantly French) stories of knights and ladies. As the word became coined in all European languages, it took on connotations of fanciful, picturesque, rugged, spontaneous, natural, and sentimental. During the early nineteenth century it was applied to groups of rebellious young artists promoting creativity, individualism, and free expression of emotion in opposition to classical canons and the regulations and standards based on "enlightened" reason that their parents' generation had espoused. For the romantics, life and art were one: as they threw out the old standards for art, so they lived their lives with bohemian freedom, following their passions or imagination rather than their reason or the "artificial" rules of society. Artistic and political ideals also intertwined: the French writer Victor Hugo called romanticism "liberalism in literature" and proclaimed that words, like postrevolutionary human beings, were now free from tyranny. By the middle of the century, however, many romantics had grown conservative, Catholic, or nationalistic, or they had retreated into an asocial dream world. This was partly because of the political scene in Europe: many who had first adored Napoleon as the

bearer of the revolution became disillusioned with Napoleon the emperor. Yet some romantics were intensely conservative from the beginning, looking back toward the Middle Ages as an ideal period of order and spirituality. (The liberals, too, liked medieval themes, but for other reasons.) It is impossible to attribute an exact beginning and end to this complex, varied, pan-European and American movement; but the French Revolution gave impetus to its latent beginnings, and it died out in most places before 1850. In Slavic countries, however, the romantic movement in literature (and in nationalistic politics) continued longer, and romantic music flourished in Germany, France, and Italy throughout the nineteenth century. It is hardly possible to attempt a global history or definition of romanticism here. We will concentrate instead on the artistic expression of some major romantic themes: revolution, the hero, nature, and love.

Enlightened Ideas, Romantic Style

The American and French revolutions fired the imaginations of the romantics because they had seemed at first to confirm the reasonableness of the philosophes. Jean-Jacques Rousseau is the single most important figure for understanding the transition between the Enlightenment and romanticism. Revered as a forefather of the revolution because of his analyses of social injustice and his "enlightened" beliefs in human dignity and freedom, Rousseau was the first in French letters to promote feeling above reason and nature above institutions. Above all, he raised the unique, individual self to a position of prime importance. The individualism propounded by Rousseau seemed to be the philosophical foundation of the new American republic, the largest territory ever ruled by a government proclaiming people to be free and equal.

Liberty, Equality, Fraternity

"Liberty, equality, fraternity," the catchwords of the French Revolution, were taken by the romantics to apply to all aspects of life. Ironically, it was outside France that these ideals first took hold as a cultural force. It is in Germany and in England that we first see poets celebrating the ideals of the revolution, and it is there, too, that other signs of budding romanticism first show themselves. Germany's two greatest writers, Johann Wolfgang von Goethe (1749–1832) and Friedrich Schiller (1759–1805), spanned neoclassicism and romanticism in their careers. Schiller's fervent belief in human rights to dignity and freedom and his lofty hopes for universal brotherhood place him in the transition between the Enlightenment and romanticism. His poem "Ode to Joy," written on the eve of the French Revolution, is a passionate statement of those beliefs and hopes that were stirring at the

time. Immortalized by Beethoven in his Ninth Symphony some thirty years later, it has become one of the great statements of romanticism.

Ludwig van Beethoven (1770–1827)

The late eighteenth and early nineteenth centuries saw the flowering of German music as well as of German literature. Beethoven, like Goethe and Schiller, is a gigantic figure whose works rise above categories like classical or romantic but include elements of both (Fig. 27-4). Like many of his generation, he was at first stirred by the ideals of the French Revolution and by their embodiment in Napoleon, and later disillusioned. Beethoven had both feet firmly planted in the fertile soil of classicism but was able to reach out with both hands to grapple with the giant problems of romanticism: the meaning of life, the values of human existence, the powers of humanity, and the importance of the individual.

What does romanticism in music really mean? What are the musical features that inform our ears about the interests and ideals of Beethoven and the nineteenth-century composers who followed him? To search for answers to these questions, let us look into a single masterpiece that fuses classical and romantic styles—the values of the Enlightenment and the passions of the romantic revolutionaries. Let us try to learn

27-4 *Ferdinand Georg Waldmuller,* Ludwig van Beethoven, *1823. (Bildarchiv Preussischer Kulturbesitz)*

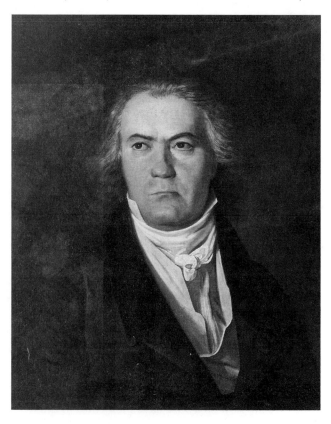

from Beethoven's last and most monumental symphony, his Symphony in D Minor, opus 125, a work familiarly known as the Ninth Symphony.

Like all classical symphonies, Beethoven's Ninth is divided into four movements, and they follow a traditional pattern: the first and fourth movements are energetic, to be played at a lively speed; the second and third movements offer contrast, one slow and the other a dance form related to the classical dance called the minuet. This four-movement, balanced structure developed as a means to create a large-scale work (a half-hour or more) capable of capturing intellectual attention for long periods of time using musical means only. In other words, the composers were seeking an answer to a compositional problem: if we exclude extramusical ideas and effects (such as a church service, a dance, a festival, and programmatic ideas), how can we keep from losing the listener's attention if we play a continuous piece of music for a very long time? Haydn, Mozart, and their mid-eighteenth-century contemporaries solved the problem by designing symphonies that had distinct movements related by key, contrasted by mood, and subdivided by various formal designs that developed contrasting melodies in a variety of ways. Their largest works lasted up to thirty or even forty minutes; Beethoven's Ninth lasts over one hour! His first movement continues as long as do most complete classical symphonies. Although Beethoven's concept of form was classical, his expansion of dimensions, his breaking of boundaries, was romantic.

Classical composers had a knack for the well-turned phrase, a neat tune of four or eight measures' duration whose shape had character and individuality and was capable of expansion or development as the piece progressed. Classical melodies had musical characteristics that allowed these tunes, usually, to be categorized as antecedent-consequent phrases; that is, the first half is answered and completed by the second half. A good example of this type of theme is Mozart's opening theme from his Symphony no. 40 in G Minor (K. 550), where both halves are similar but different, ascending and descending, opening and closing. In fact, Mozart's sense of balance was so certain and ingrained that the entire phrase can be seen as the antecedent of the next four-measure phrase.

This analytical game can be played even further, if we choose, because the two-to-two and four-to-four measure relationships can be carried even further by viewing the first eight measures as antecedent to the second eight measures. This is possible with Mozart and his G minor symphony; it is not possible with the opening theme of Beethoven's Ninth. Beethoven's "tune" is hardly a melody at all; it is a series of short *motives* laid out along a descending *arpeggiated* chord and a brief closing figure.

From small germinal ideas, Beethoven sculpts larger forms; from almost tuneless groups of notes, he creates tonal music of a relentless, soul-searching nature. Each

fragment of melody is taken in turn, examined, dissected, synthesized, and reissued in a new shape within a fresh context at a later time. The rhythm of the closing fragment becomes a driving melody for the bass instruments at one point and a lyrical, sweet passage for French horn at another. In other words, even these few processes we have discussed here sound the death knell for the ease, grace, and regularity of classical music. In time the classical forms would even be replaced or set aside, but for Beethoven it was enough to fragment the old and pile smaller blocks into larger structures.

Those who are already familiar with the Ninth Symphony will say that this analysis has been deceptive thus far, for the Ninth is also called the *Choral* Symphony and is unlike its classical predecessors if for no other reason than that. Additionally, they might add that a chorus and vocal soloists require text and that words bring extramusical ideas immediately into play. True enough, but in the Ninth Symphony of Beethoven, the vocalists do not begin their work until the last movement. Nearly an hour of instrumental music is performed before they sing their first note. To understand the Ninth, we must first grasp the meaning of this creation in purely musical terms, for it is a complex instrumental construction with a choral and literary element added to it. Without the chorus, it would still be a classical-romantic symphony. The chorus does not make it romantic; the notes do. Without an understanding of the first three movements, the fourth would be diminished. Beethoven binds the beginning to the end, for he takes the opening motive from the beginning of the symphony to play in the introduction to the fourth, or choral, movement; likewise he takes the melody of the scherzo, or second movement, for use in the finale's introduction. The restatement of earlier ideas in a Beethoven symphony is not merely saying the same thing twice; rather, it is a reiteration of initial ideas now seen in the new light cast from all the music that has been played since the ideas were first stated. Had the remainder of the symphony not been performed—that is, had the first three movements been omitted—the music of the opening of the last movement would be extraneous and the finale reduced to a skillfully orchestrated choral piece. Beethoven's way made it the crowning gem of a symphonic career. The Ninth Symphony looks both ways—back to the past and forward into the future.

Since this work is indeed a choral symphony, we must look carefully at the poem, for surely a composer's preoccupation with text is the critical event that starts the compositional process for a choral setting. In Beethoven's case it was truly a preoccupation. From a letter of 1793 written by a Viennese admirer, Bartolomeus Fischenich, when the composer was only twenty-three years old, we learn that the young musician intended to set Schiller's *Freude* (Joy) poem stanza by stanza; the Ninth Symphony was completed in 1824. Obviously Beethoven was not actively working on this symphony

for thirty-one years, but the Schiller poem seems to have been tucked within the composer's mind throughout the period of the Napoleonic exploits in France, a series of events that strongly molded Beethoven's philosophy. In fact, this poem gains even greater significance if the noted British composer Ralph Vaughan Williams is correct, for he relates:

> When I was young I was told that Schiller originally wrote his Ode to "Freedom" (*Freiheit*), not "Joy" (*Freude*), and that Beethoven knew of this when he composed the music. I have never been able to find any confirmation of this legend, but we may profitably keep it at the back of our minds when we play or sing or read, or hear this great Symphony.[1]

There is no doubt that Schiller's poem exemplifies the romantic spirit in Europe and was capable of holding special meaning for Beethoven.

> Alle Menschen werden Brueder,
> Wo dein sanfter Fluegel weilt.
>
> (Men throughout the world are brothers,
> In the haven of thy wings.)

Napoleon, until he named himself emperor, had been a hero for Beethoven, a leader of common people against the tyranny of the rich, the oppression of the aristocracy. Beethoven did not like his indebtedness to the patronage of the rich; recognizing personal worth and artistic genius to be far superior to accident of birth, he struggled constantly throughout his life to assert his independence, his freedom. To him freedom was the greatest joy, and Schiller's poem expressed in words what he felt in his soul and was capable of translating into music. (Only the portion of the poem used by Beethoven is printed here.)

FRIEDRICH SCHILLER (1759–1805)

Hymn to Joy

Translation by Louis Untermeyer

BARITONE: O Freunde, nicht diese Toene!
Sondern lasst uns angenehmere anstimmen,
und freudenvollere.

> O friends, friends, not these sounds!
> Let us sing something more pleasant,
> more full of gladness.
> O Joy, let us praise thee!

BARITONE SOLO, QUARTET AND CHORUS:
Freude, schoener Goetterfunken,
 Tochter aus Elysium,
Wir betreten feuer-trunken,
 Himmlische, dein Heiligthum!
Deine Zauber binden wieder,
 Was die Mode streng getheilt;
Alle Menschen werden Brueder,
 Wo dein sanfter Fluegel weilt.

> Joy, thou source of light immortal,
> Daughter of Elysium,
> Touched with fire, to the portal
> Of thy radiant shrine we come.
> Thy pure magic frees all others
> Held in Custom's rigid rings;
> Men throughout the world are brothers
> In the haven of thy wings.

Wem der grosse Wurf gelungen,
 Eines Freundes Freund zu sein,
Wer ein holdes Weib errungen,
 Mische seinen Jubel ein!

> He who knows the pride and pleasure
> Of a friendship firm and strong,
> He who has a wife to treasure,
> Let him swell our mighty song.

Ja, wer auch nur eine Seele
 Sein nennt auf dem Erdenrund!
Und wer's nie gekonnt, der stehle
 Weinend sich aus diesem Bund!

> If there is a single being
> Who can call a heart his own,
> And denies it—then, unseeing,
> Let him go and weep alone.

Freude trinken alle Wesen
 An den Bruesten der Natur;
Alle Guten, alle Boesen
 Folgen ihrer Rosenspur.
Kuesse gab sie uns und Reben,
 Einen Freund, geprueft im Tod;
Wollust ward dem Wurm gegeben,
 Und der Cherub steht vor Gott.

> Joy is drunk by all God's creatures
> Straight from earth's abundant breast;
> Good and bad, all things are nature's,
> And with blameless joy are blessed.
> Joy gives love and wine; her gladness
> Makes the universe her zone,
> From the worm that feels spring's madness
> To the angel near God's throne.

TENOR SOLO AND CHORUS:
Froh, wie seine Sonnen fliegen
 Durch des Himmels praecht'gen Plan,
Laufet, Brueder, eure Bahn,
Freudig, wie ein Held zum Siegen.

[1] Ralph Vaughan Williams, *Some Thoughts on Beethoven's Choral Symphony with Writings on Other Musical Subjects* (London: Oxford University Press, 1953), p. 13.

Glad, as when the suns run glorious
Through the deep and dazzling skies,
Brothers, run with shining eyes—
Heroes, happy and victorious.

Freude, schoener Goetterfunken,
Tochter aus Elysium,
Wir betreten feuer-trunken,
Himmlische, dein Heiligthum!
Deine Zauber binden wieder,
Was die Mode streng getheilt;
Alle Menschen werden Brueder,
Wo dein sanfter Fluegel weilt.

Joy, thou source of light immortal,
Daughter of Elysium,
Touched with fire, to the portal
Of thy radiant shrine we come.
Thy pure magic frees all others
Held in Custom's rigid rings;
Men throughout the world are brothers
In the haven of thy wings.

QUARTET AND CHORUS:
Seid umschlungen, Millionen!
Diesen Kuss der ganzen Welt!
Brueder, ueber'm Sternenzelt
Muss ein lieber Vater wohnen.
Ihr stuerzt neider, Millionen?
Ahnest du den Schoepfer, Welt?
Such ihn ueber'm Sternenzelt!
Ueber Sternen muss er wohnen.

Millions, myriads, rise and gather!
Share this universal kiss!
Brothers, in a heaven of bliss,
Smiles the world's all-loving Father.
Do the millions, His creation,
Know Him and His works of love?
Seek Him! In the heights above
Is His starry habitation!

Beethoven's chorus, singing in a "fire-drunk" jubilation, celebrate the human spirit; they are singing a great song for all peoples, nations, and languages. And as the fervor builds and the orchestral and vocal sounds sweep the listener away, the listener is unlikely to notice that this great romantic outpouring is framed by Beethoven's simplest, and most classical, melody. The simplicity of the *theme,* the clarity of its form (A–A–B–A–B–A), the unpretentious nature of its harmony and rhythm, make it a song for the common person, and that it has become. The works of Beethoven live today because, in addition to their sheer beauty and historical importance, they symbolize those values that we cherish now. In the words of Romain Rolland:

The music of Beethoven is the daughter of the same forces of imperious Nature that had just sought an

outlet in the man of Rousseau's *Confessions.* Each of them is the flowering of a new season. . . . [Beethoven], too, like the eagle on his rock, goes into exile on an island lost in the expanse of the seas—more truly lost than that island in the Atlantic, for he does not hear even the waves breaking on the rocks. He is immured. And when out of the silence there rises the song of the Ego of the last ten years of his life, it is no longer the same Ego; he has renounced the empire of men; he is with his God.[2]

Individualism and the Romantic Hero

From the romantic version of revolutionary ideals—as from the writings of the transitional Rousseau—there developed a new sense of the value of the unique individual. Rousseau's confession "If I am not better than other men, *at least* I am different!" would be unthinkable to a classicist. Schiller, who could write a hymn to human fellowship, could also write a play, *The Robbers,* with an individualistic outlaw as hero. People like Beethoven, and for that matter Napoleon, embodied the romantic doctrine of individual, unique, "titanic" genius.

But the romantic hero could also be a forlorn individual, solitary and alienated. Although the "suffering" type of romantic hero may wander off to commune with nature or commit suicide, the "titanic" type of rebel attempts to take destiny into his own hands. Prometheus, the deity from Greek mythology who stole the secret of fire from the gods to bring it to humanity and who defied Zeus himself, was a favorite subject of romantic verse and drama. The romantics' Prometheus goes beyond their model, the Prometheus of the Greek tragedian Aeschylus. Prometheus combines two aspects of the romantic hero that may be separate and contradictory elsewhere: he is both a self-willed individual and a benefactor of humankind. The verse drama *Prometheus Unbound* by Percy Bysshe Shelley (1792–1822) is the most extended treatment of this theme.

George Gordon, Lord Byron (1788–1824)

The short lyric "Prometheus" by the British poet Lord Byron serves as an early model for what came to be known as the Byronic hero. Byron is a good example of a romantic who lived as well as he wrote his romanticism (Fig. 27-5). Spectacularly handsome, he was involved in many unhappy love affairs. He wandered restlessly over Europe and finally died while fighting for a liberal cause, the war of the Greeks against their oppressors, the Turks. "On this day I complete my thirty-sixth year" portrays a suffering type of hero but offers a solution in dedication to revolution. Byron's literary heroes, such as Childe Harold, Manfred, and Cain, are

[2] Romain Rolland, *Beethoven the Creator,* trans. Ernest Newman (New York: Harper & Brothers, 1929), pp. 25ff.

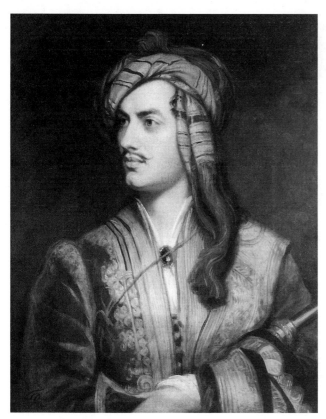

27-5 *Thomas Phillips,* Lord Byron in Albanian Costume, *1814. (National Portrait Gallery, London)*

rebellious individuals with a passionate belief in individual freedom. They are men of powerful emotions and a genius that may at times appear satanic. There is a dark side to the Byronic hero that we may see in some of the characters created in his wake, such as Melville's Captain Ahab. Byron was also capable of mocking his own heroic types with a comic antihero, Don Juan.

Other Romantic Heroes

The gothic hero and the mad scientist, two other romantic types, may be seen as offshoots of the Byronic hero. The most famous of the latter, Victor Frankenstein, was created by Mary Godwin Shelley, a close friend of Byron's. She called her novel *Frankenstein, or the Modern Prometheus.* Perhaps the most enduring romantic hero-rebel, one who goes beyond romanticism, is Goethe's Faust, in the long dramatic poem of that title. Faust's rebellion is really against human limits, or finitude. He embarks on a quest after the absolute—absolute knowledge, power, and love—and in the process puts his soul in the hands of the devil. He refuses to accept any limits on his individuality until the end of the poem, when he also becomes a benefactor of humankind.

The various types of romantic individuals took hold of the imaginations of Americans as well as Europeans. It is possible to see in the romantic hero a kind of literary prototype for the "robber barons" of the later nineteenth century. The romantic period was the time when American literature came into its own. Ralph Waldo Emerson celebrated the heroic, "self-reliant" individual; Herman Melville and Edgar Allan Poe portrayed the darker side of the soul. A different and perhaps more typically American romantic individualism emerged in the poetry of Walt Whitman (1819–1892). In his long poem *Song of Myself* he celebrates his unique self in an attempt to break down the artificial barriers that society creates between human beings. An unheroic but no less significant sense of individual uniqueness is expressed in the extraordinary poetry of Emily Dickinson (1830–1886).

Nature and "Natural People"

For the "enlightened" European or American, the word *nature* meant essentially human nature, and the natural place of human beings was among their peers. Human institutions might be corrupt, but they could be changed for the better. Civilization brought with it many ills, but it was still humanity's greatest achievement. Yet as early as the eighteenth century, we witness a kind of disillusionment with Western civilization and urban life and a curiosity about "uncivilized" peoples that came to be known as the "noble savage" craze. With this came a yearning for unspoiled natural scenery—forests, lakes, mountains, ocean.

Influence of Rousseau

Once again, Rousseau is a pivotal figure here. Just as he went beyond a doctrine of liberty to one of individuality, so he went beyond a critique of the faults of civilized society to a radical questioning of its value. The romantics who followed Rousseau eulogized the free and "natural" life of American Indians as superior to that of decadent Europeans, although few seemed to understand the social and economic threat that the new republic posed to the former. The social ideals promoted by the revolutions were also used by romantics, first British and later American, in the service of the antislavery cause that culminated in the abolitionist movement. In the romantic view, the black African was a proud, noble individual who had suffered the oppression and tyranny of the old order of Europe, an order that was now to be overthrown on all levels. The romantic liberals championed the cause of the peasant, the worker, the poor, and the oppressed; they looked with contempt on the rich bourgeois, smug and materialistic. Naturally, the champions of the oppressed tended to, as we would say, "romanticize" those that they perceived as victims, sometimes endowing them with sublime, superhuman characteristics. They were, in fact, more interested in lofty ideals than in everyday reality. Out of the revolution, they believed, a new order

DAILY LIVES

Lord Byron

Perhaps the most astute comments on Byron's personality come from Lady Blessington, who was a year younger than the poet and one of the great beauties of their generation. She and her husband met Byron in Genoa in the spring of 1823 and in a series of encounters over a two-month period saw him frequently. The following sketch is taken from her account of their conversations published in 1834, a decade after his death:[a]

> Byron is of a very suspicious nature; he dreads imposition on all points, declares that he foregoes many things, from the fear of being cheated in the purchase, and is afraid to give way to the natural impulses of his character, lest he should be duped or mocked. This does not interfere with his charities, which are frequent and liberal; but he has got into a habit of calculating even his most trifling personal expenses, that is often ludicrous, and would in England expose him to ridicule. He indulges in a self-complacency when talking of his own defects, that is amusing; and he is rather fond than reluctant of bringing them into observation. He says that money is wisdom, knowledge, and power, all combined, and that this conviction is the only one he has in common with all his countrymen. He dwells with great asperity on an acquaintance to whom he lent some money, and who has not repaid him.

> Byron seems to take a peculiar pleasure in ridiculing sentiment and romantic feelings; and yet the day after will betray both, to an extent that appears impossible to be sincere, to those who had heard his previous sarcasms: that he is sincere, is evident, as his eyes fill with tears, his voice becomes tremulous, and his whole manner evinces that he feels what he says. All this appears so inconsistent, that it destroys sympathy, or if it does not quite do that, it makes one angry with oneself for giving way to it for one who is never two days of the same way of thinking, or at least expressing himself. He talks for effect, likes to excite astonishment, and certainly destroys in the minds of his auditors all confidence in his stability of character. This must, I am certain, be felt by all who have lived much in his society; and the impression is not satisfactory. . . .

> He never appeared to so little advantage as when he talked sentiment: this did not at all strike me at first; on the contrary, it excited a powerful interest for him; but when he had vented his spleen, in sarcasms, and pointed ridicule on sentiment, reducing all that is noblest in our natures to the level of common every-day life, the charm was broken, and it was impossible to sympathise with him again. He observed something of this, and seemed dissatisfied and restless when he perceived that he could no longer excite either strong sympathy or astonishment. Notwithstanding all these contradictions in this wayward, spoiled child of genius, the impression left on my mind was, that he had both sentiment and romance in his nature; but that, from the love of displaying his wit and astonishing his hearers, he affected to despise and ridicule them.

a. E. J. Lovell Jr., ed., *Lady Blessington's Conversations of Lord Byron* (Princeton, N.J.: Princeton University Press, 1969), pp. 33–35.

would be born that would bring with it the creative freedom of the individual and the unity of all humankind.

Rousseau influenced not only the idealization of "natural" peoples but also the tendency of the "misunderstood," unhappy, and yearning urban romantic to seek solitude and solace in the natural world. In his *Reveries of the Solitary Walker*, Rousseau describes the beauty of the Swiss landscape, its mountains and lakes, and his feeling of communion with it. He also describes his joy in abandoning himself to "pure sensation" as he experiences the lapping of a mountain lake's waves. To be able to abandon thought and feel oneself in unison with nature: a romantic ideal is born.

Ideas such as returning to nature and living a natural (that is, nonartificial, nonurban) life began in the romantic period to acquire the connotations that they have today. Changes in fashion were indicative of the trend. Partly because of Rousseau, women abandoned corsets and stiffened skirts for loose, flowing, "natural" attire, and the formal, symmetrical French garden (as at Versailles) gave way to the more luxuriant, chaotic, and "natural" English garden. Hiking and mountain climbing became for the first time popular pastimes in Europe. The vine-covered cottage replaced the palace as dream house. The life of the simple peasant was prized (at least in theory) above that of the sophisticated city

dweller, and feeling, or richness of sensation, above intellectual capacity. There was even a concern for what we could call conservation and ecology. The New Englander Henry David Thoreau (1817–1862) actually carried out a solitary back-to-nature experiment, which he described both practically and emotionally in *Walden*.

Nature in Poetry, Music, and Art

The celebration of nature in romantic art took on varying aspects, corresponding to the individualistic temperaments of the artists. Romantic artists tended to depict nature as reflecting the sensations of their own souls. For some it consoled; to others it seemed indifferent. To some it was picturesque, to others fearful and sublime. Some romantics, weary of cold and sterile eighteenth-century deism, found their religious yearnings satisfied in their relations with the natural world. Those drawn back to a devout Christianity found God's bounty and goodness reflected in nature; those who shunned organized religion tended toward a kind of pantheism, worshiping the spirit of nature itself. The poetry of Samuel Taylor Coleridge (1772–1834) emphasizes the mystical, uplifting aspects of nature. A poet like John Keats (1795–1821), on the other hand, renders through language the pure sensuous feelings of an autumn day or a summer night, sensations comparable to those rendered in paint by the artist J.M.W. Turner. Emily Dickinson's close observations of natural phenomena sometimes reveal nature as a soothing mother and sometimes as a terrifying foreboder of death. In music we find composers imitating the sounds and feelings of nature with new orchestral textures. Beethoven's Pastoral Symphony (no. 6) renders a wide range of moods from the natural world—sublime, mysterious, joyful, humble—and it even imitates a thunderstorm. In painting, landscapes came into vogue. Like the romantic poets, romantic landscape painters often attempted to render the communion between human emotion and nature. The painters John Constable and Jean-François Millet, when juxtaposed with the poet William Wordsworth, exemplify some aspects of the romantic vision of nature common to both visual art and poetry.

John Constable (1776–1837)

Keen observers of the world around them, Constable and Wordsworth were more taken with the humble, everyday aspects of nature than with its sublime or mystical ones. Both were profoundly attached to their native countryside. Constable recorded his pleasure in simple phenomena: "The sound of water escaping from mill dams, willows, old rotten planks, slimy posts, brickwork. I love such things." The statement would have been inconceivable to a Renaissance or neoclassical artist. It reveals not only a sensitivity to the textures of ordinary objects but

also (especially in the escaping water and the rotten planks) a concern with mutability, the ways in which time changes things. Constable's pursuit of a means to capture his experience of the natural world led him to study clouds, rain, light, and the weather. His early pictures are not far removed from the perpetual sunlight or storm of seventeenth- and eighteenth-century pictures; but as his ideas and abilities mature, we see him open the landscape to capture the broken light of moving air and clouds. Colors become more intense, and the surface of paint is dense and wet. His brush strokes give trees a shimmer and clouds a sense of movement and energy. Constable painted only those things that he knew and loved. Debham Vale and the River Stour with fields, wagons, and water were completely familiar to him, and he took comfort and refreshment from the colors, textures, and events that filled the countryside (Color Plate XXII).

William Wordsworth (1770–1850)

A poem by Wordsworth, written on his return to a spot near the medieval ruins of Tintern Abbey, in many ways parallels Constable's and Turner's painting. The primary theme of these works is humanity's relationship to nature. J.M.W. Turner's 1794 watercolor of Tintern Abbey (Fig. 27-6) captures the romantic view

27-6 *J.M.W. Turner,* Interior of Tintern Abbey, *1794. Watercolor, 12⅝″ × 9⅞″. (© The Board of Trustees of the Victoria and Albert Museum, London)*

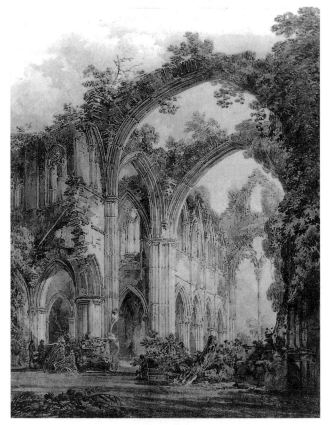

of gothic ruins that Wordsworth chose as the site of his most famous poem. "Lines Composed a Few Miles Above Tintern Abbey" paints a landscape in its first stanza and meditates on the poet's interaction with it in the rest of the poem. But the landscape painted by Wordsworth is not a simple one; it is superimposed, as in a double-exposure photograph. From the first lines the reader is aware that Wordsworth is *also* viewing this scene with the memory of how he had viewed it five years previously. A sense of the passage of time is imposed on the place. Because of this dual perception, the poet is able to reexperience his feelings as they were five years before. At that time he was able to enjoy the purely sensational effects of nature; now he finds that the recollection, as well as the new vision of the natural landscape, has a profound effect on his moral and intellectual being. Both of these perceptions are conveyed to the reader. Another dimension is added as the poet looks, through the person of his sister, Dorothy, into the future. The sensations from nature that they experience in the present will be sublimated and perpetuated as "lovely forms" in her mind's "mansion." In Wordsworth's mention of the possibility of his own death while his sister is still alive, we experience no sense of dread, or even sadness, but a sense of life as continuity. The life and death of the individual are part of the processes of nature. Still, it is through the individual's consciousness and judgment that nature is given meaning. Wordsworth's poem, like Constable's painting, brings out the interdependence between the human life cycle and nature.

Beauty, for Wordsworth, could also be found in the simple people who inhabited his countryside. One of Wordsworth's ideals was to let his poems speak for the inarticulate, to express the poetry latent in the woodsman, the peasant, or the country girl: such a poem is his "The Solitary Reaper." Here again Wordsworth emphasizes the beauty to be found in the familiar and the near at hand. The young girl reaping is a part of nature, yet her song—whether of past events or eternal emotions—gives a continuity and a temporality to the natural world that it would not otherwise have. At the end the suggestion is made that the poet will perpetuate her song into the future.

Jean-François Millet (1814–1875)

A painter who saw the same poetry in simple people at their country tasks was the Frenchman Jean-François Millet. Millet portrayed the French peasantry as virtuous, humane, and monumentally enduring. In his picture *The Sower* (c. 1850; Fig. 27-7) the figure is huge, the gesture simple, the colors earthy and rich. Unlike the romantic hero or heroine, the romantic peasant in poem and painting is anonymous and eternal, rather than individualistic. Like Wordsworth, Millet empha-

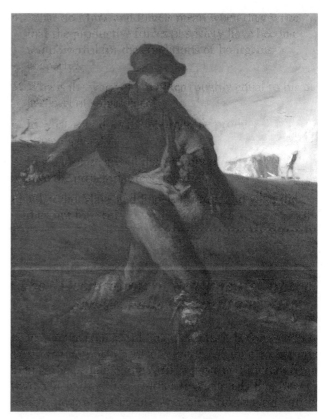

27-7 *Jean-François Millet,* The Sower, *c. 1850. Oil on canvas, 40″ × 32½″. (Courtesy, Museum of Fine Arts, Boston. Gift of Quincy Adams Shaw through Quincy Adams Shaw, Jr., and Mrs. Marian Shaw Haughton. 17.1485)*

sizes the harmony between the workers of the field and their natural surroundings.

Art: Revolution, Individualism, and Nature

We have seen how the painter David turned from neoclassicism to portray Napoleon as a romantic hero. The revolutionary ideals of liberty, equality, and fraternity had a profound influence on developing romanticism in the visual arts as in literature. There were also inventions and advances that affected art internally. The development of photography; the scientific study of light, color, and perception; and the opening of Japan and China to the Western world all had immediate repercussions in painting, sculpture, and the graphic arts.

Architecture was challenged by the growing diversification of life and human needs. Commissions for palaces and churches were replaced by industrial, commercial, and transportation needs. Hospitals, housing, and prisons were demanded as never before. The manufacture of iron, then steel, glass, and finally concrete, provided new building possibilities and problems

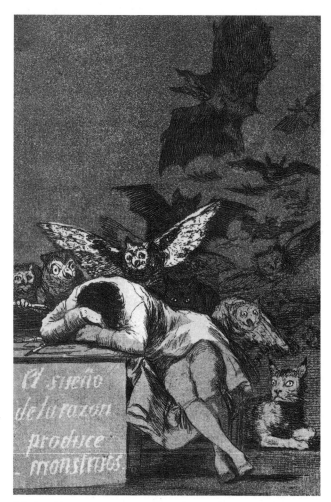

27-8 *Francisco Goya,* The Sleep of Reason Produces Monsters. *Plate #43 of* Los Caprichos. *Etching and aquatint, working proof. (Courtesy, Museum of Fine Arts, Boston. Bequest of William B. Babcock. 84165)*

without precedent. Both the private individual and governments experienced the stress of a burgeoning economy and rapidly increasing population. Systems of transportation, water, waste disposal, marketing, and housing taxed cities beyond their limits, and the vast slum became a familiar reality.

Not only were the artist and architect challenged by these things, but also the systems of education and patronage experienced pressures that were either absorbed or ignored. In France the academy that had produced David and his pupils also produced a number of artists who revolted against the doctrines of Davidian classicism; they began searching for a form and content expressive of revolutionary and romantic ideals. Three painters who typify, in different ways, the search for new forms and means of expression are the Spaniard Francisco Goya, the Frenchman Eugène Delacroix, and the Englishman J.M.W. Turner.

Francisco Goya (1746–1828)

Goya was a successful and celebrated painter in the court of Charles IV. He had begun his career as a designer of tapestries whose subjects, the amusements of the court life, document the end of an era with elegance and beauty. There was, however, a toughness and a tenacity about Goya that were first revealed in a series of etchings, *Los Caprichos* (Human Follies), executed in 1795–1796. Of this collection perhaps the most famous is one of the first, *The Sleep of Reason Produces Monsters* (Fig. 27-8). The title is a complex one. A sleeping man dreams of horrible winged creatures who hover about his head. Reason, when she sleeps, permits the appearance of the dark, demonic, undisciplined self; but a rigid and inflexible Reason produces the monsters of revolution, too. Technically, Goya draws on traditional conventions but transforms them into an awful assemblage of shadow and texture.

While serving as the court painter, he experienced the horror of the French invasion of Spain, with its guerrilla warfare. Spanish royalists fought the invaders, republicans fought the royalists, and the invaders and the ensuing chaos reduced the populace to a terror-filled mob. No longer reserved for armies and generals, war decimated the entire population. There were looting, rape, pillage, and plunder. These years are recorded in the etchings *The Disasters of War*. Probably made from scenes he witnessed, the pictures reveal the violence, brutality, and monstrous inhumanity of people. Figure 27-9, *The Disasters of War: One Can't Bear to See Such Things,* shows a family murdered. In Figure 27-10 a man stumbles on a tumbled mass of bodies; the sight and smell make him retch.

After the war Goya was commissioned to commemorate the events of May 2 and 3, 1808, when the citizenry of Madrid had attacked the soldiers of Napoleon in the Puerta del Sol. That night and the next day citizens were rounded up and summarily shot in a gesture of reprisal. *The Third of May, 1808, at Madrid* (1814) is among the most brilliant images that Goya created (Fig. 27-11). The huddled citizens, unarmed and frightened, and the anonymous rank of surging soldiery spotlighted by a flaring lamp resemble a nightmare. The open mouths and astonished faces, the blood and gore, are without precedent. The loosely handled paint is rapidly brushed, and the earthy tones, cream, and reds focus our eyes into the center foreground, where the pose of the figure with upraised arms alludes to Christ and an attitude of innocence. This is a court of no resort; no pleading protects women or children. Death is stark, awful, ignominious. The romantic revolt against tyranny is the theme, but Napoleon is the villain rather than the hero.

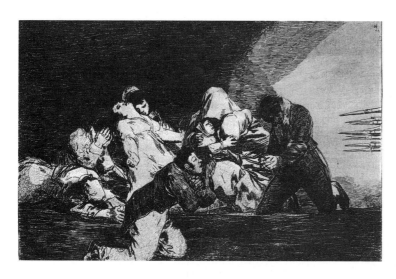

27-9 *Francisco Goya,* The Disasters of War: One Can't Bear to See Such Things, *c. 1814. Etching, aquatint, and drypoint, 5⅜″ × 8¼″. (Hispanic Society of America, New York)*

Eugène Delacroix (1798–1863)

Goya's work was known in France and was not without influence. But for the French romantic painter Eugène Delacroix, considered a revolutionary by his peers and teachers, war's terrifying nature was still susceptible to the romanticizing distance of place, if not time. Delacroix's painting *The Massacres of Chios* (Fig. 27-12), 1822–1824, recounts an event similar in nature to the murders in Madrid. Yet Delacroix was condemned for the intensity of his presentation and for the looseness of his brilliant paint. Compared to the hard coldness of Jacques-Louis David and his followers, Delacroix's work was considered a direct threat to the classicism of the academy.

In his painting *Liberty at the Barricades* (Color Plate XXVII), a scene from the Revolution of 1830, Delacroix uses a bare-breasted female to personify Liberty. The diagonal composition and the piled-up bodies recall Rubens and the monumental compositions of the baroque. Nevertheless, Delacroix, who painted nudes, animals, and scenes from the Bible, mythology, and the tales of Sir Wal-

ter Scott, exemplifies a romantic response to the strictures of the past. His emotion-filled canvases, brilliant in color and heavy with paint, are his attempt to make art in response to his personal temperament and imagination.

Charles Baudelaire, the French poet and critic (see Chapter 29), praised Delacroix for his imagination and energy, finding in his work an individual temperament given free rein to speak directly to the emotions and dreams of others. Yet Delacroix's work seems reserved and controlled when compared with the elemental passion tapped in Goya's work.

We can understand this only when we remember that Delacroix revered the art of the past, seeking to preserve it while giving it new values, whereas Goya seemed absolutely unable to incorporate his feelings and ideas in the old traditions. This split between reverence for the past and a passion for new ways of thinking, seeing, and feeling characterizes the romantic period.

Delacroix drew on the images of the past as sources for form and for inspiration. He also used photographs as a means to study poses and gestures, and he devel-

27-10 *Francisco Goya,* The Disasters of War: For This You Were Born (Para Eso Habeis Nacido). *(Photo courtesy of the Trustees of the Public Library of the City of Boston)*

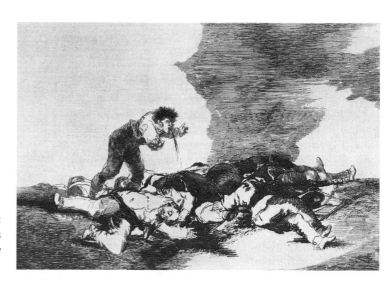

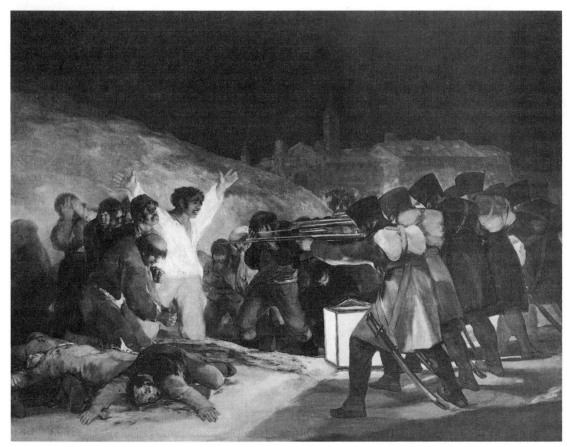

27-11 *Francisco Goya,* The Third of May, 1808, at Madrid: The Shootings on Principe Pio Mountain, *1814. Oil on canvas, 8′8¾″ × 11′3⅞″.* *Museo del Prado, Madrid)* **(W)**

• What elements in the painting appear to be taken from personal experience? What makes you think so? How does this painting relate to the prints Goya made? What does this painting have in common with Millet's *The Sower*? What is the single most "modern" aspect of the composition? Why?

27-12 *Eugène Delacroix,* The Massacres of Chios, *1822–1824. Oil on canvas, 13′10″ × 11′7″, Louvre, Paris. (Copyright 1996 ARS, NY/SPADEM, Paris)* **(W)**

• Compare this painting with Goya's *The Third of May* (Fig. 27-11). What are the sources for each artist's figures? Contrast the atmosphere and mood of each painting. What differences do the location, time of day, and apparel make with regard to your reaction to the paintings? Which seems the most "tragic"? Which the most "modern"?

oped theories about color and light that influenced his work enormously. But his interest was nevertheless in the narrative, which by its very nature depends on human figures as the *dramatis personae*.

Other painters looked at the natural world and found there the inspiration for new approaches to painting and to the landscape. In France, Corot, Millet, and others sought nature in the farmland and the forests of Barbizon. In England, J.M.W. Turner, like John Constable, drew revolutionary ideas from his observations of nature.

J.M.W. Turner (1775–1851)

Joseph Mallord William Turner began by painting the studied landscapes that one associates with early-nineteenth-century academic work, but even those showed an intense interest in light (Fig. 27-13). By the 1840s, however, Turner had transformed the light, air, and motion of the observed world into a visibly fragmented and energy-charged painted surface. *Rain, Steam and Speed—The Great Western Railway* (Color Plate XXIII), painted in 1844, was, according to Turner, a literal account of an event—a train in a snowstorm—that Turner himself had witnessed. However, it was not accepted by the public, who considered the thin veils of paint "tinted steam." Untroubled by popular opinion, Turner continued to explore similar subjects—sometimes with a narrative or moral, but more often concentrating on light. The light of the sun was energy creating, and countless fluid, light-filled, and layered canvases convey an almost tragic obsession, mitigated only by Turner's success in achieving a sense of the fluctuating, ephemeral world of light that his studies of nature revealed. Not until the impressionists—indeed, many would argue, not until the completely nonobjective paintings of the twentieth century—have there been other works similar enough to Turner's to form a basis for comparison. But he, like Constable, took his inspiration from the natural, external world, not from the internal world of the mind or from the hermetic world of paintings about painting, which was to become characteristic of the "romanticism" of the twentieth century.

The Romantic Woman and Romantic Love

Another facet of the complex romantic sensibility was its fervent interest in questions regarding the nature of women and the nature of *romantic love*. In the romantic

27-13 *J.M.W. Turner,* Mortlake Terrace: Early Summer Morning. *(The Frick Collection, New York)*

era—in life as well as in art—women undoubtedly assumed a new importance, a role more influential than in any previous cultural epoch in the West. Yet the positions assumed by women in society and as artists, and the images of women in art created by men, seem, from our modern point of view, contradictory. Liberated and autonomous, predatory and dangerous, domestic and subservient, ethereal and mystical—all are aspects of the image of romantic woman.

Romantic Women Writers

Mary Wollstonecraft Godwin (who married the poet Shelley) followed in her mother, Mary Wollstonecraft's, footsteps because she became a writer, but she typified the shift from the Enlightenment to romanticism, writing novels of fantasy rather than treatises. Her *Frankenstein* has become a classic in its genre. The early nineteenth century saw a veritable outbreak of female writers, primarily novelists, struggling against familial and social restrictions in order to live freely as human beings and as artists. Many of them published under male pen names. In England, there were the Brontë sisters and Mary Ann Evans (George Eliot); in France, Germaine Necker (known as Madame de Staël) and Aurore Dupin (Georges Sand). The United States produced the outspoken Margaret Fuller and the reclusive Emily Dickinson (1830–1886). The two Frenchwomen were particularly concerned in their novels with the nature and destinies of women. Sand (Fig. 27-14) was a liberated woman in her lifestyle, but with typical romantic contradiction, she exalts the simple, virtuous wife in many of her works. Her *Lélia* is nonetheless an apology for free love. Madame de Staël's Corinne, in the novel of that name, is a poetic genius who suffers and dies of unrequited love. Her statement on poetic inspiration is remarkable not only for its portrayal of women but also for its typically romantic exaltation of inspired genius:

> Sometimes . . . my impassioned excitement carries me beyond myself; teaches me to find in nature and my own heart such daring truths and forcible expressions as solitary meditation could never have engendered. My enthusiasm then seems supernatural: a spirit speaks within me far greater than my own; it often happens that I abandon the measure of verse to explain my thoughts in prose. . . . Sometimes my lyre, by a simple national air, may complete the effect which flies from the control of words. In truth, I feel myself a poet, less when a happy choice of rhymes, of syllables, of figures, may dazzle my auditors, than when my spirit soars disdainful of all selfish baseness; when godlike deeds appear easy to me, 'tis then my verse is at its best. I am . . . a poet while I admire or hate, not by my personal feelings nor in my own cause, but for the sake of human dignity and the glory of the world. . . . I cannot touch on any of the themes that affect me, without that kind

of thrill which is the source of ideal beauty in the arts, of religion in the recluse, generosity in heroes and disinterestedness among men.

How far we are here from the neoclassical conception of the role of the artist and the composition of the work of art! Corinne's portrayal of herself is comparable to that of an allegorical figure, like Delacroix's *Liberty at the Barricades.*

Romantic Love and Female Types

Literature and the other arts continued nevertheless to be dominated by men in the romantic period, and so it is primarily woman as viewed by man that has given us the various images of woman in romantic art. These range from the idealized, simple, domestic, virtuous girl and mother to the ethereal beauty, inspirer of lofty ideas, to the she-devil, temptress, or *femme fatale*, who seduces and ruins innocent young men. All these types may inspire romantic love, an all-consuming passion that can never be fulfilled (if it is, it usually leads to disillusionment and a new object) and often causes the hero extreme misery or even death. The romantic sufferer and the romantic lover are often one and the same,

27-14 *Auguste Charpentier,* Georges Sand, *1832. Musée Carnavalet, Paris, France. (Giraudon/Art Resource, NY)*

as in Goethe's romantic novel *The Sorrows of Young Werther*. Werther, a lover of nature and poetry but a misfit in society, is obsessed with love for a married woman, Charlotte. Unable to find any kind of satisfaction in this world, he finally commits suicide. Young people all over Europe identified with Werther, both in their art and in their lives. The novel actually provoked a rash of suicides. Romantic sufferers, pursuing an ideal, impossible love, felt themselves to be born in the wrong place at the wrong time, sensitive geniuses inevitably misunderstood by a crass society.

Throughout American romantic fiction—the novels of James Fenimore Cooper, Hawthorne, and Melville offer some examples—one can find examples of blond heroines who inspire the hero to noble thoughts and chaste love and brunettes who inevitably bring out his "darker" passions. In France, the type of the fatal woman, the femme fatale, is exemplified in Prosper Mérimée's novella *Carmen*, about a young man led to ruin by an enticing, fickle Spanish gypsy. This mythical character was developed further in the opera *Carmen* by Bizet. Romantic opera—*La Bohème* and *La Traviata* are other examples—is indeed full of free-living women who inspire consuming passions. Music, many romantics were convinced, could express the passion of love better than any other art could. Words by themselves were too limited. In the early nineteenth century, Germany witnessed an extraordinary cooperation between poets and composers that resulted in a new art form, the *lied* (art song), or the song cycle. One of the best known of the cycles on the theme of love is *Dichterliebe* (The Love of a Poet) by the poet Heinrich Heine (1797–1856) and the composer Robert Schumann (1810–1856). The culminating portrayal of romantic love in music is Richard Wagner's opera *Tristan und Isolde*, taking its subject from the literature that gave romantic love its prototype, the medieval romance. The music portrays the soaring passions of the lovers and the only climax possible—death.

Romantic Love in Music: The Example of Frédéric François Chopin (1810–1849)

Frédéric François Chopin was the quintessential romantic figure: poor but talented, handsome, and brilliant, a young man consumed and driven by the burning passions of his life—freedom, homeland, music, and love—an artist drained by tuberculosis and dead at thirty-nine. As a piano virtuoso and improviser his accomplishments are legendary, and his intuitive and inventive approach to composing for the piano was inextricably linked to the nonmusical events of his life, including his many love affairs. Though he lived in exile, he became, even before his premature death, Poland's national composer.

Born in Warsaw, Poland, in 1810, Chopin grew up in an environment of revolution and political turmoil.

While still a student at the newly founded Warsaw Conservatory, he fell in love with a younger singer, Constantia Gladkowska. Their romance and her influence stirred him to write the beautiful slow movement of the F-minor Piano Concerto, the Waltz in Db for solo piano, Op. 70, and several other works as well. Because he incorporated musical characteristics from Polish popular and folk music in his compositions, his Polish admirers recognized and appreciated the elegant use of native harmonies and rhythms in his music as well as his dazzling virtuosity at the keyboard.

Desiring to widen his musical experiences, Chopin left Poland for the major European concert centers—Vienna, Dresden, Prague, and Paris—and while he was away he learned of Warsaw's capture by the Russians in 1831. He decided never to return to his beloved homeland, and some biographers claim that he composed his "Revolutionary Etude" while in a fit of despair and defiance over the news of this terrible event. Because of the political conditions at home, he became an exile and moved to Paris. There he met many of the leading composers of the era—Liszt, Rossini, Bellini, Meyerbeer, and Berlioz—heard their music, and matched his talent against theirs. He also enjoyed the intellectual company of major artists and literary figures such as Eugène Delacroix, who painted a very romantic portrait of him (Fig. 27-15); Heinrich Heine; Victor Hugo; Balzac; and,

27-15 *Eugène Delacroix,* Frédéric Chopin, *1838. (Giraudon/Art Resource, NY)*

most important, the novelist Aurore Dupin, known as Georges Sand.

In an incredibly brief period, Chopin climbed the social ladder to the summit of Parisian society and obtained the patronage of the leading bankers of Europe, the Rothschilds. He and Georges Sand began a passionate love affair that lasted ten years. Six years older than the musician and clearly the dominant personality of the liaison, the novelist was already the mother of two children. She became his lover, artistic inspiration, traveling companion, and caregiver when tuberculosis began its deadly work. Though their passion eventually cooled to friendship and their relationship finally broke off in acrimony, this period with Georges Sand was most fertile for the musical artist's creative imagination. During these years he completed his 24 Preludes, Opus 28, the C# minor Scherzo, the C minor Polonaise, and many Nocturnes, or "night songs." Though some of Sand's descriptions of the artist at work may be more the work of the romantic novelist and less that of the scientific biographer, her words from her own autobiography, *The Story of My Life,* are fascinating:

> He [Chopin] would suddenly be struck by an altogether sublime idea while seated at the keyboard, or a voice would sing to him while he was out walking, so that he would hurry home to try out his idea at the piano. It was then, however, that there began the most painstaking work I have ever seen. There was no end to the impatient, irresolute attempts to record certain details of the theme as heard in his mind's ear. . . . He would lock himself in his room for whole days at a time, pacing up and down, breaking his pens, repeating what he had written, changing a single bar a hundred times over.[3]

Romanticism in music was a new idea in the 1830s, and romantics were fascinated with the night. Blackness, or the absence of light, seemed to deny time and space, to give birth to feelings of despair and death. But night was also the time for love, and night called for a music of its own, the Nocturne. The night, twilight, and dawn each have their own unique beauty and identifiable sounds, quite apart from the sounds and activities of the day. Night is a time for imagination, warm summer breezes, and tenderness. Chopin, the supreme master of subtlety and rubato (a technique of slowing here and speeding there to rob time from one note to place it with another), employed his artistic sensitivity and acutely tender feelings to capture the effect of starlight through the trees, moonlight on the water, gentle breezes, and perfumed memories. His music is one of nuance and emotion, uncanny pianissimos and ethereal flights of delicately curved melodies. There are majesty and heroism

in his patriotic music, his polonaises, marches, and mazurkas, but there is a gentle, ephemeral grace in his love music of the night that is matchless elsewhere in music. His Nocturne in G minor, Opus 37, number 1, was written during the early years of his romance with Georges Sand, when his love for her was both intense and fragile. One might imagine their encounter **CD-2, 12** in the evening, perhaps strolling along the moonlit Seine river. The first statement is tentative, its repeat slightly fuller and more embellished. The melody is clear, the accompaniment effervescent. No one but the composer knows exactly what images the notes represent, but the opening is surely reflective and introspective. The middle section borrows the music of a chorale, perhaps a church song he or they might hear from afar. But their thoughts return to each other and to love and, perhaps, to a little sadness, too. There are a melancholy and a mystery in this quiet ending. What will tomorrow bring?

The Romantic Ballet: Giselle

A romantic art form that gave great importance to women, both as artists and as mythical figures, and to romantic love was the ballet. The neoclassical stage ballet of the eighteenth century, like the *ballet de cour* of

27-16 *Carlotta Grisi in* Giselle, *from a lithograph by J. Bouvier. (Courtesy of the Board of Trustees, Victoria and Albert Museum, London)*

[3] Quoted by Andreas Kluge, liner notes to Fou Ts'ong, *Chopin: Nocturnes* (SONY SB2K 53249).

the seventeenth, showed an equality of roles between the sexes but gave some predominance to men in the execution of showy steps. In the romantic ballet, however, the first female dancer of the company—the *prima ballerina*—upstaged everyone. Dancing on the tips of the toes, or *pointe*, and airy tulle costumes appeared at this time. Men were sometimes reduced to machines to lift the ethereal creatures in the air. The popular notion of ballet as a woman's art, as it still is in most of the best-known ballets still performed, dates from the romantic period. Romanticism in ballet, as in the other arts, stressed exoticism, fantasy, nature, and, of course, love—an unrealizable love for an evanescent lady or a "fatal" love for a heartless temptress.

Paris, with London a close second, was the center of romantic ballet. It was there, at the opera, that the stars—the Italians Maria Taglioni and Carlotta Grisi and the Viennese Fanny Essler—became for their admirers legendary, almost goddesslike. The poet Théophile Gautier, an admirer of the art of dance, wrote the story for the greatest romantic ballet, *Giselle* (1840), based on a German legend. Set to music by Adolphe Adam, the ballet recounts the story of a young country girl who loves to dance and falls in love with a shepherd boy. Her mother foretells her fate: "Unhappy child! You will dance forever, you will kill yourself, and, when you are dead, you will become a *Wili* (a dancing spirit)." Giselle pays no heed, but the prophecy comes true. It turns out that the shepherd whom she loves is really a duke in disguise, and when Giselle learns that he is in reality engaged to a noble lady, she kills herself. We then see the *Wilis* dancing around Giselle's grave, coaxing her spirit out to become one of them. The duke, in tears, returns to her tomb, and is almost danced to death by the *Wilis*. After a frenzied dance and a passionate love scene, Giselle returns to the grave and the duke is consoled by his noble fiancée. Carlotta Grisi, according to Gautier, danced this role "with a perfection, lightness, boldness, and a chaste and refined seductiveness, which places her in the first rank. . . . She was nature and artlessness personified." The contemporary lithograph (Fig. 27-16) suggests an ethereal, floating creature, idealized and unearthly. *Giselle* continues to be popular.

ROMANTIC LYRIC POETRY

Romantic writers were prolific in all *genres*—fiction, drama, and poetry—but the movement is perhaps best remembered for its achievements in poetry. The individualistic, subjective, and emotional bent of romanticism made the *lyric* a congenial form. In contrast to the period of the Enlightenment, the romantic era was one of the great ages of lyricism. This was true all over Europe, but especially in Germany and in England. American poetry also flourished in this period. Because it is so abundant, of such greatness, and representative of the themes discussed, we have limited our literary selections to lyric poetry written in English.

WILLIAM WORDSWORTH

from *The Prelude*

Residence in France

Oh! pleasant exercise of hope and joy!
For mighty were the auxiliars which then stood
Upon our side, we who were strong in love!
Bliss was it in that dawn to be alive,
But to be young was very heaven!—Oh! times, 5
In which the meagre, stale, forbidding ways
Of custom, law, and statute, took at once
The attraction of a country in romance!
When Reason seemed the most to assert her rights,
When most intent on making of herself 10
A prime Enchantress—to assist the work
Which then was going forward in her name!
Not favoured spots alone, but the whole earth,
The beauty wore of promise, that which sets
(As at some moments might not be unfelt 15
Among the bowers of paradise itself)
The budding rose above the rose full blown.
What temper at the prospect did not wake
To happiness unthought of? The inert
Were roused, and lively natures rapt away! 20
They who had fed their childhood upon dreams,
The playfellows of fancy, who had made
All powers of swiftness, subtilty, and strength

Their ministers,—who in lordly wise had stirred
Among the grandest objects of the sense, 25
And dealt with whatsoever they found there
As if they had within some lurking right
To wield it;—they, too, who, of gentle mood,
Had watched all gentle motions, and to these
Had fitted their own thoughts, schemers more mild, 30
And in the region of their peaceful selves;—
Now was it that *both* found, the meek and lofty
Did both find, helpers to their hearts' desire,
And stuff at hand, plastic as they could wish;
Were called upon to exercise their skill, 35
Not in Utopia, subterranean fields,
Or some secreted island, Heaven knows where!
But in the very world, which is the world
Of all of us,—the place where in the end
We find our happiness, or not at all! 40

COMMENTS AND QUESTIONS

1. Whose viewpoint of the French Revolution does Wordsworth give here?

2. What is romantic in his interpretation of the revolution?

The Solitary Reaper

Behold her, single in the field,
Yon solitary Highland Lass!
Reaping and singing by herself;
Stop here, or gently pass!
Alone she cuts and binds the grain, 5
And sings a melancholy strain;
O listen! for the Vale profound
Is overflowing with the sound.
No Nightingale did ever chaunt
More welcome notes to weary bands 10
Of travellers in some shady haunt,
Among Arabian sands:
A voice so thrilling ne'er was heard
In spring-time from the Cuckoo-bird,
Breaking the silence of the seas 15
Among the farthest Hebrides.

Will no one tell me what she sings?—
Perhaps the plaintive numbers flow
For old, unhappy, far-off things,
And battles long ago: 20
Or is it some more humble lay,
Familiar matter of to-day?
Some natural sorrow, loss, or pain,
That has been, and may be again?
Whate'er the theme, the Maiden sang 25
As if her song could have no ending;
I saw her singing at her work,
And o'er the sickle bending;—
I listened, motionless and still;
And, as I mounted up the hill, 30
The music in my heart I bore,
Long after it was heard no more.

Lines

Composed a few miles above Tintern Abbey on revisiting the
banks of the Wye during a tour, July 13, 1798[1]

Five years have passed; five summers, with the length
Of five long winters! and again I hear
These waters, rolling from their mountain-springs
With a soft inland murmur. Once again
Do I behold these steep and lofty cliffs, 5
That on a wild secluded scene impress
Thoughts of more deep seclusion; and connect
The landscape with the quiet of the sky.
The day is come when I again repose
Here, under this dark sycamore, and view 10
These plots of cottage-ground, these orchard tufts,
Which at this season, with their unripe fruits,
Are clad in one green hue, and lose themselves
'Mid groves and copses. Once again I see
These hedge-rows, hardly hedge-rows, little lines 15
Of sportive wood run wild: these pastoral farms,
Green to the very door; and wreaths of smoke
Sent up, in silence, from among the trees!
With some uncertain notice, as might seem
Of vagrant dwellers in the houseless woods, 20
Or of some hermit's cave, where by his fire
The hermit sits alone.
 These beauteous forms,
Through a long absence, have not been to me
As is a landscape to a blind man's eye; 25
But oft, in lonely rooms, and 'mid the din
Of towns and cities, I have owed to them,
In hours of weariness, sensations sweet,

[1] Wordsworth wrote this poem at the age of twenty-eight; he had
first visited the ruins of the medieval abbey five years earlier while
on a solitary walking tour.

Felt in the blood, and felt along the heart;
And passing even into my purer mind, 30
With tranquil restoration—feelings too
Of unremembered pleasure: such, perhaps,
As have no slight or trivial influence
On that best portion of a good man's life,
His little, nameless, unremembered acts 35
Of kindness and of love. Nor less, I trust,
To them I may have owed another gift,
Of aspect more sublime; that blessèd mood,
In which the burthen of the mystery,
In which the heavy and the weary weight 40
Of all this unintelligible world,
Is lightened—that serene and blessèd mood,
In which the affections gently lead us on—
Until, the breath of this corporeal frame
And even the motion of our human blood 45
Almost suspended, we are laid asleep
In body, and become a living soul;
While with an eye made quiet by the power
Of harmony, and the deep power of joy,
We see into the life of things. 50
 If this
Be but a vain belief, yet, oh! how oft—
In darkness and amid the many shapes
Of joyless daylight; when the fretful stir
Unprofitable, and the fever of the world, 55
Have hung upon the beatings of my heart—
How oft, in spirit, have I turned to thee,
O sylvan Wye! thou wanderer through the woods,
How often has my spirit turned to thee!

And now, with gleams of half-extinguished
 thought, 60
With many recognitions dim and faint,
And somewhat of a sad perplexity,
The picture of the mind revives again;
While here I stand, not only with the sense
Of present pleasure, but with pleasing thoughts 65
That in this moment there is life and food
For future years. And so I dare to hope,
Though changed, no doubt, from what I was when first
I came among these hills; when like a roe
I bounded o'er the mountains, by the sides 70
Of the deep rivers, and the lonely streams,
Wherever nature led: more like a man
Flying from something that he dreads than one
Who sought the thing he loved. For nature then
(The coarser pleasures of my boyish days, 75
And their glad animal movements all gone by)
To me was all in all.—I cannot paint
What then I was. The sounding cataract
Haunted me like a passion; the tall rock,
The mountain, and the deep and gloomy wood, 80
Their colors and their forms, were then to me
An appetite; a feeling and a love,

That had no need of a remoter charm,
By thought supplied, nor any interest
Unborrowed from the eye. That time is past, 85
And all its aching joys are now no more,
And all its dizzy raptures. Not for this
Faint I, nor mourn nor murmur; other gifts
Have followed; for such loss, I would believe,
Abundant recompense. For I have learned 90
To look on nature, not as in the hour
Of thoughtless youth; but hearing oftentimes
The still, sad music of humanity,
Nor harsh nor grating, though of ample power
To chasten and subdue. And I have felt 95
A presence that disturbs me with the joy
Of elevated thoughts; a sense sublime
Of something far more deeply interfused,
Whose dwelling is the light of setting suns,
And the round ocean and the living air, 100
And the blue sky, and in the mind of man:
A motion and a spirit, that impels
All thinking things, all objects of all thought,
And rolls through all things. Therefore am I still
A lover of the meadows and the woods 105
And mountains; and of all that we behold
From this green earth; of all the mighty world
Of eye, and ear—both what they half create,
And what perceive; well pleased to recognize
In nature and the language of the sense 110
The anchor of my purest thoughts, the nurse,
The guide, the guardian of my heart, and soul
Of all my moral being.
 Nor perchance,
If I were not thus taught, should I the more 115
Suffer my genial spirits to decay:
For thou art with me here upon the banks
Of this fair river; thou my dearest Friend,°
My dear, dear Friend; and in thy voice I catch
The language of my former heart, and read 120
My former pleasures in the shooting lights
Of thy wild eyes. Oh! yet a little while
May I behold in thee what I was once,
My dear, dear Sister! and this prayer I make,
Knowing that Nature never did betray 125
The heart that loved her; 'tis her privilege,
Through all the years of this our life, to lead
From joy to joy: for she can so inform
The mind that is within us, so impress
With quietness and beauty, and so feed 130
With lofty thoughts, that neither evil tongues,
Rash judgments, nor the sneers of selfish men,
Nor greetings where no kindness is, nor all
The dreary intercourse of daily life,
Shall e'er prevail against us, or disturb 135
Our cheerful faith, that all which we behold

118. His sister, Dorothy.

Is full of blessings. Therefore let the moon
Shine on thee in thy solitary walk;
And let the misty mountain-winds be free
To blow against thee: and, in after years, 140
When these wild ecstasies shall be matured
Into a sober pleasure; when thy mind
Shall be a mansion for all lovely forms,
Thy memory be as a dwelling-place
For all sweet sounds and harmonies; oh! then, 145
If solitude, or fear, or pain, or grief,
Should be thy portion, with what healing thoughts
Of tender joy wilt thou remember me,
And these my exhortations! Nor, perchance—
If I should be where I no more can hear 150
Thy voice, nor catch from thy wild eyes these gleams
Of past existence—wilt thou then forget
That on the banks of this delightful stream
We stood together; and that I, so long
A worshiper of Nature, hither came 155
Unwearied in that service; rather say
With warmer love—oh! with far deeper zeal
Of holier love. Nor wilt thou then forget,
That after many wanderings, many years
Of absence, these steep woods and lofty cliffs, 160
And this green pastoral landscape, were to me
More dear, both for themselves and for thy sake!

COMMENTS AND QUESTIONS

1. Find all the instances of the word *nature* in the poem.
 Does it always have the same meaning? How would
 you define Wordsworth's conception of nature?

2. How does the poet describe the moral effect that
 nature has on him?

3. With what images does he convey the differences
 between his present and former selves?

4. What is the role of his sister in the poem?

5. Do you find any points of comparison between this
 poem and Constable's painting (see Color Plate
 XXII)? What are the different processes that a painter
 and a poet must go through to render a landscape?

GEORGE GORDON, LORD BYRON

Prometheus

I

Titan! to whose immortal eyes
 The sufferings of mortality,
 Seen in their sad reality,
Were not as things that gods despise;
What was thy pity's recompense? 5

A silent suffering, and intense;
The rock, the vulture, and the chain,
All that the proud can feel of pain,
The agony they do not show,
The suffocating sense of woe, 10
 Which speaks but in its loneliness,
And then is jealous lest the sky
Should have a listener, nor will sigh
 Until its voice is echoless.

II

Titan! to thee the strife was given 15
 Between the suffering and the will,
 Which torture where they cannot kill;
And the inexorable Heaven,
And the deaf tyranny of Fate,
The ruling principle of Hate, 20
Which for its pleasure doth create
The things it may annihilate,
Refused thee even the boon to die:
The wretched gift eternity
Was thine—and thou hast borne it well. 25
All that the Thunderer wrung from thee
Was but the menace which flung back
On him the torments of thy rack;
The fate thou didst so well foresee,
But would not to appease him tell; 30
And in thy Silence was his Sentence,
And in his Soul a vain repentance,
And evil dread so ill dissembled,
That in his hand the lightnings trembled.

III

Thy Godlike crime was to be kind, 35
 To render with thy precepts less
 The sum of human wretchedness,
And strengthen Man with his own mind;
But baffled as thou wert from high,
Still in thy patient energy, 40
In the endurance, and repulse
 Of thine impenetrable Spirit,
Which Earth and Heaven could not convulse,
 A mighty lesson we inherit:
Thou art a symbol and a sign 45
 To Mortals of their fate and force;
Like thee, Man is in part divine,
 A troubled stream from a pure source;
And Man in portions can foresee
His own funereal destiny; 50
His wretchedness, and his resistance,
And his sad unallied existence:
To which his Spirit may oppose
Itself—and equal to all woes,
 And a firm will, and a deep sense, 55

Which even in torture can descry
 Its own concenter'd recompense,
Triumphant where it dares defy,
And making Death a Victory.

COMMENTS AND QUESTIONS

1. Look up the myth of Prometheus if you are not familiar with it. How has Byron reinterpreted it?

2. What is the *meter* of the verse used here? How would you describe the language of the poem? How are both appropriate to the subject matter?

3. Of what is Prometheus "a symbol and a sign"? What makes him a hero? Would he be a fitting heroic symbol for our times?

On This Day I Complete My Thirty-Sixth Year

Missolonghi,[1] January 22, 1824

'Tis time this heart should be unmoved,
 Since others it hath ceased to move:
Yet, though I cannot be beloved,
 Still let me love!

My days are in the yellow leaf; 5
 The flowers and fruits of love are gone;
The worm, the canker, and the grief
 Are mine alone!

The fire that on my bosom preys
 Is lone as some volcanic isle; 10
No torch is kindled at its blaze—
 A funeral pile.

The hope, the fear, the jealous care,
 The exalted portion of the pain
And power of love, I cannot share, 15
 But wear the chain.

But 'tis not *thus*—and 'tis not *here*—
 Such thoughts should shake my soul, nor *now*,
Where glory decks the hero's bier,
 Or binds his brow. 20

The sword, the banner, and the field,
 Glory and Greece, around me see!

[1] Town in Greece where Byron had gone to help the Greeks in their war for independence from Turkey. Less than three months later he died there.

The Spartan, borne upon his shield,
 Was not more free.

Awake! (not Greece—she *is* awake!) 25
 Awake, my spirit! Think through *whom*
Thy life-blood tracks its parent lake,
 And then strike home!

Tread those reviving passions down,
 Unworthy manhood!—unto thee 30
Indifferent should the smile or frown
 Of beauty be.

If thou regrett'st thy youth, *why live?*
 The land of honorable death
Is here:—up to the field, and give 35
 Away thy breath!

Seek out—less often sought than found—
 A soldier's grave, for thee the best;
Then look around, and choose thy ground,
 And take thy rest. 40

COMMENTS AND QUESTIONS

1. What two typically romantic states of mind does Byron contrast in this poem?

2. How is political commitment understood as individual salvation?

JOHN KEATS

Ode to a Grecian Urn

Thou still unravished bride of quietness!
 Thou foster-child of Silence and slow Time,
Sylvan historian, who canst thus express
 A flowery tale more sweetly than our rhyme:
What leaf-fringed legend haunts about thy shape
 Of deities or mortals, or of both,
 In Tempe[1] or the dales of Arcady?[2]
 What men or gods are these? What maidens loath?
What mad pursuit? What struggle to escape?
 What pipes and timbrels? What wild ecstasy?

Heard melodies are sweet, but those unheard
 Are sweeter; therefore, ye soft pipes, play on;

Not to the sensual ear, but, more endeared,
 Pipe to the spirit ditties of no tone:
Fair youth, beneath the trees, thou canst not leave
 Thy song, nor ever can those trees be bare;
 Bold Lover, never, never canst thou kiss,
Though winning near the goal—yet, do not grieve;
 She cannot fade, though thou hast not thy bliss,
For ever wilt thou love, and she be fair!

Ah, happy, happy boughs! that cannot shed
 Your leaves, nor ever bid the Spring adieu;
And, happy melodist, unwearied,
 For ever piping songs for ever new;
More happy love! more happy, happy love!
 For ever warm and still to be enjoyed,
 For ever panting and for ever young;
All breathing human passion far above,
 That leaves a heart high sorrowful and cloyed,
 A burning forehead, and a parching tongue.

Who are these coming to the sacrifice?
 To what green altar, O mysterious priest,
Lead'st thou that heifer lowing at the skies,
 And all her silken flanks with garlands drest?
What little town by river or sea-shore,
 Or mountain-built with peaceful citadel,
 Is emptied of its folk, this pious morn?
And, little town, thy streets for evermore
 Will silent be; and not a soul to tell
 Why thou art desolate, can e'er return.

O Attic shape! Fair attitude! with brede
 Of marble men and maidens overwrought,
With forest branches and the trodden weed;
 Thou, silent form! dost tease us out of thought
As doth eternity: Cold Pastoral!
 When old age shall this generation waste,
 Thou shalt remain, in midst of other woe
Than ours, a friend to man, to whom thou say'st,
"Beauty is truth, truth beauty,"—that is all
 Ye know on earth, and all ye need to know.

COMMENTS AND QUESTIONS

1. Describe as exactly as you can the scene represented on the "Grecian urn." Can you compare it to any Greek vases you have seen?

2. What is the rhythmical effect of the questions and exclamations in the poem?

3. In what different ways does Keats express the superiority of art to life?

4. How does Keats express a romantic, as opposed to a neoclassical, attitude toward ancient Greece?

[1] Tempe is a valley in Greece sacred to Apollo.

[2] A region in ancient Greece given over to raising sheep and associated with a simple, untroubled existence.

PERCY BYSSHE SHELLEY

Ode to the West Wind

O wild West Wind, thou breath of Autumn's being,
Thou, from whose unseen presence the leaves dead
Are driven, like ghosts from an enchanter fleeing,
Yellow, and black, and pale, and hectic red,
Pestilence-stricken multitudes: O thou,
Who chariotest to their dark wintry bed
The wingéd seeds, where they lie cold and low,
Each like a corpse within its grave, until
Thine azure sister of the Spring shall blow
Her clarion o'er the dreaming earth, and fill
(Driving sweet buds like flocks to feed in air)
With living hues and odours plain and hill:
Wild Spirit, which art moving everywhere;
Destroyer and preserver; hear, oh, hear!

Thou on whose stream, mid the steep sky's commotion,
Loose clouds like earth's decaying leaves are shed,
Shook from the tangled boughs of Heaven and Ocean,
Angels of rain and lightning: there are spread
On the blue surface of thine aëry surge,
Like the bright hair uplifted from the head
Of some fierce Maenad,[1] even from the dim verge
Of the horizon to the zenith's height,
The locks of the approaching storm. Thou dirge
Of the dying year, to which this closing night
Will be the dome of a vast sepulchre,
Vaulted with all thy congregated might
Of vapours, from whose solid atmosphere
Black rain, and fire, and hail, will burst: O hear!

Thou who didst waken from his summer dreams
The blue Mediterranean, where he lay,
Lull'd by the coil of his crystàlline streams,
Beside a pumice isle in Baiæ's bay,[2]
And saw in sleep old palaces and towers
Quivering within the wave's intenser day,
All overgrown with azure moss, and flowers
So sweet, the sense faints picturing them! Thou
For whose path the Atlantic's level powers
Cleave themselves into chasms, while far below
The sea-blooms and the oozy woods which wear
The sapless foliage of the ocean, know
Thy voice, and suddenly grow gray with fear,
And tremble and despoil themselves: O hear!

If I were a dead leaf thou mightest bear;
If I were a swift cloud to fly with thee;

A wave to pant beneath thy power, and share
The impulse of thy strength, only less free
Than thou, O uncontrollable! if even
I were as in my boyhood, and could be
The comrade of thy wanderings over heaven,
As then, when to outstrip thy skiey speed
Scarce seem'd a vision—I would ne'er have striven
As thus with thee in prayer in my sore need.
Oh, lift me as a wave, a leaf, a cloud!
I fall upon the thorns of life! I bleed!
A heavy weight of hours has chained and bowed
One too like thee: tameless, and swift, and proud.

Make me thy lyre, even as the forest is;
What if my leaves are falling like its own!
The tumult of thy mighty harmonies
Will take from both a deep, autumnal tone,
Sweet though in sadness. Be thou, spirit fierce,
My spirit! Be thou me, impetuous one!
Drive my dead thoughts over the universe
Like withered leaves to quicken a new birth!
And, by the incantation of this verse,
Scatter, as from an unextinguished hearth
Ashes and sparks, my words among mankind!
Be through my lips to unawakened earth
The trumpet of a prophecy! O Wind,
If Winter comes, can Spring be far behind?

COMMENTS AND QUESTIONS

1. Why is the west wind both a destroyer and a preserver?

2. What appeal does the poet make to the wind? How does he identify with it?

3. How do you interpret the last line?

Ozymandias

I met a traveller from an antique land,
Who said—"Two vast and trunkless legs of stone
Stand in the desert. . . . Near them, on the sand,
Half sunk a shattered visage lies, whose frown,
And wrinkled lip, and sneer of cold command,
Tell that its sculptor well those passions read
Which yet survive, stamped on these lifeless things,
The hand that mocked them, and the heart that fed,
And on the pedestal, these words appear:
My name is Ozymandias, King of Kings,
Look on my Works, ye Mighty, and despair!
Nothing beside remains. Round the decay
Of that colossal Wreck, boundless and bare
The lone and level sands stretch far away."

[1] A wild woman, worshiper of the god of wine, Dionysius.

[2] Baiae was a beach resort of the ancient Romans. It was located on a bay near Naples.

COMMENTS AND QUESTIONS

1. Ozymandias is the Greek name given to the Egyptian pharaoh Ramses II, who reigned in the thirteenth century B.C. Why do you think that Shelley chose a pharaoh as the subject of his poem?

2. This poem is a *sonnet.* Explain why and show how it can be divided logically.

3. The ruins of ancient civilizations fascinated the romantics. Describe the visual image of the ruin here, and explain how the poet uses it.

4. What effect do the rhythm and the sounds in the last line have on you?

EMILY DICKINSON

Selected Poems

986

A narrow fellow in the grass
Occasionally rides;
You may have met him,—did you not?
His notice sudden is.
The grass divides as with a comb,
A spotted shaft is seen;
And then it closes at your feet
And opens further on.

He likes a boggy acre,
A floor too cool for corn.
Yet when a child, and barefoot,
I more than once, at morn,

Have passed, I thought, a whip-lash
Unbraiding in the sun,—
When, stooping to secure it,
It wrinkled, and was gone.

Several of nature's people
I know, and they know me;
I feel for them a transport
Of cordiality;

But never met this fellow,
Attended or alone,
Without a tighter breathing,
And zero at the bone.

987

The leaves, like women, interchange
 Sagacious confidence;
Somewhat of nods, and somewhat of
 Portentous inference,

The parties in both cases
 Enjoining secrecy,—
Inviolable compact
 To notoriety.

348

I dreaded that first robin so,
But he is mastered now,
And I'm accustomed to him grown,—
He hurts a little, though.

I thought if I could only live
Till that first shout got by,
Not all pianos in the woods
Had power to mangle me.

I dared not meet the daffodils,
For fear their yellow gown
Would pierce me with a fashion
So foreign to my own.

I wished the grass would hurry,
So when 'twas time to see,
He'd be too tall, the tallest one
Could stretch to look at me.

I could not bear the bees should come,
I wished they'd stay away
In those dim countries where they go:
What word had they for me?

They're here, though; not a creature failed,
No blossom stayed away
In gentle deference to me,
The Queen of Calvary.

Each one salutes me as he goes,
And I my childish plumes
Lift, in bereaved acknowledgment
Of their unthinking drums.

288

I'm nobody! Who are you?
Are you nobody, too?
Then there's a pair of us—don't tell!
They'd banish us, you know.
How dreary to be somebody!
How public, like a frog
To tell your name the livelong day
To an admiring bog!

249

Wild nights! Wild nights!
 Were I with thee,
Wild nights should be
 Our luxury!

Futile the winds
 To a heart in port,—
Done with the compass,
 Done with the chart.

Rowing in Eden!
 Ah! the sea!
Might I but moor
 To-night in thee!

COMMENTS AND QUESTIONS

1. How would you describe Emily Dickinson's view of nature? Compare it with that of Wordsworth and Keats.
2. How, if at all, did the fact that Dickinson was a woman influence her perception of individuality and of love?

Summary Questions

1. What were the causes of the French Revolution, and how did it begin?
2. What were the main ideas in the Declaration of the Rights of Man and of the Citizen?
3. How does the art of David represent revolutionary ideas?
4. Which aspects of Beethoven's Ninth Symphony are classical, and which are romantic?
5. Define (with examples) the various traits of the romantic hero and the romantic view of woman.
6. What did "nature" mean to the romantics? How is it expressed in painting and poetry?
7. Give examples of the romantic themes of individualism and love in painting, poetry, and music.

Key Terms

ancien régime

third estate

Jacobins

romanticism

liberty, equality, fraternity

romantic love

lyric poetry

From the Enlightenment to Romanticism

The two great political revolutions at the end of the eighteenth century, the American and the French, not only transformed the leading philosophies of government in the Western world but also dramatically altered some basic conceptions about the nature of human beings. In terms of the humanities, these revolutions embodied the ideas of the Enlightenment while exciting the passions of romanticism.

Enlightenment Ideals

The primarily middle-class philosophes challenged once and for all the medieval belief that every person occupies an individual place in a hierarchical society, a belief that still held sway in the absolutist seventeenth century. Human beings, they argued, are "naturally" equal and thus entitled to certain natural rights. Thomas Jefferson, in a sense an American philosophe, defined these as life, liberty, and the pursuit of happiness. The writers and artists of the Enlightenment submitted everything—social customs and institutions, religious beliefs, passions—to the cold light of reason.

The Enlightenment belief that the human predicament was largely the product of bad institutions raised tremendous expectations regarding the possibilities of improving human beings and their society through institutional reforms. Some philosophes were deeply engaged in drawing up sketches of model societies, which they took very seriously. Within limits, this belief in human-engineered progress provided a healthy incentive to reform what were seen as present evils. But this belief could also justify something like the Reign of Terror during the French Revolution. An idealist, Robespierre felt perfectly justified in destroying thousands of human beings in the name of a brighter tomorrow. He was not to be the last of this type.

Enlightenment Style

If the seventeenth century was an age for the grandiose in the arts, the eighteenth was an age for the small and the well ordered. Neoclassicism, no longer inspired by the baroque sense of splendor, became in the Enlightenment less ornate and somewhat colder and more mechanical. Eighteenth-century artists were more interested in sensuality than in love, in humble virtues than in religious yearnings.

Classical composers such as Mozart and Haydn made use of short phrases and strove to achieve unity, balance, and symmetry, forsaking the complex fugues of the baroque era. Architecture, such as the government buildings in Washington, D.C., and Jefferson's ideal "academical village," the University of Virginia, reflected the inspiration of classical Rome and a belief in order and rationality. Like classical Rome, with Horace and Juvenal, European literature and art in the eighteenth century reflected a strong predilection for satire and thus for examining human folly and pretensions under the light of reason. Voltaire's "philosophical tales," with their short, witty, sometimes biting humor and distrust of metaphysical abstraction, as well as Hogarth's satirical view of social institutions, represent well the style of the Enlightenment.

In our post-Freudian era we may view the Enlightenment's understanding of human nature with some skepticism. People cannot be defined primarily as atoms of reason, as some of the philosophes seemed to suppose. We cannot share all of their optimism about progress through education and science. Writers such as Phillis Wheatley and David Walker had already pointed out the glaring contradictions between Enlightenment ideology and the reality of slavery. Yet many of the assumptions of today's society were once ideals formulated in the Enlightenment. Toleration of the beliefs of others, human equality, basic human rights, the freedom to think for oneself, the concept of equal legal and social rights for women and for racial and ethnic mi-

norities—all of these practiced at least in theory by contemporary Western democracies have their origins in the thought of the Enlightenment.

Romantic Changes

The romantics adapted the ideals of the Enlightenment to their own purposes. Rejecting the belief that reason is the primary human faculty, they developed a current of sentimentality already present in the eighteenth century. The transitional Jean-Jacques Rousseau made the Enlightenment's belief in the natural goodness of human beings the basis for a romantic apology for feeling above reason and for the supremacy of the unique individual. He thus laid the groundwork for the misunderstood romantic sufferer and the titanic romantic hero. Napoleon, the rationalistic administrator, became, as in David's painting, the passionate, dashing, almost superhuman general, comparable to Byron's Prometheus, the savior of humankind.

Rousseau's mature thought made an important contribution to nascent nationalism, which began to take shape in the early decades of the nineteenth century, in a sense inspired by French aggression. Whereas the Enlightenment conceived of human beings as essentially a universal race, the proponents of nationalism saw them as divided into linguistically and culturally defined groupings. Each of these groupings had its own particular characteristics and its own political will. Further, each political will had a right to self-government.

Nothing could have been more congenial to the nationalist position than Rousseau's idea that human beings become human only by virtue of membership in a particular community. To it they owe their values and the character of their intellectual and emotional lives. Moreover, created in a very real sense by their culture, human beings have, as their very essence, a general will, which they share with other members of the community. It was easy for nineteenth-century nationalists to identify this general will as the will of the nation and to envisage it as struggling for life against other general wills that would attempt to oppress it.

Romantic Style

We have seen how the rationalistic goals of liberty, equality, and fraternity became passionate statements in the hands of romantic artists. Open to the entire range of human emotions, the romantics also tended to plumb the depths as well as scale the heights of experience. Goya, for example, who had lived through the disasters of a brutal war rather than with the theories of revolution, portrayed the demonic side of human nature while showing an intense compassion for the victims of exploitation and tyranny. The desire to portray the extremes and varieties of human passions greatly enriched the range and textures of romantic visual, literary, and musical art. The artists' need for individuality of expression also caused them to find the neat balances and rules of neoclassical art insufficient. Beethoven expanded both classical structures and orchestration, Delacroix experimented with color and composition, the English romantic poets opened poetry to music and to the sensuous imagery of painting, and Dickinson found highly personal images and rhymes. The music of Chopin demonstrates the extent to which the composer (and the piano) could express emotion.

Romantic Continuities

Romantic exuberance for social causes and for nature, as well as romantic individualism and emotionalism, is still with us. The modern concept of the artist as a supersensitive being—more likely to be misunderstood by, and at odds with, society than in harmony with it—was born with the romantics. The romantic concept of love and the romantic views of women have also, for good or ill, profoundly influenced our own.

We have seen that love, for the romantics, resembled an infinite yearning that could never really be satisfied by a finite human being. Romantic lovers in literature and life were doomed to desire the unattainable and to suffer—or to throw themselves into one passionate love affair after another. Although some "romanticized" an ideal marriage with one's soul mate, others viewed marriage and family life as too bourgeois and constricting.

In ways that are often contradictory, women became a romantic preoccupation. A romantic lover might idealize a domestic and virtuous young girl as a mysterious and ethereal creature; he might be destroyed by a femme fatale, or temptress. The romantic ballet, with the predominance it gave to the ballerina, reinforced the idealization of women. At the same time, women began to explore, in their own way, the romantic ideal of individual freedom. Feminist ideas on the liberation of women, such as those proclaimed by Mary Wollstonecraft and Georges Sand, became a way of life for some romantic women.

Contemporary concerns about ecology and the conservation of unspoiled nature began in the romantic period. The romantics were particularly prone to see their own emotions reflected in the natural world or to look on nature as a mother, a consolation for their troubles.

They spoke out against pollution and the unhealthy life in cities. Many romantics shunned organized religions, finding a substitute in the worship of nature, but even orthodox Christians found that they could approach God through immersion in his works. As they idealized nature, the romantics idealized the simple life of the "natural" peasant, unspoiled by the corruptions of the modern world. Yet the life of peasants, with the growing industrialism of Europe, was in fact beginning to be more and more affected by the modern world. For many of them, urbanization would mean a dramatic uprooting. It would also necessitate new responses in thought and style from the humanities.

PART IX

Industrialism and
the Humanities:
The Middle and Late
Nineteenth Century

28 The Industrial Revolution and New Social Thought

CENTRAL ISSUES

- The Industrial Revolution: its significance and its social effects
- The theories of Karl Marx and Friedrich Engels
- John Stuart Mill: liberalism and women's rights
- The women's rights movement
- Slavery and the abolitionist movement

By the beginning of the nineteenth century, while Keats was musing on his nightingale and Wordsworth was celebrating the English countryside and his solitary reaper, the face of rural England was in a state of transformation. Eighteenth-century country towns such as Manchester were fast becoming makeshift cities for hundreds of thousands of poor workers seeking employment in the new factories, whose belching smokestacks polluted the landscape for miles around. A few years before Wordsworth's death in 1850, engineers laid down the iron rails that were to bring the first trains across the wheat fields.

The *Industrial Revolution* could easily be considered the most important event in the history of the human race. In all previous known societies, periods of population growth were necessarily succeeded by periods of contraction caused by disease and starvation. After 1750, however, the productive capacity of the world rapidly increased to the point where population could expand un-

ceasingly and at the same time enjoy an improved standard of living. What the so-called revolution entailed was basically the massive substitution of machines and new techniques of production for human labor. The result was that, depending on the commodity, the output of the individual worker expanded five, fifty, a hundred, and even a thousand or more times, causing accumulations of goods undreamed of earlier. That human beings in such a world continued to live in dire poverty came to appear either as the fault of a backward regional system of production or as an unjust method of distributing the rewards—or a combination of both.

The Industrial Revolution was not, of course, an event like the political revolution in France that took place within a few years' time. It exerted its effect on different areas at different times. By 1785 the revolution was clearly under way in the British Isles, significant industrial development occurred on the Continent only after 1815, and before 1900 it still remained limited to western Europe, parts of North America, and Japan. Even today certain parts of the world have yet to undergo their industrial revolution.

Britain in the Lead

There are a number of reasons for British precedence in industrial development. By the early eighteenth century the British (with the Dutch) had the highest standard of living in the world. After approximately a century of applying innovative techniques, British agricultural producers were able to supply food cheaply and in abundance while still making a profit. This efficiency in agriculture also liberated a large percentage of the working population for other pursuits. British government compared with continental monarchies was inexpensive, and the low tax burden left most of the money in the pockets of those who earned it. There was consequently a good deal of money available for investment and consumption. Moreover, whereas absolutist monarchies on the Continent regulated economic life closely, productive enterprise in Britain was relatively free; personal initiative and experimentation were encouraged. Finally, in the coming age of the machine, Britain was particularly favored with its enormous deposits of a cheap fuel, coal.

The breakthrough in industrialism first came in cotton, a cloth industry that, compared with wool or silk, was very new. Because of the low cost of cotton relative to that of wool and silk, the market for cotton cloth was large, and it happened that cotton could be worked more easily by machine than by hand. By the late eighteenth century the demand for cotton cloth both in Britain and abroad was such that the raw material was in short supply. Eli Whitney's cotton gin remedied the major bottleneck in production of raw cotton, and the plantation economy of the American South soared from the 1790s on.

The mechanization of cotton production encouraged invention and investment in other areas of the economy. By the end of the eighteenth century the British had developed a relatively efficient steam engine, were able to mine coal and manufacture steel in impressive quantities, and were increasingly using new chemical discoveries for industrial purposes. The continued progress of British industry in the nineteenth century depended on Britain's capacity continually to extend its markets abroad. With the largest commercial and military fleets in the world, Britain was in a position to do so. Unrivaled in industrial production and in the means to export that production across great distances, it became by the middle of the nineteenth century the workshop of the world. Its Continental and American competitors desperately struggled to emulate the new kind of industrial civilization that Britain had created. The burst of colonial ventures and the often violent struggle for markets in Asia and Africa from the last decades of the nineteenth century suggest that by this time Britain's rivals were catching up and were seeking outlets for their own excess production.

Karl Marx (1818–1883)

The German philosopher Karl Marx, who spent much of his life in London, felt a sense of moral outrage at a system of distribution in which millions, living on the borderline of subsistence, slaved so that a few thousand could wallow in luxury and indolence. Marx expressed his theories primarily in philosophical and economic language, most notably in *Das Kapital,* his analysis of the capitalist system and of its inevitable downfall. Along with Friedrich Engels, Marx believed that bourgeois *capitalism* was a necessary stage in a historical development in which justice, in the form of true *communism,* would triumph.

Human history for Marx was characterized by a series of economic organizations, the more recent evolving out of the preceding as a result of class conflict. Slavery, the economic system of the ancient world, was brought to an end because of slave revolts. The ancient economy was replaced by a feudal one in which serfs, who were not slaves because they were tied to the land and could not be sold, worked for the benefit of the landlords. According to Marx, the continued oppression of the serf by feudal lords induced numbers of these laborers to flee. These runaways constituted the founders of the medieval merchant class. From the sixteenth century on, this merchant class, or *bourgeoisie,* gained increasing power until finally in England in the 1640s, in France in 1789, and in Germany in 1848 they were successful in overthrowing the feudal order and establishing themselves as the masters of the economy. The Industrial Revolution was the triumph of the new oppressors; the development of the factory brought into

being a new class of oppressed, the *proletariat*. These were the workers, men, women, and children, who possessed nothing but the labor of their bodies.

In Marx's theory, fierce competition among the capitalists—those who control the means of production and the goods—would result in the concentration of wealth in fewer and fewer hands and the swelling of the worker ranks by the bourgeois who go under. At the same time the need to keep up profit margins in a situation of limited markets encourages more intensive exploitation of the workers. Whereas formerly the oppressed classes had been widely diffused, by its very nature industrialism brings them together; then they gradually become aware of the injustice of the system and of their own power.

Communism

Marx firmly believed that the conflicts between classes were nearing a crisis point. A revolution of the masses against the exploiters was inevitable. When that occurred, Marx thought, the course of human history would change. Because the proletariat made up the vast majority of the people, this revolution would mark the end of class struggle and a new society would result, where all would live in harmony with one another.

Marx felt that the duty of communists was to help workers become more intensely conscious of their status and to weld them into a political class. Although Marx himself favored trade unions, he urged the workers not to be content with better wages and better conditions of work. Joining the system in this way would undermine the solidarity of the movement and, although improving the lot of certain individuals, would leave the mass of proletarians in their misery. The communist was dedicated to the destruction of private property, which was the primary tool in the hands of the bourgeoisie for the subjection of the lower class. Also slated for destruction was the state, which was the political means by which the bourgeois protected their property and controlled the workers. Once bourgeois property had been eliminated and the classless society achieved, social conflict would end and there would be no need for the oppressive power of the state.

Although Marx believed that certain members of the bourgeoisie, such as himself, could work themselves free from their class allegiances, on the whole he maintained that individual mentalities were determined by the economic class to which they belonged. Accordingly, the agencies of historical change were, for him, not individuals but classes. Nevertheless, Marx remained to the end a child of the Enlightenment. His final goal for humanity remained the attainment of personal liberty and equality. He was committed to the belief that once the forces of exploitation were annihilated, people would be rational enough to live as brothers and sisters, sharing the goods of their labor. Indeed, his faith in the power of rationality and the essential goodness of humanity was even greater than that of the philosophes, for he thought that people in the final stage would live in freedom and equality even without the presence of a government.

Although Marx developed his theories in more elaborate form in his later writings, *The Communist Manifesto*, composed in 1848, represents his basic positions most eloquently. Written in collaboration with Engels, the work was published in the very year when Europe was swept by a revolutionary fervor that threatened to destroy most of its major monarchies. In the long run all of the revolutions failed, and in none of them did Marx's thought serve as a platform for a significant group of revolutionaries. Marxism did not become a major ideological force until the twentieth century.

Material Progress

Paradoxically, Marxism enjoyed its greatest success in those countries where industrialism was only getting under way and where agriculture remained the dominant occupation. This was the case in Russia in 1917 and in China in the years immediately following World War II. In western Europe and America, however, Marx's fears were realized. In the course of the century after the publication of *The Communist Manifesto*, workers proved more concerned with immediate material gains than with ultimate goals and found that these could be accomplished with greater ease and security through trade unionism and participation in the established political system than through revolution. Although the capitalist economy suffered periodic setbacks, some of great magnitude such as the Depression of the 1930s, on the whole the working population of the Western world experienced a steady increase in its standard of living. Rather than polarizing between the extremes of rich bourgeoisie and proletariat, industrial society witnessed an enormous expansion of the middle class. Large numbers of workers were drawn into its ranks, or at least many were led to believe they belonged there. Belief in progress, scientific and technological as well as economic, came to be characteristic of all social classes in the late nineteenth century.

People rich and poor flocked to the Great Exhibition in London in 1851 at the astounding Crystal Palace (see Fig. 29-1), which they viewed as a marvel of engineering and a symbol of an optimistic age of technological achievement. Science created new wonders in daily life at an astounding rate. The railroad, the steamship, the telegraph and telephone, electricity, and the internal-combustion engine convinced most people that scientific invention was fundamentally helpful to humankind and that continual progress was inevitable. Workers' awareness of continuing economic inequalities and social

DAILY LIVES

The Lives of the Urban Poor Under the Industrial Revolution

Unable to support the family even with both mother and father working, parents were forced to send their children into the factories. Children four and five years of age worked from twelve to sixteen hours, six days a week, for pennies. Often forbidden to sit down during their hours of work, they were subject to the brutality of the overseer for the slightest infraction. In the case of babies too young to work, desperate parents, unable to pay for babysitters, resorted to "Mother's Helper," or drugs that put the baby to sleep, from early morning until late at night when they returned home. In the seething tenements of workers' quarters, twisted bodies and early death were common.

In 1844, a young German socialist and friend of Karl Marx named Friedrich Engels set himself the task of describing living conditions in the cities of England, the most advanced industrial country in Europe. What Engels exposed in *The Condition of the Working Class in England,* published in 1845, were urban conglomerations sharply divided into neighborhoods for the rich and the poor, the exploiters and the exploited, the high livers and the downtrodden. In the following passage, Engels describes the housing conditions of the London poor, both in the tenements and the shelters for the homeless:

Every great city has one or more slums, where the working-class is crowded together. True, poverty often dwells in hidden alleys close to the palaces of the rich; but, in general, a separate territory has been assigned to it, where, removed from the sight of the happier classes, it may struggle along as it can. These slums are pretty equally arranged in all the great towns of England, the worst houses in the worst quarters of the towns; usually one- or two-storied cottages in long rows, perhaps with cellars used as dwellings, almost always irregularly built. These houses of three or four rooms and a kitchen form, throughout England, some parts of London excepted, the general dwellings of the working-class. The streets are generally unpaved, rough, dirty, filled with vegetables and animal refuse, without sewers or gutters, but supplied with foul, stagnant pools instead. Moreover, ventilation is impeded by the bad, confused method of building of the whole quarter, and since many human beings here live crowded into a small space, the atmosphere that prevails in these working-men's quarters may readily be imagined. Further, the streets serve as drying grounds in fine weather; lines are stretched across from house to house, and hung with wet clothing.

. . . Scarcely a whole window-pane can be found, the walls are crumbling, doorposts and window-frames loose and broken, doors of old boards nailed together, or altogether wanting in this thieves' quarter, where no doors are needed, there being nothing to steal. Heaps of garbage and ashes lie in all directions, and the foul liquids emptied before the doors gather in stinking pools. Here live the poorest of the poor, the worst paid workers with thieves and the victims of prostitution indiscriminately huddled together, the majority Irish, or of Irish extraction, and those who have not yet sunk in the whirlpool of moral ruin which surrounds them, sinking daily deeper, losing daily more and more of their power to resist the demoralizing influence of want, filth, and evil surroundings. . . .

But in spite of all this, they who have some kind of shelter are fortunate, fortunate in comparison with the utterly homeless. In London fifty thousand human beings get up every morning, not knowing where they are to lay their heads at night. The luckiest of this multitude, those who succeed in keeping a penny or two until evening, enter a lodging-house, such as abound in every great city, where they find a bed. But what a bed! These houses are filled with beds from cellar to garret, four, five, six beds in a room; as many as can be crowded in. Into every bed four, five, or six human beings are piled, as many as can be packed in, sick and well, young and old, drunk and sober, men and women, just as they come, indiscriminately. Then come strife, blows, wounds, or, if these bed-fellows agree, so much the worse; thefts are arranged and things done which our language, grown more humane than our deeds, refuses to record. And those who cannot pay for such a refuge? They sleep where they find a place in passages, arcades, in corners where the police and the owners leave them undisturbed. A few individuals find their way to the refuges which are managed, here and there, by private charity, others sleep on the benches in the parks close under the windows of Queen Victoria.

injustices was largely overcome by a trust in future improvement and in the efficacy of political action within the system.

Liberalism

While no doubt regretting the sufferings of the poor (Fig. 28-1), an important group of English and Continental thinkers called *liberals* believed that these were minor evils compared with the greater good attained by industrialization. Espousing the Enlightenment values of liberty and equality, thinkers such as Adam Smith (1723–1790) and David Ricardo (1772–1823) argued that there was a kind of law of human nature: if individuals were allowed to follow their own enlightened self-interest, the general good and liberty of all would best be served. The state should interfere as little as possible with the exercise of individual judgment, aside from keeping order and protecting property; the economy as well as other aspects of society should be in the control of private citizens. Wages would always tend to stay at the subsistence level because, when workers rise above this, they have more children, who devour the surplus, thus forcing the family income down again. However, in a free society, the liberals argued optimistically, individuals with initiative have the opportunity of leaving this condition and joining the ranks of the successful.

Although thinkers of this stamp violently opposed it, public opinion in the 1830s and 1840s finally forced the English government to pass legislation to remedy the worst abuses. As the Continent came to industrialize, government there, too, stepped in to ameliorate the condition of workers to a degree. Some of the major proponents of this legislation belonged to a new breed of liberals. These thinkers had come to realize that, if liberty and equality were truly the goals of a society, the major threats to those principles did not come so much from the government as from private pressures. A worker's freedom was essentially limited to starving or accepting the conditions offered by an employer. The role of government, as they began to conceive it, was that of a mediator, which through its laws would prevent the oppression of one individual by another. The ideal remained, as earlier, to foster individual freedom, but the experience of the first fifty years of industrialism had shown that, paradoxically, freedom had in certain respects to be restricted by legislation in order to maximize it for everyone. The new liberals also moved gradually to the position that the lower classes must also be given the vote. Political power was not, as for earlier liberals, a privilege achieved by the successful; rather, it was a basic right. Thus, the newer *liberalism* endeavored to incorporate the workers into the establishment.

From the opening decades of the nineteenth century, however, there were critics of the industrial economy who believed that the major source of its evils came from the existence of private property. As long as the principle of private property was regarded as sacred, no amount of legislation, even by a government in which workers participated, could guarantee a just society. To a varying degree these critics maintained that basic industry and essential services should be taken out of private hands and operated by the community for the common welfare. Some of these thinkers, like Charles

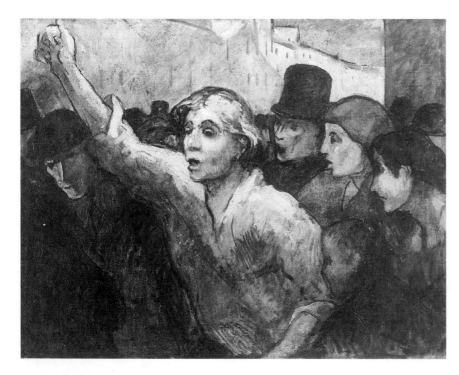

28-1 *Honoré Daumier,* The Uprising, *1848 or later. Oil on canvas, 34½ × 44½″ (87.6 × 113 cm). (The Phillips Collection, Washington, DC)*

Fourier (1772–1837), went further, devising utopian communities where each would do the work for which he or she was best suited and would receive the fruits of the collective labor according to need.

John Stuart Mill (1806–1873)

The most eloquent of the new liberals was John Stuart Mill. One of the finest, most decent spirits of his age, the author was the son of John Mill, one of the leaders of early liberalism. A disciple of his father in his youth, John Stuart Mill gradually grew disillusioned with a philosophy that, although committed to human freedom and equality, could permit the degradation of the poor and even justify it as part of the law of nature. As a writer and later a member of Parliament, he defended the rights of individuals against the oppression of the majority but at the same time urged the government to interfere when powerful individuals inflicted injury on society as a whole by abusing those same rights. Earlier liberals for him had been too selective in their espousal of the principles of liberty and equality. Conveniently, they had stopped short of ensuring such freedoms when they would interfere with their own prejudices or economic and political interests. This respect for individual personality at all levels made Mill a vigorous opponent of slavery and, in his maturity, a champion of women's rights as well. His *The Subjection of Women* (1869) was perhaps the most brilliant writing in the nineteenth century on the equality of women and the injustice of their present status.

Slavery and the Abolitionist Movement

The late nineteenth and early twentieth centuries also saw the height of European colonialism and imperialism, phenomena we will discuss in Chapter 30. The economy of the colonies—and former colonies such as the United States—in the Americas became heavily dependent on slave labor. Just as industrialism fostered the need for more workers in the urban factories, so European and American demand for products from the New World, such as sugar, cotton, and tobacco, contributed to the flourishing of slavery and the slave trade. The New World slave trade was encouraged by Bartolomé de las Casas (1474–1566), a Spanish missionary on the Caribbean island of Hispaniola. He recommended importing Africans to alleviate the sufferings of the native peoples exploited by the Spanish. Africans were brought to Virginia as laborers as early as 1619, but slavery was not instituted there until the 1690s. By the 1880s, when slavery was at last abolished in all of North and South America and the Caribbean, between ten and fifteen million Africans had been bought and sold as involuntary workers in the New World. All of the European states with colonies participated in the slave trade. The cruelest slavery existed perhaps on the sugar plantations of the Caribbean island colonies owned by Britain, France, Spain, and Holland. Because of the grueling nature of the work (fueled by the European mania for sugar), the average life expectancy of a slave there was seven years after arrival. Slaves on the cotton and tobacco plantations of the southern United States suffered countless indignities that gradually began to pique a few consciences.

Some form of protest against the enslavement of Africans in the West had been present almost from the inception of slavery. In the early 1700s an American named Samuel Sewall wrote an antislavery tract entitled *The Selling of Joseph,* and two Portuguese Jesuit missionaries in Brazil published attacks on slavery in Europe. As we saw in Chapter 24, Montesquieu argued that slavery violated natural law, and in *Candide* Voltaire satirized slaveholders and traders mercilessly. We saw in Chapter 25 how African Americans such as Phillis Wheatley and David Walker spoke out against slavery.

The moral crusade to abolish slavery, which came to be known as *abolitionism*, was initiated primarily by the Society of Friends, known as the Quakers, in the 1720s. The publication of "slave narratives," or the life stories of former slaves from the southern United States who had escaped to the North, helped to fuel the abolitionist movement in Europe as well as in the Americas. François Dominique Toussaint Louverture (1743–1803), the son of African slaves in the French colony Saint Domingue, led the greatest slave revolt in modern history to found Haiti, the first black republic, in 1793. Following the revolutionary principles of that revolt, the French abolished slavery in 1794, but Napoleon, said to have listened to his wife, Josephine, whose family owned slaves in the Caribbean, reinstated slavery in the French colonies until it was finally abolished in 1848. An abolition society was founded in London in 1787, and Britain abolished slavery throughout its empire in 1838. The last Western countries to do so were Cuba (1886) and Brazil (1888).

The abolitionist movement in the United States became organized in 1831 when the reformer William Lloyd Garrison founded the journal *The Liberator* in Boston. He was joined by numerous dedicated men and women, white and black, free and former slaves. Harriet Tubman rose to fame through her fearless leadership in the Underground Railroad (see the painting by Jacob Lawrence, Color Plate XXXIII). The most eloquent abolitionist spokesperson was Frederick Douglass (Fig. 28-2), who escaped from slavery in Maryland, where he had managed to teach himself to read. He published a riveting account of his life and joined forces with Garrison in Boston. Active in politics under President Lincoln, Douglass lived to see the end of slavery but also to understand that the problems of being black in America were far from solved. Like most abolitionists, he was also a supporter of the women's movement. He died in 1895, shortly after delivering a speech to a rally for women's rights.

28-2 *Elisha Hammond,* Frederick Douglass, *c. 1844. Oil on canvas, 69.9 × 57.1 cm. (National Portrait Gallery, Washington, DC/Art Resource, NY)*

Women's Rights Movements

The causes of the abolition of slavery and the rights of women had to some extent been joined from the start. William Lloyd Garrison called attention to the injustices perpetrated on slave women, who were subject to the sexual demands of their masters. The black woman abolitionist leader known as Sojourner Truth gave impassioned antislavery speeches to crowds in the 1840s, yet her most famous speech was delivered to a women's rights convention in 1851. Baring her muscular right arm, she stirred the audience with words, "I have plowed, and planted, and gathered into barns, and no man could head me—and ar'n't I a woman?" Yet when the abolitionists Lucretia Mott and Elizabeth Cady Stanton attended the World Anti-Slavery Convention in London in 1840, they found that they were forced to sit in a special screened-off section. This incident was one of the factors that led Mott and Stanton to organize the Seneca Falls women's rights convention.

The women convened in a town in upstate New York (Seneca Falls) the same year that Marx and Engels published the *Communist Manifesto,* in 1848. The document that they drew up, "A Declaration of Sentiments," was less radical, however, modeled as it was on the Declaration of Independence. Twelve resolutions were passed at the convention, although one of them—the demand for the right to vote—did not pass unanimously. Women did not receive this right until much later, and the passage of other reforms involving a woman's independence from her husband in legal matters was equally slow. Still, the battle had started.

Important developments in the nineteenth-century struggle for *women's suffrage* took place in England as well. One of the spokespersons was Harriet Taylor (1807–1858), John Stuart Mill's wife and close collaborator. The suffrage movement was launched to some extent by Mill's introduction of an amendment to a reform bill calling for full voting rights for women in 1867. When it failed to pass, the National Society for Women's Suffrage was formed. The movement became more militant, and even violent, under the leadership of Emmeline Pankhurst (1848–1928), who once stated, "The argument of the broken pane of glass is the most valuable argument in modern politics." Women finally acquired the vote in Canada in 1917, in the United States in 1920, and in England in 1928. In France they were denied this basic right until 1945. Even after voting rights were won, however, large areas remained in which women experienced discrimination. Enormous strides toward equality have been made, however, since the beginnings of a more global women's movement in the 1970s.

Karl Marx and Friedrich Engels

from *The Communist Manifesto*

Translation by Samuel Moore

Introduction

A spectre is haunting Europe—the spectre of Communism. All the powers of old Europe have entered into a holy alliance to exorcise this spectre: Pope and Czar, Metternich and Guizot, French Radicals and German political police.

Where is the party in opposition that has not been decried as communistic by its opponents in power? Where is the opposition that has not hurled back the branding reproach of Communism, against the more advanced opposition parties as well as against its reactionary adversaries?

Two things result from this fact:

1. Communism is already acknowledged by all European powers to be itself a power.

2. It is high time that Communists should openly, in the face of the whole world, publish their views, their aims, their tendencies, and meet this nursery tale of the spectre of Communism with a manifesto of the party itself.

To this end, Communists of various nationalities have assembled in London, and sketched the following manifesto, to be published in the English, French, German, Italian, Flemish and Danish languages.

Chapter I

Bourgeois and Proletarians

The history of all hitherto existing society is the history of class struggles.

Freeman and slave, patrician and plebeian, lord and serf, guild-master and journeyman, in a word, oppressor and oppressed, stood in constant opposition to one another, carried on an uninterrupted, now hidden, now open fight, a fight that each time ended, either in a revolutionary reconstitution of society at large, or in the common ruin of the contending classes.

In the earlier epochs of history, we find almost everywhere a complicated arrangement of society into various orders, a manifold gradation of social rank. In ancient Rome we have patricians, knights, plebeians, slaves; in the Middle Ages, feudal lords, vassals, guild-masters, journeymen, apprentices, serfs; in almost all of these classes, again, subordinate gradations.

The modern bourgeois society that has sprouted from the ruins of feudal society has not done away with class antagonisms. It has but established new classes, new conditions of oppression, new forms of struggle in place of the old ones.

Our epoch, the epoch of the bourgeoisie, possesses, however, this distinctive feature: it has simplified the class antagonisms. Society as a whole is more and more splitting up into two great hostile camps, into two great classes directly facing each other—bourgeoisie and proletariat.

From the serfs of the Middle Ages sprang the chartered Burghers of the earliest towns. From these burgesses the first elements of the bourgeoisie were developed.

The discovery of America, the rounding of the Cape, opened up fresh ground for the rising bourgeoisie. The East-Indian and Chinese markets, the colonization of America, trade with the colonies, the increase in the means of exchange and in commodities generally, gave to commerce, to navigation, to industry, an impulse never before known, and thereby, to the revolutionary element in the tottering feudal society, a rapid development.

The feudal system of industry, in which industrial production was monopolized by closed guilds, now no longer sufficed for the growing wants of the new markets. The manufacturing system took its place. The guild-masters were pushed aside by the manufacturing middle class; division of labour between the different corporate guilds vanished in the face of division of labour in each single workshop.

Meantime the markets kept ever growing, the demand ever rising. Even manufacture no longer sufficed. Thereupon, steam and machinery revolutionized industrial production. The place of manufacture was taken by the giant, modern industry, the place of the industrial

middle class by industrial millionaires, the leaders of whole industrial armies, the modern bourgeois.

Modern industry has established the world market, for which the discovery of America paved the way. This market has given an immense development to commerce, to navigation, to communication by land. This development has, in its turn, reacted on the extension of industry; and in proportion as industry, commerce, navigation, railways extended, in the same proportion the bourgeoisie developed, increased its capital, and pushed into the background every class handed down from the Middle Ages.

We see, therefore, how the modern bourgeoisie is itself the product of a long course of development, of a series of revolutions in the modes of production and of exchange.

Each step in the development of the bourgeoisie was accompanied by a corresponding political advance of that class. An oppressed class under the sway of the feudal nobility, it became an armed and self-governing association in the medieval commune; here independent urban republic (as in Italy and Germany), there taxable "third estate" of the monarchy (as in France); afterwards, in the period of manufacture proper, serving either the semi-feudal or the absolute monarchy as a counterpoise against the nobility, and, in fact, cornerstone of the great monarchies in general, the bourgeoisie has at last, since the establishment of modern industry and of the world market, conquered for itself, in the modern parliamentary State, exclusive political sway. The executive of the modern State is but a committee for managing the common affairs of the whole bourgeoisie.

The bourgeoisie, historically, has played a most revolutionary part.

The bourgeoisie, wherever it has got the upper hand, has put an end to all feudal, patriarchal, idyllic relations. It has pitilessly torn asunder the motley feudal ties that bound man to his "natural superiors," and has left no other nexus between man and man than naked self-interest, than callous "cash payment." It has drowned the most heavenly ecstasies of religious fervour, of chivalrous enthusiasm, of Philistine sentimentalism, in the icy water of egotistic calculation. It has resolved personal worth in exchange value and in place of the numberless indefeasible chartered freedoms has set up that single unconscionable freedom—Free Trade. In one word, for exploitation veiled by religious and political illusions it has substituted naked, shameless, direct, brutal exploitation. . . .

The need of a constantly-expanding market for its products chases the bourgeoisie over the whole surface of the globe. It must get a footing everywhere, settle everywhere, establish connections everywhere.

The bourgeoisie has through its exploitation of the world market given a cosmopolitan character to pro-

duction and consumption in every country. To the great chagrin of reactionaries, it has drawn from under the feet of industry the national ground on which it stood. Old established national industries have been destroyed and are still being destroyed every day. They are dislodged by new industries, whose introduction becomes a life and death question for all civilized nations, by industries that no longer work up indigenous raw material, but raw material drawn from the remotest zones; industries whose products are consumed, not only at home, but in every quarter of the globe. In place of the old wants, satisfied by the production of the country, we find new wants, requiring for their satisfaction the products of distant lands and climes. In place of the old local and national seclusion and self-sufficiency, we have exchange in every direction, universal interdependence of nations. And as in material, so also in intellectual production. The intellectual creations of individual nations become common property. National onesidedness and narrowmindedness become more and more impossible, and from the numerous national and local literatures there arises a world literature.

The bourgeoisie, by the rapid improvement of all instruments of production, by the immensely facilitated means of communication, draws all, even the most barbarian, nations into civilization. The cheap prices of its commodities are the heavy artillery with which it batters down all Chinese walls, with which it forces the barbarians' intensely obstinate hatred of foreigners to capitulate. It compels all nations, on pain of extinction, to adopt the bourgeois mode of production; it compels them to introduce what it calls civilization into their midst, i.e., to become bourgeois themselves. In one word, it creates a world after its own image. . . .

We see then: the means of production and of exchange, on whose foundation the bourgeoisie built itself up, were generated in feudal society. At a certain stage in the development of these means of production and of exchange, the conditions under which feudal society produced and exchanged, the feudal organization of agriculture and manufacturing industry, in one word, the feudal relations of property, became no longer compatible with the already developed productive forces; they hindered production instead of promoting it; they became so many fetters. They had to be burst asunder; they were burst asunder.

Into their place stepped free competition, accompanied by a social and political constitution adapted to it, and by the economical and political sway of the bourgeois class.

A similar movement is going on before our own eyes. Modern bourgeois society with its relations of production, of exchange and of property, a society that has conjured up such gigantic means of production and of exchange, is like the sorcerer who is no longer able to control the powers of the nether world whom he has

called up by his spells. For many a decade past the history of industry and commerce is but the history of the revolt of modern productive forces against modern conditions of production, against the property relations that are the conditions for the existence of the bourgeoisie and of its rule. It is enough to mention the commercial crises that by their periodical return put the existence of the entire bourgeois society on its trial, each time more threateningly. In these crises a great part, not only of the existing products, but also of the previously-created productive forces, are periodically destroyed. In these crises there breaks out an epidemic that, in all earlier epochs, would have seemed an absurdity—the epidemic of over-production. Society suddenly finds itself put back into a state of momentary barbarism; it appears as if a famine, a universal war of devastation, had cut off the supply of every means of subsistence; industry and commerce seem to be destroyed. And why? Because there is too much civilization, too much means of subsistence, too much industry, too much commerce. The productive forces at the disposal of society no longer tend to promote bourgeois civilization and bourgeois property; on the contrary, they have become too powerful for these relations, by which they are fettered, and so soon as they overcome these fetters, they bring disorder into the whole of bourgeois society, endanger the existence of bourgeois property. The conditions of bourgeois society are too narrow to contain the wealth created by them. And how does the bourgeoisie get over these crises? On the one hand by enforced destruction of a mass of productive forces; on the other, by the conquest of new markets, and by the more thorough exploitation of the old ones. That is to say, by paving the way for more extensive and more destructive crises, and by diminishing the means whereby crises are prevented.

The weapons with which the bourgeoisie felled feudalism to the ground are now turned against the bourgeoisie itself.

But not only has the bourgeoisie forged the weapons that bring death to itself; it has also called into existence the men who are to wield those weapons—the modern working class—the proletarians.

In proportion as the bourgeoisie, i.e., capital, is developed, in the same proportion is the proletariat developed—the modern class of workers, who live only so long as they find work, and who find work only so long as their labour increases capital. These workmen, who must sell themselves piecemeal, are a commodity, like every other article of commerce, and are consequently exposed to all the vicissitudes of competition, to all the fluctuations of the market.

Owing to the extensive use of machinery and to division of labour, the work of the proletarians has lost all independent character, and, consequently, all charm for the workman. He becomes a mere appendage of the machine, and it is only the most simple, most monoto-nous, and most easily acquired knack, that is required of him. Hence, the cost of production of a workman is restricted, almost entirely, to the means of subsistence that he requires for his maintenance, and for the propagation of his race. But the price of a commodity, and therefore also of labour, is equal to its cost of production. In proportion, therefore, as the repulsiveness of the work increases, the wage decreases. Nay, more, in proportion as the use of machinery and division of labour increases, in the same proportion the burden of toil also increases, whether by prolongation of the working hours, by increase of the work exacted in a given time, or by increased speed of the machinery, etc.

Modern industry has converted the little workshop of the patriarchal master into the great factory of the industrial capitalist. Masses of labourers, crowded into the factory, are organized like soldiers. As privates of the industrial army they are placed under the command of a perfect hierarchy of officers and sergeants. Not only are they slaves of the bourgeois class, and of the bourgeois State; they are daily and hourly enslaved by the machine, by the overlooker, and, above all, by the individual bourgeois manufacturer himself. The more openly this despotism proclaims gain to be its end and aim, the more petty, the more hateful and the more embittering it is.

The less the skill and exertion of strength implied in manual labour, in other words, the more modern industry becomes developed, the more is the labour of men superseded by that of women. Differences of age and sex have no longer any distinctive social validity for the working class. All are instruments of labour, more or less expensive to use, according to their age and sex.

No sooner is the exploitation of the labourer by the manufacturer so far at an end that he receives his wages in cash, than he is set upon by the other portions of the bourgeoisie, the landlord, the shopkeeper, the pawnbroker, etc.

The former lower strata of the middle class—the small manufacturers, traders and persons living on small incomes, the handicraftsmen and peasants—all these sink gradually into the proletariat, partly because their diminutive capital does not suffice for the scale on which modern industry is carried on and is swamped in the competition with the large capitalists, partly because their specialized skill is rendered worthless by new methods of production. Thus the proletariat is recruited from all classes of the population.

But with the development of industry the proletariat not only increases in number; it becomes concentrated in greater masses, its strength grows, and it feels that strength more. The various interests and conditions of life within the ranks of the proletariat are more and more equalized, in proportion as machinery obliterates all distinctions of labour, and nearly everywhere reduces wages to the same low level. The growing competition

among the bourgeois, and the resulting commercial crises, make the wages of the workers ever more fluctuating. The unceasing improvement of machinery, ever more rapidly developing, makes their livelihood more and more precarious; the collisions between individual workmen and individual bourgeois take more and more the character of collisions between two classes. Thereupon the workers begin to form combinations against the bourgeois; they club together in order to keep up the rate of wages; they themselves found permanent associations in order to make provision beforehand for these occasional revolts. Here and there the contest breaks out into riots. Now and then the workers are victorious, but only for a time. The real fruit of their battles lies, not in the immediate result, but in the ever-expanding union of the workers. This union is helped on by the improved means of communication that are created by modern industry and that place the workers of different localities in contact with one another. It was just this contact that was needed to centralize the numerous local struggles, all of the same character, into one national struggle between classes. But every class struggle is a political struggle. And that union, to attain which the Burghers of the Middle Ages, with their miserable highways, required centuries, the modern proletarians, thanks to railways, achieve in a few years.

This organization of the proletarians into a class, and consequently into a political party, is continually being upset again by the competition between the workers themselves. But it ever rises up again, stronger, firmer, mightier. It compels legislative recognition of particular interests of the workers, by taking advantage of the divisions among the bourgeoisie itself. Thus the ten-hours' bill in England was carried.

Altogether, collisions between the classes of the old society further in many ways the course of development of the proletariat. The bourgeoisie finds itself involved in a constant battle. At first with the aristocracy; later on, with those portions of the bourgeoisie itself, whose interests have become antagonistic to the progress of industry; at all times with the bourgeoisie of foreign countries. In all these battles it sees itself compelled to appeal to the proletariat, to ask for its help, and thus, to drag it into the political arena. The bourgeoisie itself, therefore, supplies the proletariat with its own elements of political and general education, in other words, it furnishes the proletariat with weapons for fighting the bourgeoisie.

Further, as we have already seen, entire sections of the ruling classes are, by the advance of industry, precipitated into the proletariat, or are at least threatened in their conditions of existence. These also supply the proletariat with fresh elements of enlightenment and progress.

Finally, in times when the class struggle nears the decisive hour, the process of dissolution going on within the ruling class, in fact within the whole range of old society, assumes such a violent, glaring character, that a small section of the ruling class cuts itself adrift, and joins the revolutionary class, the class that holds the future in its hands. Just as, therefore, at an earlier period, a section of the nobility went over to the bourgeoisie, so now a portion of the bourgeoisie goes over to the proletariat, and in particular, a portion of the bourgeois ideologists who have raised themselves to the level of comprehending theoretically the historical movement as a whole.

Of all the classes that stand face to face with the bourgeoisie today, the proletariat alone is a really revolutionary class. The other classes decay and finally disappear in the face of modern industry; the proletariat is its special and essential product.

The lower middle class, the small manufacturer, the shopkeeper, the artisan, the peasant, all these fight against the bourgeoisie, to save from extinction their existence as fractions of the middle class. They are therefore not revolutionary, but conservative. Nay, more, they are reactionary, for they try to roll back the wheel of history. If by chance they are revolutionary, they are so only in view of their impending transfer into the proletariat; they thus defend not their present, but their future interests; they desert their own standpoint to place themselves at that of the proletariat.

The "dangerous class," the social scum, that passively rotting mass thrown off by the lowest layers of old society, may, here and there, be swept into the movement by a proletarian revolution; its conditions of life, however, prepare it far more for the part of a bribed tool of reactionary intrigue.

In the conditions of the proletariat, those of old society at large are already virtually swamped. The proletarian is without property; his relation to his wife and children has no longer anything in common with the bourgeois family relations; modern industrial labour, modern subjection to capital, the same in England as in France, in America as in Germany, has stripped him of every trace of national character. Law, morality, religion, are to him so many bourgeois prejudices, behind which lurk in ambush just as many bourgeois interests.

All the preceding classes that got the upper hand sought to fortify their already-acquired status by subjecting society at large to their conditions of appropriation. The proletarians cannot become masters of the productive forces of society except by abolishing their own previous mode of appropriation, and thereby also every other previous mode of appropriation. They have nothing of their own to secure and to fortify; their mission is to destroy all previous securities for, and insurances of, individual property.

All previous historical movements were movements of minorities, or in the interest of minorities. The proletarian movement is the self-conscious, independent movement of the immense majority, in the interest of the immense majority. The proletariat, the lowest

stratum of our present society, cannot stir, cannot raise itself up, without the whole superincumbent strata of official society being sprung into the air.

Though not in substance, yet in form, the struggle of the proletariat with the bourgeoisie is at first a national struggle. The proletariat of each country must, of course, first of all settle matters with its own bourgeoisie.

In depicting the most general phases that make up the development of the proletariat, we traced the more or less veiled civil war, raging within existing society, up to the point where that war breaks out into open revolution, and where the violent overthrow of the bourgeoisie lays the foundation for the sway of the proletariat.

Hitherto, every form of society has been based, as we have already seen, on the antagonism of oppressing and oppressed classes. But in order to oppress a class, certain conditions must be assured to it under which it can, at least, continue its slavish existence. The serf, in the period of serfdom, raised himself to membership in the commune, just as the petty bourgeois, under the yoke of feudal absolutism, managed to develop into a bourgeois. The modern labourer, on the contrary, instead of rising with the progress of industry, sinks deeper and deeper below the conditions of existence of his own class. He becomes a pauper, and pauperism develops more rapidly than population and wealth. And here it becomes evident that the bourgeoisie is unfit to rule because it is incompetent to assure an existence to its slave within his slavery, because it cannot help letting him sink into such a state that it has to feed him, instead of being fed by him. Society can no longer live under this bourgeoisie; in other words, its existence is no longer compatible with society.

The essential condition for the existence and for the sway of the bourgeois class is the accumulation of wealth in the hands of private individuals, the formation and augmentation of capital; the condition for capital is wage-labour. Wage-labour rests exclusively on competition between the labourers. The advance of industry, whose involuntary promoter is the bourgeoisie, replaces the isolation of the labourers, due to competition, by their revolutionary combination, due to association. The development of modern industry, therefore, cuts from under the feet of the bourgeoisie the very foundation on which it produces and appropriates products. What the bourgeoisie therefore produces, above all, are its own grave-diggers. Its fall and the victory of the proletariat are equally inevitable.

COMMENTS AND QUESTIONS

1. How do Marx and Engels explain the triumph of the bourgeoisie over the feudal aristocracy?

2. What is the function of the state under bourgeois rule?

3. Why is bourgeois supremacy antinationalistic?

4. What do Marx and Engels mean when they write that the productive forces of society have become too powerful for the conditions of bourgeois property?

5. Why is the wage of a worker roughly equal to his or her level of subsistence?

6. In what way does the bourgeoisie produce "its own grave-diggers"?

7. In what sense are all the enemies of the bourgeoisie save the proletariat reactionary?

8. What did Marx and Engels foresee, and what did they not foresee?

The "Declaration of Sentiments" of the Seneca Falls Convention

When, in the course of human events, it becomes necessary for one portion of the family of man to assume among the people of the earth a position different from that which they have hitherto occupied, but one to which the laws of nature and of nature's God entitle them, a decent respect to the opinions of mankind requires that they should declare the causes that impel them to such a course.

We hold these truths to be self-evident: that all men and women are created equal; that they are endowed by their Creator with certain inalienable rights; that among these are life, liberty, and the pursuit of happiness; that to secure these rights governments are instituted, deriving their just powers from the consent of the governed. Whenever any form of government becomes destructive of these ends, it is the right of those who suffer from it to refuse allegiance to it, and to insist upon the institution of a new government, laying its foundation on such principles, and organizing its powers in such form, as to them shall seem most likely to effect their safety and happiness. Prudence, indeed, will dictate that governments long established should not be changed for light and transient causes; and accordingly all experience hath shown that mankind are more disposed to suffer, while evils are sufferable, than to right themselves by abolishing the forms to which they were accustomed. But when a long train of abuses and usurpations, pursuing invariably the same object, evinces a design to reduce them under absolute despotism, it is their duty to throw off such government, and to provide new guards for their future security. Such has been the patient sufferance of the women under this government, and such is now the necessity which constrains them to demand the equal situation to which they are entitled.

The history of mankind is a history of repeated injuries and usurpations on the part of man toward woman, having in direct object the establishment of an

absolute tyranny over her. To prove this, let facts be submitted to a candid world.

He has never permitted her to exercise her inalienable right to the elective franchise.

He has compelled her to submit to laws, in the formation of which she had no voice.

He has withheld from her rights which are given to the most ignorant and degraded men—both natives and foreigners.

Having deprived her of this first right of a citizen, the elective franchise, thereby leaving her without representation in the halls of legislation, he has oppressed her on all sides.

He has made her, if married, in the eye of the law, civilly dead.

He has taken from her all right in property, even to the wages she earns.

He has made her, morally, an irresponsible being, as she can commit many crimes with immunity, provided they be done in the presence of her husband. In the covenant of marriage, she is compelled to promise obedience to her husband, he becoming, to all intents and purposes, her master—the law giving him power to deprive her of her liberty, and to administer chastisement.

He has so framed the laws of divorce, as to what shall be the proper causes, and in case of separation, to whom the guardianship of the children shall be given, as to be wholly regardless of the happiness of women—the law, in all cases, going upon a false supposition of the supremacy of man, and giving all power into his hands.

After depriving her of all rights as a married woman, if single, and the owner of property, he has taxed her to support a government which recognizes her only when her property can be made profitable to it.

He has monopolized nearly all the profitable employments, and from those she is permitted to follow, she receives but a scanty remuneration. He closes against her all the avenues to wealth and distinction which he considers most honorable to himself. As a teacher of theology, medicine, or law, she is not known.

He has denied her the facilities for obtaining a thorough education, all colleges being closed against her.

He allows her in Church, as well as State, but a subordinate position, claiming Apostolic authority for her exclusion from the ministry, and, with some exceptions, from any public participation in the affairs of the Church.

He has created a false public sentiment by giving to the world a different code of morals for men and women, by which moral delinquencies which exclude women from society, are not only tolerated, but deemed of little account in man.

He has usurped the prerogative of Jehovah himself, claiming it as his right to assign for her a sphere of action, when that belongs to her conscience and to her God.

He has endeavored, in every way that he could, to destroy her confidence in her own powers, to lessen her self-respect, and to make her willing to lead a dependent and abject life.

Now, in view of this entire disfranchisement of one-half the people of this country, their social and religious degradation—in view of the unjust laws above mentioned, and because women do feel themselves aggrieved, oppressed, and fraudulently deprived of their most sacred rights, we insist that they have immediate admission to all the rights and privileges which belong to them as citizens of the United States.

In entering upon the great work before us, we anticipate no small amount of misconception, misrepresentation, and ridicule; but we shall use every instrumentality within our power to effect our object. We shall employ agents, circulate tracts, petition the State and National legislatures, and endeavor to enlist the pulpit and the press in our behalf. We hope this Convention will be followed by a series of Conventions embracing every part of the country.

COMMENTS AND QUESTIONS

1. What is the purpose of modeling this declaration on the Declaration of Independence?

2. Compare the views of women's oppressions expressed here with those of Mary Wollstonecraft (Chapter 24).

3. Which of the injustices toward women listed in the declaration have been rectified today? Are there any that still prevail?

JOHN STUART MILL

from *The Subjection of Women*

The object of this Essay is to explain as clearly as I am able, the grounds of an opinion which I have held from the very earliest period when I had formed any opinions at all on social or political matters, and which, instead of being weakened or modified, has been constantly growing stronger by the progress of reflection and the experience of life. That the principle which regulates the existing social relations between the two sexes—the legal subordination of one sex to the other—is wrong in itself, and now one of the chief hindrances to human improvement; and that it ought to be replaced by a principle of perfect equality, admitting no power or privilege on the one side, nor disability on the other. . . .

. . . It is one of the characteristic prejudices of the reaction of the nineteenth century against the eight-

eenth, to accord to the unreasoning elements in human nature the infallibility which the eighteenth century is supposed to have ascribed to the reasoning elements. For the apotheosis of Reason we have substituted that of Instinct; and we call everything instinct which we find in ourselves and for which we cannot trace any rational foundation. This idolatry, infinitely more degrading than the other, and the most pernicious of the false worships of the present day, of all of which it is now the main support, will probably hold its ground until it gives way before a sound psychology laying bare the real root of much that is bowed down to as the intention of Nature and the ordinance of God. . . .

The generality of a practice is in some cases a strong presumption that it is, or at all events once was, conducive to laudable ends. This is the case, when the practice was first adopted, or afterwards kept up, as a means to such ends, and was grounded on experience of the mode in which they could be most effectually attained. If the authority of men over women, when first established, had been the result of a conscientious comparison between different modes of constituting the government of society; if, after trying various other modes of social organisation—the government of women over men, equality between the two, and such mixed and divided modes of government as might be invented—it had been decided, on the testimony of experience, that the mode in which women are wholly under the rule of men, having no share at all in public concerns, and each in private being under the legal obligation of obedience to the man with whom she has associated her destiny, was the arrangement most conducive to the happiness and well-being of both; its general adoption might then be fairly thought to be some evidence that, at the time when it was adopted, it was the best: though even then the considerations which recommended it may, like so many other primeval social facts of the greatest importance, have subsequently, in the course of ages, ceased to exist. But the state of the case is in every respect the reverse of this. In the first place, the opinion in favour of the present system, which entirely subordinates the weaker sex to the stronger, rests upon theory only; for there never has been trial made of any other: so that experience, in the sense in which it is vulgarly opposed to theory, cannot be pretended to have pronounced any verdict. And in the second place, the adoption of this system of inequality never was the result of deliberation, or forethought, or any social ideas, or any notion whatever of what conduced to the benefit of humanity or the good order of society. It arose simply from the fact that from the very earliest twilight of human society, every woman (owing to the value attached to her by men, combined with her inferiority in muscular strength) was found in a state of bondage to some man. Laws and systems of polity always begin by recognising the relations they find already existing between individuals. They convert what was a mere physical fact into a legal right, give it the sanction of society, and principally aim at the substitution of public and organised means of asserting and protecting these rights, instead of the irregular and lawless conflict of physical strength. Those who had already been compelled to obedience became in this manner legally bound to it. Slavery, from being a mere affair of force between the master and the slave, became regularised and a matter of compact among the masters, who, binding themselves to one another for common protection, guaranteed by their collective strength the private possessions of each, including his slaves. In early times, the great majority of the male sex were slaves, as well as the whole of the female. And many ages elapsed, some of them ages of high cultivation, before any thinker was bold enough to question the rightfulness, and the absolute social necessity, either of the one slavery or of the other. By degrees such thinkers did arise; and (the general progress of society assisting) the slavery of the male sex has, in all the countries of Christian Europe at least (though, in one of them, only within the last few years) been at length abolished, and that of the female sex has been gradually changed into a milder form of dependence. But this dependence, as it exists at present, is not an original institution, taking a fresh start from considerations of justice and social expediency—it is the primitive state of slavery lasting on, through successive mitigations and modifications occasioned by the same causes which have softened the general manners, and brought all human relations more under the control of justice and the influence of humanity. It has not lost the taint of its brutal origin. No presumption in its favour, therefore, can be drawn from the fact of its existence. . . .

Some will object, that a comparison cannot fairly be made between the government of the male sex and the forms of unjust power which I have adduced in illustration of it, since these are arbitrary, and the effect of mere usurpation, while it on the contrary is natural. But was there ever any domination which did not appear natural to those who possessed it? There was a time when the division of mankind into two classes, a small one of masters and a numerous one of slaves, appeared, even to the most cultivated minds, to be natural, and the only natural, condition of the human race. No less an intellect, and one which contributed no less to the progress of human thought, than Aristotle, held this opinion without doubt or misgiving; and rested it on the same premises on which the same assertion in regard to the dominion of men over women is usually based, namely that there are different natures among mankind, free natures, and slave natures; that the Greeks were of a free nature, the barbarian races of Thracians and Asiatics of a slave nature. But why need I go back to Aristotle? Did not the slave-owners of the

Southern United States maintain the same doctrine, with all the fanaticism with which men cling to the theories that justify their passions and legitimate their personal interests? Did they not call heaven and earth to witness that the dominion of the white man over the black is natural, that the black race is by nature incapable of freedom, and marked out for slavery? some even going so far as to say that the freedom of manual labourers is an unnatural order of things anywhere. Again, the theorists of absolute monarchy have always affirmed it to be the only natural form of government; issuing from the patriarchal, which was the primitive and spontaneous form of society, framed on the model of the paternal, which is anterior to society itself, and, as they contend, the most natural authority of all. . . .

But, it will be said, the rule of men over women differs from all these others in not being a rule of force: it is accepted voluntarily; women make no complaint, and are consenting parties to it. In the first place, a great number of women do not accept it. Ever since there have been women able to make their sentiments known by their writings (the only mode of publicity which society permits to them), an increasing number of them have recorded protests against their present social condition: and recently many thousands of them, headed by the most eminent women known to the public, have petitioned Parliament for their admission to the Parliamentary Suffrage. The claim of women to be educated as solidly, and in the same branches of knowledge, as men, is urged with growing intensity, and with a great prospect of success; while the demand for their admission into professions and occupations hitherto closed against them, becomes every year more urgent. Though there are not in this country, as there are in the United States, periodical conventions and an organised party to agitate for the Rights of Women, there is a numerous and active society organised and managed by women, for the more limited object of obtaining the political franchise. Nor is it only in our own country and in America that women are beginning to protest, more or less collectively, against the disabilities under which they labour. France, and Italy, and Switzerland, and Russia now afford examples of the same thing. How many more women there are who silently cherish similar aspirations, no one can possibly know; but there are abundant tokens how many *would* cherish them, were they not so strenuously taught to repress them as contrary to the proprieties of their sex. It must be remembered, also, that no enslaved class ever asked for complete liberty at once. . . .

All causes, social and natural, combine to make it unlikely that women should be collectively rebellious to the power of men. They are so far in a position different from all other subject classes, that their masters require something more from them than actual service. Men do not want solely the obedience of women, they want their sentiments. All men, except the most brutish, desire to have, in the woman most nearly connected with them, not a forced slave but a willing one, not a slave merely, but a favourite. They have therefore put everything in practice to enslave their minds. The masters of all other slaves rely, for maintaining obedience, on fear; either fear of themselves, or religious fears. The masters of women wanted more than simple obedience, and they turned the whole force of education to effect their purpose. All women are brought up from the very earliest years in the belief that their ideal of character is the very opposite to that of men; not self-will, and government by self-control, but submission, and yielding to the control of others. All the moralities tell them that it is the duty of women, and all the current sentimentalities that it is their nature, to live for others; to make complete abnegation of themselves, and to have no life but in their affections. And by their affections are meant the only ones they are allowed to have—those to the men with whom they are connected, or to the children who constitute an additional and indefeasible tie between them and a man. When we put together three things—first, the natural attraction between opposite sexes; secondly, the wife's entire dependence on the husband, every privilege or pleasure she has being either his gift, or depending entirely on his will; and lastly, that the principal object of human pursuit, consideration, and all objects of social ambition, can in general be sought or obtained by her only through him, it would be a miracle if the object of being attractive to men had not become the polar star of feminine education and formation of character. And, this great means of influence over the minds of women having been acquired, an instinct of selfishness made men avail themselves of it to the utmost as a means of holding women in subjection, by representing to them meekness, submissiveness, and resignation of all individual will into the hands of a man, as an essential part of sexual attractiveness. Can it be doubted that any of the other yokes which mankind have succeeded in breaking, would have subsisted till now if the same means had existed, and had been so sedulously used, to bow down their minds to it? . . .

. . . What is the peculiar character of the modern world—the difference which chiefly distinguishes modern institutions, modern social ideas, modern life itself, from those of times long past? It is, that human beings are no longer born to their place in life, and chained down by an inexorable bond to the place they are born to, but are free to employ their faculties, and such favourable chances as offer, to achieve the lot which may appear to them most desirable. Human society of old was constituted on a very different principle. All were born to a fixed social position, and were mostly kept in it by law, or interdicted from any means by which they could emerge from it. As some men are born white and others black, so some were born slaves and others freemen and citizens; some were born patricians,

other plebeians; some were born feudal nobles, others commoners and *roturiers*. A slave or serf could never make himself free, nor, except by the will of his master, become so. . . .

In modern Europe, and most in those parts of it which have participated most largely in all other modern improvements, diametrically opposite doctrines now prevail. Law and government do not undertake to prescribe by whom any social or industrial operation shall or shall not be conducted, or what modes of conducting them shall be lawful. These things are left to the unfettered choice of individuals. Even the laws which required that workmen should serve an apprenticeship, have in this country been repealed: there being ample assurance that in all cases in which an apprenticeship is necessary, its necessity will suffice to enforce it. The old theory was, that the least possible should be left to the choice of the individual agent; that all he had to do should, as far as practicable, be laid down for him by superior wisdom. Left to himself he was sure to go wrong. The modern conviction, the fruit of a thousand years of experience, is, that things in which the individual is the person directly interested, never go right but as they are left to his own discretion; and that any regulation of them by authority, except to protect the rights of others, is sure to be mischievous. . . .

If this general principle of social and economical science is not true; if individuals, with such help as they can derive from the opinion of those who know them, are not better judges than the law and the government, of their own capacities and vocation; the world cannot too soon abandon this principle, and return to the old system of regulations and disabilities. But if the principle is true, we ought to act as if we believed it, and not to ordain that to be born a girl instead of a boy, any more than to be born black instead of white, or a commoner instead of a nobleman, shall decide the person's position through all life—shall interdict people from all the more elevated social positions, and from all, except a few, respectable occupations. . . .

At present, in the more improved countries, the disabilities of women are the only case, save one, in which laws and institutions take persons at their birth, and ordain that they shall never in all their lives be allowed to compete for certain things. The one exception is that of royalty. Persons still are born to the throne; no one, not of the reigning family, can ever occupy it, and no one even of that family can, by any means but the course of hereditary succession, attain it. All other dignities and social advantages are open to the whole male sex: many indeed are only attainable by wealth, but wealth may be striven for by anyone, and is actually obtained by many men of the very humblest origin. The difficulties, to the majority, are indeed insuperable without the aid of fortunate accidents; but no male human being is under any legal ban: neither law nor opinion superadd artificial obstacles to the natural ones. . . .

Neither does it avail anything to say that the *nature* of the two sexes adapts them to their present functions and position, and renders these appropriate to them. Standing on the ground of common sense and the constitution of the human mind, I deny that anyone knows, or can know, the nature of the two sexes, as long as they have only been seen in their present relation to one another. If men had ever been found in society without women, or women without men, or if there had been a society of men and women in which the women were not under the control of the men, something might have been positively known about the mental and moral differences which may be inherent in the nature of each. What is now called the nature of women is an eminently artificial thing—the result of forced repression in some directions, unnatural stimulation in others. It may be asserted without scruple, that no other class of dependents have had their character so entirely distorted from its natural proportions by their relation with their masters; for, if conquered and slave races have been, in some respects, more forcibly repressed, whatever in them has not been crushed down by an iron heel has generally been let alone, and if left with any liberty of development, it has developed itself according to its own laws; but in the case of women, a hot-house and stove cultivation has always been carried on of some of the capabilities of their nature, for the benefit and pleasure of their masters. Then, because certain products of the general vital force sprout luxuriantly and reach a great development in this heated atmosphere and under this active nurture and watering, while other shoots from the same root, which are left outside in the wintry air, with ice purposely heaped all round them, have a stunted growth, and some are burnt off with fire and disappear; men, with that inability to recognise their own work which distinguishes the unanalytic mind, indolently believe that the tree grows of itself in the way they have made it grow, and that it would die if one half of it were not kept in a vapour bath and the other half in the snow. . . .

We may safely assert that the knowledge which men can acquire of women, even as they have been and are, without reference to what they might be, is wretchedly imperfect and superficial, and always will be so, until women themselves have told all that they have to tell.

And this time has not come; nor will it come otherwise than gradually. It is but of yesterday that women have either been qualified by literary accomplishments, or permitted by society, to tell anything to the general public. As yet very few of them dare tell anything, which men, on whom their literary success depends, are unwilling to hear. Let us remember in what manner, up to a very recent time, the expression, even by a male author, of uncustomary opinions, or what are deemed eccentric feelings, usually was, and in some degree still is, received; and we may form some faint conception under

what impediments a woman, who is brought up to think custom and opinion her sovereign rule, attempts to express in books anything drawn from the depths of her own nature. The greatest woman who has left writings behind her sufficient to give her an eminent rank in the literature of her country, thought it necessary to prefix as a motto to her boldest work, "Un homme peut braver l'opinion; une femme doit s'y soumettre."[1] The greater part of what women write about women is mere sycophancy to men. In the case of unmarried women, much of it seems only intended to increase their chance of a husband. Many, both married and unmarried, overstep the mark, and inculcate a servility beyond what is desired or relished by any man, except the very vulgarest. But this is not so often the case as, even at a quite late period, it still was. Literary women are becoming more free-spoken, and more willing to express their real sentiments. Unfortunately, in this country especially, they are themselves such artificial products, that their sentiments are compounded of a small element of individual observation and consciousness, and a very large one of acquired associations. This will be less and less the case, but it will remain true to a great extent, as long as social institutions do not admit the same free development of originality in women which is possible to men. When that time comes, and not before, we shall see, and not merely hear, as much as it is necessary to know of the nature of women, and the adaptation of other things to it. . . .

One thing we may be certain of—that what is contrary to women's nature to do, they never will be made to do by simply giving their nature free play. The anxiety of mankind to interfere in behalf of nature, for fear lest nature should not succeed in effecting its purpose, is an altogether unnecessary solicitude. What women by nature cannot do, it is quite superfluous to forbid them from doing. What they can do, but not so well as the men who are their competitors, competition suffices to exclude them from; since nobody asks for protective duties and bounties in favour of women; it is only asked that the present bounties and protective duties in favour of men should be recalled. If women have a greater natural inclination for some things than for others, there is no need of laws or social inculcation to make the majority of them do the former in preference to the latter. Whatever women's services are most wanted for, the free play of competition will hold out the strongest inducements to them to undertake. And, as the words imply, they are most wanted for the things for which they are most fit; by the apportionment of which to them, the collective faculties of the two sexes can be applied on the whole with the greatest sum of valuable result.

The general opinion of men is supposed to be, that the natural vocation of a woman is that of a wife and mother. I say, is supposed to be, because, judging from acts—from the whole of the present constitution of society—one might infer that their opinion was the direct contrary. They might be supposed to think that the alleged natural vocation of women was of all things the most repugnant to their nature; insomuch that if they are free to do anything else—if any other means of living or occupation of their time and faculties, is open, which has any chance of appearing desirable to them—there will not be enough of them who will be willing to accept the condition said to be natural to them. If this is the real opinion of men in general, it would be well that it should be spoken out. I should like to hear somebody openly enunciating the doctrine (it is already implied in much that is written on the subject)—"It is necessary to society that women should marry and produce children. They will not do so unless they are compelled. Therefore it is necessary to compel them." The merits of the case would then be clearly defined. It would be exactly that of the slaveholders of South Carolina and Louisiana. "It is necessary that cotton and sugar should be grown. White men cannot produce them. Negroes will not, for any wages which we choose to give. *Ergo* they must be compelled." An illustration still closer to the point is that of impressment. Sailors must absolutely be had to defend the country. It often happens that they will not voluntarily enlist. Therefore there must be the power of forcing them. How often has this logic been used! and, but for one flaw in it, without doubt it would have been successful up to this day. But it is open to the retort—First pay the sailors the honest value of their labour. When you have made it as well worth their while to serve you, as to work for other employers, you will have no more difficulty than others have in obtaining their services. To this there is no logical answer except "I will not": and as people are now not only ashamed, but are not desirous, to rob the labourer of his hire, impressment is no longer advocated. Those who attempt to force women into marriage by closing all other doors against them, lay themselves open to a similar retort. If they mean what they say, their opinion must evidently be, that men do not render the married condition so desirable to women, as to induce them to accept it for its own recommendations. It is not a sign of one's thinking the boon one offers very attractive, when one allows only Hobson's choice, "that or none." And here, I believe, is the clue to the feelings of those men, who have a real antipathy to the equal freedom of women. I believe they are afraid, not lest women should be unwilling to marry, for I do not think that anyone in reality has that apprehension; but lest they should insist that marriage should be on equal conditions; lest all women of spirit and capacity should prefer doing almost anything else, not in their own eyes degrading, rather than marry, when marrying is giving themselves a master, and a master too of all

[1] From the title page of Mme de Staël's *Delphine:* "A man can go against public opinion; a woman must submit herself to it."

their earthly possessions. And truly, if this consequence were necessarily incident to marriage, I think that the apprehension would be very well founded. I agree in thinking it probable that few women, capable of anything else, would, unless under an irresistible *entraînement,* rendering them for the time insensible to anything but itself, choose such a lot, when any other means were open to them of filling a conventionally honourable place in life: and if men are determined that the law of marriage shall be a law of despotism, they are quite right, in point of mere policy, in leaving to women only Hobson's choice. But, in that case, all that has been done in the modern world to relax the chain on the minds of women, has been a mistake. They never should have been allowed to receive a literary education. Women who read, much more women who write, are, in the existing constitution of things, a contradiction and a disturbing element: and it was wrong to bring women up with any acquirements but those of an odalisque, or of a domestic servant.

COMMENTS AND QUESTIONS

1. List the arguments that Mill says have been made in favor of the subjection of women, and explain how he answers each of these.

2. Compare Mill's portrayal of women's condition and his arguments for women's equality with those of Mary Wollstonecraft.

3. What ideas of liberalism are reflected in this passage?

4. What comparisons does Mill make between the condition of women and slavery? How valid are these parallels in your opinion?

5. How do Mill's analyses of, and remedies for, an oppressed class differ from those of Marx?

6. How relevant are the injustices that Mill points out and the solutions that he offers to the condition of present-day women?

FREDERICK DOUGLASS

from *"What to the Slave Is the Fourth of July?": An Address Delivered in Rochester, New York, on 5 July 1852*

Douglass was both a writer and a speaker of note. Although the narrative of his life represents his most important written work, it is difficult to excerpt. The end of his speech, printed below, is representative of Douglass's passionate beliefs and powerful oratory. It also demonstrates both his pessimism and his optimism in regard to the future of blacks in the United States.

The Internal Slave Trade

Americans! your republican politics, not less than your republican religion, are flagrantly inconsistent. You boast of your love of liberty, your superior civilization, and your pure Christianity, while the whole political power of the nation (as embodied in the two great political parties), is solemnly pledged to support and perpetuate the enslavement of three millions of your countrymen. You hurl your anathemas[1] at the crowned headed tyrants of Russia and Austria, and pride yourselves on your Democratic institutions, while you yourselves consent to be the mere *tools* and *body-guards* of the tyrants of Virginia and Carolina. You invite to your shores fugitives of oppression from abroad, honor them with banquets, greet them with ovations, cheer them, toast them, salute them, protect them, and pour out your money to them like water; but the fugitives from your own land you advertise, hunt, arrest, shoot and kill. You glory in your refinement and your universal education; yet you maintain a system as barbarous and dreadful as ever stained the character of a nation—a system begun in avarice, supported in pride, perpetuated in cruelty. You shed tears over fallen Hungary,[2] and make the sad story of her wrongs the theme of your poets, statesmen and orators, till your gallant sons are ready to fly to arms to vindicate her causes against her oppressors; but, in regard to the ten thousand wrongs of the American slave, you would enforce the strictest silence, and would hail him as an enemy of the nation who dares to make those wrongs the subject of public discourse! You are all on fire at the mention of liberty for France or for Ireland; but are as cold as an iceberg at the thought of liberty for the enslaved of America. You discourse eloquently on the dignity of labor; yet, you sustain a system which, in its very essence, casts a stigma upon labor. You can bare your bosom to the storm of British artillery to throw off a threepenny tax on tea; and yet wring the last hard-earned farthing from the grasp of the black laborers of your country. You profess to believe "that, of one blood, God made all nations of men to dwell on the face of all the earth,"[3] and hath commanded all men, everywhere to love one another; yet you notoriously hate, (and glory in your hatred), all men whose skins are not colored like your own. You declare, before the world, and are understood by the world to declare, that you *"hold these truths to be self evident, that all men are created equal; and are endowed by their Creator with certain inalienable rights; and that, among these are, life, liberty, and the pursuit of happiness";*[4] and yet, you hold securely,

[1] Denunciations or curses.

[2] In August 1849 the republic of Hungary was overthrown by invading Russian and Austrian troops.

[3] Acts 17:26.

[4] From the U.S. Declaration of Independence.

in a bondage which, according to your own Thomas Jefferson, *"is worse than ages of that which your fathers rose in rebellion to oppose,"*[5] a seventh part of the inhabitants of your country.

Fellow-citizens! I will not enlarge further on your national inconsistencies. The existence of slavery in this country brands your republicanism as a sham, your humanity as a base pretence, and your Christianity as a lie. It destroys your moral power abroad; it corrupts your politicians at home. It saps the foundation of religion; it makes your name a hissing, and a byword to a mocking earth. It is the antagonistic force in your government, the only thing that seriously disturbs and endangers your *Union*. It fetters your progress; it is the enemy of improvement, the deadly foe of education; it fosters pride; it breeds insolence; it promotes vice; it shelters crime; it is a curse to the earth that supports it; and yet, you cling to it, as if it were the sheet anchor of all your hopes. Oh! be warned! be warned! a horrible reptile is coiled up in your nation's bosom; the venomous creature nursing at the tender breast of your youthful republic; *for the love of God, tear away,* and fling from you the hideous monster, and *let the weight of twenty millions crush and destroy it forever*!

The Constitution

Allow me to say, in conclusion, notwithstanding the dark picture I have this day presented of the state of the nation, I do not despair of this country. There are forces in operation, which must inevitably work the downfall of slavery. *"The arm of the Lord is not shortened,"*[6] and the doom of slavery is certain. I, therefore, leave off where I began, with *hope*. While drawing encouragement from the Declaration of Independence, the great principles it contains, and the genius of American Institutions, my spirit is also cheered by the obvious tendencies of the age. Nations do not now stand in the same relation to each other that they did ages ago. No nation can now shut itself up from the surrounding world, and trot round in the same old path of its fathers without interference. The time *was* when such could be done. Long established customs of hurtful character could formerly fence themselves in, and do their evil work with social impunity. Knowledge was then confined and enjoyed by the privileged few, and the multitude walked on in mental darkness. But a change has now come over the affairs of mankind. Walled cities and empires have

become unfashionable. The arm of commerce has borne away the gates of the strong city. Intelligence is penetrating the darkest corners of the globe. It makes its pathway over and under the sea, as well as on the earth. Wind, steam, and lightning are its chartered agents. Oceans no longer divide, but link nations together. From Boston to London is now a holiday excursion. Space is comparatively annihilated. Thoughts expressed on one side of the Atlantic are distinctly heard on the other.

The far off and almost fabulous Pacific rolls in grandeur at our feet. The Celestial Empire, the mystery of the ages, is being solved. The fiat of the Almighty, *"Let there be Light,"*[7] has not yet spent its force. No abuse, no outrage whether in taste, sport or avarice, can now hide itself from the all-pervading light. The iron shoe, and crippled foot of China must be seen, in contrast with nature. *Africa must rise and put on her yet unwoven garment. "Ethiopia shall stretch out her hand unto God."*[8] In the fervent aspirations of William Lloyd Garrison, I say, and let every heart join in saying it:

God speed the year of jubilee
 The wide world o'er!
When from their galling chains set free,
Th' oppress'd shall vilely bend the knee,
And wear the yoke of tyranny
 Like brutes no more.
That year will come, and freedom's reign,
To man his plundered rights again
 Restore.

God speed the day when human blood
 Shall cease to flow!
In every clime be understood,
The claims of human brotherhood,
And each return for evil, good,
 Not blow for blow;
That day will come all feuds to end,
And change into a faithful friend
 Each foe.

God speed the hour, the glorious hour,
 When none on earth
Shall exercise a lordly power,
Nor in a tyrant's presence cower;
But all to manhood's stature tower,
 By equal birth!
THAT HOUR WILL COME, to each, to all,
And from his prison-house, the thrall
 Go forth.

[5] Compare Jefferson's June 26, 1786, letter to Nicholas Demeunier: "Who can endure toil, famine, stripes, imprisonment or death itself in vindication of his own liberty . . . and inflict upon his fellow men a bondage, one hour of which is fraught with more misery than ages of that which he rose in rebellion to oppose."

[6] Compare Isaiah 59:1: "Behold the Lord's hand is not shortened, that it cannot save; neither his ear heavy, that it cannot hear."

[7] Genesis 1:3.

[8] Compare Psalm 68:31: "Princes shall come out of Egypt; Ethiopia shall soon stretch out her hands unto God."

Until that year, day, hour, arrive,
With head, and heart, and hand I'll strive,
To break the rod, and rend the gyve,[9]
The spoiler of his prey deprive—
 So witness Heaven!
And never from my chosen post,
Whate'er the peril or the cost,
 Be driven.[10]

[9] Shackle.
[10] William Lloyd Garrison's *The Triumph of Freedom* (1845).

COMMENTS AND QUESTIONS

1. What are the basic inconsistencies in the ideals proclaimed by white Americans and their conduct toward black Americans?
2. How do their attitudes toward the oppression of whites and blacks differ?
3. How does the continued oppression of black Americans harm the country?
4. Why does Douglass believe that the end of slavery is near?

Summary Questions

1. What was the Industrial Revolution, and where was it most important?
2. What were some of the social effects of the new industrialism?
3. What criticisms did Marx and Engels level at capitalism? How did they envision a communist society?

4. What two types of "liberals" existed in England in the nineteenth century?
5. Define John Stuart Mill's sense of liberalism.
6. How did the abolitionist movement develop, and who were some of its most important proponents?
7. How were the abolitionist and the women's rights movements related?

Key Terms

Industrial Revolution
capitalism
communism
bourgeoisie

proletariat
liberalism
abolitionism
women's suffrage

29

Art and Literature in the Industrial World: Realism and Beyond

The progressive industrialization of society in the nineteenth century forced artists, as well as social thinkers, to come to terms with it. The conventions and enthusiasms that had permitted an artist to create the gentle *Experiment with the Air-Pump* (Fig. 24-5) were no longer appropriate in an age in which scientific progress had produced the vast, dehumanizing factories of Leeds and Birmingham. Nor did the idealizing and exotic tendencies of romanticism deal adequately with the problems of the mid-nineteenth century. Industrialism and its social consequences necessitated profound changes in *all* the arts, but our examples will be drawn from architecture, painting, and literature.

Architecture

Nineteenth-century architects were hesitant in their attempts to create a new architectural language for their age. In 1847 Professor T. L. Donaldson, speaking at a meeting of the Architectural Association (an important English architectural school), said, "The great question is, are we to have an architecture of our period, a distinct, individual, palpable style of the 19th century?" Romanticism had produced a series of revivals: Gothic, Romanesque, Renaissance. It is difficult for us to imagine the controversies that raged as to which style was the most correct or appropriate for particular needs. By mid-century, the architect tended to elect forms based on associations with the functions of the building: hence, Gothic for churches and Italian Renaissance for banks and businesses. Yet the new functions, needs, and materials of architecture posed new problems and demanded new solutions, which were more frequently offered by engineers and builders than by architects. An example of such a new problem and a new solution is the Crystal Palace, created for the Great Exhibition of 1851 in London (Fig. 29-1).

A call for designs for the main exhibition hall, one-third of a mile long, produced a variety of solutions that would take too long to build, were too costly, and would be impossible to light. However, Joseph Paxton, gardener of the earl of Chatworth, proposed a modular glass box made of cast and wrought iron framing and glass. All the parts could be prefabricated, shipped by rail, and erected on the site in Hyde Park. On July 16, 1850, an agreement was signed among the commissioners of the exhibition, the engineers, and the glass manufacturers. The completed hall was handed over on January 31, 1851, ready for the installation of exhibits. Lighted naturally, cooled by giant louvered windows that could be opened mechanically, the Crystal Palace was

CENTRAL ISSUES

- The effects of industrialism on architecture, painting, and literature
- Realism and naturalism in the arts and literature
- The new theories of Darwin and Spencer
- Nietzsche's and Dostoevsky's critique of materialism and progress
- The shift from realism to impressionism and symbolism in art and literature

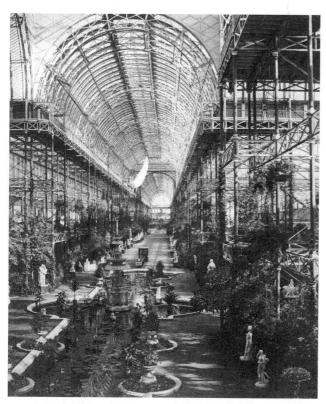

29-1 *Sir Joseph Paxton, The Crystal Palace, London, 1851; re-erected in Sydenham, 1852, destroyed 1936. (Hulton Archive/Getty Images)*

Louis Sullivan (1856–1924) and the Commercial Style

One of Chicago's most influential architects of this period, Sullivan searched for the theoretical and philosophical ideas that buildings expressed. Sullivan was born in Boston and began his higher education in MIT's architectural program but left after a year. He then worked in Philadelphia and Chicago and finally traveled to Paris, where he studied briefly at the École des Beaux Arts and worked in an architect's studio. While in Paris he absorbed the essential principles of academic architecture: functional planning, sound construction, and expressive decoration. The successful creation of the form for the tall office building, as he called it, became one of the driving forces of his architecture.

Sullivan, in partnership with Dankmar Adler (1844–1900), produced a series of buildings that addressed the problem. Sullivan suggested that the tall office building should be articulated precisely in relation to its unique visible functions: ground-floor shops and entry, midsection offices, and topmost floors where

29-2 *William LeBaron Jenney, Chicago Home Insurance Building, 1883–1885. (Chicago Architectural Photographing Company)*

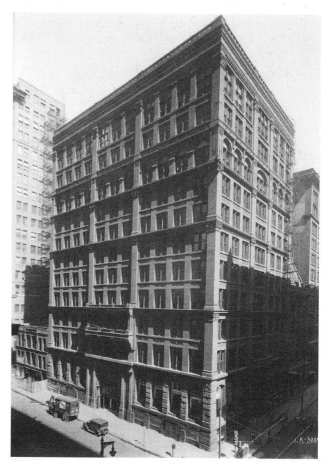

truly a marvel (although John Ruskin, the English architectural critic, refused to call it architecture). Today we see it as a modern solution to a difficulty without reliance on the visual or technical formulas of traditional architecture.

Similar requirements—limited land, money, and time; the need for adequate space and light—were the conditions that created the tall office building in Chicago in the last decades of the nineteenth century. Tall buildings had become possible with the invention of the elevator and fireproofing and with the perfection of iron and steel framing. Yet many architects tended to clothe these stacks of floors in Greek, Gothic, or Renaissance details. The problem was to decide what a skyscraper was supposed to look like. After a fire in 1871 destroyed the heart of commercial Chicago, the architects of that city were faced with problems demanding innovation.

William LeBaron Jenney (1832–1907) was one of the first architects in the city to take on the problem in his design for the Home Insurance Building (1883–1885) (Fig. 29-2). The entire surface of the building hangs on its steel and iron frame, but nothing visibly suggests the innovative nature of its design. Rather, this problem was left to many young architects who worked in Jenney's office, among them Louis Sullivan and Daniel Burnham.

mechanical systems were placed. Given that verticality was the essence of the building, Sullivan insisted that this element be emphasized. His ideas were demonstrated in a series of buildings of which the Wainwright in Saint Louis, Missouri (1890–1891), was one of the most successful. The Wainwright has all the elements of a modern skyscraper: the entire building is carried on a fireproofed steel frame, and its three sections can be easily read (Fig. 29-3). It should be compared with the Reliance Building (Fig. 29-4), designed by Burnham and Root. Built in the summer of 1891, it is also a self-supporting metal cage with glass infill. It was simple to erect and maintain. The walls were great expanses of glass, some fixed, some movable panels, providing light and ventilation for the offices lining each side of its central corridor. Visually, the building is a very clear expression of its function, which is to be, as Sullivan had noted, tall, economical, and useful. There are no classical orders, no pointed arches. Chicagoans pointed with pride to the development of the *Commercial Style,* but some critics felt that its simple expression of function

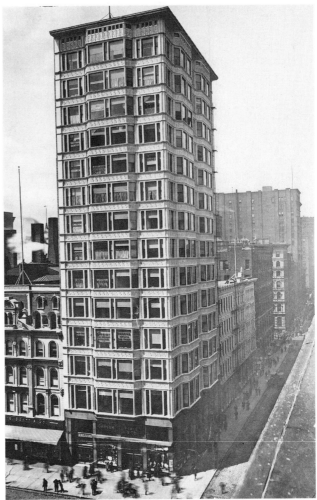

29-4 *Burnham and Root, Reliance Building, Chicago, 1891. (Chicago Architectural Photographing Company)*

29-3 *Louis Sullivan, Wainwright Building, St. Louis, 1890–1891. (Missouri Historical Society, negative #PB182)*

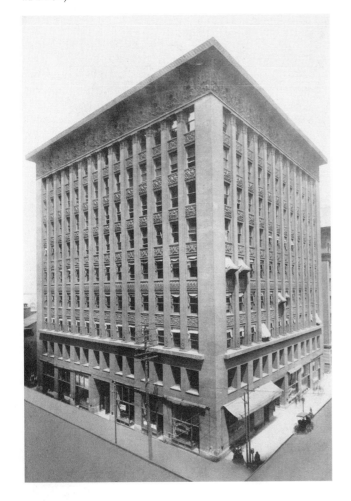

through form was too commercial, too expedient. It would not be until after World War I that the hold of tradition would be completely broken.

Painting: Realism

In architecture, as in any art, it is never enough to solve a problem. Building forms have a profound effect on the quality of life; painting and sculpture reflect, comment on, and affect the future of the arts and of humanity. In mid-century what seemed most real and most important were progress and economic expansion. In painting, the consequences of industrialism made the problems perceived by Delacroix, Goya, and Constable seem more acute. Again and again artists found themselves asking, What should they paint, for whom, and how?

Gustave Courbet (1819–1877)

The questions of what one should paint and how one should paint it are issues that were central to the de-

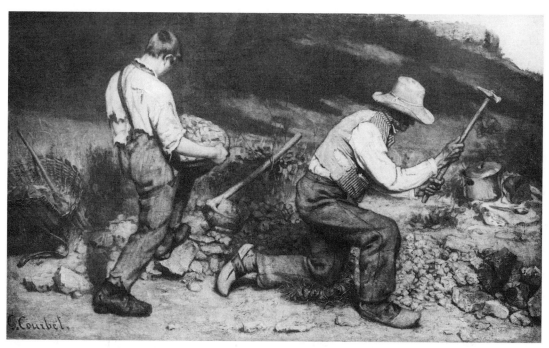

29-5 *Gustave Courbet,* The Stonebreakers, *1849. Oil on canvas, 5'3" × 8'6", formerly Gemäldegalerie, Dresden. (Staatliche Kunstsammlungen, Dresden)*

• Compare this painting with Brown's *Work* (Fig. 29-6). Does realism in these two paintings refer to the subject or to the way the painter paints? Does Courbet's focus on only two figures intensify or detract from the scene? What is the moral of each of the two paintings?

velopment of art in the nineteenth century. Turner and Constable represented one kind of revolt from the accepted academic painting that was a natural descendant of the art of the seventeenth and eighteenth centuries. Another kind of revolt was that represented by the French painter Gustave Courbet and the collection of artists who thought of themselves as realists. This group, which included landscape painters as well as figure and genre painters, succeeded in dominating trends in painting in the third quarter of the nineteenth century. In an 1855 manifesto, Courbet, the pioneer in the movement, stated his principal aims as a realist to be "to translate the customs, the ideas, the appearances of my epoch." The artist was to paint what he saw. For Courbet, this meant depicting the ugly as well as the beautiful. In his view the lower classes were more important than the upper social groups because it was on their labor that modern life was founded (Fig. 29-5).

Born in the French countryside, Courbet was the personification of the swaggering, tough, independent socialist. In rendering the harsh reality of his peasant subjects, Courbet depicted life in the country in a way far removed from romantic idealization of it. Courbet was a realist primarily because of his subject matter and his attitudes, but he was not concerned with rendering the details and textures of every object. For this reason he usually painted in his studio, doing only sketches out-of-doors. More traditional painters criticized his strong colors and his heavily layered paint, which he sometimes applied with a palette knife, a most unconventional process. The total effect of his work, however, was shocking only to those who preferred older styles of painting.

Ford Madox Brown (1821–1893)

In England the painter Ford Madox Brown, like Courbet, chose subjects that had philosophical or social relevance for the day. He filled his paintings with the minutiae of life. Brown, like Constable, worked out-of-doors, drawing his subjects from nature in an attempt to create an intensified illusion of reality. His large painting *Work,* 1862–1865 (Fig. 29-6), shows a sharp contrast between busy laborers and elegant passersby. To the right, watching the scene, is the Scottish philosopher Thomas Carlyle (hatless), who wrote about the dignity of labor. Beside Carlyle is Frederick D. Maurice, who helped to found the Working Men's College, an institution dedicated to combating social ills and raising workers' status through education. *Work* is certainly more than a picture of Hampstead on a sunny day.

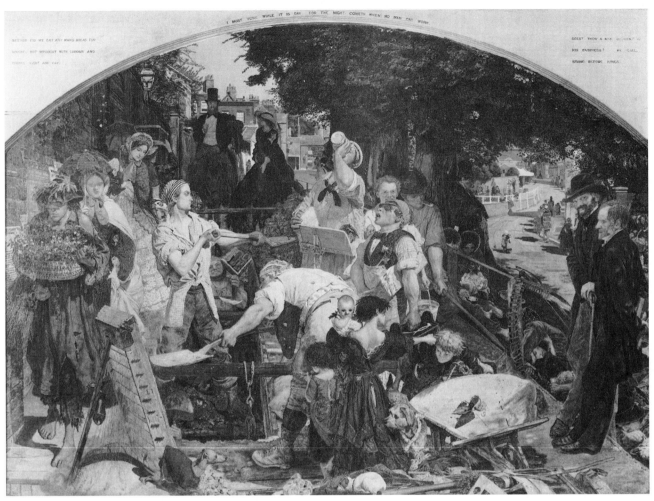

29-6 *Ford Madox Brown,* Work, *1862–1865. (Manchester City Art Galleries)*

Thomas Eakins (1844–1916)

Born in Philadelphia, Eakins studied at the Pennsylvania Academy and then traveled to France and Spain, where he was profoundly affected by the work of Velázquez. When he returned home in 1870 he began to produce the intense, ordered, and descriptive paintings that are characteristic of his particular style of *realism*. He worked out-of-doors sketching and studying light, air, and the movement of both over figures and ground. In his *Max Schmitt in a Single Scull* (Fig. 29-7) Eakins, portrayed in the far boat, pulls away from his more famous friend, whose skill at racing had made him an important figure in the Philadelphia area. Schmitt is seen in the near ground, and the effort and concentration that characterize the sport have lapsed into a momentary pause that permits us to see Schmitt and the setting as if in a single moment in time. Eakins's ability to capture a moment in time should be compared with that of Monet, the French impressionist who will be considered later in this chapter.

Photography

The problem with being a realist painter is no better revealed than when one compares a photograph with a painting. The social and economic forces that influenced the realists coincided with the technological revolution that produced new ways in which pictures could be made. Although Courbet, Brown, and Eakins might call themselves "realists," they could not compete with the ability of the camera to give an account of the thing seen. Invented in the first decades of the nineteenth century (the earliest photograph dates from c. 1826), the camera, by the 1850s, seemed able to capture more detail and information than the eye could see or the hand record. If realism was to be defined by painterly conventions that rendered everything as it was seen, then painting was in danger of being replaced. If, however, realism was an attitude that was defined by an honesty toward subject matter and a willingness to seek subject matter in the everyday life and experiences of people, then photography was

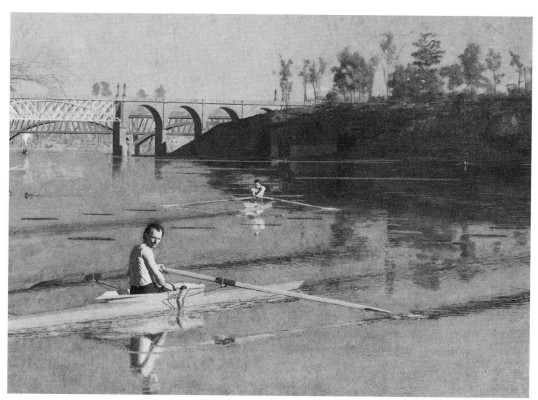

29-7 *Thomas Eakins,* Max Schmitt in a Single Scull. *Oil on canvas, 32¼" × 46¼". (The Metropolitan Museum of Art, Purchase, 1934, Alfred N. Punnett Fund and Gift of George D. Pratt. 34.92)* **(W)**

much less threatening—artists could rely on their skill in creating a convincing painting. Artists responded with some of both, and some artists saw photography as a tool that they, too, might use. Eakins and the Frenchman Edgar Degas (1834–1917) both used Eadweard Muybridge's *Studies in Animal Locomotion* (Fig. 29-8), the first important publication of both the human figure and animals in motion, as caught by time-lapse photography, to study forms in action. Eventually photographers too would seek to have their work accepted as art.

Realism in Literature

Writers in the industrial world, like artists, felt the need to portray as exactly as possible real life around them. As Courbet called for realism in painting, the French critic Philippe Duranty urged writers to strive for "the exact, complete, and sincere reproduction of the social milieu in which we live." Writers who considered themselves realists reacted against the fantastic, exotic, and ideal elements in romanticism, although in many of the greatest nineteenth-century works of literature, realism and romanticism coexist. If romanticism produced great *lyrics,* realism, as might be expected, produced great *novels,* for the novel, of all literary genres, is most

capable of representing the varied dimensions of a society and its characters. The middle to late nineteenth century was the great age of the realistic novel. The short story, also adaptable to realism, grew in popularity during this period as well.

One reason for the success of realism as a literary style in the nineteenth century was the increase in literacy among people in the middle and lower classes and the diffusion of journalism. Many novels were published in serial form in the cheap and easily accessible newspapers and journals. The new reading public was not interested in kings, gods, or ideal types; people preferred to read about others like themselves in surroundings like their own.

Realism could be considered a literary school only in France, where it had its fervent proponents and its detractors, its practitioners and its critics. The greatest realist novelists there were Stendhal (pseudonym of Henri Beyle, 1783–1842), Honoré de Balzac (1799–1850), and Gustave Flaubert (1821–1880). Stendhal, in his *The Red and the Black,* "held a mirror up to" French society of the restoration on the eve of the 1830 revolution. Balzac, in his long series of novels entitled *The Human Comedy* (in contrast to Dante's *Divine Comedy*), attempted an overall portrayal of French nineteenth-century society, creating memorable characters in the

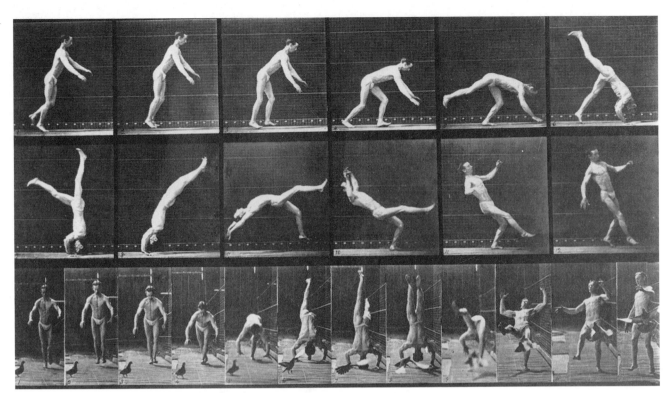

29-8 *Eadweard Muybridge,* Studies in Animal Locomotion. *(International Museum of Photography at George Eastman House)*

process. Flaubert's *Madame Bovary* (1857) had a major influence on European and American literature and is generally considered the masterpiece of literary realism. Intending to write "a book about nothing," Flaubert portrayed with scrupulous exactitude the dull life and thwarted dreams of a middle-class adulterous housewife in a small Normandy town.

In England, Charles Dickens (1812–1870), George Eliot (pseudonym of Mary Ann Evans, 1819–1880), and William Thackeray (1811–1863) exemplify realist novelists. The British realists often show in their novels their profound concern with contemporary social issues. The impact of industrialism on cities and on human life, especially the wretched condition of the poor, was a particularly apt subject for socially concerned realists. Dickens, a great literary success through his serial novels widely circulated in journals, was one of the most vivid portrayers of the new cities, the characters of all social strata within them, and the alienating effects of industrial capitalism. Because of his improbable plots and grotesque, almost monstrous characters, he cannot be called a consistently realistic novelist; still, he does to a great extent reproduce the material, social, and psychological environment of his time.

Realism in the United States began later than in Europe, but it had a considerable impact on American fiction that continues to the present day. Henry James (1843–1916) studied the French realists for his own

benefit; William Dean Howells (1837–1920) wrote against "romantic lies" in literature and in favor of realism, which portrays "men and women as they actually are, actuated by the motives and the passions in the measure we all know." Stephen Crane (1871–1900), who portrayed the harsher aspects of the Civil War, was another great American realist.

What are the basic characteristics of realism? As Howells's statement indicates, a belief in the possibility of realism implies a belief in an objective reality. Realism can be both material and psychological. It uses words to depict the way that things look and feel and the way that people act. Very often, the things influence or represent the people. The realist believes in "realistically" motivated characters who do not act in unexpected ways. Wishing to exclude nothing, realistic writers pay much attention to detail, especially the more sordid or shocking aspects of human life.

Naturalism

One characteristic of realism was to become more and more important toward the end of the nineteenth century: the determination of human character by the material and social environment. As this belief evolved into a so-called scientific credo, the movement known as *naturalism* replaced realism. The naturalists, more interested in the new theories of Charles Darwin on human evolu-

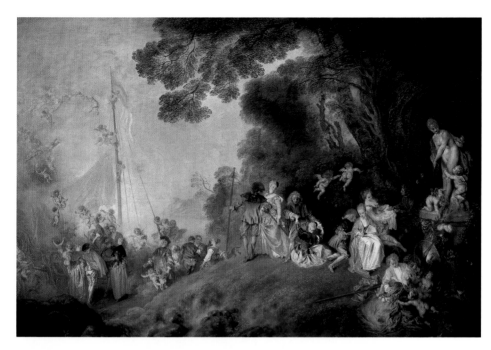

Plate XXI
Jean Antoine Watteau,
Pilgrimage to Cythera
(1717). Staatliche
Schlosser und Garten,
Berlin.
(Bildarchiv Preussischer
Kulturbesitz, Berlin/Art
Resource, NY)

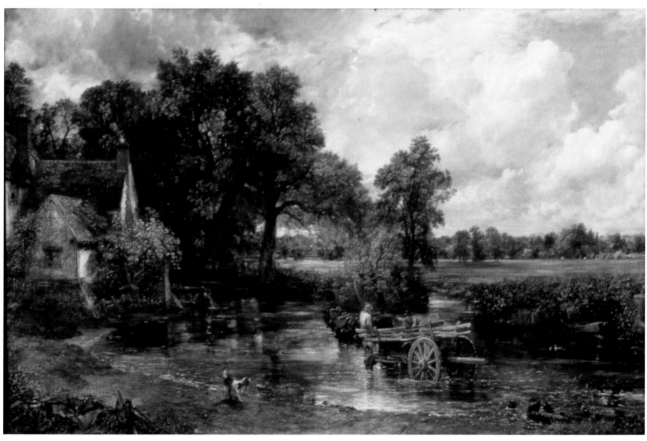

Plate XXII
John Constable, *The
Haywain* (1821). Oil on
canvas. 51¼ × 73″.
(National Gallery, London/Art
Resource, NY)

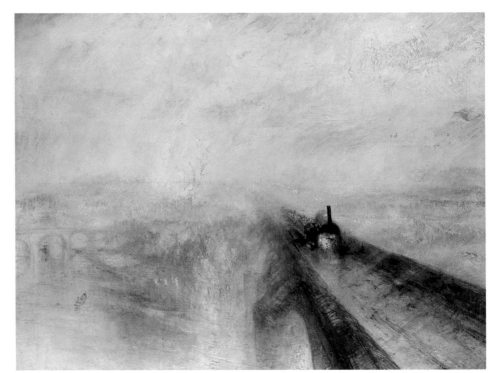

Plate XXIII
Joseph Mallord William
Turner, *Rain, Steam and
Speed—The Great Western
Railway* (1844). Oil on canvas,
35¾ × 48″.

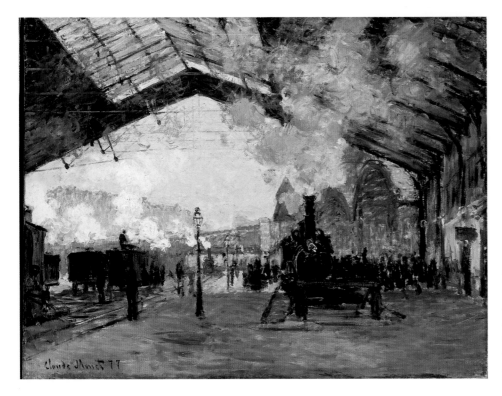

Plate XXIV
Claude Monet, *Arrival of the
Normandy Train, Gare Saint-
Lazare* (1877). Oil on canvas.
23½ × 31½″.

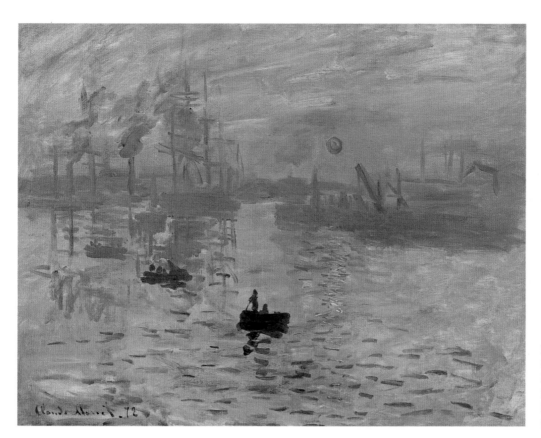

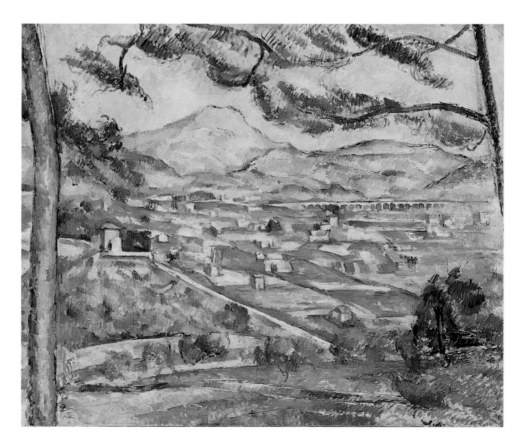

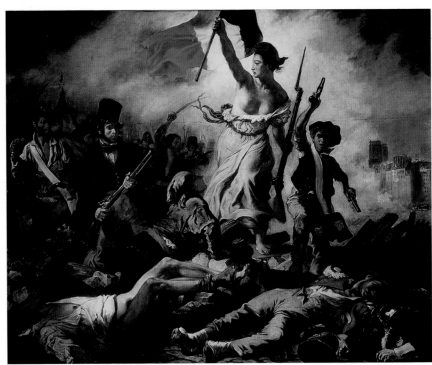

Plate XXVII
Eugéne Delacroix, *Liberty at the Barricades* (1830). Louvre, Paris.

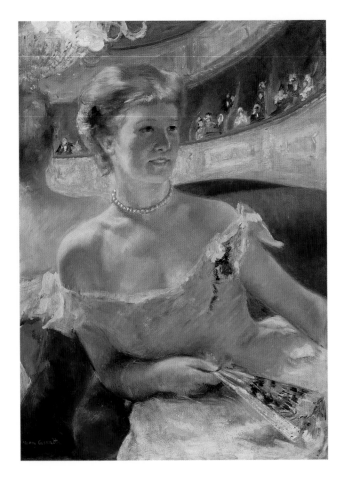

Plate XXVIII
Mary Cassatt, *Woman with a Pearl Necklace in a Loge* (1879). Oil on canvas, $31\frac{5}{8} \times 23''$.

tion than in Courbet's ideas on the reproduction of reality, tried to establish cause-and-effect laws in their novels. Certain conditions in the environment, they demonstrated, will produce certain traits in human beings. The foremost practitioner of naturalism in the novel in France was Émile Zola (1840–1902); he found an avid follower in the American Theodore Dreiser (1871–1945). As late as 1940, the black American writer Richard Wright (1908–1960) produced a great naturalistic novel, *Native Son,* which demonstrates how a young black man becomes a criminal through the influence of the racist society in which he lives.

Naturalism was also an important movement in the theater. Its most important practitioner in this genre was the Norwegian Henrik Ibsen (1828–1906). Although they depicted primarily middle-class people and their problems in his native land, Ibsen's plays were translated into many languages and became widely popular, although controversial, throughout Europe and America. Rejecting the "escapist" dramas and comedies that dominated the nineteenth-century theater, Ibsen dared to put on stage problems such as the condition and frustrations of women in *A Doll's House* and *Hedda Gabler* and syphilis in *Ghosts.* The naturalist theater also rejected decorative stage sets for highly realistic ones, exact imitations of middle-class living rooms. Ibsen's innovations in the naturalistic theater opened the path for many other dramatists, including George Bernard Shaw (1856–1950).

One of the best practitioners of naturalism in the short story was the Frenchman Guy de Maupassant (1850–1893). Like Ibsen, he was an acute observer of daily life and social problems in his own country; like Ibsen, too, his works were translated early on and became popular abroad. His most frequently anthologized story, "The Necklace," has given the impression that Maupassant was, above all, the master of the "trick ending," a device that was carried on by the American short story writer O. Henry (1862–1910). Maupassant's real talents, however, lie elsewhere. Like other naturalists, he does not hesitate to depict sordid, ugly, and brutal aspects of life, as well as the realities of sexual passion, but he does not dwell on them for shock value. Several of his stories are set in the period of the Franco-Prussian War, a time of carnage and suffering but also of acts of heroism. His acute observations of peasants in his native Normandy and of the Parisian upper classes are conveyed in a sober, exact prose and in a flawless sense of storytelling. Yet this master of the real would eventually die in a state of insanity produced by advanced syphilis. As if sensing his eventual lack of control over the portrayal of reality, he wrote in 1884: "All is mystery. We communicate with things only through our wretched, imperfect senses, so weak that they scarcely have enough strength to tell us what surrounds us."

The Poet and the City: Charles Baudelaire (1821–1867)

If one poet can be said to have been the initiator of modern poetry, it is probably the Frenchman Charles Baudelaire. An art critic as well as a poet, Baudelaire was extremely sensitive to the achievements of the best painters of his time, particularly Eugène Delacroix (see Chapter 27). Of Edouard Manet (see Fig. 29-10), he wrote (in *Esthetic Curiosities*) that he "combined with a definite taste for reality, modern reality—which is already a good sign—that ample, lively, sensitive, and daring imagination without which, it must be said, all the best faculties are only servants without a master, agents without a government." The description might be applied to Baudelaire's own poetry as well. The artist's task, for him, was to portray outward reality through an inner, spiritual vision.

When it appeared in 1857, Baudelaire's collection of poetry entitled *Les fleurs du mal* (The Flowers of Evil) shocked the bourgeois public. Along with Gustave Flaubert, who published his great realist novel *Madame Bovary* the same year, Baudelaire was put on trial for "offense to public and religious morality and to good morals." Six of the poems in the collection remained censored until 1949. One of the charges against both Baudelaire and Flaubert was their espousal of realism, defined by their accusers as a fascination with the ugly and evil and a negation of standards upholding the beautiful and the good. Yet many of Baudelaire's poems dealt with the concept of ideal beauty, a theme that was to influence the *symbolists* that followed him.

In his poems about life in the city, his native Paris, Baudelaire is the most "realistic." One section of *The Flowers of Evil* entitled "Tableaux parisiens" presents a haunted view of urban life, one that would influence the poetry of T. S. Eliot. Baudelaire also wrote poems in prose, although the collection entitled *Poems in Prose,* or *The Spleen of Paris,* was not published until 1869, two years after his death. The use of prose allows for even greater realism in poetry. In his visions of Paris, Baudelaire portrayed some of the same conditions that Engels and Dickens had observed in the industrialized cities of England: the gap between the smug, comfortable bourgeoisie and the marginalized poor, the dehumanized nature of the crowd, the alienations of modern life. But Baudelaire was a poet, not a reformer. His task was to bring "flowers from evil": to create beauty by exploring the very depths of the ugliness of modern life. His Paris was the city recently transformed by Haussmann's majestic urban renewal, with its wide new boulevards and elegant neoclassical façades. His era was Napoleon III's Second Empire (1851–1870), a time dominated by materialism and greed. Baudelaire's vision of the modern city resembles that of Dante in the *Inferno* because it becomes a symbolic representation of infinite spiritual loss.

Behind the shiny new products of materialistic progress are to be found the squalor and poverty that reveal unpleasant truths about the human condition. His poem "Correspondences" suggests that the poet can approach beauty by interpreting elements of the natural world as symbols.

Late-Nineteenth-Century Thinkers and Writers

The years corresponding to the reign of Queen Victoria in England (1837–1901) produced a number of radical changes in the ways that people in the West viewed themselves and their environment. As industrialism became a fact of life, prevailing attitudes turned more and more materialistic. Marx had taught human beings to see themselves as controlled by economic forces, although they could help to shape these forces for the cause of social justice. Some liberal thinkers envisaged a future time when the steady progress of capitalistic industry would create a society in which everyone would be surrounded by mechanical conveniences and physical comfort. Living in a world where every year seemed to witness dramatic technological achievements, middle-class Europeans and Americans (if they did not accept the predictions of Marx) had every reason to feel smug about themselves and their society.

Charles Darwin (1809–1882)

In the pure, as opposed to the applied, sciences, more fundamental changes were taking place. Among the most important of these were the evolutionary theories put forth by Charles Darwin. Darwin, who published his *Origin of Species* in 1859 and *The Descent of Man* in 1871, showed through his scientific observations of the "lower" animals that humankind was an integral part of their world. By evolution he meant that species are mutable: that each class of living organisms has developed through a series of gradual changes from a different one that preceded it. Species developed through mutations in inherited characteristics. Those inheriting the most useful characteristics—for fighting, food gathering, or mating—survived; the others died out. Thus life was basically a struggle for existence. The "survival of the fittest" was brought about through "natural selection." Humankind was one of those species that had evolved from the primate family and had managed to survive.

The protest against Darwin and his theories, which lasted well into the twentieth century, was very great indeed. Fundamentalist religious groups denounced him for proposing a theory of creation contrary to the one in Genesis; other moralists and religious authorities claimed that he had turned humanity into monkeys and undermined the foundations of human dignity, morality, and religion. The most upsetting concept in Darwin's theory of evolution was that of life as a scene of struggle and survival, of "nature red in tooth and claw." Nature could no longer be seen as the harmonious work of the Supreme Being or as the motherly source of consolation for wounded emotions. Constant flux, change, relativity of existence, and the elimination of the weak were in the natural order of things.

Herbert Spencer (1820–1903)

Nonscientific Darwin enthusiasts did not hesitate to apply his theories to human society. Herbert Spencer proclaimed a doctrine of agnosticism (the impossibility of knowing the existence of God with certainty) and what came to be known as *social Darwinism*. Spencer argued that society, like the natural world, was governed by the principle of evolution. There, too, the fittest survived and the weak went under. Social evolution was headed toward the increased freedom of the individual, and governments had no business interfering in "natural" economic processes or protecting the weak and unfit. In stressing the freedom of individual struggle in the economic process, Spencer seemed to give a scientific confirmation to the doctrines of early liberalism. His ideas had a particularly great influence in the United States, where the individualistic capitalism that led to the robber barons was booming. Thus the nineteenth-century bourgeois managed to assimilate even the radical theories of evolution into their materialistic, self-satisfied view of the world.

Friedrich Nietzsche (1844–1900)

Yet other philosophers and artists raised their voices loudly against this view of human nature and society. The highly influential German Nietzsche, a poetic more than a systematic philosopher, adapted evolutionary theories to purposes quite different from Spencer's. He denounced his bourgeois contemporaries for their hypocrisy, their stale morality, and their rationalism. He also saw human nature in terms of evolution toward freedom and elimination of weakness, but the freedom that interested him was spiritual and intellectual rather than economic and material. Rather than being satisfied with Western culture as he found it, he attacked not only its present state but also what we have seen to be its roots: the Greco-Roman and Judeo-Christian traditions. The Greek emphasis on reason as exemplified by Socrates worked against the healthy vitality of the instincts, according to Nietzsche. The moral values of Jews and Christians he found to be the expressions of weaklings or of "slaves." Christian ideas such as "pity," "turning the other cheek," and "sin" were for Nietzsche notions designed to keep people in their place instead of allowing free individuals to realize themselves to their full potential.

In his early and seminal work *The Birth of Tragedy* (1870), Nietzsche, who was at the time preparing to be a professor of classical languages, defied the prevalent conception of ancient Greek culture. According to him, the genius of the Greeks did not lie in Socratic rationalism, but rather in the Greeks' ability to give form to wild and ecstatic expressions of feeling that had originated in the East. In opposition to prevailing views, Nietzsche thus situated the origins of European culture in Asia. Using the names of two Greek gods, he called the religious expressions of ecstasy "Dionysian" and the creation of serene and harmonious forms "Apollonian." Together, these two cultural impulses led to the "birth" of the supreme artistic form, Greek tragedy. Nietzsche's views inspired others to revolt against the limits of reason and to return to greater sources of personal and cultural power in the irrational, in myth, and in artistic creation.

A philosopher who found the forms of academic philosophy too confining for his thought, Nietzsche often wrote in prose that was closer to poetry. Such a style characterizes his *Thus Spake Zarathustra* (1883–1885). Zarathustra, a kind of prophet with a Persian-sounding name, speaks in enigmatic, poetic sayings. He pronounces two of Nietzsche's most controversial and influential thoughts: "God is dead," and the *Übermensch* (translated as either "overman" or "superman") will replace him. Zarathustra seems pessimistic both about traditional religions and about the present state of humanity, but optimistic about the potential evolution of humans into superior beings, in control of their destiny.

Nietzsche's thought, interpreted in various ways, has influenced a variety of modern doctrines. Following his profound doubts about Western culture, some thinkers turned to the Orient or to Africa in an effort to find new sources of vitality for their own times. Others, following an opposite line of thought, derived racist ideas from Nietzsche, seeing in his theory of human evolution toward the free, noble "superman" a justification for beliefs in the superiority of the white, or Aryan, race. The Nazis interpreted Nietzsche in this way. Nietzsche's thought has had a deep influence on the philosophical school of existentialism, in both its Christian and its atheistic forms.

Fyodor Dostoevsky (1821–1881)

Another radical critique of materialistic and rationalistic Western society came from the Russian writer Dostoevsky. Dostoevsky, who was to have a major impact on Western literature and thought in the twentieth century, considered himself as a Russian to be outside the traditions of western Europe and thus able to view them more critically. He envisioned a major role for Russia in the destiny of the West. History proved him right in a way that he would not have approved.

Dostoevsky began his intellectual career as a socialist, associating with one of many groups of young Russians interested in the new doctrines from Europe. For this, the tsarist regime arrested him, sending him off to imprisonment in Siberia. He was at first sentenced to death, but the sentence was commuted at the last minute. During his stay in the Siberian prison, an experience that he recounted later in *The House of the Dead* (1861–1862), Dostoevsky underwent a reconversion to a mystical, Russian Orthodox Christianity. He also gained insight from observing the various criminals and political prisoners around him. In his later novels Dostoevsky portrayed characters in the extremes of moral degradation on the one hand and spiritual illumination on the other. The achievement of salvation through doubt, suffering, and even crime became one of his major themes. Like Nietzsche, Dostoevsky praised the extremes of human existence and deplored the safe, smug middle road; but, unlike Nietzsche, he believed that humanity could be saved through faith in Christ.

The much-acclaimed Crystal Palace became in Dostoevsky's first major work, *Notes from Underground* (1864), a symbol of the utopia of those who believe in the doctrines of progress through science and materialism. The kind of happiness represented by the Crystal Palace (Fig. 29-1) could, according to Dostoevsky, be achieved only through the loss of human freedom. Freedom, not political or economic but spiritual freedom of choice, was, for Dostoevsky, humanity's precious possession. People should be free to follow their irrational yearnings, their caprice, in order to develop their spiritual nature fully. People, in Dostoevsky's view, are not naturally good, as the optimists of both the eighteenth and the nineteenth centuries believed, but fallen and yet free to choose faith in Christ. Such a choice made for reasons of certainty or stability would be, however, a false one. The choice for Christ should be made irrationally, or suprarationally, through faith, taking upon oneself the burden of humanity since "everybody is guilty for all and before all." Dostoevsky came to believe that only the Russian people and the Russian church had preserved Christianity in its pure form, and he prophesied a messianic role for Russia. The West, whether materialistic or socialistic or Catholic, was for him in complete decay. Roman Catholicism he viewed as a kind of herd religion, an attempt to force belief and conformity through authority.

Dostoevsky develops these themes in his four great novels: *Crime and Punishment* (1866), *The Idiot* (1868), *The Possessed* (1871), and *The Brothers Karamazov* (1880). There his ideas are given flesh and blood through the complexity and fullness of his tortured, extremist characters and the settings in which they play out their destinies. In his ability to create living characters, Dostoevsky is in the tradition of the great

European realists and indeed is one of the masters of realism; yet his belief in human freedom puts him in direct opposition to the naturalists, who portrayed humanity as shaped by social and material conditions. His supreme interest in the exploration of the human soul made Dostoevsky break through the bounds of a style limited to everyday life and "realistic" character motivation. Influenced by Dickens, he developed aspects of the grotesque already present in the English novelist's works. For Dostoevsky, reality, in art as in life, extended beyond realism. In a letter of 1869 he wrote, "I have my own view of art, and that which the majority call fantastic and exceptional is for me the very essence of reality."

The New Painting

By the beginning of the sixth decade of the nineteenth century, a large group of artists had identified themselves as creators of new work that would not be confused with the traditional productions that filled the academy, fashionable salons, and dealers' galleries. A "Salon of the Refused" (i.e., refused by the government-sponsored salon) in 1863 included work by Edouard Manet and

Edgar Degas. In 1874 a group of young artists had banded together to produce a series of exhibitions of "new painting" that continued until 1886. Claude Monet, as well as Manet, Degas, Mary Cassatt, Paul Cézanne, and Paul Gauguin, showed work that revolutionized the ways in which paintings could and would be made. The forces that moved Constable, Courbet, Eakins, and others continued, and innovations, such as paint in tubes that allowed the artist to easily work outside, broke old habits. Japanese woodblock prints (Fig. 29-9), African and Oceanic art, and photographs brought artists new images that stimulated expression and challenged traditional ideas of what constituted art. Terms such as *realism, symbolism, pointillism, impressionism,* and *postimpressionism* have been devised to help viewers and critics to understand the variety of artistic means and intentions that resulted in new ways of artistic expression. Edouard Manet, Edgar Degas, Mary Cassatt, Claude Monet, Paul Cézanne, Vincent Van Gogh, and Paul Gauguin are among the most important. Others, including Berthe Morisot (1841–1895), Gustave Caillebotte (1848–1894), Camille Pissarro (1830–1903), Pierre Auguste Renoir (1841–1919), Alfred Sisley (1839–1899), and Georges Seurat (1859–1891), shared equally in the transformation, but space does not allow a discussion of all these artists.

The Figure and the Moment: Edouard Manet (1832–1883), Edgar Degas (1834–1917), and Mary Cassatt (1845–1926)

Manet, Degas, and Degas's pupil, the American Mary Cassatt, had the advantages of an upper-middle-class background and some financial support. Manet, the eldest, was not a conscious rebel like Courbet. Rather, he sought to present his milieu without comment. His artistic means were shaped by the art around him and by his study of Japanese prints, Velázquez, and photography, all of which provided different ways to focus attention on the subject and engage the viewer.

Olympia (Fig. 29-10), 1862, exhibited in the Salon of the Refused, typified Manet's emerging style. The reclining nude Venus or Diana was a traditional subject, but not this reclining nude, whose direct, quizzical gaze, like the pride with which she shows her body, lets the viewer know she is no ideal woman but rather a very particular and specific courtesan. The black servant, like the black cat, seems to emphasize the immediacy of the moment. Sharp contrasts of light and shade, strong edges and contours, a slightly flattened perspective, and clearly readable brushwork create an almost photographic depiction of a scene glimpsed for an instant but arrested permanently.

Manet's maturing work treated a host of subjects that were best characterized by the ephemeral nature of

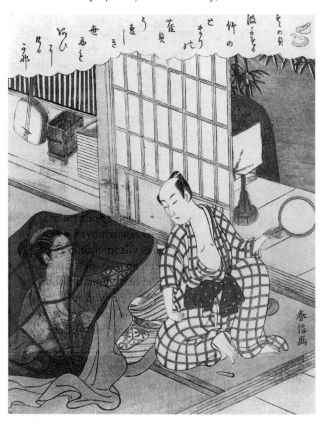

29-9 *Suzuki Harunobu (1725?–1770), Suzumegai, Japanese woodblock print from a poem by Basho. (Courtesy, Museum of Fine Arts, Boston, Asiatic Curators Fund in memory of Marjorie K. Hussey)*

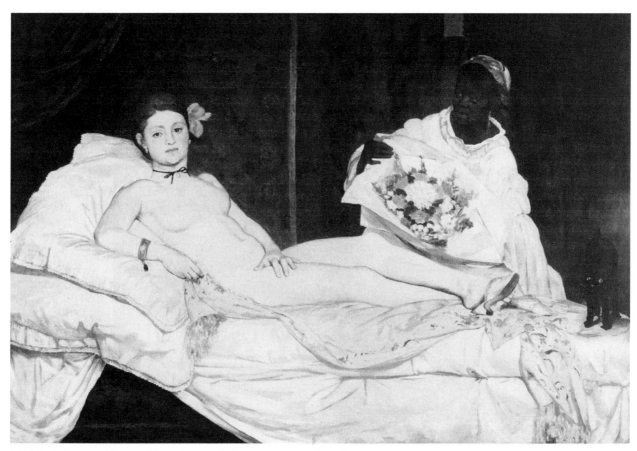

29-10 *Edouard Manet,* Olympia, *1862. Louvre, Paris. (Scala/Art Resource, NY)* **(W)**

their activity: dancers, musicians, friends on a balcony, a beach, or a firing squad. *Bar at the Folies-Bergère* (Fig. 29-11), 1881–1882, a painting that places the viewer in a mirror before a bored, detached bartender (or perhaps it's the other way around), epitomizes transient encounter and psychological distance in a rich visual setting—characteristics of modern, urban life.

Edgar Degas, like Manet, painted traditional subjects: portraits, genre scenes, even a few works with classical subjects. But he, too, wanted to express what he saw with ease and detachment, speaking truthfully about the life of his subjects. Like Manet, he was influenced by Japanese prints, and he used stop-motion photography to study bodies in motion so that he could learn how to portray their immensely expressive content.

Dancers, racehorses, prostitutes, and women ironing or washing themselves were among his favorite subjects. *Dancers Practicing at the Bar* (Fig. 29-12), like *L'Absinthe* (Fig. 29-13) painted in 1876, show Degas at his best. Figures are isolated from each other and the viewer by the compositions, which nevertheless make them the center of attention. The images are rendered with rough paint that reinforces a physical presence. Traditional critics considered the work crude and unfinished.

Philadelphia-born Mary Cassatt found people and social life irresistible, ephemeral subjects. She was a gifted colorist whose palette could render mood and moment and won her praise from contemporary critics. *Woman with a Pearl Necklace in a Loge* (Color Plate XXVIII), painted in 1879, shows the viewer a woman seen face to face and in a mirror. The scene is transitory, beautiful, and completely of the moment. It may be trite to say that she has captured a momentary impression, but her results convey that effect. What is equally important is that the viewer, more than ever, is conscious of the paint, the composition, and the hand of the artist.

The Landscape: Claude Monet (1840–1926) and Paul Cézanne (1839–1906)

Claude Monet helped organize the exhibitions of the new painting, and his interest, like that of Pissarro and Seurat, was primarily in rendering the transient light of out-of-doors. He did paint figures, but it was the landscape—water, sky, clouds, trees, light through steam and glass, light on solid objects—that attracted him. The language he developed, like that of his

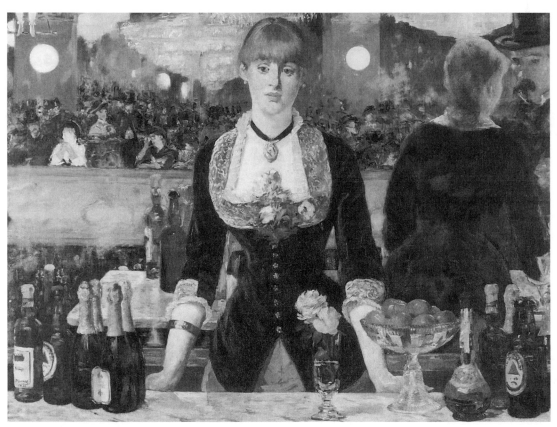

29-11 *Edouard Manet,* Bar at the Folies-Bergère, *1881–1882. Oil on canvas, 37½ × 51".*
(Courtauld Institute Galleries, University of London)

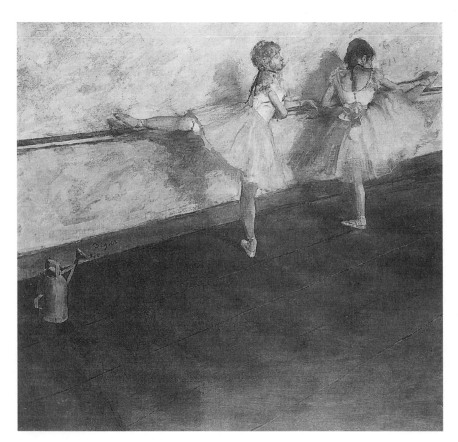

29-12 *Edgar Degas,* Dancers Practicing at the Bar. *Mixed media on canvas. 29¾" × 32". (The Metropolitan Museum of Art, H. O. Havemeyer Collection, Bequest of Mrs. H. O. Havemeyer, 1929)*

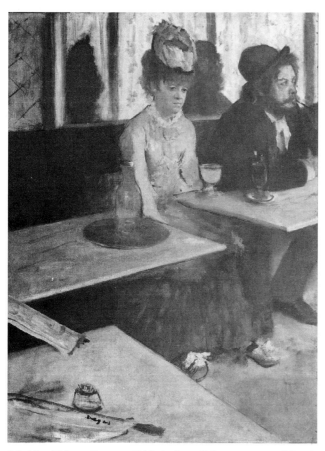

29-13 *Edgar Degas,* L'Absinthe. *Oil on canvas, Musée d'Orsay, Paris. (Giraudon/Art Resource, NY)* **(W)**

friends, was a consequence of experience, experimentation, and a growing awareness of the difficulty of the task. Consider your own experience of a sunlit field or beach. Pay attention to the ways in which every effect is constantly shifting as light changes and as you move.

To translate this experience of change onto canvas, the painters studied light and shadow. They realized (as had Delacroix) that shadows were not simply the absence of light but the contrasting color of objects, so they eliminated black, brown, and gray from the palette. The hues of the spectrum—red, orange, yellow, green, blue, and violet—were the components of color. Thus, grass is not just green but a mottled combination of colors and reflected light. Objects—a boat, a wall—take on the color of adjacent objects. All visual experiences are reflected, refracted waves of color that the eye perceives and joins into patterns. Brushstrokes became fragmented, short, commalike, or they became dots expressing a sense of immediacy and tension that paralleled the experience of trying to capture an instant of time. The loose brushwork, vivid, unmixed colors, and painting out-of-doors became characteristics associated with a new term, "impressionism," which was derived from Monet's paint-

ing titled *Impression: Sunrise* (Color Plate XXV) and was first used pejoratively.

Monet's *Impression: Sunrise,* painted in 1873 and exhibited in 1874, gave the movement its name. *Sunset on the Seine, Winter Effect* (Fig. 29-14), painted in 1880, makes an interesting comparison, and the repetition of scene—sunrise or sunset on water—points to Monet's obsession with rendering transient effects, whether on solid objects like haystacks or cathedral façades or waterlilies in his garden at Giverny. Some critics feel that the waterlilies series represents an extremity of the artistic movement that started with realism. What had begun as an attempt to paint the world "as it is" had become a means to record increasingly personal and introspective experiences.

Paul Cézanne exhibited with these painters, and his work suggests another avenue for the transformation that observation of nature could have on creating a painterly language. Cézanne's *Mont Sainte-Victoire* (Color Plate XXVI), 1886–1887, seems extreme in comparison with the two paintings by Monet. The everchanging landscape has been reduced to patterns of color and shape that emphasize the flatness of the canvas while inviting the viewer to experience the weight, volume, and space of the view. The foreground trees are rendered as a series of flat patterns of green against the equally flat blue sky. But both colors have been carefully chosen to force the eye to move back and forth from foreground to horizon. The road, fields, and buildings have been similarly simplified and carefully colored to march the mind's eye back to the mountain, and so instead of Monet's constantly shifting light, Cézanne makes paint become a stable language of color and stately movement. His painting seems almost devoid of emotion but not observation of the visual world. Both he and Monet tried to reproduce the experience of seeing in the natural world.

Postimpressionism and Symbolism

Just as Monet and Cézanne created different ways to account for the experience of the visual world, other artists who were involved in the "new painting" movement felt that a painterly language should be developed that expressed emotional and spiritual values that they believed missing from contemporary life and art. Composers Claude Debussy (1862–1918) and Maurice Ravel (1875–1937) considered themselves in that group, and in England both the Arts and Crafts Movement, founded by William Morris (1834–1896), and the aesthetic movement, heralded by Oscar Wilde (1854–1900), tried different ways of introducing meaning and spiritual value into the materialism of modern, urban, industrial society. Two painters associated with this concern were Vincent Van Gogh and Paul Gauguin.

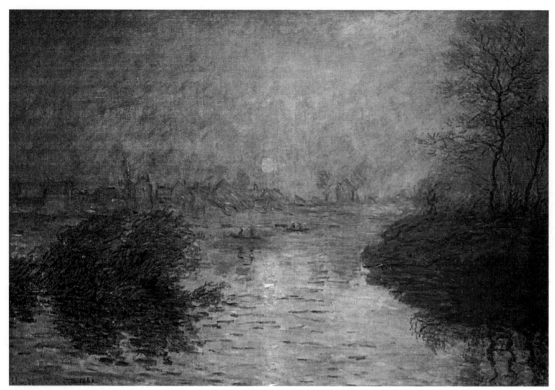

29-14 *Claude Monet,* Sunset on the Seine, Winter Effect. *(Musée du Petit Palais/Reunion des Musées Nationaux/Art Resource)* (W)

Vincent Van Gogh (1853–1890)

The Dutchman Vincent Van Gogh came to Paris to pursue his painting career but found the city unsympathetic. He moved to Arles in southern France in search of heat, light, and a more humane, rural life. Van Gogh, obsessed with the pain and suffering inflicted by contemporary urbanity and materialism, wanted to make paintings that would be comforting and uplifting. An orchard in flower, a vase of flowers, and the sun itself were, he believed, means to achieve these aims. Painting in strong, pure colors and a vigorous brushstroke that communicates energy, Van Gogh created intensely personal interpretations of the world of Arles, such as *The Sower* (Fig. 29-15), painted in 1888.

The Night Café (Fig. 29-16), 1888, is a familiar subject for this period but certainly not presented as either Degas or Cassatt would have seen such a scene. Writing of this painting, Van Gogh expressed the desire to symbolize through color: "I have tried to express humanity's terrible passions by using red and green." This basic color scheme produces intense contrasts, perceptible in the black and white reproduction, and heightens the emotions that seem to emanate from the scene. What are those emotions? What is humanity's plight?

The isolation and suffering Van Gogh experienced came in part as a result of an intractable mental illness that ended in his suicide. But his art, now incredibly popular, demonstrates the power of images to convey and connect with human emotions.

Paul Gauguin (1848–1903)

Gauguin was a stockbroker whose obsession with painting drove him from Paris to the French island colony in the Pacific, Tahiti, in search of a natural, instinctive culture free from the strictures of his own society. The experiences of this society provided him with subject matter untainted by familiarity and habit, much like Japanese prints or the art of Africa. By painting unfamiliar subjects, he forced his Western viewer to concentrate on the composition and the experience produced by seeing his paintings. In a letter to a friend written in 1893, he explained *Spirit of the Dead Watching* (Fig. 29-17), painted the previous year. The letter reveals Gauguin's active search for a pictorial language that can communicate ideas and feelings about the subject to the viewer while suggesting the emotions that he experienced and the choices he made while making what is, in fact, a painting of a young nude woman.

> What can a young native girl be doing completely nude on a bed, and in this somewhat difficult position? Preparing herself for making love? That is certainly in character, but it is indecent, and I do not wish it to be so. Sleeping: The amorous activity

29-15 *Vincent Van Gogh*, The Sower, *1888. (Vincent Van Gogh Foundation/ Van Gogh Museum, Amsterdam)* (W)

• Compare *The Night Café* with Degas's *L'Absinthe* (Fig. 29-13). Which painter seems most emotionally involved with his subject? Why? What characteristics do the two paintings have in common? How does the difference in the brush-stroke affect your response?

29-16 *Vincent Van Gogh*, The Night Café, *1888. Oil on canvas, 28½″ × 36¼″. (Yale University Art Gallery, New Haven, Connecticut. Bequest of Stephen Carlton Clark, B.A. 1903)*

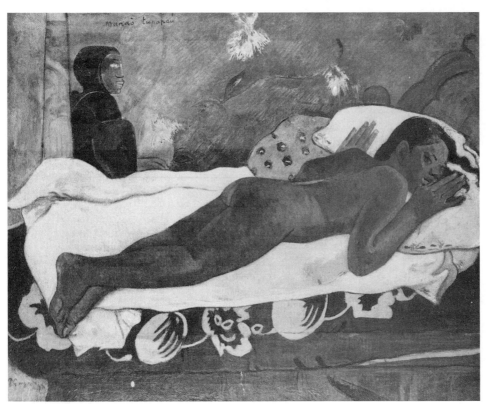

29-17 *Paul Gauguin,* Spirit of the Dead Watching, *1892. Oil on burlap mounted on canvas, 28½" × 36⅜". (Albright-Knox Art Gallery, Buffalo, New York, A. Conger Goodyear Collection, 1965)*

would then be over, and that is still indecent. I see here only fear. What kind of fear? Certainly not the fear of Susanna surprised by the elders [a famous Old Testament subject painted by many sixteenth- and seventeenth-century painters, including Rembrandt]. That kind of fear does not exist in Oceania.

Gauguin then explains the local belief of watchful dead that inspires the fear in this girl's eyes. To counter the fear, he makes the spirit, seated behind the bed, an ordinary little woman. The flowers painted under the edge of the bed cover, the intense color harmonies of the painting—blue and orange, purple and yellow—enliven and surround this study of a nude, about which, he seems to say, "If you must have a story, I have told you something." But Gauguin's preference would be for you to find your own narrative in the abstract, formal elements of line, color, and form as ways to access your own emotions and share, perhaps, in his feelings.

Guy de Maupassant

A Fishing Excursion

The setting of de Maupassant's story is the city of Paris during the Franco-Prussian War. France, fearful that Prussia would unite the independent German states under its leadership, declared war on Prussia in 1870. The war began on July 15, and on September 2 the principal French army surrendered. Paris refused to do so, and the Prussian army set siege to Paris for four months. On January 18 at Versailles the German empire was created under the leadership of Prussia, and ten days later Paris surrendered. By the terms of the subsequent peace treaty, France conceded Alsace and Lorraine to the newly united Germany.

Paris was blockaded, desolate, famished. The sparrows were few, and anything that was to be had was good to eat.

On a bright morning in January, M. Morissot, a watchmaker by trade but idler through circumstances, was walking along the boulevard, sad, hungry, with his hands in the pockets of his uniform trousers, when he came face to face with a brother-in-arms whom he recognized as an old-time friend.

Before the war Morissot could be seen at daybreak every Sunday, trudging along with a cane in one hand and a tin box on his back. He would take the train to Colombes and walk from there to the Isle of Marante where he would fish until dark.

It was there he had met M. Sauvage, who kept a little notion store in the Rue Notre Dame de Lorette, a jovial fellow and passionately fond of fishing like himself. A warm friendship had sprung up between these two, and they would fish side by side all day, very often without saying a word. Some days, when everything looked fresh and new and the beautiful spring sun gladdened every heart, M. Morissot would exclaim:

"How delightful!" and M. Sauvage would answer:

"There is nothing to equal it."

Then again on a fall evening, when the glorious setting sun, spreading its golden mantle on the already tinted leaves, would throw strange shadows around the two friends, Sauvage would say:

"What a grand picture!"

"It beats the boulevard!" would answer Morissot. But they understood each other quite as well without speaking.

The two friends had greeted each other warmly and had resumed their walk side by side, both thinking deeply of the past and present events. They entered a café, and when a glass of absinthe had been placed before each Sauvage sighed:

"What terrible events, my friend!"

"And what weather!" said Morissot sadly; "this is the first nice day we have had this year. Do you remember our fishing excursions?"

"Do I! Alas, when shall we go again!"

After a second absinthe they emerged from the café, feeling rather dizzy—that lightheaded effect which alcohol has on an empty stomach. The balmy air had made Sauvage exuberant, and he exclaimed:

"Suppose we go!"

"Where?"

"Fishing."

"Fishing! Where?"

"To our old spot, to Colombes. The French soldiers are stationed near there, and I know Colonel Dumoulin will give us a pass."

"It's a go; I am with you."

An hour after, having supplied themselves with their fishing tackle, they arrived at the colonel's villa. He had smiled at their request and had given them a pass in due form.

At about eleven o'clock they reached the advance guard and, after presenting their pass, walked through Colombes and found themselves very near their destination. Argenteuil, across the way, and the great plains toward Nanterre were all deserted. Solitary, the hill of Orgemont and Sannois rose clearly above the plains, a splendid point of observation.

"See," said Sauvage, pointing to the hills, "the Prussians are there."

Prussians! They had never seen one, but they knew that they were all around Paris, invisible and powerful, plundering, devastating and slaughtering. To their

superstitious terror they added a deep hatred for this unknown and victorious people.

"What if we should meet some?" said Morissot.

"We would ask them to join us," said Sauvage in true Parisian style.

Still they hesitated to advance. The silence frightened them. Finally Sauvage picked up courage.

"Come, let us go on cautiously."

They proceeded slowly, hiding behind bushes, looking anxiously on every side, listening to every sound. A bare strip of land had to be crossed before reaching the river. They started to run. At last they reached the bank and sank into the bushes, breathless, but relieved.

Morissot thought he heard someone walking. He listened attentively, but no, he heard no sound. They were indeed alone! The little island shielded them from view. The house where the restaurant used to be seemed deserted; feeling reassured, they settled themselves for a good day's sport.

Sauvage caught the first fish, Morissot the second, and every minute they would bring one out which they would place in a net at their feet. It was indeed miraculous! They felt that supreme joy which one feels after having been deprived for months of a pleasant pastime. They had forgotten everything, even the war!

Suddenly they heard a rumbling sound, and the earth shook beneath them. It was the cannon on Mont Valérien. Morissot looked up and saw a trail of smoke, which was instantly followed by another explosion. Then they followed in quick succession.

"They are at it again," said Sauvage, shrugging his shoulders. Morissot, who was naturally peaceful, felt a sudden, uncontrollable anger.

"Stupid fools! What pleasure can they find in killing each other?"

"They are worse than brutes!"

"It will always be thus as long as we have governments."

"Well, such is life!"

"You mean death!" said Morissot, laughing.

They continued to discuss the different political problems, while the cannon on Mont Valérien sent death and desolation among the French.

Suddenly they started. They had heard a step behind them. They turned and beheld four big men in dark uniforms, with guns pointed right at them. Their fishing lines dropped out of their hands and floated away with the current.

In a few minutes the Prussian soldiers had bound them, cast them into a boat and rowed across the river to the island which our friends had thought deserted. They soon found out their mistake when they reached the house, behind which stood a score or more of soldiers. A big burly officer, seated astride a chair, smoking an immense pipe, addressed them in excellent French:

"Well, gentlemen, have you made a good haul?"

Just then a soldier deposited at his feet the netful of fish which he had taken care to take along with him. The officer smiled and said:

"I see you have done pretty well, but let us change the subject. You are evidently sent to spy upon me. You pretended to fish so as to put me off the scent, but I am not so simple. I have caught you and shall have you shot. I am sorry, but war is war. As you passed the advance guard you certainly must have the password; give it to me, and I will set you free."

The two friends stood side by side, pale and slightly trembling, but they answered nothing.

"No one will ever know. You will go back home quietly, and the secret will disappear with you. If you refuse, it is instant death! Choose!"

They remained motionless, silent. The Prussian officer calmly pointed to the river.

"In five minutes you will be at the bottom of this river! Surely you have a family, friends, waiting for you?"

Still they kept silent. The cannon rumbled incessantly. The officer gave orders in his own tongue then moved his chair away from the prisoners. A squad of men advanced within twenty feet of them, ready for command.

"I give you one minute, not a second more!"

Suddenly approaching the two Frenchmen, he took Morissot aside and whispered:

"Quick, the password. Your friend will not know; he will think I changed my mind." Morissot said nothing.

Then, taking Sauvage aside, he asked him the same thing, but he also was silent. The officer gave further orders, and the men leveled their guns. At that moment Morissot's eyes rested on the netful of fish lying in the grass a few feet away. The sight made him faint and, though he struggled against it, his eyes filled with tears. Then, turning to his friend:

"Farewell, Monsieur Sauvage!"

"Farewell, Monsieur Morissot!"

They stood for a minute hand in hand, trembling with emotion which they were unable to control.

"Fire!" commanded the officer.

The squad of men fired as one. Sauvage fell straight on his face. Morissot, who was taller, swayed, pivoted and fell across his friend's body, his face to the sky, while blood flowed freely from the wound in the breast. The officer gave further orders, and his men disappeared. They came back presently with ropes and stones, which they tied to the feet of the two friends, and four of them carried them to the edge of the river. They swung them and threw them in as far as they could. The bodies, weighted by stones, sank immediately. A splash, a few ripples and the water resumed its usual calmness. The only thing to be seen was a little blood floating on the surface. The officer calmly retraced his steps toward the house, muttering:

"The fish will get even now."

He perceived the netful of fish, picked it up, smiled and called:

"Wilhelm!"

A soldier in a white uniform approached. The officer handed him the fish, saying:

"Fry these little things while they are still alive; they will make a delicious meal."

And, having resumed his position on the chair, he puffed away at his pipe.

COMMENTS AND QUESTIONS

1. What realistic elements do you find in the story?
2. What information does Maupassant give the reader about the Franco-Prussian War?
3. What do we know of the character of Morissot and Sauvage? Of the Prussian soldiers?
4. What is the significance of fishing in the story?
5. Why do Morissot and Sauvage make the decision not to reveal the password? Does the motivation for their decision seem convincing?

CHARLES BAUDELAIRE

from *Les Fleurs du Mal/ The Flowers of Evil*

A Une Passante

La rue assourdissante autour de moi hurlait.
Longue, mince, en grand deuil, douleur majestueuse,
Une femme passa, d'une main fastueuse
Soulevant, balançant le feston et l'ourlet;

Agile et noble, avec sa jambe de statue. 5
Moi, je buvais, crispé comme un extravagant,
Dans son œil, ciel livide où germe l'ouragan,
La douceur qui fascine et le plaisir qui tue.

Un éclair . . . puis la nuit!—Fugitive beauté
Dont le regard m'a fait soudainement renaître, 10
Ne te verrai-je plus que dans l'éternité?

Ailleurs, bien loin d'ici! trop tard! *jamais* peut-être!
Car j'ignore où tu fuis, tu ne sais où je vais,
O toi que j'eusse aimée, ô toi qui le savais!

To a Passer-By

Translation by C. F. MacIntyre

Amid the deafening traffic of the town,
Tall, slender, in deep mourning, with majesty,
A woman passed, raising, with dignity
In her poised hand, the flounces of her gown;

Graceful, noble, with a statue's form. 5
And I drank, trembling as a madman thrills,
From her eyes, ashen sky where brooded storm,
The softness that fascinates, the pleasure that kills.

A flash . . . then night!—O lovely fugitive,
I am suddenly reborn from your swift glance; 10
Shall I never see you till eternity?

Somewhere, far off! too late! *never,* perchance!
Neither knows where the other goes or lives;
We might have loved, and you knew this might be!

COMMENTS AND QUESTIONS

1. Why do you think Baudelaire uses the sonnet form in this poem? Note the rhyme scheme in the original.
2. Do you recognize any aspects of romantic love in this poem?
3. What is the tone of this poem, and how does Baudelaire convey it?
4. What role does the city play in this brief "love story"?

Correspondances

La Nature est un temple où de vivants piliers
Laissent parfois sortir de confuses paroles;
L'homme y passe à travers des forêts de symboles
Qui l'observent avec des regards familiers.

Correspondences

Translation by Wallace Fowlie

Nature is a temple where living pillars
At times allow confused words to come forth;
There man passes through forests of symbols
Which observe him with familiar eyes.

Comme de longs échos qui de loin se confondent
Dans une ténébreuse et profonde unité,
Vaste comme la nuit et comme la clarté,
Les parfums, les couleurs et les sons se répondent.

Il est des parfums frais comme des chairs d'enfants,
Doux comme les hautbois, verts comme les prairies,
—Et d'autres, corrompus, riches et triomphants,

Ayant l'expansion des choses infinies,
Comme l'ambre, le musc, le benjoin et l'encens,
Qui chantent les transports de l'esprit et des sens.

Like long echoes which in a distance are mingled
In a dark and profound unison
Vast as night is and light,
Perfumes, colors and sounds answer one another.

There are perfumes as cool as the flesh of children,
Sweet as oboes, green as prairies
—And others, corrupt, rich and triumphant,

Having the expansion of infinite things,
Like amber, musk, myrrh and incense,
Which sing of the transports of the mind and the
senses.

The Swan

Translation by Anthony Hecht

To Victor Hugo

I

Andromache, I think of you. The little stream,
A yellowing mirror that onetime beheld
The huge solemnity of your widow's grief
(That other Simois your tears have swelled)°

Suddenly flooded the memory's dark soil 5
As I was crossing the new *Place du Carrousel.*°
The old Paris is gone (the face of a town
Is more changeable than the heart of mortal man).

I see what seem the ghosts of these royal barracks,
The rough-hewn capitals, the columns waiting to
crack, 10
Weeds, and the big rocks greened with standing water,
And at the windows, a jumble of bric-a-brac.

One time a menagerie was on display there,
And there I saw one morning at the hour
Of cold and clarity when Labor rises 15
And brooms make little cyclones of soot in the air

A swan that had escaped out of his cage,
And there, web-footed on the dry sidewalk,
Dragged his white plumes over the cobblestones,
Lifting his beak at the gutter as if to talk, 20

And bathing his wings in the sifting city dust,
His heart full of some cool, remembered lake,
Said, "Water, when will you rain? Where is your
thunder?"
I can see him now, straining his twitching neck

Skyward again and again, like the man in Ovid,° 25
Toward an ironic heaven as blank as slate,
And trapped in a ruinous myth, he lifts his head
As if God were the object of his hate.

II

Paris changes, but nothing of my melancholy
Gives way. Foundations, scaffoldings, tackle and
blocks, 30
And the old suburbs drift off into allegory,
While my frailest memories take on the weight of
rocks.

And so at the Louvre one image weighs me down:
I think of my great swan, the imbecile strain
Of his head, noble and foolish as all the exiled, 35
Eaten by ceaseless needs—and once again

Of you, Andromache, from a great husband's arms
Fallen to the whip and mounted lust of Pyrrhus,
And slumped in a heap beside an empty tomb,
(Poor widow of Hector, and bride of Helenus)° 40

And think of the consumptive negress, stamping
In mud, emaciate, and trying to see
The vanished coconuts of hidden Africa
Behind the thickening granite of the mist;

4. Allusion to Book III of Virgil's *Aeneid*. Andromache, the widow of
the Trojan general Hector, and now a captive in Greece, weeps into
the stream she calls "Simois" after a Trojan river. 6. An interior
courtyard of the Louvre palace.

25. Allusion to Ovid's *Metamorphoses* I.85: "The creator gave man
a face turned toward the sun so that he could look directly at it."
40. Pyrrhus, the Greek general, abducted Andromache from Troy
and married her to Helenus.

Of whoever has lost what cannot be found again, 45
Ever, ever; of those who lap up the tears
And nurse at the teats of that motherly she-wolf,
 Sorrow;
Of orphans drying like flowers in empty jars.

So in that forest where my mind is exiled
One memory sounds like brass in the ancient war: 50
I think of sailors washed up on uncharted islands,
Of prisoners, the conquered, and more, so many
 more.

COMMENTS AND QUESTIONS

1. How does Baudelaire portray the old and the new Paris in this poem?
2. What different figures represent the theme of exile, and how?
3. What does the swan symbolize?

from *Poems in Prose (The Spleen of Paris)*

Windows

Translation by Arthur Symons

He who looks in through an open window never sees so many things as he who looks at a shut window. There is nothing more profound, more mysterious, more fertile, more gloomy, or more dazzling, than a window lighted by a candle. What we can see in the sunlight is always less interesting than what goes on behind the panes of a window. In that dark or luminous hollow, life lives, life dreams, life suffers.

Across the waves of roofs, I can see a woman of middle age, wrinkled, poor, who is always leaning over something, and who never goes out. Out of her face, out of her dress, out of her attitude, out of nothing almost, I have made up the woman's story, and sometimes I say it over to myself with tears.

If it had been a poor old man, I could have made up his just as easily.

And I go to bed, proud of having lived and suffered in others.

Perhaps you will say to me: "Are you sure that it is the real story?" What does it matter, what does any reality outside of myself matter, if it has helped me to live, to feel that I am, and what I am? . . .

Crowds

Translation by Louis Varèse

It is not given to every man to take a bath of multitude; enjoying a crowd is an art; and only he can relish a debauch of vitality at the expense of the human species, on whom, in his cradle, a fairy has bestowed the love of masks and masquerading, the hate of home, and the passion for roaming.

Multitude, solitude: identical terms, and interchangeable by the active and fertile poet. The man who is unable to people his solitude is equally unable to be alone in a bustling crowd.

The poet enjoys the incomparable privilege of being able to be himself or someone else, as he chooses. Like those wandering souls who go looking for a body, he enters as he likes into each man's personality. For him alone everything is vacant; and if certain places seem closed to him, it is only because in his eyes they are not worth visiting.

The solitary and thoughtful stroller finds a singular intoxication in this universal communion. The man who loves to lose himself in a crowd enjoys feverish delights that the egoist locked up in himself as in a box, and the slothful man like a mollusk in his shell, will be eternally deprived of. He adopts as his own all the occupations, all the joys and all the sorrows that chance offers.

What men call love is a very small, restricted, feeble thing compared with this ineffable orgy, this divine prostitution of the soul giving itself entire, all its poetry and all its charity, to the unexpected as it comes along, to the stranger as he passes.

It is a good thing sometimes to teach the fortunate of this world, if only to humble for an instant their foolish pride, that there are higher joys than theirs, finer and more uncircumscribed. The founders of colonies, shepherds of peoples, missionary priests exiled to the ends of the earth, doubtlessly know something of this mysterious drunkenness; and in the midst of the vast family created by their genius, they must often laugh at those who pity them because of their troubled fortunes and chaste lives.

COMMENTS AND QUESTIONS

1. In what sense do these poems fit the aesthetics of realism, and in what sense do they go beyond realism?
2. In your opinion, are these poems even though they are written in prose? Why do you think Baudelaire chose to write them in prose?
3. Compare Baudelaire's view of the city crowd in "To a Passer-By" and "Crowds."

FRIEDRICH NIETZSCHE

Zarathustra's Prologue

Translation by Walter Kaufman

1

When Zarathustra was thirty years old he left his home and the lake of his home and went into the mountains. Here he enjoyed his spirit and his solitude, and for ten years did not tire of it. But at last a change came over his heart, and one morning he rose with the dawn, stepped before the sun, and spoke to it thus:

"You great star, what would your happiness be had you not those for whom you shine?

"For ten years you have climbed to my cave: you would have tired of your light and of the journey had it not been for me and my eagle and my serpent.

"But we waited for you every morning, took your overflow from you, and blessed you for it.

"Behold, I am weary of my wisdom, like a bee that has gathered too much honey; I need hands outstretched to receive it.

"I would give away and distribute, until the wise among men find joy once again in their folly, and the poor in their riches.

"For that I must descend to the depths, as you do in the evening when you go behind the sea and still bring light to the underworld, you overrich star.

"Like you, I must *go under*—go down, as is said by man, to whom I want to descend.

"So bless me then, you quiet eye that can look even upon an all-too-great happiness without envy!

"Bless the cup that wants to overflow, that the water may flow from it golden and carry everywhere the reflection of your delight.

"Behold, this cup wants to become empty again, and Zarathustra wants to become man again."

Thus Zarathustra began to go under.

2

Zarathustra descended alone from the mountains, encountering no one. But when he came into the forest, all at once there stood before him an old man who had left his holy cottage to look for roots in the woods. And thus spoke the old man to Zarathustra:

"No stranger to me is this wanderer: many years ago he passed this way. Zarathustra he was called, but he has changed. At that time you carried your ashes to the mountains; would you now carry your fire into the valleys? Do you not fear to be punished as an arsonist?

"Yes, I recognize Zarathustra. His eyes are pure, and around his mouth there hides no disgust. Does he not walk like a dancer?

"Zarathustra has changed, Zarathustra has become a child, Zarathustra is an awakened one; what do you now want among the sleepers? You lived in your solitude as in the sea, and the sea carried you. Alas, would you now climb ashore? Alas, would you again drag your own body?"

Zarathustra answered: "I love man."

"Why," asked the saint, "did I go into the forest and the desert? Was it not because I loved man all-too-much? Now I love God; man I love not. Man is for me too imperfect a thing. Love of man would kill me."

Zarathustra answered: "Did I speak of love? I bring men a gift."

"Give them nothing!" said the saint. "Rather, take part of their load and help them to bear it—that will be best for them, if only it does you good! And if you want to give them something, give no more than alms, and let them beg for that!"

"No," answered Zarathustra. "I give no alms. For that I am not poor enough."

The saint laughed at Zarathustra and spoke thus: "Then see to it that they accept your treasures. They are suspicious of hermits and do not believe that we come with gifts. Our steps sound too lonely through the streets. And what if at night, in their beds, they hear a man walk by long before the sun has risen—they probably ask themselves, Where is the thief going?

"Do not go to man. Stay in the forest! Go rather even to the animals! Why do you not want to be as I am—a bear among bears, a bird among birds?"

"And what is the saint doing in the forest?" asked Zarathustra.

The saint answered: "I make songs and sing them; and when I make songs, I laugh, cry, and hum: thus I praise God. With singing, crying, laughing, and humming, I praise the god who is my god. But what do you bring us as a gift?"

When Zarathustra had heard these words he bade the saint farewell and said: "What could I have to give you? But let me go quickly lest I take something from you!" And thus they separated, the old one and the man, laughing as two boys laugh.

But when Zarathustra was alone he spoke thus to his heart: "Could it be possible? This old saint in the forest has not yet heard anything of this, that *God is dead!*"

3

When Zarathustra came into the next town, which lies on the edge of the forest, he found many people gathered together in the market place; for it had been promised that there would be a tightrope walker. And Zarathustra spoke thus to the people:

"*I teach you the overman.* Man is something that shall be overcome. What have you done to overcome him?

"All beings so far have created something beyond themselves; and do you want to be the ebb of this great flood and even go back to the beasts rather than overcome man? What is the ape to man? A laughingstock or a painful embarrassment. And man shall be just that for the overman: a laughingstock or a painful embarrassment. You have made your way from worm to man, and much in you is still worm. Once you were apes, and even now, too, man is more ape than any ape.

"Whoever is the wisest among you is also a mere conflict and cross between plant and ghost. But do I bid you become ghosts or plants?

"Behold, I teach you the overman. The overman is the meaning of the earth. Let your will say: the overman *shall be* the meaning of the earth! I beseech you, my brothers, *remain faithful to the earth,* and do not believe those who speak to you of otherworldly hopes! Poison-mixers are they, whether they know it or not. Despisers of life are they, decaying and poisoned themselves, of whom the earth is weary: so let them go.

"Once the sin against God was the greatest sin; but God died, and these sinners died with him. To sin against the earth is now the most dreadful thing, and to esteem the entrails of the unknowable higher than the meaning of the earth.

"Once the soul looked contemptuously upon the body, and then this contempt was the highest: she wanted the body meager, ghastly, and starved. Thus she hoped to escape it and the earth. Oh, this soul herself was still meager, ghastly, and starved: and cruelty was the lust of this soul. But you, too, my brothers, tell me: what does your body proclaim of your soul? Is not your soul poverty and filth and wretched contentment?

"Verily, a polluted stream is man. One must be a sea to be able to receive a polluted stream without becoming unclean. Behold, I teach you the overman: he is this sea; in him your great contempt can go under.

"What is the greatest experience you can have? It is the hour of the great contempt. The hour in which your happiness, too, arouses your disgust, and even your reason and your virtue.

"The hour when you say, 'What matters my happiness? It is poverty and filth and wretched contentment. But my happiness ought to justify existence itself.'

"The hour when you say, 'What matters my reason? Does it crave knowledge as the lion his food? It is poverty and filth and wretched contentment.'

"The hour when you say, 'What matters my virtue? As yet it has not made me rage. How weary I am of my good and my evil! All that is poverty and filth and wretched contentment.'

"The hour when you say, 'What matters my justice? I do not see that I am flames and fuel. But the just are flames and fuel.'

"The hour when you say, 'What matters my pity? Is not pity the cross on which he is nailed who loves man? But my pity is no crucifixion.'

"Have you yet spoken thus? Have you yet cried thus? Oh, that I might have heard you cry thus!

"Not your sin but your thrift cries to heaven; your meanness even in your sin cries to heaven.

"Where is the lightning to lick you with its tongue? Where is the frenzy with which you should be inoculated?

"Behold, I teach you the overman: he is this lightning, he is this frenzy."

When Zarathustra had spoken thus, one of the people cried: "Now we have heard enough about the tightrope walker; now let us see him too!" And all the people laughed at Zarathustra. But the tightrope walker, believing that the word concerned him, began his performance.

4

Zarathustra, however, beheld the people and was amazed. Then he spoke thus:

"Man is a rope, tied between beast and overman—a rope over an abyss. A dangerous across, a dangerous on-the-way, a dangerous looking-back, a dangerous shuddering and stopping.

"What is great in man is that he is a bridge and not an end: what can be loved in man is that he is an *overture* and a *going under.*

"I love those who do not know how to live, except by going under, for they are those who cross over.

"I love the great despisers because they are the great reverers and arrows of longing for the other shore.

"I love those who do not first seek behind the stars for a reason to go under and be a sacrifice, but who sacrifice themselves for the earth, that the earth may some day become the overman's.

"I love him who lives to know, and who wants to know so that the overman may live some day. And thus he wants to go under.

"I love him who works and invents to build a house for the overman and to prepare earth, animal, and plant for him: for thus he wants to go under.

"I love him who loves his virtue, for virtue is the will to go under and an arrow of longing.

"I love him who does not hold back one drop of spirit for himself, but wants to be entirely the spirit of his virtue: thus he strides over the bridge as spirit.

"I love him who makes his virtue his addiction and his catastrophe: for his virtue's sake he wants to live on and to live no longer.

"I love him who does not want to have too many virtues. One virtue is more virtue than two, because it is more of a noose on which his catastrophe may hang.

"I love him whose soul squanders itself, who wants no thanks and returns none: for he always gives away and does not want to preserve himself.

"I love him who is abashed when the dice fall to make his fortune, and asks, 'Am I then a crooked gambler?' For he wants to perish.

"I love him who casts golden words before his deeds and always does even more than he promises: for he wants to go under.

"I love him who justifies future and redeems past generations: for he wants to perish of the present.

"I love him who chastens his god because he loves his god: for he must perish of the wrath of his god.

"I love him whose soul is deep, even in being wounded, and who can perish of a small experience: thus he goes gladly over the bridge.

"I love him whose soul is overfull so that he forgets himself, and all things are in him: thus all things spell his going under.

"I love him who has a free spirit and a free heart: thus his head is only the entrails of his heart, but his heart drives him to go under.

"I love all those who are as heavy drops, falling one by one out of the dark cloud that hangs over men: they herald the advent of lightning, and, as heralds, they perish.

"Behold, I am a herald of the lightning and a heavy drop from the cloud; but this lightning is called *overman.*"...

FYODOR DOSTOEVSKY

from *Notes from Underground*
Translation by Michael Katz

This first-person narrative is composed basically of two parts. In the first, the narrator, speaking to readers he sometimes identifies as "gentlemen," exposes in a long monologue his philosophy of life and the reasons he lives "underground." The first sentences (not reproduced here) set a tone of bitterness and scorn that he maintains: "I am a sick man. . . . I am a spiteful man. I am a most unpleasant man. I think my liver is diseased. Then again, I don't know a thing about my illness; I'm not even sure what hurts." We learn that he is forty years old and that he has been living in a sordid underground room in St. Petersburg for twenty years. He describes his extreme self-consciousness, his "pleasure in despair," and his dislike of the fact that two and two make four.

In the second part, he looks back on his former life, recounting anecdotes about being humiliated with other people and his own attempts to humiliate a vulnerable young prostitute who finally reveals to him her moral superiority. The "underground man" finds no meaning in his life and no solution to his bitter hatred of contemporary society. But in his character's mention of a "thirst" for "something different," Dostoevsky seems to suggest the religious conversion that will play an important role in his later novels. The passage below is taken from the first part of the work. Part of Dostoevsky's artistry lies in his ability to communicate some of his own real criticisms of the systems—such as socialism and liberalism—espoused by his contemporaries through the mouth of a rather despicable character.

VII

. . . Oh, tell me who was first to announce, first to proclaim that man does nasty things simply because he doesn't know his own true interest; and that if he were to be enlightened, if his eyes were to be opened to his true, normal interests, he would stop doing nasty things at once and would immediately become good and noble, because, being so enlightened and understanding his real advantage, he would realize that his own advantage really did lie in the good; and that it's well known that there's not a single man capable of acting knowingly against his own interest; consequently, he would, so to speak, begin to do good out of necessity. Oh, the child! Oh, the pure, innocent babe! Well, in the first place, when was it during all these millennia, that man has ever acted only in his own self interest? What does one do with the millions of facts bearing witness to the one fact that people knowingly, that is, possessing full knowledge of their own true interests, have relegated them to the background and have rushed down a different path, that of risk and chance, compelled by no one and nothing, but merely as if they didn't want to follow the beaten track, and so they stubbornly, willfully forged another way, a difficult and absurd one, searching for it almost in the darkness? Why, then, this means that stubbornness and willfulness were really more pleasing to them than any kind of advantage. . . . Advantage! What is advantage? Will you take it upon yourself to define with absolute precision what constitutes man's advantage? And what if it turns out that man's advantage sometimes not only may, but even must in certain circumstances, consist precisely in his desiring something harmful to himself instead of something advantageous? And if this is so, if this can ever occur, then the whole theory falls to pieces. What do you think, can such a thing happen? You're laughing; laugh, gentlemen, but answer me: have man's advantages ever been calculated with absolute certainty? Aren't there some which don't fit, can't be made to fit into any classification? Why, as far as I know, you gentlemen have derived your list of human advantages from averages of statistical data and from scientific-economic formulas. But your advantages are prosperity, wealth, freedom, peace, and so on and so forth; so that a man who, for example, expressly and knowingly acts in opposition to this whole list, would be, in your opinion, and in mine, too, of course, either an obscurantist or a complete madman, wouldn't he? But now here's what's astonishing: why is it that when all these statisticians, sages, and lovers of humanity enu-

merate man's advantages, they invariably leave one out? They don't even take it into consideration in the form in which it should be considered, although the entire calculation depends upon it. There would be no great harm in considering it, this advantage, and adding it to the list. But the whole point is that this particular advantage doesn't fit into any classification and can't be found on any list. I have a friend, for instance. . . . But gentlemen! Why, he's your friend, too! In fact, he's everyone's friend! When he's preparing to do something, this gentleman straight away explains to you eloquently and clearly just how he must act according to the laws of nature and truth.[1] And that's not all: with excitement and passion he'll tell you all about genuine, normal human interests; with scorn he'll reproach the shortsighted fools who understand neither their own advantage nor the real meaning of virtue; and then—exactly a quarter of an hour later, without any sudden outside cause, but precisely because of something internal that's stronger than all his interests—he does a complete about-face; that is, he does something which clearly contradicts what he's been saying: it goes against the laws of reason and his own advantage, in a word, against everything. . . . I warn you that my friend is a collective personage; therefore it's rather difficult to blame only him. That's just it, gentlemen; in fact, isn't there something dearer to every man than his own best advantage, or (so as not to violate the rules of logic) isn't there one more advantageous advantage (exactly the one omitted, the one we mentioned before), which is more important and more advantageous than all others and, on behalf of which, a man will, if necessary, go against all laws, that is, against reason, honor, peace, and prosperity—in a word, against all those splendid and useful things, merely in order to attain this fundamental, most advantageous advantage which is dearer to him than everything else?

"Well, it's advantage all the same," you say, interrupting me. Be so kind as to allow me to explain further; besides, the point is not my pun, but the fact that this advantage is remarkable precisely because it destroys all our classifications and constantly demolishes all systems devised by lovers of humanity for the happiness of mankind. In a word, it interferes with everything. But, before I name this advantage, I want to compromise myself personally; therefore I boldly declare that all these splendid systems, all these theories to explain to mankind its real, normal interests so that, by necessarily striving to achieve them, it would immediately become good and noble—are, for the time being, in my opinion, nothing more than logical exercises! Yes, sir, logical exercises! Why, even to maintain a theory of mankind's regeneration through a system of its own advantages, why, in my opinion, that's almost the same

as . . . well, claiming, for instance, following Buckle,[2] that man has become kinder as a result of civilization; consequently, he's becoming less bloodthirsty and less inclined to war. Why, logically it all even seems to follow. But man is so partial to systems and abstract conclusions that he's ready to distort the truth intentionally, ready to deny everything that he himself has ever seen and heard, merely in order to justify his own logic. That's why I take this example, because it's such a glaring one. Just look around: rivers of blood are being spilt, and in the most cheerful way, as if it were champagne. Take this entire nineteenth century of ours during which even Buckle lived. Take Napoleon—both the great and the present one.[3] Take North America— that eternal union.[4] Take, finally, that ridiculous Schleswig-Holstein. . . .[5] What is it that civilization makes kinder in us? Civilization merely promotes a wider variety of sensations in man and . . . absolutely nothing else. . . . Previously man saw justice in bloodshed and exterminated whomever he wished with a clear conscience; whereas now, though we consider bloodshed to be abominable, we nevertheless engage in this abomination even more than before. Which is worse? Decide for yourselves. They say that Cleopatra (forgive an example from Roman history) loved to stick gold pins into the breasts of her slave girls and take pleasure in their screams and writhing. You'll say that this took place, relatively speaking, in barbaric times; that these are barbaric times too, because (also comparatively speaking), gold pins are used even now; that even now, although man has learned on occasion to see more clearly than in barbaric times, *he's still far from having learned* how to act in accordance with the dictates of reason and science. Nevertheless, you're still absolutely convinced that he will learn how to do so, as soon as he gets rid of some bad, old habits and as soon as common sense and science have completely re-educated human nature and have turned it in the proper direction. You're convinced that then man will voluntarily stop committing blunders, and that he will, so to speak, never willingly set his own will in opposition to his own normal interests. More than that: then, you say, science itself will teach man (though, in my opinion, that's already a luxury) that in fact he possesses neither

[1] Reference to doctrines of the Enlightenment.

[2] In his *History of Civilization in England* (1857–1861), Henry Thomas Buckle (1821–1862) argued that the development of civilization necessarily leads to the cessation of war. Russia had recently been involved in fierce fighting in the Crimea (1853–1856).

[3] The French emperors Napoleon I (1769–1821) and his nephew Napoleon III (1808–1873), both of whom engaged in numerous wars, though on vastly different scales.

[4] The United States was in the middle of a bloody civil war between the Union and the Confederacy (1861–1865).

[5] The German duchies of Schleswig and Holstein, held by Denmark since 1773, were reunited with Prussia after a brief war in 1864.

a will nor any whim of his own, that he never did, and that he himself is nothing more than a kind of piano key or an organ stop;[6] that, moreover, there still exist laws of nature, so that everything he's done has been not in accordance with his own desire, but in and of itself, according to the laws of nature. Consequently, we need only discover these laws of nature, and man will no longer have to answer for his own actions and will find it extremely easy to live. All human actions, it goes without saying, will then be tabulated according to these laws, mathematically, like tables of logarithms up to 108,000, and will be entered on a schedule; or even better, certain edifying works will be published, like our contemporary encyclopedic dictionaries, in which everything will be accurately calculated and specified so that there'll be no more actions or adventures left on earth.

At that time, it's still you speaking, new economic relations will be established, all ready-made, also calculated with mathematical precision, so that all possible questions will disappear in a single instant, simply because all possible answers will have been provided.[7] Then the crystal palace[8] will be built. And then . . . Well, in a word, those will be our halcyon days. Of course, there's no way to guarantee (now this is me talking) that it won't be, for instance, terribly boring then (because there won't be anything left to do, once everything has been calculated according to tables); on the other hand, everything will be extremely rational. Of course, what don't people think up out of boredom! Why, even gold pins get stuck into other people out of boredom, but that wouldn't matter. What's really bad (this is me talking again) is that for all I know, people might even be grateful for those gold pins. For man is stupid, phenomenally stupid. That is, although he's not really stupid at all, he's really so ungrateful that it's hard to find another being quite like him. Why, I, for example, wouldn't be surprised in the least, if, suddenly, for no reason at all, in the midst of this future, universal rationalism, some gentleman with an offensive, rather, a retrograde and derisive expression on his face were to stand up, put his hands on his hips, and declare to us all: "How about it, gentlemen, what if we knock over all this rationalism with one swift kick for the sole purpose of sending all these logarithms to hell, so that once again we can live according to our own stupid will!" But that wouldn't matter either; what is so annoying is that he would undoubtedly find some followers; such is the way man is made. And all because of the most foolish reason, which it seems, is hardly

worth mentioning: namely, that man, always and everywhere, whoever he is, has preferred to act as he wished, and not at all as reason and advantage have dictated; one might even desire something opposed to one's own advantage, and sometimes (this is now my idea) one *positively must do so*. One's very own free, unfettered desire, one's own whim, no matter how wild, one's own fantasy, even though sometimes roused to the point of madness— all this constitutes precisely that previously omitted, most advantageous advantage which isn't included under any classification and because of which all systems and theories are constantly smashed to smithereens. Where did these sages ever get the idea that man needs any normal, virtuous desire? How did they ever imagine that man needs any kind of rational, advantageous desire? Man needs only one thing—his own *independent* desire, whatever that independence might cost and wherever it might lead. And as far as desire goes, the devil only knows. . . .

. . . Gentlemen, you'll excuse me for all this philosophizing; it's a result of my forty years in the underground! Allow me to fantasize. Don't you see: reason is a fine thing, gentlemen, there's no doubt about it, but it's only reason, and it satisfies only man's rational faculty, whereas desire is a manifestation of all life, that is, of all human life, which includes both reason, as well as all of life's itches and scratches. And although in this manifestation life often turns out to be fairly worthless, it's life all the same, and not merely the extraction of square roots. Why, take me, for instance; I quite naturally want to live in order to satisfy all my faculties of life, not merely my rational faculty, that is, some one-twentieth of all my faculties. What does reason know? Reason knows only what it's managed to learn. (Some things it may never learn; while this offers no comfort, why not admit it openly?) But human nature acts as a whole, with all that it contains, consciously and unconsciously; and although it may tell lies, it's still alive. I suspect, gentlemen, that you're looking at me with compassion; you repeat that an enlightened and cultured man, in a word, man as he will be in the future, cannot knowingly desire something disadvantageous to himself, and that this is pure mathematics. I agree with you: it really is mathematics. But I repeat for the one-hundredth time, there is one case, only one, when a man may intentionally, consciously desire even something harmful to himself, something stupid, even very stupid, namely: in order *to have the right* to desire something even very stupid and not be bound by an obligation to desire only what's smart. After all, this very stupid thing, one's own whim, gentlemen, may in fact be the most advantageous thing on earth for people like me, especially in certain cases. In particular, it may be more advantageous than any other advantage, even in a case where it causes obvious harm and contradicts the most sensible conclusions of reason about advantage—because in any case it preserves for us what's most important and precious, that is, our person-

[6] A reference to the last discourse of the French philosopher Denis Diderot (1713–1784) in the *Conversation of D'Alembert and Diderot* (1769).

[7] Probably a reference to socialism.

[8] The building designed by Sir Joseph Paxton for the World's Fair in London in 1851 (Fig. 29-1).

ality and our individuality. There are some people who maintain that in fact this is more precious to man than anything else; of course, desire can, if it so chooses, coincide with reason, especially if it doesn't abuse this option, and chooses to coincide in moderation; this is useful and sometimes even commendable. But very often, even most of the time, desire absolutely and stubbornly disagrees with reason and . . . and . . . and, do you know, sometimes this is also useful and even very commendable? Let's assume, gentlemen, that man isn't stupid. (And really, this can't possibly be said about him at all, if only because if he's stupid, then who on earth is smart?) But even if he's not stupid, he is, nevertheless, monstrously ungrateful. Phenomenally ungrateful. I even believe that the best definition of man is this: a creature who walks on two legs and is ungrateful. But that's still not all; that's still not his main defect. His main defect is his perpetual misbehavior, perpetual from the time of the Great Flood to the Schleswig-Holstein period of human destiny. Misbehavior, and consequently, imprudence; for it's long been known that imprudence results from nothing else but misbehavior. Just cast a glance at the history of mankind; well, what do you see? Is it majestic? Well, perhaps it's majestic; why, the Colossus of Rhodes,[9] for example—that alone is worth something! Not without reason did Mr. Anaevsky[10] report that some people consider it to be the product of human hands, while others maintain that it was created by nature itself. Is it colorful? Well, perhaps it's also colorful; just consider the dress uniforms, both military and civilian, of all nations at all times—why, that alone is worth something, and if you include everyday uniforms, it'll make your eyes bulge; not one historian will be able to sort it all out. Is it monotonous? Well, perhaps it's monotonous, too: men fight and fight; now they're fighting; they fought first and they fought last—you'll agree that it's really much too monotonous. In short, anything can be said about world history, anything that might occur to the most disordered imagination. There's only one thing that can't possibly be said about it—that it's rational. You'll choke on the word. Yet here's just the sort of thing you'll encounter all the time: why, in life you're constantly running up against people who are so well-behaved and so rational, such wise men and lovers of humanity who set themselves the lifelong goal of behaving as morally and rationally as possible, so to speak, to be a beacon for their nearest and dearest, simply in order to prove that it's really possible to live one's life in a moral and rational way. And so what? It's a well-known fact that many of these lovers of humanity, sooner or later, by the end of their lives, have betrayed themselves: they've pulled off some caper, sometimes even quite an indecent one. Now I ask you: what can one expect from man as a creature endowed with such strange qualities? Why, shower him with all sorts of earthly blessings, submerge him in happiness over his head so that only little bubbles appear on the surface of this happiness, as if on water, give him such economic property that he'll have absolutely nothing left to do except sleep, eat gingerbread, and worry about the continuation of world history—even then, out of pure ingratitude, sheer perversity, he'll commit some repulsive act. He'll even risk losing his gingerbread, and will intentionally desire the most wicked rubbish, the most uneconomical absurdity, simply in order to inject his own pernicious fantastic element into all this positive rationality. He wants to hold onto those most fantastic dreams, his own indecent stupidity solely for the purpose of assuring himself (as if it were necessary) that men are still men and not piano keys, and that even if the laws of nature play upon them with their own hands, they're still threatened by being overplayed until they won't possibly desire anything more than a schedule. But that's not all: even if man really turned out to be a piano key, even if this could be demonstrated to him by natural science and pure mathematics, even then he still won't become reasonable; he'll intentionally do something to the contrary, simply out of ingratitude, merely to have his own way. If he lacks the means, he'll cause destruction and chaos, he'll devise all kinds of suffering and have his own way! He'll leash a curse upon the world; and, since man alone can do so (it's his privilege and the thing that most distinguishes him from other animals), perhaps only through this curse will he achieve his goal, that is, become really convinced that he's a man and not a piano key! If you say that one can also calculate all this according to a table, this chaos and darkness, these curses, so that the mere possibility of calculating it all in advance would stop everything and that reason alone would prevail—in that case man would go insane deliberately in order not to have reason, but to have his own way! I believe this, I vouch for it, because, after all, the whole of man's work seems to consist only in proving to himself constantly that he's a man and not an organ stop! Even if he has to lose his own skin, he'll prove it; even if he has to become a troglodyte, he'll prove it. And after that, how can one not sin, how can one not praise the fact that all this hasn't yet come to pass and that desire still depends on the devil knows what . . . ?"

You'll shout at me (if you still choose to favor me with your shouts) that no one's really depriving me of my will; that they're merely attempting to arrange things so that my will, by its own free choice, will coincide with my normal interests, with the laws of nature, and with arithmetic.

"But gentlemen, what sort of free choice will there be when it comes down to tables and arithmetic, when

[9] A large bronze statue of the sun god, Helios, built between 292 and 280 B.C. in the harbor of Rhodes (an island in the Aegean Sea) and considered one of the seven wonders of the ancient world.

[10] A. E. Anaevsky was a critic whose articles were frequently ridiculed in literary polemics of the period.

all that's left is two times two makes four? Two times two makes four even without my will. Is that what you call free choice?"

IX

Gentlemen, I'm joking of course, and I myself know that it's not a very good joke; but, after all, you can't take everything as a joke. Perhaps I'm gnashing my teeth while I joke. I'm tormented by questions, gentlemen; answer them for me. Now, for example, you want to cure man of his old habits and improve his will according to the demands of science and common sense. But how do you know not only whether it's possible, but even if it's *necessary* to remake him in this way? Why do you conclude that human desire *must* undoubtedly be improved? In short, how do you know that such improvement will really be to man's advantage? And, to be perfectly frank, why are you so *absolutely* convinced that not to oppose man's real, normal advantage guaranteed by the conclusions of reason and arithmetic is really always to man's advantage and constitutes a law for all humanity? After all, this is still only an assumption of yours. Let's suppose that it's a law of logic, but perhaps not a law of humanity. Perhaps, gentlemen, you're wondering if I'm insane? Allow me to explain. I agree that man is primarily a creative animal, destined to strive consciously toward a goal and to engage in the art of engineering, that, is, externally and incessantly building new roads for himself *wherever they lead*. But sometimes he may want to swerve aside precisely because he's *compelled* to build these roads, and perhaps also because, no matter how stupid the spontaneous man of action may generally be, nevertheless it sometimes occurs to him that the road, as it turns out, almost always leads *somewhere or other,* and that the main thing isn't so much where it goes, but the fact that it does, and that the well-behaved child, disregarding the art of engineering, shouldn't yield to pernicious idleness which, as is well known, constitutes the mother of all vices. Man loves to create and build roads; that's indisputable. But why is he also so passionately fond of destruction and chaos? Now, then, tell me. But I myself want to say a few words about this separately. Perhaps the reason that he's so fond of destruction and chaos (after all, it's indisputable that he sometimes really loves it, and that's a fact) is that he himself has an instinctive fear of achieving his goal and completing the project under construction? How do you know if perhaps he loves his building only from afar, but not from close up; perhaps he only likes building it, but not living in it, leaving it afterward *aux animaux domestiques,*[11] such as ants or sheep, or so on and so forth. Now ants have altogether different tastes. They have one astonishing

structure of a similar type, forever indestructible—the anthill.

The worthy ants began with the anthill, and most likely, they will end with the anthill, which does great credit to their perseverance and steadfastness. But man is a frivolous and unseemly creature and perhaps, like a chess player, he loves only the process of achieving his goal, and not the goal itself. And, who knows (one can't vouch for it), perhaps the only goal on earth toward which mankind is striving consists merely in this incessant process of achieving or to put it another way, in life itself, and not particularly in the goal which, of course, must always be none other than two times two makes four, that is, a formula; after all, two times two makes four is no longer life, gentlemen, but the beginning of death. At least man has always been somewhat afraid of his two times two makes four, and I'm afraid of it now, too. Let's suppose that the only thing man does is search for this two times two makes four; he sails across oceans, sacrifices his own life in the quest; but to seek it out and find it—really and truly, he's very frightened. After all, he feels that as soon as he finds it there'll be nothing left to search for. Workers, after finishing work, at least receive their wages, go off to a tavern, and then wind up at the police station—now that's a full week's occupation. But where will man go? At any rate a certain awkwardness can be observed each time he approaches the achievement of similar goals. He loves the process, but he's not so fond of the achievement, and that, of course is terribly amusing. In short, man is made in a comical way; obviously there's some sort of catch in all this. But two times two makes four is an insufferable thing, nevertheless. Two times two makes four—why, in my opinion, it's mere insolence. Two times two makes four stands there brazenly with its hands on its hips, blocking your path and spitting at you. I agree that two times two makes four is a splendid thing; but if we're going to lavish praise, then two times two makes five is sometimes also a very charming little thing.

And why are you so firmly, so triumphantly convinced that only the normal and positive—in short, only well-being is advantageous to man? Doesn't reason ever make mistakes about advantage? After all, perhaps man likes something other than well-being? Perhaps he loves suffering just as much? Perhaps suffering is just as advantageous to him as well-being? Man sometimes loves suffering terribly, to the point of passion, and that's a fact. There's no reason to study world history on this point; if indeed you're a man and have lived at all, just ask yourself. As far as my own personal opinion is concerned, to love only well-being is somehow even indecent. Whether good or bad, it's sometimes also very pleasant to demolish something. After all, I'm not standing up for suffering here, nor for well-being, either. I'm standing up for . . . my own whim and for its being guaranteed to me whenever necessary. For instance, suffering is not permitted in

[11] To domestic animals.

vaudevilles,[12] that I know. It's also inconceivable in the crystal palace; suffering is doubt and negation. What sort of crystal palace would it be if any doubt were allowed? Yet, I'm convinced that man will never renounce real suffering, that is, destruction and chaos. After all, suffering is the sole cause of consciousness. Although I stated earlier that in my opinion consciousness is man's greatest misfortune, still I know that man loves it and would not exchange it for any other sort of satisfaction. Consciousness, for example, is infinitely higher than two times two. Of course, after two times two, there's nothing left, not merely nothing to do, but nothing to learn. Then the only thing possible will be to plug up your five senses and plunge into contemplation. Well, even if you reach the same result with consciousness, that is, having nothing left to do, at least you'll be able to flog yourself from time to time, and that will liven things up a bit. Although it may be reactionary, it's still better than nothing.

X

You believe in the crystal palace, eternally indestructible, that is, one at which you can never stick out your tongue furtively nor make a rude gesture, even with your fist hidden away. Well, perhaps I'm so afraid of this building precisely because it's made of crystal and it's eternally indestructible, and because it won't be possible to stick one's tongue out even furtively.

Don't you see: if it were a chicken coop instead of a palace, and if it should rain, then perhaps I could crawl into it so as not to get drenched; but I would still not mistake a chicken coop for a palace out of gratitude, just because it sheltered me from the rain. You're laughing, you're even saying that in this case there's no difference between a chicken coop and a mansion. Yes, I reply, if the only reason for living is to keep from getting drenched.

But what if I've taken it into my head that this is not the only reason for living, and, that if one is to live at all, one might as well live in a mansion? Such is my wish, my desire. You'll expunge it from me only when you've changed my desires. Well, then, change them, tempt me with something else, give me some other ideal. In the meantime, I still won't mistake a chicken coop for a palace. But let's say that the crystal palace is a hoax, that according to the laws of nature it shouldn't exist, and that I've invented it only out of my own stupidity, as a result of certain antiquated, irrational habits of my generation. But what do I care if it doesn't exist? What difference does it make if it exists only in my own desires, or, to be more precise, if it exists as long as my desires exist? Perhaps you're laughing again? Laugh, if you wish; I'll resist all your laughter and I still won't say I'm

satiated if I'm really hungry; I know all the same that I won't accept a compromise, an infinitely recurring zero, just because it exists according to the laws of nature and it *really* does exist. I won't accept as the crown of my desires a large building with tenements for poor tenants to be rented for a thousand years and, just in case, with the name of the dentist Wagenheim on the sign. Destroy my desires, eradicate my ideals, show me something better and I'll follow you. You may say, perhaps, that it's not worth getting involved; but, in that case, I'll say the same thing in reply. We're having a serious discussion; if you don't grant me your attention, I won't grovel for it. I still have my underground.

And, as long as I'm still alive and feel desire—may my arm wither away before it contributes even one little brick to that building! Never mind that I myself have just rejected the crystal palace for the sole reason that it won't be possible to tease it by sticking out one's tongue at it. I didn't say that because I'm so fond of sticking out my tongue. Perhaps the only reason I got angry is that among all your buildings there's still not a single one where you don't feel compelled to stick out your tongue. On the contrary, I'd let my tongue be cut off out of sheer gratitude, if only things could be so arranged that I'd no longer want to stick it out. What do I care if things can't be so arranged and if I must settle for some tenements? Why was I made with such desires? Can it be that I was made this way only in order to reach the conclusion that my entire way of being is merely a fraud? Can this be the whole purpose? I don't believe it.

By the way, do you know what? I'm convinced that we underground men should be kept in check. Although capable of sitting around quietly in the underground for some forty years, once he emerges into the light of day and bursts into speech, he talks on and on and on. . . .

COMMENTS AND QUESTIONS

1. How would you describe the character of the "underground man"? To what extent is he realistic, and to what extent is he grotesque?

2. What does he mean by "advantage"? What is the one "advantage" that the "gentlemen" have not calculated?

3. What meanings does he attribute to the piano key, the organ stop, the crystal palace, and the anthill?

4. What is his quarrel with the fact that two times two make four?

5. What current nineteenth-century values and beliefs (see Chapter 28) does the underground man criticize, and how?

6. How would you summarize the underground man's view of human nature? Does the author seem to agree with it? Do you?

[12] A dramatic genre, popular on the Russian stage, consisting of scenes from contemporary life acted with a satirical twist, often in racy dialogue.

Summary Questions

1. How does nineteenth-century architecture, such as the Crystal Palace and the Chicago skyscrapers of Louis Sullivan, reflect economic and social developments and values of the time?

2. What were the major tenets of realism and of naturalism in painting and literature? Name some important realist and naturalist writers and artists.

3. Describe the development of photography in this period.

4. Why did Baudelaire call his collection of poetry *The Flowers of Evil*? How does his poetry portray life in the modern city?

5. What did Darwin mean by "evolution"?

6. What social theory did Herbert Spencer deduce from Darwin's theories?

7. Compare Nietzsche's and Dostoevsky's criticisms of their contemporary culture.

8. To what extent can Dostoevsky's style be called realist, and to what extent does it move beyond realism?

Key Terms

Commercial Style

realism

naturalism

symbolism

social Darwinism

Übermensch (Nietzschean "overman")

impressionism

Industrialism and the Humanities

The effects of industrialism on our modern world have been almost incalculable. In addition to restructuring the economic and social fabric of Western society, the Industrial Revolution contributed significantly to the ways in which human beings perceive themselves and their world.

Social, Political, and Scientific Thought

Much of the social and political thought of the nineteenth century takes the new conditions into account by extending the egalitarian ideas of the Enlightenment into the economic sphere. Early liberal stress on individual initiative in the marketplace was clearly an outgrowth of Enlightenment principles, but the cost of laissez-faire capitalism in human suffering, as Friedrich Engels's vivid descriptions of working-class life demonstrate, had to be reckoned with. Among the various socialist thinkers, Karl Marx, whose theories produced societies that might have astounded him, understood best the economic, social, and human consequences of industrialism.

Whereas most nineteenth-century socialist thought approached the problems of society from a collective viewpoint—seeing a person not so much as an individual but as a member of a group or class—the new liberalism from the middle decades of the century endeavored to foster social and economic justice while preserving an individualistic perspective. Its call for selective government intervention in the marketplace was based on the belief that such regulation would enhance the liberty of all while preventing the tyranny of the few. These newer liberals also urged extension of suffrage to members of the lower classes in the furtherance of Enlightenment goals. John Stuart Mill maintained that this goal necessitated recognition of the rights of women as well as of men. The feminist movements of the twentieth century owed much to Mill's arguments.

In any event, the pragmatic philosophy of the newer liberals, together with the preference of the lower classes for immediate economic gains, prevented the social revolution predicted by Marx and other radical thinkers.

The overall tendency in Western industrial societies by the end of the century was toward the amelioration of the living conditions of the lower classes and the rapid increase in the number of middle-class families.

Scientific and technological developments also contributed to changes in human perceptions. The evolutionary theories of Charles Darwin profoundly upset traditional religious and humanistic notions of humanity's unique position in creation. The notion of life as evolutionary, together with the increasing standard of living, generally tended to support belief in inevitable progress and to encourage an overriding interest in the material aspects of life.

Realism in the Arts

Artists responded to these conditions in various ways. Although romanticism remained the dominant trend in music until the very end of the nineteenth century, the style called realism came to dominate painting and literature around 1850. Realist artists and writers felt that the times called for depicting the world as it "really was." The invention and development of photography seemed in many ways to replace what the realists were trying to accomplish. Stressing the effects of the environment on individual characters, the realists and, even more so, the naturalists were often harshly critical of the social and psychological consequences of industrialism.

Architects tended either to escape from the modern world by building in revival styles such as Greek classical or Gothic, or to respond enthusiastically to the new technological possibilities. Unlike the often critical realistic painting and fiction, buildings such as the Crystal Palace in London and the early skyscrapers in Chicago are testimonies to a dynamic capitalistic society, proud of itself and its accomplishments.

Beyond Realism

During the closing decades of the nineteenth century many prominent artists and thinkers were reacting

333

against both the assurance that life could be portrayed as it seemed, "realistically," and the widespread contemporary self-satisfaction with material progress. Although still in the realist tradition, Dostoevsky maintained that reality was to be found more in the human soul than in the external environment. Afraid that modern emphasis on science, technology, and material progress would reduce human beings to mere automatons, Dostoevsky spoke passionately on behalf of a human freedom that sometimes runs contrary to reason. Nietzsche, who accepted Dostoevsky's emphasis on the irrational and spiritual but not his religious beliefs, insisted on the moral and intellectual weakness of Judaism and Christianity and proclaimed: "God is dead!" As a solution to the problems of humankind without God, he advocated the free development of all human potentialities in the individual "overman."

In painting, Edouard Manet served as a kind of bridge between realism and the style that became known as impressionism. Using the discoveries of photography and experimenting with light, the impressionists became more interested in rendering subjective "impressions" of the visible world than in attempting to portray objective reality. The postimpressionist artists and the symbolist poets veered even more sharply from the tenets of realism. The function of art became not to reproduce the crass material world but to create a purer—and indeed *truer*—world. Extending the romantic vision, these artists imposed a personal, symbolic view on the world of nature. By the end of the century, art seemed to many to fill the vacuum left by religion.

The City

The rapid growth of industrialism brought with it the equally rapid and unplanned development of what we have come to call urban sprawl. Cut off from the natural rhythms of rural living and from the reassurances of an ancestral homeland, millions of new city dwellers, although less likely to starve than they would have been in the country, came to experience not only the miserable living conditions but also the rootlessness and alienation endemic to city life. Social thinkers such as Engels described the sense of inhumanity present in city crowds composed of the indifferent well-off and the indigent and homeless. Novelists and poets such as Dostoevsky and Baudelaire expressed the hell-like nature of the city. For Baudelaire and the symbolist poets who followed him, the city became not so much a reality to be rendered objectively as an outward manifestation of the exploration of inner dreams and nightmares. The love-hate relationship with city life and the rift between ordinary external reality and poetic reality was to expand dramatically in the works of artists and writers of the early twentieth century.

PART X

Discontinuities:
The Early Twentieth
Century

30 Colonialism, the Great War, and Cultural Change

CHRONOLOGY

	CULTURAL	HISTORICAL
1850		Indian Mutiny (1857–1858) Berlin Conference (1885) Japanese annex Formosa (1895) Battle of Adowa (1896) Boxer Rebellion (1899)
1900	*Les Demoiselles d'Avignon* (1907) *Nude Descending a Staircase* (1912) The Robie House, Oak Park (1912) The Armory Show (1913) *The Rite of Spring* (1913)	Overthrow of Manchu dynasty in China (1911) World War I (1914–1918)
1915	Bauhaus founded (1919) Harlem Renaissance (1919–1932) T. S. Eliot's *The Wasteland* (1922) James Joyce's *Ulysses* (1922) The Radiator Building (1927) Virginia Woolf's *A Room of One's Own* (1929) Villa Savoye, Poissy (1929–1931)	Gandhi returns to India and begins struggle against British rule (1915) Russian Revolution; United States declares war on Axis (1917) Treaty of Versailles; Weimar Republic in Germany (1919) League of Nations (1920) Mussolini's dictatorship (1922) Stock market crashes (1929)
1930	*Civilization and Its Discontents* (1930) *Guernica* (1937)	Japan invades China (1931) Hitler elected chancellor of Germany (1932) The Great Depression (1932–1939) The Spanish Civil War (1936–1939)

CENTRAL ISSUES

- Radical change in the early twentieth century
- European colonialism in Africa, Asia, and the Middle East
- Western racism
- World War I and its effects on society, thought, and literature
- Communism and fascism in Europe
- Einstein's theory of relativity and its impact
- Major theories of Freud
- Japanese aggression in Asia in interwar years

The study of the humanities makes it evident that change—in forms, styles, ideas, outlooks, and especially in the apprehension of the nature of reality—is inevitable. The values and the truths of one generation cannot be those of the generation that succeeds it; the children must grow away from or revolt against the parents. We have seen that in certain periods change in the humanities comes about gradually, whereas in others it seems to erupt violently. No culture in the history of the world, however, has experienced either the extent or the intensity of change such as that which the West saw in the twentieth century. Changes in Western culture had profound repercussions on the rest of the world, and the rest of the world has in turn challenged the West's claim to leadership.

Colonialism

The late nineteenth century witnessed the development of what has been called the *new imperialism*. In many ways it was not new at all. The Portuguese, the Dutch, the French, and, above all, the British had been developing the slave trade, controlling trade routes, and acquiring overseas territory (including North America, Australia, South Africa, and Algeria) long before the late nineteenth century. But these four areas apart, the old colonialism was generally concerned with establishing a monopoly in trading with non-European areas, not with occupying the territory. European governments protected trading stations where local merchants brought goods for sale to European merchants, who carried them abroad for sale.

After 1850, with the development of industrialism in Europe and America, Western capitalists extended their grasp into areas that they had largely ignored earlier: tropical Africa, the South Pacific, and Southeast Asia. Increasingly, they installed themselves in these areas, modernized production of goods and means of transportation, and reduced large segments of the population to wage labor under their control. Colonies were now valued by the colonial power as suppliers of raw materials and cheap industrial goods as well as consumers for what the colonizer had to sell. Both to garner national prestige and to protect their citizens' investments, European governments either asserted direct political authority over non-European areas or controlled the countries through indigenous rulers. The years after about 1880 witnessed an increasingly bitter competition among European powers, notably Britain, France, and Germany, each trying to establish its flag over as many colonies in the world as possible. Beginning in the 1890s, Japan, which was rapidly becoming industrialized, joined the competition.

Africa

The competition was especially intense for colonies on the African continent and coincided with the final abolition of the transatlantic slave trade. The decisive first steps taken against the trade occurred after its formal abolition by the French in 1794 and the British and Americans in 1808 (the latter two only abolished slavery itself in 1838 and 1865, respectively). Britain then took it upon itself to intervene in West African waters in order to liberate captured slaves before they were transported to the New World. The liberated slaves were deposited in the colony of Freetown (now capital of Liberia), established on the West African coast in the late eighteenth century at the urging of abolitionists.

West African countries that had engaged in the slave trade rebounded by embracing the Europeans' new interests in developing "cash crops" in tropical products for European industries. But as the political competition among European powers intensified, Europeans sought to supplant African merchants in their own countries. By the late 1880s, significant capital resources from Europe funded the construction of major infrastructure, such as roads and railways, in the regions rich in minerals or cash crops such as rubber, cocoa, and coffee. By then, cash crop production had become an important feature of many African peoples' economy, but markets were largely controlled by Europeans.

Africans only belatedly saw that the relationship with Europe was moving from equal (or even unequal) trading partnerships to that of white businessman and African worker. In response, African leaders displayed a variety of political and diplomatic maneuvers before resorting to outright military resistance against conquest, but by that time the military superiority of European firearms resulted in the Africans' defeat everywhere except Ethiopia. The defeat of the Italian army by the Ethiopians at the Battle of Adowa in 1896 struck a blow to Italian nationalism only revenged by the fascist conquest of Ethiopia in 1935.

Throughout the last decades of the nineteenth century the nations of Europe endeavored to regulate the cutting up of Africa so as to avoid warfare among the competitors. The Berlin Conference of 1885 established the principle that a European power that had established itself on a coast had rights to the backcountry as well. However, to win recognition of ownership, a nation had to demonstrate a military and administrative presence in the area claimed. This rule ignited a scramble for territory, and by 1900, with the exception of the Kingdom of Ethiopia and Liberia (under U.S. protection), the whole continent was divided up among European powers.

Coming late to the feast, the newly formed nations of Italy (1870) and Germany (1871) were particularly eager to have a seat at the table. The Muslim countries of North Africa had long been a target for French and British business interests. Already in 1830 France claimed Algeria as a colony and encouraged French immigration. In 1881 Tunisia was annexed to France as well. The establishment of a British protectorate in Egypt in 1882, however, led France to establish a similar protectorate in Tunisia and to extend French influence in Morocco. In 1912 France and Spain partitioned Morocco.

Britain had the lion's share of East Africa. Its control of Egypt created a broad British East African empire stretching from the Mediterranean down to Cape Town in South Africa. Only Mozambique, which belonged to Portugal, and the Belgian colony of the Congo interrupted the British chain of territories. Most of West Africa belonged to the French. Nevertheless, the British also had some colonies there, as did Portugal

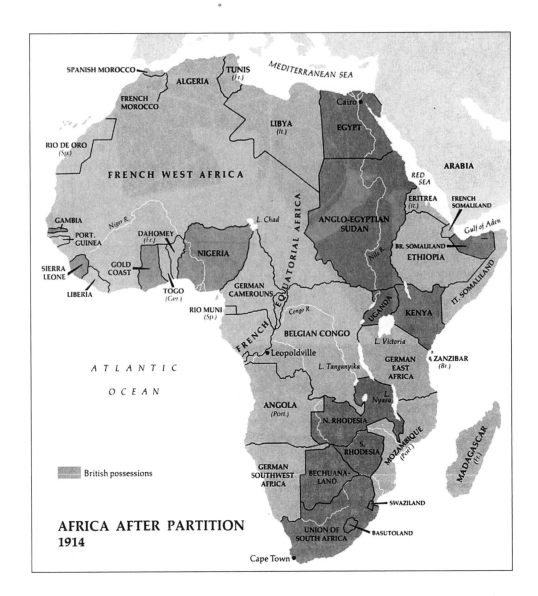

AFRICA AFTER PARTITION 1914

British possessions

in Angola, while a few Spanish colonies faced on the northern Atlantic. Disgruntled, the Germans and Italians took what was left unoccupied, the Germans along both western and eastern coasts and the Italians in North Africa and along the Red Sea (see map).

The newcomers were not the only troublemakers. Britain and France were often at loggerheads over colonial possessions. In a few instances clashes between the two powers in colonial adventures threatened to lead to war. Doubtless, the competition for colonies, especially in Africa, fueled the fires of nationalism leading up to World War I.

Asia

The situation in Asia differed from that in other regions because there Europeans lacked the human resources to govern on their own. Consequently, colonial domination of Asia depended heavily on governing through the local populations. To carry on the work of administra-

tion, the colonial rulers needed educated native clerks—which meant schools and universities and an educated middle class. At the same time, however, Western education introduced the local peoples to subversive ideas, such as those contained in the American Declaration of Independence and in *The Communist Manifesto*.

India Beginning in 1600, when it was founded, the English East India Company developed important trading stations in India, principally at Bombay, Madras, and Calcutta. By the eighteenth century company officials had learned how to exploit political conflicts between the various Indian states to the company's advantage. As its strategy of divide and conquer evolved, the company successfully replaced Indian rulers in large areas of the peninsula through the use of an army led by English officers but composed mostly of Indian troops. With the dangerous mutiny of the company's Indian army in 1857–1858, the British government decided to take over the part of India controlled by the East India

Company and in time to extend British rule over the whole subcontinent. India was the first example of the new imperialism.

Although there had been occasional resistance by traditional rulers, peasant revolts, and army mutinies, true nationalism in India was mainly a product of the growth of an educated middle class in the late nineteenth century. The Indian National Congress was founded in 1885. By the early 1900s it had become a force. During World War I, to keep India "loyal" and maintain military recruitment, the British promised self-government and eventual dominion status. When they were slow in implementing these promises, Mohandas Gandhi (1869–1948), an English-trained lawyer and religious guru, led the Indian freedom struggle along a mainly *nonviolent* path. The British could crush violence, but the unarmed Indians following Gandhi's ideas of nonviolent protest were eventually successful in overturning British rule.

Pacific Islands Among the colonizing efforts of the European powers in the Pacific Ocean, the most economically successful was the Dutch colony in the Indonesian archipelago. Although the Dutch had established a colony at Batavia (Jakarta) on the island of Java in 1619, only after the Napoleonic wars ended in 1815 did they expand their control over the entire chain of islands. Because the islands were densely inhabited, the Dutch drew profits not only from export abroad but also from an active internal trade. Dutch control was not untroubled by revolts: large areas on some islands resisted Dutch penetration into the twentieth century, and tensions between the Dutch and the largely Muslim populations often ran high. But the enormous profits derived from the colony justified the military and administrative expenses of the occupation.

China Unlike India and Indonesia, China was never formally colonized (see map). Ruled by the decadent

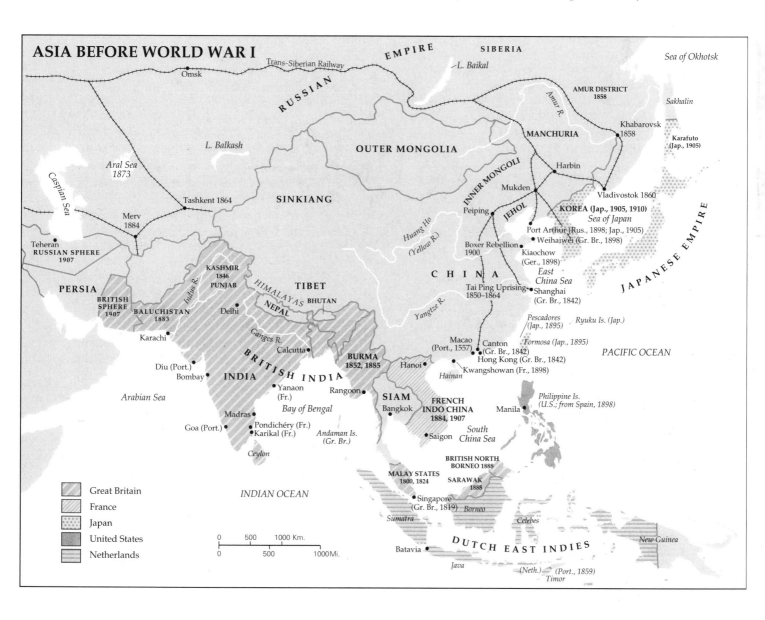

Manchu dynasty, China in the nineteenth century witnessed a number of bloody civil wars. Ever since the 1790s the Chinese had also undergone a series of destructive and humiliating defeats at the hands of European powers, including a war with the British in 1842, caused by the efforts of the Chinese government to stop British merchants from importing massive amounts of Indian opium into the country. Another war occurred in 1857 when France and Britain undertook to force China to allow their merchants to trade throughout the country exempt from Chinese law. As a result of defeat in both wars, the government ceded Hong Kong to Britain, opened a number of China's biggest ports to European settlement, granted Europeans everywhere exemption from Chinese law, and agreed to pay huge indemnities. Although the Chinese empire remained nominally independent, it was in fact carved up into "spheres of influence," areas of China in which commerce and industry were largely under the control of individual European powers.

Britain's seizure of Hong Kong was only the beginning of the dismemberment of the most outlying parts of Chinese territory. In 1860 the Russians grabbed the northernmost province of the country and in 1900 occupied Manchuria for five years. In the 1880s the French took the southernmost portion of China and incorporated it into what became Vietnam. The English in 1883 claimed Burma. Then in 1895 the Japanese took the island of Formosa and sponsored an independent Korea, which it annexed fifteen years later as its own colony.

When in 1900 the Chinese struck back in anger (led by the Order of Harmonious Fists, or Boxers) and suffered defeat, the Western nations again insisted on large indemnity payments and on the right to collect Chinese customs duties until the indemnity was paid. For an ancient, once powerful empire, it was a painful, humiliating experience. In 1911, however, a movement led by the Christian and U.S.-educated Dr. Sun Yat-sen (1866–1925) overthrew the Manchu dynasty, justifying this action with a document closely modeled on the American Declaration of Independence.

Japanese Colonialism The Japanese seizure of Formosa in 1895 was a clear sign that Japan would not permit Europeans to monopolize the profits of Asian colonialism. In the seventeenth century under the Tokugawa shogunate, the island had deliberately and effectively sealed itself off from Western intrusion, slaughtering a million or so Japanese Christians and limiting Western contact to one Dutch ship per year. Japan kept to itself until 1850 when the American commodore Matthew Perry forced his way into Tokyo harbor. Despite appearances, however, Japan opened—or rather exploded—from within. The next few years witnessed a fierce struggle between those who wished to return to isolationism and those who thought Japan had to mod-

ernize in order to survive, with the Meiji Restoration of 1868 reflecting the triumph of the latter. Then in one generation Japan built a modern army and navy, as well as an industrial system dominated by military requirements (iron and steel for guns, textiles for uniforms). Astoundingly, in 1904–1905 Japan defeated Russia, a European power. Shortly afterward, it rewarded itself for its victory by occupying Korea. With a navy, colonies, and factories, Japan was already a great power even before World War I.

The Middle East

By the nineteenth century the Ottoman Empire, product of Turkish conquests beginning in the twelfth century against Christian and other Muslim states, was commonly regarded as "the sick man of Europe." At the widest extent of their empire in the seventeenth century, the Ottoman Turks had ruled over a territory extending east from Persia to Algeria in North Africa and Austria in Europe; on the north from deep in southern Russia down to the Sudan, Saudi Arabia, and the Red Sea on the south. By the late nineteenth century the Turkish empire was still relatively large but growing weaker by the decade. In Europe and the Middle East it still ruled over a portion of the Balkans stretching from Constantinople to the Adriatic, several major islands in the Mediterranean, Syria, Palestine, and the large landmass of Anatolia. In Africa it had left only Libya and theoretical sovereignty over Egypt.

Despite centrifugal forces diminishing its authority, the empire survived largely because Britain and France feared that if it collapsed, Russia would devour so much territory that the European balance of power would be destroyed. At the same time, the weakness and financial needs of the Turkish government offered inviting opportunities to foreign investment and exploitation of Turkish resources. British, French, and Russian business interests had almost free play in Syria in the late nineteenth century. By the first decade of the twentieth century the Germans, frustrated in their pursuit of colonial acquisitions and viewing Turkey and the Balkans as a suitable alternative, poured enormous amounts of capital into the empire, thus laying the basis for the military alliance between Germany and Turkey in World War I.

The political instability of late-nineteenth-century Persia (modern Iran) was similar to that of Turkey. Susceptible to bribery and political pressure, the weak government of the shah granted European merchants extensive trading privileges, especially for the exportation of primary materials, such as cotton and tobacco, while facilitating the importation of European manufactured goods that resulted in an unfavorable balance of trade for Persia. Up to World War I the British, the dominant European traders in Persia, were fervent supporters of

the shah, as they were of the Turkish sultan, and they were fearful of the ambitious Russia, which bordered Persia on the north. In Persia and in Turkey as well as in Indonesia, all primarily Muslim countries, intellectuals were almost unanimous in opposing European colonialism, but they were deeply divided over what they wanted out of self-government. Many looked forward to the creation of a modern secular state, whereas others placed their hope in the revival of a Muslim theocratic state.

Effects of Colonization

The effects of colonization on the local populations were mixed but on balance devastating. The population of the African continent is estimated to have fallen by about one-third between 1880 and 1925, largely because of the spread of new diseases. The cultural cost is harder to determine. The disintegration of a traditional society, that of the Ibo in Nigeria, for instance, is graphically chronicled by the Nigerian writer Chinua Achebe (b. 1930) in his novel *Things Fall Apart.* Within one generation, however (as shown in his later novels dealing with descendants of the central character, Okon-kwo), the extremely aggressive, achievement-oriented, small-scale society that Achebe portrays had exploded upward and outward. It was marked by large numbers of converts to Christianity and an unquenchable thirst for education. Ibos spread all over Nigeria as clerks. Europeans brought some good, including schools, railroads, medicine, and what were sometimes favorable economic opportunities for Africans (for instance, cocoa farming in Ghana).

The influence, however, was not all one way. Especially in the visual arts in the decades before World War I, western Europeans, looking beyond their own culture, proved receptive to the civilization of the colonized peoples. Chapters 31 and 32 will assess the effects of this receptivity.

Racism

An aggressive, pseudoscientific racism served to justify the intensification of European influence on the rest of the world in the second half of the nineteenth century. The application of Darwin's ideas on evolution to that of human communities gave rise to the ranking of "civilized" and "uncivilized" peoples, which encouraged imperial conquest. According to such writers as the Frenchman Count Joseph de Gobineau and the Englishman Houston Stewart Chamberlain, the "races of man" were vastly and inherently unequal. Mental capacity was linked to size and "convolutions" of the brain, and much effort went into collecting and measuring skulls. White (Caucasian) people emerged from these investigations as the "fittest." The "civilizing mission" drew to the continent a broad range of Christian missionaries whose urgent voices joined those of the free-traders as

critical "men on the spot" enthusiasts for European imperial policy.

The racial thinking of the late nineteenth and early twentieth centuries was particularly vicious and nasty. In that period the document called the "Protocols of the Elders of Zion," supposedly outlining a Jewish conspiracy to control the world, was forged. In the United States lynching statistics grew alarmingly, and segregation became entrenched in the legal system of the South.

The Great War (World War I) and Its Aftermath

By the first decade of the twentieth century, most of the desirable opportunities for colonial expansion had already been realized by Great Britain and France, and Italy and Germany felt cheated of their share of the spoils. Conscious of being the most powerful industrial nation on the continent by 1900 and burgeoning with a highly skilled population, Germany felt particularly wronged in this regard. If, however, their efforts to replace British and French influence in Africa were largely frustrated, the Germans were highly successful in asserting their economic domination over large areas of eastern Europe, including Turkey and its Middle Eastern empire. In this undertaking the Germans were favored by the government of the sprawling Austro-Hungarian Empire, which relied on promises of German support to keep its restive national minorities in check and to extend its control farther over Serbian lands to the south. In 1914, the assassination of the heir to the Austro-Hungarian throne while he visited Serbia furnished the Austro-Hungarian government with the excuse to declare war on Serbia and almost immediately brought into play the alliance systems carefully worked out over previous decades. The Central Powers—Germany, Austria-Hungary, and Turkey—opposed the Allies: Great Britain, France, Belgium, Serbia, and Russia. Italy joined the Allies in 1915.

The Great War, as it was called, began in August 1914 in an almost careless mood, with plumes and full-dress parades, but within the first year it became a war fought across two rows of opposing trenches that stretched from the North Sea across northern France to the Swiss border (see map). Interminable days and nights of waiting in muddy holes alternated with sudden attacks across a no man's land in the face of fire from one of the new weapons of modern war, the machine gun. The growth of industrialism had made possible other technological advances for quickly killing large numbers of people: the tank, the warplane, and poison gas. Over the four-year period of war, the lines moved only slightly, and advances, often costing the lives of thousands of men, were measured in yards. The most costly battle of the war, the Battle of the Somme,

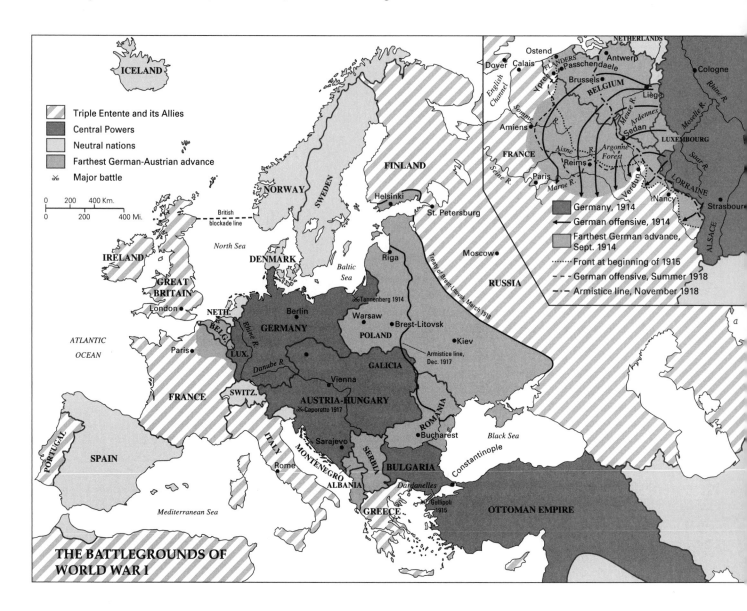

THE BATTLEGROUNDS OF
WORLD WAR I

lasted four months in 1916 and took the lives of 1.1 million men with no significant change in positions (see Daily Lives box).

The Allies' loss of Russia in 1917 (because of the revolution there) freed the Central Powers from having to fight a war on two fronts, but the entry of the United States on the Allied side in the same year more than restored the balance. Although the Central Powers put up a vigorous fight for yet another year, by the spring of 1918 American troops were pouring into France at the rate of one-quarter million a month, and the Central Powers were unable to resist the overwhelming power of the Allies. On November 11, 1918, the Central Powers begged for peace and an armistice was signed.

Europeans on both sides became almost immediately aware that the war had, if anything, aggravated long-standing problems. The losses in human life, land, and property were enormous, and it was difficult to say

that anything had been gained. At Versailles in 1919, where the peace settlement was worked out, the major European powers, primarily France and England, intentionally set out to cripple Germany so that it could not again pose a threat to the victors. Parts of its territory were taken away (see map), and the newly established democratic government, the Weimar Republic, was burdened with paying an astronomical reparations debt to its former enemies. Restrictions were placed on the size of the German army. While the fledgling government in Germany suffered peculiar handicaps, democracy there, as in the half-dozen new countries created out of the old Austro-Hungarian Empire, also suffered from the lack of any sort of republican tradition. Most, although not all, of these governments created by the victors in the lands of the vanquished had little popular support in their own country. The weakness of these new states therefore made the whole political atmosphere unstable.

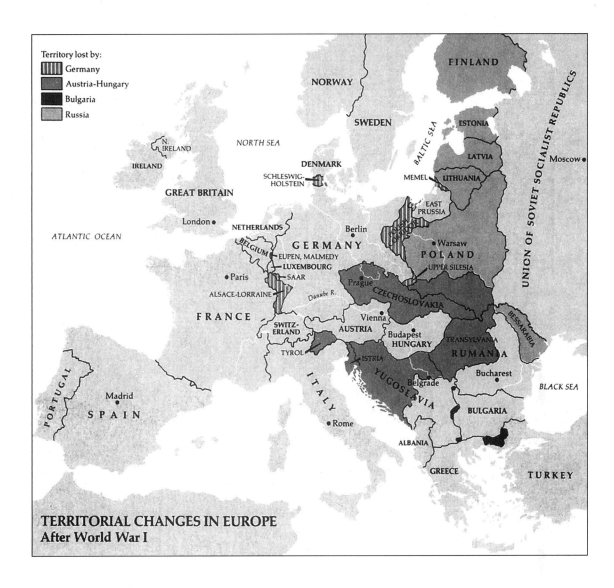

TERRITORIAL CHANGES IN EUROPE
After World War I

The League of Nations

To ensure that this war really had been *"a war to end all wars,"* the victors at Versailles, led by Woodrow Wilson, the American president, drew up a covenant, or constitution, for an international organization designed to defend the independence of every member nation. Created in 1920 at Geneva, the League of Nations further encouraged prewar colonialism by assigning former German colonies and parts of the Ottoman Empire to France and Britain as *mandates,* internationally recognized grants of administrative power over these territories. Britain received Mesopotamia (modern Iraq), Palestine, and Trans-Jordan (modern Jordan), in addition to a number of former German colonies in Africa. The French received a mandate for Syria and added most of Germany's remaining African territories. Japan was awarded many of Germany's colonies in the Pacific.

The refusal of the United States to participate in the League's operations weakened the organization

from the very beginning. Throughout its life in the years between the two world wars, the League was further hampered by conflicting interpretations of its purposes by member nations and by its inability to take decisive action when a powerful nation was party to a dispute.

The Literature of World War I

Although there was a great deal of patriotic writing about the "great war," the best literature by the writers who lived through it tends to portray the discrepancy between high-minded idealism and the shocking reality of modern warfare, with its long days in the trenches; human suffering from hunger, disease, and gas attacks; and the many lives senselessly lost. The title of Ernest Hemingway's (1899–1961) novel *A Farewell to Arms* (1929) recalls the hope that this was the war to end all wars, but the novel portrays the disappointment with that hope. Hemingway, to be sure, admired courage in battle, which he depicts with characteristic understatement, but

Life in the Trenches

In his autobiography, Robert Graves (1895–1985) vividly sketches the horrors of World War I as seen from the British trenches. He joined the war immediately after it was declared, became a commissioned officer, and served on the Western Front until he was severely wounded at the Battle of the Somme in the summer of 1916. Sent home to recuperate, he returned to the battlefield in early January 1917 but proved physically unable to sustain the rigors of the trenches. He spent the remainder of the war recovering from his wounds. The following passage is taken from his account of the Battle of the Somme in 1916, the most murderous battle of the war:[a]

. . . For the next two days we were in bivouacs outside the wood. We were in fighting kit and the nights were wet and cold. I went into the wood to find German overcoats to use as blankets. Mametz Wood was full of dead of the Prussian Guards Reserve, big men, and of Royal Welch and South Wales Borderers of the new-army battalions, little men. There was not a single tree in the wood unbroken. I got my greatcoats and came away as quickly as I could, climbing over the wreckage of green branches. Going and coming, by the only possible route, I had to pass by the corpse of a German with his back propped against a tree. He had a green face, spectacles, close shaven hair; black blood was dripping from the nose and beard. He had been there for some days and was bloated and stinking. There had been bayonet fighting in the wood. There was a man of the South Wales Borderers and one of the Lehr regiment who had succeeded in bayoneting each other simultaneously. A survivor of the fighting told me later that he had seen a young soldier of the Fourteenth Royal Welch bayoneting a German in parade-ground style, automatically exclaiming as he had been taught: "In, out, on guard." He said that it was the oddest thing he had heard in France. . . .

Our brigade, the Nineteenth, was the reserve brigade of the Thirty-third Division; the other brigades, the Ninety-ninth and Hundredth, had

attacked Martinpuich two days previously and had been stopped with heavy losses as soon as they started. Since then we had had nothing to do but sit about in shell-holes and watch the artillery duel going on. We had never seen artillery so thick. On the 18th we moved up to a position just to the north of Bazentin le Petit to relieve the Tyneside Irish. I was with D Company. The guide who was taking us up was hysterical and had forgotten the way; we put him under arrest and found it ourselves. As we went up through the ruins of the village we were shelled. We were accustomed to that, but they were gas shells. The standing order with regard to gas shells was not to put on one's respirator but hurry on. Up to that week there had been no gas shells except lachrymatory ones;[b] these were the first of the real kind, so we lost about half a dozen men. When at last we arrived at the trenches, which were scooped at a roadside and only about three feet deep, the company we were relieving hurried out without any of the usual formalities; they had been badly shaken. I asked their officer where the Germans were. He said he didn't know, but pointed vaguely towards Martinpuich, a mile to our front. Then I asked him where and what were the troops on our left. He didn't know. I cursed him and he went off. We got into touch with C Company behind us on the right and with the Fourth Suffolks not far off on the left. We began deepening the trenches and locating the Germans; they were in a trench-system about five hundred yards away but keeping fairly quiet.

The next day there was very heavy shelling at noon; shells were bracketing along our trench about five yards short and five yards over, but never quite getting it. We were having dinner and three times running my cup of tea was spilt by the concussion and filled with dirt. I was in a cheerful mood and only laughed. I had just had a parcel of kippers from home; they were far more important than the bombardment.

a. Robert Graves, *Goodbye to All That: An Autobiography* (New York: Jonathan Cape and Harrison Smith, 1930), pp. 252–255.

b. Tear gas shells.

his vision of war is ultimately a pessimistic one. The greatest World War I novel is probably *All Quiet on the Western Front* (1928), a semiautobiographical account by the German Erich Maria Remarque (1898–1970), who fought as a soldier in the trenches. Written in the first person, the present tense, and in short, simple sentences, the novel traces the experience of a young soldier and his comrades and vividly renders their reactions to shell fire, violent death, sickness, and gas attacks.

Two British poets, Rupert Brooke (1887–1915) and Wilfred Owen (1893–1918), both died while fighting in the war but left powerful poetry expressing the horror of modern combat and disillusionment with war itself. Some of Owen's poems were set to music by the composer Benjamin Britten (1913–1976) in his *War Requiem*. Although owing much to nineteenth-century English poetry, Owen introduces modern, colloquial, and graphic language in his poems to render his experience. Modernist poets such as Ezra Pound (1885–1972) and T. S. Eliot (1885–1965) were affected after the war by the sense that Western civilization itself had been mortally wounded, and that what remained was "The Waste Land" (the title of Eliot's great poem, 1922).

Decline of the West

Europe in the early 1920s was worn out and discouraged. Symptomatic of the weariness and sense of decline was the work of Otto Spengler (1880–1936) with its ominous title, *The Decline of the West*. For Spengler, Western culture was in old age, and its ruling classes were timid and not so much governing as administrating. Without faith and self-discipline, the forces of anarchy would grow in the society, and unless strong leaders arose, the West would continue its path of decline.

The new governments formed out of the defeated states proved highly unstable. The war had created a cooperative spirit between workers and bosses, but, with the war over, social conflicts increased markedly. Capitalists nervously eyed developments in Russia, where a communist state came into being infused with missionary zeal. Would the workers in the capitalist countries heed the call to revolt? Many expected another dreaded war, but it was felt more than likely that that war would be an affair not of nations but of classes.

Scientific Developments

In the pure sciences, a series of astounding new discoveries in the early twentieth century altered the scientific picture of the natural world as radically as had Newtonian physics in the seventeenth century and Darwinian biology in the nineteenth. Among the more important was Max Planck's (1858–1947) discovery at the turn of the century that atoms emit energy not with continuity but in separate units. Several years later Albert Einstein (1879–1955) initially expounded his theory of *relativity:* that space, time, and motion are not absolute (as Newtonian physics had assumed), but rather are relative to the observer's position. Newtonian conceptions appeared inapplicable to the atom or the universe where movement was measured at the speed of light.

There are, however, two essential differences between this scientific revolution and the two previous ones. First, whereas the intelligent layperson could read Newton and Darwin and gain a fairly good understanding of their theories, it was and is impossible for someone without scientific training to have more than a superficial understanding of the discoveries of Planck and Einstein. Second, whereas Newton offered a rational picture of the world and evolution stressed progressive continuity between one species and another, the new physics seemed to postulate a world without continuity or absolutes, a world in which nothing was certain. Even without a scientific knowledge of physics, twenty-first-century human beings are well aware that a world composed of subatomic particles, a world in which matter and energy, space and time, interpenetrate, a world in which scientific laws are given names like "relativity" (Einstein) or "uncertainty" (Werner Heisenberg), is a world in which nothing is as it appears to be to the human senses.

In the social sciences, too, certainties of the past gave way to uncertainties or relativities. Developments in anthropology emphasized the relativity of cultural values. The new science of psychology (launched in the 1870s) showed, first through the work of the Russian Ivan Pavlov (1849–1936), that human beings could be conditioned by their environment to elicit certain responses and thus do not act primarily from reason and conscious decision. Foremost in upsetting traditional notions about human nature was the work of Sigmund Freud. Freud's theories that our actions and behavior are rooted in our unconscious, rather than in our conscious mind, seemed to many a more pessimistic view of human nature than Darwin's theories about our ancestry.

Sigmund Freud (1856–1939)

The debacle of World War I and the precarious character of peace in the postwar years led Sigmund Freud, like Spengler and others of that generation, to meditate on the nature of civilization. As a psychologist rather than a historian, Freud was primarily interested in the conflicts between individuals and their society, and reflection led him to trace the origins of civilized life back to its source in the human psyche. Freud's thought is represented in his central work on this theme, *Civilization and Its Discontents* (1930). To

assess his considerable impact on modern culture, however, it is also necessary to know something of the development of his ideas before that work. We will summarize this development briefly.

Depth Psychology

A Viennese neurologist, Freud left his first vocation to develop what came to be called "depth psychology." This depth psychology claimed to furnish a key to the exploration of the unconscious mind and, through this, a renewed knowledge of the conscious mind, with wider application to the understanding of literature, art, religion, and culture. The first dynamic psychiatry had been, in the main, the systematization of observations made on hypnotized patients. With Freud's method of free association, a new approach was introduced. The patient, relaxed on a couch, was told the basic rule: to tell whatever came to mind, no matter how futile, absurd, embarrassing, or even offensive it seemed.

Three Parts of Mind

Much of Freud's understanding of the human individual rests on his contention that mental life is produced by the interaction of three psychic agencies: the ego, the id, and the superego. He defined the *ego* as "the coordinated organization of mental processes in a person." The *id* was not very different from what Freud had originally described as the unconscious, the seat of both the repressed material and the drives, to which had been added the unconscious fantasies and unconscious feelings, notably guilt feelings. The *superego* is the watchful, judging, punishing agency in the individual, the source of social and religious feelings in humankind.

The main aspects of depth psychology were Freud's dream theory and his theory of parapraxis, or faulty behavior, that is, slips of the tongue and erroneously carried out actions. These theories were elaborated simultaneously and presented in two of his best-known books, *The Interpretation of Dreams* in 1900 and *The Psychopathology of Everyday Life* in 1904.

Dreams

Freud's theory of dreams has been told so often that it has become, for many people, common knowledge. Among the many trivial events of the day, the dream chooses the one that shows some relationship to a childhood memory; and, as Freud puts it, the dream stands with one foot in the present and one foot in childhood. Thus one is led from the latent content of the dream still further back to a childhood memory expressing an unfulfilled wish of that remote time. Here

Freud introduced the notion he had found in his self-analysis and in his patients, the *Oedipus complex*: the little boy, wanting to possess his mother, wishes to get rid of his father; but he is frightened of this threatening rival and of castration as a punishment for his incestuous feelings toward the mother. Such is, Freud says, the terrible secret that every man keeps in the recesses of his heart, repressed and forgotten, and which appears in a veiled form in a dream every night. Freud named this complex from the Greek myth on which Sophocles built his tragedy. Freud postulated a similar trauma for women, the *Electra complex*, in which the little girl desires to have children by her father and to kill her mother. A great reader in the humanities, Freud was well aware that profound psychological truths had been expressed in literature and art before being formulated scientifically.

The dream, for Freud, is essentially a fulfillment of a repressed, unacceptable sexual wish. When controls of consciousness are relaxed, waking acts, too, can reveal repressed wishes or desires. Such acts include forgetting proper names, slips of the tongue and speech blunders, mistakes in reading and writing, acts of physical clumsiness, and intellectual errors.

The Pleasure Principle and Instincts

Also important in Freud's thinking are his theories of the pleasure principle and of the instincts, *Thanatos* and *Eros*, as discussed in his *Beyond the Pleasure Principle* (1920). The pleasure principle may be understood as a person's constant attempt to achieve pleasure and to avoid pain. As for his dualistic theory of instincts, Freud contended that Eros included the sexual instincts, most of the egoistic or self-preservative impulses, and those drives and forces that enhanced and unified life. Thanatos, on the other hand, included the tendency to self-punishment in the individual as well as those impulses that denied life and disrupted civilized existence. Thus Freud hypothesized that perhaps there was an innate tendency in the psychobiological makeup of people that overrides the pleasure principle. Or, expressed another way, since the aim of the instincts (according to Freud's older definition) was to diminish tension and since this was also his definition of pleasure, the ultimate pleasure was not life or Eros, but Thanatos, stasis or death. There is no doubt that the experience of World War I influenced Freud's concept of the "death wish."

Freud on Religion, Culture, and Literature

Soon after he had conceived his psychoanalytic theory, Freud expanded his reflection on the fields of religion, sociology, cultural history, art, and literature. In 1907 he compared obsessive-compulsive symptoms with religious rituals and creeds, concluding that religion was a

universal obsessional neurosis and that obsession was an individualized religion. Twenty years later, in *The Future of an Illusion*, Freud defined religion as an illusion inspired by infantile belief in the omnipotence of thought, a universal neurosis, a kind of narcotic that hampers the free exercise of intelligence, something that humanity will have to give up. With *Totem and Taboo* Freud undertook to retrace the origin not only of religion but of human culture as well, trying to find a link between the individual Oedipus complex and the prehistory of humankind.

Whereas Freud found religion harmful, he deemed art and literature beneficial to humanity. *The Interpretation of Dreams* contains two major ideas that have an impact on art and the criticism of art: the conception of the unconscious and the theory of the pleasure principle. Freud sees the work of art as the expression of a wish and the artist as a neurotic. Like the neurotic, artists yearn for honor, power, wealth, fame, and love; however, they do not have the necessary means of achieving these goals. Therefore, they turn their backs on reality, transferring their interests to the expression of their wishes in fantasy as creation. Art thus becomes, in Freud's view, something like a public dream, an occasion to contemplate the unconscious. "Dostoevsky and Parricide," "Leonardo da Vinci," and "The Moses of Michelangelo" are only three of the many works by Freud that reveal this psychoanalytical approach to the work of art.

Civilization and Its Discontents

In his 1930 book, *Civilization and Its Discontents*, Freud applies psychoanalytical methods to the study of civilization. He begins by asking the question, Why do so many people blame human unhappiness on civilization and technical progress? Would we in fact be better off in a "free" primitive state? Freud analyzes the clash between individual instincts, creative and destructive, and the restrictive forces of overripe Western civilization. He nevertheless argues that all societies, even the most primitive, impose restrictions and taboos and that human cultures develop through the sublimation of instinctual drives. Eros, the drive for individual happiness, may clash with social necessities, but it also takes the form of the urge that causes human beings to seek to bind together, first in families and then in larger social groups. The other basic instinct, Thanatos, conceptualized by Freud shortly after World War I, occurs both in the form of an individual "death wish" and as aggression toward others. It constantly threatens the destruction of both self and society. Freud concludes, pessimistically, that civilization of necessity had to channel and restrain people's instinctual strivings if both individuals and civilization were to survive. Unlike Marx and the tradition of Western radicalism emerging

from the Enlightenment, Freud saw no possibility for a radically different future for the majority of humankind. His philosophic outlook is often thought of as a secular variant of the doctrine of original sin.

In Freud's view, the meaning of culture is the struggle between Eros and Thanatos as it works itself out in human society. "This struggle," he says, "is what all life essentially consists of and the evolution of civilization may therefore be simply described as the struggle for the life of the human species."

The Postwar Decades

The Roaring Twenties

The postwar mood in the United States contrasted starkly with that in Europe. While many Europeans looked gloomily at the future of the human race, Americans exuded optimism. Unwilling to play its role as the key power in international relations, the United States was not reluctant to assert its economic predominance. The magic word of the decade of the 1920s was *credit*: a generous policy of lending against future earnings led to an enormous expansion of production. The first generation of installment-plan buyers in America found within its reach a range of luxuries, now considered necessities, that could be had on the promise of payment later. Because the country was the leading financial and industrial power, the economic system of other nations eventually became drawn into the same upward draft. When in 1929 panic struck Wall Street, the bubble burst and the world's economy shriveled; production statistics dropped, millions were thrown out of work, and the Great Depression of the 1930s was launched.

Politics in the 1930s: Communism and Fascism

The collapse of the world economy had its effect on almost every area of the globe, but nowhere was it as marked as in the highly developed economic countries of western Europe and the United States. Breadlines, starving sharecroppers, and dispossessed families constituted only the most obvious results of the financial disaster. In such circumstances, the gulf between the haves and the have-nots in society became glaringly obvious, with a corresponding intensification of social tension.

The sense of shock and dismay brought on by the economic crisis led to a broad questioning of traditional political values both in the United States and abroad. Could free enterprise and democracy survive? Almost totally independent of Western capitalism, the socialistic economy of the Soviet Union—although it had problems of its own—was insulated from the shock. In capitalistic countries millions of peasants and workers,

either unemployed or threatened with unemployment, looked to communism as a way out of a depression in which they were the chief sufferers.

On the other hand, large numbers of people—many members of the middle classes as well as peasants and urban workers—turned to the radical right, especially to fascism, for a solution. Partly motivated by a fear of communism, partly by an antipathy toward big business that reduced the artisan to a laborer and threatened the shopkeeper with competition, they felt the appeal of a conservative right stressing the old values of thrift, industry, national traditions, and loyalty to the country.

Communism is similar to *fascism* because it is a totalitarian political philosophy that sees the individual as having historical existence only in terms of a larger group. For the communist the larger group is the class; for the fascist it is the nation. Just as the communists declare that an individual's mentality is determined by the class to which he or she belongs, so the fascists claim that one's basic outlook derives from one's nationality. What we call reason, therefore, is relative to each nation. Like Rousseau's general will, the national will of the fascist is the deepest part of every member of the national group. Whereas the communists view class conflict as inevitable, the fascists see struggle between national wills as the central characteristic of human history. Indeed, national wills are defined primarily in their conflict with other nations. However, in contrast to communism, which tends to downplay the importance of individual leaders in accomplishing its goals, fascism sees the leader as the one who best senses the national will and therefore can effectively direct the people to realizing the nation's destiny.

More than fascism elsewhere in Europe, German Nazism had a peculiarly racial bias. Adolf Hitler (1889–1945), the leader of the movement in Germany from the 1920s, viewed German nationalism as a manifestation of superior Aryan culture. Many anthropologists believe that the Aryans were a large *linguistic* group originating in north-central Europe that around 3000 B.C. began migrating southward, eastward, and westward. For Hitler, the Aryans constituted a *racial* group and one naturally superior to all other "races." Although he regarded all non-Aryans as inferior, he despised the Jews particularly, because he considered them cultural parasites, enemies of creative societies, and a people intent on dominating the world. His book *Mein Kampf* (My Battle), published in two volumes in 1925 and 1926, called for state action not only to purify the Aryan race from racial corruption but also to build a master race by eliminating mental and physical handicaps through birth control. After seizing power in 1933, Hitler proceeded to carry out his program through massive sterilization campaigns and concentration camps.

Caught between extreme movements on the right and left, European democratic political parties were hard put to deal with enemies who would not play according to the rules. Already in the early years after World War I, Benito Mussolini (1883–1945) in Italy had successfully used the threat of communism to destroy the government and to establish a fascist state. Now, in the early 1930s, it was Germany's turn. With six million unemployed—including their families, about 40 percent of the German population was involved—Germany in 1932 was ripe for a violent change. Adolf Hitler and his *National Socialist* (Nazi) party used every trick in the election of that year to present the choice as one between communism and the forces of order. Particularly virulent were the Nazi attacks on the Jews as the authors of the Depression and the source of Germany's major ills. The result was a plurality for the Nazi party in the popular assembly, the Reichstag. Hitler was appointed chancellor, or prime minister, by the president of the Weimar Republic; within the next few years he acted to destroy any political opposition and to make Germany a fascist state. By the mid-1930s the notorious concentration camps were in operation to house political dissidents and Jews. Then Hitler embarked on his promise to the German people to undo the provisions of the Treaty of Versailles.

The Spanish Civil War　In the mid-1930s fascist Italy and Germany had an opportunity to face communist Russia in a trial war where both sides could test their weapons and the fascists their soldiers. In 1936 a combined group of high-ranking army officers, Catholic traditionalists, fascists (*Falangists*), and monarchists, supported by the Church hierarchy, revolted against the legally elected Spanish republican government in an effort to prevent the application of a reform program aimed primarily against the large landholders. General Francisco Franco took command of the right-wing groups, the Nationalists, at an early stage and requested the assistance of Italy and Germany in fighting the civil war. The principal ally of the republicans, or Loyalists, was the Soviet Union, but groups of sympathizers from America and Europe came as volunteers to help the cause as well. The Western democracies themselves, however, remained neutral. Fought with vicious cruelty on both sides, the war lasted almost three years. The distance of the Soviet Union from the fighting gave the Nationalists an advantage in allies. The powerful German and Italian air forces were used for merciless bombing of the cities occupied by the enemy. When the civil war ended with a Nationalist victory in 1939, Spain became one of the seventeen European nations out of twenty-seven to fall under the rule of a dictator.

War in Asia　In Asia, the new world power Japan had by 1939 made great strides toward conquering China

and, in alliance with Germany and Italy, set out to annex large portions of the Pacific islands and southern Asia. Since 1931, Japanese armies had taken over most of the eastern part of China from the Chinese Republic, established in 1911 by Sun Yat-sen and his party, the National People's party, or *Guomindang* (Kuomintang). Their conquest had been facilitated by the fact that the republic was divided between two warring factions.

From the beginning the government of Sun had been beset by problems both external and internal. Large sections of the vast Chinese republic remained independent under the control of local warlords. After World War I the European powers again insisted on the trade privileges they had enjoyed before the war. Japan, moreover, had taken advantage of its European trade rivals' preoccupation with the war in the West to capture some of the Chinese markets as outlets for its own rising industrial production. The Japanese also took the opportunity to expand their northern Asian holdings from the Korean peninsula by seizing portions of Chinese Siberia.

Frustrated by the continuing claims of foreign interests for commercial privileges, the Chinese in 1924 turned for help to communist Russia, which they viewed as fighting for the liberation of peoples. With Russian assistance over the next three years, the Guomindang made serious efforts to unify the country under Jiang Jieshi (Chiang Kai-shek), Sun's successor in 1925. A growing split within the Guomindang between radical and more conservative members, however, erupted in open division in 1927, and a civil war between the Guomindang, now referred to as the Nationalists, and the Chinese Communist party, broke out. Profiting from the division, the Japanese invaded Chinese territory in 1931. By taking in succession the populous cities of the eastern half of the country, they moved deep into Chinese territory by 1939. Although the League of Nations denounced the aggression, the world body was again powerless to take effective action. The Japanese invasion of China in 1931 might be seen as the first hostilities of World War II.

WILFRED OWEN

The first of these two poems re-creates in graphic detail the death of a soldier from a gas attack. It is not simply a rendering of physical horror but also a meditation on the moral and spiritual effect of the event on the narrator-witness. The title, and the full quotation in the last two lines, is an often-quoted verse from an ode by the Latin poet Horace: *"Dulce et decorum est pro patria mori."* It can be translated as "It is sweet and fitting to die for one's country." The irony in the contrast between the saying of one of the revered poets of antiquity and the reality of modern war may seem to put into question the relevancy of the humanistic tradition in a brutal modernity.

The second poem describes the "Strange Meeting" between a soldier-narrator (who may or may not be dead) and an enemy he killed in battle. Its tone is quite different from that of "Dulce et Decorum Est," and it seems to end in a kind of reconciliation. It also treats the theme of the moral degradation caused by war and suggests that war may indeed recur.

Dulce et Decorum Est

Bent double, like old beggars under sacks,
Knock-kneed, coughing like hags, we cursed through
 sludge,
Till on the haunting flares we turned our backs
And towards our distant rest began to trudge.
Men marched asleep. Many had lost their boots 5
But limped on, blood-shod. All went lame; all blind;
Drunk with fatigue; deaf even to the hoots
Of disappointed shells that dropped behind.

Gas! Gas! Quick, boys!—An ecstasy of fumbling,
Fitting the clumsy helmets just in time; 10
But someone still was yelling out and stumbling
And floundering like a man in fire or lime.—
Dim, through the misty panes and thick green light
As under a green sea, I saw him drowning.
In all my dreams, before my helpless sight, 15
He plunges at me, guttering, choking, drowning.

If in some smothering dreams you too could pace
Behind the wagon that we flung him in,
And watch the white eyes writhing in his face,

His hanging face, like a devil's sick of sin; 20
If you could hear, at every jolt, the blood
Come gargling from the froth-corrupted lungs,
Obscene as cancer, bitter as the cud
Of vile, incurable sores on innocent tongues,—
My friend, you would not tell with such high zest 25
To children ardent for some desperate glory,
The old Lie: Dulce et decorum est
Pro patria mori.

Strange Meeting

It seemed that out of battle I escaped
Down some profound dull tunnel, long since scooped
Through granites which titanic wars had groined.

Yet also there encumbered sleepers groaned,
Too fast in thought or death to be bestirred. 5
Then, as I probed them, one sprang up, and stared
With piteous recognition in fixed eyes,
Lifting distressful hands, as if to bless.
And by his smile, I knew that sullen hall,—
By his dead smile I knew we stood in Hell. 10

With a thousand pains that vision's face was grained;
Yet no blood reached there from the upper ground,
And no guns thumped, or down the flues made
 moan.
'Strange friend,' I said, 'here is no cause to mourn.'
'None,' said that other, 'save the undone years, 15
The hopelessness. Whatever hope is yours,
Was my life also; I went hunting wild
After the wildest beauty in the world,
Which lies not calm in eyes, or braided hair,
But mocks the steady running of the hour, 20
And if it grieves, grieves richlier than here.
For by my glee might many men have laughed,
And of my weeping something had been left,
Which must die now. I mean the truth untold,
The pity of war, the pity war distilled. 25
Now men will go content with what we spoiled,
Or, discontent, boil bloody, and be spilled.
They will be swift with swiftness of the tigress.
None will break ranks, though nations trek from
 progress.

Courage was mine, and I had mystery, 30
Wisdom was mine, and I had mastery:
To miss the march of this retreating world
Into vain citadels that are not walled.
Then, when much blood had clogged their chariot-
 wheels,
I would go up and wash them from sweet wells, 35
Even with truths that lie too deep for taint.
I would have poured my spirit without stint
But not through wounds; not on the cess of war.
Foreheads of men have bled where no wounds were.

'I am the enemy you killed, my friend. 40
I knew you in this dark: for so you frowned
Yesterday through me as you jabbed and killed.
I parried; but my hands were loath and cold.
Let us sleep now. . . .'

COMMENTS AND QUESTIONS

1. How would you describe the *tone* of "Dulce et Decorum Est"? Of "Strange Meeting"?

2. What changes in rhythm does the poet use? To what effect?

3. How does the choice of language contribute to each poem's meaning?

4. After reading "Dulce et Decorum Est," how do you envision a World War I gas attack?

5. How do you interpret the last four lines?

6. Note that whereas "Dulce et Decorum Est" uses full rhymes (sacks/backs, fumbling/stumbling), "Strange Meeting" uses off-rhymes or "half-rhymes" (groined/groaned, mourn/moan). What is the effect of this rhyming technique?

7. What is the effect of the "strange meeting" on the poet?

EZRA POUND

from *Hugh Selwyn Mauberly*

We will discuss the American poet Ezra Pound more fully in Chapter 32. Of interest in this group of poems from World War I, however, is a section of his long, partially autobiographical poem "Hugh Selwyn Mauberly" (1920). In that poem Pound mixes erudite references with colloquial and vulgar language to juxtapose the disillusionment arising from World War I with the beauty of classical European culture. The section reprinted here reflects specifically on the war's waste of lives and the decline of Western civilization.

IV

These fought in any case,
and some believing,
 pro domo,° in any case . . .

Some quick to arm,
some for adventure, 5
some from fear of weakness,
some from fear of censure,
some for love of slaughter, in imagination,
learning later . . .
some in fear, learning love of slaughter; 10
Died some, pro patria,
 non 'dulce' non 'et decor'° . . .
walked eye-deep in hell
believing in old men's lies, then unbelieving
came home, home to a lie, 15
home to many deceits,
home to old lies and new infamy;
usury age-old and age-thick
and liars in public places.

Daring as never before, wastage as never before. 20
Young blood and high blood,
fair cheeks, and fine bodies;
fortitude as never before

frankness as never before,
disillusions as never told in the old days, 25
hysterias, trench confessions,
laughter out of dead bellies.

V

There died a myriad,
And of the best, among them,
For an old bitch gone in the teeth, 30
For a botched civilization,

Charm, smiling at the good mouth,
Quick eyes gone under earth's lid,

For two gross of broken statues,
For a few thousand battered books. 35

COMMENTS AND QUESTIONS

1. Compare Pound's use of Horace's words to Owen's. Why was this line from Horace of such importance to both poets?

2. What is the effect of Pound's use of *anaphora* (the repetitions of "some" and of "as never before")?

3. *Pro domo* (Latin): "for home." 12. "For the country," "not 'sweet'," "not 'and fitting'." Pound is referring to the same line from Horace quoted by Wilfred Owen in "Dulce et Decorum Est."

3. What contrasts does Pound make between entry into the war and the aftermath of the war?

4. What do the images in the last two lines express?

RUDYARD KIPLING

Recessional

Kipling (1865–1936) was born in India. After attending school in England, he returned to India, where he worked as a newspaper correspondent. He wrote numerous short stories, poetry, and a well-known novel, *Kim*. Although he soon went back to England, his Indian material remains by far his best writing. He is sometimes called the Poet Laureate of Imperialism. Two of his most famous poems are "Gunga Din," about a heroic Indian water-carrier, and the "White Man's Burden," which was written to persuade the United States to maintain its control of the Philippine Islands—just conquered in the Spanish-American War—despite prolonged resistance from the Filipinos. Kipling's poem "Recessional," which was a popular hymn, presents imperialism as a moral crusade.

God of our fathers, known of old,
Lord of our far-flung battle-line,
Beneath whose awful Hand we hold
Dominion over palm and pine—
Lord God of Hosts, be with us yet, 5
Lest we forget—lest we forget!

The tumult and the shouting dies;
The Captains and the Kings depart:
Still stands Thine ancient sacrifice,
An humble and a contrite heart. 10
Lord God of Hosts, be with us yet,
Lest we forget—lest we forget!

Far-called, our navies melt away;
On dune and headland sinks the fire:
Lo, all our pomp of yesterday 15
Is one with Nineveh and Tyre!
Judge of the Nations, spare us yet,
Lest we forget—lest we forget!

If, drunk with sight of power, we loose
Wild tongues that have not Thee in awe, 20
Such boastings as the Gentiles use,
Or lesser breeds without the Law—
Lord God of Hosts, be with us yet,
Lest we forget—lest we forget!

For heathen heart that puts her trust 25
In reeking tube and iron shard,°

26. Gun and sword.

All valiant dust that builds on dust,
And guarding, calls not Thee to guard,
For frantic boast and foolish word—
Thy mercy on Thy People, Lord! 30

COMMENTS AND QUESTIONS

1. How does Kipling relate Christianity to Western imperialism?

2. How would you compare this hymn with the better-known hymn "Onward Christian Soldiers"?

MOHANDAS ("MAHATMA") GANDHI

from *Letter to Lord Irwin*

In 1917 the British had promised India rapid progress toward self-government within the British Commonwealth. Instead they dragged their feet. The English-trained lawyer, intellectual, and religious leader M. K. Gandhi, known as the Mahatma, took control of the Indian freedom movement, which he tried to conduct on nonviolent terms. In 1930 he launched a civil disobedience campaign. Its first phase was a march to the sea, where, in violation of the law that gave the government a monopoly, he would pick up and distribute salt. Just before setting out on the Salt March, he wrote the following letter to the viceroy, Lord Irwin.

Dear Friend,

Before embarking on civil disobedience and taking the risk I have dreaded to take all these years, I would fain approach you and find a way out.

My personal faith is absolutely clear. I cannot intentionally hurt anything that lives, much less fellow human beings, even though they may do the greatest wrong to me and mine. Whilst, therefore, I hold the British rule to be a curse, I do not intend harm to a single Englishman. . . . And why do I regard the British rule as a curse? It has impoverished the dumb millions by a system of progressive exploitation and by a ruinously expensive military and civil administration which the country can never afford. It has reduced us politically to serfdom. It has sapped the foundations of our culture. And, by the policy of cruel disarmament, it has degraded us spiritually. Lacking the inward strength, we have been reduced, by all but universal disarmament, to a state bordering cowardly helplessness. . . .

Take your own salary. It is over Rs. [Rupees] 21,000 per month. . . . The British Prime Minister gets £5,000 per year. . . . You are getting much over five thousand times India's average income. The British Prime Minister is getting only ninety times Britain's

average income. On bended knee I ask you to ponder over this phenomenon. . . .

The party of violence is gaining ground and making itself felt. Its end is the same as mine. But I am convinced that it cannot bring the desired relief to the dumb millions. And the conviction is growing deeper and deeper in me that nothing but unadulterated non-violence can check the organized violence of the British Government. . . . Conversion of a nation that has consciously or unconsciously preyed upon another, far more numerous, far more ancient and no less cultured than itself, is worth any amount of risk.

I have deliberately used the word "conversion." For my ambition is no less than to convert the British people through non-violence, and thus make them see the wrong they have done to India. I do not seek to harm your people. I want to serve them even as I want to serve my own. I served them up to 1919 blindly. But when my eyes were opened and I conceived non-cooperation, the object still was to serve them. I employed the same weapon that I have in all humility successfully used against the dearest members of my own family. If I have equal love for your people with mine it will not long remain hidden. . . . If the people join me as I expect they will, the sufferings they will undergo, unless the British nation sooner retraces its steps, will be enough to melt the stoniest hearts. . . .

from *A Conversation with Tobias and Mays*

The following conversation took place in 1937 among Gandhi and Channing Tobias, director of the Phelps-Stokes Fund, and Thomas Benjamin Mays, who was president of Morehouse College in Atlanta, Georgia. Morehouse later became the alma mater of Martin Luther King Jr., Andrew Young, and most of the leaders of the African American civil rights movement in the 1950s and 1960s. Before 1915, Gandhi had been leader of the Indian community in South Africa.

TOBIAS Your doctrine of non-violence has profoundly influenced my life. Do you believe in it as strongly as ever?

GANDHI I do indeed. My faith in it is growing.

TOBIAS Negroes in the U.S.A.—12 million—are struggling to obtain such fundamental rights as freedom from mob-violence, unrestricted use of the ballot, freedom from segregation, etc. Have you, out of your struggle in India, a word of advice and encouragement to give us?

GANDHI I had to contend against some such thing, though on a much smaller scale, in South Africa. The difficulties are not yet over. All I can say is that there is no other way than the way of non-violence—a way, however, not of the weak and ignorant but of the strong and wise.

TOBIAS What word shall I give my Negro brethren as to the outlook for the future?

GANDHI With right which is on their side and the choice of non-violence as their only weapon, if they will make it such, a bright future is assured. Passive resistance is a misnomer for non-violent resistance. It is much more active than violent resistance. It is direct, ceaseless, but three-fourths invisible and only one-fourth visible. In its visibility it seems to be ineffective, e.g., the spinning wheel which I have called the symbol of non-violence . . . , but it is really intensely active and most effective in ultimate result. . . . Hitler and Mussolini on the one hand and Stalin on the other are able to show the immediate effectiveness of violence. But it will be as transitory as that of Genghis [Khan's] slaughter. But the effects of Buddha's non-violent action persist and are likely to grow with age. And the more it is practiced, the more effective and inexhaustible it becomes, and ultimately the whole world stands agape and exclaims, "a miracle has happened." All miracles are due to the silent and effective working of invisible forces. Non-violence is the most invisible and the most effective.

MAYS I have no doubt in my mind about the superiority of non-violence. But the thing that bothers me is about its exercise on a large scale, the difficulty of so disciplining the mass mind on the point of love. It is easier to discipline individuals. What should be the strategy when they break out? Do we retreat or do we go on?

GANDHI I have had that experience in the course of our movement here. People do not gain the training by preaching. Non-violence cannot be preached. It has to be practiced. . . .

MAYS Is it ever possible to administer violence in a spirit of love?

GANDHI No. Never. . . .

MAYS How is a minority to act against an overwhelming majority?

GANDHI I would say that a minority can do much more in the way of non-violence than a majority. . . . I had less diffidence in handling my minority in South Africa than I had here in handling a majority. . . .

MAYS Should the thought of consequences that might accrue to the enemy as a result of your non-violence at all constrain you?

GANDHI Certainly. You may have to suspend your movement as I did in South Africa when the Government was faced [in 1911] with the revolt of European labor. The latter asked me to make common cause with them. I said "no."

MAYS And non-violence will never rebound on you, whereas violence will be self-destroyed?

GANDHI Yes. Violence must beget violence. But let me tell you that here too my argument has been countered by a great man who said: "Look at the history of non-violence. Jesus dies on the cross, but his followers shed blood." This proves nothing. We have no data before us to pass judgment. We do not know the whole of the life of Jesus. The followers perhaps had not imbibed fully the message of non-violence. But I must warn you against carrying the impression with you that I am the final word on non-violence. I know my own limitations. I am but an humble seeker after truth. And all I claim is that every experiment of mine has deepened my faith in non-violence as the greatest force at the disposal of mankind. Its use is not restricted to individuals merely, but it can be practiced on a mass scale.

COMMENTS AND QUESTIONS

1. Why might Tobias and Mays (or Martin Luther King) have been attracted to Gandhi's strategy of nonviolent resistance?

2. In what ways was Gandhi's strategy "revolutionary"?

3. How do you react to Gandhi's views on Mussolini, Hitler, and Stalin?

SIGMUND FREUD

from *Civilization and Its Discontents*

Translation by James Strachey

VI

. . . The assumption of the existence of an instinct of death or destruction has met with resistance even in analytic circles; I am aware that there is a frequent inclination rather to ascribe whatever is dangerous and hostile in love to an original bipolarity in its own nature. To begin with it was only tentatively that I put forward the views I have developed here, but in the course of time they have gained such a hold upon me that I can no longer think in any other way. To my mind, they are far more serviceable from a theoretical standpoint than any other possible ones; they provide that simplification, without either ignoring or doing violence to the facts, for which we strive in scientific work. I know that in sadism and masochism we have always seen before us manifestations of the destructive instinct (directed outwards and inwards), strongly alloyed with erotism; but I can no longer understand how we can have overlooked the ubiquity of noneritic aggressivity and destructiveness and can have failed to give it its due place in our interpretation of life. (The desire for destruction when it is directed *inwards* mostly eludes our percep-

tion, of course, unless it is tinged with erotism.) I remember my own defensive attitude when the idea of an instinct of destruction first emerged in psycho-analytic literature, and how long it took before I became receptive to it. That others should have shown, and still show, the same attitude of rejection surprises me less. For "little children do not like it"[1] when there is talk of the inborn human inclination to "badness," to aggressiveness and destructiveness, and so to cruelty as well. God has made them in the image of His own perfection; nobody wants to be reminded how hard it is to reconcile the undeniable existence of evil—despite the protestations of Christian Science—with His all-powerfulness or His all-goodness. The Devil would be the best way out as an excuse for God; in that way he would be playing the same part as an agent of economic discharge as the Jew does in the world of the Aryan ideal. But even so, one can hold God responsible for the existence of the wickedness which the Devil embodies. In view of these difficulties, each of us will be well advised, on some suitable occasion, to make a low bow to the deeply moral nature of mankind; it will help us to be generally popular and much will be forgiven us for it.

The name "libido" can once more be used to denote the manifestations of the power of Eros in order to distinguish them from the energy of the death instinct. It must be confessed that we have much greater difficulty in grasping that instinct; we can only suspect it, as it were, as something in the background behind Eros, and it escapes detection unless its presence is betrayed by its being alloyed with Eros. It is in sadism, where the death instinct twists the erotic aim in its own sense and yet at the same time fully satisfies the erotic urge, that we succeed in obtaining the clearest insight into its nature and its relation to Eros. But even where it emerges without any sexual purpose, in the blindest fury of destructiveness, we cannot fail to recognize that the satisfaction of the instinct is accompanied by an extraordinarily high degree of narcissistic enjoyment, owing to its presenting the ego with a fulfillment of the latter's old wishes for omnipotence. The instinct of destruction, moderated and tamed, and, as it were, inhibited in its aim, must, when it is directed towards objects, provide the ego with the satisfaction of its vital needs and with control over nature. Since the assumption of the existence of the instinct is mainly based on theoretical grounds, we must also admit that it is not entirely proof against theoretical objections. But this is how things appear to us now, in the present state of our knowledge; future research and reflection will no doubt bring further light which will decide the matter.

. . . The inclination to aggression is an original, self-subsisting instinctual disposition in man, and . . . it con-

[1] A quotation from a poem by Goethe. [Translator's notes.]

stitutes the greatest impediment to civilization. At one point in the course of this enquiry I was led to the idea that civilization was a special process which mankind undergoes, and I am still under the influence of that idea. I may now add that civilization is a process in the service of Eros, whose purpose is to combine single human individuals, and after that families, then races, peoples, and nations, into one great unity, the unity of mankind. Why this has to happen, we do not know; the work of Eros is precisely this. These collections of men are to be libidinally bound to one another. Necessity alone, the advantages of work in common, will not hold them together. But man's natural aggressive instinct, the hostility of each against all and of all against each, opposes this programme of civilization. This aggressive instinct is the derivative and the main representative of the death instinct which we have found alongside of Eros and which shares world-dominion with it. And now, I think, the meaning of the evolution of civilization is no longer obscure to us. It must present the struggle between Eros and Death, between the instinct of life and the instinct of destruction, as it works itself out in the human species. This struggle is what all life essentially consists of, and the evolution of civilization may therefore be simply described as the struggle for life of the human species. And it is this battle of the giants that our nurse-maids try to appease with their lullaby about Heaven.[2]

COMMENTS AND QUESTIONS

1. According to Freud, what evidence is there for the existence of the death instinct?
2. In what different ways does Eros manifest itself?
3. Compare Freud's notion of the "social contract" with Rousseau's.
4. Does Freud's theory of Eros and Thanatos lead to the repudiation of the Enlightenment?
5. How are Freud's ideas similar to traditional Judeo-Christian teachings? How are they different?
6. Do you think that Freud's emphasis on sexuality is excessive? Is the libido the underlying reality of existence or merely one facet of it?
7. Do Freud's ideas perpetuate pessimism, despair, and cynicism?

[2] *"Eiapopeia vom Himmel,"* a quotation from Heine's poem *Deutschland,* Caput I.

Summary Questions

1. What effect did industrialism and nationalism have on European colonization?
2. What were the results of the abolition of the Atlantic slave trade on Africa?
3. How was European colonial policy affected by the Berlin Conference in 1885?
4. Describe different approaches taken to colonialism depending on the area.
5. What instances of anticolonial revolt occurred in Asia?

6. How did theories of "scientific" racism influence colonialism?
7. Why did World War I seem different from all previous wars?
8. What were some of the effects of World War I on European thought and culture?
9. What was the significance of the Spanish civil war?
10. What new scientific developments in the early twentieth century had a major effect on cultural change?
11. What were some of Freud's main theories?
12. What is Freud's view of civilization in *Civilization and Its Discontents*?

Key Terms

new imperialism

nonviolence

"the war to end all wars"

mandate

relativity

ego, id, superego

Eros/Thanatos

communism

fascism

national socialism

Falangists

Guomindang

"Dulce et decorum est pro patria mori"

31

Modernism: Visual Arts, Music, and Dance

In the years between 1900 and 1930 a lifestyle that was self-consciously modern developed. The theories of Freud, often misinterpreted, led to a desire to be "liberated" from the restraints and taboos of proper Victorian society and to enjoy greater sexual freedom. Women, having finally gained the vote in England and America, began to demand greater freedoms and more of a place in society for themselves. Young women shocked their elders by wearing their hair and their skirts short and dancing modern dances such as the Charleston. African Americans, although suffering from Jim Crow laws in the South and limited employment possibilities in the North, nevertheless made substantial contributions to the art and culture of the new age. The most substantial of these was jazz, a totally new musical form. The modernist age can as well be called the jazz age, for jazz seemed to express the fast, frantic, free way of life that culminated in the Roaring Twenties. Automobiles, airplanes, radio, and technology that made possible the development of another new art form—the motion picture—all contributed to the impression that life was speeding up and changing at an incredible rate and that modern values and styles had to replace old-fashioned ones.

As is often the case, the changes in lifestyle were preceded by changes in the arts. Artists, too, became self-consciously modern, aware that art had to keep pace with, or advance, a rapidly changing society. In addition to jazz, another important new art form, modern dance, was an American creation, but the cradle of modernism in the early twentieth century was really Paris. There young painters, sculptors, writers, musicians, and dancers flocked from all over the world to exchange ideas and to participate in the creation of the new. Many Americans, white and black, fled what they considered to be the culturally backward, repressive atmosphere of the United States to give free rein to their creativity in Paris.

This period of intense modernist activity in Paris, beginning shortly before World War I, is described by Roger Shattuck as "the banquet years." The French accomplishments of the late nineteenth century seemed to offer developing artists

a feast on which to nourish themselves. Visual, musical, literary, and theatrical artists were conscious of the interrelationships among their arts as never before. During the first three decades of the twentieth century, there developed an astounding number of literary-artistic-musical schools, all with "-isms" attached to them. Their histories have been made, and we will mention only a few of them here. What we will attempt to grasp through the rich variety of expressions is just what it meant (and means) to be "modern."

Modernist Painting, 1900–1930

In the early years of the twentieth century two important trends can be distinguished. The first is the continuing transformation of the *figurative* tradition, in which the human body and the objects of habitual visual experience form the basis of art. The second is the emergence of a *nonfigurative* approach that completely rejects the visual world and attempts instead to communicate through the pure plastic possibilities of the formal elements of painting, sculpture, and graphics. Two prominent figures are associated with the first: a Frenchman, Henri Matisse, and a Spaniard, Pablo Picasso. A Russian, Wassily Kandinsky, and a Dutchman, Piet Mondrian, are representative of the second. We will consider representative works from these trends and look briefly at their influence in the United States. We will then turn to two important modernist developments after World War I: Dada and surrealism.

Henri Matisse (1869–1954)

Matisse emerged as an important artist in an exhibition of his work and that of some colleagues in 1905. Called Les Fauves (wild beasts) because of the large areas of strong, simplified colors, slashing brush strokes, and thick paint that characterized their work, these artists were all clearly inspired by impressionism, Gauguin, and Van Gogh. Matisse's *Portrait of Madame Matisse (The Green Stripe)* (Color Plate XXIX) makes use of areas of strong, contrasting colors to create a sense of space and light instead of traditional shading and shadow. Matisse's ability to suggest weight, volume, and space through color juxtaposition was further enhanced by his command of the possibilities of line and contour. In 1905–1906, when Matisse painted *The Joy of Life* (Fig. 31-1), the heavy brush strokes of his earlier work gave way to flowing contours and colors, spaciously arranged on a light ground. Compared to the canvases of Van Gogh and Gauguin, this work is empty of brooding and is filled with an almost musical lyricism and optimism. This painting truly affirms life and joy, resonating with an exploding vigor and sensuality that we will witness in the music and ballet of Stravinsky's *Rite of Spring*.

Pablo Picasso (1881–1973)

Matisse's joyful visions of life were not shared by Picasso. In his early works, done in Paris around the turn of the century, Picasso used as subjects clowns, acrobats, peasants, and the dregs of Parisian night life that had also been used by Manet, Degas, and Toulouse-Lautrec. Filled with melancholy and a brooding sense of alienation, they remain nineteenth-century pictures in spite of Picasso's unconventional use of color, distortion, and space (Fig. 31-2).

Among Matisse's most important predecessors had been Gauguin. Picasso, however, turned to the works of Paul Cézanne, finding in them another way to see and experience the world and to realize that experience in a painterly language. Cézanne had reduced objects to a series of visual references arranged in patterns of color and shape that created a sense of volume and space. For example, an orange would be represented as round and orange but with no reference to typical texture, surface formation, or any other transient characteristics of an orange—some are green, others are not orange all over, others have spots. Other objects on the picture surface would be reduced in the same way. A human figure, for example, would not have typical skin color, texture, even gesture. Rather, Cézanne would study the figure until he seemed to find the essence, an essential way for that figure to be represented that was convincing but not dependent on the painted form's being a direct copy of the seen and experienced human form. This process emphasized the nature of painting itself, as a process, and of seeing, as a collection of experiences summarized and encapsulated by the mind through human experience. It was this technique that Picasso built on in his explorations made after the turn of the century.

African and Oceanic Art

Another artistic phenomenon that had a major impact on Picasso and his friends was the art of Africa and the South Pacific. Acquaintance with such a completely different formal tradition is usually a very liberating experience to artists. It was so in the nineteenth century when Europeans became acquainted with Japanese prints. When Gauguin and others brought objects to Paris from Africa or the Pacific, interest was stimulated in what had heretofore been considered curiosities brought as memorabilia by colonists, travelers, or ethnographers. This so-called primitive art represented, as we saw in Chapter 13 on African art, completely different formal traditions. For example, in the mask in Figure 31-3, the African artist has abstracted from reality those elements that are most important for the meaning and purpose of the mask. These have been exaggerated and combined into a strong, harmonious whole by the purely formal elements of the

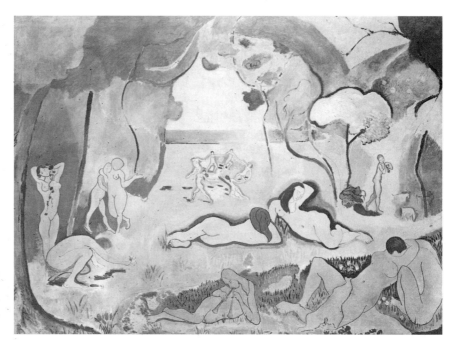

31-1 *Henri Matisse,* The Joy of Life, *1905–1906. Oil on canvas, 68½″ × 93¾″. (Copyright The Barnes Foundation, 1976, Merion Station, Pennsylvania. B.F. #719)* (**W**)

• Which work seems more influenced by Cézanne's painting? Which by Van Gogh and Gauguin? What is your evidence to support your choice? What visual characteristics are responsible for your different responses to the two works?

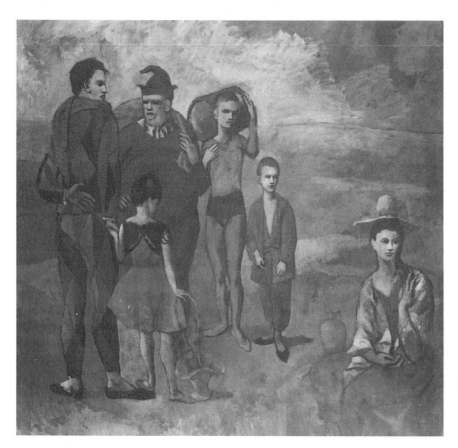

31-2 *Pablo Picasso,* Family of Saltimbanques, *1905. Oil on canvas, 83¾″ × 90⅜″. (Copyright 1996, National Gallery of Art, Washington, DC. Chester Dale Collection)*

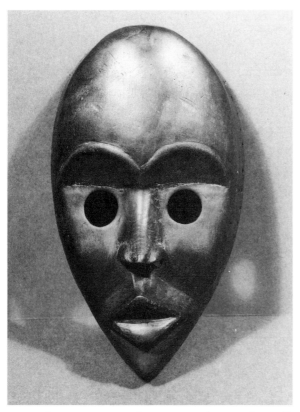

31-3 *African Dan mask. (Copyright Frank Willett, Glasgow)*

medium: plane, surface, texture, and shape. The existence of this tradition affirmed the belief of many artists that objects of art could speak in their own right, independent of the need to copy the familiar aspects of the visible world. At first these artists, including Picasso, copied the new forms and shapes, studying them and including them directly in their work. But very rapidly each artist adopted this influence to his or her particular uses, making the objects almost unrecognizable. Naturally, the majority of the European public did not receive either the African art or the work of artists inspired by it with enthusiasm.

The Influence of Cézanne and African Art on Picasso

The combined influences of Cézanne and African art help us to understand better *Les Demoiselles d'Avignon,* an unfinished picture that Picasso showed his friends in 1907 (Fig. 31-4). Interpretation of this picture is difficult because it is no longer a picture with subject matter that tells a story. What is happening may be clarified by remembering how Picasso and his friends looked at African masks and sculptures. They did not know the meaning or purpose of either, but in spite of that, they could recognize human and animal forms and patterns and colors that rendered an account of

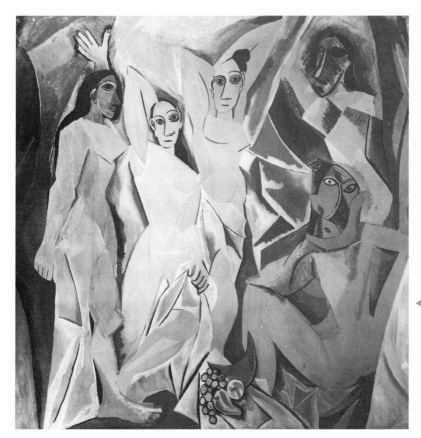

31-4 *Pablo Picasso,* Les Demoiselles d'Avignon, *1907. Oil on canvas, 8' × 7'8". (Collection, The Museum of Modern Art, New York. Acquired through the Lillie P. Bliss Bequest)*

• Find the foreground, middle, and background. Where are the figures? Are they standing, seated, or leaning on each other? Which figures seem to have faces? Which have masks? How does Picasso achieve a three-dimensional effect in the faces of the three figures center and left? What has Picasso learned from Cézanne and African art?

everyday objects. Initially, this sense of recognition was important just because it told these Western artists that, indeed, there was more than one way to experience and give form to the world. Just as the medieval or Renaissance artist created conventions to capture experience and transmit knowledge, African artists had created their conventions. Western artists' experience of African art tended to reinforce the new (and very un-African) belief that line, color, and texture, when properly ordered in a work of art, have the power to create a personal response independent of religious or literary meaning. The problem became one of defining and understanding the limits of the power of the formal elements of art. African art, in particular, with its purposeful distortions of space, scale, and location, provided a major impetus for these artists.

Determined to free the picture from its dependence on old formulas, Picasso and his friend Georges Braque (1882–1963) worked together over a period of about four years. Like Cézanne, they considered the act of seeing to be one in which, first, we perceive what we focus on; second, what we perceive is determined by the length of time that we focus; third, we perceive by manipulating objects within our frame of reference; and fourth, we perceive by filling in information based on what we already know. For these two painters, the flat canvas became an imaginary grid with squares of equal size. Thus the canvas that one usually thinks of as having a bottom and top, left, and right sides, and whose characteristics of bottom, top, left, or right side have an established value (for example, the horizon line is usually between two-thirds and halfway down from the top of the canvas), becomes a surface that can be manipulated in any direction. All directions are of equal importance. Like the mapmaker who distills the elaborate, complex, three-dimensional world into an *abstraction* of lines and colors that convey information, the two painters distilled simple, everyday, familiar objects. They eliminated bright colors from their canvases because color itself can be emotionally powerful and evocative. They eliminated the traditional three-dimensional space invented in the Renaissance, with all references to fore-, mid-, and background. Objects or fragments of objects could now be placed anywhere in the shallow space. The artist could show us backs and sides of things, arranged at will on the canvas. A face is rendered in profile and full-face; we may see the side of the head and the back

of the shoulder. References to specific objects are limited or reduced to familiar aspects.

Cubism

Picasso, instead of creating a picture to be perceived in the most habitual, traditional mode, gives us a construction, an arrangement of shapes, colors, textures, spaces, and weights that invites us to participate in the process of seeing and knowing (Fig. 31–5). We are not invited completely to "find" the man and his violin but to learn how little we must know in order to see and understand. Moreover, we become more and more familiar with the purely formal qualities of the painting, such as *balance, harmony, contrast* of color, *texture,* and *form,* that make up the experience of looking at pictures—an experience that can be enjoyable not because the picture is of "something" but because it "is." These paintings were named *cubist* by a hostile critic who pointed to their most conspicuous aspect—the small facets or planes that intersect and appear somewhat cubelike.

31-5 *Pablo Picasso,* Man with a Violin. *(Philadelphia Museum of Art: Louise and Walter Arensberg Collection. 50-134-168)*

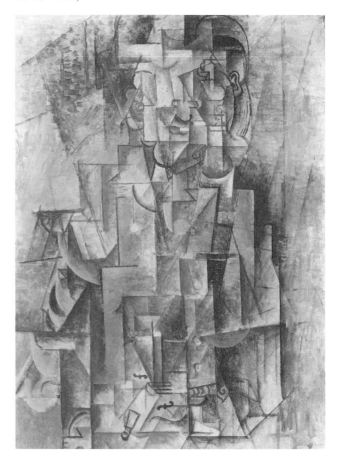

- Examine the painting *Man with a Violin.* Describe the man. What features of man or violin do you see? How does the painter suggest space, light, volume, and the weight of the man's body? How does the experience of this work differ from that of *Les Demoiselles* (Fig. 31-4)?

Collages

Neither Picasso nor Braque was content to continue in this style. They began to try other ideas, such as adding materials like sand, pasted paper, or rope to the canvas to create the first *collages* (in French, "pasting," "gluing"). The inclusion of "real" materials in their pictures increased the potential for humor and irony. For example, a head cut out of newspaper is made to stand for a three-dimensional volume, while the lettering on the paper is intrinsically flat. It is a game in which what you see may not necessarily be what you think you see; but, above all, what you see is a *made* object that is important in its own right and not because it is a copy of the familiar, habitual visual world.

The rational and orderly methodology of early cubism and the simplicity of the early collages were tested by the addition of color and the simplification of the *grid*. To what extent did pictures presenting more recognizable forms still maintain their identity as painted, made things? Picasso's *Three Musicians* (Fig. 31-6) is derived from the broken space and complicated, overlapping, superimposed views of *Man with a Violin*. The simple, vivid colors, along with the intersecting forms of the musicians and their instruments, create a rhythmic movement that visually echoes the syncopations of jazz.

Guernica

The potential inherent in the language of cubism, however, was nowhere made clearer than in *Guernica* (Fig. 31-7), Picasso's large painting commemorating the total destruction of a Basque village, Guernica, by saturation bombing during the Spanish Civil War. Because the village had given its allegiance to the Republicans in the war, its destruction by the Nationalists was to be a lesson to other opponents.

In *Guernica* (1937), Picasso did not attempt to depict the bombing of the village itself; instead, he created images that evoke the terror and destruction of war. The particular combination of images induces meaning. To viewers since World War II, the images seem prophetic of the war that was to come and of the possibilities of total destruction. The painting was very controversial in Spain and was on long-term loan to the Museum of Modern Art in New York City. After the elections of 1981 in Spain, Picasso's heirs returned the work to Spain, and it is now on permanent exhibit at the Casón del Retiro, an annex of the Prado, the Spanish national museum.

Nonobjective and Expressionist Painting

The belief in the ability of an object to act as a means of communication is nowhere more vividly tested than in

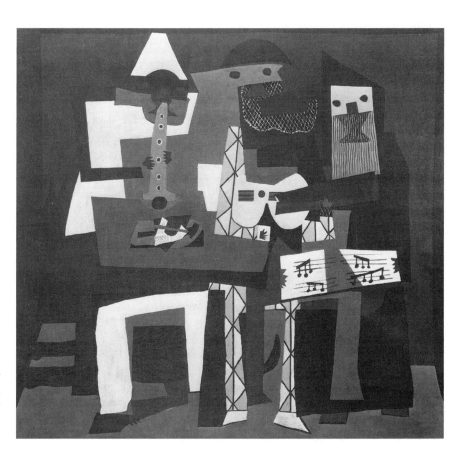

31-6 *Pablo Picasso,* Three Musicians, *1921 (summer). Oil on canvas, 6'7" × 7'3¾". (Collection, The Museum of Modern Art, New York. Mrs. Simon Guggenheim Fund)* (**W**)

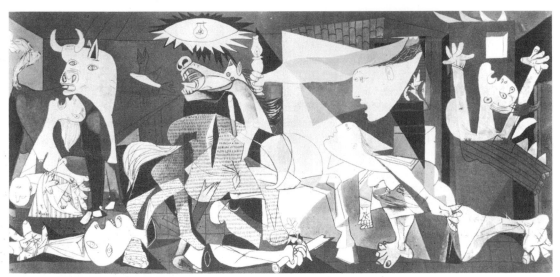

31-7 *Pablo Picasso,* Guernica, *1937. (Copyright ARS, NY. Centro de Arte Reina Sofia, Madrid. Giraudon/Art Resource, NY)*

- What elements from cubism do you discern in the painting? What elements suggest the surreal combination of the expected with the unexpected? What do you think elements such as the bull, the broken sword, the running girl, the horses, and the mother and child represent? Compare *Guernica* with Goya's *The Third of May, 1808* (Fig. 27-11). Is it possible for an artist to transform an event into a generalized, universal statement that can be understood easily? What must the artist do to accomplish this transformation?

the work of the painters Wassily Kandinsky and Piet Mondrian. Here we meet canvases that are completely free of any reference to the habitual, familiar objects and activities of our experience. We are left alone with arrangements of line and color that are, in Kandinsky's words, "a new world," capable of speaking to our conscious as well as our unconscious minds, if we will but permit it, asking not that it be a picture of something but that it just be.

Wassily Kandinsky (1866–1944)

Kandinsky became a painter when he saw one of Monet's *Haystacks* at an exhibition in Moscow. He tells us that he could not distinguish the subject. All that he saw was a veil of shimmering color, producing an emotional sensation like that produced when listening to great music. Stunned by this experience, Kandinsky traveled all over Europe, painting and absorbing the work of Gauguin, Van Gogh, Monet, and others. Settling in Munich, a place intellectually stimulating like Paris, Kandinsky began to experiment, seeking a method of painting that accomplished his aims. An incident recounted in his *Reminiscences* helps us to un-

derstand his concept of the idea of the *nonobjective painting:*

It was the hour approaching dusk. I returned home with my paint box after making a study, still dreaming and wrapped into the work completed, when suddenly I saw an indescribably beautiful picture, imbibed by an inner glow. First I hesitated, then I quickly approached this mysterious picture, on which I saw nothing but shapes and colors, and the contents of which I could not understand. I immediately found the key to the puzzle; it was a picture painted by me, leaning against the wall, standing on its side. The next day, when there was daylight, I tried to get yesterday's impression of the painting. However, I only succeeded half-ways; on its side too, I constantly recognized the objects and the fine finish of dusk was lacking. I now knew fully well, that the object harms my paintings.

A frightening abyss, a responsible load of all kinds of questions confronted me. And the most important: What should replace the missing object? . . .

Only after many years of patient working, strenuous thinking, numerous careful attempts, constantly developing ability to purely and nonobjectively feel artistic forms, to concentrate deeper and deeper into this endless depth, I arrived at the artistic forms, with which I am now working and which, I hope will develop much further.

The process was a long and arduous one. We already know that *line, color,* and *shape* can create sensations of space, movement, weight, and volume. But what about color disassociated from an object? Red, for example, will almost always conjure up images of fire, fire truck, stoplight, or car. Try to imagine a response to "winter"—a response not made of words or images of

snow and ice, but of pure shapes, lines, and colors. The process is indeed an arduous one.

Writing as he worked, Kandinsky tried to explain his ideas, particularly in *On the Spiritual in Art,* published in 1912. In this treatise Kandinsky affirms his belief in the power of art to speak to the intellect and intuition of people without benefit of the habitual, familiar objects of the material world. He also advances a philosophical basis for this belief and suggests its social implications. Western people, he felt, had become desensitized by the materialism of their society.

Only by freeing painting from the material could the painter respond to the unconscious, the spiritual, and the immaterial human longings. Moreover, a response freed from the material world would create a more universally understood language. He warned that his work was only a beginning and that future painters would be able to play on color harmonies as musicians play on the harmonies of the scales. Kandinsky's nonobjective pictures seem to build on Einstein's theories of the relativity of time and space, which were developing at this time. Indeed, Kandinsky embraces the buzzing, booming confusion of Einstein's universe in which all matter is energy. *Painting No. 201,* 1914 (Color Plate XXX), appears as an eruption of the energy of the universe. Slashing lines of color race and run, as if to leap from the space of the canvas. Rich in possibilities for fantasy, dream, and daydream, Kandinsky's pictures offered future artists an example of a language of color, line, texture, and shape unfiltered by the material world.

Expressionism

In Munich, Kandinsky formed a group of artists called the Blue Rider. Members of this group and other German artists, writers, and musicians centered in Dresden and Berlin came to be known as expressionists. *Expressionism* drew on the powerful emotional quality of Van Gogh and on the bold color and line of Gauguin and Matisse. It is essentially, as the name implies, an art of self-expression or subjectivity. Influenced by Freud, expressionist artists (and the writers and musicians associated with them) wished to express the deep, hidden drives of human beings rather than surface "reality." They sensed, along with Marxists, the alienation of the individual in modern society and the dehumanizing effects of bourgeois capitalism. They were dissatisfied with the materialism and complacency of German society and often criticized it harshly in their works. Ernst Kirchner's (1880–1938) painting *Street, Berlin* (1913) is a good example of an expressionist work (Fig. 31-8).

Piet Mondrian (1872–1944) and Purism

At the opposite pole from expressionism, another group of artists, centered primarily in Holland, celebrated the spirit of progress and humanity's rational

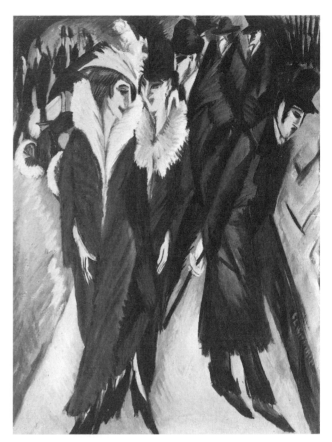

31-8 *Ernst Kirchner,* Street, Berlin, *1913. Oil on canvas, 47½″ × 35⅞″. (Collection, The Museum of Modern Art, New York. Purchase)*

• What is going on in the picture? What is the artist's attitude toward the way of life portrayed here? How does he express that attitude?

and orderly faculties. The group called De Stilj was dedicated to "the devaluation of tradition, . . . the exposure of the whole swindle of lyricism and sentiment." In their work they stressed the need for abstraction and simplification, for clarity, certainty, and order. One, Piet Mondrian, began as a traditional painter, visited Paris, learned from the cubists, and returned to Holland. He began to remove all references to the familiar visual world from his canvases, concentrating on the "pure" reality of the formal plastic elements of art, which he began to confine to a linear black grid imposed on a white ground. He inserted color, usually red, yellow, or blue (the three primaries), to create contrasts that were resolved in harmonious balance (Color Plate XXXI).

Dada and Surrealism

In 1915 a number of young people from all over Europe converged in Zurich, Switzerland, to create a movement

that sought the fantastic and absurd in art, literature, and music. The movement was called *Dada,* a term whose origin is obscure. The most frequently quoted version is that a French-German dictionary opened at random produced the word *dada,* which means a child's hobbyhorse or rocking horse. The point is, of course, that life itself is random and uncontrolled: art should reflect the randomness and pessimism that are bred by the recognition of people's inability to control their lives. The movement in Zurich was most concerned with poetry and music, producing events that combined the two in a nonsensical manner. Ridiculing the materialism of the middle classes and the optimism of the scientifically oriented progressives, the movement seemed at first merely a destructive one that challenged not only the traditional values of art but also the most recent. Nevertheless, there was a deep seriousness about these people that encouraged the artist to look again at the irrational, the subjective, the unconstructed side of the human psyche as it responded to life in the twentieth century.

Marcel Duchamp (1887–1968)

In painting, the artist who exemplifies Dada is Marcel Duchamp (one of three brothers who were deeply involved in new movements in Paris), who had already created a masterpiece in his painting *Nude Descending a Staircase, No. 2,* 1912 (Fig. 31-9). For us today, familiar with time-lapse photography, film, and the multiple images of advertising, the painting is a remarkably expressive rendering of a figure walking down the stairs. Duchamp, however, was not satisfied with painting; he felt that it was a limited process, doomed to end. By attempting a startling variety of approaches, he called into question all the processes of art. Sometimes he would reduce his subject matter to the components of a fantastic machine; at other times he rendered objects with a scientific accuracy that gave them a superreal and fantastic quality. Then, denying the hand of the artist altogether, he simply chose everyday objects, designating them "art" by the application of his signature. For the Armory Show in the United States in 1913 he signed a urinal "R Mutt" and submitted it with the name *Fountain.* It was not shown in the exhibition. These "readymades," as Duchamp called them, were offensive to many, but others saw them as the realization and affirmation of the control of the machine and machine-made products in life. In 1915 Duchamp emigrated to New York, where he associated with the group at Alfred Stieglitz's 291 gallery. There he began a work that came to be considered exemplary of *surrealism,* the movement in art that emerged from Dada after World War I.

The chief spokesman for the new movement, André Breton (1896–1966), was a writer whose experiences in World War I convinced him of the unlimited depth of the human psyche. Impressed by the ideas of Freud, he

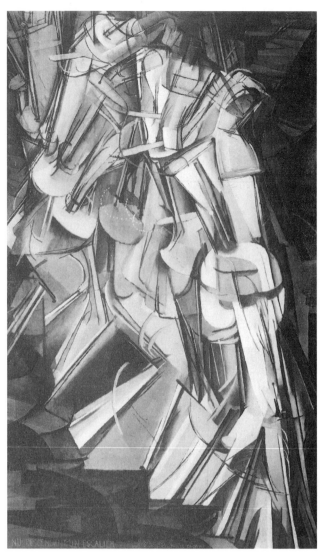

31-9 *Marcel Duchamp,* Nude Descending a Staircase, No. 2, 1912. *Oil on canvas, 58″ × 35″. (Philadelphia Museum of Art: Louise and Walter Arensberg Collection. 50-134-70)*

identified the unconscious mind as the source for a new synthesis of the sometimes unpleasant concrete world with the world of rich associations created in dream and fantasy. The goal was to free individual creativity to respond positively to the conflict between the rational and the irrational, producing a heightened awareness of the vitality of life and the mind that would ameliorate its apparent emptiness. Techniques for achieving this synthesis included collage, automatic drawing, and photographic montage of images. Generally, the results were a dreamlike or hallucinatory juxtaposition of images and objects that stimulated personal free association and intense emotional responses.

In this context Marcel Duchamp's work *Large Glass; Bride Stripped Bare by Her Bachelors* (Fig. 31-10), created circa 1915, became a seminal surrealist

• What elements in this work are also found in work by Picasso, Kandinsky, and Mondrian? What elements are borrowed from popular culture and advertising? Is the work sexist? Why?

work. Duchamp had worked on the idea for years, accumulating images that he transferred to a sheet of plate glass where dust, allowed to collect, had been glued in place. Other random elements, the frame, and, finally, the cracks in the glass itself became part of the work. According to Breton's interpretation, these images reflect the mechanization of persons and of the sexual act. Although such a representation may appear somewhat repulsive, if not inhumane, the artist intended to play on the contrast of humanity with machine and the perpetual conflict between the sexes. In so doing, he intended to enlarge our awareness of the unconscious associations that may accompany our lives.

Other artists in various media learned from surrealist techniques how to contradict our familiar and habitual perception of reality. Surrealism has been a source of inspiration not only in painting, sculpture, the graphic arts, and poetry but also in the production of motion pictures.

Salvador Dalí (1904–1989)

The tenets of surrealism were also adopted by the Spaniard Salvador Dalí. Dalí's education as an artist began traditionally, and after he emerged from the Academy of Fine Arts in Madrid he worked in a number of styles that were influential—including cubism and the neoclassicism of Picasso. To these and other important twentieth-century influences he added the ability and desire to paint in a realist way, comparable with that of Vermeer.

Dalí moved to Paris in 1929, where he associated with the French surrealists. Here he formulated a theoretical basis for his art, which he described as a visionary reality created from visions, dreams, and memories with pathological or psychological distortions. He now eschewed the formalism of the cubists and the abstraction of the constructivists. His work depended on the free association of images, and his painting style became characterized by forms of violence, destruction, decay, and transformation in which familiar objects, such as the human form, watches, telephones, pianos, insects, and images from other paintings, appeared. These forms might be multiplied obsessively or fragmented and distorted. They were rendered with a meticulous attention, creating a frightening sense of reality captured in harsh, intense, and luminescent colors. *The Persistence of Memory*, 1931 (Fig. 31-11), in which

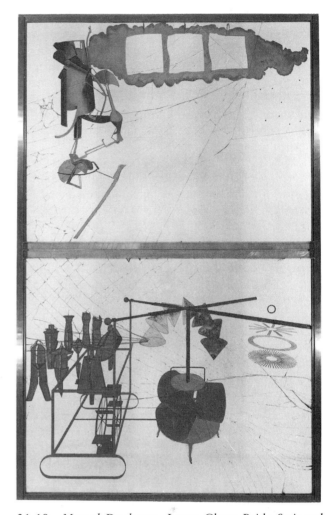

31-10 *Marcel Duchamp*, Large Glass; Bride Stripped Bare by Her Bachelors, *c. 1915. Oil, lead foil, and quicksilver on plate glass, 9'1¼" × 5'9⅛". (Philadelphia Museum of Art: Bequest of Katherine S. Dreier. 52-98-1)*

31-11 *Salvador Dalí*, The Persistence of Memory, *1931. Oil on canvas, 9½" × 13". (Collection, Museum of Modern Art, New York. Given anonymously)*

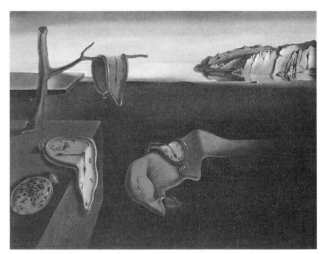

watches collapse, melt, bend, and decay, is among the most famous and familiar of this period.

By the end of the decade Dalí had moved to the United States, where he achieved ready fame with his fantastic appearance and personality and his penchant for publicity. He designed jewelry, theatrical sets, books, and objets d'art. In the 1950s he began to paint serious Christian subjects, including the Crucifixion and the Last Supper.

These later paintings are as controversial as Dalí's entire career. Some consider him a gifted painter, whereas others have considered him nothing more than a facile charlatan whose pretensions to art represent surrealism at its most excessive.

Modernist Sculpture, 1900–1930

Sculpture, like painting and graphics, responded to the same ideas and impulses that had transformed art after 1900. Just as we can distinguish those artists who continue interest in the human form as a means of communication, so we can identify artists who work only in forms, shapes, and colors freed from Renaissance and baroque conventions. Similarly, we can identify cubist sculptors, expressionist sculptors, and sculptors whose

work is always associated with Dada and surrealism. We will consider work by two artists, Constantin Brancusi (1876–1957) and Jacques Lipchitz (1891–1973).

Brancusi was a Romanian whose work really parallels that of the cubists rather than being directly influenced by it. He was trained in the academic manner; but after arriving in Paris in 1904, he turned more and more toward the evocation of forms by reducing them to bare essentials. A splendid craftsman with tremendous empathy for the textures and characteristics of a given material, he described his efforts as a search for the universally expressive essence of forms. *Bird in Space* (Fig. 31-12), made in 1924, can be interpreted as the reduction of a bird's wing, its soaring power, its light gracefulness. The beautifully polished surface of the chrome form calls out to our tactile senses, and it is possible to imagine the cool purity of the shape that a caress would produce.

The work of Jacques Lipchitz forms a strong contrast with much of that of Brancusi. Much more directly influenced by the cubist painters, he made low reliefs in stone that can be directly compared with paintings and collages by Braque and Picasso. A freestanding piece like *Figure* (Fig. 31-13), made between 1926 and 1930, is strongly suggestive of the totemic

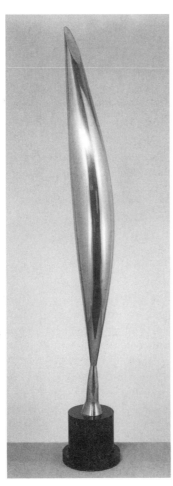

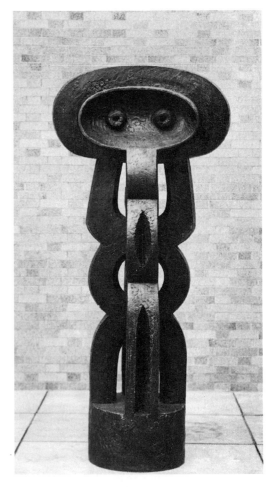

31-12 *Near right. Constantin Brancusi,* Bird in Space, *1924. (Philadelphia Museum of Art: Louise and Walter Arensberg Collection. 50-134-14)*

31-13 *Far right. Jacques Lipchitz,* Figure, *1926–1930. Bronze (cast 1937). 7'1¼" × 38⅝". (Collection, The Museum of Modern Art, New York. Van Gogh Purchase Fund)*

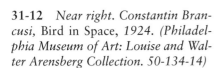

• Compare Lipchitz's *Figure* with Brancusi's *Bird in Space.* What do the two have in common besides being three-dimensional? Does *Figure* bear relationship to other sculptures we have seen? Which painter would you compare to Brancusi: Kandinsky or Mondrian? Why? Which painter would you compare to Lipchitz? Why?

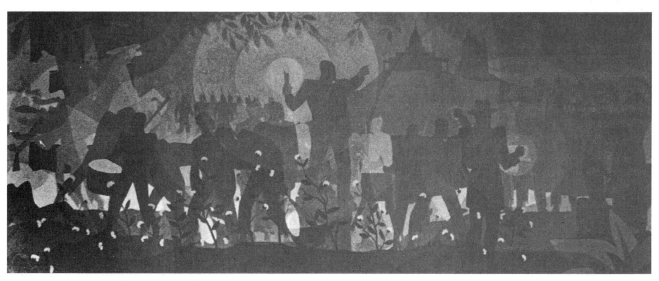

31-14 *Aaron Douglas,* Aspects of Negro Life, from Slavery Through Reconstruction, *1934. (Art & Artifacts Division, Schomburg Center for Research in Black Culture, The New York Public Library, Astor, Lenox and Tilden Foundations)*

power of African figures; but the juxtaposition of side with frontal views that occurs when one moves around a figure in space is based on the orderly perception of the interrelationship of parts—a characteristic of cubism. Lipchitz modeled figures like these in clay or plasticine for bronze casting; the complex surface, which is rough and extremely tactile, was retained in the casting process.

Modernist Painting in America

The art scene in the United States was different from that in Europe between 1900 and the beginning of World War II. American artists felt drawn in many different directions by the history of the country and by their own experiences. Two important movements, the "ashcan school" and the Harlem Renaissance, emerged in these years. Separated by race and ideals, these two groups of artists would have a profound effect on American art in the second half of the twentieth century.

The Harlem Renaissance

The *Harlem Renaissance* (as we will see in Chapter 32) was a broad cultural, artistic, and literary movement among black Americans based in Harlem, New York. It encompassed much more than the visual arts, but the period following World War I marked the emergence of African American art on the national and international levels. Early African American artists such as Edward M. Bannister, Edmonia Lewis (the first black female sculptor), R. S. Duncanson, and Henry O. Tanner were for the most part trained in the academies. Their works were cosmopolitan in theme and lacking in an obvious race consciousness. These artists viewed themselves

primarily as artists and only incidentally as black. As a result of this attitude, they were considered pretentious by both blacks and whites because academic "high" art was generally associated with wealth, leisure, and security.

Picasso and other artists in Paris helped to stimulate interest in African art. Although some black artists in America rejected identification with African art, others spoke of the need to develop an African American art idiom based on African forms. The decades of the 1920s and 1930s witnessed racially conscious African American artists who dealt with many of the themes that were articulated in the New Negro movement: the celebration of the beauty of black people, the illumination of the history of the African American experience, and the search for identity and roots.

Aaron Douglas (1889–1979) One of the most successful artists to emerge from the Harlem Renaissance was Aaron Douglas. Known for his geometric forms, stylized figures, patterns of mystical light, and exoticism, Douglas is rightly regarded as the pioneer of African style among African American painters. He led the way into a new field of African American art with wall decorations in Nashville (Fisk University), Harlem, Chicago, and elsewhere. His well-known mural in the Countee Cullen Branch of the New York Public Library is reproduced here in Figure 31-14. The mural, titled *Aspects of Negro Life* (1934), depicts the cultural and historical background of African Americans.

Jacob Lawrence (1917–2000) Another important African American painter whose work has been associated with raising consciousness of black history and experience is Jacob Lawrence, who was among the many young artists supported by the WPA Artists Relief

Program. American scene painting and American responses to European modernism combine with his experience as a black to form his art. Lawrence has always dealt with American themes, particularly work and the urban experience. He also painted several important series that narrate major events in African American history. Perhaps the best known is the series on the life of Harriet Tubman, a black woman who helped slaves gain access to freedom on the Underground Railway.

The 1967 painting illustrated here, *Forward* (Color Plate XXXIII), is executed in Lawrence's typical manner. The surface is very flat and matte, like a Renaissance wall mural. The abstracted figures are carefully arranged in a compressed space, and the narrative is described through strong, bodily gestures. The colors are also strong, flat, and limited to a few hues. This kind of work may be compared with the work of a number of other American artists, such as Milton Avery, who were also active in this period. Lawrence, like some other black artists who were deeply influenced by European modernism, experienced hostility not only toward his race but also toward his manner of painting. However, this did not deter him from creating a remarkable body of work, which can be associated not only with the African American past but also with the shared and universal themes of freedom and repression, human life, and work.

Romare Bearden (1912–1988) Like Jacob Lawrence, Romare Bearden emerged from the WPA with experience and ideas. He forged a way of working and a particular identity for his work through the association of his art with images and rhythms influenced by black American jazz and blues. Bearden recognized the originality and power of black music and understood that this music was distinctly African American. His complex visual compositions also appear to owe much to printed and woven textiles associated with West Africa. The energy of his work, however, is his. Like the work of Jacob Lawrence, Bearden's contributed to the development of American art in the last half of the twentieth century.

African American Sculpture In sculpture, a consciously African style was most clearly expressed. The works of Richmond Barthé and Sargent Johnson offer the best examples of such sculpture. Sargent Johnson's bust *Chester* (Fig. 31-15), 1931, and Barthé's *African Dancer* (Fig. 31-16), 1933, are both particularly striking for their African qualities. Yet the works of Barthé and Johnson differ from each other and from African art. The forces that motivated artists in America in the 1930s and 1940s cannot be the same as those that motivated the artist of the Benin head or the Dogon votive figure. Yet the search for roots, as surely as the presence of successful artists, exerted a profound influence on

the black artists in America who reached maturity after World War II. The recognition that the past, as well as the present, is profoundly different and tremendously rich is liberating.

The "Ashcan School"

The painters who constituted the *ashcan school* remained loyal to an essentially realist aesthetic, basing their work on that of Thomas Eakins (see Chapter 29), but their art was more reportorial and concerned with the life and times of the city. In fact, this subject matter gave their style its name. John Sloan (1871–1951), one of the most representative painters of this group, took his subject matter from the daily activities of the middle class, the poor, and the immigrant. The painters in this group were not convinced that European art could make a contribution to the development of a uniquely American art.

However, they helped to give modern art its first important, large exhibition in the United States. Arranged by an association of American artists, the Armory Show of February 1913, staged at the Armory of the Infantry in New York City, exhibited the work of

31-15 *Sargent Johnson,* Chester, *1931. Terra cotta, 10⅞″ × 6¾″ × 6⅜″. (San Francisco Museum of Modern Art, Albert M. Bender Collection, Gift of Albert M. Bender)*

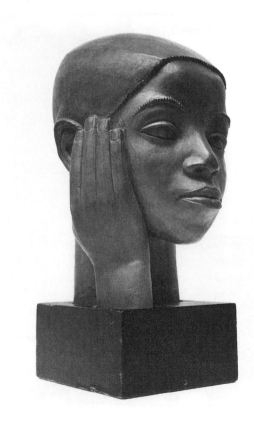

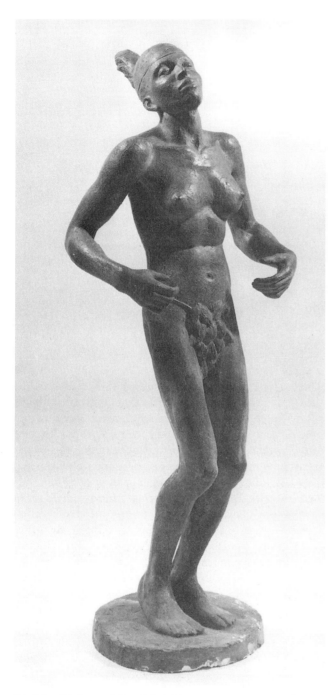

31-16 *Richmond Barthé*, African Dancer, *1933. Plaster. Overall: 43½" × 17¹/₁₆" × 14¹¹/₁₆" (110.5 × 43.3 × 37.3 cm). (Collection of Whitney Museum of American Art, New York. Purchase 33.53)*

ied in Berlin and returned to the United States. Stieglitz opened a gallery at 291 Fifth Avenue, where he exhibited the most advanced work from abroad and attracted artists and critics. Many important American artists were associated with the gallery and with the impact of European ideas on the American scene.

Stuart Davis (1894–1964)

For decades an acknowledged leader of American abstraction, Davis evolved his style out of the cubism of Picasso and the ordinary objects of American urban life. Choosing as subject matter cigarette packs, light bulbs, electric fans, rubber gloves, and an eggbeater, Davis subjected these ordinary items to a rigorous process of abstraction (Fig. 31-17). In a painting such as *Egg Beater No. 4*, Davis combines objects that seem caught in an energizing framework. Davis's painting *House and Street* (1931) also gives a powerful portrayal of a typical American scene. The juxtaposition of close-up with distant view and the simplification of forms and colors seem almost cartoonlike, but the energy that the painter gives to the place is hard to ignore. Davis's work demonstrated that abstraction had its place in American painting of the modernist period.

Georgia O'Keeffe (1887–1986)

Another important painter in this group, Georgia O'Keeffe, the wife of Stieglitz, was active as a painter until the 1970s. Her work, like that of Davis, seems to be a major bridge between the American desire for a realistic imagery and the idealism implicit in European abstraction. Certainly she created a very modern, personal idiom. She could make works that completely eliminated objects, and she painted the skyscrapers of New York City and the barns of Lake George with a clarity and rectitude comparable to the work of Charles Sheeler and George Demuth, two of her contemporaries.

O'Keeffe is most frequently associated with two kinds of images. The first are scenes of the American Southwest. Her knowledge of the area began in her late teens, and in the expansive New Mexican arid landscape, she identified feelings and discovered forms in light that seemed to confirm a vision and provide the means of achieving it. Bleached bones and bony mountains, solid adobe walls and cool, shadowed spaces are painted as intensely experienced but universalized in feeling. The juxtaposition of bones with blossoms and the reduction of endless sky to patterns of light were constant subjects of her last thirty-five years (Fig. 31-18 and Color Plate XXXII).

Second are those in which the object, usually a flower or other plant, occupies the entire picture space. In her clear, painstaking account of the magnified flower, we find a rich ground for symbolic associations.

Cézanne, Van Gogh, Gauguin, Matisse, Kandinsky, Picasso, and Duchamp, among others. The public was generally shocked and offended, but many American artists were stimulated and attracted by these works, for a strong stream of innovation already existed. These young artists had already found a rallying point in the figure of Alfred Stieglitz, a photographer who had stud-

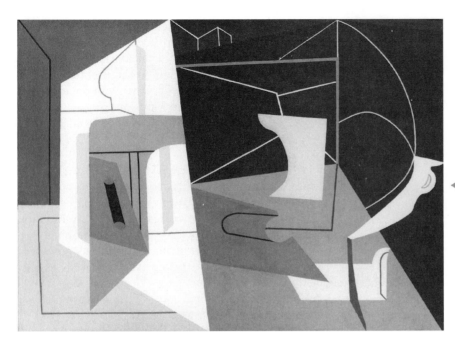

31-17 *Stuart Davis,* Egg Beater No. 4. *(The Phillips Collection, Washington, D.C.)* (**W**)

- Compare *Egg Beater No. 4* with Picasso's *Man with a Violin* (Fig. 31-5) and *Three Musicians* (Fig. 31-6). Which of the two is more like Davis's work? Why? Is there a particularly American quality to Davis's work that you do not find in Picasso's? Can you be specific? Does Davis's work have qualities in common with Mondrian's?

31-18 *Georgia O'Keeffe,* Cow's Skull with Calico Roses, *1932. Oil on canvas, 91.2 × 61 cm. (Gift of Georgia O'Keeffe, 1947.712. Photograph © 1996, The Art Institute of Chicago. All Rights Reserved)*

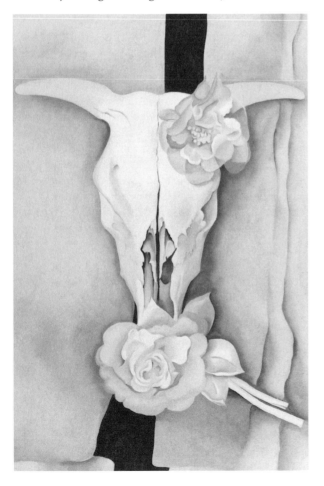

The crisp, smooth, painterly surface, however, presents the object with a cold objectivity that contrasts with our resonating fantasies. This tension between the unavoidable presence of the object and the opportunity for free fantasy seems characteristic of American life; it is a contrast like that between our great dependence on the machine and our fear of its dehumanizing possibilities.

O'Keeffe's paintings, drawings, and watercolors of flowers have always been received with critical ambivalence—great enthusiasm counterbalanced by grave reservations because of her being a woman. Historically, "flower painting" was a "woman's art," and the complex messages conveyed by her work seemed both to challenge and make fun of the idea that art created by women should be somehow different from that made by men. Further, her artistic reputation had always been colored by her associations with the artists who represented the *avant-garde* of American painting. As Stieglitz's wife and model, she was regarded as an interesting, "bohemian" figure, not an important painter. A 1991 major exhibition of her work at the National Gallery of Art took the position that it is time for serious study because it is her work and not her personality that must withstand critical assessment.

Modernist Architecture, 1900–1930

Visual artists in America learned much from Europe as well as from Africa and Asia. Architectural design was likewise influenced by ideas from other cultures. International expositions, the increased availability of builders' publications, and a rejection of the revival styles produced a complex built fabric. The skyscrapers

of William LeBaron Jenney and Louis Sullivan created a commercial architecture unsurpassed by anything in Europe for its innovation and successful experimentation with the tall office building.

At the same time, ideas from America's colonial past and forms captured from India and Japan contributed to the development of a distinctive American domestic architecture. In California the architects Bernard Maybeck (1862–1957) and the brothers Charles Sumner Greene (1868–1957) and Henry Mather Greene (1870–1954) created the bungalow—a house type believed to be Indian in origin—with wide, overhanging eaves that sheltered porches, deep windows, and plain walls. The bungalow provided easy access to the out-of-doors (Fig. 31-19). The architectural vocabulary was influenced by the predominantly wooden handcrafted architecture of Japan, the revivalism of the English Arts and Crafts Movement, and the conscious search for an American domestic architecture with links to the past.

In the Midwest Sullivan's pupil Frank Lloyd Wright and a younger generation of architects who worked well into the twentieth century also created a distinctive domestic architecture that came to be known as the *prairie style*. Like the work of the California architects, these houses represent a conflation of ideas drawn from Europe and Japan that encourage the use of wood, stucco, tile, brick, and other simple, handcrafted materials to create a spare but elegant ground-hugging dwelling. The early-twentieth-century houses of Frank Lloyd Wright, however, display a particular genius and originality in the combination and development of ideas that would, in turn, be influential in Europe.

Frank Lloyd Wright (1867–1959)

Wright left Louis Sullivan's office in 1893 to work where he lived, in a suburb of Chicago, Oak Park. He had been greatly challenged by Sullivan, but his particular interest in these early years was the single-family dwelling. The typical two-story wood frame house of the late nineteenth century was, to Wright, a disaster. It was cramped, ugly, dark, and dank. It wasted space, had no relationship to its site, ignored innovations in mechanical systems, and separated people from the land that was their aboriginal home. Wright asked fundamental questions about architecture, beginning with the abstract idea of dwelling, of shelter. He asked what features, forms, and shapes would place people in a

31-19 *Charles Sumner Greene and Henry Mather Greene, David B. Gamble House, Pasadena, California. (Courtesy, Greene and Greene Library, Gamble House)* (**W**)

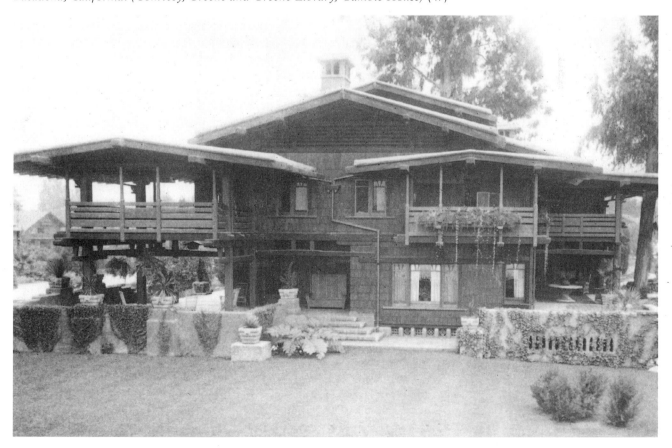

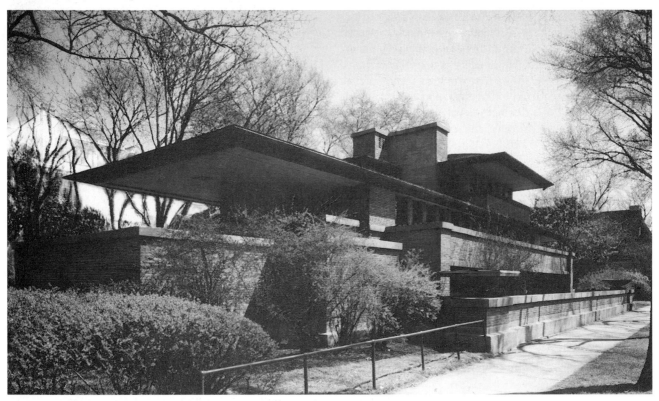

31-20 *Frank Lloyd Wright, Robie House, 1912. (Hedrich Blessing, Chicago. 19312-c)*

• Study the plan of the Robie House. Why does Wright make the hearth and fireplace the focus of the house? What is the effect of the deep, overhanging eaves and the long, continuous lines produced by the roofs and porches? Where does he use glass? Why does he partially conceal the house from the neighborhood streets? Is the combination of brick and concrete effective? Why? Why do you think Wright's work came to exemplify the possibilities for an architecture that was not "in the styles"?

harmonious relationship to the earth, giving them the comfort and warmth of the aboriginal cave. He asked what materials should be used, how, and in what forms. He asked questions about the family: how does it function as a small community, and how can the dwelling provide essential privacy for each member within the context of the family? He also asked how growing technology and machine-tooled elements might make the house more livable, comfortable, and responsive, as well as less time consuming in terms of its upkeep to free the family for more personal leisure and growth. The approximately thirty houses that grew up on the prairie of Oak Park were the answers to these questions.

Economical to build, dependent on the direct and simple use of wood, glass, brick, and stucco, the Oak Park houses were made for owners who were neither eccentric nor particularly rich. The plans of the houses frequently grew outward from a central core of hearth and services—plumbing, electricity, and heat. Bedrooms were confined to one area, kitchen and servants to another wing; the family-oriented activities were grouped in integrated spaces around the hearth. Overhanging eaves sheltered the long windows and glass doors that opened onto patio, terrace, or balcony. Low walls of stone, brick, or shrubbery separated the houses from the intrusions of the street. The owners loved their homes. Wright's solutions were among the most innovative that this country had seen. The Robie House in Chicago is a mature expression of Wright's ideas (Figs. 31-20, 31-21). The house, built in 1912 in the prairie style, produced tremendous response from the Europeans who visited Wright in Chicago. His work came to exemplify the possibilities for an architecture that was not "in the styles."

Wright's emphasis on the orderly and rational, coupled with a deep, intuitive feeling for human nature and what would make a suitable dwelling, produced a marriage of ideas that struck strong chords in European thought. His emphasis on the use of machined materials—glass, brick, veneers, and, in the Robie House, steel members for the far-reaching eaves—seemed to combine the best of two worlds: technology and the machine, people and their imagination. Although some of Wright's contributions were influential in Europe, many of his ideas seemed too romantic to the architects and theorists of the school known as the Bauhaus.

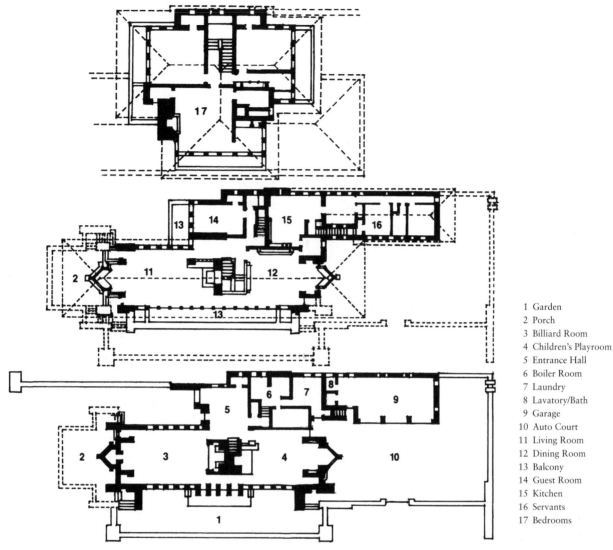

1 Garden
2 Porch
3 Billiard Room
4 Children's Playroom
5 Entrance Hall
6 Boiler Room
7 Laundry
8 Lavatory/Bath
9 Garage
10 Auto Court
11 Living Room
12 Dining Room
13 Balcony
14 Guest Room
15 Kitchen
16 Servants
17 Bedrooms

31-21 *Floor Plans, Robie House.*

The Bauhaus (1919–1933)

Founded at Weimar, then moved to Dessau, Germany, the *Bauhaus* became the most influential center for architects who shunned the past and wanted to create a rational, functional architecture for the twentieth century. These people wanted to use new materials in a direct way, taking advantage of the machine and machine production not only to create buildings but also to produce the furniture, textiles, light fixtures, and objects appropriate for a purely functional, scientific age. The physical plant for the school (Fig. 31-22), built in 1925–1926, is almost factorylike in its simplicity and directness. In fact, factories and purely commercial design had much influence on the development of these forms. The classroom block is a steel framework enclosed in a curtain of glass. The wall, with which human buildings began, has given way to a thin, light,

permeable membrane carrying no weight. It also reminds us of the Crystal Palace, for the ideas created there were admired by the Bauhaus architect.

The program of study at the Bauhaus also reflected the optimism of the new age. Students began with a yearlong course in the general principles of design, materials, and color. It was believed that if they could master the principles of design in various media, they could use that knowledge to solve any problem. The analogy, of course, is with the scientific method. After learning principles, students applied them by working in the shops of the Bauhaus, learning the various aspects of total design from the ground up, as it were. They could then specialize. The Bauhaus attracted the most advanced thinkers, artists, and designers. Kandinsky taught there, as did Paul Klee, Josef Albers, Walter Gropius, Marcel Breuer, and Ludwig Miës van der Rohe. After the latter four emigrated to America in the

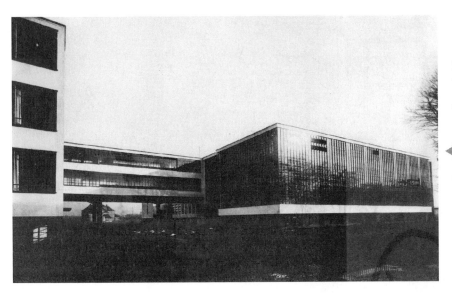

31-22 *Walter Gropius,* The Bauhaus, *Dessau, Germany, 1925–1926. (Photograph courtesy of The Museum of Modern Art, New York)*

- What characteristics does this building share with work by Wright? With the Crystal Palace (in addition to the glass; Fig. 29-1)? Compare this building with American skyscraper architecture. What common elements (site, function, materials), though they may be different, shape both?

1930s, their presence had a profound effect on art and architecture in this country.

Le Corbusier (1887–1965)

In France Le Corbusier (Charles Édouard Jeanneret) advocated principles like those of the Bauhaus architects, for like Gropius and Miës van der Rohe, he had worked with Peter Behrens, the German architect who laid the groundwork for the success of the Bauhaus. Beginning as a painter in Paris, Le Corbusier attacked the cubism of that period (c. 1918) as merely decorative. With his friend Amédée Ozenfant, he advocated an architectural simplicity in painting and the elimination of all subject matter. He sought a kind of pure painting, like that of Mondrian; in this context he also developed his idea of architecture, characterized in this period by a minimalist approach to design. At the same time he coined the phrase that a house should be a "machine for living in." In the years between 1918 and 1930 Le Corbusier pursued the problem of the house. He combined reinforced concrete, which is light, strong, and malleable, with pillars to make walls independent, free to respond to the open plan, much in the same way that Wright had done. Like Wright, he was concerned with the interpenetration of spaces, but he was more inclined to separate the house from its site, turning the house inward on itself (Figs. 31-23, 31-24).

Two New Art Forms: Photography and Film

Photography

Photography began to evolve into an art form after it was discovered in France in the 1830s. Painters such as Courbet, Degas, and Eakins used their own photographs as inspiration for their paintings, and photographers such as Nadar and Eugene Atget learned to use the camera to make pictures that were meant to be seen as art and not simply as a copy of the subject represented. Photographs allowed both painters and photographers to show viewers objects never before observed by the human eye. By the beginning of the twentieth century in Europe and America, photography had become an art form and today is fully accepted as such.

It has always been important that photographers not only expose their own film but also develop their own prints, thus controlling the many variables inherent in the process. At first, photographic subject matter was limited to carefully posed compositions such as portraits and staged dramatic scenes. The exposure of photographic film or plates was too slow to prevent anything that moved from blurring, and both photographers and their sitters had to be very patient. As the technology improved, so did the ability of photographers to record and respond to life.

Edward Steichen (1879–1973) and Alfred Stieglitz (1864–1946) are the two people most often associated with photography's development as an art form in America in the early twentieth century. Stieglitz showed photography at his New York gallery, 291, along with modern paintings and sculpture by American and European artists (Fig. 31-25). His magazine, *Camera Work*, reproduced the work of many promising artists. Both Steichen and Stieglitz chose subjects from everyday life, as well as made memorable portraits of friends and notables (Fig. 31-26). Their photographs are studies in lighting and composition, and the portraits are as psychologically revealing and emotionally rich as those done by painters. In the hands of

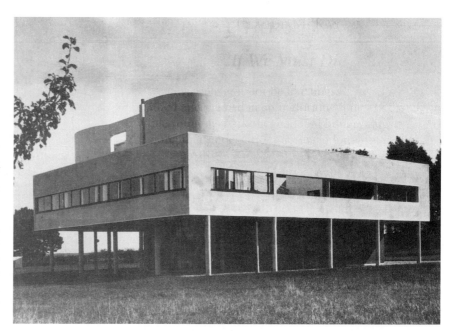

31-23 *Right. Le Corbusier,* Villa Savoye, *Poissy-sur-Seine, France, 1929–1931. (Photograph courtesy of* The Museum of Modern Art, New York)

31-24 *Below. Le Corbusier,* Villa Savoye. *(left) Plan of ground floor showing driveway and garage between the columns (pilotis), service areas, and guest quarters. (right) Plan of second floor with main living quarters and roof terrace.*

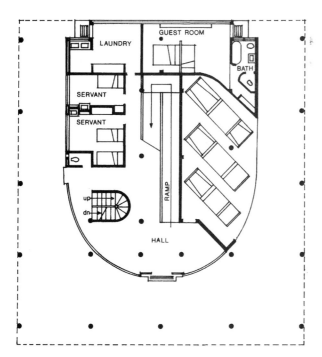

GROUND FLOOR

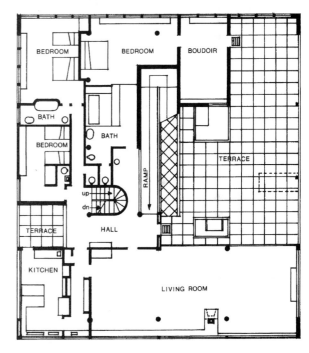

SECOND FLOOR

• Compare the Villa Savoye at Poissy with the Robie House (Figs. 31-20 and 31-21). How do the materials differ? How does the difference affect your feelings toward each house? Why? Which house seems to be more "in sympathy" with its site? Which house seems to be more "rational" and "functional"? Which seems more "modern" today? Why? Which would you prefer? Why?

others such as Lewis Hine (1874–1940) and Jacob Riis (1849–1914), who photographed immigrants struggling to survive in the tenements of New York, pho-

tographs became a tool for promoting reform. American life in all its variety was a source for artistic inspiration.

When the Great Depression cloaked the nation, photographers such as Walker Evans (1903–1975), Dorothea Lange (1895–1965), and Russell Lee traveled through the rural South and Midwest for the Farm Security Administration, documenting the suffering and displacement caused by the devastated farm economy (Fig. 31-27). Later, Walker Evans's photographs were joined with a text by James Agee, *Let Us Now Praise*

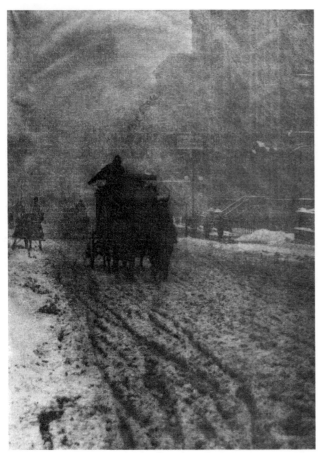

31-25 *Alfred Stieglitz,* Winter, Fifth Avenue, *1893, from* Camera Work, *Plate 2, No. 12, 1905. Photogravure, 8⅝″ × 6¹⁄₁₆″. (Collection, The Museum of Modern Art, New York)*

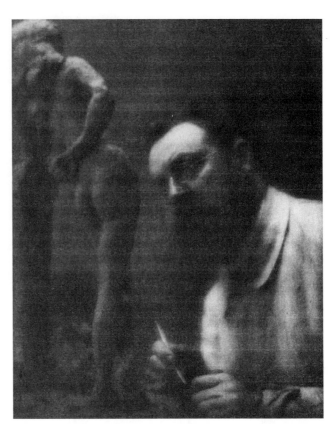

31-26 *Edward Steichen,* Henri Matisse and "The Serpentine," *1910, from* Camera Work, *Nos. XLII–XLIII, 1913. Photogravure, 8⅝″ × 6¹³⁄₁₆″. (Collection, The Museum of Modern Art, New York. Gift of William A. Grigsby)*

Famous Men, that unites words and images to create a work of art.

In the 1920s and 1930s, a group of photographers in California were inspired by Edward Weston (1886–1958) (Fig. 31-28). Working primarily with the cumbersome view camera, these artists studied and recorded objects—vegetables, fruit, the human body—as if they were abstract patterns of form, texture, shade, and shadow. They formed a group, F/64 (named after the setting on a view camera that brings the maximum area into sharp focus), and exhibited and published their work. Weston and Ansel Adams (1902–1984), also a member of F/64, emerged as two of the major figures in American photography during this period. Adams's subject, like that of W. H. Jackson and Timothy O'Sullivan before him, was the landscape of the American West (Fig. 31-29).

Photographers like Henri Cartier-Bresson (b. 1908) and Eugene Smith (1918–1978) showed that small 35 mm cameras could be used to work quickly and intuitively, producing images of street scenes and war zones that could stimulate the mind as much as photographs made with larger equipment (Fig. 31-30).

By the mid-1950s, "art" photographs were as widely collected as the work of painters and sculptors. The still photograph, whether black and white or color, has become a particularly appropriate medium for the art of the twentieth century but no more so than its counterpart—also a product of film—the motion picture.

Film

Developed barely six decades after photography, the motion picture—like oral or written literature, painting, sculpture, photography, and sound recording—is a cultural form of recorded memory. With the development of new technology and sound recording, human beings were, for the first time, able to preserve not only words and images of their culture but also its actions, sights, and sounds.

Motion pictures were at first limited to short sequences, such as a clown's trick or a locomotive seen head-on, rushing at the audience. But the silent movie, accompanied by captions and live pianists, soon developed into a genuine art form. Perhaps its most memorable figure is Charlie Chaplin (1889–1977) (Fig. 31-31), whose portrayal of the "little tramp" baffled by modern civilization made him a true comic hero of the times.

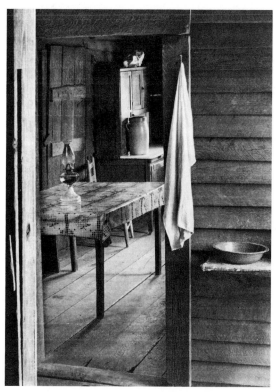

31-28 *Edward Weston, Artichoke, Halved, 1930. Gelatin-silver print, 7½″ × 9½″. (Collection, The Museum of Modern Art, New York. Gift of David H. McAlpin. © 1981, Center for Creative Photography, Arizona Board of Regents)*

31-27 *Walker Evans, Hale County, Alabama, 1936. Gelatin-silver print, 9⅜″ × 6⅝″. (Collection, The Museum of Modern Art, New York. Stephen R. Currier Memorial Fund)*

31-29 *Ansel Adams, Mount Williamson, The Sierra Nevada, from Manzanar, California, 1944. (Copyright 1992 by the Trustees of The Ansel Adams Publishing Rights Trust. All Rights Reserved)*

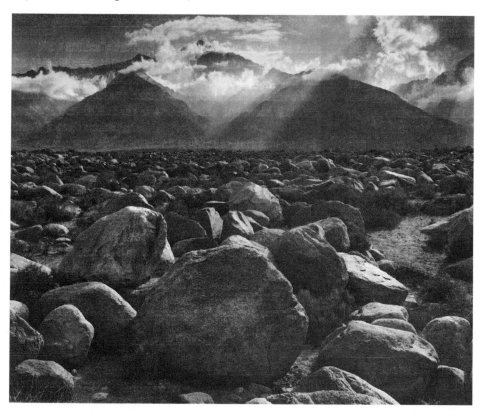

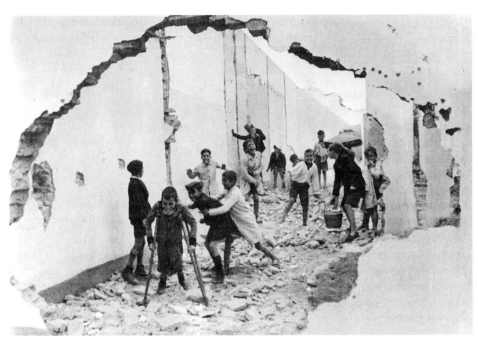

31-30 *Henri Cartier-Bresson,* Children Playing in the Ruins, Spain, *1934. (Magnum Photos)*

The full-length motion picture that presents an entire drama is obviously analogous to the theater. The mechanics of producing a play, whether on stage or for filming, involve the same elements: actors, scripts, sets, props, costumes, makeup, lighting, sound effects, director, producer, and marketing (getting the production to audiences). Recording a play on film has both advantages and disadvantages. The principal disadvantage is that the sense of immediacy is lost, and the unspoken communication between performance and audience is missing in the film.

The advantages of cinema include the ability to make a permanent and reproducible record of what happened in front of the camera and the use of *montage,* the ability to edit the performance. Unlike the stage director, the film editor can remove and replace sequences in which an actor forgot his or her lines. The editor can also show change in a way that is nearly impossible for a stage director.

In the American film *Citizen Kane* (1941), directed by Orson Welles (1915–1985), there is a sequence introduced in the script by this note:

> The following scenes, which cover a period of nine years, are played in the same set with only changes in lighting, special effects outside the window, and wardrobe.

The scriptwriter could have noted that changes in makeup also occur; the actors seem to become older as the scenes progress. What happens is this: in each of the seven brief scenes, Kane and his wife are shown in the breakfast room. The first scene presents them as newlyweds—happy, in love, and just getting home after being

up all night going to six parties. As the action progresses, the development of their marriage is revealed. Love turns to complacency, then to rancor, and finally to resignation. The last scene is silent—they are reading different newspapers. These scenes unfold rapidly, occupying only a few minutes of film, but they make a point; more importantly, they could not be done as effectively on the stage because of the necessary delays for costume and makeup changes. Naturally, these delays are not shown in the film.

The filmmaker can also move the camera. He or she can show close-ups of an actor, which is impossible for the stage director, as well as focus attention much more easily than the stage director can. The camera can also be taken out of the theater and moved to many different places.

These differences between plays and films are powerful artistic tools that have been exploited effectively by the greatest filmmakers. Techniques such as the flashback, dissolve, and close-up made it possible for avant-garde filmmakers to experiment with layers of time, symbolic images, or portrayal of the unconscious in ways parallel to such presentations in modernist literature and art.

Filmmaking, like photography, has attracted many practitioners. As with all other artistic endeavors, the criteria for success have varied from generation to generation. Following the establishment of the genre in early masterpieces such as *The Birth of a Nation* (1915), the Chaplin and Marx Brothers comedies, and Orson Welles's *Citizen Kane,* a host of important directors have created films whose situations, heroes, and heroines have established typical American archetypes: the honest politician in *Mr. Smith Goes to Washington* (1939), the war hero in *Sergeant York* (1941), the gentle giant in

Following World War I, a host of movies dealt with the trauma of that experience. With the Great Depression came a series of lavish musicals and hilarious comedies designed to help Americans forget their terrible plight. Fred Astaire and Ginger Rogers appeared in elegantly staged and beautifully choreographed dance numbers that enthralled audiences. After World War II, American and foreign films explored new conventions and new techniques. Epics such as *The Ten Commandments* (1923), made by Cecil B. De Mille (1881–1959), shared the screen with the intellectually and emotionally complex films from the European, Japanese, and Indian cinema. Each country has developed its own styles and stars. The limits of the media have been stretched considerably from those in force when *Gone with the Wind* was produced in 1938. But the film, gifted with the ability to convey many ideas and images at once, vehicle of popular entertainment as well as serious art form, continues to be a source of controversy.

From Cézanne and Picasso to Wright and Le Corbusier, to Stieglitz and Welles, we have covered the ground of the watershed period of this century in the arts. We have actually touched down only in a very few places. More is omitted than included. We have tried to outline the predicament of the visual artist in these years, torn between optimism and pessimism, and torn between the desire for an orderly and pure art and architecture and the desire to speak to the anxiety that was given its most awful expression in World War I itself, where science produced the gas bomb, the machine gun, and the airplane. On the one hand, all seems pure and promising; and on the other, all life seems destined only for suffering and death. The American artist faced the years between the wars in either a self-imposed isolation or a struggle with the implications of European work. New technologies and ideas would eventually fuse developments in Europe to produce a great American school that was also truly international.

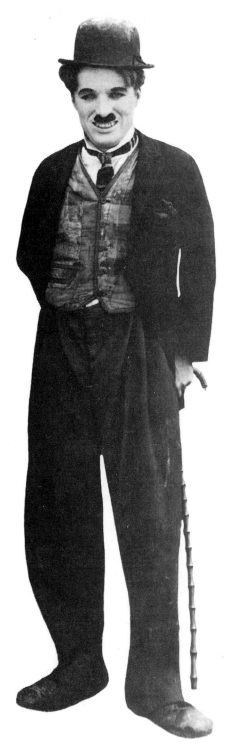

31-31 *Charlie Chaplin. (The Museum of Modern Art, New York/Film Stills Archive)*

King Kong (1933), the displaced of the Great Depression in *The Grapes of Wrath* (1940), the cruel mobster in *Scarface* (1932), and the myth of the moviemaking genre itself, the beautiful starlet who achieves great fame in *A Star Is Born* (1937). The movies also used the great drama of nineteenth-century American western expansion as the source for the cowboy film, which presented the eternal struggle of good and evil.

Igor Stravinsky (1882–1971), the Russian Ballet, and *The Rite of Spring*

Closely allied with the various modernist movements in the visual arts, artists in the fields of music and dance in the opening decades of the twentieth century showed many of the same formal and thematic concerns. Modernism, however, was and is not simply a movement limited to that era. It became a new way of representing the world through art. Generally, serious artists of the twentieth century felt the necessity either to react against modernism or to build on its innovations.

Igor Stravinsky, a Russian-born musician whose musical education and taste led him to Paris during the early years of the twentieth century, was part of the artistic revolution that sets the music, art, and literature

of the twentieth century apart from all that went be-fore. His musical roots were planted in, and flourished amid, the fertile harmonic gardens of the nineteenth century; but his branches sought light among the complex ideas of the abstract painters, modern dancers, and revolutionary men and women of letters who worked in Europe during the first two decades of the century. Stravinsky became a part of, some might say even a causal factor in, a revolution in classical music.

Stravinsky worked closely with a fellow Russian, Sergei Diaghilev (1872–1929), a theatrical impresario who had brought Russian ballet, opera, and painting exhibits to Paris in 1909. The Russian innovations in all these arts, but particularly in ballet, were to have an invigorating effect on western Europe. In the mid-nineteenth century the world center of ballet had moved from Paris to Saint Petersburg; ballet in the West had become to a great extent reduced to pretty dancing girls executing mechanical movements. The imperial ballet in Russia, however, underwent a classical revival that produced the great ballets to the music of Tchaikovsky: *Sleeping Beauty*, *Swan Lake*, and *The Nutcracker*. A young choreographer, Mikhail Fokine (1880–1942), revolted against the somewhat rigid, conventionalized vocabulary of this style of ballet. In a manifesto written in 1904, Fokine called for a greater unity of composition in ballet, more integration with the other arts, and gestures "built on the laws of natural expressiveness" to enable dance to "regain its spiritual forms and qualities." Fokine, whose ideas influenced Diaghilev, became the first choreographer for the latter's Russian Ballet troupe. Fokine's training also produced the troupe's greatest male dancer, Vaslav Nijinsky (1890–1950). The extraordinary innovations of the Diaghilev ballets in Paris sprang from the combined talents of composers such as Stravinsky; dancers and choreographers; artists who designed the sets (Picasso among them); and, later, writers such as Jean Cocteau, all under the masterful direction of Diaghilev.

Primitivism

In the section on the African Gelede festival in Chapter 13, we attempted to show that the unification of dance with the other arts, for the purpose of expressing the basic values or spiritual needs of a community, is typical of African artistic expression. European artists, seeking new ways to combine the arts through dance, were in a sense trying to recover a means of expression that they felt had been lost in their own society. Their search may be viewed as belonging to the "discontents" with "civilization" in the early twentieth century. It was in fact often combined with what is called *primitivism*, or an attempt to find fresh artistic sources in cultures less intellectualized and less specialized. Painters and sculptors, as we have seen, turned to the arts of Africa and Polynesia. But Stravinsky, with the other Russians in Paris, looked for inspiration to his native land, where

folkloric traditions were still rich and "civilization" only recent. Both the primitivist dream and the desire to recreate the unity of the arts were instrumental in the conception of Stravinsky's great musical composition *Le Sacre du Printemps* (The Rite of Spring) and its ballet.

Stravinsky himself has described the sources of his inspiration. He remembered the "violent Russian spring" that seemed to begin suddenly and to set the whole earth cracking as the most exciting yearly event of his childhood. The memory of this natural event was no doubt linked to a vision that he had while in the midst of completing *The Firebird*, another ballet score.

> I saw in imagination a solemn pagan rite: sage elders, seated in a circle, watched a young girl dance herself to death. They were sacrificing her to propitiate the god of spring. Such was the theme of the *Sacre du Printemps*. I must confess that this vision made a deep impression on me, and I at once described it to my friend, Nicholas Roerich, he being a painter who had specialized in pagan subjects. He welcomed my inspiration with enthusiasm, and became my collaborator in this creation. In Paris I told Diaghileff [Diaghilev] about it, and he was at once carried away by the idea.[1]

Diaghilev chose the revolutionary Nijinsky to do the choreography; Roerich did the sets, and the entire new production was presented to the Parisian public at the opening of the Théâtre des Champs-Elysées in the spring of 1913.

The subject matter of *The Rite of Spring*, if Russian in inspiration, is in fact universal. In searching for the cultural roots of this piece, we might consider that the prehistoric origins of all modern peoples hide pagan and barbaric customs that we would now find repulsive and dreadful. Stravinsky's *Rite* is no figment of the imagination. The ritual of human sacrifice to appease angry gods seems to reappear in every mythology, and factual evidence proving the existence of terrifying practices by humans of more recent vintage only serves to remind us that Abraham's intended sacrifice of his son Isaac and the jungle headhunter's devouring of enemies are not entirely fairy tales of another time, place, and people. In early Greece it would appear that the Dionysian festival helped ensure a bountiful harvest in the succeeding season by sacrificing the festival king. With the growth of civilization, real sacrifice is replaced by ritual or symbolic sacrifice, but the need to communicate with and appease one's god or gods seems to remain in some form a part of human nature. It is the human desire to communicate with elemental forces that challenged Stravinsky's creativity, bringing forth one of the most remarkable musical compositions of the twentieth century.

The scenario, or story line, deals with the veneration of spring by primitive peoples, a process viewed as a mystical rebirth of the earth. The decay of vegetation

[1] Igor Stravinsky, *An Autobiography* (New York: Simon & Schuster, 1936; reprinted New York: M. & J. Steuer, 1958), p. 31.

during the winter was considered to be a weakening of nature's fertility, and the rejuvenation of nature called for a sacrifice in spring, *le sacre du printemps*. A female is chosen, and she pays homage for her people with her life. To show this on the stage, Stravinsky set his music in parts, each section with a self-explanatory title. The music is continuous in each part, and the episodes follow each other without pause.

PART I

Adoration of the Earth

1. Introduction
2. Dance of the Adolescents
3. Dance of Seduction
4. Rounds of Spring
5. Games of the Rival Communities
6. Entrance of the Celebrant
7. Consecration of the Earth
8. Dance of the Earth

CD-2, 13

PART II

The Sacrifice

1. Introduction
2. Mysterious Circle of the Adolescents
3. Glorification of the Chosen One
4. Evocation of the Ancestors
5. Ritual of the Ancestors
6. Sacrificial Dance of the Chosen One

CD-2, 14

The Music

The music Stravinsky composed to set these ritual dances to had, and still has, a shocking effect on its audiences. Peculiar chords assault the ears. Not only were the combinations of notes unfamiliar to all but the most avant-garde listeners of the day; they also did not progress through familiar chord patterns that concert patrons had come to expect in music for the ballet. The music was loud, so loud; and it seemed to repeat discord after discord in irregular and jagged rhythms. Worst of all, there were no lovely, singable melodies that the music-loving French might whistle or hum as they left the theater. In fact, the first audience found this music so distasteful that they literally started a riot. Jean Cocteau describes the scene thus:

> The public played the role that it had to play. It laughed, spat, hissed, imitated animal cries. They might have eventually tired themselves of that if it had not been for the crowd of esthetes and a few musicians, who, carried by excess of zeal, insulted and even pushed the public of the boxes [the very wealthy in the box seats]. The riot degenerated into a fight. Standing in her box, her diadem askew, the old Countess de Pourtalès brandished her fan and shouted all red in the face: "It is the first time in sixty years that anyone has dared to make a fool of me!"

What was happening in music in 1913 that could cause such a hostile reaction in Paris? Basically, all the musical values of the past were being questioned and replaced with new, experimental ideas. Stravinsky was not alone in working toward a new tonal idiom, although his solutions differed from those of his important contemporaries—Claude Debussy, Erik Satie, Alexander Scriabin, Arnold Schönberg, and Anton von Webern. But whereas music to this time had been building on the past—adding to and depending on tradition—the new music of these composers, Stravinsky included, negated the validity of the past and imposed a new order on the sounds of music. *Harmony*, in the traditional sense of the word, was discarded; so were the notions of *melody* and *rhythm* that prevailed at the time. New orchestral effects were pried out of the instruments, and new types of heroes, or antiheroes, were sought for the songs and scenarios of the rebellious avant-garde composers.

Stravinsky opens his work with a bassoon solo that is "too high." Traditional composers would never have spotlighted a bassoon in that register because, they thought, it sounds strange. Stravinsky needed a primeval sound, and he found it in the bassoon. He also needed a new harmonic sound, which he found by pitting two chords against each other at the same time, an F-flat chord and an E-flat chord (an E♭7).

Needing something to replace *harmonic progression*, he chose to discard progression and substitute repetition. He would take one dissonant cluster of notes, hammering them over and over until he felt that a change was called for aesthetically. Then another cluster of notes would follow; but the choice of pitches for the second set was determined not by the old laws of harmony and chordal resolution, but by the laws of Stravinsky's ear. Like the painter Picasso, Stravinsky had all the training and technique necessary to create masterpieces in the old style. His was not the frenetic searching of an ignorant musician but the conscious decision of a master. The values of the twentieth century were not the same as those that had held sway a few short years before. And the change in values demanded the changes that took place in artistic expression.

Of all the innovative changes that Stravinsky demonstrated in his new composition of 1913, nothing captured the hearts of practicing musicians more emphatically than his use of rhythm. In *The Rite of Spring* we hear irregular series of pulses, changing *meters*, groupings of five and seven where multiples of two and three had been the norm. The effect is a sense of discontinuity and terror: a new style is introduced into twentieth-century music. The rhythm is similar to that of jazz in its energy and very different from the fluctuating pulse-beat of the late romantic composers.

At once both regular and irregular, at once both orderly and chaotic, *The Rite of Spring* communicates in the music basic conflicts between the barbaric and the civilized, the controlled and the ecstatic, the conflict of *id* and *superego*. The people of Paris were shocked by what they heard in 1913, but today this work must be called tame in comparison with those of our contemporaries. And as a commentary on how brazen we have become since Stravinsky crashed his orchestra about the ears of his public, we should note that in 1940 Walt Disney used *The Rite of Spring* as background music for a full-length cartoon, *Fantasia*, in which mesozoic monsters fight and die amid the primordial slime and volcanic dust.

But once one has overcome the effects of the novelty of the sounds themselves, one discovers that order and design are present. Reason prevails, and the artistic laws of unity and variety are still operative. The orchestration is a unifying factor; so are the dance and the story line. Rhythmic elements from earlier sections reappear at later times, sometimes transformed or disguised and sometimes not. The types of melodic units that Stravinsky employs are similar and seem to fit within a discernible style. Contrast is apparent and seems to be used judiciously. Slow sections are interspersed among the fast; heavy orchestration is balanced with solo performance and light accompaniment; chordal writing is matched with linear composition.

For all its newness, *The Rite of Spring* does not abandon *tonality*, which is the basic feature of the harmonic language of the nineteenth century. However, Stravinsky is called on to use different means to establish a feeling of tonal center for our ears; for if he cannot use standard chord progressions, cadences, and tonal melodies, what can he employ to lend tonal stability to his composition? Repetition. By repeating a chordal sound, the lowest-sounding pitches assume the functions of chordal roots. They spell out the "key" of the moment. He reinforces this by choosing clusters of tones that can be grouped into familiar chords, sounds that a layperson's ear can organize rather quickly. Nor does Stravinsky actually abandon melody. He simply uses lines of notes that do not fit easily into our common practice major-minor tonal system; he chooses intervals that are hard to sing; he sometimes calls on instruments to play them in manners that are difficult and therefore sound strained; and he does not develop them in the way that a nineteenth-century romantic composer might. Still we can analyze the piece and discern the most important "tunes" or motives of the various sections.

So what are the features that one needs to study before a comprehension of the work is possible? Strangely enough, the answer is probably "none." Stravinsky's *Rite* is music of our time: once the scenario has been digested, the sounds are accepted naturally. We all have the experience of today's television, movie, and radio music to help us, and the common sounds of today are not so different from what was novel in 1913. Stravinsky helped bridge our musical experience to the past or, more properly, connect the past with the music of the present. *The Rite of Spring* is perhaps the single most important composition of the twentieth century for its impact on all the music that followed.

The Ballet

What kind of dance could be created to accompany this music of tones and rhythms unrecognizable to the public of 1913? Certainly, the movements on stage were as shocking to the public as the sounds. Dame Marie Rambert, who had been Nijinsky's choreographic assistant, describes the nature of his choreography and the audience's reaction.

> Nijinsky again first of all established the basic position: feet very turned in, knees slightly bent, arms held in reverse of the classical position, a primitive prehistoric posture. The steps were very simple: walking smoothly or stamping, jumps mostly off both feet, landing heavily. There was only one a little more complicated, the dance for the maidens in the first scene. It was mostly done in groups, and each group has its own precise rhythm to follow. In the dance (if one can call it that) of the Wisest Elder, he walked two steps against every three steps of the ensemble. In the second scene the dance of the sacrifice of the Chosen Virgin was powerful and deeply moving. I watched Nijinsky again and again teaching it to Maria Piltz. Her reproduction was very pale by comparison with his ecstatic performance, which was the greatest tragic dance I have ever seen.
>
> The first night of that ballet was the most astonishing event. . . . At the first sounds of the music, shouts and hissing started in the audience, and it was very difficult for us on the stage to hear the music, the more so as part of the audience began to applaud in an attempt to drown the hissing. We all desperately tried to keep time without being able to hear the rhythm clearly. In the wings Nijinsky counted the bars to guide us. Pierre Monteux conducted undeterred, Diaghilev having told him to continue to play at all costs.
>
> But after the interlude things became even worse, and during the sacrificial dance real pandemonium broke out. That scene began with Maria Piltz, the Chosen Virgin, standing on the spot trembling for many bars, her folded hands under her right cheek, her feet turned in, a truly prehistoric and beautiful pose. But to the audience of the time it appeared ugly and comical.
>
> A shout went up in the gallery:
> *"Un docteur!"*
> Somebody else shouted louder:
> *"Un dentiste!"*
> Then someone else screamed:
> *"Deux dentistes!"*

And so it went on. One elegant lady leaned out of her box and slapped a man who was clapping. But the performance went on to the end.

And yet now there is no doubt that, musically and choreographically, a masterpiece had been created that night. The only ballet that could compare with it in power was Bronislava Nijinska's *Les Noces,* created in 1923. She, like her brother, produced a truly epic ballet—so far unexcelled anywhere.

Nijinsky's sister, Nijinska, was in fact a better choreographer than he, although the importance of his innovations is undeniable. Stravinsky was not particularly pleased with Nijinsky's choreography for *The Rite of Spring,* and the ballet has been redone many times since. Yet Nijinsky himself, a stunning dancer with great powers of characterization and capable of amazing leaps (Fig. 31-32), has become a legend in our cultural history. He and Anna Pavlova, another Russian who also danced for Diaghilev, are still for many the

greatest dancers of the twentieth century. In Nijinsky as in Nietzsche, however, genius bordered on madness. For several years he was confined to an asylum in Switzerland; in 1950 he killed himself in London by leaping out of a window.

Modern Dance

While Mikhail Fokine was working to revitalize ballet in Russia, an American woman from California named Isadora Duncan (1877–1927) began an entirely new approach to dance. Duncan, who made a deep impression on Fokine during a visit to Russia in 1905, wanted to dance free from the restrictions of steps, poses, and attitudes. For her, dance meant individual spontaneity and Dionysian contact with nature. She admired classical Greek art for its simplicity and natural forms and believed, like the Greeks, that the human body, without artificial decoration, is the noblest form in art. Yet she was very American in her daring defiance of tradition and reliance on individual feeling. Her dances, she declared, were inspired by her native California; her first dancing masters were "wind and wave and the winged flight of bird and bee." Since every dance she performed was spontaneous and new, she left no school and no choreography behind her. What she did leave was the impression of a soul in movement (Fig. 31-33) on those who watched her, and her re-creation of dance as self-expression left a heritage of complete freedom to those who followed her.

The great innovators in dance in the early twentieth century shared with modernists in the other arts a desire for freedom of expression; an experimental attitude toward the use of elements such as space, texture, and time; and a need to return to primitive and archaic modes of expression. Some of the leaders in the modern dance movement, such as Ruth St. Denis (1878?–1968) and Louis Horst, sought to recapture both the primitive expressivity of the body and the relationship between dance and religion.

Modern dance differs from ballet because it abandons not only the traditional steps but also *pointe* (toe-dancing) and the frothy tulle costumes. The portrayal of woman in most modern dances differs considerably from that in the romantic ballet (as we saw it in *Giselle*) or that in the Russian neoclassical ballet. The most important innovator in this aspect, as in other, more technical ones, was Martha Graham (1893–1991). In her major works from the 1930s through the 1950s, Graham presented woman not as ethereal and ideal, but as earthy, passionate, and complex. Her choreography probes the psychic depths of her characters. She reworked classical and biblical myths for dance so that they appeared told from the woman's viewpoint; for example, she re-created the Oedipus story as the experience of Jocasta. Graham

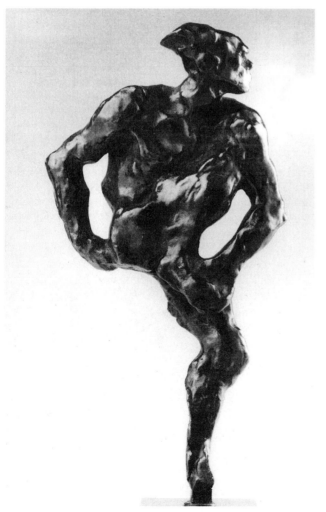

31-32 *Auguste Rodin,* Nijinsky, *1912. Bronze, 17.5 × 9.7 × 5.2 cm. (Musée Rodin, Paris/Photo copyright Bruno Jarret)*

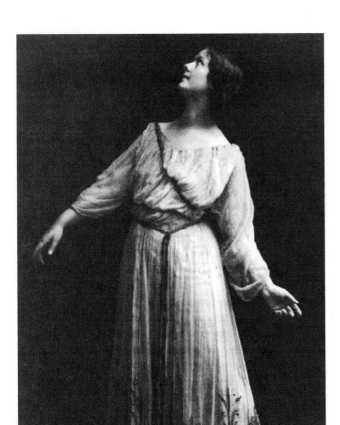

31-33 *Isadora Duncan. (Harvard Theatre Collection)*

developed a technique built on the principle of contraction and release of the muscles that continues to be taught in schools of dance. The Martha Graham Company is still a major force in the American dance world.

Modern dance and ballet have remained separate art forms, but they have borrowed from and influenced each other extensively. Fokine, as we have noted, was influenced by Duncan. Martha Graham danced the leading role in the American premiere of *The Rite of Spring* (with new choreography by Massine) in 1930. Many choreographers now work in an idiom that is partly ballet and partly modern dance. The United States remains the world leader in modern dance and shares the honors in ballet with Russia and Britain.

African American Dance

African American dance, although closely allied with the modernist movement, has sought its own directions by exploring its African roots. The black dancer and choreographer could draw on a rich folkloric tradition in African America itself, on European and white

American innovations in ballet and modern dance, and on his or her own observations and knowledge of African (as well as Caribbean) dance. The talents that have made use of these elements have created a truly unique idiom in dance.

There is no doubt that American blacks preserved an African style of dance. This developed into social dances such as the cakewalk and performing dances such as the tap dance. African Americans performed in minstrel shows touring the United States from the 1840s to the beginning of World War I. In spite of the often negative way in which whites perceived minstrels, these shows helped to establish blacks as entertainers and influenced the development of the American musical comedy.

The two dancers who did most to establish African American dance as an art form were Katherine Dunham (b. 1909) and Pearl Primus (1919–1994), both active in the 1930s and 1940s. Pearl Primus, who studied with Martha Graham, established herself as a serious concert dancer, although she also performed in night clubs. Becoming interested in African dance, she went to Africa to do research, particularly in the (then) Belgian Congo. She used this knowledge, as well as African American themes, in her choreography. One of her most moving compositions is "The Negro Speaks of Rivers," based on the Langston Hughes poem.

Black dance companies today continue to adapt African and African American styles and themes to modern dance. Until his death in 1989, Alvin Ailey was perhaps the most acclaimed black choreographer. His company, now headed by the great dancer Judith Jamison (b. 1943), continues to be one of the best and most successful on the New York scene (Fig. 31-34). Ailey's works, such as *Revelations*, set to spirituals, and *Roots of the Blues,* interpret the African American musical experience in dance. *Cry* is a tribute to black women. The company doing most to bring African dance to the American stage is that of Chuck Davis. Davis, who has studied in Africa, presents authentic African dances and his own compositions based on African movements. Cleo Parker Robinson is a choreographer who has worked to keep the traditions of African American dance alive, as well as to incorporate African rhythms and traditions into her own choreography.

Jazz

The writer F. Scott Fitzgerald justly labeled the decades of the 1920s and 1930s "the Jazz Age." Indeed, the end of World War I marks the emergence of *jazz* music as a national and international rage. Spawned in the urban poverty of African America, and born of the mingling of sacred and secular, African, European classical, and American folk music sources, this all-American art form spread from New Orleans to Kansas City, Chi-

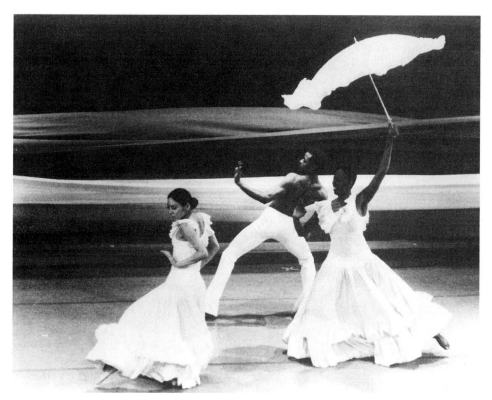

31-34 Revelations, *1960. Mari Kajiwara, Melvin Jones, Judith Jamison. (Alvin Ailey American Dance Theatre. Photo, Fred Fehl)*

cago, and New York with lightning speed and ultimately found enthusiastic adherents and vociferous critics all across the land and in Europe as well. Jazz came of age at the same time the radio and recording industries did, and the networks were soon bringing the new sounds of the 1920s into nearly every home in America.

Jazz is an *improvisatory* art. Every great performer transforms the basic materials, re-creates them. In a very real sense, every jazz performance is a new work, and through live performances, recordings, and radio, musicians everywhere learned from each other. The amateurs and hacks borrowed what they could imitate; the great talents assimilated what they heard only to move forward in an evolving art form. As early as January 1917, musicians from New Orleans, the Original Dixieland Jazz Band, were playing in New York, and it was not long before they were in the recording studios. The hot music from New Orleans was soon heard in parlors from Maine to California. It might be said that the history of the jazz age is etched in the grooves of ten-inch, three-minute-play, shellac discs.

Louis Armstrong (1901–1971)

Jazz is also a performance art. Its giants have been first and foremost virtuoso performers, whether vocalists or instrumentalists. The most successful of them knew how to combine a constantly high level of musical in-

ventiveness with crowd-pleasing showmanship. One man exemplifies all the traits of the great jazz artist. Born into the abject poverty of black uptown New Orleans on August 4, 1901, Louis "Satchmo" Armstrong apprenticed in local bands for several years, emulating his idol, Joe "King" Oliver. When the call came in 1922 to join King Oliver's Creole Jazz Band in Chicago, Armstrong not only was ready but also soon became the star. Throughout those years he developed a brilliant trumpet technique that not only made him the leading jazz virtuoso of the day, but also allowed him to turn new musical ideas into sound in some of the most creative jazz solos ever known.

Before long, as leader of his own groups, he began to temper the "hot" New Orleans style with elements of the New York ensemble sound of Fletcher Henderson and even a little of the "sweet" dance sounds of Guy Lombardo's Royal Canadians. The new synthesis can be heard on his recordings of "Cakewalking Babies" or the later "Struttin' with Some Barbeque." Armstrong's recordings with his Hot Five and Hot Seven are classics, outstanding accomplishments even compared with the great flurry of jazz activity of the time.

Throughout his career, Louis Armstrong suffered, like all African American musicians, from the racism and segregation of his native country, even as his extraordinary improvisatory skills and his ebullient personality as an entertainer brought him worldwide

DAILY LIVES

Harlem Nightlife in the Twenties

The years of the Harlem Renaissance (1919–1932) saw a flourishing of popular entertainment by African Americans, but it was a struggle for any artist of color to succeed at that time. The Jim Crow laws disfranchised black citizens and separated them from white Americans in nearly every aspect of life. Ethel Waters, born in 1896, was a popular singer and actress who came to prominence in New York during the 1920s and became part of the mainstream of American popular music in the 1930s. In her autobiography, *His Eye Is on the Sparrow,* she details what it was like for a black entertainer in Harlem during the 1920s:[a]

On reaching New York I went straight to Harlem and stayed there. The Woolworth Building, the Statue of Liberty, and all the other seven hundred wonders of the city were downtown, in white man's territory, which I had no interest in exploring. . . . In those days Harlem was anything but an exclusively Negro section. The black belt ran only from 130th to about 140th Street, between Fifth and Seventh avenues. Thousands of the people who had come up from the South to work in local munition plants during the war [WWI] had been crowded in with the folks already living in that narrow slice of Uptown New York. The district was swarming with life—men, women, and children of every shade of color. . . .

The most popular hangout for Negro sporting men and big shots was Baron Wilkins' famous night club, which also drew white trade from downtown. But the ordinary working colored people weren't wanted there and knew better than to try to get in. . . . For entertainers, the last stop on the way down in show business was Edmond's Cellar at 132nd Street and Fifth. After you had worked there, there was no place to go except into domestic service. Edmond's drew the sporting men, the hookers, and other assorted underworld characters. . . . When I did go down to Edmond's, Alice [Ramsey, a dancer], after introducing me to Edmond (Mule) Johnson, suggested that I go out on the floor and do my "Shim-Me-Sha-Wabble" number. . . . Edmond's was a small place and seated between 150 and 200 people, who sat at tables jammed close together around a handkerchief-size dance floor. It had a very low ceiling which Edmond Johnson had decorated with paper chrysanthemums and streamers. The walls were covered with fading photographs of old-time fighters and Negro entertainers. . . .

It turned out that One-Leg Shadow [a pianist] had known my father, and so he took a paternal interest in me. Shadow was a one-tune piano player. He was all right for filling in but didn't have a hell of a left hand. However, he sure knew his blues and could play fine to keep me shaking and singing the blues. . . . I am no stoolie, but I don't think it can hurt anybody if I say there were many junkers, gamblers, and thieves down in that cellar at all times. And as at the Lincoln [Theater], I was amazed at how many people who listened to me had seen me before at Gordon's [Rocky Gordon's in Philadelphia]. . . . Though I often look back on that time as the happiest in my life, working in that cellar was like my tour. There was no set closing time, and once again I was working until unconscious. We'd report at nine o'clock at night and sometimes not get out of there until eight, or even ten, the next morning. . . . Working such long and exhausting hours left me little time for recreation. But whenever I could I'd spend an afternoon in the peanut gallery of the Alhambra [Theater]. And it was there I saw for the first time the standard Negro acts that had been playing the white time for years—Bill (Bojangles) Robinson, Moss and Frye, the dancing Dotson. I also heard many of the popular white singers: Belle Baker, Sophie Tucker, Blossom Seeley, Eva Tanguay, and Trixie Friganza. . . .

Edmond, of course, wasn't the most brilliant man in Harlem or even downtown. In fact, on no Skid Row would he have stood out in the crowd of bums as A Brainy One. But when he saw the different class of people I was drawing into his low-class dump, he realized I was a real attraction. I'd changed the clientele, making Edmond's Cellar a high-class dump.

a. Ethel Waters with Charles Samuels, *His Eye Is on the Sparrow: An Autobiography* (Garden City, NY: Doubleday & Co., 1951), pp. 124–132.

recognition and honor. In the later years, when his highly acclaimed European tours had won him the official title of America's Ambassador of Jazz, his style still combined virtuoso trumpet playing and the "scat-singing" (that is, vocal performances that are instrumentally conceived and vocalized on nonsense syllables) that had become his trademark with large doses of "cornball" showmanship. Most would agree that he was protecting his ego with humor, but for a time this great man even had to suffer the rejection of many of his own people who interpreted such antics as selling out, playing Uncle Tom. Louis Armstrong carried his burden well, but he knew the meaning of "Black and Blue."

CD-2, 15

Many first-class musicians were associated over the years with Louis Armstrong, and one of the most important was Earl "Fatha" Hines (1905–1983). Their association, beginning in 1927, produced a major change in Armstrong's style as well as in the role the piano was to take in jazz ensembles. Some of the most extraordinary virtuoso pieces of the day were recorded when these two men collaborated. "Weather Bird," a duet for trumpet and piano, is unmatched as a combination whose sum is greater than the parts. It is a perfect example of how the working jazz musician draws on a finite set of musical phrases and then reworks, reshapes, and develops them under the impetus of the creative moment and the muses. During the performance he seeks a new sound, a clever turn of phrase, or an exciting rhythmic innovation. Through this process of reshaping a limited number of musical ideas within the solo, improvisational composition comes about. Structural unity and invention are developed partially through conscious thought, but a stronger determinant is the subconscious interplay of stored mental structures and habitual, reflexive lip and finger patterns. "Satch" and "Fatha" put it all together.

Duke Ellington (1899–1974)

The economic gloom that resulted from the stock market crash of 1929 created a taste for dreamy, sentimental, and blindly optimistic popular songs. Hot jazz began to lose its audience, and a number of new substyles began to develop. Also, for purely musical reasons, the emergence of the big-band concept brought a shift in jazz styles. Throughout the decade of the 1930s, a new jazz orchestra sound was taking over, a smooth, swinging music featuring mellow moods and a new sense of ensemble, interspersed with improvised solos, some hot and others not. One of the giants of the new swing music was Edward Kennedy "Duke" Ellington. Starting out as a pianist and bandleader in the 1920s, Ellington soon began to explore the possibilities of the new musical territory in his own compositions. One of

his notable accomplishments was the introduction of his own brand of chromatic harmonic thinking into jazz; another was his exploration of a broader timbral palette; and a third was the concept of writing and orchestrating music for particular jazz soloists, the members of his orchestra. Through his piano explorations he broke out of the traditional mold of simple triadic harmony to an expanded harmonic vocabulary. An excellent example is his composition "Sophisticated Lady" with its sliding, chromatic chords. His ear for sound per se (timbre) led him to score for muted brass, slides and growls, percussion effects, and winds from low baritone sax to high clarinet. Almost every recording of Ellington's orchestra illustrates a range of tonal color. The blend of composed music and swinging jazz, of arrangement and solo performance, gives the music of Duke Ellington its special appeal. "East St. Louis Toodle-Oo," "Harlem Airshaft," and "Mood Indigo" are both jazz compositions and jazz performances, pieces of music and social commentary. As the titles reflect the world of Duke Ellington, so does the music. Ellington and his orchestra also became examples and models for black America as well. They were successful, even in poverty. They were people of accomplishment and respect, even though their personal fortunes were, to a large extent, dependent on the health of the larger society and frustrated by their race. But in spite of difficulty and hostility, the Ellington orchestra rode out the storm.

CD-2, 16

Modernism and Indigenous Cultures in Latin America

While blacks in the United States were rediscovering their African heritage and attempting to integrate it with their American experience, Americans in the heterogeneous cultural and geographical area south of the Rio Grande and in the Caribbean islands were rediscovering the importance of their native American, African, and European heritages. When the thirty-five-year dictatorship of Porfirio Díaz was overthrown in 1911 in Mexico, not only the social fabric but also eventually the entire cultural orientation of the country underwent a profound alteration. The Mexican revolutionary era (1910–1916) stimulated a growth of cultural awareness on the part not only of Mexicans, but also of all Latin Americans. This upheaval, combined with the general disillusionment among the intellectuals caused by World War I, shifted the emphasis from a slavish imitation of European, essentially French, patterns to a renaissance of the Mayan, Aztec, and Olmec heritages of Mexico. These and other indigenous cultures, so long considered inferior by many of the elite, became by the 1920s a fertile source of serious study and artistic inspiration.

Indigenous Civilizations in Modern Art and Music

José Vasconcelos, then minister of education, stimulated art and literature in immediate and direct ways. He commissioned young artists such as José Clemente Orozco (1883–1949) and Diego Rivera (1886–1957) to paint murals on new and old public buildings. Their art interpreted Mexico's rich Indian and colonial past and, in allegories, its revolutionary present and future.

Vasconcelos also encouraged the formation of a national symphony orchestra under the genial leadership of Carlos Chávez, who introduced significant indigenous elements into classical musical forms. Chávez, in such works as *Sinfonia India* (Indian Symphony), successfully proved that Indian and folk music and instruments constituted a worthy base for serious symphonic music.

In his music Chávez sought to create a nationalistic voice reflective of the American character. With both Spanish and Native American blood forming his own ancestry, this composer was but an impressionable boy of twelve when the Mexican Revolution first allowed the people to elect their own constitutional president. His pride in his homeland, his frequent contact with Mexican Indian culture, and his disdain for "the useless complications of the German and French treatises" all helped channel his creative energy toward shaping a music reflective of his own homeland. With the government as a patron and with a personal desire to bring culture to the masses, he researched the preconquest indigenous Indian cultures of Mexico and applied these newfound ideas to his own music in an effort to exalt the pre-Hispanic heritage of Mexico.

The *Sinfonia India* evokes visions of Aztec culture through several musical devices. Chávez uses Indian melodic themes for melodic material, and one will note that this symphony is melodically austere. The four- and five-note scales of the Aztec flutes and whistles eliminate any possibility of complicated Romantic melodies. The chromatic possibilities of sharps and flats are simply not built into these ancient instruments. The overall sound is both modern and primitive. Part of the reason lies in his choice of simple and spare harmonies, and part lies in his choice of complex, driving rhythms. Many of the patterns are irregular, and Chávez employs polyrhythm (more than one kind of beat going on at the same time), syncopation (irregular and unexpected accents), and irregular meters (groups of notes divided into patterns of five and seven rather than the normal two, three, or four). And he tries to blend authentic Native American instrumental sounds into the standard orchestration of his symphonic orchestra. To the regular strings, brass, and winds, he adds a Yaqui drum; a clay rattle; a Yaqui metal rattle; a water gourd (when struck it sounds like a tenor drum); a soft-sounding rattle, called a *tenabari*, made from a string of butterfly cocoons; an Indian xylophone called a *teponaxtles;* a *grijutian* (another rattle made from a string of deer hooves); a *tlapanhuehuetl* (an Indian bass drum); and a Yaqui rasp.

Chávez introduced these additions to his music because he believed, as a Mexican American artist, that he had a responsibility to reinvent old forms and give a Mexican quality to his music. In listening to his *Sinfonia India*, the listener can discover why he was considered to be the leading Latin American composer of his generation. In the recorded excerpt, one can easily imagine sounds of the forest, mountain, and

CD-2, 17

desert; the excitement of Native American dance and ritual; and the majesty of an Aztec parade through the streets of their remarkable pre-Columbian cities. Carlos Chávez was a composer, pianist, conductor, teacher, and government official crucial in the development of the arts in Mexico. Eventually the world-famous Ballet Folklórico de México evolved from his efforts.

Summary Questions

1. What characterizes the art of Matisse and Picasso as "modern"? What are some of the basic differences between these two artists?

2. What was the impact of Europeans' "discovery" of African art on developments in painting?

3. Summarize Kandinsky's theory of painting. Why was it so revolutionary at the time?

4. Define "cubism," "expressionism," "Dada," and "surrealism."

5. What were the major architectural innovations of Frank Lloyd Wright, Walter Gropius and the Bauhaus school, and Le Corbusier?

6. Summarize the early development of the motion picture as an art form.

7. Choose a painting from this chapter to compare to any one of the photographs. Which works do you pair and why? Do they look alike, have similar

subject matter, produce the same responses from your experience of the works? Is *Guernica* a good comparison for *Children Playing in the Ruins, Spain*? What about comparing O'Keeffe's *Cow's Skull with Calico Roses* with Weston's *Artichoke*? What painting could be compared to Ansel Adams's landscape of Mount Williamson?

8. What was so radical about the music and the ballet of *The Rite of Spring*? How did the first audiences react?

9. What distinguishes modern dance from ballet? What contributions did African Americans make to the modern dance form?

10. What are some of the principal characteristics of jazz?

11. How did Carlos Chávez combine native traditions with modernist innovations?

Key Terms

figurative

nonfigurative

abstraction

cubism

collage

nonobjective painting

expressionism

Dada

surrealism

Harlem Renaissance

"ashcan school"

prairie style

dissonance

Bauhaus

primitivism

jazz

improvisation

32 Modernism: Theater and Literature

Closely allied with the various modernist movements in the visual arts, music, and dance, writers and theater artists in the opening decades of the twentieth century showed many of the same formal and thematic concerns. Modernism, however, was and is not simply a movement limited to that era. It became a new way of representing the world through art. Generally, serious artists of the twentieth century felt the necessity either to react against modernism or to build on its innovations. Rather than survey all of the various schools associated with modernism, we will concentrate on a few examples.

Influences of Asia on Modern European Theater

As innovators in modern art, music, and dance looked toward non-Western cultures in attempting to revitalize what they considered to be outmoded or overly rigid artistic conventions, so did some revolutionaries in the world of theater. Here it was contact with Asian theater that had the most important effects.

Antonin Artaud (1896–1948)

One of the most radical and yet most influential voices was that of Antonin Artaud, a French poet, actor, and director associated with the surrealist movement. In 1931 Artaud was profoundly influenced by a group of Balinese dancers who performed in Paris. The performers' physical language of ceremony, with its rich metaphysical and religious significance, suggested to Artaud that, whereas Western theater had become unduly limited, contact with the East might restore its infinite possibilities. Artaud's revolutionary ideas on modern theater were also influenced by his interest in the ancient rituals of traditional Mexico. Psychological, naturalistic plays that depend for their effect primarily on language and imitation of everyday reality were for Artaud a degenerate form of true theater, which has the capacity to address the body and spirit even more than the mind. In a collection of essays published in 1938 under the title *The Theater and Its Double*, Artaud called for a *theater of "cruelty,"* by which he meant a theater whose powerful physical effects, gestures, ritualized music and rhythms, together with costumes, lighting, and poetry, would awaken in the spectator deep and primitive feelings normally repressed. In such a theater the author and the text would be secondary to the director and the overall staging effects.

Although Artaud's theories interested only a few during his lifetime, in the 1960s he was rediscovered in both Europe and the United States. His ideas on revolutionizing theater then had a profound impact on numerous dramatic authors and directors, and particularly on the "theater of the absurd," to be discussed in Chapter 33.

Bertolt Brecht (1895–1956)

Another seminal dramatic theorist, as well as a dramatic author and director of the 1930s through the 1950s, was the German Bertolt Brecht. In his early years associated with German expressionism, which like surrealism had its practitioners in literature as well as in the other arts, Brecht eventually came under the influence of Marxism and movements in leftist political theater. Like Artaud, he was deeply affected by an opportunity to see a performance of Asian theater, in his case a group of Chinese actors. His essay entitled "On Alienation Effects in Chinese Acting" is crucial to understanding his theory of advocating *alienation* or "estrangement" in theater. For Brecht, Western theater has been primarily "culinary"—that is, like cooking, it allows the spectator to sink into a kind of comfortable enjoyment without reflection. The "epic" theater he calls for would, on the other hand, narrate, rather than embody, events, forcing the spectator to make decisions and to leave the theater ready to act in the world. In this type of theater, the actor should, according to Brecht, "show" the character rather than "become" the character. It is this type of acting that Brecht found in the Chinese theater, with its uses of ritual, mask, and stylization. Like Artaud, Brecht believed that Western theater could be enlarged and renovated through contact with the East. Unlike Artaud, he implemented his theories in successful plays during his lifetime.

One of Brecht's most popular plays is the musical *The Threepenny Opera* (1928), written in collaboration with the composer Kurt Weill. Although Brecht intended it as a satire on capitalism, audiences tend to identify romantically with the thieves. Other important Brecht plays include *Galileo* (1938), on the problem of the intellectual in politics; *Mother Courage* (1939), on capitalism and war; *The Good Woman of Setzuan* (1938–1940), set in China; and *The Caucasian Chalk Circle* (1943–1945), set in Russia, both of which explore the problem of goodness within a hostile society.

Modernist Movements in Fiction and Poetry

Poets and novelists, like their co-artists in the visual and performing arts, were highly conscious of the radical nature of change in the early twentieth century. The romantic notion of the writer as an outcast in his or her society seemed to take on a new meaning after World War I.

A Literature of Exiles

Most of the great modernist writers lived, at one time or another, in Paris. Besides the native French writers associated with the Dada, surrealist, and other artistic-literary modernist movements, there were German expressionists, Italian futurists, and other Europeans. Paris was also the cradle for a dynamic new African literature written in French by intellectuals from the French African colonies, some of whom were involved with the surrealist movement. It is no exaggeration to say that Paris in the early twentieth century was a fermenting center of British and American letters. James Joyce, the Irish novelist and poet who became one of the greatest and most original stylists in the English language, found as his first publisher an American in Paris—Sylvia Beach, who managed the bookstore Shakespeare and Co. American expatriates such as Gertrude Stein, Ezra Pound, F. Scott Fitzgerald, and Ernest Hemingway also gathered at Beach's bookstore. Gertrude Stein was a close associate and supporter of Picasso and other modern painters, who greatly influenced her style. Stein coined the phrase "the lost generation" to describe these Americans who had fled their country for Europe. Common among them was the feeling that a crass, philistine American public was incapable of understanding or sustaining them and that they needed to turn elsewhere for intellectual and aesthetic nourishment.

It is not surprising that a literature of expatriates, a literature responsible to no one, is a literature characterized by a sense of exile and by an extreme subjectivity. The lack of contact with a public, except for a small coterie, gives the writer great freedom to experiment but also encourages esotericism. Many of the modernist writers who did not join the expatriates in Paris experienced some sort of exile. The American T. S. Eliot did live briefly in Paris but emigrated to England. Those who were not in physical exile often experienced an inner exile. Franz Kafka (1883–1924), in his own words a "triple exile" as a German-speaking Jew living in Czechoslovakian Prague under the Austro-Hungarian Empire, produced the most innovative prose in modern German and some of the most influential modernist images. Kafka's three unfinished novels—*Amerika*, *The Trial*, and *The Castle*—deal with the modern sense of anguish and alienation in the face of a civilization characterized by a faceless bureaucracy and a cosmos that no longer offers answers to metaphysical questions. Perhaps his best-known work is the long story *The Metamorphosis*, which deals with an ordinary salesman who awakens one morning to find himself transformed into a giant beetle. Unlike many modernists, Kafka wrote in an apparently logical order, with clear sentences and close attention to external

details. After reading for a short while, we realize that we are in a grotesque world in which our ordinary values and logic do not apply, a world that conveys the nightmarish quality of everyday life. In some ways Kafka's stories resemble dreams and the surrealist exploration of the dream world. Like the expressionist painters, Kafka presents distorted, shocking images that represent some of our deepest unconscious fears.

Exploration of the Unconscious and Technical Experimentation

In spite of their sense of exile and their feeling of being misunderstood, the modernists on the whole maintained a strong belief in the saving power of art, a continuation of the late nineteenth century's adherence to the religion of art. In a declining, empty civilization, art appeared as a refuge, a form of salvation. Many of the new ideas and concerns of the twentieth century seemed to writers, as well as to artists, composers, and choreographers, to necessitate a radical breakup of traditional forms. Einstein's theories and the general sense of a breach in continuity after World War I surely had their impact, but perhaps the greatest influence was Freud's discovery of the unconscious.

The Modernist Novel

The most important experiments in rendering psychological states were done by novelists. The Frenchman Marcel Proust (1871–1922), in his monumental *Remembrance of Things Past*, found a new language for the expression of his characters' most subtle feelings and an inner, as opposed to a chronological, sense of time. The inner sense of time was also explored by the German Thomas Mann (1875–1955) in *The Magic Mountain*. The Englishwoman Virginia Woolf (1882–1941) experimented with language and time to convey inner reality in novels such as *To the Lighthouse* and *Mrs. Dalloway;* the American William Faulkner (1897–1962) used extremely long, "ungrammatical" sentences to express a world below the surface of appearance. The most radical experiments in this vein were done by James Joyce (1880–1941). The unconscious or semiconscious part of the mind, as Freud showed, functions outside the logical order and time frame established by reason. It works rather by association, by summoning images that merge past, present, and future. To convey this state, Joyce used the device of the *interior monologue* or *stream of consciousness,* abandoning rules of grammar and syntax, even inventing new words. The effect is similar to the abandonment of perspective and juxtaposition of planes and of images in modernist painting. Joyce's *Ulysses,* published in 1922, although a long novel, takes place in the course of one day in Dublin. Because of the interior monologue technique,

however, the novel can actually span all of the time within the characters' memories. In addition, the day in Dublin loosely parallels the events in Homer's *Odyssey* (hence the title), thus opening a mythic dimension.

Virginia Woolf and Modern Feminism

Along with her work as a novelist, Virginia Woolf was profoundly interested in the feminist movement that had flourished in England since the days of John Stuart Mill and had assumed renewed importance in the 1920s. Women in England received full voting rights in 1928, the year in which Woolf composed her most widely read feminist work, *A Room of One's Own*. The book grew out of a series of lectures that she gave on "women and fiction." It eventually became a mixture of an essay and a first-person fiction with a narrator called Mary Seton. It begins with the narrator's account of her visit to "Oxbridge," a college for men, and to "Fernham," a recently established college for women. At the first she was served an abundant luncheon of sole and partridge, at the second a meager dinner of boiled beef, prunes, and custard. The two scenes evoke the wealth of the male establishment and the fundamental poverty and dependence of women.

Woolf contends that economic independence and equal opportunity for education and experience are even more important than the vote to the feminist cause. As to the question of women and fiction, she says that in order to write, "a woman must have money and a room of her own." Few women have created great works of art because they have been denied opportunities to develop their talents. After examining the question historically and critically, Woolf makes a plea for an "androgynous" literature. The greatest creations will come through a fusing of male and female elements without sacrificing one to the other.

One part of *A Room of One's Own,* which reads like a complete story in itself, has been called "Shakespeare's sister." Here, the memory of a remark by an old bishop, that "it was impossible for any woman—past, present, or to come—to have the genius of Shakespeare," leads Woolf (or the narrator) to a kind of historical musing on what might have happened to a talented woman of Shakespeare's era who wanted to write for the theater.

Poetry of the City and the Theme of Spiritual Emptiness: T. S. Eliot (1888–1965)

A certain world-weariness invades much of modernist writing. The devastations of World War I seemed to confirm already-present philosophical assumptions about the futility and fragility of humankind's existence. With traditional religion and other sustaining myths dead, the individual was often left only with questions. Politics, to

most moderns, did not offer a substitute for religion; even love, or any form of real communication between individuals, seemed to many extremely problematic in the modern world. One of the best chroniclers of this state of emotional vacuum was T. S. Eliot. Eliot, who was born in Saint Louis, Missouri, studied at Harvard and moved to London in 1915. His most ambitious poem, *The Waste Land* (1922), portrays the spiritual desolation of a modern city, London, through references to ancient literature, oriental mythology, and modern poets such as Baudelaire. The influence of Baudelaire and of other French symbolist poets was in fact a decisive one for Eliot. It enabled him to throw off conventionally poetic language and imagery and to depict modern reality in all its sordidness through a language that is both dense and everyday and through images that reflect the dinginess and the futility of modern city life. Eliot sought to eliminate abstract language and explanations of feelings from his poetry and instead to convey emotion through images evoked from the external world—what he called the *objective correlative*.

One of Eliot's most influential poems is "The Love Song of J. Alfred Prufrock," written in 1915. The city it depicts is probably Boston, but the details recall as well Baudelaire's Paris, and the monotonous rhythms of urban life that are its subject matter could be found in any big city. The setting of the rest of the poem moves to London interiors inhabited by upper-class English society. Prufrock is a typically "modern" man, unable to make decisions, to act, or even to feel—an overcivilized human being in an overcivilized society. The irony with which Eliot depicts his character became a stable feature of much other twentieth-century literature. His later poetry reflects his deepening religious faith. Already in "The Hollow Men" (1925), the reader can perceive a yearning for religion as a remedy for the emptiness of modern life. In his most mature work, "The Four Quartets," Eliot explores the relation between Christian faith and modern life more deeply. For many readers, however, Eliot's greatest contribution remains his ability to express the spiritual anguish that lies at the core of modernism. The great Irish poet W. B. Yeats seemed to sum up this state with his line from "The Second Coming": "Things fall apart, the centre cannot hold."

Imagist Poetry and the Influence of China and Japan: Ezra Pound (1885–1972)

A contemporary and friend of Eliot's, Ezra Pound was another significant American poet affected by the cultural chaos following World War I. Pound was born in Idaho but was educated primarily at the University of Pennsylvania, where he studied Romance languages. He eventually left the United States to live in England, France, and Italy. A voracious reader and learner of languages, he studied Dante in Italian and the French,

Spanish, and Provençal poets in their native languages. He gradually became disillusioned with American culture and with Western civilization in general because of what he considered to be its crass materialism. His poem "Hugh Selwyn Mauberley" (1920), autobiographical to some extent, juxtaposes the disillusionment arising from World War I and the modern age with the sense of beauty in classical European culture as it mixes erudite references with colloquial and even vulgar language (anticipating *The Waste Land*). Seeing in Mussolini a potential new leader for a new civilization, Pound gave a series of radio broadcasts in Italy that caused him to be condemned for treason in his native country. He was sentenced to a hospital for the criminally insane. Eventually liberated, he lived the rest of his life in Italy. Pound's case and the relation between his poetry and his politics are still a matter of scholarly debate.

In his sense of the decline of the West, Pound, like others before and after him, turned toward the East in search of ways to revitalize Western culture. Soon after his arrival in London in 1908 he began to read Confucius, particularly the collection called *The Great Learning*. Like Voltaire, Pound thought that at a time when Christianity had lost its relevance, Confucius might offer meaningful moral guidance. For Pound, the principle of good according to Confucius consisted first of all in establishing order within oneself and not meddling in the affairs of others. This order or harmony would then spread by a kind of contagion throughout society. In his great series of poems, *The Cantos*, Pound sets Confucian China as a kind of historical model offering potential salvation to the West.

Pound also became deeply interested in the aesthetics and techniques of both Chinese and Japanese poetry. Although his knowledge of both languages was limited, he studied poems from both traditions with the help of a scholar he knew in London, and he contributed to the dissemination of this poetry with his striking, original translations. He was particularly interested in the Chinese Tang dynasty poet Li Po (701–762) and the Japanese *haiku*, or *hokku*, tradition. For Pound, Chinese ideograms, in contrast to Western phonetic languages, convey their meanings visually, and the poetry correspondingly accomplishes a kind of painting. Reacting against what he saw as the vagueness and looseness of romantic and Victorian poetry, Pound, along with other members of a group of poets who called themselves *imagists*, wanted to introduce concrete, visual images into modern poetry. Pound made use of abstract juxtapositions of startling visual images and concise expression, both in his translations and in his own poetry.

Surrealism

Most modernist artists, in all fields, lived in or visited Paris, a city that seemed to provide nourishment for

various artistic movements. One of the most important of the new movements that flourished there was *surrealism*. We discussed the origins and basic tenets of surrealism, with examples from the visual arts, in Chapter 31. Surrealist artists and writers were deeply influenced by Freud and sought a reality in the depths of the psyche, beyond superficial or "realist" appearance. In his influential surrealist manifesto, André Breton, the leader of the movement, advised writers not to write with their conscious mind: "Write quickly, without any preconceived subject, fast enough so that you will not remember what you're writing and be tempted to reread what you have written. The first sentence will come spontaneously, so compelling is the truth that with every passing second there is a sentence unknown to our consciousness which is only crying out to be heard." The subconscious mind, it was believed, would produce new, free, and startling images, unhampered by consciousness. Surrealists of all sorts experimented with this so-called automatic writing, but the poets associated with the movement who have endured—among them Guillaume Apollinaire and Robert Desnos—eventually combined the juxtaposition of surreal images with a conscious control of their craft.

Like other European primitivists, the surrealists were fascinated with African culture and art, which they considered to be untamed, elemental, and more in touch with the deep psyche than overcivilized Western art. Indeed Paris in the early twentieth century was flooded by everything African in origin: not only the sculpture admired by Picasso and others but also traditional African poetry, dance, and music; Afro-Brazilian and Caribbean rhythms; North American jazz; the American singer Josephine Baker; and writers and artists of the Harlem Renaissance. In this Parisian atmosphere, black French-speaking poets, intellectuals, and students from the French colonies in Africa and the Caribbean began to meet and discuss their own ideas on what they would call *négritude*, or blackness.

Négritude

Three student-writers from different parts of the world—Aimé Césaire from the Caribbean island of Martinique, Léon Gontran Damas (1912–1978) from French Guyana in South America, and Léopold Sédar Senghor from Senegal in West Africa—launched a movement by founding a journal in Paris called *L'étudiant noir* (The Black Student) in the mid-1930s. The term *négritude*—first coined by Césaire—meant to them not a vague search for the primitive soul of Africa but an attempt to define the specific political and cultural identity of black people and to celebrate blackness. Césaire's long autobiographical work in poetry and prose, *Notebook of a Return to the Native Land*, which he wrote on returning to his homeland after eight

years in Paris, has a political message because it deals with the devastating effects of slavery and colonization on people of African descent. It also has a poetic one because it attempts to create a language by which to convert what the French disparagingly called *nègre* to a source of pride. Thus Césaire writes:

> my negritude is neither tower nor cathedral
> it takes root in the red flesh of the soil
> it takes root in the ardent flesh of the sky
> it breaks through the opaque prostration with its
> upright patience

Senghor defined *négritude* as the "sum total of African values." For him, the African approach to the world consisted of "intuitive reason," as opposed to the Greek (thus Western) approach of "logical reason." Whereas logical reason involves a confrontation of subject and object, intuitive reason involves participation and communion between the two.

Césaire, Damas, and Senghor were all deeply influenced by surrealism, just as the French surrealists were in turn influenced by their evocations of Africa. Like other surrealists, they believed in the recovery of repressed material in the psyche as a means to forge new poetic images, and they linked their poetics to their goal of political liberation. Both Césaire and Damas became active in the anticolonialist movements in their homelands, and Senghor eventually helped to lead his land to independence and became president of the republic of Senegal (while continuing to write poetry), serving from 1960 to 1980.

The Harlem Renaissance

Among the influences on the poets of *négritude* in France was their discovery of the work of African American poets, such as Langston Hughes (1902–1967), Countee Cullen (1903–1946), and Claude McKay (1890–1948), writing in the 1920s. Their poetry helped the French-speaking writers to envision the possibility of both using and breaking away from European models while creating a poetic language with which to express black identity. The influence was a two-way street, as African American writers visited Paris and the Caribbean and considered developments there while attempting to create a new language to formulate their own cultural identity.

The literary, artistic, musical, and political movement in the 1920s that saw an outpouring of creativity and new ways of thinking by African Americans manifested itself in all of North America but was centered in Harlem, New York City, and thus became known as the *Harlem Renaissance*. Although the conscious transformation from the racial and racist stereotypes such as the minstrel clown into what became known as the "New Negro" had its origin in the prewar years, changes in American society after World War I intensified the

process. Postwar economic opportunities brought American blacks from the South to the North while the war dislodged Africans and West Indians, bringing many to New York. Pan-Africanism, the quest for black unity throughout the world, became a dominant attitude and ideology.

In addition to making African Americans conscious of the international dimension of their racial struggle, the war stimulated their eagerness to produce racial peace and equality in the United States. If they could march and fight alongside white Americans to make the world "safe for democracy," then the same, they reasoned, could be done for racial harmony in the United States. As the shift in black leadership changed from the accommodationist policy of Booker T. Washington to the radical protest of the intellectual W.E.B. Du Bois, African Americans became more racially conscious and self-assertive, proclaiming themselves to be human beings worthy of respect. Du Bois states the case in *The Souls of Black Folks*:

> The history of the American Negro is the history of this strife,—this longing to attain self-conscious manhood, to merge his double self into a better and truer self. In this merging he wishes neither of the older selves to be lost. He would not Africanize America, for America has too much to teach the world and Africa. He would not bleach his Negro soul in a flood of white Americanism, for he knows that Negro blood has a message for the world. He simply wishes to make it possible for a man to be both a Negro and an American, without being cursed and spit upon by his fellows, without having the doors of Opportunity closed roughly in his face.

This determined quest for racial equality and America's insistence on racial segregation produced the "bloody summer" of 1919, when race riots erupted in more than twenty-five U.S. cities. In reaction to this outburst of violence, the poet Claude McKay, born in Jamaica, wrote his now well-known poem "If We Must Die." It is interesting that Winston Churchill broadcast a reading of "If We Must Die" to British troops in World War II to give them courage.

McKay, along with Langston Hughes, Countee Cullen, James Weldon Johnson, Sterling Brown, and Zora Neale Hurston, became one of the leading writers of the Harlem Renaissance. An interesting but lesser-known writer was Marita Bonner (1890–1971). She grew up in Boston, graduated from Radcliffe College in 1922, and moved to Washington, DC, in 1924. Bonner was one of the few writers associated with the movement to combine feminist and racial concerns. Her essay "On Being Young—a Woman—and Colored" appeared in the major Harlem Renaissance review *Crisis* in 1925. In it, one can see the influence of modernist experiments with the interior monologue.

For most of the Harlem Renaissance writers, modernism did not mean imitating the innovations of writers such as Joyce or Eliot but finding new ways of expressing the specific concerns of black modernity. For Langston Hughes, modernism meant, among other things, an attempt to replicate in poetry the unique rhythms of jazz music.

Developments in Latin American Literature

In the literature of what we might call the Latin American modernist period, some of which was not "discovered" by the northern world until much later, three types of writers flourished: those who sought only inspiration and aesthetic values in indigenous themes expressed in realist-naturalist modes, those who pursued cosmopolitan and universal themes by adapting modernist innovations, and those who combined the search for the truly indigenous with avant-garde techniques.

Among the writers of the first group are the Mexican Mariano Azuela; Ciro Alegria, the Peruvian novelist who dealt with the life of the Andean Indians and the mestizos; and José Lins do Rego, who re-created the life of the Brazilian plantation societies of the Northeast. None of these writers rooted in the traditions of the past and the present made stylistic innovations a priority. They wrote simply of what they had known and lived. Their writings are often infused with a marked moral or social concern for their disinherited compatriots.

In the second group of writers and poets, an interest or desire to join with the rest of the world is evident. Jorge Luis Borges (1899–1986) of Buenos Aires, "vast suburb of the world," is perhaps the greatest representative of this group. Although he lived abroad for years—primarily in Switzerland and Spain—and most of what he called his "fictions" were published before 1952, he was not discovered outside his own country until the late 1950s. Since then, however, his international impact has been overwhelming. "Borgesian," like Proustian or Joycean, denotes a content and a writing style that are unique, but modernist precedents such as Kafka were important to them. Although initially he was an excellent poet and essayist, his reputation rests on a hybrid somewhere between the essay and the short story. Metaphysical rumination about time, reality, philosophies, religions, and humankind's place in the universe provide the stimulus and basis for his work. Other Latin American writers who adapted European modernism for their own purposes include Julio Cortázar of Argentina, who lived for years in Paris and is associated with the "boom" or flourishing of Latin American literature in the 1960s.

The third group, whose members combined indigenous American themes with avant-garde techniques, includes two Nobel laureates, the novelist Miguel Angel Asturias (1899–1974) of Guatemala and the poet Pablo Neruda (1904–1973) of Chile. For most of his adult

life, Asturias fought the repressive dictatorships of his country. He distilled his political experiences into masterful novels such as *El Señor Presidente* and *Week-end en Guatemala*. During a trip to London, he discovered in the British Museum the beauty and variety of Mayan art that had been neglected in his own country. He then studied Central American mythology in Paris and eventually translated some of the oldest texts of Mayan literature into Spanish. He also became acquainted with the French surrealist poets and with the colony of Spanish American writers living in Paris. There he wrote *Leyendas de Guatemala*, published in 1930. Asturias's efforts to re-create the rich Maya-Quiché[1] culture in these legends portray a blend of dream, story, myth, and poetry.

The influence of native America on Neruda is not so apparent, but much of his poetry does evoke the sounds, sights, and smells of his native Chile. Neruda's poetry evolved from symbolism into some of the richest, most innovative use of free verse and imagery in the twentieth century. People, and those things touched by, made by, or affecting them, are his subjects. Neruda is the poet of *cosalismo* ("thing-ism"), which transforms some of the most humble plants, minerals, and animals into subjects of beautiful poems. His poetry ranges from the profound, hermetic, and complex works of *Residencia en la tierra I, II* (Residence on earth, Parts I and II) and *Canto general* (General song) to the simple and touching odes to various subjects.

Another poet who could be included in this third group, although his writing extends later in time, is the Mexican Octavio Paz (1914–1998). Paz's poetry combines the influences of European modernism and surrealism, native Mexican traditions, and Asian philosophies, especially those of India, where he lived for a while. The brief poems from *Ladera este* (East Slope, 1968) recall Japanese haiku in their evocation of physical and emotional sensations through few words. In them, Paz sometimes fuses his memories of Mexico with his impressions of India.

[1] The Quiché Maya are an ancient Mayan people who originated in Guatemala and eventually expanded into Mexico.

ANTONIN ARTAUD

from *The Theater and Its Double*
Translation by Mary Caroline Richards

Oriental and Occidental Theater

The Balinese theater has revealed to us a physical and nonverbal idea of the theater, in which the theater is contained within the limits of everything that can happen on a stage, independently of the written text, whereas the theater as we conceive it in the Occident has declared its alliance with the text and finds itself limited by it. For the Occidental theater the Word is everything, and there is no possibility of expression without it; the theater is a branch of literature, a kind of sonorous species of language, and even if we admit a difference between the text spoken on the stage and the text read by the eyes, if we restrict theater to what happens between cues, we have still not managed to separate it from the idea of a *performed text.*

This idea of the supremacy of speech in the theater is so deeply rooted in us, and the theater seems to such a degree merely the material reflection of the text, that everything in the theater that exceeds this text, that is not kept within its limits and strictly conditioned by it, seems to us purely a matter of *mise en scène,*[1] and quite inferior in comparison with the text.

Presented with this subordination of theater to speech, one might indeed wonder whether the theater by any chance possesses its own language, whether it is entirely fanciful to consider it as an independent and autonomous art, of the same rank as music, painting, dance, etc. . . .

Once we regard this language of the *mise en scène* as the pure theatrical language, we must discover whether it can attain the same internal ends as speech, whether theatrically and from the point of view of the mind it can claim the same intellectual efficacy as the spoken language. One can wonder, in other words, whether it has the power, not to define thoughts but *to cause thinking,* whether it may not entice the mind to take profound and efficacious attitudes toward it from its own point of view.

In a word, to raise the question of the intellectual efficacy of expression by means of objective forms, of the intellectual efficacy of a language which would use only shapes, or noise, or gesture, is to raise the question of the intellectual efficacy of art.

If we have come to attribute to art nothing more than the values of pleasure and relaxation and constrain it to a purely formal use of forms within the harmony of certain external relations, that in no way spoils its profound expressive value; but the spiritual infirmity of the Occident, which is the place *par excellence* where men have confused art and aestheticism, is to think that its painting would function only as painting, dance which would be merely plastic, as if in an attempt to castrate the forms of art, to sever their ties with all the mystic attitudes they might acquire in confrontation with the absolute.

One therefore understands that the theater, to the very degree that it remains confined within its own language and in correlation with it, must break with actuality. Its object is not to resolve social or psychological conflicts, to serve as battlefield for moral passions, but to express objectively certain secret truths, to bring into the light of day by means of active gestures certain aspects of truth that have been buried under forms in their encounters with Becoming.

To do that, to link the theater to the expressive possibilities of forms, to everything in the domain of gestures, noises, colors, movements, etc., is to restore it to its original direction, to reinstate it in its religious and metaphysical aspect, is to reconcile it with the universe.

But words, it will be said, have metaphysical powers; it is not forbidden to conceive of speech as well as of gestures on the universal level, and it is on that level moreover that speech acquires its major efficacy, like a dissociative force exerted upon physical appearances, and upon all states in which the mind feels stabilized and tends towards repose. And we can readily answer that this metaphysical way of considering speech is not that of the Occidental theater, which employs speech not as an active force springing out of the destruction of

[1] French for staging, production.

appearances in order to reach the mind itself, but on the contrary as a completed stage of thought which is lost at the moment of its own exteriorization.

Speech in the Occidental theater is used only to express psychological conflicts particular to man and the daily reality of his life. His conflicts are clearly accessible to spoken language, and whether they remain in the psychological sphere or leave it to enter the social sphere, the interest of the drama will still remain a moral one according to the way in which its conflicts attack and disintegrate the characters. And it will indeed always be a matter of a domain in which the verbal solutions of speech will retain their advantage. But these moral conflicts by their very nature have no absolute need of the stage to be resolved. To cause spoken language or expression by words to dominate on the stage the objective expression of gestures and of everything which affects the mind by sensuous and spatial means is to turn one's back on the physical necessities of the stage and to rebel against its possibilities.

It must be said that the domain of the theater is not psychological but plastic and physical. And it is not a question of whether the physical language of theater is capable of achieving the same psychological resolutions as the language of words, whether it is able to express feelings and passions as well as words, but whether there are not attitudes in the realm of thought and intelligence that words are incapable of grasping and that gestures and everything partaking of a spatial language attain with more precision than they. . . .

It is not a matter of suppressing speech in the theater but of changing its role, and especially of reducing its position, of considering it as something else than a means of conducting human characters to their external ends, since the theater is concerned only with the way feelings and passions conflict with one another, and man with man, in life.

To change the role of speech in theater is to make use of it in a concrete and spatial sense, combining it with everything in the theater that is spatial and significant in the concrete domain;—to manipulate it like a solid object, one which overturns and disturbs things, in the air first of all, then in an infinitely more mysterious and secret domain but one that admits of extension. . . .

In the Oriental theater of metaphysical tendency, contrasted to the Occidental theater of psychological tendency, forms assume and extend their sense and their significations on all possible levels; or, if you will, they set up vibrations not on a single level, but on every level of the mind at once.

And it is because of the multiplicity of their aspects that they can disturb and charm and continuously excite the mind. It is because the Oriental theater does not deal with the external aspects of things on a single level nor rest content with the simple obstacle or with the impact of these aspects on the senses, but instead considers the degree of mental possibility from which they issue, that it participates in the intense poetry of nature and preserves its magic relations with all the objective degrees of universal magnetism.

It is in the light of magic and sorcery that the *mise en scène* must be considered, not as the reflection of a written text, the mere projection of physical doubles that is derived from the written work, but as the burning projection of all the objective consequences of a gesture, word, sound, music, and their combinations. This active projection can be made only upon the stage and its consequences found in the presence of and upon the stage; and the author who uses written words only has nothing to do with the theater and must give way to specialists in its objective and animated sorcery.

COMMENTS AND QUESTIONS

1. What, for Artaud, is the true function of theater? Why does he find a theater based on language and on imitation of reality so limiting?

2. What contrasts does Artaud make between the Occidental and the Oriental theaters?

3. If you have seen any Asian dance or theatrical productions, in what ways do you find Artaud's description applicable?

4. In what ways do you think that Artaud may have influenced modern Western theater?

FRANZ KAFKA

A Country Doctor
Translation by Willa and Edwin Muir

I was in great perplexity; I had to start on an urgent journey; a seriously ill patient was waiting for me in a village ten miles off; a thick blizzard of snow filled all the wide spaces between him and me; I had a gig, a light gig with big wheels, exactly right for our country roads; muffled in furs, my bag of instruments in my hand, I was in the courtyard all ready for the journey;

but there was no horse to be had, no horse. My own horse had died in the night, worn out by the fatigues of this icy winter; my servant girl was now running around the village trying to borrow a horse; but it was hopeless, I knew it, and I stood there forlornly, with the snow gathering more and more thickly upon me, more and more unable to move. In the gateway the girl appeared, alone, and waved the lantern; of course, who would lend a horse at this time for such a journey? I strode through the courtyard once more; I could see no way out; in my confused distress I kicked at the dilapidated door of the yearlong uninhabited pigsty. It flew open and flapped to and fro on its hinges. A steam and smell as of horses came out from it. A dim stable lantern was swinging inside from a rope. A man, crouching on his hams in that low space, showed an open blue-eyed face. "Shall I yoke up?" he asked, crawling out on all fours. I did not know what to say and merely stooped down to see what else was in the sty. The servant girl was standing beside me. "You never know what you're going to find in your own house," she said, and we both laughed. "Hey there, Brother, hey there, Sister!" called the groom, and two horses, enormous creatures with powerful flanks, one after the other, their legs tucked close to their bodies, each well-shaped head lowered like a camel's, by sheer strength of buttocking squeezed out through the door hole which they filled entirely. But at once they were standing up, their legs long and their bodies steaming thickly. "Give him a hand," I said, and the willing girl hurried to help the groom with the harnessing. Yet hardly was she beside him when the groom clipped hold of her and pushed his face against hers. She screamed and fled back to me; on her cheek stood out in red the marks of two rows of teeth. "You brute," I yelled in fury, "do you want a whipping?" but in the same moment reflected that the man was a stranger; that I did not know where he came from, and that of his own free will he was helping me out when everyone else had failed me. As if he knew my thoughts he took no offense at my threat but, still busied with the horses, only turned around once toward me. "Get in," he said then, and indeed: everything was ready. A magnificent pair of horses, I observed, such as I had never sat behind, and I climbed in happily. "But I'll drive, you don't know the way," I said. "Of course," said he, "I'm not coming with you anyway, I'm staying with Rose." "No," shrieked Rose, fleeing into the house with a justified presentiment that her fate was inescapable; I heard the door chain rattle as she put it up; I heard the key turn in the lock; I could see, moreover, how she put out the lights in the entrance hall and in further flight all through the rooms to keep herself from being discovered. "You're coming with me," I said to the groom, "or I won't go, urgent as my jour-

ney is. I'm not thinking of paying for it by handing the girl over to you." "Gee up!" he said; clapped his hands; the gig whirled off like a log in a freshet; I could just hear the door of my house splitting and bursting as the groom charged at it and then I was deafened and blinded by a storming rush that steadily buffeted all my senses. But this only for a moment, since, as if my patient's farmyard had opened out just before my courtyard gate, I was already there; the horses had come quietly to a standstill; the blizzard had stopped; moonlight all around; my patient's parents hurried out of the house, his sister behind them; I was almost lifted out of the gig; from their confused ejaculations I gathered not a word; in the sickroom the air was almost unbreathable; the neglected stove was smoking; I wanted to push open a window; but first I had to look at my patient. Gaunt, without any fever, not cold, not warm, with vacant eyes, without a shirt, the youngster heaved himself up from under the feather bedding, threw his arms around my neck, and whispered in my ear: "Doctor, let me die." I glanced around the room; no one had heard it; the parents were leaning forward in silence waiting for my verdict; the sister had set a chair for my handbag; I opened the bag and hunted among my instruments; the boy kept clutching at me from his bed to remind me of his entreaty; I picked up a pair of tweezers, examined them in the candlelight, and laid them down again. "Yes," I thought blasphemously, "in cases like this the gods are helpful, send the missing horse, add to it a second because of the urgency, and to crown everything bestow even a groom—" And only now did I remember Rose again; what was I to do, how could I rescue her, how could I pull her away from under that groom at ten miles' distance, with a team of horses I couldn't control. These horses, now, they had somehow slipped the reins loose, pushed the windows open from outside, I did not know how; each of them had stuck a head in at a window and, quite unmoved by the startled cries of the family, stood eyeing the patient. "Better go back at once," I thought, as if the horses were summoning me to the return journey, yet I permitted the patient's sister, who fancied that I was dazed by the heat, to take my fur coat from me. A glass of rum was poured out for me, the old man clapped me on the shoulder, a familiarity justified by this offer of his treasure. I shook my head; in the narrow confines of the old man's thoughts I felt ill; that was my only reason for refusing the drink. The mother stood by the bedside and cajoled me toward it; I yielded, and, while one of the horses whinnied loudly to the ceiling, laid my head to the boy's breast, which shivered under my wet beard. I confirmed what I already knew; the boy was quite sound, something a little wrong with his circulation, saturated with coffee by his solicitous mother,

but sound and best turned out of bed with one shove. I am no world reformer and so I let him lie. I was the district doctor and did my duty to the uttermost, to the point where it became almost too much. I was badly paid and yet generous and helpful to the poor. I had still to see that Rose was all right, and then the boy might have his way and I wanted to die too. What was I doing there in that endless winter! My horse was dead, and not a single person in the village would lend me another. I had to get my team out of the pigsty; if they hadn't chanced to be horses I should have had to travel with swine. That was how it was. And I nodded to the family. They knew nothing about it, and, had they known, would not have believed it. To write prescriptions is easy, but to come to an understanding with people is hard. Well, this should be the end of my visit, I had once more been called out needlessly, I was used to that, the whole district made my life a torment with my night bell, but that I should have to sacrifice Rose this time as well, the pretty girl who had lived in my house for years almost without my noticing her— that sacrifice was too much to ask, and I had somehow to get it reasoned out in my head with the help of what craft I could muster, in order not to let fly at this family, which with the best will in the world could not restore Rose to me. But as I shut my bag and put an arm out for my fur coat, the family meanwhile standing together, the father sniffing at the glass of rum in his hand, the mother, apparently disappointed in me— why, what do people expect?—biting her lips with tears in her eyes, the sister fluttering a blood-soaked towel, I was somehow ready to admit conditionally that the boy might be ill after all. I went toward him, he welcomed me smiling as if I were bringing him the most nourishing invalid broth—ah, now both horses were whinnying together; the noise, I suppose, was ordained by heaven to assist my examination of the patient—and this time I discovered that the boy was indeed ill. In his right side, near the hip, was an open wound as big as the palm of my hand. Rose-red, in many variations of shade, dark in the hollows, lighter at the edges, softly granulated, with irregular clots of blood, open as a surface mine to the daylight. That was how it looked from a distance. But on a closer inspection there was another complication. I could not help a low whistle of surprise. Worms, as thick and as long as my little finger, themselves rose-red and blood-spotted as well, were wriggling from their fastness in the interior of the wound toward the light, with small white heads and many little legs. Poor boy, you were past helping. I had discovered your great wound; this blossom in your side was destroying you. The family was pleased; they saw me busying myself; the sister told the mother, the mother the father, the father told several guests who were coming in, through the moon-light at the open door, walking on tiptoe, keeping their balance with outstretched arms. "Will you save me?" whispered the boy with a sob, quite blinded by the life within his wound. That is what people are like in my district. Always expecting the impossible from the doctor. They have lost their ancient beliefs; the parson sits at home and unravels his vestments, one after another; but the doctor is supposed to be omnipotent with his merciful surgeon's hand. Well, as it pleases them; I have not thrust my services on them; if they misuse me for sacred ends, I let that happen to me too; what better do I want, old country doctor that I am, bereft of my servant girl! And so they came, the family and the village elders, and stripped my clothes off me; a school choir with the teacher at the head of it stood before the house and sang these words to an utterly simple tune:

> Strip his clothes off, then he'll heal us,
> If he doesn't, kill him dead!
> Only a doctor, only a doctor.

Then my clothes were off and I looked at the people quietly, my fingers in my beard and my head cocked to one side. I was altogether composed and equal to the situation and remained so, although it was no help to me, since they now took me by the head and feet and carried me to the bed. They laid me down in it next to the wall, on the side of the wound. Then they all left the room; the door was shut; the singing stopped; clouds covered the moon; the bedding was warm around me; the horses' heads in the open windows wavered like shadows. "Do you know," said a voice in my ear, "I have very little confidence in you. Why, you were only blown in here, you didn't come on your own feet. Instead of helping me, you're cramping me on my deathbed. What I'd like best is to scratch your eyes out." "Right," I said, "it is a shame. And yet I am a doctor. What am I to do? Believe me, it is not too easy for me either." "Am I supposed to be content with this apology? Oh, I must be, I can't help it. I always have to put up with things. A fine wound is all I brought into the world; that was my sole endowment." "My young friend," said I, "your mistake is: you have not a wide enough view. I have been in all the sickrooms, far and wide, and I tell you: your wound is not so bad. Done in a tight corner with two strokes of the ax. Many a one proffers his side and can hardly hear the ax in the forest, far less that it is coming nearer to him." "Is that really so, or are you deluding me in my fever?" "It is really so, take the word of honor of an official doctor." And he took it and lay still. But now it was time for me to think of escaping. The horses were still standing faithfully in their places. My clothes, my fur coat, my bag were quickly collected; I didn't want to waste time dressing; if the

horses raced home as they had come, I should only be springing, as it were, out of this bed into my own. Obediently a horse backed away from the window; I threw my bundle into the gig; the fur coat missed its mark and was caught on a hook only by the sleeve. Good enough. I swung myself onto the horse. With the reins loosely trailing, one horse barely fastened to the other, the gig swaying behind, my fur coat last of all in the snow. "Gee up!" I said, but there was no galloping; slowly, like old men, we crawled through the snowy wastes; a long time echoed behind us the new but faulty song of the children:

> O be joyful, all you patients,
> The doctor's laid in bed beside you!

Never shall I reach home at this rate; my flourishing practice is done for; my successor is robbing me, but in vain, for he cannot take my place; in my house the disgusting groom is raging; Rose is his victim; I do not want to think about it anymore. Naked, exposed to the frost of this most unhappy of ages, with an earthly vehicle, unearthly horses, old man that I am, I wander astray. My fur coat is hanging from the back of the gig, but I cannot reach it, and none of my limber pack of patients lifts a finger. Betrayed! Betrayed! A false alarm on the night bell once answered—it cannot be made good, not ever.

COMMENTS AND QUESTIONS

1. This story was probably to some extent based on the experience of Kafka's uncle, who was a country doctor. What realistic elements do you find in it?

2. At what point do you realize that this story has left the domain of the realistic and entered into the fantastic or grotesque? What effect does this have on the reader?

3. "To write prescriptions is easy, but to come to an understanding with people is hard," observes the doctor. Can this phrase be used as a key to the experience the doctor undergoes in the story?

4. It is important to realize that there is no one "right" way to interpret Kafka. His stories are open-ended parables, although in some sense representative of the dilemmas of modern individuals. Give your own interpretation of the nature of the experience the doctor undergoes, along with the meaning of symbols such as the pigsty, the groom, the horses, and the wound. Compare your interpretation with those of your classmates.

T. S. ELIOT

The Love Song of J. Alfred Prufrock

S'io credessi che mia risposta fosse
a persona che mai tornasse al mondo,
questa fiamma staria senza più scosse.
Ma per ciò che giammai di questo fondo
non tornò vivo alcun, s'i'odo il vero,
senza tema d'infamia ti rispondo.[1]

Let us go then, you and I,°
When the evening is spread out against the sky
Like a patient etherised upon a table;
Let us go, through certain half-deserted streets,
The muttering retreats 5
Of restless nights in one-night cheap hotels
And sawdust restaurants with oyster-shells:
Streets that follow like a tedious argument
Of insidious intent
To lead you to an overwhelming question . . . 10
Oh, do not ask, "What is it?"
Let us go and make our visit.

In the room the women come and go
Talking of Michelangelo.

The yellow fog that rubs its back upon the window-
 panes, 15
The yellow smoke that rubs its muzzle on the
 window-panes,
Licked its tongue into the corners of the evening,
Lingered upon the pools that stand in drains,
Let fall upon its back the soot that falls from chimneys,
Slipped by the terrace, made a sudden leap, 20
And seeing that it was a soft October night,
Curled once about the house, and fell asleep.

And indeed there will be time
For the yellow smoke that slides along the street
Rubbing its back upon the window-panes; 25
There will be time, there will be time
To prepare a face to meet the faces that you meet;
There will be time to murder and create,
And time for all the works and days of hands
That lift and drop a question on your plate; 30
Time for you and time for me,

[1] Epigraph from Dante's *Inferno,* Canto 27: "If I thought that my answer was to someone who would ever return to the world, this flame would shake no more. But since no one has ever returned alive from this place [hell], if I hear rightly, without fear of infamy I will answer you." [Editor's notes.]

1. Prufrock and a companion (or his own alter ego?) are going to make a visit to a woman.

And time yet for a hundred indecisions,
And for a hundred visions and revisions,
Before the taking of a toast and tea.

In the room the women come and go 35
Talking of Michelangelo.
And indeed there will be time
To wonder, "Do I dare?" and, "Do I dare?"
Time to turn back and descend the stair,
With a bald spot in the middle of my hair— 40
(They will say: "How his hair is growing thin!")
My morning coat, my collar mounting firmly to the
 chin,
My necktie rich and modest, but asserted by a
 simple pin—
(They will say: "But how his arms and legs are thin!")
Do I dare 45
Disturb the universe?
In a minute there is time
For decisions and revisions which a minute will reverse.

For I have known them all already, known them
 all—
Have known the evenings, mornings, afternoons, 50
I have measured out my life with coffee spoons;
I know the voices dying with a dying fall
Beneath the music from a farther room.
 So how should I presume?

And I have known the eyes already, known them
 all— 55
The eyes that fix you in a formulated phrase,
And when I am formulated, sprawling on a pin,
When I am pinned and wriggling on the wall,
Then how should I begin
To spit out all the butt-ends of my days and ways? 60
 And how should I presume?

And I have known the arms already, known them
 all—
Arms that are braceleted and white and bare
(But in the lamplight, downed with light brown
 hair!)
Is it perfume from a dress 65
That makes me so digress?
Arms that lie along a table, or wrap about a shawl.
 And should I then presume?
 And how should I begin?

Shall I say, I have gone at dusk through narrow
 streets 70
And watched the smoke that rises from the pipes
Of lonely men in shirt-sleeves, leaning out of
 windows? . . .

I should have been a pair of ragged claws
Scuttling across the floors of silent seas.

And the afternoon, the evening, sleeps so peacefully! 75
Smoothed by long fingers,
Asleep . . . tired . . . or it malingers,
Stretched on the floor, here beside you and me.
Should I, after tea and cakes and ices,
Have the strength to force the moment to its crisis? 80
But though I have wept and fasted, wept and prayed,
Though I have seen my head (grown slightly bald)
 brought in upon a platter,°
I am no prophet—and here's no great matter;
I have seen the moment of my greatness flicker,
And I have seen the eternal Footman hold my coat,
 and snicker, 85
And in short, I was afraid.

And would it have been worth it, after all,°
After the cups, the marmalade, the tea,
Among the porcelain, among some talk of you and me,
Would it have been worth while, 90
To have bitten off the matter with a smile,
To have squeezed the universe into a ball
To roll it toward some overwhelming question,
To say: "I am Lazarus, come from the dead,
Come back to tell you all, I shall tell you all"— 95
If one,° settling a pillow by her head,

 Should say: "That is not what I meant at all.
 That is not it, at all."

And would it have been worth it, after all,
Would it have been worth while, 100
After the sunsets and the dooryards and the
 sprinkled streets,
After the novels, after the teacups, after the skirts
 that trail along the floor—
And this, and so much more?—
It is impossible to say just what I mean!
But as if a magic lantern threw the nerves in
 patterns on a screen: 105
Would it have been worth while
If one, settling a pillow or throwing off a shawl,
And turning toward the window, should say:
 "That is not it at all,
 That is not what I meant, at all." 110

No! I am not Prince Hamlet, nor was meant to be;
Am an attendant lord, one that will do
To swell a progress,° start a scene or two,
Advise the prince; no doubt, an easy tool,
Deferential, glad to be of use, 115
Politic, cautious, and meticulous;
Full of high sentence, but a bit obtuse;

82. Refers to the head of John the Baptist, brought to Salome, the
stepdaughter of King Herod. 87. The use of the past tense here
suggests that the moment for Prufrock to speak has passed. 96.
Prufrock's woman friend. 113. A royal journey.

At times, indeed, almost ridiculous—
Almost, at times, the Fool.

I grow old . . . I grow old . . . 120
I shall wear the bottoms of my trousers rolled.°

Shall I part my hair behind? Do I dare to eat a
 peach?
I shall wear white flannel trousers, and walk upon
 the beach.
I have heard the mermaids singing, each to each.

I do not think that they will sing to me. 125

I have seen them riding seaward on the waves
Combing the white hair of the waves blown back
When the wind blows the water white and black.

We have lingered in the chambers of the sea
By sea-girls wreathed with seaweed red and brown 130
Till human voices wake us, and we drown.

COMMENTS AND QUESTIONS

1. This poem presents itself as a *narrative*, but the action that occurs is very slight. Tell what it is.

2. Describe the character of Prufrock. What images does Eliot use to tell us about him?

3. Does Prufrock's problem seem to you a particularly modern one? Why?

4. In what sense, if any, is this a "love song"?

5. Is there any justification for the quotation from Dante's *Inferno*?

6. Do you find any images here that qualify as "objective correlatives"?

EZRA POUND

The River-Merchant's Wife: A Letter

This poem is Pound's translation, or rather adaptation, of Li Po's "Song of Chang Gan." Pound gives the Japanese version of Li Po's name, Rihaku.

(after Rihaku)

While my hair was still cut straight across my
 forehead
I played about the front gate, pulling flowers.
You came by on bamboo stilts, playing horse,
You walked about my seat, playing with blue plums. 5

121. The latest fashion.

And we went on living in the village of Chokan:
Two small people, without dislike or suspicion.

At fourteen I married My Lord you.
I never laughed, being bashful.
Lowering my head, I looked at the wall. 10
Called to, a thousand times, I never looked back.

At fifteen I stopped scowling,
I desired my dust to be mingled with yours
For ever and for ever and for ever.
Why should I climb the look out? 15

At sixteen you departed,
You went into far Ku-to-yen, by the river of swirling
 eddies,
And you have been gone five months.
The monkeys make sorrowful noise overhead. 20

You dragged your feet when you went out.
By the gate now, the moss is grown, the different
 mosses,
Too deep to clear them away!
The leaves fall early this autumn, in wind. 25
The paired butterflies are already yellow with August
Over the grass in the West garden;
They hurt me. I grow older.

If you are coming down through the narrows of the
river Kiang, 30
Please let me know beforehand,
And I will come out to meet you
As far as Cho-fu-Sa.

> The following poem imitates the Japanese haiku (also called *hokku*). A Japanese poetic form that developed in the mid-seventeenth century, it consists of seventeen syllables in three lines of five, seven, and five syllables. It should imply a season of the year, and it works by condensation and power of suggestion. Note how Pound applies the form to modern European life (the Paris subway).

In a Station of the Metro[1]

The apparition of these faces in the crowd;
Petals on a wet, black bough.

COMMENTS AND QUESTIONS

1. What are the visual images in "The River-Merchant's Wife: A Letter"? What emotions are conveyed or suggested and how?

2. Do you see any painting techniques at work in "In a Station of the Metro"? What does the image suggest to you?

VIRGINIA WOOLF

from *A Room of One's Own*

. . . I could not help thinking, as I looked at the works of Shakespeare on the shelf, that the bishop was right at least in this; it would have been impossible, completely and entirely, for any woman to have written the plays of Shakespeare in the age of Shakespeare. Let me imagine, since facts are so hard to come by, what would have happened had Shakespeare had a wonderfully gifted sister, called Judith, let us say. Shakespeare himself went, very probably—his mother was an heiress—to the grammar school, where he may have learnt Latin—Ovid, Virgil and Horace—and the elements of grammar and logic. He was, it is well known, a wild boy who poached rabbits, perhaps shot a deer, and had, rather sooner than he should have done, to marry a woman in the neighbourhood, who bore him a child rather quicker than was right. That escapade sent him to seek his fortune in London. He had, it seemed, a taste for the theatre; he began by holding horses at the stage door. Very soon he got work in the theatre, became a successful actor, and lived at the hub of the universe, meeting everybody, knowing everybody, practising his art on the boards, exercising his wits in the streets, and even getting access to the palace of the queen. Meanwhile his extraordinarily gifted sister, let us suppose, remained at home. She was as adventurous, as imaginative, as agog to see the world as he was. But she was not sent to school. She had no chance of learning grammar and logic, let alone of reading Horace and Virgil. She picked up a book now and then, one of her brother's perhaps, and read a few pages. But then her parents came in and told her to mend the stockings or mind the stew and not moon about with books and papers. They would have spoken sharply but kindly, for they were substantial people who knew the conditions of life for a woman and loved their daughter—indeed, more likely than not she was the apple of her father's eye. Perhaps she scribbled some pages up in an apple loft on the sly, but was careful to hide them or set fire to them. Soon, however, before she was out of her teens, she was to be betrothed to the son of a neighbouring wool-stapler. She cried out that marriage was hateful to her, and for that she was severely beaten by her father. Then he ceased to scold her. He begged her instead not to hurt him, not to shame him in this matter of her marriage. He would give her a chain of beads or a fine petticoat, he said; and there were tears in his eyes. How could she disobey him? How could she break his heart? The force of her own gift alone drove her to it. She made up a small parcel of her belongings, let herself down by a rope one summer's night and took the road to London. She was not seventeen. The birds that sang in the hedge were not more musical than she was. She had the quickest fancy, a gift like her brother's, for the tune of words. Like him, she had a taste for the theatre. She stood at the stage door; she wanted to act, she said. Men laughed in her face. The manager—a fat, loose-lipped man—guffawed. He bellowed something about poodles dancing and women acting—no woman, he said, could possibly be an actress. He hinted—you can imagine what. She could get no training in her craft. Could she even seek her dinner in a tavern or roam the streets at midnight? Yet her genius was for fiction and lusted to feed abundantly upon the lives of men and women and the study of their ways. At last—for she was very young, oddly like Shakespeare the poet in her face, with the same grey eyes and rounded brows—at last Nick Greene the actor-manager took pity on her; she found herself with child by that gentleman and so—who shall measure the heat and violence of the poet's heart when caught and tangled in a woman's body?—killed herself one winter's night and lies buried at some cross-roads where the omnibuses now stop outside the Elephant and Castle.

That, more or less, is how the story would run, I think, if a woman in Shakespeare's day had had Shakespeare's genius. But for my part, I agree with the deceased bishop, if such he was—it is unthinkable that any woman in Shakespeare's day should have had Shakespeare's genius. For genius like Shakespeare's is not born among labouring, uneducated, servile people. It was not born in England among the Saxons and the Britons. It is not born today among the working classes. How, then, could it have been born among women whose work began, according to Professor

[1] Of this poem Pound writes in *Gaudier-Brzeska: A Memoir* (1916): "Three years ago in Paris I got out of a 'metro' train at La Concorde, and saw suddenly a beautiful face, and then another and another, and then a beautiful child's face, and then another beautiful woman, and I tried all that day to find words for what this had meant to me, and I could not find any words that seemed to me worthy, or as lovely as that sudden emotion. And that evening . . . I was still trying and I found, suddenly, the expression. I do not mean that I found words, but there came an equation . . . not in speech, but in little splotches of colour. . . . The 'one-image poem' is a form of superposition, that is to say, it is one idea set on top of another. I found it useful in getting out of the impasse in which I had been left by my metro emotion. I wrote a thirty-line poem, and destroyed it. . . . Six months later I made a poem half that length; a year later I made the following *hokku*-like sentence." [Editor's notes.]

Trevelyan, almost before they were out of the nursery, who were forced to it by their parents and held to it by all the power of law and custom? Yet genius of a sort must have existed among women as it must have existed among the working classes. Now and again an Emily Brontë or a Robert Burns blazes out and proves its presence. But certainly it never got itself on to paper. When, however, one reads of a witch being ducked, of a woman possessed by devils, of a wise woman selling herbs, or even of a very remarkable man who had a mother, then I think we are on the track of a lost novelist, a suppressed poet, of some mute and inglorious Jane Austen, some Emily Brontë who dashed her brains out on the moor or mopped and mowed about the highways crazed with the torture that her gift had put her to. Indeed, I would venture to guess that Anon, who wrote so many poems without signing them, was often a woman. It was a woman Edward Fitzgerald, I think, suggested who made the ballads and the folk-songs, crooning them to her children, beguiling her spinning with them, or the length of the winter's night.

This may be true or it may be false—who can say?—but what is true in it, so it seemed to me, reviewing the story of Shakespeare's sister as I had made it, is that any woman born with a great gift in the sixteenth century would certainly have gone crazed, shot herself, or ended her days in some lonely cottage outside the village, half witch, half wizard, feared and mocked at. For it needs little skill in psychology to be sure that a highly gifted girl who had tried to use her gift for poetry would have been so thwarted and hindered by other people, so tortured and pulled asunder by her own contrary instincts, that she must have lost her health and sanity to a certainty. No girl could have walked to London and stood at a stage door and forced her way into the presence of actor-managers without doing herself a violence and suffering an anguish which may have been irrational—for chastity may be a fetish invented by certain societies for unknown reasons—but were none the less inevitable. Chastity had then, it has even now, a religious importance in a woman's life, and has so wrapped itself round with nerves and instincts that to cut it free and bring it to the light of day demands courage of the rarest. To have lived a free life in London in the sixteenth century would have meant for a woman who was poet and playwright a nervous stress and dilemma which might well have killed her. Had she survived, whatever she had written would have been twisted and deformed, issuing from a strained and morbid imagination. And undoubtedly, I thought, looking at the shelf where there are no plays by women, her work would have gone unsigned. That refuge she would have sought certainly. It was the relic of the sense of chastity that dictated anonymity to women even so late as the nineteenth century. Currer Bell,[1] George Eliot, George Sand, all the victims of inner strife as their writings prove, sought ineffectively to veil themselves by using the name of a man. Thus they did homage to the convention, which if not implanted by the other sex was liberally encouraged by them (the chief glory of a woman is not to be talked of, said Pericles, himself a much-talked-of man), that publicity in women is detestable. Anonymity runs in their blood. The desire to be veiled still possesses them. They are not even now as concerned about the health of their fame as men are, and, speaking generally, will pass a tombstone or a signpost without feeling an irresistible desire to cut their names on it, as Alf, Bert or Chas. must do in obedience to their instinct, which murmurs if it sees a fine woman go by, or even a dog, Ce chien est à moi. And, of course, it may not be a dog, I thought, remembering Parliament Square, the Sieges Allee and other avenues; it may be a piece of land or a man with curly black hair. It is one of the great advantages of being a woman that one can pass even a very fine negress without wishing to make an English-woman of her.

That woman, then, who was born with a gift of poetry in the sixteenth century, was an unhappy woman, a woman at strife against herself. All the conditions of her life, all her own instincts, were hostile to the state of mind which is needed to set free whatever is in the brain. But what is the state of mind that is most propitious to the act of creation, I asked. Can one come by any notion of the state that furthers and makes possible that strange activity? Here I opened the volume containing the Tragedies of Shakespeare. What was Shakespeare's state of mind, for instance, when he wrote *Lear* and *Antony and Cleopatra*? It was certainly the state of mind most favourable to poetry that there has ever existed. But Shakespeare himself said nothing about it. We only know casually and by chance that he "never blotted a line." Nothing indeed was ever said by the artist himself about his state of mind until the eighteenth century perhaps. Rousseau perhaps began it. At any rate, by the nineteenth century self-consciousness had developed so far that it was the habit for men of letters to describe their minds in confessions and autobiographies. Their lives also were written, and their letters were printed after their deaths. Thus, though we do not know what Shakespeare went through when he wrote *Lear*, we do know what Carlyle went through when he wrote the *French Revolution*; what Flaubert went through when he wrote *Madame Bovary*; what Keats was going through when he tried to write poetry against the coming of death and the indifference of the world.

[1] The pseudonym of Charlotte Brontë.

And one gathers from this enormous modern literature of confession and self-analysis that to write a work of genius is almost always a feat of prodigious difficulty. Everything is against the likelihood that it will come from the writer's mind whole and entire. Generally material circumstances are against it. Dogs will bark; people will interrupt; money must be made; health will break down. Further, accentuating all these difficulties and making them harder to bear is the world's notorious indifference. It does not ask people to write poems and novels and histories; it does not need them. It does not care whether Flaubert finds the right word or whether Carlyle scrupulously verifies this or that fact. Naturally, it will not pay for what it does not want. And so the writer Keats, Flaubert, Carlyle, suffers, especially in the creative years of youth, every form of distraction and discouragement. A curse, a cry of agony, rises from those books of analysis and confession. "Mighty poets in their misery dead"—that is the burden of their song. If anything comes through in spite of all of this, it is a miracle, and probably no book is born entire and uncrippled as it was conceived.

But for women, I thought, looking at the empty shelves, these difficulties were infinitely more formidable. In the first place, to have a room of her own, let alone a quiet room or a sound-proof room, was out of the question, unless her parents were exceptionally rich or very noble, even up to the beginning of the nineteenth century. Since her pin money, which depended on the good will of her father, was only enough to keep her clothed, she was debarred from such alleviations as came even to Keats or Tennyson or Carlyle, all poor men, from a walking tour, a little journey to France, from the separate lodging which, even if it were miserable enough, sheltered them from the claims and tyrannies of their families. Such material difficulties were formidable; but much worse were the immaterial. The indifference of the world which Keats and Flaubert and other men of genius have found so hard to bear was in her case not indifference but hostility. The world did not say to her as it said to them, Write if you choose; it makes no difference to me. The world said with a guffaw, Write? What's the good of your writing? Here the psychologists of Newnham and Girton might come to our help, I thought, looking again at the blank spaces on the shelves. For surely it is time that the effect of discouragement upon the mind of the artist should be measured, as I have seen a dairy company measure the effect of ordinary milk and Grade A milk upon the body of the rat. They set two rats in cages side by side, and of the two one was furtive, timid and small, and the other was glossy, bold and big. Now what food do we feed women as artists upon? I asked, remembering, I suppose, that dinner of prunes and custard.

COMMENTS AND QUESTIONS

1. Is the story of "Shakespeare's sister" convincing? What does it say about women and creativity?

2. What is the point of the account of the scientific experiment at the end of the passage?

3. To what extent have conditions for the intellectual or creative woman changed since 1928?

LÉOPOLD SÉDAR SENGHOR

Prayer to Masks
Translation by John Reed

Masks! Masks!
Black mask, red mask, you white-and-black masks
Masks of the four points from which the Spirit blows
In silence I salute you!
Nor you the least, Lion-headed Ancestor 5
You guard this place forbidden to all laughter of
 women, to all smiles that fade
You distil this air of eternity in which I breathe the air
 of my Fathers.
Masks of unmasked faces, stripped of the marks of 10
 illness and the lines of age
You who have fashioned this portrait, this my face
 bent over the altar of white paper
In your own image, hear me!
The Africa of the empires is dying, see, the agony of 15
 a pitiful princess
And Europe too where we are joined by the navel.
Fix your unchanging eyes upon your children, who are
 given orders
Who give away their lives like the poor their last 20
 clothes.
Let us report present at the rebirth of the World
Like the yeast which white flour needs.
For who would teach rhythm to a dead world of
 machines and guns? 25
Who would give the cry of joy to wake the dead and
 the bereaved at dawn?
Say, who would give back the memory of life to the
 man whose hopes are smashed?
They call us men of coffee cotton oil 30
They call us men of death.
We are the men of the dance, whose feet draw new
 strength pounding the hardened earth.

LÉON GONTRAN DAMAS

They came that night

Translation by Norman R. Shapiro

They came that night when the
tom
 tom
 rolled from
 rhythm 5
 to
 rhythm
 the frenzy
of eyes
the frenzy of hands 10
the frenzy
of statue feet
SINCE THEN
How many of ME ME ME
have died 15
since they came that night when the
tom
 tom
 rolled from
 rhythm 20
 to
 rhythm
 the frenzy
of eyes
the frenzy 25
of hands
the frenzy
of statue feet

COMMENTS AND QUESTIONS

1. What different associations and meanings does the mask have in Senghor's poem?

2. What contrast does Senghor make between African and European civilization? What future role does he see for Africa?

3. Describe the rhythm in Senghor's poem. What is its function?

4. What happens in "They came that night"?

5. Note how, in surrealist fashion, this poem expresses a subjective apprehension of reality by using detached, objective images. What do the images do in the poem?

CLAUDE MCKAY

If We Must Die

If we must die, let it not be like hogs
Hunted and penned in an inglorious spot,
While round us bark the mad and hungry dogs,
Making their mock at our accursed lot.
If we must die, O let us nobly die, 5
So that our precious blood may not be shed
In vain; then even the monsters we defy
Shall be constrained to honor us though dead!
O kinsmen! we must meet the common foe!
Though far outnumbered let us show us brave, 10
And for their thousand blows deal one deathblow!
What though before us lies the open grave?
Like men we'll face the murderous, cowardly pack,
Pressed to the wall, dying but fighting back!

COMMENTS AND QUESTIONS

1. To what extent does this seem to be a conventional war poem? How is it original?

2. What are McKay's main images, and what is their effect?

LANGSTON HUGHES

In "The Negro Speaks of Rivers," Hughes expresses his sense of the cultural roots of African Americans in ancient African civilizations. "Danse Africaine" shows some of the influence of the French African poets.

The Negro Speaks of Rivers

I've known rivers!
I've known rivers ancient as the world and older than
 the flow of human blood in human veins.
My soul has grown deep like the rivers.
I bathed in the Euphrates when dawns were young, 5
I built my hut near the Congo and it lulled me to sleep,
I looked upon the Nile and raised the pyramids above it.

I heard the singing of the Mississippi when Abe
 Lincoln went down to New Orleans, 10
And I've seen its muddy bosom turn all golden in the
 sunset.

I've known rivers:
Ancient, dusky rivers,
My soul has grown deep like the rivers. 15

Danse Africaine

The low beating of the tom-toms,
The slow beating of the tom-toms,
 Low . . . slow
 Slow . . . low—
 Stirs your blood. 5
 Dance!
A night-veiled girl
 Whirls softly into a
 Circle of light.
 Whirls softly . . . slowly, 10
Like a wisp of smoke around the fire—
 And the tom-toms beat,
 And the tom-toms beat,
And the low beating of the tom-toms
 Stirs your blood. 15

COMMENTS AND QUESTIONS

1. What different connotations does the word *rivers* carry in this poem?

2. Compare Hughes's use of rhythm in "Danse Africaine" to Damas's in "They came that night."

MARITA BONNER

On Being Young—a Woman— and Colored

You start out after you have gone from kindergarten to sheepskin covered with sundry Latin phrases.

At least you know what you want life to give you. A career as fixed and as calmly brilliant as the North Star. The one real thing that money buys, Time. Time to do things. A house that can be as delectably out of order and as easily put in order as the doll-house of "playing-house" days. And of course, a husband you can look up to without looking down on yourself.

Somehow you feel like a kitten in sunny catnip field that sees sleek, plump brown field mice and yellow baby chicks sitting coyly, side by side, under each leaf. A desire to dash three or four ways seizes you.

That's Youth.

But you know that things learned need testing—acid testing—to see if they are really after all, an interwoven part of you. All your life you have heard of the debt you owe "Your People" because you have managed to have the things they have not largely had.

So you find a spot where there are hordes of them—of course below the Line—to be your catnip field while you close your eyes to mice and chickens alike.

If you have never lived among your own, you feel prodigal. Some warm, untouched current flows through them—through you—and drags you out into the deep waters of a new sea of human foibles and mannerisms; of a peculiar psychology and prejudices. And one day you find yourself entangled—enmeshed—pinioned in the seaweed of a Black Ghetto.

Not a Ghetto, placid like the Strasse[1] that flows, outwardly unperturbed and calm in a stream of religious belief, but a peculiar group. Cut off, flung together, shoved aside in a bundle because of color and with no more in common.

Unless color is, after all, the real bond.

Milling around like live fish in a basket. Those at the bottom crushed into a sort of stupid apathy by the weight of those on top. Those on top leaping, leaping; leaping to scale the sides; to get out.

There are two "colored" movies, innumerable parties—and cards. Cards played so intensely that it fascinates and repulses at once.

Movies.

Movies worthy and worthless—but not even a low-caste spoken stage.

Parties, plentiful. Music and dancing and much that is wit and color and poetry. But they are like the richest chocolate; stuffed costly chocolates that make the taste go stale if you have too many of them. That make plain whole bread taste like ashes.

There are all the earmarks of a group within a group. Cut off all round from ingress from or egress to other groups. A sameness of type. The smug self-satisfaction of an inner measurement; a measurement by standards known within a limited group and not those of an unlimited, seeing, world. . . . Like the blind, blind mice. Mice whose eyes have been blinded.

Strange longing seizes hold of you. You wish yourself back where you can lay your dollar down and sit in a dollar seat to hear voices, strings, reeds that have lifted the World out, up, beyond things that have bodies and walls. Where you can marvel at new marbles and bronzes and flat colors that will make men forget that things exist in a flesh more often than in spirit. Where you can sink your body in a cushioned seat and sink your soul at the same time into a section of life set before you on the boards for a few hours.

You hear that up at New York this is to be seen; that, to be heard.

You decide the next train will take you there.

———
[1] Street (German).

You decide the next second that that train will not take you, nor the next—nor the next for some time to come.

For you know that—being a woman—you cannot twice a month or twice a year, for that matter, break away to see or hear anything in a city that is supposed to see and hear too much.

That's being a woman. A woman of any color.

You decide that something is wrong with a world that stifles and chokes; that cuts off and stunts; hedging in, pressing down on eyes, ears and throat. Somehow all wrong.

You wonder how it happens there that—say five hundred miles from the Bay State[2]—Anglo Saxon intelligence is so warped and stunted.

How judgment and discernment are bred out of the race. And what has become of discrimination? Discrimination of the right sort. Discrimination that the best minds have told you weighs shadows and nuances and spiritual differences before it catalogues. The kind they have taught you all of your life was best: that looks clearly past generalization and past appearance to dissect, to dig down to the real heart of matters. That casts aside rapid summary conclusions, drawn from primary inference, as Daniel did the spiced meats.[3]

Why can't they then perceive that there is a difference in the glance from a pair of eyes that look, mildly docile, at "white ladies" and those that impersonally and perceptively—aware of distinctions—see only women who happen to be white?

Why do they see a colored woman only as a gross collection of desires, all uncontrolled, reaching out for their Apollos and the Quasimodos[4] with avid indiscrimination?

Why unless you talk in staccato squawks—brittle as seashells—unless you "champ" gum—unless you cover two yards square when you laugh—unless your taste runs to violent colors—impossible perfumes and more impossible clothes—are you a feminine Caliban craving to pass for Ariel?[5]

An empty imitation of an empty invitation. A mime; a sham; a copy-cat. A hollow re-echo. A froth, a foam. A fleck of the ashes of superficiality?

Everything you touch or taste now is like the flesh of an unripe persimmon.

. . . Do you need to be told what that is being . . . ?

Old ideas, old fundamentals seem worm-eaten, outgrown, worthless, bitter; fit for the scrap-heap of Wisdom.

What you had thought tangible and practical has turned out to be a collection of "blue-flower" theories.

If they have not discovered how to use their accumulation of facts, they are useless to you in Their world.

Every part of you becomes bitter.

But—"In Heaven's name, do not grow bitter. Be bigger than they are"—exhort white friends who have never had to draw breath in a Jim-Crow train. Who have never had petty putrid insult dragged over them—drawing blood—like pebbled sand on your body where the skin is tenderest. On your body where the skin is thinnest and tenderest.

You long to explode and hurt everything white; friendly; unfriendly. But you know that you cannot live with a chip on your shoulder even if you can manage a smile around your eyes—without getting steely and brittle and losing the softness that makes you a woman.

For chips make you bend your body to balance them. And once you bend, you lose your poise, your balance, and the chip gets into you. The real you. You get hard.

. . . And many things in you can ossify . . .

And you know, being a woman, you have to go about it gently and quietly, to find out and to discover just what is wrong. Just what can be done.

You see clearly that they have acquired things.

Money; money. Money to build with, money to destroy. Money to swim in. Money to drown in. Money.

An ascendancy of wisdom. An incalculable hoard of wisdom in all fields, in all things collected from all quarters of humanity.

A stupendous mass of things.

Things.

So, too, the Greeks . . . Things.

And the Romans. . . .

And you wonder and wonder why they have not discovered how to handle deftly and skillfully, Wisdom, stored up for them—like the honey for the Gods on Olympus—since time unknown.

You wonder and you wonder until you wander out into Infinity, where—if it is to be found anywhere—Truth really exists.

The Greeks had possessions, culture. They were lost because they did not understand.

The Romans owned more than anyone else. Trampled under the heel of Vandals and Civilization, because they would not understand.

Greeks. Did not understand.

Romans. Would not understand.

[2] Massachusetts.

[3] See Daniel 1:8–16, where he refused to "defile himself with the portion of the king's meat."

[4] Quasimodo is the central character in Victor Hugo's *Hunchback of Notre Dame* (1831).

[5] Savage and ugly trying to pass as noble and beautiful. Caliban and Ariel are characters in Shakespeare's *Tempest*.

"They." Will not understand.

So you find they have shut Wisdom up and have forgotten to find the key that will let her out. They have trapped, trammeled, lashed her to themselves with thews and thongs and theories. They have ransacked sea and earth and air to bring every treasure to her. But she sulks and will not work for a world with a whitish hue because it has snubbed her twin sister, Understanding.

You see clearly—off there is Infinity—Understanding. Standing alone, waiting for someone to really want her.

But she is so far out there is no way to snatch at her and really drag her in.

So—being a woman—you can wait.

You must sit quietly without a chip. Not sodden—and weighted as if your feet were cast in the iron of your soul. Not wasting strength in enervating gestures as if two hundred years of bonds and whips had really tricked you into nervous uncertainty.

But quiet; quiet. Like Buddha—who brown like I am—sat entirely at ease, entirely sure of himself; motionless and knowing, a thousand years before the white man knew there was so very much difference between feet and hands.

Motionless on the outside. But on the inside?

Silent.

Still . . . "Perhaps Buddha is a woman."

So you too. Still; quiet; with a smile, ever so slight, at the eyes so that Life will flow into and not by you. And you can gather, as it passes, the essences, the overtones, the tints, the shadows; draw understanding to yourself.

And then you can, when Time is ripe, swoop to your feet—at your full height—at a single gesture.

Ready to go where?

Why . . . Wherever God motions.

COMMENTS AND QUESTIONS

1. Why do you think that Bonner writes using the second person ("you")?

2. To what extent is she expressing the feelings of a private individual and to what extent those of a race or class? Does she establish a dialogue between the two?

3. How would you describe her vision of the relations between white and black America?

4. Compare Bonner's sense of what it is to be a modern woman with that of Virginia Woolf.

JORGE LUIS BORGES

Death and the Compass

Translation by Donald A. Yates

This story, a classic detective mystery first published in the magazine *Sur* in 1942, provides the framework for an examination of the patterns of time, space, and humanity. As Borges has written in an English commentary to the story, "A triangle is suggested but the solution is really based on a rhombus. . . . The killer and the slain, whose minds work in the same way, may be the same man."

Of the many problems which exercised the reckless discernment of Lönnrot, none was so strange—so rigorously strange, shall we say—as the periodic series of bloody events which culminated at the villa of Triste-le-Roy, amid the ceaseless aroma of the eucalypti. It is true that Erik Lönnrot failed to prevent the last murder, but that he foresaw it is indisputable. Neither did he guess the identity of Yarmolinsky's luckless assassin, but he did succeed in divining the secret morphology behind the fiendish series as well as the participation of Red Scharlach, whose other nickname is Scharlach the Dandy. That criminal (as countless others) had sworn on his honor to kill Lönnrot, but the latter could never be intimidated. Lönnrot believed himself a pure reasoner, an Auguste Dupin, but there was something of the adventurer in him, and even a little of the gambler.

The first murder occurred in the Hôtel du Nord—that tall prism which dominates the estuary whose waters are the color of the desert. To that tower (which quite glaringly unites the hateful whiteness of a hospital, the numbered divisibility of a jail, and the general appearance of a bordello) there came on the third day of December the delegate from Podolsk to the Third Talmudic Congress, Doctor Marcel Yarmolinsky, a gray-bearded man with gray eyes. We shall never know whether the Hôtel du Nord pleased him; he accepted it with the ancient resignation which had allowed him to endure three years of war in the Carpathians and three thousand years of oppression and pogroms. He was given a room on Floor R, across from the suite which was occupied—not without splendor—by the Tetrarch of Galilee. Yarmolinsky supped, postponed until the following day an inspection of the unknown city, arranged in a *placard* his many books and few personal possessions, and before midnight extinguished his light. (Thus declared the Tetrarch's chauffeur who slept in the adjoining room.) On the fourth, at 11:03 A.M., the editor of the *Yidische Zaitung* put in a call to him; Doctor Yarmolinsky did not answer. He was found in his room, his face already a little dark, nearly nude beneath a large anachronistic cape. He was lying not far from the

door which opened on the hall; a deep knife wound had split his breast. A few hours later, in the same room amid journalists, photographers and policemen, Inspector Treviranus and Lönnrot were calmly discussing the problem.

"No need to look for a three-legged cat here," Treviranus was saying as he brandished an imperious cigar. "We all know that the Tetrarch of Galilee owns the finest sapphires in the world. Someone, intending to steal them, must have broken in here by mistake. Yarmolinsky got up; the robber had to kill him. How does it sound to you?"

"Possible, but not interesting," Lönnrot answered. "You'll reply that reality hasn't the least obligation to be interesting. And I'll answer you that reality may avoid that obligation but that hypotheses may not. In the hypothesis that you propose, chance intervenes copiously. Here we have a dead rabbi; I would prefer a purely rabbinical explanation, not the imaginary mischances of an imaginary robber."

Treviranus replied ill-humoredly:

"I'm not interested in rabbinical explanations. I am interested in capturing the man who stabbed this unknown person."

"Not so unknown," corrected Lönnrot. "Here are his complete works." He indicated in the wall-cupboard a row of tall books: a *Vindication of the Cabala; An Examination of the Philosophy of Robert Fludd;* a literal translation of the *Sepher Yezirah;* a *Biography of the Baal Shem;* a *History of the Hasidic Sect;* a monograph (in German) on the Tetragrammaton; another, on the divine nomenclature of the Pentateuch. The inspector regarded them with dread, almost with repulsion. Then he began to laugh.

"I'm a poor Christian," he said. "Carry off those musty volumes if you want; I don't have any time to waste on Jewish superstitions."

"Maybe the crime belongs to the history of Jewish superstitions," murmured Lönnrot.

"Like Christianity," the editor of the *Yidische Zaitung* ventured to add. He was myopic, an atheist and very shy.

No one answered him. One of the agents had found in the small typewriter a piece of paper on which was written the following unfinished sentence:

The first letter of the Name has been uttered

Lönnrot abstained from smiling. Suddenly become a bibliophile or Hebraist, he ordered a package made of the dead man's books and carried them off to his apartment. Indifferent to the police investigation, he dedicated himself to studying them. One large octavo volume revealed to him the teachings of Israel Baal Shem Tobh, founder of the sect of the Pious; another, the virtues and terrors of the Tetragrammaton, which is the unutterable name of God; another, the thesis that God has a secret name, in which is epitomized (as in the crystal sphere which the Persians ascribe to Alexander of Macedonia) his ninth attribute, eternity—that is to say, the immediate knowledge of all things that will be, which are and which have been in the universe. Tradition numbers ninety-nine names of God; the Hebraists attribute that imperfect number to magical fear of even numbers; the Hasidim reason that that hiatus indicates a hundredth name—the Absolute Name.

From this erudition Lönnrot was distracted, a few days later, by the appearance of the editor of the *Yidische Zaitung.* The latter wanted to talk about the murder; Lönnrot preferred to discuss the diverse names of God; the journalist declared, in three columns, that the investigator, Erik Lönnrot, had dedicated himself to studying the names of God in order to come across the name of the murderer. Lönnrot, accustomed to the simplifications of journalism, did not become indignant. One of those enterprising shopkeepers who have discovered that any given man is resigned to buying any given book published a popular edition of the *History of the Hasidic Sect.*

The second murder occurred on the evening of the third of January, in the most deserted and empty corner of the capital's western suburbs. Towards dawn, one of the gendarmes who patrol those solitudes on horseback saw a man in a poncho, lying prone in the shadow of an old paint shop. The harsh features seemed to be masked in blood; a deep knife wound had split his breast. On the wall, across the yellow and red diamonds, were some words written in chalk. The gendarme spelled them out. . . . That afternoon, Treviranus and Lönnrot headed for the remote scene of the crime. To the left and right of the automobile the city disintegrated; the firmament grew and houses were of less importance than a brick kiln or a poplar tree. They arrived at their miserable destination: an alley's end, with rose-colored walls which somehow seemed to reflect the extravagant sunset. The dead man had already been identified. He was Daniel Simon Azevedo, an individual of some fame in the old northern suburbs, who had risen from wagon driver to political tough, then degenerated to a thief and even an informer. (The singular style of his death seemed appropriate to them: Azevedo was the last representative of a generation of bandits who knew how to manipulate a dagger, but not a revolver.) The words in chalk were the following:

The second letter of the Name has been uttered

The third murder occurred on the night of the third of February. A little before one o'clock, the telephone in Inspector Treviranus' office rang. In avid secretiveness, a man with a guttural voice spoke; he said his name was Ginzberg (or Ginsburg) and that he was

prepared to communicate, for reasonable remuneration, the events surrounding the two sacrifices of Azevedo and Yarmolinsky. A discordant sound of whistles and horns drowned out the informer's voice. Then, the connection was broken off. Without yet rejecting the possibility of a hoax (after all, it was carnival time), Treviranus found out that he had been called from the Liverpool House, a tavern on the rue de Toulon, that dingy street where side by side exist the cosmorama and the coffee shop, the bawdy house and the bible sellers. Treviranus spoke with the owner. The latter (Black Finnegan, an old Irish criminal who was immersed in, almost overcome by, respectability) told him that the last person to use the phone was a lodger, a certain Gryphius, who had just left with some friends. Treviranus went immediately to Liverpool House. The owner related the following. Eight days ago Gryphius had rented a room above the tavern. He was a sharp-featured man with a nebulous gray beard, and was shabbily dressed in black; Finnegan (who used the room for a purpose which Treviranus guessed) demanded a rent which was undoubtedly excessive; Gryphius paid the stipulated sum without hesitation. He almost never went out; he dined and lunched in his room; his face was scarcely known in the bar. On the night in question, he came downstairs to make a phone call from Finnegan's office. A closed cab stopped in front of the tavern. The driver didn't move from his seat; several patrons recalled that he was wearing a bear's mask. Two harlequins got out of the cab; they were of short stature and no one failed to observe that they were very drunk. With a tooting of horns, they burst into Finnegan's office; they embraced Gryphius, who appeared to recognize them but responded coldly; they exchanged a few words in Yiddish—he in a low, guttural voice, they in high-pitched, false voices—and then went up to the room. Within a quarter hour the three descended, very happy. Gryphius, staggering, seemed as drunk as the others. He walked—tall and dizzy—in the middle, between the masked harlequins. (One of the women at the bar remembered the yellow, red and green diamonds.) Twice he stumbled; twice he was caught and held by the harlequins. Moving off toward the inner harbor which enclosed a rectangular body of water, the three got into a cab and disappeared. From the footboard of the cab, the last of the harlequins scrawled an obscene figure and a sentence on one of the slates of the pier shed.

Treviranus saw the sentence. It was virtually predictable. It said:

The last of the letters of the Name has been uttered

Afterwards, he examined the small room of Gryphius-Ginzberg. On the floor there was a brusque star of blood, in the corners, traces of cigarettes of a Hungarian brand; in a cabinet, a book in Latin—the *Philologus Hebraeo-Graecus* (1739) of Leusden—with several manuscript notes. Treviranus looked it over with indignation and had Lönnrot located. The latter, without removing his hat, began to read while the inspector was interrogating the contradictory witnesses to the possible kidnapping. At four o'clock they left. Out on the twisted rue de Toulon, as they were treading on the dead serpentines of the dawn, Treviranus said:

"And what if all this business tonight were just a mock rehearsal?"

Erik Lönnrot smiled and, with all gravity, read a passage (which was underlined) from the thirty-third dissertation of the *Philologus: Dies Judacorum incipit ad solisoccasum usque ad solis occasum diei sequentis.*

"This means," he added, " 'The Hebrew day begins at sundown and lasts until the following sundown.'"

The inspector attempted an irony.

"Is that fact the most valuable one you've come across tonight?"

"No. Even more valuable was a word that Ginzberg used."

The afternoon papers did not overlook the periodic disappearances. *La Cruz de la Espada* contrasted them with the admirable discipline and order of the last Hermetical Congress; Ernst Palast, in *El Mártir*, criticized "the intolerable delays in this clandestine and frugal pogrom, which has taken three months to murder three Jews"; the *Yidische Zeitung* rejected the horrible hypothesis of an anti-Semitic plot, "even though many penetrating intellects admit no other solution to the triple mystery"; the most illustrious gunman of the south, Dandy Red Scharlach, swore that in his district similar crimes could never occur, and he accused Inspector Franz Treviranus of culpable negligence.

On the night of March first, the inspector received an impressive-looking sealed envelope. He opened it; the envelope contained a letter signed "Baruch Spinoza" and a detailed plan of the city, obviously torn from a Baedeker. The letter prophesied that on the third of March there would not be a fourth murder, since the paint shop in the west, the tavern on the rue de Toulon and the Hôtel du Nord were "the perfect vertices of a mystic equilateral triangle"; the map demonstrated in red ink the regularity of the triangle. Treviranus read the *more geometrico* argument with resignation, and sent the letter and the map to Lönnrot—who, unquestionably, was deserving of such madnesses.

Erik Lönnrot studied them. The three locations were in fact equidistant. Symmetry in time (the third of December, the third of January, the third of February); symmetry in space as well. . . . Suddenly, he felt as if he were on the point of solving the mystery. A set of calipers and a compass completed his quick intu-

ition. He smiled, pronounced the word Tetragrammaton (of recent acquisition) and phoned the inspector. He said:

"Thank you for the equilateral triangle you sent me last night. It has enabled me to solve the problem. This Friday the criminals will be in jail, we may rest assured."

"Then they're not planning a fourth murder?"

"Precisely because they *are* planning a fourth murder we can rest assured."

Lönnrot hung up. One hour later he was traveling on one of the Southern Railway's trains, in the direction of the abandoned villa of Triste-le-Roy. To the south of the city of our story, flows a blind little river of muddy water, defamed by refuse and garbage. On the far side is an industrial suburb where, under the protection of a political boss from Barcelona, gunmen thrive. Lönnrot smiled at the thought that the most celebrated gunman of all—Red Scharlach—would have given a great deal to know of his clandestine visit. Azevedo had been an associate of Scharlach; Lönnrot considered the remote possibility that the fourth victim might be Scharlach himself. Then he rejected the idea. . . . He had very nearly deciphered the problem; mere circumstances, reality (names, prison records, faces, judicial and penal proceedings) hardly interested him now. He wanted to travel a bit, he wanted to rest from three months of sedentary investigation. He reflected that the explanation of the murders was in an anonymous triangle and a dusty Greek word. The mystery appeared almost crystalline to him now; he was mortified to have dedicated a hundred days to it.

The train stopped at a silent loading station. Lönnrot got off. It was one of those deserted afternoons that seem like dawns. The air of the turbid, puddled plain was damp and cold. Lönnrot began walking along the countryside. He saw dogs, he saw a car on a siding, he saw the horizon, he saw a silver-colored horse drinking the crapulous water of a puddle. It was growing dark when he saw the rectangular belvedere of the villa of Triste-le-Roy, almost as tall as the black eucalypti which surrounded it. He thought that scarcely one dawning and one nightfall (an ancient splendor in the east and another in the west) separated him from the moment long desired by the seekers of the Name.

A rusty wrought-iron fence defined the irregular perimeter of the villa. The main gate was closed. Lönnrot, without much hope of getting in, circled the area. Once again before the insurmountable gate, he placed his hand between the bars almost mechanically and encountered the bolt. The creaking of the iron surprised him. With a laborious passivity the whole gate swung back.

Lönnrot advanced among the eucalypti treading on confused generations of rigid, broken leaves. Viewed from anear, the house of the villa of Triste-le-Roy abounded in pointless symmetries and in maniacal repetitions: to one Diana in a murky niche corresponded a second Diana in another niche; one balcony was reflected in another balcony; double stairways led to double balustrades. A two-faced Hermes projected a monstrous shadow. Lönnrot circled the house as he had the villa. He examined everything; beneath the level of the terrace he saw a narrow Venetian blind.

He pushed it; a few marble steps descended to a vault. Lönnrot, who had now perceived the architects' preferences, guessed that at the opposite wall there would be another stairway. He found it, ascended, raised his hands and opened the trap door.

A brilliant light led him to a window. He opened it: a yellow, rounded moon defined two silent fountains in the melancholy garden. Lönnrot explored the house. Through anterooms and galleries he passed to duplicate patios, and time after time to the same patio. He ascended the dusty stairs to circular antechambers; he was multiplied infinitely in opposing mirrors; he grew tired of opening or half-opening windows which revealed outside the same desolate garden from various heights and various angles; inside, only pieces of furniture wrapped in yellow dust sheets and chandeliers bound up in tarlatan. A bedroom detained him; in that bedroom, one single flower in a porcelain vase; at the first touch the ancient petals fell apart. On the second floor, on the top floor, the house seemed infinite and expanding. *The house is not this large,* he thought. *Other things are making it seem larger: the dim light, the symmetry, the mirrors, so many years, my unfamiliarity, the loneliness.*

By way of a spiral staircase he arrived at the oriel. The early evening moon shone through the diamonds of the window; they were yellow, red and green. An astonishing, dizzying recollection struck him.

Two men of short stature, robust and ferocious, threw themselves on him and disarmed him; another, very tall, saluted him gravely and said:

"You are very kind. You have saved us a night and a day."

It was Red Scharlach. The men handcuffed Lönnrot. The latter at length recovered his voice.

"Scharlach, are you looking for the Secret Name?"

Scharlach remained silent, indifferent. He had not participated in the brief struggle, and he scarcely extended his hand to receive Lönnrot's revolver. He spoke; Lönnrot noted in his voice a fatigued triumph, a hatred the size of the universe, a sadness not less than that hatred.

"No," said Scharlach. "I am seeking something more ephemeral and perishable, I am seeking Erik Lönnrot. Three years ago, in a gambling house on the rue de Toulon, you arrested my brother and had him sent to

jail. My men slipped me away in a coupé from the gun battle with a policeman's bullet in my stomach. Nine days and nine nights I lay in agony in this desolate, symmetrical villa; fever was demolishing me, and the odious two-faced Janus who watches the twilights and the dawns lent horror to my dreams and to my waking. I came to abominate my body, I came to sense that two eyes, two hands, two lungs are as monstrous as two faces. An Irishman tried to convert me to the faith of Jesus; he repeated to me the phrase of the *goyim:* All roads lead to Rome. At night my delirium nurtured itself on that metaphor; I felt that the world was a labyrinth, from which it was impossible to flee, for all roads, though they pretend to lead to the north or south, actually lead to Rome, which was also the quadrilateral jail where my brother was dying and the villa of Triste-le-Roy. On those nights I swore by the God who sees with two faces and by all the gods of fever and of the mirrors to weave a labyrinth around the man who had imprisoned my brother. I have woven it and it is firm: the ingredients are a dead heresiologist, a compass, an eighteenth-century sect, a Greek word, a dagger, the diamonds of a paint shop.

"The first term of the sequence was given to me by chance. I had planned with a few colleagues—among them Daniel Azevedo—the robbery of the Tetrarch's sapphires. Azevedo betrayed us: he got drunk with the money that we had advanced him and he undertook the job a day early. He got lost in the vastness of the hotel; around two in the morning he stumbled into Yarmolinsky's room. The latter, harassed by insomnia, had started to write. He was working on some notes, apparently, for an article on the Name of God; he had already written the words: *The first letter of the Name has been uttered.* Azevedo warned him to be silent; Yarmolinsky reached out his hand for the bell which would awaken the hotel's forces; Azevedo countered with a single stab in the chest. It was almost a reflex action; half a century of violence had taught him that the easiest and surest thing is to kill. . . . Ten days later I learned through the *Yidische Zaitung* that you were seeking in Yarmolinsky's writings the key to his death. I read the *History of the Hasidic Sect;* I learned that the reverent fear of uttering the Name of God had given rise to the doctrine that that Name is all powerful and recondite. I discovered that some Hasidim, in search of that secret Name, had gone so far as to perform human sacrifices. . . . I knew that you would make the conjecture that the Hasidim had sacrificed the rabbi; I set myself the task of justifying that conjecture.

"Marcel Yarmolinsky died on the night of December third; for the second 'sacrifice' I selected the night of January third. He died in the north; for the second 'sacrifice' a place in the west was suitable. Daniel Azevedo was the necessary victim. He deserved death; he was impulsive, a traitor; his apprehension could destroy the entire plan. One of us stabbed him; in order to link his corpse to the other one I wrote on the paint shop diamonds: *The second letter of the Name has been uttered.*

"The third murder was produced on the third of February. It was, as Treviranus guessed, a mere sham. I am Gryphius-Ginzberg-Ginsburg; I endured an interminable week (supplemented by a tenuous fake beard) in the perverse cubicle on the rue de Toulon, until my friends abducted me. From the footboard of the cab, one of them wrote on a post: *The last of the letters of the Name has been uttered.* That sentence revealed that the series of murders was *triple.* Thus the public understood it; I, nevertheless, interspersed repeated signs that would allow you, Erik Lönnrot, the reasoner, to understand that the series was quadruple. A portent in the north, others in the east and west, demand a fourth portent in the south; the Tetragrammaton—the name of God, JHVH—is made up of *four* letters; the harlequins and the paint shop sign suggested four points. In the manual of Leusden I underlined a certain passage: that passage manifests that Hebrews compute the day from sunset to sunset; that passage makes known that the deaths occurred on the *fourth* of each month. I sent the equilateral triangle to Treviranus. I foresaw that you would add the missing point. The point which would form a perfect rhomb, the point which fixes in advance where a punctual death awaits you. I have premeditated everything, Erik Lönnrot, in order to attract you to the solitudes of Triste-le-Roy."

Lönnrot avoided Scharlach's eyes. He looked at the trees and the sky subdivided into diamonds of turbid yellow, green and red. He felt faintly cold, and he felt, too, an impersonal—almost anonymous—sadness. It was already night; from the dusty garden came the futile cry of a bird. For the last time, Lönnrot considered the problem of the symmetrical and periodic deaths.

"In your labyrinth there are three lines too many," he said at last. "I know of one Greek labyrinth which is a single straight line. Along that line so many philosophers have lost themselves that a mere detective might well do so, too. Scharlach, when in some other incarnation you hunt me, pretend to commit (or do commit) a crime at A, then a second crime at B, eight kilometers from A, then a third crime at C, four kilometers from A and B, half-way between the two. Wait for me afterwards at D, two kilometers from A and C, again half-way between both. Kill me at D, as you are now going to kill me at Triste-le-Roy."

"The next time I kill you," replied Scharlach, "I promise you that labyrinth, consisting of a single line which is invisible and unceasing."

He moved back a few steps. Then, very carefully, he fired.

COMMENTS AND QUESTIONS

1. In the text, there is an almost constant juxtaposition of things associated with the numbers three and four. What are these, and how do they pertain to the story?

2. Borges likes to play with words, preferring the denotation, or the strictly literal meaning of a word, to the connotation, or the affective and sometimes equivocal, ambiguous meaning of the word. For example, he describes the first murder scene as occurring in "that tall prism," the Hôtel du Nord. What is the precise definition of the word *prism,* and how does this fit into the story?

3. What kinds of time are evident in the story?

4. The characters' names are important to the structure of the story, as well as to the erasure of their individuality. What associations exist among Red, Scharlach, Lönnrot, and Erik? Are there any others?

5. At the conclusion of the story, Lönnrot ironically proposes a single-line labyrinth for the final murder in some future cycle of time. This "labyrinth" is based on Zeno's paradox (the Eleatic paradox). What is this paradox, and how does it apply to "Death and the Compass"?

MIGUEL ANGEL ASTURIAS

Tatuana's Tale

Translation by Patricia Emigh
and Frank MacShane

This tale, from *Legends of Guatemala,* portrays a magical, mythical world.

Father Almond Tree, with his pale pink beard, was one of the priests who were so richly dressed that the white men touched them to see if they were made of gold. He knew the secret of medicinal plants, the language of the gods that spoke through translucent obsidian, and he could read the hieroglyphics of the stars.

One day he appeared in the forest, without being planted, as though brought there by the spirits. He was so tall he prodded the clouds, he measured the years by the moons he saw, and was already old when he came from the Garden of Tulan.

On the full moon of Owl-Fish (one of the twenty months of the four-hundred-day year), Father Almond Tree divided his soul among the four roads. These led to the four quarters of the sky: the black quarter, the Sorcerer Night; the green quarter, Spring Storm; the red quarter, Tropical Ecstasy; the white quarter, Promise of New Lands.

"O Road! Little Road!" said a dove to White Road, but White Road did not listen. The dove wanted Father Almond Tree's soul so that it would cure its dreams. Doves and children both suffer from dreams.

"O Road! Little Road!" said a heart to Red Road, but Red Road did not listen. The heart wanted to distract Red Road so it would forget Father Almond Tree's soul. Hearts, like thieves, don't return what others leave behind.

"O Road! Little Road!" said a vine trellis to Green Road, but Green Road did not listen. It wanted the Father's soul to get back some of the leaves and shade it had squandered.

How many moons have the roads been traveling?

The fastest, Black Road, whom no one spoke to along the way, entered the city, crossed the plaza and went to the merchants' quarter, where it gave Father Almond Tree's soul to the Merchant of Priceless Jewels in exchange for a little rest.

It was the hour of white cats. They prowled back and forth through the streets. Wonder of rosebushes! The clouds looked like laundry strung across the sky.

When Father Almond Tree found out what Black Road had done, he once again took on human form, shedding his tree-like shape in a small stream that appeared like an almond blossom beneath the crimson moon. Then he left for the city.

He reached the valley after a day's travel, just at evening time when the flocks are driven home. The shepherds were dumbfounded by this man in a green cloak and pale pink beard. They thought he was an apparition and answered his questions in monosyllables.

Once in the city, he made his way to the western part of town. Men and women were standing around the public fountains. The water made a kissing sound as it filled their pitchers. Following the shadows to the merchants' quarter, he found that part of his soul Black Road had sold. The Merchant of Priceless Jewels kept it in a crystal box with gold locks. He went up to the Merchant, who was smoking in a corner, and offered him two thousand pounds of pearls for the piece of soul.

The Merchant smiled at the Father's absurd suggestion. Two thousand pounds of pearls? No, his jewels were priceless.

Father Almond Tree increased his offer. He would give him emeralds, big as kernels of corn, fifty acres of them, enough to make a lake.

The Merchant smiled again. A lake of emeralds? No, his jewels were priceless.

He would give him amulets, deer's eyes that bring rain, feathers to keep storms away, marijuana to mix with his tobacco.

The Merchant refused.

He would give him enough precious stones to build a fairy-tale palace in the middle of the emerald lake!

The Merchant still refused. His jewels were priceless—why go on talking about it? Besides, he planned to exchange this piece of soul for the most beautiful slave in the slave market.

It was useless for Father Almond Tree to keep on making offers and show how much he wanted to get his soul back. Merchants have no hearts.

A thread of tobacco smoke separated reality from dream, black cats from white cats, the Merchant from his strange customer. As he left, Father Almond Tree banged his sandals against the doorway to rid himself of the cursed dust of the house.

After a year of four hundred days, the Merchant was returning across the mountains with the slave he had bought with Father Almond Tree's soul. He was accompanied by a flower bird who turned honey into hyacinths, and by a retinue of thirty servants on horseback.

The slave was naked. Her long black hair, wrapped in a single braid like a snake, fell across her breasts and down to her legs. The Merchant was dressed in gold and his shoulders were covered with a cape woven from goat hair. His thirty servants on horseback stretched out behind like figures in a dream.

"You've no idea," said the Merchant to the slave, reining in his horse alongside hers, "what your life will be like in the city! Your house will be a palace, and all my servants will be at your call, including me, if you like." His face was half lit by the sun. "There," he continued, "everything will be yours. Do you know I refused a lake of emeralds for the piece of soul I exchanged for you? We'll lie all day in a hammock and have nothing to do but listen to a wise old woman tell stories. She knows my fate and says that it rests in a gigantic hand. She'll tell your fortune as well, if you ask her."

The slave turned to look at the countryside. It was a landscape of muted blues, growing dimmer in the distance. The trees on either side formed so fanciful a design it might have appeared on a woman's shawl. The sky was calm, and the birds seemed to be flying asleep, winglessly. In the granite silence, the panting of the horses as they went uphill sounded human.

Suddenly, huge solitary raindrops began to spatter on the road. On the slopes below, shepherds shouted as they gathered their frightened flocks. The horses stepped up their pace to find shelter, but there wasn't enough time. The wind rose, lashing the clouds, and ripping through the forest until it reached the valley, which vanished from sight under blankets of mist, while the first lightning bolts lit up the countryside like the flashes of a mad photographer.

As the horses stampeded, fleeing in fear, reins broken, legs flying, manes tangled in the wind and ears pressed back, the Merchant's horse stumbled and threw the man to the foot of a tree which at that instant, split by lightning, wrapped its roots about him like a hand snatching up a stone and hurled him into the ravine.

Meanwhile Father Almond Tree, who had remained in the city, wandered the streets like a madman, frightening children, going through garbage, talking to donkeys, oxen and stray dogs, which, like men, are all sad-eyed animals.

"How many moons have the roads been traveling?" he asked from door to door, but the people were dumbfounded by this man in a green cloak and pale pink beard, and they slammed them shut without answering as though they'd seen a specter.

At length Father Almond Tree stopped at the door of the Merchant of Priceless Jewels and spoke to the slave, who alone had survived the storm.

"How many moons have the roads been traveling?"

The answer which began to form froze on her lips. Father Almond Tree was silent. It was the full moon of Owl-Fish. In silence their eyes caressed each other's faces like two lovers who have met after a long separation.

They were interrupted by raucous shouts. They were arrested in the name of God and the King, he as a warlock and she as his accomplice. Surrounded by crosses and swords, they were taken to prison, Father Almond Tree with his pale pink beard and green cloak, the slave displaying flesh so firm it seemed to be made of gold.

Seven months later, they were condemned to be burned alive in the Plaza Mayor. On the eve of the execution, Father Almond Tree tattooed a little boat on the slave's arm with his fingernail.

"Tatuana, by means of this tattoo," he said, "you will be able to flee whenever you are in danger. I want you to be as free as my spirit. Trace this little boat on a wall, on the ground, in the air, wherever you wish. Then close your eyes, climb aboard and go . . .

"Go, my spirit is stronger than a clay idol.

"My spirit is sweeter than the honey gathered by bees sipping from the honeysuckle.

"As my spirit, you'll become invisible."

At once, Tatuana did what Father Almond Tree said: she drew a little boat, closed her eyes, and, as she got in, the boat began to move. So she escaped from prison and death.

On the following morning, day of the execution, the guards found in the cell only a withered tree, whose few almond blossoms still retained their pale pink color.

COMMENTS AND QUESTIONS

1. When do you think "Tatuana's Tale" occurs? On what do you base your answer?

2. How do Mayan elements manifest themselves, and for what purpose?

3. What meanings or interpretations does the legend have?

4. Do you see any points of comparison between this retelling of a Mayan legend and the African legends in Chapter 12?

PABLO NERUDA

Ode to Broken Things
Translation by Malcolm J. Parr

This poem is from *Navegaciones y regresos* (Voyages and homecomings), first published in 1959, and is representative of Neruda's *cosalismo* and humanism.

Things keep breaking
in the home
as though impelled
by an unseen and willful brute:
not my hands, 5
not yours,
not the girls
with the hard nails
and starry feet:
it wasn't anything or anyone, 10
it wasn't the wind,
it wasn't the orange noon,
or the earth's shadows,
it wasn't a nose, an elbow,
a curving hip, 15
an ankle
or the air:
the plate split, the lamp slipped
and all the flowerpots toppled
one by one, 20
in the middle of October,
crimson-heaped,
weighed down with violets,
and one other pot, empty,
spinning, spinning, spinning, 25
through the winter
until all that was left
was powder,
a shattered memory, a glowing dust.

And the clock 30
from which the sound
was
our life's voice,
the hidden
thread 35
of the weeks,
joining
so many hours
one by one
to honey and silence, 40
to so many births and tasks
even that clock
fell and among
the broken pieces of glass
its delicate blue entrails 45
throbbed
and its long heart
spun out.

Life goes on grinding
glasses, wearing out clothes, 50
destroying,
pulverizing
patterns,
and what time lets last is as it were
an island or a ship at sea, 55
passing,
locked in by brittle dangers,
and the menaces of relentless waters.

Let's put everything at once,
clocks, plates, wineglasses carved in ice, 60
in one sack and carry
our treasures down to the sea:
and all our possessions

will be lost
smashing and roaring 65
like a river bursting its banks;
and may the sea

in its toiling tides
bring back for us
all those useless things 70
that nobody breaks
but were broken nevertheless.

COMMENTS AND QUESTIONS

1. What is an "ode"? Why does Neruda employ this form?

2. What structural and lexical devices are used to make this poetry?

3. What is the ode's theme, and how is it developed?

OCTAVIO PAZ

Madrugada al raso

Los labios y las manos del viento
El corazón del agua
 Un eucalipto
El campamento de las nubes
La vida que nace cada día 5
La muerte que nace cada vida

Froto mis párpados:
El cielo anda en la tierra

Daybreak
Translation by Eliot Weinburger

Hands and lips of wind
Heart of water
 Eucalyptus
Campground of the clouds
The life that is born every day 5
The death that is born every life

I rub my eyes:
The sky walks the land

Escritura

Yo dibujo estas letras
Como el día dibuja sus imágenes
Y sopla sobre ellas y no vuelve

Writing

I draw these letters
As the day draws its images
And blows over them
 And does not return

La exclamación

Quieto
 No en la rama
En el aire
 No en el aire
En el instante 5
 El colibrí

Exclamation

Stillness
 Not on the branch
In the air
 Not in the air
In the moment 5
 Hummingbird

Próximo lejano

Anoche un fresno
A punto de decirme
Algo—callóse.

Distant Neighbor

Last night an ash tree
Was about to say—
But didn't

COMMENTS AND QUESTIONS

1. Each of these poems captures a particular sensation. Identify as closely as you can what each sensation is.

2. Which images do you find especially striking? Why?

3. Read or listen to someone read the poems in the original Spanish. What rhythmic effects can you identify?

Summary Questions

1. What was Antonin Artaud's major criticism of Western theater?

2. In general, what are the characteristics of modernist fiction? Of modernist poetry?

3. Summarize the feminist ideas of Virginia Woolf and Marita Bonner.

4. What was the surrealist approach to writing? How did it influence the poets of *négritude*?

5. What characterizes the literature of the Harlem Renaissance?

6. How did Latin American writers combine native traditions with modernist innovations?

7. What are some of the influences of Asian culture on modernist theater and poetry?

8. Compare Kafka's and Borges's innovations in the short story.

Key Terms

theater of cruelty

alienation

interior monologue

stream of consciousness

objective correlative

imagist poetry

surrealism

négritude

Harlem Renaissance

Maya-Quiché

cosalismo

The Early Twentieth Century: New Traditions

The Great War and Western Cultural Doubt

There is no doubt that the early twentieth century marked a deep cleft in the Western humanistic tradition. The expectations for an increasingly civilized world based largely on immense accomplishments in the material realm were dashed by World War I. Not only did the war starkly reveal the well of irrationality and violence present in human nature, but technological progress also allowed these forces to express themselves with lethal effect. For many thinkers, artists, and writers, the Greco-Roman reliance on reason, the Judeo-Christian hope in God, and, more immediately, the nineteenth century's optimistic materialism no longer seemed valid cultural centers. The titles of two important early-twentieth-century books sum up the state of affairs: Freud's *Civilization and Its Discontents* and Spengler's *The Decline of the West.*

The peace treaty of 1919 finally brought hostilities to a halt, but for the next two decades Western culture was haunted by the fear of another war. The Great Depression of the early 1930s further exacerbated the situation. For many, Marxism offered an attractive alternative to traditional capitalism. That the next war would be one of classes rather than nations became a real possibility. In Germany and Italy, leaders arose—embodiments of an irrational nationalism—who promised to squelch class conflict by violent measures. The Western democracies felt trapped between the extremism of both left and right. Given such instability, it is surprising that the next war erupted as late as 1939.

Colonialism and Imperialism

Well before the onset of World War I the great European powers, especially Britain and France, began the "scramble for Africa" and rivalry for economic and political power in Asia. Spurred by the need to stabilize markets and shored up by racial notions such as the "white man's burden" or the "civilizing mission," the establishment of colonies and of imperial rule strengthened the economic power of the colonizers. The effects on the colonized peoples were devastating in terms of the loss of power, the spread of disease, and the disintegration of culture, but the Europeans did bring technological advances and contact with Western ways of thinking. Some of these enabled the colonized peoples to organize successful resistance movements. On the other hand, Europeans and Americans who were questioning the values of their own culture proved to be receptive to the foreign cultures with which they came in contact.

Non-Western Cultural Influences on the West

In the early twentieth century the African cultural root really made its entry into the Western humanities. European and American painters and sculptors experimenting with abstraction found that African artists, who had long been creating in this style, had much to teach them. African writers who had been educated in the Western tradition turned toward their native cultures for fresh subject matter and stylistic innovation. Dancers and choreographers saw in the African union of dance with religious rites and other forms of cultural expression an art form more meaningful than the stylized, artificial ballet. African rhythms and tonalities entered into Western music in the form of jazz and profoundly altered its course. Finally, African American writers, thinkers, artists, musicians, and dancers began to turn back toward their African heritage, seeking ways of combining it with their American experience and in the process creating an important new voice on the world cultural scene.

Some Western artists were attracted to what they viewed as the spirituality of the Orient as opposed to the materialism of the Occident. Writers such as Ezra Pound found the brilliant imagery in Chinese and Japanese poetry a source for experimentation. Antonin Artaud and Bertolt Brecht, in different ways, believed

that the Western theater could be completely revitalized if playwrights and directors would draw inspiration from the theatrical traditions of Asia. Frank Lloyd Wright mixed Japanese forms with European ones in the creation of an original architecture. Eastern thought and religions would influence many who had grown tired of their own religious traditions. Later, the nonviolence doctrines of Mahatma Gandhi would have a profound influence on Martin Luther King Jr. and the American civil rights movements.

Artists looked to other cultures as well. Igor Stravinsky found in the rites of his native Russia energizing sources for creating new musical sounds. Choreographers and dancers such as Nijinsky and Duncan tried to express a new "primitive" wholeness in their dance. Frank Lloyd Wright looked even farther away toward the aboriginal cave for a basis for some of his innovations in architecture. In Latin America, artists and intellectuals looked to the heritage of pre-Columbian as well as European civilizations, fusing cultural roots in new forms and creations. Writers such as Borges would rise to world prominence as inheritors of European modernism.

Breakup in the Arts

The sense of breaking with tradition as well as contact with new traditions gave artists in this period an exhilarating sense of freedom; so did new discoveries in the sciences, such as Freud's concept of the unconscious and Einstein's relativity theory. The term *modernism* covers various experimental movements in the arts, only a few of which we have mentioned in this section. The breaking apart of traditional forms—of traditional ways of perceiving space, time, and reality—and the synthesizing of elements in new ways are perhaps the essential characteristics of modernism. In literature this included Joyce's abandonment of syntax, mixture of time frames, and portrayal of the unconscious and Kafka's and Borges's stark, fantastic realism. Painting shows Picasso's experiments with abstractions of the human figure and Kandinsky's total abandonment of subject matter for the portrayal of an inner world of form and color. The music of Stravinsky demonstrates a reorganization of the elements of rhythm, harmony, and melody. Jazz draws upon European and African traditions to create new rhythms and harmonies. Dance does away with the "classical" steps of ballet to invent original forms. The new arts of photography and film reorganize traditional ways of viewing time and space.

Feminism

The new sense of freedom and of breaking with tradition, particularly after World War I, affected customs, manners, and ways of life, as well as the arts. One of the most important legacies of this new vision was the growing concern over equality for women, culminating in the women's rights and suffrage movements and, ultimately, the vote in England and the United States. Virginia Woolf's *A Room of One's Own* is one of the most eloquent statements on the needs and rights of the modern creative woman. Contemporary feminism owes a great deal to its precursors in the modernist era.

Connections with Cultural Roots

We should perhaps stress at this point that, although modernism makes a radical break with tradition, it does not make a total break. Its innovations would not be possible without a cultural tradition to react against and, in some sense, to continue. Joyce's radically experimental novel is based on one of the oldest narratives in the Greco-Roman tradition, Homer's *Odyssey*. Distortion in art for expression of the unseen was a characteristic of medieval art and part of the inheritance of the modernists. Modern poetry, modern cinema, and modern dance are incomprehensible without the prior forms of lyric, drama, and ballet. The experiments of modernism have nonetheless endured. In the following chapters, we will witness a proliferation of cultural plurality in the late twentieth century and into the twenty-first.

PART XI

Cultural Plurality:
From the Middle
Twentieth Century On

33 Absurdity and Alienation: World War II and the Postwar Period

CENTRAL ISSUES

- World War II and its effects
- The postwar period in Europe and the United States
- Decolonization in Asia and Africa
- Black liberation movements
- Postwar European literature: existentialism and its influence
- Examples of postwar literature in the United States
- Examples of postwar jazz
- Developments in painting and sculpture

World War II

Whereas World War I had been essentially a European war, with extra-European involvement and implications, World War II was truly global. In fact, there were really four quite distinct, though interrelated conflicts, of different types, in different parts of the world, with different dates, different diplomatic preludes, and different outcomes.

The Second Anglo-French–German War, 1939–1945

This conflict was "Hitler's war," begun when Britain and France declared war after Germany's attack on Poland. It was marked by four primary events:

1. Germany's rapid defeat of France (June 1940), using combined air power and tank divisions, or *blitzkrieg*

2. The battle of Britain (1940–1941), in which the British air force denied the Germans air supremacy, forcing them to call off their invasion plans

3. The Allied attack through what Prime Minister Winston Churchill of Britain called the soft underbelly of North Africa and Italy

4. The cross-channel invasion at Normandy (June 1944)

There were two other important dimensions: the battle of the Atlantic, between German submarines and Anglo-American convoys guarded by destroyers; and unrelenting aerial bombardment, both strategic bombing (aimed at war production) and terror bombing (aimed at cities, in the hope of undermining civilian morale).

The Russo-German War, 1941–1945

This war became the largest land war in history. Between twenty and thirty million Russians died, including substantial numbers destroyed by their own communist dictator, Joseph Stalin. Although the Germans came close to victory in 1941, they were unable to take Moscow and Leningrad in the north. In the spring of 1942 they lost the decisive battle of Stalingrad in the south. American aid played an important role in supplying the Soviet forces, which bore the brunt of defeating the German army. As they moved through eastern Europe toward Germany, the Russians wiped out opponents in preparation for incorporating those countries into a postwar Soviet sphere of influence. It was largely in eastern Europe that the Germans carried out their systematic campaign of genocide, the *Holocaust,* with the aim of annihilating the Jewish people. Numerous Gypsies, homosexuals, and members of various ethnic groups that Hitler considered subhuman also died in the Nazi concentration camps.

The Japanese-American War, 1941–1945

Sea power dominated this conflict, with air and land forces mainly providing support. In their surprise attack on Pearl Harbor in Hawaii, the Japanese sank most of the American Pacific fleet. They also drove the Dutch out of Indonesia and the British out of Malaya and Burma, effectively ending colonialism in Asia. The Americans succeeded in raising some of their ships and in building others quickly so that by the spring of 1942 they could defeat the Japanese navy in the battle of Midway, which ultimately proved decisive.

However, the United States first concentrated on Germany, and initially Japan was beyond the range of American air power. Eventually, though, after a series of fierce battles, island by island, American planes relentlessly bombed Japanese cities. Although the firebombing of Tokyo actually caused more damage and casualties, the atomic bombs dropped on Hiroshima and Nagasaki evoked greater horror and fear. Whether it was necessary to drop the atomic bombs on Japan in order to subdue it is still the subject of debate. The need to use the second bomb (after an interval of less than a week) is deemed particularly questionable.

The War for Greater East Asia, 1931–1949

This conflict began with the Japanese invasion of Chinese territory in 1931. The Chinese responded by defending their country at an immense cost in lives. In territories occupied by the enemy, they waged unceasing guerrilla warfare. However, the simultaneous conflict between Nationalist forces under Jiang Jieshi (Chiang Kai-shek, 1887–1975) and the Communists under Mao Zedong (Mao Tse-tung, 1893–1976) significantly weakened the war effort. After the defeat of Japan in 1945, the civil war went into high gear. By 1949, despite American aid, the Nationalist army collapsed and Jiang fled to Taiwan.

The Human Cost of World War II

The total death toll from World War II is estimated to have been at least fifty million—and may have been a good deal higher. In contrast with World War I, civilian casualties exceeded military ones. The systematic extermination of populations by the Germans and the intensive bombing of cities by both sides explain the large losses. The introduction of the atomic bomb at the very end of the war dramatically illustrated what would occur in the event of a third world war. Apprehension intensified when the Soviet Union developed its own atomic bomb in 1946 and an arms race in nuclear weapons began. In the United States the war only sharpened what the Swedish economist Gunnar Myrdal called the *American dilemma:* the contradiction between the projection of America's democratic ideals and how it treated its African American citizens at home.

The Postwar Period

After World War II, the center of power moved out of Western Europe, and the United States became potentially the most powerful country in the world. However, the power configuration was a bipolar one, with the United States and the Soviet Union attempting to attract the other powers into their respective spheres of influence. The dissolution of the colonial empires of the European powers, either with or without the latter's consent, produced scores of new nations and furnished a fertile field for propaganda activities on both sides.

The hope of the Allies during the war had been for an international peace-keeping institution after the war; in 1945 at San Francisco the United Nations was created for that purpose. Like the League of Nations, however, the United Nations was crippled from the start by the reluctance of nations to give up any of their sovereignty. Although it provided a means for direct communication between the world powers, the organization could not prevent the reinstitution of hostile alliance systems. The United States sought its security in a number of European and Asian alliances with democratic and right-wing governments, whereas the Soviet Union fortified its position by a tight alliance with communist satellite countries in Eastern Europe and active support for sympathetic political factions elsewhere. The communist conquest of China in 1949 seemed especially alarming to the West, and in the United States itself a fear of subversion inspired a series of investigations to ferret out spies and communist sympathizers. By the early 1950s, the United States was waging war in Korea, endeavoring to stop the spread of communism in that area. Many feared that the hostility between the two superpowers, known as the Cold War, would soon reach a point of open conflict.

The Cold War

The closest the United States and the Soviet Union came to direct confrontation in the years immediately following the termination of the Korean War in 1953 was in 1962. In that year President John F. Kennedy, declaring that Soviet shipments of missiles to Cuba constituted a threat to American security, placed a naval blockade around the island. At almost the last hour before contact between Soviet freighters and American warships, Soviet premier Nikita Khrushchev backed down and agreed to remove the missiles from the island. Clearly the stakes were too high, and neither country would risk a war by interfering directly in the sphere of influence of the other.

Within the United States the first twenty years after the war saw increasing prosperity, as well as relative complacency about the American way of life and the health of U.S. political and social institutions. The country focused its enormous industrial capacity on producing a wealth of consumer goods. The two-car family became common, and television, a new medium of communication for education and entertainment, was soon considered a household necessity.

The early 1950s, however, were troubled by a widespread suspicion of a broad communist conspiracy to destroy capitalism in the United States. In 1952 U.S. senator Joseph R. McCarthy (1908–1957) tried to make political capital from these fears by conducting a series of hearings in Washington aimed at uncovering just such a plot. While the publicity wrecked the lives of a number of those mentioned in the testimonies, the hearings after several years proved to be a witch-hunt, and McCarthy was censured by the Senate.

Independence in Asia

The Japanese victories in 1942 had ended white power in Asia; the era launched by Vasco da Gama in 1498 was over. Having destroyed the American Pacific fleet at Pearl Harbor, the Japanese defeated the British at Singapore, took over their position in Burma and Malaya, and seized Indonesia from the Dutch. Although the British and Dutch rulers came back after 1945, their prestige had been dealt a blow from which it never recovered, and they were soon gone.

The French, however, tried to remain. Allied with Germany in the war, the Japanese had allowed the French to keep their colonies in Southeast Asia because, after the fall of France in June 1940, a puppet French government collaborated with the Germans and ran these colonies. The only organized opposition to continued French rule immediately after World War II came from a small movement led by a communist, Ho Chi Minh (1890–1969), who had spent much of his life as a student and photographer, living in a garret room in Paris. In 1930, he founded the Indochinese Communist party. During World War II his party organized resistance against the Japanese, and at the end of the war Ho proclaimed the Democratic Republic of Vietnam, with its capital at Hanoi.

Nevertheless, the French returned, and a war ensued between 1946 and 1954, when the French, definitively beaten at Dien Bien Phu, abandoned the country. The Geneva Accords of 1954, designed to establish peace, partitioned the country into two parts, communist North Vietnam with its capital at Hanoi, and South Vietnam ruled by Ngo Dinh Diem, a French-supported prince, who governed from Saigon. The elections designated by the Geneva Accords to be held in 1956 were never held because Diem, with French and American support, refused to hold them. Ho's response was to create an insurgent army in the south, the National Liberation Front, better known as the Vietcong, and in 1960 he began a war with attacks on the government both from the north and from within the south.

Meanwhile, World War II showed the British that they could not hope to dominate India forever. By 1947 they finally kept their promise from World War I to make the area self-governing by withdrawing. Their departure ignited a bitter religious conflict between Hindus and Muslims. It was resolved only by the division of the Indian subcontinent into two countries: India, dominated by Hindus, though with substantial numbers of Muslims; and Pakistan, dominated by Muslims.

Independence in Africa

The chronology for the liberation of most of colonial Africa paralleled that of Asia. In 1952 a military revolution destroyed the Egyptian monarchy, which had been strongly linked to British interests. A military dictatorship concerned with building up Egypt's economic and military power took its place. In the year before, Italy had granted independence to its former colony of Libya, and in 1956 France relinquished any claims to control over Tunisia and Morocco. Of all North Africa only Algeria remained under French rule. Founded as a colony in 1830, Algeria had a significant French population and was considered by France as part of France itself. A bloody war of liberation by the native Muslim population began in 1954 and ended only in 1962 with the exodus of most of the French inhabitants and the establishment of an independent Algeria.

In sub-Saharan Africa most of the major British and French colonies, along with the Belgian Congo, had gained their independence in the 1950s and early 1960s. By 1965 there were thirty-five independent African states on the continent. Of the remaining major British colonies, only Southern Rhodesia stayed under the rule of a white minority. In 1965 the local white residents created their own republic of Southern Rhodesia and held on to power for the next fifteen years, despite international sanctions and guerrilla warfare. Finally in 1980 black majority rule was established and the country was renamed Zimbabwe. Portugal resisted giving up its colonies, Angola and Mozambique, until local insurgency forced it to grant independence to both in 1975.

Neocolonialism

The relative ease with which most of the African continent was liberated has been the subject of much debate. Such figures as Kwame Nkrumah, the first premier of Ghana, show that Western powers were able to install puppet leaders who would protect Western economic and political interests. This phenomenon was called neocolonialism, since even though formal colonialism had ended, its effects were being informally maintained. To guard against it, wrote Frantz Fanon (1925–1961), a black psychoanalyst from the French island of Martinique, ordinary peasants and working people with no stake in the system—the sort of people reflected in the

title of his work, *The Wretched of the Earth*—needed to renew the revolution by periodic uprisings.

Black Liberation Movements

One of the most successful movements for black liberation began in the United States in the 1950s. Not all of America's citizens had equal access to its great postwar prosperity. Particularly disadvantaged in sharing the fruits of a high level of productivity was the country's African American population, and this inequity spurred a black liberation movement. Although the movement can be dated back to the slave revolts and the Civil War, it became an established, broad effort among African Americans after World War II. An all-out struggle for equality in American society, however, began in 1954 with the Supreme Court decision in *Brown* v. *Board of Education of Topeka* that compulsory segregation in the public schools denied equal protection under the law.

Almost immediately African Americans, impatient with the slow-moving court system, took matters into their own hands. In 1955, under the leadership of Martin Luther King Jr., they boycotted a local bus line in Montgomery, Alabama, when a black woman, Rosa Parks, was arrested for refusing to give her seat to a white passenger. The ultimate success of the boycott showed the power that united action could produce. Succeeding years witnessed the organization of sit-ins and freedom rides throughout the South, as well as protests against the subtler kinds of segregation prevailing in the North.

The Middle East

In 1917, at the height of World War I, the British issued the Balfour Declaration, in which they promised to support the idea of a Jewish "homeland" in Palestine. This commitment was included in the League of Nations mandate for Palestine assigned to Great Britain after the war. While Trans-Jordan (modern Jordan) was now defined as a separate entity with Emir Abdullah as its ruler, the mandate for Palestine incorporated the Balfour Declaration and, with it, encouragement of Jewish settlement. This development was, from the first, greeted with opposition and resistance on the part of the Arab population living in the area. British efforts to govern in the face of growing conflict led to the first suggestion of partition by the Peel Commission of 1937. Although this recommendation was not adopted at that time, it remained one of several plans to be considered after World War II, when the aftermath of the Holocaust and the resulting population of displaced persons in Europe further complicated discussions on the future of Palestine.

Exhausted by the war and now by Jewish opposition to their policy in Palestine, the British ultimately turned

to the United Nations for a decision. In November 1947, following an investigation by a special committee on Palestine, the U.N. General Assembly voted to recommend partition. This decision, which was formally opposed by all Arab states as well as by those representing the Palestinian Arab population, created the conditions for a British withdrawal that was accompanied and followed by military contestation between Jewish and Arab forces. After May 15, 1948, when the Jewish leadership declared the independence of the state of Israel, the conflict became one between the military forces of Israel and those of the surrounding Arab states. In the course of this war any possibility of establishing an Arab state in Palestine disappeared and the Palestinian Arab population, between seven hundred fifty thousand and nine hundred thousand of whom had become refugees, were left divided, vulnerable, and shocked by the enormity of their losses. While the state of Israel signed armistice agreements with the surrounding states, all efforts to resolve differences with regard to the claims of the refugees and to final borders failed. The military victory thus led to a state isolated from its surroundings and the object of intense hostility among Palestinian Arabs who felt dispossessed to make room for Jewish settlers.

European Literature

World War II and its aftermath left the humanities in a crisis. The attempted genocide of the Jews, the large-scale death camps, and, finally, the use of the atomic bomb raised terrifying questions about the extreme possibilities of people's inhumanity to others. The role of the humanities as a humanizing force, the ideal of traditional humanism, had to be put seriously in doubt. Were there not SS men who listened to their Bach or read their Goethe after a day's work at the gas chambers? The possibility of instant extermination through nuclear war made many of the traditional forms and values seem obsolete.

Literature and the Holocaust: Primo Levi (1919–1987)

Because of the unprecedented cruelty experienced in the nightmarish world of the Nazi concentration camps, many intellectuals, both Jews and non-Jews, declared that this was a subject unfit for "literature" or for "art." Its horror, they thought, was inexpressible in artistic terms, and either silence or direct, nonartistic testimony was the only possible reaction. In spite of this opinion, a flood of novels, poems, films, and other documents dealing with the experience of Jewish, Gypsy, and other "racial" concentration camp inmates, as well as with the experience of those interned or deported for political reasons, has been and continues to be produced. Many of the accounts emphasize the unspeakable horrors perpetrated by the Nazis, apparently with the goal of forcing the prisoners to abandon their hu-

manity. It is hardly surprising that some prisoners—reduced through deprivation of elementary feelings of hunger, thirst, cold, and fear, and presented with a constant image of themselves as objects—abandoned themselves to a subhuman existence. There are numerous stories of inmates stealing bread from weaker fellow prisoners, of trafficking in gold teeth or in prostitution with the Nazis, even of cannibalism. Other renderings of the experience, however, stress that inmates reduced through suffering to the barest state humanly possible acceded to a higher spiritual life. On the part of deeply religious Jews and Christians and even of fervently committed Marxists, this is perhaps not surprising. But this type of spiritual experience was possible even for those whose faith was more humanistic than religious.

Perhaps the most sensitive writer to have succeeded in communicating the experience to those who did not undergo it was Primo Levi, an Italian Jew who survived a year in the most infamous of all the Nazi camps, Auschwitz. Levi's *Se questo è un uomo,* published in 1958 and translated into English as *If This Is a Man* in 1979, and as *Survival in Auschwitz* in 1993, is a horrifying and yet extremely sober and artistic account of the literal hell of the camp. One of the discoveries that Levi makes in Auschwitz is the strangely vital, fundamental value of his profound knowledge of the humanities. There is irony but real edification in the fact that Levi, a nonreligious Jew, rediscovers what it is to be human through his memory of Dante's *Divine Comedy,* the supreme poem of Roman Catholicism but also the great cultural monument for all Italians.

Jean-Paul Sartre (1905–1980) and Existentialism

The most influential philosophical and literary movement to grow out of the war years became known as *existentialism.* As a philosophy, existentialism had actually been developed much earlier, through the influence of Nietzsche and the work of Martin Heidegger and Karl Jaspers in Germany. The French intellectual Jean-Paul Sartre did most to bring existentialism into the arts and into a search for an authentic way of life on the part of many of the disaffected youth of Europe and America. Sartre's seminal philosophical work, *Being and Nothingness* (1943), was born not only of his readings in German philosophy but through his experiences in the war years as well. As a soldier, Sartre experienced combat as well as confinement in a German prisoner-of-war camp, where he wrote his first play. Back in Paris, he lived through the years of the *German occupation of France,* a humiliating and often nightmarish experience of defeat and captivity that lasted from 1940 until the liberation of Paris in 1944.

It seemed to Sartre and to other French intellectuals at that time that the choice before the French was clear:

collaborate with the enemy (and doing nothing was in itself a form of collaboration) or resist the enemy by participating in the resistance movement. Resistance could take many forms: joining the *maquis* (underground military groups) to blow up bridges or trains used by the Nazis, hiding Jews or helping them to escape, writing for the underground press, helping to recruit and organize for the movement. Being captured by the Gestapo and identified as a member of the Resistance often meant imprisonment, torture, deportation, or execution. The extremity of the situation and the tests to which it put human choice were crucial to Sartre's development as an artist and a thinker.

At the heart of Sartrean existentialism is a sense of limitless and therefore anxiety-producing human freedom. Life for each human being is a series of situations requiring choices and acts; the acts that one chooses determine what one *is*. According to Sartre, humanity is not given *being*, but only *existence*. There is no God; there are no absolute standards of morality or of truth. Each person must forge his or her own morality and truth, must indeed create his or her own being out of existence. First, however, people must be aware of the dreadful state of freedom that is their true state of existence. Something like a Nietzschean "re-valuation of all values" is needed, but there is no superman to give guidance, only the individual. Sartre's words "life begins on the other side of despair" express the necessity for recognition of one's freedom. His "man is the sum of his acts" indicates that one's self is to be created through the use of this freedom.

Sartre found philosophy too limiting a vehicle with which to express the fundamental concerns of human beings. In a novel, *Nausea,* written before the war, he had already treated the theme of the absurdity (or, as he called it, the "contingency") of life and the outmoded hollowness of moralities such as traditional humanism. The main character of the novel, an intellectual named Roquentin, experiences an "existential crisis" as he confronts the meaninglessness of his existence.

During the war Sartre turned to the theater, which was better adapted to illustrating his theory that each situation in human life is like a trap. One works one's way out of the trap by exercising one's freedom, making a choice, and acting on it. One of Sartre's best plays, the one-act *No Exit*, portrays three dead characters trapped in a hell that they themselves created because they were unable to exercise their freedom during their lifetime.

Sartre's essays, collected in several volumes called *Situations,* treat a wide range of cultural and political topics. One of the central themes is the German occupation of France. For Sartre, the awareness of being in a situation limited by death and the necessity to choose a course of action made life under the occupation represent the existentialist situation with a clarity that the complexities of postwar life obscured.

Simone de Beauvoir (1908–1986)

Sartre met Simone de Beauvoir when both were philosophy students in Paris. Having decided to eschew marriage as a repressive bourgeois institution, the two of them vowed to become lifelong companions, an arrangement that did not preclude what they called "contingent loves." Along with Sartre, de Beauvoir embraced the major tenets of what would be known as existentialism but developed them in her own way. Although she wrote several philosophical essays, de Beauvoir, even more than Sartre, considered herself to be first and foremost a writer. Existentialism nonetheless plays a role in all of her creative works. Her novel *L'invitée* (English translation: *She Came to Stay*) explores the major existentialist theme of the self that attempts to impose itself on the world through free choice and the Other whose judgment it seeks and fears. *The Mandarins,* which won the prestigious French literary prize the Prix Goncourt, chronicles the disillusionment of leftist intellectuals in the postwar period. Some of de Beauvoir's best writing combines personal memories with both her philosophical views and her experience of the major historical events in her lifetime. Her three-volume memoirs, her meditation on old age, and her account of her mother's death (*A Very Easy Death*) all fall into this category.

Simone de Beauvoir is still best known in North America for her groundbreaking 1948 treatise, *The Second Sex*. A long and ambitious work, it views the phenomenon of what it means to be a woman from historical, biological, psychological, sociological, philosophical, and literary perspectives. One of de Beauvoir's major points is that women have always been treated as "the Other," "the second sex," something less than full human beings. Growing up in a patriarchal and repressive society, women have always encountered barriers to the assertion of their individuality and freedom. Whereas men are freer to attain "transcendence" (what Sartre would call existentialist choice), women are condemned to "immanence," that is, to being defined in terms of their biological functions and in relation to others. Although she shows that such cultural repression has existed for thousands of years, de Beauvoir argues that it should not be assumed to be "natural" and that women can take steps to free themselves. Like Virginia Woolf, de Beauvoir sees women's economic dependence on men as a major obstacle to their full development. At the end of her book, she calls for a "liberation" of women, including equal opportunity in the work force.

The book—unique in its time—was received with much hostility in France, where both men and women seemed to feel threatened by what they perceived as an attack on woman's traditional roles as wife, homemaker, and mother. It met with better reception in the United States, although only among a handful of people. Two

DAILY LIVES

The Existentialists' Life in Paris Under the German Occupation

Under the German occupation from 1940 to 1944, the people of Paris suffered electricity blackouts, shortage of heating fuel, and food shortages. Writers and artists had always gathered in cafés in Paris, but during this time they began to spend their days in them, both for company and solidarity and for warmth and light. In her memoirs, Simone de Beauvoir recounts her days spent at the Café de Flore on the Boulevard Saint Germain:[a]

> Little by little, as the morning passed, the room would fill up, till by apéritif time it was packed. You would see Picasso there, smiling at Dora Marr, who had her big dog with her on the lead; Léon-Paul Fargue would be sitting quietly in a corner, and Jacques Prévert[b] holding forth to a circle of acquaintances; while a noisy discussion would always be going on at the *cinéastes* table—they had been meeting there almost daily since 1939. Here and there in this mob you might find one or two old gentlemen who were local residents. I remember one such, who was afflicted with a disease of the prostate, and wore some kind of apparatus that bulged inside one of his trouser legs. There was another, known as

> "the Marquis" or "the Gaullist," who used to play dominoes with two young girl friends of his, whom, it was said, he maintained in fine style. He was a stoop-shouldered man, with down-thrust head and drooping mustachios; he would murmur in Jean's or Pascal's ear the news items he had just heard on the latest B.B.C. broadcast, and these would promptly be passed on from table to table. Throughout all this the two journalists still sat there and brooded, out loud, upon the possibility of exterminating the Jews.

> I would return to my hotel for lunch, after which, unless I had a class at the *lycée,*[c] I resumed my table at the Flore. I went out for dinner, and then returned again till closing time. It always gave me a thrill of pleasure at night to walk in out of the icy darkness and find myself in this warm, well-lit, snug retreat with its charming blue-and-red wallpaper. Frequently the entire "family"[d] was to be found at the Flore, but with its members, according to our principles of behavior, scattered in every corner of the room. For instance, Sartre might be chatting with Wanda at one table, Lise and Bourla at another, and Olga and I sitting together at a third. Yet Sartre and I were the only two who turned up regu-

a. Simone de Beauvoir, *The Prime of Life*, trans. Peter Green (New York: World Publishing, 1962), pp. 422–423.
b. Fargue and Prévert were well-known poets.
c. French high school.
d. Sartre and de Beauvoir's circle of friends.

decades later, as we will see in the next chapter, it would have a major impact on the women's movement in America and Europe and to some extent throughout the world. A French feminist would then say of Simone de Beauvoir, "Women, you owe her everything!"

Albert Camus (1913–1960)

The war and postwar literature of existentialism includes not only the writing of Sartre and de Beauvoir but also that of Albert Camus, who, nonetheless, refused to call himself an existentialist. In his novel *The Stranger*, written on the eve of the war and published in 1942, as well as in his essay *The Myth of Sisyphus*, Camus demonstrates his contempt for the "absurd"— the fundamental meaninglessness of human life and traditional beliefs. Camus's concept of the absurd is

perhaps clearest in the following quotation from *The Myth of Sisyphus:*

> A world that can be explained by reasoning, however faulty, is a familiar world. But in a universe that is suddenly deprived of illusions and of light, man feels a stranger. His is an irremediable exile, because he is deprived of memories of a lost homeland as much as he lacks the hope of a promised land to come. This divorce between man and his life, the actor and his setting, truly constitutes the feeling of Absurdity.

Thus the human mind demands reason, logic, order, and an explanation for the way things are, but the world offers none. Individuals must then create their own morality, their own way of resisting the "absurd."

Yet for Camus there was always "another side of the coin." His native continent being North Africa

larly every night. "When they die," Bourla remarked of us, faintly irritated, "you'll have to dig them a grave under the floor."

One evening, just as we were arriving at the Flore, we saw a flash and heard a tremendous explosion. Windows rattled, people cried out in alarm: a grenade, it transpired, had gone off in a hotel that was being used as a *Soldatenheim,* at the end of the Rue Saint-Benoît. This produced a hubbub of speculation in all the cafés round about, since an "outrage" in these parts was something very unusual.

The sirens used to sound very frequently, both in the afternoon and at night. Boubal would shoo the customers out posthaste and bolt the doors; Sartre and I and one or two others, however, he allowed, as a special favor, to come up to the first floor and remain there till the all-clear sounded. In order to avoid this upheaval, and also to get away from the noise on the ground floor, I got into the habit of going straight up the stairs after lunch anyway. One or two other writers did likewise, doubtless for very similar reasons. Our pens scratched away over the paper; we might have been in some extremely well-behaved classroom. . . .

Despite restrictions and air raids, we still found an atmosphere that was reminiscent of peacetime conditions; yet the war did penetrate our private snuggery on occasion. We were told one morning that Sonia had just been arrested; she had apparently been made the victim of another woman's jealousy—someone, at any rate, had certainly denounced her. She sent a message from Drancy,[e] asking for a sweater and some silk stockings to be forwarded; this was the last request received from her. The blonde Czech girl who lived with Jausion vanished; and a few days afterward, when Bella was asleep in her boy friend's arms, the Gestapo came knocking on their door at dawn and took her away, too. Another girl, a friend of theirs, was living with a well-connected young man who wanted to marry her; she was denounced by her future father-in-law. Our knowledge of the camps was still very incomplete; but the way these gay and beautiful girls simply vanished into the blue, without a word, was terrifying enough in itself. Jausion and his friends still came to the Flore, and even went on sitting at the same table, where they talked among themselves in an agitated, hectic sort of way. But there was no mark on the red banquette to indicate the empty place at their side. This was what seemed the most unbearable thing about any absence to me: that it was, precisely, a *nothingness.*

e. An "internment camp" where Jews and resistants were sent before being deported to Germany.

rather than Europe, he retained a belief in the regenerative value of nature—sea and sun—that is absent from Sartre's work. His postwar novel *The Plague* (1948) is about the effects of an imaginary plague on the Algerian city of Oran, but it is often read as an allegory of the German occupation of Paris. Camus, like Sartre, portrays human beings making choices in the face of an extreme situation. But Camus's values are finally closer to those of traditional humanism than Sartre's are. His heroes choose, in the face of death, in the face of absurdity, simply to do what they can, to help each other, to fight the plague. Friendship and love are in the end more important than political commitment. The revolt against the absurd becomes a way of reaffirming one's humanity. *The Plague* and Camus's philosophical work *The Rebel* precipitated a break between the two men who had become intellectual leaders in Western culture.

The reasons were complex, but basically Sartre was critical of what he felt was Camus's compromise with humanism and liberalism.

Sartre himself later moved toward a radically Marxist position, modifying considerably his view of human beings as totally free. Camus, who died in an "absurd" automobile accident in 1960, had retained his faith in the individual rebel, shunning all forms of totalitarian belief systems.

If the philosophical essay *The Myth of Sisyphus* constitutes Camus's most developed statement of "the absurd," Sisyphus himself is not mentioned until the very end. Camus's "absurd hero" is a figure from Greek mythology who represents the condition of modern humanity. Rewritings of ancient Greek myths were common in French literature around the time of World War II. It seemed that those who lived through tragic

situations could seek truth or at least guidance through a reevaluation of a fundamental root of Western culture. Camus's Sisyphus braves his superiors, the gods; states by his choice the value he places on earthly life; and, paradoxically, through his very consciousness of the meaninglessness of his condition, forges his own liberty and happiness.

In the Wake of Existentialism: The Theater of the Absurd

The French existentialists' consciousness of the absurdity of human life was balanced by the pressing need for social and political commitment. In exercising one's freedom by choosing to resist Nazi control, anguish and despair could, in some limited way at least, end in triumph. In the years following the war, however, such extreme situations, or clear opportunities for commitment, did not often present themselves. One could, of course, commit oneself to a Marxist revolution, but the rise of Stalin in the Soviet Union made that solution seem much less attractive. The terrible knowledge of the concentration camps and the nuclear bomb made life seem precarious and individual human efforts vain. The sense of despair, gloom, and absurdity in existentialism seemed more relevant than its more heroic side.

If Albert Camus was the philosopher and the novelist of "the absurd," playwrights working in Paris in the 1950s seemed to find new dramatic forms to fit the concept. This radically new type of theater was baptized the *theater of the absurd* by the British critic Martin Esslin in a groundbreaking 1961 book by that title. Although they never formed a group and never accepted the name, the writers and directors discussed by Esslin—who differ from one another radically in many respects—do seem to share a common vision and some common experimental methods. Hence the name has stuck. Many of these writers and directors came to Paris from other countries but adopted French as their language of expression. Among them were the Irish Samuel Beckett (1906–1989), whose *Waiting for Godot*, produced in a tiny theater in 1952, was immediately hailed as inaugurating a new era in theater; the Romanian-French Eugène Ionesco (1912–1994); and the Spaniard Fernando Arrabal. Esslin included the English playwright Harold Pinter, the American Edward Albee, and the Czech Václav Havel (subsequently president of the Czech Republic) among the practitioners of the theater of the absurd.

Antonin Artaud (see Chapter 32) can be viewed as the father of this new theater. Like Artaud, the new writers and their directors were in revolt against the Western tradition of psychological, mimetic, or realistic theater. Mixing tragedy with farce, they drew on the cinema of Charlie Chaplin and the Marx Brothers, vaudeville, and the music hall to create marginalized, unreal characters, outrageous or dreamlike situations, and poetic, explosive language. In ways reminiscent of Artaud's theater of "cruelty," they sometimes seem to assault the audience in order to shake it out of its complacency. Their theater exposes the limits of ordinary, cliché-ridden language as a vehicle of communication.

Eugène Ionesco (1912–1994)

Ionesco said that he began to write plays after trying to study English. The dialogue in *La Cantatrice chauve* (The Bald Soprano, 1951) makes use of the stilted, clichéd phrases found in some language manuals. While exposing the banalities and the lack of communication in ordinary speech, Ionesco also shows how words can become violent weapons. This one-act, apparently nonsensical play was so startling when first produced that it caused riots. However, it has become one of the longest-running plays in history, still showing (since a revival in the late 1950s) at the tiny Théâtre de la Huchette in Paris. Its companion piece, still playing at the Huchette as well, *The Lesson*, features a teacher who violently assaults his pupil merely through the use of words. Ionesco once claimed that he could see no difference between tragedy and comedy. Whereas most spectators see his plays as comic, he called them "tragedies of language" or "tragic farces."

Although Ionesco denounced any form of political or "committed" theater (he was particularly critical of Brecht), his own experiences with the political events of his time had their impact on his plays. Having spent much of his early life in his father's native country, Romania, he had seen firsthand the rise of fascism and then communism in that country. He was bitterly disappointed in his father's and in other acquaintances' unquestioning adherence to both totalitarian systems. His denunciation of totalitarianism and conformity is most apparent in his three-act play *Rhinoceros* (1957), in the course of which citizens in an ordinary French town begin, one by one, to turn into rhinoceroses, until only "the last man" remains. Another exploration of the absurdity of the mass desire to subordinate one's individuality to a "master" appears in the one-act *Le Maître* (translated as *The Leader*, 1958). *Le Maître* has also been set to music as an opera by the French composer Germaine Tailleferre.

In the last years of his life, Ionesco became quite religious, turning back to the Orthodox church of his youth and developing a mystical tendency that had already appeared in some of his later plays. Yet it is as one of the founders of the theater of the absurd that he has made his mark on literature.

Postwar American Literature

Much of the literature of the 1940s and 1950s, on the American continent as well as in Europe, shows the direct or indirect influence of existentialism. As in the 1920s at the time of the "lost generation," some Amer-

ican writers went to live in Europe, particularly in Paris, during this period. France was especially attractive to African American writers and intellectuals, who felt freer there than in their own country. In Paris they could discuss the latest developments in existentialism and also meet black intellectuals from Africa and the Caribbean. Richard Wright (1908–1960), who was born in poverty in Mississippi, studied at the University of Chicago, and became a well-known writer in the 1940s, left for Paris after the war and lived there until his death. His powerful naturalistic, existentialist, and Marxist novel, *Native Son,* inspired an entire generation of African American writers. A young man from Harlem, James Baldwin (1924–1987), met Wright, his "idol since childhood," in 1944. Wright encouraged him to come to Paris, where he wrote his first novel, *Go Tell It on the Mountain.* Upon returning to the United States in the 1960s, Baldwin became an articulate spokesperson for the civil rights movement. His later essays, such as *The Fire Next Time,* predict "the shape of the wrath to come" if the vestiges of American racism are not eradicated.

Ralph Ellison (1914–1994)

Unlike many of the prominent African American writers of the 1930s and 1940s, Ellison did not leave the United States to live in Europe, nor did he join the Communist party. Nevertheless, in the mid-1950s Ellison did lecture widely in Germany and Austria, and he did acknowledge a number of European influences on his art, Dostoevsky among them. Also, like Baldwin and many others of the time, he came under the strong influence of Richard Wright, having been introduced to him by Langston Hughes. Again like Baldwin, Ellison later broke away from that influence to establish his own unique style and vision.

Ellison was born in Oklahoma City, majored in music at Tuskegee Institute, was a jazz trumpeter, and originally intended to be a musician. Ultimately, music, especially African American *blues,* became the aesthetic mainspring of his writing. In 1952, *Invisible Man,* the only one of his novels to be published in his lifetime, was honored with the National Book Award and, in a *Book Week* poll, was judged "the most distinguished single work" published in America between 1945 and 1965.

In the course of a journey from the Deep South to Harlem, the protagonist of *Invisible Man* assumes a variety of roles to fit the larger society's definition of a "Negro." As a young high school boy in the South, he is a "Tom," something of a "darky" entertainer; in college, a Booker T. Washington accommodationist. When he moves north, he flirts for a while with communism. Finally, he becomes a Rinehart, Ellison's word for the alienated urban black who deliberately tries to manipulate the desires and fantasies of whites and blacks to his own advantage. Although the protagonist believes in

most of these roles at the time, each one disappoints him because they fail to take into account the complexity of his individual existence. Chaos and violence—barroom brawls, factory explosions, street fights, and race riots—are often the result of the protagonist's failure to live out the roles others have assigned to him. At the end of the novel, hidden away in a forgotten basement room in an apartment building, the protagonist comes to no true resolution of his predicament except the realization that he—that is, his humanity—is invisible to most people, black and white, and that he must discover for himself what his existence is to be.

The Prologue to *Invisible Man* is perhaps the best introduction to Ellison's literary world. It describes the protagonist in his secret basement room announcing his intention to narrate the absurd and catastrophic events of his life. He has rigged up along the walls 1,369 electric lights, whose power he has somehow managed, illegally, to acquire from the Monopolated Light and Power Company, in order to shed light on his invisibility. He has been playing a Louis Armstrong record, the punning refrain of which runs: "What did I do/To be so black/And blue?" This refrain represents the blues motif that runs throughout each major episode of the novel. As his attempts to play out the dehumanizing roles that whites have assigned him end in disaster, the invisible man in effect feels compelled to ask himself Armstrong's question. Each episode thus serves, in a sense, as an extended blues verse, with the protagonist serving as the singer. And just as the last verse of a blues song is frequently the same as the first, the novel's Epilogue brings the reader back to the present, to the secret basement room in the Prologue, with the protagonist singing his story.

CD-2, 15

The Beat Generation: Allen Ginsberg (1926–1997)

The period of the Eisenhower presidency during the 1950s proved unsettling to many artists and writers. The unprecedented prosperity, which seemed mindless to some; the conformity symbolized by "the man in the gray flannel suit"; the restrictive controls evidenced by the McCarthy "witch-hunts"; and the apparent insanity of the Cold War nuclear race stirred up an artistic and intellectual revolt against the direction in which American culture was heading. Inspired in part by existentialism, writers such as Norman Mailer and William Burroughs gave an American voice to the themes of alienation, despair, and revolt. The writers of the *beat* generation, who organized themselves in the mid-1950s at the City Lights Bookshop in San Francisco, pushed these themes to an extreme, both in form and in content. Jack Kerouac (1922–1969) published his influential novel, *On the Road,* in 1957. A tale of aimless wandering from coast to coast by a group of social dropouts, it seemed to express—like the film *Rebel*

Without a Cause, starring James Dean—the alienation and the revulsion against success-oriented American society felt by many young people.

The beats marked the beginning of what was later called the counterculture in American society. "Beat" may refer to the beat of jazz, which accompanied beat poetry readings, but it also meant "beatific." Beat poets considered themselves prophets and religious seekers as well as poets. Like other dissatisfied westerners before them, the "beatniks" turned eastward, learning Zen Buddhism through the work of Kenneth Rexroth and incorporating it into the American scene in their own writing (for example, Kerouac's *The Dharma Bums*).

One such poet-prophet, Allen Ginsberg, passed from the beat generation to the hippie counterculture of the 1960s, becoming one of its gurus. Originally from Paterson, New Jersey, where he came into contact with the poet William Carlos Williams, Ginsberg spent his formative years in New York City, leaving for San Francisco in 1953. Ginsberg's mother had been a communist during the 1930s, and so he learned radicalism at an early age. In the company of Kerouac and the other beats in San Francisco, he experimented with radical poetic forms. Influenced by the poetry of Walt Whitman, Ginsberg abandoned formal poetic meter and diction for a poetry rich in rhythmic effects but close to everyday speech. His poetry expresses disgust at aspects of American culture but a sense of wonder at America as well. During the 1950s and 1960s Ginsberg came to terms with his homosexuality, experimented with drugs, spoke and read at counterculture political gatherings, and traveled to Europe and to India. There he consulted various religious leaders, exploring states of expanded consciousness. He finally reached the conclusion that the spiritual search could be best undertaken without drugs—a modification that he expressed in the poem "The Change." *Howl* (1957), Ginsberg's first published poetry collection, included the long poem of the same name, which has remained his best-known work. It occasioned a trial on obscenity charges, of which he was eventually acquitted. When read aloud accompanied by jazz, his long, breathless lines of verse produce a hallucinatory effect.

Postwar Music: Charlie Parker (1920–1955)

In regard to American music, World War II served as a watershed that separated the traditions of the past from the new music of the day—a barrier that both protected the old traditions on one side and sped the waters of the avant-garde down the other. The advanced technology of the war effort gave classical music the computers, tape recorders, and electronic equipment—developed for military purposes—as new instruments for composition and performance. Popular music was likewise affected, and

jazz was popular music. The Special Services units of the armed forces employed thousands of young musicians full time to entertain the troops. Soldiers on duty listened to recorded jazz, and soldiers on leave frequented nightclubs in which live jazz was the rule. The music of the swing era remained popular, but a new style of jazz was also created, partially in reaction to the musical restrictions of swing, and partially as a result of the emerging freedoms and greater equality of black Americans.

"Yardbird" or "Bird," as the saxophonist Charlie Parker was known, was in a sense the embodiment of all the pent-up frustrations of black America after the war, a man who represented the crowning achievement of African American genius but was rejected and ignored by society at large. Wasted by drugs, alcohol, and a self-abusive life, he died at thirty-five. Yet his music continued to speak—the walls of Harlem, the underpasses of Chicago, and the blackboards of Los Angeles read "Bird lives!" The style he created, *bebop,* or bop, as it became known, broke with the tradition that had kept jazz tied to dance music and to popular songs. Jazz continued to evolve as the country emerged from World War II. The higher technical competence of the swing soloists had created a breed of virtuoso who could improvise at breakneck speed. Bebop introduced continually shifting accents; new, rude sounds; unexpected harmonies—and its adepts improvised at speeds that set them apart from, and above, other jazz musicians. The bop musicians, or "hipsters," developed their own private language, their own style of dress, and even an antisocial performance style (turning their backs on audiences, walking off stage when they had finished their solos) that set them apart. More importantly, they also developed a free way of treating the standard harmonic and melodic materials that allowed them to transform popular ballads into totally new jazz compositions. In his recording of "Koko," for example, Bird imposes a new tune over the changes (the pattern of harmonies) of the popular and innocuous song "Cherokee (Indian Love Song)."

Another good example of Bird's style is in "Parker's Mood." It is a music of freedom, unfettered by the rules of popular music. The melodies are not regular; they are asymmetric. A fanfarelike flourish that opens and closes it demands attention. A

CD-2, 18

laid-back phrase or two followed by a torrent of cascading sounds makes the listener struggle to follow the old, familiar blues pattern. It is a song without words; it is defiant, self-assured, and fragile at the same time. In 1940, Charlie Parker was unknown; in 1948, when he recorded "Parker's Mood," he was famous; and in 1955, he was dead. So much energy, suffering, and vision became focused and supercharged in this one man, and only through his horn was he able to speak to and for a people. Through his music he would show the way to a free-

dom he himself never had. His voice and presence in the 1940s and 1950s were a penetrating cry for the social awakening that America experienced in the 1960s.

Painting After World War II

The sense of the absurd, the feeling of alienation from society, and the emphasis on individual self-expression that were manifest in writing and in jazz music appeared also in the visual arts. In painting, the ferment that fed the Armory Show of 1913 continued, and by the late 1940s a large number of painters reached maturity. Stuart Davis (1894–1964), for example, had followed the lines of development suggested by the abstraction process of cubism and, influenced by jazz, made larger canvases filled with vaguely familiar objects, rhythmically charged with energy derived from distortion and intense color. *Owh! in San Pao* (Fig. 33-1), painted in 1951, is a careful arrangement of interlocking, overlapping forms that create a busy swirl of front, back, beside, and behind kaleidoscopic patterns held against the vibrant yellow surface by words, letters, and dots. Davis's signature is an active part of the design and punctuates the space as sharply as the bright sounds of the jazz musician fill the air. Georgia O'Keeffe (see Chapter 31) moved to the Southwest, where she created haunting visions based on the desert. These and other American artists provided the strong background against which a new style appeared in the years following World War II.

Abstract Expressionism

This style, called *abstract expressionism*, or action painting, was the product of many factors—America, the emigration of many artists from Europe during the war years, and the confluence of an almost obsessive individualism with the desire to make original and deeply serious paintings. In retrospect, the painters whose work is commonly described by the term were a most heterogeneous group of individuals, and lumping them together seems superficial and presumptuous. Nevertheless, it is possible to discern enough similarities to explain the name. Consider the canvas by Jackson Pollock (1912–1956; Fig. 33-2), painted in 1952. First, it is a very large painting, wall-size in fact. Second, it reminds us of a work by Kandinsky because it has no identifiable subject matter except the formal one that is the product of the combination of shapes, forms, and colors on the surface. It seems to be derived in part from the cubist notion, also supported by Kandinsky, that a painting is good because it is, not because it represents something. But we also know from Kandinsky, the cubists, and the surrealists (as well as from Van Gogh and Gauguin) that lines, colors, and shapes are capable of communicating directly with the viewer, through the unconscious and the intuition. By

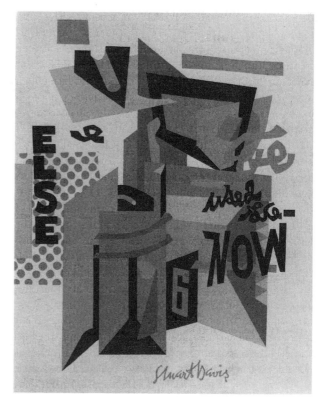

33-1 *Stuart Davis,* Owh! in San Pao, *1951. Oil on canvas, 52¼" × 41¾" (132.7 × 106 cm). (Collection of Whitney Museum of American Art, New York. Purchase 52.2. Photograph copyright 1996: Whitney Museum of American Art)*

appealing to these faculties rather than the rational, intellectualizing ones, the artist involves the spectator in a dialogue with the pure elements of the painting.

We also know, particularly from Kandinsky, how very difficult it is to create a picture outside the habitual and familiar, so we might ask how Pollock has created such seemingly random patterns on the canvas. Pollock created his paintings by dripping, pouring, and splashing paint on a canvas laid out on the floor. It was his belief that in this uninhibited way of working, he surrendered control of his rational processes; the work produced would be a reflection of interior, personal drives and motivations. He also believed that in this way his paintings would speak directly to the unconscious, therefore allowing the viewer to apprehend a shared universality existing beyond the habitual and familiar. In this painting we seem to have the unification of a number of ideas that had already emerged in the early twentieth century. The large scale of this work, however, gives it unrelieved energy and an overwhelming appeal to the emotional and the subjective, capable of creating an environment that is one with the viewer.

Not all the painters who were part of the abstract expressionist school made paintings that had no

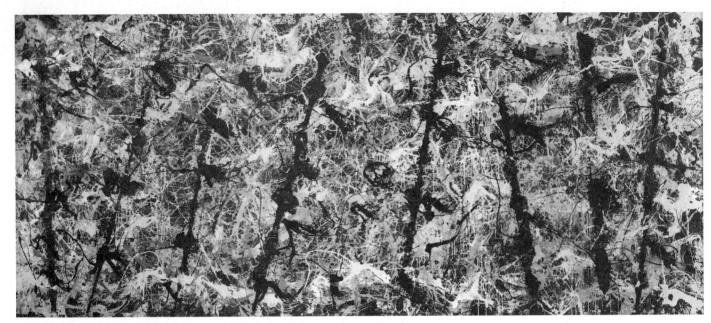

33-2 *Jackson Pollock,* Blue Poles, *1952. Oil, enamel, and aluminum paint, glass on canvas, 210.4 × 486.8 cm. (Collection: Australian National Gallery, Canberra. Copyright 1996 Pollock-Krasner Foundation/ARS, NY)*

recognizable objects. But all the painters involved gave primacy to the unconscious and to the physical act, the gesture of making the work. The two aims are, in a way, almost mutually exclusive. If the painter is to be uninhibited and have gestures as free from conscious motivation as possible, then from the moment that the first bit of paint is laid down, the painter becomes involved in an emotionally charged situation.

You can demonstrate this for yourself. Take a piece of paper. Put down a random line. Now you must decide, will the first line determine the placement of the second, or will you attempt to let the second line be as random as the first? Once two lines are down you are forced, almost unconsciously, to make some kind of decision about the placement of a third line, or form. Imagine how complicated this would become if you were working not only with a black line but also with colored lines. The factors that are unconsciously forcing you into a decision-making situation are first, the sheet of paper, which acts as a kind of frame, and second, your natural orientation to the world—top, bottom, left, right, front, back, beside, behind. Then there is an unconscious need to make the arrangement "look right," to produce a sense of balance and rhythm, order and harmony. Whether these needs are inborn or the product of culture does not matter in this instance. What is clear is the need to make "sense" of the thing: to find a personal structure and to impose it on the experience. Thus, on the one hand, the struggle is for a decisive subjective statement; on the other, it is a struggle with the powerful forces generated by the familiar

knowledge of seeing, knowing, and experiencing both the painterly world and the habitual world.

This ambiguity between ends and means makes abstract expressionist paintings so strong, enduring, and powerful. Drawn into the dialogue that the painter carries on with the canvas and paint, the viewer experiences the emotionally charged event of which the canvas is a record. However, this ambiguity also made this kind of painting a difficult act to sustain. Like Monet, who sought more and more transient effects in the landscape, these painters were forced to greater and greater personal and emotional extremes to sustain creative energy; otherwise, their gestures ran the risk of becoming hollow and repetitive. According to one abstract expressionist painter, the need for simplicity, clarity, order, and objectivity becomes overwhelming in the face of spending so much emotional energy.

Sculpture After World War II

By the end of World War I, constructed sculpture—that is, work made from metal, wood, and other materials welded, bolted, or wired together—began to assume great importance as a way of working, in addition to the traditional methods of cast bronze or carved stone. During the 1930s Alexander Calder (1898–1976), an American influenced by European surrealism, began to produce wire and wood constructions that have some of the same energy and whimsy of the Stuart Davis pieces of the same period. As Calder matured in the postwar years, his work assumed more heroic propor-

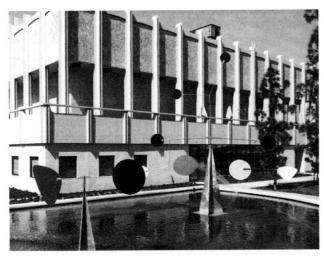

33-3 *Alexander Calder,* Hello Girls. *Painted metal mobile, 8'9" × 15' × 22'11". (Los Angeles County Museum of Art, Art Museum Council Fund. M.65.10)*

whose machinelike components seemed to echo the sleek surfaces and large scale of international style architecture (Fig. 33-3).

David Smith (1906–1965)

David Smith's early constructed works originated in surrealism's emphasis on the unconscious and on dreams as a source of forms. *The Royal Bird*, 1947–1948 (Fig. 33-4), is a bird of prey created from a nightmare. Smith's later work concentrated more and more on a sculptural language that used a few highly polished stainless steel geometric forms. As monumental as Calder's mobiles and stabiles, the works in Smith's Cubi Series—for example, *Cubi XVII*, 1963 (Fig. 33-5)—can stand powerfully in almost any landscape, rendering the space around them a frame and the distance or the building seen through their openings as a picture.

Calder and Smith represent possibilities for the sculptor opened by the nonobjective and expressive language that began with Kandinsky and evolved into constructivism in Europe and abstract expressionism in America following World War II. Both men relied on the power of form to draw the viewer into a dialogue with the work; both assumed, like Kandinsky and the abstract expressionist painters, that color and form speak directly. But other artists continued to rely on the human form as a carrier of meaning.

tions. The components of these constructed works not only decorated but also animated the architectural spaces in which they were placed. The *mobiles* (constructions suspended from a framework with moving parts) and *stabiles* (large-scale metal plate constructions) used forms that appeared to be derived from the natural world but were machined and carefully painted to create vigorous, aerodynamic, energetic sculptures

33-4 *David Smith,* The Royal Bird, 1947–1948. *Welded steel, bronze, and stainless steel, 22⅛" × 59¹³⁄₁₆" × 8½". (Collection Walker Art Center, Minneapolis. Gift of the T. B. Walker Foundation, 1952. 52.4)*

33-5 *David Smith,* Cubi XVII, *1963. Stainless steel, height 9'. (Dallas Museum of Fine Arts)*

33-6 *Alberto Giacometti,* Chariot, *1950. Bronze, 57" × 26" × 26⅛". (Collection, The Museum of Modern Art, New York. Purchase)*

Alberto Giacometti (1901–1966)

Giacometti, a Swiss-Italian artist who lived in Paris and was a friend of Sartre's, created a memorable figure type that seemed to epitomize the human condition as viewed by the existentialist. The gouged, stretched, attenuated human form, whether male or female, adult or child, presents an image that contrasts vividly with the heroic scale and optimistic power of Smith's or Calder's work. Giacometti created lonely individuals who suffer their fate and fear as they live in, but aloof from, modern society (Fig. 33-6).

The architecture of the postwar period presents a very different picture and will be discussed in the next chapter in conjunction with more recent developments.

PRIMO LEVI

from *If This Is a Man*

Translation by Stuart Woolf

In the eleventh chapter of *If This Is a Man* (also translated as *Survival in Auschwitz*), Levi attempts to teach Italian and Dante to a French fellow prisoner by reciting what he remembers of Canto 26 of the *Inferno,* the canto of Ulysses. In the canto, Dante and his guide Virgil, in the depths of hell, come to the circle where the "false counselors"—those who influence others through evil advice—are punished. Ulysses (the Roman name for Odysseus) is one of the souls condemned there because he engineered the trick of the Trojan horse and because, according to a medieval legend, he advised his men to sail beyond the straits of Gibraltar, where they drowned. Dante is here, as elsewhere, ambivalent in his attitude toward the great hero of antiquity. On the one hand, he condemns him for his transgression of the boundaries set by God for man; on the other, he admires his humanistic courage, encapsulated in the poignant lines pronounced in hell: "for brutish ignorance/ Your mettle was not made; you were made men/To follow after knowledge and excellence." This faith in human potential interests Levi. For him, as for other readers of Dante, the concentration camps represented modern equivalents of the Inferno, and the figure of Ulysses provided an example of how human resilience could brave hell itself.

Chapter 11

The Canto of Ulysses

There were six of us, scraping and cleaning the inside of an underground petrol tank; the daylight only reached us through a small manhole. It was a luxury job because no one supervised us; but it was cold and damp. The powder of the rust burnt under our eyelids and coated our throats and mouths with a taste almost like blood.

The rope-ladder hanging from the manhole began to sway: someone was coming. Deutsch extinguished his cigarette, Goldner woke Sivadjan; we all began to vigorously scrape the resonant steelplate wall.

It was not the *Vorarbeiter,*[1] it was only Jean, the Pikolo of our Kommando.[2] Jean was an Alsatian student; although he was already twenty-four, he was the youngest Häftling of the Chemical Kommando. So that he was given the post of Pikolo, which meant the messenger-clerk, responsible for the cleaning of the hut, for the distribution of tools, for the washing of bowls and for keeping record of the working hours of the Kommando.

Jean spoke French and German fluently: as soon as we recognized his shoes on the top step of the ladder we all stopped scraping.

"Also, Pikolo, was gibt es Neues?"[3]

"Qu'est ce qu'il-y-a comme soupe aujourd'hui?"[4]

. . . in what mood was the Kapo? And the affair of the twenty-five lashes given to Stern? What was the weather like outside? Had he read the newspaper? What smell was coming from the civilian kitchen? What was the time?

Jean was liked a great deal by the Kommando. One must realize that the post of Pikolo represented a quite high rank in the hierarchy of the Prominents: the Pikolo (who is usually no more than seventeen years old) does no manual work, has an absolute right to the remainder of the daily ration to be found on the bottom of the vat and can stay all day near the stove. He "therefore" has the right to a supplementary half-ration and has a good chance of becoming the friend and confidant of the Kapo, from whom he officially receives discarded clothes and shoes. Now Jean was an exceptional Pikolo. He was shrewd and physically robust, and at the same time gentle and friendly: although he continued his secret individual struggle against death, he did not neglect his human relationships with less privileged comrades; at the same time he had been so able and persevering that he had managed to establish himself in the confidence of Alex, the Kapo.

Alex had kept all his promises. He had shown himself a violent and unreliable rogue, with an armour of

[1] *Vorarbeiter:* the foreman, a prisoner.

[2] *Kommando:* a unit of workers within the camp.

[3] "What's new, little one?"

[4] "What kind of soup is there today?"

solid and compact ignorance and stupidity, always excepting his intuition and consummate technique as convict-keeper. He never let slip an opportunity of proclaiming his pride in his pure blood and his green triangle, and displayed a lofty contempt for his ragged and starving chemists: *"Ihr Doktoren! Ihr Intelligenten!"*[5] he sneered every day, watching them crowd around with their bowls held out for the distribution of the ration. He was extremely compliant and servile before the civilian *Meister* and with the SS he kept up ties of cordial friendship.

He was clearly intimidated by the register of the Kommando and by the daily report of work, and this had been the path that Pikolo had chosen to make himself indispensable. It had been a long, cautious and subtle task which the entire Kommando had followed for a month with bated breath; but at the end the porcupine's defence was penetrated, and Pikolo confirmed in his office to the satisfaction of all concerned.

Although Jean had never abused his position, we had already been able to verify that a single word of his, said in the right tone of voice and at the right moment, had great power; many times already it had saved one of us from a whipping or from being denounced to the SS. We had been friends for a week: we discovered each other during the unusual occasion of an air-raid alarm, but then, swept by the fierce rhythm of the Lager, we had only been able to greet each other fleetingly, at the latrines, in the washroom.

Hanging with one hand on the swaying ladder, he pointed to me: *"Aujourd'hui c'est Primo qui viendra avec moi chercher la soupe."*[6]

Until yesterday it had been Stern, the squinting Transylvanian; now he had fallen into disgrace for some story of brooms stolen from the store, and Pikolo had managed to support my candidature as assistant to the *"Essenholen,"* the daily corvée of the ration.

He climbed out and I followed him, blinking in the brightness of the day. It was warmish outside, the sun drew a faint smell of paint and tar from the greasy earth, which made me think of a holiday beach of my infancy. Pikolo gave me one of the two wooden poles, and we walked along under a clear June sky.

I began to thank him, but he stopped me: it was not necessary. One could see the Carpathians covered in snow. I breathed in the fresh air, I felt unusually light-hearted.

"Tu es fou de marcher si vite. On a le temps, tu sais."[7] The ration was collected half a mile away; one had to return with the pot weighing over a hundred pounds supported on the two poles. It was quite a tir-ing task, but it meant a pleasant walk there without a load, and the ever-welcome chance of going near the kitchens.

We slowed down. Pikolo was expert. He had chosen the path cleverly so that we would have to make a long detour, walking at least for an hour, without arousing suspicion. We spoke of our houses, of Strasbourg and Turin, of the books we had read, of what we had studied, of our mothers: how all mothers resemble each other! His mother too had scolded him for never knowing how much money he had in his pocket; his mother too would have been amazed if she had known that he had found his feet, that day by day he was finding his feet.

An SS man passed on a bicycle. It is Rudi, the *Blockführer*. Halt! Attention! Take off your beret! *"Sale brute, celui-là. Ein ganz gemeiner Hund."*[8] Can he speak French and German with equal facility? Yes, he thinks indifferently in both languages. He spent a month in Liguria, he likes Italy, he would like to learn Italian. I would be pleased to teach him Italian: why not try? We can do it. Why not immediately, one thing is as good as another, the important thing is not to lose time, not to waste this hour.

Limentani from Rome walks by, dragging his feet, with a bowl hidden under his jacket. Pikolo listens carefully, picks up a few words of our conversation and repeats them smiling: *"Zup-pa, cam-po, acqua."*[9]

Frenkl the spy passes. Quicken our pace, one never knows, he does evil for evil's sake.

. . . The canto of Ulysses. Who knows or how it comes into my mind. But we have no time to change, this hour is already less than an hour. If Jean is intelligent he will understand. He *will* understand—today I feel capable of so much.

. . . Who is Dante? What is the Comedy? That curious sensation of novelty which one feels if one tries to explain briefly what is the Divine Comedy. How the Inferno is divided up, what are its punishments. Virgil is Reason. Beatrice is Theology.

Jean pays great attention, and I begin slowly and accurately:

> "Then of that age-old fire the loftier horn
> Began to mutter and move, as a wavering flame
> Wrestles against the wind and is over-worn;
> And, like a speaking tongue vibrant to frame
> Language, the tip of it flickering to and fro
> Threw out a voice and answered: 'When I came . . .'"

Here I stop and try to translate. Disastrous—poor Dante and poor French! All the same, the experience seems to promise well: Jean admires the bizarre simile

[5] "You doctors, you intellectuals."

[6] "Today it's Primo who will come with me for the soup."

[7] "You're crazy to walk so fast. We have time, you know."

[8] "Dirty beast, that one. A common dog."

[9] "Soup, field, water."

of the tongue and suggests the appropriate word to translate "age-old."

And after "When I came?" Nothing. A hole in my memory. "Before Aeneas ever named it so." Another hole. A fragment floats into my mind, not relevant:

". . . nor piety To my old father, not the wedded love That should have comforted Penelope . . . ," is it correct?

". . . So on the open sea I set forth."

Of this I am certain, I am sure, I can explain it to Pikolo, I can point out why "I set forth"[10] is not *"je me mis,"* it is much stronger and more audacious, it is a chain which has been broken, it is throwing oneself on the other side of a barrier, we know the impulse well. The open sea: Pikolo has travelled by sea, and knows what it means: it is when the horizon closes in on itself, free, straight ahead and simple, and there is nothing but the smell of the sea; sweet things, ferociously far away.

We have arrived at Kraftwerk, where the cable-laying Kommando works. Engineer Levi must be here. Here he is, one can only see his head above the trench. He waves to me, he is a brave man, I have never seen his morale low, he never speaks of eating.

"Open sea," "open sea," I know it rhymes with "left me": ". . . and that small band of comrades that had never left me," but I cannot remember if it comes before or after. And the journey as well, the foolhardy journey beyond the Pillars of Hercules, how sad, I have to tell it in prose—a sacrilege. I have only rescued two lines, but they are worth stopping for:

". . . that none should prove so hardy
To venture the uncharted distances . . ."

"to venture":[11] I had to come to the Lager to realize that it is the same expression as before: "I set forth." But I say nothing to Jean, I am not sure that it is an important observation. How many things there are to say, and the sun is already high, midday is near. I am in a hurry, a terrible hurry.

Here, listen Pikolo, open your ears and your mind, you have to understand, for my sake:

"Think of your breed; for brutish ignorance
Your mettle was not made; you were made men,
To follow after knowledge and excellence."

As if I also was hearing it for the first time: like the blast of a trumpet, like the voice of God. For a moment I forget who I am and where I am.

Pikolo begs me to repeat it. How good Pikolo is, he is aware that it is doing me good. Or perhaps it is something more: perhaps, despite the wan translation and the pedestrian, rushed commentary, he has received the message, he has felt that it has to do with him, that it has to do with all men who toil, and with us in particular; and that it has to do with us two, who dare to reason of these things with the poles for the soup on our shoulders.

"My little speech made every one so keen . . ."

. . . and I try, but in vain, to explain how many things this "keen" means. There is another lacuna here, this time irreparable. ". . . the light kindles and grows Beneath the moon" or something like it; but before it? . . . Not an idea, "keine Ahnung" as they say here. Forgive me, Pikolo, I have forgotten at least four triplets.

"Ça ne fait rien, vas-y tout de même."[12]

". . . When at last hove up a mountain, grey
With distance, and so lofty and so steep,
I never had seen the like on any day."

Yes, yes, "so lofty and so steep," not "very steep,"[13] a consecutive proposition. And the mountains when one sees them in the distance . . . mountains . . . oh, Pikolo, Pikolo, say something, speak, do not let me think of my mountains which used to show up against the dusk of evening as I returned by train from Milan to Turin!

Enough, one must go on, these are things that one thinks but does not say. Pikolo waits and looks at me.

I would give today's soup to know how to connect "the like on any day" to the last lines. I try to reconstruct it through the rhymes, I close my eyes, I bite my fingers—but it is no use, the rest is silence. Other verses dance in my head: ". . . The sodden ground belched wind . . . ," no, it is something else. It is late, it is late, we have reached the kitchen, I must finish:

"And three times round she went in roaring smother
With all the waters; at the fourth the poop
Rose, and the prow went down, as pleased
Another."

I keep Pikolo back, it is vitally necessary and urgent that he listen, that he understand this "as pleased Another" before it is too late; tomorrow he or I might be dead, or we might never see each other again, I must tell him, I must explain to him about the Middle Ages, about the so human and so necessary and yet unexpected anachronism, but still more, something gigantic that I myself have only just seen, in a flash of intuition, perhaps the reason for our fate, for our being here today . . .

We are now in the soup queue, among the sordid, ragged crowd of soup-carriers from other Kommandos. Those just arrived press against our backs. *Kraut und Rüben? Kraut und Rüben.* The official announcement

[10] "Misi me." [Trans.]

[11] "Si metta." [Trans.]

[12] "It doesn't matter, go ahead anyway."

[13] "Alta tanto," not "molto alta." [Trans.]

is made that the soup today is of cabbages and turnips: "*Choux et navets. Kaposzta és répak.*"

"And over our heads the hollow seas closed up."

COMMENTS AND QUESTIONS

1. Why does Levi choose the Ulysses canto to teach to his friend?

2. What new meanings do the recited lines take on in this context? How do they differ from those intended by Dante in the context of the *Divine Comedy*? (If possible, read the canto in Chapter 10.)

3. What does this brief passage convey to you about the concentration camp experience?

JEAN-PAUL SARTRE

The Republic of Silence
Translation by Alastair Hamilton

We have never been so free as under German occupation. We had lost every right, and above all the right of speech: we were insulted every day and we had to remain silent; we were deported as laborers, as Jews, as political prisoners; everywhere, on the walls, in the newspapers, and on the screen, we saw the foul and listless face which our oppressors wanted to give us. Because of all this we were free. Since the Nazi venom penetrated our very thoughts, every true thought was a victory. Since an all-powerful police tried to force us to be silent, each word became as precious as a declaration of principle. Since we were hounded, every one of our movements had the importance of commitment. The often atrocious circumstances of our struggle had at last put us in a position to live our life without pretenses—to live in this torn, unbearable condition which we call the human condition. Exile, captivity, and above all death, which is ably disguised in periods of happiness, became the perpetual object of our concern; we discovered that they were not inevitable accidents or even constant but external threats: they had become our *lot*, our destiny, the source of our reality as men. Each second we fully realized the meaning of the trite little phrase "All men are mortal." And the choice which each man made on his own was genuine, since he made it in the presence of death, since he would always have been able to express it in terms of "better death than . . ." And I'm not talking of the elite formed by the true resistants, but of every Frenchman who, at every hour of the day and night, for four years, said no. The cruelty of the enemy pushed us to the extremes of our condition by forcing us to ask these questions which we avoid in peacetime: each of us—and what Frenchman did not at one point find himself in this position?—who knew certain details concerning the Resistance wondered anxiously: "If I were tortured, would I hold out?" Thus the question of liberty was raised and we were on the brink of the deepest knowledge that man can have of himself. Because man's secret is not his Oedipus complex or his inferiority complex, it is the limit of his freedom, it is his power to resist torture and death. To those who were active in the underground, the circumstances of this struggle were a new experience: they did not fight in the open, like soldiers; they were hunted in solitude, arrested in solitude, and it was all alone that they resisted torture: alone and naked before well-shaved, well-fed, well-dressed executioners who laughed at their wretched flesh, who with clean consciences and unlimited power, looked as though they were in the right. And yet at the depths of this solitude it was the others, all the others, all the comrades of the Resistance whom they defended. One word was enough to cause ten, a hundred arrests. Is not total responsibility in total solitude the revelation of our liberty? The need, the solitude, the enormous risk were the same for everybody, for the leaders and the men. For those who carried messages and did not know what they contained as for those who organized the whole Resistance, there was only one sentence: imprisonment, deportation, death. There is no army in the world with such equal risks for the soldiers and the general. And that is why the Resistance was a real democracy: for the soldier and for the leader there was the same danger, the same responsibility, the same absolute liberty in discipline. Thus, in darkness and in blood, the strongest republic was formed. Each of its citizens knew that he owed himself to everyone and could only count on himself; each one performed his historic part in total solitude. Each one, in defiance of the oppressor, undertook to be himself; irremediably and by freely choosing himself, he chose freedom for everybody. This republic without institutions, without army or police, had to be conquered by each Frenchman and established at every moment against Nazism. We are now on the brink of another Republic:[1] can't we preserve by day the austere virtues of the Republic of Silence and Night?

COMMENTS AND QUESTIONS

1. What is the effect of the paradox in the first line?

2. How does Sartre see the situation of the occupation as a microcosm of the human condition?

3. According to Sartre, how does individual liberty entail responsibility?

[1] The Fourth Republic, France's new government after the liberation.

SIMONE DE BEAUVOIR

from *The Second Sex*
Translation by H. M. Parshley

The major divisions of *The Second Sex* are Book One: Facts and Myths (with chapters on biology and psychology, history, and myths) and Book Two: Women's Life Today (with chapters on childhood and youth, lesbians, married women and mothers, independent women, etc.). The following passage is from the beginning of Book Two.

One is not born, but rather becomes, a woman. No biological, psychological, or economic fate determines the figure that the human female presents in society; it is civilization as a whole that produces this creature, intermediate between male and eunuch, which is described as feminine. Only the intervention of someone else can establish an individual as an *Other*. In so far as he exists in and for himself, the child would hardly be able to think of himself as sexually differentiated. In girls as in boys the body is first of all the radiation of a subjectivity, the instrument that makes possible the comprehension of the world: it is through the eyes, the hands, that children apprehend the universe, and not through the sexual parts. The dramas of birth and of weaning unfold after the same fashion for nurslings of both sexes; these have the same interests and the same pleasures; sucking is at first the source of their most agreeable sensations; then they go through an anal phase in which they get their greatest satisfactions from the excretory functions, which they have in common. Their genital development is analogous; they explore their bodies with the same curiosity and the same indifference; from clitoris and penis they derive the same vague pleasure. As their sensibility comes to require an object, it is turned toward the mother; the soft, smooth, resilient feminine flesh is what arouses sexual desires, and these desires are prehensile; the girl, like the boy, kisses, handles, and caresses her mother in an aggressive way; they feel the same jealousy if a new child is born; and they show it in similar behavior patterns: rage, sulkiness, urinary difficulties; and they resort to the same coquettish tricks to gain the love of adults. Up to the age of twelve the little girl is as strong as her brothers, and she shows the same mental powers; there is no field where she is debarred from engaging in rivalry with them. If, well before puberty and sometimes even from early infancy, she seems to us to be already sexually determined, this is not because mysterious instincts directly doom her to passivity, coquetry, maternity; it is because the influence of others upon the child is a factor almost from the start, and thus she is indoctrinated with her vocation from her earliest years.

The world is at first represented in the newborn infant only by immanent sensations; he is still immersed in the bosom of the Whole as he was when he lived in a dark womb; when he is put to the breast or the nursing bottle he is still surrounded by the warmth of maternal flesh. Little by little he learns to perceive objects as distinct and separate from himself, and to distinguish himself for them. Meanwhile he is separated more or less brutally from the nourishing body. Sometimes the infant reacts to this separation by a violent crisis;[1] in any case, it is about when the separation is accomplished, toward the age of six months, perhaps, that the child begins to show the desire to attract others through acts of mimicry that in time become real showing off. Certainly this attitude is not established through a considered choice; but it is not necessary to *conceive* a situation for it to *exist*. The nursling lives directly the basic drama of every existent: that of his relation to the Other. Man experiences with anguish his being turned loose, his forlornness. In flight from his freedom, his subjectivity, he would fain lose himself in the bosom of the Whole. Here, indeed, is the origin of his cosmic and pantheistic dreams, of his longing for oblivion, for sleep, for ecstasy, for death. He never succeeds in abolishing his separate ego, but at least he wants to attain the solidity of the in-himself, the *en-soi*, to be petrified into a thing. It is especially when he is fixed by the gaze of other persons that he appears to himself as being one.

It is in this perspective that the behavior of the child must be interpreted: in carnal form he discovers finiteness, solitude, forlorn desertion in a strange world. He endeavors to compensate for this catastrophe by projecting his existence into an image, the reality and value of which others will establish. It appears that he may begin to affirm his identity at the time when he recognizes his reflection in a mirror—a time that coincides with that of weaning:[2] his ego becomes so fully identified with this reflected image that it is formed only in being projected. Whether or not the mirror actually plays a more or less considerable part, it is certain that the child commences toward the age of six months to mimic his parents, and under their gaze to regard himself as an object. He is already an autonomous subject, in transcendence toward the outer world; but he encounters himself only in a projected form.

When the child develops further, he fights in two ways against his original abandonment. He attempts to deny the separation: rushing into his mother's arms, he

[1] Judith Gautier relates in her memoirs that she wept and pined so pitifully when taken from her nurse that they had to bring her back, and she was not weaned until much later.

[2] This theory was proposed by Dr. Lacan in *Les Complexes familiaux dans la formation de l'individu* (Familial influences on the development of the individual). This observation, one of primary importance, would explain how it is that in the course of its development "the ego retains the ambiguous aspect of a spectacle."

seeks her living warmth and demands her caresses. And he attempts to find self-justification through the approbation of others. Adults seem to him like gods, for they have the power to confer existence upon him. He feels the magic of the gaze that makes of him now a delightful little angel, now a monster. His two modes of defense are not mutually exclusive: on the contrary, they complement each other and interpenetrate. When the attempt at enticement succeeds, the sense of justification finds carnal confirmation in the kisses and caresses obtained: it all amounts to a single state of happy passivity that the child experiences in his mother's lap and under her benevolent gaze. There is no difference in the attitudes of girls and boys during the first three or four years; both try to perpetuate the happy condition that preceded weaning; in both sexes enticement and showing-off behavior occur: boys are as desirous as their sisters of pleasing adults, causing smiles, making themselves admired.

It is more satisfying to deny the anguish than to rise above it, more radical to be lost in the bosom of the Whole than to be petrified by the conscious egos of others: carnal union creates a deeper alienation than any resignation under the gaze of others. Enticement and showing off represent a more complex, a less easy stage than simple abandon in the maternal arms. The magic of the adult gaze is capricious. The child pretends to be invisible; his parents enter into the game, trying blindly to find him and laughing; but all at once they say; "You're getting tiresome, you are not invisible at all." The child has amused them with a bright saying: he repeats it, and this time they shrug their shoulders. In this world, uncertain and unpredictable as the universe of Kafka, one stumbles at every step.[3] That is why many children are afraid of growing up; they are in despair if their parents cease taking them on their knees or letting them get into the grown-ups' bed. Through the physical frustration they feel more and more cruelly the forlornness, the abandonment, which the human being can never be conscious of without anguish.

This is just where the little girls first appear as privileged beings. A second weaning, less brutal and more gradual than the first, withdraws the mother's body from the child's embraces; but the boys especially are little by little denied the kisses and caresses they have been used to. As for the little girl, she continues to be cajoled, she is allowed to cling to her mother's skirts, her father takes her on his knee and strokes her hair. She wears sweet little dresses, her tears and caprices are viewed indulgently, her hair is done up carefully, older

people are amused at her expressions and coquetries—bodily contacts and agreeable glances protect her against the anguish of solitude. The little boy, in contrast, will be denied even coquetry; his efforts at enticement, his play-acting, are irritating. He is told that "a man doesn't ask to be kissed. . . . A man doesn't look at himself in mirrors. . . . A man doesn't cry." He is urged to be "a little man"; he will obtain adult approval by becoming independent of adults. He will please them by not appearing to seek to please them.

Many boys, frightened by the hard independence they are condemned to, wish they were girls; formerly, when boys were dressed in early years like girls, they often shed tears when they had to change from dresses to trousers and saw their curls cut. Certain of them held obstinately to the choice of femininity—one form of orientation toward homosexuality. Maurice Sachs (in *Le Sabbat*) says: "I wished passionately to be a girl and I pushed my unawareness of the grandeur of being male to the point of meaning to urinate in a sitting position."

But if the boy seems at first to be less favored than his sisters, it is because great things are in store for him. The demands placed upon him at once imply a high evaluation. Maurras relates in his memoirs that he was jealous of a younger brother whom his mother and grandmother were cajoling. His father took his hand and drew him from the room, saying to him: "We are men, let us leave those women." The child is persuaded that more is demanded of boys because they are superior; to give him courage for the difficult path he must follow, pride in his manhood is instilled into him; this abstract notion takes on for him a concrete aspect: it is incarnated in his penis. . . .

Thus the passivity that is the essential characteristic of the "feminine" woman is a trait that develops in her from the earliest years. But it is wrong to assert that a biological datum in concerned; it is in fact a destiny imposed upon her by her teachers and by society. The great advantage enjoyed by the boy is that his mode of existence in relation to others leads him to assert his subjective freedom. His apprenticeship for life consists in free movement toward the outside world; he contends in hardihood and independence with other boys, he scorns girls. Climbing trees, fighting with his companions, facing them in rough games, he feels his body as a means for dominating nature and as a weapon for fighting; he takes pride in his muscles as in his sex; in games, sports, fights, challenges, trials of strength, he finds a balanced exercise of his powers; at the same time he absorbs the severe lessons of violence; he learns from an early age to take blows, to scorn pain, to keep back the tears. He undertakes, he invents, he dares. Certainly he tests himself also as if he were another; he challenges his own manhood, and many problems result in relation to adults and to other children. But what is very important is that there is no fundamental opposition between his concern for that

[3] In her *Orange bleue*, Yassu Gauclère relates anecdotes of childhood illustrating the inconsistent behavior of both her father and her mother; her childish conclusion was that "the conduct of grown-ups is decidedly incomprehensible."

objective figure which is his, and his will to self-realization in concrete projects. It is by *doing* that he creates his existence, both in one and the same action.

In woman, on the contrary, there is from the beginning a conflict between her autonomous existence and her objective self, her "being-the-other"; she is taught that to please she must try to please, she must make herself object; she should therefore renounce her autonomy. She is treated like a live doll and is refused liberty. Thus a vicious circle is formed; for the less she exercises her freedom to understand, to grasp and discover the world about her, the less resources will she find within herself, the less will she dare to affirm herself as subject. If she were encouraged in it, she could display the same lively exuberance, the same curiosity, the same initiative, the same hardihood, as a boy. This does happen occasionally, when the girl is given a boyish bringing up; in this case she is spared many problems.[4] It is noteworthy that this is the kind of education a father prefers to give his daughter; and women brought up under male guidance very largely escape the defects of femininity. But custom is opposed to treating girls like boys. I have known of little village girls of three or four being compelled by their fathers to wear trousers.[5] All the other children teased them: "Are they girls or boys?"—and they proposed to settle the matter by examination. The victims begged to wear dresses. Unless the little girl leads an unusually solitary existence, a boyish way of life, though approved by her parents, will shock her entourage, her friends, her teachers. There will always be aunts, grandmothers, cousins around to counteract the father's influence. Normally he is given a secondary role with respect to his daughters' training. One of the curses that weigh heavily upon women—as Michelet has justly pointed out—is to be left in women's hands during childhood. The boy, too, is brought up at first by his mother, but she respects his maleness and he escapes very soon;[6] whereas she fully intends to fit her daughter into the feminine world. . . .

Everything helps to confirm this hierarchy in the eyes of the little girl. The historical and literary culture to which she belongs, the songs and legends with which she is lulled to sleep, are one long exaltation of man. It was men who built up Greece, the Roman Empire, France, and all other nations, who have explored the world and invented the tools for its exploitation, who have governed it, who have filled it with sculptures, paintings, works of literature. Children's books, mythology, stories, tales, all reflect the myths born of the pride and the desires of men; thus it is that through the eyes of men the little girl discovers the world and reads therein her destiny. . . .

COMMENTS AND QUESTIONS

1. Simone de Beauvoir's opening statement here, "One is not born, but rather becomes, a woman," is one of the most famous and most discussed in the book. What does she mean by it?

2. Note that de Beauvoir outlines a kind of existentialist drama even in the development of the small child. The child is torn between his or her desire to become an independent being (a desire for freedom that entails anguish) and the satisfaction of retreat to the "whole"—the approval and care of the mother and adults in general. How might this same dilemma appear in adults?

3. Does de Beauvoir's account of the difference between raising girls and raising boys still apply in our own time?

4. Does her account of the situation of the girl (and of the woman) seem unduly pessimistic to you?

ALBERT CAMUS

from *The Myth of Sisyphus*
Translation by Justin O'Brien

The gods had condemned Sisyphus to ceaselessly rolling a rock to the top of a mountain, whence the stone would fall back of its own weight. They had thought with some reason that there is no more dreadful punishment than futile and hopeless labor.

If one believes Homer, Sisyphus was the wisest and most prudent of mortals. According to another tradition, however, he was disposed to practice the profession of highwayman. I see no contradiction in this. Opinions differ as to the reasons why he became the futile laborer of the underworld. To begin with, he is accused of a certain levity in regard to the gods. He stole their secrets. Aegina, the daughter of Aesopus, was carried off by Jupiter. The father was shocked by that disappearance and complained to Sisyphus. He, who knew of the abduction, offered to tell about it on condition that Aesopus would give water to the citadel of Corinth. To the celestial thunderbolts he preferred the benediction of water. He was punished for this in the underworld. Homer tells us also that Sisyphus had put Death in chains. Pluto could not endure the sight of his deserted, silent empire. He dispatched the god of war, who liberated Death from the hands of her conqueror.

[4] At least during early childhood. Under present social conditions, the conflicts of adolescence, on the contrary, may well be exaggerated.

[5] Quite in accordance with current American fashion!—Tr.

[6] There are of course many exceptions; but we cannot undertake here to study the part played by the mother in the boy's development.

It is said also that Sisyphus, being near to death, rashly wanted to test his wife's love. He ordered her to cast his unburied body into the middle of the public square. Sisyphus woke up in the underworld. And there, annoyed by an obedience so contrary to human love, he obtained from Pluto permission to return to earth in order to chastise his wife. But when he had seen again the face of this world, enjoyed water and sun, warm stones and the sea, he no longer wanted to go back to the infernal darkness. Recalls, signs of anger, warnings were of no avail. Many years more he lived facing the curve of the gulf, the sparkling sea, and the smiles of earth. A decree of the gods was necessary. Mercury came and seized the impudent man by the collar and, snatching him from his joys, led him forcibly back to the underworld, where his rock was ready for him.

You have already grasped that Sisyphus is the absurd hero. He *is*, as much through his passions as through his torture. His scorn of the gods, his hatred of death, and his passion for life won him that unspeakable penalty in which the whole being is exerted toward accomplishing nothing. This is the price that must be paid for the passions of this earth. Nothing is told us about Sisyphus in the underworld. Myths are made for the imagination to breathe life into them. As for this myth, one sees merely the whole effort of a body straining to raise the huge stone, to roll it and push it up a slope a hundred times over; one sees the face screwed up, the cheek tight against the stone, the shoulder bracing the clay-covered mass, the foot wedging it, the fresh start with arms outstretched, the wholly human security of two earth-clotted hands. At the very end of his long effort measured by skyless space and time without depth, the purpose is achieved. Then Sisyphus watches the stone rush down in a few moments toward that lower world whence he will have to push it up again toward the summit. He goes back down to the plain.

It is during that return, that pause, that Sisyphus interests me. A face that toils so close to stones is already stone itself! I see that man going back down with a heavy yet measured step toward the torment of which he will never know the end. That hour like a breathing-space which returns as surely as his suffering, that is the hour of consciousness. At each of those moments when he leaves the heights and gradually sinks toward the lairs of the gods, he is superior to his fate. He is stronger than his rock.

If this myth is tragic, that is because its hero is conscious. Where would his torture be, indeed, if at every step the hope of succeeding upheld him? The workman of today works every day in his life at the same tasks, and this fate is no less absurd. But it is tragic only at the rare moments when it becomes conscious. Sisyphus, proletarian of the gods, powerless and rebellious, knows the whole extent of his wretched condition: it is what he thinks of during his descent. The lucidity that was to

constitute his torture at the same time crowns his victory. There is no fate that cannot be surmounted by scorn.

If the descent is thus sometimes performed in sorrow, it can also take place in joy. This word is not too much. Again I fancy Sisyphus returning toward his rock, and the sorrow was in the beginning. When the images of earth cling too tightly to memory, when the call of happiness becomes too insistent, it happens that melancholy rises in man's heart: this is the rock's victory, this is the rock itself. The boundless grief is too heavy to bear. These are our nights of Gethsemane. But crushing truths perish from being acknowledged. Thus, Oedipus at the outset obeys fate without knowing it. But from the moment he knows, his tragedy begins. Yet at the same moment, blind and desperate, he realizes that the only bond linking him to the world is the cool hand of a girl. Then a tremendous remark rings out: "Despite so many ordeals, my advanced age and the nobility of my soul make me conclude that all is well." Sophocles' Oedipus, like Dostoevsky's Kirilov, thus gives the recipe for the absurd victory. Ancient wisdom confirms modern heroism.

One does not discover the absurd without being tempted to write a manual of happiness. "What! by such narrow ways—?" There is but one world, however. Happiness and the absurd are two sons of the same earth. They are inseparable. It would be a mistake to say that happiness necessarily springs from the absurd discovery. It happens as well that the feeling of the absurd springs from happiness. "I conclude that all is well," says Oedipus, and that remark is sacred. It echoes in the wild and limited universe of man. It teaches that all is not, has not been, exhausted. It drives out of this world a god who had come into it with dissatisfaction and a preference for futile sufferings. It makes of fate a human matter, which must be settled among men.

All Sisyphus' silent joy is contained therein. His fate belongs to him. His rock is his thing. Likewise, the absurd man, when he contemplates his torment, silences all the idols. In the universe suddenly restored to its silence, the myriad wondering little voices of the earth rise up. Unconscious, secret calls, invitations from all the faces they are the necessary reverse and price of victory. There is no sun without shadow, and it is essential to know the night. The absurd man says yes and his effort will henceforth be unceasing. If there is a personal fate, there is no higher destiny, or at least there is but one which he concludes is inevitable and despicable. For the rest, he knows himself to be the master of his days. At that subtle moment when man glances backward over his life, Sisyphus returning toward his rock, in that slight pivoting he contemplates that series of unrelated actions which becomes his fate, created by him, combined under his memory's eye and soon sealed by his death. Thus, convinced of the wholly human origin

of all that is human, a blind man eager to see who knows that the night has no end, he is still on the go. The rock is still rolling.

I leave Sisyphus at the foot of the mountain! One always finds one's burden again. But Sisyphus teaches the higher fidelity that negates the gods and raises rocks. He too concludes that all is well. This universe henceforth without a master seems to him neither sterile nor futile. Each atom of that stone, each mineral flake of that nightfilled mountain, in itself forms a world. The struggle itself toward the heights is enough to fill a man's heart. One must imagine Sisyphus happy.

COMMENTS AND QUESTIONS

1. What, exactly, is Sisyphus' condition, and how, in Camus's vision, is it representative of the human condition?

2. What seems to be the relationship between tragedy and happiness for Camus?

3. How does Camus's style differ from Sartre's? How does this style reflect Camus's view of the human condition?

4. Can you relate the myth of Sisyphus to the experiences of the concentration camp and the occupation?

EUGÈNE IONESCO

The Leader

Translation by Derek Prouse

CHARACTERS
THE ANNOUNCER
THE YOUNG LOVER
THE GIRL-FRIEND
THE ADMIRER
THE GIRL ADMIRER
THE LEADER

[*Standing with his back to the public, centre-stage, and with his eyes fixed on the up-stage exit, the* ANNOUNCER *waits for the arrival of the* LEADER. *To right and left, riveted to the walls, two of the* LEADER'S ADMIRERS, *a man and a girl, also wait for his arrival.*]

ANNOUNCER [*after a few tense moments in the same position*] There he is! There he is! At the end of the street! [*Shouts of 'Hurrah!' etc., are heard.*] There's the leader! He's coming, he's coming nearer! [*Cries of acclaim and applause are heard from the wings.*] It's better if he doesn't see us . . . [*The* TWO ADMIRERS *hug the wall even closer.*] Watch out! [*The* ANNOUNCER *gives vent to a brief display of enthusiasm.*] Hurrah! Hurrah! The leader! The leader! Long live the leader! [*The* TWO ADMIRERS

with their bodies rigid and flattened against the wall, thrust their necks and heads as far forward as they can to get a glimpse of the LEADER.] The leader! The leader! [*The* TWO ADMIRERS *in unison:*] Hurrah! Hurrah! [*Other 'Hurrahs!' mingled with 'Hurrah! Bravo!' come from the wings and gradually die down.*] Hurrah! Bravo! [*The* ANNOUNCER *takes a step up-stage, stops, then up-stage, followed by the* TWO ADMIRERS, *saying as he goes* 'Ah! Too bad! He's going away! He's going away! Follow me quickly! After him!' *The* ANNOUNCER *and the* TWO ADMIRERS *leave, crying:* 'Leader! Leeeeader! Lee-ee-eader!' *(This last 'Lee-ee-eader!' echoes in the wings like a bleating cry.)*]
[*Silence. The stage is empty for a few brief moments. The* YOUNG LOVER *enters right, and his* GIRL-FRIEND *left; they meet centre-stage.*]

YOUNG LOVER Forgive me, Madame, or should I say Mademoiselle?

GIRL-FRIEND I beg your pardon, I'm afraid I don't happen to know you!

YOUNG LOVER And I'm afraid I don't know you either!

GIRL-FRIEND Then neither of us knows each other.

YOUNG LOVER Exactly. We have something in common. It means that between us there is a basis of understanding on which we can build the edifice of our future.

GIRL-FRIEND That leaves me cold, I'm afraid.
[*She makes as if to go.*]

YOUNG LOVER Oh, my darling, I adore you.

GIRL-FRIEND Darling, so do I!
[*They embrace.*]

YOUNG LOVER I'm taking you with me, darling. We'll get married straightaway.
[*They leave left. The stage is empty for a brief moment.*]

ANNOUNCER [*enters up-stage followed by the* TWO ADMIRERS] But the leader swore that he'd be passing here.

ADMIRER Are you absolutely sure of that?

ANNOUNCER Yes, yes, of course.

GIRL ADMIRER Was it really on his way?

ANNOUNCER Yes, yes. He should have passed by here, it was marked on the Festival programme . . .

ADMIRER Did you actually see it yourself and hear it with your own eyes and ears?

ANNOUNCER He told someone. Someone else!

ADMIRER But who? Who was this someone else?

GIRL ADMIRER Was it a reliable person? A friend of yours?

ANNOUNCER A friend of mine who I know very well.
[*Suddenly in the background one hears renewed cries of* 'Hurrah!' *and* 'Long live the leader!'] That's him now! There he is! Hip! Hip! Hurrah! There he is! Hide yourselves! Hide yourselves!
[*The* TWO ADMIRERS *flatten themselves as before against the wall, stretching their necks out towards the wings from where the shouts of acclamation come; the* ANNOUNCER *watches fixedly up-stage his back to the public.*]

ANNOUNCER The leader's coming. He approaches. He's bending. He's unbending. [*At each of the AN-NOUNCER's words, the ADMIRERS give a start and stretch their necks even farther; they shudder.*] He's jumping. He's crossed the river. They're shaking his hand. He sticks out his thumb. Can you hear? They're laughing. [*The ANNOUNCER and the TWO ADMIRERS also laugh.*] Ah . . . ! they're giving him a box of tools. What's he going to do with them? Ah . . . ! he's signing autographs. The leader is stroking a hedgehog, a superb hedgehog! The crowd applauds. He's dancing, with the hedgehog in his hand. He's embracing his dancer. Hurrah! Hurrah! [*Cries are heard in the wings.*] He's being photographed, with his dancer on one hand and the hedgehog on the other . . . He greets the crowd . . . He spits a tremendous distance.

GIRL ADMIRER Is he coming past here? Is he coming in our direction?

ADMIRER Are we really on his route?

ANNOUNCER [*turns his head to the TWO ADMIRERS*] Quite, and don't move, you're spoiling everything . . .

GIRL ADMIRER But even so . . .

ANNOUNCER Keep quiet, I tell you! Didn't I tell you he'd promised, that he had fixed his itinerary himself. . . . [*He turns back up-stage and cries.*] Hurrah! Hurrah! Long live the leader! [*Silence*] Long live, long live, the leader! [*Silence*] Long live, long live, long live the lead-er! [*The TWO ADMIRERS, unable to contain themselves, also give a sudden cry of.*] Hurrah! Long live the leader!

ANNOUNCER [*to the ADMIRERS*] Quiet, you two! Calm down! You're spoiling everything! [*Then, once more looking up-stage, with the ADMIRERS silenced.*] Long live the leader! [*Wildly enthusiastic.*] Hurrah! Hurrah! He's changing his shirt. He disappears behind a red screen. He reappears! [*The applause intensifies.*] Bravo! Bravo! [*The ADMIRERS also long to cry 'Bravo' and applaud; they put their hands to their mouths to stop themselves.*] He's putting his tie on! He's reading his newspaper and drinking his morning coffee! He's still got his hedgehog . . . He's leaning on the edge of the parapet. The parapet breaks. He gets up . . . he gets up unaided! [*Applause, shouts of 'Hurrah!'*] Bravo! Well done! He brushes his clothes which had got soiled.

TWO ADMIRERS [*stamping their feet*] Oh! Ah! Oh! Oh! Ah! Ah!

ANNOUNCER He's mounting the stool! He's climbing piggy-back, they're offering him a thin-ended wedge, he knows it's meant as a joke, and he doesn't mind, he's laughing.
[*Applause and enormous acclaim.*]

ADMIRER [*to the GIRL ADMIRER*] You hear that? You hear? Oh! If I were king . . .

GIRL ADMIRER Ah . . . ! the leader!
[*This is said in an exalted tone.*]

ANNOUNCER [*still with his back to the public*] He's mounting the stool. No. He's getting down. A little girl offers him a bouquet of flowers . . . What's he going to do? He takes the flowers . . . He embraces the little girl . . . calls her 'my child' . . .

ADMIRER He embraces the little girl . . . calls her 'my child' . . .

GIRL ADMIRER He embraces the little girl . . . calls her 'my child' . . .

ANNOUNCER He gives her the hedgehog. The little girl's crying . . . Long live the leader! Long live the leead-er!

ADMIRER Is he coming past here?

GIRL ADMIRER Is he coming past here?

ANNOUNCER [*with a sudden run, dashes out up-stage*] He's going away! Hurry! Come on!
[*He disappears, followed by the TWO ADMIRERS, all crying 'Hurrah! Hurrah!'*]
[*The stage is empty for a few moments. The TWO LOVERS enter, entwined in an embrace; they halt centre-stage and separate; she carries a basket on her arm.*]

GIRL-FRIEND Let's go to the market and get some eggs!

YOUNG LOVER Oh! I love them as much as you do!
[*She takes his arm. From the right the ANNOUNCER arrives running, quickly regaining his place, back to the public, followed closely by the TWO ADMIRERS, arriving one from the left and the other from the right; the TWO ADMIRERS knock into the TWO LOVERS who were about to leave right.*]

ADMIRER Sorry!

YOUNG LOVER Oh! Sorry!

GIRL ADMIRER Sorry! Oh! Sorry!

GIRL-FRIEND Oh! Sorry, sorry, sorry, so sorry!

ADMIRER Sorry, sorry, sorry, oh! sorry, sorry, so sorry!

YOUNG LOVER Oh, oh, oh, oh, oh, oh! So sorry, everyone!

GIRL-FRIEND [*to her LOVER*] Come along, Adolphe!
[*To the TWO ADMIRERS:*] No harm done!
[*She leaves, leading her LOVER by the hand.*]

ANNOUNCER [*watching up-stage*] The leader is being pressed forward, and pressed back, and now they're pressing his trousers! [*The TWO ADMIRERS regain their places.*] The leader is smiling. Whilst they're pressing his trousers, he walks about. He tastes the flowers and the fruits growing in the stream. He's also tasting the roots of the trees. He suffers the little children to come unto him. He has confidence in everybody. He inaugurates the police force. He pays tribute to justice. He salutes the great victors and the great vanquished. Finally he recites a poem. The people are very moved.

TWO ADMIRERS Bravo! Bravo! [*Then, sobbing:*] Boo! Boo! Boo!

ANNOUNCER All the people are weeping. [*Loud cries are heard from the wings; the ANNOUNCER and the AD-MIRERS also start to bellow.*] Silence! [*The TWO ADMIRERS fall silent; and there is silence from the wings.*] They've given the leader's trousers back. The leader puts them on. He looks happy! Hurrah! [*'Bravos', and ac-*

claim from the wings. The Two Admirers *also shout their acclaim, jump about, without being able to see anything of what is presumed to be happening in the wings.*] The leader's sucking his thumb! [*To the* Two Admirers:] Back, back to your places, you two, don't move, behave yourselves and shout: 'Long live the leader!'

Two Admirers [*flattened against the wall, shouting*] Long live, long live the leader!

Announcer Be quiet, I tell you, you'll spoil everything! Look out, the leader's coming!

Admirer [*in the same position*] The leader's coming!

Girl Admirer The leader's coming!

Announcer Watch out! And keep quiet! Oh! The leader's going away! Follow him! Follow me!

[*The* Announcer *goes out up-stage, running; the* Two Admirers *leave right and left, whilst in the wings the acclaim mounts, then fades. The stage is momentarily empty. The* Young Lover, *followed by his* Girl-Friend, *appear left running across the stage right.*]

Young Lover [*running*] You won't catch me! You won't catch me!

[*Goes out.*]

Girl-Friend [*running*] Wait a moment! Wait a moment!

[*She goes out. The stage is empty for a moment; then once more the* Two Lovers *cross the stage at a run, and leave.*]

Young Lover You won't catch me!

Girl-Friend Wait a moment!

[*They leave right. The stage is empty. The* Announcer *reappears up-stage, the* Admirer *from the right, the* Girl Admirer *from the left. They meet centre.*]

Admirer We missed him!

Girl Admirer Rotten luck!

Announcer It was your fault!

Admirer That's not true!

Girl Admirer No, that's not true!

Announcer Are you suggesting it was mine?

Admirer No, we didn't mean that!

Girl Admirer No, we didn't mean that!

[*Noise of acclaim and 'Hurrahs' from the wings.*]

Announcer Hurrah!

Girl Admirer It's from over there! [*She points up-stage.*]

Admirer Yes, it's from over there! [*He points left.*]

Announcer Very well. Follow me! Long live the leader! [*He runs out right, followed by the* Two Admirers, *also shouting.*]

Two Admirers Long live the leader!

[*They leave. The stage is empty for a moment. The* Young Lover *and his* Girl-Friend *appear left; the* Young Lover *exits up-stage; the* Girl-Friend, *after saying 'I'll get you!', runs out right. The* Announcer *and the* Two Admirers *appear from up-stage; the* Announcer *says to the* Admirers:] Long live the leader! [*This is repeated by the* Admirers. *Then, still talking to the* Admirers, *he says:*] Follow me! Follow the leader! [*He leaves up-stage, still running and shouting:*] Follow him!

[*The* Admirer *exits right, the* Girl Admirer *left into the wings. During the whole of this, the acclaim is heard louder or fainter according to the rhythm of the stage action; the stage is empty for a moment, then the* Lovers *appear from right and left, crying:*]

Young Lover I'll get you!

Girl-Friend You won't get me!

[*They leave at a run, shouting:*] Long live the leader! [*The* Announcer *and the* Two Admirers *emerge from up-stage, also shouting: 'Long live the leader', followed by the* Two Lovers. *They all leave right, in single file, crying as they run: 'The leader! Long live the leader! We'll get him! It's from over here! You won't get me!'*]

[*They enter and leave, employing all the exits; finally, entering from left, from right, and from up-stage they all meet centre, whilst the acclaim and the applause from the wings becomes a fearful din. They embrace each other feverishly, crying at the tops of their voices:*] Long live the leader! Long live the leader! Long live the leader!

[*Then, abruptly, silence falls.*]

Announcer The leader is arriving. Here's the leader. To your places! Attention!

[*The* Admirer *and the* Girl-Friend *flatten themselves against the wall right; the* Girl Admirer *and the* Young Lover *against the wall left; the two couples are in each other's arms, embracing.*]

Admirer and

Girl-Friend My dear, my darling!

Girl Admirer and

Young Lover My dear, my darling!

[*Meanwhile the* Announcer *has taken up his place, back to the audience, looking fixedly up-stage; a lull in the applause.*]

Announcer Silence. The leader has eaten his soup. He is coming. He is nigh.

[*The acclaim redoubles its intensity; the* Two Admirers *and the* Two Lovers *shout:*]

All Hurrah! Hurrah! Long live the leader!

[*They throw confetti before he arrives. Then the* Announcer *hurls himself suddenly to one side to allow the* Leader *to pass; the other four characters freeze with outstretched arms holding confetti; but still say:*] Hurrah!

[*The* Leader *enters from up-stage, advances down-stage to centre; to the footlights, hesitates, makes a step to left, then takes a decision and leaves with great, energetic strides by right, to the enthusiastic 'Hurrahs!' of the* Announcer *and the feeble, somewhat astonished 'Hurrahs!' of the other four; these, in fact, have some reason to be surprised, as the* Leader *is headless, though wearing a hat. This is simple to effect: the actor playing the* Leader *needing only to wear an overcoat with the collar turned up round his forehead and topped with a hat. The-man-in-an-overcoat-with-a-hat-without-a-head is a somewhat surprising apparition and will doubtless produce a certain sensation. After the* Leader's *disappearance, the* Girl Admirer *says:*]

Girl Admirer But . . . but . . . the leader hasn't got a head!

ANNOUNCER What's he need a head for when he's got genius!
YOUNG LOVER That's true! [*To the* GIRL-FRIEND:] What's your name?
[*The* YOUNG LOVER *to the* GIRL ADMIRER, *the* GIRL ADMIRER *to the* ANNOUNCER, *the* ANNOUNCER *to the* GIRL-FRIEND, *the* GIRL-FRIEND *to the* YOUNG LOVER:] What's yours? What's yours? What's yours? [*Then, all together, one to the other:*] What's your name?

CURTAIN

COMMENTS AND QUESTIONS

1. Much of the text of *The Leader* consists of stage directions. Imagine as carefully as you can how this play could be staged. If you were the director, what effects would you attempt to achieve and how?
2. Which aspects of the play are realistic, and which are antirealistic? What is the effect of the latter?
3. Describe each of the characters and his or her function in the play.
4. How is the leader presented? What, in your opinion, does he represent?

RALPH ELLISON

Prologue to *Invisible Man*

I am an invisible man. No, I am not a spook like those who haunted Edgar Allan Poe; nor am I one of your Hollywood-movie ectoplasms. I am a man of substance, of flesh and bone, fiber and liquids—and I might even be said to possess a mind. I am invisible, understand, simply because people refuse to see me. Like the bodiless heads you see sometimes in circus sideshows, it is as though I have been surrounded by mirrors of hard, distorting glass. When they approach me they see only my surroundings, themselves, or figments of their imagination—indeed, everything and anything except me.

Nor is my invisibility exactly a matter of a biochemical accident to my epidermis. That invisibility to which I refer occurs because of a peculiar disposition of the eyes of those with whom I come in contact. A matter of the construction of their *inner* eyes, those eyes with which they look through their physical eyes upon reality. I am not complaining, nor am I protesting either. It is sometimes advantageous to be unseen, although it is most often rather wearing on the nerves.

Then too, you're constantly being bumped against by those of poor vision. Or again, you often doubt if you really exist. You wonder whether you aren't simply a phantom in other people's minds. Say, a figure in a nightmare which the sleeper tries with all his strength to destroy. It's when you feel like this that, out of resentment, you begin to bump people back. And, let me confess, you feel that way most of the time. You ache with the need to convince yourself that you do exist in the real world, that you're a part of all the sound and anguish, and you strike out with your fists, you curse and you swear to make them recognize you. And, alas, it's seldom successful.

One night I accidentally bumped into a man, and perhaps because of the near darkness he saw me and called me an insulting name. I sprang at him, seized his coat lapels and demanded that he apologize. He was a tall blond man, and as my face came close to his he looked insolently out of his blue eyes and cursed me, his breath hot in my face as he struggled. I pulled his chin down sharp upon the crown of my head, butting him as I had seen the West Indians do, and I felt his flesh tear and the blood gush out, and I yelled, "Apologize! Apologize!" But he continued to curse and struggle, and I butted him again and again until he went down heavily, on his knees, profusely bleeding. I kicked him repeatedly, in a frenzy because he still uttered insults though his lips were frothy with blood. Oh yes, I kicked him! And in my outrage I got out my knife and prepared to slit his throat, right there beneath the lamplight in the deserted street, holding him in the collar with one hand, and opening the knife with my teeth—when it occurred to me that the man had not *seen* me, actually; that he, as far as he knew, was in the midst of a walking nightmare! And I stopped the blade, slicing the air as I pushed him away, letting him fall back to the street. I stared at him hard as the lights of a car stabbed through the darkness. He lay there, moaning on the asphalt; a man almost killed by a phantom. It unnerved me. I was both disgusted and ashamed. I was like a drunken man myself, wavering about on weakened legs. Then I was amused: Something in this man's thick head had sprung out and beaten him within an inch of his life. I began to laugh at this crazy discovery. Would he have awakened at the point of death? Would Death himself have freed him for wakeful living? But I didn't linger. I ran away into the dark, laughing so hard I feared I might rupture myself. The next day I saw his picture in the *Daily News,* beneath a caption stating that he had been "mugged." Poor fool, poor blind fool, I thought with sincere compassion, mugged by an invisible man!

Most of the time (although I do not choose as I once did to deny the violence of my days by ignoring it) I am not so overtly violent. I remember that I am invisible and walk softly so as not to awaken the sleeping

ones. Sometimes it is best not to awaken them; there are few things in the world as dangerous as sleepwalkers. I learned in time though that it is possible to carry on a fight against them without their realizing it. For instance, I have been carrying on a fight with Monopolated Light & Power for some time now. I use their service and pay them nothing at all, and they don't know it. Oh, they suspect that power is being drained off, but they don't know where. All they know is that according to the master meter back there in their power station a hell of a lot of free current is disappearing somewhere into the jungle of Harlem. The joke, of course, is that I don't live in Harlem but in a border area. Several years ago (before I discovered the advantages of being invisible) I went through the routine process of buying service and paying their outrageous rates. But no more. I gave up all that, along with my apartment, and my old way of life: That was based upon the fallacious assumption that I, like other men, was visible. Now, aware of my invisibility, I live rent-free in a building rented strictly to whites, in a section of the basement that was shut off and forgotten during the nineteenth century, which I discovered when I was trying to escape in the night from Ras the Destroyer. But that's getting too far ahead of the story, almost to the end, although the end is in the beginning and lies far ahead.

The point now is that I found a home—or a hole in the ground, as you will. Now don't jump to the conclusion that because I call my home a "hole" it is damp and cold like a grave; there are cold holes and warm holes. Mine is a warm hole. And remember, a bear retires to his hole for the winter and lives until spring; then he comes strolling out like the Easter chick breaking from its shell. I say all this to assure you that it is incorrect to assume that, because I'm invisible and live in a hole, I am dead. I am neither dead nor in a state of suspended animation. Call me Jack-the-Bear, for I am in a state of hibernation.

My hole is warm and full of light. Yes, *full* of light. I doubt if there is a brighter spot in all New York than this hole of mine, and I do not exclude Broadway. Or the Empire State Building on a photographer's dream night. But that is taking advantage of you. Those two spots are among the darkest of our whole civilization—pardon me, our whole *culture* (an important distinction, I've heard)—which might sound like a hoax, or a contradiction, but that (by contradiction, I mean) is how the world moves: Not like an arrow, but a boomerang. (Beware of those who speak of the *spiral* of history; they are preparing a boomerang. Keep a steel helmet handy.) I know; I have been boomeranged across my head so much that I now can see the darkness of lightness. And I love light. Perhaps you'll think it strange that an invisible man should need light, desire light, love light. But maybe it is exactly because I *am* invisible. Light confirms my reality, gives birth to my form. A beautiful girl once told me of a recurring night-mare in which she lay in the center of a large dark room and felt her face expand until it filled the whole room, becoming a formless mass while her eyes ran in bilious jelly up the chimney. And so it is with me. Without light I am not only invisible, but formless as well; and to be unaware of one's form is to live a death. I myself, after existing some twenty years, did not become alive until I discovered my invisibility.

That is why I fight my battle with Monopolated Light & Power. The deeper reason, I mean: It allows me to feel my vital aliveness. I also fight them for taking so much of my money before I learned to protect myself. In my hole in the basement there are exactly 1,369 lights. I've wired the entire ceiling, every inch of it. And not with fluorescent bulbs, but with the older, more-expensive-to-operate kind, the filament type. An act of sabotage, you know. I've already begun to wire the wall. A junk man I know, a man of vision, has supplied me with wire and sockets. Nothing, storm or flood, must get in the way of our need for light and ever more and brighter light. The truth is the light and light is the truth. When I finish all four walls, then I'll start on the floor. Just how that will go, I don't know. Yet when you have lived invisible as long as I have you develop a certain ingenuity. I'll solve the problem. And maybe I'll invent a gadget to place my coffee pot on the fire while I lie in bed, and even invent a gadget to warm my bed—like the fellow I saw in one of the picture magazines who made himself a gadget to warm his shoes! Though invisible, I am in the great American tradition of tinkers. That makes me kin to Ford, Edison and Franklin. Call me, since I have a theory and a concept, a "thinker-tinker." Yes, I'll warm my shoes; they need it, they're usually full of holes. I'll do that and more.

Now I have one radio-phonograph; I plan to have five. There is a certain acoustical deadness in my hole, and when I have music I want to *feel* its vibration, not only with my ear but with my whole body. I'd like to hear five recordings of Louis Armstrong playing and singing "What Did I Do to Be So Black and Blue"—all at the same time. Sometimes now I listen to Louis while I have my favorite dessert of vanilla ice cream and sloe gin. I pour the red liquid over the white CD-2, 15 mound, watching it glisten and the vapor rising as Louis bends that military instrument into a beam of lyrical sound. Perhaps I like Louis Armstrong because he's made poetry out of being invisible. I think it must be because he's unaware that he *is* invisible. And my own grasp of invisibility aids me to understand his music. Once when I asked for a cigarette, some jokers gave me a reefer, which I lighted when I got home and sat listening to my phonograph. It was a strange evening. Invisibility, let me explain, gives one a slightly different sense of time, you're never quite on the beat. Sometimes you're

ahead and sometimes behind. Instead of the swift and imperceptible flowing of time, you are aware of its nodes, those points where time stands still or from which it leaps ahead. And you slip into the breaks and look around. That's what you hear vaguely in Louis' music.

Once I saw a prizefighter boxing a yokel. The fighter was swift and amazingly scientific. His body was one violent flow of rapid rhythmic action. He hit the yokel a hundred times while the yokel held up his arms in stunned surprise. But suddenly the yokel, rolling about in the gale of boxing gloves, struck one blow and knocked science, speed and footwork as cold as a well-digger's posterior. The smart money hit the canvas. The long shot got the nod. The yokel had simply stepped inside of his opponent's sense of time. So under the spell of the reefer I discovered a new analytical way of listening to music. The unheard sounds came through, and each melodic line existed of itself, stood out clearly from all the rest, said its piece, and waited patiently for the other voices to speak. That night I found myself hearing not only in time, but in space as well. I not only entered the music but descended, like Dante, into its depths. And *beneath the swiftness of the hot tempo there was a slower tempo and a cave and I entered it and looked around and heard an old woman singing a spiritual as full of Weltschmerz as flamenco, and beneath that lay a still lower level on which I saw a beautiful girl the color of ivory pleading in a voice like my mother's as she stood before a group of slaveowners who bid for her naked body, and below that I found a lower level and a more rapid tempo and I heard someone shout:*

"Brothers and sisters, my text this morning is the 'Blackness of Blackness.'"

And a congregation of voices answered: "That blackness is most black, brother, most black . . ."

"In the beginning . . ."

"At the very start," they cried.

". . . there was blackness . . ."

"Preach it . . ."

". . . and the sun . . ."

"The sun, Lawd . . ."

". . . was bloody red . . ."

"Red . . ."

"Now black is . . ." the preacher shouted.

"Bloody . . ."

"I said black is . . ."

"Preach it, brother . . ."

". . . an' black ain't . . ."

"Red, Lawd, red: He said it's red!"

"Amen, brother . . ."

"Black will git you . . ."

"Yes, it will . . ."

"Yes, it will . . ."

". . . an' black won't . . ."

"Naw, it won't!"

"It do . . ."

"It do, Lawd . . ."

". . . an' it don't."

"Halleluiah . . ."

". . . It'll put you, glory, glory, Oh my Lawd, in the whale's belly.*"*

"Preach it, dear brother . . ."

". . . an' make you tempt . . ."

"Good God a-mighty!"

"Old Aunt Nelly!"

"Black will make you . . ."

"Black . . ."

". . . or black will un-make you."

"Ain't it the truth, Lawd?"

And at that point a voice of trombone timbre screamed at me, "Git out of here, you fool! Is you ready to commit treason?"

And I tore myself away, hearing the old singer of spirituals moaning, "Go curse your God, boy, and die."

I stopped and questioned her, asked her what was wrong.

"I dearly loved my master, son," she said.

"You should have hated him," I said.

"He gave me several sons," she said, "and because I loved my sons I learned to love their father though I hated him too."

"I too have become acquainted with ambivalence," I said. "That's why I'm here."

"What's that?"

"Nothing, a word that doesn't explain it. Why do you moan?"

"I moan this way 'cause he's dead," she said.

"Then tell me, who is that laughing upstairs?"

"Them's my sons. They glad."

"Yes, I can understand that too," I said.

"I laughs too, but I moans too. He promised to set us free but he never could bring hisself to do it. Still I loved him . . ."

"Loved him? You mean . . . ?"

"Oh yes, but I loved something else even more."

"What more?"

"Freedom."

"Freedom," I said. "Maybe freedom lies in hating."

"Naw, son, it's in loving. I loved him and give him the poison and he withered away like a frost-bit apple. Them boys woulda tore him to pieces with they home-made knives."

"A mistake was made somewhere," I said, "I'm confused." And I wished to say other things, but the laughter upstairs became too loud and moan-like for me and I tried to break out of it, but I couldn't. Just as I was leaving I felt an urgent desire to ask her what freedom was and went back. She sat with her head in her hands, moaning softly; her leather-brown face was filled with sadness.

"Old woman, what is this freedom you love so well?" I asked around a corner of my mind.

She looked surprised, then thoughtful, then baffled. "I done forgot, son. It's all mixed up. First I think it's one thing, then I think it's another. It gits my head to spinning. I guess now it ain't nothing but knowing how to say what I got up in my head. But it's a hard job, son. Too much is done happen to me in too short a time. Hit's like I have a fever. Ever' time I starts to walk my head gits to swirling and I falls down. Or if it ain't that, it's the boys; they gits to laughing and wants to kill up the white folks. They's bitter, that's what they is . . ."

"But what about freedom?"

"Leave me 'lone, boy; my head aches!"

I left her, feeling dizzy myself. I didn't get far.

Suddenly one of the sons, a big fellow six feet tall, appeared out of nowhere and struck me with his fist.

"What's the matter, man?" I cried.

"You made Ma cry!"

"But how?" I said, dodging a blow.

"Askin' her them questions, that's how. Git outa here and stay, and next time you got questions like that, ask yourself!"

He held me in a grip like cold stone, his fingers fastening upon my windpipe until I thought I would suffocate before he finally allowed me to go. I stumbled about dazed, the music beating hysterically in my ears. It was dark. My head cleared and I wandered down a dark narrow passage, thinking I heard his footsteps hurrying behind me. I was sore, and into my being had come a profound craving for tranquility, for peace and quiet, a state I felt I could never achieve. For one thing, the trumpet was blaring and the rhythm was too hectic. A tom-tom beating like heart-thuds began drowning out the trumpet, filling my ears. I longed for water and I heard it rushing through the cold mains my fingers touched as I felt my way, but I couldn't stop to search because of the footsteps behind me.

"Hey, Ras," I called. "Is it you, Destroyer? Rinehart?"

No answer, only the rhythmic footsteps behind me. Once I tried crossing the road, but a speeding machine struck me, scraping the skin from my leg as it roared past.

Then somehow I came out of it, ascending hastily from this underworld of sound to hear Louis Armstrong innocently asking,

*What did I do
To be so black
And blue?*

CD-2, 15

At first I was afraid; this familiar music had demanded action, the kind of which I was incapable, and yet had I lingered there beneath the surface I might have attempted to act. Nevertheless, I know now that few really listen to this music. I sat on the chair's edge in a soaking sweat, as though each of my 1,369 bulbs had everyone become a klieg light in an individual setting for a third degree with Ras and Rinehart in charge. It was exhausting—as though I had held my breath continuously for an hour under the terrifying serenity that comes from days of intense hunger. And yet, it was a strangely satisfying experience for an invisible man to hear the silence of sound. I had discovered unrecognized compulsions of my being—even though I could not answer "yes" to their promptings. I haven't smoked a reefer since, however; not because they're illegal, but because to *see* around corners is enough (that is not unusual when you are invisible). But to hear around them is too much; it inhibits action. And despite Brother Jack and all that sad, lost period of the Brotherhood, I believe in nothing if not in action.

Please, a definition: A hibernation is a covert preparation for a more overt action.

Besides, the drug destroys one's sense of time completely. If that happened, I might forget to dodge some bright morning and some cluck would run me down with an orange and yellow street car, or a bilious bus! Or I might forget to leave my hole when the moment for action presents itself.

Meanwhile I enjoy my life with the compliments of Monopolated Light & Power. Since you never recognize me even when in closest contact with me, and since, no doubt, you'll hardly believe that I exist, it won't matter if you know that I tapped a power line leading into the building and ran it into my hole in the ground. Before that I lived in the darkness into which I was chased, but now I see. I've illuminated the blackness of my invisibility—and vice versa. And so I play the invisible music of my isolation. The last statement doesn't seem just right, does it? But it is; you hear this music simply because music is heard and seldom seen, except by musicians. Could this compulsion to put invisibility down in black and white be thus an urge to make music of invisibility? But I am an orator, a rabble rouser—Am? I *was,* and perhaps shall be again. Who knows? All sickness is not unto death, neither is invisibility.

I can hear you say, "What a horrible, irresponsible bastard!" And you're right. I leap to agree with you. I am one of the most irresponsible beings that ever lived. Irresponsibility is part of my invisibility; any way you face it, it is a denial. But to whom can I be responsible, and why should I be, when you refuse to see me? And wait until I reveal how truly irresponsible I am. Responsibility rests upon recognition, and recognition is a form of agreement. Take the man whom I almost killed: Who was responsible for that near murder—I? I don't think so, and I refuse it. I won't buy it. You can't give it to me. *He* bumped *me, he* insulted *me.* Shouldn't he, for his own personal safety, have recognized my hysteria,

my "danger potential"? He, let us say, was lost in a dream world. But didn't *he* control that dream world—which, alas, is only too real!—and didn't *he* rule me out of it? And if he had yelled for a policeman, wouldn't *I* have been taken for the offending one? Yes, yes, yes! Let me agree with you, I was the irresponsible one; for I should have used my knife to protect the higher interests of society. Some day that kind of foolishness will cause us tragic trouble. All dreamers and sleepwalkers must pay the price, and even the invisible victim is responsible for the fate of all. But I shirked that responsibility; I became too snarled in the incompatible notions that buzzed within my brain. I was a coward . . .

But what did *I* do to be so blue? Bear with me.

COMMENTS AND QUESTIONS

1. In a satire titled *Black No More,* George Schuyler, a Harlem Renaissance novelist, conceived of a plot in which the "Negro Problem" was solved by "electrical nutrition," a process that changed the texture of the hair, the skin color, and other facial features of black people, thereby making them all white. Douglas Turner Ward's *Day of Absence* is a play about the same subject: the disappearance of blacks from a southern town. Is the disappearance and resulting "invisibility" of African Americans by means of assimilation, isolation, or destruction an event that may one day come to pass?

2. The protagonist acknowledges that he is in hiding, but describes his state as "hibernation." What type of life do you foresee for him after his state of hibernation?

3. How might Dostoevsky's *Notes from Underground* have influenced this novel?

4. In what sense is the protagonist's dilemma an "existential" one? How would Sartre analyze it?

5. The Prologue to *Invisible Man* clearly employs the blues motif. What role, if any, does jazz play?

ALLEN GINSBERG

Sunflower Sutra

I walked on the banks of the tincan banana dock and
 sat down under the huge shade of a Southern Pacific
 locomotive to look at the sunset over the box house
 hills and cry.
Jack Kerouac sat beside me on a busted rusty iron pole,
 companion, we thought the same thoughts of the
 soul, bleak and blue and sad-eyed, surrounded by
 the gnarled steel roots of trees of machinery.

The oily water on the river mirrored by the red sky, sun
 sank on top of final Frisco peaks, no fish in that
 stream, no hermit in those mounts, just ourselves
 rheumy-eyed and hungover like old bums on the
 riverbank, tired and wily.
Look at the Sunflower, he said, there was a dead gray
 shadow against the sky, big as a man, sitting dry on
 top of a pile of ancient sawdust—
—I rushed up enchanted—it was my first sunflower,
 memories of Blake—my visions—Harlem
and Hells of the Eastern rivers, bridges clanking, Joes
 Greasy Sandwiches, dead baby carriages, black
 treadless tires forgotten and unretreaded, the poem
 of the riverbank, condoms & pots, steel knives,
 nothing stainless, only the dank muck and the razor
 sharp artifacts passing into the past—
and the gray Sunflower poised against the sunset,
 crackly bleak and dusty with the smut and smog and
 smoke of olden locomotives in its eye—
corolla of bleary spikes pushed down and broken like a
 battered crown, seeds fallen out of its face, soon-
 to-be-toothless mouth of sunny air, sunrays obliter-
 ated on its hairy head like a dried wire spiderweb,
leaves stuck out like arms out of the stem, gestures
 from the sawdust root, broke pieces of plaster fallen
 out of the black twigs, a dead fly in its ear,
Unholy battered old thing you were, my sunflower O
 my soul, I loved you then!
The grime was no man's grime but death and human
 locomotives,
all that dress of dust, that veil of darkened railroad
 skin, that smog of cheek, that eyelid of black
 mis'ry, that sooty hand or phallus or protuberance of
 artificial worse-than-dirt—industrial—modern—all
 that civilization spotting your crazy golden crown—
and those blear thoughts of death and dusty loveless
 eyes and ends and withered roots below, in the
 home-pile of sand and sawdust, rubber dollar bills,
 skin of machinery, the guts and innards of the weep-
 ing coughing car, . . .
entangled in your mummied roots—and you there
 standing before me in the sunset, all your glory in
 your form!
A perfect beauty of a sunflower! a perfect excellent
 lovely sunflower existence! a sweet natural eye to the
 new hip moon, woke up alive and excited grasping
 in the sunset shadow sunrise golden monthly breeze!
How many flies buzzed round you innocent of your
 grime, while you cursed the heavens of the railroad
 and your flower soul?
Poor dead flower? when did you forget you were a
 flower? when did you look at your skin and decide
 you were an impotent dirty old locomotive? the
 ghost of a locomotive? the specter and shade of a
 once powerful mad American locomotive?
You were never no locomotive, Sunflower, you were a
 sunflower!

And you Locomotive, you are a locomotive, forget me
 not!
So I grabbed up the skeleton thick sunflower and stuck
 it at my side like a scepter,
and deliver my sermon to my soul, and Jack's soul too,
 and anyone who'll listen,
—We're not our skin of grime, we're not our dread
 bleak dusty imageless locomotive, we're all beautiful
 golden sunflowers inside, we're blessed by our own
 seed & golden hairy naked accomplishment-bodies
 growing into mad black formal sunflowers in the
 sunset, spied on by our eyes under the shadow of the
 mad locomotive riverbank sunset Frisco hilly tincan
 evening sitdown vision.

COMMENTS AND QUESTIONS

1. A *sutra,* or a dialogue with the Buddha, is part of
 Buddhist scripture. How does Ginsberg fit this In-
 dian, spiritual notion into his very material Ameri-
 can poem?

2. What is the effect of all the lists of objects?

3. What do you think that the sunflower represents?
 And the locomotive?

Frantz Fanon

from *The Wretched of the Earth*
Translation by Constance Farrington

Frantz Fanon was born on the French Caribbean is-
land of Martinique. Educated in France as a psychi-
atrist, in the 1950s he went to Algeria to serve in
hospitals. The context was an intense, prolonged
war of decolonization, with entrenched settlers and
the army pitched against a determined revolutionary
movement. Although *The Wretched of the Earth*,
published in French in 1961, was Fanon's most fa-
mous book, he also published three others: *Black
Skin, White Masks; A Dying Colonialism;* and *To-
ward the African Revolution.* Fanon is widely re-
garded as the leading prophet and theoretician of the
African revolution. Many of his ideas, such as his
analysis of the role of the political party, have antici-
pated or inspired extensive academic discussions. He
died of cancer in 1961, in an American hospital,
when he was only thirty-six.

Concerning Violence

National liberation, national renaissance, the restora-
tion of nationhood to the people, commonwealth:
whatever may be the headings used or the new for-
mulas introduced, decolonization is always a violent
phenomenon. . . .

The colonial world is a world divided into compart-
ments. . . . The settlers' town is a strongly built town, all
made of stone and steel. It is a brightly lit town. . . . The
settlers' town is a town of white people, of foreigners.
The town belonging to the colonized people . . . is a
place of ill fame, peopled by men of evil repute. . . . It is
a world without spaciousness; . . . huts are built one on
top of the other. The native town is a hungry town. . . .
It is a town of niggers and dirty Arabs. . . .

In the colonies the economic substructure is also a
superstructure. The cause is the consequence; you are
rich because you are white, you are white because you
are rich. This is why Marxist analysis should always be
slightly stretched every time we have to do with the
colonial problem. . . .

The violence which has ruled over the ordering of
the colonial world, which has ceaselessly drummed the
rhythm for the destruction of native social forms and
broken up without reserve the systems of reference of
the economy . . . , that same violence will be claimed
and taken over by the native at the moment when, de-
ciding to embody history in his own person, he surges
into the forbidden quarters. . . .

But it so happens that for the colonized people this
violence, because it constitutes their only work, invests
their characters with positive and creative qualities. The
practice of violence binds them together as a whole,
since each individual forms a violent link in the great
chain, a part of the great organism of violence which
has surged upward in reaction to the settler's violence in
the beginning. . . . At the level of individuals, violence is
a cleansing force. It frees the native from his inferiority
complex and from his despair and inaction; it makes
him fearless and restores his self-respect. . . .

The Pitfalls of National Consciousness

The national middle class which takes over power at
the end of the colonial regime is an underdeveloped
middle class. It has practically no economic power, and
in any case it is in no way commensurate with the bour-
geoisie of the mother country which it hopes to replace.
In its narcissism, the national middle class is easily con-
vinced that it can advantageously replace the middle
class of the mother country. . . .

The national economy of the period of independence
is not set on a new footing. It is still concerned with the
groundnut harvest, with the cocoa crop and the olive
yield. In the same way there is no change in the market-
ing of basic products, and not a single industry is set up
in the country. We go on sending out raw materials; we
go on being Europe's small farmers, who specialize in un-
finished products. . . . The national bourgeoisie steps into
the shoes of the former European settlement. . . . Seen
through its eyes, its mission has nothing to do with

transforming the nation; it consists of being the transmission line between the nation and a capitalism, rampant though camouflaged, which today puts on the mask of neo-colonialism. . . .

The Western bourgeoisie has prepared enough fences and railings to have no real fear of the competition of those whom it exploits and holds in contempt. Western bourgeois racial prejudice as regards the nigger and the Arab is a racism of contempt; it is a racism which minimizes what it hates. Bourgeois ideology, however, which is the proclamation of an essential equality between men, manages to appear logical in its own eyes by inviting the sub-men to become human, and to take as their prototype Western humanity as incarnate in the Western bourgeoisie. . . . The national bourgeoisie of certain underdeveloped countries has learned nothing from books. If they had looked closer at the Latin American countries they doubtless would have recognized the dangers which threaten them. . . .

Conclusion

Come, then, comrades, it would be as well to decide at once to change our ways. . . . Leave this Europe where they are never done talking of Man, yet murder men everywhere they find them, at the corner of every one of their own streets, in all the corners of the globe. For centuries they have stifled almost the whole of humanity in the name of a so-called spiritual experience. . . . When I search for Man in the technique and the style of Europe, I see only a succession of negations of man, and an avalanche of murders. . . . Let us decide not to imitate Europe; let us combine our muscles and our brains in a new direction. Let us try to create the whole man, whom Europe has been incapable of bringing to triumphant birth. . . . For Europe, for ourselves, and for humanity, comrades, we must turn over a new leaf, we must work out new concepts, and try to set afoot a new man.

COMMENTS AND QUESTIONS

1. How does Fanon characterize violence in the colonial situation? What are its causes? What roles does it play?

2. Would you call Fanon a Marxist?

3. What does Fanon have to say about European humanism and the values of the Enlightenment?

4. Does Fanon's rejection of the European tradition strike you as justified?

Summary Questions

1. What were the major conflicts of World War II?

2. What characterized the postwar period?

3. What were some of the crucial events in the struggle for black liberation?

4. What were some of the major liberation movements in Africa and Asia?

5. What issues are involved in the writing of Holocaust literature?

6. What were the major concerns of existentialism?

7. How did Simone de Beauvoir apply existentialism to feminism?

8. How do existentialist themes appear in the writings of Camus, Ellison, and the beats?

9. What were the primary characteristics of the theater of the absurd?

10. What was Charlie Parker's contribution to jazz?

11. What were some of the major trends in postwar painting and sculpture?

Key Terms

Holocaust

existentialism

German occupation of France

theater of the absurd

blues

beats

bebop

abstract expressionism

34

Postcolonialism, Postmodernism, and Beyond

To define trends that have appeared only recently is a particularly risky enterprise, especially when one is trying to characterize the direction in which the cultures of the world may be moving. Contemporary thinkers tend to characterize recent decades with some consistency, using such terms as postindustrialism, postcolonialism, posthumanism, and postmodernism. This language suggests an awareness that a significant period of historical time has ended but that no label for the recent past and the present yet seems adequate. The age of information technology and the age of globalism are possible terms, but perhaps they are not comprehensive enough. In the twenty-first century, some have suggested that the postmodern age is itself about to pass. It may be time to ask the question, What was postmodernism?

The United States from the 1960s into the Twenty-First Century

Before attempting to discuss that question, let us touch on some of the historical events and cultural trends that characterized the end of the last century and the early years of the present one. By the early 1950s, the United States was engaged in a war between its ally South Korea and communist North Korea. But the war that would have the most profound impact on American culture—and beyond—occurred a decade later in Southeast Asia.

The 1960s: The Vietnam War and the Counterculture

The large-scale involvement of the United States in Vietnam beginning in 1964 has been referred to as the last colonial war. In 1963, the United States withdrew its support from the increasingly corrupt and tyrannical South Vietnamese government of Ngo Dinh Diem and Diem was assassinated. He was succeeded by a series of generals, and the United States continued to support the succeeding governments.

Envisioning the Vietcong, the South Vietnamese resistance group supported by North Vietnam, as part of the general threat of communism to the free world, the United States until 1964 had limited its assistance to South Vietnam to financial aid and military advisers. From 1964, however, the United States

457

undertook major military operations in Vietnam, which ultimately cost the lives of over fifty thousand American soldiers. Ultimately recognizing defeat, the American government recalled its troops in 1972, and the whole of Vietnam became united under the communists.

Those eight years marked a watershed in the political life of the United States. The first major armed conflict to be brought directly into American homes via television, the Vietnam War was for the U.S. government as much a battle for citizens' support as it was a struggle against the Vietcong and the North Vietnamese. Secret invasions, exaggerated body counts, claims of winning belied repeatedly by striking enemy victories, and beneath these phenomena the burning issue of whether American troops ought to be engaged in such a war—all this evoked a degree of protest unknown in American history since the Civil War. With the protests came the countercharges regarding the motives of the protesters and the effect of demonstrations on the course of the war. Many feared that the United States was losing the basic consensus needed to keep a political body alive. Protests directed against the war in many cases developed into a critique of the entire fabric of American society. The "counterculture," led by the hippies, who had succeeded the beatniks, attracted more and more of the disaffected young, many of whom lost faith in all the basic institutions of society—government, family, church, and work.

Black Liberation

Having won passage of the Civil Rights Act of 1965, the Reverend Martin Luther King Jr., by then the leading national figure in the civil rights movement, struck out at discrimination in voting rights, an effort that led to the passage of the Voting Rights Act of 1965. The middle years of the 1960s, however, marked the rise of more militant black groups, led by people such as Stokely Carmichael and Floyd McKissick. Their slogan was "Black Power," which meant the creation of separate economic and social institutions as power bases for black communities. At the same time, these leaders expressed a willingness to meet the traditional violence the white community inflicted on blacks with violence of their own. More conservative leaders like King and Roy Wilkins, head of the NAACP, could not accept this militant stance, and the civil rights movement clearly became divided.

Through the years the movement had its martyrs, but the most stunning loss came in 1968 when King was assassinated in Memphis, Tennessee. His last effort was focused on economic disparity between blacks and whites, a problem of inequality far more difficult to resolve politically than those of segregation and voting rights. No leader of comparable stature emerged to replace King, and the movement experienced further fragmentation.

After the death of King, the apostle of nonviolence, a series of violent riots racked major American cities, such as Los Angeles, Detroit, and Washington, DC. A period of white backlash, including the flight of many white people from cities to suburbs and the formation of racist groups, followed the riots. In subsequent decades some whites increasingly resented what they viewed as the excesses of affirmative action in hiring and college admissions. However, in a 2003 decision the Supreme Court affirmed that diversity was an important factor in college admissions.

The 1970s

The humiliation in 1973 of President Richard M. Nixon, who had become closely associated with the war, served perhaps to help America close the book on one of the most politically disruptive periods in its history. The shock of the great oil shortage in the winter of 1973–1974 made Americans painfully aware again that they could no longer control the world and that a group of Middle Eastern powers could, if they wished, bring the country to economic ruin. As a whole, the decade of the 1970s was a period of renewed talk of the "decline of the West" and of skepticism about the ability of political leaders to make more than superficial improvements in society. The 1970s were also the decade that the writer Tom Wolfe characterized as that of the "me generation," with the attentions of the young and the not-so-young turned less toward revolutionizing society than toward self-fulfillment by means of encounter groups, yoga, charismatic and other nonmainstream religions, or freewheeling lifestyles, drugs, and sexual liberation. The considerable expansion of the women's movement and the gay liberation movement, however, brought out the links between the personal and the political.

The 1980s

American optimism reasserted itself in the 1980s, choosing to overlook a rapidly increasing national debt, an enormous trade imbalance, and the onslaught of foreign investors eager to buy American assets. Until the last part of the decade, the effects of these factors on the daily life of most Americans were almost imperceptible. On the other hand, the Reagan administration's policy of low taxes, a minimal inflation rate, and a buoyant stock market created something of a capitalistic idyll. The counterparts of the 1980s to the hippies of the 1960s were the yuppies—young men and women whose goals in life consisted of a pursuit of financial well-being and the latest physical comforts. Nevertheless, the drastic fall in the stock market in October 1987 chastened investor optimism, while the country increasingly confirmed its status as the world's biggest debtor nation.

The 1990s

The early 1990s witnessed the onset of an economic recession accompanied by widespread unemployment among white-collar as well as blue-collar workers and a serious loss of consumer confidence. To meet serious competition from abroad, numerous American companies downsized, closing plants or divisions, forcing older employees to take early retirement, and laying off younger employees. Jobs were available, but mostly at lower pay and generally in the service sector. By 1996, however, economic dislocation, corporate belt-tightening, and increased investment in research had shaped the American economy into a leaner, more efficient mechanism. Per capita productivity rose steeply, salaries increased while the inflation rate remained low, and consumer confidence soared. The creation of the Internet gave birth to a whole new economic sector. For the first time in the nation's history, tens of millions of Americans found their economic future tied in some way to the stock market, either through retirement plans or personal investment. While Americans entered the twenty-first century with high hopes for continued economic growth, many were only too aware of the fragility of prosperity and of the unlikelihood that the secret of sustained development had finally been discovered.

The Early Twenty-First Century

The horrific destruction of the Twin Towers of the World Trade Center in New York City by Islamic terrorists on September 11, 2001, signaled the beginning of a new era for Americans. The post-September United States overnight became a less free, open country, one suspicious of immigrants and foreign residents, especially those of Arab origin. The federal government's methods of seeking out terrorists and holding suspects, justified on grounds of national security, aroused concerns regarding the preservation of civil rights. The delicate balance between personal freedom and the need for national security has yet to be met.

Afghanistan The administration of George W. Bush earned high approval ratings for its prompt and firm response to the disaster of the Twin Towers and for its vigorous pursuit of the terrorists responsible for it. These were identified as members of Al-Qaeda, an international terrorist organization of radical Muslims headed by a rich citizen of Saudi Arabia, Osama bin Laden, who was living in exile. Headquartered in Afghanistan, Al-Qaeda was supported and protected by the Taliban, an extremist Muslim party that governed that country. In October 2001, because the Taliban refused to surrender members of Al-Qaeda, the United States and its allies, acting under the authorization of the United Nations, invaded Afghanistan and within a few months destroyed the Taliban regime and killed a large number of Al-Qaeda members.

Victory over the Taliban and Al-Qaeda by the United States and its allies was swiftly achieved, but the creation of a stable Afghanistan would be more difficult. Everywhere throughout the country local warlords, formerly kept in check by the Taliban, emerged to claim control of their particular area. In the capital, Kabul, the central government under the new president, Hamid Karzai, found its exercise of power largely limited to the region around the city. At the same time, U.S. soldiers and Afghan troops had almost daily encounters with radical Muslim insurgents who crossed over the border from neighboring Pakistan to harass the countryside. Substantial sums of foreign aid would be needed to help rebuild Afghanistan and restore its shattered economy, but unless the national government succeeded in establishing peace throughout the nation, even large investments could have little permanent effect.

Iraq In the fall of 2002, while the United States and its allies were still deeply engaged in attempting to pacify Afghanistan and initiate reconstruction efforts there, the Bush administration identified Saddam Hussein's Iraq as a further serious threat to world peace. More than a decade earlier, in 1991, backed by a U.N. resolution, the United States had fought a brief, successful war against Iraq, which had invaded neighboring Kuwait late the previous year. Having driven the Iraqi army back to its own borders, the Americans, hesitant to exceed the U.N. authorization, ceased hostilities, leaving Saddam's oppressive regime intact but forcing the dictator to agree to periodic inspections of his military arsenal by the United Nations.

In the days immediately following September 11, 2001, government officials in the United States initiated a campaign to declare war on Iraq as a supporter of Al-Qaeda terrorists. The appeal of this course of action was strengthened by intelligence reports that Iraq had developed weapons of mass destruction and that it had the capability of launching an attack on the United States within forty-eight hours. Demands by the United States and by the United Nations that Saddam Hussein readmit weapons inspectors, whom he had expelled in 1994, were finally met, but even when inspectors on the ground found no trace of these weapons, it was difficult to know whether or not there were hidden arsenals.

In March 2003, after the Bush administration failed to obtain U.N. approval for a preemptive war, the United States with a coalition composed of Britain, Spain, and a mixture of small states launched an invasion of Iraq. While the generally unpopular regime of Saddam collapsed within a few weeks, the coalition was faced with the difficult task of pacifying a country sharply divided into Shiite and Sunni Muslims, Arabs,

and Kurds, and where significant remnants of Saddam supporters remained to carry on guerrilla warfare. As American casualties mounted in the postwar period and enormous sums of money were requested to pay for the occupation and reconstruction of Iraq, serious doubts were raised in the United States as to the original justification of the war. No weapons of mass destruction were found, and the administration acknowledged that it had no proof of any connection between Al-Qaeda and Saddam. Nonetheless, there was general agreement that a brutal dictatorship had been eliminated with the invasion and that the United States had to remain in Iraq to help the Iraqis rebuild their country and establish a democratic government. Were these two goals to be achieved, Iraq would become a model for the whole Middle East and the costs to the United States justified.

The U.S. Economy Already at the very end of 2000, the American economy had shown signs of weakening. Demand had slackened, and inventories had been accumulating. The public, however, was unprepared for the revelation in 2001 that some of the country's largest companies had inflated the value of their stock by falsifying their records and that highly respected accounting firms had intentionally endorsed or overlooked the deceit. The economic dislocation in New York City, the financial hub of the United States, immediately after September 11 only added to the sense of unease among consumers. Although still expanding, if at a much slower rate than in the 1990s, the U.S. economy proved unable to absorb new workers coming into the job market while foreign competition created serious unemployment in selected industries.

In an effort to jumpstart the economy, the Bush administration late in 2001 propelled through Congress a large tax cut highly favorable to upper-income groups in the expectation that increased personal savings would be used for investment and consumption. While federal revenue diminished, the costs of homeland security and of war and reconstruction in Afghanistan and Iraq raised the official federal deficit to record levels. Had not the government drawn on the huge surplus from Social Security payments, however, the deficit would have been more than double. But would Social Security remain solvent in the next decade when the large "baby-boom generation," born shortly after World War II, was ready to retire? Furthermore, the cut in federal appropriations for the states shifted a heavier burden onto state treasuries and resulted in significant reduction of services in many of them. Given the commitments of the United States to two war-torn countries and the need to keep the homeland secure, it is difficult to envisage any significant relief for the federal deficit in the near future.

The World After the Cold War

The preeminent role of the United States in world politics in 2003 was the product of a recent sea change in the world's balance of power. In 1989 the political system ruled by the two superpowers, which had maintained an enduring, if unstable, international balance since the end of World War II, began to disintegrate rapidly. The next two years witnessed the reunification of Germany under democratic rule, the replacement of communist regimes by democratic ones in most of Eastern Europe, and the breakup of the Soviet Union itself into fifteen independent republics, many of them established on an ethnic basis.

The United States emerged in the 1990s as the single great superpower, yet its capacity for policing the world and supplying economic assistance abroad was severely limited by needs at home and the disposition of its own citizens. The intense civil wars caused by religious and ethnic animosities in Bosnia (part of former Yugoslavia) in 1993 to 1995 and in Kosovo, a region of Serbia, in 1999 provided dramatic instances of the new kind of challenge confronting the United States. Hopes that the United Nations would prove an effective military alternative to unilateral action by the United States were severely tested in both these conflicts. President Bill Clinton's intention to participate in the United Nations' peace-keeping operations by sending a contingent of American soldiers encountered tough resistance at home from those who felt that American interests were not sufficiently strong in these areas to warrant the possible sacrifice of American lives.

Israel and the Arab Middle East

The victory of Israel over the surrounding Arab states in 1967, the third in a succession of wars, resulted in its occupation of Egypt's Sinai Peninsula in the south and west, of lands east to the Jordan River (the West Bank), of the Golan Heights in Syria, and of the Gaza Strip on the Mediterranean coast. Apart from the Sinai, restored to Egypt in 1979, Israel continued to occupy these territories. To better establish its control, the Israeli government actively encouraged Jewish settlement of the conquered areas. Serious efforts between 1993 and 1995 to negotiate a peace accord that allowed for Palestinian self-rule in the Gaza Strip and West Bank were frustrated by fundamentalist groups on both sides who opposed any partition, each arguing for their own peoples' rights to an undivided land. In the aftermath of the assassination of the Israeli prime minister Yitzak Rabin in November 1995, any efforts to negotiate peace were increasingly thwarted by the growing strength of militant opposition and the increased political role of Jewish settlers on the West Bank, as well as by the actions

of Palestinian groups, which served to intensify Israeli mistrust of the process.

In 1987 the population of the West Bank and Gaza expressed growing frustration in an uprising (the first intifada) against the occupation, which was characterized by the throwing of stones, mass demonstrations, and strikes. At the same time, groups such as Islamic Jihad and Hamas resorted to more violent means as well. Signed in 1993 in Oslo, Norway, the truce known as the Oslo Accords laid out a roadmap for establishing a peace agreement between the two parties, but opposition by some Palestinians to the "peace process" resulted in actions such as suicide bombings. The Israeli response was a hardening of position. In 2000, after the failure of yet another effort at negotiated settlement, Palestinians reacted with what has been referred to as the al-Aqsa intifada and Israelis reacted with intensified military efforts at suppression. The Israeli army reoccupied most of the areas that had been turned over to the Palestinian Authority in the course of years of negotiation.

Efforts by the United States to mediate between the two parties have consistently failed to overcome long-standing perceptions of American favoritism toward Israel. The view that the United States is committed to advancing Israeli interests has in fact colored Arab perceptions of the entire policy of the United States toward the Middle East. Until some way has been found to settle the claims of Palestinians to land they have traditionally occupied and of Israelis for whom Palestine is the promised land, the conflict between these two peoples will continue to serve as a focal point for the unsettled relations between the United States and the Arab nations of the Middle East.

Globalization

The term *global village*, now used to describe the human community on the planet Earth, suggests a world of intense interaction for which there is a possibility of creating a unitary policy focused on common interests. The continued expansion of mass communication via television and the Internet and the construction of a massive economic machine operating worldwide have brought this possibility closer to realization. While the construction of a more integrated world community seems almost inevitable, nationalists lament the tendency, while others disagree with the way *globalization* is being accomplished. The policy of most governments, including that of the United States, is founded on the belief that global free trade promotes economic growth throughout the world. In this view, free trade creates jobs, renders companies more competitive, and reduces consumer prices. Infusions of capital and technology to poorer nations through the World Bank and the International Monetary Fund afford them the opportunity to develop economically, and their prosperity will create conditions that favor democracy and respect for human rights.

Opponents of the present course toward globalization point to enormous job losses in certain sectors of highly developed economies to foreign countries where similar goods can be produced at significantly lower costs. Others maintain that the deregulation of international commerce is depriving governments in poorer countries of the ability to resist exploitation by international corporations, thus prolonging the old colonialism in a new form. They argue that the austerity programs imposed on debtor nations have resulted, among other things, in cuts in expenditures for health and education; reduction of government subsidies for food, energy, and so on; and increased ownership of local resources by foreigners. Lured by the promise of generous loans, poor nations have often entered into monumental projects that have proved useless but have ruined the environment and saddled the country with massive debts. The weakness of the opposition to the official approach lies in its failure to offer a practical alternative to working through these international institutions. Pushed technologically and economically as we are toward a more unified world, perhaps the managers of international development can be more responsive to real concerns raised by dissidents.

Immigration

Nowhere is globalization more dramatically demonstrated than in the immigration of large numbers of people from poorer to richer countries: North Africans to France, Indians and Pakistanis to Britain, Nigerians and Albanians to Italy, Palestinians to the Arab Emirates, Turks to Germany, Mexicans and Central Americans to the United States. The need for immigrants has been especially felt in western European nations where birth rates have fallen and the population is increasingly aging. Without the continued influx of labor from beyond their borders, the reduced number of workers would eventually be unable to maintain the economy. In England and France, the majority of immigrants come from the former colonies of those two nations. With Islam now the second largest religion in France (after Roman Catholicism) and with various British residents of Asian, African, and Caribbean origins, the former imperial nations must now learn to deal with the reality of a multicultural society within their own borders.

The booming American economy of the late 1990s created a severe shortage of both skilled and unskilled labor that promised to stunt further development. The economic difficulties of the early years of the new

millennium did not, however, significantly slow the rate of immigration from the Caribbean, Central America, Mexico, and South Asia. As a result, within a few decades the racial balance in a number of U.S. cities has been radically altered. Spanish is now the main language in many large communities. In a nation where, historically, immigrants and minorities eagerly sought to fit into the mainstream, there is increasing concern among recent immigrant groups about maintaining their cultural identity. In any case, American *multiculturalism* is now a reality.

Postcolonialism

The 1980s and 1990s witnessed the rise of the postcolonial movement in countries that had formerly been colonies of European powers. This movement focused on imperialism as a cultural process that subverted traditional societies and westernized them in regard to language, religion, literature, and other arts. This postcolonial phenomenon had already been suggested by Frantz Fanon (see Chapter 33), who had an important influence on postcolonial thinking. Western experts, argued the Palestinian American critic Edward Said in his widely discussed book *Orientalism* (1978), took possession of colonized cultures and re-created them in their own interests. The thrust of the postcolonial movement is to ferret out and discard Western assumptions and stereotypes that still pervade the mentalities of many in former colonial countries. In India, for example, historians sympathetic to *postcolonialism* insist that undue attention has been paid to the role of westernized leaders—Mahatma Gandhi or Jawaharlal Nehru, the first prime minister—and that the role of subaltern classes—peasants, workers, and women—which follow their own agenda and timetable for liberation, has been neglected.

One early manifestation of the postcolonial type of thinking that preceded Frantz Fanon was the *négritude* movement discussed in Chapter 32. This movement was to have an impact throughout Africa and among African Americans, in art and literature as well as in politics. Some English-speaking black intellectuals, however, viewed it with suspicion. The Nigerian writer and Nobel laureate Wole Soyinka criticized the ideology and poetry of *négritude* because they romanticized Africa and celebrated the past instead of dealing with present reality and social problems. African American writers and intellectuals seemed divided between those who insisted that their culture was more American than African and those who looked toward a worldwide spiritual unity of black people and a polemic against the dominant values and ideals of Western civilization. In politics, these divisions came to a head with the civil rights movement and its aftermath.

Sexual Politics

Issues involving women's rights seem to come to the forefront and then subside at various times throughout Western history. We have seen various feminist questions addressed in Mary Wollstonecraft's *Vindication of the Rights of Woman*, in John Stuart Mill's *On the Subjection of Women*, in the *Declaration of Sentiments* (read at the 1848 Seneca Falls Convention), in Virginia Woolf's *A Room of One's Own*, and in Simone de Beauvoir's *The Second Sex*. In the decades following the women's suffrage movement of the 1920s, once women had obtained the vote in England and America, feminist issues gave way to the more immediately urgent problems posed by the Depression and World War II. But the movement had been launched. Women who took over men's jobs while the men were fighting in the war learned that they could do "men's work." Simone de Beauvoir's groundbreaking work, published in 1948, just three years after the end of the war and after women had obtained the vote in France, attracted attention but stood alone. The decade of the 1950s, on both sides of the Atlantic, saw the majority of women returning to their traditional roles and the ideal of the "nurturer" of husband and children. To be "feminine" was to stay in one's place, not to be assertive. This conception of femininity was attacked by Betty Friedan in another groundbreaking work, *The Feminine Mystique* (1963), which was influenced by *The Second Sex*.

It was not until the 1970s that the women's movement really mushroomed, profoundly affecting the lives of women of all ages and social classes. Kate Millett published her influential *Sexual Politics* in 1970, and the title was picked up as a way of saying that personal matters are also political. The National Organization for Women, with Betty Friedan as president, was founded; and other women's groups all along the political spectrum sprang up. The Supreme Court's decision in the *Roe v. Wade* case in 1973 made women's right to abortion legal in the United States.

By 1995, with the convening of an international women's conference in Beijing, concern for women's rights had become a worldwide issue. Then and now, women and children constitute the majority of the world's poor, and women still lag behind men economically in the developed as well as the developing countries. The question of women's reproductive rights, including abortion, remains highly controversial throughout the world.

Meanwhile, in some universities, "women's studies" has given way to "gender studies." "Does gender make a difference?" is perhaps the most frequently asked question in areas as diverse as physics and history, as well as literature and the arts. The concept of

gender studies implies a sexual politics that transcends the battles between the two sexes. Some, by extending de Beauvoir's idea that "one is not born, but rather made, a woman," claim that the notion of gender is primarily a social construction.

In recent years gay men and lesbians have also made their voices heard in the struggle for recognition and equality. University programs in gay and lesbian studies have joined the earlier programs in black and women's studies and have brought attention to the historical and present contributions of gay people in all fields. Despite continued opposition to their demands, gays and lesbians are increasingly pushing for marriages (or for legal recognition of civil unions, as in Vermont), for child custody rights, and for stronger protection against discrimination, particularly in employment. They have also successfully demanded more research efforts for the cure of AIDS, an epidemic that has become increasingly threatening to the world and that, in Africa, kills more women than men. Clearly, the kinds of questions and the new ways of thinking that have come from feminists and gays, along with Afrocentric, postcolonial, and multicultural approaches, challenge the universalizing center of the humanities that was once known as Western man.

The Arts in the Contemporary World

In the last few decades, one black African and two African Americans have won the Nobel Prize for literature: Wole Soyinka of Nigeria (1986), Derek Walcott of St. Lucia in the West Indies (1991), and Toni Morrison of the United States (1993). One could also include in this list V. S. Naipaul, of Indian descent, but from the predominantly ethnically African island of Trinidad (2001) and J. M. Coetzee, a white South African (2003). This is only one indication of the importance that literature, and to some extent other arts, from the African continent and by artists of African descent elsewhere have assumed on the world scene.

African Literature, 1948–2000

With the publication of *Anthologie de la nouvelle poésie nègre et malgache de langue française (Anthology of the New Negro and Madagascan Poetry)* in 1948, Léopold Sédar Senghor placed before the world the poets of the *négritude* movement, whose inspiration first stirred in Paris during the 1920s (see Chapter 32). In his introduction to the anthology, Jean-Paul Sartre wrote that "for three thousand years the white man has enjoyed the privilege of seeing without being seen. . . . Today, these black men are looking at us, and our gaze comes back

to our own eyes."[1] These words suggest the movement's preoccupation with Europe and the contrasts to their homelands that their experience made plain.

Fiction writers soon followed as the pace of decolonization moved quickly toward the independence of the African colonies. In 1954, Camara Laye published (in French) *The African Child*, a story of his African childhood and early years of French schooling in Guinea. The Nigerian Chinua Achebe followed four years later with *Things Fall Apart* (in English), in which he portrayed the encounter of his people, the Ibo, with the West at the onset of colonialism. Not only has this novel been published in more languages than virtually any other African novel, but also the themes Achebe raises, and his stylistic attention to the legacy of the oral tradition, shaped the first generation of writers of independent Africa.

During the 1960s, African writers continued to explain the African past to their Western audience. They showed that far from being "backward," precolonial societies had had their own coherent traditions, heroes, and villains, just as European ones had. These writers strove to translate indigenous social life and beliefs for non-African readers. A second prominent theme was the impact of the West, usually portrayed as a negative one, on African societies through the colonial experience. Even if they did not concentrate on the brutal aspects of colonialism (as some of the *négritude* writers had), these writers viewed the long-range effect of Western values as distorting and corrupting African societies.

By the late 1960s and early 1970s, some African writers began to write more critically of the African past by portraying the oppressive features of precolonial states. This theme mirrored the artists' dismay at the rise of dictatorships in postindependent Africa and soon developed into full-fledged critiques of African leadership. Some, like Wole Soyinka, sought direction for the present by highlighting the moral integrity of indigenous culture (as opposed to the corrupting influences of the West). Others, like Wathiong'o Ngugi of Kenya and Ousmane Sembene of Senegal, adopted more materialist interpretations of the colonial experience and early postcolonial states and explored the evils of ruling elites seduced by capitalist gains.

Women, both as fictional subjects and as writers, were few in number until the 1970s and 1980s. Ama Atta Aidoo (Ghana), Flora Nwapa (Nigeria), Grace Ogot (Kenya), and Bessie Head (Botswana) led the way. Their perspectives made manifest richer interpretations of African life by incorporating the experience of the female world. Mariama Bâ of Senegal and Tsitsi

[1] Quoted in C.W.E. Bigsby, *The Black American Writer II* (Baltimore, MD: Penguin, 1971), pp. 5–6.

Dangaremgba of Zimbabwe wrote poignantly in their novels *So Long a Letter* and *Nervous Conditions* about women's response to Western culture and colonial rule. They convey with great power the tension of treading a fine line between decrying the patriarchy in African cultures and acknowledging the dangers of Western class and hierarchical social values.

Authors from Zimbabwe and South Africa were preoccupied with the struggle for liberation from white supremacy. During the apartheid years, poets such as Dennis Brutus and Mazisi Kunene conveyed the stifling of African hopes for freedom. Like the artists of precolonial Africa, postcolonial African writers strive to create explanations of the past and models for the future; their art is socially engaged in their homelands.

Writing and the African Diaspora

Négritude had its effect on both African and African American writers, although in various ways. Wole Soyinka and other English-speaking Africans criticized the movement's ideology because it romanticized Africa and the past. Writing by modern Africans, according to them, should serve a more critical function by dealing with contemporary social realities. Americans such as Ralph Ellison and James Baldwin insisted that the culture of the African American was more American than African. In the 1960s, however, the movement known as the *black aesthetic,* which grew out of the radical groups of the civil rights era, looked toward Africa and *négritude* in its proclaimed struggle against traditional Western values and norms and its search for a spiritual union of black people throughout the world. Black aesthetic writers such as Amiri Baraka (formerly LeRoi Jones), Ishmael Reed (b. 1938), and Sonia Sanchez (b. 1934) began to address themselves to other blacks by investing their work with the distinctive language and rhythms of the ghetto. Poetry, for them, needed to be in touch with the real joys, sorrows, and concerns of the black masses. Like Langston Hughes before them, they turned to jazz, particularly to the highly original music of John Coltrane, for inspiration. Writers of African descent from the Caribbean had been influenced by *négritude* from the beginning since one of its French-speaking founders, Aimé Césaire, was from the island of Martinique. Derek Walcott (b. 1930), however, explores the multicultural civilization of the islands. Of mixed race himself (his mother was white and his father black), he was raised as an English-speaking Protestant on an island where most inhabitants were Catholic and spoke a French Creole. Walcott also feels a strong connection with the cultures of the Spanish-speaking islands and South America. In his writings, he uses themes from the Carib Indians as well as from Europe, Africa, and the Americas. One of his best works, *Omeros* (1990), a long epic poem, rewrites Homer's *Iliad* in a Caribbean setting.

In recent decades, many African American writers from the United States have moved beyond the black aesthetic in the interests of addressing a larger audience. Toni Morrison succeeds in reaching a worldwide reading public with her rich and diverse style; she communicates both the African American reality and its universal human dimensions. Alice Walker, winner of a Pulitzer Prize for literature, combines feminist, racial, and universally human themes in what can be characterized as postmodern forms. Younger writers, such as the poet Rita Dove (b. 1952), have declared their desire to reject the narrow focus of the black aesthetic movement. Although Dove does write about figures in black history and about racial injustice, she declared in a 1991 interview:

> As an artist, I shun political considerations and racial or gender partiality; for example, I would find it a breach of my integrity as a writer to create a character for didactic or propaganda purposes, like concocting a strong black heroine, an idealized so-called role model, just to promote a positive image.[2]

New African Art

By the mid-twentieth century, young artists trained in Western schools began creating work that utilized materials less familiar in older traditions of African visual art, but that made clear the enduring significance of indigenous icons to their lives. In *Ogunic Exploits,* 1992, (Color Plate XXXIV), Moyo Okedeji utilizes intense color and rhythm reminiscent of African textiles to convey the dual metaphors of the Yoruba god of iron— destruction and creativity—as they transformed the artist in a psychic encounter. Ogun's power lashes out through the hooves of the horse "mounting," or possessing, the artist, prone against the bottom left border. Other hooves strike the woman in the midst of childbirth and her child. Yet the infant derives nourishment from the dog, which, as the animal sacrificed to Ogun, establishes communication between the mortal and immortal worlds. In the painting, Okedeji projects this encounter as a journey of return to the spiritual sources of his culture.[3]

[2] Quoted in Henry Gates and Nellie McKay, eds., *The Norton Anthology of African American Literature* (New York: W. W. Norton, 1997), p. 2582.

[3] Moyo Okedeji, "Of Gaboon Vipers and Guinea Corn: Iconographic Kinship Across the Atlantic," in *Contemporary Textures: Multidimensionality in Nigerian Art,* ed. Nkiru Nzegwe (Binghamton, NY: International Society for the Study of Africa, 1999), pp. 43–68, and "Returnee Recollections. Transatlantic Transformations," in *Transatlantic Dialogue: Contemporary Art In and Out of Africa,* ed. Michael D. Harris (Chapel Hill: Ackland Art Museum, University of North Carolina at Chapel Hill, 1999), pp. 32–51, painting on p. 72.

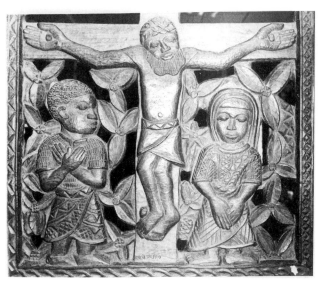

34-1 *Osagie Osifo,* Crucifixion, *1961. Wood panel for Catholic Chapel in Ibadan, Nigeria. 32". (Frank Willett,* African Art *[New York: Praeger, 1971], p. 252)*

• Compare this panel with images of the Benin plaques in Volume One, Chapter 11. The shape of the panel, use of relief, and the presentation of the figures against the trefoil patterned background are reminiscent of the older plaques. Also compare this panel to the background in Color Plate IX, Volume One, a sixteenth-century plaque representing the triumphal return of Oba Esigie from the Igala War.

Crucifixion (Fig. 34-1) was carved in wood in 1961 by Osagie Osifo for the Catholic Chapel at the University of Ibadan in Nigeria. Osifo, born in Benin, incorporates a Christian theme into a panel whose style is reminiscent of the Benin plaques of the sixteenth and seventeenth centuries. Carved in medium relief, Joseph, Mary, and the Christ figure are posed frontally and are clothed in a style of garment associated with the dress of Benin courtiers. The artist has emphasized the head and torso and shortened the legs. Together with the frontal position, this presentation mimics but transforms the ancient works. The background trefoil design draws upon the *ebe ame* (river leaf), a reference to Olokun, god of waters, who was worshiped widely among different peoples of the lower Niger River valley and delta region.

Black Aesthetic Art

Black aesthetic art was, like the literature and music of the movement, considered functional, collective, and didactic. Whereas the dominant trend of art before the 1960s was to illustrate the frustration, oppression, and domination of African Americans, the new art centered on positive and determined cultural enrich-

ment. Like Mexican and other Latin American artists before them, black artists of the 1960s chose outdoor murals for their high visibility to everyone in black neighborhoods. In these murals, the artists sought to give form and color to everyday black life, to create new images and heroes, and to provide positive teachings. In the mural *Knowledge Is Power, Stay in School* (Fig. 34-2), Dana Chandler instructs his viewers in the value of knowledge and education. Erect and sturdy black men and women are depicted freeing both children and adults from the egg (visibly white) of oppression and racism. The dominant colors of the black revolution movement—red, black, and green—stand for blood, skin color (or Africa), and renewed life, respectively.

Jazz of the 1960s: Ornette Coleman (b. 1930)

The career of one leading jazz musician exemplifies the cultural and social upheavals that shook America from the 1960s on. The changes in his music and in his public image reflect transformations taking place in American society among all races and socioeconomic groups. In many ways, jazz saxophonist Ornette Coleman was and is as much a social leader as he is a musical artist of the first rank, and his struggles with both music and society tell us much about ourselves and our country.

The significance of Coleman's contribution can be measured accurately only against a broad spectrum of music history. Jazz has many great figures—men and women of extraordinary musical talent, artistic acumen, and virtuosic technique, whose legacy of refined creation is loved, respected, replayed, re-created, imitated, and built on. In this regard, jazz is like all other serious art music of the world. But Coleman's contribution to jazz was unlike the achievements of Oscar Peterson, Duke Ellington, Louis Armstrong, or Mary Lou Williams; even those of Charlie Parker, Thelonious Monk, and Miles Davis were essentially different, because each built on the tradition handed to them by their musical predecessors. Ornette Coleman changed the nature of the language itself.

How many times in the history of Western music have there been changes in conception so pronounced that the musicians themselves, at the time the first events occurred, actually noticed a radical shift and designated a new style? In the past thousand years in the West, one can count these events on the fingers of both hands. This rarity is in itself a measure of the attainment, as well as the daring and fortitude, of the jazz artist Ornette Coleman. By way of comparison, one might look to the beginning of the fourteenth century when Philippe de Vitry declared that the then-new music with duple rhythms, new notation, and pervasive secular interests constituted an *ars nova* (new art).

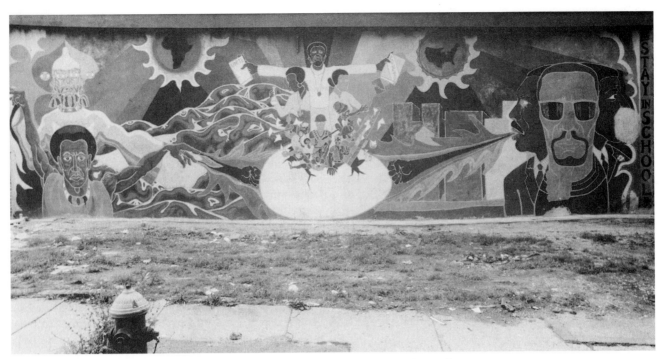

34-2 *Dana Chandler*, Knowledge Is Power, Stay in School. *Street mural, Roxbury, Massachusetts. (Copyright 1988 Mark Diamond)*

Around 1960, Coleman revolted against the restraints of jazz harmonies and traditional rhythm sections and replaced the standard melodic and harmonic style of jazz with a complicated tapestry of atonal polyphony. In so doing, he incorporated into jazz the *free form* concept that is pivotal to his thinking and the new style.

Surely the environment surrounding Coleman in the late 1950s did not lack jazz explorers paddling furiously against the current of the mainstream. Saxophonist Sonny Rollins experimented with time signatures uncommon in jazz and recorded "Valse Hot" and "Blue Seven"; Teo Macero incorporated electronic sounds and electronically distorted sounds into his music and recorded his "Sounds of May"; the exciting John Coltrane moved quickly toward "sheets of sound" and rapid harmonic changes with his "Giant Steps" album; and Miles Davis ushered in "modal" jazz when he recorded "Kind of Blue."

These examples alone represent experiments in rhythm, form, timbre, instrumental technique, harmonic progression, and modal improvisation, but they all fit within the mainstream techniques of jazz of the 1950s. This is the backdrop that set the stage for the dramatic entrance of Ornette Coleman.

Born in Texas in 1930, Coleman had little formal musical training, but by 1944, at the age of fourteen, he was playing with rhythm-and-blues bands in the Fort Worth area. In the segregated South, Coleman was an important and noteworthy catalyst in the process that first cemented the black community and later demanded and won recognition, respect, and equality for an oppressed minority. But it required of him a personal struggle that was both conscious and painful.

The music that sprang from the horns of Coleman's followers in the 1960s—people such as Archie Shepp, Sun Ra, and John Coltrane, and groups such as the Art Ensemble of Chicago—became the music of black Americans on the rise. It became a significant voice of dissent, drawing to itself the symbolism of individual and minority rights, people power, nonconformity, and freedom of expression. To say that this music answered this need innocently and by chance would be to ignore the statements and lives of its musicians, their choices of titles for the compositions, the venue of its performance, the mode of its expression, the emotion and content of its words, and the blackness of its performers.

The essence of free jazz is its liberation from tradition, the environment that restricts expression and inhibits change. *Tomorrow Is the Question, Change of the Century*, and *Free Jazz*[4] are all prophetic statements, especially when one considers that they were

[4] Contemporary S7569, Atlantic 1327, and Atlantic 1364, respectively.

produced in 1959 and 1960. But Ornette Coleman did not overtly seek social change. What transpired on a national and international level, and the role he and his music played in that development, resulted from releasing the frustrations of an entire race. He played his part by expressing his individuality in his music and letting his music exert its power on others. He did not say that music should underpin or accompany a revolt. He was and is first and foremost a musician who is primarily concerned with *The Shape of Jazz to Come.*

Society changed, in a somewhat free-form movement, to the sound of his jazz. In California Coleman met Donald Cherry, a trumpeter of like mind and extraordinary technique. In 1959, Coleman attended the Lenox School of Jazz in Massachusetts, where he interacted with John Lewis, Gunther Schuller, and other musicians thoroughly grounded in the European classical traditions, both ancient and modern. At the same time, he was reevaluating his own life and declared, along with the literary followers of the black aesthetic, "Black is beautiful." *Change of the Century,* recorded in 1959, foreshadowed the revolution that was about to erupt. Long solo lines, enormous bursts of notes, and semiunisons that gather the form together at oddly spaced points are some of the work's noteworthy characteristics. One might say that this work exemplifies and marks the end of Coleman's first period—the years of learning, growth, development, and change.

Free Jazz (1960) is the masterpiece that broke with tradition, set the standard, influenced other musicians, and truly moved jazz in a new direction. Here one finds improvisation on a grand scale and a unique sound never employed in jazz before. This effort represents a true penetration into a new frontier. One will look in vain for harmonies, recognizable melodies, rhythms to tap one's foot to. The ensemble is different: there is no piano in the rhythm section. When you play music without harmony, you have no need for an instrument capable of playing chords. The sound is harsh, strident, penetrating, and loud. When you are shouting sounds of revolution, it takes volume and energy to penetrate the conformist routine of the masses. In Coleman's quartet performance of "Civilization Day," we hear music of both tradition and revolution. Coleman espouses civilization, but not what passes for civilization in America and the rest of the "civilized world" of the 1960s. Where traditional jazz dealt with well-shaped melodic units (often singable) and well-ordered harmonic progressions, this jazz employs the near total freedom of action and reaction among musicians of like mind. The importance of the soloist is lessened as the total blend of the entire ensemble is attenuated. Instrumental virtuosity, in the old sense of the word, holds little value

CD-2, 19

here, where fast notes and slow notes vie equally for the listener's attention. The production of the music becomes a communal action, very much an African characteristic. The blending of ancient and modern, traditional and experimental, into an artistic cluster is a signal accomplishment.

Surrounded by creative musicians, Coleman continued to search not only for the sound of the future but also for clues to the past. For a while, he returned to the tenor sax, an instrument of his youth, which, in his quest for roots, he hoped might provide him with a "real" black voice. He also experimented with additional sounds from his instruments and even with the syntactical value of silence in a time art. This can be heard in "Silence" (1965), which he recorded in Europe because of the lack of enthusiasm for his music at home.[5]

Coleman has continued to search for new frontiers. "Harmolodic Bebop" from the *Opening the Caravan of Dreams*[6] album was recorded in 1985 by his group Prime Time. This work shows Coleman's new interest in electronic instruments and his continuing mastery of his free jazz style. "Song X"[7] with Pat Metheny was also recorded in 1985. This is exciting music by two masters at home in a natural surrounding.

Today, *Free Jazz* is over forty years old, and in retrospect, we might ask: How significant was the change? What effect has it had on other jazz musicians and their music? Has it played a role in influencing the composition and performance of music beyond the world of jazz? Has this music affected society at large, and in what way?

Coleman's music led other jazz musicians to question their values and sent many of these musicians on musical and spiritual quests of their own. He is a significant artist, and we can observe his influence on the music of John Coltrane, Muhal Richard Abrams and the Association for the Advancement of Creative Musicians, the Art Ensemble of Chicago, Archie Shepp, Anthony Braxton, Cecil Taylor, and even Miles Davis. *Free Jazz* is a classic, a classic of jazz dating from the 1960s.

Postmodernism, Culture, and the Arts

Despite much discussion of *postmodernism,* the one certainty about the concept is the lack of general agreement on a succinct definition. Thus rather than try to define postmodernism, let us examine briefly some of its manifestations, first in culture generally and then in the arts.

[5] "Silence," from *The Great London Concert* (Arista 1900).

[6] "Harmolodic Bebop" from *Opening the Caravan of Dreams* (Caravan of Dreams 85001).

[7] "Song X" from *Song X* (Geffen 24096-2).

Three pervasive aspects of our society, which affect everyone, characterize, at least in part, the "postmodern moment":

1. Extraordinary advances in technology, which make possible instant worldwide communication and access to information, as well as biological transformations

2. The dominant role of the mass media, especially television and the Internet, in politics, advertising, and our general awareness of the world

3. An increase in international exchange of goods and a growing sameness in consumerism, leading toward what has been dubbed a "McWorld"

To these we might add a fourth characteristic that seems to contradict the other three: a resistance to worldwide uniformity by a cherishing of the ethnic, the local, and the particular.

The Postmodern Cultural Scene

We are not yet fully aware of the profound cultural implications of new technologies. Biotechnology, for example, seems to be outdistancing science fiction. Indeed, scientists speak of a breakdown in distinctions between the artificial and the natural and between the individual and the collective. The biologist Donna Haraway, in her seminal essay "A Manifesto for Cyborgs," envisions a "postgender" creature supplemented by technology—a sort of hybrid of human and biologically engineered traits. In the field of electronic communications, digital imaging systems are replacing photography as the way we record experience. Developments in artificial intelligence and in virtual reality make possible electronic cities, virtual communities, even virtual personal relationships, far outdistancing Marshall McLuhan's concept of the "global village." Will these electronic arrangements eventually supplant physical communities? Will virtual communication become more "real" than what we now call face-to-face communication? Will access to chat rooms replace traditional communal organizations such as family, neighborhood, and religious community? Already the images and sound bites provided by television, along with the information supplied through the Internet, have begun to infiltrate or supplant our notion of what is real. Fredric Jameson, in a monumental work on the subject, states: "Postmodernism is what you have when the modernization process is complete and nature is gone for good."[8] According to Jameson, we live in a culture of the "simulacrum" and the "spectacle." Techniques of mass reproduction have made everything reproducible.

Whereas modernist avant-garde art had the power to offend and shock, postmodern spectacle society absorbs every novelty as just another image.

Yet despite its reproducibility and its superficial, "McWorld" sameness, the postmodern world is incredibly diverse. If the modernists discovered with Yeats that "things fall apart, the center cannot hold," they nevertheless accepted and established their own kinds of authority. For the most part, too, they continued to believe in the importance of the individual and the centrality of European culture and values in the world. Things could be explained by what another writer on postmodernism, J. F. Lyotard, calls "master narratives": great overarching theories or systems. Postmodernists, on the other hand, have accepted what some term infinite diversity and others chaos.

Thus in some ways the world has become smaller and its parts more closely linked. But in other ways it is filled with a dizzying variety, which disrupts traditional notions of time and space. Old modes coexist with rapidly changing new ones; for example, most thinking about the cultural significance of electronic technology is—for the time being—still published in the form of essays in books. If we walk through an airport, within a few moments we might see fat romantic novels being bought and read, piped or taped music that could be a baroque concerto on original instruments or the latest rap, steel sculptures next to reproductions of Van Gogh and Rembrandt, flight departures to all parts of the world being announced in a variety of languages, computer screens making available every type of information, people of every ethnic type and nationality walking past each other making calls on their cellular phones to every part of the globe, news broadcasts and soap operas being randomly watched. We might well believe ourselves to be living in several temporal, spatial, and cultural dimensions at once, and this is precisely what we could call the postmodern scene.

The Arts

Where does this situation leave the artist and the arts? We have seen that, since the romantic period, there has been a gradually widening cleavage between popular or mass culture on one hand and "high" or elitist culture on the other. The cleavage was recognized as an inescapable fact of life during the heyday of modernism. Six hundred people, according to Ezra Pound, are all that it takes to make a culture. Taking their art very seriously, exploring new frontiers in the use of language, sound, and visual forms, the modernist artists knew that they were creating only for the few who had the leisure and the sophistication to understand their works. Modernism in the arts is not dead, and for many the notion of the artist as an individual struggling to express his or

[8] Fredric Jameson, *Postmodernism or, The Cultural Logic of Late Capitalism* (Durham, NC: Duke University Press, 1991), p. ix.

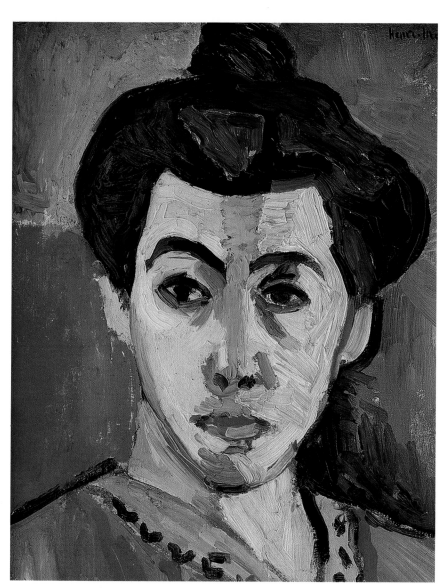

Plate XXIX
Henri Matisse, *Portrait of Madame Matisse (The Green Stripe)* (1905). Statens Museum fur Kunst, Copenhagen.

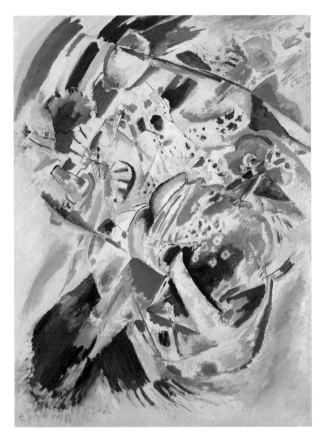

Plate XXX
Wassily Kandinsky, *Painting No. 201*
(1914). Oil on canvas, 64¼ × 48¼″.

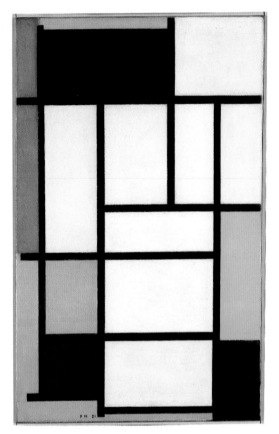

Plate XXXI
Mondrian, *Composition with
Red, Blue, and Yellow* (1921).

Plate XXXII
Georgia O'Keeffe, *Sky Above Clouds IV* (1965). Oil
on canvas. 96 × 288″.

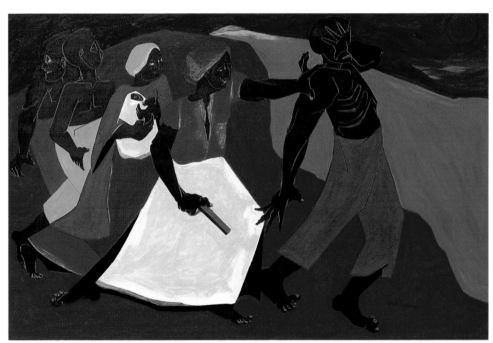

Plate XXXIII
Jacob Lawrence,
Forward (1967).
(North Carolina Museum of
Art, Raleigh. Purchased with
funds from the State of North
Carolina)

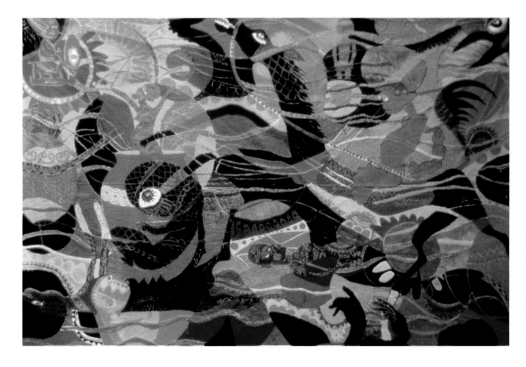

Plate XXXIV
Dr. Moyo Okediji,
Ogunic Exploits
(1992). Pigment and
glue binder on linen.
69 × 100″.
(Courtesy of Moyo Okediji,
Ph.D.)

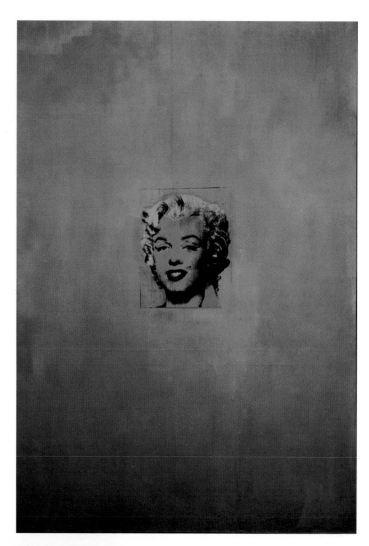

Plate XXXV
Andy Warhol, *Gold Marilyn Monroe* (1962). Synthetic polymer paint, silkscreened, and oil on canvas. 83¼ × 57″.

Plate XXXVI
Peter Voulkos, *Rocking Pot* (1956). Stoneware. 13¹/₆ × 21 × 17¹/₆″.

her highly individual view of the world still obtains. Yet alongside the artists who continue to create in the modernist vein are those who refuse to distinguish between either mass culture and elite art or between period styles. The use of video and computer art has further extended the means of expression for the postmodern artist. So has hypertext, or the notion that what was once a finished product in book form is permeable and variable. We will examine the phenomenon of postmodernism in the various arts, starting with architecture, where it began.

Architecture from the International Style to Postmodernism

The term *postmodern* has been used more consistently in architecture than in any other art form. To explore its application in this field, we must review developments in architecture since the onset of modernism. Contemporary architecture in America after Word War I came to be referred to by the phrase, the "International Style." This term was coined by architectural historian H. R. Hitchcock and architect Philip Johnson to describe work from both Europe and America that was illustrated in an exhibition of the same name at the Museum of Modern Art in 1932. Common characteristics of the work are absence of historical ornament and architectural forms; use of steel, glass, and concrete as primary materials; and the belief that the functions of a building should be expressed visually in both form and plan. Although the principles identified with the term could be applied to any architectural problem, probably the one that seemed to cry out most for a new kind of realization was the skyscraper. The Lever Building (Fig. 34-3), the first important skyscraper in the International Style, was designed by Skidmore, Owings, and Merrill for Lever Brothers' headquarters site on Park Avenue in New York City (1950–1952). The glass-curtain wall of the tower, the tower separated from the ground and from the entrance floor, the courtyard with green trees and open space all create an image of the best of technology and progress. The only decoration is that provided by the materials, by reflections, and by the spaces themselves. The tall office building is elegant and crisp, and makes a very powerful corporate image. Similar buildings began to proliferate.

The International Style was the "progressive" style. Apartment complexes, colleges, private housing, grocery stores, fire and police stations, hotels, motels, hospitals—whatever was to appear new, modern, and up-to-date—were built in this mode. The box might be of splendid marble, bronze, and dark glass, or of plain stucco and concrete, or of brick with plate-glass windows, but the sameness began to suggest that perhaps

34-3 *The Lever Building, New York, 1950–1952. (Ezra Stoller copyright ESTO)* (**W**)

this formal language, this style, had limitations, and that there might be other forms for building and more appropriate sources of inspiration for the contemporary age.

In 1967 the Museum of Modern Art published a book perhaps as important in the history of architecture as the International Style. *Complexities and Contradictions in Architecture* was written by Robert Venturi, a young graduate of the Yale School of Architecture. Venturi's book constituted a statement of the failure of confidence on the part of many in the architectural profession with regard to the forms, ideas, and logic of the International Style. The book summed up an evolutionary process that had already begun and would continue for decades. *Complexities and Contradictions* said exactly what some architects had already demonstrated and what would prove challenging to many more: architecture need not be confined to the cool, rational box of the International Style. Architecture should be humorous, contextual, traditional, personal, and emotional.

The late work of some of the great masters of the International Style in the 1960s reflects the beginnings of such a change in taste. In his only building erected in the United States, the Carpenter Center at Harvard University (Fig. 34-4), completed in 1963, Le Corbusier turned away from the pure geometry of his

34-4 *Two views of Le Corbusier's Carpenter Center, Cambridge, Massachusetts, 1963. (Harvard University News Office)*

early work to use concrete and steel-reinforced concrete as a malleable sculptural medium. Frank Lloyd Wright's Guggenheim Museum (Fig. 34-5) at Fifth Avenue and 89th Street in New York, built in 1959, is a highly personal, controversial building, both for a city and as an art museum. Centrifugal and vertiginous, the building at times seems to be better for people than for art. Eero Saarinen worked in a variety of forms and materials, attempting to give symbolic expression and imagery to building. Dulles Airport outside Washington, DC (Fig. 34-6), shows his use of reinforced concrete and steel with a glass curtain to create a building expressing the idea of flight, movement, and energy.

The disenchantment with the International Style encouraged journalists and architectural critics to seek out a deliberately "postmodern," non–International Style building that would establish, if not the vocabulary, at least the ideas that would be the inspiration for a truly postmodern architecture. This building has usually been identified as the 1978 design for the AT&T headquarters in New York by Philip Johnson, once a chief practitioner and propagator of the International Style. The building (completed in 1980), with its crowning parapet—a swan-necked, broken-pedimented top similar to that of an eighteenth-century Chippendale highboy (as it is sometimes derisively described)—makes a stunning addition to the New York skyline

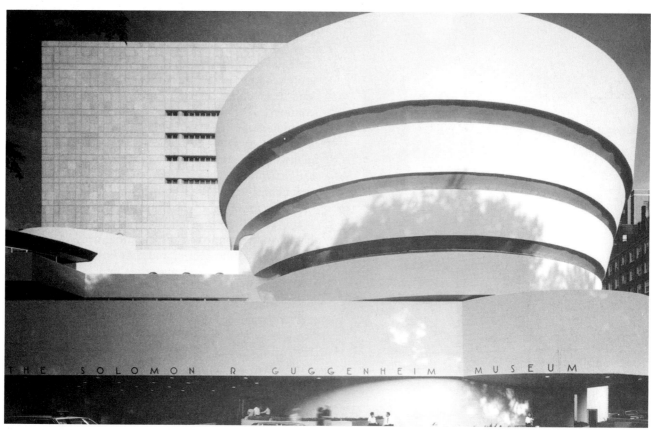

34-5 *Frank Lloyd Wright, Solomon R. Guggenheim Museum, New York City, 1959. (Courtesy of the Guggenheim Museum)*

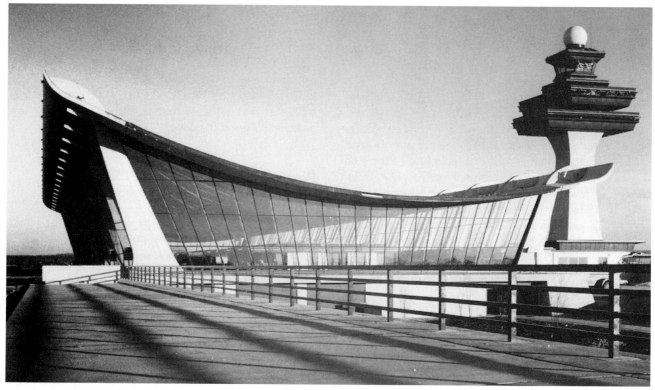

34-6 *Eero Saarinen, Dulles Airport. (Copyright 1962 by Dandelet)*

34-7 *Philip Johnson and John Burgee, AT&T Headquarters Building, New York City, 1980. (Copyright 1988 Peter Mauss/ESTO)*

(Fig. 34-7). At street-entry level, a barrel vault cuts into a columnar screen, and the entry portico looks like a Roman triumphal arch moved to the building base. Smooth, butt-jointed granite slabs face walls with almost negligible windows.

The historical allusions of Johnson's building are also deliberate and are the consequence not only of dissatisfaction with the International Style but also of renewed interest in historical architecture for its own sake. Academic interest in the architecture of the past received validation from exhibitions such as *The Architecture of the École des Beaux-Arts* (October 1975–January 1976) at the Museum of Modern Art, which revealed a great deal about the difference in ideals, training, and understanding that had created the scorned neoclassical architecture of the past.

Of almost equal importance to this changed attitude has been the growth of the historic preservation movement, which began as an elite movement to save buildings associated with great people and great deeds and broadened at the grass-roots level in towns and cities across America as urban renewal and road building threatened the historic fabric of many areas. In response to public pressure, the federal government, through the Department of the Interior, established the

National Register of Historic Places. This project set standards for the listing, care, and restoration of historic structures and sites and encouraged local and state governments to survey, identify, photograph, research, and preserve sites of local, regional, or national significance. The existing fabric of many residential, commercial, and industrial neighborhoods has been saved because the presence of these sites records important moments and events in American history. Today many of these buildings are being preserved thanks to the realization that they are part of the total complex that characterized Big City or Small Town, USA.

This movement was joined by architects who for many years had insisted that good design should be based on the context of the building, with ideas drawn from the existing fabric, and that buildings should be constructed with local materials and in concert with local traditions. So strident and successful had been the popularizers of the International Style that many important architects in America were overlooked for years while they quietly and successfully practiced architecture sympathetic to their regions in California or the Midwest or the South. Now teachers, critics, and practitioners consider this architecture truly American, because it relates directly to the place where it was built rather than being based on an abstract canon of rules.

Certainly, the new corporate and institutional architecture of the past twenty years has been more complex, varied, controversial, and contradictory in appearance than that of the International Style. Some buildings make direct historical references, others use materials in unorthodox and exciting ways, and still others seem to be designed to fit within the broader context of city, campus, or town through the use of materials and scale. Architects interpret the demands of a problem, and the results have a variety that may be much more significant than any style name. These buildings may indicate that in architecture, as in art, pluralism is good for design.

Postmodern Visual Art: Polemics or Platitudes?

The postmodern culture of the simulacrum, or reproducible image, was perhaps announced in the *pop art* of the 1960s by artists such as Andy Warhol. Warhol was perhaps best known for his serial images of popular figures such as the movie star Marilyn Monroe (Color Plate XXXV), 1962, or his giant reproductions of advertising images such as the 1965 Campbell's soup can (Fig. 34-8). Images like these triggered a new awareness of the relationships among art, advertising, and popular culture. Other artists tackled issues dealing with HIV and AIDS, human rights, war, and genocide, engendering controversy and condemnation as well as praise and support.

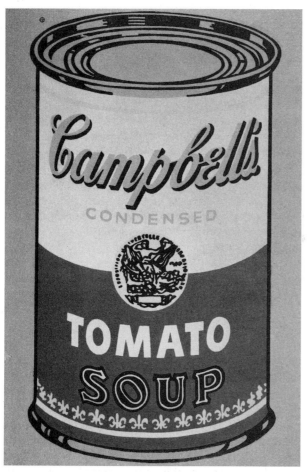

34-8 *Andy Warhol,* Campbell's Soup, *1965. Oil silkscreened on canvas, 36⅛″ × 24″. (Collection, The Museum of Modern Art, New York. Philip Johnson Fund)*

In Europe the work of postwar German artist Anselm Kiefer (b. 1945) electrified his peers because he created art that deliberately addressed Germany's fascist past. His more recent work uses images that are designed to produce meditations on life, sorrow, and death. The huge *Untitled* triptych (each panel is eleven feet high and six feet across), created between 1980 and 1986, combines acrylic and oil paint, photographic images, stones, lead, and steel (Fig. 34-9). A chaotic decimated landscape appears to dominate the panels, which contain images of a serpent, a real lead ladder, a strange funnel-shaped vessel, and six stones wrapped in steel that appear to rise rather than sink. Paint is scraped, straw is embedded in the surface and burned, and a molten lead substance has been splashed on the canvas. This image is one of the end of time, of a tormented, demented world.

In America, the feminist Judy Chicago (b. 1939) celebrated the traditional achievements and creativity of women in her monumental work *The Dinner Party* (Fig. 34-10), which took five years to complete and involved about four hundred makers. It is both a history of women and a symbol of the controversies that surround the feminist movement in art. *The Dinner Party* table is an equilateral triangle with thirty-nine individual place settings, including a plate, goblet, and cutlery, on an elaborately embroidered and appliquéd runner. Each setting identifies a different mythical or historical woman. The predominant motif of the porcelain plates is the female genitalia abstracted and represented in the lustrous colors of hand-painted china. Women at the table include Sophia (wisdom), Hatshepsut (queen of Egypt), Sappho (Greek poet), Theodora (Byzantine

34-9 *Anselm Kiefer,* Untitled, 1980–1986. (North Carolina Museum of Art, Raleigh. Purchased with funds from the State of North Carolina, W. R. Valentiner, and various donors, by exchange)* **(W)**

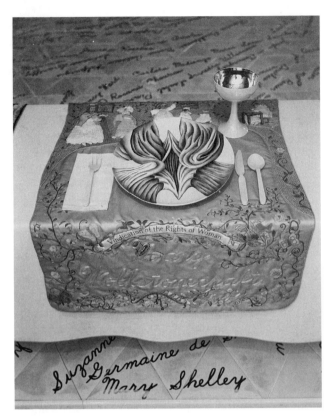

34-10 *Judy Chicago,* Mary Wollstonecraft place setting from The Dinner Party. *Detail of the installation, mixed media. (Copyright Judy Chicago 1979. Photograph by Donald Woodman) (W)*

empress), Elizabeth I, Artemisia Gentileschi (Italian painter, see Chapter 21), Sacajawea, Mary Wollstonecraft (see Chapter 24), Sojourner Truth, Susan B. Anthony, Margaret Sanger, Virginia Woolf (see Chapter 32), and Georgia O'Keeffe (see Chapter 31).

Controversy has surrounded the choice of guests, the quality of the painting of the china plates, and the focus on female genitalia. Perhaps the only element free from complaints has been the needlework of the thirty-nine individual runners and the white linen tablecloths. The success of this work, which alludes to the past and to the traditional crafts and roles of women, also references what may be the most important development in art in the United States since the end of the Korean War: the ascendancy of craft forms and craft media as ways to introduce a new human expressiveness into the detached, ironic postmodern world.

The Ascendancy of Craft: The Expansion of the Tradition

The Industrial Revolution changed the ways in which people make, use, and relate to the functional and utilitarian objects of everyday life. Machines produced ceramics, glass, textiles, and furniture once produced by hand labor. As the need for traditional craftsmanship declined, individuals recognized that the loss of these crafts not only diminished life but also threatened the foundations of the production whose forms and materials had shaped society. Beginning in Europe in the mid-nineteenth century and in America in the early twentieth century, attempts were made to revive and stabilize the vanishing craft culture. These efforts had varying degrees of success, but following World War II the *movement* to establish *craft* as a means for personal expression as well as earning a livelihood took on new energy. The Penland School of Handicrafts in western North Carolina (founded in 1929), the Haystack School in Maine (founded in 1954), and other similar schools began to produce artists who used traditional materials (clay, fiber, wood, glass, and metal) to produce new and expressive forms derived from their original functional uses.

Rocking Pot (Color Plate XXXVI) by Peter Voulkos (b. 1924), for example, reminds one of a hand-turned useful container that has been broken and wrongly reassembled, but its human scale, highly tactile surface, and warm earth colors make it an accessible and approachable way to meditate on life and death. Wendell Castle's (b. 1932) *Ghost Clock,* like Judy Kensley McKie's (b. 1944) *Monkey Settee* (Fig. 34-11), has its foundations in the great traditions of handmade carved and decorated furniture, but both use the potential of materials and the memory of more recognizable functions to create craft that is art.

Harvey Littleton (b. 1922) transformed glass into a medium that could be manipulated by the individual artist in the studio. Makers like Dale Chihuly, through the use of large studios of collaborative artists, are changing the ways in which one thinks of not only art and craft but also the artist. Quilts, fiber, clothing, and baskets have all become means of personal expression that have a deep resonance within personal experience, making the work more human and humane. They also remind everyone who sees the work that objects for use are as worthy of attention as the most intricate and provocative "fine art."

Postmodern Music and Dance

Not everyone, by any means, accepts the label "postmodern" as a valid description of, or even a tendency in, contemporary culture. Yet if used with an awareness of the difficulties of describing one's own era, it may be a helpful guide. A few brief examples from music and dance may serve as illustrations before we study some examples from literature.

John Cage (1912–1992), a composer considered by many to be a kind of apostle of the postmodern, published in 1961 a work called *Silence.* His idea was

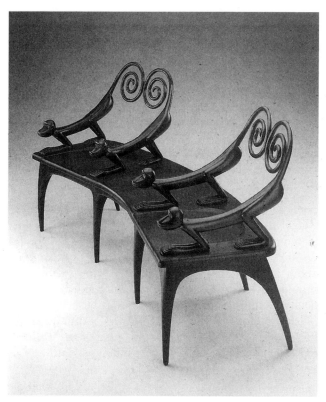

34-11 *Judy Kensley McKie,* Monkey Settee. *Walnut and bronze, 90.2 × 182.2 × 61 cm (32½ × 7¾ × 24 in). © 1995, Judy Kensley McKie. Renwick Gallery. (National Museum of American Art, Washington, DC/Art Resource, NY)*

to have the audience listen to the random sounds around them, to consider these as art. He told them:

nothing is accomplished by writing a piece of music
nothing is accomplished by hearing a piece of music
nothing is accomplished by playing a piece of music
our ears are now in excellent condition

Cage continued to experiment with random sound and silence, and his thought and work have affected a whole generation of composers.

Ruth Schonthal (b. 1924), whose early works are masterfully crafted compositions of neoclassical character, composed in 1967 an aleatoric (random) work for piano entitled *Nachklänge* (Reverberations) in which she was trying to "create the impression of something broken that once was very beautiful evoking the image of a bombed-out cathedral."[9] Seven years later (1974), presumably after random explorations on and in the piano, she settled on a fixed form of the piece that calls for wood and metal objects placed on the lower strings and

glass, plastic, and wood objects located in the middle register. In this manner, the "prepared piano," when played as indicated in the musical score, reacts to hammer strokes on the strings with sounds inconceivable for music in the times of Bach, Mozart, Beethoven, or Brahms. The ears of the postmodern listeners are able to accept a much-expanded palette of sonorities from the instrument and relate them to a global and interplanetary experience unavailable even to their grandparents. In her piece, Schonthal explains,

there are echoes freely reminiscent of a Bach chorale. A section, entitled "Nostalgia," is followed by a section, entitled "War," which remains aleatory (the out-of-control element of war). The next section uses the melody from the German soldier's song, "Ich Hatt' einen Kameraden," that bemoans the loss of a comrade. . . . It all ends with the Nostalgic theme coming to some kind of peace from within.

Thus the postmodern composer incorporates substantive issues of the surrounding culture together with experimental devices, unusual sounds, and traditional elements into an artwork that consciously "makes a statement."

In dance, the choreographer Merce Cunningham, who collaborated extensively with Cage, is generally considered the progenitor of postmodernism. Cunningham broke away from the modern dance of Martha Graham, with its symbolism and psychological exploration, to create a dance of pure movement, with the dancers often dancing to silence. Younger contemporary choreographers have tended to do away with dance as "art," having untrained performers sweep the floor, lie still, or deliver a monologue, calling everything "dance." Others, such as Laura Dean, use repetitious geometric patterns—for example, whirling in continuous circles. Twyla Tharp, in one postmodern vein, incorporates social dances from the 1920s through the 1950s into her choreography, as well as experiments with ordinary "nondance" movements and nonstage environments. In recent years, "performance artists" have mixed dance movements with verbal improvisation and media, adding another multidimensional form to the postmodern scene.

Mass Culture and Popular Music

Gloria Estefan was born in Havana, Cuba, and was raised and educated in Miami, Florida. Initially coming to prominence as lead singer of the Miami Sound Machine, her Spanish-language recordings with this group in the 1970s and early 1980s won her an enormous following in the United States, Europe, and, especially, Latin America. Following a solo career since 1989, she became the most popular Latin American singer of the last decade of the millennium with both English- and Spanish-language hits—"Cuts Both Ways," "I Don't

[9] From the liner notes of *Ruth Schonthal: Compositions for Piano,* Orion Records ORS 81413.

Wanna Lose You," and "Reach," the theme of the 1996 Olympic Games in Atlanta, where Estefan sang during the closing ceremonies. With her husband, Emilio Estefan, she writes much of the material she sings, and her experiences as a Hispanic American in a world culture have inspired many poetic and musical works of political and social commentary. Her 1995 album, *Mi Tierra*, is a collection of serious reflections on her own life and feelings: *"Mi Tierra"* (My Homeland), *"Con los Años Que Me Quedan"* (With the Years That I Have Left), *"No Hay Mal Que por Bien No Venga"* (Out of All Bad, Some Good Things Come), *"Tradición"* (Tradition), and the closing work of the album that accompanies this text, *"Hablemos el Mismo Idioma"* (Let's Speak the Same Language). With rhythms, instruments, and dance steps common in the Caribbean, Central and South America, and the Hispanic neighborhoods of the United States, Gloria Estefan employs her art, as have many artists before her, to carry a cultural message on the wings of song.

Hablemos el Mismo Idioma

(Coro)
Hablemos el mismo idioma,
que hay tantas cosas porque luchar
Hablemos el mismo idioma,
que solo unidos se lograrán
Hablemos el mismo idioma,
que nunca es tarde para empezar
Hablemos el mismo idioma,
bajo la bandera de libertad.

CD-2, 20

Let's Speak the Same Language

Words and music: Gloria Estefan and Emilio Estefan Jr.

(Chorus)
Let's speak the same language
There are so many things worth fighting for
Let's speak the same language
Only united can we achieve our hopes
Let's speak the same language
It's never too late to begin
Let's speak the same language
Under the flag of freedom.

Postmodern Literature and Theory

Postmodern architects plunder the whole repertoire of past styles, postmodern visual artists make pastiches while calling into question the very notion of "art," and postmodern composers redefine music. Like them, certain postmodern writers comment ironically on the literary canon of the past while questioning the possibility of still writing "literature." The traditional genres that we have observed throughout this book—lyric poetry,

drama, prose fiction—tend to become blurred, mixed, or done away with entirely in postmodern writing. With street theater, happenings, and performance art, theater abandoned the stage; new journalists such as Tom Wolfe have mixed subjective impressions with straight reporting; lyric poetry does not hesitate to comment on political and social questions; pop culture appears beside high culture. As genres and styles have blurred, what used to be called literary criticism has achieved a new eminence and is now referred to simply as *theory*.

The field of theory is far too complex and vast to summarize here, but one point, however simplified, needs to be made: the importance of the nature of language in understanding literature and other cultural phenomena. For a critic and theorist such as Roland Barthes (1915–1980), language is in the last analysis about itself: that is, a text is self-referential, and we should not confuse it with some hypothetical "outside reality." Thus, in an influential essay published in 1968, Barthes announced the "death of the author." Michel Foucault (1926–1984), who called himself an "archeologist of knowledge," spoke about language in the following terms:

> Having become a dense and consistent historical reality, language forms the locus of tradition, of the unspoken habits of thought, of what lies hidden in a people's mind. . . . Expressing their thoughts in words of which they are not the masters, enclosing them in verbal forms whose historical dimension they are unaware of, men believe that their speech is their servant and do not realize that they are submitting themselves to its demands.

And so we are caught in the prison house of language. There is no sovereign subject, no great author who meant to say something; there are only texts made of words on which we can write commentaries of commentaries. What Foucault proclaimed was nothing less than the death of classical humanism. We have gone from a God-centered world to a human-centered world to a world without center, a world as text.

This view of language is also reflected in a literature that appears to be about itself or about the infinite possibilities of language. Although we discussed the Argentinian Jorge Luis Borges under the heading on modernism, where he belongs in many ways, his stories that consist of commentaries on commentaries on texts may be considered postmodern. Another Argentinian postmodernist is Manuel Puig, who, in works such as *Betrayed by Rita Hayworth* (1971) and *The Kiss of the Spider Woman* (1979), portrays the increasing incursions of the fictional world of the mass media, particularly of Hollywood films, into the "real" world. The Cuban fiction writer Guillermo Cabrera Infante and the Nicaraguan poet Ernesto Cardenal (b. 1925), with his use of parody, puns, and spoken language, exemplify other aspects of post-

modernism. The Brazilian Clarice Lispector (1925–1977) is postmodern in her concern for creating a language with which to render the varieties of human perception and her experimentation with forms that merge narrative, essay, and lyric. She died of cancer in 1977, but she has been discovered in Europe and North America since then. She is now considered to be one of Latin America's most original writers.

While Latin American literature since the period in the late 1960s called *el boom* has been one of the major forces in postmodernism, many North American and European writers are often grouped under the rubric "postmodern" as well. Among them are the German Peter Handke, the Italian Italo Calvino, and the Irish-French writer Samuel Beckett. The works of African American writers such as Ishmael Reed and the later works of Toni Morrison (for instance, *Beloved* [1987] and *Love* [2003]) and Alice Walker are often considered postmodern. Also included among the North American postmodernists are Donald Barthelme, Ronald Sukenick, John Barth (b. 1930), and Don DeLillo. Barth's work, in particular, has always been concerned with the play of language and the unstable nature of the text. In a 1997 story called "Click," he moves beyond these postmodern concerns to deal with the world of computer users and what he calls "the hypertextuality of everyday life." The story recounts the relations between two lovers who communicate via computer, clicking, along with the reader, to new dimensions of words and reality.

A very different type of literature may be deemed part of the postmodern scene as well. This writing reflects the multicultural phenomenon noted earlier: the addition of new and innovative voices previously suppressed. In Latin America we could mention "testimonial" literature, often written by people from poor or oppressed groups and expressing postcolonial concerns. In the United States writing from various ethnic minorities has begun to flourish: Chicano, Native American, and Asian American, in addition to the already well-established African American literature. Japanese Americans such as Hisaye Yamamoto, Korean Americans

such as Richard Kim, and Filipino Americans such as Benvenido Santos have all attracted the attention of the reading public. The play *M. Butterfly* (1988), by David Henry Hwang, a Chinese American, met with great success on Broadway while raising profound questions about how the West views China. Chinese American women novelists and short story writers such as Amy Tan (whose *Joy Luck Club* [1989] won acclaim both as a novel and as a film), Maxine Hong Kingston, and Gish Jen convey to a diverse reading public a Chinese point of view on the problems of immigration and on the position of women in Chinese and American societies, as well as on the universal dynamics of family life. Spokesperson for another minority, the playwright Tony Kushner has brought an intensely poetic and dramatic vision of what it means to be gay in the age of AIDS. His *Angels in America: A Gay Fantasia on National Themes* (in two parts, 1990 and 1993), is an imaginative and original dramatization of the clash of gay and straight cultures.

Thus in postmodern writing, as in the other arts, highly experimental forms coexist with more conventional ones, rarefied language coexists with pop language, and Eurocentric traditions are infused with an expanding diversity of voices. It is possible, however, that future cultural historians will view the diversification or globalization of literature and the other arts in the early years of the twenty-first century as marking the passing of the postmodern moment. Global concerns, in literature as in other cultural manifestations, now seem to outweigh the interest in textuality and language play. While some writers—for example Salman Rushdie, who hails from India, Pakistan, Britain, and the United States—might best be characterized as "world writers," others remain deeply rooted in their homelands and traditions but are conscious of speaking to an international, or rather globalized, audience. Such writers include poets and storytellers from Israel and Palestine who express the sufferings of their people and the conflicts within their homeland, knowing that these are matters that affect the entire world community.

MODERN AFRICAN POEMS

Chinua Achebe (b. 1930), primarily known for his fiction embedded in the philosophical concepts of the Ibo people of southern Nigeria, reiterates the theme of the circularity of existence in his poetry. Wole Soyinka (b. 1934) has been profoundly engaged in the evolution of Nigerian political culture since the late 1950s. All of his writings, but perhaps especially his plays and his poetry, draw on Yoruba philosophical and religious ideas. The style of the poems presented here—whose subject matter is modern and contemporary—reflects the attention to imagery and metaphor from the oral literature of his people. Both of these poets assert African writers' embrace of their literary heritage.

CHINUA ACHEBE

Generation Gap

A son's arrival
is the crescent moon
too new too soon to lodge
the man's returning.
His feast of re-incarnation
must await the moon's
reopening at the naming
ceremony of his
grandson.

WOLE SOYINKA

Death in the Dawn

Traveller, you must set out
At dawn. And wipe your feet upon
The dog-nose wetness of the earth.
Let sunrise quench your lamps. And watch
Faint brush pricklings in the sky light
Cottoned feet to break the early earthworm
On the hoe. Now shadows stretch with sap
Not twilight's death and sad prostration.
This soft kindling, soft receding breeds
Racing joys and apprehensions for

A naked day. Burdened hulks retract,
Stoop to the mist in faceless throng
To wake the silent markets—swift, mute
Processions on grey byways. . . . On this
Counterpane, it was—
Sudden winter at the death
Of dawn's lone trumpeter. Cascades
Of white feather-flakes . . . but it proved
A futile rite. Propitiation sped
Grimly on, before.
The right foot for joy, the left, dread
And the mother prayed, Child
May you never walk
When the road waits, famished.
Traveller, you must set forth
At dawn.
I promise marvels of the holy hour
Presages as the white cock's flapped
Perverse impalement—as who would dare
The wrathful wings of man's Progression. . . .

But such another wraith! Brother,
Silenced in the startled hug of
Your invention—is this mocked grimace
This closed contortion—I?

I Think It Rains

I think it rains
That tongues may loosen from the parch
Uncleave roof-tops of the mouth, hang
Heavy with knowledge

I saw it raise
The sudden cloud, from ashes. Settling
They joined in a ring of grey; within,
The circling spirit

Oh it must rain
These closures on the mind, binding us
In strange despairs, teaching
Purity of sadness

And how it beats
Skeined transparencies on wings
Of our desires, searing dark longings
In cruel baptisms

Rain-reeds, practiced in
The grace of yielding, yet unbending
From afar, this your conjugation with my earth
Bares crouching rocks.

COMMENTS AND QUESTIONS

1. How is the cyclical nature of human existence conveyed in Achebe's "Generation Gap"?

2. Wole Soyinka has consistently addressed human issues through the voice of Yoruba belief and expression. Although his works are masterpieces in English, and can be understood within the English reading of them, their power and subtlety are magnified for the reader who understands something of Yoruba culture. Ogun, the god of war and destruction, of the rains, of harvest, of disintegration and death, is a favorite, although not always explicit, subject of Soyinka's. In modern Nigeria, Ogun is god of the road, a claimant of countless lives on overcrowded highways; taxi and truck drivers are among those who worship him. He is the real subject of "Death in the Dawn." When the poet writes "May you never walk / When the road waits, famished," it is Ogun that one fears may be famished. "Death in the Dawn" is not an *oriki,* but go back and reread "Oriki Ogun" (Chapter 12) after you have read Soyinka's poem. What traditional images of Ogun do you find in Soyinka's poem?

3. In "I Think It Rains," Soyinka applies the concept of drought, symbolizing moral and or political corruption in the broader society, to personal "dark longings" that are assuaged by the rains. Note how Soyinka emphasizes the paradox of the cruelty and the blessing of the rain.

FROM THE CARIBBEAN

DEREK WALCOTT

White Magic

(For Leo St. Helene)

The *gens-gagée*[1] kicks off her wrinkled skin.
Clap her soul in a jar! The half-man wolf
can trot with bending elbows, rise, and grin
in lockjawed lycanthropia.[2] Censers dissolve

the ground fog with its whistling, wandering souls, 5
the unbaptized, unfinished, and uncursed
by holy fiat. The island's griots[3] love
our mushroom elves, the devil's parasols
who creep like grubs from a trunk's rotten holes,
their mouths a sewn seam, their clubfeet reversed. 10
Exorcism cannot anachronize
those signs we hear past midnight in a wood
where a pale woman like a blind owl flies
to her forked branch, with scarlet moons for eyes
bubbling with doubt. You heard a silver splash? 15
It's nothing. If it slid from mossed rocks
dismiss it as a tired crab, a fish,
unless our water-mother with dank locks
is sliding under this page below your pen,
only a simple people think they happen. 20
Dryads and hamadryads[4] were engrained
in the wood's bark, in papyrus, and this paper;
but when our dry leaves crackle to the deer-
footed, hobbling hunter, Papa Bois,[5]
he's just Pan's[6] clone, one more translated satyr. 25
The crone who steps from her jute sugar sack
(though you line moonlit lintels with white flour),
the *beau l'homme*[7] creeping towards you, front to
 back,
the ferny footed, faceless, mouse-eared elves,
these fables of the backward and the poor 30
marbled by moonlight, will grow white and richer.
Our myths are ignorance, theirs are literature.

For Pablo Neruda[1]

I am not walking on sand,
but I feel I am walking on sand,
this poem is accompanying me on sand.
Fungus lacing the rock,
on the ribs, mould. Moss 5
feathering the mute roar
of the staved-in throat
of the wreck, the crab gripping.

[1] *gens-gagée:* Island patois for "spirit being."
[2] lycanthropia: From the Greek *lykoi* (wolf) and *anthropos* (man); lycanthropy is the belief that one has become a wolf.

[3] griots: Members of a hereditary caste among the peoples of western Africa whose function is to keep an oral history of the tribe or village and to tell the stories, songs, and poems of the people.

[4] Dryads and hamadryads: Deities or nymphs of the woods; hamadryads are spirits of particular trees.

[5] Papa Bois: Refers to a notorious pirate, Jambe de Bois (French for "wooden leg"), who had a hideout on Pigeon Island, off the west coast of St. Lucia.

[6] Pan: Greek god of pastures, flocks, and shepherds; symbolic of the sexual energy of nature, which took the form of a goatlike creature, the satyr. This figure was "translated" by medieval Christians into Satan.

[7] *beau l'homme:* French patois for "handsome man."

[1] Pablo Neruda (1904–1973): Chilean poet who wrote about the effects of colonialism on the Americas; a number of his poems depict the oppression of the Indians. (See Chapter 32.)

Why this loop of correspondences,
as your voice grows hoarser 10
than the chafed Pacific? Your voice
falling soundless as snow on
the petrified Andes, the snow
like feathers from the tilting
rudderless condors,[2] 15
emissary in a black suit, who
walks among eagles, hand, whose
five-knuckled peninsula
bars the heartbreaking ocean?

Hear the ambassador of velvet 20
open the felt-hinged door,
the black flag flaps toothless
over Isla Negra.[3] You said
when others like me despaired:
climb the moss-throated stairs 25
to the crest of Macchu Picchu,[4]
break your teeth like a pick on
the obdurate, mottled terraces,
wear the wind, soaked with rain
like a cloak, above absences, 30

and for us, in the New World,
our older world, you became
a benign, rigorous uncle,
and through you we fanned open
to others, to the sand-rasped 35
mutter of César Vallejo,[5] to
the radiant, self-circling
sunstone of Octavio,[6] men
who, unlike the Saxons,[7] I am tempted
to call by their Christian names; 40

we were all netted to one rock
by vines of iron, our livers
picked by corbeaux and condors
in the New World, in a new word,
brotherhood, word which arrests 45

the crests of the snowblowing ocean
in its flash to a sea of sierras,
the round fish mouths of our children,
the word *cantan*.[8] All this
you have done for me. Gracias. 50

COMMENTS AND QUESTIONS

1. What folk beliefs and myths appear in "White Magic"? What is their function?

2. How does Walcott suggest the contrast between the culture in which these myths flourish and modern secular culture?

3. How do you interpret the last line and the title of "White Magic"?

4. What does Walcott seem to feel he has in common with Pablo Neruda?

5. What is the effect of the various images of snow, mountains, and birds in "For Pablo Neruda?"

FROM THE UNITED STATES

Sonia Sanchez

present

this woman vomiten her
 hunger over the world
this melancholy woman forgotten
before memory came
 this yellow movement bursten forth like
Coltrane's melodies all mouth
 buttocks moven like palm trees,
this honeycoatedalabamianwoman
raining rhythms of blue / blk / smiles
this yellow woman carryen beneath her breasts
 pleasures without tongues
 this woman whose body weaves
 desert patterns,
this woman, wet with wanderen,
reviven the beauty of forests and winds
is tellen u secrets
gather up yo odors and listen
as she sings the mold from memory

[2] **condors:** In a famous line in *The Heights of Macchu Picchu*, a collection of poems about the ancient Inca city of the title located high in the Andes, Neruda mentions condors, a bird with a wingspread of twelve feet common to the Andes.

[3] **Isla Negra:** Pablo Neruda had a house in Isla Negra, on the Pacific coast in Chile. When he was in residence there, he flew a flag.

[4] **Macchu Picchu:** See note 2.

[5] **César Vallejo** (1892–1938): Peruvian poet particularly interested in social change.

[6] **Octavio:** Octavio Paz (1914–1998), a Nobel Prize winner from Mexico who often wrote about the Mexican search for identity in its Indian past; Paz's long poem "Sunstone" is a critique of Mexican apathy. *Sunstone* can also refer to gold.

[7] **Saxons:** Originally, a Germanic tribe, some of whom conquered England in the fifth and sixth centuries; the term *Anglo-Saxon* usually refers to England and the English.

[8] *cantan:* Spanish for "You (plural) sing" or "They sing."

ISHMAEL REED

beware: do not read this poem

tonite, *thriller* was
abt an ol woman, so vain she
surrounded her self w/
 many mirrors

it got so bad that finally she 5
locked herself indoors & her
whole life became the
 mirrors

one day the villagers broke
into her house, but she was too 10
swift for them. she disappeared
 into a mirror
each tenant who bought the house
after that, lost a loved one to
 the ol woman in the mirror: 15
 first a little girl
 then a young woman
 then the young woman/s husband

the hunger of this poem is legendary
it has taken in many victims 20
back off from this poem
it has drawn in yr feet
back off from this poem
it has drawn in yr legs
back off from this poem 25
it is a greedy mirror
you are into this poem. from
 the waist down
nobody can hear you can they?
this poem has had you up to her 30
 belch
this poem aint got no manners
you cant call out frm this poem
relax now & go w/ this poem
move & roll on to this poem 35
do not resist this poem
this poem has yr eyes
this poem has his head
this poem has his arms
this poem has his fingers 40
this poem has his fingertips

this poem is the reader & the
reader this poem
statistic: the us bureau of missing persons reports
 that in 1968 over 100,000 people 45
 disappeared
 leaving no solid clues
 nor trace only
a space in the lives of their friends

 there is no place
for a soft / blk / woman
there is no smile green enough or
summertime words warm enough to allow my
 growth
and in my head
i see my history
standen like a shy child
and i chant lullabies
as i ride my past on horseback
tasten the thirst of yesterday tribes
hearen the ancient / blk / woman
me singen hay-hay
 hay-hay-hay-ya-ya-ya
 hay-hay-hay
 hay-hay-ya-ya-ya
 like a slow scent
beneath the sun
 and i dance my
creation and my grandmothers gatheren
from my bones like great wooden birds
spread their wings
while their long / legged / laughter /
stretches the night.
 and i taste the
seasons of my birth, mangoes, papayas
drink my woman / coconut / milks
stalk the ancient grandfathers
sippen on proud afternoons
walk with a song round my waist
tremble like a new / born / child troubled
with new breaths
 and my singen
becomes the only sound of a
blue / blk / magical / woman. walken.
womb ripe. walken. loud with mornings. walken
maken pilgrimage to herself. walken.

COMMENTS AND QUESTIONS

1. Black aesthetic poetry is noted for its bold images
 and figures of speech. Identify some of them in this
 poem, and explain how they relate to the poem's
 overall theme.

2. How effective is Sanchez's decision to ignore the
 standard rules of grammatical form? What ideo-
 logical statement is she making?

3. What, for Sanchez, gives the black woman a privi-
 leged place in African American history?

4. Is there a "maternal instinct"? Discuss the claim
 that black women are more maternal than white
 women.

COMMENTS AND QUESTIONS

1. What is the significance of the mirror as a central postmodern image? What does it say about the postmodern view of reality?

2. Explain the meaning of the expression "this poem is the reader & the/reader this poem." What does it suggest about the postmodern attitude toward authorship?

3. What postmodern linguistic and stylistic techniques are evident in Reed's poem?

4. The fantastic, irrationality, and entropy are common themes of postmodern literature. Identify each of these elements in the poem, and discuss its function.

RITA DOVE

Rita Dove has received the Pulitzer Prize for poetry and was poet laureate of the United States from 1993 to 1995—the first African American to hold this position. She has written short stories and a novel, but her primary achievement has been in the books of poetry she has published regularly since 1977. In her 1995 book *Mother Love*, selections from which appear here, Dove explores the bond between mother and daughter through the ancient Greek myth of Demeter and Persephone. According to this myth, which appears throughout Greek literature, Demeter, goddess of the earth, began a period of wandering and mourning when her daughter, Persephone, was stolen from her by Hades (or Pluto), god of the underworld. Inconsolable, she refused to let the earth bring forth any fruit for a year. After negotiations with Zeus, Demeter agreed that Persephone would live with Hades (now her husband) in the underworld one-third of the year but return to her for the other two-thirds. Thus, the changes of season are explained: the earth mourns and sleeps in winter while Persephone is gone, but rejoices when she returns in the spring.

Persephone Abducted

She cried out for Mama, who did not
hear. She left with a wild eye thrown back,
she left with curses, rage
that withered her features to a hag's.
No one can tell a mother how to act: 5
there are no laws when laws are broken, no names
to call upon. Some say there's nourishment for pain,

and call it Philosophy.
That's for the birds, vulture and hawk,
the large ones who praise 10

the miracle of flight because
they use it so diligently.
She left us singing in the field, oblivious
to all but the ache of our own bent backs.

Demeter Mourning

Nothing can console me. You may bring silk
to make skin sigh, dispense yellow roses
in the manner of ripened dignitaries.
You can tell me repeatedly
I am unbearable (and I know this): 5
still, nothing turns the gold to corn,
nothing is sweet to the tooth crushing in.

I'll not ask for the impossible;
one learns to walk by walking.
In time I'll forget this empty brimming, 10
I may laugh again at
a bird, perhaps, chucking the nest—
but it will not be happiness,
for I have known that.

COMMENTS AND QUESTIONS

1. How has Dove modernized the Greek myth? Which elements of the ancient myth appear in the poems?

2. Which images in these poems do you find particularly striking and why?

3. How would you describe Dove's language and tone?

4. How does "mother love" appear in these poems? How is the relationship between mother and daughter described?

JOHN BARTH

Autobiography: A Self-Recorded Fiction

You who listen give me life in a manner of speaking.
 I won't hold you responsible.
 My first words weren't my first words. I wish I'd begun differently.
 Among other things I haven't a proper name. The one I bear's misleading, if not false. I didn't choose it either.
 I don't recall asking to be conceived! Neither did my parents come to think of it. Even so. Score to be settled. Children are vengeance.
 I seem to've known myself from the beginning without knowing I knew; no news is good news; perhaps I'm mistaken.
 Now that I reflect I'm not enjoying this life: my link with the world.

My situation appears to me as follows: I speak in a curious, detached manner, and don't necessarily hear myself. I'm grateful for small mercies. Whether anyone follows me I can't tell.

Are you there? If so I'm blind and deaf to you, or you are me, or both're both. One may be imaginary; I've had stranger ideas. I hope I'm a fiction without real hope. Where there's a voice there's a speaker.

I see I see myself as a halt narrative: first person, tiresome. Pronoun sans ante or precedent, warrant or respite. Surrogate for the substantive; contentless form, interestless principle; blind eye blinking at nothing. Who am I. A little *crise d'identité*[1] for you.

I must compose myself.

Look, I'm writing. No, listen, I'm nothing but talk; I won't last long. The odds against my conception were splendid; against my birth excellent; against my continuance favorable. Are yet. On the other hand, if my sort are permitted a certain age and growth, God help us, our life expectancy's been known to increase at an obscene rate instead of petering out. Let me squeak on long enough, I just might live forever: a word to the wise.

My beginning was comparatively interesting, believe it or not. Exposition. I was spawned not long since in an American state and born in no better. Grew in no worse. Persist in a representative. Prohibition, Depression, Radicalism, Decadence, and what have you. An eye sir for an eye. It's alleged, now, that Mother was a mere passing fancy who didn't pass quickly enough; there's evidence also that she was a mere novel device, just in style, soon to become a commonplace, to which Dad resorted one day when he found himself by himself with pointless pen. In either case she was mere, Mom; at any event Dad dallied. He has me to explain. Bear in mind, I suppose he told her. A child is not its parents, but sum of their conjoined shames. A figure of speech. Their manner of speaking. No wonder I'm heterodoxical.

Nothing lasts longer than a mood. Dad's infatuation passed: I remained. He understood, about time, that anything conceived in so unnatural and fugitive a fashion was apt to be freakish, even monstrous—and an advertisement of his folly. His second thought therefore was to destroy me before I spoke a word. He knew how these things work; he went by the book. To expose ourselves publicly is frowned upon; therefore we do it to one another in private. He me, I him; one was bound to be the case. What fathers can't forgive is that their offspring receive and sow broadcast their shortcomings. From my conception to the present moment Dad's tried to turn me off; not ardently, not consistently, not successfully so far; but persistently, persistently, with at least half a heart. How do I know? I'm his bloody mirror!

Which is to say, upon reflection I reverse and distort him. For I suspect that my true father's sentiments are the contrary of murderous. That one only imagines he begot me; mightn't he be deceived and deadly jealous? In his heart of hearts he wonders whether I mayn't after all be the get of a nobler spirit, taken by beauty past his grasp. Or else, what comes to the same thing, to me, I've a pair of dads, to match my pair of moms. How account for my contradictions except as the vices of their versus? Beneath self-contempt, I particularly scorn my fondness for paradox. I despise pessimism, narcissism, solipsism,[2] truculence, word-play, and pusillanimity, my chiefer inclinations; loathe self-loathers *ergo me*;[3] have no pity for self-pity and so am free of that sweet baseness. I doubt I am. Being me's no joke.

I continued the tale of my forebears. Thus my exposure; thus my escape. This cursed me, turned me out; that, curse him, save me; right hand slipped me through left's fingers. Unless on a third hand I somehow preserved myself. Unless unless: the mercy-killing was successful. Buzzards let us say made brunch of me betimes but couldn't stomach my voice, which persists like the Nauseous Danaid.[4] We . . . monstrosities are easilier achieved than got rid of.

In sum I'm not what either parent or I had in mind. One hoped I'd be astonishing, forceful, triumphant—heroical in other words. One dead. I myself conventional. I turn out I. Not every kid thrown to the wolves ends a hero: for each survivor, a mountain of beast-baits; for every Oedipus, a city of feebs.[5]

So much for my dramatic exposition: seems not to've worked. Here I am, Dad: Your creature! Your caricature!

Unhappily, things get clearer as we go along. I perceive that I have no body. What's less, I've been speaking of myself without delight or alternative as self-consciousness pure and sour; I declare now that even that isn't true. I'm not aware of myself at all, as far as I know. I don't think . . . I know what I'm talking about.

Well, well, being well into my life as it's been called I see well how it'll end, unless in some meaningless surprise. If anything dramatic were going to happen to make me successfuller . . . agreeabler . . . endurabler . . .

[1] *Crise d'identité* is French for "identity crisis." [Notes from *The Heath Anthology of American Literature*.]

[2] Narcissism is the love of one's self; solipsism is the philosophical position that nothing exists but the contents of one's own mind.

[3] *Ergo me* is Latin for "therefore me."

[4] A Danaid is one of the mythical fifty daughters of Danaus, ruler of Argos, who ordered his daughters to murder their husbands on their wedding night.

[5] Oedipus, the mythical ruler of Thebes (rhymes with "feebs"), unknowingly killed his father and married his mother. Oedipus was left out on a hillside (exposed) when born because his father, Laïos, wished to avoid the prophecy that he would be slain by his son. Oedipus was saved by shepherds, who raised him. See Sophocles' tragedy *Oedipus Rex,* Chapter 4.

it should've happened by now, we will agree. A change for the better still isn't unthinkable; miracles can be cited. But the odds against a wireless *deus ex machina*[6] aren't encouraging.

Here, a confession: Early on I too aspired to immortality. Assumed I'd be beautiful, powerful, loving, loved. At least commonplace. Anyhow human. Even the revelation of my several defects—absence of presence to name one—didn't fetch me right to despair: crippledness affords its own heroisms, does it not; heroes are typically gimpish, are they not. But your crippled hero's one thing, a bloody hero after all; your heroic cripple another, etcetcetcetcetcet. Being an ideal's warped image, my fancy's own twist figure, is what undoes me.

I wonder if I repeat myself. One-track minds may lead to their origins. Perhaps I'm still in utero,[7] hung up in my delivery; my exposition and the rest merely foreshadow what's to come, the argument for an interrupted pregnancy.

Womb, coffin, can—in any case, from my viewless viewpoint I see no point in going further. Since Dad among his other failings failed to end me when he should've, I'll turn myself off if I can this instant.

Can't. *Then if anyone hears me, speaking from here inside like a sunk submariner, and has the means to my end, I pray him do us both a kindness.*

Didn't. Very well, my ace in the hole: *Father, have mercy, I dare you! Wretched old fabricator, where's your shame? Put an end to this, for pity's sake! Now! Now!*

So. My last trump, and I blew it. Not much in the way of a climax; more a climacteric. I'm not the dramatic sort. May the end come quietly, then, without my knowing it. In the course of any breath. In the heart of any word. This one. This one.

Perhaps I'll have a posthumous cautionary value, like gibbeted corpses,[8] pickled freaks. Self-preservation, it seems, may smell of formaldehyde.[9]

A proper ending wouldn't spin out so.

I suppose I might have managed things to better effect, in spite of the old boy. Too late now.

Basket case. Waste.

Shake up some memorable last words at least. There seems to be time.

Nonsense, I'll mutter to the end, one word after another, string the rascals out, mad or not, heard or not, my last words will be my last words.

6 *Deus ex machina* literally means "god from a machine," a stage device used in Greek drama that would lower an actor, dressed up as a god, to unravel complicated plots and bring about a happy ending.

7 *In utero* is a medical term for "in the womb."

8 Gibbeted corpses were dead persons left hanging on the gallows.

9 Formaldehyde is a chemical used for preserving dead bodies.

COMMENTS AND QUESTIONS

1. Who is the speaker in this story?

2. Who is the speaker's father?

3. How does the speaker call attention to the structure of the story?

4. In what ways is the relationship between a protagonist and its author an example of narcissism? Of solipsism?

5. In what way is the Oedipus story a model of the relationship between an author and his protagonist?

6. Are the puns appropriate to this story? Explain.

FROM LATIN AMERICA

Ernesto Cardenal

This poet priest, like so many other Latin Americans before him, has lived in Nicaragua under the harsh oppression of a long-term dictatorship. He combines Christian and biblical forms with themes of social protest and revolution. His is the voice of the voiceless. An echo of liberation theology can be heard in much of his profoundly religious poetry. Since the overthrow of the Somozas, he has become an active participant in the formation of a new Nicaragua. His poetry contains both postmodern themes and a pervasive tone of imminent social upheaval.

Prayer for Marilyn Monroe
Translation by Robert Pring-Mill

Lord
accept this girl called Marilyn Monroe throughout
 the world
though that was not her name
(but You know her real name, that of the orphan 5
 raped at nine,
the shopgirl who tried to kill herself aged just
 sixteen)
who now goes into Your presence without make-up
without her Press Agent 10
without her photographs or signing autographs
lonely as an astronaut facing the darkness of outer
 space.
When she was a child, she dreamed she was naked in
 a church 15
 (according to *Time*)
standing in front of a prostrate multitude, heads to
 the ground, and had to walk on tiptoe to avoid
 the heads.

You know our dreams better than the psychiatrists. 20
Church, house, or cave all represent the safety of the
 womb
but also something more. . . .
The heads are admirers, so much is clear (that
mass of heads in the darkness below the beam to the 25
 screen).
But the temple isn't the studio of 20th-Century Fox.
The temple, of gold and marble, is the temple of her
 body
in which the Son of Man stands whip in hand 30
driving out the money-changers of 20th-Century
 Fox
who made Your house of prayer a den of thieves.

Lord,
in this world defiled by radioactivity and sin,
surely You will not blame a shopgirl 35
who (like any other shopgirl) dreamed of being a
 star.
And her dream became "reality" (Technicolor
 reality).
All she did was follow the script we gave her, 40
that of our own lives, but it was meaningless.
Forgive her Lord and forgive all of us
for this our 20th Century
and the Mammoth Super-Production in whose
 making we all shared. 45

She was hungry for love and we offered her
 tranquilizers.
For the sadness of our not being saints they
 recommended Psychoanalysis.
Remember Lord her increasing terror of the camera 50
and hatred of make-up (yet her insistence on fresh
 make-up
for each scene) and how the terror grew
and how her unpunctuality at the studios grew.

Like any other shopgirl 55
she dreamed of being a star.
And her life was as unreal as a dream an analyst
 reads and files.

Her romances were kisses with closed eyes
which when the eyes are opened 60
are seen to have been played out beneath the
 spotlights and the spotlights are switched off

and the two walls of the room (it was a set) are
 taken down
while the Director moves away notebook in hand, 65
 the scene being safely canned.
Or like a cruise on a yacht, a kiss in Singapore, a
 dance in Rio,
a reception in the mansion of the Duke and Duchess
 of Windsor viewed in the sad tawdriness of a 70
 cheap apartment.

The film ended without the final kiss.
They found her dead in bed, hand on the phone.
And the detectives never learned who she was going
 to call. 75
It was as
though someone had dialed the only friendly voice
and heard a prerecorded tape just saying "WRONG
 NUMBER";
or like someone wounded by gangsters, who 80
reaches out toward a disconnected phone.

Lord, whoever
it may have been that she was going to call
but did not (and perhaps it was no one at all
or Someone not in the Los Angeles telephone book), 85
 Lord, You pick up that phone.

COMMENTS AND QUESTIONS

1. What postmodernist themes appear in "Prayer for
 Marilyn Monroe"? Why has the poet employed a
 prayer as his vehicle here?

2. Compare the image of Marilyn Monroe in this
 poem with that used by Andy Warhol in his
 silkscreen (Color Plate XXXV).

CLARICE LISPECTOR

One of Brazil's greatest modern writers, Lispector was
born in Ukraine to Jewish parents who immigrated to
Brazil when she was only two months old. She started
writing early in life and continued, through law
school, marriage, travel, and raising a family. Al-
though influences from Brazilian-Portuguese and Eu-
ropean literature can be discerned in her work, her
style is truly unique. She excels in short stories—some-
times mixed with philosophical and lyrical medita-
tions—that culminate in what James Joyce called an
"epiphany," or revelation that changes a life. She is
also fond of the short-short story, a form in which
much must be suggested rather than said. The follow-
ing, from her collection *Soulstorm* (1974), is an
example.

He Soaked Me Up

Translation by Alexis Levitin

It did! It really happened!

Serjoca was a beautician. But he wanted nothing
from women. He liked men.

And he did Aurelia Nascimento's make-up. Aurelia
was pretty, and made up she became radiant. She was
blonde, wore a wig and false eyelashes. They became

friends. They went out together, you know, for a meal at a bar, that kind of thing.

Whenever Aurelia wanted to look good, she called up Serjoca. Serjoca himself was good-looking. He was tall and slender.

And so it went. A telephone call and they would agree to meet. She would dress well, outdoing herself. She wore contact lenses. And falsies. Her own breasts were pointed, pretty. She only used falsies because she was small breasted. Her mouth was a red rosebud. Her teeth were large and white.

One day, at six in the evening, just when the traffic was at its worst, Aurelia and Serjoca were standing in front of the Copacabana Palace[1] waiting in vain for a taxi: Serjoca, worn out, was leaning against a tree. Aurelia was impatient. She suggested that they give the doorman ten cruzeiros to get them a cab. Serjoca refused: he was tough when it came to money.

It was almost seven o'clock. It was getting dark. What should they do?

Near them stood Affonso Carvalho. Manufacturer. Industrialist. He was waiting for his chauffeur with the Mercedes. It was hot out, but the car was air conditioned and had a telephone and refrigerator. Affonso had turned forty the day before.

He noticed the impatience of Aurelia, who was tapping her foot on the pavement. An interesting woman, thought Affonso. And she needs a ride. He turned to her:

"Excuse me, are you having some difficulty in finding a taxi?"

"I've been here since six o'clock and not one taxi has stopped for us. I can't take it much longer."

"My chauffeur will be here shortly," said Affonso. "Could I give you two a ride somewhere?"

"I would be most grateful, especially since my feet ache."

But she didn't say that she had corns. She hid the defect. She was fully made up and looked at the man with desire. Serjoca was very quiet.

Finally the chauffeur arrived, got out, and opened the door. The three got in back. She discreetly took off a shoe and sighed with relief.

"Where do you want to go?"

"We don't have anywhere in particular to go," Aurelia said, more and more aroused by Affonso's virile face.

He said: "What if we go to the Number One for a drink?"

"I'd love to," said Aurelia. "Wouldn't you, Serjoca?"

"Sure, I need a strong drink."

So they went to the bar, almost empty at that hour. As they talked Affonso talked of metallurgy. The other two didn't understand a thing. But they pretended to understand. It was boring. But Affonso was carried away and, under the table, put his foot on top of Aurelia's foot. Precisely the foot with a corn. Excited, she responded. Then Affonso said:

"And what if we were to have dinner at my house? Today I'm having escargots and chicken with truffles. What do you say?"

"I'm starving."

Serjoca said nothing. He too was on fire for Affonso.

The apartment was carpeted in white, and there was a sculpture by Bruno Giorgi. They sat down, had another drink, and went into the dining room. A table of dark rosewood. A waiter serving from the left. Serjoca didn't know how to eat snails and fumbled ineptly with the special silverware. He didn't like it. But Aurelia enjoyed it a lot, even though she was afraid of smelling of garlic. And they all drank French champagne throughout the meal. No one wanted dessert, they just wanted coffee.

And they went into the living room. There Serjoca came alive. And began to talk as if he'd never stop. He threw languid glances at the businessman, who on his part was surprised at the eloquence of the good-looking young fellow. The next day he would call Aurelia to tell her Serjoca was a lovely person.

And they agreed to meet again. This time at a restaurant, the Albamar. They ate oysters to begin with. Again, Serjoca had trouble eating the oysters. I'm a failure, he thought.

But before they got together, Aurelia had called up Serjoca: she desperately needed to be made up. He went to her house.

Then, while she was being made up, she thought: Serjoca is taking off my face.

It felt as if he were wiping away her features: emptiness, a face merely of flesh. Brown flesh.

She felt ill. She excused herself and went to the bathroom to look at herself in the mirror. It was just as she had imagined: Serjoca had destroyed her face. Even the bones—and she had spectacular bone structure—even the bones had disappeared. He's soaking me up, she thought, he's going to destroy me. And it's on account of Affonso.

She returned dispirited. At the restaurant she scarcely spoke. Affonso spoke mostly with Serjoca, hardly looking at Aurelia: he was interested in the young man.

Finally, finally the luncheon ended.

Serjoca made a date to meet Affonso that night. Aurelia said she couldn't go, that she was tired. It was a lie: she wouldn't go because she didn't have a face to show.

Arriving home, she took a long bubble bath and sat thinking: a little longer and he'll take away my body as well. What could she do to recover what had been hers? Her individuality?

[1] A luxury hotel in the Copacabana section of Rio de Janeiro, on the beach.

She left the bathroom thoughtfully. She dried herself with an enormous red towel. Thinking the whole time. She weighed herself on the scale: her weight was good. A little longer and he'll take away my weight as well, she thought.

She went to the mirror. She looked at herself for a long time. But she was nothing anymore.

Then—then, suddenly, she gave herself a hard slap on the left side of her face. To wake up. She stood still, looking at herself. And, as if it hadn't been enough, she gave herself two more slaps. To find herself.

And it really happened!

In the mirror she finally saw a human face. Sad. Delicate. She was Aurelia Nascimento. She had just been born. Nas-ci-men-to.[2]

COMMENTS AND QUESTIONS

1. In this very short form, almost every detail must count. What do we know about the three characters, and how do we know it?
2. How would you describe the author's attitude toward the characters and the events? Are there comic moments? Where?
3. How do you interpret Aurelia's impression that Serjoca is "taking off her face" and "soaking her up"?
4. What is the significance of Aurelia's "birth" in the last paragraph?

FROM ISRAEL/PALESTINE

YEHUDA AMICHAI

Yehuda Amichai (1924–2000) is one of the best-known Israeli poets and received the Israel Prize of Poetry in 1982. He was born in 1924 in Wurzburg, Germany, and emigrated to Israel in 1935, settling finally in Jerusalem. He began writing poetry in 1949, and his work, which includes prose as well as poetry, has been widely recognized and translated into thirty-seven languages. Many of his poems speak of Jerusalem, where he died on September 22, 2000.

Jerusalem

Translation by Stephen Mitchell

On a roof in the Old City
laundry hanging in the late afternoon sunlight:
the white sheet of a woman who is my enemy,
the towel of a man who is my enemy,
to wipe off the sweat of his brow.

[2] *Nascimento* means *birth* in Italian. (Brazil has a large Italian community.)

In the sky of the Old City
a kite.
At the other end of the string,
a child
I can't see
because of the wall.

We have put up many flags,
they have put up many flags.
To make us think that they're happy.
To make them think that we're happy.

18

"One sees all kinds of things," said the Swedish
officer observing at the armistice line.
"All kinds of things," and said nothing more.

"One sees a lot of things," said the old
shoeshine man by the Jaffa gate
when a Swedish girl in a very short dress
stood above him, without looking at him
with her proud eyes.

The prophet who looked into the opening heaven saw,
and so did God, "all kinds of things" down there
 beyond the smoke,
and the surgeon saw when he cut open a cancerous
 belly
and closed it again.

"One sees all kinds of things," said
our ancestor Jacob on his bed after the blessing
which took his last strength. "All kinds
of things," and he turned
toward the wall and he died.

42

These words, like heaps of feathers
on the edge of Jerusalem, above the Valley of the
 Cross.
There, in my childhood, the women sat
plucking chickens.
These words fly now all over the world.
The rest is slaughtered, eaten,
digested, decayed, forgotten.

The hermaphrodite of time
who is neither day nor night
has wiped out this valley
with green well-groomed gardens.
Once experts of love used to come here
to perform their expertise
in the dry grass of summer nights.

That's how it started.
Since then—many words, many loves,
many flowers

bought for warm hands to hold
or to decorate tombs.

That's how it started
and I don't know how it will end.
But still, from beyond the valley,
from pain, and from distance
we shall forever go on calling out
to each other: "We'll change."

COMMENTS AND QUESTIONS

1. What effect does the everyday imagery (laundry hanging, plucking chickens, etc.) have in Amichai's poems?

2. What do you think the "all kinds of things" in poem "18" might refer to?

3. Is there a political (or other) message in these poems? If so, what is it, and how is it conveyed?

MAHMOUD DARWISH

Mahmoud Darwish (b. 1941) has been called the Palestinian national poet. He was born in the village of Berweh, Palestine (now in Israel). He left Israel in 1970 and settled in Beirut in 1972, where he continued to write the poetry that has made him one of the most recognized living Arab poets. When the Palestine Liberation Organization was expelled from Beirut in 1982, Darwish left Lebanon; after a period of living in Cyprus, Paris, and Tunis, he settled in Ramallah in 1996.

Identity Card

Translation by Denys Johnson-Davies

Put it on record.
 I am an Arab
And the number of my card is fifty thousand
I have eight children
And the ninth is due after summer.
What's there to be angry about?

Put it on record.
 I am an Arab
Working with comrades of toil in a quarry.
I have eight children
For them I wrest the loaf of bread,
The clothes and exercise books
From the rocks
And beg for no alms at your door,
 Lower not myself at your doorstep.
 What's there to be angry about?

Put it on record.
 I am an Arab.

I am a name without a title,
Patient in a country where everything
Lives in a whirlpool of anger.
 My roots
 Took hold before the birth of time
 Before the burgeoning of the ages,
 Before cypress and olive trees,
 Before the proliferation of weeds.
My father is from the family of the plough
 Not from highborn nobles.
And my grandfather was a peasant
 Without line or genealogy.
My house is a watchman's hut
 Made of sticks and reeds.
Does my status satisfy you?
 I am a name without a surname.

Put it on record.
 I am an Arab.
Colour of hair: jet black.
Colour of eyes: brown.
My distinguishing features:
 On my head the *'iqal* cords over a *keffiyeh*[1]
 Scratching him who touches it.
My address:
 I'm from a village, remote, forgotten,
 Its streets without name
 And all its men in the fields and quarry.

 What's there to be angry about?

Put it on record.
 I am an Arab.
You stole my forefathers' vineyards
 And land I used to till,
 I and all my children,
 And you left us and all my grandchildren
 Nothing but these rocks.
 Will your government be taking them too
 As is being said?

So!
 Put it on record at the top of page one:
 I don't hate people,
 I trespass on no one's property.

COMMENTS AND QUESTIONS

1. Which lines are repeated in this poem? What is the effect of this repetition?

2. Whom is the poet addressing and in what circumstances?

3. How does the poet portray himself?

4. What political statement is he making and how?

[1] The keffiyeh is the large square headgear worn by men. It is kept in place by a headband called an 'iqal.

Summary Questions

1. What effects did the war in Vietnam have on American culture?

2. Why did Americans' confidence, low in the 1970s, reassert itself in the 1980s?

3. What new challenges to the United States does the international war against terrorism present?

4. How have problems of international peace and war changed since the end of the Cold War?

5. What has caused the impasse between Israel and the Palestinians?

6. What are the arguments in support of official policy encouraging globalization? What are the arguments against it?

7. What are the trends and effects of immigration?

8. What developments in sexual politics have taken place over the last thirty to forty years?

9. What is postcolonialism, and what effect has it had on the humanities?

10. What events and movements in the arts characterized the 1960s?

11. What innovations did Coleman make in free form jazz?

12. What are the primary characteristics of postmodernism?

13. What differentiates postmodern architecture from the International Style?

14. What is pop art?

15. What social concerns have appeared in the visual arts over the last three decades?

16. What accounts for the renewed interest in crafts as art?

17. What is the view of language in postmodern theory and literature?

18. What role do computers and the Internet play in our changing notions of reality?

Key Terms

globalization

multiculturalism

postcolonialism

sexual politics

black aesthetic

free form jazz

postmodernism

International Style

pop art

crafts movement

theory

terrorism

The Humanities from the
Middle Twentieth Century On

The human creations of the last half-century exhibit a discontinuity with tradition in appearance even more radical than did those of the early twentieth century. The great systems of the past that once served as intellectual frameworks fell apart, as we have seen, at that time. As yet, no dominant system of belief has restored to Western culture its lost unity. Our own time is rather one of searching, of experimentation, and of multiplicity in morality and ideology as well as in the arts. The artistic freedom for which the great modernist innovators struggled has been achieved, or overachieved. Whereas the artists who made the first break with the representation of the real world shocked their public by challenging its cultural assumptions and traditions, contemporary artists confront a public that is virtually shockproof. The necessity to innovate seems constant; indeed styles, trends, and schools appear and disappear within periods of a few years. The fact that they also coexist makes the contemporary scene one characterized by a bewildering, yet exhilarating plurality of forms.

The explanation of this state of affairs lies not only in the evolution of the humanities themselves but also in the economic, political, and social environment in which the changes have taken place. Support for arts and letters in the West has been, until recently, in the keeping of a well-educated, relatively small class of individuals who had both leisure and wealth to devote to such pursuits. During the past century, with the beginnings of redistribution of income and the rise in the standards of living and literacy in the lower classes, this cultural hegemony has gradually diminished. In addition, the rise in immigration to the West from non-Western countries and from Latin America and the Caribbean, along with the spread of Afrocentric, Latino, Native American, and feminist and gay movements, has made multiculturalism a force to be reckoned with. Mass communications, especially television and the Internet, have increased the facility and speed with which cultural products can be distributed. But mass communications also change the

nature of these products. A play seen on television, a symphony heard on compact disk, artwork viewed on a website, and a text read in digital form offer experiences different from those of a theater, a concert hall, a museum, and a book. As more and more art and cultural artifacts are distributed electronically, the question of whether the forms we call "literature," "art," and "music" will survive at all is a legitimate one.

Mass communications have also vastly increased our access to cultures outside the one in which we live, although not necessarily our understanding of these cultures. Postcolonial and multicultural assertion of difference has contributed to make our sense of cultural relativity deeper and more pervasive than it was in the days of Montaigne or Voltaire. The shifting balance of the West's position in international politics has also had its impact on culture and the arts. Europe is no longer able to impose its cultural values on the rest of the world, as it had done since the seventeenth century. The prominence of Latin American and African writers on the international literary scene may be symptomatic. More remote cultures are constantly gaining a stronger presence. In the course of a few days, we may watch a program on life in the South Pacific, attend a performance of a touring company doing Chinese dances, hear a lecture on Islam and the Middle East, listen to Japanese music or to medieval European music on authentic instruments reproduced by Japanese technology, see a film by Native Americans, and read a newly published novel by an African writer. As the developing world continues to adopt Western technology, some Europeans and Americans, sensing a spiritual vacuum in the West, have turned toward Eastern philosophies, religions, and healing arts. And yet there is no doubt that in popular culture, the United States remains dominant.

The feeling of being able to exist in several temporal, spatial, and cultural zones at once is, as we have seen, characteristic of the postmodern era. Expressing this sense of pluralism, postmodern architects play with elements of various styles. The "culture wars" of the

1980s and 1990s led to an opening of the canon, or the "sacred texts," of the Western tradition. Feminists called attention to the neglect of the study of creative works by women and also proposed "woman-centered" approaches to the reading of old texts. African Americans, Native Americans, Hispanics, and recent immigrant minorities succeeded in legitimizing their formerly neglected contributions.

In the postmodern arts, popular and high culture, less distinct than formerly, blend and exchange forms. Contemporary serious composers learn from and incorporate pop, rock, and jazz; choreographers use popular and nondance steps; painters and advertisers share some of the same visual language; films and television programs speak to cultured and uncultured alike. The development of the crafts movement betrays a revolt against mass production and a desire to emulate traditional cultures (as in Africa) where arts and crafts are one. Still, it is possible to make at least one basic distinction between the true artist and the producer of mass entertainment. The former demands from his or her public an *active* participation—an involvement of the mind, spirit, and senses—very much, as we have seen, within the tradition of the humanities. The latter, in accord with many other aspects of modern life, encourages passive consumption.

Rather than luring or spellbinding their audiences with a smooth, finished product, many artists today like to show the wheels in their machines. Theater audiences are constantly reminded that they are witnessing a play, an artifice, not a window on the world. The actors may even enter into a dialogue with the audience. Similarly, novelists, poets, and filmmakers tend to say, in effect, "I am writing a novel," "I am trying to create a poem," "I am making a film." In literary works "published" as hypertexts on the Internet, this is carried even further because the reader may have an impact on the text. Visual artists, taking their work out of the museum and into the environment, emphasize both the differences between their creations and the natural world, and the dialogue that must take place between them. Architects are not afraid to expose things such as wiring and plumbing. Musicians make compositions of *sounds*, not pure music, using tape recorders and electronic synthesizers along with acoustic instruments.

Our acceptance of an art without bounds is closely related to the growing tendency to integrate the arts into society. The elitist quality, characteristic of Western art from the Renaissance through the modernist period, might in a sense be viewed as a deviation from the history of the humanities not only in other areas of the world but even in Europe itself. Although lacking the cohesive, unitary vision of ancient Greeks or medieval Christians—cultures in which many forms of the humanities had vital, everyday impact—modern Americans recognize the significant role that the arts and humanities can play in a community, whether local or electronic-global. The multicultural movement has made us more aware of art as the preserver and communicator of cultural values.

Although in some ways postmodern expressions are more accessible and more in tune with popular culture than were their modernist counterparts, in other ways they are more remote. While using electronics or images from advertising, postmodern artists may be making a violent critique of bland, passive mass culture. The domain of theory is difficult not just for the average readers but even for many highly educated ones. Yet in their demonstrations of our dependence on images, our imprisonment in "textuality" or systems of language, the "death of the author," and the collapse of traditional Western notions of reality, the theorists have formulated some of the important underpinnings of contemporary culture.

Everyone is aware that our world today is characterized by increased bureaucracy and regimentation. The events of September 11, 2001, resulted in a massive increase in governmental control and an ongoing debate over the proper boundaries between security and civil rights. Data banks, computers, and officials intervene constantly in daily life. The fear of being reduced to automatons, however, has in some cases led to an awareness of the need for creative expression, and for the humanities generally, in modern life. One of the most important tasks before those dedicated to the humanities is to help prevent the vital, creative being from being replaced by a passive, docile consumer.

Naturally, if the humanities are to be relevant to contemporary problems, they must keep pace with the rapid changes in contemporary life. What is called for are forms and thoughts oriented toward the future, not a self-satisfied idealization of the past. Yet, paradoxically, the humanist who would be future-oriented must be well versed in the past. Human beings are not islands in time, just as they are not islands in space—their modes of feeling and thinking, as well as their material way of life, are to a great extent shaped by what took place before they existed. Only through awareness of cultural roots, as we have tried to emphasize throughout this book, can people be equipped to understand and to shape the humanities of the future. Of course, every generation will conceive of its roots in slightly different ways and will find that certain works or periods from the past speak to it more urgently than do others. We are beginning to understand the African, Asian, and Middle Eastern contributions to our cultural heritage and to envision ourselves as a multicultural society.

Yet the Western humanities, with their roots in the Greco-Roman and Judeo-Christian traditions, are still present in current forms of American cultural expression. An African American poet, Rita Dove, finds that she can communicate some of her concerns most effectively through Greek mythology. Even if artists work with laser beams rather than paint, hypertext rather than print, and even if they decry the cultural hegemony and the patriarchy of the monuments of the Western world, they affirm a continuity by the very force of their reaction. In the midst of change and diversity, we can be fairly certain that if we manage not to destroy our planet, people centuries from now will still be reading Dostoevsky, visiting Versailles, and listening to Beethoven. They will react to these works with their intelligence and sensibility, absorbing them as part of their individual and collective cultures. North Americans and Europeans will also, with increasing frequency, integrate aspects of African, Asian, Latin American, and other artistic and philosophical creations into their culture. Perhaps eventually we will witness the evolution of a world culture with forms of artistic communication accessible to everyone, and perhaps we will learn to concentrate more on what unifies, rather than on what differentiates, us. The ways in which the traditions of the humanities will be carried forward into the future will be determined by their present students.

Glossary

Italics are used within the definitions to indicate terms that are themselves defined elsewhere in the glossary and, in a few cases, to distinguish titles of works or foreign words.

ABA Form MUSIC: A particular organization of parts used in a musical *composition* in which there are three units, the first and third of which are the same. See *Da capo aria.*

Abbey Religious body governed by an abbot or abbess, or the collection of buildings themselves, also called a monastery.

Absolutism The theory that all political power in a society is derived from one authority, normally a monarch.

Abstract VISUAL ARTS: Not representational or *illusionistic.* Describes painting or sculpture that simplifies or distills figures from the material world into *forms,* lines, *colors.*

Affect MUSIC: The production of emotional reactions in the listener by certain musical sounds, according to a theory from the baroque period. For example, sorrow should be characterized by slow-moving music, hatred by very repulsive harmonies.

African Survival A specific form or function of an institution, ritual, belief, language, or art that is clearly identifiable with an African origin, although adapted to the situation of African descendants in the New World.

Allegory LITERATURE, VISUAL ARTS: The technique of making concrete things, animals, or persons represent abstract ideas or morals. A literary allegory usually takes the form of a *narrative* which may be read on at least two levels; for example, Dante's *Divine Comedy.* Medieval sculptures often have allegorical significance.

Altarpiece VISUAL ARTS: A painted or sculptured decoration on canvas or panels placed behind or above an altar.

Ambulatory ARCHITECTURE: A covered passageway for walking. In a church, the semicircular passage around the main altar.

Anaphora (ah-na′fo-rah) LITERATURE: A rhetorical figure which uses the repetition of the same word or phrase to introduce two or more clauses or lines of verse.

Animism The belief that parts of nature, such as water, trees, etc., have souls and can influence human events. The term is used by Westerners to describe African religions.

Antiphon MUSIC: In Gregorian chant, a short text from the Scriptures or elsewhere set to music in a simple *style,* and sung before and after a Psalm or a canticle.

Antiphonal MUSIC: See *Antiphony.*

Antiphony (an-ti′fo-ny) MUSIC: The sound produced by *choirs* or instruments "answering" one another. For instance, one choir will sing, and then it is "answered" by another choir.

Antithesis LITERATURE: The balance of parallel word groups conveying opposing ideas.

Apse (aap′ss) ARCHITECTURE: A large semicircular or polygonal *niche, domed* or *vaulted.* In a Roman *basilica* the apse was placed at one or both ends or sides of the building. In a Christian church it is usually placed at the east end of the *nave* beyond the *choir.*

Arcade ARCHITECTURE: A covered walk made of *arches* on *piers* or *columns,* rather than *lintels.*

Arch ARCHITECTURE: 1. Commonly, any curved structural member that is used to span an opening. 2. Specifically, restricted to the spanning members of a curved opening that are constructed of wedge-shaped stones called *voussoirs.* Arches may be of many shapes, basically round or pointed. See Roman Architecture (Ch. 6) and Gothic Architecture (Ch. 9).

Archaic 1. Obsolete. 2. In its formative or early stages.

Architrave (ahr′kuh-trave) ARCHITECTURE: A *beam* that rests directly on the *columns;* the lowest part of the *entablature.*

Aria (ah′ree-ah) MUSIC: An elaborate *composition* for solo voice with instrumental accompaniment.

Aristocracy Form of government from Greek word meaning "rule by the few for the common good."

Arpeggiated MUSIC: Describes a rippling effect produced by playing the notes of a chord one after another instead of simultaneously. See *Chord.*

Asantehene (a-sahn′tee-hee-nee) The Akan term for the King of the Ashanti state.

Ase (ah-say′) Yoruba word meaning power, authority, potential energy.

Atman Hindu word for self.

Atmospheric Perspective See *Perspective.*

Atonal MUSIC: Describes music written with an intentional disregard for a central keynote (or tonal center). This style of composition was developed after World War I by Arnold Schoenberg and his followers.

Aulos (ow′los) MUSIC: The most important wind instrument of the ancient Greeks. It is not a flute (as is often stated), but a shrill-sounding oboe. It originated in the Orient and was associated with the orgiastic rites of the god Dionysus.

Axis VISUAL ARTS: The imaginary line that can be passed through a building or a figure, around which the principal parts revolve. See *Balance.*

Balance VISUAL ARTS: The creation of an apparent equilibrium or *harmony* between all the parts of a *composition,* be it a building, painting, or sculpture.

Ballad A narrative poem or song in short stanzas, usually with a refrain, often handed down orally.

Balustrade ARCHITECTURE: A rail or handrail along the top edge of a roof or balcony, made up of a top horizontal rail, a bottom rail, and short *columns* between.

Baptistry ARCHITECTURE: The building or room for performing the rite of baptism. Contains a basin or pool.

Baroque Term first applied to the visual arts and later to the music and literature of the 17th and 18th centuries to designate a style characterized by energy, movement, realism, and violent contrasts. The baroque style is often set in opposition to the orderly and formal "classical" style of the High Renaissance.

Barrel Vault See *Vault.*

Base ARCHITECTURE: 1. The lowest visible part of a building. 2. The slab on which some *column* shafts rest. See *Orders*.

Basilica (bah-sil'i-cah) ARCHITECTURE: A large, rectangular hall with a central space surrounded by aisles on the sides and an *apse* at one or each end or side. The basilica was used as a court of justice by the Romans and adopted by the early Christians as a church.

Bay ARCHITECTURE: One of a series of regularly repeated spaces of a building marked off by vertical elements.

Beam ARCHITECTURE: A large piece of squared timber, long in proportion to its breadth and thickness, used for spanning spaces. A *lintel* is a specific kind of beam.

Blank Verse LITERATURE: Unrhymed lines in *iambic pentameter*. A common form for dramatic verse in English. See Shakespeare (Ch. 19).

Boss ARCHITECTURE: The circular *keystone* at the crossing of diagonal *ribs*. May be richly carved and decorated.

Brahman Hindu word for godhead. Also refers to the priestly class.

Buttress ARCHITECTURE: The vertical exterior mass of masonry built at right angles into the *wall* to strengthen it and to counteract the lateral *thrust* of a *vault* or *arch*. Architecture of the Gothic period developed this *form* into the flying buttress, which is a combination of the regular or *pier*-like buttress and the arched buttress. See *Chartres* (Ch. 9).

Cadence MUSIC: A formula or cliché that indicates a point of repose. The cadence is one of several possible melodic, rhythmic, or harmonic combinations that signal a slowing down or stopping of the forward motion.

Calligraphy The art of beautiful handwriting—important in Chinese poetry and painting.

Candace Title of the Queen Mother in Nubia.

Cantilever ARCHITECTURE: 1. A horizontally projecting member, sometimes called a bracket, used to carry the cornice or eaves of a building. 2. A beam or slab, projecting beyond the wall or supporting column, whose outward thrust or span is held down at one end only. See Robie House (Ch. 31).

Capital ARCHITECTURE: The uppermost or crowning member of a *column*, *pilaster*, or *pier* that forms the visual transition from the post to the *lintel* above. See *Orders*.

Caryatid (kahr'ee-ah-tid) ARCHITECTURE: The name given a *column* when it is disguised as a female figure.

Caste The term used to translate Hindu *jati*, a kinship and/or occupational group in Indian society.

Casting SCULPTURE: A method of reproducing sculpture through the use of a mold that is the receptacle for a liquid which hardens when cooled. The method may be used to produce solid or hollow cast *forms*.

Cathedral Principal church of a diocese, literally the location of the bishop's throne, or *cathedra*.

Cella ARCHITECTURE: The principal chamber of a Greek or Roman temple, housing the cult image.

Centering ARCHITECTURE: The temporary wooden *structure* that supports an *arch* or dome while it is being erected.

Chaitya ARCHITECTURE: Buddhist term for the hall of worship.

Chapel ARCHITECTURE: 1. A small church. 2. A separate compartment in a large church that has its own altar.

Choir ARCHITECTURE: The part of the church reserved for clergy and singers, usually the space between the crossing and the *apse*. MUSIC: A group of singers in a church.

Chord MUSIC: The simultaneous sounding of three or more usually harmonious *tones*.

Chordal MUSIC: Characterized by the employment of *chords* in a logical progression of harmonies.

Choreographer DANCE: Person responsible for the *choreography* of a dance.

Choreography DANCE: The design and arrangement of the movements of a ballet or modern dance.

Chromatic MUSIC: Describes a scale progressing by half-tones instead of the normal degrees of the scale; e.g., in C major: c-c#-d-d#-e instead of c-d-e. VISUAL ARTS: Refers to the visual spectrum of hues. See *Color*.

Cire Perdu (seer pehr-doo') SCULPTURE: French expression meaning "lost wax." Technique for making bronze sculpture that involves molding wax over a clay mold, encasing it with another clay mold, heating the mold, then allowing the wax to drain out and replacing it with molten bronze.

Classic, Classical ALL ARTS: Recognized generally to be excellent, time-tested. LITERATURE AND VISUAL ARTS: 1. From ancient Greece or Rome. 2. From "classical" (fifth century B.C.) Greece or having properties such as *harmony*, *balance*, moderation, and magnitude characteristic of art of that period. MUSIC: The musical *style* of the late 18th century. Leading composers in the classical style are Haydn, Mozart, and the early Beethoven.

Clerestory (clear'story) ARCHITECTURE: An upper story in a building that carries windows or openings for the transmission of light to the space beneath.

Coda MUSIC: A passage of music added to the end of a piece to confirm an impression of finality.

Coffer, Coffering ARCHITECTURE: Originally a casket or box, later, a recessed ceiling panel. Coffering is a technique for making a ceiling of recessed panels.

Collage (kohl-lahzh') VISUAL ARTS: From the French, *coller*, "to glue." A technique for creating *compositions* by pasting or in some way attaching a variety of materials or objects to a flat surface or canvas.

Colonnade ARCHITECTURE: A series of regularly spaced *columns* supporting a *lintel* or *entablature*.

Color VISUAL ARTS: A quality perceived in objects by the human eye that derives from the length of the light waves reflected by individual surfaces. The visible spectrum is divided into six basic hues: red, orange, yellow, green, blue, and violet. Red, yellow, and blue are called the *primary colors*; the others, which result from mixing adjacent primary colors, are called *secondary colors*. White, black, and grays result from mixing these six hues and are not *chromatic*: they cannot be distinguished by hue, only by value. Value is the property of a color that distinguishes it as light or dark. Colors that are "high" in value are light colors; those that are "low" in value are dark colors. Adding white to a color will raise its value to make a *tint*; adding black to a color will lower its value to make a *shade*. Saturation is the property of a color by which its vividness or purity is distinguished. See also *Complementary Colors, Cool Colors, Warm Colors*.

Column ARCHITECTURE: A cylindrical, upright post or pillar. It may contain three parts: *base*, *shaft*, and *capital*.

Comedy LITERATURE: A drama that ends happily, intended to provoke laughter from its audience. Comedy often includes *satire* on types of characters or societies.

Complementary Colors VISUAL ARTS: Hues that form a neutral gray when mixed but, when juxtaposed, form a sharp contrast. The complementary of any *primary color* (red, yel-

low, or blue) is made by mixing the other two primaries. Example: The complementary of red is green, obtained by mixing yellow with blue.

Composition VISUAL ARTS: The arrangements of elements within the work in order to create a certain effect based on a variety of principles and conventions: e.g., *balance, color, contour, focal point*, proportion, scale, *symmetry, volume*. MUSIC: The putting together of elements such as *melody, harmony, rhythm*, and orchestration into a musical *form*. The term may be used similarly to denote a putting together of elements in a dance or film. LITERATURE: The act of composing an oral or written work.

Compound Pier ARCHITECTURE: A *pier* or post made up of attached *columns*. See *Chartres* (Ch. 9).

Concerto (con-chair′toe) MUSIC: A composition for one or more solo instruments and an orchestra, each competing with the other on an equal basis.

Content ALL ARTS: What the *form* contains and means. Content may include subject matter and theme. The quality of a work of art is often judged by the appropriateness, or apparent inseparability, of form and content.

Continuo MUSIC: In the scores of baroque composers (Bach, Handel) the bass part, performed by the harpsichord or organ, together with a viola da gamba or cello. The continuo, during the baroque era, provided the harmonic structure of the pieces being performed.

Contour PAINTING, DRAWING: The visible edge or outline of an object, *form*, or shape, used especially to suggest volume or mass by means of the distinctness, thickness, or color of the edge or line.

Contrapuntal (con-tra-pun′tal) MUSIC: In a *style* that employs *counterpoint*.

Cool Colors VISUAL ARTS: Blues, greens, and associated hues. Cool colors will appear to recede from the viewer in a picture, while *warm colors* will tend to project.

Cornice ARCHITECTURE: 1. The horizontal projection that finishes the top of a *wall*. 2. In classical architecture, the third or uppermost horizontal section of an *entablature*. See *Orders*.

Counterpoint MUSIC: Music consisting of two or more *melodies* played simultaneously. The term is practically synonymous with *polyphony*.

Couplet LITERATURE: Two lines of poetry together, of the same meter and rhyme.

Crossing In a church, the intersection of the *nave* and *transept* in front of the *apse*.

Cuneiform Writing system used in Mesopotamia, based on wedge shapes.

Da Capo Aria (dah cah′poh ahr′ee-ah) MUSIC: A particular type of *aria* that developed in the baroque period (17th and 18th centuries). It consists of two sections, the first of which is repeated after the second. The result is the *ABA form*. See *Aria, ABA Form*.

Daimyo Regional governors, subordinate to the shogunate in Japan (17th–19th centuries).

Deduction PHILOSOPHY: Reasoning from a general principle to a specific fact or case, or from a premise to a logical conclusion.

Democracy From the Greek word meaning "rule by the people." A form of government in which the electorate is coincident with the adult population (sometimes only the adult males) of a community.

Demotic The most simplified, "popular" Egyptian writing system.

Despotism Government by a ruler with unlimited powers.

Dharma Hindu term for one's role in life, determined by class and *caste*.

Dialectic PHILOSOPHY: 1. Platonic—A method of logical examination of beliefs, proceeding by question and answer. 2. Hegelian and Marxian—A logical method that proceeds by the contradiction of opposites (thesis, antithesis) to their resolution in a synthesis.

Dome ARCHITECTURE: A curved or hemispherical roof structure spanning a space and resting on a curved, circular, or polygonal *base*. Theoretically, a dome is an *arch* rotated 360 degrees around a central *axis*. See *Pantheon* (Ch. 6).

Drapery SCULPTURE: The clothing of a figure or *form* in a usually nonspecific but *tactile* and responsive material.

Drum ARCHITECTURE: The cylindrical or polygonal *structure* that rises above the body of a building to support a *dome*.

Duration MUSIC: The time-value assigned to a musical note; that is, how long it is to be played or sung.

Dynamics MUSIC: Words or signs that indicate the varying degrees of loudness in the music. For instance, *forte* (loud), *piano* (soft, quiet), *diminuendo* (decrease volume gradually).

Ego In Freudian theory, one of the three parts of the mind. The ego is the conscious, controlling, self-directed part.

Egungun (eh-goon-goon) Yoruba masqueraders concerned with mediating between the community of the living and that of the recently dead.

Elevation ARCHITECTURE: 1. Generally, a term that refers to one of the sides of a building. 2. Specifically, a drawing or graphic representation showing one face or side of a building. It can be of the interior or exterior.

E-maki Japanese picture scrolls, used to illustrate *The Tale of Genji* (c. 13th–17th centuries, Ch. 15).

Empiricism PHILOSOPHY: The theory that knowledge is derived from observation of nature and by experiment.

Entablature ARCHITECTURE: The upper section of a classical *order* resting on the capitals of the columns and including architrave, frieze, *cornice*, and pediment.

Epic LITERATURE: A long *narrative* poem that recounts an event of importance in a culture's history and presents a hero of that culture. See section on Homer (Ch. 3).

Episode LITERATURE: In Greek tragedy, a section of action between two choruses. In drama and fiction generally, a group of events having unity in itself. A story is created from a series of related episodes. A fiction is said to be episodic if the episodes fall into no logical relationship.

Epithet LITERATURE: A short phrase used to modify a noun by pointing out a salient characteristic. Epithets (e.g., Homer's "swift-footed Achilles") are often used in epic poetry.

Eros In Greek mythology, son of Aphrodite and god of sexual love, called "Cupid" by the Romans.

Ethics PHILOSOPHY: The branch of philosophy dealing with problems of good and bad, right and wrong, in human conduct.

Façade (fa-sahd′) ARCHITECTURE: A face of a building.

Fetish Statue or other object believed to embody supernatural power.

Figurative VISUAL ARTS: Describes painting or sculpture in which the human body and the objects of habitual visual experience are clearly recognizable in the work.

Fluting ARCHITECTURE: The grooves or channels, usually parallel, that decorate the shafts of *columns*. Fluting may run up and down a shaft or around the shaft in various directions.

Focal Point VISUAL ARTS: The place of major or dominant interest on which the eyes repeatedly focus in a painting, drawing, or architectural arrangement.

Foreshortening PAINTING: The method of representing objects or parts of objects as if seen from an angle so that the object seems to recede into space instead of being seen in a frontal or profile view. The technique is based on the principle of continuous diminution in size along the length of the object or figure. See *Perspective* and *Vanishing Point*.

Form ALL ARTS: The arrangement or organization of the elements of a work of art in space (visual arts) or time (literary, musical, performing arts). A form may be conventional or imposed by tradition (the Greek temple, the sonnet, the sonata, the five-act play) or original with the artist. In the latter case, form is said to follow from, or adapt itself to, *content*.

Free Verse LITERATURE: Poetic lines with no conventional meter or rhyme.

Fresco PAINTING: The technique of making a painting on new, wet plaster. Fresco painting was particularly favored in Italy from Roman times until the eighteenth century. See Ch. 17.

Frieze ARCHITECTURE: 1. Middle horizontal element of the classical *entablature*. See *Orders*. 2. A decorative band near the top of an interior wall that is below the *cornice* molding.

Frontality (adj. frontally) Artistic device used by the Egyptians whereby part of the body appears frontally and part in profile.

Fugal MUSIC: Characteristic of the *fugue*.

Fugue (fewg) MUSIC: A *composition* based on a *theme* (known as the *subject*) that is stated at the beginning in one voice part alone and is then restated by the other voice parts in succession. The theme reappears at various places throughout the composition in one voice part or another in combination with forms of itself.

Gable ARCHITECTURE: The triangular space at the end of a building formed by the slopes of a pitched roof, extending from the *cornice* or eaves to the *ridge*. In classical architecture the gable is called a *pediment*.

Gallery ARCHITECTURE: A long, covered area, usually elevated, that acts as a passageway on the inside or exterior of a building.

Genre (john'ruh) LITERATURE: A literary type or form. Genres include *tragedy*, *comedy*, *epic*, *lyric*, *novel*, short story, essay.

Greco-Roman Belonging to the cultures of ancient Greece and Rome.

Grid VISUAL ARTS: A pattern of vertical and horizontal lines forming squares of uniform size on a chart, map, drawing, etc.

Griot (gree-oh') African oral poet, musician, and historian.

Groin Vault See *Vault*.

Ground Plan ARCHITECTURE: A drawing of a horizontal *section* of a building that shows the arrangement of the *walls*, windows, supports, and other elements. A ground plan is used to produce blueprints.

Ground Plane PAINTING: In a picture, the surface, apparently receding into the distance, on which the figures seem to stand. It is sometimes thought of as comparable to a kind of stage space.

Harmonic Modulation MUSIC: The change of key within a composition. Modulations are accomplished by means of a *chord* (or chords) common to the old key as well as the new one.

Harmony MUSIC: The chordal structure of music familiar to most Western listeners in the pleasing or appropriate sounds of the accompaniment of popular songs by guitars, keyboards, or bands.

Hebraic Belonging to the Hebrews, Jews, or Israelites. Refers primarily to the culture of the ancient Hebrews of biblical times.

Hebraism Hebrew culture, thought, institutions.

Hellenic Greek. Usually refers to the "classical" period of Greek culture; i.e., the fifth and fourth centuries B.C.

Hellenism The culture of ancient Greece.

Hellenistic Literally, "Greek-like." Refers to Greek history and artistic style from the third century B.C.

Hieratic Egyptian writing system; a simplified cursive form of hieroglyphics. See *Hieroglyphic*.

Hieroglyphic Egyptian writing system, originally based on pictures.

Homophonic (hawm-o-fon'ic) Characteristic of *homophony*.

Homophony (hoh-maw'foh-nee) MUSIC: A single *melody* line supported by its accompanying *chords* and/or voice parts. See *Monophony*, *Polyphony*, *Chord*, and *Texture*.

Hubris (hyoo'bris) A Greek word meaning arrogance or excessive pride.

Hue See *Color*.

Hyperbole (high-purr'boh-lee) LITERATURE: A figure of speech that uses obvious exaggeration.

Iamb (eye'amb) LITERATURE: A metrical "foot" consisting of one short (or unaccented) syllable and one long (or accented) syllable. Example: hĕllō.

Iambic Pentameter (eye-am'bic pen-tam'eh-ter) LITERATURE: The most common metrical line in English verse, consisting of five *iambs*. Example, from Shakespeare: "Shăll Ī cŏmpāre theē tō ă sūmmĕr's dāy?"

Id In Freudian theory, one of the three parts of the mind. The id is the instinctive, non-controlled part.

Ideograph Sign depicting an abstract idea in Chinese writing.

Ifa (ee'fah) A Yoruba system of divination in which a priest advises his clients of proper courses of behavior based upon the casting of palm kernels and the interpretation of poems chosen for their numerical links to the patterns of thrown kernels.

Illusionism VISUAL ARTS: The attempt by artists to create the illusion of reality in their work. Illusionism may also be called realism. It is important to remember that illusionism is not the motivating intention of all works of art.

Image ALL ARTS: The representation of sense impressions to the imagination. Images are a fundamental part of the language of art. They differ from the abstract terminology of science and philosophy in that they are a means whereby complex emotional experience is communicated. Images may be tactile, auditory, olfactory, etc., but the word is ordinarily used for visual impressions.

Imagery LITERATURE: Patterns of images in a specific work or in the entire works of an author. May refer to a specific type (animal imagery, garden imagery). VISUAL ARTS: The

objects, *forms,* or shapes depicted by the artist in a particular work.

Impasto (em-pah′stoh) PAINTING: Paint that has the consistency of thick paste, used for bright highlights or to suggest *texture.* Examples: Rembrandt and Van Gogh.

Improvisation MUSIC: The art of performing spontaneously rather than recreating written music.

Induction PHILOSOPHY: Reasoning from particular facts or cases to a general conclusion.

Inflection MUSIC: The shaping or changing of a musical passage in a way that is unique to the individual performer of the music.

Initiation Ceremonies or rites by which a young person is brought into manhood or womanhood, or an older person is made a member of a secret society, brotherhood, etc.

Inquisition A former tribunal in the Roman Catholic Church directed at the suppression of heresy.

Irony LITERATURE: A manner of speaking by which the author says the opposite of what he means, characteristically using words of praise to imply scorn. Dramatic or tragic irony means that the audience is aware of truths which the character speaking does not understand.

Iwi (ee′wee) Yoruba poems sung by *Egungun* masqueraders.

Jamb ARCHITECTURE: A vertical member at either side of a door frame or window frame. When sculpture is attached to this member it is called a jamb sculpture or jamb figure. See *Chartres* (Ch. 9).

Karma Hindu term for the accumulated record of the many lives an individual has led through *reincarnation.*

Kente (ken′teh) Large ceremonial cloth from Ghana made of narrow strips sewn together and distinguished by elaborate, multicolored geometric designs of silk.

Keystone ARCHITECTURE: The central wedge-shaped stone of an *arch* that locks together the others.

Komos Greek word for a revel. Root of the word *comedy.*

Kouros (koo′rohs), **Kore** (koh′ray) SCULPTURE: Greek for a male nude votive figure, female votive figure.

Labarai (lah-bah-rye′) Hausa tales told by old men, involving cultural, family, and group history.

Lantern ARCHITECTURE: The windowed turret or tower-like form that crowns a *dome* or roof.

Libretto (lih-bret′toe) MUSIC: The text of an opera, *oratorio,* or other dramatic musical work.

Linear Perspective See *Perspective.*

Lintel ARCHITECTURE: The horizontal member or *beam* that spans an opening between two upright members, or posts, over a window, door, or similar opening.

Lyric LITERATURE: A short poem or song characterized by personal feeling and intense emotional expression. Originally, in Greece, lyrics were accompanied by the music of a lyre.

Mandate An order granted by the League of Nations to a member nation for the establishment of a responsible government over colonies belonging to defeated Central Powers like Germany.

Matrilineal System of descent in which inheritance of goods, access to land, and group leadership pass to the children through the family of the mother.

Medium (pl. media) ALL ARTS: 1. The material or materials with which the artist works. Examples from VISUAL ARTS: paint, stone, wood, bronze, plaster, concrete. MUSIC: sound. LITERATURE: language. CINEMA: film. DANCE: human body. DRAMA: language, costume, lighting, actors, sound, etc. 2. Modern means of communication (television, radio, newspapers). 3. PAINTING: A substance such as oil, egg, or water with which *pigment* is mixed.

Melodic Elaboration MUSIC: The ornamentation of *melody* by one or more of a number of possible musical devices, such as added notes, interval changes, etc.

Melody MUSIC: A succession of musical *tones.* Often the melody is known as the "tune," and is not to be confused with the other accompanying parts of a song. See *Homophony.*

Metaphor LITERATURE: A figure of speech that states or implies an analogy between two objects or between an object and a mental or emotional state. Example: "My days are in the yellow leaf;/The flowers and fruits of love are gone" (Byron) makes an analogy between the poet's life and the seasonal changes of a tree.

Metaphorical Describing statements or representations to be taken as analogy, not to be taken literally.

Meter POETRY: A regularly recurring rhythmic pattern. Meter in English is most commonly measured by accents, or stresses, and syllables. The most common metric "foot" in English is the *iamb.* The most common verse line is the *iambic pentameter* (five iambs). MUSIC: A pattern of fixed temporal units. For example, ¾ meter means one beat to a quarter note and three beats to a measure. In a musical *composition* meter is the basic grouping of notes in time.

Metope (meh′toh-pay) ARCHITECTURE: The blank space of block between the *triglyphs* in the Doric *frieze,* sometimes sculpted in low *relief.* See *Orders.*

Michi The way or the path in Japanese, specifically with reference to artistic apprenticeship and achievement (Ch. 15).

Modal MUSIC: Describes a type of music conforming to the scale patterns of the medieval Church *modes.* See *Modes.*

Modeling VISUAL ARTS: 1. The creation of a three-dimensional *form* in clay or other responsive material, such as wax, soap, soft bone, ivory, etc. 2. By analogy, in painting and drawing, the process of suggesting a three-dimensional *form* by the creation of *shade* and shadow.

Modernism Generic name given to a variety of movements in all the arts, beginning in the early 20th century. Promotes a subjective or inner view of reality and uses diverse experimental techniques.

Modes MUSIC: Melodic scales used for church music of the Middle Ages. The modes are organized according to *pitches* similar to our modern major and minor scales, yet different enough to set them apart from the modern scales.

Molding ARCHITECTURE: A member used in construction or decoration that produces a variety in edges or contours by virtue of its curved surface.

Monastery The dwelling place of a community of monks. See *Abbey.*

Monasticism A way of life assumed by those who voluntarily separate themselves from the world to contemplate divine nature. See *Monastery.*

Monophonic (mo-no-fohn′ic) Characteristic of *monophony.*

Monophony (mo-nof′o-nee) MUSIC: A simple *melody* without additional parts of accompaniment, such as the music of a flute playing alone or of a woman singing by herself. See *Homophony, Polyphony, Texture.*

Mosaic VISUAL ARTS: A *form* of surface decoration made by inlaying small pieces of glass, tile, enamel, or varicolored stones in a cement or plaster matrix or ground.

Motet (moh-tette') MUSIC: Usually an unaccompanied choral composition based on a Latin sacred text. The motet was one of the most important forms of *polyphonic* composition from the thirteenth through the seventeenth centuries.

Motif (moh-teef'), **Motive** (moh-teev') LITERATURE: A basic element that recurs, and may serve as a kind of foundation, in a long poem, fiction, or drama. A young woman awakened by love is the motif of many tales, such as *Sleeping Beauty*. VISUAL ARTS: An element of design repeated and developed in a painting, sculpture, or building. MUSIC: A recurring melodic phrase, sometimes used as a basis for variation.

Mural PAINTING: Large painting in oil, fresco, or other *medium* made for a particular *wall*, ceiling, or similar large surface.

Myth Stories developed anonymously within a culture that attempt to explain natural events from a supernatural or religious point of view.

Mythology The body of myths from a particular cultural group.

Naos (nah'ohs) ARCHITECTURE: Greek word for the *cella* or main body of a Greek temple.

Narrative LITERATURE: 1. (noun) Any *form* that tells a story or recounts a sequence of events (*novel, tale*, essay, article, film). 2. (adj.) In story form, recounting.

Narthex ARCHITECTURE: The entrance hall or porch that stands before the *nave* of a church.

Naturalism LITERATURE, VISUAL ARTS: Faithful adherence to the appearance of nature or outer reality.

Nave ARCHITECTURE: In Roman architecture, the central space of a *basilica*; in Christian architecture, the central longitudinal or circular space in the church, bounded by aisles.

Nave Arcade ARCHITECTURE: The open passageway or screen between the central space and the *side aisles* in a church.

Nemesis (neh'ma-sis) Greek goddess of Fate. Word means retribution, punishment.

Neoclassicism ALL ARTS: A movement that flourished in Europe and America in the late seventeenth and eighteenth centuries, heavily influenced by the classical style of Greece and Rome. Neoclassical art and literature is characterized by sobriety, balance, logic, and restraint. The corresponding musical style (18th century) is usually called *classical*.

Neolithic The stage in the evolution of human societies when peoples began systematic cultivation and the domestication of animals.

Niche (nish) ARCHITECTURE: A semicircular or similarly shaped recess in a *wall* designed to contain sculpture, an urn, or other object. It is usually covered by a half*dome*.

Nirvana Hindu and Buddhist term for ultimate blissful peace.

Noh Talent, skill in Japanese. 14th-century Japanese theatrical form (Ch. 15).

Nonobjective VISUAL ARTS: Not representing objects in the material world.

Novel LITERATURE: A lengthy prose narrative, traditionally spanning a broad period of time, containing a plot and developing characters. The modern European novel took form in the eighteenth century.

Oba Name for the chief ruler of Benin.

Oculus (ock'you-luhs) ARCHITECTURE: Circular opening at the crown of a *dome*. See *Pantheon* (Ch. 6).

Odu (oh'doo) A secret body of poetry used in the Yoruba *Ifa* divination process.

Oil Painting The practice of painting by using *pigments* suspended in oil (walnut, linseed, etc.).

Oligarchy (oh'lih-gar-key) Greek word meaning "rule by the few." Rule by the few where the state is primarily utilized to serve the interest of the governors. Traditionally contrasted with *aristocracy*, rule by the few for the common good.

Olorun (oh-low'roon), **Oludumare** (oh-loo-doo-mah'ray) The Yoruba term for the supreme high deity.

Open Fifths MUSIC: *Chords*, normally made of three sounds, with the middle *pitch* absent.

Oratorio MUSIC: An extended musical setting for solo voices, chorus, and orchestra, of a religious or contemplative nature. An oratorio is performed in a concert hall or church, without scenery, costumes, or physical action. One of the greatest examples is Handel's *Messiah*.

Orchestration MUSIC: Orchestration is the art of writing music for the instruments of the orchestra that will bring out desired effects of the various instruments. Indeed, it is the art of "blending" the voices of the orchestra so that a pleasing sound is the end result.

Orders ARCHITECTURE: Types of *columns* with *entablatures* developed in classical Greece. The orders are basically three: Doric, Ionic, and Corinthian. They determine not only the scale and therefore dimensions of a temple but also the experience generated by the building, or its *style*. See section on Greek Architecture and diagram of the orders (Ch. 4).

Oriki (ohr-ee'key) Yoruba term meaning praise poems based on names given to gods, places, rulers, and important persons.

Orisha (ohr-ee'sha) In Yoruba religion, lesser gods (below the chief god) and sometimes ancestor figures, ancient kings, and founders of cities who have been deified.

Ostinato (aw-stee-nah'toe) MUSIC: Italian for obstinate or stubborn; the persistent repetition of a clearly defined *melody*, usually in the same voice. This device is often used in a bass part to organize a *composition* for successive variations.

Oxymoron (ock-see-mohr'on) LITERATURE: A figure of speech that brings together two contradictory terms, such as "sweet sorrow."

Palazzo (pa-laht'so) ARCHITECTURE: Italian for palace, or large, impressive building.

Palladian ARCHITECTURE: Designating the Renaissance architectural style of Andrea Palladio.

Panel Painting A painting made on a ground or panel of wood, as distinguished from a *fresco* or a painting on canvas.

Parapet ARCHITECTURE: In an exterior *wall*, the part entirely above the roof. The term may also describe a low wall that acts as a guard at a sudden edge or drop, as on the edge of a roof, battlement, or wall.

Parody LITERATURE: A work that exaggerates or burlesques another, serious one. Often a parody pokes fun at an author and his style. The parody may be compared to a visual caricature or cartoon.

Pathos (pay'thaws) ALL ARTS: A quality that sets off deep feeling or compassion in the spectator or reader.

Patrilineal System of descent in which inheritance of goods, access to land, and group leadership passes to the children through the family of the father.

Pediment ARCHITECTURE: In classical architecture the triangular space at the end of a roof formed by the sloping ridges of the roof. The pediment was often filled with decoration which could be painted or sculpted or both.

Pentatonic Scale MUSIC: Five-note scale that occurs in the music of nearly all ancient cultures. It is common in West African music and is found in jazz.

Perspective VISUAL ARTS: Generally, the representation of three-dimensional objects in space on a two-dimensional surface. There are a variety of means to achieve this. The most familiar is that of "linear perspective" developed in the fifteenth century and codified by Brunelleschi, in which all parallel lines and edges of surfaces recede at the same angle and are drawn, on the picture plane, to converge at a single *vanishing point*. The process of diminution in size of objects with respect to location is very regular and precise. Other techniques, often used in combination with linear perspective, include: (a) vertical perspective—objects further from the observer are shown higher up on the picture, (b) diagonal perspective—objects are not only higher but aligned along an oblique *axis* producing the sensation of continuous recession, (c) overlapping, (d) *foreshortening*, (e) *modeling*, (f) *shadows*, and (g) atmospheric perspective, the use of conventions such as blurring of outlines, alternation of hue toward blue, and decrease of *color* saturation.

Philosophe (fee-low-soph') Eighteenth-century French intellectual and writer; not usually a systematic philosopher.

Phrase MUSIC: A natural division of the *melody*; in a manner of speaking, a musical "sentence."

Picture Plane PAINTING: The surface on which the picture is painted.

Picture Space PAINTING: The space that extends behind or beyond the picture plane; created by devices such as *linear perspective*. Picture space is usually described by foreground, middleground, and background.

Pier ARCHITECTURE: A *column*, post, or similar member designed to carry a great load; may also refer to a thickened vertical mass within the *wall* designed to provide additional support.

Pigment PAINTING: The grains or powder that give a *medium* its *color*. Can be derived from a variety of sources: clays, stones, metals, shells, animal and vegetable matter.

Pilaster (pih'lass-ter) ARCHITECTURE: A flattened engaged *column* or *pier* that may have a *capital* and *base*. It may be purely decorative or it may reinforce a *wall*.

Pitch MUSIC: A technical term identifying a single musical sound, taking into consideration the frequency of its fundamental vibrations. Some songs, or instruments, are pitched high and others are pitched low.

Plan See *Ground Plan*.

Plane A flat surface.

Plasticity VISUAL ARTS: The quality of roundness, palpability, solidity, or three-dimensionality of a *form*.

Plinth A block or slab on which a statue, pedestal, or column is placed, and, by extension, the base on which a building rests or appears to rest.

Podium ARCHITECTURE: The high platform or *base* of a Roman temple, or any elevated platform.

Polis (poh'liss) The ancient Greek city-state.

Polyphonic (paul-ee-fon'ick) Characteristic of *polyphony*.

Polyphony (paul-if'o-nee) MUSIC: Describes *composition* or *improvisations* in which more than one *melody* sounds simultaneously—that is, two or more tunes at the same time. Polyphony is characterized by the combining of a number of individual melodies into a harmonizing and agreeable whole. See *Homophony*, *Monophony*, and *Texture*.

Portico ARCHITECTURE: Porch or covered walk consisting of a roof supported by *columns*.

Post-and-Lintel ARCHITECTURE: An essential system of building characterized by the use of uprights—posts—which support horizontal *beams*—lintels—in order to span spaces. Used as supports for a window or door, the posts are the *jambs* and the *lintel* is the window head.

Primary Colors Red, yellow, blue—the three primary hues of the spectrum. See *Color*.

Pronaos (pro'nah-ohs) ARCHITECTURE: In classical architecture, the inner *portico* or room in front of the *naos* or *cella*.

Prose LITERATURE: Generally, may mean any kind of discourse, written or spoken, which cannot be classified as poetry. More specifically, prose refers to written expression characterized by logical, grammatical order, *style*, and even *rhythm* (but not *meter*).

Proverb A saying that succinctly and effectively expresses a truth recognized by a community or a wise observation about life. Proverbs are most often transmitted orally.

Rasa LITERATURE: Sanskrit term for emotion evoked through poetic meter and sound effects.

Rationalism PHILOSOPHY: The theory that general principles are essentially deductive; i.e., deducible from an examination of human reason. Reason, not the senses, is the ultimate source of basic truths.

Realism LITERATURE, VISUAL ARTS: A movement which began in the mid-nineteenth century and which holds that art should be a faithful reproduction of reality and that artists should deal with contemporary people and their everyday experience.

Recitative (reh-see-tah-teev') MUSIC: A vocal style used to introduce ideas and persons in the musical *composition*, or to relate a given amount of information within a short period of time. The recitative has practically no melodic value. This device is employed extensively in Handel's *Messiah*.

Reincarnation Hindu belief that the soul progresses through a cycle of deaths and rebirths until it ultimately attains peace.

Relief Sculpture Sculpture that is not freestanding but projects from a surface of which it is a part. A slight projection is called low relief (bas-relief); a more pronounced projection, high relief.

Republic A form of government in which ultimate power resides in the hands of a fairly large number of people but not necessarily the entire community. This power is exercised through representatives. The word derives from Latin meaning "public thing."

Response MUSIC: A solo-chorus relationship in which the soloist alternates performance with the chorus. The response is a particularly noteworthy device in traditional African music as well as in Gregorian chant.

Responsorial MUSIC: Describing the performance of a chant in alternation between a soloist and a chorus. (It is unlike antiphonal music, where alternating choruses sing.)

Rhythm ALL ARTS: An overall sense of systematic movement. In music, poetry, and dance this movement may be literally felt; in the visual arts it refers to the regular repetition of a *form*, conveying a sense of movement by the contrast between a form and its interval.

Rib ARCHITECTURE: Generally a curved structural member that supports any curved shape or panel.

Ribbed Vault ARCHITECTURE: A *vault* whose sections seem to be supported or are supported by slender, curved structural members that also define the sections of the vault. The ribs may run either transversely, that is from side to side, or diagonally, from corner to corner of the vault.

Riddle A form of popular, usually oral, literature that asks an answer to a veiled question. Riddles often make use of striking *images* and *metaphors*.

Ridge ARCHITECTURE: The line defined by the meeting of the two sides of a sloping roof.

Romance LITERATURE: A long narrative in a *Romance language*, presenting chivalrous ideals, heroes involved in adventures, and love affairs from medieval legends.

Romance Language One of the languages that developed from popular Latin speech during the Middle Ages, and that exist now as French, Italian, Spanish, Portuguese, Catalan, Provençal, Romanic, and Rumanian.

Romanesque An artistic movement of the eleventh and twelfth centuries, primarily in architecture. The name comes from similarities with Roman architecture.

Romanticism A movement in all of the arts as well as in philosophy, religion, and politics that spread throughout Europe and America in the early nineteenth century. The romantics revolted against the Neoclassical emphasis on order and reason and substituted an inclination for nature and imagination. See Ch. 27.

Rose Window ARCHITECTURE: The round ornamental window frequently found over the entrances of Gothic cathedrals.

Sarcophagus (sahr-cough′a-gus) A large stone coffin. It may be elaborately carved and decorated.

Satire A mode of expression that criticizes social institutions or human foibles humorously. The Romans invented the verse satire, but satire may appear in any literary *genre*, in visual art, in film, mime, and dance.

Satyr (say′ter) **Play** LITERATURE: A light, burlesque play given along with *tragedies* and *comedies* at the festival of Dionysus in ancient Athens.

Scholasticism PHILOSOPHY: A way of thought that attempted to reconcile Christian truth with truth established by natural reason. Originating in the early Middle Ages, it reached its height in the thirteenth century in response to the recovery of Aristotle's scientific and philosophical writings.

Secondary Colors See *Color*.

Section ARCHITECTURE: The drawing that represents a vertical slide through the interior or exterior of a building, showing the relation of floor to floor.

Shade PAINTING: A *color* mixed with black. Mixing a color with white produces a *tint*.

Shading VISUAL ARTS: The process of indicating by graphics or paint the change in *color* of an object when light falls on its surface revealing its three-dimensional qualities. Shading can be produced not only by a change of color, but also by the addition of black, brown, or gray, or by drawing techniques.

Shadow VISUAL ARTS: The *form* cast by an object in response to the direction of light.

Shaman A medium, or holy person who has direct access to the spiritual world. Shamanism is the belief system involving shamans.

Shed Roof ARCHITECTURE: A roof shape with only one sloping *plane*, such as the roof of a lean-to, or that over the *side aisle* in a Gothic or Romanesque church.

Shinto The "way of the gods." Indigenous Japanese beliefs regarding natural spirits (Ch. 15).

Shogun A military governor in Japan, 12th–19th centuries. A shogunate is the administration of the shogun (Ch. 15).

Side Aisle ARCHITECTURE: The aisles on either side of, and therefore parallel to, the *nave* in a Christian church or Roman *basilica*.

Simile (sim′eh-lee) LITERATURE: A type of *metaphor* which makes an explicit comparison. Example: "My love is like a red, red rose."

Sonata MUSIC: An important form of instrumental music in use from the baroque era to the present. It is a *composition* usually with three or four movements, each movement adhering to a pattern of contrasting tempos. Example: Allegro, Adagio, Scherzo, Allegro.

Sonnet LITERATURE: A *lyric* poem of fourteen lines, following one of several conventions. The two main types of sonnet are the Italian (Petrarchan), which divides the poem into octave (eight lines) and sestet (six lines), and the English (Shakespearean), which divides the poem into three quatrains of four lines each and a final rhyming couplet.

Span ARCHITECTURE: The interval between two posts, *arches*, *walls*, or other supports.

Stained Glass ARCHITECTURE: Glass to which a *color* is added during its molten state, or glass which is given a hue by firing or otherwise causing color to adhere to the glass.

Stela (stee′la) ARCHITECTURE: In classical Greece a stone upright or slab used commemoratively; it may mark a grave or record an offering or important event.

Stretto MUSIC: The repetition of a *theme* (*subject*) that has been collapsed by diminishing the time values of the notes. As a result, the listener is literally propelled to the dramatic end or climactic conclusion of the music. Handel used this *fugal* device effectively in the last chorus of his *Messiah*.

Structure ALL ARTS: The relationship of the parts to the whole in a work of art. A structure may be mechanical (division of a play into acts, a symphony into movements) or may be more concealed and based on such things as the interrelationships of *images*, *themes*, *motifs*, *colors*, shapes. In a *narrative* the structure usually refers to the arrangement of the sequence of events. In architecture structure may refer either to the actual system of building or to the relationships between the elements of the system of building.

Stupa ARCHITECTURE: A Buddhist shrine, often in the shape of a simple, small mound.

Style ALL ARTS: Characteristics of *form* and technique that enable us to identify a particular work with a certain historical period, place, group, or individual. Painters in Florence in the 15th and 16th centuries used *perspective*, *color*, etc., in ways that allow us to identify a Renaissance style, but within that group we may distinguish the individual style of Leonardo from that of Raphael. The impressionist painters in France at the end of the 19th century used light and *color* in a particular way: a painting in which this technique is followed has an impressionistic style. But the use of certain *forms*, *colors*, design, and *composition* enables us to distinguish within this group the style of Renoir

from that of Monet. Afro-European *rhythms* and *improvisation* distinguish a jazz style, but within that general category are many schools of jazz or even different styles of one individual, such as Duke Ellington. Literary style is determined by choices of words, sentence *structure* and syntax *rhythm*, figurative language, rhetorical devices, etc. One may speak of an ornate, simple, formal, or colloquial style; of a period style such as *Neoclassical, romantic, realist*; or of an individual's style. Style is sometimes contrasted with *content*.

Stylization The reduction of visual characteristics of objects or persons to conventional, repeated ways of presentation, for instance, hair reduced to circles inscribed on the head, eyes represented as round openings, and leaves as flat circles. Compare *abstract*.

Subject ALL ARTS: What the work is about. The subject of the painting *Mont Ste Victoire* is that particular mountain; the subject of Richard Wright's *Native Son* is a young black man in Chicago. MUSIC: The *melody* used as the basis of a *contrapuntal composition* (e.g., the subject of a *fugue*).

Suite MUSIC: An important instrumental form of baroque music, consisting of a grouping of several dancelike movements, all in the same key.

Superego In Freudian theory, one of the three parts of the mind. The superego is the censuring faculty, replacing parents or other authorities.

Sutra A canonical Buddhist scripture.

Symbol VISUAL ARTS, LITERATURE: An *image* that suggests an idea, a spiritual or religious concept, or an emotion beyond itself. It differs from *metaphor* in that the term of comparison is not explicitly stated. Symbols may be conventional; i.e., have a culturally defined meaning such as the Christian cross or the Jewish star of David. Since the nineteenth century, symbols have tended to denote a variety or an ambiguity of meanings.

Symbolism 1. The use of symbol in any art. 2. A literary school which began in France in the late nineteenth century, characterized by the use of obscure or ambiguous *symbols*.

Symmetry VISUAL ARTS: The balance of proportions achieved by the repetition of parts on either side of a central *axis*. The two sides may be identical, in which case we can speak of bilateral symmetry.

Syncretism Attempt to accommodate and reconcile one set of beliefs into another.

Syncopation MUSIC: A rhythmic device characterized as a deliberate disturbance of a regularly recurring pulse. Accented offbeats or irregular *meter* changes are two means of achieving syncopation.

Tactile VISUAL ARTS, LITERATURE: Refers to the sense of touch. In the visual arts, tactile *values* are created by techniques and conventions that specifically stimulate the sense of touch in order to enhance suggestions of weight, *volume* (roundness), visual approximation, and therefore three-dimensionality. Writers may also create tactile effects, as in the description of cloth or skin.

Tale LITERATURE: A simple *narrative*, whose subject matter may be real or imaginary, and whose purpose is primarily to entertain. Tales may also make use of "morals" to instruct.

Tanka Short Japanese poem, 5 lines long, with 31 syllables, usually 5-7-5-7-7 (Ch. 15).

Tatsuniyoyi (taht-soon-yoh'yee) Hausa tales about animals and people told by old women to entertain and instruct young children.

Tempera (tehm'per-ah) PAINTING: Technique in which the *pigment* is suspended in egg, glue, or a similar soluble *medium*, like water. Tempera paint dries very quickly and does not blend easily, producing a matte (flat, nonreflective) surface, because, unlike *oil paint*, it is essentially an opaque medium.

Texture VISUAL ARTS: Surface quality (rough, smooth, grainy, etc.). LITERATURE: Elements such as *imagery*, sound patterns, etc. apart from the *subject* and *structure* of the work. MUSIC: The working relationship between the *melody* line and the other accompanying parts, or the characteristic "weaving" of a musical *composition*. There are three basic musical textures: *monophonic* (a single line), *homophonic* (a melody supported by *chords*), and *polyphonic* (multiple melodic lines).

Thanatos Greek word for death. For Freud, the death-wish or death-force, opposed to Eros, the life force.

Theme VISUAL ARTS: A *color* or pattern taken as a subject for repetition and modification. Example: a piece of sculpture may have a cubical theme. MUSIC: A *melody* which constitutes the basis of variation and development. Example: "The Ode to Joy" song in the last movement of Beethoven's Ninth Symphony. LITERATURE AND PERFORMING ARTS: An emotion or idea that receives major attention in the work. A novel or film may contain several themes, such as love, war, death. A dance may be composed on the theme of struggle, joy, etc. Theme is sometimes used in this sense for visual arts and music as well.

Threnody (threh'no-dee) MUSIC: A song of lamentation, a very mournful song.

Through-Composed MUSIC: Describes a type of song in which new music is provided for each stanza. A through-composed song is thus unlike most modern hymns, folk, and popular songs, which use the same tune for each stanza.

Thrust ARCHITECTURE: The downward and outward pressure exerted by a *vault* or *dome* on the *walls* supporting it.

Timbre (taam'bruh) MUSIC: The quality of "color" of a particular musical *tone* produced by the various instruments. For instance, the very "nasal" sound of the oboe is markedly different from the very "pure" sound of the flute.

Tint VISUAL ARTS: The *color* achieved by adding white to a hue to raise its *value*, in contrast to a *shade*, which is a hue mixed with black to lower its value.

Tonal MUSIC: Organized around a pitch center. A tonal *composition* is one in which the *pitches* of all the various *chords* and *melodies* relate well to one another. Tonal music has a recognizable beginning, middle, and end. See *Chord, Melody, Pitch*.

Tonality MUSIC: The specific *tonal* organization of a composition.

Tone ALL ARTS: The creation of a mood or an emotional state. In painting, tone may refer specifically to the prevailing effect of a *color*. Thus, a painting may be said to have a silvery, bluish, light, or dark tone as well as a wistful, melancholy, or joyful tone. The term may also refer to *value* or *shade* (see *Color*). In literature, tone usually describes the prevailing attitude of an author toward his material, audience, or both. Thus a tone may be cynical, sentimental, satirical, etc. In music, "tone color" may be used as a synonym for *timbre*. Tone in music also means a sound of

definite *pitch* and duration (as distinct from noise), the true building material of music. The notes on a written page of music are merely symbols that represent the tones that actually make the music.

Tornada (tore-nah′dah) MUSIC: In troubadour songs, a short stanza added at the end as a "send-off."

Tracery ARCHITECTURE: The curvilinear or rectilinear pattern of open stonework or wood that supports the glass or other transparent or translucent material in a window or similar opening. May also be used generally to refer to decorative patterns carved similarly on wood or stone.

Tragedy LITERATURE: A serious drama that recounts the events in the life of a great person which bring him or her from fortune to misfortune. Tragedies usually meditate on the relation between human beings and their destiny. Tragedies first developed in ancient Greece; other great periods of tragedy include Elizabethan England and France under Louis XIV. The word is sometimes used to describe a novel or story.

Transept ARCHITECTURE: The transverse portion of a church that crosses the central *axis* of the *nave* at right angles between the nave and *apse* to form a cross-shaped (cruciform) planned building.

Triglyph (try′glif) ARCHITECTURE: The block carved with three channels or grooves that alternates with the *metopes* is a classical Doric *frieze*. See *Orders*.

Triumphal Arch ARCHITECTURE: The monumental urban gateway, invented by the Romans, set up along a major street to commemorate important military successes. It may have one or three arched openings and is usually decorated with inscriptions, *reliefs*, and freestanding sculpture on the top.

Trope MUSIC: Lengthened musical passage or elaboration on the Mass used during the Middle Ages. LITERATURE: 1. Verbal amplification of the text of the Mass. 2. A figure of speech.

Troubadour A lyric poet and singer, including wandering minstrels, originating in Provence in the eleventh century and flourishing throughout southern France, northern Italy, and eastern Spain during the twelfth and thirteenth centuries.

Truss ARCHITECTURE: Originally a wooden structural member composed of smaller, lighter pieces of wood joined to form rigid triangles and capable of spanning spaces by acting as a *beam*.

Tympanum (tihm′pah-nuhm) ARCHITECTURE: The triangular or similarly shaped space enclosed by an *arch* or *pediment*.

Tyranny In ancient Greece, meant "rule of the strong man." Historically, came to mean arbitrary rule of one, but generally taken to mean arbitrary political rule of any kind.

Value See *Color*.

Vanishing Point PAINTING: The point or points of convergence for all lines forming an angle to the *picture plane* in pictures constructed according to the principles of linear *perspective*.

Vault ARCHITECTURE: The covering or spanning of a space employing the principle of the *arch* and using masonry, brick, plaster, or similar malleable materials. The extension of an arch infinitely in one plane creates a barrel or tunnel vault.

The intersection of two barrel vaults at right angles to each other produces a cross or groin vault. *Ribs* are sometimes placed along the intersections of a groin vault to produce a *ribbed vault*.

Veneer VISUAL ARTS: A thin layer of precious or valuable material glued or otherwise attached to the surface of another, less expensive, or less beautiful material. The Romans, for example, applied thin layers of marble to the concrete and rubble fill surfaces of their buildings to produce a more splendid effect. In this century, valuable woods like walnut or mahogany are applied as veneers to the surfaces of plywood.

Verisimilitude Literally, "true-seeming." LITERATURE: A doctrine prevalent in the *Neoclassical* period, which holds that elements in a story must be so arranged that they seem to be true or that they could actually occur. VISUAL ARTS: The effect of near-perfect emulation or reproduction of objects in the visual world. Not to be confused with *realism*.

Vernacular The common daily speech of the people; non-literary language. During the Middle Ages, any language that was not Latin.

Viewpoint The position or place from which the viewer looks at an object or the visual field.

Vihara ARCHITECTURE: Buddhist term for the monastic cell group.

Vizier A chief administrator.

Volume ARCHITECTURE: Refers to the void or solid three-dimensional quality of a space or *form* whether completely enclosed or created by the presence of forms which act as boundaries. Compare the "volume" of the *Parthenon* with the "volume" of the *Pantheon*.

Volute A spiral or scroll-like ornamental form, which may be used either as a purely decorative or as a supporting member in an architectural ensemble. The curvilinear portion of an Ionic capital is a volute, and by extension a portion of such a shape is a volute.

Voussoir (voo-swahr′) ARCHITECTURE: The wedge-shaped stone or masonry unit of an *arch*, wider at the top and tapering toward the bottom.

Wall ARCHITECTURE: A broad, substantial upright slab that acts as an enclosing *form* capable of supporting its own weight and the weight of *beams* or *arches* to span and enclose space.

Warm Colors VISUAL ARTS: The hues commonly associated with warmth—yellow, red, and orange. In *compositions* the warm colors tend to advance, in contrast to the *cool colors*, which tend to recede from the viewer.

Watercolor PAINTING: Technique using water as the *medium* for very fine *pigment*. Watercolor dries very fast and can be extremely transparent.

Yoga Hindu word meaning the yoke between body and soul. It refers to deep breathing exercises, meditation, and physical conditioning.

Ziggurat ARCHITECTURE: The Mesopotamian temple-tower.

Credits

Chapter 16 Page 7: From *Selected Letters of Alessandra Strozzi, Bilingual Edition,* translated by Heather Gregory. University of California Press, 1997. Used by permission of The University of California Press. **Page 9:** Reprinted by permission of the publisher from Petrarch's *Lyric Poems: The Rime Sparse and Other Lyrics,* translated and edited by Robert Durling, pp. 36, 40–41, 244, and 270. Cambridge, Mass.: Harvard University Press, copyright © 1976 by Robert M. Durling. **Page 13:** Reprinted by permission of the Center for Medieval and Renaissance Studies, State University of New York at Binghamton.

Chapter 19 Page 56: From pp. 90–95, 104–105 of *Praise of Folly & Letter to Martin Dorp 1515* by Erasmus of Rotterdam, translated by Betty Radice (Penguin Classics, 1971). Translation © Betty Radice, 1971. Reproduced by permission of Penguin Books, Ltd. **Page 62:** William Shakespeare, *The Tempest,* in *The Riverside Shakespeare,* 2/e, Houghton Mifflin, 1997. Used by permission of Houghton Mifflin Company.

Chapter 20 Page 110: *Discourse on Methods: Descartes* by Laurence La Fleur, copyright © 1960. Reprinted by permission of Prentice-Hall, Inc., Upper Saddle River, NJ.

Chapter 21 Page 132: From *The Collected Works of St. Teresa of Avila, Volume One,* translated by Kieran Kavanaugh and Otilio Rodriguez. Copyright © 1976 by Washington Province of Discalced Carmelites ICS Publications, 2131 Lincoln Road, NE, Washington, DC 20002-1199, U.S.A. www.icspublications.org. **133:** "Satirá filosófica" ("A Philosophical Satire") and "Procura desmentir los elogios que a un retrato de la Poétisa inscribió la verdad, que llama pasión," ("She Attempts to Minimize the Praise Occasioned by a Portrait of Herself Inscribed by Truth—Which She Calls Ardor") from Sor Juana Inés de la Cruz. Poems translated by Margaret Sayers Peden. Copyright © 1985 by Bilingual Press/Ediotrial Bilingue. Used by permission of Bilingual Press/Editorial Bilingue, Arizona State University, Tempe, AZ.

Chapter 23 Page 158: *Tartuffe* by Molière, English translation copyright © 1963, 1962, 1961 and renewed 1991, 1990 and 1989 by Richard Wilbur, reprinted by permission of Harcourt, Inc. CAUTION: Professionals and amateurs are hereby warned that this translation, being fully protected under the copyright laws of the United States of America, the British Empire, including the Dominion of Canada, and all other countries which are signatories to the Universal Copyright Convention and the International Copyright Union, are subject to royalty. All rights, including professional, amateur, motion picture, recitation, lecturing, public reading, radio broadcasting, and television, are strictly reserved. Particular emphasis is laid on the question of readings, permission for which must be secured from the author's agent in writing. Inquiries on professional rights (except for amateur rights) should be addressed to Mr. Gilbert Parker, William Morris Agency, 1325 Avenue of the Americas, New York, NY 10019; inquiries on translation rights should be addressed to Harcourt, Inc., Permissions Department, Orlando, FL 32887. The stock and amateur acting rights of *Tartuffe* are controlled exclusively by the Dramatists Play Service, Inc., 440 Park Avenue South, New York, NY. No amateur performance of the play may be given without obtaining in advance the written permission of the Dramatists Play Service, Inc., and paying the requisite fee.

Chapter 25 Page 233: From *The Poems of Phillis Wheatley* edited and with an introduction by Julian D. Mason, Jr. Copyright © 1966 by the University of North Carolina Press, renewed 1989. Used by permission of the publisher.

Chapter 27 Page 256: The English text of "Hymn to Joy" is a free translation by Louis Untermeyer. Copyright © 1952 by RCA Records. Reprinted by permission of RCA and Bryna Untermeyer. **Page 259:** Lovell, Ernest J., *Blessington's Conversations of Lord Byron.* Copyright © 1969 Princeton University Press, 1987 renewed PUP. Reprinted by permission of Princeton University Press. **Page 276:** Reprinted by permission of the publishers and the Trustees of Amherst College from *The Poems of Emily Dickinson,* Thomas H. Johnson, ed., Cambridge, Mass.: The Belknap Press of Harvard University Press. Copyright © 1951, 1955, 1979 by the President and Fellows of Harvard College.

Chapter 29 Page 321: "To a Passer-By" by Baudelaire, translated by C. F. MacIntyre from *100 Poems from Les Fleurs du Mal,* copyright © 1947 by University of California Press. Reprinted by permission of the publisher. **Page 321:** Charles Baudelaire, "Correspondences" from *Les Fleurs du Mal* translated by Wallace Fowlie, Bantam Books, 1963, 1964. Used by permission of the Estate of Wallace Fowlie. **Page 322:** "The Swan" by Charles Baudelaire, translated by Anthony Hecht. From the bilingual edition of *Baudelaire's Les Fleurs du Mal,* edited by Marthiel and Jackson Mathews, published by New Directions. **Page 323:** "Crowds," by Charles Baudelaire, translated by Louise Varese, from Paris Spleen, copyright © 1947 by New Directions Publishing Corp. Reprinted by permission of New Directions Publishing Corp. **Page 324:** From *Thus Spoke Zarathustra* by Frederick Nietzsche, translated by Walter Kaufmann, copyright © 1954, 1966 by The Viking Press, Inc. Used by permission of Viking Penguin, a division of Penguin Group (USA) Inc. **Page 326:** "Notes from Underground" from *Notes from Underground: A Norton Critical Edition* by Fyodor Dostoevsky, translated by Michael R. Katz. Copyright © 1989 by W.W. Norton & Company, Inc. Used by permission of W. W. Norton & Company, Inc.

Index